THE GREAT
CONTEMPORARY
ISSUES

# THE ARTS

# THE GREAT
# CONTEMPORARY
# ISSUES

## OTHER BOOKS IN THE SERIES

DRUGS
  *Introduction by J. Anthony Lukas*
THE MASS MEDIA AND POLITICS
  *Introduction by Walter Cronkite*
CHINA
  O. Edmund Clubb, *Advisory Editor*
LABOR AND MANAGEMENT
  Richard B. Morris, *Advisory Editor*
WOMEN: THEIR CHANGING ROLES
  Elizabeth Janeway, *Advisory Editor*
BLACK AFRICA
  Hollis Lynch, *Advisory Editor*
EDUCATION U.S.A.
  James Cass, *Advisory Editor*
VALUES AMERICANS LIVE BY
  Garry Wills, *Advisory Editor*
CRIME AND JUSTICE
  Ramsey Clark, *Advisory Editor*
JAPAN
  Edwin O. Reischauer, *Advisory Editor*
THE PRESIDENCY
  George E. Reedy, *Advisory Editor*
POPULAR CULTURE
  David Manning White, *Advisory Editor*
FOOD AND POPULATION: THE WORLD IN CRISIS
  George S. McGovern, *Advisory Editor*
THE U.S. AND THE WORLD ECONOMY
  Leonard Silk, *Advisory Editor*
SCIENCE IN THE TWENTIETH CENTURY
  Walter Sullivan, *Advisory Editor*
THE MIDDLE EAST
  John C. Campbell, *Advisory Editor*
THE CITIES
  Richard C. Wade, *Advisory Editor*
MEDICINE AND HEALTH CARE
  Saul Jarcho, *Advisory Editor*
LOYALTY AND SECURITY IN A DEMOCRATIC STATE
  Richard Rovere, *Advisory Editor*
RELIGION IN AMERICA
  Gillian Lindt, *Advisory Editor*
POLITICAL PARTIES
  William E. Leuchtenburg, *Advisory Editor*
ETHNIC GROUPS IN AMERICAN LIFE
  James P. Shenton, *Advisory Editor*

THE GREAT
CONTEMPORARY
ISSUES

# THE ARTS

𝕮𝖍𝖊 𝕹𝖊𝖜 𝖄𝖔𝖗𝖐 𝕿𝖎𝖒𝖊𝖘

**ARNO PRESS**
**NEW YORK/ 1978**

**RICHARD McLANATHAN**
*Advisory Editor*

**GENE BROWN**
*Editor*

**Library of Congress Cataloging in Publication Data**

Main entry under title:

The Arts.

(The Great contemporary issues)
Bibliography.
Includes index.
1. Arts, American—Addresses, essays, lectures.
2. Arts, Modern—20th century—United States—
Addresses, essays, lectures. I. McLanathan,
Richard B. K. II. Brown, Gene. III. New York
times. IV. Series.
NX504. A857     700'.973     78-2846
ISBN 0-405-11153-3

Manufactured in the United States of America

The editors express special thanks to The Associated Press,
United Press International, and Reuters for permission to
include in this series of books a number of dispatches originally
distributed by those news services.

Book design by Stephanie Rhodes

# Contents

# Publisher's Note About the Series

It would take even an accomplished speed-reader, moving at full throttle, some three and a half solid hours a day to work his way through all the news The New York Times prints. The sad irony, of course, is that even such indefatigable devotion to life's carnival would scarcely assure a decent understanding of what it was really all about. For even the most dutiful reader might easily overlook an occasional long-range trend of importance, or perhaps some of the fragile, elusive relationships between events that sometimes turn out to be more significant than the events themselves.

This is why "The Great Contemporary Issues" was created—to help make sense out of some of the major forces and counterforces at large in today's world. The philosophical conviction behind the series is a simple one: that the past not only can illuminate the present but must. ("Continuity with the past," declared Oliver Wendell Holmes, "is a necessity, not a duty.") Each book in the series, therefore has as its subject some central issue of our time that needs to be viewed in the context of its antecedents if it is to be fully understood. By showing, through a substantial selection of contemporary accounts from The New York Times, the evolution of a subject and its significance, each book in the series offers a perspective that is available in no other way. For while most books on contemporary affairs specialize, for excellent reasons, in predigested facts and neatly drawn conclusions, the books in this series allow the reader to draw his own conclusions on the basis of the facts as they appeared at virtually the moment of their occurrence. This is not to argue that there is no place for events recollected in tranquility; it is simply to say that when fresh, raw truths are allowed to speak for themselves, some quite distinct values often emerge.

For this reason, most of the articles in "The Great Contemporary Issues" are reprinted in their entirety, even in those cases where portions are not central to a given book's theme. Editing has been done only rarely, and in all such cases it is clearly indicated. (Such an excision occasionally occurs, for example, in the case of a Presidential State of the Union Message, where only brief portions are germane to a particular volume, and in the case of some names, where for legal reasons or reasons of taste it is preferable not to republish specific identifications.) Similarly, typographical errors, where they occur, have been allowed to stand as originally printed.

"The Great Contemporary Issues" inevitably encompasses a substantial amount of history. In order to explore their subjects fully, some of the books go back a century or more. Yet their fundamental theme is not the past but the present. In this series the past is of significance insofar as it suggests how we got where we are today. These books, therefore, do not always treat a subject in a purely chronological way. Rather, their material is arranged to point up trends and interrelationships that the editors believe are more illuminating than a chronological listing would be.

"The Great Contemporary Issues" series will ultimately constitute an encyclopedic library of today's major issues. Long before editorial work on the first volume had even begun, some fifty specific titles had already been either scheduled for definite publication or listed as candidates. Since then, events have prompted the inclusion of a number of additional titles, and the editors are, moreover, alert not only for new issues as they emerge but also for issues whose development may call for the publication of sequel volumes. We will, of course, also welcome readers' suggestions for future topics.

# Introduction

The last century of American art is characterized by an increasing stylistic variety in all creative fields, and is punctuated by certain artistic events whose impact on their development was crucial. The Civil War had not only torn the nation apart, but had also changed America from an agricultural and trading country to a predominantly industrialized state, setting off a social as well as an economic revolution in the process. The Greek Revival had become a national style in antebellum architecture, and revivalism continued after the war to produce the charming fantasies of Andrew Jackson Downing and Alexander Jackson Davis, largely in domestic building, and those of James Renwick, whose Gothic Revival, St. Patrick's Cathedral, in New York, and medievalizing Smithsonian Institution in Washington are landmarks of architectural romanticism.

Growing industrialism produced a pride of new millionaires who sought legitimacy by collecting art, almost entirely the prizewinning academic works from European salons, then admired and now largely forgotten, and by building elaborate palaces on Fifth Avenue and at Newport, designed for the most part by Richard Morris Hunt and his successors at the famous firm of McKim, Mead, and White. It was an era of rampant materialism described by Mark Twain and Charles Dudley Warner as the "Gilded Age," and gilded it was, though far from golden. Many artists, like Mary Cassatt, James A. McNeill Whistler, and the novelist, Henry James, sought sanctuary in Europe. Others, like Winslow Homer, Thomas Eakins, and Albert P. Ryder, withdrew into themselves and continued careers of serious and lasting achievement regardless of what went on in fashionable circles.

It was not the commissions of the nouveaux riches which influenced the future of American architecture any more than their taste in painting and sculpture with its predominantly European and academic bias. It was the admirable career of Henry Hobson Richardson which presaged the future, especially in such works as the Marshall Field Wholesale Warehouse built in 1885-87. Occupying an entire business block in downtown Chicago, its extreme simplicity and the ruggedness of its masonry anticipated the revolutionary concepts of Louis Sullivan and his successor, Frank Lloyd Wright. The important project of Trinity Church on Copley Square in Boston, carried out in the early 1870s, with the collaboration of painters led by John La Farge and of sculptors led by Augustus Saint-Gaudens, made Richardson's reputation and established him as a pioneer of architectural modernism. But it was the Marshall Field Store that made it inevitable that the architectural leadership of the country move westward to Chicago with the development of the skyscraper.

The year 1900 passed quietly, with little to suggest that a revolution in the arts was soon to break out. The fashionable style in painting was a rather pale impressionism as practiced by Theodore Robinson, John H. Twachtman, and Childe Hassam, though the three giants of American painting were still hard at work. Several of Homer's most epic seascapes were yet to come. Eakins was painting some of his most perceptive portraits, including the *Self-Portrait* in the National Academy. Ryder did not complete his unforget-

table *Death on a Pale Horse* until 1910. Whistler continued his colorful career at a safe distance, in London. John Singer Sargeant was busy with as many portrait commissions as he could handle on both sides of the Atlantic, yet found time to paint dozens of watercolors in the fresh and breezy style that belied his skillful control of this difficult medium.

Architecture during these years generally followed the example of the World's Columbian Exposition of 1893 whose endless files of classical columns and infinite perspectives of dazzlingly white classical structures built along Chicago's lake front were designed by a team headed by Richard Morris Hunt, Daniel Burnham, and others, while Frederick Law Olmsted was responsible for the landscaping. But there were other forces at work in Chicago. The partnership of Louis Sullivan with an experienced engineer, Dankmar Adler, completed the Auditorium Building in 1889 in a rugged style reminiscent of Richardson. By 1895 Sullivan's finest skyscraper, the Guaranty Building in Buffalo was completed, and by 1899 his Carson, Pirie, Scott and Company's building, perhaps his finest large-scale design, was under construction on the southeast corner of State and Madison, and the leadership of the Chicago school was assured.

Though a veritable army of artists was assembled for the Columbian Exposition, Augustus Saint-Gaudens and Daniel Chester French led the sculptors, and Mary Cassatt, John La Farge, Elihu Vedder and Kenyon Cox were outstanding among the painters. The White City, as the Exposition was called, led to several decades of classical dominance in architecture. In the meantime, however, Sullivan was pioneering in the direction the future was to follow.

The five year period from 1908 to 1912 was a turning point in the cultural life of America. In the late fall of 1908 an exhibition called "Eight American Painters" opened at the Macbeth Gallery in New York. William Macbeth was convinced that there was more interesting work being done in America than that shown at the annual exhibitions of the conservative National Academy. He asked Arthur B. Davies, an artist friend, to exhibit, and also to choose pictures by others which were in his opinion worthy of exhibition, but which were not included in the Academy's annual. The result was what was known thereafter as "The Eight."

To any knowledgeable European observer their paintings would have appeared old-fashioned, but except for the few artists who had been working abroad, Americans, in general, were unaware of the experiments of Cezanne, Van Gogh, and others, so soon to be superseded by the Cubism of Braque and Picasso. Among The Eight was Robert Henri, the leader of a group of artists experienced as newspaper illustrators, including William Glackens, John Sloan, George Luks, and Everett Shinn, all of whom exhibited. Ernest Lawson, another of The Eight, had seen the work of the Impressionists in Paris, and his own style reflected that experience. Maurice Prendergast, the last of the group, was an older man who had several years' experience abroad. Davies himself painted in a dreamlike, romantic mode which belied the revolutionary part he was to play.

The resulting exhibition would seem far from shocking today, and it is difficult to understand the outrage with which it was greeted. Davies' and Prendergast's contributions were visionary and idyllic. Lawson's canvasses gave poetic glimpses of land - and cityscape. It was the subject matter of Henri and his group which caused the label, Ash Can School, to be applied indiscriminately to the whole. Because of their previous experience as illustrators, they painted scenes of everyday life with gusto and close observation in much the same spirit as shown in the short stories of O. Henry and the novels of Theodore Dreiser and Frank Norris. Because the subjects were not idealized, they were considered vulgar, and roundly condemned.

Davies was also the leading spirit in organizing the Armory Show four years later. A perceptive connoisseur of the various aspects of modernism then unfolding in Europe, he was determined that

Americans have the opportunity to see all that had gone on in recent years. In 1912 he and Walt Kuhn, who had started out as a cartoonist and is best known for his paintings of circus performers, went off to Europe in search of painting and sculpture to be shown at the 69th Regiment Armory on Lexington Avenue between 25th and 26th Streets in the winter of the next year. They visited galleries and collectors, including Gertrude Stein, and the studios of dozens of artists, and selected a large group of contemporary works including examples of almost all of the avant-garde from Cezanne and Rodin to Marcel Duchamps' *Nude Descending a Staircase* which became the single best known and most criticized work in the show. Kuhn predicted that the resulting exhibition would be a "bombshell" and he was right.

At the opening on February 17th, 1913, the four thousand guests viewed with feelings ranging from outrage to admiration, the most important art exhibition ever staged in America. Within the framework of a single exhibit, Americans were brought forcibly up to date on all that had been going on in Europe, from Impressionism through the Fauves to Cubism, Pointillism, Expressionism, Surrealism, and the latest non-objective experiments. Where the Macbeth showing of The Eight represented a revolution in subject through an essentially realistic, reportorial view of the world, the Armory Show signalized a revolution in the very idea and ideal of what art was and could be. It was a watershed between eras. As the *New York Globe* reported to its readers the next day, "American art will never be the same again."

Another significant force for the future was exerted by such dedicated connoisseurs as the sculptor Gertrude Vanderbilt Whitney, whose Whitney Studio Club evolved into the Whitney Museum of American Art, and who gave help and encouragement to many a struggling artist. The irascible photographer, Alfred Steiglitz, was another. In his small galleries, first at 291 Fifth Avenue, later in the Intimate Gallery, and then at An American Place, farther uptown, he provided a showcase for the avant-grade. There he exhibited the paintings of Arthur Dove, Marsden Hartley, Charles Demuth, John Marin, and Georgia O'Keeffe, whom he later married. He showed Rodin drawings, Cezanne watercolors, and sculptures by Matisse and Brancusi, and also photographs by Clarence White, Gertrude Kasabier, Paul Strand, Edward Steichen, and others, as well as his own classic prints.

The disruption of the First World War, which brought Marcel Duchamps and a number of other European artists to America, was followed by the political corruption, gang wars, bootlegging and speakeasies of the "Jazz Age." The Twenties produced John Held's flapper and her coon-coated collegiate escort who frequently appeared in the original *Life* magazine. It was the era of *The Great Gatsby,* of Charlie Chaplin's brilliant *Gold Rush,* and George Gershwin's *Rhapsody in Blue,* of the development of the musical comedy from vaudeville, variety, and jazz. Hybrid though it may be as an art form, musical comedy has flourished in America, providing a medium for some of our most gifted writers and composers, among them George S. Kauffman, Richard Rogers, Oscar Hammerstein, and Cole Porter, and producing such classic musicals as *Of Thee I Sing, Oklahoma,* and *Camelot.*

The Twenties are called the "Jazz Age." Popular music flourished, Duke Ellington, Earl Hines, Louis Armstrong, and many others became celebrities, and the rhythms of New Orleans, Memphis, Chicago, and Harlem became the tempo of America. In the Thirties, the big bands of Paul Whiteman, Benny Goodman, Artie Shaw, Harry James, Glen Gray, Glenn Miller, and many others attracted tens of thousands to dance halls across the country with their rich sound and danceable rhythms. Their recordings sold widely, and by means of radio they reached an even larger and growing public.

In 1927 the first talking picture, *The Jazz Singer,* appeared starring Al Jolson. Cinema had made great strides since that first film with any sort of plot or continuity, *The Great Train Robbery,*

was produced by the Edison Studio in 1903. By the Twenties, the name of Hollywood had come to mean moving pictures, the gaudy and tinseled dream world inhabited by the beautiful, the glamorous, and the rich, whose every move seemed larger than life and constantly newsworthy, no matter how trivial. The star system created dozens of popular heros and heroines whose costume and lifestyle set standards which were influential throughout the nation. But it also produced the zany humor of the Keystone Kops, Buster Keaton, the Marx brothers, the incomparable Charlie Chaplin, and many others.

As others had done earlier, many sought to escape the brashness of America during the Twenties by settling in Europe, among them were the poets T. S. Eliot, whose *The Waste Land* (1922) was a landmark in American literature and English verse, and Ezra Pound, whose *Cantos* were profoundly influential. Paris was a popular refuge. There, Ernest Hemingway, F. Scott Fitzgerald, and many other aspiring American writers might be seen in earnest discussion at cafe tables, or found in the congenial atmosphere of the book store, Shakespeare & Co., which was a popular meeting place for artists and writers. At home, in the meantime, Eugene O'Neill, Marc Connelly, and Thornton Wilder were making their mark in American theater, as was Virgil Thompson in music.

In the Depression year of 1929, the Museum of Modern Art appeared on the scene to become, under the leadership of Alfred Barr, an almost instant arbiter of taste through its exhibition of contemporary and recent experiments in the arts. Never again were Americans to be as ignorant of the latest trends in the arts as they were before the Armory Show. But American artists followed their own paths. Charles Sheeler first photographed, then painted, the new industrial cityscape with immense factories and skyscrapers. Joseph Stella recreated on canvas *The Bridge* much as it was celebrated in the poem of that name by Hart Crane. The photographs of Berenice Abbott and Walker

Evans and the austere paintings of Edward Hopper paralleled the cool record of the appearance of things in an industrialized America. Louis Hine, Ben Shahn (who later turned to painting), and other photographers, recorded the America of the Depression, the bread lines, the violence of the growing labor movement, the rural hopelessness and stubborn battle against odds of the Okies, the immigrants, the sharecroppers and the factory workers; the underdogs memorialized by John Steinbeck.

In reaction to the disturbances in the west of the world, American artists turned increasingly to their own heritage for inspiration. Thomas Hart Benton swore off all European experiments as "Cock-eyed isms" and spent the rest of his life painting the people and the landscape of his native Missouri in a naturalistic style owing something to the Baroque. John Steuart Curry produced expansive landscapes of the fertile fields and the agrarian life of the Great Plains. Of him, the critic Edward Alden Jewell wrote, "Kansas has found her Homer." Grant Wood painted the legends of a more innocent age, such as *Parson Weems' Fable* showing a youthful George Washington having just cut down the legendary cherry tree, and recorded with sharp satire the narrowmindedness and smug self-satisfaction of middle-class Americans.

Writers also felt the impact of regionalism. It infused the poetry of Carl Sandburg, Vachel Lindsay, Edgar Lee Masters, and Robert Frost, and the novels of Sherwood Anderson, Sinclair Lewis, John Steinbeck, William Saroyan, and William Faulkner. As had Edward MacDowell earlier, Charles Ives used traditional themes in his complex and powerful compositions which have only recently begun to be appreciated. Exhibitions of primitive art by Steiglitz and by the Museum of Modern Art called the attention of a growing audience to the relation to the contemporary avant-garde of the arts of people formerly considered as little more than savages. The museum's photographic exhibitions, often chosen by Edward Steichen, himself a great photographer, established the medium as an art form. Charles Sheeler and

Paul Strand, a photographer, displayed their shared Whitmanesque vision in the documentary-styled moving picture they called *Mannahatta* which they produced in 1921. Amidst a spate of experimental films, Pare Lorenz's *The River* (1937), created for the Farm Security Administration, and with a score by Virgil Thompson, stood out as having captured in another medium, the epic quality sought by such earlier artists as the landscapists Thomas Cole and Frederic Church.

The Twenties saw the rediscovery of the American past which, in turn, led to the discovery as art, of the traditional folk arts in America with their various ethnic backgrounds. The collection of the sculptor Elie Nadelman became the nucleus of the Abby Aldrich Rockefeller collection, now at Williamsburg, the first among several other such collections. *The Index of American Design,* a Works Progress Administration project involving dozens of artists throughout the country, served to document the richness of this field. There was a revival of interest in classic American literature with an accompanying revaluation of, as well as an interest in, folklore and regional traditions. Vernon Parrington's study of the *Main Currents in American Thought* was almost completed at his death in 1929, while Van Wyck Brooks' interpretive essays on American literature followed.

The Thirties felt the impact of the powerful paintings of the Mexican muralists, Diego Rivera, José Orozco, and David Sequeiros in celebration of their revolution, who by their example gave a sharper edge to the work of a growing number of artists registering their protests against the inequities of the Depression years. The Federal Arts Project of the Works Progress Administration enlisted the skills of hundreds of artists, actors, writers, photographers, and musicians, and brought them to the attention of a public hungry for the arts in a period of bleakness and discontent. Yet in 1939 the United States Congress, despite the impassioned pleas of artists and cultural leaders, refused to vote on the Fine Arts Bill which would have given government a continuing role in the development of the nation's creative resources. It was not until the Sixties that Congress created the National Endowments for the Arts and the Humanities.

America's artists viewed with horror the growing strength of Fascism in Italy and of Nazism in Germany, Japan's brutal invasion of China, the civil war in Spain, and finally Hitler's blitzkrieg on Poland and the start of a second and more dreadful world war. To demonstrate their concern, they convened the First Artists' Congress in New York in 1936 to express their patriotism and their liberal convictions. Many Europeans fled to America. Among them were the architects Mies van der Rohe and Walter Gropius who applied the ideals of the Bauhaus to American design, the painters Josef Albers and Hans Hoffmann who became influential reachers, Naum Gabo the Constructivist sculptor, and many others. From this point on, there was an increasing internationalization of the arts in America.

Also of great significance was the presence in America of the brilliant Russian choreographer, George Balanchine. Bringing with him the knowledge and tradition of the Russian ballet, and with the backing of Lincoln Kirstein, he did much to establish the leadership of America in the dance. Isadora Duncan, Ruth St. Denis, and Martha Graham, and others made remarkable contributions also. The result of this flowering of ballet in America was to make it, not a static art form as in the Soviet Union, where the classic choreography of Petipa still rules but to keep it dynamic and evolving, thus attracting such superb dancers as Nureyev and Baryshnikov from Russia to join American dance groups.

Despite the social unrest and the hardships of the Depression years, the nation's creative life went on. Charlie Chaplin completed *Shoulder Arms* in 1931, using a musical score instead of the recent invention of the talkies. It portrayed Everyman at war, and its mixture of pathos and comedy "moves like a drumroll," as Jean Cocteau remarked. The Harlem renaissance of the Twenties and Thirties produced not only music but also writing

which culminated in Richard Wright's harrowing *Native Son* in 1940. Jacob Lawrence's *Migration of the Negro* series, painted as a Federal Arts project, gave powerful expression to the tragic course of black history in America. In 1936 Gershwin wrote *Porgy and Bess,* treating a black subject in a style deeply influenced by jazz, itself a black contribution to American culture. The abstract and colorful paintings of Stuart Davis, a pupil of Henri, reflected the popular music of the Twenties and Thirties, often having the clear definition and patterned control of a Scott Joplin piano rag.

*The Dial,* which moved its headquarters from Chicago to New York in 1916, shared the position of the leading art journal of the Twenties with *The Arts,* which had been established by Hamilton Easter Field in 1920, with the backing of Mrs. Whitney and with the editorship of Forbes Watson. In the pages of *The Dial* as well as in a number of other periodicals, the critic Henry McBride wrote his illuminating and good-humored observations of the contemporary art scene which bear reading today as particularly perspicacious. From 1925 on, Harold Ross' *New Yorker,* "the semi-official organ of sophistication," as Gilbert Seldes called it, carried informed commentaries on the creative life of the city. Its pages were enlivened by the witty drawings of Peter Arno, James Thurber, and others whose work also often appeared in *Vanity Fair.*

The foundation in 1936 of the Society of Abstract Artists showed a reawakening of interest in the experimental frontiers of modernism, under the influence of such European masters as Picasso, Miro, Arp, and Braque. The reaction from realism increased during and after the Second World War and reached a climax in the Forties and during the middle years of the century with the emergence of a group of painters in New York which came to be called the New York School. The movement, also called Action Painting and Abstract Expressionism, was short-lived and transitional. The group of artists so described did not really form a school any more than did The Eight. They happened to be in the same place at the same time, to be influenced by similar motivations, particularly by the automatism of Surrealism to regard the process of painting as the primary factor, the completed work valued basically as the record of the creative act.

Jackson Pollock, with his rhythmic swirls and interlaces of color, reminiscent of Merce Cunningham's modern dance, was a leader of the movement. Like Pollock, Willem de Kooning and Franz Kline were also action painters. Robert Motherwell, Clifford Still, and Mark Rothko are other members of the New York School. Still's colossal canvasses relate his work both to environmental art and to minimal sculpture in its drastic reduction, while Robert Rauschenberg's assemblages of cloth, paper, automobile tires, and all sorts of other ingredients, with visual metaphor and echoes of concrete poetry, suggest the significance of the found object in the evolution of modern art. Such works are neither paintings nor sculptures, but combine elements of both. When movement was added, following the lead of Alexander Calder's famous mobiles, the major elements of a happening coalesced, with its affinities to the Theater of the Absurd, to Dadaist meaninglessness, to the random principle of aleatory music of the composer John Cage, and the deliberate disregard of purpose of an Andy Warhol moving picture.

From the brief and imperfect synthesis of Abstract Expressionism emerged the diversity of the contemporary art scene, by way of Pop Art, with its satiric emphasis on banal elements of material culture, Op Art, color field painting, the new realism, and all the rest. At the same time the old masters of the period continued in their accustomed ways, producing admirable works in a style untouched by the compulsive drive to innovation which seems a major motivating force in today's creative world. Throughout a long career Edward Hopper continued to depict the austerities of America, while Mark Tobey in what he called "white writing," played variations on natural themes in calligraphic compositions in the spirit of Oriental art, and Charles Burchfield portrayed haunted scenes of farm and

village, with delapidated houses and barns, and of fields and woods, animated alike by invisible forces of nature to become a numinous world suggestive of Walt Disney's filmed fantasies. Calder continued to grow in his art throughout a long life, proving to be perhaps, the leading monumental sculptor of the period, while David Smith's nonobjective abstractions in steel, his Tanktotems of the late Fifties and Cubi series of the Sixties, have a harsh and uncompromising presence.

As a result of the years of experiment and of pursuit of novelty, the boundaries between the various art forms have broken down. Painting merges with sculpture, and both with theater. Architecture is becoming romanticized again, with echoes of period styles breaking the monotony of the standard skyscraper. Some of the most impressive architectural monuments have been created by engineers, the Golden Gate and Verrazano Bridges, Buckminster Fuller's geodesic domes, and the immense grain elevators rising like cathedrals from the western plains, "the magnificent firsts of the new age," as the Swiss architect and critic called them. Architectural fancy flies yet further with Paolo Solari's underground dwellings, such as the troglidytic villages in Spain, and his man-made, habitable asteroids. Instant communication has shrunk the size of the world so that creative minds can momentarily interact across great distances. Artists everywhere and of all persuasions and mediums, freed from what Clifford Still has called "the banal concepts of space and time," pursue the journey into the future each "one must make, walking straight and alone."

**Richard McLanathan**

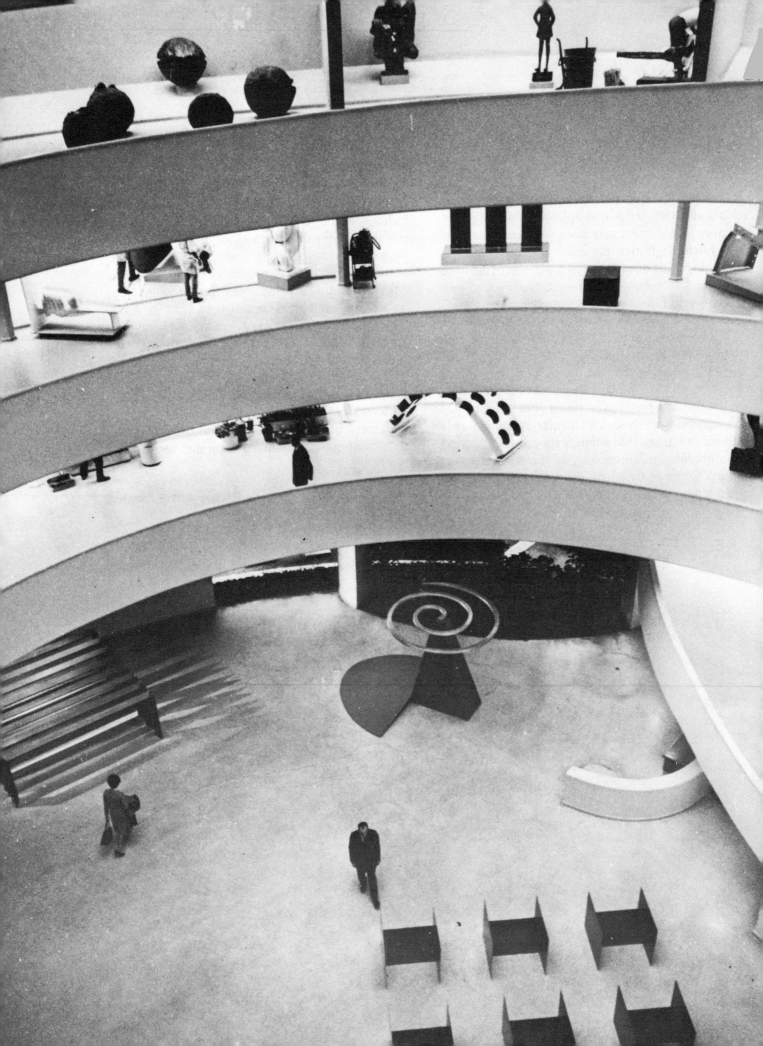

# The Visual Arts

An interior view of the Guggenheim Museum
in New York City. The spiral shaped mobile
on the ground floor is by Alexander Calder.

*Robert Walker/NYT Pictures*

# EIGHT ARTISTS JOIN IN AN EXHIBITION

## Davies, Glackens, Henri, Lawson, Luks, Prendergast, Shinn, and Sloan Combine.

## SOME FINE LANDSCAPES

### "Swimming Hole" and "Abandoned Farm" Among the Notable Canvases Shown.

In the Macbeth Galleries, 450 Fifth Avenue, may be seen at present the work of eight men who have banded together for exhibition purposes. The painters represented are Arthur B. Davies, William J. Glackens, Robert Henri, Ernest Lawson, George Luks, Maurice B. Prendergast, Everett Shinn, and John Sloan. The showing made by their paintings is both varied and surprising. With the exception, perhaps of Prendergast, the pictures reveal little that is new in direction or treatment to that with which the knowing in art have become familiar.

Everett Shinn is here represented by eight paintings variously called "Galété, Montparnassi," "Rehearsal of the Ballet," "The White Ballet," "Leader of the Orchestra," "The Gingerbread Man," "The Orchestra Pit," "Girl in Blue," "The Hippodrome, London."

Ernest Lawson, the landscape painter, contributes four canvases in his most characteristic manner, called "Swimming Hole," "Abandoned Farm," "Early Summer," and "Floating Ice."

John Sloan shows seven pictures of New York scenes representing "Easter Eve," "Hairdresser's Window, Sixth Avenue," "The Cot," "Sixth Avenue and Thirtieth Street, 1907," "Election Night," "Nurse Girls, Spring," and "Moving Pictures, Five Cents."

Maurice B. Prendergast is represented by seventeen small canvases, ten of which are either studies or subjects in and about St. Malo, while the others are entitled "Drépuscle," "Young Girls at Play," "Bathing," "Corner of the Village," "The Park," "Decorative Study," and "The Tower."

George Luks shows six paintings, of which three are quite new, being painted last Summer and Fall. They are presentations of his favorite subjects, such as "The Duchess," "Macaws," "Street Scenes," "Pigs," "The Pet Goose," "Mammy Groody."

Robert Henri contributes nine recently finished canvases, most of which are the result of his last Summer's trip to Holland, which finds its expression in the "Dutch Girl," "The Dutch Soldier," "The Laughing Child," "Little Girl in White Apron," and "Portrait of a Girl." Besides these he shows "A Fisherman," "Spain," and "Coast of Monhegan, Me."

William J. Glackens exhibits his Carnegie prize winner, "At Mouquin's," now properly shown for the first time in New York; also his "Coasting, Central Park," "The Shoppers," "Gray Day, Central Park," "Brighton Beach Race Track," "Bues Retiro," Madrid."

Arthur B. Davies shows six landscapes, with figures and without, in his familiar vein. He calls them "Many Waters," "Autumn Bower," "Across the Bay," "Seawind and Sea," "A Mighty Forest—Maenads," and "Girdle of Arcs."

The exhibition will continue until Feb. 15, and will be carefully reviewed in a later issue.

February 6, 1908

---

# FUTURISTS CONDEMN NUDITY IN PAINTING

## Men Who Urged Factories Instead of Palaces for Venice Issue Another Manifesto

## FORMULATE NEW ART CREED

### Portrait Should Not Resemble Its Model; Landscape Should Be Imaginary—Space No Longer Exists.

From the office of Poesia, "Moteur du Futurisme," at Milan, has come another of those surprising Futurist manifestoes that, if they are nothing else, are at any rate suggestive and interesting.

This manifesto is rather more definite than its predecessors, in that it formulates a more or less understandable programme and expresses some new theories in reward to pictorial art. It is signed by five artists—Umberto Boccloni, Carlo D. Cara, and Luigi Russolo of Milan; Giacomo Balla of Rome, and Gino Severini of Paris.

The manifesto begins by referring to the first declaration of the Futurists, "hurled at the public" from the stage of the Chiarella Theatre at Turin in March, 1910. It will be remembered that the Futurists, among other things, demanded that Venice be turned into a city of factories and declared that factory chimneys were more beautiful that quattrocento palaces.

"The fight at Turin," says the new manifesto, "has become legendary. We exchanged almost as many blows as ideas in our struggle to rescue from a miserable death the genius of Italian art. It was a fierce and formidable struggle, and during this momentary truce we come forward to explain as untechnically as possible what we meant by futurism in painting, though at our exhibition at Milan we have already given a practical demonstration."

The manifesto proceeds to formulate a new art creed.

"Our growing art," it says, "can no longer be satisfied with form and color: what we wish to produce on canvas will no longer be one fixed instant of universal dynamism; it will simply be the dynamic sensation itself.

"Everything is movement, transformation. A profile is never motionless, but is constantly varying. Objects in movement multiply themselves, become deformed in pursuing each other, like hurried vibrations. For instance, a runaway horse has not four legs, but twenty, and their movement is triangular. In art all is conventional, nothing is absolute. That which yesterday was a truth to-day is nothing but a lie.

"We declare, for instance, that a portrait must not resemble its model and that a painter must draw from his own inspiration the landscape he wishes to fix on canvas. To paint a human face one must not only reproduce the features, but also the surrounding atmosphere.

"Space no longer exists; in fact, the pavement of a street soaked by rain beneath the dazzle of electric lamps grows immensely hollow down to the centre of the earth.

"Thousands of miles divide us from the sun, but that does not prevent the house before us being incased in the solar disk.

"Who can believe in the opaqueness of bodies since our sensibilities have become sharpened and multiplied through the obscure manifestations of mediumnity?

"Why do we forget in our creations the doubled power of our sight with its scope of vision almost equal in power to that of X rays?

"It will be enough to quote a few of the innumerable examples which prove our statements.

"The sixteen persons around you in a tramcar are by turn and at one and the same time one, ten, four, three, they are motionless yet change places; they come and go, are abruptly devoured by the sun, yet all the time are sitting before us and could serve as symbols of universal vibration. How often, while talking to a friend do we see on his cheek the reflection of the horse passing far off at the top of the street. Our bodies enter the sofa on which we sit and the sofa becomes part of our body. The tramway is engulfed in the houses it passes and the houses rush on the tramway and melt with it. The construction of pictures has hitherto been stupidly conventional. The painters have always depicted the objects and persons as being in front of us. Henceforth the spectator will be in the centre of the picture. In all domains of the human spirit a clearsighted, individual inquiry has swept away the obscurities of dogma. So also the life-giving tide of science must free painting from the bonds of acedemical tradition. We must be born again. Has not science disowned her past in order better to satisfy the material needs of our day? So must art deny her past in order to satisfy our modern intellectual needs.

"To our renewed consciousness man is no longer the centre of universal life. The suffering of a man is as interesting in our eyes as the pain of an electric lamp which suffers with spasmodic starts and shrieks, with the most heart-rending expressions of color. The harmony of the lines and folds of a contemporary costume exercises on our sensibility the same stirring and symbolic power as nudity did to the ancients.

"To understand the beauties of a futurist picture the soul must be purified and the eye delivered from the veil of atavism and culture; go to nature and not to museums. When this result is obtained it will be perceived that brown has never circulated beneath our epidermis, that yellow shines in our flesh, that red flashes, and that green, blue, and violet dance there with voluptuous and winning graces. How can one still see pink in the human face, when our life doubled by nocturne life has multiplied our colorists' perceptions? The human face flashes of red, yellow, green, blue, and violet. The pallor of a woman gazing at a jeweler's shop window has rainbow hues more intense than the flashes of the jewels which fascinate her like a lark.

"Our ideas on painting can no longer be whispered, but must be sung and must ring on our canvases like triumphant fanfares. Our eyes, accustomed to twilight, will soon be dazzled by the full light of day. Our shadows will be more brilliant than the strongest light of our predecessors, and our pictures beside those in museums will shine as a blinding day compared to a gloomy night. We now conclude that now-a-days there can exist no painting without divisionism. It is not a question of a process which can be learned and applied freely. Divisionism for the modern painter must be inborn complementarism, which we declare to be essential and necessary.

"Our art will probably be accused of decadence or lunacy, but we shall simply answer that, on the contrary, we are primitives with quickened sensibilities, and that our art is spontaneous and powerful."

The futurists proceed to make the following "declaration":

That all forms of imitation must be despised and all forms of originality glorified;

That we must rebel against the tyranny of harmony and good taste, which could easily condemn the works of Rembrandt, Goya, and Rodin;

That art critics are useless or harmful;

That all worn-out subjects must be swept away, in order that we may have scope for the expression of our stormy life of steel, pride fever, and swiftness;

That the name of madmen with which they try to hamper innovators, shall hence-

2

forth be considered a title of honor;
That inborn complimentarism is an absolute necessity in painting as free verse in poetry and polyphony in music;
That universal dynamism must be rendered in painting as a dynamic sensation;
That above all sincerity and purity are required in the portrayal of nature;
That movement and light destroy the materiality of bodies.
"We fight," say the signers of the manifesto.
Against the bituminous colors with which one struggles to obtain the patin of time on modern pictures;

Against superficial and elementary archaism founded on flat uniform tints and which, imitating the linear manner of the Egyptians, reduces painting to an impotent childish and grotesque synthesis;
Against the false avenirism of secessionists and independents, who have installed new academies as traditional as the former ones;
Against nudity in painting as nauseous and tiring as adultery in literature
"Let us," the Futurists conclude, "explain this last question. There is nothing immoral in our eyes; it is the monotony of nudity that we fight against. It is

said subject is nothing, and all depends upon the way of treating it. Granted. We also admit it. But this truth which was unobjectionable and absolute fifty years ago is no longer so to-day, as to nudity, since painters beset by the longing to reproduce on canvas the bodies of their lady loves have transformed exhibitions into fairs of rotten hams! We require during the next ten years the total suppression of nudity in painting!"

August 20, 1911

# DECADE OF THE NEW ART MOVEMENT SHOWS BIG CHANGES

## Ten Years Ago Paul Cezanne Stood Alone, Now There Are a Dozen Rivals for Leadership in These Freak Schools— Matisse an Important Factor.

### By James Huneker.

TEN years ago I was present at the first varnishing day of the Autumn Salon in the Grand Palais des Châmps-Elysées, and a week ago I attended the tenth exhibition of all these young and mature Independents, Cubists, Futurists, Post-Impressionists, and other wild animals from the remotest jungles of Darkest Art, and I was able to estimate the progress made since the first function. Great has been the change. Whereas a decade ago the god of that time was Paul Cézanne, to-day there are a dozen rival claimants for the job, vying with one another in every form of extravagance, so as to catch the eye. Manet, Monet, Degas, Pissarro, Sisley were in the eyes of his admirers dethroned ten years ago by Cézanne; Paul Gauguin, Vincent Van Gogh; now it's Matisse, Picasso, Picabia, Van Dongen, to mention a few, who look upon the trio of Post-Impressionists as "old masters," and, to tell the truth, seem masters in comparison with the new crowd who have contemptuously pitched overboard everything that we oldsters consider as essentials in pictorial or plastic art.

Will they, too, be voted "played out" ten years hence? Is there a still profounder level of ugliness and repulsiveness and idiotic trickery, or has the lowest been reached?

To answer these questions one must not resort to the old argument as does a writer in the catalogue of the Autumn Salon, pointing out that Manet, Wagner, Ibsen, Maeterlinck, Rodin were voted incomprehensible. That is too easy. Even in the depths of un-

critical ignorance there were gleams of sympathy for the above mentioned men. At no period does a genius escape the notice of at least a few of his contemporaries. And in all the ruck and welter of the new movements there are a few men whose work will stand the test of time, and to-day shows mastery, originality, obscured as it may be by wilful eccentricities and occasional posturing to the gallery—a gallery, be it understood, composed of the gay young dogs who yawp in paint and screech themselves hoarse whenever a colleague cuts up infernal didoes. One of the "new" men I think will come to something is Henri Matisse.

I am not a prophet, though I listen to prophets. I met one ten years ago who had marched to the front with Edouard Manet, but has declined to go any further in the company of Paul Cézanne. For him the art of Cézanne was a distinct retrogression, and, recalling the stern admonition of Charles Baudelaire—truly a clairvoyant critic—who had warned Manet that he was the last of his line, en plein décadence, my painter friend pointed out to me that the camp followers of Cézanne, the sans culottes of art, the ragtag and bobtail regiment would end by disintegrating the elements of art, all beauty, nobility, line, color, would be sacrificed to a search for "truth," "decoration," and the "characteristic," said qualities being a new name for ugliness, ignorance, vulgarity.

"They want to do in a year what Cézanne couldn't accomplish in a lifetime," wailed my friend. "They are too lazy to master the grammar of

their art, and they take Cézanne as a model, forgetting that he, like Manet, had diligently practiced his scales for years before he began to play on canvas." And Henri Matisse? I asked. Well, perhaps Matisse was a "talent," but he had received a very sound education, and knew what he was about. If he choose to pitch his palette over the moon he must abide by the consequences. So Matisse, despite his fumèsterie, is admitted on all sides as worth while, though he is bitterly attacked for his volcanic outbursts and general deviations from the normal. But you can always tell a human figure of his from a cow, and the same can't be said of the extraordinary productions of Picasso or Picabia. The last is easily the worst.

### Extent of the Exhibitions.

The catalogue of the Tenth Autumn Salon shows the astonishing number of 1,770 works, which dose not include the 221 in the retrospective portrait exhibition, or several other minor exhibitions. Out of this formidable number there are few masterpieces, much sterile posing in paint, any quantity of mediocre talent, and in several salles devoted to the Cubists and others of the ilk any amount of mystification, charlatanry, and an occasional glimpse of individuality. The School of the Purple Calyx, as that eminently romantic landscapist, Robert van Boskerck, puts it, is in full flowering, and at times you don't know whether to laugh or weep. I am in sympathy with revolutionary movements in art, but now I know that my sympathies have reached their outermost verge.

I confess that I can't unravel the meanings of the Cubists, though I catch here and there a hint of their decorative quality, while shuddering at the hideous tonalities—strictly speaking there are no tonalities, only blocks of raw primary color juxtaposed with the childlike ingenuousness of the Assyrian mural decorations. Massive as is Matisse in his wall painting, he sets up no puerile riddles to be demolished by the critic. New formulas these young men have not invented. To recapture the "innocence of the eyes" they have naïvely gone back to the Greek frieze, to the figures on Greek vases, to Egyp-

3

tian tombs, to archaic bas-reliefs; they are desperate in their desire for the archaic. Picasso proudly asserted the other day that there are "no feet in nature," and some of his nudes seem to bear out this statement. Not to be natural, that is the new law. Not to represent, but interpret; not to show us the tangible, but the abstract. New mathematicians, seekers after a third dimension in paints, these young men must not be all set down as fakers. They are deliberately flouting the old conventions and missing thick butter on their daily bread. Sincere some of them are, apart from the usual wish, so dear to the budding students, of startling the bourgeois. And this same bourgeois goes to the exhibition and holds his sides with laughter, never buys a canvas, and disports himself generally as did his father before the pictures of M. Manet. Meanwhile some art dealers are sitting up and taking notice. Matisse sells, Chabaub sells, so does Van Dongen, and several others.

Such accomplished artists as Desvallières, 'D'Espagnat, Mme. Marval, Flandrin, Bonnard, Villéon, Frantz Jourdani, · Dezire, Picart-Ledoux, Albert André, Mlle. Charmy, Lucien Stoltz, Valloton, Maufra, Maxime Dethomas, and others do much to redeem the weariness aroused by the contemplation of the Cubist section, the galleries set aside for the "Searchers," as they are called. What of that terrifying "Woman in Blue"! What of "Mountaineers Attacked by Bears"! Matisse is not at his best, though, his work is comparatively clearer than last year. Those three flame-colored nudes dancing against a blue background are very rhythmic. They bring into relief a red bottle entwined with nasturtium leaves and flowers. A pail of blue water in which swim gold fish is decorative. However, I was slightly disappointed in this slim showing, only to be consoled later in London. Mme. Georgette Agutte presents a remarkable Japanese interior, very effective in both color and composition. Attractive are the plaster heads of Réne Carrière, who models the head of his mother with the same divining touch which his father manifested in his famous portraits of his wife.

Curiously enough, the clou of the collection was not to be found in the work of the younger men, but in the splendid retrospective exhibition of nineteenth century · portraiture, which, while it was incomplete, still atoned for the many gaps by some superb examples. One looked in vain for Prud'hon, (died in 1823,) for Gros, (died in 1835,) Géricault, the precursor of realism, who paved the way for Delacroix, and Courbet was missing. Boilly is insignificantly represented.

The head of George Sand by Delacroix is a sketch. Ingres is not seen at his best. Ary Scheffer is absent, (I shan't complain, though his "Laménais" at the Louvre is not) to be sneered at.) Cogniet, De Heim, Trufat, Couture, Emile Levy, Legros, Hebert, Winterhalter, Bastien-Lepage, where are they? No Monet. No Lenbach, Zorn, Kröyer, or Liebermann. But with these men absent, nevertheless there were com-

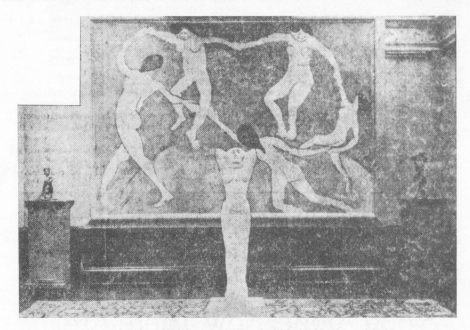

"The Dancers," by Henri Matisse

pensations. Such old favorites as Carrière's "Alphonse Daudet and His Daughter," a sketch of Col. Picard by the same painter, Aman Jean's portrait of Dampt the sculptor, Collet's figure of a girl in brown, Besnard's portrait of his family, a portrait by Courbet of a man in a red waistcoat, a Millet drawing, the head of a man by Fantin-Latour, Bonnat's "Renan"— which is a solid, sober portrait, still holding its own—our own John W. Alexander's portrait of a girl in white reading on a sofa, several Boldinis, and Raffaeli's portrait of his daughter. Huguetin, Baudry, Bracquemond, (the head of Edmond de Goncourt,) Cabanel, Breslau, three Cézannes, Mary Cassatt, Chapu, Chasseriau, Raphael Collin, two Corots, Cottet, Dalou, Daumier, David, David D'Angers, Degus, Delacroix, Delaroche, Dupré, Falquière, Paul Gauguin, Gerard, Henner, Manet, Monticelli, Renoir, Pissarro, Ribot, Ricard, Roty, John S. Sargent, Seurat, Toulouse-Lautrec, Vincent Van Gogh—the portrait of Père Tanguy, and that of his brother, both powerful presentations—Horace Vernet, Vibert, Vuillard, Zuloaga, Whistler— these are a few of the strangely jostling names that are to be found in this skillfully arranged exhibition. And it has proved the strongest attraction of the tenth Autumn Salon.

## II.

The Post-Impressionist Exhibition at the Grafton Galleries, London, is the second of the sort, and it will continue till the first of the year. There are British, French, and Russian groups. Two years ago the first show of the so-called Post-Impressionists— unhappy title!—scandalized and amused all London. Clive Bell says in the catalogue that the battle has been won, and to-day Cézanne, Gauguin, Van Gogh are the "old masters" of the

new movement. Roger Frey, well known to New York as art critic, is in charge and he tells us that the idea of the present exhibition is to show Post-Impressionism in its contemporary development not only in France, its native place, but in England, where it is of very recent growth, and in Russia, where it has liberated and revived an old native tradition.

"It would, of course," continues Mr. Frey, "have been possible to extend the geographical area immensely." Post-Impressionist schools are flourishing in Switzerland, Austro-Hungary, and most of all in Germany. In Italy, the Futurists have succeeded in developing a whole system of aesthetics out of a misapprehension of some of Picasso's recondite and difficult works. We have ceased to ask, "What does this picture represent?" and ask instead, "What does it make us feel?" We expect a work of plastic art to have more in common with a piece of music than with a colored photograph. These English artists are of the movement because in choice of subjects they recognize no authority but the truth that is in them; in choice of form, none but the need of expressing it. That is Post-Impressionism.

### Simplification a Shibboleth.

Simplification and plastic design are the shibboleths of the movement. Volume is far superior to "values," rhythm outweighs all linear design. For Mr. Bell "simplification" is obvious. A literary artist who wishes to express what he feels for a forest thinks himself under no obligation to give an account of its fauna and flora. (One recalls Mallarmé's "silent thunder in the leaves" at this juncture.) The Post-Impressionist claims similar privileges; those facts that any one can observe for himself or discover in a textbook he leaves to the makers of Christmas cards and diagrams. He simplifies, omits details, that is to say, to concentrate on something more important—on the signifi-

cance of form. We may regard an object solely as a means and feel emotion for it as such. It is possible to contemplate emotionally a coal scuttle as the friend of man. We can consider it in relation to the toes of the family circle and the paws of the watchdog. And, certainly, this emotion can be suggested in line and color. But the artist who could do so can but describe the coal scuttle and its patrons, trusting that its forms will remind the spectator of a moving situation. His description may interest, but at best it will move us far less than that of a capable writer. Yet most English painters have attempted nothing more serious. Their drawing and design have been merely descriptive; their art at best romantic. How, then, does the Post-Impressionist regard a coal scuttle? He regards it as an end in itself, as a significant form related on terms of equality with other significant forms. Thus have all great artists regarded objects. (The names of Vermeer or Chardin come to us in this regard.) Form and the relation of form have been for them not means of suggesting emotion, but objects of emotion. It is this emotion they have expressed. Their drawing and design have been plastic and not descriptive. That is the supreme virtue of modern French art: of nothing does English stand in greater need.

After visiting the Tate Gallery, that home of mediocrities, Mr. Bell's remarks about English art are not amiss. But in practice the English Cubists and Post-Impressionists do not bear out his hopeful words. "A Mother and Child," by Wyndham Lewis, may be at once a "simplification," but its plasticity of design is far to seek. With "The Dead Mole," by Etchells, it shares honors in the domain of the grotesque. A large wooden doll holding in its wooden-painted arms a wooden baby, to which

this wooden mother is giving ligneous nourishment from a wooden bust is as "emotional" as a basket of chips. As for "The Dead Mole," that will be a joy forever. It is so comical that all notion of an artistic formula is forgotten in what Henry James would call "the emotion of recognition." The looker-on recognizes the absolute imbecility of the design and smiles accordingly.

Mr. Fry declares that no such extreme abstraction marks the work of Matisse. He thinks that the feeling of opposition on the part of the public arises from a simple misunderstanding of what these artists set out to do. The difficulty springs from a deep-rooted conviction, due to long-established custom, that the aim of painting is the descriptive imitation of natural forms. Now, these artists do not seek to give what can, after all, be but a pale reflex of actual appearance, but to arouse the conviction of a new and definite reality. They do not seek to imitate form, but to create form; not to imitate life, but to find an equivalent for life. They wish to make images which by the clearness of their logical structure, and by their closely knit unity of texture, shall appeal to our disinterested and contemplative imagination with something of the same vividness as the things of actual life appeal to our practical activities. In fact, they aim not at illusion, but reality.

The logical extreme of such a method would undoubtedly be the attempts to give up all resemblance to natural form and to create a purely abstract language of form—a visual music, and the later works of Picasso show this

clearly enough. The actual objects which stimulated the creative inventions of Matisse are recognizable enough. But here, too, is an equivalence, not a likeness.

In opposition to Picasso, who is preeminently plastic, Matisse aims at convincing us of the reality of the forms by the continuity and flow of his rhythmic line, by the logic of his space relations, and, above all, by an entirely new use of color. In this, as in his markedly rhythmic design, he approaches more than any other European to the ideals of Chinese art. His word has to an extraordinary degree that decorative unity of design which distinguishes all the artists of this school.

Symbolists would be a better title for Matisse and his fellow-artists than the meaningless phrase Post-Impressionism, for despite Mr. Fry's belief that they aim at reality rather than illusion, they are essentially symbolists, and, like the Chinese, by a purely arbitrary line seek to express their idea of decoration. I once described music as "emotional mathematics," and Mr. Fry's "visual music" (have you ever read "The Piper of Dreams" in "Melomaniacs"?) is but emotional geometrizing. At the best, in the hands of a big man such experimenting is a dangerous thing; when employed as a working formula by lesser artists, such as Derani, Braque, Herbin, Marchand, L'Hote, Doucets, Asselm, and others, the results do not justify the means. Even Mr. Fry in his landscapes does not go too far; they wear a gentle air of the Italian Primitives. The portrait of his wife by Picasso did not shock me, for only the day before I had seen hanging in the National Gallery a head by Piero della Francesca, pure gold against a hard terra cotta background. The color contrasts of the new men.

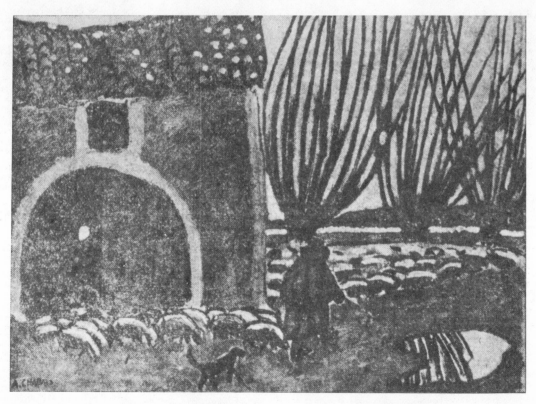

"Sheep Going to Graze After the Rain," by Auguste Chabaud.

while harsh as to modulation, do not offend the eye nearly so much as do those involved mosaics by the Cubists. What does Braque mean by his "Kubelik-Mozart" picture? Or Picasso's "Buffalo Bill"? "The Woman and the Mustard Pot" is emotional enough, for the unhappy creature is weeping, no doubt, because of the mustard in her eyes; certainly because of the mustard smeared over her dress. A pungent design, indeed.

Matisse is at his best—also at his most terrific. One nude sits on a chair drying herself with a bath towel. You look another way. Degas at his frankest never revealed so much. Nothing occult here. All plain sailing for the man in the street. Presently you cover your eyes with your hand; then you peer through your fingers. All as bald as the hills. The Eternal Female, and at her ugliest. What's the symbol? There is none, but volume and planes. Matisse models in paint. But you catch a glimpse of his Dancers—a design for a decoration in the Palace of Prince Tschonkine, Moscow, and you admire the bacchantic rhythm, the flat pattern of rose, black, blue, the scheme of contrasted color, the boldness, the vivacity of the design. It is wonderfully rhythmic, this arabesque. Near by are some of his sculptures. They

are hideous, just as hideous as when they were shown by Alfred Stieglits at his Photo-Secession gallery last season. There is strong modeling in his "La Coiffeuse"; indeed, it is impossible to deny the power of this painter, deny his marked individuality. His designs (there are several in the Metropolitan Museum) reveal his creative rhythms. and if, as has been said, genius is mainly a matter of energy, then Henri Matisse is a genius. But, alas! your eye alights upon that grotesque "conversation" and you murmur: "No, not a matter of energy but of pajamas." Again the risible rib is tickled. For Friess we have not particular liking, while M. Puy's portrait of Madame Puy is a tart, not a pie. (Yes, such painting provokes to Post-Impressionistic puns.) Picasso's "Nature Morte" is dead, not still life. His master, Cézanne, knew how to portray potatoes and onions which were real if not precisely emotional. Two pictures, are by Auguste Chabaud, a young Paris painter who lives all the year around in the country.

His exhibition at Bernheim's last Spring won for him attention and praise. His design is large, simple, vir-

ile; his sincere feeling for landscape is not to be doubted, though his coloring is rather sombre. A road scene in the hills, with its firm silhouette, and his sheep leaving the fold after the rain is rhythmic, especially the figures of the shepherd and his dog. At first I fancied the sheep were moles, then tapirs, then cockroaches, but they soon resolved themselves into sheep. Chabaud is not given over to paint metaphysics. He writes, it is true, but he writes sensibly. In art, he says, we invent nothing. Art is not of yesterday, nor of to-day, nor of to-morrow; it is eternal. He mocks at the words classic, romantic, ancient, modern. Some of the new crowd might pattern after his wisdom. The Russians give us Byzantine figures in hieratic attitudes. They are monotonous. And in the octagon room are four Cézannes, a painter who, with all his departures from tradition, nevertheless respected the integrity of his design, respected the integrity of his design, respected his surfaces, was reverent in the use of his medium. Cézanne is a classic. It is difficult to predict if even Henri Matisse will become one.

November 10, 1912

## ART NOTES

The conflict between the old and the new has been commemorated repeatedly in all forms of art and criticism. It is not so easy to undertake the reconciliation of the new with the old, and indicate the development of the modern from the ancient. The old wine, enriched and mellowed by the passage of time, is effectually concealed in the shining new bottles with their aggressive labels. In the great show opening to the public tomorrow at the Sixty-ninth Regiment Armory on Lexington Avenue, between Twenty-fifth and Twenty-sixth streets, we find our opportunity, however, to learn the points of contact between an Ingres and a Maurice Denis, between a Corot and a Zak. It will not be done in one visit or in twenty and some of us may never find our right way along this psychological path that leads from somewhere to somewhere, but a first glimpse of the show proves that it offers real things, not sham, and that no one within reach of it can afford to ignore it.

Entering the great drill hall of the armory we find it divided into temporary galleries lettered from A to R, with the four most important rooms in the central court and the others ranged about them. The entrance court contains sculpture and the walls are decorated by Robert W. Chanler's superb screens, which have never been publicly shown in America before, although they have been exhibited in the Paris Salons. The color, which has almost the depth of tone one gets from Chinese porcelains, the interesting zoological themes with a quaint humor, and the fine decorative spacing of the designs make of these screens a vigorous and splendid note of attraction for the entering visitor.

Passing to the right we find Gallery B, leading off with an American group of painters. Here are Jonas Lie, with "A Hill Top," the "Black Tea Pot," and other of his recent full colored paintings; Marion Beckett, whose charming, some-

what Whistlerian art has moved toward the newer school; Philip Hale with his dark and plastic group of art students; May Wilson Preston, George Lukas, Ernest Lawson, Henry Fitch Taylor, and Elmer MacRae.

Gallery C is also American. Among the exhibitors are such dissimilar painters as Leon Dabo and Warshawsky, George Bellows, Aileen Dresser, Marsden Hartley and Sidney Dale Shaw. In Gallery D are Ruth McEnery's nudes, the gray conceptions of Kenneth Hayes Zorach, and works by Glenn O. Coleman, Allen Tucker, H. W. Coates and F. William Weber, among others. Gallery E has one wall given to J. Alden Weir, a profile in rose and gray, his "Factory Village," his beautiful study of field lillies and a portrait. In the same gallery are Walt Kuhn, Arthur Davies, Bernard Gussow, and David Milne. It is easy to see that in this exhibition at least a democratic arrangement has been insisted upon. In Gallery F there is a wall of Hassams, once we knew them as almost too brilliant for the naked eye to bear, but the eye in question has borne such violence of hue before reaching them that they seem to have retired behind a thin gray mist. In this gallery are also Wangant, Homer Boss, Brinley, Kenneth Frazer and Katherine Dreier.

With Gallery G we come to Augustus John, Jack Yeats, Charles Conder, Phelan Gibbs and Walter Sickert. There is no special force of color in the general impression given these painters and even Conder's gleaming harmonies are somewhat dulled in the examples shown.

With Gallery H we reach the Frenchmen and the general public will find them all its fancy painted. Matisse fills one wall with sharp, high notes of color, Maurice Denis shows important decorative studies, George Roualt is impressive in "Le Parade," and Zak has something distinctly his own to say in "Le Berger." We enter the company of the Cubists in Gallery I Here are the tetrahedrons and octahedrons and dodecahedrons: here are prisms and pyramids and parallelo-pipeds; here are planes and volumes and angles,

a veritable Euclidean Paradise. And if we of the old-fashioned type are not asked to read the names attached to the pictures, if we are not urged to bring in the literary and story-telling element, we are entirely ready to confess that some very beautiful arrangements of form and color have come out of this fresh interpretation of the aim of art.

The first view of this tremendous exhibition gives, however, no chance for discussion of the varied qualities. We must stick to our last as the reporter of facts, not fancies nor opinions. It is a fact, that in this gallery we find Picabla, who said that he was not a Cubist, and also Picasso, never, to our knowledge, has denied the hard impeachment. Here also is the Cubist house a dignified structure with good spacing.

Gallery J is almost wholly given over to the haunting charms of Odillon Redon. There are in addition some drawings by Matisse and some paintings by Seurat and Bourdelle and Sousa, but in the main there are flowers and horses and classic serious heads—pure Redon. Galleries K and L are given to drawings and water colors: M and N to the American painters again—Glackens, Maurer, Mager, Sloan, Karl Anderson and others. In Gallery P are Corot, Delacroix, Goya, Daumier, A. P. Ryder, Courbet, Matthew Maris, Whistler, Ingres, Puvis de Chavannes and a few others. In Gallery Q are the works of that genius Van Gogh, and here in Gallery R we find Cezanne and Gauguin, and more of Picasso and Matisse and Augustus John and Puvis de Chavannes.

It is out of the question to attempt more in this preliminary notice than the mere enumeration of the principal features of the exhibition, but this enumeration will serve to indicate to the public that the Association of American Painters and Sculptors has done what it has been promising to do, and it must be added that it has done it in a worthy manner. The Armory is satisfactory in point of lighting, size and convenience, and the decoration of the vast spaces has been accomplished with a high degree of success.

February 17, 1913

## "ART" IN THE ARMORY

### Resembles the Ancient Brush-marks of Prehistoric Man.

*To the Editor of The New York Times:*

A painter and student of matters of art —please note the distinction—would like the privilege of your columns to say: Do not be disturbed—you have not gone crazy, and art, the dainty goddess, still is. I address you as having visited the exhibition now at the Sixty-ninth Regiment Armory.

Savages and children practice this art sincerely, and get over it as fast as they can. In the new Encyclopaedia Britannica (see Painting) there is a picture of the extinct European bison, done 50,000 years ago. It is the oldest painting known. It is identically the art of the armory, only it is real and not an imitation.

Observe that brush marks may do two things; they may depict solids imaginatively extant behind the canvas—which implies a knowledge of the forms of the solids; and they may please by their inherent beauty, which implies the enjoyment of abstract order—taste. And the whole history of painting is a series of compromises between these two different ends. Abstract order, pattern, or, if I use a popular barbarism, decoration, exists for its own beauty only; whereas depiction is for representing objects of assorted interests. For 2,000 years European painting has been increasing the emphasis upon depiction, which means a growth away from design and taste, and toward

representation and knowledge. The antique sculpture merely helped the people of the Renaissance to forget that painting had another field. Thereby came into existence a pictorial art having exactly the motive of the "living picture." And in 600 more years after Cimabue this art arrives at—Carolus Duran.

In all academic art the object of the painter is the rotundity of a nude figure, exactly as in sculpture, so that painting, as an art having powers denied to sculpture, ceases to exist. Yet this pseudo painting has been enthroned in Europe for centuries—not, however, because of its beauty, but because of its ability to present objects having other interests, as those of religion, war, personal vanity, &c. Esthetically, this art wearies us by the contradiction between its theory of an illusion of depth and its inability to give the illusion because the eye is compelled to remain at focus on the picture plane. It is inherently imperfect, and, in a way, the better it is the worse it is. This is painting as it is understood at the Ecole des Beaux Arts, the Royal Academy, and the like. Its logical and ultimate result is Bouguereau and Alma Tadema. And yet Turner, Corot, Rousseau, Whistler, Courbet, Maret, Inness, Tryon, Twachtman, and Wyant have gone quite other ways and have given us better work.

But the conflict between depiction and decoration is fundamental, and the ground between them that they have truly in common is very small. In early Italian painting the pattern, while not the sole concern, was yet always clear. And in his group of Primavera girls Botticelli achieves the most per-

fect balance ever effected between depiction and decoration, between knowledge and taste. With more knowledge and less taste you get Ingres; with more taste and less knowledge you get Koriusai.

Now as to those louder armory pictures—disregarding cubism, &c.— one has no difficulty in seeing that they consist of a jumble of lines and patches, and that they are very ugly. The formula for their production is to compel a painter to use only 2 per cent. of either his knowledge or his taste. With greater knowledge, they would be more like natural things—with greater taste, more like beautiful patterns. Having the least possible quantity of either, they neither interest nor please, they are neither words nor music. As to color—it does not exist; its place is taken by mere pigment. As a whole, they are to art what "pi" is to literature.

Brains and taste, labor and skill, love and patience, are back of all art. Omit these and you get—these other things.

The art of the future will carry the art of the past not backward, but forward. Pictorial painting, practiced as art and not as illustration, far from being exhausted has been but touched. The esthetic masters of light have been few—masters of color, still fewer. And the world awaits an art that shall give in the flat perfectly all that the flat can perfectly give of the spirit of Ingres and the spirit of Koriusai. Why not? BOLTON BROWN.

New York, Feb. 27, 1913.

March 1, 1913

---

### NEW ART SHOCKS CHICAGO.

#### Vice Commission Will Investigate Cubists and Post-Impressionists.

CHICAGO, April 2.—Charges that the International Exhibition, of which Cubist, Futurist and Post-Impression pictures are the sensational feature, now at the Art Institute, contains many indecent canvases and sculptures will be investigated at once by the Illinois Legislative "White Slave" Commission. A visit of an investigator to the show and his report on the pictures caused Lieut. Gov. O'Hara to order an immediate examination of the entire exhibition.

Mr. O'Hara sent the investigator to look over the pictures after he had received many complaints of the character of the show. "We are not condemning the International Exhibition without an impartial investigation," said the Lieutenant Governor to-day. "I have received many complaints, however, and we owe it to the public that the subject be looked into thoroughly."

The investigator reported that a number of the pictures were "immoral and suggestive." Senators Woodward and Beall, of the commission, will visit the exhibition to-day.

April 3, 1913

### Chicago Stirred by Modernists.

The Press Committee of the International Exhibition of Modern Art sends a jubilant report from Chicago. On march 30 more than 17,000 people visited the exhibition. Probably the figures will run up to 200,000 for the three weeks. The catalogue went into a second edition at the end of the first week. An explanatory booklet "giving both sides of the question" is to be issued. There has been the good luck of hostile criticism and a lecture delivered against the modernists that is to be repeated for the benefit of those who couldn't get in. Another lecture expressing an opposite judgment is also to be repeated for the same reason. A Woman's club is to discuss the exhibition and its effects. The fact that both Mr. Roosevelt and the Mayor of Chicago passed unappalled through the review of the Post-Impressionist and Cubist works is considered pretty conclusive evidence that no one need worry. The Rev. Dr. Gunsaulus is quoted as saying that the exhibition is making more of a fuss in Chicago than a Sullivan prizefight and National convention rolled into one. This pungent comparison ends the account of the first week's fortunes.

April 4, 1913

# Some of the Works Exhibited at Armory Show of 1913— And a Sampling of Comments on the Display

## THE REACTION IN 1913: CARTOONISTS JOINED CRITICS IN RIDICULING THE SHOW

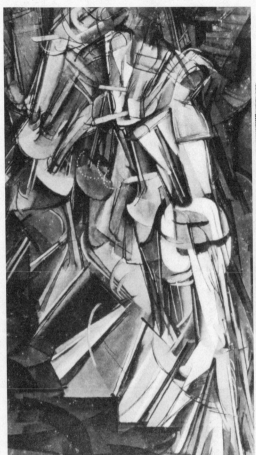

Marcel Duchamp's "Nude Descending a Staircase," a storm center in 1913 show and now in Philadelphia, has become a grand old dowager.

The Rude Descending a Staircase (Rush Hour at the Subway)

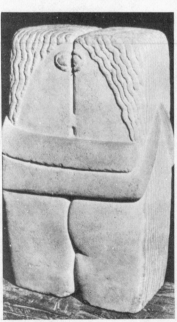

"The Kiss," a work in limestone, was shown by Constantin Brancusi.

"I TUK THE FUST PRIZE AT THE FAIR LAST FALL"

THE ORIGINAL CUBIST

"Goldfish and Sculpture" was the contribution of Matisse, one of the "wild beasts of painting."

April 5, 1963

# Discontent Set Off an Explosion

THE STORY OF THE ARMORY SHOW. By Milton W. Brown. Illustrated. 320 pp. Greenwich, Conn.: The New York Graphic Society. $5.50.

### BY PAUL BIRD

ALTHOUGH the "International Exhibition of Modern Art, 1913," which opened on February 17, just 50 years ago, in Manhattan's 69th Regiment Armory, was one of the most sensationally important events in American cultural history, it has remained until now one of the least documented.

The reason is that it was conceived and run by working American artists, not museumologists, and their main desire afterwards was to get back to their studios and work off their own emotional shock of recognition. And what a shock it was —the first mass confrontation of an esthetically tranquilized nation with the galvanizing visual experiments of Cézanne, Van Gogh, Gauguin, Matisse, Picasso and the other great rebels of European art.

Milton W. Brown's well-documented story of the exhibition is as definitive as any could be at this point. A professor of art history at Brooklyn College and author of "American Painting From the Armory Show to the Depression," he was

*Mr. Bird, former editor of Art Digest, wrote "Fifty Paintings by Walt Kuhn."*

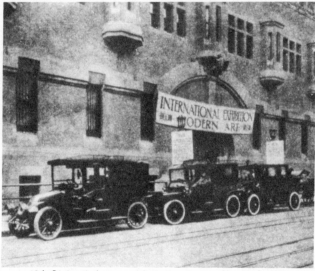

69th Regiment Armory on Lexington Avenue, New York, 1913.

originally commissioned by the Joseph H. Hirshhorn Collection to write a 50th-anniversary account based upon newly acquired Armory Show records and documents of the late Elmer Livingston MacRae, treasurer of the group that originally sponsored the exhibit. As the anniversary approached, additional material turned up that could not be ignored, including voluminous records of the late Walt Kuhn, secretary of the group, and researches by Joseph S. Trovato, assistant director of

the Munson - Williams - Proctor Institute, Utica, N. Y. The Institute was assembling a re-creation of the 1913 show, which was exhibited in Utica and then, under the auspices of the Henry Street Settlement, at the original armory, where 370 resurrected works were viewed last month by 75,000 visitors.

IN all fairness it should be recorded that this documentation parallels in some important respects that of the sumptuous, 212-page, illustrated

catalogue of the 1963 anniversary exhibition, which, incidentally, also features an essay by Mr. Brown. Both books include a *catalogue raisonné* of the 1913 show.

For the art lover and general reader, Mr. Brown's book is the most complete available. It is a richly detailed, judiciously culled, fascinating narration of the origin, the actuality and the after-effects of that epic 1913 event. The author follows in the main an outline account published in 1938 by Walt Kuhn in a now-rare pamphlet, which set the record straight at a time, 25 years later, when legend, hearsay and personal exaggeration were obscuring the factual reality of the Armory Show.

ESSENTIALLY the story is one of discontent among young artists who refused to follow the stifling canons of the powerful National Academy; their decision to do something; the formation of a 25-member Association of American Painters and Sculptors; the unswerving determination of their president, Arthur B. Davies, to have a truly big exhibition of both American and foreign progressive art; the accomplishment of that goal, with financial assistance from some wealthy well-wishers—and the cyclone that ensued.

Central to an understanding of what happened are the personalities and the roles of Davies and Kuhn and, to a lesser

9

degree, Walter Pach, an American painter in Paris who was conversant with the modern artists and the movement, and who helped to select the European works, and later to explain them.

The 50-year-old Davies was a shy, retiring professor type, a successful painter with connections with wealthy women patrons, and a strong sympathy for young progressive artists. He was a member of "The Eight," later called the Ashcan group, although his dreamy Arcadian groves with ethereal nudes had little to do with the group's usual life-as-it-is subject matter. He had uncanny good taste in art and a sense of its organic history. To everyone's surprise, he also had unsuspected qualities of steely leadership.

Part of the enigma of Davies is dispelled by Mr. Brown's disclosure of a dual life that he led, unknown even to his friends, during which he maintained over the years a domestic hearth both upstate and in Manhattan. This may help explain his self-effacing manner, and, as Mr. Brown suggests, clear up what at the time was called a "mystery" surrounding his death in Italy in 1928.

Walt Kuhn, in his early thirties was a dynamo of energy with a flair for showmanship well tempered, however, by his complete devotion to art and to Davies's taste and knowledge.

The big show opened with approximately 1,275—the exact number is not known—paintings, sculptures and prints, of which one-third were modern European examples. The American section had been selected by a committee headed by William Glackens under Davies's watchful eye. Excellent as it

## INTERNATIONAL EXHIBITION OF MODERN ART
### ASSOCIATION OF AMERICAN PAINTERS AND SCULPTORS
69th INF'TY REGT ARMORY, NEW YORK CITY
FEBRUARY 15th TO MARCH 15th 1913
AMERICAN & FOREIGN ART.

AMONG THE GUESTS WILL BE — INGRES, DELACROIX, DEGAS, CÉZANNE, REDON, RENOIR, MONET, SEURAT, VAN GOGH, HODLER, SLEVOGT, JOHN, PRYDE, SICKERT, MAILLOL, BRANCUSI, LEHMBRUCK, BERNARD, MATISSE, MANET, SIGNAC, LAUTREC, CONDER, DENIS, RUSSELL, DUFY, BRAQUE, HERBIN, GLEIZES, SOUZA-CARDOZO, ZAK, DU CHAMP-VILLON, GAUGUIN, ARCHIPENKO, BOURDELLE, C. DE SEGONZAC.

*Illustrations from "The Story of the Armory Show."*
**Armory Show poster.**

was, the American art hardly had a chance in the same hall with the modern European art, completely new to America.

Mr. Brown's narration of what happened, laced with illustrations of the works, the personalities, newspaper articles and cartoons, letters and memorabilia, catches much of the excitement that must have occurred. The reporters and critics had a field day, particularly with Marcel Duchamp's "Nude Descending a Staircase." The conservative Kenyon Cox went into a high dudgeon, as

did Teddy Roosevelt, writing in Outlook Magazine. Walter Pach, then back in America, and the journalist, Frederick J. Gregg, did their best to try to explain the new movement. Some 87,000 jammed the Armory, and the last day was a near-riot, so many tried to push in. Then, in an abbreviated version, the exhibit went on to an even wilder reception in Chicago at the Art Institute, where it was hooted by the Institute's faculty and students. It closed rather tamely later in Boston.

**M**R. BROWN includes in his catalogue many of the original prices of the works, as well as their present whereabouts, if known. He tells how the artist-sponsors stimulated collectors of modern art to make their first bargain purchases at the Armory Show. Among the buyers were John Quinn, Lillie Bliss, Dr. Albert C. Barnes, Arthur Jerome Eddy and Walter Arensberg, whose collections today form the nuclei of many an outstanding museum display. Even the Metropolitan Museum purchased its first Cézanne from the Show—"Poorhouse on the Hill," for only $6,700.

The artists' wind-up of Armory Show affairs was a protracted business, and not without acrimony on the part of some of the association members. Although the show effectively broke for all time the power of the Academy, ironically, it also largely destroyed the influence of the Ashcan group who were among its early sponsors. Some of that group had opposed from the start the inclusion of the European moderns and, with their nationalistic point of view, they sensed a doom the show was bringing, particularly to their hero, Robert Henri.

These and other forgotten sidelights of the Armory Show spice Mr. Brown's excellent reconstruction of the event. He leaves to other art writers the show's ultimate historic significance. Many have given their own final word on this, with as yet little agreement among them. What they have needed is this first source book to tell them what actually happened.

June 2, 1963

---

## ART NOTES.

### Paintings by Max Weber.

The exhibition of paintings and drawings by Max Weber now on view at the Ehrich Galleries is retrospective in character. It goes back to the artist's portrait of his studio in Paris in 1907, a painting that shows something of his power as a colorist, and predicts the palette of eight years later. Figure studies follow, and flower studies and still life, not all in the Cubistic convention, but tending more or less toward it, and expressing a genuine personality even when most fettered and distorted by the theories of modern art. The latest things show a definite development of this personal feeling. The color has become organized and expressive to a degree achieved by none of the modern Frenchmen now with us. A panel with a bit of vase form and chair form and

other fragments of remembered form shows intersecting planes, exquisitely related tones of color, and there is beauty. The same thing might be done academically and produce no aesthetic emotion in the observer, and the same thing might be done by an "advanced" Cubist without becoming in the least interesting. One needs to be a true musician in order to make music and a true painter in order to make a picture with color and line. These panels of still life, this cold "Interior of a Fourth Dimension," this "Memory of a Symphony" are sufficiently puzzling to the public, for whom problems of painting detached from representation have no charm, but they prove Mr. Weber a true painter for whom among other things quarter-tones in the color scale exist.

February 12, 1915

## ART NOTES.

### Picasso at the Modern Gallery.

The Modern Gallery sits silently triumphant in the presence of Picasso's latest, which is not the reactionary normal salonistic production recently described, but a more than ever abstractly cryptic combination of little pieces of substances and applications of pigment. Its name is "Nature Morte dans un Jardin." The Jardin is a little round plaque, of wood perhaps, painted green, and little cubes attached to this in a geometrically conceived design stimulate your sense of touch as nicely as did the bits of sandpaper in the old designs. It is quite impossible not to handle Picasso's paintings. If there is any fear for their continued integrity under handling they ought to be accompanied by "Keep Off the Canvas" signs. You rub them to feel if the piece of something that looks like calico is calico or illusion. You run your finger over the piece of newspaper to see if the ink on it will smudge as it does on your own last edition. You can't rest until you know whether what looks rough is rough and what looks smooth is smooth. That's Picasso. But not quite all of Picasso. He is really to be admired for carrying it further than mere cheating of the eye, for such cheating is child's play to his technical command.

Aside from the fun of trying to make out his absurdly complicated riddles, he offers you drawing of consummate skill and very nice color that has no hateful quality of crudeness. Why should he go back to the sanity required by deep thought and passionate feeling? Let us hope that he will keep on with his play on line and color, his technical conundrums, his entirely serious jokes. They constitute his method of expression, and so long as we are comfortably ignorant of what he is trying to express we are perfectly happy in the presence of his work—which is more than can be said in the case of some of his followers.

December 21, 1915

## Exhibition

### Sculpture by Brancusi.

Several sculptures by Brancusi are at the Modern Gallery until Nov. 11. In each of them you feel the intensity of the sculptor's interest in his material expressing itself in his skillful wooing of surfaces and the obedience of his tool to the character of what it works in. Compare his carved wood, his work in marble, and his work in bronze, and whatever you make of his unfamiliar conventions you find an extraordinary and exquisite sensitiveness to the properties of the substance under his hand. His marbles so gracious and inviting in their bland smoothness plead for contact with the hand, and his woods equally tempt the tactile sense with their delicate rugosities. He represents movement with the same subtlety. The lines of his abstract forms flow out sinuously or break into sharp angles and sudden changes of direction. The public still enamored of representation—and this is all but the most minute portion of the general public—will regret Brancusi's following of the modern gods. He is the gifted successor of Rodin in his treatment of marble.

October 29, 1916

## TOPICS OF THE TIMES.

### Eccentric Art Explained.

Painters — it is not quite necessary to call them "artists" — who belong to the schools designated by such names as "cubist" and "futurist," can find themselves and their curious productions explained with what, to those painters and to their admirers, will be decidedly painful plausibility in the leading editorial article in the current issue of The New York Medical Record.

The writer of this article does not make the mistake of which so many of us have been guilty—that of declaring these pictures as meaningless as they are ugly. On the contrary, he asserts that they are full of significance. It is, however, a significance that can be brought out only by an application of the principles and methods of psychoanalysis. That done, all their mysteries are soon dissipated, and the result is a valuable contribution, not to the realm of art, but to that of mental pathology.

What the futurist does is to reveal his own struggles with reality and environment, and the partial adjustment thereto which he has succeeded in establishing through these projections into visibility of his vital energies. The results are not pictures in the ordinary sense of that word, for they fail to meet two decisive tests—they do not convey any meaning at all to "the man in the street," and even the producer, if confronted by a new work in his own manner, produced by a member of his own school, could not tell what its originator intended to convey. He would, indeed, get an impression of some sort, but the sort would be determined by his own psychic condition, not by that of the painter.

Pictures more or less like these are produced in great numbers in insane asylums, especially by sufferers from the form of alienation known as dementia precox, and it is to that class that the writer of The Record's article assigns the painters of these new schools. There is some comfort for them, however, in the fact that in them the process of regression toward infantilism has been arrested, temporarily at least, and perhaps permanently. That occasionally happens in dementia precox, and those thus favored by fortune are not only saved from sequestration, but they may even remain of some real social value.

Of course, the elderly psychologists who reject with such amusing manifestations of indignation or horror the theories of FREUD will scorn this interpretation of futurism and the related eccentricities, and that ought to start a really interesting row in medical and art circles.

April 2, 1917

## ART NOTES.

### Malvina Hoffman's Sculpture

At Mrs. H. P. Whitney's studio sculpture by Malvina Hoffman and decorations by Arthur Crisp are on view until March 18. Miss Hoffman's work has won its place among the serious sculpture of the present day, and, seeing it for the first time together in public, the great sincerity of its method is freshly appreciated. It would take but a little less of such sincerity to make such subjects as those offered by the Russian dancers a weariness to the observer. We all know how tiresome the momentary gesture becomes when it is permanently fixed by an incompetent artist. Miss Hoffman has invited all difficulties, submitted herself to all dangers, in undertaking her plastic celebration of the dance—and she has triumphed. The interest of her dancing figures does not diminish, it increases with time and repeated opportunity. This, of course, is proof that the splendid rhythms and organic structures are understood and used by a truly creative mind.

In the other subjects there is much to repay attention. The pretty realism of the fountain figure, "The Shivering Girl," with its drooping dripping line, the shrinking of the little sharp shoulder, the nervous contraction of the little foot under the impact of the water—nothing could be more charming in daintiness of suggestion. In the head of "Richard the Third, Age 10 Months" is the rare quality of humor curving the lips and playing over the unformed features. The marble portrait of the artist's mother, mobile, sensitive and spiritual, is the most beautiful of the portraits; the unusual pose, the head leaning slightly to the left and resting against the folded hands, establishing at once for the observer the mood of quiet and deep reflection.

February 26, 1919

# ART

John Marin's water colors at the Daniel Gallery are so clever in the use of the medium that it seems hardly worth while to ask more of them than this brilliant quality. Water color is the most amiable medium in the world; there is nothing it declines to do for you if you show some confidence in it, but it is like the historic nettle—if you act afraid of it, it will sting you for your pains. "Grasp it like a man of mettle" and you have any result you wish.

Mr. Marin is one of the most skillful of technicians, and his color often is carried to extremes of intensity. These New England studies are less studies of New England than studies of color. They have as little as possible the feeling of locality, yet those that are most impressed upon the mind of the ordinary observer have a recognizable relation to the scene inspiring them. One, with the specific title, "Low Tide, Moose Island, Maine," is powerful portraiture of place, giving the essential character of color and form. The impression you get from the roomful of paintings—from the two rooms, in fact—is of color that has force in even the most delicate wash. There are no gray pictures in these rooms, although there are many that are blonde and some that are pale with a pleasant warm pallor. It is an exhibition that sends you to other galleries accustomed to stimulating freshness of palette that makes any less energetic color schemes a trifle suffocating until you are used to the different air.

**March 28, 1920**

# ART

AT the Weyhe Galleries is an exhibition of etchings, monotypes and sketches by Joseph Stella, whose work has an unusual delicacy and sensitiveness in the sketches and etchings (the latter are quite early), and a fine color sense in the monotypes. Monotypes, however fascinating as they are in the accidental character inevitable to them, call for a special knack of mind on the part of the artist. Some quite poor painters have produced delightful monotypes. Others more liberally gifted with qualities indispensable to an artist of serious achievement are helpless with this mocking medium. Mr. Stella is better in everything else than in his monotypes, and shows the special and rare quality of his talent most freely in the etcher's medium, which he seems to have abandoned in recent years.

**May 22, 1921**

# EXHIBITIONS

### Georgia O'Keeffe, American.

Just why Alfred Stieglitz, who "presents" one hundred pictures by Georgia O'Keeffe at the Anderson Galleries, should insist upon Miss O'Keeffe's Americanism, it is difficult to see, but the pictures are not. They line the brave walls of the Anderson rooms with pinks and purples and greens that would lend themselves happily to color reproduction, and in their carrying power would make capital posters. Some of the subjects are abstract, another way perhaps of saying that you don't know what they mean. When you do know, as in the case of the fruits, some of them, it is very pleasant. It is small wonder that people buy the pears, and they do, at Fifth Avenue fruiterers' prices. The plums have a look of Tyrian dyes that becomes them less well. All the color is rather fresh and new, naturally, as the artist says her art is only seven years old. She says that she does it to please herself, and there is true originality in not saying that she does it to express herself. She expresses in many of her paintings the contemporary urge—there is no other easy word for it—toward yawning mouths of color, but not all are mouths; a few, though very few, are rectangular and prim. Marsden Hartley has written with extraordinary frankness his idea of Miss O'Keeffe, which is, among other things, that she "has had her feet scorched in the laval effusiveness of terrible experience," that she "has walked on fire and listened to the hissing of vapors round her person." Her drawings are supposed to be as frank as Mr. Hartley, but their abstract character saves the public from knowing it.

**February 4, 1923**

# EXHIBITIONS

### A Scientific Modernist.

The Société Anonyme are giving us another opportunity to struggle with a painting by Kandinsky. His book, "The Art of Spiritual Harmony," explains his point of view, that art is a scientific organization of form and color designed to create emotion, but to borrow from F. P. A.:

"Sound or spurious, gold or dross
Art's but art that gets across.
If it hit nor mind nor heart,
It is anything but art."

Kandinsky's four or five paintings say nothing for themselves, are still in the laboratory state of research and experimentation, unsolved problems.

Paul Klee also builds with abstract form but understandingly and musically. His scale is nearer the closer toned one of the East than ours of seven intervals, the forms are as easily related to music as his color. He directs the small colored forms, orders and arranges and without the aid of a book of explanation, forgetting books, one is drawn out of one's self by the joyousness of the designs. Kandinsky and Paul Klee, Société Anonyme, Jan. 7-Feb. 7.

**January 20, 1924**

# EXHIBITIONS

### Maillol and Rousseau.

It took in this case at least two visits to the Whitney Studio to be sufficiently sensitized by the drawings and sculpture of Aristide Maillol to in any way formulate a reaction. Even now one must ignominiously confess to being tongue-tied. A great deal has been said and there has been much enthusiasm and a long article in this month's Arts by Waldemar George. Each piece seems to struggle to express, with the greatest possible completeness and intensity, one simple movement, a stride forward, wrestling, an upward movement. The question is whether, in spite of intensity and completeness, the expression is an esthetic one. Abundant opinion has answered in the affirmative.

Henri Rousseau paints frightening tropical scenes, unhealthy and powerful, full of beautifully drawn, thickly modeled green stuff, poisonous, not in color but in intent; a dreadful Solomon's seal sort of thing grows handsomely out of its evil surroundings and the land is peopled with wicked animal and human faces. Maillol and Rousseau, the Whitney Studio, Feb. 18-March 8.

**March 2, 1924**

# PARIS GALLERIES

### Braques.

Georges Braques is an intellectual. There is nothing hypnotic about him, and it is only after close study one recognizes his charm. He paints in black and white, a dull yellow and a dull green, occasionally bringing the green up a little brighter and higher. To guess at his method, he seems to plan the architecture of the composition, a black outline controls the form, with a brisk contrast of round and angular line, and then, with great dexterity, he fills the shapes with objects—bowls and pitchers and fruit. It is interesting to note how abstract the forms are and at the same time how cleverly he has made them play a realistic part; accents become high lights and squared and round outlines become depth and modeling. Texture is always very beautiful, very sensitive and delicate.

**June 1, 1924**

# PAINTERS DEBATE ART POLICIES HERE

## Rockwell Kent Attacks Stand of Museum on Native Work, Saying Europe's Is Favored.

## WANTS AMERICANS AIDED

### Walter Pach of the Metropolitan Defends Purchasing Plan—Holds Our Students Need the Best.

Starting as a friendly debate—in which the attitude of American museums and collectors toward American art was attacked by Rockwell Kent, painter, and defended by Walter Pach, also a painter and lecturer on art at the Metropolitan Museum, a meeting under the auspices of the Society of Independent Artists last evening at the Waldorf-Astoria ended in a group discussion that brought forth personal criticism.

John Sloan, President of the society, presided and allowed remarks from the floor when the debaters had concluded. When Alfred Stieglitz, noted as a photographer, and Gaston LaChaise, sculptor, took the floor to attack Mr. Pach's work rather than his viewpoint on museums, Mr. Sloan interrupted and asked them to confine themselves to the subject. The audience apparently was with Mr. Sloan in both instances, judging by the applause.

### Mr. Pach's Argument.

Mr. Pach based his arguments on the viewpoint that American art should be judged by its quality rather than by the nationality of the artist, and that American museums should be and have proved to be the study places of people interested in art and so should contain only the best in art in order that Americans might develop a sense of the best rather than a sense merely of the American. He traced the history of American art, denying statements made in a letter by Mr. Kent to the effect that American genius was being destroyed because American buyers cared nothing for works that were not old and foreign.

"American artists do not want to be given philanthropy," said Mr. Pach. "They want their paintings to be judged for quality, and the place of the museum is to be the hanging place of the best. When it steps out of that rôle it diminishes its capacity for good."

He said other nations collected the great works of earlier days and the United States was showing no disregard for its own work because it bought the great works of other nations, also. He cited France as having realized that Italy's background was better than her own and having gone to Italy to study her works, thus to build the foundation of her own art.

"The United States must face the issue, too," he said, "and the museum is the means of facing it."

### Wants Own Art Developed.

Mr. Kent argued that America should develop her own art and that her collectors should aid the artists by purchasing their works.

"When the excavators dig in the ruins of this nation," he said, "they will find a lot of old art and statuary and Grecian mummies. They will not know what our art has been. After all, all the rich people are the only ones who build substantial homes and fill galleries, but what are they putting into their homes? Second-rate European stuff, while hundreds of American artists go along with no encouragement.

"Europeans came to this country and this nation has been built up. There was nothing in Europe like conditions here. We were individual, but we have built up no individual art and the world looks to us asking when it will come."

He pictured American collectors as in the hands of dealers they recommended the purchase of European works because they could buy such works for $5,000 and sell them for $100,000 but would have to be satisfied with 20 per cent. of the price of an American painting.

"American artists will produce? as much as Americans want," he said, "but our Morgans and the rest show them no encouragement. The American millionaire merely wants to fill his home with old art and furniture."

He suggested as the answer, the expenditure of the Munsey millions as a support for American art.

### Attacks Artist's Writings.

Mr. Pach was attacked for certain of his writings, Mr. Stieglitz charging that he had always favored French works rather than the American, and that he stood before a meeting under the auspices of the Independent Artists although he was not himself an independent. Mr. Stieglitz also said that Mr. Pach compared American millionaires with wealthy persons of the past who supported art, but that he erred, for the American millionaire today did not support art of his own day, whereas the earlier-day collector did.

Mr. Pach replied that the old collectors gathered old works for the knowledge they could obtain from them, and that the American collector today did the same thing. The debate was held in connection with the annual exhibition of the Independent Artists. About 300 persons attended.

March 15, 1926

---

## YIELDS TO THE MODERNISTS

### National Academy of Design to Show Some New Art March 22.

The National Academy of Design, hitherto listed as Tory in its art affiliations, has capitulated to some extent before the onslaughts of the spirit of the age, for an entire room of the four that will house its Spring exhibition will be devoted to modernistic art, it became known yesterday. The exhibition will open March 22 with a private showing, and will be held at 215 West Fifty-seventh Street.

Although most of the pictures have not been hung, there were enough on the walls of the "modernistic" room yesterday to give some idea of what it will be like. One painting, called "Fourteenth Street Sugar Babies," by Reginald Marsh, depicted a line of chorus girls, mostly ugly, fishing with actual fishing poles for the favor of bald head row. Another painting, by Joseph Stella, of several swans, seems to express abstract neck.

None of the artists in the modernistic room belongs to the National Academy. They have been invited by the Academy, it was explained, so that the Spring exhibition may illustrate tendencies in contemporary art in addition to showing late work in the more formal and traditional fields of painting. Two rooms will be given over to the work of the members of the Academy and their brothers who remain classic in their manner, while one room is set aside for black and white.

March 13, 1927

---

# INDEPENDENTS COLD TO ART ACADEMY BID

## Call Offer to Take Works of Radicals 'Catchpenny' Plan to Aid New Building.

## INSINCERITY IS CHARGED

### Modernists Say Institution Lacks Understanding, Not Space— Academician Makes Reply.

The Independent Artists, who are exhibiting their wares at the Waldorf, just won't be respectable, conventional, dead or "old fogy." To be respectable means, in the parlance of their President, John Sloan, to be recognized as artists by the National Academy of Design, or, for that matter, by any other group of men who are "institutional." And so, when Mr. Sloan and others of the Board of Directors of the Independent Artists read yesterday that the Academy of Design had invited modernistic artists to occupy one-fourth of the wall space in its forthcoming Spring exhibition they were disturbed. And when they read a statement attributed to Charles C. Curran, Secretary of the National Academy, that his organization wished to obtain a larger building to house all forms of art, the Independent Artists denounced the Academy's invitation to the modernists as a "catchpenny device to attract money for such a building."

All this was announced last night by Mr. Sloan, who had sat in council during the day with Samuel Halpert, his Vice President; A. S. Baylinson, the Secretary; Walter Pach, the Treasurer; Fred D. Gardner, Bernard Gussow, A. Walkowitz, Warren Wheelock and Robert Henri, who himself is a member of the National Academy of Design.

Mr. Sloan had another objection to the invitation. The National Academy had said, he declared, that because its exhibition quarters at 215 West Fifty-seventh Street were so small, it would be compelled to "refuse some one hundred pictures which otherwise would have been exhibited." He pointed out that for eleven years the Independent Artists, with no building of their own and without permanent funds of any kind, had shown 15,000 works—every work of art that had been proffered by a member for exhibition.

The resolution adopted by the Independents yesterday concluded: "And, further, the Board of Directors denounces the falseness and insincerity of the Academy's propaganda, since its previous attitude toward exhibitors has not been determined by lack of space but by lack of understanding."

Mr. Curran, whose announcement precipitated all the commotion, said: "We of the National Academy are trying to be hospitable, for there are certain Academicians who think we should recognize the younger painters. We don't care much what the Independents say. When they accuse us of 'catchpenny' practices it is about what we expect. Do you think, really, that one room of their art would attract the $5,000,000 necessary for a new building?"

A report printed in THE NEW YORK TIMES of March 12 that a bust of Senator Alexander Simpson of New Jersey exhibited in the Independent Artists' show was by a New Jersey sculptor was wrong. The bust was made by Smiles-Alexandre Zeitlin.

March 14, 1927

13

# MODERN ART MUSEUM TO OPEN HERE NOV. 1

## Mrs. J. D. Rockefeller Jr. One of Distinguished Group Backing the New Institution.

## GREAT COLLECTION IS AIM

### Gallery Would Complement the Metropolitan as Luxembourg Does the Louvre.

A permanent museum of modern art is to be founded in New York, including among its organizers Mrs. John D. Rockefeller Jr., who will act as treasurer, and A. Conger Goodyear, lumber merchant and banker, who will be the chairman, it was announced yesterday.

The plans, formulated at a luncheon in the Hotel Madison, call for the establishment of a gallery to display the works of modern and contemporary painters and sculptors to whom such an institution as the Metropolitan Museum of Art denies a place because its policy demands that the lapse of time eliminate the possibility of error over the value of a work of art.

The sponsors of the new museum intend that it shall complement the Metropolitan in much the same relationship that the Luxembourg bears to the Louvre.

"It is not unreasonable to suppose," a prospectus of the museum says, "that within ten years New York, with its vast wealth, its already magnificent private collections and its enthusiastic but not organized interest in modern art, could achieve perhaps the greatest modern museum in the world."

The museum, which is expected ultimately to have a building of its own, will find temporary quarters on the twelfth floor of the Heckscher Building on Fifth Avenue. Exhibition space there will make it possible to show about 100 canvases at a time and there is room on the same floor for expansion.

**French Works to Be Shown.**

Paintings and drawings by Cezanne, Van Gogh, Gauguin, Renoir and Seurat, French forefathers of the modern art of today, will comprise the first exhibition of the museum, which will function at the beginning as a gallery for temporary loan exhibitions, each to remain for one month. This first showing will open about Nov. 1.

A group of American painters, masters of the last fifty years, Ryder, Winslow, Homer, Eakins and others, will be shown later. Exhibitions of the works of distinguished living American, French, German and Mexican artists will follow.

The director of the museum will be Alfred H. Barr, who has done extensive work at Princeton, Harvard and the Fogg Museum in Cambridge. In addition to Mrs. Rockefeller and Mr. Goodyear, the organizers include Professor Paul J. Sachs, who has been associated in the direction of the Fogg Museum; Frank Crowninshield, Miss Lizzie Bliss, Mrs. W. Murray Crane and Mrs. Cornelius J. Sullivan.

While for the first year or two the new museum will be largely a loan affair, it is hoped gradually to acquire works of art and also to arrange semi-permanent exhibitions. The museum hopes first to establish "a very fine collection of the immediate ancestors, American and European, of the modern movement—artists whose paintings are still too controversial for universal acceptance." This collection would be formed by gifts, bequests, purchase and perhaps by semi-permanent loans. Permanent collections of the most important living artists, it is also hoped, may be formed.

"Experience has shown," observes the prospectus, "that the best way of giving to modern art a fair presentation is to establish a gallery devoted frankly to the works of artists who most truly reflect the taste, feeling and tendencies of the day. The Louvre, the National Gallery of England and the Kaiser Freidrich Museum, to mention only three national museums, follow a policy similar to that of our Metropolitan. But they are comparatively free of criticism because there are in Paris, London and Berlin in addition to and distinct from these great historical collections—museums devoted entirely to the exhibition of modern art. There can be no rivalry between these institutions because they supplement each other and are at times in close cooperation.

The Museum of Modern Art would in no way conflict with the Metropolitan, says the prospectus. The policy of the Metropolitan, often criticized as ultra-conservative, is thus defended by the sponsors of the new museum:

"Its policy is reasonable and probably wise. The Metropolitan, as a great museum, may justly take the stand that it wishes to acquire only those works of art which seem certainly and permanently valuable. It can well afford to wait until the present shall become the past; until time, that nearly infallible critic, shall have eliminated the probability of error.

"But the public interested in modern art does not wish to wait. Nor can it depend upon the occasional generosity of collectors and dealers to give it more than a haphazard impression of what has developed in the last half-century."

September 6, 1929

# MODERN ART MUSEUM

## CONTEMPORARY AMERICAN

### Debating Inclusion of Certain Artists in a Show That, However, Has Many Pinnacles

By EDWARD ALDEN JEWELL.

SOME one entering the Museum of Modern Art, where the contemporary American show is hung, exclaimed: "Why, it's Arabia!" Of course Arabia, with the nights of which it is famous, could mean almost anything, and in the strictest sense it would be unfair to say that of the present array, supposed to represent the best American art by living American painters; on the other hand, one somehow isn't altogether dumfounded at hearing such an outcry, for a birdseye view does not quite tempt one to exclaim: "Why, it's America!"

Now, the matter of deciding what artists ought to be put on a list of this sort and what artists ought to be left out is highly controversial. The Museum of Modern Art will probably never again face so formidable a task. However hard you try, there's no pleasing everybody. That the committee is pleased with the affair may be taken for granted. All this reviewer can do is offer a few of his own reactions—those, merely, of one gallery visitor.

SOME first-rate American painters are noticeably absent. True, a longer list would have been less effective, since fewer, pictures by each artist could then have been shown. But eyebrows well may lift over certain participants whose inclusion in the opening American performance makes such absence obligatory.

The wisdom of putting in a man like Lyonel Feininger seems most conspicuously debatable. The fact that every one began at once asking, "Who is he?" would discount the reasonableness of his being considered a representative American painter. In the Kronprinzenpalast in Berlin, we are informed, Feininger is classed as one of the twelve best contemporary German artists; in New York he is now classed as one of the nineteen best Americans—a numerical ratio that would make him appear seven degrees more German. We must guard against being too literal-minded in a case like this. All the same, it does seem conceivable that among our native painters not already admitted there might have been found one who could tolerably fill Feininger's role.

Then take Jules Pascin. That his mother was Spanish, his father Serbian. That the artist was born in Bulgaria that all Europe in a way was his home cannot logically forbid his being finally an American. What we do have difficulty, though, in overlooking is Pascin's close identification of late years with the modern French school. So inescapable is this identification that only the other day he appeared at the Newhouse Galleries in this city along with other French artists chosen by M. Raymond of the Louvre. Is Pascin quite as essentially American in his art as, say, Alexander Brook and as, say, Georgina Klitgaard are essentially American in the pictures that have brought them into prominence? Mrs. Klitgaard, by the way, might so agreeably have kept the lone woman painter, Georgia O'Keeffe, company.

Again, consider Yasuo Kuniyoshi. There need be no alarms and excursions over, his citizenship papers. That is not the point. The point is that—to his credit no doubt be it said—Kuniyoshi has retained a dominant Japanese flavor, however fashionably adapted to a still prevalent modern Occidental mold of expression; besides which it is a fairly safe guess that his painting technique would be precisely what it is today had he spent all of his time since leaving the fatherland, instead of only a part of it, in Paris. Setting aside his artistic caliber, and keeping foremost in mind the title that has been given to this exhibition, do you consider Kuniyoshi quite as American as, say, H. E. Schnakenberg, or as, say James Chapin?

Well, these are ingredients that, to the reviewer's way of thinking, help produce Arabia in the Heckscher Building. Defense might well put the baffling query: What is America? Dodging this conundrum without ceremony, we pose the counterquery: Granting that in the main the list is a strong one, might not the first contemporary American show in our new Museum of Modern Art advantageously have stuck a trifle more closely to home-brew? It would be absurd, of course, to limit representation of those who are descendants of the Mayflower pioneers. But if quality alone, regardless, be the criterion, then ought not this have been called just an exhibition of contemporary art, let sources be what they will, omitting the national slant entirely? Our feeling is that, especially since it treads so closely upon the heels of the French group inaugurating the museum, the American performance would have made a better all-round impression had it reflected a bit less saliently the atmosphere of older civilizations across the seas.

TAKING the exhibition as it stands, there is much to be said in praise of the elements that compose it. Charles Burchfield has perhaps never appeared to better advantage. All of his six contributions are noteworthy. What a stirring, clean piece of work the 1920 water color. "Railroad Gantry" is: and what a delight to see once more the pungently satiric "Promenade" Another of the large water colors (painted this year). "Sulphurous Evening," achieves genius loci of the most mordant variety, Sullenly that dreadful old black house stares back at an angry lemon sky. When the storm breaks, how those doleful

**"Girl With Blackberries," by Maurice Sterne.**

*In Exhibition at Museum of Modern Art.*

windows will shake and rattle; how the disillusioned clapboards will stream, the aged rafters groan. But if, as is often the case with the clouds so sulphurous, the storm threatens merely and then peters out, the indifferent, dour old domicile will settle itself grimly for the night another day got through, and can dies of hope such as once lighted the morrow long guttered.

More oblique, less downright in his satire, and for the most part using oils instead of water color, Edward Hopper pursues substantially the same theme. He gives us phases of America that are immediately recognized. Accepting them at once as veritable documents, we respond as well to the artist's able command of his materials, and carry away a sort of reinforced persuasion of heaven's fine impartiality; the light that glorifies yon house by the railroad might gladden with equal, though not enhanced, radiance the pavements of paradise. The fog horn and the lighthouse share in this brilliantly contrived bath of pure light. These three pictures exemplify the inwardness of objectivity; an inwardness not grasped by those who complain that Hopper is photographic. Hopper's "Automat" explores a different realm, the realm of human episode so dear to John Sloan. The latter artist paints you a restaurant in cheerier mood — "Renganeschi's" — though here festivity, so at variance with the forlornness of "Automat," probes with less power the mysteries of emotion externalized in conduct. Sloan's aptness as a raconteur takes on in this instance an illustrative flavor that is entirely missing in the beautiful, low-keyed "Ferryboat" of 1907. But even at his most superficial, John Sloan is an excellent painter, an excellent story-teller.

And with what infectious humor, interpreted by means of artistry how superb, Pop Hart relates his adventures all up and down the world. There is the priceless "Mule Car", boarded in New Orleans; there are the "Fruit Gatherers," "The Jury," "The Merry-go-round," belonging to the Mexican scene; and there is the exquisite Moroccan landscape, which bears the latest date. These four artists—Burchfield, Hopper, Sloan and Hart — together with a few others, constitute a kind of sub-

stantial American nucleus about which the exhibition builds. Not one of them could possibly be spared.

⁂

GALLERY sofas are conveniently placed before the more important nudes, so that perusal of their virtues may be engaged in without fatigue. However, so great are the crowds and so prone, somehow, is the art pilgrim interveningly to loiter in the vicinity of works of this nature, that the comfortably seated onlooker finds himself frequently at a disadvantage. Very popular indeed are proving Eugene Speicher's "Hilda" and the two nudes by Bernard Karfiol. Much conversation, sometimes quite excited conversation, fills the air. There are those who admire more the quiet charm of "Hilda"; those who prefer the robuster warmth of the Karfiol brushwork. This reviewer confesses, with a stab of regret, that for him Speicher's young lady grows continually sweeter, until at length she is perilously close to the saccharine, despite her undoubted quality. The Karfiol etudes, "Reclining" and "Seated," seem much more vital. It

is very interesting to watch this artist in process of changing his style completely. Abandoned now is the vintage of "Summer," which brought him considerable renown a few years ago; there is a souvenir, fortunately, in this exhibition—"Boy," painted in 1922. In "Three Seated Figures" we encounter transition under full sail. The two nudes spoken of above more nearly approximate what apparently he is after, though one does not feel that Karfiol has yet reached his goal in this direction. Perhaps he is still some distance off.

Kuniyoshi, on the other hand, assuredly has arrived at the fullest command of his resources. The great sprawled nude so artistically integrated, nevertheless, with all the other features of the canvas leaves nothing that is essential to the design unsaid.

Pascin's well-known partly draped figures combine the softness of pale maple sugar and a certain aristocratic wistfulness. The result is distinguished, but pale, pale, and eventually a little wearisome. May he never return to subjects like "Susannah and the Elders"! The "Cafe, New Orleans," however, a small piece, one of the smallest in the show, is admirable, and if Pascin ever tires of the occupants of overstuffed chairs, more compositions of the "Cafe" ilk would be all to the good. Kenneth Hays Miller often attains his best results with the nude, though his most monumental works in this field seem seldom to make a public appearance: in them one finds a more warm-blooded Rubens type of three-dimensional painting than is to be found in the rather brightly wooden arrangements of shoppers.

WALT KUHN, when inspired, is as attractive a painter as you could ask to see. Not always does the flame of inspiration burn brightly. He is not, upon the whole, very well represented at the Museum of Modern Art. "Jeannette" however, and "The White Clown" are in his best manner. Maurice Sterne's present group is much more even in quality, and it very satisfactorily touches upon the many-sidedness of this accomplished artist. "Girl With

Blackberries," an expert design, full of vigorous drawing and color, is bound to make the most decided general impression. For our part, give us the nearly achromatized little still life, "Eggs and Water Pitcher," done in 1922, a magnificent bit of painting, and one of the subtlest things in the exhibition.

As it happens, still life again seems best in Max Weber's group; the picture incorporating a loaf of bread. Perhaps it is because this work falls more completely within the writer's grasp of a "difficult" artist's scheme. "The Worshipper," presumably important as a link in the chain of Mr. Weber's experience, leaves us bewildered, as does, in lesser degree, "Alone." There are painters who require, and reward, prolonged acquaintance, and it may well be that as yet we do not know Mr. Weber well enough.

John Marin, like Walt Kuhn indeed, like a good many others—does not invariable "realize." Water-colors of the "Maine Islands," "Sail Boat" (1926) and "Presidential Range" sort are instantly recognizable as Marin triumphant. One questions "Red Lightning" and "Back of Bear Mountain," just as one questions Preston Dickinson's "Landscape With Bridge," and even, after repeated seeing, the less bizarre "Old Quarter, Quebec," full though this landscape be of authority and imagination. Dickinson's still life work is always effective, if mannered, and architecturally it inhabits the heights.

Georgia O'Keeffe makes one wall memorable with her sensitive flower forms, so beautiful in color and so instinct with the very spirit if motion. She is as sensitive as Charles Demuth, though how utterly unlike these two artists are! The same passionate attentiveness to unstrummed music informs the work of both. Demuth's gamut is the more elastic; circus riders, flowers, dancing sailors, fruit, paquebots—even a very curious venture called "My Egypt," which has nothing whatever to do with the Nile or the Pyramids.

O'Keeffe and Demuth, Marin and Weber posit problems sometimes easily soluble, sometimes eluding. They relate themselves definitely to the American scene—in part, paradoxically perhaps, because they do not at all literally interpret it. It is important that we keep clear of entangling alliances with the topography of place. By their deeds, not by what they have looked upon, shall ye judge them. Ernest Lawson, though he paints the American countryside, does not become thereby more eligible. "After Rain" is one of the most satisfying of Mr. Lawson's landscapes—a finely spun green poem, yet in no sense slight. Rockwell Kent's early "Vermont Landscape" is a poem too: gray and brooding, with much latent power, power that becomes more sharply articulate in the also early "Toilers of the Sea," but that declines again in the posterlike and highly stylized "Voyaging" and "Cromlech" (ah, in the last named, if the suspended stone should fall!— or is the man recumbent beneath it already dead?). It will be very interesting to see what Mr. Kent has been painting up in Greenland, whence he has just safely returned to be snatched from the jaws of shipwreck.

**"House by the Railroad," by Edward Hopper.**

*In Exhibition at Museum of Modern Art.*

**December 22, 1929**

# THE ART OF RYDER, EAKINS, HOMER—OTHER EVENTS

## MUSEUM OF MODERN ART

### Work by Three Noted American 'Ancestors' —Their Relationship to Our Own Times

By ELISABETH LUTHER CARY.

THE Museum of Modern Art is showing this month the work of three noted and notable American painters, not yet "early American" but certainly not modern, except as all good belongs to all time. The three are Winslow Homer, Albert Pinkham Ryder and Thomas Eakins. Of these Ryder, whose methods are least similar to those of the present, makes the most definite impression of relationship to the spirit of modernism, essentially a free spirit detached from literal representation.

No artist more than Ryder, whatever his "period" may be, responds to Kandinsky's vision of art as primarily an expression of an "inner need." A picture, Kandinsky says, is only well painted if its spiritual value is complete and satisfying. Good drawing, he says, is drawing that cannot be altered without destruction of this inner value, quite irrespective of its correctness as anatomy, botany or any other science. Colors need not be true to nature, but they must be necessary to the particular picture in which they are used. Neither the quality of the inner need nor its subjective form can be measured or weighed. The artist must be blind to distinctions between recognized and unrecognized conventions of form, deaf to the transitory teachings of his time. All means are sacred which are called for by the inner need, all sinful which obscure that need. Thus Kandinsky writes. Thus Ryder painted.

•.•

ALBERT RYDER, one of the most most personal of painters, nevertheless conformed in his external life in a singular degree to an old-fashioned idea of the "typical" artist. Mr. Sherman's fine little biography and appreciation of him offers two versions of the disorderly simplicity in which he chose to live. One is the version of a writer for the press who saw the Fifteenth Street studio objectively, as most of us would have seen it, and carefully described the streamers of paper hanging from the ceiling, the teacups, bowls, crocks, milk bottles, boxes of apples, cereals, &c., on the floor; the pile of empty cereal containers that reached to the height of the room in one corner, the carved wedding chest smothered in odds and ends, a splendid Greek sculpture on top of it, flanked by a foot bath on one side and a box of hay on the other, other items in a confusion "unimaginable, incredible."

Ryder's own version of this incredible place shows us how it helped him toward the expression of that "inner need" from which his painting sprang. His two windows, he tells us, looked out on an old garden with big trees whose leafage cast beautiful shadows on his floor. Adjacent roof tops were low and over them swept "the eternal firmament with its ever-changing panorama of mystery and beauty." These two windows he would not exchange for a

"The Actress," by Thomas Eakins, 1903.

palace "with less a vision than this old garden with its whispering leafage." It is doubtful if he even saw the pile of empty containers or the shreds of paper hanging from the ceiling. His eyes were not upon them.

In this studio he could be found in overalls and carpet slippers, mild and courteous always, Mr. Sherman says. And when he went out among others he dressed as those others dressed, not elaborately but quite correctly. It was not his idea to appear eccentric; but he held that an artist needs only shelter, plain

food and his materials. "He must live to paint," he wrote, "not paint to live. He cannot be a good fellow; he is rarely a wealthy man, and upon the potboiler is inscribed the epitaph of his art."

Such is the picture Mr. Sherman gives us of the man Ryder, and the group of thirty-five paintings at the Museum of Modern Art gives us the rest. His paintings of the sea, unlike any other marine paintings though they are, remind us that he was raised by the sea and among sea-going people. His sails under skies of formal pattern and riding

moonlit waves communicate the mystery of the sea as truly as Winslow Homer's famous sea pictures communicate its force.

His "Death on a Pale Horse" communicates the mystery of irresistible oncoming death, devoid of gruesome detail, appearing as he must appear to all sensitive onlookers, a spectre from another world; a very different conception from that of Holbein and his forerunners, to whom death was wrapped in grotesque form, the physical skeleton of the charnel-house.

•.•

OF the other two painters Thomas Eakins is the more closely allied to Ryder. Apostle of realism though he was, Eakins realized with an intensity comparable to that of Ryder's inner vision. No one can observe his portraits without seeing how deeply he probed the character of his sitters and how every literal line of his portraiture contributes to the sum of the character portrayed. In the painting called "The Old-Fashioned Dress," where the costume is avowedly the picture, it is more than ever apparent that so great a psychologist could not subordinate to puffed sleeves and pearled trimmings the human quality behind the absent-minded physiognomy and revealed even in the lax pose of the hand on the back of the chair.

Portraits abound in the collection, and it is interesting to note the direction followed by the artist's always personal style on its way from the warm and sturdy "Marguerite in Skating Costume" of 1871 to the warm and reticent portrait of Mgr. Diomede Falconio of 1905. During those thirty-four years we see him becoming more and more aware of the undiscoverable background in which every personality is more or less merged. He takes account of it in his own way, with no lessening of veracious transcription, but with an increasing breadth of view that recognizes the limits beyond which none can go in the exploration of character. In the "Addie" of 1899 we have the last of the laboratory portraits shown in this restricted group. In the "Portrait of Mrs. Frishmuth" of the following year we have the first intimation of inscrutability perceived and subtly indicated.

As for the qualities before which a student bends his knee in adoration, they are present everywhere, as much in the drawings as in the paintings. In the "Blindfolded Model" not merely the construction with its anatomical perfection appeals to one's zest for technical triumphs, but the simplification which, although not stylized in the modern manner, has the weight and substance toward which most of the younger sculptors are striving.

•.•

WINSLOW HOMER unexpectedly declines fully to affirm his affinity with his companions. Logically enough, he looks years older than either of them. As

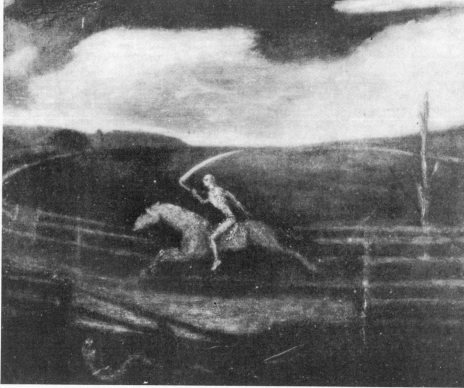

Above—"Driftwood," by Winslow Homer. Left—"Death on a Pale Horse," by Albert P. Ryder, collection of Cleveland Museum of Art.

a matter of date, he is eight years older than Eakins and eleven years older than Ryder. But dates can be left out of our consideration. The real matter is that, alone of the triad, Homer, retaining his conscience as an illustrator, told his story first. It seldom detracts from the force of his art, but its presence makes itself felt with a certain insistence of which one is not conscious in seeing his work with that of lesser men.

It would be impossible to tell a story better, and these tales of the sea are stuff to feed the imagination. The noble directness and purity of style in "Eight Bells" raise the subject to the highest plane of descriptive painting; all that is lacking is the transmutation of reality into emotional truth such as Ryder spoke in his "Tragedy of the Sea."

The inclusion of Homer in the triangular group increases, however, the interest of the whole, not only by adding a powerful personality to the exhibition, but in providing a first stage for a progressive flight from the past toward the future. The splendor of his technical quality is best seen in his water-colors, which capture the spontaneity of his impression and hold it so lightly that its brilliancy is undiminished by the slightest film of perceptible labor in the workmanship.

One of the early oil paintings, the "Croquet" of 1866, is the most charming performance in the room. All that the quaint costume of the time held of graciousness and gayety is seen in these butterfly figures on a green lawn. From this bright interlude to the more sophisticated brilliancy of the Bahama water-colors is a logical progression. In between came the powerful thunderous visions of wreck and storm upon which Homer's great fame has been built.

An exhibition full of suggestion and inspiration, this latest chapter in the history of the museum will not be missed by any one conscious of the house of art as a household of continuance.

May 11, 1930

# HOPPER'S PICTURES ON VIEW TODAY

### The Museum of Modern Art to Give Private View of One-Man Show.

### WORK IS IN 3 MEDIUMS

### Hopper Seen as One of Most Original and Accomplished of American Artists.

By EDWARD ALDEN JEWELL.

In presenting a series of carefully planned, thoroughly representative, one-man shows of work by American artists, the Museum of Modern Art has undertaken a service of the utmost value. Last season the artist thus brought forward was Maurice Sterne. This season it is Edward Hopper, whose exhibition opens today to members of the museum and tomorrow to the public. It will remain until Dec. 7.

Not too much material has been included and examples of work in the three mediums Mr. Hopper employs are found displayed in separate groups, so that there is no confusion. On the ground floor are the water-colors—all of them save an amusing little set of Parisian "types," which has a wall to itself elsewhere in the building. On the floor above have been hung most of the oils. Of these there are only twenty-five in all, and in the spacious quarters provided each picture has plenty of elbow room. The effect is dignified and inviting. On the third floor, in one of the small galleries, are found the etchings.

"The story of Edward Hopper," observes the museum's director, Alfred H. Barr Jr., in the admirably complete catalogue, "abounds in curious anomalies. He is now famous, but for twenty years his career as an artist was obscure to the point of mystery. He is now famous as a painter, but he first won wide recognition as an etcher. He is now famous as a painter of landscape and architecture, but his student years were devoted exclusively to figure painting and illustration. He is now famous as a painter of emphatically American landscape and architecture, but the landscape and architecture which first interested him were French."

Surprising, perhaps, but at any rate here it is—so simple and clear in its statement of aim and in its measure of accomplishment as almost to persuade one that the artist never went through any struggles at all. There are, it is true, certain notes that may be called transitional. For instance, the canvas entitled "Two on the Aisle," which, painted in 1927, contains traces of the illustrator's point of view—a point of view that nowhere in the later work suggests itself.

Mr. Hopper made his living as an illustrator for many years. But it appears to have been a rather unhappy period, "filled with disappointment and discouragement." It was not until 1923 that substantial attainment began to enjoy recognition. In this year he painted some water-colors, one of which was purchased by the Brooklyn Museum.

After that Frank K. M. Rehn gave him an exhibition, "which," as Mr. Barr says, "marked the turning point in Hopper's career." Discontinuing his commercial work, the artist took to oils again, and gradually moved onward to a place of real distinction in the American art world.

And that Edward Hopper is one of America's most vital, original and accomplished artists this exhibition is amply prepared to attest.

October 31, 1933

# OUR MURALS

## National Survey of A Developing Art

By EDWARD ALDEN JEWELL.

WE may as well admit, and squarely face the admission, that there is a good deal to be said in favor of bare walls. With the outside world so full of distraction, so stridulent, at most times, with the tumult of daily living, it may be esteemed not absolutely essential that, indoors, we should provide ourselves with an orgy of pictorial excitement. This isn't at all by way of implying that murals are to be discouraged. It is, however, by way of suggesting that if we do cover our walls with murals, the decoration — besides, of course, being appropriate to its setting—should be, on the side of quality, good enough to justify such employment of space and of talent.

The current exhibition at the Grand Central Galleries, sponsored by the Mural Painters Society, merits large attendance and the public's gratitude as directed to those who, with very slender capital upon which to call but with tireless devotion, have assembled and ably presented this material. The exhibition, besides, contains much that commands admiration and respect, much that cannot but appear encouraging to those of us who ardently believe in American art, potential and already accomplished. Yet the exhibition is plentifully encumbered, too, with documents that bring us to pause; that, as we weigh them impartially, reinforce a prudent insistence upon standards sufficiently high to make an important enterprise justify itself, proving, in the performance, worth while.

* * *

IT is peculiarly difficult to exhibit murals. Severed from the environment for which they were planned, murals can never be judged with entire confidence. Then, too, in many, in most instances, the actual murals are not shown at all. They must instead be proxied by cartoons, sketches, small detail panels or photographs. For these reasons one hesitates to undertake a more than tentative inventory of the results exposed to view.

Certain examples that, illustrated alone by photographs, are barely noticed by the visitor, may in reality be of outstanding significance. For instance, several very excellent murals were produced under the PWAP, among them the agricultural series from the cooperative workshop of Grant Wood, out in Iowa. The catalogue explains that of the numerous PWAP mural projects, "many of the best are permanently installed, and adequate space could not be given in this exhibition to studies and sketches for them, while it would also be impossible to present a true picture of the achievement in photographic form." From the government was nevertheless secured a small group of photographs, which should be studied carefully.

When we come to the mural activities directed by the College Art Association under various auspices, including the Works Division of the Emergency Relief Bureau and TERA, the results are more conspicuously in evidence. Some of these projects have been discussed ere this in our Sunday columns, among them Edward Laning's highly effective work in fresco at the Hudson Guild Neighborhood House (cartoon shown in the present exhibition). Other ambitious projects promoted by the College Art Association are also illustrated, such as the Ben Shahn prison murals, the series of pictorial maps of the world designed and expertly worked out by Ben Knotts and Guy Maccoy for the Julia Richman High School, and the vast decorative scheme devised for the Textile High School (a model of the foyer is on hand).

The College Art Association has devoted its best energies to this relief program; and if not all of the mural work accomplished can be called—with severe critical standards operative—significant, the program is yet deserving of full support, since it provides a field for practical experimentation and is in line with the sound and generous procedure initiated by our government last year.

* * *

IN a review on Tuesday I mentioned a number of murals that struck me as being of particular merit. In stating that beyond these there was little work of consequence, I may unwittingly have created a somewhat false impression. Since I considered the exhibition entirely in terms of its representing American artists, no allusion was made to anything by either of the Mexican artists, Rivera and Orozco. Certainly the sweeping dismissal was not intended to embrace Orozco's magnificent murals at Dartmouth. Also the catalogue now before me lists things I was unable, in the brief time at my disposal on the opening day, even to locate. Considerable search, for instance, failed to bring to light the proposed "Labors of

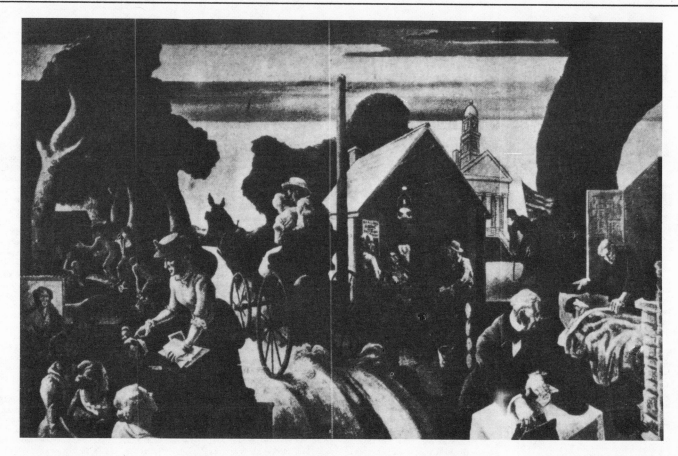

the Mind'' and ''Labors of the Hand'' by Hildreth Meière, who has acted as chairman of the exhibition committee—though I did go into the Grand Central Palace, where the Trade Fair was in progress, to see her interesting, decorative sixty-foot mural, ''Onward March of American Women''—marred alone by the conventional stage-property figure of Clio at the end.

It seems to me that as an American mural Thomas Benton's Indiana sequence (first shown at the Century of Progress in Chicago) deserves the highest honor. I should also place high in the scale Jacob Burck's ''Five-Year Plan,'' designed for Intourist, Inc., three panels of which are reproduced on this page. Mr. Burck has arranged his figures with most uncommon skill, achieving a pattern of splendidly organized vitality. How effective this series will be when executed (and ever so much must depend upon the color) remains to

be seen. George Biddle, too, makes an impressive showing with his ''Hosiery Workers,'' the industrial motifs regimented with monumental simplicity. The John Steuart Curry murals, ''Tragedy'' and ''Comedy,'' done in fresco at the Bedford Junior High School, Westport, must be grand; in this instance, enlarged photographs can leave very little doubt in one's mind.

Then there are refreshing items such as William Gropper's ''Wine Festival'' (a real lift, this gives, after so much in the exhibition that is merely pedestrian, or worse); Louis Bouché's delightful still-life mural on glass, shown by courtesy of John Wanamaker, and the Joseph Stella arabesque of ''Flowers.'' The cartoon section from William C. Palmer's mural for Queens General Hospital (designed under PWAP, financed by TERA) is extremely well done, making an excellent impression in black and

white, though the small accompanying sketch disappoints because of its anemic color.

Much that deserves to be commented upon will at this time have to be passed over in silence. However, room must be found for mention of Lucia Wiley's altogether charming panel, ''The March of Youth'' (No. 158 in the catalogue); for the very pleasing spiral design upon which the ''Three Girls'' panel by Jared French is constructed; for Louis G. Ferstadt's capable though, in color, somewhat washed-out ''Students in the School''; Dunbar Beck's distinguished decoration, which won first prize in the recent competition held by the Ever Ready Label Corporation; the vigorous details done in fresco by Stefan Hirsch and Henry Varnum Poor; Henry Billing's well-painted if not entirely convincing ''Fascism''; a small fresco detail (the subject, a child) by Lucienne Block and Dane Chanase's project.

There are other worth-while things, some of which were touched upon in our previous notice. There is also, alas, very, very much in this exhibition that would seem to merit being scrapped—pretentious things; obscure or empty trivialities (often huge); work ill-painted, half-baked in concept; again, work that is perhaps respectable as decoration, but hopelessly commonplace. To the ignominious bottom of the heap may be consigned those products in which are published the misguided artist's abject pilferings from Mexico.

February 10, 1935

### Grant Wood Show Opens.

Grant Wood, the now celebrated Iowa artist, is having his first one-man show in New York at the Ferargil Gallery, 63 East Fifty-seventh Street. His work, however, is already well known here, having been included frequently in group exhibitions.

The present show is large and thoroughly representative, containing not only oils, early and late, but also drawings. That Grant Wood's worth as an artist has come quickly to be appreciated is attested

by the fact that nearly everything on view has been lent from private and public collections.

Among the oils one is glad to find that most famous of all the Grant Wood paintings, ''American Gothic.'' The almost equally popular ''Daughters of the American Revolution'' could not be secured, but it has been shown in New York ere this. Other conspicuously successful or peculiarly interesting canvases included are ''Midnight Ride of Paul Revere,'' ''Birthplace of Herbert Hoover'' (oil and drawing), the beautiful panel, ''Dinner

for Threshers,'' which proved one of the best things in the 1934 Carnegie International at Pittsburgh, ''Arbor Day'' and the elaborate, superbly painted landscape, ''Stone City.''

The exhibition will be discussed critically at a later writing. It follows the just-concluded exhibition of paintings by another leading American artist, Thomas Benton, several of whose canvases have been rehung in the basement gallery at the Ferargil.

April 16, 1935

# BEWARE THE PENDULUM!

## Chastening Thoughts Anent a National Habit—Variety on the Calendar

### By EDWARD ALDEN JEWELL.

IN its immemorial swing, the art pendulum tempts to extremes that the wise learn to guard against. At most times we can if we will uncover, conveniently at hand, object lessons in the matter of snap or emotionally off-balance judgment. Just now, it may be feared, repudiation of what we have come to call the gravely suspect "American scene" is in danger of sweeping into eclipse many a talent that deserves, by a good deal, less cavalier treatment. Americans pride themselves upon doing things in a big way and also upon not doing things by halves. But this laudable trait may occasionally lead in its thoroughness to some pretty dubious postures.

It stands to our credit, beyond question, that we should have become alert, almost at once, to the quicksands upon which, not so long ago, this "American scene" cult set up its overnight façade of time-serving, back-scratching, cheap surface display and general quackery. To change the metaphor, what looked for a while like a terrible conflagration turned out to be, after all, only a flimsy stage effect. No one was burned by it, though a few got smoke in their eyes.

But this very admirable you-don't-fool-me attitude toward an epidemic of sign-board art may temporarily have blinded some of us to the solid virtues of certain painters who, because they were prominently identified with the movement at the outset, have come to be esteemed guilty along with the small fry that afterward turned the whole thing into academic disrepute.

\* \* \*

BENTON, Grant Wood and John Steuart Curry are now quite often referred to as the "Big Three." The term has slyly unflattering connotations and in simple fairness, the sooner it is scrapped the better. These American artists have elected to explore themes peculiar to this country. They are striving, each in his own way, to get at underlying rhythms, sovereign emotions, root characteristics of the American people. It is a large and serious responsibility. Sometimes they may succeed, sometimes fail—being, alas! through no fault of their own, merely human. But it strikes me that, whatever the specific result, such effort as theirs should command the respect, at least, of all those who know the difference between a quest and a silo.

In his newly opened gallery at 108 East Fifty-seventh Street Maynard Walker has just placed on view work by these artists, along with canvases by an earlier American trio: Thomas Eakins, Winslow Homer and Albert P. Ryder. It seemed to me that, absorbed in the exhibition's idea itself, Mr. Walker had to some extent lost sight of the importance of securing for this occasion the best possible examples by his six artists. There are a few high spots, among them "The Wreck" by Homer, borrowed from Carnegie Institute, and Ryder's "Forest of Arden," lent by the Misses Dodsworth. But if we except also the "Dinner for Threshers," by which Grant Wood is uniquely represented, and Curry's remarkable "Hogs Killing a Rattlesnake," the initial display at this gallery isn't very much; isn't, certainly, as rewarding as one had anticipated.

All the same, the juxtaposition here proposed and, if not in an ideal manner, as here accomplished, is constructive. It tends to suggest the fluid continuance of a tradition.

Upon the one hand we have three American artists whose period is past, whose life work has been completed; upon the other hand, three Americans whose experience is contemporaneous with our own, who live and work for tomorrow as well as for today. Could it be proved that their interest attaches purely or primarily to the act of transcribing, in terms of unimaginative, uncreative photographic naturalism, vicarious surface aspects of an environment vicariously and superficially theirs, then it would seem useless to concern ourselves with the possibility that they might be misunderstood. But proof of that sort—whatever the shortcomings on which it is ostensibly based—has yet to be established.

THEN there is James Chapin, now returned to us (in his current exhibition at the Rehn Gallery) after an absence of several seasons.

Chapin had the misfortune to begin his really serious work—as an American painter responsive to the richness and stimulating vitality of American life—at a time when the local art world was helplessly enamored of the School of Paris; befogged by incense rising before the shrine of a modern movement overseas.

That was a good many years ago. And as a matter of fact (which did not make his path any easier at the time) he withdrew to a rural hinterland, steeping himself in its rude, homespun existence, because he felt, because he deeply and passionately felt, that American artists would never get anywhere in the way of sincere, convincing personal utterance so long as they clung, with emulative reverence, to the skirts of an alien culture.

When the Marvin saga began to come through in paint, Chapin's work was frequently dismissed as "illustration." It was often considered mere meticulous naturalism. To me it never seemed that. There was a note that went very much deeper. These were genuine characterizations, full of the flavor of personalities he had come really to know; full, too, of an American spirit that, in those beautifully painted comments, took the form of symbol.

The new work, now being shown, reveals this artist engaged in creative labor of somewhat the same type, though the present realm of activity is far removed from that of the remote earlier countryside. Chapin has addressed himself again, and with manifest relish, to portraiture, after a period of transition in which a generally differing sort of subject-matter was lieutenanted by a looser, more impressionistic style. Portraits such as those of Katharine Hepburn (reproduced) and of Doris Lindeman—these especially—suggest the depth and stature of Chapin's art.

Much that is excellent, to be sure, appears in the other new portraits, which, however, may be felt less tellingly to gauge the artist's capacity or to suggest the probable direction of future endeavor.

There are danger signals that, I think, Chapin should meditate. One of these (and it obtrudes to some extent in even the finely modeled, sympathetically studied portraits of the two sitters mentioned) is a proneness to "enamel"—the only term that seems to fit this case. There is too much polish. It intensifies a certain look of rigidity or hardness that cannot be said to further the effect toward which, one is pretty sure, the artist has aimed. Also Chapin's use of color seems often to get rather in the way of his always more cogent drawing.

Sometimes, indeed, when we turn to the drawings themselves (hung in the small room at Rehn's) we come closer to an apprehension of his essential quality; are able more clearly to appreciate the high worth of a talent that has contributed something of real fineness and substance to our American tradition, and that promises more.

November 17, 1935

# EXHIBITION OPENS OF 'FANTASTIC ART'

## 700 Objects by European and American Artists Shown at Modern Museum.

### DADAISM CULT PREVAILS

### By EDWARD ALDEN JEWELL

The exhibition called "Fantastic Art, Dada, Surréalism" opened last night at the Museum of Modern Art, 11 West Fifty-third Street. There was a preview reception at 10 o'clock held by the trustees for members of the museum and their friends. But the real test will come today, when the doors are opened to the public. It may prove a test of endurance on both sides. Whether the Van Gogh record is to be challenged and broken, time must tell. As the public little by little gets wind of what is in store for it there, the doors will probably have to be closed at frequent intervals to prevent trampling. The show is that "marvelous."

Europe, it becomes at once manifest, has been ransacked. Alfred Barr was abroad all last Summer, and most of the show has already been seen by our customs officials. What they made of it is not known. But they let it through. As for the American quota, that must have been much less difficult to manage — just a matter of calling up Mr. Budworth and asking him to stop at studios with his truck. But it remained for the museum staff to assemble these 700 and more objects by more than 157 European and American artists. And any one who has assembled a dada and surréalist show can tell you that it isn't as easy as building a Coney Island.

To avoid possible misapprehension, the public would do well to read this paragraph in Mr. Barr's catalogue preface before looking at anything in the museum:

"It should, however, be stated that surréalism as an art movement is a serious affair and that for many it is more than an art movement: it is a philosophy, a way of life, a cause to which some of the most brilliant painters and poets of our age are giving themselves with consuming devotion."

After that the visitor is better prepared to appreciate the life-sized object called "Agog," created in 1935 by Wallace Putnam, which stands just to the right of the entrance, an object seriously compounded of umbrella vertebra, a piece of hose, a rolling pin, a colander, a funnel, a feather plume and, indeed, more plastic ingredients than can be recalled in an impromptu way.

Not all of the objects in this lavish show, of course, are as complicated as that. There are, for instance, the simple cup, plate and spoon by Meret Oppenheim, made of fur. And—still in the realm of sculpture—there is Miro's object, No. 444, which rises out of a damaged derby, incorporates the model of a woman's leg, a pink toy goldfish, a ball suspended at the end of a bit of string, the whole miraculous device surmounted by a stuffed parrot in quite good condition.

The paintings are often just paintings, although pretty frequently, too—as in the shingle-and-yardstick portrait of Ralph Dusenberry by Arthur Dove, or the "Peregrinations of Georges Hugnet," by Oscar Dominguez, which shows a toy horse trotting through a toy bicycle, or Max Ernst's "Two Children Men-

aced by a Nightingale," in which the gate swings outward—the paintings do not remain in two dimensions.

Both dadaism and surréalism belong to a charming interlude of irrationality before our world went altogether mad. Dada, as Georges Hugnet explains in his essay in the museum bulletin, was born in a Zurich night club in 1916. But beyond that it is "ageless," has no parents, stands alone, makes "no distinction between what is and what is not."

And what is the precise difference between dadaism (ironically and optimistically and idealistically started as an "ism" to end all "isms") and surréalism which reaches out to mesmerize the Sub-

lime? Well, even Mr. Hugnet leaves that question a trifle vague when he says that surréalism "springs from the marvelous and has always existed." Those who insist upon dates may find comfort in the fact that "the first theoretical foundations were laid in 1924."

The show at the museum, however, delves much further into the past, by way of demonstrating that elements of the "fantastic" in art existed hundreds of years before there was any nightclub in Zurich and before dada began to "make a clean sweep of everything."

So we find certain hallucinations and paradoxical broodings by artists of the fifteenth and sixteenth centuries, among them Hans Baldung, with his "Bewitched

Groom," Pieter Brueghel the Elder, Giuseppe Arcimboldo, Duerer, Hans Holbein the Younger, Schongauer, Leonardo da Vinci and Hieronymus Bosch—his study for a "Temptation of St. Anthony" is lent by the Louvre, and from our own Metropolitan comes the wonderful "Descent into Hell," attributed to the "school of" rather than to Bosch himself, though it is quite worthy of him.

The roster of "moderns"—even if held to the twentieth century and made to omit such artists as Hogarth, Blake, Daumier, Meryon, Victor Hugo (a "Satanic Head" in wash) Edward Lear and Odilon Redon—would be far too vast to permit of full enumeration here. Among the outstanding men of our

epoch represented are Chagall, Chirico, Marcel Duchamp (his "King and Queen Traversed by Swift Nudes" hangs near the famous "Coffee Mill" of 1911), Kandinsky, Klee, Picasso, Man Ray, Miro and Salvador Dali.

Miro, by the way, is now having a one-man show at the Pierre Matisse Gallery, and Dali, just arrived in America, will show some of his new pictures at the Julien Levy beginning tomorrow.

Dada rides in the saddle, messieurs, mesdames. The bars are down and the season of exquisite mal-de-lune has blossomed in all its splendor of hokuspochondria.

December 9, 1936

---

## CALDER MOBILES

IT is blithe news that mobiles and stabiles by Alexander Calder (all 1939 model) are now to be seen at the Pierre Matisse.

Several of the new pieces are quite larg, and elaborate, designed for the garden. It may be said of this work that for the most part it remains essentially in the sculpture field, even when, on a design basis, the forms seem three-dimensional variants of twentieth century abstract painting. Now and then the effect of painting will be more insistently adhered to (especially the effect of painting by Joan Miro). When this happens the result is inclined to be less persuasive. For Calder's gift is the sculptor's, just as a boy's will is the wind's will.

There, in that field, he functions —decoratively, dynamically, amusingly, joyously, often irresistibly— and without, in just this field, a rival.

May 14, 1939

---

# ART SHOWS OFFER STRIKING CONTRAST

Paintings of Chagall, Russian, and C. H. Carter, American, at Neighboring Galleries

## FORMER TRUE FANTASIST

Long Identified With Paris— Latter, Naturalistic Artist, With Carnegie Institute

### By EDWARD ALDEN JEWELL

Striking contrast is afforded by two of the one-man shows that opened this week in neighboring Fifty-seventh Street galleries. The artists concerned are Marc Chagall at the Pierre Matisse Gallery (41 East) and Clarence H. Carter at the Ferargil (63 East). Chagall is a Russian painter, long identified with the Ecole de Paris. Carter is American and teaches art at Carnegie Institute of Technology in Pittsburgh.

The work of these two painters is divergent in just about every respect. Chagall, if we are to accept the evidence at its face value, is a naive fantasist, whose strange creations are impregnated with a spirit of caprice and irrational whimsicality. He has been linked with the surrealists. And it is easy to see why, long before the advent

of surrealism. Chagall's radical break with precepts of naturalism should have provided a stimulus also for the expressionist movement in Germany.

Pierre Matisse has assembled the following facts:

"Marc Chagall was born in Vitebsk, Russia, on July 7, 1887. He started painting in 1907 and studied with Bakst for a short time. In 1910 he arrived in Paris and exhibited at the Salon des Indépendants. It was Guillaume Apollinaire, poet of the 'avant-garde,' who, in 1911, after having seen the paintings of Chagall in his studio, pronounced them 'supernatural.' Later it was Apollinaire who, in Berlin, organized at Der Sturm Gallery the first large Chagall exhibition (200 pictures), and wrote a poem for the catalogue introduction."

### Group Is Retrospective

To the extent that I know it, Chagall's painting has adhered to a single "norm" right through the years. The group at the Pierre Matisse Gallery is retrospective, the earliest canvas, "La Noce," dated 1910, the year the artist first exhibited in Paris. In one respect "La Noce" differs a little from the examples that follow: it seems more down-to-earth. Analyzing on a literal basis, that is probably because it contains no feats of levitation. But the floating idea was not slow in developing, for the next canvas in the sequence—a 1911 "A la Russie, aux Anes et aux Autres"—is replete with forms lighter than air; queer forms suspended in what our "avant-garde" poet would call the realm of the "supernatural."

After that, we perceive, anything can happen. A blue fiddler, up in the sky with an ox, serenades a woman in red, recumbent upon a sofa in the garden. A suspended fish with wings of fire, companioned by a huge clock, makes no apparent difference to the lovers below on the blue bank of a river. Again, the fiddler looks down upon angels, people and houses from the top of an immense bouquet of flowers. A double-faced man confronts a man-faced cat near the Eiffel Tower, while a railroad train goes by, imperturbably upside down.

Themes such as these are typical. We must make of them what we can, conceding Chagall to be a true mystical fantasist, or wondering, in the margin of our minds, whether his "naiveté" ought to be taken with some skeptically distributed grains of salt.

Chagall, though master of a quite individual style, is seen at one period to have felt the influence of Cubism. Traces of that may be found in "N'Importe ou hors du Monde," of 1916.

However we decide that his strange symbols and topsy-turvy motifs should be interpreted, we are likely to agree as to the brooding richness of this artist's color. It smolders and glows, yet the flame is irradiated with an eerie coolness. That, I daresay, Guillaume Apollinaire would pronounce supernatural too.

### Carter's Work Analyzed

Now, Clarence Carter's painting, at the Ferargil, is diametrically opposed to all this. No one would call Carter's painting supernatural in the least. He is a naturalistic

painter. His people stay on the ground. Nor are his themes wrought out of naively mystical symbols. His canvases and water-colors would be much more prosaically denominated just as landscapes, still-lifes and figure subjects.

Yet when style enters the equation (and Mr. Carter has very definitely a style of his own) it will always be necessary to qualify one's use of terms such as naturalism. As a matter of fact, though never supernatural, Carter's painting technique often partakes of what we may call the supernaturalistic approach. This results, as in the excellent "Tech Belle," in a kind of sharpened definition of form and hyperclear finish of surface. In other words, whether carried to that extreme or not, Carter's work is never "photographic" in its naturalism.

His color is cool, in an entirely different sense than that that applies to Chagall's color. It is not rich, but it is firm and true and precisely used. It is inclined to be pale color, but it is never pallid. In fact, it possesses, both in oil and in water-color, a kind of acid strength that becomes one of the prime ingredients of a particular and intelligently directed style.

The present paintings are not by any means all of equal merit, among the best being the subject mentioned above, "Smoldering Fires," "White Flowers," "Refreshments" (a still-life remarkable for its texture), and, in the water-color list, "Pattern in Green," "Storm Over the Greenhouse" and "Mullein."

November 28, 1941

# TOWARD ABSTRACT, OR AWAY?

## By EDWARD ALDEN JEWELL

SEVERAL weeks ago Impresario Howard Putzel of the 67 Gallery (so-called because that is its East Fifty-seventh Street address) opened an exhibition that served to pose "A Problem for Critics." The event was recorded briefly then in these columns, but, since the week had been heavily stocked with openings, the "problem" could not be gone into. Conditions, at length, with the season dwindled to a mere faint ripple, are more propitious.

It should be noted, however, that the exhibition has nearly reached the end of its run. Mr. Putzel is extending it, but only through the week at hand. Examination of the paintings at the 67 Gallery might be followed up by visits to the Museum of Modern Art, now holding a large show of material in the permanent collection; to the Museum of Nonobjective Painting, where abstract work by Americans is exhibited and the Kandinsky memorial continues; also to Peggy Guggenheim's Art of This Century —and in fact any galleries in which work of an abstract nature can be found.

Artists represented in the comparatively small exhibition at the 67 are Jean Arp, Joan Miro and Picasso, considered as "forerunners" of the movement to which Mr. Putzel refers; Hans Hofmann, André Masson, Mark Rothko, Charles Seliger, Rufuno Tamayo, Leonore Krassner, Jackson Pollock. R. W. Pousette-Dart, Arshile Gorky and Adolph Gottlieb.

Since we want to know precisely what we are asked to decide, I shall first quote in full Mr. Putzel's statement published by him as an accompaniment to the exhibition:

Classification is extraneous to art. Most labels attached to painting are unenlightening. Talent's the thing. "Isms" are literature. Nevertheless, a large part of the public that looks at contemporary painting demands classification. Possibly classification leads to clarification. The word Cubism, though inaccurate, is apt. I hope that some art critic, museum official or someone will find as pertinent a first syllable which may be applied to the new "ism."

During the past dozen years, and particularly since 1940, the tendency toward a new metamorphism was manifest in painting. However this may seem related with totemic images, earliest Mediterranean art and other archaic material, it does not, on re-examination, appear to utilize any of these for direct inspirational sources. One discovers that the real forerunners of the new "ism" were Arp and Miro. Some of Picasso's paintings fit in the same category, but the series he calls Metamorphoses is, in aspect, more sculptural than pictorial.

Here the new "ism" finds its most effective support among American painters. The closeness of objective resemblance to pre-Columbian expressions indigenous to this hemisphere is an incidental factor. What counts is that the painters, however respectful, are unimpressed with any idea of becoming "another Picasso" or "another Miro," and that their works indicate genuine talent, enthusiasm and originality. I believe we see real American painting beginning now.

I found Howard Putzel's argument arresting but not sufficiently explicit to serve as a base for operations, and asked him if he would expand it a bit. The following supplementary statement arrived in due course:

Examining the history of art one discovers that when a type of imagery has been worked out to its final possibilities, this has been replaced by another type of imagery. Academism shows us that, although history may repeat itself, no one can successfully repeat an act of history.

Abstraction from realism ended with Mondrian. During the last two decades of his life not even Mondrian added anything to the imagery of this type of abstraction, although his methods were marvelously enriched. Surrealism attempted to satisfy the need for a new imagery. But with one or two notable exceptions surrealist painting was weakened by too great an involvement with literary factors and soon deteriorated into a kind of genre which is, at times, indistinguishable from neo-romanticism.

Dadaism, which commenced about 1916, constituted an action against the imagery of abstraction. Arp, who was one of the leaders, used a kind of automatism: a deliberate start from a formless field of emotion or "inspiration," which he worked toward, but not into, direct resemblance to recognizably familiar things. It seems to me that Arp is a forerunner of, for example, Adolph Gottlieb, Hans Hofmann, Jackson Pollock and Mark Rothko, who also work toward rather than away from direct resemblances.

This new direction offers the possibility of considerable variety and also extension, and that constitutes a part of its inherent strength.

Assuming that Mr. Putzel really has got hold of something here (and the point is open to debate) it becomes apparent that the gist of the potential new "ism" resides in the phrase "toward rather than away from direct resemblances." In other words, it seems that whereas the cubists strove first to turn real forms into abstraction by breaking up the surfaces into basic planes (thus changing, too, the content or form of the volumes), certain artists today, proceeding in reverse, start with complete abstraction and move in the direction of real forms.

Stated as a theory or "problem," this sounds reasonable enough. It might imply that, given time, the artists would arrive back once more at what had previously been the cubists' points of departure.

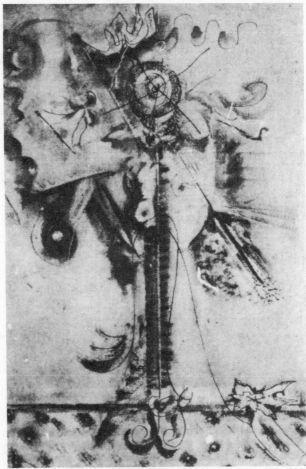

"Water-color," by Mark Rothko.

Thus a cycle would be completed, and with the sort of inevitability that might be applauded by gods whose mills, if they grind slowly, grind "exceeding small."

Mr. Putzel sees the beginning of this return exemplified in painting by Jean Arp. Picasso's "Harlequin," which we reproduce, would indicate another facet in the "reverse" pattern, the trend away from abstraction and toward "actuality"—a trend followed, we are invited to agree, by several contemporary painters now represented at the 67.

I am not convinced, nor am I yet even strongly persuaded, that there is any such new "ism." Mr. Putzel may be right in his analysis of types of abstract painting that have developed within the last decade. So far I have been unable positively to distinguish them from types antecedent. Some of the work at the 67 Gallery appears to be quite nonobjective. And when it comes to individual pictures in which concrete forms may seem to be hinted at, there is nothing, it strikes me, to indicate that the movement is toward, instead of still away from, naturalism. It would be very interesting to learn just what the artists concerned have to say about all this.

Much recent abstraction is markedly expressionist in character. This type is encountered again and again. To it belongs work by Jackson Pollock: a vigorous new talent that could advantageously bend its wild will to a lot more discipline. R. W. Pousette-Dart's canvas at the 67 looks somewhat like an abstract variation on a theme by Rouault, though if compared with this murky palimpsest a typical Rouault would look as clear and simple as sunshine. Hans Hofmann's radiant "Painting" seems to me pure lyric nonobjective abstraction, tortuously to shepherd which into a trend toward "resemblance" would be, I should say, difficult indeed. The delicate water-color by Rothko, reproduced, might, if you like, be a figure or a still-life, but with summer here at last I think I'd prefer just to call it nonobjective, period.

Mr. Putzel's "problem for critics" has stimulated considerable controversy and may well occasion more. Maude Riley, in The Art Digest, decided that the walls submit "insufficient evidence." Emily Genauer, in The World-Telegram, felt that "really, we have plenty of problems as it is." Clement Greenberg, in the June 9 issue of The Nation, discussed the "problem" at some length, and you will find an at least related article by Manny Farber (whose subject is Jackson Pollock) in the June 25 issue of The New Republic.

If readers desire to express opinions, let those, please, be very terse, for our supreme problem just now is space.

July 1, 1945

# ART SHOW OFFERS DISPLAY BY MOORE

## Modern Art Opens Exhibition of Sculpture and Drawings by Contemporary Artist

### By EDWARD ALDEN JEWELL

A one man show of sculpture and drawings by the distinguished contemporary British artist, Henry Moore, opened with a preview last evening at the Museum of Modern Art, 11 West Fifty-third Street. This unusually interesting and challenging survey, installed in galleries on the third floor of the museum, opens to the public today and will continue through March 16. It was organized by James Johnson Sweeney, who recently resigned as director of the department of painting and sculpture at the Modern.

In selecting the work Mr. Swee-ney was assisted by the sculptor himself and by the Arts Council of Great Britain. Also Moore, now visiting this country, was consulted in the matter of installation. The fifty-eight pieces of sculpture and forty-eight drawings are presented to excellent advantage, above all spaciously. There is no sense of crowding or clutter. This is especially important in view of the prevailing serenity of the work.

While most of the material now exhibited was shipped over here from England for the showings at the Museum of Modern Art and (later) at the Chicago Art Institute and the San Francisco Museum of Art, certain examples were supplied, it is announced, by American collectors.

The illustrated catalogue, with text by Mr. Sweeney, has not yet been issued, but a check list furnished at yesterday's press view reveals that the Moore retrospective covers a period of twenty-four years, the earliest piece of sculpture, "Head of a Girl," having been made in 1922. One of the frequently encountered "Reclining Figures" and a "Family Group," together with a couple of drawings, were completed this year.

All of Henry Moore's work is abstract in some degree. One of the most naturalistic of the sculptural pieces is a fairly large "Reclining Woman" of 1932. Although a measure of distortion is involved, the representational element predominates, as contrasted with, for instance, the treatment of the two larger reclining figures done respectively in 1939-40 and 1945-46, which employ the human form as a basis only upon which a monumentally abstract theme may be developed. Some of the pieces are unqualifiedly nonobjective. Yet even these seem related to life.

A few years ago, in a volume edited by Herbert Read and published in London by Percy Lund, Humphries, and in New York by Curt Valentin, Henry Moore phrased with terseness and clarity what may be considered the core of his sculptural quest:

"For me a work must first have a vitality of its own. I do not mean a reflection of the vitality of life, of movement, physical action, frisking, dancing figures and so on, but that a work can have in it a pent-up energy, an intense life of its own, independent of the object it may represent. When a work has this powerful vitality we do not connect the word Beauty with it.

"Beauty, in the later Greek or Renaissance sense, is not the aim of my sculpture.

"Between beauty of expression and power of expression there is a difference of function. The first aims at pleasing the senses, the second has a spiritual vitality which for me is more moving and goes deeper than the senses."

Reproduced in the form of a wall placard, this explanation should make less baffling the average spectator's task of appreciation. It is accompanied by other helpful statements, most of them concerned with problems of medium and of design.

Among the drawings are many that represent studies made by Moore in London's air-raid shelters during the war. These are packed with terror and pathos and unconquerable hope. Other drawings are more closely related to sculptural projects.

December 18, 1946

---

# ART

ANDOVER, MASS.: Against the background of the Addison Gallery's staid collection of American painting (where Homer's "Eight Bells" is a perennial favorite) stands Director Bartlett H. Hayes Jr., known to his New England colleagues as "a live wire." Annually he jolts the Andover student body and the neighboring Boston gentry by an exhibition explaining the advanced currents of art. This year he is currently giving German-born, Paris-trained Hans Hoffman his first full-length exhibition in America.

The paintings show how Hoffman's scientific background in part conditioned his approach so that cause and effect and physical forces became increasingly more interesting than naturalistic representation. Hoffman has taught in many parts of America in the last eighteen years, and recently his preoccupation with tensions and mood have made impact on many of the more imaginative (withal controversial) younger painters.

February 15, 1948

---

## de Kooning

### By SAM HUNTER

ABSTRACT: One of the stronger currents of abstract art today has become an obsession with the medium of paint itself for its internal dramatic possibilities. Characteristic are the paintings by William de Kooning, holding his first American show at the Egan Gallery. His canvases are scarred, kneaded, dragged with amorphous squibs of paint that bear testimony to the violence and anguish of the struggle of his forms from their raw estate as possibilities upward toward realization. Curiously enough the artist seems to controvert his own aims by withholding life from these forms at the crucial moment when they are about to emerge from their dense, seething web of automatic activity. This method of canceling out, contradiction, of maintaining an interminable fluidity either adds up to an impression of imprisonment with possible contemporary spiritual implications, or one of lugubrious vacillation and paucity of motifs and content, according to your point of view.

April 25, 1948

---

# DIVERSE MODERNISM

## New Shows of Paintings By Contemporaries

### By SAM HUNTER

SIMULTANEOUS shows of paintings by Ben-Zion are being held at the Jewish Museum and Bertha Schaefer's gallery this week. This artist is one of a few moderns who seems able to venture onto the quicksands of religious emotion without going under in a bath of bromides and spurious extravaganzas of feeling. His work is certainly uneven, part of the time inept and groping, but its best (the two huge rooms of biblical paintings at the Jewish Museum are a very good best) bears comparison in some respects with work by Rouault, Beckmann and Chagall. There is a similar ability to externalize fantastic daemonic material in elementary, almost banal, visual terms and to reach out toward the extremities of feeling.

For the most part Ben-Zion holds to the simple story-telling device of depicting scenes from the Old Testament and Hebraic mythology. His compositions are massive, with a dragging cumbersome weight as if their figures were heavily suspended or unwillingly engaged, chain-fashion, by their ropy black outlines to face the wrath of their God. The mental abstracts of dread and lamentation are felt almost as if physical burdens. The bareness and abruptness of style have a grating eloquence and ruthless austerity that are almost obsessive and again eminently suitable for projecting emotional forces.

These forces at one pole are the awareness of evil, a felt presence that reduces the canvas "In the Garden of Evil" to a leering pigmy Adam and Eve and giant serpent; at the other, bewildered fantasy dreams of supernatural bliss—as in "Noah in the Ark," where Noah is surrounded by a horde of voluptuously plumed, expressionless fowl.

ABSTRACT: If Ben-Zion may be said to externalize his demons in myths, a pictorial genre of legend, Motherwell's latest abstractions at the Kootz Gallery seem to invert the process and subjectify certain contemporary fictions into daemonic images. A point of view is inescapable even from these shapeless, deliberately infelicitous forms and it seems to be in the way of ironic comment on the inconsequence, anonymity and violence of modern man's urban experience. At times, as in "Man," the image degenerates almost into muddy dadaist farce. In other moments the image shines with a virile oriental splendor and barbarity.

All along, a good deal of wry wit is in evidence. "The Best Toys Are Made of Paper" is a fetching collage salvaged from the rubbage heap and then deliberately defiled by a meaningless liquefying drivel of paint. Destructive painting for a destructive age. For all that, the work is uniformly strong in design and pictorial ideas, courageous in its disregard of adventitious matter and full of personal discoveries, the best of which are the "Red Skirt," "The Emperor of China" and the "Painter." The imaginative quality of this work is difficult to ignore. On the other hand, it still tends to be centered in itself, and the limitations imposed by its own methods and destructions inhibit its creative power.

May 16, 1948

# CHIEFLY ABSTRACT

## Paintings by Sutherland, Millman and Gorky

### By SAM HUNTER

THE new Graham Sutherland show at the Buchholz Gallery, his second here, may be expected to stir up controversy. It is uncompromising in its own way. The laconic and disjunctive composition, matted, dead color and horny shapes are far from gratifying the eye. And the evocation of a still denatured landscape in limbo that accommodates the terrible as well as the beautiful will make even enthusiasts quail.

There have been misgivings about Sutherland before. Reputable American critics have found him provincial and a fundamentally weak abstractionist. A persuasive English critic has raised the more serious charge of gratuitous morbidity, a lack of viable ends.

To the first we might suggest the proof of the abstract pudding is in the eating. For Sutherland a limited abstract scale appears to serve his interests adequately, less in the matter of invention or for establishing a monumental syntax than as a subtle, transfiguring alchemy for certain states of mind.

As to the second we might inquire if the sad diminuendo, the dying away of the artist's grasp of tense, natural reality is not less a shadow of his own wish than a testimony to the realistic modern circumstances confronting a painter whose true spiritual sympathy is with now out of tune lyrical landscapists. To my view even his most cruel and myopic inventions have always derived a certain fullness from their part in the scene of traditional English romantic painting. And supporting this is the fact that the current show has progressed toward sanguinity.

For the artist has transplanted his rather tortured English thorn trees in the Southern sun. Out of a Mediterranean trip issues a record of a new-discovered formal species, observed not entirely with rancor—a series of spacious pergolas only a little agonized by dense creepers, spiky palms, cicadas not altogether chimerical and fructifying maize—all in a palette more mauve, sedative and generous in feeling. Perhaps Sutherland has taken a leaf from the late stern but praiseful moods of Picasso. He still evokes a dry season but his orchard has become altogether more fruitful.

TWO: Arshile Gorky's memorial show at Julien Levy's reveals a mature invention and an almost breath-taking calligraphic faculty, somehow sufficiently intense and unreiterative to outweigh the definite formal mannerisms. There is a considerable range from the suave, enameled surfaces and poeticized realism of "Self-portrait with Mother" of 1926 to the fatly pigmented "Garden in Sochi" and the last cellophane-thin creations. Altogether the impression is of an extraordinarily delicate, tactile talent that had blossomed to full intensity.

At the Associated American Artists, Edward Millman is showing oils that enlarge upon an on-the-spot wartime Philippine diary. If the stylized landscape of ruin, wry-necked, malformed humanity and somewhat sensational cock fights seem to have surrendered some of the spontaneity of the occasion for slickness, the painting itself is very knowing. And perhaps in view of the gain in technique, it was intelligent to put the more unmanageable personal responses in cold storage for the time being.

November 21, 1948

# 'MODERN ART': ATTACK AND DEFENSE

## A Survey of Arguments On an Old Problem During the Year

### By ALINE B. LOUCHHEIM

THIS was the year of sharp controversy and loud argument about modern art. The topic spread from the art pages into the general magazines, became subject of a museum's manifesto and even turned up on television. The old lines no longer held. Old champions joined the attackers for a pot shot or two; the guerrillas came out into the open no longer afraid of being called Philistines. All in all, the attackers far outnumbered the defenders.

Although the antagonists differed widely in position and authority, many of their opinions have so much in common that the attack assumes general significance beyond individual action.

Early in the year the Boston Institute built into a spectacular bale the many single straws in the wind. By changing its name from Institute of "Modern" Art to Institute of "Contemporary" Art, by denouncing "modern art" as synonomous with unintelligibility, exploitation, double-talk and chicanery (and then burying it), and by "enjoining" the artist to come forward with a "strong, clear affirmation of humanity," the Institute synthesized and widely publicized an attitude which had been emerging since late 1947 and has flourished since.

### Modern vs. Contemporary

The new semantics were soon adopted: "modern" began to be considered a discreditable term and "contemporary" one of approbation—though neither was ever defined.

Taken together, the manifesto, an article by Francis Henry Taylor in the December "Atlantic," various pieces by Alfred Frankfurter in "Art News," and the voices of many participants in "Life's" Round-Table all seemed to spring from a kind of thinking which implies abstract moral judgments.

We are reminded, in fact, of Ruskin, who wrote in "The Stones of Venice": "I might insist at length on the absurdity of [Renaissance] construction . . . but it is not the form of this architecture against which I plead. Its defects are shared by many of the noblest forms of earlier building and might have been entirely atoned for by excellence of spirit. But it is the moral nature of it which is corrupt. . . . It is base, unnatural, unfruitful, unenjoyable and impious."

This tone runs through many of the current attacks. The ethical approach leads from general assumptions to lofty conclusions and seems, en route, to have overlooked the paintings in question. Theory seems to obscure perception.

### More Confusion

The result is that these attacks have perpetrated new confusions. They disregard anything which does not substantiate the argument, often employing as example the extraneous instead of the essential manifestation. They let a single example—often out of context—serve as springboard to wholesale attack (a fallacy brilliantly exemplified in a recent "Life" editorial which used one artist's trivial work to disparage all modernism).

Most commonly, the attackers take refuge in generalizations, or in such all-inclusive slanders as "the pseudo-scientists and psychiatrists of Greenwich Village have had to find an outlet either in the non-objective plagiarism of machine design or in the diverting pornographic possibilities of Dr. Freud." They have referred to "hollow imitators" and "new third-raters of modernism"—phrases which bolster theory but are never clarified in terms of a specific artist or painting. They declare a whole kind of painting forever dead without reservation.

This year these critics in their moralizing have not stopped at cussing. They have progressed, if not to enjoining, at least to admonishing and advising. But again lack of definition has bred confusion. The artist is told he is to be "free, but not irresponsible." Does that mean responsibility lies in conforming to the theories of the given admonisher? He is told if he is an "artist of good-will and integrity he must work out the problem for himself," which, it would seem, is precisely what artists of such caliber have been trying to do. Yet those who have been most vocal with advice have failed to point out which artists (if any) have achieved a solution and why.

### The Chaotic Age

Several of the antagonists, including Mr. Taylor and some of the "Life" Round Table speakers, forgive what they consider the artists' failures by explaining that you cannot expect dignity and grandeur of expression from men living in a time of chaos, in "an intellectual and moral vacuum."

It would seem that here is another confusion. Does expression of chaos imply necessarily that a work of art is chaotic? Does the theme of man's degradation of man indicate a lack of dignity in art? Are such works as Picasso's "Guernica," Beckmann's "Departure," Rouault's "Three Judges," Henry Moore's "Shelter Drawings," Tamayo's terrified personages, even Matta's machine-meshed humans chaotic, uncontrolled or tainted by "private cynicism"?

Does close observation and abstraction of organic forms of nature deny human reference in a world in which we are ever more aware of organic growth and man's relation to the cosmos? Is a Baziotes abstraction less related to the dignity of life than a romantic landscape?

Is the dignity of a work of art limited to those manifestations which were created according to the Greek ideal, or the monotheistic medieval world, or the man-centered universe of the Renaissance?

### Esthetics and Ethics

Even if one admits a connection between esthetics and ethics, I think the fallacy of this year's moral attacks lies in the fact that ethical judgments have obscured the best of the works of art of our time. The attackers seem not to have looked first to see if the object has realized and fulfilled its own aims; they appear not to admit that it is the profundity and sincerity of concept, rather than its narrower moral import, which distinguishes the great from the trivial; that its ethical quality is a reference.

Geoffrey Scott has wisely said that the inherent dignity of a work of art is discerned esthetically, and then the moral echo is in our minds. But the echo, he points out, must be dependent on

the sound. Are there not, even now, some new sounds which ring true for our time?

A quite special and separate argument with some manifestations of modern art was voiced by the writer, collector and impresario Lincoln Kirstein in the October "Harpers." He pleaded for art of "adequate intellectual capacity and manual skill" and anonymity.

Again specific examples were avoided, but Mr. Kirstein's ideals can be interpreted to embrace the best of that painting which represents "a carefully selected and constructed legible image" — such as that by Shahn and Perlin—as well as such frigid nouveau-academicism as work by Cadmus and French. A code is set up and criticism works from the top down, instead of from the object up, so that there is no qualitative differentiation on the basis of specific work.

**The Defense**

An effort at interpretation and clarification marked the few voices which spoke out in general defense of modern art this year. Among the most eloquent was Eric Newton, the English critic, who wrote in THE TIMES Magazine: "Tradition is built up slowly over the decades by trial and error, and as I see it, the modern tradition is in its infancy. If Picasso is the new Giotto, the new Masaccio is not due for a decade or two, and the grand climax of modernism will occur about a century hence. I, for one, am content. I would rather live in an age of experimental primitivism than in a period of decadence or even maturity."

As the new year approaches, this more liberal attitude seems once more to be emerging—perhaps as a reaction to the extreme attacks. Maybe in 1949 detached theory and noisy argument will resolve into investigation and clarification and specific discussion.

December 26, 1948

# AMONG THE NEW SHOWS

### By SAM HUNTER

ALTHOUGH there are undoubtedly an equal number of sins committed in the name of representational painting today, the slips and imprecisions of the abstract artist are somehow more glaring for us and invariably collect a richer body of invective. Since it is the particular nature of recent abstract or nonobjective painting — dehydrating phrases to begin with—to deal with error and hesitation; and since for better or worse these genres perhaps most sensitively figure the doubts, insecurities and extremities of the post-war world, it is not surprising that their failures are more naked and appalling.

A series of shows in the same week by abstract and nonobjective artists who have been responsible in large measure for the year-long dispute on unintelligibility in art focus some of these matters for us. If there is a single impression conveyed by this work—and particularly by that reflecting the recent tidal wave of subjectivism in abstract art—it is less of unintelligibility than predictability. For an art that derives much of its material from the recurrent patterns and rhythms of the night-side of the individual mind rather than a more socialized experience the dangerous tendency seems paradoxically less toward profundity than shallowness.

**POLLOCK:** Jackson Pollock's show at the Betty Parson's Gallery certainly reflects an advanced stage of the disintegration of the modern painting. But it is disintegration with a possibly liberating and cathartic effect and informed by a highly individual rhythm. It would seem that the main intention of these curiously webbed linear variations — in clamant streaks and rays of aluminum and resonant blacks and grays for the most part—is a deliberate assault on our image-making faculty. At every point of concentration of these high-tension moments of bravura phrasing (which visually are like agitated coils of barbed wire) there is a disappointing absence of resolution in an image or pictorial incident, for all their magical diffusion of power. And then, wonder of wonders, by a curious reversal which seems a natural paradox in art, the individual canvases assume a whole image-making activity and singleness of aspect.

Certainly Pollock has carried the irrational quality in picture making to one extremity. It is an absolute kind of expression and the dangers for imitators in such a directly physical expression of states of being rather than of thinking or knowing is obvious. Even in his case the work is not perhaps sufficiently sustained by a unifying or major theme or experience and is too prodigal with clusters of surrealist intuitions. What does emerge is the large scale of Pollock's operations, his highly personal rhythm and finally something like a pure calligraphic metaphor for a ravaging, aggressive virility.

**ARCHAIST:** At the Jacques Seligmann Gallery Adolph Gottlieb's new exhibition proceeds in general by the same kind of intuition that governs Pollock's work, but at a lower spiritual tension and with recourse to symbol and archaic image.

The serial progression from panel to panel and the slow tempo of line perhaps tend to distribute energies too evenly. There still seems a certain contradiction here between the mild, descriptive and anecdotal feeling and its encasement in a modern symbolism.

**BY TWO:** Although both Joseph Albers and Fritz Glarner developed their purist nonobjective genres in Europe some time ago, the current interest in this kind of work here may possibly be taken as a portent of a recall to order from the emotionalism of our more absolute and subjective abstract artists.

The Sidney Janis and Egan Galleries have collaborated for a joint exhibition of Albers' work. At the Janis Gallery are a series of color and optical variations on a single theme of interpenetrating rectangles while the Egan Gallery is showing a variety of canvases and incised plastic panels. A positive mastery of limited plastic means and a first-rate design intelligence are impressively demonstrated in both shows.

Glarner's ascendant rectangles and asymmetrical balances in large rectangular canvases and tondos extract personal variations from a Mondrian idiom. This work is being shown at the Pinacotheca, in the new quarters at 40 East Sixty-eighth Street.

January 30, 1949

---

### Trio of One-Man Shows

Three of the newly-opened one-man shows provide striking diversity in the week's art events. Rolph Scarlett is showing a group of his latest non-objective paintings at the Jacques Seligmann Gallery. Their titles, "Dancing Yellows," "Dynamic Towards Left," etc., give a good idea of their subject matter which has no human or symbolic associations in its spirited working out of line and color relationships.

Scarlett's forms, if such they can be called, are indicated in a whip-lash of black line which crackles over the shifting background of violently opposed colors. The impression made by these paintings is one of originality and strength.

The Norlyst Gallery's most recent offerings are paintings and woodcuts of Leon G. Miller, who is also active in the field of industrial design. Miller gives his urban landscapes a semi-abstract look by breaking them up into a patchwork of angular shapes, strongly defined in somber colors. He has a good eye for the accidents in a scene that automatically make a striking design and has profited by a study of cubism.

At the Jane Street Gallery, Larry Rivers' warmly colored, sensuous paintings, figures, still-lifes and interiors, take no cognizance of the abstraction so prevalent in these last forty years. The great days of impressionism are evoked (one picture is actually, and properly, called "After Renoir"), for these big golden nudes, slowly undressing in sunny studios riotous with the color of flowers, live in a joyous, decorative world. However, their slightly dated look should not prevent the spectator from appreciating Rivers' feeling for color.

S. P.

March 26, 1949

# BY TWO MODERNISTS

## Development of Gleizes And Mondrian

### By STUART PRESTON

IT can no longer be denied that Cubism and Constructivism, two great tributaries of the main stream of twentieth century painting, have swept on into history. Even by 1920 their heroic inventive days were over, though for about another decade more their esthetic claims were still being washed for gold. This week their life stories are re-enacted in two exceedingly interesting exhibitions—they could almost be called obituaries—devoted to the work of their most single-minded expo-

nents. At the Passedoit Gallery canvases by the veteran Frenchman Albert Gleizes are on view, while Sidney Janis is giving a memorial show to Piet Mondrian, the Dutch painter who died in 1944.

Gleizes' art has developed through a long painting career, but he has never renounced the first principles of cubism. "La Femme à la Cuisine" perfectly illustrates to what degree, in 1911, the cubists had succeeded in dissecting the visible world. The subject is still recognizable as such, but the woman, the child and the still life are cut up into semi-geometrical shapes, dead-leaf in color, swirling on the canvas like dead leaves.

By 1915 this naturalistic basis is far less apparent. Some buildings and a bridge make up the idea behind "Paysage Lorrain." But they are no more than suggestions for the remarkable circular design.

From then on Gleizes' work branches off in two directions. One leads to pure abstraction. No. 11

is the skeleton of the kind of design that he ornaments and elaborates in other, more frankly decorative, paintings. The sureness of their rhythms never fails but, by the Nineteen Thirties, Gleizes, not having gone beyond cubism, merely became its virtuoso. It is a disappointment that the emotional feeling that lent such distinction to the earlier work has, in the later, noticeably diminished.

### Mondrian's Progress

Compared to Mondrian, Gleizes is an old-fashioned painter. He transforms what the eye sees; he does not banish it to make way for a purely intellectual scheme such as Mondrian's patterning of colored rectilinear shapes. Unlike Gleizes, Mondrian started rather weakly. His pre-1914 work reveals him as a sort of wobbly cubist whose pictures are muddy in color and indecisive in design.

Then his singular genius began to assert itself. The little rectan-

gles break loose from one another and scatter, with the geometrical exactitude of frost particles, over the white ground. Later still the design is composed by criss-crossing black verticals and horizontals whose intersections occasionally imprison squares of bright primary color. Form and content are now one, exclusive and inseparable.

It is hard to imagine a more reasoned art, iconoclastic, too, in that it aimed to invent a new formal language entirely free from all personal or representational bias. Mondrian was the artist as scientist. He worked with shape and color as if they were materials to be analyzed in a laboratory. And yet the unexpected exhilaration that is aroused by the chilly perfection of his art is, in the end, based upon his unusual, individual sensibility.

**October 16, 1949**

---

## Diversified Talents Exhibited at Galleries—Reinhardt's New Oils a Feature

No thematic thread holds together seven widely varied one-man shows of paintings now on exhibition.

At the Betty Parsons Gallery there is a double-header. Abstract forms are firmly disciplined in Ad Reinhardt's new oils. In most of them there is no over-all design, but the system of rhythmical repeats that governs their disposition on the canvases keeps them balanced and static, like the pieces in a mosaic. Some of these shapes are graceful calligraphic strokes, others are solid chunks of brilliant color; all function efficiently.

In the next room are Marie Menken's precious, small collages which make the most of rich and curious surfaces. Colored sand, thread and wire build into a dense matter. In some the scale is too small for such substantiality, others are more effective.

**November 5, 1949**

---

## Diversity in Modernism —Drawings by Masters

### By STUART PRESTON

A LEADING English art critic has recently offered an explanation for the adoption of abstraction by most avant garde American painters today. "It is," Denys Sutton writes, "an art * * * divorced from tradition yet at the same time it provides a refuge from materialism." Some may find this generalization no truer than another; in any case it is strikingly supported in two current exhibitions, those of work by Mark Tobey at the Willard Gal-

lery and by Weldon Kees at the Peridot.

Actually Tobey has reversed the artist's usual progress. In his latest work the spiritual quality that infuses his whole oeuvre is expressed in a much more accessible fashion than before. True enough, "Awakening Night" and "Multiple Margins of Space" look like the surface of a frozen pond after a hard day's skating. Their staccato notations of white on gray are the artist's way of expressing a thought or a mood in pictorial symbols that are as perfectly abstract as musical notes. They are "written" in a visual language too intensely private ever to be comprehensible by more than a happy few. But in the majority of Tobey's

new canvases the subjects are not only recognizable but have roots in common human experience. Here, for example, are versions of "The Flight Into Egypt," "The Last Supper" and "Deposition." They will never supersede the Sistine Madonna in popularity but their religious feeling is impressive and convincing. In style they recall Henry Moore's "shelter" drawings, employing, as they do, the same system of insistent, wavy lines to construct the figures, further brought to life in pale, delicate colors that lie on them like a blush.

No such a visionary is Kees. Not knowing anything about him you might suspect that his new paintings were the exercises of a sculptor tapping for original plastic

ideas. These abstract shapes are given such aggressive solidity in themselves that the monochromatic backgrounds are forced into becoming the empty space in which the shapes move and have their being. Oval, pyramidal and pear-shaped forms intersect, couple, split apart. They are not remotely related to human figures, yet there is something sensuous and provocative about their interaction. This impression is strengthened by Kees' genuine feeling for paint and by the originality with which he harmonizes his strong colors. Such satisfying qualities relieve the fundamental asceticism of this art.

**November 6, 1949**

# MUSEUMS DEMAND FREEDOM FOR ARTS

## Manifesto on Modern Work Cites Its Broad Influence, Defines Exhibitor's Role

### DIVERSITY TERMED VITAL

## Two Institutions Here, One in Boston Join in Rejecting 'Narrow Nationalism'

Three museums whose interests center on modern art issued yesterday a joint statement affirming their belief in the necessity of expression in the arts, and defining their function as objective surveyors presenting an impartial review of the contemporary scene.

The document was drawn up by the Museum of Modern Art and the Whitney Museum of American Art in New York, which have formed a program of coordinated activity for the future, and the Institute of Contemporary Art in Boston. In the past few years the Boston Institute has been collaborating with the Modern Museum in exchange exhibitions.

The signers were Rene D'Harnoncourt, director; Alfred H. Barr Jr., director of museum collections, and Andrew C. Ritchie, director of painting and sculpture, all of the Modern Museum; Hermon More, director, and Lloyd Goodrich, associate director, of the Whitney; and James S. Plaut, director, and Frederick S. Wight, director of education of the Boston institute.

### MUSEUMS' MANIFESTO

The statement follows:
This statement is made in the hope that it may help to clarify current controversial issues about modern art, which are confusing to the public and harmful to the artist. Its object is not to bar honest differences of opinion, but to state certain broad principles on which we are agreed.

The field of contemporary art is immensely wide and varied, with many diverse viewpoints and styles. We believe that this diversity is a sign of vitality and of the freedom of expression inherent in a democratic society. We oppose any attempt to make art or opinion about art conform to a single point of view.

We affirm our belief in the continuing validity of what is generally known as modern art, the multiform movement which was in progress during the opening years of the twentieth century and which has produced the most original and significant art of our period. We believe that the modern movement was a vital force not only in its pioneer phases, but that its broad, everchanging tradition of courageous exploration and creative achievement is a force today, as is proved by the continuing capacity of the younger generation of artists to embody new ideas in new forms.

At the same time we believe in the validity of conservative and retrospective tendencies when they make creative use of traditional values. We do not assume that modernity in itself is any guarantee of quality or importance.

We believe that a primary duty of a museum concerned with contemporary art is to be receptive to new tendencies and talents. We recognize the historic fact that the new in art, as in all other creative activities, is appreciated at first by a relatively small proportion of the public; almost all the art of the past hundred and fifty years now generally accepted as good was originally misunderstood, neglected or ridiculed not only by the public but by many artists, critics and museum officials.

### Merit Versus Acceptance

We place in evidence the careers of Blake, Turner, Constable, Delacroix, Corot, Millet, Courbet, Manet, Whistler, Monet, Cézanne, Renoir, Rodin, Gauguin, van Gogh, Eakins, Ryder, not to mention the leaders of the twentieth century. We also recognize that some artists of unquestionable merit never become popular, although their work may eventually have a widespread influence. We therefore believe that it is a museum's duty to present the art that it considers good, even if it is not yet generally accepted. By so doing, we believe, the museum best fulfills its long-range responsibility to the public.

We believe that the so-called "unintelligibility" of some modern art is an inevitable result of its exploration of new frontiers. Like the scientist's innovations, the procedures of the artist are often not readily understood and make him an easy target for reactionary attack. We do not believe that many artists deliberately aim to be unintelligible, or have voluntarily withdrawn from the public. On the contrary, we believe that most artists today desire communication with a receptive audience.

The gap between artist and public, in our opinion, has been greatly exaggerated; actually the public interest in progressive art, as proved by attendance at exhibitions and by attention in the popular press, is larger than at any previous time in history.

We believe in the humanistic value of modern art even though it may not adhere to academic humanism with its insistence on the human figure as the central element of art. Art which explores newly discovered levels of consciousness, new concepts of science and new technological methods is contributing to humanism in the deepest sense, by helping humanity to come to terms with the modern world, not by retreating from it but by facing and mastering it.

We recognize the humanistic value of abstract art, as an expression of thought and emotion and the basic human aspirations toward freedom and order. In these ways modern art contributes to the dignity of man.

Contrary to those who attack the advanced artist as anti-social, we believe in his spiritual and social role. We honor the man who is prepared to sacrifice popularity and economic security to be true to his personal vision. We believe that his unworldly pursuit of perfection has a moral and therefore a social value. But we do not believe that unreasonable demands should be made on him. Though his spiritual energy may be religious in the broadest sense, he should not be asked to be priest or saint. Though his art may symbolize discipline or liberty, he cannot be asked to save civilization.

### Reject Narrow Nationalism

Believing strongly in the quality and vitality of American art, we oppose its definition in narrow nationalistic terms. We hold that American art which is international in character is as valid as art obviously American in subject-matter. We deplore the revival of the tendency to identify American art exclusively with popular realism, regional subject and nationalistic sentiment.

We also reject the assumption that art which is esthetically an innovation must somehow be socially or politically subversive, and therefore un-American. We deplore the reckless and ignorant use of political or moral terms in attacking modern art.

We recall that the Nazis suppressed modern art, branding it "degenerate," bolshevistic," "international" and "un-German"; and that the Soviets suppressed modern art as "formalistic," "bourgeois," "subjective," "nihilistic" and "un-Russian"; and that Nazi officials insisted and Soviet officials still insist upon a hackneyed realism saturated with nationalistic propaganda.

We believe that it is not a museum's function to try to control the course of art or to tell the artist what he shall or shall not do; or to impose its tastes dogmatically upon the public. A museum's proper function, in our opinion, is to survey what artists are doing as objectively as possible, and to present their works to the public as impartially as is consistent with those standards of quality which the museum must try to maintain.

We acknowledge that humility is required of those who select works of art, as it is of those who create them or seek to understand them.

We believe that there is urgent need for an objective and open-minded attitude toward the art of our time, and for an affirmative faith to match the creative energy and integrity of the living artist.

March 28, 1950

## 18 Painters Boycott Metropolitan; Charge 'Hostility to Advanced Art'

Eighteen well-known advanced American painters have served notice on the Metropolitan Museum of Art that they will not participate in a national exhibition at the museum in December because the award juries are "notoriously hostile to advanced art."

This was made known last night in an open letter to Roland L. Redmond, museum president, in which the painters and sculptors asserted that the organization of the exhibition and the choice of the jurors "does not warrant any hope that a just proportion of advanced art will be included."

The letter charged that Francis Henry Taylor, museum director, had "on more than one occasion publicly declared his contempt for modern painting." It added that Robert Beverly Hale, the museum's associate curator of American art, had, in "accepting a jury notoriously hostile to advanced art," taken his "place beside Mr. Taylor."

"We draw to the attention of those gentlemen," the letter went on, "the historical fact that, for roughly 100 years, only advanced art has made any consequential contribution to civilization."

The letter declared the signers' belief that "all the advanced artists of America will join us in our stand."

The artists who signed the letter were Jimmy Ernst, Adolph Gottlieb, Robert Motherwell, William Baziotes, Hans Hofmann, Barnett Newman, Clyfford Still, Richard Pousette-Dart, Theodoros Stamos, Ad Reinhardt, Jackson Pollock, Mark Rothko, Bradley Walker Tomlin, Willem de Kooning, Hedda Sterne, James Brooks, Weldon Kees and Fritz Bultman.

The letter also was signed by ten sculptors with the notation that they supported the artists' stand. The sculptors were Herbert Ferber, David Smith, Ibram Lassaw, Mary Callery, Day Schnabel, Seymour Lipton, Peter Grippe, Theodore Roszak, David Hare and Louise Bourgeois.

Mr. Newman, one of the artists, explained that he and his colleagues were critical of the membership of all five regional juries established for the exhibition but were specifically opposed to the New York group, the "national jury of selection" and the "jury of awards."

The New York jurors are Charles Burchfield, Yasuo Kuniyoshi, Leon Kroll, Ogden Pleissner, Vaclav Vytlacil and Paul Sample. The national jury is composed of Mr. Hale, Mr. Pleissner, Maurice Sterne, Millard Sheets, Howard Cook, Lamar Dodd, Francis Chapin, Zoltan Sepeshy and Esther Williams.

The jury of awards, which will confer the prizes, includes William M. Milliken, Franklin C. Watkins and Eugene Speicher. First prize is $3,500, second $2,500, third $1,500 and fourth $1,000. The exhibition is to be known as "American Painting Today—1950."

Mr. Redmond is in Europe and could not be reached for comment. Both Mr. Taylor and Mr. Hale said they preferred not to comment until they had seen the letter.

May 22, 1950

# DIVERSE NEW SHOWS

## Drawings by Modigliani—Newman, Foy, Wells

### By STUART PRESTON

THE discovery of Negro art by the Cubists between 1907 and 1909 was one of those events not unknown elsewhere in art history. For the paradoxical forward step of cutting roots with the present and planting them far away in time and space can be compared, as M. Kahnweiler has observed, to the Renaissance passion for Graeco-Roman art and to the Impressionists' use of the Japanese print. Picasso and Matisse soon moved on from this stage but Modigliani never lost his enthusiasm for African sculpture. For this reason, the current hanging, at the Perls Gallery, of his work alongside masks and figures from the Ivory Coast sheds valuable light on the formation of his style. But his borrowings were only skin-deep. He was no Mantegna breathing the very air of another culture. A similar show could prove equally well how this essentially derivative artist was affected by Sienese primitives and by Byzantine mosaics.

**THEORY:** No matter what else you may feel about Barnett Newman's canvases at the Betty Parsons Gallery, you will not find it hard to agree that he has carried abstraction to its extreme conclusion. A white bar on limitless white; red bars punctuating a reddish field. Compared to these dehydrated canvases, a Fernand Léger looks as old-fashioned as a Sir Luke Fildes. Art has finally been emptied of content. Content has been replaced by, what? What are the feelings that the artist is expressing here? The image of what thought confronts one? Is he proving some new theory of composition, or is he attempting to isolate the pure substance of painting? Perhaps the extreme detachment of this artist's emotions and interest is not intended to be shared by the observer. Such questioning is fair because you are obliged to find here exactly what you will. Newman might reply that he has selected quasi-mathematical color rhythms as those that hold the strongest meaning for him. This is tenable ground, but if he finds that subject matter is exhausted, might it not simply be that he has exhausted it? These canvases are of interest because they put the challenge of extreme abstract theory so cleanly. They point to arguments that have more to do with philosophy than with art criticism. For works of art are not made with theories but with paint and stone.

April 29, 1951

# Wyeth—Conservative Avant-Gardist

**In combining meticulous detail with haunting mood, a 36-year-old painter has won favor with both traditionalists and experimentalists.**

### By ALINE B. LOUCHHEIM

CHADDS FORD, Pa.

ANDREW WYETH is unique among modern artists. His meticulous tempera paintings and his expert water-colors have enough apparent versimilitude to endear him to the most esthetically conservative of art lovers, yet advocates of avant-garde art are also champions of his work, because they see that what appears to be literal transcription is instead a highly selective means toward an intense, subjective and wholly twentieth-century expression.

At 36 he is no struggling unknown. His first one-man show, held in 1937, when he was 19, sold out within twenty-four hours; since then, museums and important collectors have bought his work steadily; the demand for his temperas outstrips supply; and three new ones, which will be among the examples from a decade's work in a show opening Wednesday at Knoedler's, have already been snapped up by eager buyers.

At first glance, Andrew Wyeth is also a personal paradox. He is so beguilingly sincere, so genuinely friendly, so delightedly, boyishly pleased with his wife and sons, and his triangular mouth and gray-blue eyes are so ready to wrinkle into a grin, that he is universally loved as "Andy." But there is in his paintings so ominous, tragic and disquieting a statement that they have earned for him from friends and neighbors in these parts the epithet of "the gloomy painter over there."

To understand both Andrew Wyeth and his work, you must see him in relation to the place and the people who have formed him and his art. You must see not only the brooding forests, the dunes, the spindrifts and the austere New Englanders of Port Clyde, Me., where he spends his summers, but, more importantly, you must know the generous hills, the spacious orchards and fields, the stone houses and the proud but friendly farmers of the Chadds Ford, Pa., region, where he was born and has always lived.

You can see this Brandywine countryside now, this October (when it eschews vulgarly vivid autumn foliage for a more discreet copper burnishing), but, best of all, you should see it in February and March. That is when the painter likes it best; when, he says, "it gets a bleak quality—the color of a young fawn. Then to me it's just epic. The earth stripped down to its simplest parts, so you can really get the structure and the essence." And by all means you should see it, as Wyeth prefers it, either in the gray coldness of early morning or in the late afternoon, when the shadows stretch out and the light is beamed in dramatic shafts.

You will notice immediately how Wyeth's invariably under-stated palette grows from the tawny color of the dry fields and the grays, oyster-whites, blues and tans of the stone houses and walls. You will understand why he likes the egg tempera technique: it allows this subtle color range, and its infinite, fine strokes provide means for capturing the sharp edges and marvelously distinct textures of this landscape. It is good to know this countryside, for the painter holds deep communion with it and everything he paints (even in Maine) is related mystically—almost metaphysically—to it.

IF you walk into the white, stone, converted schoolhouse of the Eighteen Twenties in which he lives, you meet his wife, Betsy, vivacious and strikingly pretty with her wide eyes, generous mouth and short black hair, and his 9- and 7-year-old sons, Nicky and Jamie, who have inherited their father's slight frame. But you will also find clues to those elements in his own childhood which were important to the making of the artist.

Above the fireplace is a large oil painting of an open-mouthed blind man in a black cloak and wide-brimmed hat, groping and tapping frenziedly with his cane as he lurches down an eerie, moonlit, cobblestone street. It is a *(Continued)*

ALINE B. LOUCHHEIM covers the field of fine arts as associate art editor of The Times.

"FAR AWAY"—In this dry-brush water-color of his son Jamie (which might almost be a portrait of himself as a child) Wyeth was intrigued by the boy's "thoughts-being-worked-out look." The 'coon for the hat was "killed right behind this Brandywine hill."

portrait of Old Pew—one of the seventeen illustrations painted in 1911 for the famous Scribner's edition of "Treasure Island." And it was painted, of course, by N. C. Wyeth, Andrew's father, a renowned illustrator in the Howard Pyle tradition, whose pictures for "King Arthur," "Robin Hood," "Westward Ho!" and the Cooper, Scott and Stevenson stories shaped the literary vision of several generations.

ANDREW acquired the painting only last spring when, after a fire, a club in New York State put it on the market. "Gracious, I couldn't get to the phone fast enough," he says, "and we gave up the idea of a new car." Then he shows you a letter N. C. Wyeth wrote to his mother on July 26, 1911:

" 'Treasure Island' complete! I write that as though I were glad. In one way I am—to know that I pulled through the entire set of seventeen canvases (almost as tall as I am) without one break in my enthusiasm and spirit. The result is I've turned out a set of pictures, without doubt far better in every quality than anything I ever did." On the fifth page of the letter is a pen-and-ink sketch of a two-story house—the house which he was to build with the $10,000 the "Treasure Island" illustrations yielded and the house in which Andrew, his brother and his three sisters were brought up and where his mother and

sister Caroline still live (sister Henrietta, also a painter, is married to the artist Peter Hurd and sister Ann to artist John McCoy).

Close by is N. C. Wyeth's studio, a grandiose affair, in scale with the big, burly illustrator—so large that the thirty-odd easels of pupils whom Caroline now teaches there hardly crowd it. "It was the day of show-place studios," Andrew says. "I couldn't work there. I'd feel lost." (His own home-studio is small, sparse and severely uncluttered.) N. C. Wyeth's studio is still filled with the vast panoply of props for illustrations of romantic tales — pistols from the Spanish Armada, Daniel Boone's gun, a pirate's chest—and an elaborate array of costumes. "When he was away, we'd all come here and dress up," the son recalls. "Halloween is still marvelous."

IF the father found the Brandywine country suitable background for Guinevere and Sir Amyas Leigh, so, for the son, nourished on these romances, it served as a setting for childhood fantasies. Sickly, he was taken from school in first grade and never returned. When the other members of the big family went off to school, he would roam the countryside alone (for a while with a Negro boy, Coo-Coo, he formed a Robin Hood band and "raised the devil"). He grew to know the land inti

mately and to feel the timeless quality he now gets into his paintings. "This hill could be 100 years ago or now or 100 years in the future. The feet walking in the old boots in my painting 'The Trodden Weed'—when did that happen?"

THE solitude and isolation of his boyhood strongly mark his paintings, too. He uses a single, silent, withdrawn figure to portray mood—or bleak and desolate landscapes, or rooms where blowing curtains or the crumbling plaster emphasize the emptiness and poignantly point up themes of loneliness and isolation, death, the transitoriness of life and nature's timelessness.

Indoors, as a boy, he played endlessly with a toy theatre and, especially, with toy soldiers. Many of these—medieval knights, American Revolutionaries, British guards—still troop in neat formations over shelves in the living room. Young Jamie plays with a fabulous castle (complete with moat, torture cage and movable drawbridge and portcullis) which Andrew's brother built and which his father painted and used as background for "The Black Arrow" illustrations. "I love miniature things," Andrew, small-scaled himself, says. "Perhaps that's another reason I turned to tempera."

As a boy he drew incessantly—closely observed bits of nature and "intricate things

of knights." At 12, he made headings for the Brandywine edition of "Robin Hood." At 16 his father said, "Andy, you're ready to come into my studio." Then began strict drill—drawings from casts and still-lifes in oil. "My father didn't teach his method, just kept at me to try to express an object as clearly as possible. I still feel if you really love an object and you want to use it to say something you really feel, you're not content with just an impression of it."

AFTER the sell-out show at Macbeth, when he was 19, "a feeling came over me of clarity," he remembers, "a feeling that I'd gotten by with these water-colors on only a rather clever brilliance, and I came back and went to my father's lower studio and drew and drew."

Two years later he started doing tempera, learning the technique from his brother-in-law, Peter Hurd. But in 1938 a tempera was invited to the Chicago Art Institute annual; in 1940 another to the Pittsburgh Carnegie; and in 1941, Dorothy Miller and Alfred Barr of the Museum of Modern Art saw one at the Corcoran show in Washington and wrote to inquire about buying it. "That was the turning point," he says. "I must have walked five miles that day, on that encouragement. I believed in the temperas—and so did Betsy. This confirmed it." In 1943 he was included in the Modern Museum's "Realist and Magic Realist" show.

Freud says a father's death is "the most important event, the most poignant loss in a man's life." It is true for Andrew Wyeth. His father was killed in 1945 when a train demolished his car at a railroad crossing.

OF the period after his father's death, Andrew says: "I can't paint unless I'm stirred, unless emotion gets hold of me. It's strange how tragedy shapes your life. When my father was killed, I was in terrible gloom—I loved him and he was the one person I had real contact with in art. Shortly afterward I was painting a shadow on a field and it seemed to become more and more symbolic—like the eyelid of night. Altogether, I feel I got more depth and mood in my work by my father's death. I see into things more than I ever could before. An experience like that galvanizes you—you've got to come through from then on, or never.

"Gradually, too," he goes on,

"I stopped painting portraits of people and painted portraits of mood." You see what he means in "Karl." You meet Karl Kuerner: he is a German-born farmer who has brought to his fields the efficiency he expended on a machine gun in World War I, a red-cheeked, blue-eyed, genial man who wants to share with you the champagne-sparkling cider he has made. In Wyeth's painting, he becomes merged with the artist's father—and it is the steeliness of the eyes, the listening ear, the sharpness, authority, unbendable strength and domination which come through, emphasized by the cold light and the menacing black hook in the cracked ceiling.

His father's death also brought a special release. N. C. Wyeth had not tried to dictate to his son. At most, there were arguments when the elder tried vainly to urge "You ought to use stronger color." But he was a powerful personality. One day Betsy, angrily telling him to stop interfering even by suggestion, slammed the studio door so hard that plaster fell from the ceiling. The elder man respected and liked the stanch, spirited girl; he took her advice. But his Teutonic-plus-New England background had bred in him a stern sense of regular work production. "When he'd say to me, 'Well, what did you accomplish today?' I'd feel inferior and think, 'Not very much,'" Andrew recalls. "Betsy never asks that."

This tolerance is essential for any creative artist; the more so for Andrew Wyeth. He can wander through the country and old buildings and

turn out water-colors—"I do hundreds of them and maybe two out of thirty will come off"—but for the tempera paintings he has to feel a real emotional connection with what he wants to paint (from this comes the intensity which lifts his work into art) and he cannot be pushed.

"**B**UT if I get the emotion of something I want to paint, it stays in my mind. I dream about it and think about it. It's funny, I may even go into my studio and put down one or two lines—as if to protect the emotion—and put it away and then glance at it from time to time. I do dozens and dozens of careful precise drawings, but when I get to the painting I never look at them."

All this means months between tempera paintings and then a long tedious work period and a consequent maximum production of two or three major paintings a year.

So convinced is he now that what he does is right for him that he has turned down all recent offers to continue the Wyeth tradition of illustration. "When I paint what I don't feel, it turns out boringly academic; when I try to illustrate, my father takes over and it's a bad imitation."

**Y**OU realize how "realism" does not mean transcription when you compare the hills, the octagonal house, the water-bucket poles and the individuals with the paintings in which they figure. You see the process of extreme distillation and selection; you see how the preserved and cherished details become almost abstract vehicles and symbols for expression of mood and

"THE TRODDEN WEED"—The boots in Wyeth's haunting tempera are those which Howard Pyle once used as pirate props.

emotion; you see how light is made an expressive agent.

Wyeth's drawings have been compared with Duerer's whom he has admired and studied since boyhood; his water-colors have been compared to Winslow Homer's whose brilliant technique he examined. But his art is not like theirs, nor like the Renaissance artists who used egg tempera. In spirit, he is closer to Hopper than any other artist. But his closest affinity—in his recognition of the timelessness of the countryside and the passing of human life, his expressions of loneliness and solitude and his loving yet objective respect

for the dignity and austerity of the human being—is not to a painter at all, but to the poet Robert Frost. But, above all, Andrew Wyeth is himself.

"Painting is living to me. If I had to stop painting, I'd just as leave die," he says. This is not rhetoric; it comes from the heart. And beyond excellence in design, in color relationships and in a wizardry with light, it is this concentrated emotion which transfigures and apotheosizes the lineaments of reality in Andrew Wyeth's work.

October 25, 1953

# Sir Jacob Epstein, 78, Is Dead After Stormy Career as Sculptor

Special to The New York Times.

LONDON, Aug. 21—Sir Jacob Epstein, who rose from the slums of New York's lower East Side to become a sculptor of world renown, died Wednesday of a coronary thrombosis at his home here. He was 78 years old.

Sir Jacob had had one of the stormiest careers in the annals of modern art. His widow, Kathleen, who was with him when he died, said she had delayed the announcement of his death because she wished to rest before facing publicity.

Always in the thick of con-

troversy, Sir Jacob had heard some of his work, particularly his monumental statues on religious themes, denounced as "pagan," "hideous," "rude," and "obscene."

But he waged what he called his "Thirty Years' War" with the public and the critics with indomitable energy and lived to become British sculpture's Grand Old Man.

Today the art world mourned its loss. Many tributes were paid to Sir Jacob at home and abroad.

"He was by far the greatest

portrait sculptor of his time," Sir John Rothenstein, director of the Tate National Gallery of Modern Art, said in London. Four years ago, the Tate Gallery gave Sir Jacob a retrospective exhibition that drew 30,981 visitors in three weeks.

Prof. Pierre Gregoire of the Netherlands State Academy of Plastic Arts described Sir Jacob's influence as "revolutionary." Dr. Fritz Novodny of Vienna's Belvedere Museum said Sir Jacob had been "one of the greatest figures in the history of modern sculpture."

Sir Jacob had lived in London for fifty-four years. There was a time when he and his first wife, the late Mrs. Margaret Epstein, had lived in two bare rooms.

But Sir Jacob's success brought affluence. He died in Kensington in a gray brick mansion in Hyde Park Gate. Across

the way lives another artist-knight—Sir Winston Churchill.

Sir Jacob is also survived by a son, Jackie. His two children were of his earlier marriage. He married Mrs. Kathleen Garman in 1955.

**Challenge to Conformity**

Sir Jacob's name was controversial for so long that many failed to appreciate his true talent. Each successive Epstein work aroused anger and scorn from the artistic coteries, the man in the street, the clergy and the advocates of traditional art.

He seemed to have a special talent for disturbing the British. He had settled in England in 1905 at a time when conformity and literalism were strong. But, even as a young sculptor, he did not seek to shock as a means of gaining publicity.

Sir Jacob, who was knighted in 1954, was sensitive to criti-

cism. Outbursts of publicity, he wrote, made him feel "like a criminal in the dock."

His autobiography, written in 1940 when criticism of his work was beginning to wane, showed how deeply he had been scarred by then. The book consisted largely of documented histories of each controversy in turn, with his angry rebuttal to each critic.

In his old age, Sir Jacob was seemingly as obsessed by his own antagonism toward abstract and modern sculpture as others had been toward his own work. He often called well-known abstractionists "fakers." At other times he granted their sincerity, but said their school was "aimless and will lead to nothing."

He defined his style at "realistic and emotional." Although distorting natural shapes, he never abandoned the forms of reality, and particularly of human beings, who remained the constant object of his loving and brooding curiosity.

The sculptor was born Nov. 10, 1880, on Hester Street, then crowded with the various overflow of Europe's slums and ghettos. He said its "sight, smells and sounds had the vividness and sharp impact of an Oriental city."

Combine
**Sir Jacob Epstein**

The third of a large family of Polish immigrant Jews, Jacob was sickly and was petted.

He turned to drawing, and then, when he was hampered by eyestrain, to sculpture.

**Spent Days Sketching**

When his family prospered and moved uptown, the sculptor would not follow, since he was in need of the "gallery" of ghetto types for models. He took a room on Hester Street and spent his days sketching.

In 1902, Sir Jacob turned his back on the United States for what proved to be a quarter of a century. He went to Paris, where he studied with single-minded fervor—"I threw myself at the clay." He had few friends and took no recreation and colleagues predicted he would wear himself out.

His first important commission, in 1907, was for eighteen larger-than-life figures carved into the stone of the British Medical Association's new building on the Strand. Their nudity scandalized professional censors, and a large section of the press protested. The first Epstein scandal was born.

The figures stayed for almost thirty years. When the Government of Southern Rhodesia purchased the building, it announced its intention to destroy the figures. A new controversy ended in their substantial mutilation.

Sir Jacob first offended religious sensibilities with his figure of Christ in 1920. The head was actually that of Bernard van Dieren, the composer, who had been sketched as he lay seriously ill. The criticism that followed moved the late George Bernard Shaw to come to Sir Jacob's defense in a brilliantly scintillating article, as he did on other occasions.

Last year Sir Jacob's 1931 "Genesis" was acquired for £4,200 ($11,760), by the manager of Louis Tussaud's Waxworks, a popular tourist attraction on the waterfront at the English resort town of Blackpool. It was placed alongside Sir Jacob's "Adam," "Eve," "Jacob and the Angel" and "Consummatum Est" in a separate art department.

"That my work should be shown in that fashion is abominable," Sir Jacob said. He deplored the failure of Britain's

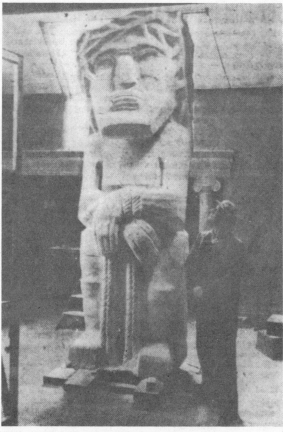

Combine

**The sculptor in 1958 with his 11-foot, six-ton statue of Christ, entitled "Ecce Homo," or "Behold the man." This work, created in 1933, caused controversy that resulted in its being officially barred from an Anglican church.**

art galleries to make a greater effort to obtain his works.

**'Ecce Homo' Caused Stir**

His six-ton granite statue "Ecce Homo," carved in 1933, stirred a new row. In 1935, the Anglican newspaper Church Times described the squat figure of Christ wearing his crown of thorns as "blasphemy" and a "monstrosity."

Nevertheless, Sir Jacob offered the statue to Selby Abbey last year. The vicar and the church wardens voted to accept it but 430 residents of Selby signed a petition opposing the move on the ground that the statue was "hideous in the extreme." Last month, the Chancellor of the Diocese of York ruled that the statue could not be accepted.

Sir Jacob had suffered from a failing heart for many months. In March of last year he went to a hospital for a rest, but recently he took a lively part in the row over "Ecce Homo."

At his death, he was working on a half-length statue of Princess Margaret commissioned by the University College of North Staffordshire.

August 22, 1959

---

# Russians at U. S. Fair Debate Abstract Art and Right to Like It

### By OSGOOD CARUTHERS
Special to The New York Times.

MOSCOW, Sept. 3—A vigorous debate on United States art, abstract and otherwise, has reached a climax at the American National Exhibition as it nears its close Friday.

"What good is abstract art?" "Did a monkey really win first prize in an American art contest?" "But who would hang

that on the wall in his apartment?" "Why do they paint negative things?"

These are some of the questions one hears from Soviet art connoisseurs and the uninitiated who stream by the thousands daily through the exhibit of paintings and sculpture on the second floor of the glass pavilion.

The extraordinary thing is that more and more Russians themselves are answering the questions, and openly defending the exhibit.

**A Safe Subject**

It is one subject upon which all seem to feel on safe ground in arguing the pros and cons, even though the party line has flatly condemned abstract art and impressionism as degenerate, bourgeois, formalist, cosmopolitan, subjective and negative.

One does not hear so much an attack on or defense of

"socialist realism" as a defense of the idea that those who like it can have it and those who like other forms of expression should have their choice.

A knot of more than fifty persons was clustered yesterday around three or four young men who were propounding these ideas.

"But what good is this crazy painting? What does it mean? Who would buy it?" asked a ruddy-faced, heavy-set and excited working man in his fifties.

"Naturally somebody buys it and pays good money for it, because these artists keep on doing such work," replied a dark-

haired, bespectacled youth.

"And what about socialist realism?" somebody asked.

Another young man answered with bold pride: "Socialist realism is realism plus Soviet power."

The art exhibit is wide in range. There are thousands to be seen staring long and appreciatively at such classics as Stuart's portrait of Washington, a seascape by Winslow Homer, a picture of a Rough Rider by Remington and other realistic paintings.

The excitement waxes around the modern works. Loud guffaws and jeering gestures are hurled at paintings of Jackson Pollock and Ben Shahn. But many visitors study these paintings carefully, and many flock around Richard B. K. McLanathan, a museum director of Utica, N. Y., to ask questions.

Mr. McLanathan, who took charge of the art show after its originator, Edith G. Halpert of the Downtown Gallery in New York, returned home, has made an interesting discovery.

"I have found that, to my sorrow, I was mistaken at first in speaking about art in elementary terms," he said. "Now I have found that I can speak in the most complicated intellectual and philosophical and technical terms, and I get extraordinary response. Where there is difficulty in translating, people in the crowd help with suggestions."

During these final days, he said, growing numbers of Soviet citizens themselves have taken over in the crowds to explain, often echoing his own words.

This has been the most rewarding experience, he said. And while perhaps the great majority of visitors go away unconvinced, just as do unsympathetic viewers in the United States, those in charge feel that among artists and genuine art lovers this part of the fair has been a cultural highlight.

September 4, 1959

# HAPPY NEW YEAR!

## Thoughts on Critics and Certain Painters as the Season Opens

### By JOHN CANADAY

THE New Year in these parts has so little to do with the first day of January and so much to do with the first Monday in September that Labor Day's Eve, which is tonight, would be a good time to ring the bells and blow the whistles while everyone wishes everyone else the best of everything for the next twelve months—including a lot less pother about abstract expressionism. With any luck, 1959-60 might even go down in history as the year abstract art in general accepted the responsibilities of middle age.

Kandinsky painted the first completely abstract composition half a century ago (forty-nine years, to split hairs), yet we are still talking about "the new art." Impressionism, a genuine scandal where abstract expressionism is a synthetic one, took less than half that many years to be born, to mature and to give way in its turn to the various innovations of post-impressionism. And a little quick arithmetic based on the birth and death dates of fauvism, cubism and surrealism as proselytizing movements should make the abstract expressionists feel embarrassed in their protracted adolescence. Fifty years is a long time to have remained so starry eyed, and some of the sparkle, examined at close range, is beginning to look distressingly like crow's feet.

### A New Salon

There can be no objection to abstract expressionism as one manifestation of this complicated time of ours. The best abstract expressionists are as good as ever they were—a statement not meant to carry a concealed edge. But as for the freaks, the charlatans and the misled who surround this handful of serious and talented artists, let us admit at least that the nature of abstract expressionism allows exceptional tolerance for incompetence and deception.

The art of the French Salon, recognized as deadly, is the only school comparable in prolix mediocrity to the rank and file of abstract expressionist work today. Yet Salon art did require of its practitioners at least a manual talent for the imitation of academic disciplines, while anyone, literally, can paint in a kind of abstract expressionist idiom. Sweet innocence of technical fetters may even give the most unconsidered daub an individual character. Witness the highly personal work of Betsy the Ape, conspicuous not long ago in the newspapers, but the recipient of the silent treatment in the art magazines. Of course Betsy's work was not art, but it was certainly abstract and, in its own way, quite expressive of her own gay, outgoing self.

Yet the fact that a reasonable, if reprehensible, approximation of abstract expressionism can be executed in ten minutes by a novice with a large brush, is not sufficient explanation for so prolific a growth among painters who regard themselves as profession-

als. The question is why so many painters have adopted a form of art that should seem pointless except to the recondite, and why a large public is so humble in the face of an art that violates every one of its esthetic convictions. Bad painters we must always have, but how does it happen that we have them in such profusion in such a limited field, and why are we taking them so seriously?

The fault, I am afraid, lies quite directly with professors, museum men and critics, including this writer, who has functioned in all three capacities. In our missionary fervor for the best of it, we have managed to create the impression that all abstract art per se must be given the breaks on the probability that there is more there than meets the eye, while all other art per se must be regarded with suspicion on the probability that it isn't as good as it looks. Things have come to the point where it is amusing to dismiss the Renaissance with a quip, but dangerous to one's critical reputation not to discover in any second-rate abstract exercise some cosmic implication.

### A New Bias

Ever since poor Ruskin ruined himself by accusing Whistler of throwing a pot of paint in the public's face and losing the libel suit that Whistler clapped on him, timid critics have been wiping the paint out of their eyes with a smile. But critics who think of themselves as adventurous have been even more responsible for an attitude that has changed art criticism from a rational evaluative process to a blind defense of any departure from convention, including pretentious novelties.

We suffer, actually, from a kind of mass guilt complex. Because Delacroix was spurned by the Academy until he was old and sick, because Courbet had to build his own exhibition hall

in 1855 to get a showing for pictures that are now in the Louvre, because Manet was laughed at, because Cézanne worked in obscurity, because Van Gogh sold only one picture during his lifetime, because Gauguin died in poverty and alone, because nineteenth-century critics and teachers and art officials seemed determined to annihilate every painter of genius—because of all this we have tried to atone to a current generation of pretenders to martyrdom. Somewhere at the basis of their thinking, and the thinking of several generations of college students who have taken the art appreciation course, is the premise that wild unintelligibility alone places a contemporary artist in line with great men who were misunderstood by their contemporaries.

Recognizing a Frankenstein's monster when they see it—and lately they can't miss it—some critics and teachers wail, "But what are we going to do? We can't go back to all those old Grant Woods again." Of course it is not a matter of going backward, but forward—somewhere. That we will go forward from abstract expressionism seems unlikely, since it is more and more evident that these artists have either reached the end of a blind alley or painted themselves into a corner. In either case, they are milling around in a very small area—which, come to think of it, may explain why they are increasingly under a compulsion to paint such very large canvases.

In the meanwhile, critics and educators have been hoist with their own petard, sold down the river. We have been had. In the most wonderful and terrible time of history, the abstract expressionists have responded with the narrowest and most lopsided art on record. Never before have painters found so little in so much.

September 6, 1959

# Art: Worlds of Fantasy

## Louise Nevelson's Sculpture at Jackson Gallery

### By DORE ASHTON

ONCE again Louise Nevelson, grand mistress of the marvelous, illumines her fabled world at the Martha Jackson Gallery, 32 East Sixty-ninth Street. In this sculpture exhibition Miss Nevelson surpasses everything she has done before. Called "Sky-Columns-Presence," the show reveals not one fantasy world but a multitude of worlds, charting the "in between places" Miss Nevelson has always known so intimately.

There is no single way of seeing the show. It may be seen as an ensemble, an intimate theatre housing what architects call an "articulated" wall. Tier upon tier of Miss Nevelson's black vertical boxes with their cryptic contents form an entire wall of the exhibition. Facing them are the columns—tall, totemic forms richly adorned with detail and thrown into lunar shadows. All forms are played over by special lights (designed by Schuyler Watts) that unite them while at the same time they pull out salient details in greenish or grayish hues.

But the magical effect of the lighting is only an added attraction because Miss Nevelson's structures are discrete, each capable of absorbing the viewer's attention wholly. There are circular compositions with elegant plays of half-moon and angular shapes; long plaques with flutters of small elements sifting into "in between places" of melting shadow; pegs, lattices, dividers, dominoes, wheels and chevrons. There is even a ghostly structure resembling a pianoforte that would have looked quite seemly, in Roderick Usher's study.

This impressive variety appears despite the fact that without exception Miss Nevelson's constructions are made of wood, painted matte black and dependent on relief effects.

Miss Nevelson is not the first to have conceived of a total ambiance of sculpture. Long ago the constructivists and suprematists dreamed of huge sculptured rooms. And the dadaists, particularly Kurt Schwitters, experimented with the idea. Even the neo-plasticists thought along these lines. But never has anyone saturated a room with such ideally idiosyncratic poetry.

Part of Miss Nevelson's force derives from her ability to sense and fulfill emotional needs, and basic ones. Her characteristic vertical boxes with their half-obscured contents and doors slightly ajar play on essential emotions. A door half opened, a drawer with a keyhole, a high narrow window—things, in short, that symbolize secrecy, hidden riches or sorrows, are always moving. They are irreducible, archetypal symbols, and Miss Nevelson knows how to exploit them. Her doors within doors within doors, and the many self-contained secret compartments, create visual similes for a specified état d'ame.

October 29, 1959

# Machine Tries to Die for Its Art

## Device Saws, Melts and Beats Itself at Museum

### By JOHN CANADAY

Eighty bicycle, tricycle and wagon wheels, a piano of sorts, some metal drums, an addressing machine, a child's cart, an enameled bathtub, a meteorological trial balloon, a bunch of bottles, and a certain amount of material picked up in city dumps in New Jersey, all painted white, were scheduled to commit mutual murder and suicide by sawing, hammering and melting one another in the garden of the Museum of Modern Art last evening.

They came close to doing so, and may in fact be written off as a dead loss, the rescue squad having arrived a bit too late to save them. But the rescue squad was still a lot too early from the point of view of some 250 invited spectators who had waited an hour and a half with their feet in cold slush to witness the promised spectacle.

The machine composed of the listed objects and many others was powered by fifteen motors to be a "self-destroying work of art conceived and built for this occasion" by Jean Tinguely, a Swiss.

Called "Homage to New York," a title that gives one to think, the machine was an object of bizarre attraction if not of classical beauty. Before it began making trouble for itself it measured 23 feet long by 27 feet high.

From the beginning the process of destruction failed to go according to schedule. A roll

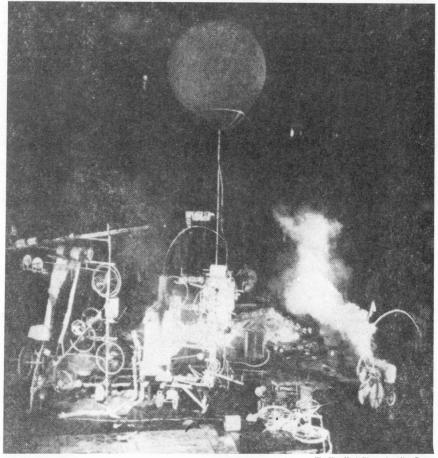

Smoke rises from a burning section of "Homage to New York," Jean Tinguely's machine

of paper that was supposed to move under the caresses of some large paint brushes and get painted, moved instead in the opposite direction and escaped.

A large section of the machine fell over on its side before it was supposed to do so, and although Mr. Tinguely managed to make one section of it walk away under its own power for a few feet, he had the rest of his trouble of construction for nothing.

Also he had to goad his monster from time to time, apparently when relay systems failed to function.

Things weren't going too bad-ly, however, until a watchful fireman decided things were out of control and applied an extinguisher. (An automatic one had been built into the piano, which was in flames as planned, but failed to function.) The spectacle ended with boos for the fireman and loyal bravos for Mr. Tinguely.

However, the significance of the event lies not in the fact that it was, over-all, a fiasco, but in the intention of Mr. Tinguely and the Museum of Modern Art in staging it in the first place.

In conceiving and carrying out (as far as he was able) what must seem to most people only a preposterous and wasteful stunt, Mr. Tinguely was, rather, a kind of philosopher, even if one of nihilism, and the leading one of a current generation of artists descended from the dadaists of World War I times.

Dada, which was an art dedicated to the cultivation of nonsense as a manifestation of despair, seemed to have burned itself out as an intellectual escape during the Twenties. Its recent revival, in force, is without much question a reflection of a similar despair in our own moment.

Described as "an ironic, witty and thoughtful comment on contemporary life and art," the self-destroying machine is—or rather was exactly that, a legitimate work of art as social expression, even if it pooped a bit.

Mr. Tinguely makes fools of machines, while the rest of mankind supinely permits machines to make fools of them.

A little irony over and above the intended irony, however, is that Mr. Tinguely's machine wasn't quite good enough, as a machine, to make his point, even before it fell afoul of the city's fire code.

March 18, 1960

# PAINTERS FUMING AT TWO MUSEUMS

## Established Artists Protest to Whitney and Novices Assail the Modern

## ALL TIRED OF ABSTRACT

## Threat of Picketing Reminds Official of 1940, When Realism Was Fought

**By PHILIP BENJAMIN**

A dudgeon of angry young painters and an umbrage of angry older painters have opened attacks against two prominent museums of contemporary art.

This Sunday the angry young painters will drop their madder yellow and their linseed oil, don their best blue jeans and picket the Museum of Modern Art at 11 West Fifty-third Street.

The angry older and better-known painters have written to the Whitney Museum of American Art, in back of the Modern Museum at 22 West Fifty-fourth Street, protesting its policies.

Although the attacks are apparently unaffiliated, both cry that the museums are stifling the development of American art. Both call for more representational art.

### Protest of Left Bank

The leaders of the crusade against the Museum of Modern Art are two young and relatively unknown painters, John Dobbs and Daniel Brown. They have circulated about 2,000 fliers in art stores, art schools and universities calling for a "Protest against the Museum of Modern Art."

The museum, the flier says, "has become a club of the initiated elite."

The museum has also "attempted to elevate handicrafts, industrial design and children's art to the highest forms of human endeavor," it charges.

Mr. Dobbs, who is 28 years old, calls himself a "figurative or realistic painter." He said yesterday that he and his friends were preparing placards.

Some placards will carry reproductions of paintings in the museum collection, including one of Mr. Dobbs' pet aversions, "White on White," by Kasimir Malevich. This is a picture of a white square set at an angle on a larger tattle-tale grayish square.

### 22 Write the Whitney

The letter to the Whitney Museum was signed by twenty-two prominent artists, including Edward Hopper, Jack Levine, Henry Varnum Poor and Moses and Raphael Soyer. All have works in the Whitney.

Describing themselves as "a new kind of 'Friends of the Whitney,'" the artists said that they were "deeply disturbed by the role of museums in the contemporary art scene."

They said that at the last annual show there had been 145 paintings, "of which 102 were nonobjective, seventeen abstract and seventeen semi-abstract, leaving only nine paintings in which the image had not receded or disappeared."

Commenting on the plans to picket the Museum of Modern Art, Rene d'Harnoncourt, its director, recalled that twenty years ago, on April 17, 1940, the museum had been picketed by artists demanding more abstract art.

The museum, he said, "has always welcomed comments on its program, in whatever form."

Lloyd Goodrich, director of the Whitney, said he had not yet prepared a reply to the artists' letter.

"A lot of these artists are very good friends of mine," he said.

April 22, 1960

# Art: American Symbolists

## Contrasting Styles of Charles Burchfield and Peter Blume on View in Shows

### By JOHN CANADAY

TWO American painters of major reputation are exhibiting again this week after recesses of five years, and both are symbolists, although of contrasting kinds. At the Rehn Gallery, 36 East Sixty-first Street, Charles Burchfield has a show of nine pictures, the first since his retrospective at the Whitney Museum of American Art in January, 1956. At Durlacher Brothers, 11 East Fifty-seventh Street, Peter Blume is showing a single painting, "Tasso's Oak," a continuation of his series of allegories on the city of Rome, of which the preceding episode was "Passage to Etna," also 1956.

At Rehn's, Mr. Burchfield is again the pure fantasist that he was in his earliest work, and that he has been sporadically even while he was preoccupied with the American scene in the paintings for which he is best known generally. Mr. Burchfield's unequivocal return to personal symbolism will be the most welcome of news for one group of his admirers, since they have always preferred this painter as a mystic symbolist rather than a realist.

Additionally, the American scene does seem to have left its best days behind, as material for painters, and for a while it seemed that Mr. Burchfield might be left behind with them, in spite of the fact that as an observer of that scene he made the most subtle comments of any painter who worked with it. In his new pictures Mr. Burch-field is much happier than he was in the terminating ones of his retrospective five years ago, which was an uneasy mixture of fantasy and realism.

Moons glow, suns blaze, flowers expand, leaves whirl in the autumn wind, trees dance and mist rises at dawn in Mr. Burchfield's mammoth water-colors. But these are landscapes only in a secondary sense. First of all they are celebrations of the cycle of nature in acutely personal terms, centering on a theme picture, "The Four Seasons," in which the times of year advance and merge with one another from the depth of the picture toward the observer through a cathedral-like forest. The presence of man in a world otherwise primeval is suggested in a single painting, an anachronistic "Old House and Spruce Trees."

•

Where Mr. Burchfield's symbolism is personal, general and painterly, Mr. Blume's at Durlacher's is the opposite—historical, specific and literary. "Tasso's Oak" is an elaborately extended pictori-al metaphor of Rome's past, present and perhaps future, in which every detail has an explicit function. The painter offers no explanatory key, but there are obvious meanings to attach to knitting women, young lovers, busy nuns, the combination of babies, young matrons and old women, plus little boys tracing cryptographic patterns on the pavement.

Tasso's oak, around which these figures are grouped, actually exists on the Janiculum. Under it Tasso is supposed to have worked on his sixteenth-century epic poems. With its ancient stump held together in death by iron girders and braces—providing a fantastic centerpiece for Mr. Blume's composition—the oak sprouts from its roots a new shoot that curls snake-like upward through the picture against a red sky.

A full-size preliminary cartoon for "Tasso's Oak" and a large number of related drawings turn this one-picture exhibition into a one-man show of good size.

January 4, 1961

# A LETTER TO THE NEW YORK TIMES

*To The New York Times:*

Reading Mr. John Canaday's columns on contemporary art, we regard as offensive his consistent practice of going beyond discussion of exhibitions in order to impute to living artists en masse, as well as to critics, collectors and scholars of present-day American art, dishonorable motives, those of cheats, greedy lackeys or senseless dupes.

Here are some instances:

Sept. 20, 1959: "* * * a situation built on fraud at worst and gullibility at best has produced a school of such prolix mediocrity * * *."

July 24, 1960: "The chaotic, haphazard and bizarre nature of modern art is easily explained: The painter finally settles for whatever satisfaction may be involved in working not as an independent member of a society that needs him, but as a retainer for a small group of people who as a profession or as a hobby are interested in the game of comparing one mutation with another."

Sept. 6, 1959: "But as for the freaks, the charlatans and the misled who surround this handful of serious and talented artists, let us admit at least that the nature of abstract expressionism allows exceptional tolerance for incompetence and deception."

"In the meanwhile, critics and educators have been hoist with their own petard, sold down the river. We have been had."

Sept. 11, 1960: "* * * for a decade the bulk of abstract art in America has followed that course of least resistance and quickest profit."

"There is not a dealer in town, nor a collector, nor a painter hoping to hang in the Museum of Modern Art who doesn't study each of Mr. Barr's syllables in an effort to deduce what he should offer for sale, what he should buy, or what he should paint * * *."

Oct. 23, 1960: "* * * brainwashing * * * goes on in universities and museums."

Mr. Canaday is entitled, of course, to the freedom of his opinions regarding works of art. We submit, however, that his terminology of insults is scarcely adequate to describe emerging art works and tendencies, and we scorn this waging of a polemical campaign under the guise of topical reporting.

If Mr. Canaday has a political or social or esthetic "position" or philosophy, let him state what it is and openly promote his aims. Every style and movement in art history contains examples of work by imitative or uninteresting artists. To keep referring to these in order to impugn the whole, instead of attempting to deal seriously with the work of the movement, is the activity not of a critic but of an agitator.

JAMES S. ACKERMAN, Professor of Fine Arts, Harvard.
WILLIAM BARRETT, Professor of Philosophy, N. Y. U.
DONALD BLINKEN, Collector.
WALTER BAREISS, Collector.
BERNARD BRODSKY, M. D., Collector.
JAMES BROOKS, Painter.
JOHN CAGE, Composer.
BERNARD CHAET, Chairman, Dept. of Art & Architecture, Yale.
HOWARD CONANT, Chairman, Dept of Art Education, N. Y. U.
STUART DAVIS, Painter.
EDWIN DENBY, Writer.
HENRY EPSTEIN, Collector.
JOHN FERREN, Painter.
ALFRED FRANKFURTER, Editor & President, "Art News."
PERCIVAL GOODMAN, Architect, F. A. I. A.
ADOLPH GOTTLIEB, Painter.
JACK M. GREENBAUM, Collector.
MR. & MRS. I. HAROLD GROSSMAN, Collectors.
DAVID HARE, Sculptor.
BEN HELLER, Collector.
THOMAS B. HESS, Executive Editor, "Art News."
HANS HOFMANN, Painter.
SAM HUNTER, Director, Rose Art Museum, Brandeis.
KENNETH KOCH, Writer.
WILLEM DE KOONING, Painter.
STANLEY KUNITZ, Poet.
KERMIT LANSNER, Writer.
BORIS LEAVITT, Collector.
ERLE LORAN, Painter and Teacher.
ARNOLD H. MAREMONT, Collector, Chicago.
ROBERT MOTHERWELL, Painter.
E. A. NAVARETTA, Poet and Critic.
ALBERT H. NEWMAN, Collector.
BARNETT NEWMAN, Painter.
RAYMOND PARKER, Painter.
PHILLIP PAVIA, Sculptor, Editor, "It Is."
GIFFORD PHILLIPS, Collector, Publisher, Frontier Magazine.
WILLIAM PHILLIPS, Editor, "Partisan Review."
FAIRFIELD PORTER, Art Critic, "The Nation."
DAVID A. PRAGER, Collector.
HAROLD ROSENBERG, Writer.
ROBERT ROSENBLUM, Assistant Professor, Dept. of Art & Archaeology, Princeton.
BARNEY ROSSETT, Publisher, Grove Press.
IRVING SANDLER, Writer and Critic.
KENNETH B. SAWYER, Art Critic, Baltimore Sun.
DAVID SMITH, Sculptor.
WHITNEY S. STODDARD, Director, Lawrence Art Museum, Williams.
METER SCHAPIRO, Professor of Art, Columbia.
PAUL WEISS, Professor of Philosophy, Yale

February 26, 1961

# LETTER ON A DILEMMA

*To the Art Editor:*

I THINK it is important to point out just now that in addition to those who say so openly, there are many artists, museum men, professors, teachers of art and art critics who now privately question the views they have held supporting abstract expressionism, action painting and neo-dadaism in art. The trouble is that many who had been enthusiastic about these forms of modern art (until, like myself, they began dropping off the bandwagon in increasing numbers during the decline of the Nineteen Fifties) still cannot afford to express openly their true opinions.

Some of these men have told me so, after exacting a pledge of secrecy. Others would tell only their best friends or no one at all. The dilemma is that so many have so much to lose by re-examining their fundamental premises in evaluating art. The loss is primarily in terms of self-esteem and professional reputation, but often in financial investment as well.

## Non-art

The producers of art with a built-in non-art value have a lifetime investment in the *Zeitgeist* theories that support the movement, and their livelihood depends upon preventing damaging criticism of it. Almost as serious is the case of the collectors, museum directors, and trustees who have purchased at high prices and exhibited and defended such works of art. Can they now suddenly say they made a costly, but an honest mistake?

Then there are the professors and artist-teachers who have sincerely taught a generation of students to esteem radical eccentricities and to be ultra-tolerant of experimental work because it is "contemporaneous in spirit." Their students have learned to do nothing else, so that even though they may harbor doubts they have not the technical and conceptual resources to undertake anything more demanding. They must go on imitating those abstract artists who are successfully promoted, must continue teaching academic "self-expression" to another generation of high school and college students.

It is quite true that "we have been had." But it would be hard to say that anyone is at fault. We all did it to ourselves, usually with the utmost sincerity, by convincing ourselves that we were being original and contemporaneous and that this is all that really counts.

## Precedent

In the late nineteenth century, the major artists and critics nearly all made similar fundamental errors of judgment, and much of the work that was then highly esteemed and bought is now in the basements of museums or otherwise disposed of. Very likely, a generation hence, the art now enjoying highest prestige will suffer the same fate. But there is too much at stake among the participants for this re-evaluation to occur quickly. We will know the corner has been turned when the press no longer considers it news to publish the latest neo-dada prank in its art columns.

We may hope this time will come soon, since we seem to be reaching a turning point in history. The new mood in the United States to redefine our ultimate purposes, and to take more constructive steps to control our destiny, leaves little time to dissipate our spiritual resources in self-expression as an end in itself, or escapism through trivial abstractions, or action painting, rubbish constructions, and other anti-art gestures.

## Obligation

Obviously, we have the competence to distinguish between the better artists now in vogue by accepting the premises of the theory of art that supports them. But the time has come for the most serious artists, professors, museum authorities and critics to call in question the whole movement. Its superficial radicalism yields increasingly minimal returns, and has become the true conservatism of our day. The truly radical critic today must be the one who goes to the roots of the question of value, who is in advance of his time and consequently misunderstood. Our problem now is to locate artists who are equally advanced and give them due recognition.

LESTER D. LONGMAN.

(Dr. Longman is chairman of the Department of Art, University of California at Los Angeles.)

April 30, 1961

# A LETTER: PERILS OF ZEITGEISTISM

*Last week a letter from Lester D. Longman, chairman of the Department of Art, University of California, Los Angeles, stated that many educators, critics and museum men now secretly question the validity of abstract expressionism, neo-dada and action painting as non-art forms that they sponsored in an effort to be "contemporaneous," and are reluctant to admit their mistake because of the investments of reputation and money involved. A new seriousness of purpose in this country was held antithetical to such non-art, and a change to art reflecting the new times was called for. The following response from an associate professor of philosophy at Columbia University questions Professor Longman's argument.*

*To the Art Editor:*

I HAD hoped that Mr. Longman really was going to attack those "Zeitgeist theories" in which, he says, "the producers of art with built-in non-art value have a lifetime investment." Instead, he revealed himself as just another Zeitgeister, objecting only to those who have not, according to him, correctly read the spirit of the times.

This spirit, he contends, is to be detected by attending to "the new mood in the United States." But he is only exposing critics and professors to a fresh but similar danger of spending money upon and investing their reputations in those artists who express the new national mood.

The mistake all along was to use timeliness rather than artistic excellence as the criterion for selecting artists worthy of recognition and support. A painting may (perhaps must) be representative of its time, and yet have no artistic merit whatsoever: witness the tiresome acres of paintings in the recent "Splendid Century" exhibition at the Metropolitan Museum, which deserve preservation only as indices of their time and place. Whether abstract expressionist (or any other) paintings have artistic qualities is an esthetic and not a historical question.

The art critic of The New York Times has come under fire for asserting the existence of a kind of conspiracy in favor of an art style which he regards as singularly susceptible to bogus productions, but he is clearly prepared to acknowledge excellence where he finds it, independently of its stylistic vehicle. This is different from engaging in the game of Zeitgeist-spotting, which not merely perpetuates a conceptually confused state of affairs, but places an irrelevant burden upon artists and critics alike.

If artists take seriously the "new mood" and try to paint in accordance with it, they may produce good paintings, but their doing so will be incidental to their avowed purpose. And if Mr. Longman's acquaintances truly have changed their minds —for the reasons he mentions— regarding the paintings which they still publicly sponsor, they have done so far the wrong reasons.  ARTHUR C. DANTO.

May 7, 1961

# HAMMOCK READING

## A Critic Questions a Critical Approach

### By JOHN CANADAY

SUMMER in the art world is a time for catching your breath after the activities of the winter, sometimes known as the rat race. Traditionally, summer is a time for lying in the hammock and not thinking much. But before the heat reduces his brain to pudding, a critic might take advantage of the breather to ask himself some questions about his profession, bolstered by the knowledge that between May and September he is liable to be read so casually, if at all, that no serious harm will be done if he reaches a damaging conclusion.

A critic should begin by asking himself whether critics in general, including himself as a member of a band rather than as an individual, are necessary, beneficial, only harmless, or actually harmful forces. Having turned this one over a few times, I fear that there are reasons to regard them as the last —to the extent, at any rate, that they are responsible for a schizoid condition peculiar to avant-garde art in the middle third of the twentieth century.

Modern art's typical symptoms of schizophrenia — delusions of persecution and omnipotence—are complicated by a bad case of narcissism that in its own turn splits in two directions. With one eye cocked on itself as innovational, contemporary art has cocked the other in the opposite direction, toward itself as history, the temporary end result of a long development.

This divided focus is not conducive to clear vision, and its contradiction is summarized in a term conceived in recent years, "museum of modern art." (We are talking about the term, not about any one of the institutions bearing that or similar titles in this or other countries.) It is a term implying a stance with one foot in the grave of the past and the other on the banana peel of the moment.

### Double Hazard

Thus combining impaired vision with precarious footing, critics have come up with some bizarre rationalizations and have stimulated artists to some curious expressions leading to further bizarre analyses, thence to even more curious artistic expressions, and so on in a circle of intellectual incest. This circle has been winding like an ingrown hair ever since critic-historians began operating on a double standard by which avant-garde art was found interesting to the extent that it was (a) completely original, and (b) the natural consequence of the originality that was immediately contemporary last week. Week by month by year by century by millenium, the origins of modern art have been traced back to the art of the prehistoric caves.

The paradox of rejecting the past with contempt and at the same time calling on it for a certificate of legitimacy seems never to have disturbed the practitioners of that form of critical graph-making that evaluates the present and divines the future by charting the course of the past.

The technique of prophecy by graph has been applied to the stock market and other variable factors of contemporary life, but art is a special case in which developments can be warped into their expected shape by a watchful avant-garde. That is, you can *expect* the market to go up or down because that is what it should logically do to maintain the graph-pattern, but you can't *make* it do so. But you can create works of art that comply with an expected direction—and that is a terrible thing.

### Distorted Course

Instead of following a natural development induced by a truly profound response to life, art can self-consciously set out to do what is anticipated by those who chart it. Thus innovation ceases to be innovation, and becomes only the next step in a predetermined and hence not very adventurous course. In a day when art is supposed to be adventurous and exciting beyond the art of any other day, it toes the line as much as it has done in its least imaginative periods. The fact that the line resembles a roller-coaster makes it no less devoid of surprise, and the fact that the swoops and rises and descents may make you catch your breath when you are going along for the ride, does not affect the fact that you are in an amusement park, not involved with life itself.

To whatever extent critics are responsible for all this, and I think the extent is great, they are a vicious element. Not vicious by intention, but no less vicious in effect for all that. Critics should not know artists and artists should not know critics. But since we can't make a law against such fraternization, a critic's obligation is to make certain that what he writes (and talks) is after-the-fact judgment on what the artist creates. And the artist should create without thinking of the critic or of his, the artist's, position on a graph.

June 25, 1961

# ALL UNQUIET ON THE WIDE ABSTRACT EXPRESSIONIST FRONT

**By STUART PRESTON**

THE Guggenheim Museum's large new loan exhibition, "American Abstract Expressionists and Imagists, 1961," would have done well to concentrate exclusively on one or the other rather than try, more cunningly than successfully, to maintain that a single unbroken tradition connects the fauves of 1945 with those of 1961.

For the new abstract front is still in a fluid condition, launching sorties in a number of directions. It is not one but many things while abstract expressionism proper already has its niche in history. The latter came into being at the end of the last war, negatively as a break with exhausted traditions, and positively as a determination to express in painting the new awareness of psychological elements in the making of a work of art, and of the direct intervention of the unconscious on the artist's manner of working. With neither of these was tradition able to cope with any success relevant to modern times.

Although, as Meyer Schapiro points out, abstract expressionism derived stylistically in part from the abstract wing of European expressionism and owed much, as well, to surrealism in its cultivation of instinct and free association, it actually represented an unparalleled plunge into the depths of the creative, not necessarily artistic, personality.

Hence the cult of accidental effects; the fondness for exploiting the gratuitous act, for the sensuousness of pigment itself, and for the feelings of liberation in self-expressive marks and gestures.

Since these arbitrary manipulations sprang fully armed from the artist's pre-visual inner being abstract expressionism was ipso facto at a furthest remove from any kind of realism. However the fact remains that exclusion from sharing the action painter's interests and emotions does not seem to have impaired genuine appreciation of his work on the part of the observer. Undoubtedly snobbery and the desire to be in the swim affected some conversions to the new style. They cannot pretend to account for the decisive influence it has had on contemporary painting the world over. Furthermore it enlarged the basis of appreciation to include elements unknown or disregarded in painting before then. To quote Meyer Schapiro once more, it "made people more conscious of painting as a living art."

Such was the significance of the abstract expressionist revolution. Like all extreme positions it involved losses as well as gains, in many ways impoverishing painting by cutting off large areas of meaningful experience which had previously been art's province. There was something absurd in reducing the act of painting to private notations to which access for the outsider was difficult if not impossible. And by canonizing the gesture and the accident the way was laid open, as anyone can see in the present show, for camp followers to revel in the decorative and the chichi.

Taking more notice of art than of life it actually narrowed the former's compass. Inevitably a reaction has come, and with a vengeance. One way of interpreting the torrent of romantic fantasy and literary symbolism flooding the Museum of Modern Art's "Assemblage" show is to see in it the expression of wild exasperation at art for art's sake.

On the whole the choice of paintings at the Guggenheim is "loaded" in the direction of assuming that the new imagists and the abstract expressionists are almost indivisible in their rarefied non-objective gambits. This affects the selection from both groups. The new explosiveness of form and idea is severely played down, and we have Motherwell as an esthetic non-objectivist rather than as the creator of the powerful Spanish War abstractions; Hans Hofmann in a mild and chastened mood; and de Kooning as a formalist rather than as a shattering figure painter. Both the James Brooks and the Philip Guston are curiously tentative and indecisive. Pulling punches does no service to either school. But a darker thought occurs. The abstract expressionist pictures are all dated 1961. Is that force spent?

Thus the impression finally made is an oddly tame one, even, on occasion, slick and academic. Presenting both groups as dexterous manual performers, excelling in the making of eye-catching, harmless pictures is an ungrateful claw-pulling operation.

Three aspects of abstract painting's adventurousness today are handsomely represented at the Guggenheim, geometrical lucidity with Ellsworth Kelly; symbolism with Jasper Johns, and highly charged technical expressiveness in Robert Richenburg's fiery knots of color. The same tendencies make their appearance in a number of gallery shows this week.

Geometrics are practiced by two, austerely by Bolotowsky at the Borgenicht Gallery, more relaxedly by Helen Gerardia at the Bodley. Scrupulously planned, measured and balanced in both shape and color, the former's lack, somehow, the weighty authoritativeness of Mondrian with whom Bolotowsky must be compared. He executes a pirouette rather than a graver measure, whereas Miss Gerardia's weavings of planes, though engaging, lack this genre's necessary tension.

Muffled, semi-precise organic or flower forms float with effortless elegance in Paul Jenkins' new abstract oils at Martha Jackson's. For color and exotic character they might be gigantically enlarged depictions of anemones. One can only admire the skill with which paint stains the canvas apparently without the intervention of the human hand. Jenkins strikes an exquisite rather than a powerful note.

*October 15, 1961*

# SCULPTURE COMING UP

### It Dominates Painting In the Sixties

**By JOHN CANADAY**

YOU cannot spend much time in the New York galleries without coming to the conclusion that the stimulation our century provides for all artists, a stimulation that is intense, is working more to the advantage of sculptors than of painters. True, there is much more painting than sculpture around. But proportionately the sculpture is better than the painting. And it has been a long time—at least 250 years—since such a statement could be made.

Almost any week's exhibitions can supply a point of departure for conjectures as to why this should be so. Currently a nice, compact query is offered by "Twenty Sculptors" at Staempfli's, with a pertinent footnote at the Bertha Schaefer Gallery. These are stops on a tour that can include any gallery exhibiting contemporary sculpture or, as at Bertha Schaefer's, certain variants.

### Technology

A first reason for sculpture's rebirth is that technology has served it quite directly by offering new materials—although these materials were not manufactured with sculpture in mind. Brigitte Meier - Denninghoff's "Daphne," illustrated on the following page, is made of bronze rods (soldered with lead) of the kind turned out by the mile with beautiful uniformity for prosaic uses. But for a sculptor they can also be plastic material peculiar to our time and hence productive of forms that are integrated with our technological culture without being directly produced by it.

Similarly, Max Bill's "Endless Loop II," also illustrated, is cut from a thin flat sheet of brass milled for other purposes but seized upon by this sculptor to create a form that could have been created with such immaculate purity only in this century. It could, at best, have been approximated before today in hand beaten metal by, say, Leonardo da Vinci as an anachronistic experiment in his ponderings of mathematics.

As materials of pure sculpture, bronze rods and sheet metal are natural materials in 1961 just as raw Pentelic marble was in ancient Athens. We could make up a virtually endless list of other manufactured metal forms, new alloys, plastics, machine tools and machine processes that, most legitimately and appropriately, have transformed the look of sculpture. But what has technology offered the painter?

There are new paints that dry faster, react differently with one another, and are occasionally of unusual texture. But their new qualities are not apparent in the end product; they have not dictated or formed to new expressive concepts. They offer new speed and convenience but effectually they are the same pigments that have been standard over hundreds of years or that, new-

# Painting and Sculpture

SCULPTURE IN OUR CENTURY—Left to right, Brigitte Meier-Denninghoff's "Daphne," bronze rods with lead, and Max Bill's "Endless Loop II," bronze, both at Staempfli's.

ly invented, served the nineteenth century's sudden stepping up of color intensities.

Science has also served sculpture, and failed painting, in a more subjective way. "Endless Loop" is a flat circular band that has been cut through at one point and there rejoined—with the two surface twisted into reserved relationship. The resultant form has neither a front nor a back surface. One is led endlessly around it in a way that fascinates the layman and is, to the scientist, an equally fascinating variation on Möbius's strip, an invention of the German mathematician August F. Möbius, who died in 1868.

You might call this diagrammatic sculpture. Diagramatic painting, however, if we may call one school of precisionist abstract painting diagrammatic, runs second to the immaculate precision of expert working drawings never thought of, and never exhibited as, art. In the freer kinds of abstract painting, one customarily points out coincidental resemblances to microphotographs produced in the study of metallurgy, biology, and other sciences. The resemblances can be startling and may, indeed, demonstrate that the painter, working from esthetic principles alone, is in tune with a time dominated by scientists. But the trouble is

that the microphotographs are too often superior to the paintings in a kind of veracity that goes beyond the veracity of scientific fact and takes on the veracity of revelation, which is painting's chief function.

## Assemblage

The sculptor may borrow not only the raw material but also the end products of a technological age. At Staempfli's, Wilfrid M. Zogbaum builds an abstract structure around a sheet of steel half an inch thick, which is cut, punctured and polished with the exquisite precision possible only when steel is worked by machines rather than by hand. This element—strong, elegant and pure—is a fragment of a motor. We approach then the junk sculpture, made not of such perfect forms but of the discards of our civilization, the rusted and battered bits of metal, lately too familiar, which have their counterpart in the rags, trash paper, and other oddments assembled on canvas.

Sculptors have abused junk sculpture just as painters have abused what we might call detritus painting. But if we concern ourselves only with legitimate work in both areas, the painters are still stepchildren. Their turning to this medium demonstrates the starvation that so afflicts painting today that its practitioners turn more and more toward material and

approaches that are more sculptural than painterly.

Painting is a two-dimensional art, but exhibitions give us more and more works classified as "painting" that are actually three-dimensional. James Harvey, to take one painter among hordes, loads his paint until it stands an inch or more above surrounding territory like mountains on a relief map. A bigger name, Antonio Tapiès, again one of many, not only builds up his pigment in relief, but then carves back into it. There can be no objection to this technique, but there must be all kinds of wonder as to why such painters are tending not so much to revolutionize painting as to abandon it for a form of sculpture.

## The Hybrids

A perfect hybrid, at Bertha Schaefer's, is Glen Michaels, who paints (if you will) by applying thousands of stones, bits of wood, glass, terra cotta, metal (or what you will) into dense, ornamentally organized panels. (His companion exhibitors are Joseph Kanzal, a proficient junk sculptor, and Irwin Rubin, who glues together patterns of colored blocks.) Mr. Michaels is even better seen, however, in a newly completed mural in the reception room of the Bulova Watch Company, thirty-sixth floor of 630 Fifth Avenue. Whether he is a painter or a

sculptor makes no difference except that he is concerned, as any artist must be, with the process of transformation.

Art is a process of transformation. Painting's magic has always been that on a two-dimensional surface it can open up whole worlds. Pure illusion can be only a trick, but so long as painting was concerned with creating three-dimensional pictorial images on a two-dimensional surface it was possessed of a magic unique to itself. The twentieth century, with the camera and the consequent triumph of abstraction in painting (this threadbare explanation of the decline of realistic painting is as valid as it is obvious)—the twentieth century has robbed painting of its birthright without giving it adequate substitutes.

## Sculpture Freed

With sculpture the reverse has happened. The creation of a three-dimensional representation in bronze, stone or wood is not so much a form of magic as it is a superior craft, which is why sculpture in the nineteenth century, when art was primarily devoted to realism in one form or another, was only an inferior variation on painting. Abstraction is said by its protagonists to have freed painting. It has rather cut painting loose from its anchor and set it adrift. The art it

has truly freed is sculpture.

The painter has been forced inward by a freedom that turned out to be a limitation, but the sculptor has become a pure creator once more after having degenerated into a superior workman who more or less repeated the dimensions of nature, in another material and perhaps at another scale. There is magic even in merely imitative painting, but no magic, only competence, in imitative sculpture. Abstraction freed sculpture from its parasitic relation to painting and brought it back to its true parent, architecture. And even the most abstract sculpture must depend for existence on the tangibility of material, a contradiction that gives to sculpture an undeniable and forceful existence denied most abstract painting.

And yet none of this explains the vitality of a sculptor like Fritz Koenig, also at Staempfli's, who works in a conventional medium (cast bronze) and who may be as representational as he is abstract. Could we believe that sculpture today attracts proportionately more sound talents by the simple fact of being more demanding in its physical execution?

The greatest artists of all, I suspect, are the greatest painters. But they are poorly nourished just now, while the sculptors thrive.

January 7, 1962

## 'In' Audience Sees Girl Doused: What Happened? A Happening

### New 'Art Form' in Town Is Described as 'Combination of Expressionistic Theatre and Kenetic Sculpture'

The "In" people are discovering a far-out entertainment more sophisticated than the twist, more psychological than a seance and twice as exasperating as a game of charades.

The new conversation piece is called a Happening.

Greenwich Village basements, West Side lofts and East Side art studios supply the milieu for what leaders of this movement call a new art form.

The thirty or forty persons who make reservations for a Happening may see a beautiful girl dumped into a bathtub filled with water, three persons eating pink food and talking in three languages, or two men, dressed completely in brown wrapping paper, wrestling.

Claes Oldenburg, an artist who presents Happenings in his studio at 107 East Second Street on week-ends, described them recently as "a combination of expressionistic theatre and kinetic sculpture."

"There is no story and the events are seemingly meaningless," Mr. Oldenburg said, "but there is a disorganized pattern that acquires definition during a performance." He added that if he and his actors are successful, the session should be a "cathartic experience for us as well as the audience."

These Happenings are gaining such status that they are presented even in museums. In fact, Mr. Oldenburg and his wife just returned from Dallas, where avant-garde Texans viewed two Happenings at the Museum for Contemporary Arts.

Mr. Oldenburg and his actors do not follow a script or rehearse. But they meet at his studio during the week to discuss "positions and objects."

Before a performance begins, Happening-goers, who have each contributed $1. gather in Mr. Oldenburg's studio and scrutinize one another.

There are girls without make-up and others with silver cheeks and blue eyelids. There are young men in bulky sweaters and Levis, and others in vests and Ivy League slacks. There are artists, students, beatniks, writers and a few chic visitors from the East Sixties who are slumming.

The performance takes place in the rear two rooms, where the audience sits on benches or stands on wooden crates. The lights may go on or off or keep blinking. Slowly the actors appear—from a closet, a kitchen, or a trapdoor.

If a happening is comic, the spectators will laugh and applaud. If it is somber and intense, the squeamish members may close their eyes or resume staring at their neighbors.

"That was a total immersement," a girl said enthusiastically after one happening. "I'm coming back next week."

"But what motivates them?" her companion asked.

"Oh, ridiculous," interrupted a woman in a windbreaker and boots who disappeared shaking her head.

A pale young man with a shock of blond hair and a Vandyke beard said, "Ach, it was depressing. I don't like that. It makes me think of life."

Then he hopped into a powder-blue sports car and drove away.

April 30, 1962

# LEONARD BASKIN

### New Exhibition by a Major American Reaffirms His Expressive Power

By JOHN CANADAY

LEONARD BASKIN, who is holding another one-man show at the Borgenicht Gallery only fourteen months after his last one, must be the hardest working artist in this country. Among his chosen media at least two —wood engraving and wood carving—are extremely demanding of time and physical labor, and are correspondingly demanding of time and physical labor, and are correspondingly demanding of esthetic decisiveness, since they rule out dependence on fortunate accident and other currently popular esthetic shortcuts—and short change.

Baskin is a full-time professor at Smith College, yet he produces a steady stream of new work, which his rigid disciplines, aside from the demands of his job, might be expected to reduce to a trickle. Furthermore, he holds to a level of expressive intensity that should drain the emotional reservoir of any artists today who are possessed of such a reservoir and willing to tap it.

### Range of Acclaim

Baskin must also be as widely acclaimed as any contemporary American artist (except Calder) in terms of the range of that acclaim. Although he is essentially a traditional artist and pre-eminently a figurative one, he has been a darling of the perspicacious Museum of Modern Art even while it has been among the revelers in the bacchanale centering on abstract expressionism and experimental art per se. If the faint light (perceptible or imagined) on the horizon should prove to be a new dawn during which the museum must share the typical pangs of a morning after, Baskin's sturdy presence among a pale and trembling company is going to supply great comfort.

Baskin was selected by the museum as one of fourteen artists to represent this country at last year's Bienal in São Paulo, Brazil, and one of the three to be represented by a considerable group of works. He was awarded the international prize for engraving and was received the most sympathetically of any American, if we discount the judgments of those journals that might be mistaken for house organs of the Establishment.

As something of a maverick, Baskin belongs to no establishment, major, minor, or hopeful. But he is an elected hero, and the whitest hope, of that small group of artists, and the isolated critic or two dedicated to their aggrandizement, who constitute the sturm, drang und angst division of American neohumanism. In spite of its adoption of Baskin, the group has hardly been able to get close enough to the banquet table to pick up a few crumbs.

The trouble is that Baskin makes a fine hero but not a very good opening wedge. He sets so high a standard in so difficult a field that he stands alone. The early heroes of abstract expressionism and related movements set no measurable standard; rather they supplied a legitimate manner susceptible to bastard approximations not immediately detectable as fraudulent or incompetent. As opening wedges, they were too effective even for their own good, contaminated as they have been by the inrush of debauching imitators.

Against the orgiastic background, a Baskin show is additionally important. The importance lies less in the question attached to the annual displays by others of our most productive artists—less in "What's new with Baskin this year?"—than in the reassurance that an independent artist may survive, that he may find sustenance outside the group programs that seem necessary to most artists today, and that he may find an audience for themes that most people would rather avoid thinking about and that do not allow for an optically delightful display of facility.

39

HOMAGE TO REMBRANDT—"Dutch Artist," 1962, 22½" high in black ink, by Leonard Baskin at Borgenicht's.

Baskin's theme begins with unquestioning acceptance of man's mortality, the frailty of the flesh, not against temptation but against time, and it concludes with a statement of faith in "the legitimacy of life and the importance of man's obligation to accept its continuity as meaningful in spite of its brevity for the individual." The quote is from comments made here a year ago. It still holds for the current show, composed of wood and bronze sculptures and ink drawings.

But "What's new with Baskin?" does have some pertinence, after all, in one of these sculptures and in a series of huge drawings of heads with such titles as "Dutch Artist," "Flemish Artist," and "Youth of Rembrandt." (One is illustrated at the top of this page.) The sculpture is a St. Thomas Aquinas lightened by a certain sly good humor—whether Baskin's own or Baskin's attribution to the philosopher, I am not ready to decide on short acquaintance. And in the drawings just mentioned there is also a similar leavening, an element close to humor that is a welcome modifier in an art that over-all may have demanded too unrelentingly tragic a response from even Baskin's most fervent admirers.

### Rembrandt

Baskin's theme is close to Rembrandt's, but as a twentieth-century man he has come closer to despair than Rembrandt ever did. A year ago Baskin visited Rotterdam, the Netherlands, for the opening, at the Boymans Museum, of the European tour of his one-man show arranged by the Museum of Modern Art's International Council. The large "Dutch" drawings could be given a group title, "Homage to Rembrandt," as a result of this trip.

In their descriptive function the huge areas of wash could be enlargements of Rembrandt's tiny but revealing notations of light and shade, but in their exaggerated size and abstract pattern they verge upon that contemporary field where the drama of means becomes as important as the quality of expression. But Baskin makes sure that the balance remains where it belongs, on the side of expression. That the expression is a bit less persistently tragic is in a double sense a happy change.

May 13, 1962

# ROBERT RAUSCHENBERG

### By BRIAN O'DOHERTY

THE most obstreperous creation in Robert Rauschenberg's large retrospective exhibition at the Jewish Museum is something called "Broadcast" (1959), which accompanies the spectator everywhere with cacophonous sounds. The noise is transmitted from behind the picture surface by three radios tuned to a single control. Twist the control knob and you come up with three new stations, randomly selecting odd combinations of pop music, newscasts and static. The auditory image is of overcrowded wave lengths choking in their hurry to feed the masses.

The scrambled sound blares from behind a typical Rauschenberg collage, combining slashes of paint, a piece of comb, the word HELP, and newsphotos of such mass diversions as a horse race, the city, a police beating. From close up the photos demand individual attention. As you move out they blur into a visual delirium that matches the sound, and as you withdraw further, they sink into a strong abstraction that swings in its own way.

Obviously a new era is at hand. If you can't lick the environment, join it. For many years Mr. Rauschenberg has been pointing steadily towards an annihilation of conventions in a new freedom. His main characteristic is a conquest of common, everyday reality from a bridgehead of abstract expressionism. He is trying to materialize an ambiguous limbo between high art and low life. His "combines," as he calls them, are on the crest of a new popular wave they helped to start. At 38, Mr. Rauschenberg

is both contemporary and historical, and his creations tend to force a redefinition of what art is all about.

As in much modern art, his work makes the common distinction between painting and sculpture outdated. Combining sound, flashing lights (and occasionally movement) with hand painting, his pieces aspire to the dimension of time, and thus performance. The collage materials are lovingly gathered from the encounters of real life—he has a fondness for such rejects as old tires, old newsprint, old clothes. As if in tribute to the Unknown Bum, this flotsam is battered by time and the anonymous hands that have touched it, used it, thrown it away. When everything is put together, the main adhesive force is the anti-logic of the subconscious.

Indeed it is this that enables him to blaze a road from abstract expressionism to "pop." Each of these in its own way draws on surrealism. Abstract expressionism found some authority in surrealist automatism. "Pop" at its infrequent best depends in part on the shocks produced by free association.

Obviously, if he wanted to, Mr. Rauschenberg could be a fine abstract expressionist or a fine Neo-Dadaist. But the fas-

cinating thing about him is that he seems to feel the need of a new method, a process that swallows life whole, and presents it with enough transformation to aspire incidentally to art. In his useful catalogue, Alan R. Solomon draws attention to a crucial quote from Mr. Rauschenberg that can be paraphrased "I try to act in that gap between . . . art and life.". Since Mr. Rauschenberg's esthetic digestion is occasionally not strong enough to take care of stuffed fowl and zipfasteners, his work is sometimes defeated by life and rejected by art.

But the general success of his work, invaded by life and aspiring toward art, is most impressive. It is far from being just Dadaism or surrealism once more with feeling. It negates nihilism to lay claim to life and its confusions. It implies a respect for an audience and an attempt to meet it—a new development in modern art, also seen in the "Happening," a semi-theatrical extension of Mr. Rauschenberg's performance between life and art.

As distinct from the blank anonymous face of the "pop" artist Mr. Rauschenberg decisively retains for himself the personal role of creator. All his work is steeped (sometimes lit-

erally) in 'abstract expressionism. Most of his appendages —Coca-Cola bottles, a clock, stuffed birds (some of whom had to have hernias repaired by a taxidermist before the show) — are related to, or incorporated into, canvases by a sensibility that of its nature abhors disorder. In everything he does, he feels the lyric pull -- and maybe he is too lyric an artist for the rough, tough role of pioneer. Such constructs as "Rhyme," "Wager" and "Hymenal" are exquisite in a way that completely transforms their collage elements. Life is overcome by art. Mr. Rauschenberg is a great civilizer of objects, from the torn telephone book in a tabernacle-like inset to Coca-Cola bottles transformed into slim, elegant presences. His sensibility and his sense of revolution are at odds in the failures and pull together in the total successes. In his most individual and interesting work they fight, occupying his chosen gap between life and art.

### Double Vision

His use of collage elements, especially newsphotos, can be confusing. From a distance they are drowned in total abstraction. Up close, they often refuse to settle in, selfishly declaring their individuality. Although

chosen by Mr. Rauschenberg during meaningful encounters, their obvious meaning (or lack of it in their present situation) can be disturbing. Perhaps, as the general trend of his work indicates, they are part of an attempt to come in contact with indubitable bits of reality, which are lost in the flux of abstraction as one retreats from the work.

Thus, perhaps, Mr. Rauschenberg marries two realities — abstract energy with its connotations of the unseen, as in physics, and the fragment that has an obvious relevance to everyday life. This is an ambiguity shared by us as we live, as well as by Mr. Rauschenberg's constructions. Such an explanation gives authority to his work, if it does not justify it on current esthetic grounds. But it is a measure of his performance that it brings up the question of the redefinition of these grounds.

Mr. Rauschenberg is one of the most fascinating artists around. Poised between painting and the object, between art and life, his work is part of a new question thrown at the confused nature of reality, and thus of art.

April 28, 1963

# LICHTENSTEIN: DOUBTFUL BUT DEFINITE TRIUMPH OF THE BANAL

By BRIAN O'DOHERTY

ONE of the worst artists in America has raised some of the most difficult problems in art.

The artist is Roy Lichtenstein, whose recent exhibition at the Castelli Gallery continued what some might be impolite enough to call his gimmick —pop paintings based on comic strips and done in a sort of typewriter pointillism (derived from photoengravings) that laboriously hammers out such moments as a jet shooting down another jet with a big BLAM and a baseball player scowling because, according to an expert on the gallery floor—a child —"he got hurt and didn't know if he could pitch again." Such matters of iconography aside, Mr. Lichtenstein briskly went about making a sow's ear out of a sow's ear. Vacancy is a mode of expression that apparently suits him.

The first argument that fills the vacuum around Mr. Lichtenstein's paintings is whether he reproduces his comic-strip originals or whether he transforms them. Lichtenstein experts say

his work shows slight differences from the originals, proving that he doesn't transcribe but transforms like a good artist should, differences it takes a Lichenstein expert to find.

The question of transformation became acute when Mr. Lichenstein lifted a diagram "explaining" a portrait of Mde. Cézanne from a monograph by Erle Loran, a California professor. Enlarged with mechanical devotion, it became art. Or did it? And the game was on.

It's not a new game. Marcel Duchamp, the old master of innovation, started it all years ago by setting up his readymades (suitcases, a urinal, etc.) and calling them art, leaving on us the burden of proof that they were not. Forty years later, they are definitely part of the history of art. Since then there have been numerous such acts of wicked aplomb, all forcing a definition of art, and all putting stress on the basic idea that art in some way alters or transforms life, nature, reality or whatever you want to call it. Mr. Lichtenstein's art is in the category, I suppose,

of the handmade readymade.

What he has done is put a frame of consciousness around a major part of American life (the funnies) we take for granted, fulfilling a criterion students have been writing about in their notebooks for years—"Art intensifies one's sense of the world around us."

In fact his banal work fulfills enough textbook criteria of what art should be that it calls the criteria into question. The Lichtenstein controversy is really a symptom of a deep unease among critics, historians and some artists as to what art is all about—a more difficult problem than usual nowadays when anyone with any honesty often has to admit he just doesn't know.

So exactly how does one express a deep conviction that Mr. Lichtenstein's work isn't art, or more important, isn't worthy of becoming so?

Those holding that Lichtenstein transforms his material are wide open. Naturally, his subject matter is beyond attack, since anything can be the subject of art. But the content

**POP—A recent Lichtenstein.**

of a work of art is partly in its attitude—formal or otherwise—to its subject. The best Mr. Lichtenstein can do is offer us a dead-pan vacuity. His work provokes a double-take because nothing could be that empty. (It is, which may be a creative achievement of a sort). However, the point is how long banality can represent banality and

41

where it stops.

But when one looks at Mr. Lichtenstein's paintings as handmade readymades, the problems are much more complex. While in my opinion, what he does is certainly not art, time may make it so, with a little help from the present.

It becomes art through a process that forces the critic outside art as such to become a sort of social critic. For unless one goes around with one's eyes closed one cannot help but notice how art of no importance, such as Mr. Lichtenstein's, is written about, talked about, sold, forced into social history and thus the history of taste, where it is next door to acceptance as art. One cannot escape an uneasy sense that for the first time in history, instead of our art choosing us, we are choosing our art. The next question is "Who does the choosing?"—a question that brings the Furies down on one's head, half of them pure believers, the other half, naturally, vested interests. They elect to choose, denying others the freedom to unchoose. There is something wrong in a process that makes the artist a bystander at a struggle deciding whether his work will qualify or not.

Mr. Lichtenstein has produced paintings that carry no inherent scale of value, leaving that value to be determined on how successfully they can be rationalized, tucked into society and placed in line for the future to assimilate as history, which it shows every sign of doing. A strange convergence of circumstances has enabled Mr. Lichtenstein to add an unworthy graft to the body of art. It seems to be taking, and there seems to be nothing one can do to stop it.

October 27, 1963

# DISPOSABLE ART: PROGRESS BY DESTRUCTION

### By BRIAN O'DOHERTY

ART movements in America come, conquer, and then seem to be suddenly and totally displaced by a new movement that eventually suffers the same fate. They never seem to have an organic growth, decay and transformation as in Europe.

After keeping an eye out at the galleries for post-abstract expressionist art—the transformation of a style that one somehow expected—the conclusion has to be that apart from a handful of personal adaptions of the style (including Budd Hopkins, Elise Asher, Warren Brandt, Julian Hatofsky, perhaps Friedel Dzubas) it doesn't exist in any sizable way. A case could be made tracing the effect of the freedoms and attitudes it initiated. But the point is relative. The extent of abstract expressionism's disappearance is shocking — as complete as that movement's elimination of the social realism triumphant in the thirties. Social realism, you remember, delivered the coup-de-grace to the early modernism of the twenties (or at least shelved it for a decade), while the Armory Show virtually eliminated The Eight.

This "cuckoo's egg phenomenon" seems traditionally American, especially as one writes from a city in such permanent flux that if you stand at the same corner long enough the buildings will be changed. There is something brutal about the dynamic optimism of a society projecting the present into the future so eagerly that it coincidently murders the past. The elimination of whatever is considered to have served its purpose—from paper dishes to buildings, from people (the country is full of homes for disposable, i.e. old, people) to art movements — makes our society a vast unstable puzzle, full of serialized vacuums. This passion for impermanence seems to produce an inability to learn from (and an ignorance of) the past which foreigners sometimes call "American naivete" and other times call "liberation from tradition" and "sense of infinite potential."

The principle of disposal as applied to art movements has some advantages but in general it seems pretty devastating, since it ties art to social forces not inherent in it. A cross-section of European art at any time in the past 300 years shows a constellation of styles, usually with one predominant, waxing and waning, with ideas being assimilated and transformed.

In our country the abrupt amputation of a style is determined by the very fact of its success. As we all know by now (particularly from "The Tradition of the New") this appetite for novelty demands invention at any cost. The artist at the rim of society (his traditional position in America) invents something—a style, an attitude, a synthesis—that the society blows up, wallows in, destroys, then waits for the next. The analysis of this process is avoided by most critics.

The effect of this on the artist is maiming. He may simply zig-zag (as many do) from one movement to the next, an adjustment that tends to be corrupting. Others stick to their guns, have a good inning (like ballplayers, another disposable commodity) and then, out of fashion, suffer the private erosions of confidence forced on them by a milieu that uses novelty and quality interchangeably. Thus there is no standard Academy or Establishment, merely rapid series of avant-gardes shunting into series of establishments. The revolutionary quickly finds himself a reactionary, all his teeth drawn by complete acceptance.

The actual force that devalues new styles and artistic innovations is difficult to identify. It may as some have said, be mere surfeit. Or the ministrations of that branch of the national economy (dealers, museums, collectors) channeling art into the society. The essential point is that there is a distortion of the artist's contribution as it is interpreted and exploited that numbs and deadens its vitality as a work of art.

Now the two movements that displaced (or succeeded if you like) abstract expressionism are in process—Pop (New Realism) and the New Abstraction (Optical Art). Although hardly out of their infancy, the numbing force is already at work on them.

Both these movements are unique however in that they have a high potential for transformation, new to art in America, and an awareness that may be a sort of built-in resistance to corruption. Both have a curious duality—they are personal and impersonal, individual and yet social. Their source of origin seems as much at the center of society as at the well-worn rim. Neither is committed to the self-limiting ideologies that are esthetic suicide.

Both, in fact, are so supple and adjustable that it is hard to see how they can be shaken off quickly for a new development — although their emotional coolness is a future invitation to some form of expressionism. In many ways, these two movements hold solutions to the dilemmas of being—and staying—modern. They may well provide an art that, like a race or species, is disposable in its individual units, but survives as a style. Thus one would have an art both disposable and permanent — capable of withstanding what seems, in America, inevitable total eclipse and replacement.

April 12, 1964

# ART NOTES

### By GRACE GLUECK

**RINGERS**

"Is this an art gallery or Gristede's warehouse?" said a viewer when pop artist Andy Warhol's new show opened at the Stable Gallery April 21. Stacked from floor to ceiling were some 400 plywood grocery cartons, painted to resemble cardboard and bearing big-as-life replica trademarks — Brillo, Heinz Ketchup, Campbell's Tomato Juice, and so on. That was the show. As one observer said, "Anti-Art with capital A's."

Last week, a couple of days before closing, enough Warhol cartons had been unloaded to gladden a grocer's heart. At prices ranging from $200 to $400, depending on size, some collectors had bought five or six at a clip. The show's biggest buyers were a well-known New York collector couple, who spurned the smaller Brillo cartons marked "3c Off" which sold for $200, to plunk down $6,000 for 20 of the regular size.

When he heard about *that*, an abstract painter named Jim Harvey felt slightly (but not very) manqué. On the job for the industrial designing firm of Stuart & Gunn, where

**BRILLO BOXES, WARHOL VERSION**—For clever collectors, a fortune may lurk in the supermarket.

he is regularly employed, he had designed the *real* Brillo crate in 1961, and somehow failed and still fails to see its potential. "A good commercial design," he says, "but that's all." What's more, his version is cheaper. Each cardboard carton, duly trademarked, costs the Brillo people between 10 and 15 cents.

May 10, 1964

# That's Right It's Wrong

### By JOHN CANADAY

OUR famed but so-called culture explosion becomes more and more obviously expended as a mammoth backfire. A latest symptom is that the painting by Bridget Riley reproduced just to your right was selected only after questions as to whether a Bridget Riley might not be a bit out of date. Miss Riley's first New York exhibition opened 12 days ago today. Figure that out.

The red dot meaning "sold" was pre-attached to each of the labels on her paintings when the exhibition was installed at the Feigen Gallery on March 2. The exhibition was sold out sight unseen. In addition, the gallery has a waiting list of people who want "a Riley." Not some-

thing they have seen and liked and feel they have to have because they like it, but just "a Riley."

One day last week a young woman was begging, "Isn't there *any* way I can get one? Isn't there *anything* you can do? Well maybe if you have a cancellation—"

She was speaking with the urgency of a woman pleading with her hairdresser, and from much the same point of view. If you can't go to a really smart cocktail party without the latest hairdo, neither can you give one without a Riley on the wall.

**Good Luck, Bad Luck**

Photogenic herself and the creator of the most photographable paintings of the new optical rage, Miss Riley has had the tables turned on her. She has become, by write-in vote, the symbol of a movement of which she is only a small, if altogether admirable, part. The excitement has reached such proportions that only a fractional percentage of it has anything to do with her art. On the contrary, the personality cult is opposed to the studious anonymity of that art. In an appalling way, the hullabaloo makes her less

of an artist than she is, just as the wrong light may deform a painting.

Everything in a situation where fashionable excitement becomes the point of departure for the way we look at a painting is a distortion of that painting. Miss Riley suddenly finds that her paintings are translated into fabric designs that will be draped and cut, whereas the essence of her art is illusion created on an absolutely flat surface of specific dimensions. (She has authorized no such uses of her paintings, but if at the time of sale an artist does not make the necessary legal restrictions concerning the use of the painting, he is helpless against any uses that are made.) Manufacturers of products of all kinds have been trying to give their packaging the Bridget Riley look, and have harassed the gallery with unwelcome offers. The most ironic proposition to date has come from a manufacturer of a headache remedy.

Miss Riley paints too slowly to supply a demand that she is not interested in satisfying anyway ("Burn," illustrated here, is the result of 12 preliminary sketches and four destroyed paintings) but

she will be imitated now by the little people who have just enough patience to approximate her effects without understanding much of the invention that went into their creation.

Should this worry us? Should we care that a wide public supposedly interested in art doesn't know the difference between the real thing and the imitation? Perhaps not, but we should stop patting ourselves on the back with the idea that this has anything to do with a cultural renaissance. Riley fabrics are only a degree less obviously a perversion than the pasting of Rembrandt reproductions on artistic wastebaskets. Rembrandt on the wastebasket is a good enough symbol of just how effective 99 percent of our cultural renaissance has been.

If we are still left with that dangling one percent we can be thankful for it. But let's stop cheering.

**Because—**

While Miss Riley's exhibition was being hung with its uniform red dots, there were exhibitions by major artists at major galleries that were coming down with hard-

Bridget Riley's "Burn"

ly a red dot to their name. These were exhibitions of those painterly painters who have managed to survive the debacle of the abstract expressionist decline, painters who have won international prizes and who for a while were established as modern masters. Even a year ago their sales would have been good; three or four years ago they would have been selling out. They are as good as ever they were, but they are no longer in vogue. Young painters who rose with the movement, whether they are good or were only facile riders on the crest, don't stand a chance. The trouble is that whether they were good, or only hangers-on makes no difference.

To see the parasitic crest-riders weeded out would be satisfying indeed if the good guys weren't pulled up by the roots at the same time.

Today there are painters in their thirties who five years ago were launched on a career, and have since become members of a twice-forgotten generation, displaced first by pop and now by optical art.

Optical art may be (and I firmly believe that it is) potentially the most important development in several decades, but its rage has become so extreme that from week to week you can hardly keep up with its rise and fall. And so far as I can see, nothing can be done to stop the bandwagon-steamroller that carries one group of artists along with it while crushing all the rest beneath it. The cultural renaissance is not a cultural renaissance any longer, if ever it was one, but is only a high-powered adaptation of the pressure techniques that we use in the sale of every-

thing from politicians to soap.

The fact that everybody already knows this should not make its reiteration anything less than pointless in the face of the general helplessness against these techniques, which involve not only opportunistic salesmen but the critics eager for an audience and the museums that need a big gate to survive.

Everyone in the business is caught by the necessity to maintain a feeling of excitement about what is happening. Everyone is trapped by the idea that the public must be amused. (Education can be fun.) Everyone is defeated by the idea that art is something that can be predigested and served up with plenty of spicy garnish as a dish at once palatable and nourishing.

Somewhere the nourish-

ment gets lost. The food turns out to be a form of dope.

Learning ancient art history, children stand in front of a Picasso with their school teachers, who ask, "Now, children what is this an example of?"

"In-ter-pen-ee-tra-shun-of-form-and-space," they pipe.

"That's right, children." says the teacher. "Now the next picture."

"Ack-shun-painting," in a sweet treble.

"That's right. And this one?"

"Superman!—Er-no, - Raw-wee-Lich-ten-stein."

"That's right. And this?"

"Brid-git-ri-ley. Op-ti-cal." That's right.

But it doesn't mean a thing. It's wrong.

# Now All Artists Are Surrealists

By MARTIN ESSLIN

**MARTIN ESSLIN,** a London theatrical producer and director of drama for B.B.C., is the author of "Brecht: The Man and His Work," and "Theater of the Absurd."

A RE-EMERGENCE of surrealism — or perhaps we should call it a new awareness of the continuing influence of that school — has been evident this season in retrospective exhibitions of the work of several surrealist painters and sculptors and in the publication of critical studies of the movement's leading poets and dramatists—artists who, as recently as ten years ago, were looked upon as passé and insignificant. The influence of the surrealists is clear in several areas of the avant-garde art of today—from the Beat poets to the action painters and the Pop artists, from the inventors of "happenings" to the practitioners of "concrete verse."

The surrealists were even more shocking and revolutionary in their day than artistic innovators usually are. They aimed particularly violent and insulting invectives at their opponents, calling Anatole France a corpse when he was still very much alive; scorning Paul Claudel, the great Catholic poet (who admittedly had called them pederasts); and arranging for cries of "Long live the Germans!" at public function in Paris not long after the end of World War I. Their initial claims as inventors of a wholly new art were particularly extravagant and, in addition, they presented to the outside observer a picture of continuous internal feud and factional strife which could not but reinforce the impression of a crowd of silly humbugs.

And yet, behind this façade of silliness and mutual recrimination, the surrealists produced major works in literature, the drama, painting and sculpture, as well as in the cinema, in

## THIS WAS THE MOVEMENT THAT WAS (AND IS)

Museum of Modern Art.

Salvador Dali's famous "The Persistence of Memory," painted in 1931.

"The Enigma of Isidore Ducasse," by Man Ray, Philadelphia's contribution to surrealism.

Guillaume Apollinaire—he wrote a "drame surrealiste" in 1903.

Collection of D. & J. de Menil. Houston

René Magritte's "Golconda" (1953), a study representing the standardization of 20th-century man.

A scene from "The Chairs." Ionesco's work clearly shows the influence of the surrealist school.

Louis Aragon, poet, who later became editor of the pro-Communist Paris newspaper Ce Soir.

# Painting and Sculpture

photography and in a number of totally new artistic fields. The literary output of their major poets, however—difficult of access, recognized by relatively few critics at the time—is only now coming into its own, often as a result of the success of a new generation of writers who have achieved greater popular success (Ionesco, for example, would be unthinkable without Artaud and Vitrac). In painting and sculpture, the surrealists suffered from the fact that surrealism, being a literary movement and a literary idea, does not really represent a recognizable style. In a period in which criticism of the fine arts concentrated entirely on form, texture and color, it became only too easy to dismiss all surrealist painters and sculptors as illustrators. This is probably the main reason why surrealism's reputation, in the fine arts at least, declined as much as it did in the late forties and fifties.

Time, the great solvent and clarifier in art history, is now restoring the balance. The figures emerge. Max Ernst, René Magritte, Giacometti, Picabia, Man Ray, Chirico, Dali, Henry Moore (a member of the surrealist movement between 1935 and 1939), André Masson, Arp, Yves Tanguy are all being recognized as major artists in their own right—each different from the others, each with his own approach to the world and his own technique, yet all of them owing a great debt to surrealist theory and practice.

**W**HAT then is it that the surrealists have contributed to the art of our time? What is surrealism? Above all: Surrealism is more than merely a method of painting, or a style of writing. It is an attitude of mind, almost a way of life; certainly a way of looking at the world. That is why it is not confined to literature or the

visual arts. It covers the spectrum of artistic activity.

The term surrealism was first used by Guillaume Apollinaire (1880-1918), the eccentric French poet of Polish origin—his real name was Wilhelm-Apollinaris de Kostrowitsky and he was born in Rome, the illegitimate son of a Polish lady and an unknown father who was rumored to have been an ecclesiastical dignitary—who exercised an enormous influence not only on the avant-garde poetry of his time, but also on painting. Apollinaire's short and zany play "The Breasts of Tiresias" (first performed in 1917, but written in 1903) is subtitled "drame surréaliste." In his preface, and in the prologue to the play, Apollinaire explained that what he meant by surrealism was a mode of capturing the essence of reality not by copying nature, but by expressing it in ways that make the work of art *more real* (Continued)

**The nose-thumbing artists of 40 years ago whose aim was the creation of the 'super-real'— or 'sur-real'—today exert an influence that surpasses even their extravagant predictions.**

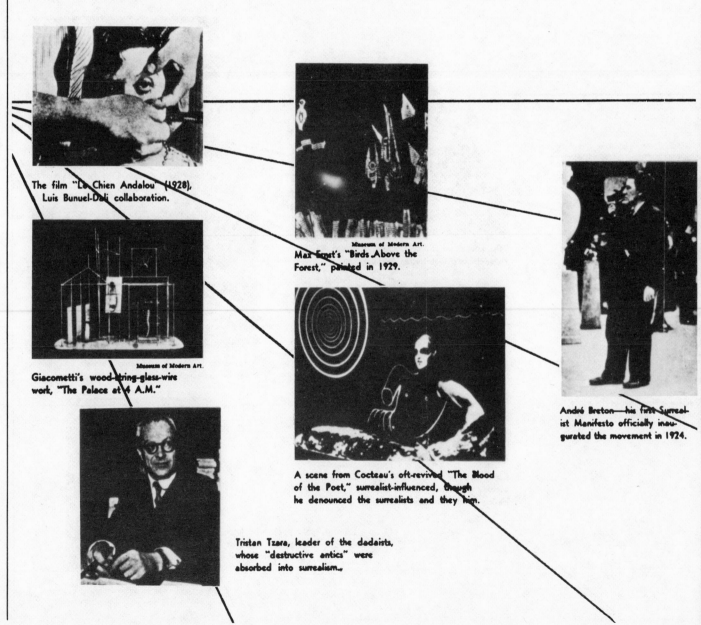

The film "Le Chien Andalou" (1928), Luis Bunuel-Dali collaboration.

Museum of Modern Art.
Max Ernst's "Birds Above the Forest," painted in 1929.

Giacometti's wood-string-glass-wire work, "The Palace at 4 A.M."
Museum of Modern Art.

André Breton—his first Surrealist Manifesto officially inaugurated the movement in 1924.

A scene from Cocteau's oft-revived "The Blood of the Poet," surrealist-influenced, though he denounced the surrealists and they him.

Tristan Tzara, leader of the dadaists, whose "destructive antics" were absorbed into surrealism.

*than reality*, i.e. super-real, sur-real.

"When man wanted to imitate the action of walking, he created the wheel, which does not resemble a leg," Apollinaire wrote. In the prologue he argued that the artist must be completely free to reshape the world in order to achieve this super-reality: "His universe is the play/ Within which he is God the Creator/ Who disposes at will/Of sounds, gestures, movements, masses, colors/Not merely in order/To photograph what is called a slice of life/But to bring forth life itself in all its truth..."

Apollinaire died on Armistice Day, 1918. It was a significant, a symbolic date. For the World War which ended on that day had not only destroyed the political mold, but also the seemingly unshakably solid structure of the social life of 19th-century Europe and the seemingly unshakable canons of what had once been regarded as the sublime and beautiful in art. The seeds sown in the prewar era by men like Jarry, Apollinaire (and the Cubist and post-impressionist painters he had championed), the early German expressionists, the abstract experiments of painters like Malevich and Kandinsky, the destructive antics of the dadaists (a group of German, French and East European fugitives from the war who had found refuge in neutral Zurich)—all these seeds now germinated into a harvest of artistic creation that frightened the adherents of the old standards out of their wits.

**P**ARIS inevitably became one of the centers of this artistic revolution. Among the young, hopeful artists returning from the war was André Breton, then in his early 20's—he was born in 1896—who had been called to the colors from his medical studies, had served in the army as a psychiatrist and was one of the first Frenchmen to recognize the importance of the work of Sigmund Freud. Moreover, in his army days, he had frequently been in touch with Apollinaire.

In 1919, Breton published his first volume of verse and became, together with Louis Aragon (born 1897) and Philippe Soupault (also born 1897), editor of a review, *Littérature,* which devoted itself to avant-garde poetry. This group was drawn into the activities of the dadaists, led by Tristan Tzara, who at that time scandalized bourgeois circles in Paris by organizing demonstrations that often ended in brawls. The dadaists were purely negative in intention: they wanted to destroy the bourgeois concept of art by pouring ridicule on *any* idealistic concept of beauty. It was a healthy reaction in many ways, but bound to remain sterile. Gradually Breton and his friends turned against dada. Under the influence of Freud, whom he had visited in Vienna in 1921, Breton became deeply preoccupied with the artistic potentialities of the human subconscious.

With the members of his group, Breton embarked on a number of ex-

periments involving hypnotism, automatic writing and the recording of dreams. This first nucleus of surrealists already contained men of the highest talent: Aragon, the brilliant poet and fanatic, who once said that compared to the surrealist revolution the Russian revolution was a miserable little thing (and has ended up a loyal follower of the Communist party line); Paul Eluard (1895-1952), one of the greatest poets France has produced in this century, who during World War II became the great spokesman of the Resistance; Max Ernst, the German romantic painter and poet, with the gift of turning any accidental blob of paint into a dream landscape of haunting power and lyrical delicacy; Robert Desnos (1900-1945), another poet of the dream vision, who developed an uncanny ability to dream with his eyes open and then write down what he had seen (he died in a German concentration camp, at the very moment of the liberation); René Crevel (1900-1935), an eccentric bohemian poet who committed suicide; Jacques Rigaut (1899-1929), a black humorist who publicly condemned himself to death in 1919, when he was 20, granted himself a stay of execution for 10 years, and promptly killed himself at the age of 30; and Francis Picabia (1879-1953), poet and painter, an older man of established reputation who had been a dadaist and looked at the surrealist movement with a mixture of enthusiasm and irony.

**I**N his *"Manifeste du Surréalisme"* (the first Surrealist Manifesto), which officially inaugurated the movement in 1924, Breton describes their efforts to remove rationality, and conscious deliberation, from the creative process. He and Soupault had endeavored to write down anything that came into their minds *at extreme speed.*

"At the end of the first day," Breton says, "we were able to read to each other some 50 pages we had obtained by this method and to start to compare results. On the whole, Soupault's efforts and my own showed a remarkable analogy: the same faults of construction, the same shortcomings, but also, on the other hand, an impression of extraordinary fervor, a great deal of emotion, a considerable number of images of a quality of which we should not have been able to produce even a single example by deliberate rational effort, a very special picturesqueness, and, here and there, some passage of a sharply comic flavor."

Here, then, we have the principle of surrealism as Breton and his school understood it: the absolute supremacy of the subconscious impulse in the process of artistic creation. Hitherto, art had been regarded as an act of supreme deliberateness and rationality, the application of the highest degree of conscious design, learned skills and ingenious methods

developed to produce foreseeable and intentional effects.

Freud had pointed out that *behind* the deliberate plan of the artist, however, there had always been at work a subconscious motivation which made use of and molded his conscious efforts. Breton was the first to base artistic activity on a voluntary abdication of conscious planning, a deliberate passive yielding to the promptings of the subconscious.

There is a world of difference between this conception and Apollinaire's use of the term surrealism. Nevertheless, Breton and Soupault followed Apollinaire in christening their new method. "In homage to Guillaume Apollinaire," Breton continues in his account in the first Surrealist Manifesto, "who had just died and who, we felt, had at various occasions followed a similar impulse without, however, having abandoned mediocre literary methods in its favor, Soupault and I gave the name Surrealism to the new pure method of expression which we now had at our disposal and which we made available to our friends without delay."

The first Surrealist Manifesto includes a dictionary-like definition of the new term by Breton:

SURREALISM. Noun. Masculine. Pure psychic automatism by which it is intended to express, be it verbally, in

## One of their basic slogans was "To transform the world!"

writing or by any other means, the true functioning of thought. Dictation of thought without any control by reason, and outside any aesthetic or moral preoccupation.

And Breton followed this definition with a short description of the kind found in encyclopaedias:

Surrealism is based on the belief in the superior reality of certain forms of association hitherto neglected, in the omnipotence of the dream, in the free play of thought. It tends toward the definitive destruction of all other psychic mechanisms and to put itself in their place in the solution of the main problems of life . . .

While insisting that nobody before him had consciously practiced surrealism as a method, Breton nevertheless listed a number of writers and painters who, he felt, had, without knowing it, sometimes used similar processes of direct expression of the currents of the subconscious. Chief among these was that mysterious and eccentric genius of the Romantic Agony, Isidore Ducasse (1847-1870), a native of Montevideo who had written, under the pen name Comte de Lautréamont, a strange prose-poem of wild dreamlike fantasy about hatred, evil and madness, *"Les Chants de Maldoror."* It contains the surreal-

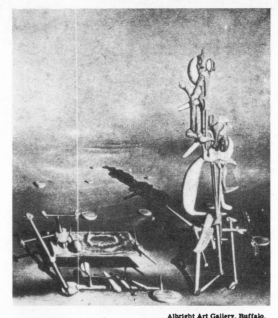

**MINDSCAPE**—This work, "Divisibilité Indéfinie," was painted in 1943 by Yves Tanguy.

ists' favorite definition of beauty: "Beautiful as the unexpected meeting on a dissection table of a sewing machine and an umbrella . . ."

Among other precursors named by Breton in his first manifesto we find Swift, de Sade, Chateaubriand (for his exoticism), Constant, Hugo, Poe (surrealist of adventure), Baudelaire, Rimbaud, Mallarmé, Jarry, St.-John Perse, Roussel and others. In a footnote, Breton added some names of painters who qualified as surrealist precursors: "In the past only Uccello, in modern times Seurat, Gustave Moreau, Matisse, Derain, Picasso (by far the purest), Braque, Duchamp, Picabia, Chirico, Klee, Man Ray, Max Ernst and André Masson."

**A**FTER publication of the first Surrealist Manifesto, with Breton as high priest of the movement, the title of the review *Littérature* was changed to *La Révolution Surréaliste* and a Bureau of Surrealist Research was established in premises in the Rue de Grenelle off the Boulevard St. Germain.

The revolutionary implication of the title of the new publication was quite seriously meant. Breton insisted that the movement was far more than purely artistic, that it had two basic slogans: "To change life!", derived from Rimbaud, and "To transform the world!", derived from Marx. For believers in the supreme power of the subconscious to have put their faith in Marx, the extreme rationalist who wanted to transform the world on verifiable scientific principles (however mistaken he may have been in this conviction), must appear as the ultimate paradox. Nevertheless, in those heady days following the Bolshevik revolution all antibourgeois elements in Europe (and the United States as well) were bound to pin their highest hopes on the vociferously antibourgeois Communists. Many of the bitter feuds within the surrealist movement had their origin in the consequences of this first commitment to Marxism. Aragon, Eluard and a number of others became loyal party members and were eventually lost to the cause of surrealism. Breton grew increasingly disgusted with the dogmatism of the party, briefly hitched his wagon to the star of Leon Trotsky (whom he visited in his Mexican exile in 1938) and later even became for a time a supporter of the postwar world-citizen movement of Garry Davis.

Breton's assumption of the mantle of the supreme arbiter of surrealism, with the power to adopt and to expel anyone he wished, has made the history of the movement an endless record of heresies and their persecution, of violent rifts and schisms, the creation of splinter groups and the most complicated maneuvers and countermaneuvers among the various factions. One has, in fact, to distinguish between officially recognized surrealists and an outer fringe com-

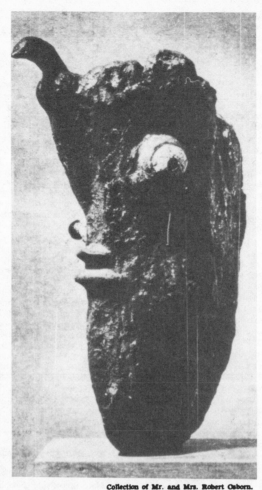

Collection of Mr. and Mrs. Robert Osborn.

**CERAMIC**—Joan Miro was a signatory of the first Surrealist Manifesto. This is his "Head."

posed of artists who were merely influenced by Breton's ideas at a distance, or have at one time or another belonged to the movement before being expelled and excommunicated.

One can, however, quite safely venture to say that it is the *outer*, rather than the *inner*, circle which will give the measure of the true importance of surrealism. Indeed, some of the most considerable creative artists who bear witness to the influence of the surrealist movement have never formally belonged to it at all, or may not even have been conscious of its direct influence. On the other hand, this should not lessen the value of Breton's insistence on the purity of the inner circle. It was, after all, from this inner core, and from Breton himself, that the initial impulse radiated.

**W**HAT of Breton's insistence on *pure automatism?* Most of the writers and painters concerned *used* the concept in the sense that they were able to incorporate ideas produced by yielding to passive subconscious impulses into conscious and deliberate work. Such use was, necessarily, far less possible for those working in such fields as the theater or cinema.

Over all, the recognition of the value of the subconscious impulse proved immensely fruitful. Automatic writing is only one of these methods. The painters and sculptors among the surrealists developed a number of procedures by which their subconscious could be stimulated: drawing at extreme speed (Masson); collages —i.e., the more or less chance juxtaposition of snippets of illustrations, newspaper cuttings, etc.; working a blob of paint on a piece of paper into a pattern of surprising forms by folding the paper, rubbing other paper against it, etc.; Marcel Duchamp's "ready-mades," which were constructions including real objects that appealed to his subconscious—a lavatory bowl, a bicycle handlebar, etc. From these Max Ernst, Kurt Schwitters, Arp and Dali developed more complex collages of real objects.

Present-day Pop art is the direct descendant of these techniques. And action painting clearly derives from the method of ultra-rapid drawing and reliance on the element of chance. Max Ernst's advice to young painters in 1942 was: "Attach an empty tin can to a thread a meter or two long, punch a small hole in the bottom, fill the can with paint, liquid enough to flow freely. Let the can swing from the end of the thread over a piece of canvas resting on a flat surface, then change the direction of the can by movements of the hands, arms, shoulder and entire body. Surprising lines thus drip upon the canvas. The play of association then begins."

**A**LL these techniques of painting and sculpture are concerned with *formal invention* by free association. Another group of surrealist painters and sculptors proceeded in a totally different way: they used well-established traditional formal techniques for the meticulous depiction of *subconscious contents*. If the former group might be called subconscious formalists, the latter are the naturalists of the imagination.

Chief among the "naturalists" are undoubtedly the Belgian René Magritte (1898) and the Spaniard Salvador Dali (born 1904). Dali, long since excommunicated by Breton, who objected to his commercialism and publicity-consciousness (he renamed him, in an anagram, Avida Dollars), nevertheless remains one of the chief glories of surrealism. However bizarre his behavior (he once gave a lecture at the Sorbonne with his bare right foot soaking in a pan of milk), however cynical his attitude (in a recent interview in the Paris periodical Arts he declared that he lived in New York "because there I am in the middle of a cascade of cheques which arrive like diarrhea"), Dali is a very considerable painter with the power to project genuine dream images onto his canvas.

Magritte, less showy and less publicity-conscious, is perhaps even more powerful a painter of bizarre night-

mare images. Using a Pop pictorial style, Magritte manages to displace his audience's sense of reality by investing objects of every-day life with frightening changes of place and emphasis: a marble statue of a nude woman which appears to be composed of flesh above the navel—but lacks a head; an athlete raising a pair of dumbbells—one of them covers his head—no, it *is* his head, etc.

One of the century's greatest sculptors, Alberto Giacometti, of Italian-Swiss origin (1901-1966) also derived a great deal of inspiration from both official and unofficial surrealists: his forests of thin, elongated bodies walking through a dessicated world are among the most powerful images of our time. His "Palace at 4 A.M." at the Museum of Modern Art is a fine example of his surrealist period.

Man Ray (born 1890 in Philadelphia), the first American to join Breton's circle, was among the precursors of the movement in New York during the First World War. He is a painter, maker of surrealist objects, collagist, and, above all, a virtuoso with photographic techniques: he invented rayograms, pictures taken without a lens which turn the most ordinary objects into fantastic apparitions.

Joan Miró (born 1893), another Spaniard and a signatory of the first Surrealist Manifesto, is, unlike Dali, an almost nonrepresentational painter who builds up his canvas from the simplest blobs of paint—schematized, childlike images of reality, ideographs.

Paul Klee (1879-1940) never officially belonged to the surrealists, but was revered by them: he, too, uses ideographs, in a manner not unlike Miró's.

IN the field of literature the influence of surrealism is certainly even wider than in the fine arts; yet the fact that it is so widespread—and the influence often indirect—makes it far more difficult to be specific in showing how the work of a certain poet or novelist derives from surrealist inspiration.

Modern French poetry is certainly profoundly affected by surrealist techniques and conceptions. In addition to the founder members of the movement, René Char, Jacques Prévert (the author of many of the most famous popular *chansons* of the last decade and scenarist of many famous films), Raymond Queneau, who is also a novelist, Julien Gracq and René Daumal were at one time or another active supporters of Breton. (But is there, in point of fact, any major poet now active in France who does not bear the mark of his influence?)

As to non-French literature —where is one to draw the line? e. e. cummings certainly shows surrealist influences. So do the Beat poets, with their insistence on spontaneity. So does Samuel Beckett, in his prose works—a record of a multitude of voices speaking from the subconscious (although Beckett, a great master of form, consciously shapes the material).

IN drama, there is Antonin Artaud (1896-1948), the theoretician of the Theater of Cruelty, who was one of the most active members of the surrealist movement until he was excommunicated by Breton for the sin of wanting to start a company playing to a paying public. Artaud deeply influenced modern playwriting, as well as techniques of staging, thus carrying the surrealist influence far and wide into the contemporary theater. Ionesco, Adamov and the numerous adherents of the Theater of the Absurd clearly also derive from the surrealist impulse to seek the sources of creative energy in the dream and the subconscious.

In the cinema, too, surrealist influence has been powerful and pervasive. One of the greatest French directors, René Clair, started out as an avant-gardist deeply influenced by the surrealists (one of his first films, "Entr'acte," was made in collaboration with Picabia); Man Ray made a number of highly influential experimental films; the surrealist poet Robert Desnos wrote several scenarios; and Luis Buñuel made two films in collaboration with Dali — "*Le Chien Andalou*" (1928), and "*L'Age d'Or*" (1930). The first of these contains one of the most frequently quoted surrealist images: a group of monks dragging a piano on which lie the rotting carcasses of asses. Nor can Cocteau's films be considered uninfluenced by the surrealists, although the surrealists strenuously denounced Cocteau—and Cocteau, equally strenuously, the surrealists. And again: which film-maker of imagination now active would claim not to have felt the influence of one or more of these great pioneers, and thus ultimately that of the surrealists themselves?

ANDRE BRETON, the founder of the surrealist movement, was 70 years old on Feb. 18 of this year. Most of the pioneers who are still alive have already passed, or are rapidly approaching, the Biblical age of three score and ten. The avant-gardists of the twenties and thirties have become revered elders. When the numerous, and often ludicrously petty, controversies generated by Breton's pose as the Pope of Surrealism were at their height, the temptation to dismiss him and all his works as the expression of childish fads and pretentious crankiness was understandably great. Today we can overlook these storms and merely be amused at the almost incredible political naiveté displayed by what, after all, were artists who had no idea whatever about politics.

But if we disregard these aspects of surrealism, what remains is a truly impressive achievement: no less than a complete reshaping of man's concept of artistic creativeness, the uncovering of vast areas of new sources of creative energy. Insofar as there can hardly be an artist today who is unaware of the fact that his creative power has subconscious sources, which he must deliberately nourish and cultivate, *all* artists are surrealists in our time.

May 22, 1966

---

## Ben Shahn, Artist, Is Dead Here at 70

Ben Shahn, one of America's most popular painters, who made his art serve the liberal social and political causes in which he believed, died late last night at Mount Sinai Hospital. He was 70 years old.

Mr. Shahn, who was also recognized as a first-rate commercial artist, poster maker and book illustrator, lived in Roosevelt, N. J.

He had been in the hospital for several weeks, and underwent major surgery Wednesday.

### Painter and Polemicist

In 1930, during a summer of work and soul-searching at Truro on Cape Cod, Ben Shahn came to a decision about the path he wanted to follow as an artist. "I had seen all the right pictures and read all the right books," he recalled, "but it still didn't add up to anything.

"Here I am, I said to myself, 32 years old, the son of a carpenter. I like stories and people. The French school is not for me."

Behind him were a rigorous slum childhood in Brooklyn's Williamsburg, 17 years of work as a commercial lithographer, night courses at City College, New York University and the National Academy of Design, his first one-man show and two long stays in Europe during which he had been influenced by the work of Georges Rouault and Raoul Dufy.

But cubism, abstraction and technical exercises for their own sake seemed to him barren. Then, as later, he wanted to make what he called "social communication" with his art. He found himself and his subject in the trial and execution of Nicola Sacco and Bartolomeo Vanzetti.

With the 23 small gouaches and two large panels he did on the case, Mr. Shahn established himself as a strong

painter-polemicist. Three decades later, these works have lost their power to shock, but to do them in that time—they were shown in New York and in Cambridge in 1932 — took both political and artistic courage.

### A Radical Departure

The case still was bitterly controversial, yet Mr. Shahn depicted it unequivocally as a martyrdom of innocents. And his manner was a radical departure from the polite, sentimental, almost folksy regionalism then dominant in American art.

The style he developed was basically realist—although late in life he did some abstract works — but it was a realism transmuted by poetry, magic and mystery. He was the first American to combine social observation with a kind of surrealism, and improbable as the term social-surrealism seems, Mr. Shahn, through his particular talents, made a success of it.

He also was successful in adapting the commonplace aspects of American culture to artistic ends. His 1952 drawing "Television Antenna," which is a forest of spindly, criss-crossed TV aerials, and a similar work he did with supermarket carts have been imitated so often in advertising that most people have forgotten it was Mr. Shahn who first saw the peculiar qualities of these modern-day artifacts.

The personal universe he created on his canvases was filled with an incredibly lonely space. In "Spring," a 1946 painting, the world recedes behind two lovers and is drawn out into infinity by two roads that meet at a point the eye cannot quite see.

The lovers are utterly alone, intent upon a sprig of pink flowers, despite the presence of another couple skipping a rope up one of the roads.

Discussing his work in a 1965 interview, Mr. Shahn said he had just three subjects: "aloneness; the impossibility of people to communicate with each other, which accounts for the aloneness, and thirdly the sort of indestructible spirit of man to keep on going beyond the time when he thinks it would be impossible to arrive anywhere."

In recent years some critics reproached Mr. Shahn for putting too much sentiment into his paintings and others berated him for being out of step with the abstract modes of the times. He replied indignantly:

"Is there nothing to weep about in this world any more? Is all our pity and anger to be reduced to a few tastefully arranged straight lines or petulant squirts from a tube held over a canvas?"

A more sympathetic view was given by James Thrall Soby, who organized a major retrospective show of Mr. Shahn's paintings, drawings,

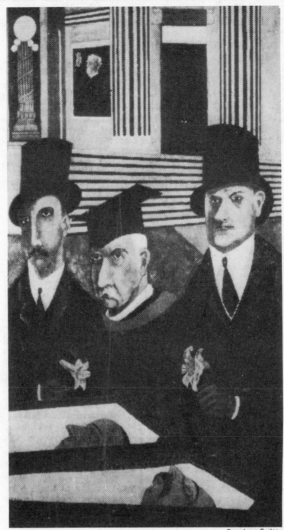

Downtown Gallery

**Mr. Shahn's "The Passion of Sacco and Vanzetti," part of series in which he first used art as social commentary.**

posters, book illustrations and photographs for the Museum of Modern Art in 1947 and who later edited books on his paintings and graphics. In an assessment of the artist Mr. Soby said:

"He is one of the most authentic and powerful American humanists, an artist who translated the American scene into a strikingly personal statement of sympathy for mankind."

### Murals and Posters

Unlike many modern-day artists who seek only an intensely personal esthetic statement, Mr. Shahn was very much a public man. In the nineteen-thirties he undertook commissions for murals in public buildings. In the forties he did posters for the Office of War Information, for the Congress of Industrial Organizations and for Henry A. Wallace's Progressive party.

More recently he did book illustrations and commercial assignments for the Container Corporation of America, the Columbia Broadcasting System, Esquire, Fortune, Time, Columbia Records and others.

He is thought to have made a significant contribution to raising the quality of commercial art, and he took pride in all his work, no matter what the genre. "I do the best I know how," he said, "and I never let out a thing until I'd be as happy with it hanging in a museum or reproduced in The Daily News. I don't care where."

Benjamin Shahn was born September 12, 1898, in Kaunas, Lithuania, to Hessel and Gittel Lieberman Shahn. His father a woodcarver and carpenter, was a member of the Misnagdim Jewish sect, which places a high value on craftsmanship. When Ben was 8 years old, the family, in which there were four other children, emigrated and settled in a two-room coldwater flat in Brooklyn.

### One-Man Show in 1930

From his earliest days he amused himself with scribbling and sketching. He won favor with neighborhood children by doing chalk portraits of sports heroes

on the sidewalks. At the age of 15 he became an apprentice in a lithographer's shop, continuing his high school studies at night.

Intermittent work in lithography supported him through studies at college and at the National Academy of Design and through travels in 1925 and 1927-29 to France, Italy, North Africa and Spain.

He got his first one-man show at the Downtown Gallery in 1930. Then, in 1931 he began working on the Sacco-Vanzetti series with which he made his first big impact on the art world.

He followed that group with another series, 15 paintings and a panel on another famous trial of the day, the case of Tom Mooney. These works were admired by the Mexican muralist Diego Rivera. He engaged Mr. Shahn to assist him in the execution of the "Man at the Crossroads" fresco for the RCA Building in Rockefeller Center. Rivera refused a request from the Rockefellers to paint over a likeness of Lenin and the mural later was chipped off the wall.

A fresco Mr. Shahn did in 1938 for the community center of a housing project for garment workers in Jersey Homesteads, N. J. (later renamed Roosevelt) showed both the influence of Rivera and of the artist's own background. The mural depicts immigrants arriving from Eastern Europe and their determined march to economic freedom. Trade unions, sweatshops, the Triangle Shirtwaist Company fire, labor and civic leaders—all were portrayed in Mr. Shahn's work. Its style was epic, in keeping with the Rivera concepts.

Among Mr. Shahn's other major murals were those he did for the Bronx Central Annex Post Office and the Federal Security Building (then the Social Security Building) in Washington. With another artist, Lou Block, he prepared designs for a 100-foot-long mural for the Rikers Island Penitentiary. Although approved by the Mayor and the Corrections Commissioner, the design was rejected by the Municipal Art Commission as "artistically and in other respects . . . unsatisfactory for the location."

In 1939 Mr. Shahn completed, among other easel paintings, three that became especially popular: "Seurat's Lunch," "Vacant Lot" and "Handball." All three were exhibited at the Museum of Modern Art show in 1947.

### Posters for War Office

In World War II he designed posters for the Office of War Information, and in 1944 he was the chief artist for the Political Action Committee of the Congress

of Industrial Organizations, for which he worked for nominal pay because of his attachment to labor's cause.

He continued to do posters after the war. Among the most notable of these were those he did for the Spoleto Festival of Two Worlds, for the opening of Philharmonic Hall at Lincoln Center and for the Presidential campaign of Senator Eugene McCarthy.

Many of his pictures bore a labor message, or reflected his view of social significance. Among these were "Death of a Miner." "The World's Greatest Comics," "The Violin Player" and "East Twelfth Street."

Of these and similar paintings a critic once commented: "Often Shahn seems bent upon telling us that this is a terrible and a cruel and a heart-breaking world. Yet there are the stimulating swift and keen imaginative flights. And his color can be such as an angel might use."

In 1954 Mr. Shahn received international recognition when 34 of his works were hung in the United States pavilion at the Venice Biennale. The Museum of Modern Art which mounted the exhibition, chose the work of only two artists—Mr. Shahn and Willem de Kooning, an abstract expressionist. Among major Shahn paintings on display in Italy that year were "The Red Stairway," "Spring" and Composition with Clarinets and Tin Horn."

### Appointed by Harvard

Harvard University honored Mr. Shahn in 1956 by naming him Charles Eliot Norton Professor for that year. The following year the university published his lectures under the title "The Shape of Content." The book sums up Mr. Shahn's views on the role of the artist, his education, his place in academic life and his status as a nonconformist. On this last point he said:

"The artist occupies a unique position vis-a-vis the society in which he lives. However dependent upon it he may be for his livelihood, he is still somewhat removed from its immediate struggles for social status or for economic supremacy. He has no really vested interest in the status quo."

Mr. Shahn was profoundly moved by the prospect of thermonuclear war which was the theme of an exhibition at the Downtown Gallery in 1961. Reviewing it for The Times, Brian O'Doherty said:

"The new series is called 'The Saga of the Lucky Dragon.' In it, the old master is masterly.

"'The Lucky Dragon,' its name now a classic irony, was the Japanese fishing boat dusted by lethal fallout after the United States H-bomb test at Bikini on March 1, 1954. The shadow of that tragedy is one that falls more and more urgently over all of us these days, so that to see Mr.

Shahn's exhibition becomes almost a duty. For one of those superb services art can perform, and rarely does, he takes the inhuman energies that threaten to destroy us and simply puts them in human perspectives. It is impossible to contemplate The Bomb. At the Downtown Gallery, one can."

### Espoused Liberal Causes

Mr. Shahn's belief that an artist should be actively engaged in the life of his time led him to lend his name and prestige to a great many liberal causes. In the fifties this brought attacks by right-wingers and attempts to have his work excluded from Government-sponsored art shows that were sent abroad. In 1959, he was summoned before the House Committee on Un-American Activities, but he declined to discuss his political affiliations.

In the same year, Amerika, the State Department magazine that is distributed in the Soviet Union, carried a 10-page article on his art. The Russians, however, did not like what they saw and declared that his paintings and sketches reflected abstract decadence.

Mr. Shahn received many awards for his work. Among them were the Gold Medal of the American Institute of Graphic Arts and a prize from the Corcoran Art Gallery in Washington.

He was a member of Artists Equity, the American Academy of Arts and Letters and the National Institute of Arts and Letters.

With his easy smile, white mustache, closely cropped white hair and heavily muscled body on a large frame, Mr. Shahn had the look of an amiable, avuncular bear. But there was a temper behind the smile and he did not welcome casual visitors to his home and studio in the New Jersey community of Roosevelt.

"I used to meet sightseers with a brush between my teeth," he told an interviewer in 1965. "The mumbling ended the conversation pretty quickly. I'd only take the brush out if I wanted to get involved . . . I don't like to talk shop."

A one-room building behind the house was the place where he did most of his work. Although it had the cluttered look of most artists' studios, he knew exactly where to find whatever he wanted. He had a file of his works and a note book catalogue that told him which drawer held which picture.

Mr. Shahn married twice. His first wife was Tillie Goldstein whom he wed in 1922. The couple had two children, Judith and Ezra. The marriage was terminated by divorce, and in 1935 he married Bernarda Bryson, also an artist. They had three children, Susanna, Jonathan and Abigail.

A funeral service will be held at 11 A.M. tomorrow at the Roosevelt (N. J.) Cemetery.

March 15, 1969

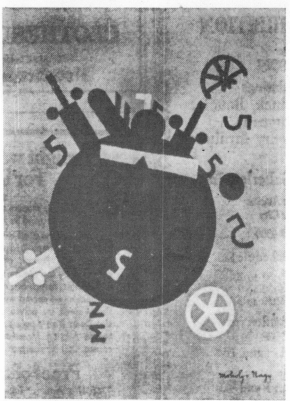

"Large Emotion Meter," one of Laszlo Moholy-Nagy's works being exhibited at Chicago Museum of Contemporary Art.

# In Chicago: A Moholy-Nagy Comprehensive Show

### By HILTON KRAMER
Special to The New York Times

CHICAGO, June 1—Laszlo Moholy-Nagy, who died here in 1946 at the age of 51, was one of the most gifted and versatile artists of the 20th century. Besides being an abstract painter and sculptor of some consequence, he was a designer of genius, and he was also a very original photographer and filmmaker. In addition, he was one of the most influential art teachers of his time, first in Europe and then in the United States, and a brilliant theoretician in nearly every department of visual culture.

Moholy-Nagy was indeed a visionary who tried to bring together in a single coherent effort the resources of modern industrial technology and the spiritual values of modernist art. He was thus a pioneer in exploring many of the artistic and technical problems that have come to occupy artists today.

A comprehensive look at

this artist's many-sided contribution to the visual arts has long been needed, and now at last it has been attempted — appropriately enough, by the Museum of Contemporary Art in Chicago, the city where Moholy-Nagy founded his own School of Design in 1938, and in which he made his home during the last nine years of his life.

The result is an uncommonly interesting — exhibition—an exhibition which illuminates both an extraordinary career and a crucial chapter in the history of modern art.

Moholy (as he was always called) was born in Hungary and educated in law at the University of Budapest. He served in the Austro-Hungarian Army on the Russian front in World War I, and was severely wounded. During his convalescence he turned his attention to art, and within a year after the Armistice he was deeply immersed in the most radi-

cal avant-garde movements of the period.

There are strong traces of cubist, futurist and dada elements in Moholy's early abstract paintings, but the most decisive influence on his pictorial development was undoubtedly that of the Russian avant-garde, particularly Kasimir Malevich and El Lissitzky. From these leaders in the development of pure geometrical abstraction, Moholy derived his purity of style. Like them, he aspired to make that purity of style a vehicle for revolutionary social values.

That double vision, which saw the most avant-garde artistic movements and the most revolutionary political movements as related attempts to revise the basic values of modern society, provided the impetus behind all of Moholy's audacious theories. It made him an ideal candidate for the staff of the Weimar Bauhaus, and in 1923 he joined the staff of that celebrated workshop and school.

### Energy Survived Exile

Moholy's subsequent career was clouded by the necessity of political exile, but it showed no diminution of energy or invention. He worked in the theater, films, architecture and commercial art. He moved from Germany to the Netherlands, from there to Britain, and then to Chicago, where in 1937 he tried to establish the New Bauhaus. When that failed a year later, he opened his own School of Design, which, as it happens, occupied the site next door to the present Museum of Contemporary Art on East Ontario Street.

The exhibition that Jan van der Marck, the museum's director, has brought to Chicago consists of 69 paintings, 14 collages, 36 prints and drawings, eight sculptures, and a small anthology of photographs, photograms and typographic designs. Programs of the artist's films are also being shown. The show thus provides us with a nearly complete profile of Moholy's achievements in these diverse media.

### A Yearning for Perfection

It does not, I think, establish Moholy as a great painter or sculptor, but it does give us ample evidence of his amazing visual intelligence, which was undoubtedly touched by genius. It was an intelligence that yearned for a more perfect and har-monious world than any the artist found in his lifetime. There is thus an air of Utopianism about this show, and it is that which gives the exhibition a certain tragic quality.

The exhibition has been handsomely installed in the museum's immaculately white galleries. A very useful catalogue with a text by the artist's widow, Sibyl Moholy-Nagy, herself an architectural historian of distinction, has been published to accompany the show.

After its showing in Chicago, where it remains on view through July 13, the exhibition will travel to California and Seattle, and will go to the Guggenheim Museum in New York next February.

June 2, 1969

# Judging Art by Gender?

### By LEAH GORDON

THE MOMENT was propitious. For months women's rights had been an issue. And so, with strategic foresight, the Whitney Museum elected last spring to devote its yearly holiday exhibition to women artists.

Unlike the Whitney Annual which opened earlier this month amid demonstrations and sit-ins, this show started quietly ten days ago and runs through Jan 19. It includes 52 of the 450 works by female painters and sculptors represented in the museum's permanent holdings.

But without being told, could anybody know that these works were by women? Only one, a sculpture by the museum's founder and benefactress, Gertrude Vanderbilt Whitney, takes the mother and child for its theme. The paintings yield no trace of maternity; the sculptures no evidence of sex. The critical conclusion, as with any contrived group display, is predictable —to judge art by gender is as biased as believing that blondes have more fun.

The outstanding pieces would gain attention anywhere. Georgia O'Keeffe, among the painters, rises like a western butte—solid, weathered and unassailable; her position in art history secure. "The White Flower," painted in 1931, is typical O'Keeffe. A single, solitary rose, magnified into swirling ovular shapes, is so lush that the viewer can almost smell its perfume and feel its velvet petals.

Few will dispute the eminence of Louise Nevelson among American sculptors. Nor is Marisol far behind. Yet each is here represented with a print. Why? According to curator Elke Solomon who organized the show, Marisol's "Woman and Dog," the only Marisol sculpture the museum owns, has been exhibited many times, and Nevelson's sculptures have just been dismantled after a month-long display. Although the prints are admirable, they hardly convey the power and mystery of a Nevelson wall piece, or the whimsical poignancy of Marisol's group figures.

Among the sculptures, Lee Bontecou's untitled work dominates the show, demonstrating once again her ability to make something unreal assertive and unforgettable. Constructed from canvas and welded metal, the 5½-foot-high piece juts out from the wall like a monster air-flow engine abandoned in a junkyard—an icon of our time.

The exhibit is not without surprise. I. (Irene) Rice Pereira is hardly an unknown, yet she has rarely been exhibited since the mid-50's when her style fell out of fashion. In "Oblique Progression," a viewer, after not see-ing her work for a long time, is struck by her skill. The canvas is a constructivist's delight, laced with interlocking geometric shapes leaping out from a graph-paper background. The technique is precision-perfect and seemingly as accurate as an architect's blueprint.

Any survey of American women artists should include Helen Frankenthaler, Loren MacIver, Peggy Bacon, Dorothea Tanning and Hedda Sterne. All are in the Whitney exhibit. But the display also has some regrettable omissions—Marguerite Zorach, Mary Cassatt, Isabel Bishop, Mary Callery and the primitivists Ruth Henshaw Bascom and Grandma Moses. Unfortunately, only Isabel Bishop, is even represented in the Whitney's permanent collection.

But this exhibition raises larger questions beyond the esthetic. Why, as Havelock Ellis observed, "have there been thousands of women painters, but only the men remembered?" Why is there no female Cézanne, Picasso, Rembrandt or Rodin? Historically, woman has been the inspiration for great art, not the creator. Her nude body has sent many an artist to spectacular artistic heights, and her place more properly has been in the canvas, not in front of the easel.

\*

Women with artistic bent were urged to excel in craft, stitching needlework pictures, snipping silhouettes or drawing pastel flowers. Rather than dirty her hands in paint or marble, a cultured lady became the more socially acceptable patron. To be an artist was to be a deviant. Rosa Bonheur masqueraded as a young man when she visited the horse market to savor the local color for her famous painting, "Horse Fair." "In a world oriented toward men, you had to be a freak to be an artist," says Louise Nevelson. "I don't know if I would have had the guts for it in an earlier time."

There were notable, if not well-known exceptions—Caterina Vigri in 15th-century Italy, Angelica Kauffmann, who was a founding member of the Royal Academy, and the impressionist, Berthe Morisot. But prior to the 20th century, women for the most part were relegated to an artistic bush league.

In recent years, with increased social freedom, several significant female artists have emerged: Suzanne Valadon, Kaethe Kollwitz, Marie Laurencin, Sonia Delaunay, Barbara Hepworth, Sophie Taüber-Arp. Women, in many respects fared better in the art world than in the business and professional sphere. Particularly since World War II, women artists have blossomed. In art schools female enrollment runs as high as 75 per cent. Many of the artists themselves are unsure to what extent their sex has determined their success, or lack of it. "I never encountered any prejudice," says H. Rice Pereira. "My work stood on its own. Whatever trouble I had came from other women." Marisol quickly found a gal-

lery and Betty Parsons, a dealer and artist in her own right, experienced nothing but "courtesy, respect and enthusiasm. A good painter is a good painter," she says.

In many ways, the girls themselves have sold out. From art school the easiest and most natural road leads to marriage and family. It takes a dedicated and driven woman to pursue the lonely, arduous career of the artist.

Nevertheless, the question nags: why has no woman artist equaled the best of men? Is it, as Picasso says, that he who creates in a new way is forced, in the struggle and intensity of creation, to produce a certain ugliness. At least the jolt of the fresh vision appears to be ugly. It is the followers who impart to the new object or style a seeming beauty—or something that the eye, once

initiated, is prepared to accept as beautiful.

Are women inherently the followers? Do men probe for the seed, while women focus on the flower? History seems to point that way. Undoubtedly history is largely to blame for women's minor artistic role. But not until they produce a trailblazer will women gain unquestioned recognition as creative equals to men. The answer lies with

the female Picasso who is yet to stand up—beyond the protesting militants who demean their sex by leaving tampons on the Whitney's staircase, and beyond the women artists, a few of them notably innovative, now exhibited at the Whitney.

September 26, 1971

## Art Mailbag
# Sex and the Woman Artist

TO THE EDITOR:

LEAH GORDON'S article, "Judging Art by Gender," is a classic illustration of how women continue to put themselves and the rest of their sex right behind the eight ball. The author, after writing this piece, must be suffering from a bad case of mental dyspepsia, since she has swallowed a whole bunch of chestnuts about women as artists. Again she brings up the same old irrelevant question which goes, "Why has no woman artist equaled the best of men," and then proceeds to suggest the same old prejudiced answers that have been offered by male chauvinists and their female sympathizers in the arts ever since women made it clear that they too had a right to

pursue professional artistic careers.

Why is it necessary for women in the 1970's in this land of equal opportunity to be put on the defensive about their ability to create an art equal to that of men? Why should the acceptance of the work of women artists be contingent upon the appearance of a female Picasso? Why should women artists be deprived of the opportunity of making art history today because an unfair system made it impossible for them to make art history in the past?

Up until the 19th century most women were tolerated in the arts only as assistants to their more famous fathers, brothers, and husbands. The few women artists who

achieved any fame in their own right were always careful to make themselves agreeable to the men in their profession and never to challenge the male authorities who grudgingly admitted them into the art establishment.

Even under the most ideal circumstances, recognition for female artists was never easily won. Marie Antoinette herself had to command the French Academy to let her favorite painter, Vigee Lebrun, into their exalted ranks. How many women have been able to count on the assistance of a queen to insure their entry into the male art community?

It is surprising that, with so many documentations of women's suppression available at every bookstore, any

intelligent person would not realize the absurdity of posing such questions as "Are women inherently followers? Do men probe the seed while women focus on the flowers?"

It takes education, encouragement, and most of all freedom, to become a trailblazer. When potential for greatness in the arts is truly universally accepted for women as well as for men, a great "mistress" (it's ironic that the only feminine equivalent of the word "master" has all sorts of ambivalent connotations) will emerge. One can hope she will be closer in spirit to Titian and Matisse than to Picasso who has shown a rather infantile inability to get beyond certain masculine sexual hangups.

CINDY NEMSER
Brooklyn.

February 7, 1971

# *Picasso*: Protean and Prodigious, the Greatest Single Force in 70 Years of Art

### By ALDEN WHITMAN

There was Picasso the neoclassicist; Picasso the cubist; Picasso the surrealist; Picasso the modernist; Picasso the ceramist; Picasso the lithographer; Picasso the sculptor; Picasso the superb draftsman; Picasso the effervescent and exuberant; Picasso the saturnine and surly; Picasso the faithful and faithless lover; Picasso the cunning financial man; Picasso the publicity seeker; Picasso the smoldering Spaniard; Picasso the joker and performer of charades; Picasso the generous; Picasso the Scrooge; even Picasso the playwright.

A genius for the ages, a man who played wonderful yet sometimes outrageous changes with art, Pablo Picasso remains without doubt the most original, the most protean and the most forceful personality in the visual arts in the first three-quarters of this century. He took a prodigious gift and with it transformed

the universe of art.

Henri Matisse and Georges Braque, two painters with assured stature in modern art and both his close friends, were also original; but both developed a style and stuck pretty much to it, whereas Picasso, with a feverish creativity and lavish talent lasting into old age, was a man of many styles whose artistic life revealed a continuous process of exploration. He created his own universe, investing it with his own human beings and his own forms of beasts and myths.

"For me, a picture is neither an end nor an achievement but rather a lucky chance and art experience," he once explained. "I try to represent what I have found, not what I am seeking. I do not seek — I find."

### 'One Step on a Long Road'

On another occasion, however, he saw his work in a different light. "Every-

thing I do," he remarked at 76, "is only one step on a long road. It is a preliminary process that may be achieved much later. Therefore my works must be seen in relation to one another, keeping in mind what I have already done and what I will do."

For all his guises, or disguises, Picasso had an amazing fecundity of imagination that permitted him to metamorphize a mood or an idea into a work of art with bewildering quickness. He was, in André Malraux's phrase, "the archwizard of modern art," a man who, as a painter alone, produced well over 6,000 pictures. Some he splashed off in a few hours; others took weeks.

In 1969, his 88th year, he produced out of his volcanic energy a total of 165 paintings and 45 drawings, which were exhibited at the Palace of the Popes in Avignon, France. Crowding the walls of that venerable structure,

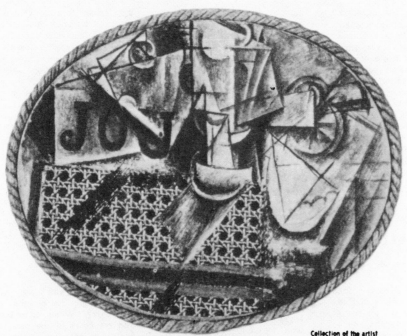

Collection of the artist

'STILL LIFE WITH CHAIR CANING,' dated 1911-12, is believed to be the first cubist collage. To this painting Picasso added a new element by pasting across the canvas a piece of oilcloth realistically printed in a chair-caning pattern, which he then partly overpainted with shadows. The picture is framed with rope. At about the same time that he invented two-dimensional collage, he produced a three-dimensional work, "Guitar," of sheet metal and wire, which was the forerunner of modern constructed sculpture.

the Picasso array drew exclamatory throngs and moved Emily Genauer, the critic, to say, "I think Picasso's new pictures are the fire of heaven."

Explaining the source of this energy, Picasso said as he neared 90, "Everyone is the age he has decided on, and I have decided to remain 30."

The painter was so much known for works that blurred or obliterated conventional distinctions between beauty and ugliness and for depersonalized forms that he was accused of being an antihumanist. That appraisal disturbed him, for he regarded himself, with all his vagaries, as having created new insights into a seen and unseen world in which fragmentation of form was the basis for a new synthesis.

### A Bull From a Bicycle Seat

"What is art?" a visitor once asked him. "What is not?" he replied. And he substantiated this point once by combining a bicycle seat and a pair of handlebars to make a bull's head.

"Whatever the source of the emotion that drives me to create, I want to give it a form that has some connection with the visible world, even if it is only to wage war on that world," he explained to Françoise Gilot, who was one of his mistresses and herself a painter.

"Otherwise," he continued, "a painting is just an old grab bag for everyone to reach into and pull out what he himself has put in. I want my paintings to be able to defend themselves, to resist the invader, just as though there were razor blades on all surfaces so no one could touch them without cutting his hands. A painting isn't a market basket or a woman's handbag, full of combs, hairpins, lipstick, old love letters and keys to the garage.

"Valéry [Paul Valéry, the French poet]

used to say, 'I write half the poem. The reader writes the other half.' That's all right for him, maybe, but I don't want there to be three or four thousand possibilities of interpreting my canvas. I want there to be only one and in that one to some extent the possibility of recognizing nature, even distorted nature, which is, after all, a kind of struggle between my interior life and the external world as it exists for most people.

"As I've often said, I don't try to express nature; rather, as the Chinese put it, to work like nature. And I want that internal surge — my creative dynamism — to propose itself to the viewer in the form of traditional painting violated."

In the long course of upending traditionalism, Picasso became a one-man history of modern art. In every phase of its turbulent (and often violent) development he was either a daring pioneer or a gifted practitioner. The sheer variousness of his creations reflected his probings of modern art for ways to communicate the multiplicity of its expressions; and so Picasso could not be categorized as belonging to this or that school, for he opened and tried virtually all of them.

In his peripateticism he worked in oils, water-colors, pastels, gouaches, pencil and ink drawings and aquatints; he etched, made lithographs, sculptured, fashioned ceramics, put together mosaics and constructed murals.

One of his masterpieces was "Guernica," painted in 1937 and on loan for many years to the Museum of Modern Art in New York. An oil on canvas 11¼ feet high and 25½ feet long, it is a majestic, stirring indictment of the destructiveness of modern war. By con-

trast, another masterpiece was a simply and perfectly drawn white pigeon, "The Dove," which was disseminated around the world as a symbol of peace. But masterpiece or something not so exalted, virtually all Picasso were interesting and provocative. Praised or reviled, his work never evoked quiet judgments.

### A Different View

The artist, however, held a different view. "There is no such thing as a bad Picasso," he said, "some are less good than others."

Exhibitions of his work, especially in his later years, were sure-fire attractions. The mention of his name was sufficient to lure thousands, many of them only barely acquainted with any art, to museums and galleries and benefits. Reproductions and prints were nailed up in homes all over the Western world, a certain mark of the owner's claim to culture. Originals were widely dispersed, both in museums and in the hands of collectors wealthy enough to meet Picasso's prices. And they were steep. In 1965 he charged London's Tate Gallery $168,000 for "Les Trois Danseuses," a painting he did in 1925. For a current painting, private collectors felt that $20,000 was a steal and $35,000 not too much.

For the last 50 years there has been no such thing as a cheap Picasso. Indeed, Leo and Gertrude Stein and Ambroise Vollard, a Paris dealer, may have been the last to get a Picasso for $30, and that was in 1906 and 1907.

### Income Grew With Fame

As Picasso's fame grew, so did his income until it got so that he could manufacture money by sketching a few lines on a piece of paper and tacking on his dramatic signature. He was probably the world's highest paid pieceworker, and there were many years in which he garnered more than $1-million.

"I am rich enough to throw away a thousand dollars," he told a friend with some glee.

The artist, however, was canny about money, driving hard bargains with his dealers and keeping the bulk of his work off the market. He released for sale about 40 of his paintings a year out of a production of hundreds, so that the market for his work was never glutted. What he did not sell (and he said that many of these constituted the best from his palette) he squirreled away in bank vaults, studios, in a castle not far from the Riviera and in empty rooms in his villa near Cannes. Picasso did not exactly hide his collection, for on occasion he permitted special friends to see it, to photograph it and to publish the results.

Toward the close of his life he donated 800 to 900 of his finest early works to a Barcelona museum. Worth a multi-million-dollar fortune, his works represented his Spanish period and were given in memory of Jaime Sabartés, his longtime secretary. In 1971 he gave an early constructed sculpture, "Guitar," to the Museum of Modern Art in New York.

Mostly, though, Picasso took a merchant's delight in acquiring his money. "Art is a salable commodity," he once observed. "If I want as much money as I can get for my art, it is because I know what I want to do with it." But just what that was only a few intimates knew. He is said to have owned a great deal of real estate in France and to have made some excellent stock investments.

Contrary to Miss Gilot's suggestion that Picasso was tightfisted, he gave large sums to the Republican side in the Spanish Civil War and then to refugee groups that cared for the defeated Republicans who had fled to France.

"He was a very generous man," Daniel-Henry Kahnweiler, his principal dealer since 1912, said of him. "He supported for many years more than a dozen indigent painters, most of whom would have been living in poverty but for his help. And whenever he was asked to help some charities, he always gave something."

He was, surprisingly, even open-handed in a quiet fashion with women of his past. One of these was Fernande Olivier, who was his mistress for a number of years until 1912 and whose book about her experiences with him was not flattering. However, when Picasso heard that her funds were running low, he saw to it that she was supplied with money.

Nonetheless, his generosity, like his temperament, could be fitful. Once, when the faking of Picassos was a small industry, a friend brought the painter a small work belonging to a poor artist for authentication so that it could be sold. "It's false," said Picasso.

From a different source the friend brought another Picasso, and then a third. "It's false," Picasso said each time.

"Now listen, Pablo," the friend said of the third painting. "I watched you paint this with my own eyes."

"I can paint false Picassos just as well as anybody," Picasso replied. And then he bought the first Picasso at four times the amount the poor artist had hoped it would fetch.

As for himself, Picasso, from the time he began to take in appreciable sums until his death, lived like an Okie, albeit one who never had to worry about where his next meal or his next pair of trousers was coming from. "I should like to live like a poor man with a lot of money," he had said in the days when he was desperately poor and burning some of his paintings for heat.

## Collector of Oddments

All his studios and homes—even the 18-room rambling La Californie at Cannes — were crammed and cluttered with junk—pebbles, rocks, pieces of glass, a hollow elephant's foot, a bird cage, African drums, wooden crocodiles, parts of old bicycles, ancient newspapers, broken crockery, bullfight posters, old hats, weird ceramics. Picasso was a compulsive collector of oddments, and he never threw any of them away, or permitted anyone to move any object once he had dropped it, tossed it or placed it somewhere.

To compound the chaos inside La Californie, the villa's lawn was home to clucking chickens, pigeons, at least one goat, dogs and children. They all disported among bronze owls, fountains and statuary scattered about the grounds. Freedom for animals and children was a cardinal belief.

In later years this villa became a weekend residence, while his main home was Notre Dame de Vie in nearby Mougins. He also owned two chateaus, Vauvenargues, in Provence, and Boigeloup, in Normandy.

Despite the disorganization with which he surrounded himself, Picasso was a most methodical man. When he drove to Cannes or to Arles he invariably followed the same route; and when he lived in Paris he walked or rode the same streets in a fixed order. When his Paris studio was at 7 rue des Grand-Augustins on the Left Bank, he almost always dined at La Brasserie Lipp on the Boulévard Saint-Germain and then cross the street to the Café Flore to join friends in a mineral water and con-

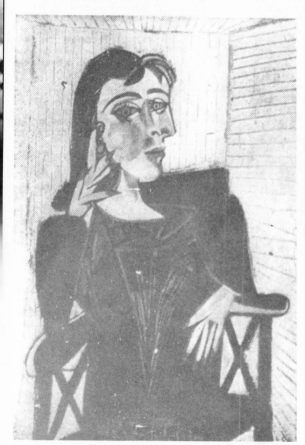

Museum of Modern Art

'PORTRAIT OF DORA MAAR,' the Yugoslav painter and photographer, employed cubist techniques. "For Picasso, the subject has been the victim of his will to destroy appearances," wrote his biographer, Roland Penrose. Always concerned with an emotional likeness rather than a physical image, Picasso used the double profile for this portrait of 1937. Its riotously rich colors do not imitate life but have poetic associations. One red and one blue eye sparkle in a face painted in greens, reds and yellows—intended to convey the vivacity and freshness of the subject's youth.

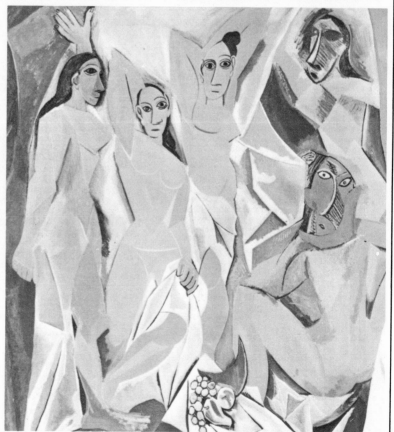

Museum of Modern Art

'LES DEMOISELLES D'AVIGNON,' Picasso's landmark canvas of 1907, started the movement known as cubism, called the greatest revolution in painting since the Renaissance. In reducing the appearance of objects to what he considered their significant forms, he broke up the canvas into geometric planes and angles. Though distorted, the figures on the left still refer to the nudes of ancient art. The two on the right, with their grotesquely dislocated bodies and masklike faces that show the influence of African sculpture, represent a complete break with the past. The squatting figure is seen from several different angles simultaneously. With "Les Demoiselles d'Avignon," painting was liberated from its fidelity to surface appearance.

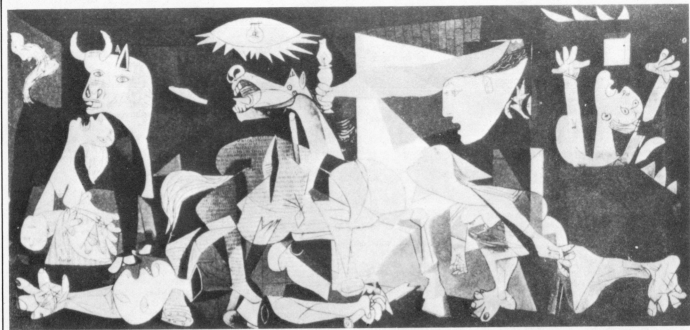

'GUERNICA,' Picasso's monumental political work, was inspired by the mercenary bombing of a Basque town during the Spanish Civil War. Its nightmare imagery, a combination of the tragic and the grotesque, evokes symbolically the agony of war. The emotional effect is heightened by anatomical distortions: At right, a half-dressed woman stumbles, pitifully hampered by misshapen legs and feet. Another falls from a burning building, her face a twisted mask of terror. The dead child at left is held by its screaming mother, and beneath the stricken horse, a shattered figure clutches a broken sword, traditional emblem of heroic resistance. The significance of the horse and the bull has aroused much speculation, although Picasso once said of them, "The bull is not Fascism, but brutality and darkness. The horse represents the people." The mural, done in 1937, is on loan to the Museum of Modern Art.

versation before going home.

One Picasso day was, in outline, much like the next. He arose late, usually around 10 or 11, devoted two or three hours to friends, conversation, business, letters and lunch; then, at 3 or 4, he would go to his studio to work in Trappist silence, often for 12 hours at a stretch, breaking off only for dinner around 10:30. Afterward, he sometimes worked until 2 or 3 in the morning.

When Miss Gilot was living with Picasso in Paris, she found that one of her most difficult tasks was to get him started on his day. "He always woke up submerged in pessimism, and there was a definite ritual to be followed, a litany that had to be repeated every day," she recalled in her book, "Life With Picasso," published in 1964 by McGraw-Hill.

The rigamarole, as Miss Gilot recounts it, had largely to do with reassuring Picasso that his lamentations were falsely based. "Well, I do despair," he would say in Miss Gilot's reconstruction. "I'm pretty nearly desperate. I wonder, really, why I bother to get up. Why should I paint? Why should I continue to exist like this? A life like mine is unbearable."

Eventually, of course, Picasso permitted himself to be convinced that the world was not in conspiracy against him. Part of his maledicent mood could perhaps be traced to the physical aspects of his bedroom.

"At the far end was a high Louis XIII secretary," according to Miss Gilot, "and, along the left-hand wall, a chest of the same period, both completely covered with papers, books, magazines and mail that Pablo hadn't answered and never would, drawings piled up helter skelter, and packages of cigarettes. Above the bed was a naked electric-light bulb. Behind the bed were drawings Pablo was particularly fond of, attached by clothespins to nails driven into the wall.

## Letters Pinned on Wires

"The so-called more important letters, which he didn't answer either but kept before him as a permanent reminder and reproach, were pinned up, also with clothespins, onto wires that stretched from the electric-light wire to the stove-pipe. There was almost no other furniture, except a Swedish chair in laminated wood."

By early afternoon, Picasso, amid the bustle of the household and friends who came to pay him court, was bubbly and sunny. He liked not so much to converse as to talk, and his monologues were usually witty. His agile mind leaped from subject to subject, and he had almost total recall.

He always had several projects in hand at the same time, and to each he seemed equally lavish with his talent. "Painting is my hobby," he said. "When I am finished painting, I paint again for relaxation."

"He used no palette," Miss Gilot wrote of his working habits. "At his right [as he addressed his easel] was a small table covered with newspapers and three or four large cans filled with brushes standing in turpentine.

"Every time he took a brush he wiped it off on the newspapers, which were a jungle of colored smudges and slashes. Whenever he wanted pure color, he squeezed some from a tube onto the newspaper. At his feet and around the base of the easel were cans — mostly tomato cans of various sizes—that held gray and neutral tones and other colors that he had previously mixed.

## Stood for Several Hours

"He stood before the canvas for three or four hours at a stretch. He made almost no superfluous gestures. I asked him if it didn't tire him to stand so long in one spot. He shook his head.

"'No,' he said. 'That is why painters live so long. While I work I leave my body outside the door, the way Moslems take off their shoes before entering the mosque.'"

"Occasionally he walked to the other end of the atelier and sat in a wicker armchair. He would cross his legs, plant one elbow on his knee and, resting his chin on his fist, would stay there studying the painting without speaking for as long as an hour.

"After that he would generally go back to work on the portrait. Sometimes he would say, 'I can't carry that plastic idea any further today,' and then begin to work on another painting. He always had several half-dry unfinished canvases to choose from.

"There was total silence in the atelier, broken only by Pablo's monologues or an occasional conversation; never an interruption from the world outside. When daylight began to fade from the canvas he switched on two spotlights and everything but the picture surface fell away into the shadows.

"'There must be darkness everywhere except on the canvas, so that the painter becomes hypnotized by his own work and paints almost as though he were in a trance,' he said. 'He must stay as close as possible to his own inner world if he wants to transcend the limitations his reason is always trying to impose on him.'"

Mood was a vital ingredient of Picasso. Everything he saw, felt or did was for him an incomplete experience until it had been released and recorded. Once he was lunching on sole and happened to hold up the skeleton so that it caught his glance. He got up from the table and returned almost immediately with a tray of clay in which he made an imprint of the skeleton. After lunch he drew colorful designs around the filigree of the bones, and the eventual result was one of his most beautiful plates.

Here, as in other art areas, when the inspiration was upon him he worked ceaselessly and with such concentration that he could, for example, paint

a good-sized picture in three hours.

Just as intensely, Picasso loved to mime, to clown, to play charades, to joke. To amuse his friends (and himself) he would don a tuxedo, red socks and funny hats; or he would put on Chaplinesque garb and engage in horseplay.

## Disguises for Visitors

"The moment when disguises are called for most urgently is on the arrival of visitors, especially those from abroad," Roland Penrose, a British friend, wrote in his "Picasso: His Life and Work." "The less known or the more intimidating the guest may be, the more likely it is that he will find himself confronted by the master not as he expected to find him but as a burlesque little figure wearing perhaps a yachting cap with horn-rimmed spectacles, a red nose and black side-whiskers and brandishing a saber."

He put on disguises, too, to romp with children, and they loved him for the ease with which he entered their fantasy world.

Picasso was a short, squat man with broad, muscular shoulders and arms. He was proud of his small hands and feet and of his hairy chest. In old age his body was firm and compact; and his cannon-ball head, which was almost bald, gleamed like bronze. Set into it were deep black eyes of such penetration and alertness that they became his hallmark.

Photographs from his younger years showed him a handsome man with jet-black hair. Apart from the absence of hair, the description of him by Miss Olivier, his first long-term mistress, could have applied to the artist of later years.

"Small, dark, thickset, unquiet, disquieting, with somber eyes, deep-set, piercing, strange, almost fixed," she wrote. "Awkward gestures, a woman's hands, ill-dressed, careless. A thick lock of hair, black and glossy, cut across his intelligent, obstinate forehead. Half Bohemian, half workman in his clothes; his hair, which was too long, brushing the collar of his worn-out coat."

Although at various times in his life Picasso dressed as a dandy, he was never comfortable in conventional clothes. He preferred corduroy or heavy velvet jackets, a T shirt and heavy trousers made of a blanket type of wool. These, after he could afford them, were custom-made in odd designs. Sometimes he varied his get-up by wearing a striped jersey pull-over; and sometimes he just walked around in shorts. It was all a matter of whim.

## Scores of Close Friends

Although whim at times governed whom he would see and for how long, Picasso was generally a hospitable host in the Spanish manner. He had scores of close friends—Mr. Kahnweiler, Jean Cocteau, Paul Eluard and Louis Aragon among many others.

However, as with most illustrious men, Picasso attracted gushing admirers and sycophants. Some called him "maestro" and fawned on him for the subsidiary fame that came from standing in his light. He was not above their company; and, indeed, he seemed to have relished some who gave him favorable publicity.

Women were one of Picasso's most persistent preoccupations. Apart from fleeting affairs, there were seven women significant in his personal and ar-

tistic life. He married two of them, but his relationships with the five others were well recognized and generally respected. Two of his companions bore three of his four children.

The artist's wives and mistresses served as his models, organized the domestic aspects of his household so far as that was possible, petted him, suffered his mercurial moods and greeted his friends.

In Picasso's early days in Paris, his mistress was Miss Olivier, a young painter and teacher, who lived, as he did, in the Bateau-Lavoir—a Montmartre building called that by the poet and painter Max Jacob because it swayed like a creaky Seine laundry boat.

"I met Picasso as I was coming home one stormy evening," Miss Olivier recalled. "He had a tiny kitten in his arms, which he laughingly offered me, at the same time blocking my path. I laughed with him. He invited me to his studio."

Their liaison lasted until 1912, when Picasso met Marcelle Humbert, the mistress of a sculptor friend. The two ran off together, and there followed a series of superb canvases expressing the artist's happiness. He called Miss Humbert "Eva" and signed two of his works "J'aime Eva." Miss Humbert died in 1914.

In Rome, early in 1917, he met Olga Khoklova, a ballerina with Sergei Diaghilev's Ballets Russes. He painted her in a Spanish mantilla, and he and Olga were married in 1918. Three years later a son, Paolo—Italian for Pablo or Paul—was born.

## Separated for 20 Years

The marriage broke up in 1935, and Olga died in southern France 20 years later. The couple were never divorced. One reason, it is said, was that they had been married under a community property arrangement that would have obliged Picasso to divide his fortune with her.

At the time of the separation Picasso's mistress was his blond model, Marie-Thérèse Walter. In 1935 she bore him a daughter, Marie de la Concepcíon.

A portrait of the girl, known as Maïa, was one of Picasso's most fetching naturalist studies.

Dora Maar, a young Yugoslav photographer, was the painter's next mistress. Their companionship lasted until 1944.

The same year, when Picasso was 62, he began an 11-year liaison with Miss Gilot. Their children were Claude, born in 1947, and Paloma, born in 1949. In 1970 Miss Gilot was married to Dr. Jonas E. Salk, the polio-vaccine developer.

Picasso's final attachment was to Jacqueline Roque, who became his mistress in 1955, and his wife in 1961, when she was 35 and he was 79. Miss Roque had a rather wry sense of her role in the painter's life. A member of a movie crew that was making a picture at their home asked her quite innocently who she was. "Me, I'm the new Egeria," she replied; and from all accounts she was happy in devoting her life to her husband's.

Amid the Bohemian clutter in which he lived and thrived, despite the concomitant disarray of his personal affairs, Picasso maintained a strong, consistent and lasting emotional bond to the country of his birth. This bond influenced his painting and, after 1936

and the Spanish Civil War, propelled him for the first time into politics. His attachment to Spain was romantic and passionate; and the fact that he shunned Generalissimo Francisco Franco's Spain yet kept his Spanish nationality was an expression of his umbilical feeling for the country.

There were two principal consequences of this bond: One was "Guernica" and the other was his membership in the French Communist party, which he joined in 1944. "Up to the time of the Spanish Civil War, Picasso was completely apolitical," Mr. Kahnweiler, his agent, recalled. "He did not even know the names of the different parties. The Civil War changed all that."

Previously, Picasso's insurgency had been that of every artist against the constrictions of conventional life. But with the outbreak of conflict in his homeland, Picasso became instinctively an aroused partisan of the Republican Government.

In January, 1937, he began etching the two large plates of "Sueño y Mentira de Franco" (The Dream and Lie of Franco). These showed the rebel leader as a perpetrator of symbolic horrors —himself ultimately transformed into a centaur and gored to death by a bull. Countless copies of these etchings were dropped like propaganda leaflets over Franco territory.

But it took the bombing of the Basque town of Guernica y Luno on April 26, 1937, to drive Picasso to the heights of his genius. At 4:30 on that cloudless Monday afternoon, Germen airmen, who had been provvided to Franco by Adolf Hitler, descended on Guernica, a town of no military importance, in a test of the joint effect of explosive and incendiary bombs on civilians. The carnage was enormous, and news of it appalled the civilized world.

At the time Picasso had been engaged by the Loyalist Government to do a mural for its pavilion at a Paris fair later that year. The outrage at Guernica gave him his subject and in a month of furious and volcanic work he completed his great and stunning painting.

## In Trust for the Nation

The monochromatic mural, stark in black, gray and white, was retained by the artist in trust for the Spanish nation. It was to be given to the nation when it became a republic again.

Assessing the picture's searing impact on viewers over the years, Roland Penrose wrote:

"It is the simplicity of 'Guernica' that makes it a picture which can be readily understood. The forms are divested of all complications which would distract from their meaning. The flames that rise from the burning house and flicker on the dress of the fallen woman are described by signs as unmistakable as those used by primitive artists.

"The nail-studded hoof, the hand with deeply furrowed palm and the sun illuminated with an electric-light bulb are drawn with a childlike simplicity, startling in its directness."

"Guernica" was responsible for one of Picasso's most noteworthy ripostes. During the Nazi occupation of France in World War II, a German officer visited the artist's studio, where a large reproduction of the mural was on display.

"Ah, so it was you who did that," the German said.

"No," snapped Picasso. "You did it!"

Picasso painted two other major historical pictures, "The Korean Massacres" and "War and Peace." The two large compositions are in an old chapel in Vallauris, France. Both were intended to arouse the conscience of mankind to the horrors of war.

Toward the close of World War II the artist joined the Communist party, and L'Humanité, the party daily, marked the occasion by publishing almost a full-page photograph of him. Although his decision seemed clearly motivated by the Spanish War and the ensuing World War, there were many who thought at first that the action was another of Picasso's caprices.

He responded to such charges with a statement published in Les Lettres Françaises, which said in part:

"What do you think an artist is? An imbecile who has only his eyes if he is a painter, or his ears if a musician, or a lyre at every level of his heart if he is a poet, or, if he is merely a boxer, only his muscles?

"On the contrary, he is at the same time a political being, constantly alert to the heart-rending, burning, or happy events in the world, molding himself in their likeness.

"How could it be possible to feel no interest in other people and, because of an ivory-tower indifference, detach yourself from the life they bring with such open hands?

"No, painting is not made to decorate apartments. It is an instrument of war, for attack and defense against the enemy."

### Denounced by Soviet Critic

But Picasso's brand of Communism was not Moscow's, at least in the Kremlin's Stalinist period. In 1948, his works were denounced by Vladimir Kemenov, a Soviet art critic, as an "apology for capitalistic esthetics that provokes the indignation of the simple people, if not the bourgeoisie."

"His pathology has created repugnant monstrosities," Mr. Kemenov went on. "In his 'Guernica' he portrayed not the Spanish Republic but monsters. He treads the path of cosmopolitanism, of empty geometric forms. His every canvas deforms man—his body and his face."

Picasso was pained but unmoved by the attack. "I don't try to advise the Russians on economics. Why should they tell me how to paint?" he remarked to a friend.

About that time, according to one account, an orthodox Soviet painter said to Picasso on being introduced, "I have known of you for some time as a good Communist, but I'm afraid I don't like your painting."

"I can say the same about you, comrade," Picasso shot back.

After Mr. Kemenov's appraisal, Moscow's attitude to the artist fluctuated. "The Dove" helped, quite unintentionally, to create a thaw, and it came about this way:

One day in 1949 Matisse came to visit Picasso, bringing a white fantail pigeon for his friend's cote. Virtually on the spot, Picasso made a naturalistic lithograph of the newcomer; and Louis Aragon, the Communist poet and novelist, who saw it shortly afterward, realized its possibilities at once.

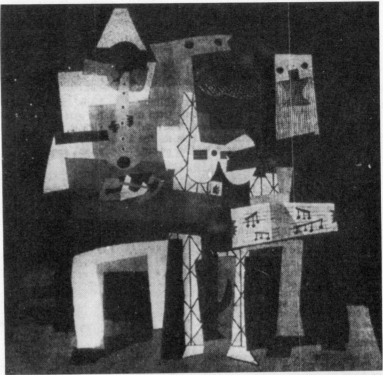

Museum of Modern Art

'THREE MUSICIANS,' produced by Picasso in 1921 during his last phase of cubism. Pierrot (left) and Harlequin (center) are the summation of a long series of figures from the Italian comedy. Although rendered entirely in paint, the flat, colored shapes derive from the collage techniques developed earlier by Picasso and Bracque, in which thicknesses of cut-out paper and other materials gave the canvas a three-dimensional effect without the use of perspective. The shapes anticipate some of the metal sculptures Picasso was to make in the next decade. In the painting here, Pierrot plays a clarinet and Harlequin strums a guitar while another mummer, costumed as a monk, holds a musical score.

The lithograph, signed by the artist, was first used as a poster at a World Peace Conference. And from that introduction it flew around the world, reproduced in all sizes and in all media as a peace symbol.

Picasso got into Communist hot water again, however, in 1953. This time the attack came from his French comrades. The occasion was Stalin's death and a crayon portrait that the artist sketched. The imaginative likeness of Stalin as a young man stirred up the working-class members of the French party. Mr. Aragon, who had published it, felt obliged to recant in public, and Picasso was not amused.

"When you send a funeral wreath, the family customarily doesn't criticize your choice of flowers," he said.

Nevertheless, in 1954 Moscow appeared to relent, for it took out of hiding its 37 precious early Picassos (they had never been shown to the Soviet public) and lent them to a Paris exhibition. And two years later the Soviet Union marked the painter's 75th birthday by showing a large number of his pictures and ceramics to the public.

Picasso's distortions of reality, to which Mr. Kemenov objected, also baffled less political critics who were unaccustomed to the artist's private language and private mythology or who did not appreciate the esthetics of plane and solid geometry and of Mercator-like projections of the human face and form.

### Born on Spain's South Coast

The man who so largely created the special esthetic of modern art was born on the night of Oct. 25, 1881, in Málaga, on Spain's south coast.

Picasso's father was José Ruiz, an Andalusian who taught for small pay in the local school of arts and crafts. His mother was Maria Picasso, a Majorcan. Pablo could draw as soon as he could grasp a pencil, but as a pupil in the ordinary sense he preferred looking at the clock to doing sums and reading. Save for art, he managed to avoid all but the rudiments of formal schooling. He was obstinate about this, as in other matters.

As a child, Picasso often accompanied his father to the bullfights. These made an indelible impression, for throughout his life bullring scenes and variations on them were a significant part of his work, recurring more persistently than any other single symbol. His first oil, at the age of 9, was of the bullring.

In 1895 the family moved to Barcelona, where Pablo's father taught at the School of Fine Arts. By that time the youngster's talent was truly Mozartean, so obviously so that his father solemnly presented him with his own palette and brushes. This confidence was justified when Pablo, at 15, competed for admission to the art school. A month was ordinarily allowed, but he

completed his picture, a male nude, in a single day and was admitted to classes in 1896.

He remained there for a year before going to Madrid for further study. During an illness he lived among the peasants of Catalonia, the poverty and barrenness of whose lives appalled him. From them and from the countryside, he said later, he learned "everything I know."

## Dropped Father's Name

Late in 1898, the young artist dropped his father's name from the signature "P. Ruiz Picasso" for reasons that have never been made clear. (His full baptismal name had been Pablo Diego José Francisco de Paula Nepomuceno Paria de los Remedios de la Santísima Trinidad Ruiz Picasso.)

Picasso paid his first visit to Paris in 1900 and after three more visits settled in Paris in 1904. On one of these visits he met Max Jacob, who was, next to Pierre Reverdy, his most appreciative friend until his death in a Nazi concentration camp. Picasso also became acquainted with Berthe Weill, the art dealer, who purchased some of his paintings, and Petrus Manach, another dealer, who was to support him briefly at the rate of $37.50 a month.

Meanwhile, Picasso's "blue" pictures had established him as an artist with a personal voice. This period, ending about 1904, was characterized by his use of the color blue to depict fatalistically the haunting melancholy of dying clowns, most of them in catatonic states, and agonized acrobats. "La Mort d'Arlequin" is one of the most widely known of these.

When the artist moved into the Bateau-Lavoir, his rickety and drafty studio became an important meeting and talking place for persons later to be famous in arts and letters. In addition to Mr. Jacob there were Guillaume Apollinaire, the poet; André Salmon, the writer; Matisse; Braque; Le Douanier Rousseau; Juan Gris, the Spanish painter; Cocteau, Dufy, Gertrude and Leo Stein, Utrillo, Lipschitz and Marcoussis. Apollinaire, Picasso's spiritual guide in those days, introduced him to the public with a long article in a Paris review in 1905.

One of Picasso's lifelong habits, painting at night, started during this time, and for the simple reason that his day was frequently absorbed by friends and visitors. It was also the time of his two-year "rose period," generally dated from 1904 to 1906, so-called because hues of that color dominated his pictures.

Near the rose period's close, he was taken up by the Steins, American expatriates in Paris. Leo and Gertrude did not so much discover the painter as popularize him. He, in turn, did a portrait of Gertrude with a face far from representational. When Miss Stein protested that she didn't look like that, Picasso replied, "But you will," and, indeed, in her old age Miss Stein came to resemble her picture.

The year 1907, the end of a very brief "Negroid" or "African period," was a milestone for the painter, for it marked the birth of cubism in an oil of five distorted nudes called "Les Demoiselles d'Avignon."

With cubism, Picasso—along with Braque—rejected light and perspective, painting not what he saw, but what he represented to himself through analysis. (The name "cubism" was coined afterward, and it was based on the cube forms into which Picasso and Braque tended to break up the external world.)

"When we painted as we did," Picasso said later, "we had no intention of creating cubism, but only of expressing what was inside us.

"Cubism is neither a seed nor a fetus, but an art which is primarily concerned with form, and, once a form ... en created, then it exists and goes on living its own life."

This was also the case when Picasso added a new dimension to cubism in 1911 or 1912 by inventing the collage by gluing a piece of imitation chair caning to a still life. Later he went on to an even less academic cubism, sometimes called rococo cubism.

## Invention of the Collage

These expressions in the cubist manner were not Picasso's total expression in the years from 1907 to 1917, for at the same time he was painting realistically.

His first substantial recognition came in this period through an exhibition in New York in 1911 and one in London in 1912. His pictures began to fetch high prices—almost $3,000 for "Acrobats" in 1914.

With the war and his marriage to a ballerina, Picasso was a costume designer and scenery painter for the Ballets Russes up to about 1925, all the while painting for himself, mostly in a neoclassic and romantic manner. "The Woman in White" is among the best-known of these naturalistic pictures.

With the advent of the surrealist movement in the middle twenties, the artist's work turned to the grotesque. Some of his figures were endowed with several heads, displaced noses, mouths and eyes, overenlarged limbs. Turbulence and violence seemed to be at the bottom of his feelings.

Then, in 1929, Picasso returned somewhat abruptly to sculpture, of which he had done little for 15 years. But again it was not a full preoccupation, and he was soon attacking his easel, this time with variations within a distinctive generally surrealistic framework. One typical picture was "Young Woman With a Looking-glass," painted in 1932.

With these and other pictures of a similar genre, the artist's renown and income reached new heights. Life was also quieter for him, especially after 1935 when Dora Maar helped put routine into his daily existence. She was also the model for a notable series of portraits in which the Mercator projection principle was applied to the human face.

Serenity, or as much of it as ever was possible for Picasso, persisted until the fall of Paris in 1940. He rejected an opportunity to escape to the United States, and, instead, remained in Paris throughout the war, painting industriously amid considerable personal hardship and the prying of Nazi soldiers. It was forbidden to exhibit his pictures or to print his name in the newspapers.

## Lithography and Ceramics

After the war, Picasso became enchanted by lithography, which he taught himself. In a short period he turned out more than 200 lithographs.

He was at the same time painting, in Paris and in Antibes, and restlessly investigating pottery. Ceramics entranced him, and his work with clay created an industry for the town of Vallauris, not far from the Riviera. In a single year he made and decorated 600 figures and vessels, all different.

Even this concentration on one medium seemed not to diminish the intensity with which he, at the time, painted, sculptured and illustrated books.

His painting style, although it had moments of naturalism, contained wild reinventions of anatomy but in such an idiosyncratic way that surrealism or any other "ism" did not appear to apply. Picasso had isolated an idiom for himself.

Toward the close of his life he also produced a number of seascapes and paintings as a composer would write variations on another's theme. Among Picasso's more notable variations were 10 on Cranach's "David and Bathsheba," 15 on Delacroix's "Femmes d'Alger" and 44 on Velázquez's "Las Meninas."

'SEATED MAN,' a 1969 oil done on corrugated cardboard, is one of more than 200 works produced in Picasso's 88th year and exhibited at the Palace of the Popes in Avignon, France. The paintings and drawings showed an unflagging energy and zest for life.

He also painted scores of portraits of his wife in a variety of poses—on a bed fondling a cat, seated nude in his studio, reading. They were portraits only in the sense that they were vaguely representational of Jacqueline Roque, for the figure and the face were almost always distorted.

Many of these pictures were published in "The Artist and His Model." They gave the impression of a man of unlimited vitality in a perpetual state of creation. As if in confirmation of this, Picasso told a visitor who admired the vigor of the works:

"A painter never finishes. There's never a moment when you can say, 'I've worked well and tomorrow is Sunday.' As soon as you stop, it's because you've started again. You can put a picture aside and say you won't touch it again. But you can never write THE END."

Landscapes were another fascination. Some were of the sunlit terrain near his villa at Notre Dame de Vie; others were of countryside painted from an undimmed memory.

Although the bulk of his paintings were not placed on the market, many were published in color reproduction by Harry N. Abrams in New York, an art book house.

### Acclaim Mounted With Age

Popular acclaim for Picasso seemed to mount with his age. In 1967, when he was 86, "Homage to Picasso," an exhibition of some of his works, drew throngs to museums here and abroad. His sculpture was given a special exhibition at the Museum of Modern Art in New York. One example of his sculpture, "Bust of Sylvette," is a 60-ton, sand-blasted work that rests in University Plaza, in downtown New York.

A Picasso play also attracted attention, not to say notoriety. It was "Desire Caught by the Tail," which he had written in three days on a sickbed in 1941. It was produced privately in Paris three years later with a cast that included the playwright, Simone de Beauvoir, Valentine Hugo, Albert Camus, Raymond Queneau and Jean-Paul Sartre. The main prop was a big black box that served as a bed, bathtub and coffin for the two principal characters, Fat Anxiety and Thin Anxiety. The play's action was earthy.

When "Desire" was commercially staged in St. Tropez in 1967, it aroused protests even in that resort town's atmosphere of tolerance. The objection was that some of the characters were expected to urinate on stage. Although this did not take place, the play was thought overly suggestive.

Picasso wrote a second play, "The Four Girls," in 1965, but it was not produced.

The painter did not venture to St. Tropez for his play, nor did he often leave his hilltop villa in his last years. He seemed to feel the world slipping away from him, especially when his old friends died one after another. He shut himself up, refusing to answer the telephone, for example, to mourn Ilya Ehrenburg in September, 1967.

But for the most part he painted. Rather than stand, he sat down, bending almost in half over his canvas. Age lines in his face underscored an intensity of purpose hardly abated by time. And as he painted his nostrils flared, his eyes widened, he frowned and all the while his hand was never still.

He was, in the words of a friend, "like a sturdy old oaken tub brimful of the wine of life."

"You would think," another friend said, "he is trying to do a few more centuries of work in what he has left to live."

April 9, 1973

# Link to Heroic Period

### Lipchitz, 'Always a Cubist,' Was Noted For the Peculiar Eloquence in His Art

#### By HILTON KRAMER

With the death of Jacques Lipchitz, one of the last of our living links with the heroic period of the School of Paris—the period of cubism—is gone. Lipchitz was, as he once said himself, "always a cubist" in his art, and his earliest claim to distinction lay in being one of the first to apply the principles of cubist form to sculpture. But his real achievement is not to be found in matters of historical priority—Picasso, after all, had made cubist sculpture before him—but in the peculiar eloquence and ambition he brought to the sculptor's vocation.

He belonged in his youth to the greatest avant-garde movement of the modern epoch, and his early works —masterly stone carvings of figures and objects—were as powerful as they were inventive. They will always have a place among the classics of cubist art, for their great purity of form and technical precision embodied the quintessential strengths of the cubist esthetic. "Cubism was essentially a search for a new syntax," Lipchitz said, and his own cubist sculptures carried that search to some of its finest expressions.

#### Art of Heroic Form

But these early works were only a prelude to his most audacious inventions, which came in 1927 with his so-called "transparencies," small modeled sculptures in which open space was employed as expressively as the masses that enclosed it. Still adhering to the syntax derived from cubism, he significantly extended its range, and at the same time indicated that he no longer felt bound by its narrow repertory of forms.

For cubism had always been an art of heroic form rather than of heroic themes, and Lipchitz—from the nineteen-thirties onward—became more and more interested in heroic subjects drawn from mythology and the Bible, and he set out to create a new style that could accommodate such themes. His work became more violent and baroque, more openly emotional in its appeal to the public.

His ideal was no longer the elegant, discrete arrangement of cubist planes, but the dramatic figures of Rodin. And he seemed, in his later years, to enter into a kind of competition with Rodin's memory, creating a series of monumental works that would speak not merely for the modern age but transcend it in an epochal timeless statement.

He continued to produce smaller sculptures of many kinds, and they were often dazzling in their creative details, but his greatest energies were reserved for the mythological, monumental works upon which he clearly felt his immortality would depend. In some ways he ceased to be a modern artist—at least in his own eyes—and had transformed himself into an old master.

#### Artist Twice Born

He was, then, an artist twice born—first as a precocious avant-garde talent, swift and brilliant in his mastery of a difficult new approach to sculptural form, and then again, as an epic poet who turned his back on the experiments of his youth to produce a more conservative art that would be capable of sustaining the grandeur and eloquence that haunted him.

Yet even the monumental works of his later years still owed much to that purity of form Lipchitz had mastered in the School of Paris. They were always intensely felt and beautifully conceived. Their merits will be debated for many years to come, but I suspect they are going to survive the reaction against them that had already set in before the master's death. For a master he was—an artist of immense power and originality, who helped to create the basic grammar of modern art and then aspired to go beyond his own creation.

May 28, 1973

*An Appraisal*

# Question: How Do You Buy A Work of Art Like This?

**By ROY BONGARTZ**

WITHIN the last few years, art lovers have been treated to some pretty wild experiences. In Berne, Switzerland, the artist Michael Heizer used a house-wrecking machine to smash up the asphalt outside a museum where his works were being exhibited. This demolition was the main event of his show. Another artist built an igloo at the entrance to his exhibition at the Whitney Museum in New York City, and a fellow Whitney exhibitor dug away part of the foundation of the museum and ground it to dust—presenting the dust as a work of art. Walter de Maria filled a Munich art gallery with a three-foot level of dirt. Later, he planted tall, sharp steel spikes all over the floor of his New York dealer's showroom and then made viewers sign a document releasing him from legal liability in case they accidentally skewered themselves.

Piero Mangoni, an Italian artist, sent his own excrement to his Milan gallery in cans labeled "Mierda d'Artista," while Robert Barry put up a notice on the door of an Amsterdam art gallery declaring that his entire show consisted of closing the place for two weeks. Chris Burden, a Los Angeles artist, staged a work of art in which he had himself shot by a friend with a .22 rifle. (Actually, the plan had been to inflict only a grazing wound, but Burden's over-zealous collaborator sent the bullet slicing through the artist's left arm, making necessary a brief hospitalization and the telling of a hoked-up story to the police.)

People who witnessed these activities wondered, naturally enough, just what the devil was going on. No group was more curious than the gallery owners themselves, and along with them art collectors and museum curators. In time, they got an explanation: these artists, all of them young "conceptualists," had decided to lift their work clear out of the category of investment property. By shifting the emphasis of their work to the pure thought and by refusing to offer any saleable object, they were mounting a deliberate attack on the traditional business of art. The artists' intention was to leave the dealer with nothing to sell, the collector with nothing to buy and the museum with nothing to squirrel away.

With so much art produced over the last five years now cached away in the

Barbara Smith

Chris Burden, a Los Angeles artist, recently designed a work of art that consisted of having himself shot in the arm. But how can such works be bought and sold? The answer is the "authentication" in this case the photographs above—which now bring handsome prices.

*Roy Bongartz, a freelance writer who lives in Rhode Island, has been following the conceptual art movement for several years.*

# Answer: With a Check

Ronald Feldman, a New York City art dealer, wrote this check to buy a number of photographs, including those above, authenticating the work of Chris Burden.

artists' own minds, on their skins and lost in the wilderness, one might guess that the art dealer and his clients have been left out in the cold. But that is not the case at all. The artists who sought to eschew all crass business considerations soon found that they had cut off their chief means of getting a living. And so they came back from their exploits with "authentications" of their faraway doings—with written accounts, with photographs, with video tapes, with relics and with other sorts of documentation which served to authenticate their work.

And thus, while the regular art-loving public might have been dismayed at witnessing the disappearance of art, astute dealers, in touch with the latest ephemera, knew for sure that art would never die so easily. The secret is that there is always something to sell. If there is not, then the artist will starve some time before the dealer does. This homily soon sank into the busy minds of the conceptual artists—thus the current rash of documentation of many of these elusive works.

It does take some dedication to sell, or, for that matter, to buy, some examples of this new art. Among the conceptualists there are earth artists, who etch their work in inaccessible places such as the desert and the floor of the sea; body artists, who perform the cultural deed upon the flesh of models or on their own hides; language artists, who play with words; performance artists, who act out their aesthetic impulses. Still others virtually defy classification. A Long Island artist, Ray Johnson, just sends people letters—that's the opus. Joseph Beuys makes speeches that will "sculpture the society." Fred Sandback of New York has merely stretched a rubber band across the middle of a gallery, dividing it in two. Another artist whose work is displayed in New York, Robert Ryman, attaches sheets of blank paper to the wall. Ian Wilson, a kind of extremist even in SoHo, simply comes in and talks. This is all that he does, and he's made a career of it. "Here," explains Ealan Wingate, the young and enthusiastic director of the Sonnabend Gallery, a leading exponent of these new forms, "the

art becomes so abstracted there is no object whatever. Yet in a way there is always an object because an idea can be a subject. There is, also, always the piece of paper, the bill of sale, which says you bought it." You can commission Wilson to do a piece; for example, he may come to your house and talk with you about Plato for a while. The two of you might discuss, say, the subject of unreality, and that would be it—and you'd get your receipt.

Chris Burden's pace-setting works aren't too easy to move off the shelf, either. In addition to having himself shot, Burden also had himself crucified with real nails driven through the palms of his hands and into the top of a Volkswagen. In another work, Burden nearly electrocuted himself. ("I didn't want to die," he said later, "but I wanted to come close.") Los Angeles critic Donald Carroll reports that Burden's friends "can no longer decide whether they are being asked to participate in the last rictus of Expressionism or the last grimace of masochism."

There was a time when Burden's wife supported him while he created these painful sculptures. Lately, however, he has made movies starring himself crawling on his bare stomach through a 50-foot stretch of broken glass in a parking lot, and showed them in 10-second spots on Channel 9 in Los Angeles. Burden paid for the air time with an award he'd won from the Los Angeles County Museum (which takes his work very seriously) and the exposure helped to make his name. Now the Rico Mizuno Gallery in Los Angeles sells tickets for Burden performances. It also purveys picture books showing Burden at work. A signed copy goes for $300.

Vito Acconci, another Sonnabend artist, in one work simply bit himself all over his body, or over as much of it as he could manage. In another show, he masturbated under a ramp as visitors walked over it. He has also dressed up his penis in doll's clothing. (Acconci has not reached the dedication of the late Austrian Rudolf Schwarzkogler, who for art's sake began cutting off his penis bit by bit until he finally sliced himself to a hero's death at 29.) Acconci was commissioned to do all these pieces

by his gallery or by private collectors, and in each case the patron got photographic documentation.

Wherever artists may have wished to go with their art—into the desert or only out to collect the garbage of other artists to package, sign and sell, like the French artist Arman—they all finally end up back in the gallery. Whatever there is to sell the dealer will find out what it is and sell it. The harder the work may be to understand, or even to find, the more valuable it can be because it will appeal to a collector of things that are hard to understand.

One such private collector, a New York City manufacturer who has been commissioning conceptual art for several years now, doesn't want his name mentioned in the paper, conceivably because to do so might send conceptual art prices up out of sight. He has underwritten the demolishing of a house in New Jersey (stages in the collapse were photographed), and the placing of some pieces of bread around a Mexican volcano to see if the heat would make them go moldy faster than usual (he got the toast). Another work he commissioned is the "photo" of a daughter he never had. Using photographs of the collector's two sons, an artist synthesized the image of a 14-year-old girl. "We haven't named her yet," says the collector.

The only modification he sees in the standard dealings with galleries is that some of the early works were not available through dealers at all, so he dealt directly with the artists. "Previously we had always had this buffer, the dealer, between us." Now the dealer is in his place once again.

Ealan Wingate says that the relationships among dealer, artist and collector haven't changed a bit, basically. "A lot of the work has to be installed by the artist personally," Wingate admits. Because of its nature—papers or photographs spaced around the place in certain formations—"I can't shift things around so much for myself, as I would with conventional paintings." Gallery people may be called upon nowadays to explain matters a bit more than they used to. He shows, for example, a work of Mel Bochner's consisting of two pieces

of paper, framed and glassed, blank save for a tiny red dot in the middle of one and a tiny gray dot in the middle of the other, and he explains that what's interesting here is that the red dot is in the measured center of its paper, while the gray dot is in only the estimated center. "I make this clear to people," Wingate says. "Otherwise they are working their asses off for nothing, trying to figure the thing out."

Wingate does not believe that a desire to escape the commercial art scene lay behind the movement away from traditional art objects. "An artist makes works he is compelled to make, whether it is to bite his own body or construct a spiral jetty in the salt flats," he says. (The jetty was a land-fill project by the late Robert Smithson.) Naomi Spector, director of the John Weber Gallery, agrees with him. "No good artist is working just to break away from something," Miss Spector says. "An artist works only from his own ideas." She believes that no matter what form art takes, the artist will always be helped by being represented professionally by a gallery.

Susan Gibson, who helps her husband John run the John Gibson gallery, is another enthusiast of the new art. She says she has watched the artist first abandon the framed painting and sculpture-on-a-pedestal to explore the land and the sea, and then return to a perception of his own body, which naturally led into the head, where he is now. She identifies one new school as "narrative art." These works consist of little stories or scenarios either typed on paper, tape-recorded by voice or shown in photographs. "It's not necessarily a good story," says Mrs. Gibson, "because the artist is not a writer." This does not matter, however, because the work is not literature anyway.

The new art has made one major change in the business, according to Mrs. Gibson, and that's in the demand it makes on the collector. "Now the human mind itself is a sculptural thing," she says. "If people cannot see ideas as sculpture, "they are not extending their minds enough." She admits that some hidebound collectors are reluctant to consider conceptual art as a good

investment, but says that "they are only the people who want art to stay the same." She points out that documents concerning a Dennis Oppenheim work— he has plowed circles in snow on a frozen river and moved all the trash paper from the floor of the New York Stock Exchange to the roof of his own building in Manhattan— have tripled in value within two years. She believes that good art will always be a good investment, even if it consists only in a bill of sale proving the piece once existed in some form or another.

That form can change according to what the artist says about it. The Gibson Gallery shows photographs by Roger Cutforth, for example, that are not to be looked at as photographs, but as graphic representations of ideas or "sculptures," a term that has been extended to include conceptual art. There is a snapshot of a hand holding a snapshot, for instance, and it is to be bought and judged not as photography but as a transcendental form.

This idea of the photograph documenting a work of art has been hard to establish, Mrs. Gibson admits. She points out an invitation from a Washington, D. C., gallery to Robert Cumming, who works with narratives and photographs, to show in a group show—in the photography section! Mrs. Gibson insisted Cumming's work go into the fine arts section because he was not showing photographs, but conceptual art. The reply was, well, we hope this is what photography will become. "Too late," said Mrs. Gibson. "This is what fine art has become." It was a standoff—no show for Cumming.

An advantage of certain conceptual art is that when you move you can easily recreate the work wherever you settle. If, for example, you've bought Sol LeWitt's "The Location of Points," what you get is detailed instructions ("the sixth point is located at a point equidistant to points two and four and a point halfway between the first point and a point halfway between the midpoint of the bottom side and the lower left corner"). Following these directions, you mark the points on a wall and you've got the piece again. Since it's the idea that counts it doesn't matter at all whether it's you, Sol LeWitt or

your Uncle Elmer who does the marking. (A major wall instruction by LeWitt sells for as much as $8,000.)

Most ethereal of the new artists is an Anglo-American group of five thinkers who publish booklets in fine print and style themselves Art-Language. One of them, Ian Burn, says, "We're making a series of mappings of our feelings about language." A mapping—or "coding"— could be, say, a note that a certain word is cold or hot or wet or dry. Burn admits that for a while the group was too far out to have anything to bring to market, but some of the artists have come around. "Generally we do have one object," Burn says now—it might be a large card with words on it. "But we're not very comfortable with it," he says. "We've also sold the initial drafts of some of our articles. People have bought stuff like that." Those who have tried reading the Art-Language booklets find them rough going, because the A-L fellows are far from having cleared up conceptual problems for themselves. As one of them writes: "It may be that we can't say much until we've located things on a fairly substantial topology of possibilia forming a basis for proposition modality."

However brainy, invisible or whimsical idea art may become, it seems clear that because artists need something to sell to make a living they'll find it somehow, and galleries will sell it. Nevertheless, a few artists are still trying to lead art to out-of-sight destinations. A French conceptualist, Daniel Buren, whose works sometimes involve green-and-white striped awnings, insists that a "complete rupture with art—such as it is envisaged, such as it is known, such as it is practiced—has become the only possible means of proceeding along the path of no return upon which thought must embark. . . . Panic strikes the art establishment as its members begin to realize that the very foundation on which their power is established—art itself—is about to disappear." If there should be anything at all remaining, Bu... ...dicts it... ould be "an inquiry —a work... ...uch nothing can be said, except that it is."

August 11, 1974

# Museums and Artists Learn To Live With the 70's

By MARTIN FRIEDMAN

**R**emember the 1960's? In the dark shadow of Vietnam, those were palmy days for artists and museums, a thriving period of art-a-go-go, seemingly endless invention and the wherewithal

to realize great plans. American museums specializing in contemporary art could draw their energies from a virtually inexhaustible range of artistic activity. Each season brought its artists, media and techniques.

The situation in the 70's bears little relationship to those extravagant days. We are now, it seems, all too conscious of the limits of invention and the ca-

pacity to support such creative energy. This shift in attitude is particularly apparent as we focus on the changing relationship of the museum to the living artist.

In the 60's, thanks to an expanding economy, vigorous creative resources and—not least—the success of the great generation of Abstract Expressionists who, though belatedly recog-

nized by museums and the public, had achieved the status of legendary form-givers, this country became the international center for contemporary art. The explosions of creative activity in New York reverberated in Los Angeles, Chicago, Minneapolis.

The Abstract Expressionist success propelled a younger generation of painters and sculptors to even greater prominence, and American museums systematically began to acquire their work. A major boost was provided in the early 1960's by the entrance of the United States Government as an official patron of the arts, with the establishment of the National Endowment for the Arts. State and regional arts councils followed the Federal lead, some by providing financial aid for the exhibition and acquisiton of works.

To accommodate the expanding activity and provide a focus for the public's apparently insatiable new interest in the arts, a now memorable era of bricks and mortar began. Governing boards of American museums, convinced that the well would never run dry, raised vast sums to enlarge existing buildings and to construct new ones. In this coast-to-coast phenomenon, according to the 1975 publication "Museums U.S.A.," 26 percent of the 340 museum facilities now in operation were built in the years 1960 to 1969.

The contemporary artist had a considerable influence on the character of these museum spaces. The new American painting, monumental in scale, required special showing conditions—assertive but noncompetitive spaces with high ceilings and unbroken vistas. Such specifications accelerated the transition of museum design from temple to warehouse, flexible enough to accommodate large works, yet easily partitioned for more intimate presentations.

●

An innovative development occurred as the size and price of art began to increase, and emphasis shifted from building collections to programming. The "art center," a peculiarly American institution, took hold, stressing interrelationships among the visual and performing arts. Focusing on the work of living artists, the centers presented diversified programs of exhibitions, dance, experimental music and film. Each category attracted its distinct audience; at the same time, a sense of commonality within the arts was made apparent.

For American artists and museums, never had there been such an age of experiment. It was an era when traditional boundaries were dissolved—between painting and sculpture, the visual and the performing arts, the arts and the sciences. Many painters, for example, seeking fully to realize their spatial ideas, began working with three-dimensional forms, including the Minimalists Don Judd and Dan Flavin as well as the Southern California sculptors Larry Bell and Robert Irwin. Rauschenberg's and Johns's "combine paintings" contained familiar objects, and thus became sculptural.

The artist could be a performer, too,

The New York Times/James Meehan

Oldenburg's "Lipstick"— a statement of the 60's

as in the wildly imaginative Happenings and theater pieces with which Robert Whitman, Allan Kaprow and Claes Oldenburg were involved, produced in lofts, garages, butcher shops and—on occasion—in museums. And such new areas as the natural sciences and technology were invaded by vanguard artists, who saw art as "research," and cooperated with specialists in the use of such esoteric apparatus as laser beams and computers.

The 60's also brought a new role to the museum director, that of impresario. With no small degree of trepidation, museum directors and their curators began to invite artists to create works, often of enormous size, for inside and outside spaces; then raised funds and located sites for the creation of these environmental structures. The transformation of museum gallery into artist's workroom had now occurred.

The impresario role, an exciting if uneasy one for the museum official, was a radical departure from the time-honored view that the museum should maintain Olympian distance from transitory manifestations. Blinded by strobe light explosions and vertigo-inducing moires, directors cautiously navigated through the superproductions known as "light shows." With

fixed smiles, they stoically endured assaults on their pristine white spaces. They saw their walls splattered with molten lead and flinched while their new travertine floors groaned under the weight of timber and steel plate.

●

The dramatic increase in public acceptance of the new art during the 1960's was due in large part to the media. New art was *news*. The artist as superstar was prime copy for the dailies and glossies. Pop art, a parody of the media, was embraced by it. Weekly color sections of the latest manifestations in the galleries, and coverage of the new exhibitions, mostly in New York, had wide national circulation. Pollock, de Kooning, Rauschenberg and Warhol almost became household words—certainly a novel condition for American painters and sculptors. Museums, also in the information business, spawned elaborate education programs including lectures, panels and films to make the work of the living artist accessible to an increasingly young, more knowledgeable public.

But, perhaps inevitably, this decade of Periclean splendor ended on a sour note. Trouble began to brew in Paradise, artistically and politically. Museums committed to new art were increasingly unable to accommodate to ever-growing demands for space and funding. Further, as with all existing institutions, the American art museum was subjected to forces in the late 60's, persisting into the 70's with which it has not been able to cope. Because of its "palace" origins the museum became a focus of the socio-political tensions that were transforming American society.

Artists, affected by the change in the zeitgeist, began to direct their concepts not only against the museum as a symbol of established culture but against the idea of ownership itself. A period of anti-formalism ensued, a departure from traditional "object" art to diverse projects that extended well beyond the spatial capacity of museums. One such departure was earth art, an expression which, in its fully realized state, implies the massive rearrangement of the natural environment. This is best experienced in nature. The museum at most can show hints and reproductions, sketches and large-scale photographs of the results. In a more radical vein, Conceptual art, a product of general disaffection with the consumer-oriented tradition of object-making, took as its major premise the elimination of the object in favor of a sheet of typewritten paper that contained proposals, manifestos, instructions and philosophical statements.

●

Now, the hard fact is that the golden age of the 60's is over, and these are problem times for museums. The socio-political tensions have ebbed somewhat, but the spirit they generated remains. Further, bad economic weather plus the widening demand for their services has made museums more dependent on public support, hence sus-

ceptible to external as well as artistic influences. The symbiotic relationship of present-day economic and artistic conditions is a particular problem of the museum specializing in contemporary art, since not only the presentation of art but also its creation requires adequate funding. (The idea that artists require assured income to buy time as well as materials for their work is not yet appreciated by a public that enjoys what they create.) Unless their financial stability is assured, most museums will have to curtail their purchase and exhibition programs, directly affecting the presentation of new art.

In the museum building boom of the 1960's, few boards of trustees anticipated that endowment funds, heretofore inviolate, might have to be used to pay the light bills. For most museums, budgetary crises are now routine, and the basic problem is to keep the doors open in the face of rising operational costs. Such basic needs are taking priority over organizing exhibitions and building collections.

Some trustees, alarmed by the eroding effects of inflation, are applying drastic business strategies to the management of museums, strategies that are inevitably transforming their roles. The sure-fire exhibition calculated to draw large audiences, and thereby pay for itself, is one way to balance the budget. A major exhibition of historical art, for example, can do well on admissions and catalogue sales, despite the astronomical costs of its organization. On the other hand, shows of work by contemporary artists rarely draw crowds to the box office, a factor that has affected many museums' exhibition planning.

Economic problems, in fact, loom so large that they can inhibit discussion of the artistic issues that should concern museums today, and this uncertainty on the economic front is matched by ambiguity in the present artistic situation.

After the heavy creativity of the 1960's, with its unpredictable consequences for museums, it is ironic that the heretofore scorned mode of academic realism should emerge as a dominant style. This is a return to the old populist virtues with results that look comfortable on museum walls. In its embodiments, this new Academy both re-warms the Beaux Arts tradition and returns to the proletarian attributes of genre art. Parallel to this development is a heightened interest in photography, with its all-accepting objectivity. During the last five years, the number of photographic exhibitions in museums has increased dramatically.

If the spirit of the art scene in the 60's was expansive, its character in the 70's is quite the opposite. This "loner" mentality permeates other areas of our culture. Analogies, perhaps, can be made to meditation and other forms of self-realization. It is a detachment from shared experience, a withdrawal from public issues, and has produced individuals who prefer to work away from the crowd. Much of what is being made today is of private rather than of public nature, as seen in such manifestations as video art, with its emphasis on the artist's autobiography.

The Rabelaisian Happenings of the 60's, involving masses of enthusiastic participants, have now been succeeded by solitary, static and often voyeuristic performances of which "body art" is an example. Many artists have retreated from making the large-scale and the heroic painting or sculpture in favor of the controllable, portable microcosm. Some younger artists are making sculptures that miniaturize the universe, obsessive expressions just large enough to be visible. On the other hand, in formalist sculpture there is a trend toward a public orientation, with the proliferation of large-scale steel works by such artists as Mark di Suvero, Claes Oldenburg, Louise Nevelson and

Chuck Ginnever in public spaces—many as government-sponsored commissions. These are generally amplifications of ideas staked out in the 60's and have little relationship to the introspective object-making of many artists today.

What, in the face of our current difficulties, is the future for American museums that focus on contemporary art? Financially, the situation is not altogether bleak. The role of the National Endowment has become especially important in museum program support. Matching grants have enabled many museums to continue, and even broaden, their concentration on exhibiting and purchasing works by living American artists. This government assistance is a necessity, since private support is diminishing. Without Federal, state and local aid, many museums would be unable to maintain existing programs or develop new ones.

Actually, there is no shortage of talent or invention in the area of new art. The somewhat undefined, even vaporous condition of current art is worldwide. We are definitely in a period of dissolution of old forms, and the spectacle is as tantalizing as it is disorienting. However, this inevitable process is releasing new creative energies by freeing the young artist from the dominance of the 60's.

As yet, no definite stylistic patterns have emerged, but this decade could be, as the 40's were for Abstract Expressionism, a formative one for American art. The museum can have a crucial role in this creative evolutionary process by strengthening its support of the living artist, through exhibition and purchase, and by developing a knowledgeable audience to experience the results. ∎

*Martin Friedman is director of the Walker Art Center in Minneapolis.*

September 12, 1976

# 'Black Art' Label Disputed by Curator

### By C. GERALD FRASER

As guest curator, David C. Driskell put together the Brooklyn Museum's exhibition, "Two Centuries of Black American Art," the first major historical survey of the black aspect of American art, but he does not believe there actually is such a thing as black art.

"I have no dislike for the term black art," said Professor Driskell. "I think it's a sociological concept. I don't think it's anything stylistic.

"We don't go around saying white art, but I think it's very important for us to keep saying black art until it becomes recognized as American art."

The idea for the exhibition originated with the Black Arts Council of the Los Angeles County Museum, where the exhibition was first seen as part of that museum's Bicentennial observance.

The exhibition drew the largest number of visitors ever to see a show of domestic art at the Los Angeles Museum. Since then, the show has been displayed at the Dallas Museum of Fine Arts and the High Museum of Art of Atlanta. Brooklyn is the last stop.

"Two Centuries of Black Art" includes paintings, sculptures, samples of crafts and decorative arts, and photographs of American buildings and their African antecedents.

The work is the product of 63 known black artists and a number of anony-

mous craftsworkers. The youngest of them were born in the 1920's.

### Project Began in Mid-1974

Mr. Driskell, who was born in Eatonton, Ga., in 1931, is a professor of art at the University of Maryland. Before joining the Maryland faculty, he was chairman of the art department at Fisk University in Nashville.

In the living room of a friend's West End Avenue apartment, Professor Driskell explained what he set out to do when he organized the exhibition, a task that got under way in mid-1974.

"Well, number one, I was not looking for a unified theme. And this, of course, usually upsets the critics because they want to see a continuous kind of thing," he said.

"I was looking for a body of work which showed first of all that blacks had been stable participants in American visual culture for more than 200 years, and by stable participants I simply mean that in many cases they had been the backbone.

"Secondly, I wanted quality work which reflected the kind of cultural

65

emancipation that blacks subscribed to in the 18th and 19th centuries, which, contrary to popular opinion, was not social emancipation as we are experiencing now.

"It was to show that they were good artists and that's all they were interested in."

The nation's early black artists, said Professor Driskell, "were not caught up in subject matter that reflected ethnic themes."

He cited Joshua Johnston, who was born in 1765; Robert S. Duncanson (1821), Edward Mitchell Bannister (1828) and Henry O. Tanner (1859) as painters who "were literally part of the mainstream of American art."

### Art in the Mainstream

Their patrons were white, he said, and their work was collected by Europeans as well as Americans. "The critic of The Times of London," said Professor Driskell, said in 1866 that Robert Duncanson was "the best landscape painter in the Western world."

In the 20th century, however, racial prejudice closed exhibition halls and gallery doors to black artists. "I think it was a developing trend, for the most part, which was characteristic of the social times. It just wasn't fashionable to encourage [black artists], it was fashionable to discourage them."

Acceptance of black art in the 20th century had to come through "the back door," Professor Driskell explained, by way of the Harlem Renaissance of the 1920's and early 30's.

"Whites," he said, "elevated themselves through black culture. The Harlem Renaissance wasn't the glorification of black culture so much as it was to glorify whites in the process of patronizing black culture."

In the 1920's, according to Professor Driskell, there was, among some artists, a "kind of forced consciousness of a return to Africa and black expression." And in the 1930's some artists dealt with "themes reflecting their own condition and identity."

This type of content, he said, was not sufficient to identify a work as the product of a black mind. Men such as Reginald Marsh and Ben Shahn, for example, used black themes.

Pointing to an abstract painting on the living room wall, Professor Driskell said: "I couldn't walk in here and say, yes, that's a black work because it was done by Betty Blayton. I know Betty Blayton is black. But what in that work tells me she is? The iconography of it, no. The symbolism, no."

Some critics ask, he said, why mount a black show in 1977. "I answer: Because you have propagated the notion that blacks are not a part of the system. So until such time as you free your thinking enough to see that they've always been a part of it, and should rightly be included in the history books and what have you, we'll have to keep having black shows."

June 29, 1977

---

## ARCHITECTURE

---

# A Free School of Architecture

PERHAPS the only great volunteer system of unpaid teaching in this country (except those Sunday-school ones) came to the front last week when the $3,000 Paris prize of the Beaux Arts Institute of Design was awarded. Outside of the stone and brick and blueprint architectural world, it is not generally known that the Society of Beaux Arts runs all over this country architectural schools called ateliers, where the instructors receive no salary and where tuition is $2 a year.

There are more than forty such schools, which are conducted by the architects for the mere love of their profession and for its advancement. It is true that H. W. Corbett, popularly known as architect of the Bush Terminal Building, is a salaried associate of the Columbia University Architectural School by day and by night is teacher, for no remuneration, in an atelier of the Institute of Beaux Arts. In Chicago, St. Paul, San Francisco and in the other cities architects of equal prominence are the volunteer teachers in the ateliers. It is a chip of the old block, the Ecole des Beaux Arts, where no instructors receive salaries, and where in consequence instructors who are not for sale instruct.

In short, this institute is an in-strument of propaganda (even if it does not call itself by that pompous name) which has been going along its quiet way since 1894 in an endeavor to purify American architecture of the fungus growth accumulated in the Dark Ages of 1830 to the late 70s. In a way the tale goes back to the late 70s themselves, which mark the end of the era when architecture had actually ceased in this country, because there were no trained architects, and only building went along upon its unpleasant way.

It goes back to the days when Richardson returned from France, bearing with him the influence of the Beaux Arts—the first trained architect to attain prominence in this country since the days of Thomas Jefferson and Bullfinch.

The Beaux Arts influence was destined to exert itself upon the renaissance of American architecture as truly as did the power of ancient Rome upon the Renaissance of Italy. Had Richardson, our first strong man, trained in Rome or London or Dresden, today our schools might be manned by graduates of their schools and Fifth Avenue would show a different façade. It was not to be. The modern French school is our destiny, be it in theatre or apartment house.

Richardson had not only studied at the Beaux Arts under the men who were doing work for Napoleon III., but for seven years he had worked on the additions to the Louvre as draftsman. He traveled into Southern France, and the Romanesque had set its stamp upon him when he came back a strong enough architect and a strong enough personality to put life into dead American building —and to inspire others with the desire for Beaux Arts training. They, too, would build churches like Trinity in Boston, and Romanesque structures like the famous Albany City Hall.

The actual copies of Richardson's style by untrained American builders resulted chiefly in bulging "bay windows" on the brownstone fronts and in bulbous city castles in Indiana. Nevertheless, his real message to America had been delivered and it was slowly getting learned. American architects must train and travel—and, since the master builder himself had done so, why not get that training at the Beaux Arts?

The Hunt influence followed after Richardson's by only a few years, though Hunt himself happened to be older by ten years. He brought back the neo-classic spirit which prevailed in Paris at the time of his sojourn. The Lenox Library, while it lasted, preserved a memory of him. The Metropolitan Museum is a daily reminder of the Parisian adapted classic path which the feet of American architecture had now definitely taken. McKim came next, then Stanford White, and with the old firm of McKim, Mead & White doing more than all the civic leagues and propagandas to change the brownstone face of New York into

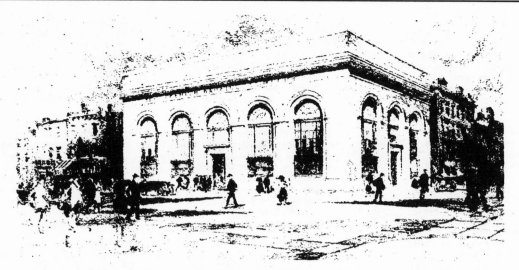

Design for a Bank in Trenton by the Beaux Arts Prize Winner of 1916, Frederic Hirons, of Dennison & Hirons, Architects.

a thing of beauty, it was small wonder that our younger men selected the Ecole des Beaux Arts as the line of least resistance, until now almost the entire cast of American architecture has been trained in the Paris school or by teachers who are graduates of that school. There has been no such closed shop in history since Europe was all Catholic.

Not that there have not been rebels and exceptions. Cram carefully avoided the Ecole des Beaux Arts. Goodhue is practically self-trained as far as schools go, and advises his protégés to "detour around Paris." Some debate hotly that the exuberant decoration and large-scaled ornament of our city architecture are a morbid offshoot of Napoleon III.'s proud Opéra, for which the Ecole des Beaux Arts is directly responsible.

These are moot questions. There is nothing "moot" about the fact that no Luther has appeared with sufficient power to remove that influence and break up the closed shop.

For every important architectural school in this country is manned by Beaux Arts men. When a vacancy occurs a request comes to the Society of Beaux Arts to supply the new man, until the influence has just naturally been automatic ever since there have been American architectural schools: Columbia, Cornell, Boston Tech, Yale, Carnegie, University of California—all are under the same moral sway.

This educational work is the real purpose for which the Society of Beaux Arts exists—popular belief that it exists for the benefit of the annual Beaux Arts ball to the contrary. The real purpose of that famous ball, by the way, is merely to raise funds for the institute to run on. The expenses of this school amount to some $10,000, and it is educating more than 1,200 students annually. The $3,000 more to finance the Paris Prize is usually made up by private subscription, and that is the magnificent budget of the organization.

To tell the truth this school is an idea instead of a newly physical thing. This particular idea is the French theory of higher education which the graduates of the Ecole des Beaux Arts are trying out on American youth. The French plan is a system of learning. The American plan is a system of teaching. In America the college practically makes a contract with a boy's parent to educate that boy—say for $250 a year—so a member of the Committee on Education explains it. It is the college's side of the contract to put $250 worth of knowledge into that boy—or explain why not—at the end of the first semester. So into him go the calculus, the freehand drawing, and all the rest of the schoolastic table d'hote menu.

In France there is no contract. The knowledge is there, cafeteria plan, take it or leave it. Pascal, Laloux and the other great French teachers are receiving no salary—they aren't even "dollar-a-year" men. With them the parent has made no contract. A boy may be enrolled in classes year after year. If he is doing good work the instructors are conscious of his existence and pay him attention. If he is doing poor work or no work, the instructors classify him as one of the "uninteresting boys." And, if a parent objects at the end of one year or five years that his son has learned nothing—well, all that he can expect is a shrug of the shoulders and a "then why didn't you send us a son who was some good?"

So here's the French idea offered by the school of the Society of Beaux Arts to the architects, draftsmen and would-be architects of America. Courses of study for elementary and advanced students are made out each year by the Committee on Education, and it's take it or leave it. There is enough material in the two courses to extend intensive study over two or three years, but, as most of the men who work in the ateliers are practical draftsmen by day, the course is apt to extend over four years, and, even then, you can't tell who has received the degree of the institute and who has not, for the ambitious man is as apt to go through the next set of problems in advanced design as the graduate doctor is to attend clinics.

The patron himself spends two and three evenings a week in the atelier giving criticisms, and there is yet other instruction on a co-operative plan. For this training is supplemented by the advanced students who advise and help the beginners who, in their turn, will do rudimentary work on an advanced designer's drawing, such as inking in his penciled line. There is nothing else like it in the United States.

On the other hand, fully half of the students enrolled on the institute books are doing their work in the regular curriculum of the architectural school which they attend. For the course has become the curriculum, either in part or in its entirety, in all but one of the architectural schools of this country, and that one, Boston Tech, will introduce one-third of the course next year as its regular class work. All of the colleges enter the institute competitions, where frequent money prizes are awarded, and there is hot rivalry between the colleges and between the different ateliers, for "mentions" and most awards. To tell the truth, the colleges have little choice about entering these competitions and stacking up their output. They are practically forced into it by public opinion, and, once in, public opinion no more allows them to decline this public competition that it permits Yale some season or other to decide that she'd rather not play the Yale-harvard game.

To illustrate the importance of these competitions several seasons ago one of the schools carried away

more than its accustomed quota of mentions, and a rival school fell below par. Did it cause the disgruntled school to decline? Not a bit of it. Instead it caused an investigation of the teaching methods and a reorganizing of the department till practically a new staff of teachers was employed the next Fall.

So it can be understood how significant an event in the architectural world is this annual Paris Prize. The man who wins it becomes a marked man to his fellows. He goes abroad for his two years' study to find that he enters the Ecole des Beaux Arts without examination, where examinationsare so discriminating that out of the usual 500 applicants only 60 are admitted, 15 of them foreigners and 45 of them Frenchmen.

This year the prize has been won by Duncan McLachlan, Jr. He has been for six years a practical draftsman (during all of which time he worked by night in the ateliers), and then for two years a student in the post-graduate school at Harvard. Indeed, although the competition is open to any man under 28 in the country who pays a $2 fee, and although the competition is anonymous, invariably the Paris Prize has been won by a well-seasoned student of architecture. And of the accomplishments of those who have won in the past, there is already a goodly showing since the first Paris Prize award in 1904. Frederic Hirons, who won in 1916, has risen to prominence in the firm of Dennison & Hirons. Sidney Warren has a partnership interest in the George B. Post firm.

Licht has a partnership in the firm of Delano & Aldrich. John Wynkoop, with an office in his own name, was the architect of the police station in Centre Street, and is responsible for various churches and of other monumental forms of architecture. The younger men who have won the prize and experienced their years of study in Paris are now designers of mark in the offices of older firms. Not one award has resulted in a flivver. They return, as Richardson and Hunt and McKim before them, to carry on the Beaux Arts tradition—Americanizing it according to their taste—but with new achievement rooted in the seasoned knowledge of the Old World.

August 1, 1920

# FRENCH MODERNIST URGES NEW ART IN ARCHITECTURE

LE CORBUSIER, a widely known French architect, in building houses in Paris and other French cities is putting into practice his personal theories. He believes that this age calls for a new architecture; that most "styles" are bad, false, imitative and no longer useful, and he says "style" is distinct from styles, and, to him, means unity.

In a home the beauty should be in its proportions, not in its decorations, he theorizes. It should also be nearly empty. A minimum of furniture is his aim and that built in wherever possible, like bunks on shipboard, shelves, closets and lockers. Every house, even the simplest workingman's home, should have all modern conveniences—sanitation, terraces, garage, roof garden, or sufficient ground for a garden around it. Believing all this is possible by building along the line of his ideas for reducing cost, he has drawn plans for a "villa apartment" house of two-story homes with "hanging gardens"—that is, individual gardens on every floor and a communal roof garden, swimming pool, outdoor gymnasium and autodrome on the roof.

His book on architecture has caused much controversy on the Continent. Our modern achievement, even in America, he thinks, has been all in the direction of engineering, which has progressed while architecture has stood still. Where it has advanced, it has applied the lessons to be learned from the engineers, Le Corbusier believes.

### Industrial Architecture.

The best architecture to be seen today is not in homes, museums or other public buildings, but in office buildings, warehouses, grain elevators, he asserts. These answer the purpose they are built for—have unity, simplicity and usually are constructed with primary geometric forms. He admires American office buildings and factories when no architectural decoration has been added.

Le Corbusier furthermore believes that the greatest beauty has been achieved in this age by industrial products. The automobile, the airplane, the transatlantic liner are beautiful; the average house is not. He feels that this is due largely to standardization.

In building an airplane, an automobile or a boat there is a constant attempt to solve a problem, to make them answer the purpose for which they are made. This, judging from the results, is not always the case in building houses; else they would not be so inconvenient, unhealthy and ugly as they usually are. The automobile and the airplane are beautiful although there is little attempt to make them decorative. We have achieved these results with automobile and airplane through standardization and selection. They are now built on inevitable lines. Why not apply these same principles to houses? Thus argues Le Corbusier.

Le Corbusier believes that all houses will eventually be factory made of standardized parts. He has constructed several houses in this way and one entire industrial village is under construction at Bordeaux. He asserts his theories apply not to cheap dwellings—although construction will be very much cheaper even when more elaborate than at present. His houses have all modern conveniences —a basic requirement.

He believes that the Parthenon is the supreme achievement in sculpture for all time and says this is also a result of standardization and selection. The Greeks had been building temples for a hundred years, always along the same lines. The supreme genius of Phidias selected from the other models and produced something we have never equaled. He thinks our nearest approach to it has been in industry and engineering.

We can also learn from the Romans and the Egyptians, Le Corbusier continues, because they used primary geometric forms, but not from Gothic. "A cathedral is not really beautiful. It may be dramatic and interesting, but it is essentially a drama rather than a plastic work of art—a conflict against gravity. We are compelled to invest it with all sorts of subjective emotions to be able to believe it is beautiful."

### An Ideal of Harmony.

Le Corbusier is not merely utilitarian, however. Over and above his ideas of simplicity and utility, of the essential adaptation of a building to its function, there is an ideal of harmony which is achieved in this way and which is, he says, the essence of architecture and is all too rarely achieved. Architecture, he says, is a pure creation of the spirit. That is why it should not copy nature or anything else; why "styles" and "periods" are bad.

Architecture should be based, he believes, on geometry, especially on primary geometric forms—cubes, triangles, cones, cylinders. It should have the respect for line, mass and space which we have to a great extent lost. Blank spaces, if harmoniously proportioned, are not ugly, but most of our attempts at decorating them are ugly. Blank surfaces, consequently, form a feature in his architecture.

November 28, 1926

# A PIONEER IN ARCHITECTURE THAT IS CALLED MODERN
## Frank Lloyd Wright, Who Proposes a Glass Tower for New York, Has Adapted His Art to the Machine Age

*By H. I. BROCK*

IF Thomas Jefferson was answerable for a rash of rotundas and porticoes all over the country for which he wrote a Declaration of Independence, and if Henry H. Richardson must accept a not remote responsibility for a bumper crop of postoffice buildings eclectically built and rusticated in rude granite, in every city in the Union, there is no reason why Frank Lloyd Wright should deny being the stepfather of the little low bungalow in the West.

It is no subtraction from Wright's merits to say so. Washington was, indeed, the Father of his Country. But Jefferson was the father, not only of the country houses of his countrymen, but in a sense, grand artificer of their Capitols, a classical collection beginning with the copy of the temple of Nîmes high above the James at Richmond. And Richardson was the liberator of his country from the tyranny of the Jeffersonian classical tradition.

To each his credit, well earned—and to each his consequences unforeseen, lingering to plague him. It was Wright's ill luck that his consequences overtook him. In his own country, at least, they so obscured his achievement that it was not until a certain type of "modernism" in building, of which he was one of the pioneers, returned to us with the stamp of European approval that he received the recognition that was his due.

Only the other day the architects of New York gave in their clubhouse their first exhibition of the work of a man to whom the more outstanding among them for up-to-date achievement acknowledge considerable obligation for putting them on the path which, for some, has led to fame and fortune. Yet it was back in the 1890s, before the World's Fair that left us the Midway, that Wright was at work out in Chicago with Louis H. Sullivan,

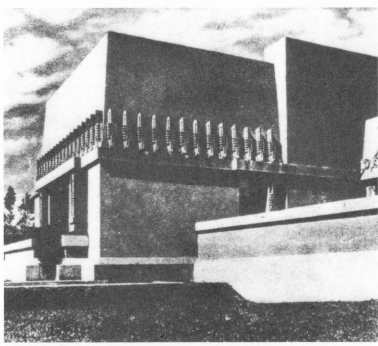

A Striking Example of the Wright Method of Bands of Decoration Applied to the Plain Surfaces of a Hollywood Estate.

*Photograph from Frank Lloyd Wright.*

to whom, by general consent, is assigned the glory of inventing the thing that has become the sky-scraper and at last, in the tall chromium spike of the Chrysler Building, has overtopped every other monument of man.

Wright, born in 1869 and a graduate in engineering of the University of Wisconsin, did not, however, like Sullivan, go in for the vertical. His line was the horizontal—the domestic or home line, as he calls it. He is a man with a gift for phrases not inferior, perhaps, to his gift for architecture. His prairie-bred style of building calls, in his own words, for "gently sloping roofs, low proportions, quiet sky-lines, suppressed heavy-set chimneys, sheltering overhangs, low terraces, out-reaching walls."

It is the elected country architecture of a flat land—which is, no doubt, one reason why it has taken the fancy of the North Germans and the Dutch, who have made a sort of demigod of Wright. It is also one reason why, though the West is profusely sprinkled with imitation Wright architecture, other parts of the country have not taken so kindly even to imitations. We have also our mountains and our rolling hills with a home-grown—even if derivative—architecture of their own. It is architecture rooted in tradition and not easily dislodged by the argument that modern materials should take the place of well-accustomed brick and wood and stone, and impose their own character not less upon the country home than upon the city filing-case of flats or offices, or the mechanic-architectural aggregation known as the factory or "plant."

It is basically as such a mechanical organization of material for a purpose that Wright pretends to see architecture whole. But as one of his foreign admirers, J. J. Oud, observes, there is in him a "plastic exuberance" which carries him beyond the utilitarian theory which allies him with the cubists. Ultimately that theory is that, while the older architecture is sculptural, the new architecture is organic; while the older architecture makes a form to be cut up into boxlike

compartments, the form of the new architecture is arrived at by synthesis of the functional cells of which the dwelling, office, factory (or whatever the job is) consists.

G. H. Edgell of Harvard has pointed out that it is precisely thus that the medieval yeoman's dwelling was constructed and that the early American farmhouse—the successor to the unicellular cabin of the pioneer—exemplified the same principle. Edgell also notes that this principle persisted in practice among humbler folk over here even after the gentry—the rich planters and traders—had adopted the "sculptural" formality of the school of Inigo Jones and Christopher Wren. Thus, the principle itself is certainly not new. The real novelty is the application of the most elementary architectural recipe to houses in which the "cells" are specialized as to function and sharply differentiated, as they are in the modern building with its plumbing and other mechanical appliances. Because these things had come into use after the older forms were "set," because they had been awkwardly thrust into the old houses of the old form, a habit had got started of awkward "inorganic" makeshift compromises in these matters with the architectural form of even new houses of any pretension. And the habit was hard to break.

* * *

THIS was only one of many bad building habits when Wright came along—when building was at the top of the tide of standardized quantity production of houses from mill stock. As Wright puts it: "A piece of wood without a molding was an anomaly, a plain wooden slat instead of a turned baluster a joke, the omission of the merchantable grille a crime; plain fabrics for hangings or floor coverings were nowhere in stock." People were so used to "guillotine windows" that they utterly refused the casement style.

That last item is a fair measure of how far things have moved since Wright was a pioneer. All of it explains eloquently why nobody but the rich could afford to have a

house done by Wright, because so many things that Wright put into his houses had to be made to order from his own designs. Per contra, that is why, after the fashion in the new gimcracks had taken hold, and they were being turned out wholesale by the "trade," the followers and (in a fashion) imitators of Wright flourished so exceedingly, with small acknowledgment to him for the favor, which, after all, was not entirely his favor. There were other influences, some of which went all the way back to William Morris in England.

The Wright doctrine is that the machine has got us. Since it is "irrevocably fastened upon us," we are to make it a blessing instead of a curse. "Standardization and repetition are thus to be realized and beautified as the service of the machine to civilization." Among other things the machine is to build our houses (which, as we have

seen, are conceived as living machines) and our prime concern is to see that they are beautifully machine built. Where William Morris looked back yearningly at the handicraftsman to save the world for beauty, Wright looks forward enthusiastically to the power plant and the concrete mixer for the same service. To quote again—quotation is easy when this artist takes the stand as his own witness—"steel framing constitutes the skeleton to be clothed with living flesh, reinforced concrete contributes the splay and the cantilever and the continuous slab." And so we build "monoliths in place of patched and petty aggregations."

Thus speaks the man whom Lewis Mumford calls "our most distinguished outcast," the man to whom Ely Kahn, builder on the slope of Murray Hill itself of great masses full of acres of loft space for the silk trade, was referred

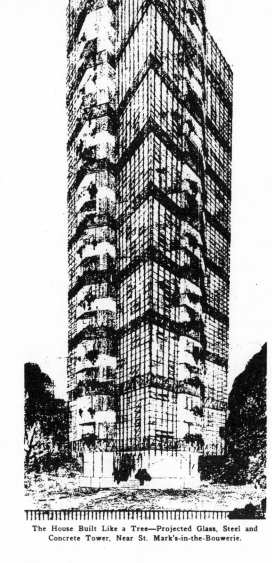

The House Built Like a Tree—Projected Glass, Steel and Concrete Tower, Near St. Mark's-in-the-Bouwerie.

When he voyaged over to Europe to study modern architecture at the feet of the Germans. "Go back," the German said, "across the Atlantic and get the stuff from the man who gave it to us." At least that is the story.

What this man's idea is of the older American architecture—the omnivorously electric architecture which was still flourishing all over our home lot up to the moment when the outsides of our skyscrapers went modern, the moment which marked the end of the Woolworth and the beginning of the Chrysler era—you may gather from the following: "We have seen in America," he says, "the logical conclusion of the ideal of Rehash underlying the European Renaissance—a mongrel admixture of all the styles in the world." One of his aphorisms is that "creation never imitates, creation assimilates"; but, in the architecture of that long admired and sentimentally worshiped Renaissance, "style corrodes style and all forms are stultified." For example, columns are reduced to pilasters by building walls between the columns, and the process is continued by "cutting holes in the wall and pasting on cornices with more pilasters." Thus are disposed of those famous monumental facades of Europe and those gracious doorways and pilladian windows which our more ambitious country house architecture has conserved from the time of William Buckland operating in the eighteenth century in Annapolis with aid and comfort from the books of Gibbs and Swan and the rest imported from the mother country. Jefferson also trusted greatly to the books as later men have done. But our reformer's finger of scorn, it may be presumed, is pointed rather at the abuses of the privilege of selection which this sort of bookishness leads to, than to the results achieved by the right use of that privilege. His own prescription for his art reads: "Simplicity and repose. As few rooms as may be, so that utility may go hand in hand with beauty. Openings as integral parts of the structure and form—if possible its natural ornamentation."

* * *

AS it happens, all these qualities are characteristic of the best American Georgian houses. More especially the last is inherent. For, except where there is a portico, the windows and the doors are with every intention disposed as the natural and only ornamentation of the exterior and are integrated most carefully with the structure of the brick wall. Moreover, the best of them make use in the interior of arrangements in the way of wainscoting, molding, flat wall and cornice, of those large plain surfaces and horizontal bands of rich ornamentation which are so favored a device with Wright himself in his exteriors.

Wright has built a great deal and that in very solid fashion. He has built town and country houses and factories as far west as our Pacific Coast. Likewise, he has set up pleasure gardens of the sort that are not mere plantations. It is not his fault that they have vanished. And it was he who built the Imperial Hotel in Tokyo in 1916 and built a vast spread-out thing of concrete slabs threaded with steel rods to withstand earthquake strains, all this plated with bricks, tiles and hewn lava blocks. He built it all so successfully that in the great earthquake of 1923, which laid low so much of Tokyo and other Japanese cities, the hotel contrived out of solid material by the American architect stood firm and suffered very little damage. This last is a practical achievement of prodigious importance to the people who live in volcanic areas, and

irrefutable testimony to the adequacy of the engineer behind the adventurous architectural experimenter and the amazingly clever and facile draughtsman. After all, if Wright is a pioneer and a prophet of a new dispensation, the advance agent of a new line of goods, his ability to give his ideas magic appeal on paper is hardly less important than his ability to give them substantiality in concrete assisted by steel and stone and tiles and brick and glass.

Among his recent projects not the least curious—if less certainly among the most beautiful—is the extraordinary plan and model of the tower proposed to be placed close by St. Mark's-in-the-Bouwerie, looking down from aloft on the tomb of gold peg-leg Peter Stuyvesant, last Dutch Governor of the city now ruled over by James J. Walker. The model of the tower looks rather like a playhouse for white mice—so somebody said who saw it at the Wright show at the Architectural League. Wright explains that it is built like a tree. The support of the entire structure consists of four reinforced concrete piers running up the middle of it like the trunk of the tree. Upon these piers the successive floors are hung on cantilevers as the limbs of the tree hang from the trunk. The hanging structure is of steel and glass, and every apartment in the building is an outside apartment flooded with light.

The base of the building is considerably smaller than the top, for not only does the steel cagework spread as it goes up, a few inches to each story, but the base area is only the space within the circuit of the piers—the area of the base of the tree trunk. The first story and all the rest overhang. The elevators are in the core or trunk, of course, and so are all the other general functional arrangements of the building as an organism. So far, this tower

has not been built. It is a project, not a fact. But Wright will show you that, in spite of its extraordinary outward appearance, it provides commodious living quarters.

The nature of his achieved work so far makes it probable that Wright is more significant as an image-breaker than as an image-maker, that this greatest value consists in the ferment set up by resentment at his contempt for "orders" of of architecture as eternal shackles on the builder's imagination, no matter what new materials he finds ready to his hand and no matter what new needs he has to meet. But the fact is not to be gainsaid that at the very beginning of the century he was doing those very flat-topped houses with horizontal bands of windows which are now being exploited by our most advanced young architects as the newest thing in building and in enfranchised art.

The experimenters in Europe, who are bolder than ours, have hailed the man from Wisconsin, the man of many inventions and adventures, as a genius and major pathfinder in new provinces for art to conquer. Our own boldest experimenters have been mainly concentrated upon the vertical and not the horizontal, upon the line not of domesticity but of pyramided big business. But it is significant that men like Raymond Hood, president of the Architectural League of New York, and marked out from the rest by such achievements as The Chicago Tribune Building and the black and gold American Radiator Building beside Bryant Park in Manhattan, are among those who credit Frank Lloyd Wright with most influence toward enfranchising and reforming the art of architecture to meet the needs of modern life.

**June 29, 1930**

---

# IN BERLIN

## Comment on Building Exposition

### By PHILIP JOHNSON.

BERLIN.

MIES VAN DER ROHE'S name will become synonymous with the Berlin Building Exposition of 1931. Although Mies was made director of only one section, it is by this section that the exposition will be remembered. Only here has architecture been handled as an art. With the exception of the Mies section, the enormous exposition is devoted to city planning, garden planning, use of construction materials, garages—all conceived in so different a spirit that critical justice could be done only by a separate treatment.

That the city of Berlin should hold such an ambitious exposition at all when its inhabitants are daily expecting complete bankruptcy is a wonder. That the city should at the same time pick its best modern architect to direct the architectural section is a second wonder. One shudders to contemplate whom the

city officials of New York would choose for a like position. Mies has had complete charge of this section; his was not only the selection of the architects, but the decision as to what and where to build. All the objects shown had first to meet the approval of the director; no industry could dictate what of its work should be exhibited. Consequently, the crowded confusion, typical of the second floor of the league show in New York last Spring, is absent. The advantage to the firm of having a strict esthetic judgment applied before its object is displayed is many times greater than carte blanche to a three-thousand-dollar-a-week niche at the Grand Central Palace. German industries learned this lesson slowly, and it was not until the success of the German exhibits at Barcelona in 1929, also arranged by Mies, that they were finally convinced that submission to an artistic dictator is better than an anarchy of selfish personal opinion. America, which can make changes so quickly, must also one day wake up.

* * *

ANOTHER advantage of this system to the exhibitor is the artistic unity of the whole arrangement. The art of exhibiting is a branch of architecture and should be

practiced as such. Mies has designed the entire hall, containing houses and apartments by the various architects, as itself one piece of architecture. The result is a clear arrangement inviting inspection, instead of the usual long central hall, with exhibits placed side by side.

As in the Werkbund Exposition of 1927, Mies van der Rohe selected only those architects to build who work in the international style—a type of architecture which in America can as yet be seen only in the shops of the rejected architects. The "modernistic" style, as we know it in America, has never really been prevalent here; the Paris 1925 mode has not swept Germany. The equivalent is the Kunstgewerblich, the kind of thing that is known best in America in the work of Bruno Paul or the Wiener Werkstätte. At least in Berlin the modern has triumphed over the Kunstgewerblich.

Among the houses the one-story single house of Mies stands out above the others. The walls are mainly of glass, with one solid wall facing the street. In spite of the use of glass and the fact that there are no interior doors except the ones that lead to the kitchen, privacy is not lacking. The walls of the bedroom, for instance, separate it not only from

the living quarters, but, extending beyond the house into the garden, cut off the bedroom from all but a small portion of the garden. Thus the bedroom, with only glass walls on the outdoors side, is as large as the space inclosed by the solid walls.

The esthetic appearance of the house differs from the box effect of four visible surfaces broken by windows and doors and is rather a three-dimensional space intersected by planes—the thin roof slab and the partition walls.

* * *

THE house is not, as so many architects here and in America would prefer to have it, purely functional. That is, it could have been built at a lesser cost and have been more economical of space and still have served equally as well its function of living quarters for a married couple. But Mies has long since passed the stage where the house is regarded by the architect as the cheapest, best-planned expression of the needs of the family. The Mies home is admittedly luxurious. For this reason Mies is disliked by many architects and critics, especially the Communists. On the other hand, the public still apparently wants beauty in its everyday surroundings. There is in the house none of that arbitrariness which Germans call

"Spielerei." Functionalism has at least a negative force in modern architecture. In defense of each element of a building the architect must be able to answer the question: "Why?" This basis of modern architecture in function, Miës and the post-functionalists freely admit. The exaggeration of functionalism into a theory of building where esthetic considerations do not enter at all is the attitude they oppose.

Ornament is absent in the Miës house, nor is any needed. The richness of the beautiful woods, the sheets of plate glass and the gleaming chrome steel posts suffice. The essential beauty of the house lies in handling the walls as planes and not as supporting elements. Miës has so placed these planes that space seems to open up in every direction, giving the feeling of openness that, perhaps more than anything else, is the prime characteristic of modern architecture.

WALTER GROPIUS, founder and builder of the Bauhaus, is the second great name in the exposition. His exhibit, however, is much the same as his last year's work at the Paris Salon des Artistes Decorateurs. The development of Gropius through constructivism and Bauhaus Sachlichkeit is evident in his preference for painted wood and artificial materials like oilcloth, linoleum, rubber and trolit.

Two among the other architects deserve mention. Otto Haesler, who has the reputation of being the most economic planner and builder among the modern architects of the world, has contributed a section of a great housing project. Of the younger men, Jan Ruhtenberg is the most gifted and original. The work of the also-ran is good, but the genius of Miës depresses the general level.

August 9, 1931

# ARCHITECTURE STYLED "INTERNATIONAL"

## Its Principles Set Forth in Models Displayed in a New York Exhibition

*On Wednesday there will open at the Gallery of the Museum of Modern Art an exhibition—the most inclusive this country has so far had—of so-called "Modern" or "International" architecture, exemplifying the horizontal principle of construction which Europe has been developing since the World War, while we have continued vertical expression in our skyscrapers. There has been much controversy over this European style. The following article endeavors to place the "International" program in the whole architectural perspective.*

### By H. I. BROCK

THE architecture usually called "Modern" has reached a stage where it must be treated at least as a present phenomenon. By its votaries it is described as the first definite style since the Gothic to be "created on the basis of a new type of construction." In other words, it is a logical outcome of the substitution of steel cages for supporting walls and of reinforced concrete for the old-fashioned materials of floors and roofs. As such, its advocates proclaim it the only logical form of building for this age. Any other form is an anachronism.

Because steel and concrete are used in building all over the civilized world, the commercial manner of building induced by these materials is internationally distributed. Therefore, the propagandists of that manner have of late undertaken to substitute for the label "Modern" (which obviously means nothing permanently) that of "International."

Much acrimony has been expended, both by architects and lay critics, in discussing the question whether "Modern" or "International" architecture is, or is not, architecture at all in the esthetic sense. On this point, even the people who actually build, or plan to build, in the fashion to which these words are applied as labels, are themselves divided into two camps. In one camp are those—and these do 90 per cent of the building—who call themselves "functionalists" or words to that effect, who build merely for maximum use at minimum cost, and who do not care whether or not what they turn out is "architecture" from the esthetic point of view. If it is, it is an accident. These practical people are not concerned with beauty. And they say so right out.

In the other camp are those who profess to be super-esthetes, who discover in precisely this same new manner of building, based strictly on economy in the use of new materials, a style of architecture more chaste and beautiful, elegant and sincere, than the world has ever known. Naturally, it is from this second camp that the articulate promoters of the cause proceed. Between what the builders have structurally produced and what the esthetes have proclaimed, the world has been considerably impressed—and more than a little puzzled.

* * *

AS it happens, we in America are strong conservatives in architecture as in other fields. We are, in spite of the prodigious crop of our steel-cage skyscrapers, in spite of having produced decades ago Frank Lloyd Wright, who is an acknowledged prophet of the new school, though he refuses to submit to the "rigid discipline" of the sacrosanct style to which his disciples have committed their fortunes. Such conservatives are we, indeed, that we have extant in the year 1932 almost

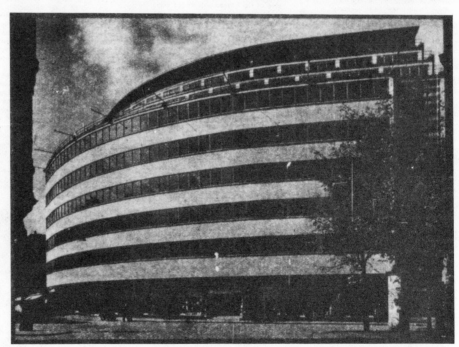
*New Architecture for Commerce—The Façade of a German Department Store.*
Erich Mendelsohn, Architect.

nothing in the way of the architecture which alone is acceptably "Modern" to the "Modernists."

This architecture loftily rejects the verticality which has been the pride of our tower builders. It scouts the great tower builders and flouts the tall towers as mighty spurious imitations of what they are not. It has grown up in Europe—in France, Holland and Germany, principally—since the war. Observe that what the Swedes have done is as clearly out of the picture as our towers. The hierarchs of the movement are the French-Swiss, Le Corbusier, arch-propagandist, the Germans Gropius and Mies van der Rohe, and the Hollander Oud.

Examples of the thing they do (and preach the gospel of) exist in European countries as remote from the seat of authority and inspiration as England, Spain and Czechoslovakia. Examples may also be found in Brazil and Japan—even on our Pacific Coast.

But New York has nothing nearer the real thing than Raymond Hood's blue-green McGraw-Hill building, which, though a skyscraper, emphasizes the horizontals. Notoriously Hood will try anything in the way of a building—once. Besides, he had just the year before gone the limit of the vertical in The Daily News Building, with its effect of a coop of giant palings or palisades.

Hence the value of assembling here in this city models and plans of all the "Moderns" who are recognized as authentically such by the insiders in the movement. Those who have not been able to get to Europe to see the new buildings—or who, getting to Europe in spite of the depression, have found the old place full of things more interesting, tempting or important and have not taken time off to look at the new buildings—all those may this week go to the Museum of Modern Art in Fifth Avenue, just a block from the plaza of the Grand Army, and see at least the models and the pictures and the plans.

After six weeks in New York the exhibition is advertised to go on a three-year tour of the country, so that our principal cities, North,

# Architecture

South, East and West—all the way to Los Angeles—may have a chance to see what (we are told) we are coming to in the way of the new housing accommodations.

In the group are factories, department stores. schools, town and country houses, and wholesale housing developments on a great scale — including one partly exe-

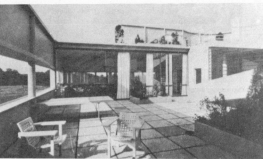

*Le Corbusier and Pierre Jeannerett, Architects.*

The Villa Savoye

cuted in Cassel in Germany and one projected for the recently devastated area between Chrystie and Forsyth Streets on the lower east side of Manhattan. Each of these last projects, by the way, is represented by an elaborate model and each is doubly interesting—first, as a piece of ingenious machinery and second, as an index to what the standardized tenant of the future (the fellow who has to pay minimum rent) is expected "internationaliy" to be like. In New York, as in Germany, he is expected to be tame and neat. In Germany he has three times as much space to be tame and neat in. Even churches and gasoline service stations are included in the show. Every item is done in the new ferro-concrete manner and each item is presented as an authentic example of that authentic manner. This is true even where the architects have professed to be no more than hard-boiled executants of a complex engineering job.

* * *

HOOD is included in the group—not with the McGraw-Hill Building, but with an experiment in spaced skyscrapers for garden suburbs (a sort of variant on the Radio City formula) with which he has been playing for some time. Wright also is included. But (it is explained) he really counts only as the greatest and most incorrigible of the individualists whose experiments opened the way for a style professing to be thoroughly integral and disciplined. Discipline is a watchword of this school, whereas Wright is a rebel to all discipline. Howe and Lescaze are responsible for the very interesting Chrystie and Forsyth Streets wholesale housing plan. Otto Haesler for the Cassel plan.

The material—mostly from Europe—has been assembled by Philip Johnson of Cleveland, after a careful survey of the actual buildings in situ in the various countries where they have been built. The photographs and plans tell something. But "Modern" architecture has been so touted that a great many of the photographs can hardly be new to magazine and newspaper readers in this country. Most can be learned from the models. Indeed, models in three dimensions are almost indispensable elements of such a show. "Modern" or "International" architecture, being the architecture of the functioning machine, can hardly be judged from "elevations"—façades rendered photographically or otherwise. Mere plans chiefly confuse the layman. Whereas a model is a toy. Anybody can become interested in a toy. Most people are curious enough to try to find out how it works. That is what happens with these models, many of which are very handsome —as models.

SINCE the "International" style is so different from any previous style of architecture as confessedly to require for just appreciation a "new esthetic"—in other and plain words a revised conception of beauty; since it is credited, as a "conscious integrated style,"

with being only about ten years old, it would seem that we ought to let the insiders tell us what they think it is. According to Mr. Johnson, who is the director of the show, and to Henry-Russell Hitchcock Jr., who collaborated in the survey of the field which produced the exhibition, the essential principles of international architecture may be reduced to three.

First, this architecture conceives of a building as volume (or space enclosed by thin planes) and not as a mass of sculptured or to be sculptured, as in the older styles. Secondly, it substitutes regularity (derived from the fact that each standardized building consists of multiples of the bay or unit of the steel cage) for such qualities as axial symmetry or balance otherwise artfully arrived at. Thirdly, "arbitrarily applied ornament" is rigidly proscribed.

As the walls are ideally a weightless fabric stretched tightly over a light framework, it is axiomatic that everything on the wall must be flush on the outside. There must be no window reveals suggestive of masonry construction (even when the wall is actually, though only a "screen," built of brick and thick accordingly), and, of course, no water-tables or cornices. In practice, the windows are either glass sides to certain rooms or horizontal slits at about the eye-level of a standing person in other rooms. Out of this simple combination

must be extracted whatever interest fenestration may give to a façade which must, by rigid rule, have no other ornament and which, by strict dogma, should be flat and white wherever it is not glass.

ASYMMETRICAL composition is avoided wherever possible. No reason for this appears in the structural basis of the style. Quite the contrary. Presumably it grows out of the fact that, though the problems of structure are handled in the Gothic manner (by piers or posts as supports instead of walls merely), the design is devotedly horizontal. Thus willy nilly it relates itself to the Classic. Suspicion of aping the Classic or harking back to it is, therefore, most simply removed by studious rejection of the Classic principle of symmetry of composition.

It seems that a fourth principle should be added to the three — the obligation of the slab or flat roof, whether there is any use for the flat roof or not in a given climate— in ours on this Atlantic seaboard, for example. There is, of course, no reason inherent in concrete and steel construction why one should not have peaked or gable roofs, if for any cause of design or utility it seemed desirable to have either of them. But peaked or gable roofs are picturesque. That quality effectually excludes them. Thus is revealed another and fifth principle—which some suspect to be the main principle and others diagnose as the fatal weakness of the style. That principle is nothing more nor less than the paramount importance of being different from every familiar and approved other architectural style.

Emphasis is laid upon the claim that though the manner is only ten years old, there exists already a "single body of discipline fixed enough to integrate the contemporary style as a reality and elastic enough to permit individual interpretation and to encourage growth." This is, of course, precisely the discipline which the veteran rebel, Wright, rejects. What cannot escape the eye of one as yet esthetically unreconstructed is the insistent monotony which runs

through the work of all the exemplars of the school.

* * *

EXCEPT for the variety imposed by provision for different functions in a large set-up—as in the Bauhaus, or School of Architecture at Dessau, by Walter Gropius—every kind of house for every kind of purpose looks in this style like any other kind of house for any purpose or none. A suburban villa is hardly to be distinguished by its façade from a shop in a city street or from an automobile filling station.

It may be said that architects practicing a style of architecture only a single decade old are still of necessity using a rudimentary language. and are thus inevitably handicapped in free architectural expression. Feeling for the true inwardness of the new principles and the new rules is not sure enough to allow the professed servant of these principles and these rules to become their master—to break them with impunity and advantage, as a master of a fully developed language can and does break his rules. Even supposing this mastery to exist in the architect, the language itself is still a handicap. For, in a formative stage, it lacks many inflections and refinements.

Hence the "proscription of ornament." Sensible modernists will tell you that they do not yet know what a right "ornament" in the new style is. They play safe with no ornament. It is at this point that the unconverted person raises the question whether the modern or international style has yet established title to be the sort of major style its votaries are so sure it is. It may indeed be the newly elected language of the master builders. But on the other hand it may be, no better than Volapük, a fad or fancy—or at best an "international" makeshift, like pigeon English.

THE monotony which is so evident at present may be, as has been said, due to the infancy of the style. But this is what we find set down in the doctrine which gives the rigid body of discipline sanction. "Within this style there are no subsidiary manners which are eccle-

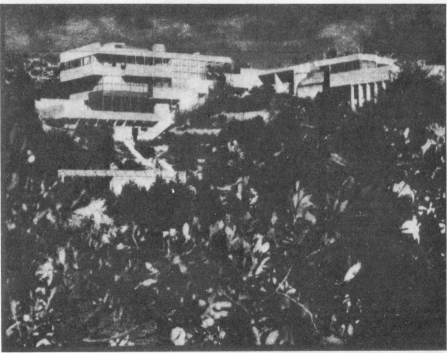

*Richard J. Neutra, Architect. Luckhaus Photo.*

**New Architecture for Dwelling—A Steel Construction House in Los Angeles.**

siastical or domestic or industrial. The symbolic expression of function by allusion to the past, which the half-modern architects at the beginning of the century developed, has ceased to be necessary. Where function is straightforwardly expressed, one type of building will not be confounded with another."

As to that, it has just been noted that it is very hard to tell any building from any other building or guess the function of any building. A church and a factory are easy to confuse. Nevertheless, there is suggested in the quotation above a mental slavery to the machine idea

that is or ought to be peculiar to the passing moment in our machine age when our fascination with the magnificence of our man-made gadgets sets us itching to improve man by making him a gadget of his own machine. The machine-made notion of "function" cannot obscure the fact that the historically true function of a church is to excite and keep alive religious emotion.

That being the case, "allusion to the past" may not be airily swept aside as no part of a "straightforward" solution of the problem of church architecture.

Nevertheless, modern architecture's presentation of itself is an arresting spectacle. There is a certain logic in the premises if there is rarely, as yet, a convincing art in the practical solutions of given problems of modern housing. Except in one or two examples, notably a house in Brno, Czechoslovakia, by Mies van der Rohe, what seems to have gone by the board—possibly in eager quest of difference—is proportion.

Proportion is a thing sensible in all good architecture hitherto, from Greek to Baroque. Perhaps (this was officially suggested) our idea

of proportion is tied to the gravitational idea of "mass" which the new school fancies it has eliminated from the visual impression of its work. There may be the parting of the ways—the arrow pointing toward the new esthetic. That esthetic is the esthetic of weightless architecture. But gravity is gravity still; and even modern houses on stilts still rest on the ground. Houses on stilts or piles are indeed old stuff. And as a matter of fact these airy bird cages are held down by heavy slabs of concrete doing duty as roofs.

February 7, 1932

# Architect, Artist, Finn, American

**Eliel Saarinen has put his mark on America, and now, at 75, his sights are on tomorrow.**

### By ALINE B. LOUCHHEIM

WHEN you ask Eliel Saarinen, the distinguished expatriate Finnish architect, which he considers his most important building, his face wrinkles up into a wry smile and he says: "The next one." This remark explains why the celebration of his seventy-fifth birthday, just two days ago, was nothing more than a physical milestone in a busy life. And it shows why he will return, at the end of a brief Cape Cod vacation, to his teaching post at Michigan's Cranbrook Academy and to the drafting board on which lie plans for a war memorial in Milwaukee.

Most men at 75 look backward, but Saarinen casts no complacent glance at yesterday. His sights are on tomorrow. At the three-quarter of a century mark he is a nimble little man, his walk and gestures as jaunty as his customary bow tie. Hair, brows and lashes are bleached to inconspicuousness. The fine network of lines which covers his face seems as much the result of an all-over spreading smile as of time. Under deep, vertical lids, startlingly blue eyes shine out like tiny, twinkling disks. They alone disclose that he too, is enjoying his dead-pan humor.

ABOUT half of Saarinen's work was done in Finland, and the rest in America, for he came here in 1923. Thus he belongs with the older generation of architects in Europe, who, working independently, were searching for freedom from historic-imitative styles toward modern design based on structure.

**Eliel Saarinen.**

While the revolt of others led to puristically functional solutions, Saarinen kept his faith with the past. As his countryman, architect Alvar Aalto writes (in the foreword of the biography by Albert Christ-Janer soon to be published by the University of Chicago Press), he was a bridge between his architectural heritage and the future.

Stripping his buildings of the many obscuring excrescences, he turned back to essentials of form and material. More than any of his contemporaries, he has maintained a Scandinavian respect for fine craftsmanship and a belief in the interrelation of the arts. The result is buildings—such as those at Cranbrook, the impressive church at Columbus, Ind., and the new Des Moines Fine Arts Center—wherein functionalism meets happily with a rather tranquil, homey beauty.

There are those critics who take issue with his work, accusing him of too much romantic affection for prettiness, for an arbitrary use of ornament and a sort of craftlike, handmade look. But far larger numbers rank him with the first group of those strategic pioneers who developed what—when the word "modern" no longer makes sense—may some day be called "the twentieth-century style." They respect his logical and imaginative city

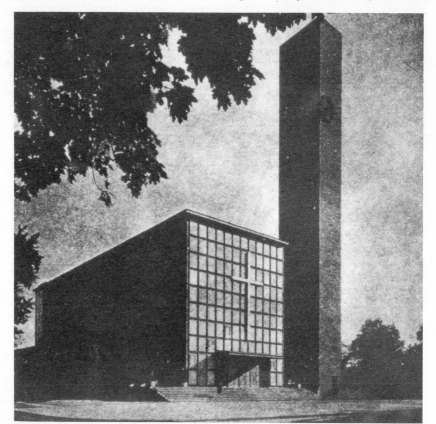

**MODERN CHURCH, 1940** — For the Tabernacle Church of Christ in Columbus, Ind., the architect characteristically balanced a bold vertical with a horizontal mass. Completely functional in plan, the building maintains a traditional dignity and tranquillity.

ALINE B. LOUCHHEIM, associate art editor of The Times, is author of numerous articles in her field and of the book, "5,000 Years of Art."

plans, and they recognize that in the best of his work he avoids sentimentality, yet designs buildings which, as Aalto says, "foster sentiments of warmth and well-being." The key to these distinguishing qualities is in the man himself.

WHEN Eliel Saarinen was born on Aug. 20, 1873, Finland was a grand duchy under Russian sovereignty. His father, a Lutheran minister, was stationed for a while in Russia, but Eliel went to school in Finland. "I was a poor student," he recalls, "a lazy one — always drawing and painting instead of doing my lessons." On visits to his parents he used to stop in at the great Hermitage museum — "where I liked the Rembrandts" — and painting, in the academic style of the Paris salons, became his first career. His direct sketches of the towering firs and the tender, little birch trees, however, are free and fresh and show the feeling for nature which is apparent even today in his latest architectural works and their ornamental motifs.

For several years Eliel simultaneously studied painting and architecture in Helsinki. The die was cast in favor of the latter art when, at the age of twenty-three and still in school, he founded an architectural firm with two fellow-students. The young men had surprisingly swift success. They worked feverishly, their central idea a forthright use of materials, especially wood and stone. They built their country's pavilion for the Paris Exposition of 1900, an astonishingly direct solution among the wedding-cake edifices of other nations. Their major early work, however, was the studio-house, built on a bluff above the romantic White Lake outside Helsinki. Here Saarinen brought his sculptress bride, Loja, in 1904.

SAARINEN is at once a thoughtful and convivial person with amiable charm, and soon the house became a gathering-place for young artists and intellectuals. The musicians Sibelius and Mahler were frequent visitors. The artist Gallén-Kallela and the French actor Jean Coquelin were guests. The inflammatory Maxim Gorky, fleeing Russian police, stopped with the Saarinens on his way to his Capri refuge. Meier-Graefe worked on his book about Cézanne at their house. Sounds of piano playing and high-pitched gaiety were heard in the big living room late into the night.

Eliel was at times a genial, at times an insouciant host busy with his sketchbook. He remembers one night that while a buxom lady guest performed the "Moonlight Sonata" he worked out complete drawings for the Finnish Parliament Building.

DURING these years Saarinen was busy. Of his many projects and buildings the Helsinki Railroad Station is the one which claimed greatest in-ternational recognition. Its vigorous design and structural integrity and what then seemed an almost lack of ornament were acclaimed everywhere. Saarinen's reputation grew on the basis of such monumental buildings.

But after World War I, construction of similar edifices slackened and the architect returned to painting. He even designed the paper currency for the newly independent Finland — currency which was in use until recent days. "That was amusing," Saarinen remembers, "We were all living together — even my aged father — and there, walking around all the time, was the nude model I used for the designs on the money."

Astrologers might find comfort in the fact that Eliel Saarinen's thirty - eight - year-old son Eero, whose birthday is the same day as his father's, followed the same profession and is now a distinguished designer and architect in his own right. And they might find explanation in the stars for the fact that twenty-five years ago Eliel Saarinen won the second prize in The Chicago Tribune Tower competition and that twenty-five years later Eero won the coveted award for the Jefferson Memorial in St. Louis. "Perhaps in another quarter of a century my youngest grandson Eric will win another competition," Eliel proudly muses.

ACTUALLY, it was not the stars but the general pattern of family life which steered Eero into his father's profession. "The studio was connecting with the house," Eliel explains, "and he was born practically on the drafting board." "Loja," he says, turning with an affectionate glance to the capable and spirited woman who has been his wife for forty-four years, "was doing sculpture, architectural models and weaving then. Eero hung around the drafting room and when he was 8 could do perspective drawings. His sister Pipsan was already at the loom. But we never forced Eero. We just believed that a home must have some place where people work together, because working like that keeps the family a unit."

The year 1922 was a strategic one both for modern architecture and for the Saarinens. Like others of the pioneering architects Eliel entered the international competition, instituted by The Chicago Tribune, for "a design for a structure distinctive and imposing — 'the most beautiful office building in the world!'"

"Don't ask me about The Chicago Tribune Tower," Saarinen smilingly protests to-day, "everywhere I am known as the second-rate second-prize-winner." Of course, as is now architectural history, it was this second-prize-winning design which made the greatest impression and which, in distinction to the Gothicized first-award design, was to have such widespread influence on subsequent skyscrapers.

ALTHOUGH Saarinen was unfamiliar with skyscraper construction and had "to read up on it," the brilliant design represents a logical step. In all his buildings he had been trying to keep his vertical accents strong—"keep them from sinking in," his son says —and to maintain the silhouette of his soaring masses. In the Tribune Tower he achieved these ends. Although the design may look dated today, the simplification, the absence of a Gothic or Classical "icing," and the clear emphasis on structure were astounding innovations at the time.

If this spectacular design opened America's eyes to European architecture, it also stimulated the curiosity of the Finn about the land for which it had been projected. Saarinen and his wife were energetic travelers who had crisscrossed Europe many times. Now in 1923 Eliel sailed for America — and a few months later, believing the future for monumental buildings lay in this country, he summoned his wife and children.

When they first came to America, Saarinen was disturbed at the sight of people chewing gum and upset by his inability to make puns in the new language. What appalled him most, however, was the unsightliness of Chicago—the snarled traffic, the way buildings nudged each other, the disregard of the lakefront possibilities. He was depressed by the dismal slums he saw from the "El." Quietly, in his home in Evanston, he drew plans for remodeling the city. A year later, when he became visiting professor at the University of Michigan, he made another scheme for the transformation of Detroit. "I thought at that time that Detroit was the ugliest city in the United States," he remarked the other day, "but since then I have seen Atlantic City!"

THE idea of Cranbrook was conceived in 1925, when Saarinen met George G. Booth, publisher of The Detroit News. "Mr. Booth had lots of money, lots of land in Bloomfield Hills near Detroit and lots of interest in art," Saarinen explains. "He said buying old masters was just lining dealers' pockets and buying living art, you never knew what you were getting. So he wanted to work toward developing creative artists by educating children."

Booth was a medievalist, with a taste for the artsy-craftsy, but Saarinen helped guide him. Together they evolved the idea of an educational center and a place where artists could work together in the isolation they deemed desirable for creation. "In America, architects go to schools of architecture and forget architecture is only a shell to house the other arts." Thus the Cranbrook project began, headed by Saarinen until 1940. Today, the complex, inter-related buildings include boys' and girls' schools, dormitories, a science institute, church, departments of architecture, painting, weaving, ceramics, metal work, and a museum and library—the last two completed only eight years ago.

THE Saarinens have lived at Cranbrook since its beginning and Cranbrook acted as a catalyst in developing Eliel's great friendship with Carl Milles. The architect and the Swedish sculptor had known each other's work in their youth, but they met for the first time at a dinner party in Sweden in 1912, during the Olympics. "Milles had a big, big beard," Saarinen recalls. "The Saarinens were very kind, very elegant," says Milles.

In 1929 Milles accepted Saarinen's invitation to head Cranbrook's sculpture department. "I promised to be at Cranbrook three months every year," Milles says now, "but every sculptor knows—when he starts big things, he is glued on the spot until he is ready—and I am still here soon twenty years, next neighbor to Mr. and Mrs. E. Saarinen." During these years Milles designed the suave figures which dot the fountains, the shining pools and the cool green lawns at the Academy.

"We have been close friends," Milles says, "been arguing, been quarreling and through the years I have learned to know what it is like to be a stubborn, humoristic Finnish architect and man and what Finn friendship is."

"The Finns like to fight," Milles explains, "and like to show their superiority—which makes me sometimes think when I meet our admired friend Frank Lloyd Wright—that he must be a Finn, too."

SAARINEN and Wright are also friends, and in 1930 they traveled together to Rio to judge a competition. "He

is a sweet man underneath," Saarinen says. But the temptation to tease the temperamental American and to prick his carefully nurtured dignity is too great for the Finn to resist. He has a treasured store of Wright stories which he delights in telling. For example, he remembers the time Wright was asked to name the greatest modern architect and replied, "I am too modest to answer that." And Saarinen recalls that when his students reproached him for not having an august philosophy of architecture such as Wright has, he told them: "He is always Frank, but is he always Wright?"

"THE young people who love him," says Carl Milles, "round us always when we old men meet, all have a good time. There his great humor comes fully out." The students flock to the house in which, as Loja Saarinen says, "everything is 'home-made!'" Together they designed and created furniture, textiles, rugs, even the letter-opener. "My mother loves to give parties," Eero adds, "and people always ask for her recipes of the Swedish and Russian dishes which are the basis of Finnish cooking. And there is always schnapps or beer or something, because my father, like all Finns, is proud of his ability to drink."

There is often music at the Saarinen gatherings, but not jazz. "It is always good to try new things," Saarinen says, "but I agree with Sibelius that no one has yet made an art of all that discord." He doesn't like such modern painters as Picasso and Matisse either, but he defends modern art vehemently as an expression of our time and a search for new directions.

FATHER and son work together now in the firm of Saarinen, Saarinen and Associates—and one of the latter is Eero's wife, the sculptress, Lily Swann Saarinen. Of the many buildings on which they have collaborated, perhaps the best known are the Tanglewood and Buffalo concert halls and the Crow Island School at Winnetka, Ill. Today their styles are quite different, as the younger man's approach is less romantic. Their mutual respect, however, has never lessened.

When the telegram announcing the winning of the Jefferson Memorial competition arrived the family thought it was intended for Eliel. Two weeks later the mistake was rectified and the son was designated as winner. "It was fine: we just had an excuse for a second celebration," they say.

Saarinen works at home in the mornings and goes to the office around eleven or twelve. At lunch time he orders a dry martini and his wife a whisky sour, and then there is a sort of ritualistic discussion about whether he should have a beer. In the afternoon, he returns to his studio and to his students who work next door.

The sole course in his architectural department is city-planning. This subject (which is the theme of his first and influential book) characteristically interests him above all others.

"In 1899," he says, "I thought of city planning as an artistic problem—then it became a technical one—then a social one—then a mental one. You've got to change the mentality of the people. Maybe now there are too many politics and too many real estate interests. But you have to keep looking ahead. I'm a hopeful pessimist on the subject.

"Each student has such a town-planning project, usually for the place he came from—China, India, South America. One year," he adds, chuckling, "there was only one American and they called him a 'foreigner.' I guess he was—he came from Texas!"

"I don't teach: the students learn. We analyze, discuss, talk. We are good friends."

SAARINEN'S most recently completed job is the Des Moines Fine Arts Center, a building which shows his progression toward simpler, cleaner masses and toward a diminution of ornament. ("When I was young, I had to cover up lack of ideas with ornament," he says slyly.) When he went to Iowa for the Center's opening, Saarinen was awarded an honorary degree at Drake University, the latest in an impressive list of degrees, awards and honors.

Current projects include, besides the Milwaukee scheme, a church for Minneapolis, a civic center for Detroit, and a museum for Fort Wayne. Father and son will collaborate on these, although in each case one of them plays the major role.

Each job is a challenge. If these new buildings bring forth no revolutionary innovations, they will still mark the continuing development of one of our leading architects. "Once someone criticized me for being too romantic and many years later when I met him, he said, 'Forgive me, I was wrong.' By that time," Saarinen recalls, "I had changed, so I said, 'No, you were right.' Everyone changes and the romantic and the puristic come together—in Gropius, in Breuer, in Wright, all of us, always changing, always progressing."

*August 22, 1948*

# McKim, Mead, White: Their Mark Remains

### The architects' firm and its Renaissance glories still weather the test of time.

#### By WAYNE ANDREWS

THOUGH it isn't at all remarkable for a banking house to be older than a century, it is rather unusual for an architectural firm to outlast the lives of the original partners. For fashions in architecture, unlike the principles of sound banking, vary from generation to generation, and it's nothing short of astonishing that the famous firm of McKim, Mead & White has survived, with no apparent damage to its dignity, all the fads and fancies in building and decoration with

WAYNE ANDREWS is at work on a history of American architecture. He is on the staff of the New York Historical Society.

which we've been blessed (or cursed) since Rutherford B. Hayes was in the White House.

Now in its seventy-second year, the firm has just presented its archives—a matter of three or four tons of glass negatives, plans, specifications, elevations, and letters to and from patrons —to the New York Historical Society, which is opening, on Wednesday, a retrospective exhibition of over a hundred photographs and drawings. These date from the days when Charles Follen McKim, William Rutherford Mead, and Stanford White were out stalking their first clients to the work now in progress by the present partners, Lawrence Grant White, son of the late Stanford White, and James Kellum Smith.

TO summarize the achievements of the original partners and their successors in a single sentence is not the easiest thing in the world, for architectural history since 1879 is not any less complicated than political history, but any architect could tell you that McKim, Mead and White have long been conspicuous for their devotion to the ideals of the Renaissance. Agreeing with Edith Wharton that architecture and decoration can be set right "only by a close study of the best models"— models "chiefly to be found in buildings erected in Italy after the beginning of the sixteenth century, and in other European countries after the full assimilation of the Italian influence"— the members of the firm have never been happier than when designing in the Renaissance manner. It is in that style that they have created most of the Manhattan landmarks on view at The New York Historical Society and it is to that style that they have remained faithful down to the present time.

Even the most casual visitor to the exhibition will be confronted by so many familiar facades that he will be

likely to wonder how other New York architects managed to earn a living, especially in the early days when the partners were eagerly bidding for the magnificent commissions on which they based their reputation. While it is true that old Madison Square Garden has been razed, and the Madison Square Presbyterian Church as well, New Yorkers will probably be living in the shadow of McKim, Mead and White for centuries to come, so vast is the evidence of the firm's activity. The babies having their first good cry at Bellevue Hospital, the commuters plodding home through Pennsylvania Station, the professors doing their level best to educate the coming generation at Columbia University, the postmen reporting for duty at the General Post Office, the out-of-towners checking in at the Statler or Savoy Plaza Hotels, all of them, like the clubmen biting into their cigars in the quiet of the Harvard, University, Metropolitan and Century Clubs, have McKim, Mead and White to thank for the stage set on which they act out a great many scenes of their daily lives.

FROM what has already been said, no one will be amazed to learn that McKim, Mead and White have enjoyed the greatest prestige of any architects in our history, and exerted an influence that anyone can estimate by counting the cornices in his home town. Whether this influence has been for good or evil is a question that is sure to start a row in almost any drafting room, for the laws of taste have never been formulated in as definitive a form as the Ten Commandments, and arguments pro and con the Renaissance have been bitter enough to break up old friendships.

In the eyes of the older generation of American architects, those who were overcome in their youth by the splendor of the Chicago World's Fair of 1893, and impressed in their middle age by the magnificent vistas opened up by the revival of L'Enfant's plan for Washington, both of which projects were carried out under the energetic leadership of Charles Follen McKim, the founders of the firm we're discussing are no less than gods on earth.

ON the other hand, certain modern architects, and Frank Lloyd Wright is one of them, feel that the Renaissance tradition, with its emphasis on symmetry and perfection of proportion rather than structural dynamics, has been no more beneficial to humanity than the bubonic plague, and would have us believe that any and all practitioners in this style in the United States are no better than typhoid carriers. Perhaps the most savage critic of McKim, Mead and White was the late Louis Sullivan, who grimly prophesied that "the damage wrought by the

## 'ARCHITECTS: McKIM, MEAD AND WHITE'

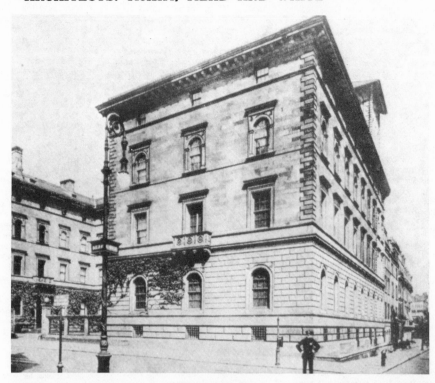

The Villard Houses

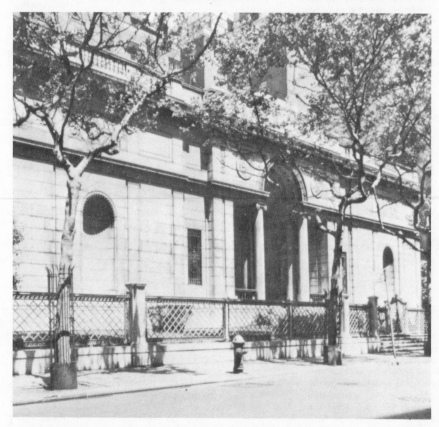

The Pierpont Morgan Library

World's Fair will last for half a century from its date, if not longer."

Since 1943 has already passed by, there is no point in wrestling with Sullivan's charges at the moment, but there is no reason why we should deny ourselves the fun of guessing what will be the ulti-

mate verdict of history on the work of McKim, Mead and White. More than likely the ultimate verdict will lean, as such judgments usually do, neither to the left nor to the right, pleasing neither the radicals nor the conservatives. Not every building the office produced has been a masterpiece, a statement with which the partners past and present would probably be the first to agree, but nevertheless the quality of the designs has been surprisingly high, no mean achievement in view of the enormous amount of work for which the firm has been responsible.

MOREOVER—and this is something that may startle an earnest modernist—the story of modern architecture in America is only half told if the early work of McKim, Mead and White is not given its due consideration. In the first eight years of the firm's history, from 1879 to 1887, the partners, who had not yet fallen completely under the spell of the Renaissance, were famous for their personal, inventive solution of the problem of the summer or seaside house. Fascinated by the timeless appearance which shingles, stained or unstained, gradually assume, McKim, Mead and White created a number of casinos and villas large and small in this "shingle" style, which deserves to be remembered long after the last lecturer has explained the whys and wherefores of the modern movement. These early triumphs have not been overlooked by the New York Historical Society; perhaps the most modern of all those on exhibit is the former W. G. Low house now opened by Paul C. Nicholson at Bristol, R. I., whose daringly simplified triangular facade must be credited to McKim himself.

WE shouldn't forget that these miracles occurred at a time when architectural taste was almost as frantic as the floor of the Stock Exchange at the eleventh hour of one of Jay Gould's battles with Commodore Vanderbilt. Contractors were blissfully lining the streets of Manhattan with brownstone fronts, and conscientious young architects didn't know which way to turn, whether to flatter the millionaires in the Saratoga set by adding to the number of mansard-roofed villas in the "Second Empire" style or to seek out the "artistic" clients who fancied the gingerbread effects which fill us with such horror today.

As one might imagine, the three young men who performed such feats in these trying years were not only supremely sensitive but superbly trained. No doubt the best prepared of the three, and certainly the most purposeful was McKim, who may have inherited his dogged streak from his father, an Abolitionist notorious in his day for his skill in smuggling runaway slaves across state lines. No lackadaisical student either at Harvard or at the Ecole des Beaux Arts, young McKim made up his mind on his return from abroad to talk H. H. Richardson into a job, and in this he had no particular trouble, for once his mind was made up, he was irresistible. The opportunity was priceless, for Richardson was the greatest American architect of the time, the genius who forced a generation to admire the beauties of simplification in masonry construction, and at that very moment was laboring over the drawings of Trinity Church, Boston, the masterpiece which launched the romanesque revival.

Like McKim, Stanford White was privileged to serve as one of Richardson's draftsmen at

**Front elevation of Mrs. W. K. Vanderbilt Jr.'s home, now razed.**

the time of the building of Trinity Church, but while McKim was a cautious, reflective soul, White was ever imaginative and enthusiastic. The son of Richard Grant White, a literary critic who teased the Tweed Ring, doted on the violin and published what once looked like the definitive edition of Shakespeare's plays, young White was no less versatile than his father. On a minute's notice he could design a necklace sure to create a sensation in the most crowd-

ed ballroom, a picture frame fit for the portrait of an exquisite beauty, or a magazine cover for thousands to spot in the newsracks; he was responsible for the covers of Scribners, The Century and the old Cosmopolitan. He might have been a painter, and his eye was quick to detect the picturesque accents in almost any landscape, whether in France, which he reveled in visiting with his good friend, Augustus St. Gaudens, or on the New England seacoast, which he and McKim and Mead explored in 1877, sketching on their way the then utterly neglected remains of our Colonial architecture.

William Rutherford Mead, who lived on until 1928, nineteen years after McKim's death and twenty-two years after White's, once snorted that it took all his time to keep his partners from "making damn fools of themselves," and it was true that he was the level-headed member of the firm, the man who could argue McKim out of an obstinate mood or pop up with a sensible suggestion when White was overly optimistic. The brother of the sculptor Larkin Goldsmith Mead and the brother-in-law of William Dean Howells, Mead earned his own reputation for what Stanford White's son has called "that instinctive sense of scale and proportion which makes the development of the elevations follow naturally and logically from the plan."

LONG before the firm was founded, he personally inspected the evidence of the Renaissance, having decided, shortly after he was graduated from Amherst, that it would be a smart idea to spend a year and a half with his brother in Florence. No doubt Russell Sturgis, the architect in whose office he was then a draftsman, shook his head sadly over the young man's decision. Sturgis, who eventually abandoned the practice of architecture for the pleasure of writing architectural history, was so extravagant in his admiration of the Gothic tradition of structural integrity that he never could conceal his contempt for what he believed to be the false gods of Florence, Rome and Venice. One of the first critics to hail Louis Sullivan's skyscrapers, whose superb expression of function he could not help comparing with the functional cathedrals of the Middle Ages, he naturally insisted that the early work was the best of

McKim, Mead and White.

What Russell Sturgis forgot, and what too many enemies of the Renaissance tradition have overlooked, was that no architect since the beginning of time created a more splendid setting than Bramante, Michelangelo, Palladio and the other leaders who spread the Italian gospel through the world. Splendor may not be the essence of architecture, but it is by no means an undesirable characteristic, and the buildings which won McKim, Mead and White their greatest fame were splendid indeed.

WHAT'S more, it is time the legend was exploded that the major achievements of McKim, Mead and White and the other traditional architects were just so many dead and dignified replicas. Architecture made easy in ten lessons won't explain the success of McKim, Mead and White or of the other great eclectics who drew their inspiration from the past. While it is safe to say that they usually ignored the challenge of new materials such as steel and concrete, they were not mere plagiarists but rather artists inventing in an old and established style.

ANYONE who wishes to check the truth of this would do well to take a look at the Villard mansion or mansions, the complex of six houses which McKim, Mead and White completed in 1885 for Henry Villard and his associates and which is still standing intact on Madison Avenue between Fiftieth and Fifty-first Street, the north end now occupied by Random House and the remainder by the Archdiocesan headquarters of the Roman Catholic Church. The very first design of the firm to be inspired by Italian precedents, it is as useful an example as any other to disprove the charge of pilfering the brains of the illustrious dead. Though it has sometimes been assumed that the Villard group was a reproduction of the Cancelleria Palace in Rome by Bramante, anyone who takes the trouble to compare the two will be more amazed by the difference than by the resemblances, and will end by agreeing that this is no copy but a palace, and a magnificent palace, besides, in the Italian manner for the particular needs of an American railroad king.

If we go on playing the game of checking the supposed replicas with the originals, we may begin to wonder

whether certain critics have not been unduly eager to write off McKim, Mead and White as figures of no consequence in the history of American architecture. For if the old Tiffany Building on Fifth Avenue and Thirty-seventh Street is not exactly like the Cornaro Palace in Venice, the University Club on Fifth Avenue and Fifty-fourth Street is much more than an imitation of either the Strozzi or the Riccardi Palace in Florence. As for "Rosecliff," the old Oelrichs showplace at Newport, while obviously reminiscent of the Grand Trianon at Versailles, far too many freedoms have been taken for it to be judged a facsimile.

This talk of palaces, this mention of Versailles, forces one to remember that McKim, Mead and White could pick and choose their clients, who were usually the wealthiest of the wealthy in a day when the rich weren't ashamed to spend their incomes. This meant that the partners could do pretty much what they pleased without worrying over things like building costs, and J. P. Morgan is known to have complained that the Morgan Library wasn't really his but McKim's. Now and then, however, a client was startled into indignation over the expenses involved in dealing with a genius like Stanford White. Col. Oliver H. Payne, for instance, was appalled at the bill for decorating the town house of his nephew Payne Whitney, a situation which called for all the tact at White's command.

"I know," he wrote Colonel Payne, "that all kinds of small extras have crept in and that the changes I made in the treatment of the smaller rooms have added over a hundred thousand dollars to the price of the house, and I have dreaded to speak to you about it until the house was far enough finished for you to see the result, as, although I feared that you would be angry at first, I thought if you saw the money had been wisely spent and that I have given Payne and Helen a house to live in which was really of the first water and could stand in beauty with any house in the world, that you would forgive me and I believed in my heart that you would in the end approve of what I had done, but your saying to me yesterday that you could not see where the money has gone has taken all the sand out of me and made me very unhappy, for I know from the character of the work and in comparison with other houses that it is not extravagant. However, I must not say more until you receive and go over the accounts to-morrow, but I am sure you will not find it as bad as you think."

WE must hope that Colonel Payne didn't find it as bad as he thought, for Manhattan would be a drab island without the splendid evidence of Stanford White's career. In fact, New York City minus McKim, Mead and White would be as poor a thing as a parade without banners.

January 7, 1951

# Pioneer of Modern Architecture

**Long before World War I, Louis Sullivan, Frank Lloyd Wright's 'beloved master,' set a pattern for our builders to aspire to today.**

By ALINE B. SAARINEN

THE fact that Louis Sullivan was born 100 years ago furnishes an additionally cogent reason for bringing public recognition to a man who, though justly called "the father of modern American architecture," is but vaguely known outside the architectural world. There are some who remember uncertainly that he declared that "Form follows function," and that in some way he gave artistic form to the skyscraper. Others recall that as the "beloved master" he is the only architect besides himself whom Frank Lloyd Wright admires. A few, whose memories go back, recollect vaguely that beside the cold-cream whiteness of the neo-classical buildings at the Chicago World's Fair of 1893, there was Sullivan's Transportation Exhibit Building, a bold, original, colorful edifice with a glistening, ornamented entrance called "The Golden Door."

Now, in Sullivan's centennial year, the Art Institute of Chicago—the city from which his fame spread—is holding a handsome retrospective exhibition with spectacular twelve-foot-high, black-and-white photographs, huge color projections and other visual materials to explain him. The exhibition could not have come at a better moment. Our contemporary architecture, now maturing beyond the doctrines of "purist" modern, is ready for the thoughts and works of Louis Sullivan.

ALINE B. SAARINEN is an associate art critic for The New York Times.

Louis Sullivan, second son of an Irish dancing master and a musically accomplished Swiss mother, was born in Boston and early displayed a flair for drawing—especially flowers and plants —a questing mind and a headstrong will. At 16 he spent an impatient year at M. I. T., then talked his way into a progressive architectural office and, in 1873, pushed on to Chicago to join his family.

He had come to the right place at the right time. Two years after the Great Fire, Chicago was still a wasteland of rubble and ashes, although recovery had started and building was booming. As Hugh Morrison, Sullivan's biographer, points out, architects' output was being measured by the mile. But along with those who were simply turning out "first-class front," there were engineers experimenting with the new steel skeleton and new pier footings, and architects searching for forms new and appropriate to America.

ELSEWHERE in America, architecture was mostly a formula built of historic styles. Some men were arriving at brilliant, personal solutions (which we are perhaps still too nearsighted to appreciate fully), but even these were based on past styles. Only in Chicago was there an opportunity to try out the revolutionary ideas of structural expression which men like Viollet-le-Duc were sounding elsewhere in the world, and to try to build a new architecture for America.

Sullivan was entranced. He found in all this "a crude extravaganza, an intoxicating rawness, a sense of big things to be done * * *." He landed himself a job in the thick of it all, in the office of Major William LeBaron Jenney, one of the first men to build a steel-frame skyscraper.

His enthusiasms were jelling. He was associating with engineers and prying into the possibilities of structure. The ideas of organic growth, which he was avidly absorbing from the works of philosopher Herbert Spencer and botanist Asa Gray, both stanch evolutionists, were becoming the basis of his architectural thinking. His moment arrived when, in 1879, he went to work for Denkmar Adler, a brilliant engineer whose practice and prowess were already well established. Within a year, the lettering on the door read "Adler and Sullivan."

In talents and personalities, the 36-year-old engineer and the 24-year-old designer complemented each other splendidly. According to Frank Lloyd Wright, then a lanky 18-year-old from Wisconsin, who joined them as a draftsman in 1888, Adler was "a personality, short-built and heavy like an old Byzantine church * * * one to inspire others with confidence in his power at once." Sullivan was a man with "a haughty air * * * [whose] very walk at this time bore a dangerous resemblance to a strut," a man with glinting brown eyes, elegant clothes and a carefully trimmed brown beard.

He was always arrogant, assured and egocentric. Except for another Chicagoan, John Root, he held all archi-

tects in contempt. He liked to lecture, especially to a single listener. In restaurants, in bars and after dark in the office he would deliver wordy monologues to young Wright on Wagner, on Whitman, on Spencer. Some, like Wright, would recognize beneath the imperiousness "the rich humor," but even he found some of his master's turgid prose "a kind of baying at the moon."

THESE were Sullivan's days of glory. During the fifteen years from 1880 to 1895 he became the most famous of the progressive architects, the most original designer of his day. He disdained completely the precedents, rules and false fronts of the historic-style architecture of the time. He developed a language of form and ornament which, based on his ideas of organic growth, grew from the building's structure, function and spirit.

There were plenty of opportunities. In 1886, for instance, the firm received the most gigantic commission of the time—the great Auditorium Building which, with an opera house to seat over 4,000, a hotel, a bar, ballrooms, offices and so on, was a sort of cultural-commercial civic center ultimately to encompass 8,737,000 cubic feet. The building was an engineering and architectural triumph. Adler achieved an acoustical miracle. Sullivan enhanced the building everywhere with an exuberant use of color and gold ornament. These flowing, virile forms, personal as handwriting, were new and eye-filling, completely unlike the rigid, conventionalized ornament of "correct" architecture.

COMMISSIONS poured into the office—theatres, clubs, office buildings, warehouses, railway stations, houses, monuments. The skyscraper was becoming familiar in America, but architects had not yet faced this new symbol of American free enterprise. Seemingly embarrassed by its height and its structure, they simply piled up layers of Classical or Renaissance-type palaces or, as Sullivan said, "threw up a swaggering mass of Roman remnants."

In the skyscraper, this "new thing under the sun," Sullivan proved his greatness. For in St. Louis' Wainwright Building of 1891—and in many others, especially the Guaranty Building in Buffalo—he gave artistic form to the skyscraper. What seems a commonplace today was then a radical move. What Sullivan did was to recognize that a commercial building could have a beauty and dignity of its own. Beginning with what he termed a "thoroughly sound, logical, coherent expression of the conditions," he then heeded "the imperative voice of emotion." The chief characteristic of the tall building, he said, was its loftiness. It must "be tall. The force and power of altitude must be in *(Continued)*

Louis Sullivan in 1899, at the age of 43.

**SPECIMENS OF THE SULLIVAN STAMP**

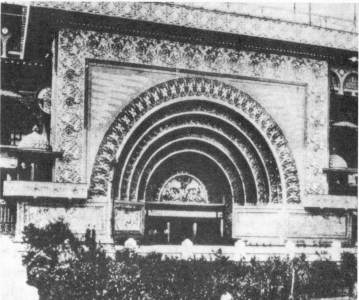

"THE GOLDEN DOOR," 1893—Sullivan's Transportation Building was a notable protest against the official white-plaster neo-classical style of the Chicago World's Fair.

BANK, COLUMBUS, WIS., 1919—Refuting neo-classical styles, Sullivan used dark red brick, green-blue terracotta ornament and stained glass to make the bank a little "jewel box" suited to function.

it. * * * It must be every inch a proud and soaring thing, rising in sheer exultation that from bottom to top it is a unit line * * *."

HE faced a new problem and solved it in its own terms. He gave the structure expression and articulated it with his brilliant ornament. The vertical continuity and emphasis, which were so widely followed, were born in these buildings. The office of Adler and Sullivan and the whole "Chicago School"—much of it under their influence—was riding high. However, principally because of the untimely death of John Root, the power over design for the World's Fair fell to eastern architects, including the classically minded McKim and Hunt. Thus, the grandeur that was Rome rose in glistening white plaster on the lagoons by Lake Michigan.

Sullivan still triumphed personally. His Transportation Exhibit Building treated plaster frankly as an ornamental surface for color and gilt. It was a building wholly appropriate to a fair. His fame crossed the Atlantic. At home, the expensive splendor of the neo-classic style impressed a nouveau-riche nation not yet culturally mature enough to trust itself.

The fair had opened despite the panic of 1893, but the economic depression was deepening. The building business was hard hit. By 1895, commissions, even for Adler and Sullivan, were thinning out. Adler, with a family to support, desperately went into business. The partnership was dissolved in bitterness.

Only a combination of causes can explain the dismal decline of Sullivan's subsequent years. The depression was the major one. The loss of Adler—who won confidence of client and contractor alike and smoothed the way for the recalcitrant designer—was another. The fact that Sullivan's late marriage (in 1899) was a failure did not help the situation. Always addicted to coffee and alcohol, he began to drink to excess. Moreover the fashion for the historic styles was now in full swing.

"In the fifteen years between 1880 and 1895," says Hugh Morrison, "Sullivan had designed more than 100 buildings. During the nearly thirty years that remained of his life he built only twenty." One of them was the Chicago department store now known as Carson Pirie Scott, with a handsome, cage-like facade framing big windows and elegantly feminine ornament festooning its lower floor. But the few other commissions were tiny.

Among them were small-town banks in Minnesota, Iowa and Wisconsin. Sullivan had always derided a modern "banker sitting in a Roman temple," and suggested that he should wear a toga, not a business suit. Now he had his chance to give banks a contemporary character. Suited to their function, these small buildings of dark, reddish brick, green-blue terracotta and stained glass are, as he called them, "jewel boxes."

THEY drew critical praise but no big jobs. Drink, dissipation and poverty took hold. Draftsmen around Chicago and former pupils remember lending Louis Sullivan "a buck." But Sullivan still knew his worth. As John Swarkowski relates in a new book on Sullivan, when the owner of a Wisconsin bank worried that the cost of the building would bankrupt him, the architect said loftily: "Just remember; you will have the only Louis Sullivan bank in the state of Wisconsin."

Nor did he lose his architectural convictions. He turned more and more to writing. "Kindergarten Chats" are a treasure of his philosophy. His last years were spent on ornamental plates and "The Autobiography of an Idea." As he lay dying in 1924, he looked on these books, just off the press, as consummations of his work.

WHAT is the meaning of Louis Sullivan to architecture today?

On the one hand, he remains the prophetic pioneer who fought vigorously for many things which have become primary disciplines—if not overriding esthetic principles —in our architecture. The battle against historic eclecticism is long since won. If he were to return today, he would be surprised that few young architectural students can draw an Ionic capital and that even conservative church and school boards rarely demand buildings in imitation of past styles. Sullivan would be astounded, too, to see that commercial and industrial buildings are not only considered respectable themes for architecture, but that it is in this genre that modern architecture has made its widest— and perhaps its best—contribution.

More significantly, he would be astonished to see how commonplace his conception of honest expression of structure has become. The dramatization of the structural-steel frame and the creation of glass and panel curtain walls, which are literally what their name implies, have proceeded

to a point which he, relatively tentative in his own expression of structure, could barely have envisioned. He would find it surprising that this dramatized expression of structure has, in many cases, become an esthetic end in itself.

BUT if he is a herald of some of our proudest victories, he is also a man whose theory and practice jolt us into an awareness that the victory is as yet only a partial one. For, in different guises, many of the aspects and attitudes against which he fought are still prevalent today.

There was a time, shortly after his death, when his famous phrase, "Form follows function," was given a limited, perverted meaning and was used as a sort of slogan for the "functionalists." In oversimplified terms, they believed that if one paid strict attention to "function," primarily in the narrow sense of use, the resultant form would automatically be architecture.

Today, we are no longer "functionalists" in the sense that we believe that the mere fulfillment of utilitarian considerations produces great architecture ipso facto. Nor do we allow these considerations to override esthetic ones. But we are still far from understanding "Form follows function" in Sullivan's profound sense. For him, function meant what a thing is, "its inner life, its native quality" and form meant its physical counterpart, its visible image. Thus, we come face to face with the whole problem of expression, the aspect of architecture which is at the root of his philosophy and the one in which we today are weakest.

Louis Sullivan was worried, for example, that there were "libraries that might be mistaken for banks, hospitals that might be mistaken for hotels * * *." The style is modern now, but he might well still worry. There is still a tendency toward empty formalism. We are in danger of falling into an almost academic architectural vernacular which is applied regardless of the content and circumstances of the building. The glass-steel-aluminum idiom and the hyperbolic-parabaloid concrete idiom give buildings a "new look." But a hospital could be a hotel, an art gallery a warehouse, a college dormitory an office building. This kind of anonymous interchangeability denied for Sullivan the whole purpose of architecture. A building, he believed, should express wholeness of purpose and spirit. "What the people are within, the buildings express without," he said. And,

"Every building tells its own story, tells it plainly."

NOT only were houses, mausoleums and skyscrapers separate problems for Sullivan, but each was a challenge dependent on a hundred particular conditions. "Every problem," he said, "contains its own solution. Don't waste time looking anywhere else for it." Today, when so much architecture is turned out by the module or by the slab, his words might well be heeded.

Sullivan, enthusiastic about

Detail from the Sullivan-designed Guaranty Building, in Buffalo.

ornament and exuberant in his use of it, was still farsighted and candid enough to admit that "It would be greatly for the esthetic good if we should refrain entirely from the use of ornament for a period of years, in order that our thought might concentrate acutely upon the production of buildings well-formed and comely in the nude."

This happened. Indeed, one of the reasons that buildings today are "well-formed" is because architecture subjected itself to the violent therapy of stripping down to essentials in order to see freshly and find contemporary design.

BUT we are beginning to tire of the nude, however comely. It begins to seem a little stark, a little monotonous. We are beginning to crave variation. We are eager for the delight of color. We feel a need for small-scale elements that help us relate ourselves to the bigger architectural scale. Indeed, we are even daring to shed our purism to the extent of looking for the symbolic, expressive aspects of enrichment. However beautiful the chance reflections of clouds on glass facades, they do not seem enough.

Sullivan's ornament was intensely personal, a marvelously imaginative calligraphy of botanical forms. Like the ornament devised by other experimental architects of his time in America and abroad, it was a defiant gesture against the conventionalized, lifeless formulae.

He thought of it as part of the total expression, an organic outgrowth of the building. Although he said the "mass composition" gave the more profound expression, the decorative ornamentation gave the "more intense" expression. His use of ornament was, as he put it, a thing expressive of the spirit of the structure, as much a part of the whole as leaves to a tree.

The forms of his ornament are no model for today. They belong to him and his time. Even the way in which he used ornament will not always seem sympathetic to contemporary architectural concepts. But it is not in the ornamental forms themselves nor in their particular use that Sullivan makes his challenge, but rather in the fact of their existence and their effect as intensifying and electrifying elements of architecture.

That modern architects are beginning to seek this extra quality of enrichment is pointed up by a few examples in the exhibition. The way is not easy. There is no direct tradition on which they can build in their search for ornament as organically related to their art as Sullivan's was to his. So far their attempts are feeble. Perhaps his challenge will intensify their effort.

SULLIVAN'S greatest pertinence today is a general one. In our time, when building is booming and much architecture is merely something turned out by cliché or to make money by filling the zoning envelope, and when a city like New York can make of its great Coliseum a grossly undistinguished specimen of architecture, it is valuable for public and profession alike to be reminded that architecture is not a "prescription to be filled at any architectural department store," but art which can express the whole of life.

More than any other single person, Louis Sullivan's talented young draftsman from Wisconsin has kept his master's theories alive, both in his own practice and in words rather similar in their rhetoric and the arrogance of their delivery. The manner of Sullivan's and Wright's work belongs to themselves. But the message and matter that impelled that work have such potent meaning for architecture today that if they are not at least faced we will be the poorer.

October 28, 1956

# Use of Reinforced Concrete Lends Buoyant Look to Weighty Structures

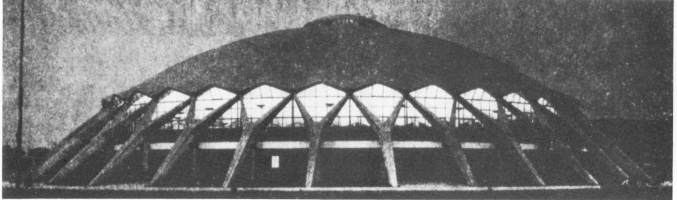

This is the Palazetto, one of the three stadiums built by Pier Luigi Nervi, Italian engineer, for the 1960 Olympic Games in Rome. The structure, of quick-hardening reinforced concrete, has circular vaulted roof spanning a diameter of 194 feet. It was erected in forty days. At left is its interior, a broad expanse with unobstructed views.

## ITALIAN ENGINEER OPENS NEW PATHS

### Pier Nervi's Work Receives Attention Here—Long Noted in Europe

**By THOMAS W. ENNIS**

Reinforced concrete as it has been used by an Italian engineer has opened the way to a new new and spectacular architecture.

The engineer is Pier Luigi Nervi of Rome. He believes that reinforced concrete is the "finest material man has found to this day." It is, he says, "a living creature which can adapt to any form, any need, any stress."

His work, which is influencing a number of today's leading architects was recently the subject of a photographic display at the Architectural League, here.

This was the first major exhibition of Signor Nervi's work in this country and was especially prepared by him.

Beginning in September the exhibition will be shown in cities throughout the nation over a two-year period under the joint sponsorship of the American Federation of Arts and the Architectural League.

Concrete has the resistance of rock, but under stress in bending it can break and crack. If it is to span a large space, it must be reinforced, and this is done by placing steel rods in the concrete.

### Advantages of Material

The reinforced concrete, Signor Nervi says, then becomes "melted stone," which can be molded into any shape and yet be used to perform any structural task, for it combines the plasticity of concrete with the strength of steel.

Reinforced concrete has been used for many years by archi-

tects and engineers in the United States and abroad, but no one, it appears, has used the material with as much originality as Signor Nervi.

Building elements of reinforced concrete, like steel, may be prefabricated. Thus it is possible to build with great speed, economy and ease.

Reinforced concrete is especially practical in Italy, where most of the Nervi-designed structures are built, because steel and wood are scarce and expensive there.

For example, in a series of aircraft hangars built in Italy during World War II, Signor Nervi used precast reinforced concrete structural members as if they were steel girders.

Normally, the concrete would have been poured into place in framing that would have required numerous supports. Signor Nervi used the precasting method primarily to save critical materials. He reportedly saved 30 per cent on steel; 35 per cent on concrete; and 60 per cent on form lumber.

During World War II, Signor Nervi perfected a new building material that he calls "ferro cemento." It is a quick-hardening and extremely durable concrete reinforced with fine steel mesh rather than with steel rods. It can be cast in sheets one-half to three-eighths of an inch thick.

Allan Temko, architectural historian, in the current issue of Horizon magazine says in an article on Signor Nervi that ferro cemento is one of the most versatile building materials yet devised by man.

Precast ferro cemento building elements have been used to erect Signor Nervi's latest, and perhaps finest, structures, which were designed in collaboration with first-rate architects.

The material as used by Signor Nervi is as powerful as steel, and it has made possible buildings with an enormous roof span that also display lightness and grace.

A latticework of intersecting concrete beams compose the roofs of many of Signor Nervi's structures. The device seems to be his trade-mark.

### Florence Stadium Cited

His work in reinforced concrete from the start of his career forty years ago includes, in addition to hangars, exhibition halls, factories, stadiums, and even a sailboat with a hull made of a half-inch covering of ferro cemento.

A stadium completed in 1932 in Florence established Signor Nervi's world-wide reputation and set the pattern for the rest of his work.

Around a playing field 660 feet long, about twice the length of a football field, he erected stands that basically are continuous flights of steps. The steps serve both as beams and seats. They are supported at intervals by rising diagonal braces that in turn are mounted on pillars.

A roof is cantilevered seventy-five feet into space above the main grandstand, providing shelter without marring an un-

*Courtesy Museum of Modern Art*

Signor Nervi's stadium in Florence, opened in 1932, established his reputation and set pattern for his later work. The roof is cantilevered seventy-five feet into space above the grandstand. The seats also act as beams and are supported by rising diagonal braces.

*Vasari, Rome (Courtesy Museum of Modern Art)*

One of his World War II airplane hangars in Italy showed handling of precast concrete as if it were steel. Signor Nervi reported the technique saved on critical materials.

obstructed view of the playing field.

In 1935 Signor Nervi was commissioned to design a number of hangars for the Italian Air Force. The structures have had a continuing influence on modern architecture.

The hangers were immense —330 by 130 feet—and the area was covered by a lattice-work of reinforced concrete. These hangers and several structures later designed by Signor Nervi were destroyed by the Germans in the war.

One of Signor Nervi's most famous buildings is the automobile and industrial exhibition hall erected soon after the war in Turin, Italy's Detroit. He won the commission by inventing ways to prefabricate economically most of the structure in reinforced concrete.

The main exhibition hall, all space and light, is 320 feet wide and 246 feet long. It is covered with a corrugated barrel-vault ceiling made of precast glazed ferro cemento segments.

At one of the main halls is a rotunda, built like another room, 132 feet in diameter.

Signor Nervi also has collaborated in the design of the UNESCO headquarters recently completed in Paris, which has been described as one of the most exciting architectural commissions of the century. The

collaborating architects were Marcel Breuer of the United States and Bernard Zehrfuss of France.

In association with the Italian architect, Gio Ponti, Signor Nervi designed the new thirty-story Pirelli skyscraper in Milan. Reinforced concrete was used, since structural steel for a building of that size would have been prohibitively expensive in Italy. The building, however, has curtain walls of glass.

Now at 68, Signor Nervi is executing his first big projects in Rome — three stadiums for the 1960 Olympic Games.

These are, such critics of architecture as Mr. Temko say, the most splendid ensemble of structures ever built for sporting events. Signor Nervi's son, Antonio, and Marcello Piacentini were the architects collaborating in the design.

The largest of the stadiums is an arena for field events that will hold 50,000 spectators. 8,000 of them under a shell roof of prestressed concrete cantilevered outward above the central stand.

The two other stadiums are entirely covered. The smaller of these, called the Palazzeto, will seat 5,000 for wrestling or boxing matches and 4,000 for tennis and basketball. It has

a circular vaulted roof of precast ferro cemento spanning a diameter of 194 feet. It was erected in forty days.

The larger of the two stadiums is the Palazzo, and is nearly completed. It will seat 15,000 persons. The amphitheatre is walled by curving expanses of glass, and is covered by a dome some 300 feet in diameter, one of the largest in the world.

Reinforced concrete was first used about 1850 when Joseph Monier, a French gardener, built thin-walled concrete tubs, tanks and garden pots with metal reinforcement. Monier was granted his first patent on a system of reinforced concrete in 1857, but his method was not put into general use until about 1880.

Research by the Portland Cement Association finds that among the most important early reinforced concrete patents was one issued in 1877 to Thaddeus Hyatt, an American lawyer and inventor. The theories advanced in his patent applications were based in part on laboratory tests of reinforced concrete beams. The principles derived from these beam tests strongly influenced the development of reinforced concrete construction.

April 19, 1959

# FUTURE PREVIEWED?

## Innovations of Buckminster Fuller Could Transform Architecture

### By ADA LOUISE HUXTABLE

THE world of tomorrow is here today at the Museum of Modern Art. Three revolutionary structures by R. Buckminster Fuller —a "geodesic dome," an "octet truss space frame," and a "tensegrity mast." (Mr. Fuller's inventive engineering is equalled only by his inventive vocabulary)—will share the museum garden with the lovely ladies of Maillol and Lachaise through the winter months. Mr. Fuller's space frames and enclosures represent the greatest advance in building since the invention of the arch. Their building at full size in the heart of Manhattan, is splendid showmanship in the museum's tradition — a tradition that has seemed a little tarnished lately. This is an exhibition with the museum's old flair; a superior blend of the startling and the significant, for a lively presentation of the latest frontiers of art.

Under the enthusiastic supervision of Arthur Drexler, director of the Department of Architecture and Design, these strange structures have been taking shape for the past month.

Both the concept and the method of construction of Mr. Fuller's work are new. By utilizing the forces of tension and compression that are present in all structure, but by doing so in an unusual way, he has invented a new kind of building. The solid, right-angled post and beam that have been the accepted basis of architecture since the beginning of shelter are supplanted by constructions of tetrahedrons (four-sided pyramids) and octahedrons (eight-sided figures), creating lacy frameworks of the widest versatility. Mr. Fuller claims that these are nature's building forms, the efficient shapes of crystals and atoms. Unlike familiar, straight-line construction, these forms can grow in any direction (he calls them "omnidirectional") for an infinite variety of unconventional space-spanning shapes and enclosures, of equally unconventional appearance. Lighter and stronger than any other structures yet conceived, they enclose maximum area with minimum use of material, and they have an unlimited practical potential.

The "geodesic" dome ("geodesics" is a Fuller-term for his patented system of tetrahedron constructions based on his own 'energetic-synergetic" geometry) is a three-quarter sphere in greenish plastic, fifty five feet in diameter. It is composed entirely of triangular and diamond shaped sections, bolted together on the site. These sections, or pans, form the building's complete surface and support; skin and skeleton are one.

The 100-foot-long "octet truss," constructed of aluminum tubes, is an extraordinarily flexible building unit capable of extension in many directions, with supports placed almost at will. What can be seen at the museum is a kind of sample super-skeleton; it would be formed to purpose and finished with an outer skin. Construction of airport hangars, shopping centers, sports arenas and factories could be radically altered by its use.

The "tensegrity" mast is a dramatic aluminum and monel column, a purely theoretical demonstration of Mr. Fuller's most remarkable innovation: a system in which the basic load-carrying structure is a lightweight tensile net, totally isolated from its compression rods. Because it utilizes tensile power, which is so much greater than compressive power, this system has unprecedented strength. Its rigidity increases, rather than weakens, as it grows larger; actually, the thirty six foot mast could be built to any height. This accomplishment reverses the history of architecture to date which has been a step-by-step struggle against the strength limitations of buildings of increasing size. It presents truly astounding possibilities. It could mean building in miles, instead of in feet. Whole cities could be covered by domes; entire geographic areas could be roofed over; theoretically, we could build to the moon.

### Architectural Implications

Undoubtedly, this is exciting and astonishing engineering. But its meaning as architecture is even more notable.

To those concerned with architecture—and this includes the artist, the technician, and the layman who lives with it—the horizons opened stagger belief. Looking far ahead, the museum visualizes a fantastic new world. "This changes all of our notions about architecture," says Mr. Drexler.

"Buildings might no longer be a series of separate boxes, with people moving from one to the other. These infinite clear spans suggest a new kind of shelter—vast domes enclosing entire communities, permitting continuous control of the environment. In effect, the city would be one building, with its necessary functions accommodated quite differently than they are today. We could climate-control and reclaim whole areas of the Sahara, or of the Arctic. We would have to re-think architecture as we know it now."

### A Problem Unsolved

Even the immediate, practical application of these structures requires some architectural rethinking. Capitalizing on this efficient and economical engineering for specific needs, like an auditorium or an arena, creates unsual problems. Mr. Fuller's domes rest uneasily on their architect-designed foundations; the substructures, entrances, and other necessary additions are always at esthetic odds with the engineering forms. Like oil and water, radical engineering and conventional architecture just won't mix. The domes alone are beautiful; adapted to ordinary uses, their beauty is aborted. There seems to be no answer in terms of our present architecture; the problem is as yet unsolved.

This conflict between "art" and "structure," however, points an obvious moral. More than ever, it becomes evident that the architecture of the twentieth century is a technological phenomenon—that its "look" cannot be divorced from its techniques. To disguise or reject these expressions of contemporary engineering is to deny the true nature of the art of architecture today.

**INNOVATIONS—Portions of Fuller's "Geodesic Dome" and "Octet Truss Space Frame," two of three structures in the garden of the Museum of Modern Art.**

September 27, 1959

# EERO SAARINEN, 51, ARCHITECT, IS DEAD

## Versatile Designer Created Terminal for T.W.A. Here and Embassies for U. S.

### DISCIPLE OF HIS FATHER

ANN ARBOR, Mich., Sept. 1 (AP)—Eero Saarinen, internationally known architect, died today in the University of Michigan Medical Center. Mr. Saarinen underwent a two-hour operation for a brain tumor yesterday. His age was 51.

Among his best-known creations are the United States Embassy in London, the Trans World Airlines Terminal at New York International Airport and the sprawling General Motors Technical Center near Detroit.

Mr. Saarinen entered the hospital a week ago, forcing cancellation of a reception here at which he was to have received an honorary degree from the Technical University of Hanover, Germany. He would have been one of five living men to receive the award.

### In Father's Footsteps

The son of a great architect, Mr. Saarinen became a great architect himself. Both were born on the same date, Aug. 20 —Eero in 1910, on the thirty-seventh birthday of his father, Eliel.

From the moment the 3-year-old boy crawled under the drafting table of the studio-house at Hvittrask, Finland, and started to draw, the older Saarinen had no doubt that his son would be an architect.

And, as Eero himself recounted years later, "except for a brief excursion into sculpture it never occurred to me to do anything but follow my father's footsteps."

Mr. Saarinen was born in Kirkkonummi in southern Finland. His father, whose work had established the national romantic school of architecture in his homeland, moved his family to this country in 1923. This was a year after the boy had won his first competition—by illustrating a self-written story with a design made of matches. The contest was sponsored by a Swedish newspaper.

"My father helped me with the text," Mr. Saarinen recalled.

At high school in Michigan, Eero won first prize in a national soap-sculpture competition. And from 1931 to 1934, at the Yale School of Architecture, he won so many awards in Beaux Arts competitions that he was dubbed "Second Medal Saarinen."

There was a hopeful irony in this, however. In 1922, his father had won $20,000 as second prize in an international competition for the new build-

Camera Press—Pix
**Eero Saarinen**

ing of The Chicago Tribune. The Saarinen design had more influence on the development of the American skyscraper than the design by the winner, John Mead Howells, son of the novelist, William Dean Howells.

And the younger Saarinen was headed for top honors. These began to fall to him soon after he got his fine arts degree at Yale, and traveled through Europe from 1934 to 1936 on a Charles O. Matcham Fellowship.

With associates, including his father, he won the competition for the Smithsonian Institution Gallery of Art in 1939. With Charles Eames, who was one of his closest associates, he won the Museum of Modern Art's contest for organic-furniture design in 1941.

In 1948, for the first time, father and son submitted separately to the same competition—the Jefferson National Expansion Memorial in St. Louis. When the telegram arrived addressed simply to "Saarinen," Eero and his wife helped in arranging the champagne celebration of Eliel's victory. But the wire turned out to be for Eero.

The Jefferson memorial project, dominated by a controversial stainless-steel arch symbolizing the gateway to the West, is in construction, due to be completed in 1964.

In the last years of Eliel's life, father and son and their families lived in Bloomfield Hills, the community surrounding the Cranbrook Academy of Arts near Detroit.

Eliel Saarinen, who in middle life had looked like an advance model of Dag Hammarskjold, Secretary-General of the United Nations, died July 1, 1950. Thereafter, Eero was freed to follow his own directions, although his father's influence

remained strong in his approach to his work; for instance, in always seeing something in relation to a larger whole—a chair in a room, a room in a building, a building in a city.

His heritage and his own talent made him one of this country's best-known, most respected and sought-after architects. His work has adorned many sections of the United States. He also designed the American Embassy in Oslo, Norway, officially occupied by Ambassador Frances E. Willis on June 15, 1959; and the more controversial chancery building of the embassy in London.

Much of the discussion about the six-story structure on Grosvenor Square related to a 36-foot gold-color eagle with spread wings, a sculpture by Theodore Roszak. The architect had selected it to top the building.

Mr. Saarinen had served as a member of the State Department's architectural committee.

The architect was a consultant to Air Force Secretary Harold E. Talbott on the Air Force Academy at Colorado Springs. And with Jo Mielziner, noted stage designer, Mr. Saarinen collaborated on the Lincoln Center Repertory Theatre, a principal unit of the Lincoln Center for the Performing Arts.

Mr. Mielziner said last December that he and Mr. Saarinen had worked for more than two years toward a "design philosophy" for the structure.

Mr. Saarinen also designed a bold terminal for Trans World Airlines at the International Airport, Idlewild, Queens. The plans were announced in 1957 and the birdlike building is scheduled to be completed and go into use next spring.

In the same field, Mr. Saarinen was invited to submit plans for the terminal building at Washington's new Dulles International Airport, near Chantilly, Va. Instead of the familiar "finger" loading platforms for passengers, he devised a system of mobile lounges. The building has been started; the airport is tentatively scheduled to go into operation in October, 1962.

Instead of boarding planes directly, often after long walks, passengers will board the lounges—in effect, double-width buses with comfortable seats, high enough to permit direct access to plane doors.

The architect was principal partner in Eero Saarinen and Associates, Birmingham, Mich. His versatility is suggested by this further sampling of his work:

Buildings completed between the death of Eliel Saarinen in 1950 and last month:

Drake University, science and pharmacy buildings, dormitories and dining hall, Bible School, 1950-55; Stephens College, Columbia, Mo., chapel, 1954; General Motors Technical Center, Warren, Mich., 1954. (This was

a $68,000,000, 320-acre project involving complete design and planning of seventeen major structures and subsidiary buildings for advanced research. It is generally regarded as one of Mr. Saarinen's most important works.)

Auditorium and chapel for the Massachusetts Institute of Technology, 1955. (Another major work, this involved a self-contained plaza with an auditorium seating 1,200, covered by a dome of thin shell concrete construction, and small brick chapel.)

The Irwin-Union Bank and Trust Company, Columbus, Ind., 1956; Milwaukee County War Memorial Center, Milwaukee, 1957 (part of a larger plan for a new cultural center.) Concordia Senior College, Fort Wayne, Ind., 1958; David S. Ingalls Skating Rink, Yale University, 1958; women's residence hall, Vassar College, 1958; International Business Machines Corporation, administration and manufacturing, Rochester, Minn., 1958.

University of Chicago, women's residence halls, law school, 1959-60; Research center, International Business Machines Corporation, Yorktown, N. Y., 1961.

Under construction or with Mr. Saarinen's designs completed before construction:

Morse and Stiles Colleges, Yale University. (Two new colleges described as "polygonal citadels," designed with an emphasis on individuality of student living, scheduled for completion in summer, 1962); Research Center, Bell Laboratories, Inc., Holmdel, N. J.; (scheduled for completion this November); Deere & Co., Moline, Ill., an administrative center scheduled for completion in June, 1963; headquarters building, Columbia Broadcasting System, New York.

Mr. Saarinen was naturalized as a citizen in 1940. A year earlier he had married Lillian Swann, a sculptor, from whom he was divorced in 1953. They had two children, Eric and Susan.

On Feb. 8, 1954, Mr. Saarinen married Aline Bernstein Louchheim, at the time and until 1959 associate art editor of The New York Times. A son, Eames, was born in December of the same year. Mrs. Saarinen also had two sons by a previous marriage.

Perhaps as accurate a summation as any of the work of the architect was written in 1953 by the woman who became his second wife a year later. She had previously written at length about his father.

"The son's contribution," the then Mrs. Louchheim asserted in The New York Times Magazine, "is in giving form or visual order to the industrial civilization to which he belongs, designing imaginatively and soundly within the new esthetics which the machine demands and allows. His buildings, which interlock form, honest functional solutions and structural clarity, become an expression of our way of life."

September 2, 1961

# Books of The Times

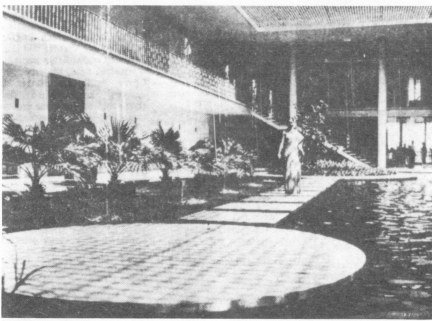

From "The Evolution of an Architect."

**The United States Embassy in New Delhi, which was designed by Edward Durell Stone**

### By G. E. KIDDER SMITH
#### Special to The New York Times.

NEW YORK.

One of the most encouraging aspects of our mid-20th-century culture—a culture which is so broadly booming with museums and music —is that within the last few years architecture, the so-called Mother of the Arts, is being rediscovered. No self-respecting book-review section or literary magazine is without full-page advertisements on architectural books directed to the layman. Inexpensive editions are both excellent and widely available. This is, of course, just what our showing environment (i.e. architecture-cum-planning) needs, for until the public is more informed and more critically intelligent on the buildings and cities it so naively commissions, our chaos will be compounded.

Much of this burgeoning interest in architects and architecture is due to the efforts of several perceptive publishers; some of it, amusingly enough, comes from Hollywood, where the Naughty Boys of the profession and the image of a Lancelot with T-square have proved comfortably profitable; a bit might stem from the popular semantics of the day ("the **architect** of victory," etc.); but the giant who single-handedly established architecture on the American scene—bless him—was, of course, the late Frank Lloyd Wright, His magnificient buildings and often outrageous statements made an ever larger share of the public aware of what was being done and what had to be done to create a finer ambiance.

Of the architects since Wright who have achieved that elusive rapport and "name" with the public, Edward Durell Stone — whose hero Wright was—is at the top. The

American Embassy which he did in New Delhi is a scintillating jewel on the Punjab plain, one of the loveliest buildings we have ever erected overseas, and architecturally one of our most respectful—and respected — good neighbors. His United States Pavilion at the Brussels Fair of 1958 was the most memorable building there: it enchanted all visitors, and deservedly so. The public nature and personal delight of these two buildings made a star of Stone within a few years. He was launched in the world's eye and relaunched in the professional's, where he had always been highly esteemed.

Of late a shifting of accolades is taking place: his work is more and more known to, and sought by, the public—which is fine—but, to use the vernacular, he is less and less of an architect's architect. A too-easy pattern is wrapping every building in a pretty package of pierced grilles and "surface embroidery," as it has been called; a disturbing insistence on an almost BeauxArts symmetry appears to determine all planning. This is too bad, for architectural needlepoint and neo-formality are not the only answers.

The book traces and lavishly illustrates much of the above in a sometimes folksy unrolling of Ed Stone's architectural life and his thoughts upon it. It is easy, almost elementary, reading that will garner no literary awards; yet in engaging fashion it limns the mercurial, sometimes desperate, ups and downs—and rewards—of the little understood profession of architecture. Furthermore, his constructive thoughts on the automobile (get it out of downtown areas) and long-range planning (more of it, with the government taking a central role) are admirably brought forth, and should be required reading for all. Thus, although some architects and critics may take issue with a number of the author's most recent buildings, the layman will gain from this book a fresh view of the environmental forces that are shaping his every hour.

**January 15, 1963**

*THE EVOLUTION OF AN ARCHITECT. By Edward Durell Stone. Illustrated. 288 pp. New York: Horizon Press. $15.*

*Mr. Smith, a Fellow of the American Institute of Architects has written on many aspects of contemporary architecture, most recently in "The New Architecture of Europe."*

# He Adds Elegance
# To Modern Architecture

**Philip Johnson strikes a new note in homes
and buildings by his special use of the past.**

By **ADA LOUISE HUXTABLE**

THIS is the year of Philip Johnson, a modern architect with a difference—instead of throwing away the past, he makes use of it in new and startling ways. At 57, he has emerged as a top tastemaker, a powerful influence in the market place where all cultural styles wind up, despite the fact that he has been an architect for only 11 years, coming to the practice after a long and successful career as director of the Museum of Modern Art's Department of Architecture, architectural critic, iconoclast and rebel against "the Establishment."

Just how important a pace-setter

**ADA LOUISE HUXTABLE** has been architecture critic of The Times for the past year.

Johnson is has become evident this spring with the unveiling of three of his newest buildings in New York City. At the World's Fair, the New York State Pavilion was immediately hailed as the architectural delight of Flushing Meadow. His design of the State Theater at Lincoln Center caused as much comment as the works performed inside it. And tomorrow the nation's First Lady, Mrs. Lyndon B. Johnson, will dedicate his rebuilt and remodeled Museum of Modern Art.

What Johnson is bringing to New York, and to a good many cities across the country, is a kind of architectural elegance that has not been seen since the turn-of-the-century days of McKim, Mead and White and the splendid "Re-

naissance" palaces built for the business aristocracy. But his is a new kind of elegance in completely contemporary terms—a modern architecture with the timeless values of beauty and luxury that have a universal appeal, whereas the more startling contemporary styles do not.

"I call myself a traditionalist, although I have fought against tradition all my life," he explains. "I like to be buttoned onto tradition. The thing is to improve it, twist it and mold it; to make something new of it; not to deny it. The riches of history can be plucked at any point."

IN practice, the result is a frankly romantic and sensuous group of buildings which look toward the past knowledgeably, although they never copy it and can be mistaken for nothing but of the present. There are suggestions of the work of the 19th-century Englishman, John Soane, for example, in the dome of Johnson's Kneses Tifereth Israel Synagogue in Port Chester, N. Y., and of the German classicist, Karl Friedrich Schinkel, in the stylized colonnades of Johnson's museums in Nebraska and Texas. But the echoes are faint; Johnson plays on new instruments, in new keys.

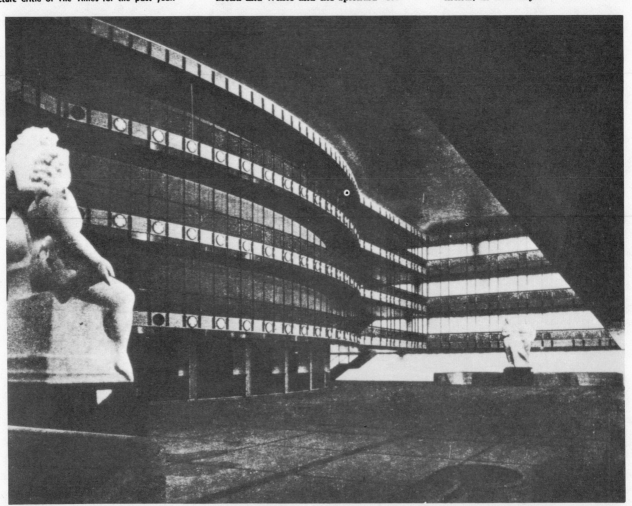

**THEATER**—Travertine and marble floors, gold-leaf ceiling and tiers of gold-screened balconies with diamondlike lights impart Johnsonian elegance to the lobby of the New York State Theater at Lincoln Center. The architect himself selected the marble statues by Elie Nadelman.

It is a controversial style, praised as a "breakthrough" by some, damned as "decorative" or "reactionary" by others, who feel that plucking the past is not a genuinely creative act and may even be something of a betrayal of modern architecture's search for completely new solutions for our time. All agree, however, that the plucking and molding are done with finesse and taste, and often result in effects of exquisite sensibility. His design of Washington's Dumbarton Oaks Museum, for example, is a cluster of round pavilions, like glass-walled jewel cases, fitted with precious teak, marble and bronze. This is an architecture of painstaking refinement, at a time when most building is grossly and flashily vulgar.

It is not surprising, therefore, that Johnson specializes in prestige construction—museums, churches and theaters—the great "one-room buildings" that are the architect's most coveted commissions because they give him the best opportunity for creative expression. The Johnson museums are multiplying across the country, from Utica, N. Y., to Fort Worth, Tex., and to Lincoln, Neb. Churches in New Harmony, Ind., and an abbey in Washington show similar concern for exquisite form, as do a nuclear reactor in Rehovot, Israel, and new science buildings at Yale.

**H**IS houses are extravagant pleasure-palaces of carefully unostentatious richness for a Who's Who of art patrons and wealthy collectors. A Johnson house is something like the legendary Morgan yacht—if you have to ask how much it costs, you can't afford it. He is not looking for budget jobs, but he is a bit rueful that his reputation as a rich man's architect has kept away some commercial or corporate clients who consider him too expensive.

Nevertheless, he has produced at least one commercial landmark of unassailable magnificence, the Seagram Building in New York, on which he collaborated with Mies van der Rohe in 1956-58. But the building that brought him instant fame was his own glass house, which shocked his neighbors and the world when he built it in New Canaan, Conn., in 1949. It is strongly influenced by Mies, whom he has always admired. In his role as critic and proselytizer at the Museum of Modern Art, Johnson wrote the authoritative biography of Mies van der Rohe in 1947, and when he turned from critical observation to practice, Mies was his mentor and his first buildings were all in Mies's severe, spare style.

**T**HE glass house, once attacked so violently, is now preferred by some critics to his more recent historic-romantic work. (The tales of shock generated by the house are legion, but the best has become an oft-told classic. To the lady visitor who professed that she could never live there, Johnson, a bachelor, replied, "I haven't asked you to, madam.")

Today, *(Continued)*

**GLASS HOUSE**—The view from his home in New Canaan, Conn., says architect Johnson, "makes beautiful wallpaper."

Philip Johnson's work stands somewhere between the rigid boxes of the diehard functionalists and the free-form flights of fancy of the neobaroque experimenters. He has given rich, traditional materials, like marble and travertine, equal status in the modern vocabulary with contemporary steel and glass, and he has restored the backward look at history to respectability for a generation of architects that had renounced the past with an almost religious fervor.

**I**N Johnson's work, everything — whether unusual construction, like the tension-compression ring design of the great bicycle roof of the World's Fair pavilion, or just a preoccupation with the play of light and shadow of classically inspired colonnades—is a means to a single end. It is beauty that he is really after, and history and structure are his convenient tools. This sometimes turns an artful device into "art for art's sake," and even makes structure look a little thin. But beauty is seductive, and so are his buildings.

His least successful work borders on the decorative (a pejorative adjective) with subtle overtones of decadence. While his devices work — the giant truss from which his museum in Utica, N.Y., is suspended, for example, serves the useful purpose of making a column-free, open interior space—the impression is that these devices are picked primarily because he likes the way they look. This suggests preoccupation with petty effects rather than design breakthroughs.

As a man, Philip Johnson is as soigné as his architecture, with the kind of knowing discern...ient that eschews the too silken necktie, the too obvious gold cuff links, the too smooth, overtly rich effect. With the correct credentials of money, family and looks, he has been an elegant maverick all his life, a confirmed, conscientious nonconformist and privileged insider whose pleasure is in shaking up the Establishment.

The Johnson skill in shockmanship and one-upmanship is matched by a sincere, sensitive erudition. He excels in historical name-dropping and watches its devastating effects with sly delight. But the scholarly references are serious. His work and attitudes are motivated by studied convictions about the importance of modern art and architecture and a consciously and unapologetically aristocratic and esthetic approach to life.

His one disappointment is that he has ceased to shock the Establishment. He is the Establishment now, a completely accepted architectural leader of unimpeachable authority. But he still has the pleasure of outraging the bourgeoisie, as he did with the Pop art embellishments that he commissioned for the state pavilion at the fair.

Johnson's success story is something other than the battle of the conventional struggler against conventional odds. Born in Cleveland in 1906, the son of a wealthy, land-owning lawyer, he followed the privileged path of good schools, like Harvard, and travel. In the soul-searching nineteen-thirties when other young intellectuals were facing left, he turned to the political far right, supporting Huey Long, among others.

In 1932, he went to the newly formed Museum of Modern Art, where he founded the Department of Architecture and proceeded to bring the word about the modern movement, then booming among the European intelligentsia, to a reluctant and rather uninterested New World. He defined the new architecture in a landmark book, "The International Style," in collaboration with the historian, Henry - Russell Hitchcock.

In the early nineteen-forties, he went back to Harvard for his degree in architecture. He had the advantage of maturity, and the even greater advantage of being able to build his master's thesis rather than draw it — he built a walled modern house that created in Cambridge the kind of stunned reaction that was to greet his later glass house in Connecticut. His talent for design has always exceeded his ability to draw, being more verbal than visual and consisting of descriptive airy gestures amplified by quick rough strokes of a soft pencil on paper. Ironically, when he took the New York State registration examinations he failed—and had to repeat—the design section.

Returning to the museum, he continued to function as critic, trend - setter and close friend and associate of the élite group that controls the country's cultural conscience and purse strings through its major institutions. He finally opened his own office in 1953. This all led inevitably, if not exactly in Horatio Alger fashion, to an international reputation for buildings of fastidious taste and elegant detail for a top-drawer clientele.

For the client who might come complacently to his discreetly luxurious offices in the Seagram Building for some discreetly luxurious job, the first confrontation is with an old automobile tire, a blue light and some carefully ar-

ranged debris in a startling collage facing the entrance, a work by the Pop artist, Robert Rauschenberg. For Johnson, a collector who has always promoted the avant-garde, this is as right as the fresh flowers carefully arranged according to the season and the properly accented receptionist. The message is offbeat, but far from beatnik. The suggestion is of breeding and daring, a combination that reassures and challenges. He leads, so it is safe, and profitable, to follow.

HIS opinions are outspoken; he treads on toes gracefully and firmly. Washington is "dull, mediocre monotony"; the Pan Am Building, "ruinous, a building nobody wanted"; Kennedy Airport, "a congeries of cheapies"; lowcost housing, "monstrous brick prisons rising from the streets like untidy asparagus." The war between the old and young generations in art and architecture is "rational and healthy"; his advice to students, "leave school."

His thoughts on the present condition of architecture: "There are many directions—all welcome and good. We don't have a single style. We run the gamut from British brutalism — you know, things that look like blown-up water tanks in a semi-crude state— to the lacework of Yamasaki. It's enriching; it's more like the 19th century. Architecture is in an extraordinarily fluid state.

"IN my own work, I'd say I'm a classicist, but I look everywhere for my solutions. I don't study the toilet-living habits of my clients, although that's a popular approach. First, I think of every building in history that has been similar in purpose. Then I think of the functional program — that's a major part of the study. At the same time, forms and processionalism are floating around in my head. Processionalism is primary—how you get from one place to another, the relationships and effects of spaces as you move about in them. That's worked out awfully well in the State Theater. I'm a 'straight-in' man myself; I'm too nervous, I like to know where I am.

"I also like to know where I'm going. I think the future, the important future of architecture, is in public building. We have a great private architecture now, and I believe we're moving toward a great public architecture. There are signs of government sponsorship.

"My ambition? I'd like to be *l'architecte du roi.*" There is a quick smile, a sidelong glance, to see if the dropped phrase has been understood, and if it has had the proper shock value. "The king's architect," he goes on. "We have no phrase for it today, but I mean the country's official architect for its great public buildings. I'm not thinking just of myself, but of all our top talent." He offers another calculated heresy: "I want to take the dirty connotations out of the words 'official' and 'academic.'"

From the glass house and the glass-walled office in the Seagram Building, Johnson continues to throw well-selected, beautifully polished stones; the royal rebel is growing gracefully into the next generation's grand old man.

May 24, 1964

# The Bauhaus Is Alive And Well in Soup Plates And Skyscrapers

## By JAMES R. MELLOW

THE 50th anniversary of the Bauhaus—that long-defunct but still legendary German school of architecture and design—is being marked this year by two notable events. The first is a mammoth exhibition, "50 Years Bauhaus," being sponsored by the Federal Republic of Germany in cooperation with several international institutions; the second is an equally ponderous undertaking —the publication of "Bauhaus," a heavily illustrated, massively documented history of the school and its tragic fate that is certain to remain the source book on the subject for years to come. Compiled by Bauhaus archivist Hans Wingler, the book will be issued by the M.I.T. Press late in September. The exhibition — the most comprehensive survey of the school ever attempted — is currently on view at the Illinois Institute of Technology in Chicago. Comprising more than 2,500 exhibits—a vast panorama of the furniture, household appliances, architectural projects, theater productions and graphic designs produced by the Bauhaus workshops (many of which look as modern today as they did when they were created several decades ago) — the exhibition has already toured Stuttgart, London and Paris and will travel to Toronto, Pasadena and the 1970 World's Fair in Osaka, following its Chicago appearance.

Both these events commemorate what was one of the 20th century's most remarkable—if short-lived—institutions. The most influential design school of modern times, a progenitor of like-minded institutions throughout the world, probably the most ambitious attempt ever made by high-minded artists and idealistic students to come to grips with this century's industrial and technological revolutions, the Bauhaus was founded with the express purpose of reconstructing society by reshaping the environment it lived in. Reacting against "salon art," architectural eclecticism, the shabbily conceived, machine-made products of the day, the school's architect-founder, the late Walter Gropius, proposed to educate an élite corps of dedicated artist-craftsmen who would redesign man's habitat—including everything from soup plates to skyscrapers—according to rational principles of design derived from both the formal discoveries of modern art and the production capacities of modern technology. For that purpose, he gathered together a faculty of "masters," as they were called, that included some of the most exalted names in modern art, architecture and design—among them Marcel Breuer, Wassily Kandinsky, Paul Klee, Lyonel Feininger, Josef Albers, Laszlo Moholy-Nagy, Herbert Bayer, Oskar Schlemmer.

But the Bauhaus was a school with a historic mission in an unpropitious time. Its fate—both as a brave new cultural venture and an eventual cultural sacrifice — was inextricably woven into the fabric of Germany's political and social life during a period of crisis. Founded as the "Staatliches Bauhaus" in Weimar in 1919—the year that the harsh terms of the Treaty of Versailles were imposed upon a defeated Germany—it

JAMES R. MELLOW, a freelance critic, is currently at work on a book about the history of modern design.

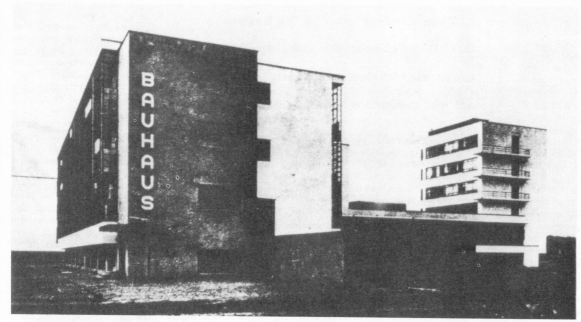

*The Bauhaus in Dessau*

ended during the rise of Hitler's Third Reich. In its brief 14 years of existence, it was forced to move twice as a result of hostile political pressures and ensuing financial difficulties. In 1925, it relocated in Dessau where it enjoyed, for a time, the protection of the liberal-minded mayor of that city, Fritz Hesse. In 1932, it moved again—this time to Berlin, where it made its last stand in an old telephone factory rented by its third director, the celebrated architect, the late Ludwig Mies van der Rohe.

On April 11, 1933—three months after Hitler's appointment as Chancellor of Germany and several weeks after the Reichstag fire—a cordon of German police, at the request of the Nazi authorities, surrounded the Berlin Bauhaus, searched the premises for Communist propaganda, arrested 32 students and closed the doors of the school.

THE Nazis regarded the Bauhaus as a hotbed of "cultural Bolshevism," a convenient propaganda target in their war against the "degeneracy" of all forms of modern art. But their persecution only served to extend the influence of the school, the continuation of its unique educational practices. As a result of the exodus of Bauhaus masters and students — or Bauhauslers, as they have lately been called — the good tidings of good design were spread throughout architectural and industrial design offices, schools and universities in continental Europe and America. The United States, indeed, received an important share of emigrating Bauhauslers. Albers, the noted teacher and color theorist, brought the Bauhaus meth-

THE END—*A Japanese Bauhaus student made this collage, after the Dessau Bauhaus was shut down by the Nazis in 1932. Ironically, the resulting exodus of Bauhauslers from Nazi Germany only extended the school's influence.*

ods to Black Mountain College in North Carolina in 1933, later transferred them to Yale for a decade of influential teaching. (He was accompanied by his wife, Anni, a star pupil of the school's weaving workshop.)

Gropius repaired to Harvard in 1937, turning the university's School of Architecture into one of the most eminent centers of architectural study and practice in the United States. Breuer served as a professor there from 1937 until 1946 when he set up his own practice in New York. (His prominent architectural commissions in this country include St. John's Abbey in Collegeville, Minn., and the new Whitney Museum of American Art in New York.) Bayer established himself as a graphic designer in New York in 1938, attracting such notable clients as the J. Walter Thompson agency and the Container Corporation of America. Less famous Bauhauslers have designed everything from covers for Fortune magazine to office buildings for Alcoa.

I N this respect, the Chicago setting for the Bauhaus retrospective is a particularly appropriate one. The Illinois Institute of Technology contains the highest concentration of Bauhaus-derived design departments in the country. Mies headed its department of architecture until 1957, Moholy-Nagy founded its Institute of Design under the name, The New Bauhaus, in 1937; the late Ludwig Hilberseimer, another eminent Bauhausler, directed the Institute's department of city and regional planning until his death in 1967. Appropriately, too, the exhibition — with a special, Bayer-designed installation—is being held in Crown Hall, a fastidious, Mies-designed glass and steel structure.

This Bauhaus-in-exile, in fact, accounts for a good deal of the design that we see around us — the furniture we live with, the architecture we work in, the advertisements we see in newspapers. As a hothouse for the International Style in architecture, the Bauhaus promoted that taste for systematically produced, straight-sided, glass-walled buildings that is still with us —though too often reduced to

the ubiquitous office-crate. (In the twenties, it seems, Bauhaus directors dreamed of constructing American-type skyscrapers; years later, translated into reality, the results have not been laudable in every case. Gropius's Pan Am Building, lording it over the architectural jumble surrounding New York's Grand Central station, throws up a wall against what had been a lovely prospect down Park Avenue. But several blocks north, Mies's Seagram Building rises in elegant isolation, a bronze monument among the city's growing architectural follies.)

As for the strength of the Bauhaus influence on industrial design, any well-stocked department store with rows of strictly unadorned cups and saucers, functional furniture and no-nonsense lamps, can attest to its longevity. Anywhere, in fact, that an object of daily use or daily comfort espouses the plain configurations of the cube, the sphere and the cone, the basic formal precepts of the Bauhaus are still in operation. Even the famous Bauhaus typographic style—which insisted on sans-serif typefaces and the abolishment of capital letters in body texts — has proved eminently adaptable for contemporary magazine layouts, book jackets, promotional brochures. Initiated in the twenties, it constituted a minor revolution of sorts. To conservative Germans — used to their ornate Gothic alphabet and their reverentially capitalized nouns — it must have seemed a deliberate insult to the Fatherland.

D ESPITE this prestigious history, the Bauhaus has its critics. Confirmed painters and sculptors, for example, take a dim view of the school and its methods since both those arts were assigned inferior roles in the Bauhaus curriculum—subsidiaries, as it were, to the building trades. (One reason, perhaps—though not the official one—for the

fact that "50 Years Bauhaus" will not be seen in New York where painting and sculpture occupy the vanguard. Officially, the exhibition was deemed too large and too late to fit into the tight exhibition schedules of the city's museums.) In architecture and design, the Bauhaus record may be brilliant but, with the sole exception of Albers (whose influential color theories were a later development), it had little direct effect upon the course of modern painting and sculpture. Ironically, it proved to be more influential at reshaping the styles of its established masters—like Kandinsky and Klee — than in producing major young painters and sculptors.

For other critics, the Bauhaus has become a chapter in the history of taste—a commercial success but a sociological failure. Its program of better living through better design—even in the hands of its practitioners — has made little progress against the apparently insurmountable problems of urban chaos. Its promotion of rationally designed products intended to grace the home of Everyman (some of them, like Breuer's classic tubular steel chairs, still being marketed) has more often resulted in the development of high-priced items for the luxury trade.

The severest critics of the historic Bauhaus, strangely enough, are the Bauhauslers themselves. Even 50 years after its inception, the school remains a thorn in the side of those who feel their contributions have never been duly acknowledged, a topic they adamantly refuse to discuss. Some maintain that the historic Bauhaus has engendered its own "master" race, in which the credit is always given to the celebrated names while those who designed the products, taught the classes, realized the goals that made the school famous, have been relegated to the supplemental attendance lists. (To their sur-

prise, the organizers of "50 Years Bauhaus" found that several Bauhauslers were unwilling to participate in the exhibition, viewing it as only another perpetuation of the history-book myth with the same star-studded cast.)

A few Bauhauslers claim that it was really the students—a visionary and impoverished lot — who gave the school its definitive stature. Even at the Valhallic level of the school's directorship, there is dissension. "The Bauhaus! You know I was just the clean-up woman at the Bauhaus!" Mies is said to have remarked, apropos the minor role he has been assigned in some personal and published accounts of the school.

W HEN Gropius founded the Weimar Bauhaus in April, 1919, from the makings of two former and conventional arts and crafts schools, his intentions were strictly honorable. What he proposed was a marriage of convenience between modern art and modern technology. Urbane—indeed eclectic—in that pursuit, he brought to the task his own keen awareness of the currents of modern thought and an optimistic faith in the possibilities of modern technology. (Curiously, though, he proceeded to run the school along certain antiquarian lines, combining the medieval guild structure of "masters" and journeymen-apprentices with the genteel traditions of the 19th century's arts-and-crafts movement.) Under Gropius's leadership, the Bauhaus became a clearinghouse and testing ground for every modernist doctrine. Its ecumenical spirit was truly amazing—a bewildering mix of Parisian Cubism, German Expressionism, Russian Constructivism and International Dadaism.

I T was, in many ways, the best and worst of times for such a venture. Germany's defeat in World War I and the revolutionary conditions it created had wiped away the authority of the past. "After that violent eruption," Gropius once explained, "every thinking man felt the necessity for an intellectual change of front." His opening manifesto for the school, in which architecture was assigned the

> **66When Gropius founded the Bauhaus in 1919 he proposed a marriage of convenience between modern art and modern technology.99**

messianic role of effecting a new society, had the appeal of political oratory: "Architects, sculptors, painters, we must all turn to the crafts.... Together let us conceive and create the new building of the future, which will embrace architecture and sculpture and painting in one unity and which will rise one day toward heaven from the hands of a million workers like the crystal symbol of a new faith." The announcement acted as a clarion call for the young and the disaffected. They came from everywhere in Germany (later, from as far away as Japan); artists and art students, craftsmen, designers, army veterans, young idealists and radicals from the youth movements.

From the beginning, however, the "new faith" was tested against the political realities of Germany in a period of crisis. The Weimar Republic was attempting to hold its precarious balance between an obstreperous left and an increasingly aggressive right. It was a period of mass unemployment, disastrous currency deflation, extremist agitation and political murder. Rosa Luxemburg and Karl Liebknecht (New Leftists of their day) had been brutally murdered the year the Bauhaus was founded; Walter Rathenau, the moderate Jewish foreign minister of the Weimar Republic, was shot down by proto-Nazis in 1922. The economic situation of Germany, struggling under the impossible terms of the Treaty of Versailles, was equally catastrophic.

The Bauhaus exhibited its own signs of dissension, both within the school itself and in its relationships with the local community. Greeted by an influx of strange young idealists —bearded and sandaled, wearing Russian smocks and converted army uniforms — the conservative citizens of Weimar, which one student has described as "a sleepy provincial town, full of tradition, museums and retired officials," took fright. They organized citizens' committees and issued warning bulletins ("Men and Women of Weimar! Our old and famous Art School is in danger!"). Incoming students, in search of housing, were advised not to mention that they were at-tending the infamous school.

Not all of the criticisms, however, issued from the Philistine right. Theo van Doesburg, for example, that aggressive and spirited evangelist for de Stijl, the Dutch art movement which enlisted the right angle and right thinking in the service of utopian social ideals, took a dim view of the Bauhaus. "As the church is a parody of Christianity," van Doesburg wrote in 1922, "so is Gropius's Bauhaus in Weimar a parody of the new creativity...." This opinion was offered in the pages of his magazine, entitled de Stijl, following a visit to the German school.

Van Doesburg found the Bauhaus awash with pernicious doctrines. Modern "isms" he could take, more or less, in his stride; what he found culpable was a laissez-faire attitude which allowed the students to become corrupted by the worst forms of individualism and personal expressionism. An aggressive talker, he adopted the simple expedient of lecturing the Bauhaus students on the one true faith—that of de Stijl. He was rewarded (according to his own account) by having started a number of them on the path toward rectitude.

**T**HE principal target of these criticisms from both the right and the right-minded was one of the oddest and most controversial members of the Bauhaus faculty—Johannes Itten. A gifted Swiss teacher with a taste for Persian mysticism and unusual forms of dress (he invented an early version of the Nehru jacket as his customary classroom habit), Itten indoctrinated his students with a wide variety of devotional practices intended to purify their minds and bodies. The list included the deep-breathing and eurythmic exercises, and meditation sessions, with which he began his classes, as well as a number of severe dietary prohibitions. (Invited to one of Itten's frugal meals, Klee observed that if he were forced to live on Itten's diet for any length of time, even his worms would desert him.) In the classroom, Itten presented a striking appearance. Bespectacled, his head clean-shaven, he looked like a gentle, but wild-eyed, Buddhist monk set down in the middle of a German factory.

Itten's influence at the school was pervasive; it became something of a life style for his ardent disciples who adopted his unconventional forms of dress, slept on straw pallets, and, as aids to meditation, painted huge blue circles on the walls of their rooms. Eventually, it extended even to the student canteen where his belief in the purificatory virtues of certain herbs added spice to the inexpensive vegetarian meals. ("Why do they all smell so of garlic?" one curious visitor asked about the highly redolent student body.) Students who favored neither Itten's mysticism nor his menu (some of them riled up by van Doesburg) repaired to the local soup kitchen where, for a few pennies, they could get a bowl of nonideological barley soup.

It was Itten who invented and administered the famous Vorkurs, or preliminary course. (Later purged of its mystical overtones by Moholy-Nagy and Albers, it became the basic course for all progressive forms of design education.) Under Itten, however, the Vorkurs constituted a kind of mystical brainwashing, a six-month initiation rite, intended to rid the student of his preconceptions about art and to acquaint him with the nature of the materials he would be dealing with. Vorkurs-students were allowed to follow their own bent, creating Dadaist collages and constructions of ordinary materials — string, wire, wood shavings, scraps of wool. They were also encouraged to analyze the masterpieces of the past in terms of that ubiquitous Bauhaus trinity of basic forms—the triangle, the circle and the square.

Following this initiation, the most promising students were admitted to the workshops (metalworking, carpentry, wall-painting, weaving, etc.) where they were expected to acquire a trade. They were provided with both esthetic and practical experience under the joint direction of artists and technicians.

The range of subsidiary courses and lectures offered —both at Weimar and Dessau—was broad, but heavily laced with theory. Kandinsky, for instance, held seminars on color theory (he proposed red squares, blue circles and yellow triangles as the primal forms); Schlemmer offered a course on "Man," a bio-mechanical-mathematical study of human anatomy.

At the end of his three-year workshop training, the student was examined by the Bauhaus masters and awarded his journeyman's certificate. With it, he might proceed to the study of "Building," the discipline that occupied the center of Gropius's philosophy of design and the core of the circular diagram he devised to explain the Bauhaus curriculum. (Ironically, the core of Gropius's circular mandala was missing for several years. Although he gave his students practical experience through working on his private architectural commissions, there were never sufficient funds at Weimar to establish a real department of architecture.)

**S**TUDENT life at the Bauhaus had its idyllic aspects as well. Klee, an accomplished violinist, filled the lecture hall for concerts of Mozart and Bach. Schlemmer and his students in the stage workshop presented mechanistic ballets in which the dancers were encased in the Bauhaus's endemic geometric forms. On Saturday nights there were dances held in the country inns, supplied with music by an efficient Bauhaus jazz band playing on homemade instruments.

There were festivals of every description — "White" festivals; "Beard, Nose and Heart" festivals; kite-flying festivals; paper dragon festivals, all of which sent the students into weeks of frenzied activity, designing masks and costumes, posters and printed invitations. There were Chinese lantern parades, conducted through the nighttime streets of Weimar.

And there was talk: an endless, vehement, playful, ardent stream of talk that would erupt suddenly during the workbreaks and would be carried over to lunch sessions in the student cafeteria—talk between advocates of the red circle as the perfect form and adherents of the blue square, between pro-expressionists and pro-constructivists, between pro-Dutch constructivists and pro-Russian constructivists, between apostles

91

of van Doesburg's de Stijl and disciples of Itten's *mystique.*

It was indeed "talk"—about Itten's damaging influence to the school's image — that brought the Bauhaus director and its mystical master to a parting of the ways. In 1923, under mounting conservative pressure from the Weimar authorities, Gropius informed Itten he could no longer support his strange classroom procedures and his intuitive philosophy of design. Itten resigned immediately, his clouds of Eastern mysticism trailing after him. Anxious to effect a rapprochement with both industry and the community, Gropius let it be known that, in his opinion, the modern artist should appear in society conventionally dressed. Thereafter, the mark of a Bauhaus master was not to be Itten's fanciful get-ups, but Kandinsky's buttoned-up and thoroughly correct business suit.

Unfortunately, the bid for respectability came too late. In the growing storm of political reaction, stepped-up newspaper campaigns against the school headlined the familiar Philistine catchwords, "Swindle! . . . Rubbish! . . . Menace!" Police searches for Communist material both at the school and in Gropius's home forecast the end. ("I am ashamed for my country, Your Excellency, that I am apparently unprotected in my country in spite of my achievements. . . ." Gropius wrote to the military commander of Thuringia.) In 1924 archreactionary elements gained control of the Thuringian government. The school was given notice that no new teaching contracts would be issued without a clause allowing the authorities to dismiss the Bauhaus staff on six months'. notice. Acting on their own initiative, Gropius, his staff and students—in a last gesture of solidarity — closed down the Weimar Bauhaus themselves.

**W**ELCOMED to Dessau— and on very generous terms— the Bauhaus enjoyed its most prestigious and prosperous era. The buildings which Gropius designed for the new institution (the school itself, a student dormitory, residences for the masters) became a

landmark of the International Style, attracting visitors from around the world. (Later put to use as a training school by the Nazis, the complex is now running to seed behind the Iron Curtain.) Radically asymmetric in plan, with glittering expanses of glass curtainwalls, the school buildings were outfitted with Breuer furniture and with lighting fixtures, hardware and wall decorations designed by the various workshops.

The Russian writer, Ilya Ehrenburg, visiting Dessau in 1927, admired the industry and ingenuity displayed at the Bauhaus. "It is mostly switches and levers that perform in the house of the architect Gropius," he noted, "Laundry flies through the chutes like mail in dispatch tubes. Plates reach the dining room directly from the kitchen. Everything is thought through, down to the dustbin which opens and closes automatically." But he caught, there, a glimpse of a future, full of ultramodern conveniences, that would produce a state of boredom and sterile ease: "People will sit in incredibly comfortable easy chairs, they shall sit there and yawn. But who can express the great, indescribable, jaw-dislocating and heart-rending boredom of the hyperimproved bucket?"

Buckets in the *style moderne* were not to become part of the standard Bauhaus inventory, but with new and better equipped workshops, students and masters turned out the innovative designs for furniture, lamps, household utensils that made the name of the Dessau Bauhaus synonymous with modern design. Enterprising German factories began producing Bauhaus-designed lighting fixtures, chairs, textiles and wallpapers under royalty agreements. Representatives of German industry regularly toured the Bauhaus facilities; students, in turn, were apprenticed to German factories to gain experience in machine production. Thus the old craft-orientation of the Bauhaus was discarded; a new liaison with industry was effected.

One of the most marked changes between the old and the new Bauhaus can be seen in the work of the *Vorkurs* students. Under Albers and Moholy-Nagy, the *Vorkurs* work consisted of ingenious

paper constructions and structures of metal and glass that revealed the principles of Russian Constructivism at full force. Moholy - Nagy, a dedicated artist and theoretician, exerted as powerful an influence over the new Bauhaus as Itten had at Weimar. He sponsored the use of photography as a creative design medium, promoted the famous Bauhaus books, a vanguard publishing venture that featured texts by Mondrian, Malevich, the Bauhaus masters Kandinsky and Klee, and even that old enemy of the school, van Doesburg. He converted the metal workshop, devoted to jewelry and silversmithing, into a modern machine shop. Working with Bayer, he established a first-rate typographic workshop.

Moholy-Nagy gave the Bauhaus a new religion—the religion of the modern machine age. Although he maintained that "Man, not the product, is the aim," his faith in the capabilities of modern technology was legendary: well in advance of current methods of artistic production, he once ordered three enamel paintings made by telephone, specifying standard industrial colors and indicating the disposition of the forms by means of graph paper.

**I**N 1928, Gropius suddenly resigned from the Bauhaus, partly because he felt that a renewed series of political attacks against the school had been directed at him, personally, and partly because he wanted to devote his time to his own architectural practice. Moholy-Nagy, Breuer and Bayer decided to leave with him for a variety of personal reasons. Stunned by the news, one of his senior students confronted the architect: "You have made many mistakes, Gropius, but there is no one to fill your shoes. You oughtn't to leave."

For his successor, Gropius recommended Hannes Meyer, the Swiss architect he had called to Dessau the year before to head the school's "Building" course. To his credit, Meyer established a functioning architectural department and increased the production of the workshops, thereby increasing the school's income from royalties. But his appointment was unfortunate

in other respects. A handsome, brusque, opinionated man, Meyer deplored the emphasis previously given to esthetics. "Shall we turn our attention to the needs of humanity and collaborate in building a new way of life, or shall we become an island . . .?" was the question he put to his students in his opening address.

His political views were decidedly far to the left of the gentlemanly Socialist posture maintained during the Gropius era. His motto was: "Building is a collective activity," and he encouraged his students to engage in political activities as a necessary part of their experience. His uncompromising political stance soon brought him into conflict with the Dessau authorities and he was forced to resign in 1930. Following a series of bitter exchanges, he left the school, taking a handful of his most dedicated students with him to Russia. "I see through it all," he wrote to the mayor of Dessau, "but I understand nothing."

The salvation of the Bauhaus—in these shaky political circumstances—was then entrusted to Mies van der Rohe. At the time, he was already an established architect with an international reputation in vanguard circles. (One of his earlier buildings, the 1929 Barcelona Pavilion has been called "the temple of the International Style.") An aloof and reticent man, a stickler for detail, an architect with a passion for clarity, order and unobstructed space, Mies proved to be a hard taskmaster in the classroom. An American student, Howard Dearstyne, relates that one of his first ambitious studentprojects — the design of a small, one-bedroom house — was nearly discarded because the demanding architect couldn't find a place for a garbage pail in its kitchen. Mies claimed that if an architect could design a house well — even a modest one — he could design anything.

His three-year tenure at the Bauhaus, however, was beset with political difficulties and with internal dissension. Students—a few of them volubly communistic — were disgruntled over Meyer's forced resignation. They maintained that Mies was a "formalist" (a hated word in the Meyer lexi-

**bauhaus**—*A cover of the quarterly journal published by the Dessau Bauhaus from 1926 to 1931. The planes and solids hint at the "ubiquitous Bauhaus trinity of basic forms—the triangle, the circle and the square."*

con), a designer of luxury villas for the rich. During unruly sessions in the student canteen, they insisted that the architect put on an exhibition of his work so they could judge his qualifications for running the school. At one point, they sent up an ultinatum to his office in the glass "bridge." (An unusual architectural feature, it connected the Bauhaus proper with the municipal trade school that had been foisted upon Gropius by the Dessau officials.) It was a case, apparently, of liking neither Mies's attitude nor his altitude, for they demanded that he come down to defend his position. Mies ordered the canteen cleared. When the students refused, he called in the Dessau police. Only after several weeks, during which the school was shut down by the Dessau authorities and the ringleaders of the student revolt expelled, did the school return to normal. In the end, Mies won over the students by the authority of his work and the strict professional standards he maintained.

IN 1932, the Nazi party gained control of the province of Anhalt and the fate of the Bauhaus was sealed. Its establishment during a Socialist regime, its stormy career, its eviction from Weimar, the politics of the Meyer years, all provided grist for the Nazi propaganda mills. Despite a wave of international protests, the school was shut down in October of the same year. Mies's attempt to reopen the Bauhaus as a private venture in Berlin provided only a brief stay of execution. The vindictive Dessau authorities, claiming that confiscated material had been spirited away from the Dessau premises, instigated a search of the Berlin school. A pro-Nazi newspaper account of the Berlin raid charged that large amounts of illegal propaganda had been seized. To nail down its case for the over-all degeneracy of the Bauhaus staff, it asserted that the former director (Gropius) was in Russia, while the present director "preferred to move to Paris a few days ago." None of the charges were true.

Mies, in fact, began a weekly campaign to persuade the Gestapo authorities to allow him to reopen the school. (With the inveterate habits of a designer, he recalled that the bench on which he had to wait interminable hours at Gestapo headquarters was badly designed—only six inches wide.) Finally granted an interview, he was questioned in depth about the Bauhaus and its staff—and in particular about Kandinsky. Mies assured the curious young Gestapo chief that the Russian painter was "an absolutely normal Russian—White Russian, too. He isn't a Communist or anything like that." Told he would have personally to vouch for Kandinsky, Mies readily agreed. "Don't be so eager," the Gestapo chief countered, "they are the worst people."

Weeks later a letter from the Gestapo arrived, granting him permission to open the Bauhaus—but under the auspices of the Ministry of Culture and Education. Mies called the faculty together, acknowledged that they could resume, but proposed, instead, that they officially close down the school themselves. His last official act as director was to write, as he said, "a very fine letter—to the Gestapo—that it is too late." The time had come to consign the Bauhaus to history. ∎

September 14, 1969

## Louis I. Kahn Dies; Architect Was 73

### By PAUL GOLDBERGER

Louis I. Kahn, whose strong forms of brick and concrete influenced a generation of architects and made him, in the opinion of most architectural scholars, America's foremost living architect, died Sunday evening, apparently of a heart attack, in Pennsylvania Station. He was 73 years old.

Among Mr. Kahn's major projects were the master plan for a second capital at Dacca, East Pakistan, which is now the capital of Bangladesh; the Richards Medical Research Laboratories at the University of Pennsylvania; the Kimbell Art Museum in Fort Worth, Tex., and the Yale Art Gallery, which was completed in 1951 and was his first major building.

Mr. Kahn was returning from India, where he had gone to oversee further work on his partly completed complex of buildings for the Institute of Management at Ahmedabad, one of many Kahn works at various stages of development when he died. After a week's absence, he was on his way back to meet his Monday-morning class in architecture at the University of Pennsylvania in Philadelphia.

His body was picked up by the police and taken to the City Morgue. Identification was made on a tentative basis through his passport, which showed that he had just returned to this country by way of John F. Kennedy International Airport from London and earlier from Bombay.

The passport gave Mr. Kahn's office and home addresses in Philadelphia. The police called the office and, finding it closed for the weekend, sent a teletype to the Philadelphia police, but, the architect's wife, the former Esther Virginia Israeli, was never notified.

#### Modest Appearance

As time passed without word from her husband, Mrs. Kahn placed calls overseas and finally, to the New York police. They disclosed that his body had been taken to the Medical Examiner's office and that they had notified the Philadelphia police.

Mr. Kahn was a small man whose white hair and bow tie were often in disarray, but his modest physical appearance was in sharp contrast to the vastness of his influence on architects both in America and abroad. He fit into neither the "organic" school of Frank Lloyd Wright nor the other major modern movement, the clean, pure European modernism of Le Corbusier and Mies van der Rohe, but sought to redefine architecture in a fundamental way for himself.

That redefinition, for Mr. Kahn, involved searching for the essential qualities not of a particular building, but of architecture itself. His somewhat fundamentalist approach led him toward strong, simple geometric forms and basic materials such as brick and concrete, which he often left in its unfinished state as a better means of expressing the material's nature.

Mr. Kahn was fond of speaking in the most basic terms about architecture. One of his favorite lines, often repeated in writings and lectures, was that his work was an attempt to discover "what the building wants to be." He frequently said that he wanted to rethink architecture not from Volume I of its history but from what he liked to call "Volume Zero."

"Volume Zero," he said, "is what precedes shape, it is the source."

In his rejection of both of the orthodox modernist schools, Mr. Kahn was considered for some time to work outside the mainstream of modern architecture. His influence did not begin to make itself felt until the completion of the Yale Art Gallery, a four-story building of brick and glass that was the first strong statement of the Kahn approach.

The Art Gallery reflects, to some extent, the influence of Mies and the International Style. Its rear wall is of glass, facing a sculpture garden, and the interior spaces are free and open, divided only by moving partitions that could be rearranged to suit specific exhibitions.

But the Yale Art Gallery began to move away from the International Style of pure, clean modernism with its ceiling of exposed concrete in tetrahedronal patterns. The harsh ceiling, which was part of the building's structural support, left exposed the air and heat ducts and lighting equipment.

It was considered raw by some visitors at first. Later, as Mr. Kahn's device of allowing certain materials to appear unfinished as a deliberate means of enhancing what he saw as their natural qualities became more accepted, the gallery came to be considered one of the major buildings of the nineteen-fifties.

## 'Served' and 'Servant' Spaces

The Gallery was one of the first statements of Mr. Kahn's concepts of "served" and "servant" spaces. As part of his attempt to deal in architecture's essentials, he emphasized the differentiation between the mechanical innards of a building, which he called the "servant" spaces, and the rest of the building, the "served" spaces.

Mr. Kahn considered the "servant" spaces more than merely functional: to him, they were as much a part of the esthetic essence of the building as the "served" spaces were, and he objected to their being hidden away so as not to violate the esthetic purity of the

Cowles Syndicate

**Louis I. Kahn at the Salk Institute in La Jolla, Calif.**

"served" spaces. For Mr. Kahn, the purity was violated by the covering up of pipes and air ducts, not by their being exposed.

The major statement of Mr. Kahn's "servant" and "served" concept came with the Richards Laboratories at the University of Pennsylvania in 1960, Vincent Scully, the architectural historian who in 1964 wrote the first major study of Mr. Kahn's work, called it a building "which created an epoch."

The Richards building is a grouping of four seven-story towers of brick that contain the stairwells, elevators and exhaust systems for the laboratories. The laboratories—the "served" spaces—are largely of glass, and they are interspersed among the "servant" towers, which are themselves the dominant visual element in the strong and balanced visual composition.

### Functional Difficulties

The building has had a number of functional problems—the laboratories are small, and the glass walls are often impractical for controlled experiments—but it is generally considered one of the major esthetic statements of the sixties.

After the Richards building, Dr. Jonas Salk, the developer of the polio vaccine, commissioned Mr. Kahn to design the Salk Institute, a complex of

laboratories in La Jolla, California, completed in 1965.

The LaJolla buildings, on a stunning site overlooking the Pacific Ocean, consist of layers of laboratories and studies alternating with layers of mechanical equipment. The materials here are wood and concrete, combined with meticulous refinement and care, and in characteristic Kahn fashion, the imprint of the plywood forms on which the concrete hardened was left on.

Dr. Salk approached Kahn, he later said, because he wanted a building "which he could invite Picasso to." He gave Mr. Kahn a detailed functional program but few other esthetic stipulations. The freedom Dr. Salk gave Mr. Kahn led the architect later to praise him as the ideal client—"one who knows not what he wants, but what he aspires to."

### Much Work Under Way

Mr. Kahn's more recent work, much of which is still on the drawing boards or under construction, continued to reflect the concerns expressed in the Yale Art Gallery, the Richards Laboratories and the Salk Institute.

The new library at Phillips Exeter Academy in Exeter, N.H., completed in 1972, is a 108-foot square with brick walls on the outside and an eight-story court on the inside. The court is walled by great

arches of concrete, and it is a space of simple geometry but subtle power.

Mr. Kahn's fondness for brick—and his eagerness to create a building that would be compatible with its neo-Georgian surroundings—were the dominant factors in determining the exterior design. The interior, which is one of his more important recent rooms, is a product of more modern, technological leanings combined with Mr. Kahn's sympathy for concrete.

Mr. Kahn's two projects on the subcontinent—at Ahmedabad and at Dacca, are also powerful forms of brick and concrete. In both, arches play a major formal role. ("Brick wants to make an arch," Mr. Kahn said characteristically.)

For the Kimbell Museum, completed in 1972, Mr. Kahn used a series of long cycloid vaults open at the top to admit light, which was then deflected towash down the inside of the concrete vaults. One of the most important museum buildings of recent years, the Kimbell reflects Mr. Kahn's deep concern with the relationship of light to his buildings, both inside and outside.

Another museum, the Yale Center for British Art and British Studies, the gift of Paul Mellon, is now under construction facing Mr. Kahn's Yale Art Gallery. The new building's stainless-steel and concrete facade and the old building's front of brick will complement each other not only esthetically, but as early and final works of his career.

Born in Estonia, Mr. Kahn came to this country in 1905. He lived and worked in Philadelphia most of his life, graduating from the architecture school of the University of Pennsylvania in 1924 with the third medal out of a class of 35.

### Had Classical Training

His training at Penn was largely in the classical, Beaux Arts tradition, and it was a major factor in leading Mr. Kahn to avoid the major movements of the then-developing modernist school. He did not adopt the "revival" approach of many Beaux Arts graduates, and later said that his Beaux Arts training had taught him not to imitate historical styles, as so many Beaux Arts graduates did, but to apply the basic Beaux Arts principles of symmetry, grand spaces and balanced geometric masses to his own architecture.

He thought of the Beaux Arts approach, he once said, not as a tradition but as "an introduction to the spirit of architecture."

Mr. Kahn was a lifelong teacher, and at his death was Professor of Architecture at Penn. He had also taught at Yale, and lectured widely both here and abroad.

It was in the late fifties that a group of young architects began to gather around Mr. Kahn at Penn, and he became the major inspiration for the "post-

modern" school of such architects as Robert Venturi, Charles Moore, Denise Scott Brown and Romaldo Giurgola.

While none of these architects designed precisely in the Kahn mold, they all built on his philosophical approach, and he is generally credited with having made such movements as the Venturi "pop" esthetic possible by providing a philo-

sophical basis for the rejection of standard modernism.

At heart, Mr. Kahn was always a teacher, and while he generally avoided discussing his buildings in particular terms he was fond of repeating a number of observations that he felt helped to explain his approach to architecture.

One, "the sun never knew how great it was till it hit the

side of a building reflected his obsession with light and the way he tried to make it a vital part of his architecture.

His other remark went deeper, perhaps, to the basis for his view of his role. "The creation of art is not the fulfillment of a need but the creation of a need," he often said. "The world never needed Beethoven's Fifth Symphony

until he created it. Now we could not live without it."

Besides his wife, Mr. Kahn leaves a daughter, Sue Ann.

A funeral service will be held at 10 A.M. Friday at the Oliver Bair funeral establishment in Philadelphia.

March 20, 1974

# The Gospel According To Giedion and Gropius Is Under Attack

## By ADA LOUISE HUXTABLE

Modern architecture is at a turning point. A half century after the revolution that ushered in the modern movement and changed the look and character of the built world, we are in the midst of a counter revolution. Although the streets of cities everywhere are lined with the glass and steel towers that testify to the genius and influence of Mies van der Rohe, and the sculptured concrete forms of Le Corbusier have transformed our surroundings, from public buildings to housing, the theory and practice of modernism are under serious attack.

There is no controversy about the monuments themselves. Such structures as Le Corbusier's Marseilles apartments and chapel at Ronchamps are among the ranking prototypes of 20th-century high-rise and symbolic

construction; the prophetic vision of Mies's post-World War I glass skyscrapers have been fulfilled handsomely in Chicago in the 1960's. The equally prophetic humanism of Alvar Aalto, the early work of Walter Gropius, and all of the landmark examples of the leaders of the International Style remain among the icons of the profession.

But other icons are being broken. The beliefs and tenets of the modern movement that created these buildings—the gospel according to Giedion and Gropius that preached functional and formal purity and rejection of the past—is being increasingly debated and denied. There is in process now a complex, provocative and generation-splitting restructuring of what Martin Pawley and other writers have called the "architectural belief systems" of the 20th century. The philosophy, art and prac-

tice of architecture are changing.

The evidence of these changes is clear. Last fall, the Museum of Modern Art, which introduced the International Style to the United

States in 1932 and retained its ideological fervor for 40 years, staged a huge Beaux Arts show—a literal exhumation of the specific style and teaching that modernism rebelled against. This spring, at

A new school of young architects whose work is "romantic, eclectic and fiercely intellectual," as represented by Robert Venturi's Guild House, are in revolt against the "pure functionalism of such masters as Mies van der Rohe, whose Federal Center in Chicago is a modernist icon.

# Architecture

the same time that Chicago has honored its celebrated skyscraper heritage with a major exhibition, a counter-show of "what the Chicago School left out" has been causing furious comment. Both the New York exhibition and the rebel show in Chicago lean heavily on a change of heart and eye that rejects accepted doctrine and "rediscovers" what the modernists discarded.

Among architects, a group of "young Turks" has embraced this "radical" re-viewing of the past, and much more. In Philadelphia and at Yale, academic movements strongly influenced by architects Louis Kahn and Charles Moore and historian Vincent Scully, have produced a generation of heretics. Their approach is romantic, eclectic, and fiercely intellectual, a far-cry from the hard-line, functional esthetic of the 1920's and 30's that was to save society as it created art.

•

Today, New York architect Richard Meier builds houses of exquisite Corbusian nostalgia that are anything but "machines to live in." The Philadelphia firm of Venturi and Rauch draws equally from the near and distant past and the vernacular scene for low-key designs that are viewed by some as leg-pulling satire and by others as serious innovation. The New York firm of Hardy, Holzman, Pfeiffer uses the "industrial esthetic" of the early modernists with the same tongue-in-cheek delight that it applies to the inclusion of camp details. The younger Chicago architects are reviving local 1930's modernism with aesthetic nostalgia rather than with functionalist doctrine.

This work is being forged out of new ideas that incorporate everything from visual irony and scholarly exercises in historical revisionism to a powerful disillusionment with the failure of the dream of the world of the future promised by the modernists. The broad outlines of the new architecture—for there are diverse and interlocking trends—are part of a culture that is currently rejecting or questioning older values, discovering a new populism and pluralism, and is increasingly informed and selective in its taste.

The result is neither static nor stagnant; this is a period of vital exploration. But there

is little agreement about what is going on. The older generation sees the new directions as blasphemous and the younger generation sees them as the creative reopening of the limits of design.

The counter revolution had to happen, not just because history and art never stand still, but because so much else has happened in these fifty years in which the modern style has become the established way of building. Modern architecture is acknowledged to be an immense, incontrovertible and and often magnificent fait accompli, paralleled in importance and achievement by only a few periods in civilization. It glorified new structural materials and systems, and developed a style based on the expressive use of these elements.

At the same time, it was closely allied to the growth of abstraction in the other arts, with its insistence on flat surfaces, simple geometric shapes and primary colors. There were laws, written and unwritten. Ornament was crime. Form followed function. Industrial processes and materials, or the machine esthetic, replaced handcrafts. The break with the past was to be total.

But rules are made to be broken. The present generation of architects, using the advances in structural technology freely, detours significantly from the earlier functional straitjacket. It is no longer considered essential to reveal or express basic structure; the best recent work of Kevin Roche, for example, conceals it with a flat glass and metal skin whose elements express a quite different scale, without sacrificing a rational relationship between the two. There is a rising emphasis on the use of structure and technology to create an esthetic of formal drama for its own sake, related to function, but quite independent of it.

The forms that once followed function are treated as abstract sculpture. Elements of technology — industrial trusses, exposed ducts, factory glazing—are used as a decorative vocabulary of symbolic objects and intrinsic ornament rather than as objects of utility. The English work of James Stirling carries this practice to an expert high.

The idea of a building and its uses expressed with basic

simplicity and clarity is often replaced, in the work of younger practitioners, by ambiguity and playfulness. The kind of complexity and even arbitrariness in the way the components of a building are combined and the calculated effects that result suggest the architecture of Mannerism or the Baroque rather than the puritanical pieties of modernism. In fact, an eclectic mannerism that would have the modern masters turning in their graves is replacing the "purism" and "functionalism" of the 20th-century architectural revolution.

The new approach requires skill and carries a high amount of risk. At the same time there is a careful questioning of everything the modern movement has promised and delivered.

And we can see now the limitations of modernist doctrine. The modernists promised Utopia; their vision was of a cleaner, brighter, more efficient and orderly universe in which architecture and technology would create healthful and happy housing for all countries and classes. It was to be free of all hypocrisy and cant and any reference to history.

Le Corbusier proposed tearing down part of Paris for towers in a park and shocked no one; the Deutsche Werkbund built model housing that housed very few; Hugh Ferriss drew "future metropolises" that never came to pass. But it was truly believed that architecture was to be a social tool in a marriage of morality and art that would have confounded even Ruskin, and architects were to be the missionaries of a new and better world.

•

It did not work because it promised too much, and what it promised was unreal. Modern architecture is perhaps a classic case of the disappointments — no matter how great the very real accomplishments—that go with too-high expectations. The question asked by a new generation of students is how such high ideals could have produced so much inhumanity.

The dream of modernism was caught in other 20th-century revolutions, in racial, social and moral upheavals far beyond the architects' control that made their panaceas seem touchingly naive. It was crushed by economics, which reduced a reductionary esthetic still further, from the

bare beauty of the new technology to the cheap, stripped expediency of businessmen and bankers. It was distorted and turned into clichés by speculators and jerry-builders.

The basic belief that functional and mechanical logic led naturally to elegance and beauty was disproved in a million sterile downtown "renewals." And the kind of architectural sociology that replaced the 19th-century row houses of the Gorbals in Glasgow, for example, with modern high-rise towers, simply exchanged one kind of slum for another.

There were, in addition, theoretical blind spots that courted disaster. If modernism rejected history, it also rejected reality. It still retained the traditional idea of the building as monument, ignoring great masses of lesser construction, and imposed its monuments on their surroundings with a stunning lack of environmental empathy.

Environment, in fact, was the important missing concept. There was little concern for the need to relate building elements to each other in a social, functional and esthetic pattern beyond the most abstract planning diagrams. The organic strengths and accretions of the ad hoc environment were anathema.

All this—the perversion of the modernist ideal, the failure of its social aims, the explosion of the myth of progress, the deadly spread of the commercial cliché, the disruptive impact on the receiving environment, plus the poverty and rigidity of design from which any allusion to the past has been expunged — led inevitably to disenchantment. And then came a new generation, which had no bad associations with history, for whom old buildings did not mean oppressive ideas or conditions, and who did not share the taboos of their fathers.

Looking for enrichment, both visually and emotionally, this generation has indulged in a romantic revivalism that accommodates both the most superficial nostalgic kitsch and the most informed historicism. It is an orgy of rediscovery.

Architects have developed a new set of attitudes and interests based on new perceptions of history and the environment. The two are inextricably linked. To see the environment whole, one must see history whole, and it has become necessary to deal

sensitively with older buildings and values. It has become equally necessary to acknowledge the rationale and the result of disorderly, but vital organic growth.

Today's architect, therefore, does not find history expendable; this is one profession that went through the "history is irrelevant" bit half a century ago. In fact, historicism, and in particular, historical revisionism, is one of the leading factors in the new architecture. But history is seen and used very differently now. There is a selective preoccupation with those periods that serve the almost perverse complexity of the contemporary condition: Mannerism, the Baroque, Romantic Classicism. There is great interest in those styles that were declared despicable, dead, or non-existent by the modernists: the Beaux Arts, Victoriana, Art Deco and all the products of the near-past that were deleted by revolutionary taste or doctrine. There is a fascinating rewriting of recent history to restore suppressed styles and periods.

•

Fringe figures, not-long-buried or still alive, are being revived and reinterpreted: George Howe, George Fred Keck, Andrew Rebori, Barry Byrne and Ely Jacques Kahn among the modernists; Ralph Adams Cram, a "modern" medievalist; Frank Furness, the most exuberantly outré of the Victorians. Continuities and sequences are being filled in and rearranged, and all of this work is being given fresh meaning.

But this process, too, is not without its own architectural belief system. The philosophy of eclectic revivalism was synthesized by Robert Venturi in a slim, catalytic book called "Complexity and Contradiction in Architecture" published by the Museum of Modern Art in 1966.

(When the Museum opened its "scandalous" Beaux Arts exhibition in 1975, it signified the official acceptance of the new respectability of the Academy and put its official stamp on the broadening of modernist horizons through the examination of the past. The expected shock waves never materialized because historical eclecticism had already been embraced by the architectural avant garde.)

•

Venturi's point, now generally accepted, was that the art of architecture was an in-clusionary whole, made up of all of history and all of the elements of the environment, and that examination of this continuity, with its contrasts and intricacies, had much to teach the designer about the richness of esthetic and functional relationships. He called strict modernist doctrine exclusionary in its renunciation of these models and effects. He endorsed a vital and messy disorder over an orderly sterility, and suiting his own taste for a sensitive, suggestive esthetic, incorporated mannerist elements of symbolism and ambiguity into his style.

An even earlier eclectic precedent is to be found in the frankly sybaritic borrowings from Soane and Ledoux and other 19th century Romantic Classicists in the work of Philip Johnson in the 1950's and 60's, to an obligato of embarrassment and abuse from the righteous. The buildings weren't always very good, and some were even quite bad, but these experiments led to Johnson's liberated, crystalline geometry that is in the front ranks of today's creative work.

The liberating example of Louis Kahn, puzzling at first but increasingly understood and hailed as architectural horizons widened, is now seen to be of paramount importance. Kahn, trained in the Beaux Arts, never scuttled its lessons; his underlying love of classicism and solidity created a unique modern style. He managed to incorporate a sense of the timeless qualities of architecture, from antiquity on, in his striking contemporary work, opening the eyes and minds of an entire generation of students to the universality of the building art.

A young New York group has taken closer historical models. John Hejduk plays on Corbusian themes and motifs; Richard Meier, Charles Gwathmey and others ring changes on the nostalgic and formalistic elements of the International Style. This is an expert game of almost instant recall, totally divorced from the theories and conditions that shaped those forms in the first place.

In a sense, this is modern architecture turned inside out, its basic elements transformed into an arcane but elegant vocabulary for a tour de force kind of building based on special references for those in the know. This rearranging and incorporating of motifs becomes a style in itself, abstract to the point of sculpture, aggressively and hermetically esthetic at a time of declared emphasis on social utility and human needs. This is consummate mannerism. And it is also an élite style when élitism is a pejorative word. It is producing some of today's most skilled and handsome building, as well as some architectural navel watching, and there is the danger of an exotic dead end.

•

What is most significant about this kind of history is that it is being transmuted into something totally new. It is all revisionist, whether it is a group of architects rewriting the history of the Chicago School, or another group using rediscovered design principles in an uncommon or unusual way. No one intends to engage in conventional revivals; there will be no neo-Gothic or neo-Baroque or copies of medieval or mannerist monuments or traditional systems of ornament. But architects raised on "less is more" are hungrily groping for a little more.

They are avid for the revelations of space and facade afforded by the classical Beaux Arts; they are admiring of the picturesque use of light, level and surface enrichment as tools of functional purpose and sensuous response in High Victorian styles; they can fall in love with a 1920's facade. The recycling of old buildings is no accident at this time. But these lessons are not being taken literally, and their interest comes from much more than nostalgia. What is being sought are ways to achieve an enlargement and elaboration of modern vision, technique and effect.

Interpretively, everything is "in" that the modernists threw out. This principle of inclusionism, or almost anything goes, extends to another parallel new interest: the vernacular or Pop environment. The architectural avant garde is equally intrigued by the rediscovery of history and the new discovery of the popular landscape—the hagiography of signs and symbols, motels, fast sales and fast food, of the highway, the suburb and the city. Chaotic commercial accretions are carefully dissected for function and symbolism.

•

Here, too, Robert Venturi and his wife, Denise Scott Brown, must be credited. They achieved the apotheosis of the "dumb and ordinary" building and environment—an event that has a clear parallel in Pop Art. The architectural message was delivered in the 1960's through articles and a book, "Learning from Las Vegas." This was a much harder bullet for most architects to bite than the rehabilitation of history in "Complexity and Contradiction."

But this perception of the vernacular environment adds another valuable chapter to history. Its insights and evaluations are revealing. Beyond that, however, the Venturis have translated their observations into debatable, didactic principles for the practice of architectural design. These principles not only turn architecture inside out, they turn élitism inside out. In their kind of inversion, the builders' economic and functional justifications for junk become the architect's guidelines for art. A stunning contradiction is produced: élite populism. What is most significant, however, is that this intellectual exercise, too, is a form of eclecticism, with an input into the design process similar to neohistoricism. It is, in fact, part of the same architectural package.

A particularly quixotic kind of élite populism can be seen in the work of the firm of Hardy, Holzman, Pfeiffer, which incorporates elements of kitsch, dumb-and-ordinary and near-history into a product frequently distinguished by urbane wit and skill. Simple industrial materials and mechanical elements are celebrated as high art. But the ultimate example of this popular mechanics approach is probably Paris's Centre Pompidou, the prizewinning design by Piano and Rogers, now in construction for the new museum (more correctly an information, entertainment and cultural center) that will be Paris's contemporary cultural showplace. Described in Architectural Design (a British periodical that regularly feels the pulse of the avant garde) as an "urban machine, fluid and flexible," it is to be a place where specialists and laymen "design their own needs into the building, as free as possible from the limitations of architectural form."

•

Old dreams die hard. We have come full circle. Here again is the modernists' wonderful machine for living and doing other things in, married this time, with remark-

able ingenuity, to the new populism: everyone is to share in giving the building its identity. Since its identity has already been firmly established by the architects, in a *macho* structural steel-and-glass esthetic of elaborate, mechanistic symbolism and indelible style, this may be paternalistic populism. And we are back to the monument again.

All of these trends represent attitudes and styles only possible at a time of the near-total reevaluations that are currently running through most of the institutions of contemporary society. This new architecture is a part of its time. Its polarities of subject and style are due to another current concept, the idea of "pluralism," an already overworked word that implies a permissable and desirable cultural diversity. And its products are only possible in the hands of extremely able, acutely well-educated, worldly professionals of highly developed sensibilities.

The words that tie these many directions together are revisionism and romanticism. Austerity is now a matter of economics more often than of taste, and never of decree. History and hedonism are back. Architecture is admittedly not going to save the world and it has a far gentler moral stance. It may still improve parts of the environment noticeably, and it has developed a commendable social awareness.

But two things are being reordered radically today: the history of the modern movement and the theories and principles upon which the contemporary practice of architecture rests. The nostalgia, the revivalism, the symbolism, the arcane and arbitrary uses of the past, the canonization of the recent and the ordinary, bespeak a cultural sophistication rather than a cultural copout. These references are being employed carefully and creatively, with immense calculation and rigorous intellect, for a cool and challenging art. ■

June 27, 1976

# PHOTOGRAPHY

### PHOTO-SECESSION EXHIBITION

Remarkable Work by Stiechen, White, Seeley, Coburn, and Stieglitz.

To those interested in seeing what photography can accomplish artistically, the exhibition now on of the work of the members of the Photo-Secession at 291 Fifth Avenue will furnish something to think about.

The advent of photography forever disposed of the time-honored notion that the delineation of form was the sole province of the human eye and hand. Hitherto the printer was the monopolist of the graphic modes. But the first daguerreotype, with its delicate silver image traced and fixed upon the copper plate by the action of light, marked the birth of a new artistry that revealed the natural aspect of things with such unflinching veracity and unsuspected beauty as no draughtsman, however gifted, might ever hope to rival.

At first, wholly mechanical, exceedingly circumscribed and impersonal, photography has gradually become more and more individual, until to-day it verges close on being an altogether plastic medium of personal expression.

Pictorial photography stands firmrooted in the principle that the laws of artistic expression are unconditioned—that there is no virtue in the burin, the needle, the brush, or the pencil, which may not inhere in the lens used with a similar degree of skill and moved by a soul similarity fired with high ideality.

As in all the arts, it was a few highly gifted and imaginative spirits who disclosed the possibilities of this latest medium. It is a curious coincidence that the two greatest discoveries in the character and application of light should have first been made in France, and then brought to their present state of high development in America. The knowledge of light contributed to the art of painting by the observations of Monet, Manet, and their adherents has in this country been supplemented in the paintings of Leon Dabo, whose work is characterized by an unusual ambience of light. The discoveries of Daguerre of Damachy, of Pere Lunière have been so far surpassed by Stieglitz, Stiechen, Coburn, and White as to give American pictorial photography the place of supremacy.

If photography is ever to attain a permanent place among the arts, it will be by virtue of its intrinsic merit, not by its success in counterfeiting the characteristics of some other art. In its course of development photography has not infrequently been misused, being made to simulate etchings, paintings, wash-drawings, and a variety of things that it was not in the mistaken belief that this was the real thing in artistic photography. So great was the demand for this so-called high-art photography that for a time some of the best photographers were drawn into this maelstrom of charlatanism that swallowed up many promising talents. Only a few succeeded in extricating themselves—commercial success ingulfing the others.

Of the more serious practitioners of pictorial photography who have achieved success artistically, Mrs. Kasebier and Miss Alice Boughton were perhaps most guilty of these doubtful practices. In their manipulation of prints they departed radically from true photographic ideals, some evidence of which is discernible in Mrs. Kasebier's print called "The Enchantment" shown in this exhibition, which lacks depth and weight. More representative of the best side of her work is the print called "French Landscape," which has a delicate, soft Corot-like quality obtained largely by printing on Japan paper, which gives it in addition the appearance of an old print. It has a completeness missing in "The Terrace" with its conflicting spots of light that utterly spoil what might otherwise have been an effective print. These three prints may be said to be fairly representative of the range of Mrs. Kasebier's work, and illustrate her shortcomings as well as her good qualities.

Miss Boughton's work has much of real merit and a distinct personal touch, characterized, however, by a certain irrelevancy at times which continually keeps her prints from taking the highest rank. It is imbued with good ideas backed up by a tolerable knowledge of her metier, but somehow it often fails of being wholly convincing, which makes one feel that either it is not well thought out or the thought behind it is inadequate. This is well illustrated by her print, "The Seasons," which we reproduce in the Pictorial Section. It has a very definite charm in the arrangement and posing of the figures which, in the original is almost nullified by its lack of quality and the disagreeable white space above the figures which detracts from the interest of the composition. This has quite disappeared in the half-tone reproduction, which only confirms my contention that she fails to fully develop the possibility of her subjects.

In sharp contrast with the foregoing methods is Coburn's portrait of Mrs. Kasebier, shown here. This is good, straightforward photography wherein the subordination of conflicting details has been achieved by printing; that is, by the use of light. The test of portraiture is perhaps the severest test of all to which to submit photography. But it is in this very field that it has won its greatest triumphs. Such a portrait as that of Leon Dabo, despite its faults of overaccentuation in the drawing of the ear and the somewhat pale tone, could nevertheless be surpassed by but few portrait painters to-day.

Possessed of a more unerring pictorial sense, and at times of greater inspirational qualities than most of his fellowsecessionists, Stiechen is now and then betrayed into a harking back to the old masters of painting for his most striking effects, as in the case of his rembrandt-esque portrait of Lady Ian Hamilton, which we reproduce in the Pictorial Section. But, nevertheless, when one remembers that this has been done with a camera, one is surprised at its fine pictorial value, its great dignity, and the consummate mastery of the execution.

That pictorial photography as practiced by the members of the Photo-Secession is not dependent on any fortuitous combination of circumstances would seem to be amply proved by the series of pictures made by Alfred Stieglitz of scenes in and about commonplace New York, wherein the qualities of selection and sympathetic interpretation are highly developed. All his work exhibits a clearly defined intention, expressed with great skill and a fine sense for the pictorial possibilities of undoctored photography. His town or country scenes, as delicately atmospheric as the best canvases of any of the impressionists, are never reminiscent of this or that painter, nor does it suggest painting at all. This is its chief virtue: that it is, first and last, good, sound photography, in which the limitations as well as the possibilities of the camera have been recognized. That he succeeds in making such a subject as the print reproduced in the Pictorial Section called "In the grand Central Yards" interesting to us is proof that he is gifted with a rare vision that discovers beauty in unexpected places.

Perhaps the most gifted of them all, surely the most unostentatious, and the most poetic, is Clarence White, who is now giving a course of lectures on Pictorial Photography in Columbia University. His work reveals a mind unusually sensitive to the glory of light, and his work illustrates the best achievements of modern photography as a medium of personal expression. In portraiture he has succeeded more uniformly than any of the others in conveying the personality of the sitters, whom he prefers to depict in their own environment, rather than in the artificial glare of the studio light. This probably accounts for the intimate nature of his portraits. White's work is beginning to draw to it kindred spirits. It has had an undeniable influence in shaping the talent of George Seeley, a newcomer of much promise and not inconsiderable achievement, whose prints echo some of the strange beauty of "the misty mid-region of Weir." His "Prosperina" and "The Globe" reveal the poetry of a head far more than the work of steichen, and they have greater quality than the prints by Coburn on the opposite wall, which look rather superficial by comparison.

Another newcomer, whose work also brings a new note into these shows, is Mrs. Annie W. Brigman, whose "Soul of the Blasted Pine" we reproduce in the Pictorial Section. There is a note of primitive, elemental power in these prints that is akin to nothing so much as the spirit of the old Norse sagas, for which they might well serve as illustrations. Moreover, they are the straightest kind of straight photography, without any claptrap scenic arrangements, such as were hinted at by a certain writer innocent of the subject. Her work is a notable addition to a company already distinguished by its lofty ideals.

The exhibition continues until the end of the month, after which a collection of some fifty drawings by Rodin will be placed on exhibition.

December 8, 1907

# THE CAMERA

## Five Exhibitions of Photography

### By KATHARINE GRANT STERNE.

THE week just concluded has seen a sudden plethora of photographic shows in New York. Margaret Bourke-White's Russian photographs, taken during her recent tour through the U. S. R., were put on view at the American Russian Institute. Work by H. I. Williams, a well-known commercial photographer, opened at the Camera Club; and photographs of important people (Clémenceau, Foch, Herriot, &c.) at the Museum of French Art. E. P. Dutton brought the sixth annual Kodak International Exhibition to New York from Rochester. The employes of Western Electric inaugurated the first Telephone Camera Club show in the Telephone Building in West Street. Photography, long a parvenu among the fine arts, seems at last to have received the accolade.

It has been argued, with reason, that the invention of photography, by releasing the painter from the onerous task of making journeyman likenesses of uninteresting persons, left him free to develop painting as a fine art. It is a historic fact that the emancipation of painting from the realistic canons that had governed it since the time of Massaccio, Uccello and Pollaiuolo, coincides with the perfection of a practical method for photography. To what extent the "modern" movement owes its being to the invention of a mechanical process of pictorial recording it is, of course, impossible to say. Other factors, economic, intellectual and social in the broad sense, must be considered; but it is a safe hazard that painting would not have attained the extraordinary imaginative freedom that characterizes the modern schools had not the office of realistic reproduction of nature been usurped by the lens.

Photography, on the other hand, has long since ceased to be a mere utilitarian instrument. Since the last decades of the nineteenth century when Nadar, Stieglitz and Kasebier were finding themselves, since as early as 1843, if we accept the isolated instance of the great portraitist, David Octavius Hill, photography has gradually assumed its place as an art different in kind rather than calibre from the related pictorial art of painting. Modern photography is aggressive in its autonomy; any attempt to imitate painting, either in spirit or in technique, is anathema in contemporary practice.

Photography is the machine-age art par excellence. The moving picture and the snap-shot mark the tempo of our time. The mass production implicit in the photographic process is economically modern. With architecture (or engineering) it is the liturgical art of the culte mécanique. "The well-dressed" room in the year 1931 is decorated with plates by Moholy-Nagy, Strand and Atget. They harmonize with the aluminum furniture, for one thing; and they express the state of mind that substitutes the shingle for the pompadour, the vitamin for the viand, gin for Burgundy and Ernest Hemingway for Henry James.

\* \* \*

ENTHUSIASM for photography is, of course, no new thing. There are magazines in several languages devoted to photography as a fine art; Camera Work, the most important American publication, was founded in 1903. General art reviews, (The Arts, Creative Art) and more or less "advanced" literary periodicals (The Little Review, Transition, Hound and Horn) have included reproductions of modern photographs as an important part of their contents. The Condé Nast publications did much to popularize Steichen, de Meyer, Hiller and a few others in the United States, while in Europe more magazines than there is space to mention stress photography at least as much as painting and the other plastic arts.

Certain eminent masters—Moholy-Nagy, Steichen, Atget, Lerski and, most recently, David Octavius Hill—have been honored with monographs. A very new and striking sort of photographic book illustration is exemplified by Léon-Paul Fargue's "Banalité" and André Breton's "Nadja."

Photographic exhibitions have enjoyed a moderate popularity for several decades. In addition to the annual salons at the Camera Club, galleries devoted to painting and the graphic arts have held occasional photographic shows. Since the days of "291," Alfred Stieglitz has featured his own and Paul Strand's work regularly. Last Summer Erhard Weyhe had an excellent Atget exhibition. Bourke-White, Walker Evans, Ralph Steiner have been seen at John Becker's, and the Delphic studio has shown Edward Weston and Moholy-Nagy.

Outside New York, the Society for Contemporary Arts at Harvard and the Albright Art Gallery in Buffalo have had important exhibitions of modern photography. It remained, however, for Julien Levy, a young man who has worked in the motion pictures, to open a gallery dedicated primarily to the fascinating art of photography.

In his first show, "A Retrospective Exhibition of American Photography," Mr. Levy attempted to demonstrate the mutations of photography in this country from such beautiful early work as Steichen's Whistlerian "Self-Portrait" (1898), Stieglitz's epoch-making "Steerage" (1907), and the sensitive "Seated Woman" by Clarence White (1896), to the latest portrait of a typewriter by Charles Sheeler, or the most severely literal abstraction by Paul Strand. In his next exhibition, Atget and Nadar, which opens Dec. 12, Mr. Levy turns again, with enthusiasm, to the romantic reaches of the nineteenth century.

December 6, 1931

## Photography Gains Recognition as an Art; Modern Museum Sets Up Department for It

Recognition of photography as a branch of art by an outstanding American museum came yesterday with the announcement by the Museum of Modern Art, 11 West Fifty-third Street, that it had established a department photography.

Alfred H. Barr Jr., director of the museum, made the announcement in connection with a preview of the first exhibition organized by the new department. The show is called "Sixty Photographs: A Survey of Camera Aesthetics," and will be opened to the public today.

Photography already had been recognized by the museum to the extent of several important exhibitions, notably the large retrospective show held in 1937 called "Photography 1839-1937."

A collection of photographs was started some time ago as well as a reference library of photographic material. The success of these enterprises, according to Mr. Barr, led the trustees of the museum to create a department of photography. Beaumont Newhall, librarian of the museum, has been appointed curator of the department.

"Eleven years ago," Mr. Barr said, "when the Museum of Modern Art was founded, the arts of painting and sculpture were its principal concern. Gradually other departments were formed, architecture in 1933, to which was added industrial art; then the Film Library in 1936, and now photography.

"By exhibitions, both in the museum and throughout the country, by increasing in size and scope the photograph collection and reference library, by publication and lectures, it is hoped that the department will serve as a center for those artists who have chosen photography as their medium, and will bring before the public work which, in the opinion of the curator and the committee, represents the best of the present and the past."

The department of photography has been organized and its preliminary program worked out by a committee working in close cooperation with the museum. The committee consists of David H. McAlpin, chairman; Ansel Adams, vice chairman; John E. Abbott, Alfred H. Barr Jr., Dr. Walter Clark, Beaumont Newhall, Archibald MacLeish, Laurance S. Rockefeller and James Thrall Soby.

The exhibition to be opened today ranges in subject-matter from portraiture to informal studies of persons, architectural subjects and landscapes, and from objective interpretation to abstract creation. In date the photographs range from the Civil War to the present. The show will continue through Jan. 12.

December 31, 1940

# THE CAMERA VERSUS THE ARTIST

**By ALINE B. SAARINEN**

THE current exhibition at the Museum of Modern Art packs a terrific emotional wallop. It is a show not of paintings but of photographs: Edward Steichen's tremendous "Family of Man" exhibition, consisting of over 500 photographs of man's moods from birth to death. Its impact is so forceful, in fact, that it raises a nudging question: has photography replaced painting as the great visual art form of our time?

Once the question is allowed admittance, instances come to mind that accelerate an affirmative answer. Which are the unforgettable images of our age? What more poignantly represents the nightmare of the atomic bomb than the photograph of the crying little girl alone in the desolate, bombed landscape of Nakasaki? Is the fall of France more penetratingly etched on memory than in the photograph of the middle-aged bourgeois Parisian with tears streaking his face? And in this show, does not the photograph of the soldier saying good-bye to his little boy unveil a universal truth about war?

More arguments rush forward to defend this young art form. Granting that all art is an expression of a response to life and a communication of emotion, is it not true that photography makes itself immediately intelligible and that its statement is undeniably universal? Conversely, has not painting become so introverted, so personal, so intellectualized that it has lost both its emotion and its power of communication?

The argument needs testing. Let us try a sobering question or two. Suppose one had to choose between saving the life work of the ten best painters and the ten best photographers of our time? One pauses. Picasso's "Guernica," Matisse's "La Danse" come to mind. Horror of man's inhumanity to man: the apotheosis of joyousness. Mondrian; Miro; Leger. Surely one would have to save the work of the painters in such a choice.

## The Artist's Vision

They are the ones who have invented a whole way of seeing for our age. Their statements have irrevocably influenced our life. And no matter how debased and vulgar their color and form may have become in the ad and the automobile, their vision has still directed almost everything we see and use. Moreover, through their work we are reminded, as in a Boromini church or a Beethoven symphony, of the dignity of man, for it is in his personal creativeness that he most triumphantly asserts this fact.

So, we must save the work of the ten great painters. But now suppose we have to choose between all the rest of the paintings of our time and all the rest of the photographs. The answer is easy. Let us save the photograph. For surely as against the mass of the painting, derivative or tentative, the photographs in this totality have a validity, a directness and a powerful statement that the paintings lack.

Suddenly the smoke clears. The answer is apparent. Painting is in our time, as it always has been in the hands of its giants, a great and strong means of expression. But photography is the marvelous, anonymous folk-art of our time. Test this further. Steichen made his show from over 2,500,000 prints that were submitted by professionals and amateurs in sixty-eight countries. Suppose the Museum had invited paintings on the same basis. The thought of what the 500 objects would look like is appalling!

This sort of speculation and the Steichen show make another point about painting and photography eminently clear. And that is the distinction between the two visual forms.

A painting, however realistic, is always an abstraction. A photograph, no matter how abstract, is always basically actual. The painter starts with an empty canvas and creates an image, seen or imagined. The photographer starts with the finished image and creates by selectivity.

Recently, as Steichen points out, certain photographers borrowed the artist's *concept*, playing up form and fragment as an abstraction, submerging subject-matter to composition.

One of the fascinating aspects of the "Family of Man" show is that it is composed almost entirely of those photographs which capitalize on the special and peculiar virtue of the camera: what Steichen calls "the swiftness of seeing," the ability to fix an exact, transitory instant. This is photography at its purest best.

Conversely, one need only think of how banal the moving photograph of the flag-raising at Iwo Jima became when it was cast into bronze sculpture to see that the plastic arts, too, are weakened when they trespass into the area of another medium.

That each of the art forms of painting and photography is most forcible and effective when it is truest to itself is perhaps the lesson of the "Family of Man" which painters should take most to heart. Let them not resent the fact that his folk-art, as all folk-art always is, is replete with easily assimilable emotional impact. Let them instead be reinforced in their conviction that they have no *responsibility* toward depicting the outward appearance of the world or even finding the "hidden significance in a given text." Theirs is the prerogative to invent and create the image and to write the text which conveys the significance.

But let them also be reminded by this exhibition that communication of emotion is at the basis of any art.

**February 6, 1955**

# IN THE MAIL: ART VERSUS CAMERA

*To the Art Editor:*

THIS is to take some exception to your review entitled "The Camera versus the Artist" which discusses the magnificent photographic exhibition arranged by Edward Steichen at the Museum of Modern Art and called "The Family of Man."

One would not ordinarily feel it necessary to express his disagreement with such a discussion. However, in this case, I feel that the assumptions made actually do a great disservice to both art and photography, and that perhaps one should make some sort of comment about them.

Your reviewer, Aline Saarinen, was greatly affected by the exhibition even though it stands in exultant contradiction to every precious principle which she and the majority of other art writers have laboriously hung about the neck of art across a decade of literary effort.

In order to reconcile the contradiction between, on the one hand, the precious principles, and on the other, the undeniable impact of Steichen's great assemblage, it became necessary for the reviewer to do some fine scalpelwork upon those Siamese twins —art and photography. With the separation accomplished we are presented with two curious anomalies—photography emerges as "folk-art," but "responsible," while art remains art, but is warned that if its meanings become too "easily assimilable" it may fall into the category of folk-art, God forfend!

## Easily Recognizable

A few days ago The Times reproduced a painting by El Greco showing the body of Christ received in the arms of Mary. The meaning of the work is so easily assimilable that not even a single line of art comment is required for full comprehension. Is El Greco, then, a folk-artist?

The reviewer, it seems to me presses upon the artist a *responsibility* more onerous than any he has ever yet had to bear—namely the warning that responsibility may not be for him. Has it ever occurred to Mrs. Saarinen that perhaps the artist *wants* to be responsible? Is he not human? Does he not share the great common experiences of man? Has he not witnessed death and tragedy and birth? And is he, by some grievous miracle, exempt from the ordinary human reactions to such experience?

A further *responsibility* which your reviewer presses upon the artist is the injunction not to depict the outward appearance of the world. Must one then cease to admire David because one loves Klee? Must one reject Praxitiles in order to appreciate Noguchi?

A third *responsibility* placed upon the artist in this review is the prohibition against "trespassing" upon that area which is the proper preserve of photography. To this, one can only answer that there is no area anywhere that does not rightly belong to both painting and photography, provided the able painter or photographer sees in that area the making of a great symbol.

Obviously such efforts to exempt the artist from responsibility are only an attempt to make him feel free. That is not necessary. The artist who has great powers will feel free whether anyone "frees" him or not. But art, quite like small children, must have some structure of discipline to be able to grow. Without discipline, both atrophy.

## Defense of Photography

On behalf of the photographer I would take issue with the term "folk-art." Photography is a very highly developed art and keenly sophisticated. Both qualities are just the opposite of the earnest awkwardness and simplicity of folk-art.

I feel that the status of painting as an art is a higher one than that of photography not because the one is responsible, the other irresponsible, but simply because painting is able to call much more out of the artist himself, and is able to contain a fuller expression of the artist's own capacities than is photography.

But let us also note that it is not at all surprising that the public turns to the Steichen show with such undivided enthusiasm. The reason is, I am sure, that the public is impatient for some exercise of its faculties; it is hungry for thinking, for feeling, for real experience; it is eager for some new philosophical outlook, for new kinds of truth; it wants

contact with live minds; it wants to feel compassion; it wants to grow emotionally and intellectually; it wants to live. In past times all this has been largely the function of art. If art today repudiates this role, can we wonder that the public turns to photography; and particularly to this vivid show of photographs that have, it seems, *trespassed* into almost every area of experience.

BEN SHAHN.
Roosevelt, N. J.

To the Art Editor:

In her article "The Camera versus the Artist," Aline Saarinen raises what she calls "a nudging question: has photography replaced painting as the great visual art form of our time?" The very existence of this kind of thinking must surely force the artist to ponder the greater problem of the entire direction of painting today. Mrs. Saarinen asks whether painting has become "so introverted, so personal, so intellectualized that it has lost both its emotion and its power of communication?" It has become precisely that. Modern painting has relinquished the responsibility of expressing "a response to life" and an identification with life.

But if we follow her line of reasoning to its extreme, Mrs. Saar-

inen would l e to concede that the camera can adequately replace the entire tradition of Realism—that tradition from which the experimental branches of painting have grown. None of these branches can ever replace the tree itself though they may have great validity and enjoy great vogue.

DANIEL SCHWARTZ.
New York.

To the Art Editor:

Aline B. Saarinen's article "The Camera Versus the Painter" seems to me to sum up current opinion on her subject and to reveal an astonishing blindness at that opinion's core. The opinion runs: if you want to see events and things and people, look at photographs, and if you want a "way of seeing for our age" and "personal creativeness," look at the paintings of Picasso, Matisse and their colleagues. This is supposed to cover the ground. Actually, it ignores a tremendous range of visual possibilities.

Hang a photograph or a Picasso or a Matisse alongside a well-preserved painting by an Old Master and you cannot fail to remark the visible thinness and shallowness of the first, the visible solidity and richness of the last. In baldest terms, the

Old Master painting offers more for the eye to see.

Yours truly,
RICHARD BAUM.
Stonington, Conn.

The diversity of arguments and understanding in the three letters quoted above confirms the interesting fact that each reader interprets or twists an author's meaning to suit his own conviction. However, I feel it necessary to clarify a few points in my article, "The Camera Versus the Artist."

First, I thank Mr. Shahn for so lucidly rephrasing my reasons for defending painting as a higher art in the hands of its best practitioners than photography. But may I restate that, as opposed to the fully creative personal expression which painting demands, photography is (as the Steichen show emphasizes) indeed a "folk art" in that its expression is part of an anonymous collective vision. Nor did I use "folk art" in any derogatory sense; nor do I agree that "folk art" must lack sophistication.

Second, I deplore the misunderstanding of my use of the word "responsible." My statement was simply that since the invention of the camera the artist no longer has a responsibility for recording the outward aspects of the

world. There was, incidentally, no "injunction" against his doing so—nor any other injunction. Nor did I even hint that any art can exist without a sense of responsibility and discipline.

Third, as one of the artists who most admirably, himself, transforms the material in a documentary photograph into a painting of personally created images and emotions, Mr. Shahn must surely have understood my distinction between such use of the photograph as he and Cézanne employ and the "tresspassing" into the other field (as the Iwo Jima sculpture or, as Steichen points out, such photographs as those by Moholy-Nagy in relation to painting).

Fourth, although there is much mediocre abstract painting, there is much good abstract painting. Neither I nor "the majority of other art writers" find this art devoid of emotional communication, but it does not worry us that just as painting "calls out much more" from the artist than photography does, it may make greater demands on its audience. "*Ease* of assimilability is no assurance of greatness or failure."

A. B. S.

February 13, 1955

# The Classicism of Henri Cartier-Bresson

## By HILTON KRAMER

THERE are some forms of art that need to be protected from their own popularity. The pleasure they offer is so immediate and the obstacles we encounter so few that we are in some danger of underrating the scope and the profundity of the art itself. A sense of the familiar tends to dissipate our sense of what is truly special; we feel that we are already in possession of the materials of such art even before we have taken hold of its true esthetic character.

Such, at least, seems to be the case with the art of photography. No other form of visual art seems more accessible to our sensibilities, none is more eagerly or more quickly consumed, none invites such an easy and unconscious blurring of the excellent and the indifferent. To appreciate the art of the photograph, it often seems that one need only have an appreciation of life itself. The intercession of the esthetic and critical faculties seems—almost — a form of supererogation.

Yet one has only to confront the work of a master to

realize that in this art, as in others, an immense—and an immensely refined—capacity for discrimination is essential, that an uncommon intelligence is indispensable and a certain passion—passion informed by intelligence —is central to the whole enterprise. And to realize this is already to be aware of the esthetic faculty that distinguishes, first in the mind of the artist and then in the mind of his audience, the significant from the insignificant, the true work of art from the raw, unformed materials of art.

Among the living masters of photography, Henri Cartier-Bresson is perhaps the most famous. He has often functioned as a photo-journalist for some of the best of the mass-circulation picture magazines in this country and abroad, and photo-journalism is surely the medium that has been pre-eminent in bringing us into a close and steady contact with a certain kind of photograph—the quick, head-on glimpse of an historical moment or (what Mr. Cartier-Bresson has virtually made a genre all his own) the oblique view that distills the emo-

tional essence of an event in an ironic concentration on its least "significant" details. Mr. Cartier-Bresson has worked in this realm long enough—well over three decades now — and with sufficient influence to have won for himself both a worldwide renown and an enormous corps of imitators, yet he remains a rarity. He is at once the Balzac and the Poussin of the modern camera, displaying both an extraordinary appetite for experience and a sublime sense of form in rendering it.

The exhibition of Mr. Cartier-Bresson's work which John Szarkowski, the Director of the Department of Photography at the Museum of Modern Art, has now installed in the museum's first floor galleries is called "Recent Photographs," and dwells for the most part on pictures from the last decade. But Mr. Szarkowski has also included a small retrospective survey of photographs from the years 1929-1950. The subject-matter ranges from landscape to portraits, from moments of tragedy to vignettes of utter hilarity, from mob scenes to delicate

glimpses of loneliness, isolation, and meditation. A dozen or more countries provide the settings, and almost every social class on the face of the globe is represented. All in all, about 150 pictures are on view—a small sampling considering Mr. Cartier-Bresson's tireless production, but more than enough to confirm his genius and to give us a renewed sense of the elements of which it is composed.

Foremost among these elements are the two I have already mentioned—the photographer's appetite and sympathy for experience and the sense of form that, without exactly dominating that sympathy, is clearly in control of its response to every detail of the subject at hand. Mr. Cartier-Bresson has himself observed: "The chief requirement is to be fully involved in this reality which we delineate in the viewfinder," and his own work does convey a terrific sense of devotion—at once humane and analytical—to precisely those observable surfaces of life that may, in a work of art, be made to signify so much of what lies beyond the observable — so much in the

101

# Photography

Henri Cartier-Bresson's "Yugoslavia" (1962), at the Museum of Modern Art.
*"The Balzac and the Poussin of the modern camera"*

way of meaning and value and emotional import.

But it is probably a mistake to try to distinguish this quality of empathy—which is a form of moral delicacy—from the formal intelligence so evident in this work. The analytical detachment which Mr. Cartier-Bresson achieves in the face of his subjects and which is very much a part of that empathy is itself indicative of a certain disposition to form — specifically, to a kind of classicism that is essentially French. Mr. Cartier-Bresson, who once aspired to be a painter, studied in his early years with André Lhote, and he brings to his photographic work a sensibility imbued with the Cubist esthetic. There are no abstract images in this work; it abounds in vivid representations of particulars, in anec-

dote and reportage and minute attention to concrete detail. Yet the work belongs to Cubism, and to the larger tradition of French classicism of which Cubism is but the most recent chapter, by virtue of its compositional rigor, its clear and highly rational placement of forms, and its impeccable pictorial logic.

Some day a study will have to be written of the esthetic commerce that has obtained between the inventions of modern pictorial art and the photographic styles that have followed in their wake. The subject is by no means a simple one. Nor are the explanations to be found entirely in the realm of technique or its cultural employment, though this undoubtedly plays a part. The classical or Poussinesque element in the art of Mr.

Cartier-Bresson has a great many analogues in the painting of our time, and, as I have suggested, is to some degree derived from them, but there are virtually no analogues to the Balzacian element that is equally a claim to glory. In this respect, one is made almost painfully conscious, on seeing an art as powerful and accomplished as Mr. Cartier-Bresson's, of the enormous expressive freedom that has passed from the hands of the painter to the hand and the eye of the photographer.

*

The camera is still a relatively new artistic vehicle—new, indeed, when one measures its short history against the entire history of pictorial art — and the photographer has, in a sense, become the

heir to a great artistic fortune. He has been freer to negotiate the resources of this fortune than the painters themselves, who have grown increasingly more conscious of their limitations than of their freedom. In many ways, the photographer in the twentieth century tends, in his relation to the painter, to resemble the novelist in the nineteenth century in his relation to the poet: the epic and dramatic materials have passed into the hands of the photographers in our time just as they passed into the hands of the novelists a century or more ago. The poets remained the custodians of the lyrical impulse, but the larger forms proved unworkable, and this is pretty much the case with painters today.

July 7, 1968

# Beyond Peppers And Cabbages

**By A. D. COLEMAN**

**W**ITH photographers, as with other artists in our culture, we have a decided tendency to anthologize. Within a few years after a photographer's demise (and sometimes even during his lifetime), a mysterious proc-

ess seems to take control of his/her total body of work, divesting it of all but the very skeleton of development and continuity, stripping it down to a handful of images. The end product of this process is, inevitably, a "Greatest Hits of— —" collection, with which we beat our-

selves unmercifully over the head (or, rather, around the eyes) in exhibit after exhibit, until finally we simply stop seeing them. Then, after a brief period of blind homage paid to such ikons, we may finally write them off for lack of staying power.

This is, of course, roughly

equivalent to banging our heads against walls because it feels so good when we stop. The motives behind such a compulsion toward cultural masochism are not entirely clear to me, but the syndrome is nevertheless obvious. In certain instances—as when dealing with photographers whose output was highly limited, or whose major work was done during a very brief period—it actually

102

gives a semblance of making sense (which makes the habit that much harder to break), but its awkwardness and insufficiency are most apparent when it is applied to the *oeuvre* of any photographer with a long creative life and a consistent output.

Two who have suffered in this way are Eugene Atget and Edward Weston. In terms of homage paid, the posthumous cups of both overfloweth; yet how many members of the audience—excepting those few with access to their respective archives—have seen more than the five or six dozen "standards" which we assume define the Photographer but may in fact only define the sensibilities of the exhibitors who chose them.

The necessity of breaking our mental set in relation to certain photographers is what makes shows such as the Witkin Gallery's first presentation in its new quarters at 243 East 60th Street—"Edward Weston: Nudes and Vegetables"—so vital. For,

though it reiterates a number of Weston classics, it does so within a context which includes a large number of unfamiliar images, a context which makes one rethink his attitudes toward Weston.

Not all these images are neglected masterpieces, by any means, but the revelation that Weston put his stamp of approval on work of lesser significance—such as "Nude and Oven, 1941"—is revealing in itself. However, there are a number of truly exciting finds among the unknowns, in this show, each of which affords insights. The four small, compact, dynamic nudes grouped together on the west wall, for example, are not only a concise restatement of Weston's approach to the human body as form but also an indication of his ability to abstract without depersonalizing, despite the headlessness of almost all his models.

His nude on a bed of palm fronds with a gas mask remains an unsuccessful it not

entirely uninteresting gag, but Weston's sense of humor appears in a much clearer light when this image is contrasted to his charming self-advertisement and the jocular ominousness of a trench-coated nude (which has a direct, electric eroticism I would not have expected from Weston).

The selection of vegetable images in the show also takes us well beyond the normal boundaries of peppers and cabbage leaves, to squash and eggplants and cantaloupes and watermelons, in all of which we can see Weston searching out fantastic forms in unaccustomed ways. The watermelon, for example. There is not much you can do with a watermelon; its lines are less than fluid and rarely unique. Weston perched his atop a basket of some sort, horizontally, where it sits incongruously in its placid bulk, looking for all the world like a refugee from Uelsmann's negative file.

The show is accompanied

by a portfolio of prints from Weston's negatives made by his son, Cole, and published in a numbered edition of 50 copies by Witkin-Berley, Ltd., an offshoot of the gallery. Priced at $600 through December of this year ($750 thereafter), the portfolio contains nine black-and-white prints, mostly classics, and a dye-transfer print of "The Blue Dune," one of Weston's few color images. Though it takes time to get used to, the latter is a beautiful object, though that very beauty—given the astringency of Weston's vision in black-and-white—makes it seem somewhat decorative. Despite that, though, I'd love to see a book of Weston's forty-odd color photographs (made during the middle 1960's); it seems silly to hide them away, which in effect is what had been done with them, and such a volume strikes me as a natural for the Sierra Club.

September 12, 1971

# *Princeton Sets Up Photo Arts Chair*

**By GRACE GLUECK**

When Peter C. Bunnell set out to study the history of photography only a dozen years ago, there was really no place to go.

"There were lots of schools where you could learn to take pictures," recalls the 34-year-old curator of photography at the Museum of Modern Art. "But despite a growing awareness of still photography's importance, there was no program anywhere to study its esthetics and history. You had to pick your way through a variety of academic programs, and if you were lucky, the Fine Arts faculty would graciously give you permission to concentrate on photography."

Now the situation, barely improved since Mr. Bunnell's student days, is about to change dramatically. In what it considers a "significant departure" for the study of art history, Princeton University has established this country's first professorship of the history of photography. Its first occupant? None other than Mr. Bunnell, who has been teaching photography courses at Princeton for the last two years, and who has vigorously campaigned for the establishment of a permanent program.

**Million in Endowment**

"The student today can take a course at various universities, such as Harvard, Yale, N.Y.U.," Mr. Bunnell pointed out. "At the University of New Mexico, he can study for a master's degree in the history of photography. But Princton will eventually provide a full complement of courses."

Mr. Bunnell's new chair, funded by an endowment of $1-million, is named the David Hunter McAlpin Professorship of the History of Photography and Modern Art. Mr. McAlpin, an investment banker who graduated from Princeton in 1920, has for many years collected photographs, and was instrumental in the founding and development of the photography programs at the Museum of Modern Art and the Metropolitan Museum. In 1967, he established the Alfred Stieglitz Memorial Lectures on photography at Princeton.

According to Mr. Bunnell, the Princeton program is intended to establish the university as a "major center" for intensive photographic studies. A strong hope is that it will help overcome a manpower shortage in the field, supplying for universities and museums elsewhere "the necessary staff to develop a new depth in the study of photog-

raphy."

"But I don't see, the program as an isolated intellectual experience," Mr. Bunnell continued. "The student will concentrate on photography within the context of the fine arts program. Photography needs a broadened base of understanding that it does belong to a community of the arts. For instance, no survey of the history of art published today has a photography section in it. How can a student in art history even conceive of photography as a serious medium if he doesn't confront it?"

The program's funding also provides for publications, exhibitions, acquisitions, and the establishment of a major library in the field. "One of our main jobs is to build up the library," Mr. Bunnell said. "But we'll have to do some reclassification work. The Library of Congress, for instance, still only recognizes photography as a craft, not an art medium. So in libraries today the photographer Edward Weston's book, 'California and the West,' is filed under 'Travel.'"

The basis of the program's collections will be the hundreds of prints given by Mr. McAlpin. "We'll start to acquire other things immediately," Mr. Bunnell said. "But there are some wonderful

holdings in collections already at the Princeton Library. For instance, among the papers of Sylvia Beach, who ran the bookstore Shakespeare & Co. in Paris in the 1920's, we found a great group of photographs by Man Ray.

"With all this organizing to do, I can't give the illusion that next fall we'll have the greatest program ever. It will take five years to build the major center I envision."

The first course in the new program, he added, would be a graduate seminar in the work of Alfred Stieglitz, the noted American photographer, on whom Mr. Bunnell is writing his doctoral thesis at Yale (the first doctoral dissertation ever written on a photographer at that university).

Mr. Bunnell, whose appointment will take effect on July 1, will retain no formal ties with the Museum of Modern Art, but anticipates "a close working relationship" with the museum's facilities.

He glanced around his neat office at the Modern, where he has spent six years. "I'm leaving with a little bit of reluctance, but a great sense of challenge," he said.

April 18, 1972

# 125 Photos By Arbus On Display

### By HILTON KRAMER

Few photographers of the past decade have had as powerful an impact on the practice of their own medium as that of Diane Arbus, who died last year at the age of 48. In a remarkably short time—her serious work was all done in a period of 10 years—she drastically altered our sense of what was permissible in photography and extended the range of what could be considered a sympathetic subject. She altered, too, some of the established notions of photographic style, substituting for the familiar compositional niceties a radical candor and an extraordinary empathy.

Thus the retrospect exhibition of her photographs that John Szarkowski has now organized at the Museum of Modern Art, 11 West 53d Street, brings us a body of work that is at once a classic and a matter of controversy. For many connoisseurs of photographic art, especially for the younger generation of photographers on whom Mrs. Arbus has been a decisive influence, the exhibition is a summary—and vindication—of a new esthetic attitude. For others, less familiar with the imperatives of her style

Lent by Doon Arbus

**Diane Arbus's photograph of identical twins, Roselle, N. J., 1967, is at the Museum of Modern Art.**

and less prepared for the shocks it contains, the exhibition is likely to be, at the least, a revelation.

For this retrospective Mr. Szarkowski, director of the museum's department of photography, has chosen 125 prints. Among their subjects there is a high preponderance of social and biological oddities—identical twins, dwarfs, nudists, transvestites, carnival freaks and retarded women. And even those subjects that

are not social oddities—older middle-class couples, young working-class couples, babies, suburban families, etc. — are depicted with a close-up, unembellished frankness that links their identities with those who qualify as social freaks.

These pictures astonish us in two quite different ways. Their first impact derives from their unfamiliarity: We are shocked to be seeing what we are seeing. But their more

permanent impact — and the real source of their power—derives from the intimacy of their outlook and the completely relaxed acceptance of their subjects' existence. The spectator, like the photographer herself, is not allowed to stand at a distance, but is brought directly into the life of the subject.

In order to accomplish work of this sort, Mrs. Arbus had to abandon not only certain social inhibitions but certain esthetic inhibitions as well. It would not do to pretend that the subject was not "aware" of the picture-making process. The subject now had to collaborate in the process. And once that collaboration was in effect, it would not do, either, to pretend that the picture derived from an outside glimpse of the subject. The result was a vision that is posed, patient and studied—a portrait that is a kind of dialogue between the photographer and his subject—both an unexplored subject-ject.

This whole new approach to matter and a self-conscious attitude toward the picture-making process brought to photography some of that first-person directness that was, perhaps, one of few significant developments in all of the arts in the nineteen-sixties, and in the art of photography, it was Diane Arbus who set the pace.

November 8, 1972

# Kertesz Conveys Poetic Significance of Details

### By HILTON KRAMER

The career of André Kertész is one of the longest and most distinguished of living photographers. Among his professional peers, Mr. Kertész—now 78 years old and a resident of New York since 1936 — has long been acknowledged as one of the master artists of the photographic medium.

**An Appraisal**

Yet his career has been a difficult one, and his work has remained, until very recently, remarkably little-known to the American public. For this reason, as well as for its intrinsic quality, the exhibition opening today at the Hallmark Gallery, Fifth Avenue at 56th Street, is an event. Entitled "André Kertész: Themes and Variations," it brings us more than 200 pictures surveying an achievement that had its beginnings in the artist's native Hungary on the eve of

World War I and continues unabated today.

It is an achievement of many facets, ranging from an early documentary realism to that pure analysis of form which identifies Mr. Kertész as esthetic kin to the great painters and sculptors of the School of Paris. What one finds in this work, at every stage of its development, is a keen curiosity and sympathy for the ways of the world, but a curiosity and sympathy always tempered and transformed by a very personal sense of style.

●

The essence of this style is to be found in its steadfast pursuit of what, to a more commonplace vision, may often appear to be marginal or even trivial details, but which in Mr. Kertész's realization of them become the most affecting of pictorial revelations. Thus, in the early pictures taken in Eastern Europe during World War

I, we are given not battle scenes but glimpses of a soldiers' latrine on the Polish front and a group of Esztergom street urchins absorbed in reading a book.

In his later pictures of

New York, too, the photographer addresses his attention to the "unimportant" detail or anecdote—to textures and manners and objects that, in Mr. Kertész's version of them, assume a high poetic significance. But this later work is also characterized by an extraordinary composi-

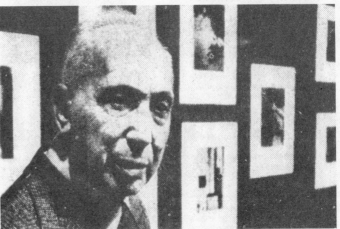

The New York Times/Barton Silverman

**André Kertész and a few of his photographs**

Reading, 1915, Esztergom

"No Title," Oct. 22, 1959, New York

tional eye—extraordinary not only in its immaculate sense of form but in its deep sense of irony.

Often this sense of irony is expressed in a vivid glimpse of the human comedy; Mr. Kertész has a wonderful eye for human foibles. But this sense of irony also finds poetic expression even where no obvious anecdotal element is present—in those marvelous juxtapositions of objects and surfaces that have afforded the photographer some of his most moving subjects.

●

No doubt the most crucial period in Mr. Kertész's career consists of the 11 years—1925-1936—he spent in Paris. These were the years—happily, well represented in the current exhibition—when the

photographer absorbed the lessons of Parisian esthetics, when his early documentary interests were assimilated in a more analytical and self-conscious sense of form.

This interest in form was sometimes carried to an extreme point, as in the so-called "Distortions" of the nude which occupied the photographer in the early thirties. But this tendency to exploit form for its own sake, though it yielded some remarkable pictures, was never Mr. Kertész's principal interest. He remained a loyal follower of the School of Paris in balancing the claims of his subject matter against the imperatives of his formal interests, and we see this balance beautifully expressed in, among other pictures, the

superlative portraits of other artists (Brancusi, Derain, Calder, Eisenstein, Colette and others) he produced in his Paris period.

●

It is in this ability to deal with the real world, but to deal with it in terms of its inner poetry and secret ironies, that Mr. Kertész's great distinction lies.

His is a style that now exerts an enormous appeal—the appeal of a vision that finds its revelations in the small detail, the unexpected aside, the marginal glimpse, and yet confers on this "minor" material a formal rigor of the highest order. But it was not a style that won Mr. Kertész much of a following during his first two decades or more in this country. For

years he was a kind of casualty of our inability to appreciate his subtlety and humor and great refinement.

The current show at the Hallmark Gallery is the latest in a series of recent events marking a new recognition of his achievement. Last fall a handsome volume, "André Kertész: Sixty Years of Photography," was published here by Grossman, and more recently the Light Gallery has brought out two large portfolios of his prints. Even so, the Hallmark show includes a great many pictures not published heretofore. We are still in the process of acquainting ourselves with this master of the photographic medium.

January 17, 1973

# Edward Steichen Is Dead at 93; Made Photography an Art Form

## By ALDEN WHITMAN

Edward Steichen, the photographer, died yesterday at his home in West Redding, Conn., after an illness of several months. He would have been 94 years old tomorrow.

Mr. Steichen, the country's most celebrated and highest-priced photographer, was hailed as a craftsman of genius who transformed his medium into an art.

A humanist, he disclosed and interpreted man through probing portraiture, and as a person of extraordinary sensitivity, he gave his century a new vision of flowers, trees, insects and cityscapes as well as of commercial artifacts.

His first photographs, taken as a boy of 16, were so disappointing that they were almost his last. He had bought a Kodak with his mother's money and made 50 exposures, chiefly of subjects about the house.

"When the film came back, I had a real shock," he recalled. "Only one picture in the lot had been considered clear enough to print.

"My father thought one picture out of 50 was a hopeless proposition, but my mother said the picture [of his sister at the piano] was so beautiful and so wonderful that it was worth 49 failures."

Brightened by his mother's cheerful attitude, the youth went on to teach himself photography, experimenting as he learned. He came to use a camera lens like a painter's brush. His pictures possessed mood and emotion, and they were composed with a keen sense of design, a heritage of his years as a fashionable painter in the manner of Whistler and Sargent.

### Like Impressionist Works

Some of his photographs resembled French impressionist paintings in their blurred softness; some, in their use of light and shadow, seemed like Rembrandt; others were utterly stark, as if they had been executed by De Chirico. Few of his pictures were dull or jaded.

"I know that to him the universe is as fresh and as strange now as it was back then," Carl Sandburg said a few years ago of Mr. Steichen, his brother-in-law and longtime friend.

Explaining his conception of his art, Mr. Steichen put it this way:

"I don't think any medium is an art in itself. It is the person who creates a work of art. It's perfectly clear that photography is different from any other medium — but that's only procedurally.

"Every other artist begins from scratch, a blank canvas, a piece of paper, and gradually builds up the conception he has. The photographer begins with the finished product. When that shutter clicks, anything else that can be done afterward is not worth consideration.

"At that point the differences between photography and any other medium stop because the photographer has brought to that instant anything any artist has to bring into action for the creative act."

In line with this view, Mr. Steichen concentrated on preparation. He once took more than 1,000 shots of a single cup and saucer as he experimented with the effects of various lighting arrangements. It was this infinite pain — and the knowledge that it produced — that gave his pictures their special quality.

His picture of Auguste Rodin, the sculptor, was a case in point. Before taking the photograph, Mr. Steichen spent every Saturday for a year studying Rodin as he walked among his works at his Paris studio; and only when he had decided on the composition he wanted did he bring his camera.

### Scrutinized 10,000 Prints

Mr. Steichen was almost as famous as a picture editor as he was as a picture taker. In 1942, in World War II, he set up the exhibition "Road to Victory" at the Museum of Modern Art in New York. He scrutinized 10,000 prints before selecting 150 that he believed reflected the quality and spirit of the American people, their land and their resources.

Ten years later, as director of the museum's department of photography, he traveled to 11 countries in search of material for the "Family of Man" exhibition. He selected 503 pictures, as he said, a "mirror of the essential oneness of mankind throughout the world." The exhibition opened in 1955 and was ultimately viewed by more than 9 million people in 69 lands. In book form, "The Family of Man'" sold 3 million copies.

Outside of photography, Mr. Steichen achieved a more limited renown for his cross-breeding of plants, especially delphiniums, in which he had been interested since 1910. His delphiniums sprouted flowers so profusely that they resembled bushes rather than the

usual spires. He also developed a new type of oriental poppy, more delicate and smaller than the usual flower.

Six feet tall and with wide-set blue eyes, Mr. Steichen was not a jocose person. "On looks Steichen might be taken for a priest," Mr. Sandburg wrote in 1929. "He is solemn, with grave spiritual quality; reverence is a commanding element in his make-up."

Starting in 1957, the photographer altered his visage by growing a magnificent white beard that was flecked with gray and black. It gave him the appearance of a biblical patriarch, especially when he neglected to trim it regularly.

Even as an old man he had the questing, eager mind that set him apart as a youth.

Edouard (it became Edward early in his career) Jean Steichen was born March 27, 1879, in Luxembourg, the only son of Jean Pierre and Marie Kemp Steichen. Three years later the family migrated to Hancock, Mich., where the elder Steichen worked in the copper mines and his wife had a millinery shop. Their daughter, Lilian Paula, who became Mrs. Sandburg, was born in Hancock. She survives her brother.

Edward's mother was the dominant influence in his childhood, shaping an outlook on the world that remained with him through his life. Recalling an instance of this in his autobiography, "A Life in Photography," he wrote:

Joan Miller

**Mr. Steichen in what he considered his "official" portrait**

"Once, when I was 10 years old, I came home from school, and as I was entering the door of her millinery shop I turned back and shouted into the street, 'You dirty little kike!'

"My mother called me over to the counter where she was serving customers and asked me what it was that I had called out. With innocent frankness, I repeated the insulting remark. She requested the customers to excuse her, locked the door of the shop and took me upstairs to our apartment.

### Important Moment

"There, she talked to me quietly and earnestly for a long, long time, explaining that all people were alike regardless of race, creed, or color. She talked about the evils of bigotry and intolerance.

"This was possibly the most important single moment in my growth toward manhood, and it was certainly on that day the seed was sown that, 66 years later, grew into an exhibition called 'The Family of Man.'"

After the family moved to Milwaukee, Edward left school at the age of 15 and became an apprentice in lithography at the American Fine Art Company, working up from nothing a week the first year to $4 the fourth. He added to his pay by becoming the unofficial photographer of picnics and outings. He also painted and sketched in his spare hours.

As a lithographer, the youth made his mark by creating a large Ruben's like woman reclining in the enlarged capital "C" of the slogan "Cascarets—They Work While You Sleep." The figure of the languorous lady was almost as famous as the Gibson Girl.

At the same time he was experimenting with his camera, trying to capture on film the blurred softness of a painting. To achieve a misty effect, he would spit on his lens or give the tripod a kick as he tripped the shutter. One of these out-of-focus pictures, "The Lady in the Doorway," brought him recognition as a photographer in the Second Philadelphia Salon in 1899.

A year later he was on his way to Paris, intending to study painting and to continue with photography, the latter in line with a promise to Alfred Stieglitz, a photographic pioneer, whom Mr. Steichen had met in passing through New York.

### Noted for Portraits

Painting and photographing by turns, he built a reputation for portraiture of notables — his Rodin won a prize, and his picture of Maurice Maeterlinck, the poet and playwright, was highly regarded. Returning to New York in 1902, he became friendly with Mr. Stieglitz, opened a studio at 291 Fifth Avenue and began doing portraits commercially.

His "most concentrated and exciting experience" was in snapping J. P. Morgan and Eleonora Duse, the actress, in less than an hour. The Morgan picture came about accidentally when a painter, finding the financier too restive for a sitting, got Mr. Steichen to take a picture from which to paint.

Using a janitor as a stand-in, Mr. Steichen composed the picture before the banker arrived and quickly made a two-second exposure. Then he made another exposure for himself, with a different position of the hands and head that brought out Morgan's dynamic self-assertion.

Morgan liked the picture taken for the portrait, for which he paid $500, but tore up a print of the second exposure. Later, though, when he was told how wonderful it was, he offered $5,000 for it.

In 1905, Mr. Steichen, with Mr. Stieglitz, established the Photo-Secession Galleries, where art works of all mediums were shown. Through it, Mr. Steichen introduced Cézanne, Picasso, Rodin and Matisse to the United States. But, restless and feeling stultified as a professional portrait photographer, Mr. Steichen returned to Paris in 1906 and devoted himself to painting, photography and botany at his home in Voulangis.

When the United States entered World War I in 1917, the photographer volunteered for service as an aerial cameraman with the Signal Corps. He took part in major operations in France and won both a Distinguished Service Citation and membership in the Legion of Honor. With the Armistice he returned to Voulangis and his palette.

"One morning, when I went to my studio, I found a very free copy of a flower painting I had been working on," he recounted. "It had been done by the gardener, a Brittany peasant, and it had the curious charm and direct simplicity of much primitive painting. As such, it was better than what I had been trying to do.

"I called the gardener, and we pulled all the paintings out of my studio into an open area and made a bonfire. I was through with painting.

"The wartime problem of making sharp, clear pictures from a vibrating, speeding plane 10,000 to 20,000 feet in the air had brought me a new kind of technical interest in photography. . . Now I wanted to know all that could be expected from photography."

Mr. Steichen spent three years in experimentation. His pictures became precise, filled with detail and with light and shadow. And in 1923 he signed to do portrait and fashion photography for Vanity Fair and Vogue magazines for $35,000 a year. Among those who posed for him over the years were Greta Garbo, Charlie Chaplin, Beatrice Lillie, Mary Pickford, Martha Graham, the Barrymores, Katharine Cornell, Paul Robeson and Lillian Gish.

### Worked for Ad Agency

Branching out from the Condé Nast Publications, Mr. Steichen took commissions from the J. Walter Thompson agency for advertising work. He promoted such things as mattresses, creams, silks, pills and vacuum cleaners. He was often reproached for going commercial, but he steadfastly denied any meretriciousness.

"If my technique, imagination and vision are any good I ought to be able to put the best values of my noncommercial and experimental photographs into a pair of shoes, a tube of toothpaste, a jar of face cream, a mattress or any object I want to light up and make humanly interesting in an advertising photograph," he once said. He added:

"A thing is beautiful if it fulfills its purpose, if it functions. To my mind, a modern icebox is a thing of beauty."

In 1938, however, he closed his New York studio, announcing that his work had become routine and repetitious. He did not retire, but spent more time with delphiniums ("my vital preoccupation") at his Umpawaug Breeding Farm in West Redding.

When World War II broke out, he organized a unit to photograph naval aviation operations. By the end of the war he was in charge of all Navy combat photography. He was discharged in 1946 with the rank of captain. His war experiences are recorded in "The Blue Ghost: A Photographic Log and Personal Narrative of the Aircraft Carrier U.S.S. Lexington in Combat Operations." He also supervised the film "The Fighting Lady."

For 15 years, from 1947 to 1962, he was with the Museum of Modern Art, supervising exhibitions of photography. To achieve objectivity, he virtually gave up his own work in those years. The museum honored him in 1961 with a one-man show of 300 pictures taken from more than 30,000 negatives. It later established the Edward Steichen Photography Center.

After he retired from the museum, he produced a documentary show on the plight of the farmer during the Depression. It opened in 1962 as "The Bitter Years: 1935-41 — Rural America as Seen by the Photographers of the Farm Security Administration."

Mr. Steichen, even in his advanced years, never gave up photography completely. On his farm in recent years he experimented with a movie camera filming a flowering shadblow tree. The result was a startlingly beautiful chronology of its moods and seasons.

At his 90th birthday party at the Plaza Hotel in 1969, Mr. Steichen took the floor to say

"When I first became interested in photography, I thought it was the whole cheese. My idea was to have it recognized as one of the fine arts. Today I don't give a hoot in hell about that. The mission of photography is to explain man to man and each man to himself. And that is no mean function. Man is the most complicated thing on earth and also as naive as a tender plant."

### Received Many Honors

He received many awards and decorations, including the Presidential Medal of Freedom, the Distinguished Service Medal and decorations from France and Luxembourg. At the end of this month he was to be honored at the Birmingham (Ala.) Art Festival.

Mr. Steichen married three times. His first wife was the former Clara E. Smith. They were married in 1903 and had two daughters, Dr. Mary Steichen Calderone, a physician and co-founder of the Sex Information and Education Council of the United States, and Kate Rodina Steichen, a writer. After a divorce in 1921, he married Dana Desboro Glover, an actress, who died in 1957. In 1960, he married Joanna Taub, a woman in her twenties.

They lived in West Redding in a Steichen-designed house on property strewn with rocks. Under one, a large perpendicular boulder, he said, he hoped to be buried.

A memorial service will be held at the Museum of Modern Art in New York at a date to be announced.

March 26, 1973

# Ansel Adams: Trophies From Eden

**By HILTON KRAMER**

THE exhibition of photographs by Ansel Adams, organized by Andrea Rawle and Phyllis D. Massar at the Metropolitan Museum of Art, brings us 156 prints by one of the most celebrated figures in the field. Mr. Adams has occupied so large a place in the development of American photography that its history, at least since the nineteen-thirties, could scarcely be written without ample consideration of his many-sided accomplishments. Although trained originally as a concert pianist, he has been exhibiting and publishing his photographs since the twenties. In 1932, the year that he was given his first one-man show at the DeYoung Museum in San Francisco, he founded the Group f/64 with Edward Weston, Willard Van Dyke, Imogen Cunningham, Sonia Noskowiak and Henry Swift, and four years later he was given a one-man show at Alfred Stieglitz's An American Place.

*

Since that time, he has published a great many books, conducted numerous

workshops and given many lectures, organized important enterprises—he was, for example, one of the people responsible for establishing the Department of Photography at the Museum of Modern Art—and, in just about every way that the field affords, has made himself a force, to reckon with. Academically, journalistically and museologically he is a recognized leader, and few honors have been denied him.

Yet the work that one sees at the Metropolitan Museum does not strike one as the work of a major artist. True, the exhibition is not a comprehensive retrospective, but it ranges over the whole course of Mr. Adams's work since the thirties, and one somehow doubts that a fuller exhibition would significantly modify one's judgment. Indeed, the present exhibition is somewhat larger than the work itself seems to warrant—not because of any repetition of images but because of the radically delimited outlook that encloses so much of the work that is shown.

Mr. Adams is, above all, a photographer of nature, a man in love with the grandeur of uninhabited spaces. The High Sierras and Yosemite Valley, the national parks and other outposts of uncultivated and unmolested landscape have long been his favorite subjects, and he has lived long enough to see this personal esthetic bias confirmed in the conservationist movement to preserve these landscapes from ecological disaster. His association with the Sierra Club dates from 1920, and in more than half a century of activity on its behalf he has only deepened his commitment to a view of

nature that effectively separates it from the workaday world of human affairs.

Nature, in this view, is a romance that the fatal hand of civilization must never be allowed to penetrate. Of all the despised objects that modern technology has produced to dim our spirits and threaten our existence, only one—the camera—is exempted from adverse judgment. Only the camera is allowed to pass into paradise in order to bring back evidence of its superior attributes—superior precisely because of their untouched purity and their distance from the dead hand of human intervention.

In these photographs of untrammeled nature, we are given a world sealed off from time and history, where events are measured by the geological calendar and change occurs beyond the range of human perception. It is indeed a world of rare beauty, and no one has explored its myriad nuances with more painstaking attention or with a keener eye for their spectacular visual drama than Mr. Adams. But this rarity is exactly what places so fixed a boundary on the photographer's vision. Nature becomes a sanctuary where beautiful effects can be stalked with impunity, and as the trophies brought back from Eden multiply, they lose something important—if not their credibility, at least their power to engage our deepest emotions.

The very perfection that Mr. Adams brings to every print—a technical perfection for which he has few peers—contributes, moreover, to a certain air of unreality in his work. One marvels, of course, at this extraordinary clarity of image, in which every visual value, no mat-

ter how subtle, is brilliantly articulated. One takes pleasure in all this technical virtuosity, but one also wonders about it — wonders about the meaning of this technological finesse placed at the service of a subject that seems to deny its significance. In the end, it isn't nature that one responds to in this work so much as the craft of the darkroom, and this response only reinforces one's feeling that nature, in this case, is somehow being "used"—that it may be only another resource exploited in the interests of a technological feat.

Fortunately, for those of us who entertain doubts of this sort, Mr. Adams's camera has not been completely confined to the romance of nature. His encounters with a world that you and I might easily recognize as our own are also represented in this exhibition, and it is in such pictures of people and places that the real strength of this exhibition is to be found, at least for anyone not easily susceptible to the contradictions and mystifications I have described.

For myself, the look on the face of Georgia O'Keeffe —in the 1937 photograph included here—is worth all the views of Yosemite Valley ever committed to film, and the "Family at Melones, Calif.," from 1953, easily takes its place beside similar pictures of rural family groups that still haunt us from the photography of the thirties. The marvelous close-up portrait of Brassai, taken last year, is likewise one of those pictures so charged with life that it seems to flatten everything else in the vicinity.

In addition to these and other portrait photographs,

there are some small gems of observation and composition in the group of original Polaroid Land photographs that is one of the most appealing sections of the exhibition. · My own favorite among these is the picture of "Rundel Park Through Window Screen, Winter, Rochester" (1960), in which the mesh pattern of the screen, exquisitely visible, transforms frame houses, trees and even a parked car into a "flat" pointillist image of extraordinary delicacy. How grateful one is, after so many stumps of trees and distant skies and orchestrated clouds, to see an automobile and a front stoop!

This particular picture resembles the portraits in one particular respect that seems to me important: in the way it immediately suggests a time-bound subject. For photography is a medium in which time—both the moment captured and the very sense of its pastness—is an ineluctable collaborator. Where this collaboration is openly invited, or at least undisguised, our emotions are, I think, more deeply engaged. It is because so many of Ansel Adams's photographs of nature seem designed to escape this sense of time—to take refuge in the sanctuary of an eternal present—that they seem to consign themselves to a realm where feeling no longer counts. One might even go so far as to say that to the extent that photography resists the texture of historical time, it is resisting an essential part of its own nature.

The exhibition remains at the Met through June 30.

May 12, 1974

# *Art Critics: Our Weakest Link*

By A. D. COLEMAN

ONE of the most serious shortcomings of art criticism during the past century has been its utter and continuing failure to engage meaningfully with the most diversified and revolutionary image-making medium to evolve during that period.

The art establishment's initial reaction to photography blended equal parts of hysteria and disdain, which

gradually mellowed into a casual but virtually total disregard. Inevitably, this led to an ignorance so widespread and profound that there is hardly an art critic today competent to discuss photography as a branch of printmaking, much less as a creative graphic medium with a unique and distinctive field of ideas.

•

Understandably, such ignorance proves embarrassing at this juncture. Art criticism

itself is heavily dependent on the photographic image, since many critics (and much of the art audience) experience painting and sculpture not in the flesh, so to speak, but through its photographic representation. Painters have drawn very heavily on photographic imagery from the very inception of the photographic medium, a long-suppressed though now much touted fact. Photography has increasingly been woven into the fabric of 20th-century art

of all sorts, beginning with Dadaist and Surrealist collages and continuing through the current work of Warhol, Rauschenberg and a host of others. And, of course, a great many contemporary artists' creations — performances, conceptual pieces, earthworks, and the like—live on only in the form of photographs.

If this ignorance affected no one but the art critics themselves, it would be only regrettable. Critics, however,

are part of an informational circuit on which the evolutionary process of art is based. As a group, the critics in any given field inform the audience what the artists are up to, serve as a sounding board for the artists, and inform the artists themselves as to what their often widely dispersed co-workers are about. In such a circuit, ignorance begets ignorance. The lack of knowledgeability of the art critics in regard to photography does not stop with them; it is transmitted to both the audience and the artists. Such a situation is not merely regrettable, but damaging to all concerned.

For example, one direct result is the recent spate of veneration heaped on Paul Strand, Ansel Adams and Edward Weston by art critics around the nation, in conjunction with the appearance of an assortment of monographs and retrospectives. These three appear to be the photographers with whose work art critics feel most comfortable. The reasons for this are not entirely clear to me (though all three do share a devotion to the original print as a precious object). Insofar as ideation is concerned, however, their contributions to their medium were concluded decades ago.

There has been no change and little growth in Strand's image-making since the original publication of "The Mexican Portfolio" in 1933, and his continued romanticization of the noble peasant seems increasingly mawkish and patronizing.

Adams provided photography with an invaluable codification of craft principles (now largely outdated, according to a number of

teachers), helped establish and maintain much-needed craft standards for photography as a form of printmaking, and built up a body of work important in its description of America's Western parklands; but there has been little creative risk-taking in his photography as a whole, and a scarcity of original ideas and provocative theories in his published writings. (Wynn Bullock's inquiries into the photograph as a space-time matrix, and Minor White's investigations of sequential imagery and the reading of photographs, have a lot more philosophical heft to them).

Edward Weston, of course, is 15 years dead, and his work is a decreasingly active influence on young photographers even in his home territory, as several recent regional exhibits on the West Coast have demonstrated. The "purism" he advocated is creatively inhibiting and so closely linked to a particular subject matter, style and camera format as to negate large segments of the photographic vocabulary and eliminate broad areas of experience from the photographer's imagistic concerns.

Weston's approach inherently restricts itself (as is apparent from his own body of work) to formal portraiture, landscape, still life, and the nude—the traditional subject matter of painting, it should be noted. Within those tight parameters, he created a major oeuvre, big enough that its limitations are not immediately apparent nor finally self-defeating. Yet, though his body of work is, for me, more resonant by far than those of Strand or Adams, it is my belief that he will even-

tually be seen as an awesome, monumental boulder in the path of the evolution of photography in the 20th century. For the theory which accompanied his work is both a summation and a source of the central misunderstanding of photographic communication: the confusion between the being, object, or event in front of the lens and the image which is made thereof.

These are not one and the same thing. The photograph is its maker's subjective description of his-her experience, in silver particles on paper. It is not, as Weston would have it, the "essential form" of "the thing itself." To insist otherwise is to demand a leap of faith, rather than to state a demonstrable fact. (There is an image by Todd Walker which sums this up neatly. It is a silkscreen of a photograph of a leaf, over which are superimposed these words: "A photograph of a leaf is not the leaf. It may not be a photograph.")

As it happens, the illusionism of photography is seductive enough that we are generally willing to ignore this crucial distinction and make that leap without peeping. This does not validate the jump; it merely affirms our own credulity and the effectiveness of the photographic deception. As Paul Byers has written, "Cameras don't take pictures."

The dominance of the Westonian thesis (which has its corollary in "documentary" photography also) in mid-century American photography is a historical fact. That does not make it true, for the thesis fails to resolve the profoundly equivocal relationship between the photograph-

ic image and "the thing itself." It is also a historical fact that there exist alternative approaches to photography, approaches which embrace the full range of available means within the medium, which acknowledge its subjectivity and which consciously confront its illusionism. (Examples would include work by Man Ray, Moholy-Nagy, Edmund Teske, Harry Callahan, Bill Brandt, Robert Frank, Jerry Uelsmann, and a list of others too numerous to cite one by one.)

The affirmation and valorization of the Westonian thesis—to which Strand and Adams are basically bound—is a matter of legitimate critical choice, if undertaken in recognition of that thesis's cyclical necessity, its inherent limitations, its present moribundity, and the flourishing extant alternatives. If based only on whim—or on the equally irresponsible premise that photography plays an increasingly prominent role in current art activity and so one must, after all, say something about it to prove one is in the swim—such affirmation is not merely meaningless and supercilious. It also seriously misleads the larger art community, and denies to photography's diverse practitioners the richness of their own heritage and the credit due many of them for pioneering expeditions into territories which—as a direct result of the wholesale critical oversight of the accounts these adventurers sent back —are still believed by artists and public alike to remain entirely unexplored.

October 6, 1974

## PHOTOGRAPHY VIEW

**GENE THORNTON**

# At Last, a Photography Museum

The International Center of Photography, which opened yesterday with three exhibitions, is New York City's first museum devoted exclusively to photography, and its opening points up the astonishing growth of interest in the medium that has occurred in the past few years. Seven years ago there were only two photography galleries in New York. Now there are more than 30, ranging from store-front cooperatives and displays in major photo processors' waiting rooms to flourishing commercial galleries. In addition, several art galleries formerly confined to painting

and sculpture now show photographs as well.
At auctions and galleries here and abroad, dealers and collectors are buying steadily, driving up prices of old and rare prints and creating the beginnings of a market for contemporary work. Museums from Atlanta and New Orleans to Colorado and Canada have begun to collect and exhibit photographs, often as the result of public pressure, and critics are increasingly writing about photography on the art pages of newspapers and magazines.

What all this adds up to is the recognition of photography as art. This may not mean much in an age that is prepared

to recognize as works of art a signed urinal, a blank canvas, a chance arrangement of sounds or an eight-hour movie of a sleeping man. It may also not mean much to professional photographers who find it increasingly hard to earn a living by taking pictures. However, the growing interest in photography as art has certainly won it a kind of respect it has not enjoyed since the early years of this century.

With this new respect (which sometimes borders on awe) comes a tendency to transform photographs and the act of looking at them from something everyday and ordinary, like reading a newspaper or watching television, to something difficult and unusual. People who understood well enough what a picture in Life magazine meant, and who still understand a photograph used on a billboard advertisement, suddenly go shy when they see the same picture in a museum. "What does it really mean?" they ask themselves, as if the change of location had wrought some magical change in the essence of the photograph itself.

Partly this new attitude is simply a response to rising prices. Even the dullest head knows that something extraordinary has happened when an anonymous daguerreotype sells for $35,000, as did an 1848 portrait of Edgar Allen Poe last spring. The new attitude of awe is also in part a response to the hushed and holy, don't-touch-it atmosphere of the typical art museum. Despite recent moves toward a more relaxed approach by some curators and museum directors, an air of uplift still clings to the museum. Most people still believe that things shown in a museum must be art, and most people still assume that art has little to do with everyday life.

Thus the recognition of photography as art has encumbered it with all the weighty paraphernalia of art appreciation and has given rise to a new literature of photographic exegesis and explication. It has prompted educators to celebrate the mysteries of visual literacy. It has encouraged self-proclaimed gurus to transform photography into a means of salvation. It has led a whole generation of young photographers to make photographs that do indeed badly need explication. It has also encouraged exhibition into works of surrealist fantasy by removing captions and accompanying text blocks before exhibiting them.

All this is perfectly harmless in itself and provides many people with innocent satisfaction. Sometimes it is even illuminating. However, the transformation of photog-

raphy into art tends to obscure the fact that photography is —and has been throughout the 20th century—primarily a means of communication via the mass media. Before the advent of television photography was the principal way of showing people what unfamiliar peoples, places and things looked like—a task that painting had long since abandoned as beneath its dignity. Even today, most photography is devoted to the kind of humdrum visual communication that everyone takes for granted as an essential part of ordinary life, though like the telephone, it scarcely existed a hundred years ago.

It is the special virtue of the new International Center of Photography that it is concentrating on photography as a means of communication rather than as art. A non-profit, tax-exempt private institution dedicated to photographic education, exhibitions, publications and archival preservation, the Center is an offshoot of the International Fund for Concerned Photography, Inc., founded in 1966 with former Life photographer Cornell Capa as executive director. Under either name, the Center is interested in photography in which the primary aim is communication rather than self-expression or medium manipulation. More specifically, it is interested in the school of committed photojournalism that flourished during the thirties and forties, and with such antecedents for it as may be found in the works of documentary photographers like Lewis Hine. The coming of television and the subsequent collapse of the big picture magazines destroyed the chief support for this type of photography and threatened to consign it to oblivion. The ICP hopes to see that the great achievements of the thirties and forties ar not forgotten and that photographs of this kind will continue to be made.

These goals are somewhat quixotic. Pictures originally intended for mass publication are subtly transformed when seen in a museum context. In any case, it is uncertain whether photojournalism can continue on any significant scale without the support of the big picture magazines. However, ICP's three-part opening exhibition makes clear how much will be lost if this type of photography does come to an end. Featuring the works of Lewis Hine, Robert Capa, Werner Bischof, Henri Cartier-Bresson and many others, it brilliantly demonstrates photography's achievement in recording and preserving the splendors and miseries of an era.

November 17, 1974

## ART VIEW

### HILTON KRAMER

# Remembering Cunningham And White

**B**y an odd twist of fate, death came to two of our most illustrious photographers — Imogen Cunningham and Minor White—almost at the same time, but at opposite ends of the country, just over a month ago. Reading their obituaries— printed side by side, like entries in an encyclopedia, in The New York Times of June 26—gave one a peculiar sensation. It was not only the sensation of loss, although that was certainly part of it, but also of pride and curiosity. What a lot of history is contained in these two careers, and what a lot remains to be learned about them! The so-called photography boom had arrived in time to elevate them to a new celebrity in the world beyond the photo-

graphic community that had long esteemed them, but not soon enough to give us a really comprehensive account of their work. With photographers, as with poets, there is a tendency to judge them by often reprinted anthology pieces. There is a tendency, too, to attribute consistency to a body of work that may contain a significant diversity, if not outright contradictions. We do better, I think, to begin with a recognition of their diversity.

• • •

Imogen Cunningham, who died in San Francisco, was 93; Minor White, who died in Boston, was 67. Although their lives touched at various point—the most beautiful portraits I have seen of White's handsome, fawn-like face are Cunningham's—they belonged to different generations, were very different personalities, and took very different views of their art. Cunningham was the least mystical of women; she was earthy, humorous, downright and realistic; whereas for White the entire world of existence—and the place of photography in that world—was enclosed in a mysterious penumbra of spirituality. Cunningham reveled in playing the sassy old lady, celebrated for her candor, whereas White was the very archetype of the artist-as-guru. If for the one photography had become a form of straight talk, concerned above all with immediacy and truth, for the other it had long been a form of prayer.

I met each of them once, visiting Cunningham at her house in San Francisco a year before she died, meeting White a year before that at the exhibition he organized at M.I.T. on the occasion of his retirement as professor of photography. Cunningham spoke of what it felt like to be

Imogen Cunningham's famous "Magnolia Blossom" of 1925

old; and her current project was photographing old people —"most of them," as she hastened to point out "younger than me." White spoke of recovering a sense of "the sacred" in his art. He was not so much troubled as challenged by the thought that photography, unlike the other arts, traced its origin not to the mythic roots of ancient ritual but to modern technology. In Cambridge, at the very nerve center of a great technological institute, White yearned for spiritual transcendence. In San Francisco, at ease among the remnants among the mystical flower children, Cunningham remained the complete realist.

Yet each could look back on a career that embraced attitudes very different from those upheld at the end. Cunningham was, at the start and for some years thereafter, very much the romantic, producing dreamy, soft-focus pictures in the Whistlerian mode. Her early work recalls us to the spirit of Bohemian estheticism that flourished in the period before the first World War. Looking at the nudes and draped figures of 1910-15, we are reminded that she was a contemporary of Isadora Duncan.

She went on to become, among other things, an accomplished formalist, with a passion for abstract form that sometimes astonished her, in later years, when she looked back on it. He pictures of agaves, water hyacinths and the like, in the 1920's, bear comparison with Edward Weston's "Peppers." And the same photographer excelled as a portraitist of movie stars for Vanity Fair in the 1930's. (Her famous "Magnolia Blossom" of 1925 combines, in a way, both her formalist interests and her gift for capturing the special glamour of her movie star subjects—though she never photographed a star as beautiful as this "Blossom.")

What we now tend to think of as the characteristic Cunningham style, because of its clarity and immediacy, probably dates from her association with f/64 Group founded by Ansel Adams, Willard Van Dyke, Cunningham and others in San Francisco in 1932. (The name derived from the lens opening deemed to produce the most sharply defined image.) And it is certainly true that, from the 1930's onward, Cunningham's pictures acquired a new freedom and ease—a freedom from, among other things, what might be called artistic anxiety. It is worth remembering that the attitude we have come to prize in Cunningham's later work—that straightforward address to the subject that places the interests of life before those of art—was not something she came by quickly or easily. In 1933, Imogen Cunningham was 50 years old.

White, whose career was shorter and much occupied with writing and editing, with educational projects and exhibitions, was not without his own "contradictions." The mystic of the later years, producing photographic mediations on a Zen koan by concentrating his camera on the patterns of frost on the windows of his apartment in Rochester, N.Y., had earlier on—in 1939-41—worked as a master of the documentary mode. The pictures of iron-front buildings in Portland, Ore., that White took in these years as part of his work for the Works Progress Administration are still, I think, among the best he ever made. I certainly prefer them to the nature-abstractions that came to occupy so large a place in his art in the later years—but then, I have to confess to being of a very unmystical temperament myself.

The turn toward mysticism came, for White, in the 1950's, and in the chronology of his career that Peter Bunnell compiled a few years ago, one can find the sequence of titles and authors that influenced his course—Underhill's "Mysticism," Herrigel's "Zen and the Art of Archery," Huxley's "The Doors of Perception," the "I Ching," Gurdjieff, and so on. The camera became, for White, a form of spiritual meditation, and the things of this world lost, not their visual immediacy—for White had a flawless eye—but something of their material reality, becoming instead metaphors of the unseen. Looking at White's later work, I am reminded of what Paul Klee wrote about himself in 1918: "My work probably lacks a passionate kind of humanity. I do not love animals and other creatures with an earthly heartiness . . . the idea of the cosmos displaces that of earthliness . . . in my work, man is not a species, but a cosmic point."

This is what "the sacred" meant, I think, to Minor White, and it required a renunciation of that "earthly heartiness" that Imogen Cunningham made the mark of all her later work. How we shall miss them both!

August 1, 1976

# Music and the Dance

Martha Graham.

*NYT Pictures*

## MR. E. A. MACDOWELL'S RECITALS

### An American Composer and Pianist Who Ranks Among the Best.

E. A. MacDowell, an American composer, who is well, but ought to be better, known, gave the first of two piano recitals yesterday afternoon in the Madison Square Garden Concert Hall. Mr. MacDowell's principal purpose was to make known some of his own compositions, but, in order to give variety to his programme, and probably also to show that he had some claims to recognition as an interpreter of other men's works, he played numbers from the familiar repertory of pianists. Assistance was given to the pianist by Mrs. J. L. Wyman, who sang three songs by Templeton Strong and four by Mr. MacDowell.

The original compositions on the programme were the songs, "Deserted," Opus 9, No. 1; "The Robin Sings in the Apple Tree," "The Sea," and "Idyll," Opus 33, No. 3, and the piano pieces, "Poem," Opus 31, No. 2; "Czardas," Opus 24, No. 4; prelude, Opus 10, No. 1; "Idyll," Opus 39, No. 7; "Witches' Dance," Opus 17, No. 2, and "Idyll," Opus 28, No. 5.

It is not necessary at this time to announce that Mr. MacDowell is among our foremost native writers, for that fact is generally conceded. But it may not be so widely known that he enjoys as high a reputation in Europe, and that he thoroughly deserves it. His compositions are all rich and vital with the truest romantic spirit, and they are plentifully supplied with fruitful musical ideas. In structure they are graceful, symmetrical, and well-knit, and there is always a suggestion of repose and reserve power. No composer has been more successful in the embodiment of a poetic picture than Mr. MacDowell has been in embodying the dramatic feeling of the scene, which is the inspiration of his "Poem." It is a clear-cut, powerful little musical drama.

The prelude is noble in breadth and in richness of treatment, and "The Witches' Dance" is full of sylvan romance. Of the songs, all of which were excellently sung by Mrs. Wyman, the most nearly flawless is the "Idyl," though it has a close second in "The Robin Sings in the Apple Tree." But there are character and color in all the songs, and charming feeling in the handling of the accompaniments.

Though Mr. MacDowell is not usually classed among the virtuosi of the piano, it ought to be said that he is a good deal more interesting than most of them. In fact, he is the most satisfying pianist that has been heard here since Paderewski; not because he is brilliant or always correct, but because he displays a profound sympathy with his instrument and its literature. His playing is not cast in the large mold of D'Albert's, nor has it the infinite complexity and color of Paderewski's, but it is essentially pianistic—if we may be permitted to use that awkward word—and completely musical. In the performance of the two Bach numbers, for instance, he employed an exaggerated tempo rubato, quite out of keeping with Bach, but his tone-color and dynamics were exquisitely adjusted to the interpretation of works written for the old clavichord. The archaic flavor of the performance would have been perfect but for the exaggeration already mentioned.

The Schubert minuet Opus 78, No. 3, and the allegro of Schumann's second sonata were played excellently, and the Alabieff-Liszt "The Nightingale" beautifully, but the two Chopin waltzes, Opus 64, No. 3, and Opus 69, No. 1, were not well performed, especially the second, which was phrased incorrectly. But in spite of the errors in Mr. MacDowell's work, it interested, both because of its musical beauty and because of the influential projection of the pianist's personality. At his second recital, to-morrow afternoon, Mr. MacDowell will play, among other things, his "Sonata Tragica," which is said to be one of the finest piano works yet produced on this side of the Atlantic.

March 1, 1895

# OPERA SEASON OPENS WITH GREAT ECLAT

## Immense Audience Applauds Performance of "Rigoletto."

### SOCIETY OUT IN FULL FORCE

Resplendent in new decorations, under a new manager, with every promise of a public support such as has never before been given to opera in New York, the Metropolitan Opera House was reopened last evening in a blaze of glory, so far as glory could inhere in a performance of "Rigoletto." The occasion was an auspicious one, brilliant in every way that wealth and love of luxury and of the outward glitter of artistic things can create brilliancy.

So far as eye could see or ear hear, there was promise of success for the operatic season that was ushered in by last evening's performance of "Rigoletto." What questions the inward voice of experience and of prophecy may have suggested were crowned in the universal acclaim. The house was filled with an enormous audience, lovers of music and devotees of fashion, not only seats but standing places being entirely filled.

Old habitués of the house admired the new decorations that have transformed the interior and that make it a place of festal and dignified appearance. The dull gold and its touches of deep red and the red of the boxes make a glowing setting for the audience, and the proscenium arch, with a design that shows the brain and skill of an artist, instead of the fretted and meaningless filigree that has adorned it in recent years, affords a frame for the picture on the stage that increases and harmonizes with its brilliancy.

The edge of the stage has receded many feet, and no longer will singers troop across it in front of the curtain. Instead, the curtain, which is parted in the middle and drawn back on each side, permits them to emerge before the prompter's box—which has also experienced the touch of an artist—to bow their acknowledgments.

A still further change was evident in the placing of the orchestra, which was sunk out of sight. The effect of this upon the musical results is, of course, destined to be far-reaching, but so far as it concerned the performance last evening it was of small importance, except that it relieved the spectators from the disturbing sight of the conductor's and the musicians' labors. The orchestra is an entirely subsidiary affair in "Rigoletto."

### A SUPERB PERFORMANCE.

Whether or not there is any significance to be put upon the opening of the season with a work that has been so far outgrown by the public taste as "Rigoletto" is not now to be determined. The opera did not greatly matter. Its performance was in every way superb. It signalized the first appearance of one of the most important of Mr. Conried's new artists, one upon whom much will depend during the coming season—Enrico Caruso, who took the part of the Duke. He made a highly favorable impression, and he went far to substantiate the reputation that had preceded him to this country. He is an Italian in all his fibre, and his singing and acting are characteristic of what Italy now affords in those arts. His voice is purely a tenor in its quality, of high range, and of large power, but inclined to take on the "white" quality in its upper ranges when he lets it forth. In mezzo voce it has expressiveness and flexibility, and when so used its beauty is most apparent. Mr. Caruso appeared last evening capable of intelligence and of passion in both his singing and his acting, and gave reason to believe in his value as an acquisition to the company.

November 24, 1903

# CONCERT OF OLD MUSIC

## First of Sam Franko's Series in the New Lyceum Theatre.

### Selections from Mozart, Bach, Haydn, and Lully in the Programme.

Mr. Sam Franko began yesterday afternoon in the New Lyceum Theatre his series of concerts devoted to ancient music. These have been in the past occasions of great interest, as affording a glimpse into some of the almost forgotten ideals and methods of an earlier period; into the works of great men that are scarcely more than a record to-day, and into the processes by which music came to be what it is. They are valuable to intelligent amateurs as giving a sort of perspective for their outlook upon the art; but more than this they are delightful for those who have ears to hear and taste to understand the charm of music written in an idiom unfamiliar to-day.

Mr. Franko is a student of earlier periods of composition and of the true methods of performing the music belonging to them. He always succeeds in presenting something worthy of the attention of music lovers. Furthermore, the circumstances and the forces employed are such as to reproduce measurably the effects as the composers intended them. A small auditorium such as the New Lyceum Theatre, and a small orchestra, based upon six first violins and five seconds, with the wind instruments as prescribed, gives the tonal effect of such a symphony as the early one of Mozart's in G minor and the first of Bach's Brandenburg concertos as they may have sounded to Mozart and to Bach.

The programme yesterday included, besides these, Haydn's concerto for violoncello in D major and two dance tunes by Lully and an unknown composer. The order of the programme was inverted because of the tardy arrival of the hornist engaged to play the difficult part in the concerto grosso by Bach that was to begin the proceedings, and the first movement of Mozart's symphony was played before he arrived. Then the concerto and the rest of the programme were taken up, and the last three movements of the symphony closed the concert, but this, after all, was quite in keeping with the methods of the eighteenth century, when a symphony was not generally regarded as an entity that could not be divided for the sake of diversity and relief.

The symphony seems slight to-day compared with that other and greater one in G minor written fifteen years later and still living in the concert halls of to-day, yet it shows the mastery of the boy of seventeen years who composed it—his fertility of ideas and his instinctive skill in treating a form that had not even then been confidently established, as well as his independence in going counter to the taste of the day by the seriousness he put even into the minuet and finale. It is music that can appeal to our taste, and has much that is expressive and beautiful, put into a form clear and

lucid, even if it seems simple and naïve.

The concerto by Bach, which goes back fifty years further, is the product of a different ideal of music altogether and of an art and a power already riper and more certain of themselves. The idea of a concerto for solo instruments scarcely appears in this piece, which has the general effect of a symphonic suite, although the parts for some of the instruments, notably the horns, are of uncommon difficulty, and can be mastered only by a virtuoso.

It may be said that it was not mastered in the performance yesterday, and that it was played with evidences of a struggle with its difficulties. The nobility and splendid freshness of this music, the impassioned

eloquence of the adagio, and the grace and finesse of the dance movements with which it closes make it seem much nearer to this age in spirit than the symphony—it is music for all time, imperishable in its beauty. Mr. Franko did a real service in reviving it, for its difficulties are such that it has been scarcely known upon modern concert programmes. The two dance airs of the old French school were charming additions to the programme, in contrast to the more serious music of Bach and Mozart. though they are for dancing of the decorous and stately sort that prevailed two hundred years ago.

The soloist of this concert was Mr. Pablo Casals, a young Spanish violoncellist, who

played Haydn's violoncello concerto in D major, as arranged for modern performance by F. A. Gevaert. Mr. Casals showed an extremely charming artistic capacity and and exquisitely finished technique. His tone is small, and his style is small, to judge from his playing of this concerto, but grace, delicacy, and a truly musical feeling were inherent in all he did. He inserted cadenzas of his own in the concerto that showed taste and skill. He was enthusiastically recalled, and finally came out and played two movements from Bach's third solo 'cello suite.

*January 13, 1904*

## PHILADELPHIA ORCHESTRA.

### First Appearance in New York of Arthur Rubinstein, Pianist.

The Philadelphia Orchestra, under the direction of Fritz Scheel, gave a second concert here last evening in Carnegie Hall. It served to introduce to New York a young pianist with the somewhat onerous name of Rubinstein; but it was not a concert of the kind usually arranged for the special benefit of a soloist. It was a dignified programme of music substantially valuable, culminating in Brahms's second symphony. But the pianist was the subject of chief interest.

His coming had been preceded by circumstantial stories of his past and present prowess. He was an infant progidy, but was preserved from the fate of infant progidies, and is now a mature artist, though he is still a youth. This younger Rubinstein is undoubtedly a talented youth, but his talent at present seems to reside chiefly in his fingers. He played by Saint-Saëns's G minor concerto. This is not, to be sure, a work that is calculated to bring out much of the

deeper strain of the artistic nature in emotional power or passion or poetical insight.

But it is one in which a mature artist can exhibit a certain weight and dignity and many of the finer graces of style. Mr. Rubinstein has scarcely arrived at these qualities. He is full of the exuberance and exaggeration of youth, and he is at present concerned chiefly with the exploitation of his dexterity and with impressing not only the ears, but also the eyes, of his hearers with his personality and the brilliancy of the effects he can produce. For this he is well equipped. He has a crisp and brilliant touch, remarkable facility and fleetness of technique—though this is not altogether flawness—and much strength of finger and arm. He knows how to make all these things count for the utmost; and his performance of the concerto was imposing, if there was no thought of any deeper significance that lay behind the notes.

His delivery of the preluding of the opening movement, with its suggestion of Bach, was emphatic without being really impressive; and its rhytmical structure was not fully made clear. There was grace in the scherzo, and the tarentelle of the last movement, which he took in a great speed was brilliant and also heard. There is little warmth or beauty in Mr. Rubinstein's tone, and little variety in his effects. All is meant for brilliancy

and display; and in so far he is highly successful. It would be interesting to know whether he can expect some of the deeper things there are in music of deeper import. Until he can show this he is not likely to impress himself upon this public as a musician of influence.

He was much applauded after the concerto, and played again, a piece of pure display, an arrangement for piano of Liszt's orchestral piece, "The Mephisto Waltz" in the "Episodes from Lenau's Faust."

The orchestra opened the concert with Georg Schumann's overture, "Liebesfrühling," a melodious and spirited work made known here a couple of seasons ago by the Boston Symphony Orchestra, that leans strongly upon "Die Meistersinger," but is pleasing in its delineation of a light-hearted mood. It was admirably performed. Mr. Scheel's reading of Brahms's symphony aimed at variety of nuance and of tempo, but it was gained at the expense of repose and proportion, though there were many interesting details in it. The brass choir which did well at the first concert of the orchestra here a month ago, did not at all distinguish itself this time, but committed a number of blunders. The programme closed with Max Schillings's symphonic prologue to Sophocles's "Oedipus Rex."

*January 9, 1906*

## THE LATEST RUSSIAN PIANIST

### Josef Lhevinne Makes an Excellent Impression at His First Concert.

It is a far cry in these days of trouble for Russia from the scenes of riot and carnage in Moscow to the peace and quiet of Carnegie Hall. Only a few weeks ago Josef Lhevinne. the young Russian pianist, was practically imprisoned in Moscow and almost in despair lest he should be unable to meet his engagements to play in America.

Last night he sat at the piano on the stage in Carnegie Hall and played with brilliancy and great technical skill the Fifth Concerto (in E flat) of his great countryman, Anton Rubinstein, and by a happy chance (and the courtesy of the New York Philharmonic Society) he was enabled to make his artistic bow in America under the sympathetic leadership of

his friend and teacher, Wassily Safonoff, at the third concert of the Russian Symphony Society of New York. His surroundings and his reception must have brought joy to his heart.

So much for the romantic and sentimental side of last night's performance. If there be the virtue in much heralding that most press agents assume, Mr. Lhevinne should have had a larger audience. The circumstances of his publicity were not of his making nor of the ingenuity of his press agent, and yet they were dramatic enough, most press agents would think, to arouse eager curiosity. In that respect they failed, and for a wider hearing than the moderate-sized audience of last night could give Mr. Lhevinne must now depend on his art alone.

The young pianist chose for his introduction to this public a work which gave him admirable scope for demonstrating a high degree of proficiency in the technical side of his art, and he did not fail to take advantage of the opportunity. What he can do with compositions which call for deeper poetical and musical insight remains to be shown. Last night's

concert revealed only virtuosity of a high order.

Both Mr. Safonoff and Mr. Lhevinne were received with enthusiasm on their entrance, and after the Rubinstein concerto the pianist was insistently recalled. He responded with a Chopin etude, followed by a nocturne, composed by Scriabine, another pupil of Safonoff who, being paralyzed in the right hand, has written some charming pianoforte music which is played with the left hand only.

The concert was opened with Mozart's A major symphony, played in commemoration of the 150th anniversary of the birth of the pioneer in symphonic writing. It was closed with Tschaikowsky's Symphony No. 1 in G minor. The contrast was most interesting, affording, as it did, a chance for immediate comparison of the naïve, dainty orchestration and treatment of the father of symphonic literature with the many-voiced, complicated utterances of one of the most modern of modern composers. Both of these numbers were conducted by Modest Altschuler.

*January 28, 1906*

## MAHLER'S FIFTH SYMPHONY PLAYED

### The Boston Symphony Orchestra's Concert in Carnegie Hall.

### A NEW AND DIFFICULT WORK

The fourth evening concert of the Boston Symphony Orchestra was given last evening in Carnegie Hall, before one of the finest audiences the orchestra has had. It was made notable by the per-

formance of Gustav Mahler's fifth symphony for the first time in New York. But, notwithstanding the notability of this event, there was still much distinction in the first part of the concert, which consisted of Beethoven's "Egmont Overture," played with nobility of style, but without the dramatic nuances that Wagner advocated. Mr. Harold Bauer played Schumann's pianoforte concerto with exquisite poetical grace and charm, and rhythmic coherency; it was playing that had truly musical qualities, that sought to express only such qualities, without an effort to turn the first and last movements into brilliant display pieces.

Mahler's symphony imposes by its length and breadth, the vast number and extent of its themes, the skillful handicraft with which they are put together,

the bigness of the orchestral apparatus, the extraordinary skill with which it is managed. Yet it is a less unusual apparatus than that required by the less impressive fourth symphony, with its singing voice in the last movement, as it was heard here last season; and a much less elaborate machinery than is required for Mahler's second symphony, which has never been done in this country. This fifth symphony is a work that cannot be dismissed at one hearing as harsh, diffuse, lacking in distinction of theme and definiteness of purpose; although all these things appeared from time to time to be true of it, as it was unfolded before an uncommonly attentive and patient audience last evening.

That t is deeply felt and tremendously sincere music is continually borne in upon

the listener; but that it is not the product of a strong and vigorous creative genius, an original force in music, is also evident. It seems that the composer is most strenuously seeking for self-expression; but though he is equipped with all that modern musical skill can give him in methods of treatment and resources of orchestration, his achievement seems continually to pant behind his ambition, rarely overtaking it.

There was discussion and explanation at length in last Sunday's TIMES of Herr Mahler's work and his attitude toward the "programme" and the explanation of music. This symphony has no suggestion of what it is; and the lack of one is inevitably felt as a bar to its understanding. For Herr Mahler plainly had some definite idea in his mind. We simply do not know what he is driving at; for it seems undeniable that many portions of his five movements are not intelligible simply as music—the treatment and the development seem unable to account for themselves purely as such.

The unusual division of the work was described the other day in THE TIMES. The funeral march with which the symphony opens is highly effective—yet there are certain commonplace passages in it that let down the "high erected thoughts" with jarring suddenness. The episode of wild and passionate outbursts in the midst of this march is seizing. The second movement carries on the feeling of the march, but is less tangible. In the Scherzo Herr Mahler has sought for a contrast with all this. Here is a " Ländler," a country waltz theme of naïve tunefulness; but here, too, is the Mahler of the fourth symphony, who produces naïve tunes only to toss them about and torment them with strange development and strained harmonies that leave little of their pretty and somewhat commonplace lustre.

There is here, and through the work, an ingenious and bold utilization of numerous themes in the crass kind of forced union that does duty in these most modern days as counterpoint—a union that is effected without regard to euphony. The adagietto has more ingratiating traits than any of the other movements; there is a poetical suggestion in it that the others have not, yet even here there is a certain lack of cogency and point; the movement seems to have little definite issue. The last movement is a "rondo-finale," and still shows the lack of a clearly discernible purpose. It has many interesting moments. There is a

fugato of considerable extent; there is a long climax in a sustained melody of a choralelike character that is developed. There is also much that is dry and harsh, as there is in every one of these five movements.

The symphony arrests the attention of the listener for the hour of its duration. Its vague and indeterminate bigness of conception and elaborate dexterity of execution engage the interest of those who wish to follow the technical methods of the composer. But of specific musical inspiration it seems, from the first hearing of the work, that the composer has little. He appears, for instance, to stand considerably below Strauss in originality. He is in many respects dramatically opposed to Strauss; but he seems a lesser talent.

The performance of this symphony was an extraordinary achievement on the part of the orchestra and Mr. Gericke. He had devoted great care to its preparation, and the perfection of its reproduction was the result of much labor. It is said that Herr Mahler had sent Mr. Gericke some revisions of the orchestration. The audience listened to it with close attention to the end, but manifested little enthusiasm over it.

February 16, 1906

## HOW THE AUDIENCE TOOK IT.

### Many Disgusted by the Dance and the Kissing of the Dead Head.

Ten extra policemen were required last night to handle the crowds who flocked to the Metropolitan Opera House to hear the Oscar Wilde version of the story of Salome and John the Baptist set to music by Richard Strauss.

The dance of Salome before Herod for the head of the prophet, and the report that the opera would contain many other sensational features brought a throng of men and women such as no previous opera has drawn to the Metropolitan.

Herr Conried was ill, but his assistants were on the spot, and they, with the police, tried to control the crowd. At 8:30 o'clock the speculators in front of the building left, and the man in the box office declined to sell even a ticket for standing room.

It was between 9:30 and 10 o'clock when the preliminary concert was over and the curtain went up.

The three balconies over the horseshoe were packed with men and women anxious to hear the music that Strauss had written for the Wilde play. There were many Germans present. Those who were not Germans bought librettos giving the

German and English versions of the work. In the orchestra the seats were all filled, and the aisles behind the seats and at the side were packed with standing men and women.

Puccini and Mme. Cavalieri were in a box. In the grand tier the seats began to fill a few minutes before the musical tragedy began. Although it was not a subscription night and the public had its choice of seats, there was a rustle of gowns and a craning of necks in the pit which told of the arrival of this or that social celebrity.

After the curtain went up on " Salome " there was no sensation until the dance began. It was the dance that women turn away from, and many of the women in the Metropolitan Opera House last night turned away from it. Very few men in the audience seemed comfortable. They twisted in their chairs, and before it was over there were numbers of them who decided to go to the corridors and smoke.

But when, following the lines of Wilde's play, Mme. Fremstad began to sing to the head before her, the horror of the thing started a party of men and women from the front row, and from Boxes 27 and 29 in the Golden Horseshoe two parties tumbled precipitately into the corridors and called to a waiting employe of the house to get their carriages.

But in the galleries men and women left their seats to stand so that they might look down upon the prima donna as she kissed the dead lips of the head of John the Baptist. Then they sank back in their chairs and shuddered.

January 23, 1907

## FIRST HEARING HERE OF DEBUSSY'S OPERA

### "Pelleas et Melisande" Sung at the Manhattan Before a Crowded House.
#### MUSIC OF STRANGE QUALITY

Melisande .................... Miss Mary Garden
Genevieve ................... Mille. Gerville-Reache
Little Yniold ...................... Mille, Sigrist
Pelleas ..................... M. Jean Perier
Golaud ..................... M. Hector Dufrane
Arkel ........................... M. Arimondi
The Doctor ..................... M. Crabbe
Musical Director .......... M. Cleofonte Campanini

Claude Debussy's opera, "Pelleas et

Melisande," was produced for the first time in America last evening at the Manhattan Opera House. There was a very large audience present—an audience of an altogether unusual intellectual quality and musical discrimination—that listened to the work with intense interest and absorption. There has been a great curiosity on the part of the music-loving public not only in New York but in other musical centres as well to become acquainted with this remarkable product of twentieth century art, and there were persons present who had come from a long distance to witness this performance.

The production was generally acknowledged to be a highly important one, on account of the position that Debussy has taken as the leader and most original exponent of a new departure in music;

in the eyes of his admirers it was of an importance comparable to the productions of "Parsifal" and "Salome." It was an act of courage and daring on Mr. Hammerstein's part to bring out in New York a work of such a character that its appeal to the operatic public on which he relies for his support must necessarily be a matter of uncertainty; and still more, to bring over for the purpose two of the singers from the Opera Comique in Paris who have been indentified with it from the beginning, Messrs. Dufrane and Périer, besides two more whom he already had in his company, Miss Mary Garden and Miss Gerville-Réache. To do so was, as a matter of fact, the only way to make possible the production of a work that is absolutely sui generis, that departs widely from the methods and traditions of the lyric drama as hitherto ac-

cepted, and whose spirit and essence can be caught and set forth only by artists who have become fully possessed by them.

## Mr. Campanini's Feat.

An altogether remarkable exception to this statement is the fact that the performance was prepared and carried out under the direction of Mr. Cleofonte Campanini. He had never even heard the work; and Italian though he is by birth, and cosmopolitan by virtue of his profession and experience, he found the innermost secret of this most elusive of all music, and his rendering of the score was a marvel of sympathy, of subtle appreciation of the composer's purpose, and mastery of the refinements of his orchestration. All this he secured in the short space of two weeks, and with a very limited number of rehearsals. He had, to be sure, the invaluable counsel and assistance of singers to whom the work and all its secrets are as an open book; but the task was one that only a musician of the highest powers and widest sympathies could have accomplished as Mr. Campanini has accomplished it. Never, indeed, has the commanding genius of this great artist so completely established itself as in this achievement.

Maeterlinck's drama, as Debussy has used it for his musical setting, was described at length in last Sunday's TIMES. Yet description of the action is far from giving an insight into the meaning of the piece. The music by which Debussy interprets the drama is equally elusive of analysis. It is cast in the same spiritual mold; it is an absolute reflex of the drama, the thing itself transmuted into tones. It seems like the same intellectual and emotional stuff in another form, so subtly and so exactly has he found expression for it in all its qualities. Maeterlinck's play is far removed from the realities of life, as it is from the conventionalities of the drama. It is a dim and shadowy world in which these characters move, as in a dream. They are drawn by the inevitable power of fate toward catastrophe; and this power is ominously indicated, suggested rather than delineated, by effects that the dramatists use. The personages themselves are compounded of mystery; they reveal themselves by speech and action that seem like the operation of their consciousness or even their volition. What they do, "gentle, hesitating figures that speak in the voices of dreamland," is less action than it is the disclosure of their souls' state. Withal, they exert a strange fascination upon the sympathies of the listener, and the development of their relations and the maturing of their fate, limned as they are in suggestion and vague outline, rather than in unmistakable traits, may work upon the sensibilities more deeply than forms and concepts of sharper reality.

## Story of Wandering Souls.

Yet these characters have strong and clearly discerned lineaments of their own; Golaud, the elder brother, is the dominating figure upon the scene; a figure tormented by the doubts that come to him, a stern man uncertain of his way through the baffling circumstances that beset him, and seeking it with intermittent rude force; desponding, and at the end torturing his dying wife to resolve, for the sake of his own pride, doubts whose resolution can avail nothing. Pelléas and Mélisande are wandering souls, drifting on the current of their own feelings, which bears them steadily toward the inevitable end; Pelléas hesitant impotently, vaguely thinking to free himself by going away, but never going; Mélisande, simple, ingenuous, wistful, passive, and but dimly conscious of the forces that are bearing her, absolutely straightforward in her answers to her lord's feverish questioning as she lies dying. Arkël embodies the gracious and sweet benignity of the wisdom of age, and there is much that is beautiful and touching that comes from his lips.

There has been much said about the symbolism of Maeterlinck's drama. It is not necessary to enter into much perplexity on this account; especially in the form in which Debussy has compressed it, in which certain passages of symbolic import are eliminated. There are some scenes that seem disconnected with the progress of the drama, even accepting the vague and disconnected sequence that forms its substance. These may be felt to be suggestions pointing the way to the end, and contributing by the indirection and indecision, which are of the essence of Maeterlinck's art, to the result he is striving for. The drama explains itself to the sympathetic listener with its indication of character, its representation of mismated souls, its under current of foreboding, its dim and subtle imaginative suggestion.

It is fascinating; and its fascination is now, and is likely long to be, inseparable from the music through which Debussy

has heightened and deepened its significance. Debussy's art has heretofore become familiar to the frequenters of orchestral concerts; and it is essentially the same, as he has molded it to dramatic purposes in " Pelléas et Mélisande." Its beauty is almost indefinable; strange and unaccustomed; but it is very real. It may be said to be, for the opera goer accustomed to all the wide gamut of musical expression from Gluck and Mozart to Wagner and even Strauss, almost a complete negative of all that has been hitherto accepted as music. It is a complete stranger to traditional art.

Melody, even as melody has been recognized in the most recent of Debussy's predecessors, is here only dimly hinted at, and such melody as there is but the slender scaffolding for a rich and ever varying harmonic structure. It is by the shimmering and iridescent play and change of harmonic and orchestral color that this music has its most potent effect. The orchestra has the entire predominance. Of vocal melody there is nothing. The voices have not even the endless arioso of Wagner's style. Their declamation is little more than sustained speech in musical tones, sometimes falling into a suggestion of Gregorian chant. Around this flows an endless orchestral stream of marvelous and delicate beauty. It is saying too much to say that this music is built up of " leading motives " in the sense that Wagner has made familiar. There are recognizable harmonic groups and melodic outlines, but their definite association with particular ideas, or emotions, or personages, is by no means certain. Yet this orchestral part is poignantly and potently suggestive of the changing moods of the drama. Of musical characterization of the personages there can scarcely be said to be any. There is no place in this music for the sharp outlines, the strong coloring, that such characterization would imply. Suggestion, allusion, shifting colors and interplay of light and shadow are what Debussy has aimed at and what he has achieved.

## In a Strange Wonderland.

In his harmonic substance, of which his music is so largely composed, Debussy has penetrated into a strange, new wonderland. He owes no allegiance to any harmonic system; tonality, the very foundation of hitherto accepted harmony, is almost non-existent in this music. He has gone to the very extreme of new and unfamiliar combinations, of progressions and juxtapositions, that seem fantastically to mock the rules and the axioms of the musical grammarians. These discords—if a term of the ancients may be used in connection with this new art—have scarcely a name and a designation in those rules. And it has been said of them that they are so far from being justified by the grammarian that they cannot even be convicted by him. Yet they bear their own justification with them to the ear that is attuned to hear their strange eloquence. The beauty of this harmonic flow is inexplicable, but is irresistible.

All this is inseparably connected with the skill in orchestration that the composer has shown. What looks harsh and unbearable on paper, what sounds impossible upon the piano, is transformed into a golden and opalescent beauty by the magic of the instrumental color. Debussy's technical mastery of his medium is of the highest. His orchestra is small; he makes no demand for extra instruments, but from the familiar choirs he extracts timbres of exquisite beauty, lucid, transparent, delicate, incessantly changing. The orchestral part is subdued, rarely rising to a fortissimo; and it is adjusted with an unerring skill to support and envelop the voices upon the stage.

Debussy, even when the opportunity is offered him to suggest exterior impressions with his orchestra, abstains; as when he could suggest the murmur of the sea, or the whispering of the wind through the leaves, or the striking of a beam of moonlight into the dim recesses of the cave, or the flash of Mélisande's ring falling into the fountain. His artistic reserve prompts him to deal more with the psychological than the sensuous.

It is difficult to point out scenes and passages that one of especial beauty in a score so intimately knit, and so consistent in its structure. The first scene, of the meeting between Golaud and Mélisande, the scene where Pelléas comes to Mélisande's window in the tower and seeks to touch her hand and her long hair, their scene by the fountain, when the ring is lost, their final scene together when the passion of their love is fully disclosed, and several of the passages that fall to Arkël, linger and haunt the memory.

## Weaknesses of the Score.

The weakest places of the score are the passages the orchestra plays between the scenes while the curtain is down; and the history of these explains their weakness. They were extended by the composer after he had finished his work, to

meet the exigencies of the scene shifters —to last for so and so many minutes each. They are hence an excrescence upon the conception of the work as the composer originally conceived it. But from this must be excepted the music that accompanies the change before the last scene of the fourth act, which is of superb eloquence, the orchestra rising to a power steadily denied it theretofore.

Debussy in this music is as original as it is given any creative artist to be in an art that is built upon the achievements of those who have gone before. It is comparable with no other music but his own. It is easy to say that but for Wagner and César Frank the score could not exist as it is, but that is scarcely more than to say that Debussy comes after those two masters in point of time. There are, indeed, traces a few of " Tristan," of " Parsifal," but they are not important. It is an artistic phenomenon that, as far as may be, begins with this composer. Whether it will end with him is something for the future to discover.

The interpreters of Debussy's opera gave a performance, which, so far as the principal characters were concerned, was of a rare finish and perfection. Of Mr. Campanini's part in it we have already spoken. The Misses Garden and Gerville-Réache and Messrs. Périer and Dufrane created in Paris the rôles of Mélisande, Geneviève, Pelléas, and Golaud, respectively; and they are completely identified with its spirit at every point. Miss Garden made in it a new disclosure of her art and of the power of her dramatic personality. She is the dreamy, wistful maiden, wandering, uncertain, unhappy; and her denotement of the wistful and mysterious character is of much beauty and plastic grace. In places, as in the difficult scene with the wounded Golaud, and in the scene in which he does her violence, she rises to a height of tragic power that ought to put her among the greatest of lyric actresses. It was difficult to believe this statuesque mediaeval maiden was of the same stuff as Thais, as Louise. Mélisande adds many cubits to Miss Garden's artistic stature.

## The Newcomer.

The two newcomers are both important additions to singers who have been heard here. Mr. Dufrane has a baritone voice of resonance, of dark and rich color; his enunciation is of exquisite perfection, his treatment of the phrase most musical, his declamation of true eloquence. He is an actor of strong individuality and varied resources. So is Mr. Périer, the tenor, whose representation of the hero has the suggestion of longing, of hesitancy, of waxing passion. His voice, which has something of the baritone about it, has less of fine quality as it is disclosed in this music, but he has admirable enunciation and admirable skill in the management of it. Mr. Arimondi, naturally enough, could make less of the part of Arkël, to which he is new, nor is his French diction above reproach. But it was a creditable attempt at a difficult part. Miss Sigrist, in the slight part of Yniold, the little boy, met with fair success.

An elaborate series of scenic pictures is an indispensable part of the representation of Debussy's opera, and these had been provided. They are admirable in design, and they give the pictures that are evoked by the text. Their deficiency lies in their color, which has not been applied always with the eye and the feeling for harmony of an artist. Some have richness of effect, as the scene of the window of the castle looking out over the sea, and that of the castle tower. In others a garish note has been allowed to obtrude. The management of the lights, while it was well planned, sometimes resulted in somewhat too great an illumination of what should have been more dim, more mysterious. There are many rapid changes of the scene during the playing of the orchestral interludes, which, it is quite indispensable, should be done promptly, and they were most successful.

The audience, while it was not at first highly demonstrative, was closely attentive, restrained its applause during the changes of scene, and at the ends of the acts let its appreciation find expression. This expression reached its highest pitch after the fourth act, in which theatrical effect is strongest. Here it became positive enthusiasm. All the principals were called out repeatedly, and then Mr. Campanini and Mr. Coini, the stage manager. Finally Mr. Hammerstein came and made a speech. He said:

"If a work of such sublime poetry and musical grandeur meets with your approbation and receives your support, it places New York at the head of cities of musical culture throughout the world. As for myself, I have had but one object in presenting the opera—to endear myself to you and perpetuate myself in your memory."

February 20, 1908

**FOUR GREAT FIDDLERS.**

At a dinner given by a musical club of this city to EUGENE YSAYE, on Sunday night, the four greatest living violinists sat at the board. There were other musicians of world-wide fame there, pianists, composers, orchestra leaders, but let us consider the fiddlers. Masters of the violin are scarce in any age. There have probably been none whose mastery was more generally recognized since BEETHOVEN wrote his great concerto. If any violinist excels FRITZ KREISLER in the performance of that masterwork, it is YSAYE; we have KREISLER'S word that YSAYE is the greatest of them all. Probably KREISLER is too modest. But MISCHA ELMAN, ZIMBALIST, YSAYE, and KREISLER are all of the line of WILHELMJ and WIENIAWSKI, and if the two Russians, the Belgian, and the Vienna artist have any formidable rival living, it is KUBELIK as a master of technic.

That these four renowned fiddlers should all be in New York at the same time, that they should all be able to command here the enthusiastic support and sympathetic appreciation of a multitude of music lovers, is not strange, of course, in these days of musical progress, but it assuredly emphasizes the extraordinary development of musical taste in this country. Nobody would specially remark the simultaneous presence of all four in Paris, Berlin, Vienna, or even in London, but only a few years ago New York was artistically remote from those centres of aesthetic development. New York is no longer merely a possibility in the itinerary of the musical artist.

December 24, 1912

# SCHOENBERG, MUSICAL ANARCHIST, WHO HAS UPSET EUROPE

## James Huneker Writes of This Max Stirner Among Composers, Who Aroused the Ire of German Critics and the Merriment of His Audiences---A Word, Too, About the Youthful Erich Korngold.

**By James Huneker.**

TWO decades ago, more or less, John M. Robertson, M. P., published two volumes chiefly concerned with the gentle art of criticism. Mr. Robertson introduced to the English-reading world the critical theories of Emile Hennequin, whose essays on Poe, Dostoiewsky, and Turgenev may be remembered. It is a cardinal doctrine of Hennequin and Robertson that as the personal element plays the chief rôle in everything the critic writes he himself should be the first to submit to a grilling; in a word, to be put through his paces and tell us in advance of his likes and dislikes, his prejudices and passions. Naturally, it doesn't take long to discover the particular bias of a critic's mind. He writes himself down whenever he puts pen to paper.

For instance, there is the historic duel between Anatole France, a freelance among critics, and Ferdinand Brunetière, intrenched behind the bastions of tradition, not to mention the Revue des deux Mondes. That discussion, while amusing, was so much thrashing of academic straw. M. France disclaimed all authority—he, erudite among scholars; M. Brunetière praised impersonality in criticism—he, the most personal among writers—not a pleasing or expansive personality, be it understood; but, narrow as he was, his personality shone through every page.

Now, says Mr. Robertson, why not ask every critic about to bring forth an opinion for a sort of chart on which will be shown his various qualities of mind, character; yes, and even his physical temperament; whether sanguine or melancholic, bilious or eupeptic, young or old, peaceful or truculent; also his tastes in literature, art, music, politics and religion. It reminds you of an old-fashioned game, no longer in vogue. All this long-winded preamble to tell you that the case of Arnold Schoenberg, musical anarchist, and an Austrian composer who has at once aroused the ire and indignation of musical Germany, demands just such a confession from a critic about to hold in the balance the music, or unmusic (the Germans have such a handy word) of Schoenberg. You wouldn't go, for example, to Mr. Krehbiel for his opinion concerning the now bourgeois Richard Strauss; nor would you coax from Mr. Henderson what he thought about the singing of Mary Garden, nor ask Mr. Finck why he liked Chopin. Yet, Strauss makes music that is liked by many of his fellow-humans, and Mary Garden is simply fascinating as Mélisande, and in the Juggler of Notre Dame (among other noteworthy assumptions.) Therefore, before I attempt a critical or uncritical valuation of the art of Arnold Schoenberg let me make a clean breast of my prejudices in the manner suggested by Hennequin and Robertson. Besides, it is a holy and unwholesome idea to purge the mind.

**First:** I place pure music above impure, i. e., instrumental above mixed. I dislike grand opera as a miserable mishmash of styles, compromises, and arrant ugliness. The moment the human voice intrudes in an orchestral work my dream-world of music vanishes. Mother Church is right in banishing from within the walls of her temples the female voice. The world, the flesh, and the devil lurk in the larynx of the soprano or alto, and her place is before the footlights, not as a vocal staircase to paradise. I say this, knowing in my heart that nothing is so thrilling as "Tristan and Isolde," and my memory cells hold marvelous pictures of Lilli Lehmann, Milka Ternina, and Olive Fremstad. So, I'm neither logical nor sincere; nevertheless, I maintain the opinion that absolute music, not programmed, not music-drama, is the apogee of the art. A Beethoven string quartet holds more genuine music for me than the entire works of Wagner. There's a prejudiced statement for you.

Second: I fear and dislike the music of Arnold Schoenberg, who may be called the Max Stirner of music. Now, the field being cleared, let us see what the music of the new man is like. Certainly, he is the hardest musical nut to crack of his generation, and the shell is very bitter in the mouth.

Early in December last the fourth performance of a curious composition by Schoenberg was given at the Choralionsaal in the Bellevuestrasse, Berlin. The work is entitled "Lieder des Pierrot Lunaire," the text of which is a fairly good translation of a poem cycle by Albert Guiraud. This translation was made by the late Otto Erich Hartleben, himself a poet and dramatist (can't he write "Rosenmontage"?) I have not read the original French verse, but the idea seems to be faithfully represented in the German version. This moon-stricken Pierrot chants—rather declaims—his woes and occasional joys to the music of the

Viennese composer, whose score requires a reciter, (female,) a piano, flute, (also piccolo,) clarinet, (also bass clarinet,) violin, (also viola,) and violoncello. The piece is described as a melodrama. I heard it on a Sunday morning, and I confess that Sunday at noon is not a time propitious to the mood musical. It was also the first time I had heard a note of Schoenberg's. In vain I had tried to get some of his scores; not even the six little piano pieces could I secure. Instead, my inquiries were met with dubious or pitying smiles—your music clerk is a terrible critic betimes, and his mind oft takes upon it the color of his customer's orders. So there I was, to be pitched overboard into a new sea, to sink or float, and all the while wishing myself miles away.

A lady of pleasing appearance, attired in a mollified Pierrot costume, stood before some Japanese screens and began to intone—to cantillate, would be a better expression. She told of a monstrous moon-drunken world, then she described Columbine, a dandy, a pale washerwoman — "Eine blasse wäscherin wäscht zur Nachtzeit bleiche Tücker"—and always with a refrain, for Guiraud employs the device to excess. A valse of Chopin followed, in verse, of course (poor suffering Frederic!) and part first—there are seven poems, each in three sections—ended with one entitled Madonna, and another, the Sick Moon. The musicians were concealed behind the screens, (dear old Mark Twain would have said, to escape the outraged audience,) but, ach Gott! we heard them, we heard them only too clearly!

It is the decomposition of the art, I thought, as I held myself in my seat. Of course, I meant decomposition of tones, as they say in the slang of the ateliers.

What did I hear? At first, the sound of delicate china shivering into a thousand luminous fragments. In the welter of tonalities that bruised each other as they passed and repassed, in the preliminary grip of enharmonies that almost made the ears bleed, the eyes water, the scalp to freeze, I could not get a central grip on myself. It was new music, or new exquisitely horrible sounds, with a vengeance. The very ecstasy of the hideous! I say "exquisitely horrible," for pain can be at once exquisite and horrible; consider toothache and its first cousin, neuralgia. And the borderland between pain and pleasure is a territory hitherto unexplored by musical composers. Wagner suggests poetic anguish; Schoenberg not only arouses the image of anguish, but he brings it home to his auditory in the most subjective way. You suffer the anguish with the fictitious character in the poem. Your nerves—and remember the porches of the ears are the gateways to the brain and ganglionic centres—are literally pinched, scraped.

I wondered that morning if I were not in a nervous condition. I looked about me in the sparsely filled hall. People sat still, they didn't wriggle; perhaps their souls wriggled. They neither smiled nor wept. Yet on the wharf of hell the lost souls disembarked and wept and lamented. What was the matter with my own ego? My conscience reported a clean bill of health, I had gone to bed early the previous night wishing to prepare for the ordeal. Evidently I was out of condition, (critics are like prizefighters, they must

keep in constant training else they go "stale.") Or was the music to blame? Schoenberg is, I said to myself, the cruelest of all composers, for he mingles with his music sharp daggers at white heat, with which he pares away tiny slices of his victim's flesh. Anon he twists the knife in the fresh wound and you receive another horrible thrill, all the time wondering over the fate of the Lunar Pierrot and—hold on! Here's the first clue. If this new music is so distractingly atrocious what right has a listener to bother about Pierrot? What's Pierrot to him or he to Pierrot? Perhaps Schoenberg had caught his fish in the musical net he used, and what more did he want, or what more could his listeners expect?—for to be hooked or netted by the stronger volition of an artist is the object of all the seven arts.

How does Schoenberg do it? How does he pull off the trick? It is not a question to be lightly answered. In the first place the personality of the listener is bound to obtrude itself; dissociation from one's ego—if such a thing were possible—would be intellectual death; only by the clear, persistent image of ourselves do we exist—banal psychology as old as the hills. And the ear, like the eye, soon "accommodates" itself to new perspectives and unrelated harmonies.

I had felt, without clearly knowing the reason, that when Albertine Zehme so eloquently declaimed the lines of Madonna, the sixth stanza of part I., beginning "Steig, o Mutter, aller Schmerzen auf den Altar meiner Töne!" that the background of poignant noise supplied by the composer was more than apposite, and in the mood-key of the poem. The flute, bass clarinet, and violoncello were so cleverly handled that the color of the doleful verse was enhanced, the mood expanded; perhaps the Hebraic strain in the composer's blood has endowed him with the gift of expressing sorrow and desolation and the abomination of living. How far are we here from the current notion that music is a consoler, is joy-breeding, or should, according to the Aristotleian formula, purge the soul through pity and terror. I felt the terror, but pity was absent. Blood-red clouds swept over vague horizons. It was a new land through which I wandered. And so it went on to the end, and I noted as we progressed that Schoenberg, despite his ugly sounds, was master of more than one mood; witness the shocking cynicism of the gallows song "Die dürre Dirne nich langen Halse." Such music is shameful—"and that's the precise effect I was after"—would the composer triumphantly answer, and he would be right. What kind of music is this, without melody, in the ordinary sense; without themes, yet every acorn of a phrase contrapuntally developed by an adept, without a harmony that did not smite the ears, lacerate, figuratively speaking, the eardrums; keys forced into hateful marriage that are miles asunder, or else too closely related for aural matrimony; no form, that is, in the scholastic formal sense, and rhythms that are so persistently varied as to become monotonous—what kind of music, I repeat, is this that can paint a "crystal sigh," the blackness of prehistoric night, the abysm of a morbid soul, the man in the moon, the faint sweet odors of an impossible fairyland, and the strut of the dandy from Bergamo? (see the Guiraud poem.) There is no melodic or harmonic

line, only a series of points, dots, dashes, or phrases that sob and scream, despair, explode, exalt, blaspheme.

I give the conundrum the go-by; I only know that when I finally surrendered myself to the composer he worked his will on my fancy and on my raw nerves, and I followed the poems, loathing the music all the while, with intense interest. Indeed, I couldn't let go the skein of the story for fear that I might fall off somewhere into a gloomy chasm and be devoured by chromatic wolves. I was miserable afterward all the afternoon, my nerves fretted and on edge, and not even the sorcery of the pale amber witch, Donna Pilsner, soothed me. There was no antidote for the poison but sleep. I recalled one extraordinary moment at the close of the composition when a simple major chord was sounded and how to my ears it was a supernal beauty; after the perilous tossing and pitching on a treacherous sea of no-harmonies it was like a field of firm ice under the feet.

I told myself that it served me right, that I was too old to go gallivanting around with this younger generation, that if I would eat prickly musical pears I must not be surprised if I suffered from aural colic. Nevertheless, when certain of the Schoenberg compositions reached me from Vienna I eagerly fell to studying them. I saw then that he had adopted as his motto, Evil, be thou my good! And that a man who could portray in tone sheer ugliness with such crystal clearness is to be reckoned with in these topsy-turvy times.

I have called Arnold Schoenberg a musical anarchist, using the word in its best estate—anarchos, without a head. Perhaps he is a superman also, and the world doesn't know it. His admirers and pupils think so, however, and several of them have recorded their opinion in a little book, published at Munich, 1912, by R. Piper & Co.

The life of Arnold Schoenberg, its outer side, has thus far been uneventful, though doubtless rich in the psychical sense. He is still young, having been born in Vienna Sept. 13, 1874. He lived there till 1901, then in the December of that year he went to Berlin, where he was for a short time conductor in Walzogen's Bunten Theatre, and also teacher of composition at Stern's Conservatory. In 1903 he returned to Vienna, where he taught— he is pre-eminently a pedagogue, even pedantic as I hope to presently prove— in the K. K. Akademie für Musik. In 1911 Berlin again beckoned to him, and as hope ever burns in the bosom of composers, young and old, he no doubt believes that his day will come. Certainly, his disciples, few as they may be, make up by their enthusiasm for the public and critical flouting. I can't help recalling the Italian Futurists when I think of Schoenberg. The same wrath may be noted in the galleries where the young Italian painters exhibit. So it was at the end of the concert. One man, a sane person, was positively purple with rage, (evidently he had paid for his seat,) and swore that the composer was "verrückt." Well, the old song has it, "Du bist verrückt mein Kind, und muss nach' Berlin." Schoenberg is now in Berlin, the right man in the right place, according to the truthful lyric.

His compositions are not numerous. Schoenberg appears to be a reflective rather than a spontaneous creator.

# Music

Here is an abridged list: Opus 1, 2, and 3, (composed, 1898-1900); Op. 4, string sextet, which bears the title "Verklärte Nacht," (1899); gurre Lieder, after J. P. Jacobsen, for solos; chorus and orchestra, (1900,) published in the Universal Edition, Vienna; Op. 5, "Pelleas and Melisande," symphonic poem for orchestra, (1902,) Universal Edition aforesaid; Op. 6, eight lieder, (about 1905); Op. 7, E string quartet D minor, (1905); Op. 8, six orchestral lieder, (1904); Op. 9, Kammer symphony, (1906); two ballads for voice and piano, (1907); "Peace on Earth," mixed chorus à capella, (1908,) manuscript; Op. 10, II. string quartet, F sharp minor, (1907-8); fifteen lieder, after Stefan George, a talented Viennese poet, one of the Jung-Wien group, (1908,) manuscript; Op. 11, three piano pieces (1908); five pieces for orchestra (1909) in the Peters edition, monodrama, "Erwartung," (1909); "Gluckliche Hand," drama with music, text by composer, not yet finished, (1910,) and six piano pieces (1911). His book on harmony appeared in 1910 and was universally treated as the production of a madman, and, finally, as far as this chronicle goes, in 1911-12 he finished "Pierrot Lunaire," which was first produced in Berlin.

One thing is certain, and this hardly need assure my musical readers, the old tonal order has changed forever: there are plenty of signs in the musical firmament to prove this. Moussorgsky preceded Debussy in his use of whole tone harmonies, and a contemporary of Debussy, and equally as gifted a musician, Martin Loeffler, was experimenting before Debussy himself in a dark but delectable harmonic region. The tyranny of the diatonic and chromatic scales, the tiresome revolutions of the major and minor modes, the critical Canutes who sit at the seaside and say to the modern waves: Thus far and no farther; and then hastily abandon their chairs and rush to safety else be overwhelmed, all these things are of the past, whether in music, art, literature, and, let Nietzsche speak, in ethics. Even philosophy has become a plaything, and logic "a dodge," as Prof. Jowett puts it. Every stronghold is being assailed, from the "divine" rights of property to the common chord of C major. With Schoenberg, freedom in modulation is not only permissible, but is an iron rule; he is obsessed by the theory of

**Schoenberg's Idea of Himself.**

overtones, and his music is not only horizontally and vertically -planned, but, so I pretend to hear, also in a circular fashion. There is no such thing as consonance or dissonance, only imperfect training of the ear, (I am quoting from his "Harmony," certainly a bible for musical supermen.) He says: "Harmonie—fremde Töne gibt es also nicht"—and a sly dig at the old-timers, "Sondern nur dem Harmoniesystem fremde." After carefully listening I noted that he too has his mannerisms, that in his chaos there is a certain order, that his madness is very methodical. For one thing he abuses the interval of the fourth, and he enjoys juggling with the chord of the ninth. Vagabond harmonies, in which the remotest keys lovingly hold hands, do not prevent the sensation of a central tonality somewhere—in the cellar, on the roof, in the gutter, up in the sky. The inner ear tells you that the D minor quartet is really thought, though not altogether played in that key. As for form, you must not expect it from a man who declares: " decide my form during composition only through feeling." Every chord is the outcome of an emotion, the emotion aroused by the poem or idea which gives birth to the composition. Such antique things as the cyclic form or community of themes, &c., are not to be expected in Schoenberg's bright lexicon of anarchy. He boils down the classic form to one movement and, so it seemed to my hearing, he begins developing his idea as soon as it is announced.

Such polyphony! Such interweaving of voices—eleven and twelve and fifteen are a matter of course—as would make envious the old tonal weavers of the Netherlands. There is, literally, no waste ornament or filling in his scores; every theme, every subsidiary figure, is set spinning so that you dream of fireworks spouting in every direction, only the fire is vitriolic and burns the tympani of the ears. Seriously, like all complex effects, the Schoenberg scores soon become legible if scrutinized without prejudice. I submit a page from the string sextet which, if compared to the later music, is sunny and Mozartean in its melodic and harmonic simplicity. They tell me that Schoenberg once wrote freely in the normal manner, but finding that he could not attract attention he deliberately set himself to make abnormal music. I don't know how true this may be; the same was said of Mallarmé and Paul Cézanne and Richard Strauss, and was absolutely without foundation.

Schoenberg is an auto-didact, the lessons in composition from Alexander von Zemlinsky not affecting his future pathbreaking propensities. His mission is to free harmony from all rules. A man doesn't hit on such combinations, especially in his acrid instrumentation, without heroic labors. His knowledge must be enormous, for his scores are as logical as a highly wrought mosaic; that is, logical, if you grant him his premises. He is perverse and he wills his music, but he is a master in delineating certain moods, though the means he employs revolt our ears. To call him "crazy" is merely amusing. No man is less crazy, few men are so conscious of what they are doing, and few modern composers boast such a faculty of attention. Concentration is the keynote of his work; concentration—or condensation formal, concentration of thematic material—to the vanishing point; and conciseness in treatment,

**Page from the String Sextet, Opus 4, by Arnold Schoenberg.**

although every license is allowed in modulation.

Every composer has his aura; the aura of Arnold Schoenberg is, for me, the aura of original depravity, of subtle ugliness, of basest egoism, of hatred and contempt, of cruelty, and of the mystic grandiose. He is never petty. He sins in the grand manner of Nietzsche's Superman, and he has the courage of his chromatics. If such music-making is ever to become accepted, then I long for Death the Releaser. More shocking still would be the suspicion that in time I might be persuaded to like this music, to embrace, after abhoring, it.

As for Schoenberg, the painter—he paints, too!—I won't take even the guarded praise of such an accomplished artist as Kandinsky as sufficient evidence. I've not seen any of the composer's "purple cows," and hope I never shall see them, but I give you an opportunity to judge for yourselves from several of the black and whites in the book quoted above. They look pretty bad to me, and not nearly as original as his music. The portrait of the lady (who seems to be listening to Schoenbergian harmonies) hasn't much color, a critic tells us, only a sickly rose in her dress. He also paints gray-green landscapes and sickly visions, the latter dug up from the abysmal depths of his subconsciousness. Schoenberg is, at least, the object of considerable curiosity. What he will do next no man may say; but at least it won't be like the work of any one else. The only distinct reminiscence of an older composer that I could discover in his "Pierrot" was Richard Wagner, (toujours Wagner, whether Humperdinck or Strauss or Debussy,) and of him, the first page of the introduction to the last act of "Tristan and Isolde," more the mood than the actual themes. Schoenberg is always atmospheric. So is a tornado. He is the poet whose flowers are soil, the spirit that denies; never a realist, like Strauss, ingeniously imitating natural sounds, he may be truthfully described as a musical symbolist.

January 19, 1913

# TOSCANINI CONDUCTS SYMPHONY CONCERT

## In Wagner's "Faust Overture," Strauss's "Till Eulenspiegel," and the Ninth Symphony.

## A SUPERB PERFORMANCE

### Great Qualities of the Conductor Disclosed — Orchestra, Chorus, and Quartet Meet High Expectations.

The last of the season's Sunday night concerts at the Metropolitan Opera House took on a character that this popular series has but once before assumed—the character of a symphony concert of the highest type, conducted by Mr. Toscanini, who then made his first appearance in America as a symphonic conductor. When Felix Mottl first came as a conductor to the Metropolitan ten years ago, he conducted one symphony concert of this kind; but Mr. Conried saw, or thought he saw, signs that this was not the sort of thing his Sunday night audiences wanted, and the concerts promptly resumed the ephemeral and popular character they have retained ever since.

Last night, however, it was clear that this was the sort of thing this particular Sunday night audience wanted. The announcement that Mr. Toscanini would conduct Beethoven's Ninth Symphony, Wagner's "Faust" Overture, and Strauss's "Till Eulenspiegel" had aroused the greatest interest among the educated and discriminating members of the New York musical public. for whom the ordinary Sunday night concert scarcely exists, and the house was filled to its utmost capacity in every part. It was an audience in which, besides habituées, there were many prominent musicians, and many fastidious lovers of symphonic music. Mr. Toscanini has made so profound an impression as a dramatic conductor that there was the keenest interest to observe what he would accomplish in another field—a field in which his remarkable powers must necessarily achieve remarkable results.

The orchestra was the orchestra of the Opera House, somewhat augmented; the chorus that of the Opera, and the solo quartet comprised members of the company—Miss Frieda Hempel, soprano; Mme. Louise Homer, contralto, and Messrs. Carl Jörn, tenor, and Putnam Griswold, bass. The orchestra in the years that it has been under the control of Mr. Toscanini has gained greatly in suppleness and plasticity as well as in precision and perfection of ensemble; and in last evening's concert it accomplished some remarkable things. Its quality of tone is not of the highest beauty or richness; but in all the music played last evening it was a most responsive instrument under Mr. Toscanini's hands.

He revealed in the fullest measure the qualities of the great symphonic conductor. He showed that he had a profound understanding of the widely differing character of the three compositions that made up the programme, and that he brought his ideas to the fullest realization seemed evident. The "Faust Overture" has seldom been made more impressive in its gloom and pessimistic spirit. The "Till Eulenspiegel" has seldom been played with a more dazzling brilliancy, verve, and bravura, with a more perfect ensemble, or a more complete mastery of all its bristling difficulties, especially those of its rhythms, that make its ensemble difficult.

Interesting as these were and satisfying—perhaps, even to those zealous enthusiasts who did not know "Till Eulenspiegel," or the movements of the symphony, well enough to refrain from applauding till their end—attention was naturally centred chiefly upon Mr. Toscanini's performance of Beethoven's Ninth Symphony, which he, as well as most others of his guild, evidently looks upon as the supreme task of a symphonic conductor.

In this Mr. Toscanini met in an unusual degree Wagner's criterion of the "melos," of keeping unbroken the essential melodic line that underlies it. The orchestra sang throughout; in all the nuances of his performance the melodic line was not interrupted; nor, in all the plastic shaping of phrase was the symmetry of the larger proportions or the organic unity of the whole lost sight of. It was rhythmically of extraordinary vitality. It was a conservative reading without exaggerations or excesses. There were subtle and significant modifications of tempo, but never of a disturbing sort. It was devoted to the exposition of Beethoven and not of Mr. Toscanini, and it rose to heights of eloquence without the intrusion of the conductor's personality. Some may have preferred the adagio a little slower, and Mr. Toscanini would have done well to have joined this movement to the final one without making the break that he did.

The effect of the last movement was supremely stirring, and it marked in many ways the summit of Mr. Toscanini's achievement. It is not often that the movement is presented with so few evidences of labor and effort on the part of the singers. The chorus sang with thrilling vigor and apparent spontaneity, and attacked the cruel high passages with spirit and elasticity. So, too, the solo quartet mastered the difficulties that confronted it with the appearance of ease that made for the finer elaboration of the musical effects. Mr. Griswold declaimed the bass recitative with dramatic power and cogency, and Miss Hempel's command of the high tones of her part enabled her to move at ease among them. And Mme. Homer and Mr. Jörn were their fitting companions in the quartet.

It was recognized as a remarkable performance, and a profoundly impressive one. And one of its obvious results was to prompt the wish that a way might be found for Mr. Toscanini to conduct more symphonic concerts for the New York public.

April 14, 1913

# PARISIANS HISS NEW BALLET

## Russian Dancer's Latest Offering, "The Consecration of Spring," a Failure.

## HAS TO TURN UP LIGHTS

### Manager of Theatre Takes This Means to Stop Hostile Demonstrations as Dance Goes On.

By Marconi Transatlantic Wireless Telegraph to The New York Times.

PARIS, June 7.—"Bluffing the idle rich of Paris through appeals to their snobbery is a delightfully simple matter," says Alfred Capus in Le Figaro this week. "The only condition precedent thereto is that they be gorged with publicity."

"Having entertained the public with brilliant dances," he adds, "the Russian ballet and Nijinsky now think that the time is ripe to sacrifice fashionable snobs on art's altar. The process works out as follows:

"Take the best society possible, composed of rich, simple-minded, idle people. Then submit them to an intense régime of publicity. By booklets, newspaper articles, lectures, personal visits and all other appeals to their snobbery, persuade them that hitherto they have seen only vulgar spectacles, and are at last to know what is art and beauty.

"Impress them with cabalistic formulae. They have not the slightest notion of music, literature, painting, and dancing; still, they have heretofore seen under these names only a rude imitation of the real thing. Finally, assure them that they are about to see real dancing and hear real music.

"It will then be necessary to double the prices at the theatre, so great will be the rush of shallow worshippers at this false shrine.

"This," observes M. Capus, "is what the Russian dancers have been doing to Paris. The other night, however, the plan miscarried. The piece was 'The Consecration of Spring,' and the stage represented humanity. On the right are strong young persons picking flowers, while a woman, 300 years old, dances frenziedly. On the left an old man studies the stars, while here and there sacrifices are made to the God of Light.

"The public could not swallow this. They promptly hissed the piece. A few days ago they might have applauded it. The Russians, who are not entirely acquainted with the manners and customs of the countries they visit, did not know that the French people protested readily enough when the last degree of stupidity was reached."

In conclusion, M. Capus warns Parisian snobs not to make fools of themselves by going into ecstasies over the Polish actors who opened a season at the Gymnase this week.

Since M. Capus's article there have been disorderly scenes at the Champs Elysée Théâtre, where the Russian ballet is appearing.

"The Consecration of Spring" was received with a storm of hissing. The manager, M. Astruc, however, has devised a novel method for silencing a demonstration. When hisses are mingled with counter-cheers, as they were the other night, M. Astruc orders the lights turned up. Instantly the booing and hissing stop. Well-known people who are hostile to the ballet do not desire to appear in an undignified rôle.

Igor Stravinsky, who wrote the music of "The Consecration of Spring," says that the demonstrations are a bitter blow to the amour propre of the Russian ballet dancers, who are sensitive to such displays of feeling and fear they may be unable to continue the performances of the piece.

"And that is all we get," added M. Stravinsky, "after a hundred rehearsals and one year's hard work."

The composer, however, is not altogether pessimistic, for, he adds: "No doubt it will be understood one day that I sprang a surprise on Paris, and Paris was disconcerted. But it will soon forget its bad temper."

Nijinsky himself is responsible for the stage setting of the piece, which theatregoers here aver is badly done. He is a wonderful dancer, Parisians admit, but they add that he knows little about stage setting.

June 8, 1913

121

## A NEW VIOLINIST PLAYS.

### Jascha Heifetz, Russian, Makes a Success in Carnegie Hall.

Another was added yesterday to the number of remarkable violinists who have come to this country out of Russia, in Jascha Heifetz, who made his first American appearance in Carnegie Hall. There was a large audience, in which there were many musicians full of enthusiasm which was eminently justified.

Mr. Heifetz is a pupil of Leopold Auer, who has sent many excellent violinists out into the world. He is young; he is said to be only 18 years old; but in his art he is mature, and there is no suggestion, in his appearance or his manner or his performance, of the juvenile or the phenomenal. There was never a more unassuming player who demonstrated great abilities, or one more intent upon his art and so oblivious of his listeners as he stands upon the platform.

Mr. Heifetz produces tone of remark-able beauty and purity; a tone of power, smoothness and roundness, of searching expressiveness, of subtle modulation in power and color. His bowing is of rare elasticity and vigor, excellent in many details; as is his left hand execution, which is accurate in all sorts of difficulties. In his technical equipment Mr. Heifetz is unusual.

As to the higher elements of his musicianship, it is perhaps too soon to judge from yesterday's recital. There was nothing in its program that exacted the highest qualities. He plays with great repose and dignity, with simplicity and directness, with purity of taste, shown in the Chaconne by Vitall so often heard here in recent years, perhaps oftener than its real value would warrant, and in some of the smaller pieces that followed. There was real breadth and warm sincerity here and in many another number of his program. There was the true feeling for the finish and effect of detail. There have been more scintillating performances of Wieniawski's D minor concerto; but Mr. Heifetz's was not lacking in brilliancy, or in a perfect command of all its difficulties; and his playing of Paganini's twenty-fourth capriccio, as retouched by Auer, was a performance in many ways masterly. In all his passage work, in his up-bow spiccato, his singularly pure harmonics, his double stopings, there was much to admire; and it was all so easily accomplished, and with such perfect taste.

Mr. Heifitz seemed yesterday somewhat reserved in the expression and communication of emotion. When he plays a program of a little higher order or appears in some of the greater works with orchestra he will disclose whether he can proclaim profound passion, flaming eloquence, the deeper emotions that are manifested in the greatest music. For the present it is enough to recognize the disclosure of a surpassing talent, well-nigh complete mastery of all the problems of violin playing, a sensitive, dignified, and unassuming musician of such youth that much may still be expected in his development.

The audience applauded warmly and persistently; but Mr. Heifetz only gave one encore, Tartini's variations on a theme by Corelli, till he had finished his program. André Benoist played the accompaniments beautifully.

**October 28, 1917**

# SERGE PROKOFIEFF A VIRILE PIANIST

## Young Russian Composer Makes New Music and an Instant Success at Debut.

New ears for new music! The new ears were necessary to appreciate the new music made by Serge Prokofieff in his first pianoforte recital at Aeolian Hall yesterday afternoon. He is younger looking than his years, which are partiarchal, almost twenty-seven. He is blond, slender, modest as a musician, and his impassibility contrasted with the volcanic eruptions he produced on the keyboard. We have already one musical anarch here, Leo Ornstein, yet that youth's "Wild Man's Dance" is a mere exercise in euphony, a piece positively Mozartian, in comparison with the astounding disharmonies gentle Serge extorted from his suffering pianoforte; the young man's style is orchestral, and the instruments of percussion rule in his Scythian drama.

He is an individual virtuoso with a technique all his own. He can create big sonorities, sometimes mellow to raucous. His fingers are steel, his wrists steel, his biceps and triceps steel, his seapula steel. He is a tonal steel trust. He has speed, surely, but a narrow gamut of dynamics, all crash or whisperings; no tonal gradations, with a special aptitude in the performance of double notes, octaves and chords taken at a dizzy tempo, again orchestral, all this. It is for Prokofieff the mere breaking of a butterfly on a wheel to play other men's music. But the gracious butterfly of Scriabine was metamorphosed into a gigantic prehistoric pterodactyl with horrid snout and crocodile wings which ominously whirred as they flew over the pianist. Ah! a Jabberwock, it was not a butterfly!

He played in addition to his own music three preludes of Rachmaninoff—who was in the audience—and two etudes of Scriabine, one in C sharp minor, the other in D sharp minor, (Dis Moll.) and introduced here by Josef Hofmann, who plays it in the grand manner without shattering its syntax or our ear-drums. It is really, this study, in echo of Chopin's D minor prelude and not so poetic. One of the Rachmaninoff preludes in G minor is also a Hofmann favorite. Prokofieff did not play it like Hofmann. He is not that sort of a virtuoso. His treatment of trifles is brutal. But unquestionably a virile pianist.

As a composer he is cerebral. His music is volitional and essentially cold, as are all cerebral composers. At first you are stunned by the overwhelming quality of his music; presently a pattern is noted. The lyric themes are generally insipid. The etude-form, and there is a well-defined one, predominates. Immense technical difficulties deafen one to the intrinsic poverty of ideas in his music. The four etudes have in a nutshell his style; the sonata, a second one, contains no sustained musical development, the first allegro being a mosaic, violent in transitions, in moods rather monotonous; but in the scherzo he swept everything before him with its tremendous rhythmic urge. Again, the etude scheme. His sonata form is rather negligible, the very formal virtue which Scriabine possesses. Scriabine evidently has been an inspiration to this gifted young man. The finale of the work evoked visions of a charge of Mammoths on some vast immemorial Asiatic plateau. Rebikoff seems a miniaturist after this.

Prokofieff uses, like Arnold Schoenberg, the entire modern harmonies. The House of Bondage of normal key relationships is discarded. He is a psychologist of the uglier emotions—hatred, contempt, rage—above all rage—disgust, despair, mockery, and defiance legitimately serve as models for moods. Occasionally there are moments of tenderness, exquisite jewels that briefly sparkle and then melt into seething undertow. The danger in all this highly spiced music is manifest; it soon exhausts our faculty of attention; Pelion must be piled on Ossa, else the lights burn dimmer. His scale scheme is omnitonic-or is it emphatic? But now and then we get a glimpse of a recondite region, of a No Man's Land wherein wander enigmatic and fascinating figures, and unearthly landscape, an atmosphere, murky and ominous, but painted in bold, feverish strokes. We confess that we anticipate novel things in the Prokofieff concerto for pianoforte, which he has played for Harold Bauer; also something new in his symphony, which we are to hear next month at a concert of the Russian Symphony Orchestra. The gavotte he gave yesterday is one of the movements, certainly it is symphonic in tone. His "Suggestion Diabolique," which barring several encores, closed the afternoon, derives from Liszt—the B minor dance in Lenau's "Faust."

A parterre of pianists greeted the newcomer with dynamic applause. Of his instant success there can be no doubt. Whether he will last—Ah! new music for new ears. Serge Prokofieff is very startling.

**November 21, 1918**

# MUSIC
### By RICHARD ALDRICH.

#### Miss Myra Hess's Piano Recital.

An extraordinary artist made her appearance in New York yesterday afternoon in Aeolian Hall without preliminary heralding; one whose achievements gave all the more pleasure for their unexpectedness: Miss Myra Hess, a young English pianist. Miss Hess is a strongly individual artistic personality, self-possessed, reposeful; but she is one who is devoted wholly to expounding the music she plays and who takes no thought of injecting her personality into it, or of making a display of her powers as a performer.

She is a true interpreter; and makes her interpretations deeply engrossing through their vitality, their finesse and subtle qualities, their intensity and glowing warmth. Her technique is of a high development, and is wholly under her control. It is, indeed, of an uncommon brilliancy and security, even in these days of brilliant and secure technique; but it does not shine as such, because it is so wholly devoted to the true uses of a technique as a means of interpretation.

Her tone is clear, pure, delicately and warmly colored; her touch has variety of quality, power and force, and in its lighter manifestations is delightful in its crispness. In rhythmic power and in the point and finish of her phrasing there is much in her playing to admire.

Miss Hess's program showed in itself the operations of an individual point of view as well as a wide sympathy. She began with three of Domenico Scarlatti's "sonatas"—three of the 445 that are not hackneyed by the repeated attentions of pianists; she played the B flat prelude and fugue from the first book of Bach's "Well - Tempered Clavier"; César Franck's "Prelude, Aria and Finale," generally neglected in favor of his other triptych for the piano; Schumann's "Papillons," which seldom see daylight on a pianist's program; five of Debussy's pieces, and Chopin's nocturne in C minor and his A flat Polonaise. At the end she added one of his études.

It may truly be said that there was an aristocratic distinction in her playing of all this music, as well as a rich gusto and a singular power of identifying herself with the many different styles involved, and setting forth each piece in its own distinctive and essential spirit. Perhaps the most fascinating of all her playing was that of Schu-mann's "Papillons," those preliminary studies for the "Carnaval," as they have been called; yet this is perhaps to undervalue their own charm and musical significance. They glowed and glittered under her hands. Their graphic picturesqueness, their varying moods, their gayety, tenderness, yearning boisterousness, are a genuine expression of the flood of Schumann's earliest romantic spirit poured out in the music; and, as they are in the music, they were delightfully reproduced in Miss Hess's playing.

There were grace and spirit in Scarlatti's "sonatas;"—a name that does not connect them with the sonatas of the classical period—and the prelude and fugue by Bach she played not as contrapuntal exercises but as living pieces of deeply felt music. Miss Hess showed an equal sympathy of the five pieces by Debussy, to each of which she gave characteristic physiognomy. And in Chopin's nocturne there was a poetical tenderness, while the polonaise was made something more than a thunderous procession.

Miss Hess's calibre as an artist is such that she ought to be heard from again, and then again, before the season is closed. She will add to it something to delight music lovers.

**January 18, 1922**

# MUSIC

## By RICHARD ALDRICH.

### Bruno Walter Conducts.

Another of the visiting conductors in New York, "guests," made his appearance yesterday afternoon for the first time—Bruno Walter—conducting the New York Symphony Orchestra in the brief interim between Mr. Coates's departure and Mr. Damrosch's return. Mr. Walter has lately been active in Munich, and before that was in Vienna as an operatic conductor.

He showed yesterday, however, that he is also quite at home on the concert stage. His program comprised Beethoven's "Leonore Overture"—mirabile dictu, not No. 3, but No. 2—Mozart's Symphony in D, one not frequently played, and Brahms's first symphony. This is not such a selection as is usually made by "guest" conductors wishing to make impressive effects. Only the symphony by Brahms is among the familiar items of the orchestral repertory, and that, indeed, had been played here last week.

Mr. Walter's reading was not one devoted chiefly to attaining the fullest and richest colors, or to drench the work in fine sonorities; although Brahms's orchestration was made to glow. He sought for the finest and subtlest exposition of the outline delicate contrasts, significant phrasing, pulsing rhythms, subtle modifications of tempo—modifications that were not thrown at the listener's head, but were such as to be felt, rather than noticed. It was the reading of a sensitive musician, forceful without violence—the statement of the horn theme and one or two bursts of the kettle drum in the last movement made the nearest approach to violence—and finding and emphasizing more than anything else the poetic feeling, the romantic pulse of the movement. In one or two places some may have found the tempo more measured than was needful or right as the broad theme of the last movement. But on the whole the performance was one of distinction, a true representation of Brahms's thought and intention.

The playing of Mozart's symphony was especially fine in its delicacy, its clarity, its silvery beauty of tone, its gracious spirit. And in giving a hearing to Beethoven's second Leonore overture Mr. Walter did a service to many who have not heard this version of the work or who have not heard it for many years. It is obviously less great, less magisterial than the form in which it is generally known; less moving in its dramatic suggestion. Yet it has a beauty and a practical significance of its own that make it something more than a historical document illustrating the workings of Beethoven's genius, a mere object of comparison.

Mr. Walter's methods as a conductor, so far as they are revealed to the public, are of the simplest. His movements are direct and explicit, intended to obtain results already known and accomplished at rehearsal. He has nothing for public view, either in the expression of his back or the curve of his left arm. He has authority and knowledge of orchestral technique. There was an evident intention on his part in yesterday's concert to play the several movements of the two symphonies without a pause for rest, refreshment and applause; but the public accustomed to applaud at the end of each symphonic movement, did not allow this purpose to be carried out entirely.

Mr. Walter was hospitably greeted and received cordial approbation from his audience.

**February 16, 1923**

---

# MUSIC

### Gives Harpsichord Recital.

Mme. Landowska, lately heard as harpsichord and piano soloist with orchestras here, was greeted by a cordial audience at her recital in Aeolian Hall last night. It was her first solo program, aside from a public trial of rare instruments in the Metropolitan Museum of Art. The accomplished player seemed again "a spinner of the sun" of Bach and Handel and of old masters, both Latin and French, with applauded piano interludes of Mozart and Haydn. From Scarlatti's "La Chasse" to Daquin's "Le Coucou" and Rameau's "La Poule"—perhaps the first "modernist" picture-music—she drew exquisite miniatures from plucked strings. Bach's "Caprice on a Brother's Departure" added the note of humor in trilled negations of dissuading friends, their plaint of disaster and a jolly fugue on the tune of the coachman's horn.

**January 17, 1924**

---

# MUSIC

## A Concert of Jazz.

### By OLIN DOWNES.

A concert of popular American music was given yesterday afternoon in Aeolian Hall by Paul Whiteman and his orchestra of the Palais Royal. The stage setting was unconventional as the program. Pianos in various stages of deshabille stood about, amid a litter of every imaginable contraption of wind and percussion instruments. Two Chinese mandarins, surmounting pillars, looked down upon a scene that would have curdled the blood of a Stokowski or a Mengelberg. The golden sheen of brass instruments of lesser and greater dimensions was caught up by a gleaming gong and carried out by bright patches of an Oriental back-drop. There were also lying or hanging about frying pans, large tin utensils and a speaking trumpet, later stuck into the end of a trombone—and what a silky, silkily tone came from that accommodating instrument! This singular assemblage of things was more than once, in some strange way, to combine to evoke uncommon and fascinating sonorities.

There were verbal as well as programmatic explanations. The concert was referred to as "educational," to show the development of this type of music. Thus the "Livery Stable Blues" was introduced apologetically as an example of the depraved past from which modern jazz has risen. The apology is herewith indignantly rejected, for this is a gorgeous piece of impudence, much better in its unbuttoned jocosity and Rabelasian laughter than other and more polite compositions that came later.

The pianist gathered about him some five fellow-performers. The man with the clarinet wore a battered top hat that had ostensibly seen better days. Sometimes he wore it, and sometimes played into it. The man with the trombone played it as its, but also, on occasion, picked up a bath tub or something of the kind from the floor and blew into that. The instruments made odd, unseemly, bushman sounds. The instrumentalists rocked about. Jests permissible in musical terms but otherwise not printable were passed between these friends of music. The laughter of the music and its interpreters was tornadic. It was—should be blush to say it?—a phase of America. It reminded the writer of some one's remark that an Englishman entered a place as if he were its master, whereas an American entered as if he didn't care who in blazes the master might be. Something like that was in this music.

There were later remarkably beautiful examples of scoring for a few instruments; scoring of singular economy, balance, color and effectiveness; music at times vulgar, cheap, in poor taste, elsewhere of irresistible swing and insouciance and recklessness and life; music played as only such players as these may play it. They have a technic of their own. They play with an abandon equaled only by that race of born musicians—the American negro, who has surely contributed fundamentally to this art which can neither be frowned nor sneered away. They did not play like an army going through ordered manoeuvres, but like the melomaniacs they are, bitten by rhythms that would have twiddled the toes of St. Anthony. They beat time with their feet—less majesté in a symphony orchestra. They fidgeted uncomfortably when for a moment they had to stop playing. And there were the incredible gyrations of that virtuoso and imp of the perverse, Ross Gorman. And then there was Mr. Whiteman. He does not conduct. He trembles, wabbles, quivers—a piece of jazz jelly, conducting the orchestra with the back of the trouser of the right leg, and the face of a mandarin the while.

There was an ovation for Victor Herbert, that master of instrumentation, when his four "Serenades" composed for this occasion were played, and Mr. Herbert acknowledged the applause from the gallery. Then stepped upon the stage, sheepishly, a lank and dark young man—George Gershwin. He was to play the piano part in the first public performance of his "Rhapsody in Blue" for piano and orchestra. This composition shows extraordinary talent, just as it also shows a young composer with aims that go far beyond those of his ilk, struggling with a form of which he is far from being master. It is important to bear both these facts in mind in estimating the composition. Often Mr. Gershwin's purpose is defeated by technical immaturity, but in spite of that technical immaturity, a lack of knowledge of how to write effectively for piano alone or in combination with orchestra, an unconscious attempt to rhapsodize in the manner of Franz Liszt, a naiveté which at times

123

stresses something unimportant while something of value and effectiveness goes by so quickly that it is lost—in spite of all this he has expressed himself in a significant, and on the whole, highly original manner.

His first theme alone, with its caprice, humor and exotic outline, would show a talent to be reckoned with. It starts with an outrageous cadenza of the clarinet. It has subsidiary phrases, logically growing out of it, and integral to the thought. These chief phrase and subsidiaries are often ingeniously metamorphosed by devices of rhythm and instrumentation. There is an Oriental twist to the whole business that is not hackneyed or superficial. And—what is important—this is no mere dance-tune set for piano and other instruments. It is an idea, or several ideas correlated and combined, in varying and well contrasted rhythms that immediately intrigue the hearer. This, in essence, is

fresh and new, and full of future promise.

The second theme, with a lovely sentimental line, is more after the manner of some of Mr. Gershwin's colleagues. Tuttis are too long, cadenzas are too long, the peroration at the end loses a large measure of wildness and magnificence it could easily have if it were more broadly prepared, and, for all that, the audience was stirred, and many a hardened concertgoer excited with the sensation of a new talent finding its voice, and likely to say something personally and racially important to the world. A talent and an idiom, also rich in possibilities for that generally exhausted and outworn form of the classic piano concerto.

Mr. Gershwin's rhapsody also stands out as counter-acting, quite unconsciously, a weakness of the program, that is, a tendency to sameness of rhythm and

sentiment in the music. When a program consists almost entirely of modern dance music, that is naturally a danger, since American dances of today do not boast great variety of step or character; but it should be possible for Mr. Whiteman to remedy this in a second program, which he will give later in the season. There was tumultuous applause for Mr. Gershwin's composition. There was realization of the irresistible vitality and genuineness of much of the music heard on this occasion, as opposed to the pitiful sterility of the average production of the "serious" American composer. The audience packed a house that could have been sold out twice over.

February 13, 1924

# SCHOENBERG AND MUSIC-DRAMA

## Berg's "Wozzek" Produced and Prohibited at Prague—Formal and Dramatic Procedure of Disciple of Atonality

### By OLIN DOWNES.

RIOTOUS scenes accompanied a performance of Alban Berg's opera "Wozzek" in the Prague National Theatre. They surpassed the demonstrations at the première of the opera in Berlin Dec. 14, 1925. On the 29th of last November the Prague authorities intervened and ordered the production stopped. In that city, in Vienna, in Berlin, where Schönberg has accepted an appointment at the Academy, musical factions are active. The Schönberg and anti-Schönberg parties do not confine their activities to the newspapers which advance or oppose their cause. Berg, with Anton Webern, stands today among Schönberg's most favored pupils and exponents. No doubt, aside from the character of his opera, he could not have escaped the consequences of this artistic relation. A manifesto signed by leading musicians, artists and intellectuals of Prague protests against the official intervention and stresses the "organized" character of the disturbance in the theatre. "Wozzek" has created trouble wherever it was given. An opera that creates disturbance is not necessarily of artistic value. An examination of text and piano score of "Wozzek" gives more than one possible reason for its explosive effect. But it is unusual music, not to be estimated from such superficial acquaintance; the score is curious in construction and significant of the effect of Schönberg and his ideas in dramatic music.

In New York the firm of Schönberg, Webern and Berg is known principally for chamber music. Orchestral pieces by Schönberg, his "Pierrot Lunaire"—which has strongly influenced Berg in writing for the voice —and some of the songs, including excerpts from the "Gurrelieder," have also been heard. But the movement of which he is the leader also concerns itself very seriously with the stage. The more radically minded of European musicians go so far as to say that it opens new paths in the rubbish-strewn terrain of opera, a form which has shown no fresh signs of life since Debussy's "Pelléas et Mélisande." At any rate Berg's treatment of the musico-dramatic form and his musical tendencies are fully exemplified in his late and provocative work.

The Schönberg school of composers

insists on its theory of music that is "absolute," i. e., purely musical, polyphonic in texture and owing nothing to outside materials or ideas. "Music," says the master of atonality, "describes the adventures of themes." Then Schönberg industriously sets to music the verses of "Pierrot Lunaire," the "Gurrelieder" and much other verse; he composes scores to subjects which are not only extra-musical but, in the opinion of many, of a neurotic and highly unmusical nature in their character. Is it not patent that the moment a composer sets a poem to music or produces an opera that he ceases from that moment to write "absolute," or "pure," music? The fact seems fairly obvious, the questions which decide the value of a song or opera being the worth of text and the music, and the suitability of these different elements to each other. Berg, confronted with this problem in "Wozzek," undertakes a method that is at least novel in theory in the attempt to combine "absolute" and "dramatic" forms of expression.

He endeavors to preserve in his opera the elements of long-established musical structures, those which have laid the foundations of instrumental and symphonic music, such as the suite, sonata, fugue and various dance forms. It is true that these forms are present in the score of "Wozzek" rather in inner constitution than in precise outer aspect. They are treated, in fact, so freely and in such a coordinated manner that it is not readily perceptible to the eye or the ear where the boundaries of one form end and those of another begin. It is constructive principles native to pure music that Berg claims to have built upon, rather than the exact observance of principles laid down by classic masters. Therefore it is that the music of the first act of "Wozzek" includes in its design a rhapsody, a military march, a cradle song, a "passacaglia," with twenty-one variations. The first scene is described as in the form of the suite, containing a sarabande, gigue, gavotte and "double." The second scene is accompanied by a fantasy on three chords. The theme and variations of the fourth scene accompany the conversation of a doctor who keeps returning to one subject with which he is preoccupied.

The second act is described as a "symphony" in five movements, di-

vided into a sonata movement, a prelude and fugue on three themes, a slow movement for chamber orchestra —the orchestra being identical with that of Schönberg's Chamber Symphony—a scherzo and a rondo. The music of the third act consists of six "inventions," to wit: A set of variations and fugue; a movement on one note, i. e., on a pedal point; a movement in a rhythm—meaning, a polka for piano; a movement on six notes, heard now as a chord, and now in melodic succession; a movement in a key—from an atonalist—otherwise an orchestral interlude in the key of D minor, with atonalic frills and furbishings; and, finally, what may be freely construed as a toccata!

More evident to the unaccustomed eye than those classic divisions and subdivisions is interrelation of many of the parts of the score, and, at least on paper, the general continuity of the musical fabric. Essentials of the old forms there may be in fact as well as theory, but for the greater part of the opera there is musical unity and also brevity for scenes that are usually short and that succeed each other with very brief intervals. There are modern "symphonies" which would last longer than the final act of "Wozzek," with all its details. Brevity, concentration, flexibility, are characteristics of dramatic music which have created much dissension.

And what is the drama to which this score is fitted—or which is fitted to this score? "Wozzek" was the last dramatic work of Georg Bücher, a genius who died young in 1837, at the age of 24. It is feverish and insurrectionary with the spirit of the '30s, a story of humble, tragic lines, with psychological and pathological elements that could have come from the pen of a Wassermann or an epileptic Russian. Wozzek, an ignorant soldier, weak of will, a prey to impulse and circumstance, adrift in a world that he cannot understand, is the servant and sport of his captain and the subject of medical experiments by the dishonest doctor of the regiment. Wozzek has been for three years the lover of Marie, to whom he gives all his earnings for their child. But Wozzek's mistress tires of her brooding and irascible lover, becoming the easy conquest of the drum-major who struts past. Wozzek attacks him in the barracks, but is knocked senseless, while

his rival laughs. Marie is first scornful, then repentant, but too late. Wozzek meets her on a lonely road by a lake and cuts her throat. He returns to the scene of his crime, converses with Marie's ghost, and kills himself. The doctor and the captain appear. Did they hear a cry from the water? They decide that they were mistaken and renew their walk. "This story is told to the little child, who quietly goes on with his games."

The music of the opera is "atonal." Save in special instances, the old system and the old ideals of tonality are abandoned. The scenes and the music are condensed to their utter essentials. From the singers, who, like the players, have hideously difficult parts (the Berlin première of "Wozzek" was preceded by 137 rehearsals), the composer asks not song, but the "sprechstimme," the half song, half speech of Schönberg's "Pierrot Lunaire," with cries, groans and whisperings as additional stimuli. The orchestra is employed variously, sometimes for stunning crashes of tone and elsewhere for subtle and subdued effects of color. In its dimensions this score would have satisfied a Strauss or a Mahler. It requires all the customary wood and brass instruments in groups of four, adding to the orchestra before the stage a bass clarinet, a contra-bas-

soon, a contra-bass tuba and most of the pulsatile instruments that are procurable. In addition there is music back of the scene—military music by wood, brass and percussion, and music for the scene in the inn, which asks, among other things, for clarinet, harmonica, accordion and guitar. But these are exterior characteristics, interesting only as they point to the mind and the tendencies of the composer. They point straight back from Berg to his master, and from Schönberg back to the nineteenth century romanticism toward which a notable group of modern German and Austrian composers turn. The orchestral style has evidently, to judge from competent report, many subtleties that Mahler and Strauss did not dream of. That is a new technical position, of great importance in so far as it extends the expressive boundaries of music, but not the answer to the riddle, "What is Schönberg? Where are he and his disciples bound?" The dimensions of Berg's orchestra and the subject he chose, the creation of a late romantic, a successor in Germany of E. T. A. Hoffman, appear as an indication of his true tendencies. With all its experiments, theories and divagations, the Schönberg school stems from the great romantics of the nineteenth century, and is not a new par-

turition of the twentieth. Berg is part of the time perversely economical of instruments and notes, but he orchestrates, at the climaxes of "Wozzek," in what Paul Stefan calls "the grand manner," with the sensuousness and color of an earlier time. These tendencies of a past period are cited by certain commentators as proof that the Schönberg school has come to the end of its tether. It is not necessarily so. There is no important art which has not its origins in that which has gone before, and "Wozzek" seems to have made a very considerable effect on more than a few radicals or Schönberg adherents. Its oppressive but highly dramatic atmosphere is conceded by critics who do not approve the nature of the work or the ideas of the composer. "For Berlin and Germany," says Adolph Weissmann, " 'Wozzek,' for some time to come, has now shifted the burden from concert music to the field of opera. • • • " That "Wozzek" is undoubtedly the most remarkable attempt in the field of opera since Debussy's "Pelléas et Mélisande" may or may not be a localism, but certain it is that the opera has had a surprisingly energetic public reaction and has proved of steadily increasing interest to modern European students and composers.

December 26, 1926

# BOY VIOLINIST STIRS HEARERS TO CHEERS

Yehudi Menuhin, 11 Years Old, Playing Beethoven Concerto, Wins Great Ovation.

## AUDIENCE LINGERS LONG

New York Symphony Musicians Join in Demonstration Over Brilliancy of His Art.

### By OLIN DOWNES.

There was an extraordinary demonstration when the 11-year-old violinist, Yehudi Menuhin, played the Beethoven concerto with the New York Symphony Orchestra last night in Carnegie Hall. The hall was crowded to capacity with an audience which had gathered with curiosity rather than belief that a child could adequately interpret such a composition, even if he were able to deal with its technical demands. But when the bow touched the strings it was evident that an exceptional musical intelligence and sensibility, as well as uncommonly good technical groundwork, were behind the performance. There was the silence that betokens the most intent listening until the cadenza of the first movement, when applause broke out and threatened to stop the performance.

Master Menuhin's interpretation of the slow movement and the finale were, if anything, of a finer quality than his playing of the first, perhaps because of the complete mastery of the situation that he had gained by

that time. He felt and he conveyed very beautifully the poetry of the slow movement and his playing of the finale was of refreshing taste and simplicity. In this place, especially for modern-minded audiences, the music verges perilously on the conventionalities of Beethoven's period. Last night the finale was another story. When it finished hardened concert-goers applauded, cheered and crowded to the stage. The orchestra applauded as loudly.

The stature of the performer being slight, he was finally led to the conductor's stand, from which he waved his acknowledgments to the players and audience. Still the audience would not go, and Fritz Busch, conductor, led the soloist back again to the stage.

It would seem, therefore, that that object ordinarily loathed by reviewers and serious lovers of music—the infant prodigy—is not wholly a thing of myth. It is three years since Yehudi Menuhin gave his first public concert in San Francisco as a pupil of Louis Persinger of that city. Nearly two years ago he played in the Manhattan Opera House in this city. The concert was barely noticed at the time. Last March he played with the orchestra of the Paris Conservatoire and gave two recitals in the Salle Gaveau. Since press notices from Paris are by no means invariably reliable, and since press descriptions of Menuhin's playing in America seemed also vastly exaggerated, they acted against rather than for his reception in this city. Last night was virtually the occasion of his début in New York, and the net result was the recognition of a new and phenomenal talent of the youngest generation.

Master Menuhin has a technic that is not only brilliant but finely tempered. It is not a technic of tricks, but one much more solidly established, and governed by innate sensitiveness and taste. It seems ridiculous to say that he showed a mature conception of Beethoven's concerto, but that is the fact. Few violinists of years and experience, known to this public, have played Beethoven with as true a feeling for his form and content, with such healthy, noble, but unexaggerated sentiment, with such poetic feeling in the slow movement and unforced humor in the finale.

His tone is surprisingly sonorous, refined and rich in color. This was the case even though a boy whose small hands made it difficult for him to tune his instrument, which he frequently passed to the concert master for this purpose, was playing on a Grancino fiddle, three-quarters size. This violin had limited capacities, yet the tone carried to the uttermost limits of the hall. Now and again there were indications of a sagging string, but these incidents did not impair the quality of the performance.

For the cadenza of the first movement Menuhin played the one by Joachim, which is very difficult. His fluency, confidence and aplomb might well have been envied by older players. It was at the end of this cadenza that the audience first threatened to "hold up" the performance. But it was in the two last movements, in the slow movement which is the great test of a musician's sincerity and depth of feeling, and in the finale, so surely and delightfully performed, that a boy of 11 proved conclusively his right to be ranked, irrespective of his years, with outstanding interpreters of this music. It is a pleasure to add that he appeared genuinely absorbed in his task, and not in the sensation he was creating. From the first concerts of a career which began at 8, Master Menuhin, who is now a pupil of Enesco, has been carefully and admirably trained, and protected by his parents from educational "forcing" or public exploitation.

This performance represented the second half of the concert. The first half consisted of a long and vigorous symphony in three movements by Adolf Busch, brother of the conductor of the concert. The symphony is earnestly and conventionally written. The composer is popular on German programs, and it would be unjust to deny him some genuine melodic ideas and a brilliant, if over-done, orchestration. But we cannot find very much that is distinctive in the work heard last night, though Mr. Busch gave everything of his best to the performance, while the orchestra again displayed admirable virtuosity.

November 26, 1927

# BEECHAM CHEERED AT HIS DEBUT HERE

## Sir Thomas, Guest Conductor of Philharmonic, a Musician of Magnetism and Power.

## PIANIST CREATES FUROR

## Vladimir Horowitz, Also Making American Debut, Shares Honors by His Superb Playing.

### By OLIN DOWNES.

The deeds of a new conductor, a striking figure among the "guest" leaders who are deluging America this season, and the power of a young virtuoso of brilliant technic and overwhelming temperament to fairly stampede an audience, were memorable features of the concert given by the New York Philharmonic Society last night in Carnegie Hall.

The conductor was Sir Thomas Beecham, then making his first bow to an American audience. The pianist was the Russian Vladimir Horowitz, who also made his American debut on this occasion, and by his sensational, if by no means impeccable, performance caused most of the intermission to be occupied in applauding and cheering him and calling him back to the stage. It has been years since a pianist created such a furor with an audience in this city. At the end of the concert there were many recalls and more cheering for Sir Thomas.

To what extent all this excitement was due to other elements than the purely musical will be revealed by later concerts and recitals. Certainly both artists had reason to be pleased with the reception. Sir Thomas, of course, was the first to confront the audience. When he ap-

peared he was urbanity itself, confidence, poise. A man of some height and of a stocky build, groomed and mundane, he surveyed the audience and the hall with deliberate interest, while the audience surveyed him.

The guest was evidently master of the situation, and apparently in excellent fettle. He conducted without score, as many of the leading conductors of the day do. If he had had a score before him there might have been smoother cooperation with the pianist in the performance of the concerto. But this question need not here detain us. What is more important is the fact that Sir Thomas Beecham quickly proved himself a musician of unusual enthusiasm, magnetism and purpose, and that he provided a program refreshing in its contents as in its execution.

This program offered for the first time in America three pieces of delightful music from the inexhaustible treasure house of George Frederick Handel. They all came from Handel operas which are quite unknown to this generation—the overture to "Teseo"; the Musette from "Il Pastor Fido"; the Bourree from "Rodrigo." There was another first New York performance of "The Walk to the Paradise Garden," from Delius's opera, also unknown here. "A Village Romeo and Juliet," and still another first Philharmonic performance, the "Chase Royale et l'Orage," from Berlioz's "Les Troyens." The remaining pieces were the Mozart symphony in C major (Kochel 338) and the Wagner prelude to "Die Meistersinger." A program too long for American custom, and if anything too full of good things! But what a list! And there are conductors who play war-horses season in and season out in this city, and profess it difficult to find unfamiliar music that is worth while for their audiences. Sir Thomas has been for many years in England a beacon light for musical progress, a man utterly intolerant of routine, mental laziness or blind tradition.

He is not a virtuoso conductor in the ordinary sense of that word. Not that he lacks the gesture eccentric or impetuous. Quite the contrary. This is the most athletic conductor America has seen for many a season. He is energetic and to the point. His movements, as he conducts from memory and strides about his rostrum, are careless of the audience. Sir Thomas is making music. His beat for the superb opening of the

"Teseo" overture was a beat and a sweep of the arm which evoked from the men the big curve, the splendid stride of Handel's magnificent, stately phrases. Sir Thomas's rhythm and line, as they might be called, changed with the character of the music. Now he was as the strong swimmer breasting the tide, or he crouched like a panther, ready to spring upon a piece of counterpoint the instant that its head projected from its lair. Pleasantries aside, he gained the results that he wanted from the men. He always conveyed the big line and the rhythmical breath of the music, conducting with entire authority, without affectation, with a directness and vitality which brought an immediate response from the listeners.

It may even prove that Sir Thomas Beecham is a musician first and a conductor afterward. It would not be at all bad for Philharmonic audiences if future concerts should show this. The musical health of his interpretations would commend them if they had not other distinctive qualities. As a matter of fact, while he did not fuss and fret over details he showed when the occasion warranted a mastery of nuance, as in one of the Handel pieces, where he gave three successive shadings to certain repeated figures—a forte, a piano, a pianissimo, and from that point to the end a fine diminuendo which merged into silence. But none of this was finicky or superfluous or for purposes of exhibition. It seemed inevitable, inherent in the music.

There was the same sincerity and regard only for the task in hand in the interpretation of the music of Delius, which abounds in characteristic qualities of that extremely sensitive and imaginative composer. The interlude is sensuous, impassioned and of a fine texture. Does it rank among Delius's greatest pages? That also is a question for future performances to answer. Certainly it was music worth the hearing, and to those who heard it for the first time the interpretation seemed fortunate, revealing.

Then came a more debatable piece of conducting, with Mr. Horowitz's performance of the concerto. It was quickly evident, either that conductor and pianist had not sufficiently rehearsed, to the point of thorough understanding, or that there was difference of conception which would not down in their ideas of the concerto. No doubt the former expla-

nation is the one. In any event, the pianist at the beginning wanted a faster tempi than the conductor conceded, and there were many pages when the two see-sawed in their ideas. Despite this, and some imperfect balances, sometimes the fault of Mr. Horowitz, he made a tremendous impression on the audience. His treatment of the work was a whirlwind of virtuoso interpretation. Mr. Horowitz has amazing technic, amazing strength, irresistible youth and temperament. If one judged his tone only by the first and last movements, it would be described as very brilliant, very strong, but hard.

In the slow movement, however, there was another quality, which showed that the pianist could sing and could evoke beautiful colors with the pedal of his instrument. But there could be many reservations about this performance, as for instance tempi, already referred to, sometimes too slow and sometimes too fast—usually too fast—the many places in which Mr. Horowitz played, accompanying passages with unnecessarily loud and prominent tone, the prevailing scarcity of understanding between him and the conductor. The performance triumphed immensely in spite of these things. It was big playing, however it were picked to pieces. It would have overwhelmed the audience if Mr. Horowitz had played much worse and far more inartistically than he did—which truth is rather tragic. He would have triumphed, in any case, by his electrical temperament, his capacity for animal excitement and his physical capacity for tremendous climax of sonority and for lightning speed. Very possibly Mr. Horowitz is a great musician as well as virtuoso. The first movement of the concerto implied as much. But he has that to prove. What is to be recorded is the wildest welcome that a pianist has received in many seasons in New York, the appearance of a new pianistic talent which cannot be ignored or minimized, however it is estimated artistically, and a concert of many and spectacular attractions. As has often been said in these columns, one concert does not make a conductor or a virtuoso either. Half a dozen hardly suffice to test a new leader. But within the limits of a single concert there was no question of the triumph.

January 13, 1928

# RADIO AND THE PUBLIC TASTE

## Demand for Better Programs Increasing — Their Effect on the Concert Situation

### By OLIN DOWNES.

COMMEND us for the full and free expression of the critical spirit to the men who heard Walter Damrosch and his orchestra play Honegger's "Pacific 231" — the symphonic movement which the composer associates with a giant locomotive hurtling through the air—over the radio. He promptly wrote his opinion to the company: "If I could compose, I'd compose a 'Pacific 230' and have the two of 'em meet on the same track head on, and end the business!" The radio is developing a generation of critics.

What is the radio doing for or against the development of musical taste and the propagation of good music?

At the least, the radio is giving the public the opportunity of hearing much good music, finding out

what music it likes, and expressing an honest opinion of that music, either by silently shutting off the machine if it is displeased or by writing in to the management. This is for the good of the art. It is, furthermore, expressive of an attitude much more honest than that of the average audience in a concert hall. In a concert hall, at least in the United States, a false decorum and consideration for the comfort of other people prevent the individual from expressing himself. Very often he is afraid of expressing himself because he fears to look foolish in the light of the newspaper reviews of the next morning—though heaven knows why these reviews should have such an effect upon him. But often the thought of them does. Whereas the honest reaction of the individual who only listens when he wants to, and rejects what he does

not like, and feels a proprietary interest in the performance through his personal ownership of a radio set—this marks a step toward real artistic progress.

∗∗

First, being honest with himself, he finds out what he likes, and why. Then he usually experiments further, being unawed by any "authorities" in the vicinity and independent of the opinions of "musical" friends. He begins to pick and choose his music. And, as usual, experience leads to rejection of the non-essential. As every one susceptible to music discovers, the best music improves upon acquaintance and poor music wears out its welcome. If any proof of this were needed, it would be found in the immense improvement, enforced by public demand, in the last five years, of radio programs. It may be admitted that

in this direction there is still much to be desired, and it is true that in this respect the records have kept more abreast of enlightened public taste and demand than the radio, but changes for the better are taking place swiftly in the latter field; the last five years have brought improvements that the most optimistic could hardly have foreseen.

These improvements have resulted from the pressure of public opinion, which is the best testimony to their significance and genuineness. Consistently better programs and higher standards of performance have become imperative on the part of the leading radio organizations. The reception of the Damrosch programs must have surprised even their sponsors. They have proved beyond a doubt the attitude of the public toward good music. An immense infant industry is responding with alacrity to this and other signs of the times. Not only better programs but the services of the greatest artists for their interpretation! Not all of these artists have responded. Mr. Paderewski, who once gave a recital for a radio audience in England, has never accepted such an arrangement in America. He is one of the few, as he is the most dis-

tinguished of the artists, who refuse to consort with the microphone. But the number of musicians so minded is rapidly dwindling. Meanwhile, certain managers who insisted a few years ago on contract clauses prohibiting their artists from accepting radio engagements are today active and in keen competition, "on the air," with their colleagues. These new conditions, this fresh competition, have come about simply through the operation of laws of demand and supply.

In the operation of these laws business interests have not been a negligible factor. These interests seek an effective way of addressing the public. As all of us know, the radio has become in late years a very popular and attractive form of advertisement. Large concerns devote immense sums yearly to this purpose. These firms find that the kind of musical entertainment they formerly offered their patrons, which was usually of cabaret or vaudeville quality, is becoming inadequate to the situation. As a result, persons of experience and authority in musical matters are engaged to secure artists and arrange programs. The recent engagement of George Engles to supervise the concert bureau of the National Broadcasting Company is only one instance, though a very significant one, of procedure of this kind. There has never been so much good music dispensed over so wide a territory in this country as today.

Of course these considerations affect musical conditions everywhere. A new machine is bringing about a revolution in the musical world. This is not the first time that professions or industries have been thus affected. And the new order gives plentiful cause for alarm. More than a year ago an article in these columns discussed the possible effect of the radio in the concert world and the misgivings of musicians, music lovers and music managers that its advent caused. Their complaints are not

lightly to be dismissed. Radio concerts given on an immense scale must constitute a menace to the career of the talented artist of the second rank. Radio concerts also discourage the activities of the musical clubs and other organizations which, throughout the land, have done so much in the past to promote important series of concerts and assemble a local public for them. If Fritz Kreisler is broadcast over Connecticut and half of the rest of the country, what will become of the concert tomorrow night in Bridgeport? How many subscriptions to Mr. Manager's concert series will the local musical club be able to drum up—concerts which offer a very respectable array of talent, with one or two artists of international reputation to bolster up the list—when John Smith can stay at home and hear Pablo Casals or the London String Quartet by turning a button?

Naturally, these possibilities alarm the managers and their artists, too. Then there is the more fundamental and disinterested objection of thoughtful people who have nothing material at stake, but who see Americans increasingly addicted to buying this music and having it made for them, instead of producing and performing music themselves. How many would be willing to undergo the technical drudgery of an instrument, when they can tune in in the fraction of a second on Jascha Heifetz and the "Symphonie Espagnole"? Why undertake the difficulty and danger of singing lessons in the face of John McCormack or Beniamino Gigli and almost any other star of the vocal firmament? But to turn to machines for musical expression is not, as a nation, to become musical. Many rejoinders can be made to the foregoing, which may or may not constitute sound answers. Perhaps we are inclined to be optimistic. On the whole, we expect much of the radio and the records. We do not point to them with alarm. We be-

lieve that they stimulate and in general educate interest in music. They have certainly increased the great public's understanding of the art, in almost the only ways in which a public so widely dispersed, over such immense stretches of territory, could have been reached. That is something. There is no place in the whole United States today where good music cannot be heard, and is not heard. Suppose that John and Jane, in view of the performance of Mr. Gieseking, are discouraged from taking piano lessons. Is that an unendurable calamity? As a matter of fact, if John or Jane had possessed unmistakable talent and the inclination toward music which usually accompanies it, they would be inspired by the example of a great musician to go and do likewise. If they have not these incentives within them, is it not very much the best for them to turn to more humdrum pursuits than to pass a life of hard labor, bitterness and lost illusions?

As to audiences, let us admit that Mr. Engles has reason to speak enthusiastically of radio and the musical public of the future. Nevertheless, his experience and opinions are eminently practical. He has been a concert manager of wide and intensive experience. He also knew audiences, before he managed concerts, from the viewpoint of the theatre. He might be taken to know the psychology, the make-up, the tendencies of the average audience. His conclusions are suggestive. First of all, musical audiences have not grown smaller, but larger, in the last five years. Their growth is much greater proportionately than the growth of population. Artists whose audiences have materially increased are in many instances artists who have frequently performed for the radio.

He has observed the suggestive fact that the percentage of men has greatly increased in concert audi-

ences of the last fifteen years. Probably the radio is not solely responsible for this, but certainly music is taken much more seriously today than ever before in America, and it is believed that the radio has had much to do with the growing interest that American men have taken of late years in this art.

Has this come about through purely artistic experience on the part of the radio addict? Presumably not. Many a man's discovery of good music came from the fact that he strove for many hours to get New Orleans or Toronto or Mount Shasta and kept on picking up the New York Philharmonic concerts as relayed from Denver or some other remote spot. In other words, he encountered much music in his ramblings over unlimited space, and little by little he began to listen to it. What he heard, in most cases, would not please the habitual concertgoer, since radio transmission has still a distance to go before the listener with an ordinarily good receiving set will get as vivid and exact an impression of the music as a listener in Carnegie Hall. But to one unversed in scores the sounds he heard were new and astonishingly beautiful. He began to become familiar with good music, and Theodore Thomas's remark, to the effect that good music had only to become familiar to be liked, had reason and experience behind it.

Is it not fair to conclude that the radio is creating healthy and widespread interest in music; that it is developing public taste in this direction more rapidly than could otherwise have been done; and that in proportion to one artist whom it deprives of a job, it creates work for twenty? This also may be hoped: that it will tend to discourage musical mediocrity.

May 20, 1928

---

# HISSES AT CONCERT ROUSE STOKOWSKI

## Makes a Speech of Protest Over Disapproval of Schoenberg's Work.

### "STAND ASIDE" HE PLEADS

#### Audience Applauds Philadelphia Conductor—Most Are Apathetic to the New Piece.

**By OLIN DOWNES.**

The concert given by the Philadelphia Orchestra last night in Carnegie Hall was distinguished by mingled hisses and applause for the first New York performance of the extremely cacaphonous "Variations for Orchestra, Op. 31," of Arnold Schoenberg, and it was graced by a speech Leopold Stokowski made from the plat-

form, as one who should defend the right and pour oil on troubled waters.

In its way it was a curious speech. Mr. Stokowski began by observing that the audience should hiss, if it liked. "You have that right," he said. "We, on our part, have the right to play the things in which we believe." He said that he had heard hissing before, inside concert halls, and similar noises, outside in nature. But he asked the audience if it would not be broad-minded, exceptionally broad-minded, especially broad-minded in its attitude toward the new things that are being done today. Then came the most astonishing part of this unexpected speech. Mr. Stokowski asked the audience, if it did not like what he and the orchestra played, would it not stand aside and let others who are curious about such matters have a chance to hear it. He remarked that the Philadelphia Orchestra concerts are oversold and he asked, in all courtesy, in all friendliness and respect, if his hearers did not like it, would they not "stand aside" for the sake of the others.

America, Mr. Stokowski continued, with her unique destiny, particularly owed it to herself, her history, her traditions, to bring to what is new a receptive attitude and an appreciation, based upon the knowl-

edge and understanding of the past, of the music of the present and the future. He and his orchestra, so long as he was the head of it, or the head of any other orchestra, would continue to play the greatest music of the past and the best music of the present for the advancement of the art.

The audience, of which a small part had been hissing the Schoenberg music, and another smaller part applauding it, while most of the listeners who packed the hall sat in a kind of discouraged apathy, applauded brightly the words of Mr. Stokowski. He turned about and concluded the concert with Wagner's "Prelude to Die Meistersinger."

But the sensation aroused by the Schoenberg Variations was not a wild one, not nearly as savage as that which accompanied the first public performance of this work in Berlin, under our old friend, Wilhelm Furtwängler, on Dec. 2 last year, when factions almost came to blows, and critics fell upon each other, if not by hand, at least with ink. Perhaps the sensation was not as great as Mr. Stokowski himself had anticipated. When the pieces were played for the first time in America, last Friday afternoon in Philadelphia, a few hissed and a few left the hall, according to dispatches that described the occasion. Last night there was principally disheartened apathy. The music is so bloodless, such paper music. How we would have been thrilled by some

gold old red-blooded, rousing tune of Edgar Varese. He, alas, is in Europe, and apparently nothing has erupted from his pen for some time. Schoenberg, after all, was a rather pale and wan substitute. If Mr. Varese's music is strepitant and irresponsible, if it runs amuck in ways neither of reason nor righteousness, it at least makes loud and strange noises, while the music of Schoenberg is weak and wan, "sicklied o'er with the pale cast of thought." It is tortuous, meagre-hued music, anemic music. It is geometrical music. Important only on paper; hideous, without vitality, and signifying nothing that matters. If it were uglier and more salient, it would be welcomed. If the hair-splitting of Schoenberg's counterpoint and Schoenberg's orchestration meant anything but the hair-splitting of one who has left no impulse to do anything else, it would arouse a different reaction. Most of us were not shocked, were not angry, were not excited, only infinitely wearied, by this ugly and futile music.

From the ocular standpoint, as we say, the music is interesting. The theme is written in the manner of the subject of the "crab" canon. That is to say, it consists of five measures and seven measures, each repeated in alternation and each reading the same backward as forward! This is geometry; it is not music.

Then the theme is broken into a thousand little pieces and variously

put together again. The orchestration is very fussy. Again, on paper, its ingenuity is apparent. Heard in performance it is merely the letter that killeth. To add to the irony of this proceeding Schoenberg places by his own theme and his own counterpoint a short subject of four notes, built on Bach's great name—a name which, in German musical terminology, gives us the notes B-flat, A, C, B. This musical motive is blazoned forth in its original form and in "inversion" in many pages. Is Schoenberg guilty of such megalomania that he really thinks he is a modern Bach, and is thus slyly revealing himself and his cunning to a comprehending posterity? Or what does he think? Unhappily, this does not matter. The music does not matter even though the first five measures contain all the notes of Schoenberg's twelve-tone scale, and the last chord every note of this scale except C—that interval being omitted, apparently, because it has been powerfully struck in the preceding chord, and if it

were struck again might give the listener the erroneous impression that Schoenberg, who denies all keys and key-relationships as they are commonly understood, had accidentally suggested a tonality!

The other music on the program was the Schubert C major Symphony and the Wagner Prelude. The marvelous beauty of the symphony stole over every one, in advance of Schoenberg, as it would have triumphed after him. We have always felt that Wagner's famous phrase about Beethoven's Seventh Symphony, the "apotheosis of the dance," should properly have been bestowed upon this incomparable, rapturous music of Schubert. It is a giddy, ecstatic flight into the infinite. The very planets whirl by singing a mighty song. The horn that opens the symphony soars into the blue sky, and the peaks and the green valleys of the Austrian mountains that Schubert loved are beneath us. There is a Dionysiac dance of life. Pegasus,

in the finale, stamps his foot impatiently, and the very earth trembles with his strength and his intoxication of power and joy. From far away, in the Andante, comes the poignant questing song of heavy-laden humanity.

And all this is so simply said—so simply said by Schubert, without any purple and striving phrases. But it was not said simply by Mr. Stokowski, whose nervous temperament found its best expression in the whirling finale, but who often hurried his tempi unnecessarily, and conducted the slow movementas if he had been conducting an Italian opera. In places he made wonderful effects, effects so new that at times there was the suspicion he had tampered with the orchestration. He squeezed the last drop of color from the score, he unfolded splendid vistas of tone and made delirious climaxes. For all that, he ranted, and often the orchestra was noisy, forced and heavy, and heaviness is the very antithesis and also the ban—

of the winged genius of Schubert. It is not given to many conductors to read this symphony in a really unforced and felicitous way. None that we recall has done so in this city since a memorable performance given by Bruno Walter either four or five seasons ago. That was Schubert, and Schubert, like many very great and very simple things, eludes most interpreters.

There was a praiseworthy innovation by Mr. Stokowski at this concert. He had announced in advance that those who came late would not be admitted to the hall until after the performance of the entire symphony that Schumann described as of "heavenly length." The doors were held open four minutes longer than customary time on account of the bad weather. As a result, according to the statement of the management, hardly more than twenty people were late to this concert.

October 23, 1929

## Metropolitan Broadcasts First Full Opera; Hailed as a Success as Millions Listen In

Almost twenty-two years ago a microphone was placed on the stage of the Metropolitan Opera House and Enrico Caruso and Emmy Destinn sang a few solos and duets from the opera "Tosca." Their voices were heard by a few amateur experimenters, and it was generally decided that there were "insurmountable obstacles" to the broadcasting of opera.

The Metropolitan went on the air again yesterday and the melodious strains of Humperdinck's opera, "Hänsel und Gretel" were carried without distortion to millions of radio listeners in the United States and abroad.

In the intervening years since the pioneer broadcast from the Metropolitan's stage radio had surmounted the "insurmountable"; it had proved its boast that it could translate sound waves to electric waves and then back to sound again without losing a single note.

Only one wonder of modern science, television, was lacking. Its use would have conveyed radio listeners almost physically to a seat before the footlights. And even this lack was compensated for by Deems Taylor, the composer, whose voice described the action on the operatic stage.

The opera was broadcast here over the coast-to-coast network of the National Broadcasting Company, going to audiences of more than 100 radio stations in the United States. Powerful short-wave transmitters carried Humperdinck's famous fairy opera to specific far-distant cities of the world, spanning the Pacific and being received over thousands of sets in Japan and other Oriental countries. A dispatch from London reported that listeners in England did not get a chance to hear the opera as the British Broadcasting Corporation made no arrangements for a rebroadcast. A Berlin dispatch indicated the opera was not reproduced there.

The opera went on the air at 1:45 o'clock yesterday afternoon while radio executives, officials of the opera house and music critics waited anxiously for the results of the ex-

periment. The question was not long in doubt. Before the first fifteen minutes had passed hundreds of congratulatory messages poured in from listeners all over the country.

A few of the callers wanted to know "who was talking and spoiling the music?" That was their reaction to the voice of the composer whose opera "Peter Ibbetson" was greeted

with such acclaim at the Metropolitan recently. But these were in the minority, a very small minority, for most of the messages praised his method of handling the narration.

### Gatti-Casazza Gratified.

Giulio Gatti-Casazza, the manager of the opera house for twenty-three years and for long one of the most skeptical of the opera-by-radio critics, shuttled incessantly from the wings to William J. Guard's office in the Metropolitan, where a radio receiver had been installed. Toward the last it was observed that he spent more time before the loud-speaker than

near the stage.

He was completely convinced at the end that his beloved opera had not been "disgraced" by the broadcast and, smiling broadly at his most recent success, was found with a group of radio executives back stage posing for a picture.

"I am very happy to see that this experiment has proved such a great success," he said.

Mr. Gatti was not the only one concerned with the broadcast. Mmes. Wakefield and Besuner, both members of the cast, slipped away for a while when they were not due on the stage to listen in Mr. Guard's office to the voices of their fellow-

**LISTENING TO THE FIRST BROADCAST OF METROPOLITAN OPERA.**

Associated Press Photo.    Associated Press Photo.

At the left are Paul D. Cravath, president of the Metropolitan Opera Company (sitting) and Merlin H. Aylesworth, president of N. B. C., listening in the studio of the company to the broadcasting of "Hänsel und Gretel, the first opera broadcast from the stage of the Metropolitan Opera House. At the right is Deems Taylor, shown in a special booth in the wall of the opera house, as he described the action of the production to the radio audience.

singers. They approved, enthusiastically and volubly. Old stagehands, most of whom are as conversant with the scores as any of the principals, deserted their posts to hear the radio version and added their words of praise.

So universal was the appreciation of the opera broadcast that their continuation was assured yesterday. The last two acts of Bellini's "Norma," with Rosa Ponselle in the title rôle, will be carried over the National Broadcasting Company network this afternoon at 3:45 o'clock. "La Bohème" will be broadcast on the afternoon of Jan. 1 and the première of "Donna Juanita" on Jan. 2. Thereafter a regular series of Saturday afternoon broadcasts will be begun, it was announced, with Mr. Taylor continuing in the rôle of narrator.

### No Confusion on Stage.

To outward appearances there was nothing unusual about yesterday's performance at the Metropolitan. There were no microphones in evidence, no soundproof rooms or hangings, no requests of the audience to refrain from applauding, no whistles backstage notifying members of the cast that it was time to "shoot" another scene. None, in brief, of the characteristics of the sound motion-picture studio, even of the regular broadcasting studio.

The key to the success of the broadcast, according to the radio engineers, was the parabolic microphone, which first entered general radio use about a year ago. It is a device with a face measuring from four to six feet in diameter, and resembling a large horseshoe crab. The engineers call it a reflector, because it handles sound in much the same way that a searchlight reflects light.

The big microphone is set on a swivel so it can be turned in any direction to get the best results, and has been employed in broadcasting the performances of the Chicago Opera Company and in picking up

the yells of the crowd at big football games.

A box in the grand tier was converted into a control and observation booth from which the engineers reduced or amplified the use of two smaller microphones hidden in the footlights at each side of the stage. The parabolic microphone was suspended high above the orchestra but almost passed unnoticed. Mr. Taylor's description came from the control box.

### Speakers Hail Occasion.

Just before the opera broadcast began, Paul D. Cravath, chairman of the board of the opera company, and M. H. Aylesworth, president of the National Broadcasting Company, spoke briefly. Mr. Aylesworth said he considered it a great privilege to have been permitted to take part in arranging the first world-wide grand opera broadcast from the Metropolitan and predicted that such broadcasts would add rather than detract, from attendance at the opera.

Mr. Cravath said the broadcast was an important event in the history of the opera in America and added:

"It has been very slow in coming, for Gatti-Casazza and Mr. Ziegler, who direct the destinies of the opera house, are very cautious and conservative men. They were afraid that broadcasting would not do justice to the beauty of their music. Recent experiments of the engineers have entirely removed their fears in this regard. I suspect they also feared that their box office might suffer; that when listeners found how perfectly they could hear the broadcast music in their homes they would not take the trouble to go to the opera house.

"I do not share this fear. I believe that interest in the opera will be so stimulated by broadcasting that listeners will flock in such numbers to the opera house—where they can see opera as well as hear it—that we will have to build a new and bigger opera home to hold them.

"Let me assure the millions of my listeners who have heard opera in

the Metropolitan that the grand opera you will see and hear there surpasses the music you hear over the radio, perfect as it is, just as a beautiful woman standing before you in all her glory surpasses her pale image cast upon a screen."

Mr. Taylor's narration, considered by several persons as one of the most difficult elements in broadcasting the opera, was begun a few minutes before the curtain rose with a brief outline of the life of the composer, Engelbert Humperdinck, and the acclaim that he had received when his opera was last produced in Weimar, Germany, on Dec. 23, 1893. Its first presntation in this country was in New York on Oct. 8, 1895.

He translated some of his description into German, French and Italian for the benefit of foreign listeners and attempted always to insert his remarks at points in the production where they would least interfere with the music.

In the cast ware [Hansel], Editha Fleischer; [Gretel], Queena Mario; [the witch], Dorothee Manski; [the mother], Henriette Wakefield; [the father], Gustav Schutzendorf; [the sand man], Dorothea Flexer; [the fairy], Pearl Besuner. The conductor was Karl Riedel.

### Damrosch Praises Broadcast.

Among the messages from listeners received by the broadcasting company was one from Dr. Walter Damrosch. It said:

"I consider the broadcast of Hansel and Gretel by the Metropolitan a triumph for the engineers of the National Broadcasting Company. It was a miracle of artistic reproduction of the voices of the singers and the instruments of the orchestra. The most delicate effects as well as the greatest climaxes came over the air with absolute fidelity to the richly colored Wagnerian score of the composer. What a subtle task it must have been to arrange a microphone over the vast space of the Metropolitan stage and to achieve such results."

From Nicolai Sokoloff, conductor of the Cleveland Orchestra, was received the following:

"First performance of 'Haensel und Gretel' from the Metropolitan by the NBC highly successful. Perfect pick-up between the stage and the orchestra. Congratulate Deems Taylor. It was a beautiful Christmas gift from the NBC to the music lovers of the world."

John Alden Carpenter, composer of "Skyscrapers," which has been produced by the Metropolitan, sent the following:

"The Metropolitan, the N. B. C. and Santa Claus are today distributing a rich bonus to the American people. My best wishes for this wise and generous project."

Herbert Witherspoon, former Metropolitan Opera baritone, now vice president in charge of opera of the Chicago Civic Opera Company, reported reception very good in the Middle West.

Alfred Hertz, retired conductor of the San Francisco Opera, called the broadcast a "wonderful Christmas gift to the children of California and one of the finest things the N. B. C. has done."

Mme. Frances Alda, former soprano of the Metropolitan, expressed her appreciation. She said:

"Opera will now be heard by the millions who heretofore have not had the opportunity."

Arthur Fried, music critic of The San Francisco Chronicle, called the broadcast "an epoch-making thing, marking the beginning of a new era in music for which radio is to be thanked."

Dr. Glenn Dillard Gunn, critic of The Chicago Herald Examiner, sent word that the broadcast was the first he had ever heard in which the voices and the orchestra were in perfect balance.

Many messages were received by Queena Mario, soprano, who was Gretel in the broadcast performance.

December 26, 1931

---

# STEIN OPERA SUNG BY ALL-NEGRO CAST

## It Is Marked by a Spirit of Inspired Madness, but Is Highly Melodious.

## PREMIERE AT HARTFORD

## Production Opens New Wing of the Wadsworth Antheneaum —Coming Here Later.

FOUR SAINTS IN THREE ACTS. Opera in Gertrude Stein's English with music by Virgil Thomson. Scenario by Maurice Grosser. World premiere at the Avery Memorial Theatre of the Hartford Athenaeum, Hartford, Conn.

Compere ...................Abner Dorsey
Commere ...................Altonell Hines
St. Ignatius ..............Edward Mathews
St. Therese I .....Beatrice Robinson Wayne
St. Therese II .............Bruce Howard
St. Chavez ................Ertiby Bonner
Sts. Settlement, Ferdinand, Plan, Stephen, Cecilia, Giuseppe, Anselmo, Sara, Bernardine, Absalon, Answers and Eustace sung by Bertha Baker, Leonard Franklyn, George Timber, David Bethe, Kitty Mason, Thomas Anderson, Charles Spinnard, Marguerite Perry Flossie Roberts, Edward Batten, Florence Hester and Randolph Robinson.

Chorus of thirty-seven male and female saints.

Alexander Smallens, conductor.

### From a Staff Correspondent.

Special to THE NEW YORK TIMES.

HARTFORD, Conn., Feb. 8.—The fabulous rumors of an all-Negro cast singing in tan-face and cos-

tumed in cellophane; of a libretto whose words were unintelligible and an opera whose stage directions were set to music—all this crammed the new Avery Memorial Theatre with a highly sophisticated and curious audience tonight. The audience, literary and musical, came in part from New York and New England for an event sponsored by "The Friends and Enemies of Modern Music," a New England organization, and occasioned by the opening of the Avery Memorial wing of the Wadsworth Athenaeum under Everett Austin Jr., curator. The opera, given a public dress rehearsal Wednesday night and scheduled to run here to houses already sold out the rest of this week, will open at the Forty-fourth Street Theatre in New York on Feb. 20.

The cast has been rehearsing under Mr. Smallens, assistant conductor of the Philadelphia Orchestra, for many weeks. Frederick Ashton from England assisted John Houseman in the choreography and staging. Florine Stettheimer designed sets and costumes and A. Feder the lighting. Despite these impressive preparations, the advance tidings somewhat exhaled the bizarre preciosity of post-war Paris under Cocteau, and some skeptics audibly wondered whether these manifold mountains would bring forth more than a rococo mouse.

Mr. Thomson, native of Kansas City, Mo., graduate of Harvard and pupil of Nadia Boulanger, composed the opera in Paris in 1928 to a text Miss Stein wrote at his request. They previously collaborated on a

cantata, "Capitals Capitals," performed some years ago in New York. The composer has written numerous choral and instrumental works.

### Words That Eschew Meanings.

Miss Stein's writing roused violent controversy in Paris—fifteen years ago. Save in "Three Lives" and her recent autobiography, she apparently uses words for sound instead of meaning. Only quotations can do justice to the result. These are taken at random from the libretto:

> To know to know to lover her so.
> Four saints prepare for saints.
> It makes it well fish.
> Four saints it makes it well fish.

> Saint Blar. In the middle of their pleasurable resolutions resolving in their adequate announcing left to it by this by this means.
> And out.

#### Scene IV.

##### Usefully.

> Saint Therese. Having happily married.
> Saint Therese. Having happily beside.
> Saint Therese. Having happily had it with a spoon.

#### Act I.

> Saint Therese in a storm at Avila there can be rain and warm snow and warm that is the water is warm the river is not warm the sun is not warm and if to stay to cry.
> Saint Therese half in and half out of doors.

#### Scene III.

> There is a difference between Barcelona and Avila. What difference.

### Objectives of the Authors.

Mr. Thomson, recently interviewed, informed the writer that he and Miss Stein worked out a narrative; a "baroque fantasy" about seventeenth-century Spanish saints to be told not by the text but by pantomime, choreography and music. Miss Stein then clothed this story in a sound-pattern of words

vaguely suggesting its atmosphere at times. Mr. Thomson found this pattern brilliantly singable; a prosody uncontaminated by emotional or expressive content. Most plots and even texts of operas as sung were largely unintelligible, he suggested. A good verbal pattern was more important.

The composer has set this "pattern" to music as candidly melodious as "Pinafore" and as rhythmically flexible as Gregorian chant. There are not ten measures of "dissonance" in the entire score. It abounds in tunes. The orchestra is subordinate. The result is an effective marriage of pseudo-simple harmony with a highly decorative vocal line. Mr. Thomson chose a Negro cast, he said, because he felt they had better diction and a more direct and unself-conscious approach to religious fantasy.

This choice seemed amply to have justified itself last night. In spite of the relatively simple idiom in which Mr. Thomson has written, the free rhythms and the task of committing to memory a text without meaning in its usual sense, made unusual demands upon the singers. They acquitted themselves admirably. The work is scored for double mixed chorus, numerous minor rôles and five principal rôles—the two Saints Therese, St. Ignatius and the Commere and Compere. It is doubtful if white singers could have given the score, with its strange alternations of comedy and exaltation, the flavor it requires, or have projected the vocal lines with the startling clarity and beauty of phrasing that they achieved.

To be sure, the spirit of inspired madness animates the whole piece. Kneeling and solemn deacons sud-

129

denly break into a fandango, as an angel presents it. Ignatius with a lute, ballets of angels, sailors and señoritas abruptly animate a scene filled with solemn saints in prayer. Miss Stettheimer has provided fantastically absurd and effective sets and costumes; also a bower of cellophane in which St. Therese,

clad in crimson velvet, appears. The tan-faced (not white, as rumored) chorus in silver haloes and silver-studded gloves and long, blue robes, carried out the originality, glitter and imaginative quality given the whole production.

Mr. Smallens and the cast de-

serve high praise for their achievement. Edward Mathews as St. Ignatius and Beatrice Robinson Wayne as St. Therese, gave outstandingly fine readings, among many good performances. There were occasional rough spots in the orchestra and in the singing, which further performance may clear up.

"But does it make sense?" the serious minded will ask. It does not—to the too serious minded. But neither do "Alice in Wonderland" and other creations of fantasy. Nor was "The Green Pastures" to be taken literally.　　　　H. H.

February 9, 1934

# A NOTABLE EXPERIMENT

## Ten Years of Work for the American Composer at the Eastman School

*To the Music Editor:*

The Eastman School of Music has this year completed the first ten years of its American Composers' project, and some of the results of the experiment may be of interest to your readers. You will recall, I am sure, the origin of the plan. There was at that time no place in the United States where a young composer, without an already established reputation, could send his works with any assurance that they might receive a hearing. The established orchestras could hardly be expected to turn their regular series of concerts into a laboratory, and though there had been some "reading rehearsals" carried on previously, these had been only sporadic.

The first practical discussion of the idea took place, as you will recall, at a luncheon at the Hotel Roosevelt which was attended by a number of distinguished musicians and critics. Acting on Mr. George Eastman's behalf and with the enthusiastic support of President Rush Rhees of the University of Rochester, I journeyed to New York and explained to the group what we hoped to do in Rochester. An interesting discussion followed, giving rise to many helpful suggestions. It was determined to follow certain definite policies: first, that the choice of works should not be confined to any one "school," but should be as catholic as possible, with every effort made to discover and perform new works which had not yet received performances; second, that the works should not be "read," but should be carefully rehearsed and performed before an audience; third, that the concerts be free to the public to eliminate any "box-office" influence in the experiment.

\* \* \*

It would be presumptuous of me to take the time of your readers in

detailing the many steps in the working out of the experiment. We made, undoubtedly, many mistakes and attempted to profit from them. We made also many changes designed for the purpose of increasing the efficacy of the experiment. The concerts were held first in the Eastman Theatre, then moved to the smaller Kilbourn Hall for a more intimate atmosphere and then moved back again to the large theatre when the size of the audience overwhelmed the small hall.

The need for such a laboratory was immediately apparent. From the very beginning the office was flooded with orchestral manuscripts of every possible size and quality, none of which had ever been translated into sound. The number of concerts has been increased from one a year to four or five, with an entire festival of American music added, and still it is possible to perform but a small percentage of the scores submitted. (This in spite of the fact that we have in the past ten years performed about the same number of American works as the Boston Symphony has played in its long history, and it has played a great many!)

In the early days of the experiment almost all of the works played were from the pens of young, and in many cases unknown, composers. Later, however, wellknown composers began to signify their desire to have their works performed on these programs, and the plan was expanded to include scores by many distinguished names in American composition.

At this time a new and very interesting factor entered the scene—the audience. Rochester showed a decided interest in the experiment. As one composer remarked, "They suffer, but they keep coming!" And they did keep coming, and in in-

creasing numbers, until at certain of the more popular performances the audience crowded the Eastman Theatre and it was necessary to ask for additional traffic police to handle the crowds!

\* \* \*

The reactions of this audience were in themselves as interesting as the works performed. This audience was not a formal symphony audience, though it numbered hundreds of regular symphony-goers. It was an intensely interested, curious and eager audience, positive and unfailing in its reactions. Its opinions were its own. They had to be, for there was no "Bach," "Beethoven" or "Brahms" on the righthand side of the program to indicate whether or not the music was "good" music. I publicly disclaimed responsibility, telling the audience that some of the numbers which we played I cordially disliked, though I would do my best to keep the audience from discovering which they were!

And their judgment seemed to me, in the great majority of cases, to be critically sound, giving me new confidence in a natural audience reaction if that reaction is in fact "natural" and uninfluenced. They were not greatly upset by "modernism," but did not take kindly to formlessness. A work which meandered through yards of score-paper without, as they expressed it, "getting anywhere" received scant applause. They showed admiration for a good tune, for infectious rhythm and for musical vitality, and a work such as Randall Thompson's Second symphony" (first produced at these concerts and later performed by the New York Philharmonic under Bruno Walter), which has all three of these qualities, earned their immediate affection and had to be repeated at later concerts.

I have been often asked whether a distinctly American idiom was developing in these concerts. I have never known exactly what "American music" was except in its simplest definition—viz., music written by Americans; but I must admit that the Thompson work, together with others such as Burrill Phillips's

"Selections From McGuffey's Readers," have something about them that smells American and which is quickly perceived by the audience. I don't know exactly what it is. Perhaps it is partly rhythmic, partly a homely sentimental quality of melody and mood, and probably it is something much less tangible. Whatever it is, it is certainly there, and those who insist on a typically "American" idiom can rest content. They are going to get it.

Another point should be mentioned—the enormous orchestral technique of these young composers. Any one who says that the young American cannot write for orchestra simply doesn't know his American scores. The weakest point, I believe, lies generally in the matter of form; that is, form taken in its broadest sense. With the ultimate relaxing of all formal restrictions there is a tendency for the young composer to spread himself over a large canvas with not always a keen enough sense of architectural necessities.

Statistics are dull things, but this report to you would not be complete without noting the fact that we have performed over 200 works during the past ten years at the concerts and festivals more than half of which were given their first performance. In addition, student composition has been so stimulated that it has been necessary to give two orchestral concerts a year in addition to and outside of the American series. Seventy-five of these student orchestral works have been given, many of which compare favorably in quality with the works performed on the regular series. Which leads me to reiterate again my belief that composition is like farming: the more you cultivate the soil the better crops you grow!

I appreciate, sir, the constant interest that you have taken in our experiment and your consistent helpfulness.

HOWARD HANSON.
Rochester, N. Y., July 29, 1935.

August 11, 1935

# GERSHWIN'S OPERA MAKES BOSTON HIT

Special to THE NEW YORK TIMES.

BOSTON, Sept. 30.—Both musically and theatrically, George Gershwin's and the Theatre Guild's new folk opera, "Porgy and Bess," which had its first performance at

the Colonial here this evening, was an event. An audience which assembled, uncertain whether they should find a heavy operatic work or something more closely resembling musical comedy, discovered a form of entertainment which stands midway between the two. The immediate response was one of enthusiasm that grew rather than diminished as the evening progressed.

Aided by a workable libretto from Du Bose Heyward, and lyrics by Mr. Heyward and Ira Gershwin

that have an idiomatic tang, the composer has put together a score which, so far as the layman can tell, is one of distinction and power. Except for the words of a few white players in an almost all-Negro cast, practically everything is sung. But the music and dances seem to spring naturally from the place and people. Many of the songs—"Summer Time," for instance or "Porgy's I Got Plenty O'Nuttin'"—seem destined for immediate popularity.

In the lighting and direction,

Rouben Mamoulian has done an enviable job. At the end of the performance, he, the composer and Alexander Smallens, who conducted an orchestra that approached operatic proportions, were called to the footlights.

**Pattern of Play Followed.**

In its outlines the opera follows the pattern of the play from which it derives, with a division into three acts and nine scenes. For backgrounds Sergei Souderikine has designed believably Charleston set-

tings, counterparts to those of the original production. One is the courtyard of Catfish Row, surrounded by dilapidated buildings with crazily shuttered windows from which the teeming population of the Negro settlement can peep in moments of excitement, or behind which they can retire to leave the court as silent and deserted as a churchyard when white men come and danger threatens.

A second sets forth the palmetto jungle where the picnic takes place and the fugitive Crown recaptures temporarily his woman Bess. The third is in a room of the quarter, with bare walls against which gigantic human shadows tower as the mourners chant for the dead—and gather pennies for his burial—or from which echo the tumult of the hurricane and the shouts of Crown, come to reclaim his woman.

Though there have been necessary minor omissions, the story keeps to the narrative of the play. The surprising thing is that so much wealth of incident could be retained.

There is the crap game, with its racial humors and excitements; the murder of Serena's husband, the flight of Crown and the shelter which the crippled beggar Porgy alone is willing to offer the deserted Bess. There is her gradual reform under Porgy's influence. Set to music, her divorce from Crown so that she could become Porgy's, with the added "complication" in the fact that she had never been married, is still richly comic.

**Characterizing Detail Praised.**

There is the final conflict between Crown and Porgy for possession of the woman, and the slaying of Crown by the cripple, the taking of Porgy into custody as a matter of routine to identify the body, the departure of Bess, lured away by the persistent sporting life with his "Happy Dust" and his promises of the luxuries of New York, influenced too by her belief that Porgy is lost to her forever. In the opera as in the play, Porgy returns to find her gone, and, a pathetically heroic figure, starts off in his goat cart to discover her even in that distant land.

Round this tale of primitive passions, fears and faiths clings a rich embroidery of characterizing detail to present a rounded picture of the place and its inhabitants, their joys and sorrows, their terrors and superstitions, the homely routine of their lives—the departure of the fishermen who were to perish in the storm, the crying of the wares of the honey man—jigs and lullabies as well as swift hatreds and violent deeds.

Even without a synopsis in the program, those unfamiliar with the play or novel could follow the action, so clearly do the singers enunciate. In the more conversational scenes, with the necessity for singing the dialogue, the pace is unavoidably retarded. But in the emotional moments, the music of Mr. Gershwin imparts a new and heightened intensity.

Todd Brown as Porgy, Anne Wiggins Brown as Bess, Warren Coleman as Crown, Bubbles (once of Buck and Bubbles) as Sporting Life, Ruby Elzy as Serena and the others of a large company convey the sense of characters as well as the pleasures of the music. Through them and the other elements of a polished production this is not only a fresh adventure in opera, but entertainment in its larger meaning. With their aid the guild and Mr. Gershwin have proved that opera of the American folk variety can be a cause for general rejoicing.

E. F. M.

October 1, 1935

---

### PHILADELPHIA BOOS MUSIC

**Sessions Symphony at Premiere Arouses Hisses of Hearers.**

PHILADELPHIA, Dec. 20 (P).— Alexander Smallens, former assistant conductor of the Philadelphia Orchestra, was guest conductor today, but that did not prevent hisses and boos from the audience during the playing of Symphony No. 1 by Roger Sessions, modern American composer.

The work, never before heard in Philadelphia, aroused hisses and caused several to walk out when, as one critic said, "The healthy modern counterpoint proved a little too healthy."

Mr. Smallens will conduct the orchestra in the same program again tomorrow night.

The Academy of Music announced that next Friday the orchestra, under Leopold Stokowski, would offer Poulenc's concerto in D minor for two pianos and orchestra for its first performance in the United States.

December 21, 1935

---

# TOSCANINI OFFERS ELOQUENT PIANIST

**Leads the Applause for Rudolf Serkin, Soloist With the Philharmonic-Symphony.**

### BEETHOVEN WORKS GIVEN

**By OLIN DOWNES.**

It is very rarely that the performance of a soloist can match an orchestral interpretation directed by Arturo Toscanini. When a soloist of such capacity arrives, and Mr. Toscanini from his stand on the rostrum discourses great music with him and the audience, it is an occasion to remember. Such an occasion was the concert given by the Philharmonic-Symphony Orchestra, with Mr. Toscanini conducting, and Rudolf Serkin, pianist, taking the solo parts in concertos of Beethoven and Mozart, last night in Carnegie Hall.

Rarely at a Toscanini concert has such enthusiasm after the performance of a concerto been witnessed, and this is mentioned here not merely as a matter of chronicle but because of the testimony it afforded of a public which immediately recognized the significance of an interpretation which had only the qualities of mastery and none of the qualities of sensationalism about it. But Mr. Toscanini, with his complete self-abnegation and his profound and intuitive understanding of music, has through seasons accustomed his audiences to such revelations of masterpieces. His own pleasure in the success of a young colleague was obvious, as he applauded him after the performance. It was not only the generous enthusiasm of a great artist. It was more: it was gratitude for aid in rediscovering and worthily conveying the secret of Beethoven.

The first concerto was Beethoven's Fourth. It was preceded by the most appropriate introduction possible under the circumstances: Beethoven's First symphony, played with a reduced orchestra, and this with a clarity, grace and modified sonority which constituted a precise observance of the character of the work and its place in musical evolution. For the boldness of the introduction was not that of the later Beethoven, either in volume of sound or manner of utterance. The allegro was not taken too heavily or portentously; its relation to the Haydn style was implicit.

The Mozartean flow of the slow movement, with the delightful formality of its "imitations," was observed by the tempo as well as by phrasing. Too slow a tempo is here the course of too many conductors. It was in the movement misnamed "menuetto"—since it clearly deserves, as much as any corresponding movement in the later Beethoven, the title of "scherzo"—that the horns and hoofs of the demon of the new genius in music showed themselves unmistakably; but, even here, with an ideal beauty of tone and simplicity of statement. It is extremely hard, it demands supreme mastery, to give a performance of that simplicity.

Characteristics of Mr. Serkin's Beethoven performance deserve detailed mention. We have seldom heard a pianist's performance which so admirably combined the most penetrating analysis with artistic enthusiasm and warm feeling. Similarly, the technical performance was clean and precise, but also beautiful and of a poetic coloring. All this was part of a symphonic conception of the score.

Most pianists, realizing the rarely intimate and romantic nature of this concerto (in which Beethoven anticipates Schumann of a later generation, but within the grandeurs of a form of which Schumann was incapable) emphasize its introspective measures, but neglect to convey the full measure of characteristic force and energy which are also present, especially in the first movement. Although it was only once, in the powerful repetition, with full chords, of the initial motive, that Mr. Serkin allowed himself to utilize the full resources of the modern piano, he played with a prevailing virility and fire which gave the music all its qualities instead of some of them, including the strength and architecture which underlie Beethoven's lyricism.

The slow movement, with the wonderful dialogue of the piano and strings, is one of the things of which a well-advised person hardly attempts to speak. Here it need only be said that its mood and its utterly original beauty were fully conveyed. Nor did the impetuous measures of passage work just before the end of this movement break the spell. They only enhanced it.

The whole performance was so adjusted that one recurring chord, in the last movement, too sharply accented, emerged as disproportionate. No doubt Mr. Serkin, who obviously is a passionate student of Beethoven, would have his reasons for that. The question that it raised only threw into relief the quality of the whole performance. In the first movement Mr. Serkin played the second cadenza—and a magnificent passage it is—that Beethoven composed for this work.

The remainder of the program consisted of Mozart's last piano concerto in B flat, admirably interpreted, but by no means one of Mozart's strongest concertos, and Sir Henry Woods's noisy orchestral transcription of the Bach D minor organ toccata and fugue, which might be appropriate in Queens Hall, if nowhere else. Need it be said that the audience which assembled last night was carried away so that applause crashed, long and loud, at every opportunity? None of the scores was of revolutionary import. At the same time, one was aware of a past period of very great music.

February 21, 1936

131

# ISAAC STERN PLAYS TO LARGE AUDIENCE

## Young Violinist Makes First Appearance in New York at the Town Hall

### AT HOME IN MODERN IDIOM

#### By OLIN DOWNES

Isaac Stern, a young violinist who has studied with leading teachers in this country and also appeared in recital in other places and as soloist with the San Francisco Symphony Orchestra, made his first New York appearance last night in Town Hall. He pleased a large audience by the extent of his technic and his spirited, straightforward playing. At the same time he seldom went far below the surface of his music, or displayed very much warmth or distinction of style.

The most interesting performance of a series which included the Tartini sonata with the famous trill, the Glazounoff concerto, and Desplane's "Intrada" was that of the poetical and fantastic "Nocturne Tarantelle" by the late Karol Szymanowski. That performance had a sensitiveness which had not always been conspicuous, and it implied that Mr. Stern finds himself especially at home in the modern musical idiom. This is said without having heard his final group of pieces by Ravel and Dohnanyi. But those works are more concerned with virtuoso effect than with emotional expression.

### Best Music Tartini's Work

Indeed this is a criticism which can be made of the character of the program, which gave too little opportunity to estimate Mr. Stern as an interpretive artist. Its best music was certainly the Tartini sonata, which was confidently advanced, and characterized by some fine passages, but which, in toto, needed more of the delicate and romantic which is to be found within the classic mold. As for Glazunoff's concerto, it is long and dull enough, aside from its display passages, of which no note was abandoned. The justification of its performance must lie in an unusual interpretation. It is a score to which a master may give significance, but a perilous one for less than a master to bestow upon an audience.

### Quick With Left Hand

Technically speaking, Mr. Stern's left hand is quick and unusually competent. He plays with clean and manly intent, but not with the consistent beauty and resiliency of tone which should be his. It could be said that his bow presses too hard and vibrates the string too little. This pressure gives a fine sonority on the lower strings, but frequent stridency in upper registers. These limitations of tone perhaps make consequent certain shortcomings of interpretation, where nuance and elasticity of phrase are concerned. It is clear, notwithstanding the foregoing, that Mr. Stern has unusual potencies as an artist. Self-criticism and maturity can carry him far. Arpad Sandor played musicianly accompaniments.

October 12, 1937

---

# TOSCANINI PLAYS TWO NEW WORKS

## Two by Barber, American Composer, 'Adagio for Strings' and 'Essay for Orchestra'

### By OLIN DOWNES

The audience assembled last night for the Toscanini concert of the NBC Symphony Orchestra with the same agerness, and listened and applauded with the same intensity which is customary at this series of events. There was the same almost laughable silence and solemnity as the orchestra ceased tuning and the gathering waited for seconds for the conductor to step silently through the door that opens on the stage. And there was the same highly privileged sensation of listening to performances which had almost the clarity and purity of chamber music, and finally, of hearing some interesting new scores.

Two works by Samuel Barber, the young American composer, twenty-eight years old, were performed for the first time anywhere. They are an "Adagio for Strings" and an "Essay for Orchestra". It goes without saying that Toscanini conducted these scores as if his reputation rested upon the results. He does that with whatever he undertakes.

Mr. Barber had reason for thankfulness for a premier under such leadership. And the music proved eminently worth playing. The Adagio for the strings, particularly, is the work of a young musician of true talent, rapidly increasing skill, and, one would infer, capacity for self-criticism. It is not pretentious music. Its author does not pose and posture in his score. He writes with a definite purpose, a clear objective and a sense of structure.

### Arch of Melody and Form

A long line, in the Adagio, is well sustained. There is an arch of melody and form. The composition is most simple at the climaxes, when it develops that the simplest chord, or figure, is the one most significant. That is because we have here honest music, by a musician not striving for pretentious effect, not behaving as a writer would who, having a clear, short, popular word handy for his purpose, got the dictionary and fished out a long one.

This is the product of a musically creative nature, and an earnest student who leaves nothing undone to achieve something as perfect in mass and detail as his craftsmanship permits. A young man who has so genuine a talent and purpose should go far.

The "Essay for Orchestra," modestly named, is well integrated, with clear instrumentation, and with development of the ideas that unifies the music in spite of changes of tempo and marked contrasts of orchestration. The Adagio impressed this chronicler, at the first hearing, as the better composition of the two, but it would be premature to put this down as a definite conclusion, and it is a matter of secondary importance. Of the first importance is the fact of a composer who is attempting no more than he can do, and doing that genuinely, and well.

November 6, 1938

---

# COMPOSERS' FORUM OPENS MUSIC WEEK

## Smallens Conducts Works of Five Guggenheim Fellows at Carnegie Hall

The Composers' Forum-Laboratory inaugurated the National Music Week activities of the Federal Music Project of New York City with a concert of works by five Guggenheim Fellows in Composition last night at Carnegie Hall. The elaborate and provocative program was performed by the Federal Symphony Orchestra of New York City, under Alexander Smallens and Alexander Richter. The assisting participants included Johana Harris, Paul Nordoff and Allison Drake, pianist, and a chorus of 200 mixed voices from the High School of Music and Art.

This concert, which proved to be the most important event staged here to date by the Forum-Laboratory, cast great credit on all concerned. Mr. Smallens, who conducted all of the offerings except the final number, had rehearsed the orchestra so efficiently that each and all of the exacting works enjoyed most excellent presentation from every point of view.

Three of the compositions received their New York premières. These were Roy Harris's Second symphony, William Schuman's latest creation, a prologue for chorus and orchestra, and Walter Piston's concertino for piano and chamber orchestra. Aaron Copland's "An Outdoor Overture," and Paul Nordoff's concerto for two pianos completed the list.

### Choral Setting a Poem

Of the five modernistic works, Mr. Harris's symphony and Mr. Schuman's prologue were the most significant contributions set forth. Mr. Schuman, whose choral setting of a poem by Genevieve Taggard concerning the opening of "tomorrow's door" was splendidly sung by the youthful members of the assisting chorus, possessed the most positive and straightforward ideas of any of the composers represented. There was a clarity of line, a transparency in every phrase of this richly promising piece of writing that showed how rapidly Mr. Schuman is forging to the front among native composers of the day. Mr. Richter and his forces gave it a reading that was admirable in its tonal firmness and purity, the choristers singing with noteworthy diction and with sure intonation in music that made severe demands on the vocalists' sense of pitch.

If Mr. Schuman's prologue was the most completely satisfying of these compositions, the finest music of the concert was vouchsafed in the first half of the slow movement of Mr. Harris's symphony. Here Mr. Harris was really creative to a degree unapproached elsewhere on the program. The movement in question was built up on the device of canon, and unfortunately Mr. Harris's concern with the technical problems involved gradually led to obscurity after the superb opening half of this andante, which, had the composer been able to sustain his inspiration, would have resulted in a masterpiece.

### Other Works Are Heard

Mr. Copland in his overture displayed his usual intelligence, but, like the skillfully fabricated concertino of Mr. Piston, its bustling measures had little depth of meaning. Mrs. Harris gave a brilliant performance at the keyboard in Mr. Piston's concertino. Mr. Drake and Mr. Nordhoff also played in bravura style the latter's two-piano concerto, which was the least convincing of the works put forth in its peculiar admixture of poorly fused modern and conservative elements.

Mr. Smallens read the four compositions entrusted to his guidance with fine authority and deep understanding. His interpretations were replete with life, energy and human feeling. Each of the numbers presented met with a fervent welcome on the part of the large audience, and all five composers were called before the footlights.    N. S.

May 8, 1939

# BOSTON SYMPHONY OPENS SEASON HERE

## Koussevitzky Directs Program Devoted to Symphonies by American Composers

### CARNEGIE HALL IS PACKED

#### Brilliant Audience Applauds Long and Vigorously for Each Performance

### By OLIN DOWNES

Dr. Koussevitzky and the Boston Symphony Orchestra gave a program consisting entirely of American music at the opening concert of their New York season last night in Carnegie Hall.

To the best of the writer's recollection this is the first time that a leading orchestra of the country has devoted two of its subscription concerts exclusively to symphonic works by native composers. Dr. Koussevitzky believes that Americans have produced enough music and to spare that is worthy of such exploitation. He himself has been exceptionally curious as to the product and encouraging to American creative musicians from the time of his arrival in this country fifteen years ago.

In fact the entire program of yesterday evening consisted of works that the Boston Symphony Orchestra had already played at various concerts, although on the previous occasions they had been interspersed with European scores. These two programs of American music—that of last night and that which will be played tomorrow afternoon—represent a selection from one hundred and twenty-six compositions by forty-seven American composers which Dr. Koussevitzky has performed during his tenure of office at the head of the Boston Symphony.

### Works Vigorously Applauded

It is a pleasure to record, before statements of personal opinions of the music heard last night, that Carnegie Hall was packed for this occasion with a very brilliant and representative audience, and that each performance was long and vigorously applauded. How much of this applause proceeded from the sympathy of the audience for the native sons and how much was induced by playing so finished in technique and so glorious in its euphony and richness of color that much poorer music would have sounded with deceptive magnificence could be matters for debate. In any event, the occasion constituted a public welcome and an artistic triumph for the courageous step taken in the composition of the program.

This program consisted of Arthur Foote's E major suite for string orchestra, Walter Piston's "Concertino" for piano and orchestra, with Jesus Sanroma as soloist; Roy Harris's Third symphony and Randall Thompson's Second symphony. The music was full of interesting and suggestive contrasts. Each work was unlike the others, in technic, style, approach and development of subject-matter. And each was well written, and some put down with sheer virtuosity—above all, in this respect, the "Concertino" of Mr. Piston.

This might not have been the case twenty-five years ago in this country. Certainly, at that time, no program which presented one American composer no longer living but three in their creative prime would have demonstrated such craftsmanship and thorough acquaintance with the modern devices of the art. There were some pages, in different places, not as strong as others. But in no case was there technical ineptitude or amateurish orchestration. This program alone would have demonstrated that the day is past when any American composer need be told that he doesn't know his business.

### Importance to Future Seen

This is important; not only for the present, but even more important for the future, because it means that at last our composers have sharpened their weapons and learned how to use their tools.

However, the leading question is yet to be considered. Admitted all the highly creditable facts just cited, what had the composers to say?

The Foote Suite is charming, not highly original; in the first movement redolent of Schumann; in the second, the pizzicato, inescapably reminiscent of a certain familiar symphonic movement of Tschaikovsky; yet entertaining, written with sincerity, refinement and grace in the style of an earlier day; and, in the case of the final fugue—certainly the best of the three movements—constructed with genuine skill and created with musical passion. It is music. It grows and accumulates and sweeps to a climax —the work of a true maker of beautiful sounds, who long since won the high respect bestowed upon him in his lifetime and now accorded his memory.

Came the exhilarating technic and the nervous flight of Mr. Piston's highly modern "concertino." It is a work remarkably made, reminding one in some pages of Hindemith. It is not all polytonal counterpoint either. The middle part has a Hindemithian shadow, a dark and brooding quality, with much color, some melodic substance, but little actual invention.

Then the fast movement returns and there is an electrical conclusion. The thing is that this music remains dry, juiceless, in a sense academic; for you do not have to be somnolent to be academic, or even old-fashioned. This very expert music of Mr. Piston often ticks, and one feels a mild curiosity to take apart the clock-work. But the curiosity is only mild. There is more music, in this writer's belief, in other scores of Mr. Piston. The orchestral performance was of the finest; the piano part was played with soundest musicianship and fingers of quicksilver by Mr. Sanroma. As virtuoso and musician he would have deserved anywhere the homage he received.

Mr. Harris's symphony is a striking advance, according to last night's impression, over his previous work in the same form, and, indeed, over his other instrumental compositions that we have heard. It is much clearer, stripped to simplicities, shaped with great care. The opening is striking in the breadth, the fashioning and the spacious intervals of the main theme, not in itself distinguished or fascinating, but projected with a fine starkness, yet suppleness of line, against a meager tonal background. Some might say that the heroic bare hills and plains of parts of America could have inspired that. Others might discover in it more direct relationship to plainchant, of which Mr. Harris has made an earnest study in recent years. This introduction, however, demands much to complete it, and that "much" is not wholly forthcoming.

### Figures for Strings

There is a lighter passage of some length, with persistent waving figures for the strings, and short singing phrases put over them. But, while the sonorous effect is pleasing, the passage does not impress the listener as being more than a bridge for connecting two places. A passage that comes considerably later, an ostinato over a drum-beat, is the most immediately effective passage in the symphony. The final part falls short, because it does not really get anywhere. A short and explosive motto theme hurls out from brass instruments; it twists and turns about, in and on itself. Can one say that here, either, is a genuine musical fruition?

For us there is the spectacle of a highly encouraging advance over Mr. Harris's earlier symphony; of a work, written in one movement, but which, essentially, seemed almost to drop apart into an introduction and a three-section structure, which seems divided in parts none too well fitted together. Or, on paper, they may fit. But the eye is not the ear.

Mr. Thompson's symphony is commendable for its unaffected and spontaneous ease of manner, its real melodic content, its lack of portentousness. There is much in it that is Negroid, as for instance the opening theme; the "blues" song of the middle movement, so short, as though it feared to attempt development. One must admit that the scherzo is mostly a rhythmic figure which keeps repeating, while the listener says, "Good boy; but, now that you've got the preliminaries out of the way, what's your theme?"

### A Rythmic Profile

That theme does not materialize. It may be remarked that this would not be the first scherzo to hurry along without any real theme except a certain rhythmic profile. The best movement is surely the finale, the glorification of the singing theme, its alternation with other matter, and the peroration, which delighted the audience. It is a symphony which is slight of material, slight in other dimensions, but melodic, expressive, attempting no more than its nature justifies, expressing high spirits, sentimentality, zest. The ideas are mostly short-breathed. Sequences, as also in another way by Mr. Harris, are overworked, etc. But a symphony by a real musician, palpably an American, with an entertaining style.

The concert was rewarding, and not only to the composers, most of them present, and called in turn to the platform to acknowledge the applause.

November 24, 1939

---

## *Young Aide Leads Philharmonic, Steps In When Bruno Walter Is Ill*

A nation-wide radio audience and several thousand persons in Carnegie Hall were treated to a dramatic musical event yesterday afternoon when the 25-year-old assistant conductor of the New York Philharmonic Symphony Orchestra Leonard Bernstein, substituted on a few hours' notice for Bruno Walter, who had become ill, and led the orchestra through its entire program.

Enthusiastic applause greeted the performance of the youthful musician, who went through the ordeal with no signs of strain or nervousness. Artur Rodzinski, the orchestra's permanent conductor and musical director, who arrived at intermission time after motoring from his home in Stockbridge, Mass., declared the young man had "prodigious talent," adding that "we wish to give him every opportunity in the future."

Mr. Bernstein, appointed to his post at the beginning of the current season, was notified of Mr. Walter's illness in the morning by Bruno Zirato, assistant manager. Mr. Walter, who was said to be suffering from a stomach disorder, was to have been the guest conductor for the afternoon performance, broadcast over the Columbia network.

The young conductor, a native of Lawrence, Mass., and a Harvard graduate, had no opportunity for rehearsal before opening the program with Schumann's Overture to "Manfred." The program also included Rozsa's "Theme, Variations and Finale"; Strauss' "Don Quixote" and Wagner's Prelude to "Die Meistersinger."

Mr. Bernstein received hearty applause at the end of the Schumann overture, but was recalled four times when he concluded the Rozsa variations. The audience warmed increasingly to his performance during the remainder of the program and, at its end, was wildly demonstrative.

After the performance Mr. Bernstein disclosed that he had been told on Saturday evening that Mr. Walter was ill and that he "might" be called upon to take his place at Sunday's concert. The possibility

seemed remote, and the young man went to a song recital. When he got home, however, he decided to look over the scores of the Philharmonic program "just in case."

"I stayed up until about 4:30 A. M., alternately dozing, sipping coffee and studying the scores," he said. "I fell into a sound sleep about 5:30 A. M. and awakened at 9 A. M. An hour later Mr. Zirato telephoned and said: 'You're going to conduct.'

"My first reaction was one of shock. I then became very excited over my unexpected debut and, I may add, not a little frightened. Knowing it would be impossible to assemble the orchestra for a re-

hearsal on a Sunday, I went over to Mr. Walter's home and went over the scores with him.

"I found Mr. Walter sitting up but wrapped in blankets and he obligingly showed me just how he did it."

Mr. Bernstein said he was too intent on his work to feel nervous during the performance.

By a happy coincidence, Mr. Bernstein's father and mother, Mr. and Mrs. Samuel Bernstein, had come from their home in Sharon, Mass., to visit their son and so they were able to attend the concert. Mr. Bernstein's 12-year-old brother, Burton, also was with his

parents.

Mr. Bernstein attended the Boston Latin School before entering Harvard, where he majored in music, studying composition under Walter Piston and Edward Burlingame Hill and piano with Heinrich Gebhard. He was graduated in 1939.

He spent the next two years at the Curtis Institute in Philadelphia, where he worked under Fritz Reiner in conducting and Randall Thompson in orchestration. Continuing his piano studies with Mme. Isabella Vengerova, he was accepted by Sergei Koussevitzky and trained by him in conducting at the Berkshire Music Center at

Tanglewood, Mass.

He returned as Mr. Koussevitzky's assistant in the summer of 1942 after spending the winter season in Boston teaching, composing and producing a number of operas for the Institute of Modern Art in that city. It was during this season that his Clarinet Sonata had its first hearing.

Mr. Bernstein has been continuing his composing here for the last year and his First Symphony is to have its première under Mr. Koussevitzky with the Boston Symphony this season.

November 15, 1943

# SUITE BY COPLAND HEARD AT CONCERT

## Koussevitzky Conducts Boston Symphony in Composer's 'Appalachian Spring'

### By OLIN DOWNES

Aaron Copland's suite from the ballet "Appalachian Spring" was the most modern music on the program given by Serge Koussevitzky and the Boston Symphony Orchestra last night in Carnegie Hall. The music was heard for the second time here this season, and its repetition was more than welcome. For this is certainly one of the best of Mr. Copland's scores,

and of them all the most tender and poetical in character.

In it the folk element is strongly present; it is neither disguised nor disfigured by affectation. A modern composer takes this material as his own—as a musical substance that has for him a beauty as of today—and not as some archaic relic of an imaginary past. The music is simple and full of feeling. It is admirably orchestrated, with fine taste and a sure hand. Some of the movements become a little long and have a degree of sameness of coloring without the dancers on the stage. But the sum of it is a charming and sincere score, by a composer whose craftsmanship develops and acquires fresh distinction as he advances. The performance was a wonder of delicacy, finish and imagination.

Mr. Copland was present in the

upper part of the house and he was repeatedly called upon to acknowledge the applause.

The two classics of the evening were the Haydn G major Symphony numbered on last night's program, 88, and Brahms' Second, the latter work receiving a memorable reading. With Haydn it was not the same. His work sounded in the manner of a polite curtain-raiser to the entertainment to come, rather than the voice of Haydn the peasant-born, Haydn the architect and the virile precursor of Beethoven.

In other words, we like our Haydn rougher, more zestful, and with a broader humor. We do not like his slow movement taken so portentously, and we like to hear the off-key strokes of the violins over the drone bass in the trio of the minuet for what they are—broad strokes of shrewd peasant humor. Perhaps no other orchestra can play the finale with such finish and at such a tempo as this one. Granted, but let us have a

sharper edge to the jest, and not quite such polished manners.

Or was there the thought of contrasting Haydn, at the beginning, with the more rugged manner of Johannes Brahms, whose second symphony brought the end? The symphony was gloriously played. It also is primavera. Not only in the Appalachians was it spring! The performance of the symphony had equally the lyricism and the ruggedness of Brahms' style. Seldom has a conductor so sustained the great line of the slow movement, or imparted more grace, brilliancy, power, as the passage might be, to the whole work. Every voice in the orchestra sang; every instrument glowed with color refracted, as it were, from choir to choir. With this well-known symphony Dr. Koussevitzky and his men achieved a summit of their New York season.

April 11, 1946

# CHANGES IN BALANCE OF POWER

### By OLIN DOWNES

IT would be interesting, though beyond the confines of the present article, to trace the processes which have led, since the turn of the century, to the changes in he balance of musical power between Europe and America. Two world wars have been primarily responsible for this. They have resulted in successive developments of great importance to American music.

The first was the influx of leading foreign artists in the United States consequent upon the first World War—a process intensified by the events of the second conflagration, and still in operation. The second is the unprecedented cultivation and fostering of American musical talent, in both the interpretive and creative fields, today.

With the first of the two great wars, where artists of the concert hall and opera house were concern-

ed, America was on the receiving end. Most of the great virtuosos, as well as the great teachers, were overseas with the outbreak of hostilities, and in America's years of neutrality, many of these masters came here—and, in considerable numbers, stayed.

### Benefits to Us

They became citizens, and part of the musical life of the nation. Their presence gave Americans the opportunity for the most eminent instruction at home, which it had formerly been considered necessary to go overseas to obtain. This had an immense influence, and on the whole a decidedly beneficial one, on musical levels of performance and understanding in the land of their adoption. American musical development went forward more rapidly and intensively than ever before in the history of the nation. True, there were other reasons than those of the foreign immigration for this evolution, but none that affected more the quality of the musical fabric.

With the second World War came a new necessity. For the first time, with the complete inaccessibility of the musical market abroad, came the need for the American musician, composer or performer as he might be, to supply the public

its music. Metropolitan Opera singers, for instance, became in a preponderant degree Americans. In the concert field the native sons and daughters had less the ascendancy, but they too gained in prestige and patronage, even if we have still a distance to go to produce our Heifetzes and Horowitzes. The point is that at present American performers, conductors, composers receive a degree of opportunity and recognition that they never had before, and that at long last the extent of the musical talent latent in the nation, and the need of developing it are becoming widely recognized.

New activities are in evidence all along the line in this direction. One was noted recently in these columns in the establishment of two "apprentice" conductorships by George Szell with the Cleveland Orchestra. Another comes to hand in the announcement by Efrem Kurtz, of the Kansas City Philharmonic, of the engagement of eight young American soloists for the orchestra's "Pop" concerts next season, and the inference that this arrangement will be continued in seasons to come.

Mr. Kurtz believes that American composers, as a class, are now considerably in the clear. They re-

ceive numerous performances, scholarships, prizes, etc. For the conductors, who have had no simple time of it, he sees a future stemming from such a training centre as Koussevitzky's Berkshire Music Center, which has already launched some brilliant talent on its career, and other openings in this field, such as have been mentioned. But Mr. Kurtz thinks that the young American virtuoso needs opportunities of a more substantial kind than are now his for recognition, experience, and the establishment of a career.

### Young Artist's Dilemma

As an orchestral conductor, he has had experience of the young native artist's dilemma. By experience he knows that when the directors' board of an orchestra looks at the prospective list of soloists for the coming season it seeks, with entire logic, for names which spell box-office receipts. The orchestra has to be financed, and the yearly deficits, large or small, met by a board responsible for this eventuality. Mr. Kurtz is also fully aware that the orchestra's public looks for celebrated names when it buys its seats, and that managers with many artists on their lists find those musicians very difficult to

sell who have not a big reputation. It is a vicious cycle. No engagements without a reputation, no reputation without engagements. The concert business works most infernally that way.

Of course, it would be constructive, enterprising, and probably, in the final analysis, profitable for directors born with imagination and confidence, to put each season, side by side with the internationally celebrated artists, two or three young native musicians who prove their talent. But it is seldom that such bodies have either the initiative or the confidence in their judgment to do this. It is a hard condition to break through. The best way to do it is to seek talent among the young artists and then give publicity and the test of their talents in actual performance.

It would be illogical to take the inexperienced and immature artist, however talented, and put him in an instant in a position of comparison with a past master. For this reason, in making special provision for young artists who wait so long here for openings, Mr. Kurtz will give the eight whom he has selected appearances at the "Pop" concerts rather than the main subscription events of the winter. These concerts, as fully patronized as those of the more pretentious series, take place in Kansas City in the winter. Their programs consist half of classics, but are less weighty than those of the main series. A young and gifted soloist should add to their interest while the opportunity cannot fail to be of special value to the soloist.

June 30, 1946

# PREPARED PIANOS GIVE ODD PROGRAM

## John Cage, Inventor, Offers a Program of His Own Works Without Being Seen

John Cage, pianist, composer and inventor, who already had demonstrated his music for prepared pianos at the Museum of Modern Art and the New School for Social Research, last night took a step nearer the conventional concert hall. He presented a program of his music at Carnegie Chamber Music Hall.

Mr. Cage never appeared on the stage, but it was a one-man show nevertheless. As well as inventing the form, he managed the event, composed all the music, and prepared the five pianos so it was possible to play his compositions.

For Mr. Cage, "preparing" a piano means converting it into a miniature percussion orchestra by inserting dampers of wood, metal, rubber, felt and other materials between the strings. It is a painstaking business, for each damper is placed in a carefully gauged position, each composition requires a differently prepared instrument, and for each performance the piano has to be prepared afresh.

Yesterday it took Mr. Cage ten hours to get the pianos ready.

Once prepared, the pianos emit a series of unexpected sounds. Occasionally the sound is metallic, like the striking of a spoon on a frying pan, but most of the time the sounds are subdued and unresonant. At different times the instruments suggested last night Balinese gamelans, harpsichords, castanets, ticking grandfather clocks and water dripping in rain barrels.

There was a highly intellectual audience. One wit suggested the event represented "the dividing line between the peanuts and the caviar." But this was unfair. Mr. Cage is obviously a serious musician, and his prepared instruments opened up all sorts of new and undreamed of rhythmic possibilities and musical effects in a fascinating world of tiny sonorities.

He engaged two of the best among the current crop of talented young pianists to perform for him, Maro Ajemian and William Masselos. Together they played "Three Dances for Two Pianos" and went through the thirty-one-minute "Book of Music for Two Pianos." Alone Miss Ajemian played four of the thirty sonatas Mr. Cage has projected. As well as including prepared tones, these also had unprepared ones, or ordinary piano notes. The program will be repeated at the hall tonight.     R. P.

December 11, 1946

# RECORDS: NEW TYPE

## Long-Playing Disks Put Out by Columbia Are Improvement on Old

### By HOWARD TAUBMAN

AT least one aspect of the future in records has been tried, and it works. Columbia's contribution to making the life of the record collector pleasanter, its "Long-Playing Microgroove Record," appears to be nearly everything the ballyhoo has claimed for it.

This department has been conducting its own tests with the new record. A new Columbia Player Attachment has been connected to our phonograph, and ten long-playing disks chosen from the more than 100 the company has on the market were tested on the device. The regular records—shall we now call them short-playing disks?—were then played in the usual way for purposes of comparison.

The long-playing records gave excellent results. It is, of course, a luxury to have a whole symphony on the two sides of one disk. An efficient, modern record-changer approximates this effect, but there is always the inevitable break while the records are being shifted. With the long-playing record you have no hiatus during movements. The performance in your home—at least in its continuity—equals concert conditions.

### Question of Speed

The long-playing record, if you have not become au courant with its basic theory, has been accomplished by two developments. The new record is played at a speed of thirty-three and a third revolutions per minute, while the regular commercial disk travels at a speed of seventy-eight revolutions per minute. In addition, the new record has much thinner grooves, making it possible to get more of them on each disk.

Summed up in this way, the new records sound simple and, indeed, are simple to operate. But one gathers that it took years to perfect them. Columbia credits Dr. Peter Goldmark with developing them in cooperation with its own engineers.

Of course, it was not enough to develop the records. Once you had them, you had to develop a mechanism to play them. The familiar phonograph is not equipped to play records at the slower rate of speed, nor are its pick-up and needle delicate enough for the much thinner groove. Therefore, as part of the process of making its new long-playing records commercially feasible, Columbia had to see to it that a playing mechanism was made available simultaneously.

The Columbia Player Attachment—it is put out by Philco under its own trade name, too—is an uncomplicated little box with a turntable and a surprisingly light pick-up and delicate needle. Probably you could do the attaching yourself, if you are mechanically skillful; otherwise, it would be safer to call in an expert. Once attached, it works without difficulty.

### Good Machine Needed

The Columbia Player Attachment, the long-playing records and a good machine will guarantee you high-fidelity performance. But note well that a good machine is important.

The long-playing records, pressed on vinylite, produce a fine, authentic sound. Since vinylite is in use there is less surface noise than on the ordinary shellac disks. But in the last analysis, there is the same performance on the long-playing disks as on the shellac records. The same masters, we are told, have been used. It was a difficult technical and artistic problem to transfer the masters to the long-playing disk so that the breaks would be patched together imperceptibly. But a good job has been done.

Bearing in mind, then, that the quality of music and performance on the long-playing disk is high, the results you get in your home depend on your phonograph. It is only the higher and highest priced models that reproduce the lows and the highs in the frequency wave range. Too many, if not all, of the low-priced machines do not provide more than 4,000 to 6,000 frequency cycle maximum, which rules out good rounded quality.

### Disks Tested

This point is stressed because the value of long-playing record equipment in your home will be in proportion to the quality of the machine you have. The report in this corner this morning is based on testing with a first-rate phonograph with a maximum frequency of 14,000 cycles.

The ten long-playing disks we tested were:

**Brahms: Symphony No. 4.** Eugene Ormandy and the Philadelphia Orchestra.

**Music of Jerome Kern.** André Kostelanetz and his orchestra.

**Celebrated Operatic Arias.** Bidu Sayáo, with Metropolitan Opera Orchestra conducted by Fausto Cleva.

**Mozart Operatic Arias.** Ezio Pinza, with Metropolitan Opera Orchestra conducted by Bruno Walter.

**Bach: Concerto for Two Violins.** Adolf Busch, Frances Magnes and the Busch Chamber Players.

**Brahms: Concerto for Violin.** Joseph Szigeti with Philadelphia Orchestra led by Ormandy.

**Khatchaturian: Gayne Ballet Suites.** New York Philharmonic-Symphony conducted by Efrem Kurtz.

**Beethoven: Quartet No. 15, Op. 132.** Budapest String Quartet.

**Schumann: Piano Concerto.** Rudolf Serkin, with Philadelphia Orchestra under Ormandy.

**For You Alone.** Buddy Clark, vocalist of pop tunes.

### Greater Fidelity

In some cases, particularly the vocal works, one found better fidelity with the long-playing disks than with the older kind. In no case was the long-playing disk any worse than the older version. In short, the long-playing disk would seem to be here to stay. You may be sure that Columbia's competitors will be bestirring themselves to come up with something as useful.

The long-playing disk has advantages that are obvious. Any one who owns a lot of records knows what a storage and moving problem they pose. These light, new disks lessen that headache. Then there is the question of price. A twelve-inch long-playing disk costs $4.85, while an album of the same thing might run over $8.

The twelve-inch long-playing disk can capture about forty-five minutes of music; a ten-inch long-playing disk has a maximum of twenty-seven minutes. Now, if the inventors will see to it that the new machine turns over the long-playing disk automatically, there will be nothing left to do but listen.

*August 8, 1948*

---

## Menotti Opera, the First for TV, Has Its Premiere; Boy, 12, Is Star

### By OLIN DOWNES

The first television opera ever composed was produced last night in Studio H-8 in Radio City. It was Gian-Carlo Menotti's "Amahl and the Night Visitors."

Mr. Menotti with rare art has produced a work that few indeed could have seen and heard last night save through blurred eyes and with emotions that were not easy to conceal.

It may be said at once that if nothing else had been accomplished by this work, television, operatically speaking, has come of age.

The opera was commissioned by the National Broadcasting Company through Samuel Chotzinoff, musical director of that organization and the producer of last night's spectacle. It is story of the Magi following their star on their way to the Manger of the Infant Jesus, and the miracle that befell the beggar boy Amahl, who, picking up his crutches to send them as a tribute to the Holy Child, found on advancing to tender them to the wise men that he could walk.

Menotti in composing this tender and exquisite piece was inspired by the painting "The Adoration of the Magi," by Hieronymous Bosch, the fifteenth-century Fleming in the Metropolitan Museum of Art. His creation is itself in the spirit of a Flemish or Italian primitive, with its archaic simplicity and naiveté of effect, and the true emotion which is conveyed by the most unpretentious means.

The opera was worthily interpreted. The performances of the singing actors were crowned by that of the beggar boy—young Chet Allen, the 12-year-old soprano who made his first appearance on the television screen on this occasion. The clarity and tone quality of his accomplished singing were secondary to his remarkable acting and facial expression. Nor was this merely an imitative reciting of a lesson. The real feeling, the emotion, the moving representation of a young boy, fascinated by the sight of the Three Kings as they came in, watching the heavens and the shining star above the poverty-stricken hut, piteously defending his mother against hurt made, through all the mechanical devices of video, a throbbing personal communication.

The manner in which Mr. Menotti has measured the capacities and the limitations of video in its present state, and fitted his sound-play to them, is the highest testimony to his talent as a creator for any form of musical theatre. He has few characters to take up space. He can concentrate the camera upon each successive episode as a complete spectacle. The author of his own text as well as music, he has been able to secure a maximum of clean pronunciation and the matching of tone to text by all concerned.

### Intensifying Beauty in Music

The music is written often in recitative but with intensifying beauty at the climactic moments, as when the child walks and the King chants of the power and majesty of the Savior who needs neither gold nor might to establish his kingdom of love. But there seems no place in this cast carefully proportioned score which falls short of the required dramatic effect.

The choruses of the approaching and departing shepherds and other ensemble pieces are always poetical and atmospheric, never obvious or banal. Mr. Menotti has used no folk-airs or Christmas chants in this score but he has written delightfully and characteristically in his music for the peasant dances. His tune of the beggar boy's pipe, which begins and ends the play as he departs with the Magi on their journey, is one of his happiest ideas. A small chamber orchestra supplies the instrumentation, always effective and in excellent taste.

By the side of the performance of Chet Allen was that of the Three Kings, David Aitken, Leon Lishner and Andrew McKinley— three very human Kings, as Mr. Menotti meant them to be, without pretensions and with a stick of licorice in the chest of gifts for a small hungry boy. Francis Monachino, the servant, was admirable in the smaller part.

Mr. Menotti has told us that in his childhood his brother conceived of Caspar as being for some reason rather deaf, and Caspar last night had also this failing, and was humbly respectful to the admonitions of his brothers.

Rosemary Kuhlmann's mother is a moving portrayal, enhanced by the resources of her voice. She made occasionally the error of using too much tone, and this sometimes affected the distinctiveness of her enunciation. It was a small detail of a highly intelligent and authoritative impersonation.

There is, however, one significant disproportion in this very serious, original and artistic presentation. This creation is somewhat ahead of the present resources of television. Eugene Berman's sets are imaginative and suggestive, but they do not completely fulfill scenic requirements, or did not completely compass desired effects last night. Thomas Schippers's conducting was of the first order. John Butler's choreography for the rude peasant dances was precisely in the right vein, and accomplished with virtuosity.

With other technical aspects of the production this writer cannot profess to deal. He is concerned only with what he saw and heard. And what he saw and heard must be considered as a historic event in the rapidly evolving art of television.

*December 25, 1951*

---

## TOSCANINI DIRECTS WAGNER PROGRAM

### Distinguished Audience Fills Carnegie Hall for His Last Concert With N. B. C.

N. B. C. SYMPHONY, Arturo Toscanini, conductor. At Carnegie Hall. Wagner program.
Preludes to Acts 1 and 3 of Lohengrin; Dawn and Siegfried's Rhine Journey from Goetterdaemmerung; Overture and Bacchanale from Tannhaeuser; Prelude to Die Meistersinger.

### By OLIN DOWNES

Arturo Toscanini made his last appearance with the N. B. C. Symphony Orchestra last evening in Carnegie Hall. He thereupon concluded his long engagement as leader of that body, which was established for him, and officially ended sixty-eight years of a conductor's career.

In that space of time, this phenomenal musician and high priest of his art has achieved everything that such a master could logically expect to accomplish in his profession, and has enjoyed nearly every honor that a grateful public and the governments of the world could bestow upon him.

One of the most distinguished audiences to gather in recent years on any artistic occasion in this city assembled to pay him homage, anticipating the electrical effect that Toscanini, this season as in seasons past, has habitually communicated. These performances can be described without ornamenting the facts as among the greatest in Toscanini's career.

Yesterday, for whatever reasons, it was not so. It would be useless and beside the mark and disrespectful to this master to pay him false conventional compliments at this time. And whatever the reasons were, they were within Mr. Toscanini's mind, they were not due to any physical recession. Evidently he was conducting with other matters oppressing his mind.

### Decision Made Long Ago

Nor is it to be believed that only the circumstances of the official termination of his work with the N. B. C. Orchestra was accountable for his depression. Toscanini had long since decided to terminate his engagement for a regular series of concerts in the future. It was believed, however, and it is very much to be hoped, that he would be open to guest appearances on special occasions and at irregular intervals.

For there has seldom been a man of 87 so young, so virile, and so perfectly coordinated in hand, heart and mind, who remains so perfectly and completely the authoritative musician as he.

The man whose incredible reserves of strength have astonished those near him and who often fatigued the musicians of the orchestras by his energy and unceasing insistence for the supreme excellence before he would let them go, was yesterday, as an interpreter, not himself.

Mr. Toscanini was conducting a Wagner program. In the "Lohengrin" Overture, there was a degree of uncertainty and a moment of false intonation in the strings, unthinkable with Toscanini in a customary frame of mind. The "Siegfried" music went without a hitch, if also without the customary nuance

and atmosphere he bestows upon those pages.

At the last moment, Mr. Toscanini had made a change in the program which, although it was for the radio as well as those in the concert hall, went fifteen minutes longer than scheduled on account of the length of the Overture and Bacchanale from "Tannhaeuser" (Paris version) which he had listed at the last moment.

It is a long excerpt, and it ends with the softest sonorities, echoing as from the distance, of which strings are capable. As the sound faded farther in the distance, the conductor was bending his head, as if listening to something far away.

He continued, hardly bowing to the audience, with the "Meistersinger" Prelude. Here he appeared to give the orchestra few cues; balances were wrong, entrances were timid, for it was evident that the men hardly knew what he wanted.

With the last chord, the master hand, which has so long and gloriously held the baton, dropped it to the floor, as Toscanini, almost before the sound had stopped, stepped from the podium, left the platform, and never returned to the stage.

For the moment, at least, he chose to leave. But we need not have heard the last of Toscanini and his phenomenal interpretive powers, unless he himself decides so. Should this have been his permanent farewell to any kind of a public appearance, his name will remain supreme and his achievement immortally revered.

There has never been a more gallant and intrepid champion of great music, or a spirit that flamed higher, or a nobler defender of the faith.

April 5, 1954

# Music: Lady From Spain

### Local Piano Debut by Alicia de Larrocha

**Alicia de Larrocha**

ALICIA DE LARROCHA, pianist. At Town Hall.
Suite Francaise..........Herbert Murrill
Sonata in A flat, Op. 110....Beethoven
Carnaval..................Schumann
Three Spanish Songs and Dances
                          Surinach
Los Requiebros; Que o la Maya y el
Ruisenor; El Pelele.........Granados
El Polo; Lavapies; Eritana......Albeniz

ALICIA DE LARROCHA, a diminutive lady from Spain with the technique and stamina of a man, made her New York debut yesterday afternoon in Town Hall. Her program was not an easy one, but she played everything with security. It was after the intermission, however, with the Spanish pieces, that her playing really came to life.

In the Beethoven A flat Sonata and in Schumann's "Carnaval," especially in the latter, Señorita de Larrocha was always the skillful pianist, attending to the music in a businesslike manner, frequently turning a phrase with spirit, but never showing any great identification with the musical style. Planning rather than spontaneity was in evidence.

But in the Spanish group the playing was difficult to overpraise. It had style and skill, subtlety and color. Even in so long and difficult a piece as the "Requiebros" from the "Goyescas" set by Granados, Señorita de Larrocha carried the music superbly, never letting the immense technical demands distract her from the plasticity of the writing.

She had a way of idiomatically shaping a musical phrase that cannot be taught—a sudden dynamic shift, a note instinctively accented, a touch of the pedal, an application of rubato. Her rhythm was extraordinarily flexible. Obviously this music was in the pianist's blood. She invested it with a degree of life and imagination that not many pianists before the public today could begin to duplicate.

Fortunately her tone never lost color. Some artists who specialize in Spanish piano music bring a highly percussive touch to their playing, using the pedal sparingly and adopting a semi-detached type of fingering that makes the music sound angular. Señorita de Larrocha maintained a legato touch, except, of course, in those instances where the music called for abrupt attacks.

The "Suite Française" that unconventionally opened the program was composed by Herbert Murrill, a British composer and former music director of the B. B. C., who died in 1949. Very much in the French style, even to almost actual quotation from Ravel's "Tombeau de Couperin," it is expertly laid out for the piano. And that is about all that can be said for it.

H. C. S.

April 17, 1955

# BARTOK TRIBUTE

## Appreciation of the Composers' Music Grows in the Past Decade

*It will be ten years tomorrow that Béla Bartók died. A concert in his memory will be presented tomorrow evening at Columbia University. The following appreciation of the great composer has been written by a friend and associate.*

### By TIBOR SERLY

MUCH has been said about how Béla Bartók and his music were neglected during the years he spent in America. And though this now may be embarrassing as well as unpleasant to recall, it must be permanently recorded, if only for the sake of historic documentation.

On the other hand, rumor has had it, particularly in his homeland, that the Bartók family was constantly in dire straits, even going so far as to suggest that Bartók's illness developed as a result of fear for his future. This is grossly exaggerated. While Bartók naturally was concerned about his family —not having the security of a salaried position such as he had enjoyed as a professor in the Budapest Royal Academy of Music—it should be made clear that at no time was the Bartók family without adequate food and shelter in America. One probable reason for the false rumors may have been due to some casual acquaintance's having observed Bartók's Spartan, economical mode of living which to him, however, was perfectly normal, as one instance will well illustrate.

Bartók habitually purchased the cheapest manuscript music paper and never more than a few sheets at a time. Not only did he clutter the pages thick and full with his sketches, but besides would continually add more writing space by ruling out lines beyond the regular staff, to the very end of each sheet. It mattered not that he was later presented with reams of music paper gratis; he still continued relentlessly crowding the pages.

### Declining Popularity

Reverting to the neglect of his music, it must be reported that had it not been for an incurable disease that wore down his strength during the last two years to such extent that his friends became alarmed and were obliged to seek outside help, it is quite conceivable that his situation could have changed for the worse. For had he not bitterly stated, shortly before he became bedridden: "Not only do they not like my music, but they also do not like my piano playing."

Suffice it to say, his friends turned first to the American Society of Composers, Authors and Publishers for assistance. ASCAP not only responded generously, but knowledge of his plight brought sympathy and offers of help also from other sources. Thus a visit by the late conductor Serge Koussevitzky heartened and cheered him, and a commission to write a work for the Koussevitzky Foundation set him to work with a new lease on life. Later this was followed by other commissions, including one from William Primrose to write a viola concerto. It should be mentioned, however, that Bartók never accepted either commission fees in advance, nor would he consider offers of advance royalties from his publishers.

Nevertheless, Bartók continued to live on borrowed time for another two years, and not only rewarded the Koussevitzky Foundation with his Concerto for Orchestra, perhaps destined to become his most popular work, but composed three other major compositions, the Solo Sonata for Violin, the Third Piano Concerto and the posthumous Viola Concerto, before he died in New York.

The significance of this little story is that help came generously at the eleventh hour, not through recognition here of the greatness of the man or artist, but because we Americans, being a sentimental people, could not bear to witness the unfortunate

plight of a distinguished foreign musician without doing something about it.

In the decade gone by since Bartók died in exile from his native Hungary, I can think of no composer's music, comparatively unappreciated during his lifetime, that parallels the steady progress and speed with which Bartók's music has climbed to the top,

Bartók's real tragedy was not that the ever-conservative public could not appreciate his music. This has happened to others before and will surely happen again. It was the painful knowledge that in the midst of perhaps the most revolutionary half century, 1900-50, of iconoclastic changes music ever went through, Bartók's superior talent was all but obliterated by those legions of mediocrities of the experimental Twenties and Thirties who could have benefited most by the teachings engendered by his music. And without intent either to belittle, or to take credit away from, the contributions made in this century by several of Bartók's more illustrious contemporaries, the fact remains that Bartók during his lifetime had neither the following Stravinsky enjoyed among the avant-garde, nor the religious fervor, at times mounting to idolatry, that Schoenberg's disciples aroused. All the more astounding has been the unprecedented upsurge of Bartók's name during the past decade as a musical prophet as well as composer of genius.

September 25, 1955

# NOBLE EFFORT

## Louisville Does Its Best For Modern Music

### By HAROLD C. SCHONBERG

AT one point during the third annual Music Critics Workshop, which ended last Sunday in Louisville, a panel discussion got wound up in the distinction between art and entertainment. Robert Whitney, conductor of the Louisville Orchestra, got to his feet and faced the audience. "We are not the Brooklyn Dodgers," he testily said.

Mr. Whitney, American born and bred, would disclaim any animus against the Dodgers. His point was that box-office and entertainment value by themselves had nothing to do with the artistic results achieved by the commissioning program of the Louisville Orchestra.

And there is no doubt that musical communities throughout America have been watching closely, and admiring, the progress of the Louisville plan. From 1948 to 1953 the orchestra was commissioning five new works a year. After April, 1953, the orchestra began to work under the provision of a $400,000 grant from the Rockefeller Foundation. Twenty-eight annual commissions went into effect, plus ten student commissions, plus two full-length operas.

Lest it be thought that Louisville music-lovers subsisted only on modern music, it must be explained that a large percentage of it was presented in forty-two Saturday afternoon concerts. The public was invited, at 50 cents admission, to hear the new music. A faithful nucleus of approximately 200 invariably was in attendance. At the five pairs of subscription concerts, from October through March, one new work was on each program.

### LP Subscription

As originally conceived, the Rockefeller subsidy would be made self-perpetuating by means of LP record sales. Every month a disk has been released. The disks are not available individually; a subscription for twelve disks costs $65. Income from sales, it was hoped, would eventually cover the cost of the entire project. Unfortunately, the American public has shown no inclination to support the recorded series. A grand total of 605 sets has been sold since the inception of the plan. Which means that slightly under $40,000 has been taken in. Nearly half a million has been spent (the Rockefeller Foundation two weeks ago gave another $100,000 to the orchestra).

As a result of diminishing funds, the current season has been altered. As before, there will be the five pairs of subscription concerts. But the commissioning plan has been cut in half—fourteen new works instead of twenty-eight; six LP disks instead of twelve; one opera and five student commissions. The Saturday afternoon concerts have been reduced from forty-two to twenty-three. Rehearsals, however, have been doubled.

Charles Farnsley, ex-Mayor of Louisville and president of the orchestra, estimates that as it now stands, and with its present funds, the commissioning plan can exist for another three years.

Louisville has a problem. Any sales representative of a major record company would have laughed out loud at the mere possibility of selling enough sets of modern music, at $65 a set, to begin to approach the sum of money desired. To say that Louisville officials were a little naive would be the understatement of the year.

The quality of music also enters into the picture. On Oct. 7, the Louisville Orchestra presented its hundredth commissioned work. Nobody will pretend that the majority of those hundred works are of permanent interest. Nor could they be. But the record public, specialists aside, is not likely to spend a fairly sizable amount for disks that get a questionable reception in the critical press.

### The Risk

On the other hand—and when discussing modern music there always is another hand—the actual merit of the music in question is less important than the fact that the composer has had a forum. When you commission a work, you can't know in advance how it will turn out. It may be a masterpiece, it may be a dud. But it should be heard.

As yet, Louisville has not mobilized its Police Department to herd shuddering, shrieking citizens into the concert hall. Nobody has to attend the Saturday afternoon concerts. As for the subscription concerts: Wednesday nights are completely sold out, Thursday nights about three-quarters full.

Whether or not the Rockefeller Foundation will again support the project when the final $100,000 disappears is a question nobody can answer at present. If the foundation does withdraw its support, the orchestra is fully prepared to continue its program of new music as best it can. Whatever the final result, Louisville can glory in a stand well taken. Those responsible for the idea have fought the good fight, breaking away from the oppressive stagnation that has enveloped so many musical organizations.

October 16, 1955

---

## Concert of Novelties

MUSIC composed for the tape recorder was the most striking novelty in a concert made up almost entirely of novelties late yesterday afternoon at the Ninety-second Street Young Men's and Young Women's Hebrew Association. This was the seventh program in Max Pollikoff's adventurous series, "Music in Our Time: 1900-1956."

Vladimir Ussachevsky's "Piece for Tape Recorder" consisted of many musical and other sounds, which had been recorded, then distorted by electronic or mechanical means, and finally combined. His results were imaginative and extremely interesting.

There were two other first performances: a pair of Philip James' "Twenty Preludes for Piano" and Mel Powell's Second Sonatina for piano, the latter performed by the composer. The program also included Lester Trimble's "Duo for Viola and Piano," Willis Charnowsky's Sonata in B for piano and Otto Luening's "Trio for Flute, Violin and Piano."

E. D.

March 19, 1956

# Music: Russian 'Cellist in U. S. Debut

## Rostropovich Is Heard at Carnegie Hall

MSTISLAV ROSTROPOVICH, 'cellist.
Accompanied by Alexandre Dedukhin.
At Carnegie Hall.
Sonata in E minor ............... Brahms
Suite No. 6 for Unaccompanied 'Cello ........... Bach
'Cello Sonata ............... Shostakovich
Etude ............... Scriabin-Piatigorsky
Claire de lune: Minstrels ......... Debussy
Humoresque ............... Rostropovich

### By HOWARD TAUBMAN

MSTISLAV ROSTROPO-VICH, the Russian 'cellist, who made his American debut at Carnegie Hall last night, is the third of a kind. Like his compatriots, David Oistrakh and Emil Gilels, who were here earlier in the season, he is an outstanding artist.

Mr. Rostropovich does not stress virtuosity, though he can unleash enough to suit his purposes. He impresses with his musicianship; he makes an effort to say something with each work he undertakes. His formidable technique and particularly his command of light and shade are directed at expressiveness.

A tall, lean man of 29, the visitor has virtually no mannerisms in appearance or performance. With his slightly bald head and narrow, bespectacled face, he looks a little like Rudolf Serkin. He appears modest, and his playing has an essential modesty.

The tone is neither big nor luscious. Mr. Rostropovich can apply vibrato and draw a rich, singing sound from the 'cello, but his preference is evidently for a wide range of nuance within a relatively limited compass of soft to loud. When this listener heard him for the first time five years ago in Florence in a room at the Pitti Palace, the cellist's tone seemed bigger and his style more ardent. But Carnegie Hall is a great deal larger, and here the impression was one of delicacy and refinement.

If memory is to be trusted, one would say that Mr. Rostropovich's art has been maturing. He played last night with inwardness and subtlety. There was a suggestion that he had gone too much in the direction of finesse. If that is not the case, if refinement is his natural style, then he lacks the grand temperament that can enkindle an audience in a large hall.

The performances last night had the proportions ideal for chamber music in a smaller auditorium. In the Brahms E minor Sonata, the accompanist, Alexandre Dedukhin, also from the Soviet Union, kept the lid down on the piano, and then played discreetly. The piano had to be subdued because Mr. Rostropovich's playing was subdued in scope.

This sonata relies a great deal on the low strings, and Mr. Rostropovich refused to push the tone at the sacrifice of quality. In the triple fugue of the final movement, the balance was not too felicitous. On the whole, this was tasteful and sensitive but not stirring Brahms.

Mr. Rostropovich's credentials for pre-eminence were the security and musicianship of his performance of Bach's unaccompanied D major Suite. To get through Bach's suites for 'cello alone is a task in itself; to make music with them is the achievement of an artist. One might disagree with Mr. Rostropovich on details, such as the slow tempo in the Allemande and the lack of bite and fire in the Gavotte I, but what he did represented a consistent point of view.

The Shostakovich Sonata, trivial as music, showed the 'cellist in a more expansive mood, and in the Scriabin he poured out opulent tone.

April 5, 1956

# Russians Cheer U. S. Pianist, 23

**Van Cliburn**

Abresch

## Texan Wins Ovation for His Brilliance at Moscow Fete

### By MAX FRANKEL
Special to The New York Times.

MOSCOW, April 11—A boyish-looking, curly-haired young man from Kilgore, Tex., took musical Moscow by storm tonight.

Van Cliburn, a 23-year-old pianist, played in the finals of the Tchaikovsky International Piano and Violin Festival. He dazzled the audience with a display of technical skill that Russians have long considered their special forte. He added to it a majestic romantic style that his 1,500 listeners could not resist.

Mr. Cliburn had emerged from the first two rounds of the competition as the rage of the town. Nothing has been so scarce here in a long time as a ticket to his performance.

Militiamen were ranged in front of the Tchaikovsky Conservatory to keep order among the enthusiastic crowds. Members of the well-dressed audience greeted each other as influential persons for having managed to get to the concert. Standees filled the aisles into deep balconies. The conservatory's office was telling hundreds of callers:

"Cliburn is playing tonight.

Call back for tickets tomorrow."

When the young pianist finished his final piece, Rachmaninoff's Third Piano Concerto in D minor, he received a standing ovation. Even some of the jurors applauded. Shouts of "Bravo" rang out for eight and a half minutes until the judges permitted a violation of the contest rules and sent Mr. Cliburn out for a second bow.

Backstage, Emil Gilels, one of the leading Soviet pianists and chairman of the international jury in the contest, embraced the young American. So did other jurors, and Kiril P. Kondrashin, who had conducted. Members of the orchestra stood on stage to join in the applause.

Although six other young pianists were still to perform in the finals, including three highly rated Russians, conservatory students were shouting "First prize" throughout the ovation for Mr. Cliburn. Alexander M. Goldenweiser, white-haired octogenarian who is dean of Soviet pianists and a contemporary of Rachmaninoff, said he had never heard the concerto played better since Rachmaninoff last performed it. He walked down the center aisle mumbling "genius."

It is far from certain that Mr. Cliburn will win first prize in the competition. The nine finalists are all first rate and include another American, Daniel Pollack of Los Angeles. But Mr. Cliburn is clearly the popular favorite and all Moscow is wondering whether an American will walk off with top honors.

The results will be announced Monday.

The competition is not just another cultural event here. It has gripped the city as the baseball world series captivates Americans.

Mr. Cliburn, a graduate of the Juilliard School of Music who had been taught only by his mother until he was 17, lives at 205 West Fifty-seventh Street in New York. He is tall and thin and has a powerful twelve-note span. His physical endurance seems to be a match for his musical ability, for he performed two concertos and a shorter piece this evening only nine hours after he had played the entire program in rehearsal.

Besides the Rachmaninoff, he played the Tchaikovsky First Piano Concerto in B flat minor and a rondo composed for the competition by Dmitri Kabalevsky. The latter works are required pieces in the finals.

But it is generally conceded here that, despite his talent, it is the fact that he is the product of an American education that has propelled Mr. Cliburn to fame here. He has taken Moscow not only by storm but by surprise. The outcome of the contest seemed almost of secondary importance tonight.

April 12, 1958

# RICHTER, PIANIST, HEARD IN MOSCOW

## Much-Heralded Performer Does Not Disappoint in Concerto by Mozart

**By HOWARD TAUBMAN**
Special to The New York Times.

MOSCOW, May 19—Ever since this writer's arrival in this capital people have been telling him, "wait till you hear Richter." The reputation of Svyatoslav Richter, indeed, had reached the United States months ago. Tonight there was an opportunity to make his acquaintance. To put it simply, he is a superb pianist.

Mr. Richter appeared at Tchaikovsky Hall. The work was Mozart's D minor Concerto. The orchestra was the Moscow Philharmonic, and it supplied an accompaniment unworthy of the musician it was privileged to support.

Mr. Richter plays the piano with the emphasis on the inner meaning of a score. He is a brilliant technician, but you are scarcely aware of the ease and security of his command of the instrument. When one examined the performance in retrospect one realized only then that the marksmanship had been perfect.

His tone is pure velvet. He manages to keep it smooth and glowing even on a piano that needs a better bass and improved voicing. His sense of rhythm is wholly admirable—flexible within a classic framework. His phrasing is sensitive. There is a wealth of nuance, all bent to the demand of the music.

### A Searching Performance

This was a radiant, searching reading of Mozart's familiar score. Mr. Richter resisted any temptation to romanticize. He sang the slow movement with enamoring feeling and gave the agitated middle section irresistible tension.

The other movements were subtly differentiated. The first unfolded its bitter-sweet song with touching poignance, and the third had a delightful buoyancy. The cadenzas were exciting in their thrust and fire. Only a virtuoso could play with such temperament, and yet at no time did he allow virtuosity to become an end in itself.

It would be interesting to hear Mr. Richter in one of the big romantic concertos. Assuredly he is a Mozartean of the first order. How wide is his range? In Moscow there are many who insist he is the superior of Emil Gilels. One would say that he is the deep poet while Mr. Gilels is the virtuoso.

Lovers of the enkindling pianism should not get too excited about the possibility of hearing Mr. Richter in the United States. There is no immediate prospect of his being sent to America. At the Ministry of Culture they said today that he would be tied up with other engagements at least until 1960. He has not traveled outside the Soviet orbit thus far. Let us hope that the authorities will give Americans a chance to hear him.

May 20, 1958

# Music: Work by Carter

## Second String Quartet in Debut at Juilliard

**By HOWARD TAUBMAN**

WITH his Second String Quartet Elliott Carter rivets his right to be regarded as one of the most distinguished of living composers.

Mr. Carter is an American, but there is no need to speak of him parochially or chauvinistically. His quartet, which had its première at the Juilliard School last night, has no national boundary lines. It can stand solidly on its own feet as an authentic achievement of the imagination.

•

Mr. Carter, who is 51, has forged his own style. Its basis is a system that has been described as "metrical modulation," which was the foundation of the impressive String Quartet No. 1 of 1951. Under this approach, if one must attempt a simple explanation, continual changes of speed profoundly affect the growth and character of a work.

In the Second Quartet Mr. Carter has not been content to use a technique that worked so well for the First. He has set himself new problems, but one of his fundamental concerns has remained the creative use of polyrhythms. The four instruments have been treated with almost rigorous independence, and yet they interact to enrich one another.

**Elliott Carter**

### The Program

JUILLIARD STRING QUARTET. At the Juilliard School.
String Quartet No. 2 in A........Arriaga
Second String Quartet (first performance).....................Carter
String Quartet in C sharp minor, Op. 131 ....................Beethoven

The sum is greater than the parts.

The organization of this piece is complex. One could discant learnedly on the special intervals the composer has assigned to each instrument. Minor thirds, perfect fifths and major ninths, for example, are vital building blocks of the first-violin part, which is predominantly brilliant and aerial.

•

But details of construction are the private affair of the composer and students who wish to study his methods. For the listener it is important only to pay heed to what Mr. Carter has to say. His means may be intellectual, but his matter speaks to the heart.

The quartet does not yield its communication without some effort on the part of the listener. But to one who has heard it in rehearsal and examined the score it becomes more meaningful with each hearing. It has fantasy, humor, passion, tension and affecting gravity.

The section marked Andante Espressivo, the equivalent of a slow movement, is music of rare originality and beauty, and the final measures are filled with a sense of sad mystery. At the end one feels one has completed a momentous journey into a wholly new and magical land.

The quartet, which is about half the length of the forty-five-minute No. 1, is played without pause. Its main sections are joined by cadenzas for viola, 'cello and violin. It poses enormous technical problems to the performers, but the members of the Juilliard String Quartet—Robert Mann, Isidore Cohen, Raphael Hillyer and Claus Adam—played with remarkable authority.

They are excellent, dedicated musicians, and they have worked for weeks under the composer's supervision. But give credit to the Juilliard School, which had the foresight to create and keep the ensemble in being. In supporting such a unit, which played Arriaga and Beethoven at his greatest as well as Carter with high skill, the school discharges a duty to music. In its sponsorship of the première of a significant new work, the school functions with admirable responsibility.

•

There are honors to share on a broader front. The work, completed last May, was commissioned by the Stanley String Quartet of the University of Michigan, which gave up its rights to the first performance. But there is no reason to stand on ceremony about premières. This quartet has an excellent chance of long life. In time many ensembles will be proud to be associated with it.

March 26, 1960

# NEGRO CONDUCTS COAST SYMPHONY

## Henry Lewis First of Race to Lead Major Orchestra in Regular Concert

### By MURRAY SCHUMACH

Special to The New York Times.

LOS ANGELES, Feb. 9—Racial integration took a long step forward here tonight in the field of serious music. Henry Lewis, a Negro, conducted the Los Angeles Philharmonic.

It was the first time a Negro had conducted a major symphony orchestra at its home base during the regular concert season. Mr. Lewis will conduct once more here at the Philharmonic Auditorium this season.

Before tonight he had led the orchestra outside Los Angeles and he will be conducting it in six other programs in smaller California cities. His appearance tonight was greeted with an ovation.

"Too often talented Negroes have been reluctant to compete in this field because they were convinced their color would be counted against them," said the lean, tense conductor in an interview before the concert. "One of the most important things I can do now is to give to other Negroes the incentive to try to win positions with symphonic organizations," he said.

### Wife Is Soloist

The 28-year-old conductor, a double bass player with the Philharmonic, filled in for Igor Markevitch, who canceled his programs here because of his physician's orders.

An extraordinary aspect of this evening's concert was that the soprano soloist was his wife, Marilyn Horne.

A double bass player with the Philharmonic since he was 18, Mr. Lewis wanted to be a conductor when he was in junior high school. He formed the String Society of Los Angeles in 1958, using eighteen members of the Philharmonic. It was through this group that Mr. Lewis won the attention of George Kuyp.r, the manager of the Philharmonic.

Mr. Lewis was born in Los Angeles. At 4 he began studying the piano. At the Susan Dorsey High School here, he joined the school orchestra as a double bass player.

While majoring in music at the University of Southern California, he applied for a job with the Los Angeles Philharmonic. He auditioned and got the job when he was 18.

In 1955, he was drafted and assigned to the Seventh Army Orchestra in Germany, later becoming its conductor. Mr. Lewis returned to the orchestra in 1957.

### Dixon Conducted in '41

Dean Dixon of New York was the first member of his race to receive an important conducting engagement in this country. His first big chance came in 1941, when he conducted the N. B. C. Summer Symphony for a radio concert. This came to him largely because of an earlier concert at the Heckscher Theatre, which was called to public attention because Mrs. Franklin D. Roosevelt attended.

In the summers of 1941 and 1942 Mr. Dixon had single concerts with the New York Philharmonic at the Lewisohn Stadium and in the 1949-50 season.

Shortly after that children's concert Mr. Dixon, in discouragement, went to live in Europe. He made his home in Paris and conducted in Denmark, Sweden, Norway, Finland, Belgium, Austria and Israel. Four years ago he was made conductor of the Goteborg Symphony of Sweden. After leading it three years, he moved to take up duties in Frankfurt where he is now the conductor of the Hesse Radio Orchestra.

February 10, 1961

# STUBBORN YANKEE

## Ives' Iconoclasm and His Individuality Are Always American in Accent

### By HAROLD C. SCHONBERG

THE music of Charles Ives was in the news last week, what with Leonard Bernstein programing his Second Symphony with the New York Philharmonic, a group of his songs being sung at the Museum of Modern Art and "Decoration Day" being given at the Hunter College Assembly Hall. The latter work might well have been receiving its first New York performance. As for the Second Symphony, it was good news that Mr. Bernstein is making a repertory piece of it. He must like it: he previously had conducted it several times before with the Philharmonic, and he has recorded the work. Unlike the Third, the Second Symphony has not languished in complete neglect.

It is a remarkable piece of music. Flawed as it may be, it is one of the few examples of real nationalism that American music has produced. We have not had many true nationalists. The first one was Gottschalk, who died in 1869, and whose piano pieces amazingly anticipate the twentieth century in their use of folk and jazz-like elements (long before "jazz"). Then there is a long interim. Composers like MacDowell, William Henry Fry, Foote, Paine and the others, were German-oriented, and most of their music could have been written by any Kapellmeister.

### National Elements

What is nationalism? Does the mere fact that a composer latches on to folk-like melodies and rides along with them make him a nationalist? A composer like Aaron Copland, for example, has dived deep into Americana for certain works—"Rodeo," "Billy the Kid" and "Appalachian Spring." Yet Copland, with his restless intellect, is more a cosmopolitan than a nationalist. His bread-and-butter music does make use of national elements; but the abstract music he has written, represented by the Piano Fantasy and the Sextet, has little that is discernibly "American' 'in it.

Whereas a true nationalist, like Smetana, Dvorak or Mussorgsky, cannot write a note without betraying his country of origin. He may or may not use actual folk elements, but it makes no difference. Now, it may be that all music is nationalistic in that German music (Bach, Beethoven, Brahms) is quite different from French music (Couperin, Fauré, Debussy) or Italian music (Donizetti, Verdi, Puccini). But some composers have planted roots so deeply in their own plot of earth that they speak with an accent that is completely local.

Charles Ives (1874-1954) was one of those composers. Much has been written about his anticipations of devices used by later men. In the Eighteen Nineties he was happily splashing around in atonality, bitonality, stereophony, tone clusters and what have you. But that is not really the important thing about Ives. What counts is that he was able to express, in his unorthodox way, a vision of himself and a vision of America that no composer has come remotely close to approaching. Compared to him, Copland is a cowboy from Brooklyn in a Brooks Brothers suit, and Virgil Thomson is a Kansas City Parisian sipping tea with raised little finger.

### Part-Time Composer

Ives was a part-time composer, who wrote music on week-ends away from his insurance business. Despite the claims of some of his admirers, he was a very bad technician. Not only that, but some of his music is unplayable. And all of it is eccentric. The ear is liable to be assaulted with horrendous discords, and in the larger works the formal elements are crudely pasted together.

But through every measure shines a fascinating complex of the elements that made Ives tick. In his music is the damndest conglomeration of folk tunes, hymn tunes, popular melodies, anthems, mysticism, Thoreau, Emerson, Whitman, New England Yankeeism and plain orneriness. Melodic snatches bump into each other and depart without apologizing. Or they march abreast, in different keys, defiantly going their own way. None of this bothered Ives, who always considered the intent and meaning of a phrase much more important than how it sounded. In 1931 an orchestra attempting to play one of his pieces completely broke up and ended in chaos. Ives listen.d admiringly. "Just like a town meeting — every man for himself. Wonderful how it came out," he said.

### Influences

He got this kind of listening habits from his father, a Civil War bandmaster. His father later conducted a choir and had great admiration for one of his singers, a stonemason named John Bell. Bell never could sing in tune, but that was not important to the elder Ives. "Look into his face and hear the music of the ages," he said. "Don't pay too much attention to the sounds. If you do, you may miss the music. You won't get a heroic ride to heaven on pretty little sounds."

Ives, like his father, grew up despising pretty little sounds. Part of it was reaction against the Harvard school of composers (Ives studied at Yale) with their genteel ways and their harmonic timidity. Part of it was sheer eccentricity. Part of it was the need to strike off on new paths. Part of it was genius.

And as Ives did not depend

141

on music for a living, he could do what he pleased. Which he did, but if ever there was a composer who worked in a vacuum, it was Charles Ives. The bulk of his music falls between 1896 and 1916, but he did not get a performance of an orchestral work until 1927.

Much of his work remains in manuscript, and pretty near undecipherable manuscript at that. He himself published some of his music, giving the edition away to anybody who was interested. (Note to publishers: Ives' own editions are long out of print and unavailable. Anybody interested?)

He was the most American of composers because America was the warp and woof of his soul, and he was not ashamed of it. With complete un-self-consciousness he would throw together snatches of "Turkey in the Straw," "America the Beautiful," "Camping Tonight," "Dixie" and "Yankee Doodle," mixing them up and shaking well, harmonizing them with ferocious dissonance. It is this constant emotional polyphony, a sort of musical *recherche du temps perdu*, that makes his music so distinctive. He used these elements not for local color—that was the last thing

in his mind—but because they were his speech and the very accent of his speech.

Some of his music fails to come off. Some of it, though, rises triumphantly over the hedges of technical impossibilities and just plain bad writing. The Second Symphony, the marvelous String Quartet No. 2, "The Unanswered Question," "Three Places in New England" —the more one hears scores like these, the more one realizes he is in the presence of an unusual, undisciplined if you will, genius; a combination of primitive and sophisticate and rugged individualist.

Insurance was his business; art was his life. If he was an iconoclast, it was through the bitter necessity of having to write music that nobody wanted to hear. That did not cause him to lose confidence. He was a fighter and a stubborn Yankee. Once he made up his mind he was in the right, he grimly followed the course he had to follow. "Keep up our fight—*art!* —hard at it—don't quit because the ladybirds don't like it," he once wrote. The ladybirds didn't, and still don't; but his fight goes on.

March 5, 1961

# Philadelphia Boy Is Hailed in Debut as Pianist

## Youth Substitutes for Glenn Gould at Philharmonic

**By ROSS PARMENTER**
Special to The New York Times.

NEW YORK.
The audience that assembled at Philharmonic Hall Thursday night had expected to hear Glenn Gould in two piano concertos. Instead it heard a single concerto played by a 16-year-old pianist most of the listeners had never heard of.

But if there were some who were disappointed at the start, the demonstration for the young man at the end of the program showed that there were few who felt short-changed.

Not only did Andre Watts — for that is his name — play extremely well, but there was the added excitement that always attends the appearance of a major new talent. In this case, too, it was intensified by the dramatic circumstances behind his unexpected opportunity.

The youth, who comes from Philadelphia, is a student of Genia Robinor at the Philadelphia Musical Academy. He first played with the Robin Hood Dell orchestra at the age of 9, and last year he was a soloist with the Philadelphia orchestra. The time seemed ripe to try out for a New York engagement. Accordingly, he came here to audition for an appearance at one of the Young People's Concerts of the New York Philharmonic.

### Made Impression on TV

Helen Coates, who screens the applicants for Leonard Bernstein, was impressed with the Philadelphia boy's talents. When Mr. Bernstein heard him, he was impressed too. He engaged him to play the Liszt E flat Concerto at the "young performers" program of Jan. 12 — a program, incidentally, that

Associated Press Wirephoto

Conductor Leonard Bernstein has approving pat on head for Andre Watts after concert

was telecast three days later. Andre made a hit, with both the concert auditors and home viewers.

On Tuesday, Mr. Gould let the Philharmonic know that, because of illness, he could not fulfill his engagement with the orchestra this week. A replacement was needed on short notice. Mr. Bernstein, who got his first big break through another person's illness (Bruno Walter's), thought of Andre. He was willing.

And when he played those first ringing chords of the Liszt on Thursday night, it was obvious, too, that he was able. Those chords had splendid ringing sonority. After the opening display of power, there came a ravishing modulation to poetic lyricism. The young man made the ensuing gentle passages sing exquisitely.

When the music grew fast, he displayed still another facet of his gifts, for he made the music dance along with infectious

playfulness and rhythmic life. And his playing, perfectly disciplined though it was, seemed wonderfully spontaneous. No wonder a cheer went up at the end of the concerto. The men of the orchestra joined in the approval. In coming back for his bows, the young pianist was poised and boyishly appealing.

Andre, who has been described by Mr. Bernstein as looking like a Persian prince, is half American and half Hungarian. His father, Herman Watts, is a United States soldier, who, while stationed in Germany, married a Hungarian girl. The boy was born in Nuremburg and his parents brought him to this country at the age of six. He is now a student at the Lincoln Preparatory School in Philadelphia.

For many of the listeners the program contained a shock as well as a surprise. Not having the newspapers to read, there were many who did not know that Francis Poulenc, one of

France's greatest composers, had died on Tuesday. They gasped when Mr. Bernstein mentioned it in explaining that the orchestra would pay its "memorial respects" to the composer by opening with Bach's "Kom susser Tod."

Schubert's Fifth Symphony and Aaron Copland's "Connotations for Orchestra" were the only anticipated pieces on the program, as Strauss's "Don Juan" was substituted for one of the concertos that Mr. Gould had been expected to play.

The Copland work, thought still jagged and dissonant, made a far more favorable impression than it did at its premier on Sept. 23, the night Philharmonic Hall opened. The composer was present to acknowledge the applause. However, it was young Mr. Watts who was the chief excitement of the evening.

February 2, 1963

# Our Changing Musical Language

### By HAROLD C. SCHONBERG

QUITE a few serious people are worried about the direction music has been taking, and one of them is Howard Hanson. Not long aggo that veteran composer and teacher was interviewed by Albert Goldberg, the critic of the Los Angeles Times. Among other things, Hanson made the point that the major triad—C, E, G and its equivalent in any key—"is to music what such words as God and love are to language. When a composer for 20 minutes or more on end assiduously avoids a common word, he does not have a vocabulary, and he is not increasing the vocabulary. Rather he is throwing away a vocabulary that has served many masters well."

And so forth. It is not a new argument. Nor is it an especially cogent one. Language is constantly in the process of change, and that goes as much for musical as for spoken language. The point is that composers all over the world *have* evolved a new vocabulary, and it is one in common use. Hanson may not like it, the public may not like it, most musicians may not like it—but there it is, and it is being used. It is heard from all the advanced composers in this country today, and it is a common speech, shared alike by the participants in Gunther Schuller's Twentieth Century Innovations series, in Lukas Foss's Evenings for New Music, in the Group for Contemporary Music holding forth at the McMillin Theatre of Columbia University.

How to describe this speech? It is an international language (heard in Cologne, Darmstadt, Berlin, Milan, Paris, Rio de Janeiro), immediately recognizable to any listener who has had any reasonable exposure to it. It is even a very fashionable speech. Mostly it stems from Webern and is rooted in dodecaphony. But nobody—or hardly anybody—writes strict Schoenberg or Webern dodecaphony any more. There are regional accents. In France the language has grown out of Webern by way of Boulez. In Germany, Webern by way of Stockhausen and Cage. In America, Webern by way of Babbitt and Cage. Milton Babbitt, who is scarcely a household name, has probably been the greatest influence on the shaping of avant-garde post-World War II American composers. John Cage, accepted more in Europe than America, has also exerted a great deal of influence. But his stems more from Dada than anything else.

The language involves many things. Total organization plays a part. Here not only the notes, but the rhythms, silences, textures and, indeed, every factor of the composition are organized according to—loosely—serial principles. In serial music the entire composition is based on the initial tone row of twelve notes—the series, hence the term "serial"—that the composer has devised. (This is a loose definition, and today many composers have broken away from the strict twelve-tone row established by Arnold Schoenberg and his pupils.)

Along with total organization, there is the opposite—aleatory, in which the performers themselves are free to improvise within certain bounds set by the composer. All of this music has certain things in common. The language calls for highly disjunct lines in which melody in the traditional sense is pulverized. These composers are looking for different things than melody. Rhythms, too, are pulverized. Dissonance is total. The avant-garde composer avoids any hint of consonance with the same determination that a minor 18th-century composer avoided any hint of dissonance. Like it or not, it is a language and it has a vocabulary; and the younger generation throughout much of the world are eagerly speaking it.

It is a strange turn that music has taken, and it is understandable that many resist it. Only 30 years ago we in America were set for a musical renaissance. Copland, Piston, Barber, Schuman, Harris—these were the composers who were going to be the backbone of a great new American school, along with Thomson, the emergent Mennin and Dello Joio, and a dozen others one could mention. Then came the war, the discovery of Webern and the rediscovery of Schoenberg, and all of a sudden music took a right-angle turn. There had been nothing to indicate such a departure, and almost immediately the American Big Five found themselves in the backwash.

Except for Copland, they have remained in the backwash, in that they have just about nothing to communicate to the younger men. They are played, they get respectful attention (as Old Masters should), but it is to the banner of the Babbitts and Carters, the Nonos and Stockhausens, the Cages and Bussottis, the Boulezes and Barraqués, that the post-war generation has flocked. A parallel development occurred in painting and sculpture. Curt Sachs always did maintain that music never lagged behind the other arts, as had been believed.

## Safe Ground

But where the avant-garde in painting and sculpture has swept the public as well as the creators of the Western world, the avant-garde in music has not. And here skeptics like Hanson are on safe ground wondering where it all can lead to. Back in the nineteen thirties, the big men of music—the American Big Five, Bartók, Prokofiev, Hindemith, Stravinsky, Poulenc and the others—were constantly being discussed, written about and played. They had a relatively wide public, and some of them had a really big one. That does not exist today, at least in the musical avant-garde. Hanson has a right to be disturbed when he observes "a group of composers writing for each other or for a precious audience of 100." In New York the figure is a little higher, but not by much.

Up to our generation, the history of music has showed that every important avant-garde composer made a sizable public impact. His works may have been derided in some circles, but they always were praised in others. For every opponent there was a supporter, and that applied as much to Chopin, Schumann and Wagner as to Stravinsky, Prokofiev and Bartók. Yes, even to Arnold Schoenberg. They were public figures. Their music was played and discussed, and even if the large public did not at first like what they wrote, at least they did not write in a vacuum.

Whereas today the very names of the American musical avant-garde are unknown to the public at large. The one exception might be John Cage, whose ability to get into the news is a kind of genius in itself. Otherwise there are Feldman, Young, Martirano, Wuorinen, Sollberger, Powell, Subotnick, Myrow—but why go on! Not one of them has captured the imagination of the public. And while it is most dangerous even to hint at equating a composer's worth with his public acceptance, the fact remains that the musical avant-garde in this country is an inbred group that, despite wild activity, has not been able to make a dent in the armor of public indifference that surrounds it. And that, rather than the new vocabulary, is an indication that the members of this group may be on a road to nowhere.

January 31, 1965

---

## INTREPID DUO PLAYS BACH FLUTE SONATAS

Jean-Pierre Rampal, flutist and Robert Veyron-Lacroix, harpsichordist, an intrepid duo, indeed, undertook to play all the Bach flute sonatas in their program at Philharmonic Hall last night.

It really doesn't matter that three of the sonatas—C, E flat and G minor—are dubious Bach to some musicologists. Custom has long since decided that they are to be grouped as "the seven Bach flute sonatas," and that's how they were given last night.

Whether all seven stretched end to end reach as far as any one taken separately is debatable.

Mr. Rampal was his usual effortless self, and his pure, shimmery tones never had a flaw on them. Mr. Veyron-Lacroix tinkled energetically in the background. As a duo, their style is urbane and aristocratic to an extreme.

To such an extreme, in fact, that style sometimes takes over from musical content, particularly in fast movements, where vulgar emphasis is never allowed to humanize the perfect flow of sound.

But is it difficult to fault Mr. Rampal—his technique and tone production are so remarkably even. One listener hit the nail on the head during intermission: "Imagine what he'd do for the V.F.W. fife and drum corps!"　　　　T.M.S.

December 12, 1966

## Music

# Beethoven—and R. Rodgers

By HAROLD C. SCHONBERG

EVERY year sees the publication of the Broadcast Music, Inc., Orchestral Program Survey, worked up in collaboration with the American Symphony Orchestra League. Both BMI and ASOL are vitally interested in the repertory played by American symphony orchestras. How much contemporary music is being played? What is the ratio to standard music? Who are the most - programmed classical composers? Modern composers? In which direction is the symphonic repertory heading?

Important questions; and eight years ago BMI and ASOL culled 74 orchestras and presented the results. Onward and upward. In the current survey, there are 557 American and Canadian orchestras, and 5,684 concerts have been studied and tabulated. That meant 23,126 performances of individual works. An awful lot of secretarial work and a very large number of file cards went into the current survey. (There were some errors along the line, with things like the Bizet C major Symphony listed among works composed after 1940. On the whole, though, the tabulations are accurate.)

*

As always, the results make provocative reading. Of the 23,126 individual works, 13,955 were composed before 1900; and 9,171 belong, chronologically, to the twentieth century. That means only a 60-40 ratio in favor of the standard repertory, a rather amazing figure. But it is somewhat less amazing when the specific content is studied.

Let's look at the standard repertory first. That, at any rate, holds no surprises. The five standard composers most performed were, for 1966-67, Beethoven, Mozart, Tchaikovsky, Brahms and Bach. And the five specific works most performed were Brahms's Symphony No. 1, Beethoven's "Egmont" Overture, Mozart's "Marriage of Figaro" Overture, Tchaikovsky's Symphony No. 5 and the Brahms Symphony No. 2. And so down the list with the usual symphonies, concertos and overtures. It should be emphasized that the BMI survey reflects the taste of the country, not of New York. For instance, the New York symphonic scene in the last five years or so has been dominated by the revival of Mahler and Bruckner, the former especially. But in the survey, Mahler first appears far down the list, with his First Symphony. Bruckner turns up even lower. During 1966-67 his most popular orchestral work with American and Canadian orchestras was his Ninth Symphony, but it turns up as No. 133 on the list (the Mahler is No. 81). Beethoven's Fifth Symphony, incidentally, is No. 10. Not many years ago it automatically would have been No. 1. Schubert's "Unfinished" is No. 28.

*

In handling the modern side of the repertory, the BMI-ASOL survey breaks the content into two categories: the period from 1900 through the 1966-67 season, and the period after 1940. In the former, the most-played composers were Prokofiev, Stravinsky, Ravel, Copland and Bartók, with Richard Rodgers running a close sixth. But if pieces of music composed after 1940 are studied, the composer most frequently played by American and Canadian symphony orchestras was—Richard Rodgers, followed by Copland, Bernstein, Schuman and Leroy Anderson. Hm.

Again going back to the 1900-1967 period, the five most popular works were the Mussorgsky-Ravel "Pictures at an Exhibition," Morton Gould's "American Salute," excerpts from Stravinsky's "Firebird" Suite, excerpts from Rodgers's "Sound of Music" and Glière's "Russian Sailors' Dance." Now take the period from 1940 on. The five most popular pieces were Gould's "American Salute," Rodgers's "Sound of Music," Bernstein's "West Side Story," Loewe's "My Fair Lady" and the Ives-Schuman "Variations on America."

Now, not even the most voluble admirers of Messrs. Gould, Rodgers, Bernstein and Loewe are going to maintain that their heroes are among the most significant contributors to twentieth-century music. Then who are? Well, the consensus of musically literate persons would indicate Stravinsky, Schoenberg, Bartók and Prokofiev as four of the most important creators of the twentieth century. And in the period after 1940 the list would include composers like Webern, Berg (though, of course, he died before 1940, but his influence became strong after World War II), Boulez, Babbitt, Stockhausen, Cage, Nono, Dallapiccola and Berio, to take an assorted handful. How do they fare in the survey?

*

They don't, hardly at all. Take away Stravinsky's "Firebird" and "Petrouchka," and the man widely regarded as today's greatest living composer is low down on the list. During 1966-67 the orchestras represented in the BMI-ASOL survey did not present any of his most recent works, did not see fit to play anything later than "Agon." Schoenberg first makes his entry far down the list, with his Five Pieces (Op. 16), and toward the bottom there are sporadic performances of other works. Bartók and Prokofiev stand very high, however, and so does Shostakovich. Ives is rather low on the list.

There are no listings for music by Boulez, Cage and Babbitt, none for Nono and Berio, a scattered few for Dallapiccola, none for Stockhausen. It must be conceded that most of these composers do very little writing for symphony orchestra, though that does pose the question of cause and effect. None of them would turn down a commission for an orchestral work. They all would compose orchestral works if there were any chance that their music would be performed. But even the prestigious Boulez, whose "Marteau sans Maître" is considered one of the most significant orchestral works of the postwar period, does not seem to be able to crack the American repertory. Generation gap? Credibility gap? So the avant-garde, making a virtue of necessity, continues to compose for small ensembles, often loudly protesting that the symphony orchestra is dead. The logic seems to be that if orchestras and audiences do

not want their music, it is proof of the decadence of the Establishment.

\*

In the meantime, the contemporary symphonic repertory is being filled out by excerpts from Broadway musical comedy and even film scores. That too is unhealthy. We are in a peculiar age. The public continues to reject the new music, and in particular the new music of the serial school. That includes Stravinsky. The bigger men of the more conservative school, Britten and Shostakovich above all, hold their own, but nobody seems to be coming up to replace them. Some veteran American composers have all but ceased production. The PMI-ASOL survey of the twentieth-century repertory is dispiriting, and that promising 60-40 ratio does not mean a thing, not when "West Side Story," "Fiddler on the Roof" and other such scores are high up on the list of twentieth century works played by American symphony orchestras.

March 10, 1968

## Barenboim Displays Maturity In 3 Beethoven Piano Sonatas

### By ALLEN HUGHES

What is one to say of a 25-year-old pianist who plays Beethoven with the maturity of a performer twice his age and so splendidly that his achievements might well be envied by most pianists of any age?

Well, one could give his name, which is Daniel Barenboim, and report that he appeared at Carnegie Hall last nigh in the course of his 10th tour of the United States. His program consisted of the Sonata in D (Op. 10, No. 3), the "Appassionata" Sonata (Op. 57) and the Sonata in C minor (Op. 111).

The logic and execution of Mr. Barenboim's performances left no room for argument. This is not to say that everyone would necessarily prefer his interpretations to those of other performers. It is to say, rather, that they were absolutely right in themselves, and that his projection of them was totally convincing.

Skeptics should have heard Mr. Barenboim's slow movement from the Sonata in D for an impressive demonstration of the richness of his musical insights. This is a piece that for a long stretch has very few notes, and there is no easy way out of it. The pianist either finds something significant in the scant supply of notes or does not; there are no flashy or fluttery passages to distract the listener. Mr. Barenboim found the drama of the piece and gave it eloquent expression.

Since the Argentine-born Israeli pianist is a master technician and superb musician, it followed almost automatically that something like the "Appassionata" and even the Op. 111 would take shape easily and properly as he played.

If his interpretations here seemed less revelatory than in the D major, it was probably because these two bigger sonatas are played more frequently by artists of stature and there is less opportunity for revelation in them nowadays than in the other work.

March 30, 1968

# George Szell, Conductor, Is Dead

Photomontage of George Szell conducting the Cleveland Orchestra at Carnegie Hall, 1959

### By DONAL HENAHAN

George Szell, conductor of the Cleveland Orchestra since 1946, died last night in Hanna House of University Hospital in Cleveland, where he had been under treatment since June 16. He was 73 years old.

Mr. Szell had entered the hospital with a fever of unknown origin after returning with the orchestra from a Far Eastern tour. It was discovered that he had suffered a heart attack and had bone cancer. Because of the heart attack, no operation to halt the cancer was possible.

The conductor, who in his 24-year reign as music director built the Cleveland Orchestra into what many critics regarded as the world's keenest symphonic instrument, never courted popularity. Particularly among musicians whom he faced as a guest conductor, his reputation was that of a ferocious bully, a fearsomely intelligent pedant and a martinet.

But one Cleveland player, the principal clarinetist Robert Marcellus, put the man and musician in clearer perspective: "Everybody knows that Szell is a terrifying authoritarian of the old school, but they also know that he is an artist of terrific ability."

Even when past 70, Mr. Szell (pronounced Sell) looked the part of the podium tyrant. An inch over 6 feet in height,

erect and sinewy of figure, his balding head ringed by an aureole of white hair, the Budapest-born conductor exuded the imperious air of a Nazi submarine commander in an old war movie. (In fact, he was a fierce anti-Nazi and a wartime refugee.)

Orchestras responded to him by producing sounds that seemed to match Mr. Szell's concert-hall image: lean, precise, structurally lucid, severe and incredibly rich in detail. Always the boss, Mr. Szell seconded the Toscanini dictum: democracy in politics, aristocracy in music.

Like Brahms, he believed that "a symphony is no joke." The various sounds to be blended into orchestral tone were weighed as on an apothecary's scale. His ideal, he once said, was to become so much a part of the score that intellect and emotion would merge. A real conductor, he believed, must "think with the heart and feel with the brain."

From behind thick glasses, Mr. Szell's rather bulging eyes watched his musicians so closely that they referred to him as "Cyclops." In his first season as leader of the Cleveland Orchestra in 1946, he dismissed 12 of the 94 musicians. His rehearsals, following the Tosca-

nini tradition, were legendary — tense and sometimes sharpened by what Martin Mayer in a New York Times Magazine article described as "an imaginative command of obscene English." First-desk players, the cream of the orchestra, were addressed by name; others answered to such titles as Mr. Bassoon or Mr. Triangle. Some of the rank and file bridled at that.

Mr. Szell idolized the memory of Toscanini, and contended that the Italian conductor had done more to purify musical taste than any other musician in recent times.

Mr. Szell was not, however, an angry baton-breaker in rehearsal. Far from breaking or throwing batons, he coddled them, scraping them with sandpaper until they were narrow and sharply pointed. He liked them less than a quarter-ounce, and balanced.

### A Swordsman's Lunge

With this sharp baton he made incisive patterns that his musicians could read instantaneously, without having to wonder at what precise point in the downbeat, for instance, he meant the music to begin. Some of his baton technique was idiosyncratic but extremely suggestive and effective: For a particular kind of climax, he would lunge forward from the hip with the sharpened stick, like a swordsman.

His wit was pointed, too. Asked why he did not conduct programs entirely devoted to contemporary music, Mr. Szell explained, "I do not believe in the mass grave of an all-contemporary concert." When Philharmonic Hall, an acoustical disaster at its opening, was given its first remodeling in 1963, the conductor's opinion of the change was solicited.

"Let me give you a little simile," he said. "Imagine a woman, lame, a hunchback, cross-eyed and with two warts. They've removed the warts."

His humor could be cruel, some people complained. When he was told that one of his violinists had taken a bad fall down a flight of steps, Mr. Szell's question was, "Did he break his fiddle"

### He Was Not Amused

Early in his Cleveland career, in 1954, he failed an important sense-of-humor test in that baseball-mad city. The Cleveland Indians had just won the pennant, and the orchestra decided to greet Mr. Szell's first downbeat at rehearsal with "Take Me Out to the Ballgame." The conductor was appalled. "No, no. The Mahler comes first," he exclaimed.

Later, Mr. Szell defended his sense of humor by contending that he would have laughed if he had recognized the tune—a dig, perhaps, at the quality of

the performance as well as a reminder that he was not native-born.

George Szell was born in Budapest on June 7, 1897. His father, a Hungarian businessman and a lawyer, discovered when the boy was 7 years old that he could write down tunes after hearing them only once, and pushed him into musical training.

Even before that, at 4, George had shown aptitude for his life's work, supervising his mother's piano playing and correcting wrong notes by tapping her wrist. The pedagogic urge, often pressed to the point of pedanticism, stayed with him and became part of the Szell legend.

One of Mr. Szell's oldest friends, Joseph Wechsberg, wrote in The New Yorker in 1965 about this pedagogic impulse: "He teaches expert golfers how to play golf (he plays badly himself), racing drivers how to drive, Parisian couturiers how to make dresses, Mrs. Szell how to cook, and writers how to write."

### A Virtuoso Pianist

At rehearsals, Mr. Szell would sit down at the piano and show a famous soloist how the piece ought to be played. A virtuoso pianist before he took up conducting, Mr. Szell retained his keyboard technique throughout his career. In 1967, he recorded four Mozart sonatas for piano and violin with his Cleveland concertmaster, Rafael Druian, astonishing critics with his undiminished skills.

Mr. Szell's career at the piano did not begin auspiciously. When George was 7 and living in Vienna, his father took him to the great teacher Theodor Leschetizky, who heard the child play and decided not to accept him as a pupil. Leschetizky felt that George Szell did not have it in him to make a career. Leschetisky, it is said, did not much care for prodigies. Later, the boy was accepted by Richard Robert, another Viennese teacher.

Taken out of school about 1904, Mr. Szell never again entered one as a student. He studied composition and theory in Leipzig with Max Reger, the German composer, and in Vienna with others, including Eusebius Mandyczewski, who had been a friend of Brahms.

Conducting came by lucky chance, as it so often does. A brilliant score reader, Mr. Szell could play piano transcriptions of the most complex orchestral pieces, even early in his training period. One day in Bad Kissingen, he was hanging around a Vienna Symphony rehearsal when the scheduled conductor, Martin Sporr, turned up with an injured arm.

Mr. Szell, then 17 years old, was invited by the regular leader to conduct the program. As he remembered it years

later, there were seven pieces, including Beethoven's "Emperor" Concerto, Richard Strauss's "Till Eulenspiegel" and a symphonic work of his own, composed at age 14.

After that concert, a debut in the mythic pattern familiar from biographies of other leading conductors, Mr. Szell was on his way. He appeared the following year with the Berlin Philharmonic in the triple role of conductor, pianist and composer. Richard Strauss soon afterward appointed him to the conducting staff of the Berlin State Opera, after hearing the young musician play his own piano transcription of Strauss's tone poem, "Till Eulenspiegel." (Even in his late years, Mr. Szell remained proud of his piano performance of "Till," and would play it for friends, complete with a brush of a cufflink along the keys to simulate the rachet's whir at Till's execution.)

Mr. Szell stayed two years in Berlin, where he worked without fee, for the experience, and on Strauss's recommendation succeeded Otto Klemperer in 1917 as conductor of the Strasbourg Municipal Theater. In 1921, at age 24, he became principal conductor of the Court Theater in Darmstadt, and later held a similar post at Düsseldorf.

From 1924 to 1929 he was chief conductor of the Berlin State Opera and of the Berlin Broadcasting Company orchestra. Moving to Prague in 1929, Mr. Szell directed the German Opera House and orchestra concerts, while embarking on a guest-conducting career that took him before most of Europe's important orchestras.

Mr. Szell's American career began with guest engagements in 1930 and 1931 with the St. Louis Symphony. In 1939, while on the way back to Europe from an Australian tour, he found himself marooned in New York by the outbreak of World War II.

He made his New York debut on March 1, 1941, as guest conductor of Toscanini's N.B.C. Symphony, engagements followed with orchestras in Boston, New York, Philadelphia, Chicago, Los Angeles, Detroit and Cleveland. After his debut with the New York Philharmonic in 1944, he returned regularly as a guest.

During the war years, from 1942 to 1946, he served as regular conductor of the Metropolitan Opera.

A teacher much of his life, Mr. Szell had been on the faculties of the Hochschule für Musik in Berlin and the Academy of Music and Dramatic Arts in Prague. In New York he taught composition at the Mannes School.

When he first took the Cleveland Orchestra post in 1946 (he became a United States citizen the same year), it was believed that Mr. Szell's hope

was to follow the path of Artur Rodzinski, who had come from the Cleveland podium to take charge of the New York Philharmonic.

But Cleveland turned out to be made for Mr. Szell, and he for Cleveland. In 1955 he bought a luxurious suburban home in Shaker Heights, not far from Severance Hall, a neoclassic structure on Cleveland's East Side that the conductor liked so much that he encouraged the orchestra's trustees to remodel it acoustically, at the cost of $1-million in 1960. He dropped his title of permanent guest conductor of Amsterdam's Concertgebouw in 1959, and settled down to remaking the Cleveland Orchestra into a musical ensemble closer to his heart's desire.

"Cleveland is my home," he announced. Part of his plan included building esteem for orchestra musicians in their community by extending the orchestra's season, increasing pay and taking the Cleveland Orchestra on European tours. From these tours, which earned extraordinary applause in European cities, and from the orchestra's continued visits to Carnegie Hall, the Cleveland Orchestra emerged with a reputation for technical skill and musicianship that almost satisfied even the hard-to-please Mr. Szell.

### Classical Masters Favored

Mr. Szell's musical interests centered on the classical masters—Mozart, Haydn, Schumann, Schubert—but he conducted with enthusiasm such later Middle Europeans as Brahms, Smetana, Dvorak, Bruckner, Mahler and Wagner. His sympathies did not extend far or deep into the modern period, although he championed a few living composers such as Samuel Barber and William Walton.

It was at Mr. Szell's urging, however, that the Cleveland Orchestra engaged Pierre Boulez, then a controversial avant-garde composer and conductor, for a five-year guest engagement. Mr. Szell also served as music adviser and senior guest conductor of the New York Philharmonic during the interim period before Mr. Boulez's arrival to succeed Leonard Bernstein as music director.

In his own way, close associates insisted, Mr. Szell could be a warm man and a generous colleague. The maestro and Glenn Gould, the eccentric Canadian pianist, locked in a bitter battle at their first rehearsal together, and Mr. Szell declined to conduct for subsequent Gould concerts.

Nevertheless, Mr. Szell invited Mr. Gould back to Cleveland to play under other conductors. After hearing one such performance of a Beethoven concerto, the maestro made a generous concession: "That nut's a genius."

### 'Seven Concerts a Week'

Much of Mr. Szell's fearsome reputation stemmed from such famous rehearsal sessions. A rehearsal for him was an event, not a run-through. "The Cleveland Orchestra," he once told an interviewer, "plays seven concerts a week, and admits the public to the final two. We do some of our best playing in rehearsals."

Although he played no orchestral instruments, his knowledge of their capabilities was enormous and his identification with the ensemble complete. Cloyd Duff, Cleveland's timpanist, said that "Szell considers the orchestra an extension of himself, and so do we. We seem to react to him."

Some of his men were proud of the musical integrity that they felt Mr. Szell instilled in his men, and contrasted the idealism within the Cleveland Orchestra's ranks with what seemed to them cynical professionalism in other orchestras.

"Even when we have disputes and are not happy," a second violinist said, "we play well for Szell. We do it out of respect for him, and perhaps out of fear."

### Opera-House Tradition

Mr. Szell came out of the Middle European opera tradition that produced a stream of important conductors including Bruno Walter, Wilhelm Furtwängler, Gustav Mahler and Fritz Reiner. In the years after World War II, that stream dried up to a great extent, although such conductors such as Herbert von Karajan, Georg Soli, Eugene Ormandy and Erich Leinsdorf still carry on the tradition that the best orchestra conductors receive their early training in opera houses.

Coming from that tradition-steeped milieu, Mr. Szell knew exactly what to value in European musical performance, and what American orchestras had to offer. "I wanted to combine the Americans' purity and beauty of sound and their virtuosity of execution with the European sense of tradition, warmth of expression and sense of style," he said.

His orchestra, regardless of whatever outside reputation Mr. Szell acquired over the years, came to accept and cherish his musical standards. One guest conductor, after appearing for the first time in Cleveland, confessed that it had been "a frightening experience — you feel that you're facing a hundred little Szells."

Proud of his musical integrity and bluntly outspoken when others chose to soften their opinions, Mr. Szell spared no one's feeling. When the New York Philharmonic asked him for a recommendation on what to do about its new hall at Lincoln Center, he said, "Tear the place down and start again. The hall is an insult to music."

Even at home, Mr. Szell's musical integrity would not be silenced. He would sometimes stop and correct his wife's casual whistling, insisting that as long as she was going to whistle she might as well get the tempo and the pitch right.

Mrs. Szell, the former Helene Schulz of Prague, whom he married in 1938 in Glasgow when he was conductor of the Scottish Orchestra, cultivated forebearance and a dry wit during her years with Mr. Szell. She needled him about his methodical habits and mania for instructing others.

Both the Szells had been married once previously, he as a young conductor to a girl who decided she liked his concertmaster better and left him.

When he was not polishing orchestras or worrying about the excessive popularization of good music, Mr. Szell interested himself in a few hobbies, fanatically pursued. He collected art and fine wines. A serious gourmet, he enjoyed putting on an apron and making a bouillabaise, leaving the kitchen (according to his wife) in remarkably untidy shape.

Visitors sometimes were surprised to discover that his knowledge of painting, literature and history was encyclopedic. Annually he made a trip to Switzerland, where he played golf incessantly, whittling away at what was believed to be a high handicap (his salary and his golf scores were closely kept secrets in Cleveland). At one time he enjoyed "collecting odd journalistic misprints," according to an official biography.

His response to crisis was a musician's byword. Whether a confused tenor suddenly dropped 40 measures from an opera aria or a horn player found his instrument mysteriously unable to produce a sound during a long solo passage, Mr. Szell kept cool.

However, to the imputation of emotional coolness in his interpretations, which followed him throughout his conducting life, Mr. Szell replied with a shrug. "The borderline is very thin between clarity and coolness, self-discipline and severity," he said. And to those who wondered why his Mozart, for instance, could not be warmer in tone, he had a gourmet's answer "I cannot pour chocolate sauce over asparagus."

Mr. Szell was awarded honorary doctorates by Western Reserve University and by Oberlin College, and he held the rank of Chevalier in the French Legion of Honor. His Cleveland Orchestra recordings, first for Epic and then for Columbia, include some of the most highly regarded performances of classical repertory to appear on disks during the long-playing era.

The funeral will be private. A memorial service is planned for a date to be announced.

July 31, 1970

# Igor Stravinsky: An 'Inventor of Music' Whose Works Created a Revolution

During World War I, Igor Stravinsky was asked by a guard at the French border to declare his profession. "An inventor of music," he said.

It was a typical Stravinsky remark: flat, self-assured, flagrantly antiromantic. The composer who revolutionized the music of his time was a dapper little man who prided himself on keeping "banker's hours" at his work table. Let others wait for artistic inspiration; what inspired Igor Stravinsky, he said, was the "exact requirements" of the next work.

Between the early pieces, written under the eye of his only teacher, Nikolai Rimsky-Korsakov, and the compositions of Stravinsky's old age, there were more than 100 works: symphonies, concertos, chamber pieces, songs, piano sonatas, operas and, above all, ballets.

The influence of these work was profound. As early as 1913, Claude Debussy was praising Stravinsky for having "enlarged the boundaries of the permissible" in music. Forty years later, the tribute of Lincoln Kirstein, director of the New York City Ballet, was remarkably similar: "Sounds he has found or invented, however strange or forbidding at the outset, have become domesticated in our ears."

Aaron Copland estimated that Stravinsky's work had influenced three generations of American composers; a decade later Copland revised the estimate to four generations, and added European composers as well. In 1965 the American Musicological Society voted Stravinsky the composer born after 1870 who was most likely to be honored in the future.

He was not unanimously honored during his lifetime. Three colorful works of his young manhood — "L'Oiseau de Feu" ("The Firebird"), "Petrushka" and "Le Sacre du Printemps" ("The Rite of Spring") — were generally admitted to be masterpieces.

But about his conversion to the austerities of neoclassicism in the nineteen-twenties, and his even more startling conversion to a cryptic serial style in the nineteen-fifties, there was critical disagreement. To some, his later works were thin and bloodless; to others, they showed a mastery only hinted at in the vivid early pieces.

### Figure of Fascination

To all, Stravinsky the man was a figure of fascination. The contradictions were dazzling. The composer marched through a long career with the self-assurance of a Wagner —and was so nervous when performing in public that he thrice forgot his own piano concerto.

He once refused to compose a liturgical ballet for his earliest patron, Serge Diaghilev, "both because I disapproved of the idea of presenting the mass as a ballet spectacle and because Diaghilev wanted me to compose it and 'Les Noces' for the same price."

His Charles Eliot Norton lectures at Harvard in 1939-40 were dignified papers, delivered in French, on the high seriousness of the artist's calling. Three years later he wrote a polka for an elephant in the Ringling Brothers and Barnum & Bailey Circus.

He had many friends—Claude Debussy, Maurice Ravel, Pablo Picasso, Vaslav Nijinsky, André Gide, Jean Cocteau—and many homes: Russia until 1914; Switzerland (1914-20), France (1920-39), the United States (1939 until his death). In every home he was restless at night

147

unless a light burned outside his bedroom. That was how he slept, he explained, as a boy in St. Petersburg (now Leningrad).

Igor Feodorovich Stravinsky was born in a suburb of St. Petersburg—Oranienbaum, a village where his parents were spending the summer—on June 17, 1882: St. Igor's Day. He was the third of four sons born to Anna Kholodovsky and Feodor Ignatievitch Stravinsky. His father was the leading bass singer at the Imperial Opera in St. Petersburg.

The composer once described his childhood as "a period of waiting for the moment when I could send everyone and everything connected with it to hell." For his family he felt only "duties." At school he made few friends and proved only a mediocre student.

Music was a bright spot. At the age of 2 he surprised his parents by humming from memory a folk tune he had heard some women singing.

He dated his career as a composer from the afternoon a few years later when he tried to duplicate on one of the two grand pianos in the family's drawing room the blare of a marine band playing outside.

"I tried to pick out the intervals I had heard . . . but found other intervals in the process I liked better, which already made me a composer," Stravinsky said.

At 9, Igor started piano lessons and proved a good student, but no prodigy. Nevertheless, his interest in music grew. An uncle—"the only one in the family who believed I had any talent"—encouraged him. As a teen-ager he haunted his father's rehearsals at the Maryinsky Theater.

To his parents, the boy's interest in music was "mere amateurism, to be encouraged up to a point, without taking into consideration the degree to which my aptitudes might be developed." They agreed to let him study harmony with a private teacher—on the condition that he also study law at the University of St. Petersburg.

In four years at the university, Stravinsky recalled, "I probably did not hear more than 50 lectures." For by this time he had taken the first step toward becoming a composer.

### A Refusal at First

One of his classmates was a son of the great Russian composer Rimsky-Korsakov. In 1902 Stravinsky visited the elder man, gave him some of his early piano pieces for criticism and asked to become his pupil. The composer looked at the scores and replied noncommittally that the young man would need more technical preparation before he could accept him as a student.

Crestfallen at first, Stravinsky decided to take this as encouragement. After a year's outside study, he applied again to the master and was accepted.

It was under the supervision of Rimsky-Korsakov that Stravinsky's first orchestral works —a symphony, a suite ("Le Faune et la Bergère"), the Scherzo Fantastique — were composed and performed.

In 1908, a few days after he had mailed his teacher the score of a new orchestral piece, "Fireworks," the package was returned to the young composer with the note: "Not delivered on account of death of addressee." Stravinsky's formal education was over.

Later that year Stravinsky met Serge Diaghilev, then assembling a company of Russian dancers for a season in Paris. Impressed with the composer's first work, Diaghilev had a job for him: to orchestrate two piano pieces by Chopin for the ballet "Les Sylphides." The commission was gratefully accepted—Stravinsky now had a wife and two children—and impressively fulfilled.

A year later there was a more important Diaghilev commission: a ballet on a Russian folk tale, "The Firebird," for the Russian Ballet's second season at the Paris Opera House. Somewhat apprehensively — "I was still unaware of my own capabilities"—Stravinsky set to work.

The flashing, vigorous "Firebird" was a great success: so great a success that Stravinsky, in his later years, thought of it as an albatross around his neck. Arranged as an orchestral suite, it was played all over the world; the composer was asked to conduct it everywhere; it was the work the man-in-the-street most associated with the name Stravinsky. (On a train the composer met a man who called him "Mister Fireberg.") The irony was that because Russia had no international copyright protection, "The Firebird" brought him few royalties.

The next Stravinsky-Diaghilev production was "Petrushka" (1911), a brash, colorful ballet about puppets come to life. To signify the insolence of one of the puppets, Stravinsky put some of the music in two keys at once. The combination of an F sharp major arpeggio (all black notes on the piano) and a C major arpeggio (all white notes) was to be known ever afterward as "the Petrushka" chord: it was the first important use of bitonality in modern music.

The ballet, with Nijinsky in the title role, was another popular success. More important, said the composer, "it gave me absolute conviction of my ear."

While completing "The Firebird," Stravinsky had a daydream about a pagan ritual in which a young girl danced herself to death. This was the genesis of "The Rite of Spring," a revolutionary work whose premiere on May 29, 1913, caused one of the noisiest scandals in the history of music.

An open dress rehearsal had gone quietly, but protests against the music—barbarous, erotic, unlike anything Paris had ever heard—began almost as soon as the curtain went up on opening night.

Soon the Théâtre des Champs-Elysées was in an uproar. Stravinsky hurried backstage to find Diaghilev flicking the house lights in an attempt to restore order and Nijinsky, the choreographer, bawling counts at the dancers from the wings.

Stravinsky was furious; Di-

This 1946 portrait of Igor Stravinsky, widely reproduced, led the composer to tell the photographer, "Arnold Newman, you have made me famous."

aghilev, who knew the value of publicity, said afterward that the crowd's reaction had been "exactly what I wanted." Less than a year later, Pierre Monteux conducted a concert version of the score in Paris and Stravinsky received a hero's ovation.

World War I separated the composer permanently from his homeland (he did not see Russia again until a tour in 1962) and temporarily from Diaghilev. It also marked the start of a new style for Stravinsky—a leaner, more astringent, less colorful musical idiom that critics were to label "neoclassical."

### Economy Was Necessity

An early work in the new manner was "Histoire du Soldat" ("The Soldier's Tale"), written in 1918. This was a jazzy theater piece with only seven instrumentalists. The economy of orchestration was less a matter of esthetic choice than of practical necessity — Stravinsky and his collaborators, down on their luck in Switzerland, wanted a work that would tour cheaply—but the composer found austerity to his liking.

In the years that followed Stravinsky's postwar move to Paris, the "Apollonian principles" (as he liked to call them) of order and restraint replaced the Dionysian ecstasy of the big early works.

"One is tired of being saturated with timbres," he decided. "One wants no more of this overfeeding."

"Les Noces" (1923), a throbbing Russian wedding cantata, seemed a throwback to the Dionysian style. Actually, most of it had been composed before the war and could be seen, in retrospect, as part of the transition from opulence to severity.

Representative of another aspect of the new style was "Pulcinella" (1920), a ballet at Diaghilev's suggestion. This work employed themes attributed to the 18th-century composer Giovanni Battista Pergolesi, with contemporary glosses by Stravinsky. The composer called it "my discovery of the past."

Stravinsky now looked to the past for his models; the trick, he said, would be "to make use of academic forms . . . without becoming academic."

A piano concerto composed for his first American tour, in 1925, evoked Bach and the baroque. "Oedipus Rex" (1926) suggested a Handel oratorio. "Le Baiser de la Fée" (1928) was an explicit tribute to Tchaikovsky.

"Apollon Musagète" (1928) was a ballet scored for strings alone. "Capriccio" for piano and orchestra (1929) reminded some of an up-to-date Carl Maria Von Weber. "Perséphone" (1933) wore the pastels of the impressionists.

The forms had been used by others. The contents were unquestionably new and unques-

tionably Stravinsky's — complicated, tic-like rhythms; harmonies no less audacious for being uttered in a moderate tone of voice. During this period the composer was often accused of antiquarianism, but no one ever called him old-fashioned.

### Purely Instrumental

In his middle years, Stravinsky turned more and more to purely instrumental music, including the "Dumbarton Oaks" Concerto for chamber orchestra (1938), the Symphony in C (1940), the Symphony in Three Movements (1946).

His dogged productivity did not lessen with increasing age. Having moved to the United States in 1939, Stravinsky arranged "The Star-Spangled Banner" for a performance in Boston—and brought in the police, who almost arrested him for tampering with the national anthem.

Then he moved to Los Angeles, where he composed the rest of his works. "Danses Concertantes" (1942), a chamber piece, was commissioned by the Werner Janssen Symphony Orchestra of that city. "Orpheus" (1948) was a ballet choreographed by an old friend, George Balanchine.

As a young man Stravinsky had written two operas: "The Emperor's Nightingale" (1908-1914) and "Mavra" (1922). After World War II he began a third. "The Rake's Progress," with libretto by W. H. Auden and Chester Kallman, was a deliberate re-creation of Mozartean 18th-century style. First performed in 1951, it received the composer's usual mixed reviews.

"You never see the change when you are driving along," Stravinsky told an interviewer in 1948. "A little curve in the road and suddenly you are proceeding east. . . ."

Donning the monk's cloth of neoclassicism had been such a change for the composer; an even more unexpected one was to come.

For years Stravinsky and Arnold Schoenberg were thought to divide the world of contemporary music between them. Stravinsky was head of the tonal camp: those whose works, dissonant or not, inhabited a universe of harmonic gravity; the world of "key."

Schoenberg and his disciples belonged to the 12-tone camp: a world where all notes of the scale were in free fall, none having more harmonic weight or status than another. It was a style of composition, Stravinsky had said, "essentially different" from his own.

Soon after "The Rake's Progress," however, Stravinsky himself became a 12-tone composer: more precisely, a "serial" composer, who based each work on a series of notes stated as a "tone row" in the opening measures.

Picasso's sketch of Stravinsky, dated May, 1920.

Robert Craft, a young musician whom Stravinsky had hired as an assistant in 1947, unquestionably had much to do with the composer's conversion to serialism. It is also apparent that Stravinsky, to whom obstacles were inspirations, was attracted by what he called the "dogmatism" of the row.

Whatever the reason, the tone row was the spine of his last works, among them "Agon," a ballet (1957); "Movements" for Piano and Orchestra (1960); and "Abraham and Isaac," a "sacred ballad" (1964). The change kept him a controversial composer to the last.

This did not bother Stravinsky. "I don't mind my music going on trial," he wrote in 1957. "If I'm to keep my position as a promising young composer I must accept that."

What Stravinsky could not accept was "the professional ignoramus, the journalist-reviewer pest." His battles with music critics became legendary.

At first he was above battling. In 1929 he stated grandly that his music "was not to be discussed or criticized."

"One does not criticize somebody or something that is in a functional state. The nose is not manufactured. The nose is. Thus also my art," he said.

Thirty years later he was naming the "pests." Winthrop Sargeant, music critic for The New Yorker magazine, was, to Stravinsky, "W. S. Deaf." Paul Henry Lang's unfavorable review of Stravinsky's ballet "The Flood" (1962), composed for television, brought a telegram from the composer to The New York Herald Tribune accusing the critic of "gratuitous malice."

But Stravinsky's scorn was not reserved for writers only. He disliked showy performers and conductors ("Stokowski's Bach? Bach's Stokowski would be more like it"). The dislike turned to loathing when the performer was caught mis-"interpreting" (a word the meticulous composer considered a personal affront) one

of his pieces.

To show musicians exactly how his compositions were to be performed, especially as to their tempos, Stravinsky made piano-roll transcriptions of his works for the Pleyel Company in the early nineteen-twenties. For the same purpose, he signed an exclusive contract with Columbia Records in 1928. Well before his death, Stravinsky and his assistant, Mr. Craft, had recorded nearly all his works for Columbia.

During the twenties Stravinsky also began to conduct and perform his works in public. Never a virtuoso pianist and scarcely trained at all in conducting, he suffered acute stage fright before his first appearances and seldom performed without a score.

Stravinsky was a small, wiry man (5 feet 3 inches, 120 pounds) whose morning regimen, until he was 67, started with a set of "Hungarian calisthenics" (including walking on his hands). A renowned hypochondriac, according to his friends, the composer would visit his Los Angeles doctor almost every day—and then hike two miles home.

### Sketch Caused Furor

Stravinsky's remarkable face —long-lobed ears, hooded eyes, large nose, small mustache, full lips—tempted portraits from many artists. A straightforward Picasso sketch of the composer once caused a furor at the Italian border. A guard refused to let it out of the country on the suspicion that it was not a portrait at all but a mysterious, and probably subversive, "plan." "It is a plan of my face," Stravinsky protested. But the sketch had to leave the country in a diplomatic pouch from the British Embassy.

To Stravinsky, composing music was a process of solving musical problems: problems that he insisted on defining before he started to work.

Before writing "Apollon Musagète," for example, he wrote to Elizabeth Sprague Coolidge, who had commissioned the ballet, for the exact dimensions of the hall in which it would be performed, the number of seats in the hall, even the direction in which the orchestra would be facing.

"The more constraints one imposes, the more one frees one's self," he would say. "And the arbitrariness of the constraint serves only to obtain precision of execution."

He worked like a craftsman in a room that looked like a laboratory, organized down to the very labels on the gum erasers and the pens for different-colored inks. He worked almost every day, behind closed doors ("I have never been able to compose unless sure that no one would hear me"). Unlike many composers, he worked directly at the piano.

Some took this to indicate that Stravinsky's "ear" was not

as acute as one might have expected. He defended the practice: "Fingers are not to be despised. . . [they] often give birth to subconscious ideas that might otherwise never come to life. . . . I think it is a thousand times better to compose in direct contact with the physical medium of sound than to work in the abstract medium produced by one's imagination."

"Our Igor," Diaghilev used to sigh. "Always money, money, money." It was a frequent criticism of the composer that he not only worked like a businessman but also charged like one.

Stravinsky coolly agreed that he had never "regarded poverty as attractive" and that his ambition was "to earn every penny that my art would enable me to extract" from a society that had let Mozart and Bartók die in poverty.

Most of his works were written on commission—"the trick," he once wrote, "is to compose what one wants to compose and get it commissioned afterwards"—and the fees were handsome. But they did not affect his artistic independence.

Many of Stravinsky's works, especially during his last years, were based on religious themes —"Symphony of Psalms" (1930), "Canticum Sacrum" (1956), "Threni" (1958) and others.

To write good church music, the composer maintained, one had to believe, literally, in what the church stood for: "the Person of the Lord, the Person of the Devil and the Miracles of the Church."

He was himself such a believer. Born into the Russian Orthodox Church, he left it in 1910. Later he discovered "the necessity of religious belief" and was a regular communicant from 1926 to 1939. Thereafter his churchgoing lapsed a bit. (The music, he complained, all sounded "like Rachmaninoff" and once in confession the priest had asked him for his autograph.)

### Fascinated by Words

But to the end he considered himself stanchly Russian Orthodox, tempted at times by Roman Catholicism—he wrote a Roman Catholic mass in 1948— but remaining with the faith of his fathers "for linguistic reasons."

Words fascinated Stravinsky. Besides Russian he could hold forth, and make puns, in French, German and English.

"When I work with words in music, my musical saliva is set in motion by the sounds and rhythms of the syllables," he said.

Stravinsky wrote his own librettos for two works — "Renard" (1915) and "Les Noces" — and wrote several books as well.

"Chronicles of My Life" (1936) and "Poetics of Music" (1948), the latter his Harvard lectures, expounded Stravinsky's ideas about music with dry, episcopal confidence:

"Music is by its very nature essentially powerless to express anything at all. . . . The sensation produced by music is that evoked by contemplation of the interplay of architectural forms. . . . The more art is controlled, limited, worked over, the more it is free."

No less controversial but far more lively were the books written with the help of Mr. Craft: "Conversations with Igor Stravinsky" (1958); "Memories and Commentaries" (1959); "Expositions and Developments" (1962); "Dialogues and a Diary" (1963); "Themes and Episodes" (1966) and "Retrospections and Conclusions" (1969).

These "disguised monologues" combined contradictory recollections of the past, domestic trivia, name-dropping anecdotage, gratuitous insults, handsome compliments, bad puns and stunning insights into life, art and self. They were a portrait of the composer that few artists would have dared paint, and Stravinsky was proud of them.

Stravinsky married twice. His first wife, Catherine Nossenko ("my dearest friend and playmate"), was his first cousin. Married in 1906, they had four children: Theodore, Ludmilla, Sviatoslav Soulima and Maria Milena. Ludmilla died in 1938 and Mrs. Stravinsky in 1939, both of tuberculosis.

In 1940 Stravinsky married Vera de Bossett, a painter. They had no children.

April 7, 1971

# Lazar Berman, Russian Pianist, Heard

BROOKLYN PHILHARMONIA, Lukas Foss, conductor; Lazar Berman, pianist. At the Brooklyn Academy of Music.
The Tempest .............. Tchaikovsky
Baiser de la Fée ........... Stravinsky
Piano Concerto No. 1 .... Tchaikovsky

**By HAROLD C. SCHONBERG**

Lazar Berman, billed as the "legendary Russian pianist," made his local debut Saturday evening at the Brooklyn Academy of Music. He played, with the Brooklyn Philharmonia under Lukas Foss, the Tchaikovsky B flat minor Piano Concerto. Legendary? That remains to be seen. But the big Russian is indeed a pianist.

For two of the three movements of the Tchaikovsky, he played steadily, rather quietly, even reflectively. It was a performance very much in the modern Russian tradition that Sviatoslav Richter has set and that so many pianists the world over have followed. Mr. Berman a bearded Russian bear whose bulk all but dwarfs the piano, was careful to present a scrupulously note-perfect interpretation. It had a combination of power and finesse, and there never was a doubt that a master technician was at the keyboard, but it also was a little dull.

In the finale, however, Mr. Berman did not pattern his playing so closely after the Richter model. There was more tempo fluctuation, and a more personal approach. When the final round of octaves came, Mr. Berman let loose with an electrifying Horowitzlike volley.

He had not done this in the first movement, playing the octaves strictly as written. It is true that Tchaikovsky did not write an accellerando in these final measures. It is also true that without a spurt, the kinesthetic feeling is lost. If ever in a piano concerto a feeling of élan is needed, it is in these two octave passages. Mr. Berman missed it in the first movement. He fully captured it in the finale.

Obviously he is a major virtuoso, with all tools at his disposal. He draws a firm, full sound, has a relaxed wrist, has all the technique in the world and—judging from the three encores he played—has a great deal of personality as a soloist.

Those three encores were the C sharp minor Prelude by Rachmaninoff, the Beethoven-Liszt "Turkish March" and Scriabin's Etude in D sharp minor. The second was especially interesting. Mr. Berman played it rather

Jacques Leiser

**Lazar Berman**

tongue-in-cheek, extracting from it all of the period flavor yet never condescending to the dated writing.

●

In the familiar Scriabin étude there were some striking left-hand passages. Mr. Berman is not afraid of strong accents. He may be that rarest of musicians—a real, true-blue romantic, one who understands the conventions and has the ability to put them into effect.

The Brooklyn Philharmonia did well for Mr. Berman. It is not one of the big orchestras, and its tone can be rather thin, but Mr. Foss— himself a fine pianist—provided a well-integrated accompaniment, and the orchestra obviously liked playing for the Russian visitor. The program also contained Tchaikovsky's "Tempest" and the Divertimento from Stravinsky's "Baiser de la Fée."

January 19, 1976

## Recital: Music at Its Best

### By DONAL HENAHAN

There is a wide and unbridgeable gap between the kind of recital in which one musician dominates while the other accompanies and the sort given yesterday at Alice Tully Hall by Lynn Harrell and James Levine. Here, in a program of three Beethoven sonatas for cello and piano, we had two important artists engaged in a dialogue of equals, and an almost totally absorbing one.

Mr. Harrell, whose participation in this recital resulted from his winning of the Avery Fisher Prize for young artists last year, is the one-time principal cellist of the Cleveland Orchestra under George Szell and more recently a soloist in much demand. Mr. Levine is the music director of the Metropolitan Opera, a rapidly rising conductor and—in the tradition of George Szell, whose protégé he also once was—a whiz of a pianist. Put it all together and it spells a memorable day of Beethoven.

Three of the five sonatas were played: the G minor (Op. 5, No. 2), the A major (Op. 69) and the D major (Op. 102, No. 2). If one questionable characteristic stood out, it was a breathless briskness in the quick movements. Since Beethoven wrote comparatively few slow pages in these sonatas, the program's pace tended to seem unrelenting at times. Here and there, the cello, the less nimble of the two instruments, was pressed into fleeting passages of shaky intonation.

But one finds it necessary to fall back on a couple of words scribbled in the program book for such a quibble. Over-all, what took place was on so high a level of musicianship that flaws want to slip from the memory. Mr. Levine's playing was clean and nimble, pedaled so lightly that the modern piano's potentially bullying tone never blotted out the cello, either in melodic line or secondary detail. Both instruments seemed more consciously in search of musical content than sensuous tone, which the pacing of the performances would have made difficult in any event.

No repeats were taken until the final sonata on the program, possibly because the earlier works were considered less significant and time had to be conserved somewhere. Still, this was one of those rare instances where the logic and persuasiveness of the readings were such that repetitions would have been welcome. One final quibbling point: the Sonata in D's slow movement was taken so slowly that the musicians' hard work showed and the sentiment sagged.

January 26, 1976

# Neo-Romantic Music Warms a Public Chilled by the Avant-Garde

### By HAROLD C. SCHONBERG

A couple of years ago Isaac Stern played a new violin concerto by the American composer George Rochberg. Now, Rochberg during the 1960's had been a prominent, card-carrying member of the serial movement. He composed music that to most listeners was abstract, atonal, severe, unmelodic. He was not alone in this, of course. Most of the music composed by the academic avant-garde all over the world had similar stigmata. So when Stern stepped on stage, on expected still another well-made piece of musical *assemblage* that would perhaps jostle the intellect but at the same time would make the emotions yawn.

But no. Rochberg had composed a concerto that looked back to, believe it or not, Brahms. It was largely tonal, and it had one lyric, haunting movement that still rings in the memory. It was romantic, really romantic, but this was no slavish Romanticism. It was a modern Romanticism, a neo-Romanticism, if you will, in which Brahmsian post-Romanticism was filtered through a contemporary mind, emerging as something new. Stravinsky had done much the equivalent when he broke from the Slavic nationalism of his three Russian ballets and went off into a new style. Stravinsky went back to Bach and the Baroque, using old forms that he filtered through his unique vision. Thus neo-Classicism arrived.

Today's emergent romanticism is not a matter of composing "in the style of." That is why the term neo-Romanticism is used. It is a looking-back to the Romantic ideal, but an evocation that is expressed in modern terms. Nobody would expect, or want, a composer today to write symphonies that are a copy of Beethoven's or Brahms's. When Prokofiev composed his "Classical" Symphony, it may have been patterned after old forms and styles, but the result was echt-Prokofiev. Similarly when a Rochberg today composes a romantic violin concerto, it is expressed in a language that remains very much of our own time, and is hence a neo-Romantic statement.

Perhaps Rochberg's neo-Romanticism was not as surprising as it appeared to be. For the last 10 years or so there has been unease in all of the arts. Painting, which so often takes the esthetic lead, could have offered a clue to what was suddenly happening in music. For many years, the fashionable style in the art world was abstractionism, most of it defiantly anti-Romantic. But whether the public eventually got tired of it, or whether the *Zeitgeist* (if there is any such thing, and there probably is) demanded a change, or whether the tastemakers and entrepreneurs of the art world decided to push something new—whatever the reason or combination of reasons, the human figure was suddenly in.

Realistic art returned, and with a vengeance, to the point where some of the younge artists started to turn out hard-edged examples of absolutely photographic realism. Along with that, artists of the past, formerly despised, began to attract respectful attention. The Barbizon painters, the Hudson River School, Corot, Greuze. Big museums were not ashamed to reach into their basements and actually put back on the walls such things as Rosa Bonheur's "The Horse Fair" —a painting that only a short time ago was universally considered synonymous with everything bad in salon painting.

Nostalgia was part of the package. It was almost as if there were a revulsion toward intellectual or academic art in all forms. This too could have been part of the *Zeitgeist*. We all had been concerned about the Bomb and a possible end to humanity, but that scare seems to have faded away. Tensions there still were, of course, but tension always has been part of the human condition; and, by and large, the world seemed less tense than it had been. Creators in art could relax a bit, and they did, giving audiences what they apparently had been yearning for all along.

● ● ●

Life was not all grim future. There was a past, too. A public that had often been intimidated by the avant-garde lobby began to wash its hands of the whole thing. That goes for members of the avant-garde itself. Many artists, composers, sculptors, architects started deserting the schools with which they had been associated and looking for better ways to communicate their vision. The commercial side of the arts, sensing what was going on, hastened to supply a commodity. Audiences regaled themselves

151

with happy reminders of a more innocent past. The nostalgia craze was on. Scott Joplin. "No, No, Nanette." "Upstairs, Downstairs" and, more recently, "The Pallisers," not to mention the England of Dorothy Sayers and Lord Peter Wimsey. "King Kong," for crying out loud. Nadar photographs.

And in music, a re-examination of Romanticism in general and Romantic opera in particular. The years immediately following the war saw the exhumation of bel canto operas. Now we have moved forward from bel canto to an investigation of the later part of the century. In New York alone this season there have been revivals of such forgotten romantic operas as Meyerbeer's "Le Prophète," Massenet's "Esclarmonde," Smetana's "Dalibor," Chabrier's "Le Roi malgré lui" and Wolf-Ferrari's "I Quattro Rusteghi" with Tchaikovsky's "Iolanta" to come this Thursday.

In the last few decades, avant-garde music alone of the arts failed to achieve any kind of following, and the current, enthusiastic exploration of minor Romantics is in many respects a reaction to the sterilities imposed on the public by strict serial music and its various offshoots. The more conservative composers of the day—men like Britten, Poulenc, Shostakovich and Menotti—got plenty of performances. But that was not where the action was. All over the world the young composers, for about 20 years and more, wrote a kind of deadening, mass-produced music that represented the most advanced thinking but which completely alienated themselves from all but a tiny audience (and that audience consisted mainly of professionals).

Today one can say this; it is a fact. In those days, however, anybody who pointed out the futility of that kind of music was branded as an enemy, a hopeless reactionary. Music became hermetic. Lacking an audience, the composers retreated into the universities and started writing for each other. They also had a grand time analyzing each other's music in various academic publications. Our time will come, they kept assuring themselves. It never occurred to them that perhaps they and not the public were at fault.

For it might have been—though they could not possibly admit it—that the very esthetic on which their music was based was alien to music. If music fails to communicate, must it always be the fault of the public? How long is a cultural lag supposed to operate? Ten years? Twenty-five years? A century? Most of Arnold Schoenberg's music has failed to enter the active repertory. Only a few Berg pieces are popular. The great Webern fad of the 1950's has died down; audiences simply would not respond. Perhaps it is the fault of the music? Take even so revered a figure as Igor Stravinsky. Remove the three ballets and a few other scores, such as "Oedipus Rex" and "Symphony of Psalms," and it is amazing how little of his music is played.

At the end, it is the public that decides whether a piece of music lives or dies. There are some composers who infuriate the intellectuals, but those composers stubbornly maintain their popularity. Rachmaninoff is a case in point. At the turn of the century he was writing music that today

## 'The neo-Romantic phenomenon is not yet in full swing but is inescapably with us.'

is considered in execrable taste by many professionals. It makes no difference. Pianists all over the world have Rachmaninoff in their ongoing repertory, and audiences love to hear his music. The man has become a classic, and he gets played more than the three Viennese atonalists and all their offshoots rolled together.

Music has been subject to a much more stringent snobbery than the other arts. Even during the high point of abstract expressionism in painting, attention was paid to minor artists of the past, and museums always hung their works. But in music the equivalent of the museums—the major symphony orchestras and opera houses—placed an iron curtain across the minor Romantics starting after World War I. The then new composers were anti-Romantics, and Romanticism rapidly went out of fashion. Naturally the great composers held their own, but the repertory degen-

erated into what used to be called The Fifty Pieces. Those were played over and over again, and the newer composers somehow managed to get into the act, but a very large area of music was completely ignored.

Today things are changing, and fast. The new Romanticism is very much in the air. One reason was the failure of the avant-garde serial movement. About 10 years ago it began to be apparent that Serialism was going nowhere, and the alienation of the public became a matter of growing concern to young musicians ready to move into the field. Where the academics of the immediate past proudly said that they did not want an audience, the newer crop refused to go along with that kind of thinking.

So they began to break away. What resulted was a period of experimentation, of consolidation, and we are still in it. The experimentation was not within the established avant-garde textures. Rather it was an eclecticism that took all music as its province. Composers began to look at rock, at raga, at Broadway, at tape and films, at African drumming and American spirituals, at Mahler and the post-Romantics, at everything. The new composers—Peter Maxwell Davies in England is a good example—began to write scores that contained a highly personal mishmash of what could be a capsule history of music. A representative Davies score could contain Gregorian and Renaissance elements mingled with dodecaphony, a parody of musical comedy tunes, a hint at a sentimental music-hall ballad, some down-and-out jazz.

Or in the United States a composer like George Crumb began to attract attention with a technique that went back to Henry Cowell and John Cage. His was an introspective kind of music, full of allusions to music of the past even with its new technique, emerging with almost a Debussyan coloration. Basically the man was a combination of Impressionist and neo-romanticist. Or there were new composers like Dominick Argento, who wrote songs that were undeniably modern, yet touched with a real melodic line and vocal resource that went back to Fauré and the German lied. Or there were such formalists as Rochberg, whose roots recently have been absorbing nourishment from late 19th-century ideas of form and harmony.

Not only are composers more relaxed, unafraid to write real melodies and not worried too much about being called conservative. The emergent neo-Romanticism also has extended to ideas of programming. Ten years ago about the only places in the country one could hear minor Romantic figures were at the Indianapolis and Newport music festivals. Today nearly all performing musicians are jumping on the bandwagon.

Pianists are beginning to take Moszkowski, Gottschalk and other salon composers into their repertory, finding often to their surprise that this is not junk music but the work of highly sophisticated technicians. (Audiences love it.) Singers are giving Schubert, Schumann, Brahms and Wolf a rest, and are starting to look at the songs of Liszt, Franz, Loewe. Chamber groups have begun to examine out-of-the-way 19th-century repertory, and also are taking a look at neglected works of the masters. Even conductors, who generally hate to learn new scores, are bringing in neglected Romantic works.

The neo-Romantic phenomenon is not yet in full swing, but is nevertheless now inescapably with us, and one has no hesitation predicting that it will grow. Abstractionism is definitely out. Instead of laying out music by the yard, with a concentration on a stringent, objective, dispassionate working-out of material, composers suddenly are waking up to the fact that the job of a creator is to state a personal message, to reflect an emotion through his own psyche. Which is what Romanticism is all about. Romanticism is concerned with a personal vision, with the ego, with unabashed sentiment (not sentimentality, though undisciplined composers can wallow in that).

We will be getting more and more of this kind of neo-romanticism in the immediate future. Eventually the time will come when a new Berlioz or Chopin or Wagner arrives to put everything together. Neo-romanticism has no leader as yet. He will be recognized when he arrives, as leaders always have been recognized: first by the professionals, then by the public. In the meantime, a much more relaxed quality has entered music. Nobody can guess exactly what the next 10 years is going to bring, but there can be no hesitation in saying that it is going to be a happier time than the previous decade was.

March 20, 1977

## THE DANCE

# ISADORA DUNCAN IN GRECIAN DANCES

### Reappears After Ten Years' Absence and Delights Audience at the Criterion.

## MUCH SPIRIT AND POETRY

### Miss Duncan Was the Dancing Teacher Who Marched Her Class in Safety from Windsor Hotel Fire.

Isadora Duncan, who was last known in New York as the dancing teacher who marched her class in good order from the ballroom of the burning Hotel Windsor, nearly ten years ago, returned to New York last night at the Criterion Theatre as a dancer of classical dances. Since the day of the Windsor fire Miss Duncan has traveled far. She has studied the poses of Grecian dancers on vases and the relics of antiquity, and has reproduced these in a creative harmony of succession, building up from the separate poses a series of dances. With these dances she has been seen in the great European cities.

Last night's audience testified, through applause and cries of "Bravo!" that, so far as it was concerned, Miss Duncan's engagement here shall be as successful as her European appearances.

Miss Duncan chose as the medium of her American début the dances and choruses from Gluck's opera, "Iphigenie en Aulide," (1774,) which follows the story of the daughter of Agamemnon and Clytemnestra after the manner of Euripides's play, known in the English translations as "Iphigenia at Aulis." Artemis having been offended, the Greek fleet is detained at Aulis. Calchas, the seer, declares that the goddess can be appeased only through the sacrifice of Iphigenia. At the last moment Artemis relents and substitutes a hind in the sacrifice. Iphigenia is carried by Artemis to Tauris that she may become the priestess of Artemis.

When the curtain went up last night after an augmented orchestra had played some of the Gluck music, the audience saw a stage set only with dull gray draperies. Miss Duncan started with a handicap. The audience saw a woman who at first glance did not appear overly attractive, apparently in bare feet, and clad in a loose gray robe. The dance, one of little skipping steps and supplicating arm postures with a constant play of happy feature and side to side head movement, slowly assumed the familiar poses of the dance known to us through Grecian antiquities. Miss Duncan had interested her audience at once. Still she was not as yet in its mind graceful. The succession of postures was too rugged.

Grace, however, was added in the second dance, which represented the maidens of Chalkis playing at ball and knuckle bones by the seashore. The costume was perhaps a little looser and fell more from the shoulders. It still came to the seemingly bare ankles. The dance as the imaginary ball was tossed in the air and caught was graceful, but the gestures of the dancer as she half reclined and tossed and caught the knuckle bones removed entirely the audience's first impression.

Then the costume became shorter. There was a dance of the maidens (represented alone by Miss Duncan) as they saw the Greek fleet in the distance and danced for joy. All five movements of this dance expressed joy, but the air gai of the final movement seemed to catch at familiar memories. Its tempo for the first time was quick and whirlingly joyous. The audience thought with a smile of a cake walk, but if cake walk it was it was a sublimated cake walk. Then there was a gay little dance in abbreviated red costume in which seemingly bare limbs flashed out "Choer des Pretesses," followed by a clothed slower atmospheric aftermath.

"Danses des Scythes" was a rhythm of motion, whose theme was manifestly reaping. After Musette, Sicilienne, and Bacchanale, dances of life and movement in which flowers played a part, Miss Duncan, in response to the demands of her audience, danced her interpretations of Schubert's "Musical Moment" and the Strauss waltz, "Blue Danube," as encores. These were the lighter parts of Miss Duncan's store. She even added a Spanish dance.

In Miss Duncan's dancing there is the spirit and poetry of things suggested. There is no hint of the personality of the artiste. Neither is there tone of sensuous or sensual. The dancer's costumes appear merely a background for her art. The audience never centres its attention upon them to the exclusion of the dance's theme.

Last night the orchestra, by beginning the wrong dance twice, put Miss Duncan from poised flight to immobility, but by a suggestion as elusive in analysis of means employed as any she conveyed during the evening, she set them right.

The effect of the orchestral feature was heightened at times during the overtures, when the dancer changed her costume, by the addition of the low voice of a woman who was seated with the orchestra. In all, Miss Duncan danced nearly an hour and a quarter, counting the time when the stage was bare and the orchestra was playing.

August 19, 1908

# ANNA PAVLOWA A WONDERFUL DANCER

### Little Russian, Lithe, Exquisitely Formed, Captures Metropolitan Audience in First Waltz.

## HER DEBUT IN "COPPELIA"

### Her Technique of a Sort to Dazzle the Eye, and She Has Grace and Humor—Mordkine Assists.

More than two-thirds of the boxes at the Metropolitan Opera House were still filled with their occupants at half after 12 last night. It was not a performance of "Götterdämmerung" without cuts that kept a fashionable Monday night audience in its seats, but the American début of Anna Pavlowa, the Russian dancer from the Imperial Opera in St. Petersburg. Mme. Pavlowa appeared in a revival of "Coppelia," which was given at the Metropolitan for the first time since the season of 1904-5. As this was preceded by a performance of "Werther," the ballet did not commence until after 11, and it was nearly 1 before it was finished.

However, Mme. Pavlowa easily held most of her audience. It is safe to say that such dancing has not been seen on the local stage during the present generation. If Pavlowa were a regular member of the Metropolitan Opera Company it would also be safe to prophecy a revival of favor for the classic ballet.

The little dancer is lithe and exquisitely formed. When she first appeared just after the curtain rose there was a dead silence. She received no welcome. She wore the conventional ballet dress and her dark hair was bound back with a blue band.

After the first waltz, which immediately follows her entrance, the audience burst into vociferous applause, which was thereafter repeated at every possible opportunity. Pavlowa received an ovation of the sort which is seldom given to anybody at this theatre.

And her dancing deserved it. To begin with, her technique is of a sort to dazzle the eye. The most difficult tricks of the art of the dancer she executed with supreme ease. She even went further. There were gasps of astonishment and bursts of applause after several of her remarkable feats, all of which were accomplished with the greatest ease and lightness.

Grace, a certain sensuous charm, and a decided sense of humor are other qualities which she possesses. In fact, it would be difficult to conceive a dancer who so nearly realizes the ideal of this sort of dancing.

In the first act she was assisted at times by Michael Mordkine, who also comes from St. Petersburg, and who is only second to Pavlowa as a remarkable dancer. Their pas de deux near the end of the act was perhaps the best-liked bit of the evening. It was in the second act in her impersonation of the doll that Pavlowa disclosed her charming sense of humor.

At this time it is impossible to write any more about this dancer, but there is no doubt that she will prove a great attraction while she remains in New York.

The performance of "Werther," which preceded the ballet, was the first that has been given this season at the Metropolitan. This lyric drama, of Massenet's has been heard previously this year at The New Theatre, however. The cast last night included Miss Farrar and Messrs. Clement and Gilly.

March 1, 1910

# DE DIAGHILEFF'S BALLET IMPRESSIVE

## Russian Dancers' Performance at Century the Most Elaborate Ever Seen Here.

## ITS PRODUCT IS ARTISTIC

### Effects Obtained by Bewildering Color Combinations in Costuming and by Music—The Artists.

The Serge de Diaghileff Ballet Russe gave its first performance in America last night at the Century Theatre. For months the newspapers and magazines have been printing the bright-hued colors of its costume plates, or black and white reproductions of its artists and scenes. For months they have been devoting their reading columns to exposition, illustration and argument concerning various phases of its being, until finally there seemed nothing left for pictures or printed words in their task of explaining the fame the organization had won. Now it is here itself to tell its own story, the first chapter of which was set forth last night.

The bill consisted of "L'Oiseau de Feu," by Fokine, with music by Igor Stravinsky; "La Princesse Enchantee," music by Tschaikowsky; "Soleil de Nuit," by Massine, music by Rimsky-Korsakow, and "Scheherazade," by Bakst and Fokine, music by Rimsky-Korsakow.

What was shown on the stage of the Century Theatre last night constitutes the most elaborate and impressive offering that has yet been made in this country in the name of the ballet as an art form. The ballet has not fared well in America. A little less than a century ago, when the Bowery Theatre was the centre of fashionable theatregoing, was opened, our forefathers are said to have seen the ballet skirt for the first time, with the result that when the dancer appeared on the stage the ladies in boxes arose and left the theatre. Thus the ballet skirt was officially snubbed at the beginning of its American career.

It is different now. Anyway, the Diaghileff Russian Ballet is a thing different from what has gone before and apparently the public nowadays is not indifferent to it. There was an audience last night which filled every available seat. It watched and listened eagerly, discussed volubly, and seemed much impressed.

#### Make Good Its Title.

Let it be said at once that the Diaghileff Ballet made good its title to being an organization with an impressive individuality. Even the hitherto skeptical in the audience must feel that in what it does there is always a sensitive and broadminded artistic intelligence at work. Its effects are obtained now by the dancing, now by the imaginative effects in the scenery and stage business, now by flashing or bewildering color combinations in the costuming, now by the music. The interrelation of all these is active, and its product is an artistic whole, quite different from anything our public has previously known.

To this extent the first appearance was eminently successful, and according as to whether this has the power to interest and satisfy the public, the ballet will be a success here. It seems quite likely that it will.

On the other hand, this a ballet whose dancers do not measure up individually to the success that has been made in other departments. It is a familiar story that Nijinsky and Karsavina, who were the principal dancers of the company in Europe, are not here with it. What their absence means to the company is not matter for speculation to us in America, who must take it as we find it.

#### The Principal Dancers.

In last night's program Xenia Maclezowa, Lubow Tchernichewa, Flore Ravalles, Adolf Bohm, and Leonide Massine appeared as the principal dancers. Mlle. Maclezowa had the greatest burden to bear, for she had the leading female parts in "L'Oiseau de Feu" and "La Princesse Enchantée." She is not an impressive dancer, for though she possesses certain technical skill, she lacks finish and surety in it, and the spark of vivid personality needed to supply the final touch to a dancer's art. Neither does Mr. Massine impress himself particularly in his work.

Adolf Bohm worked under the disadvantage of illness, which perhaps militated against his appearing in his best form. Among the five principal dancers only Lubow Tchernichewa seemed to measure up to what we have been led to expect, although her role was not of the importance to make this observation in the abstract wholly just to the others. It nevertheless remains the fact that the dancing done by the principals has been surpassed by others, and not only by the one other who would be thought of among the women, but by several.

As a matter of fact, however, this does not have the importance it might seem to among those who have not seen the performances. There is so much to occupy the attention and stimulate the imagination that an audience of the right sort will not feel a lack of great personalities among the dancers.

So far nothing has been said about the music. The orchestra was organized several months ago by Nahan Franko, and rehearsed under him for some time before the ballet's conductor, Ernest Ansermet, arrived to take charge of it. The result of this care, apparently characteristic of the company's methods, is that such difficult music as Stravinsky has written for his "L'Oiseau de Feu," was presented practically without a blemish. Mr. Ansermet is a skillful conductor and obtains distinctive results.

This "L'Oiseau de Feu" of Stravinsky's was perhaps the most important number on the program, viewed from all aspects, especially since the music of Rimsky-Korsakoff's symphonic suite "Scheherazade," the other long piece, has been so often heard in the concert rooms and in two different ballet productions.

"L'Oiseau de Feu" is the first piece of Stravinsky's which was done by the Diaghileff Ballet, which gave it in June. 1910, and its success led him to link his musical fortunes with this organization. The work is in the "advanced" style which the composer's later works have carried a step further, and it is one of those compositions identified with the organization which have made its name a factor to be reckoned with when musical history is written.

What must undoubtedly have struck those in the audience last night who have heard Stravinsky's "advanced" work in the concert room, or have heard some of the other new Diaghileff ballet music performed in concert form is the fact that its presentation with the accompanying explanatory action on the stage is a relelation. What was so puzzling before and so bewildering as to cause almost the impression of absurdity, becomes plain immediately.

Instead of a "wild futurist" Stravinsky becomes very talented young man with decided gift for vivid orchestral coloring and much skill in writing descriptive music. There are still things which the conservative will not accept, but they are toned down, either because their purpose is understandable, or because with the action going on, one only half hears the music. Musical psychologists should get much entertainment out of deciding which.

The stage settings of Bakst, Golovine, and Larionow that were shown last night need not be enlarged upon, for their effectiveness is an old story. Suffice it to say that when seen on the stage they perform their function of arresting the attention, or being delicately suggestive of the atmosphere of the particular ballet, or startling you, and always succeed in appealing to the fancy or the imagination. The gorgeous crimson landscape from no existing land that Bakst has devised for an ordinary pas de deux, "La Princess Enchantée," lifts it out of the ordinary immediately and almost suggests that the title means something, which it does not.

Another point that must be noticed is the general direction of choreography. We have been accustomed in a ballet to seeing the principals dance, while the coryphees stood about in lifeless groups and watched. Last night there was a constant meaning to the subordinate groups, which always had something worked out for them which was significant, even if it was only as one group did in "L'Oiseau de Feu," to sit huddled on the steps outside the gate and sway in rhythmical motion. On paper that does not sound impressive, but as a matter of fact in practice it lent a subtle touch in characterizing the weird doings of The Immortal and his bizarre retinue.

There were some minor defects in the staging. Such a thing as letting the young hero climb over a "stone" wall which sagged and wobbled painfully, or throwing open the mysterious gates to the Immortal One's palace and letting it be seen they were very obviously held together by thin laths and faith, were among such defects. Also the miming was sometimes very obvious and "theatrical," when from such an organization one would expect a departure from the time-worn into more subtle dramatic means.

Yet, casting whatever can be said against it into one side of the balance, the other will rise swiftly, for the Diaghileff ballet is the most impressive new stage enterprise with an artistic meaning that has been seen here for a long time.

**January 18, 1916**

# THE REVOLUTIONARY MR. DIAGHILEFF

WE were all revolutionists in those days, when we were fighting for the cause of Russian art, and I myself—it was only by a small chance that I escaped becoming a revolutionist in other things than color and music!

The heavy face of the speaker, a face curiously suggestive, like the immense frame, of unlimited animalism and latent energy, lit up, or rather smoldered, with a smile. The face of Serge de Diaghileff, director of the Russian ballet, which has made a sensation in New York, is typically Russian, in its combination of heaviness and sensibility. The man carries himself with the indolence which proceeds from great physical strength. The neck and the lips are thick. The eyes are those of a dreamer and an artist.

He was speaking of the early days of his career, the remarkable career of man who says, "to be quite modest," that he is "over thirty." He was born in Novgorod, and as a youth was attached for years to the Court of the Grand Duke Vladimir. The more astonishing his outspoken convictions.

Diaghileff is ideally fitted for his present work. He is not only an artist, but one well acquainted with the practical problems of the stage. He is a connoisseur of art in many forms, a man whose temperament and sensibility had led him to what is almost a new art. Yet he commenced his career as a musician and graduated with honors in music from the Conservatory of Petrograd. He studied the stage. He edited an art paper in which the most advanced ideas of the band he gathered about him found expression, and this paper exerted a significant influence in the country until, owing to the financial conditions in Russia consequent on the war with Japan, it was suspended. It was soon after this that there occurred the extraordinary union of artistic forces in the persons of Bakst, Fokine, and Diaghileff, resulting in the Russian ballet which has set Europe, and now America, on fire with the power and the fantasy of a new art.

Mr. Diaghileff laughed reminiscently, "I think we began by questioning and overthrowing every precedent we encountered. And in the main we were right. Nowhere in the art world was there more need of iconoclasm than there was in Russia. Nothing less than the most radical attitude and the most stubborn convictions could have blazed a way for a real Russian art. Remember that for centuries we had labored under the superficial and unfruitful influences of European culture. All the traditions of the nobility and the educated classes in general were against us. We had to begin by uprooting this artificial growth. I assure you we warmed to the task!

"Where did we go for suggestion and inspiration? We went where you in America will have to go before you can produce art of your own—to the people."

"American art! Dear Sir, there is plenty of American art—good, virile, characteristic art. But how long is it going to take America, I wonder, to realize this? The idea here is still imitation of Europe, and in America that which is palpably vulgar and parvenu is beautiful, and that which is beautiful is, of course, vulgar!"

"For instance?"

"For instance?" he flashed back. "For instance I am shown an immense mansion which is an ugly and inartistic imitation of the Gothic, and am asked to admire its architecture! For instance, when I marvel and am thrilled by the life and the power of Broadway at night, people laugh at me! They think I am joking.

"Well I am not joking! America will produce much great art when she has realized herself, but not before. Broadway is one of the genuine places in America. Broadway is certainly one of your sources of a strong and expressive art. But Americans, while they love it, will deny its existence in their drawing rooms. It is unrefined! And they copy Europe. Copy Europe, and continue their futile attempts to establish here the art which is a result of centuries of culture originating in the temperament and the experiences of races which are daily receding further and further from the temperament and the experiences of the American people.

"No individual, no nation, can say a thing worth saying until it has confidence in itself. I have seen this demonstrated, most impressively, in the course of researches which I made at first hand in studying Russian art of the sixteenth, seventeenth, and eighteenth centuries. During those 300 years every tendency not Russian was received eagerly and imitated slavishly in Russia. French culture dazzled us. Italian music was our passion. Later on German literature found a wide acceptance and an influential following. None of these influences, in themselves, would have been harmful. If they had only been balanced by self-realization.

"I found in the most unexpected places the real art of Russia, cropping out where it could, flourishing, vigorous and true, wherever it had been able to escape the attention of the educated classes, and developed in a sincere and normal way. Occasionally I would come across a picture done by a gifted serf whom his master had encouraged. Sometimes these efforts of unsophisticated Russians were misconceived, grotesque, misshapen, sometimes only laughable in their naïveté and their ineffectuality, and sometimes very beautiful. But do you think these precious tokens fame from the courts, or from the artists imported with such ceremony and expense? They came from the people. They were found by myself and my colleagues in the shapes of domestic implements in the country districts, in the painting of sleds, in the designs and the colors of dresses, in the carving about a window, and so forth.

"It was on this foundation that we built. Think what we have accomplished! And in scarcely fifteen years! In that time we have originated a new art, which has flourished and put out branches and leaves until, thanks to the genius of Bakst and a number of other remarkably gifted men less known at present in America. It has influenced not merely scenic decoration, but decoration in every field, and has given new inspiration to those, wherever they are, who create beauty and express life.

And this change is synchronous with the spiritual change which is being felt by the whole nation. In the year 1905, the year of the Revolution, I had collected in my investigations 2,800 portraits of Russian nobility from the country-wide, and these portraits were displayed in the Palais de la Tauride in Petrograd—the place built by Catherine the Great. But the times were changing rapidly. It has always been wonderful to me that in the same year the portraits of the nobility went out, and the Duma, the instrument of the rights of the Russian people, came in.

"By looking first within, and being unflinchingly ourselves, I believe we have succeeded in producing a distinctively Russian art hitherto unknown to the world. We have done this, first of all, by going straight to the nation's treasures of music and folk-lore, and employing all the arts of the theatre save the art of speech to present their complete and harmonious symbols on the stage. 'The Fire Bird' is far more like the creation of a single brain than the result of the collaboration of several. It is composed, painted, and danced by Russians, who have evolved fresh principles of dancing, far freer and more dramatic than the conventional movements of the French school of the ballet.

"I believe that in this field and in this way there are immense possibilities of development. The ballet is even yet in its early stages in Russia. The experiments become every year bolder and more original. I do not believe that this ballet will ever replace the opera, but I do think it will occupy an ever greater province of its own, that its limitations are in some respects less binding than the limitations of the music drama, and than its practices are sure to influence materially future methods of musicodramatic presentation.

"The mechanism of opera is yet," said Mr. Diaghileff, "as it always has been, imperfect. The normal musical development is often at odds with the situation or the dialogue on the stage. The situation on the stage hampers the composer, who, when most inspired, is bound by it as by iron chains. But in the ballet we have not these discordant and often irreconcilable elements. All of our factors may combine and each will offset the other most effectively. Not only is this the case, but we also have actors really capable of finished and effective representation on the stage, which, indeed, so often presents childish obstacles to one's enjoyment of music drama, but an obstacle, nevertheless, which we are unable to ignore.

"I mean for such things as singers, unable to act, no longer in their first youth, without beauty or presence, and utterly outside of the conceptions of composer and dramatist. Most of us learn very soon to accept this convention, and we even forget it. But it is there; it is a false harmony, which can be eliminated.

"Do you know what we did in Paris when we mounted Rimsky-Korsakoff's satirical opera, 'The Golden Cock'? We seated the chorus in a decorative manner at the sides of the stage. The voices, for the greater number, came from behind the scenes, and the acting was done by leading dancers. Many connoisseurs pronounced this one of the most interesting and successful productions they had seen."

OLIN DOWNES.

**January 23, 1916**

## POLICE ARE TO EDIT THE RUSSIAN BALLET

### After Complaints a Letter Summons Manager to Magistrate McAdoo's Office.

The Russian ballet by the Serge de Diaghileff dancers under the auspices of the Metropolitan Opera Company at the Century has run afoul of the Police Department. John Brown, General Manager of the Metropolitan, yesterday received a letter from Third Deputy Commissioner Lawrence Dunham, asking him to meet representatives of the department at the office of Chief Magistrate McAdoo this morning to confer with the Magistrate and representatives of the department about making certain changes in some of the ballets.

The action of Deputy Commissioner Dunham followed a visit of department representatives to the Century for the matinée performance Saturday. These witnesses were sent to watch the dancing after many letters of complaint had been received at headquarters.

The program at the matinée included two of the ballets calculated to arouse the most discussion—"Scheherezade" and "L'apres-midi d'un faune." The former pictures in pantomime an episode in a harem, when the Sultan, returning, finds the women of the harem have been holding revel with the slaves. Their punishment is death at the hands of the Sultan's guard. The latter is a pastoral study, in which a faun frightens away seven Greek maidens who are disporting themselves near his cave, and carries away a garment one of the maidens had removed.

The letter sent to Mr. Brown follows:

Serious complaints have been received by this department as to certain alleged objectionable features of the Russian ballet being performed at the Century. In order to get at the facts the Saturday matinee was attended by witnesses in whose judgment the department has confidence, and their statements are on hand.

In order to avoid recourse to the law and assuming that after the objections have been pointed out to you you will correct the same, and after consulting Chief City Magistrate McAdoo, I am writing this requesting your presence at Judge McAdoo's office 300 Mulberry Street, at 11 o'clock tomorrow (Tuesday) morning, where you will be joined by representatives of this department. It is important that you be present at the time and place mentioned.

It was reported yesterday that the Catholic Theatre Movement, a society formed several years ago to censor theatrical entertainments by issuing a white list of approved ones to its members, had circulated a private bulletin against the Russian ballet.

**January 25, 1916**

## NIJINSKI PUTS LIFE IN BALLET RUSSE

### He Shows Grace and Finish at His Debut in "Le Spectre de la Rose."

Warslav Nijinski made his first appearance in this country yesterday afternoon at the matinée performance of the Diaghileff Ballet Russe at the Metropolitan Opera House. He danced in "Le Spectre de la Rose," a pas de deux in which the other rôle brings forward Mlle. Lopokova, and in "Petrouchka," Stravinsky's ballet, which enlists the services of most of the company, with Mlle. Lopokova and Messrs. Bolm and Cechetti in the other principal characters. The remainder of the bill comprised the Polovtsian dances from "Prince Igor," and the ballet, "Scheherazade."

Mr. Nijinski's début was a success, though he scarcely provided the sensational features that this public had been led to expect of him. This was to some extent due to the rôles in which he appeared, which are limited in their possibilities in one sense because they are "character rôles." The guise in which he presented himself yesterday was rather that of a highly accomplished dancer whose work put new life into those appearing with him, than as one especially remarkable in himself. The public will probably have to wait for his appearance in ballets of the purely classic style to get more knowledge of the technical wonders that have been so liberally promised and that were indeed foreshadowed yesterday.

To a certain extent his rôle in "Le Spectre de la Rose" is in the classical style, but story and atmospheric demands restrict the dancer in several directions. There is no denying that new meaning was read into the little ballet by the version of yesterday, and that the grace and the finish of Nijinski's dancing and his intelligence as a stage director were largely responsible for this.

There was a discordant note in a super-refinement of gesture and posture that amounted to effeminacy. The costume of the dancer, fashioned about the shoulders exactly like a woman's decollete, with shoulder-and-arm straps even, helped to emphasize this, as did certain technical details of the dancing, such as dancing on the toes, which is not ordinarily indulged in by male dancers. The obvious reflection in justification of Mr. Nijinski's characterization is that the ghost of a rose is not exactly a masculine commodity. Precisely! Then why devise a ballet in which a man dances that character? As well put a lyric soprano to singing Rhadames in "Aïda"!

As Petrouchka, the dancer gave a splendid performance of this fantastic role. Both in the purely external characteristics of the puppet-lover and in suggesting an actual pathos in his imaginary life-drama, he made his effects with mastery. The tales of his rehearsing the ballets in which he appears were borne out in the performance of this work, as well as in the case of Le Spectre de la Rose." By little touches of stage management the story was made easier to follow. Among those that come to mind quickly were those concerned in the first dance of the three puppets, where the showman's manipulation of them was more clearly suggested, and in the entrance of the bear. The prominence of the music gives the latter incident was formerly somewhat obscured by the crowding of the stage. Yesterday the bear was visible to the audience as soon as he appeared, and the sudden ponderous voice of the orchestra music was thus immediately explained. These are only two points of many.

**April 13, 1916**

# BROADWAY

RUTH ST. DENIS has finally reaped the rich reward of a long engagement in vaudeville at a big salary after many years of pioneering in the field of aesthetic dancing. For two weeks Miss St. Denis packed the Palace Theatre, a feat which the grateful entrepreneurs of the varieties usually reward with a tour of their principal houses. A return engagement in the Spring at this aristocrat of vaudeville theatres is also promised the dancer.

Miss St. Denis's road to the golden goal has been a tortuous one. She has danced around the world year after year, acquiring a small but loyal following, but never till now achieving real popularity. At last it has come, and she feels that she is no longer a prophet without honor in her own country. Miss St. Denis believes that America is at the threshold of a dance renaissance, and that this important but neglected form of expression will receive more and more its due in the future.

"Dancing releases certain pent-up emotions," said Miss St. Denis in her dressing room the other afternoon, "that otherwise must remain unexpressed. For years we have allowed ourselves to be choked with them, and when finally they are set free by the dance it will be like taking a great, deep breath.

"The one thing we need to hasten the revival is fine, virile American men who will not be ashamed to take up the work seriously. Why should they be? Think of the manliness of the Greeks, and yet they indulged in dances and games."

This led to the question of whether professional dancing necessarily had an effeminating effect on a man.

"To be a good dancer," said Miss St. Denis, "a man must have a certain amount of the feminine in him. Without it he cannot have the proper appreciation of line and color and rhythm, the requisite degree of sensuousness. All artists have a certain per cent. of the feminine in their make-ups. It is a question of whether the man who becomes a professional dancer is 49 per cent. feminine or 51 per cent., whether or not he deteriorates into the unpleasant person that some professional dancers are. It is up here," and Miss St. Denis tapped her forehead; "it is the mental attitude.

"Otho Cushing, the illustrator, was telling me an amusing incident the other day that illustrates the apathy of American men to dancing. He was putting on a pageant at West Point, and the cadets absolutely refused to play the parts of men of antiquity and expose their bodies. Finally it reached a stage where some drastic action had to be taken or there would be no pageant, and conscription was resorted to. The cadets were ordered to the swimming pool, and each Apollo as he was discovered was pointed out and assigned a rôle whether he wanted it or not."

Out in Los Angeles Miss St. Denis and her husband and dancing partner, Ted Shawn, established an open-air dancing school last year. The school occupies an old estate in the city. There is an acre of ground surrounded by eucalyptus trees on the top of a hill, which insures a degree of privacy. Classes are held on a large platform to the music of a phonograph, which Miss St. Denis says she has found best adapted to the needs of teaching because of the perfect time. The pupils wear one-piece suits to allow the greatest freedom of motion. The school is called Denishawn, for obvious reasons.

"We had a most successful first season," said Miss St. Denis, "and while we did not make a great amount of money we feel we have made a good beginning. What we really hope to do is to found a school of dancing that will be to America what the Imperial School is to Russia. We shall use the technique of the ballet up to a certain point and then discard it and develop each pupil from that point in the direction in which he or she shows the greatest aptitude.

"You may remember the Delsartian craze that swept the country some years ago. Of course as it was executed—I use the word advisedly—here there was much that was ridiculous in large groups of fat women attitudinizing in parlors, but Delsarte, its originator, held a theory I believe in. He said that each part of the body had a special significance—that one part was the physical or sensuous, another expressed the emotions, another the mental, and so on. Now if a pupil shows an aptitude in any particular kind of dancing it would be absurd not to train him or her along that line. The great artist is the one who expresses that which is within him in his own way."

At the end of their vaudeville tour Miss St. Denis and Mr. Shawn will reopen their California school and from May till September will devote their energies to inspiring Young America to go on with the dance. America, says Miss St. Denis, has done its part in arousing interest in this ancient art.

"Wherever you see a barefoot dancer," says Miss St. Denis, "there has been the influence of Isadore Duncan. Before I began dancing the only kind of Oriental dances known to the Occident were those of the Midway Plaisance. Today the mention of Oriental dancing no longer suggests a show to be patronized by men."

February 27, 1916

# Incorrigibly Dramatic Dancing

## By WILLIAM B. CHASE

THE dramatic dance—and Isadora Duncan's free dancing is called incorrigibly dramatic —owes a world-wide cultivation among the greatest artists to one untrained American woman's idea. How does it happen that she has been able to inspire sculptors and painters, famous actors, technically trained dancers, to accept as authentic and to champion a virtual amateur? Is she yet a prophet without honor in her own country, in view of the late unreadiness momentarily to readmit her at Ellis Island's gates?

These are questions many persons have asked, quite as pertinently as those in the official inquiry now become a celebrated case. The artist's age, condition and recent change of citizenship by her marriage to a Russian poet had to do with that day's detention on returning to America. She came off with flying colors, posing for the photographers but protesting at too strong a light.

"Too many wrinkles," she said. As to whether or not she was to be considered a classic dancer, her frank reply had been, "I do not know; my dancing is personal." And further, "They wanted to know what I looked like on the stage. I answered that I could not tell, as I had never seen myself dance."

A natural selection is found in most popular figures of the stage, above all, in the dancers, whose whole physical being becomes their means of expression to the eye. To this selection they add training from childhood. The toe-dancer for half a lifetime develops nerves and sinews of steel. Not so Miss Duncan. She selected herself, chose her own manner of development, evolved forms of grace free and

From a
Sketch of
Isadora
Duncan
by Antoine
Bourdelle.

new, except as they were drawn from the classic model on some Greek vase. Her broad effects of plastic dancing, her barefoot ambling to entire symphonies, have been copied, borrowed, improved, not by one but by many younger successors with more of physical and technical equipment. She remains, as she was, a sphinx whose riddle is unanswered, while her work stands as an uncommon piece of pioneering, an extraordinary proof of power.

It is now many years ago that a

ten-year-old girl—gawky and self-willed, morose and lyric by turns, as a friend recalled her—was restlessly hovering about a California lawn. One of her brothers cultivated oratory, and indoors he was sonorously reading from a school book. The girl on the lawn heard him:

I shot an arrow into the air,
It fell to earth, I know not where.

Something stirred in the breast of the girl. "The arrow became a dimly conceived symbol—youth, life, love, achievement." Unconsciously she began to move, to gesticulate, to run, leap, dance. Untaught Isadora Duncan, "the amateur," began her life's work. Unrecognized in her own land, she went to Europe, and in the alien cities of Munich, Paris and London won what had been denied her in America.

"Once, in Chicago, when I was a little girl," she said in these after. years. "I had an interview with the late Augustin Daly. I told him that I had the germ of a great idea, a revolutionary idea, which would awaken the world to an intimacy with the art of dancing. I think results have proved my statement to be true." Another time she related her early experiences in New York, some of which have never been told. Mr. Daly encouraged her to come to New York, she said, and gave her a part as one of the fairies in a production he was making of "A Midsummer Night's Dream."

Miss Duncan lived in this city, with her mother and two brothers, in West 189th Street, and she walked each day from her home to the theatre in lower Broadway to attend rehearsals. Instead of going out to lunch, for she had no money for car fare, let alone for luncheon, she would crawl into one of the boxes of Mr. Daly's darkened theatre and go to sleep. Finally, she was able, with the help of a few wealthy persons, to raise $150, which paid the passage to Europe for herself and the family on board a cattle ship.

"And we nearly starved in London, and Paris, too," was her comment on that time.

She had first danced in New York in the late Ethelbert Nevin's studio at Carnegie Hall, where a few appreciative folk recognized her as doing rare and lovely things. Then, with her bits of rose and gray gauze, her ideals and her courage, she sailed away. The progress led to Germany. There she chanced one night to dance in the studio of a popular artist, Franz Stuck, and the art world of Munich was talking of her work next day. It was there in Munich that Miss Duncan's dancing was established as a definite, significant art; it was also in Germany that she acquired the confidence in her work which enabled her later to start her Paris school, as well as her sister's in Berlin, and prepare to perpetuate "The Dance of the Future."

That futurist dance was designed as "a return to simplicity, beauty and truth." As Miss Duncan said in her lectures: "All other arts have recognized that great art must be

Isadora Duncan. From a Sketch by Van Deering Perrine.

nude art. Dancing alone has feared the nude." Thus proclaiming it as one of the elements of all supreme plastic art, as in practice did the Greeks, Miss Duncan dared to insist upon a freedom from all but the merest illusion of clothes and, to the terror of the prude and the interest of the vulgar, danced with arms and legs bare and uncorseted body, draped only with lightly blowing gauze.

Whatever its technical shortcomings, the new idea was indeed revolutionary in the classic ballet. "All the movements of our modern ballet school are sterile movements because they are unnatural," she argued. "Their purpose is to create the delusion that the law of gravitation does not exist for them. The primary or fundamental movements of the new school of the dance must have within them the seeds from which will evolve all other movements, each in turn to give birth to others in unending sequence of still higher expressions, thoughts and ideas."

To those who still enjoyed the conventional ballet from historical or "choreographic" or whatever other reasons, her answer was: "They see no further than the skirts and tights. But look—under the skirts, under the tights, are dancing deformed muscles. Look still further—underneath the muscles are deformed bones. A deformed skeleton is dancing before you. This deformation through incorrect dress and incorrect movement is the result of the training necessary to the ballet.

"The ballet condemns itself by enforcing the deformation of the beautiful woman's body. No historical, no choreographic reasons can prevail against that."

There is a story that for five years Miss Duncan studied Beethoven's

Seventh Symphony before venturing to dance to it in public. It was remarked as a coincidence that Wagner, in his "Art-work of the Future," had said of this symphony of Beethoven that it is "The Apotheosis of Dance," and that Miss Duncan in fact danced to it for the first time before Frau Cosima Wagner. The Russians, with their then existing imperial schools of ballet, were first to follow and even far outrank her with performances of endless variety. But they called Isadora Duncan, all unaware, their teacher, when they followed her West.

Ellen Terry, watching the American woman's performance for the first time in London, suddenly sprang to her feet, turned to the audience, and exclaimed: "Do you realize what you are looking at? Do you understand that this is the most incomparably beautiful dancing in the world? Do you appreciate what this woman is doing for you—bringing back the lost beauty of the old world of art?" It was thus that the two artists met and a lasting friendship began. In Miss Terry, too, the later-arriving Russians of Diaghileff found their first English spokesman in her little volume on "The Ballet Russe."

Jacob Adler, the Jewish tragedian, paid a remarkable tribute to Isadora Duncan on this side of the Atlantic. "I had always thought that dancing was a light pleasure," he said, "a joyous thing, sometimes a vulgar thing, often a thing that provoked the sensual instincts that our Hebrew morality has tried for ages to suppress. But I suddenly saw something very beautiful, and I found myself weeping. There was an exaltation and inspiration. I saw that she was one of the rare persons of this world, and that her art could, in some strange way, bring completeness to what was otherwise so discouragingly incomplete."

The late August Rodin declared Miss Duncan had achieved in sculpture "feeling without effort." Seeing her in Paris, he said: "She is natural on the stage where nature is so seldom seen. She preserves in the dance the perfection of line, and at the same time is as simple as the antique, which is the synonym of beauty. Suppleness and feeling—these are the great qualities."

If the Winged Victory, wrote a French critic, could sway and bend from her high pedestal in the Louvre, the motion would surely be the same as that which Miss Duncan shows in her series of dances picturing Gluck's "Iphigénie en Aulide." He added: "You do not recall a single step of all the dancing, for this woman of the hilltops has no practiced 'stunt' to remember and repeat." It was the American artist, George Gray Barnard, who asked: "Why cannot we of the New World, the new epoch, grasp the fact that one of our own children comes endowed with the sacred fire of in-

tuition, holding forth to us, not the copies of dying Greek art or dead Rome, but the living laws within the human body?''

A nature less assertive than was the subject of all these personal responses to her appeal might have withered under the sheer weight of artistic responsibility. Miss Duncan wanted to tell the world and teach it. '' If the Crown Prince of Germany,'' she exclaimed not long since, '' had learned before his sixth year to dance to the music of Beethoven's ' Ode to Joy,' instead of being permitted to play with toy soldiers, the World War might have been

averted.'' That war found the dancer back in Europe, where her school near Paris was converted into a hospital. Last year the plight of the Russian people aroused her sympathy, and she—characteristically and literally—flew there to introduce her dancing as a welfare work among the children of Moscow.

A thousand children were placed under her tutelage by the Soviet Government, some of whom, from 7 to 14 years old, were recently announced to accompany her present '' Farewell '' American tour. In order to avoid legal entanglements in taking them across two continents, Miss

Duncan was officially made their guardian. A surprising fact was that four of these children were born in America and lived here until the overthrow of the late Czar, when their parents saw the opportunity to return to Russia without fear of political persecution. Two others of the dancer's new protégés were born in Germany, the rest in Russia. '' Here, in the melting pot of developing minds,'' she said, '' will simmer the best instincts of sturdy nations and races, to which, when their material growth is again on the increase, their representatives now full-grown shall return to revitalize the arts.''

October 15, 1922

---

## BARS ISADORA DUNCAN FROM BOSTON STAGE

### Mayor Curley Moved by Protests —Dancer Denounces 'Puritan Vulgarity.'

*Special to The New York Times.*

BOSTON, Oct. 23.—This city has seen the last of Isadora Duncan on the stage, if Mayor Curley lives up to his present intentions. Aroused by the widespread criticism of her appearance last week in Symphony Hall, the Mayor is determined that the dancer shall not appear again on any Boston stage.

Miss Duncan does not take kindly to Boston's attitude.

'' Bostonians are afraid of the truth.'' was her parting shot as she left the city for more appreciative fields. ''They want to satisfy baseness without admitting

it. A suggestively clothed body delights them. There is a Puritanical instinct for concealed lust. All Puritan vulgarity centres in Boston. The Back Bay conservatives are impoverished by custom and taboo. They are the lifeless and sterile of this country.''

Before bidding farewell to the Hub at the Copley Plaza Miss Duncan said that her art was symbolic of but one thing— the freedom of woman. She said that when she danced her object was to inspire reverence, and not suggest anything vulgar. She maintained that she did not appeal to the lowest instincts, as she said some half-clad chorus girls were doing.

She declared that she sought the emancipation of women from the ''hidebound conventions'' of New England Puritanism. '' To expose one's body is art; concealment is vulgar,'' she maintained.

In the meantime Boston is talking of the two performances which Miss Duncan gave at Symphony Hall. Many in both audiences, shocked by her scanty costumes and radical addresses, left the hall.

October 24, 1922

---

## AMERICAN BALLET MAKES ITS DEBUT

### Crowded House at Metropolitan Greets Native Dancers Trained by Fokine.

### THEY PERFORM IN "ELVES"

His former compatriots filled most of the crowded Metropolitan last evening at Michel Fokine's first public appearance after some three years spent in

developing an American ballet. Society, too, was in the boxes for once on opera's off night. It was apparently a spontaneous popular greeting to the one-time Czar's dance creator ''the brains of the Russian ballet,'' and his beautiful wife, infrequently seen since they first came to America in 1919. There was interest for Russians in an orchestra of their own nationals, led by Alexander Aslanoff, formerly of the Imperial Theatre, Petrograd, while for Americans, at any rate, curiosity ran high as to a new and native ballet.

They made their debut—sixty young American dancers—at the evening's start, in a fantastic piece called ''Elves,'' in costumes still more fantastic on the line of futuristic art, though danced to such classic music as had been arranged from Mendelssohn's violin concerto and his ''Midsummer Night's Dream.''

In a list of printed names were mentioned Beatrice Belrava, Inga Bredahl,

Helen Denison, Desha Podgorska, Lora Vinci, Doris Niles, Barbara Clough, Madeleine Parker, Jeanette Wilde, Janet Justice, Tania Smirnova, Terry Bauer, Nelly Savage, Dorsha Denmead, Alice Wynne and Constance Keller, Vitale Antonoff, Raymond Guerrard and Jack Scott.

Some of those who appeared later were Frances Mahan, Renee Wilde and Katia Repelska, as Greek maidens; Polly Klots, Dorothy Harris, Hebe Halpin, Vera Boudin, among the ''waves,'' and Sigmond Grenewitch among the ''warriors,'' with others as ''morning brides,'' in Fokine's ''Medusa,'' announced as a world-premiere. In important minor rôles were Scott as Poseidon and Nelly Savage as Pallas Athene.

The ''Medusa'' was danced to music from Tschaikovsky's symphony ''Pathetique,'' just as the first Russian ballet ever seen here, that of ''Scheherazade,'' given in 1910 by Morris Gest at the Winter Garden, and later by Diaghileff, was done as a ''tragedy of the harem,'' also arranged by Fokine, and not as the wreck of Sinbad's ship originally depicted by Rimsky-Korsakoff.

A new Rimsky-Korsakoff dance last night was ''Ole, Toro,'' to that composer's popular ''Caprice Espagnole,'' with the Fokines as a gypsy and a toreador and Jack Scott as ''the rival,'' El Jesloso, unknown to ''Carmen,'' which is chiefly recalled. Charmian Edlin assisted the pair in ''Le Rêve de la Marquise'' and Mme. Fokine revived Saint-Saens's ''The Swan,'' prime favorite of Pavlowa.

A percentage of the receipts will be given to the Russian Relief Fund through the Monday Opera Supper Club. Among the members of the Supper Club who took boxes and seats were Mrs. Richard Mortimer, Mrs. Henry P. Loomis, Miss Lucile Thornton, Mrs. John Aspegren, Mrs. Ethan Allen, Mrs. Arthur Ryle, Mrs. H. Edward Manville, Miss Elizabeth Achelis, Mrs. E. Roland Harriman, Mrs. W. S. Moore, Mrs. Hoffman Miller, Mrs. Monroe Robinson, Mrs. W. D. Orvis, Mrs. Langdon K. Thorne and Mrs. Alfred Loomis.

February 27, 1924

---

## 'SKYSCRAPERS' HERE WITH 'JAZZ' SCORE

### By OLIN DOWNES

SKYSCRAPERS, a twentieth century ballet in one act and five scenes. Music by John Alden Carpenter. First performance anywhere, in triple bill with ''Gianni Schicchi'' and ''Pagliacci.'' At the Metropolitan Opera House.

The Strutter..................Albert Troy
Herself................Rita de Lepote
White Wings.............Roger Dodge
Conductor, Louis Hasselmans.

There was an event last night in the Metropolitan Opera House of perhaps more importance than the débuts of young prima donnas, however exciting these may be, namely, the first performance on any stage of the ballet ''Sky-Scrapers,'' the music by John Alden Carpenter, the scenic settings by Robert Edmond Jones, the dances directed by Mr. Samuel Lee.

This is one of the most interesting of the productions given this season at the Metropolitan, and it is auspicious for the development of a specifically American art form. ''Sky-Scrapers'' is a free fantasy on certain phases of

American life. These are symbolized by fantastical scenery and by choreography based upon American dances, as Mr Carpenter's score is based upon ''jazz'' rhythms.

There is an admirable synthesis of these elements, there is play of imagination and transformation of common and even vulgar sights and sounds of the life in an American city into forms of distinction and artistic suggestiveness. It is all accomplished, finally, without posturing or pretentiousness, with deftness, humor, technical skill and a light touch.

The fundamental underlying motive is the work and the play of the masses in any great city. The stage curtain

rises to disclose a second curtain, which, as it were, hits and dazes the eye—a symbolic design of dizzying converging lines of black and white. On each side of the stage are huge blinking lights. The curtain of black and white, to whistling and clanging sounds in the orchestra, gives place to stage designs suggestive of the confused and prodigious architecture of a great city, with its streets and passing crowds for a half-illumined background seen to the right or left of a towering skyscraper. Back of it loom other huge and lofty shapes, and at the foot of it are gangs of laborers, one group with sledges, another of steel riveters, and others higher up on

the structure—all delving and forging the great stride over them. The suggestions of color are admirable throughout. There is singular use of light and shadow. The garments of the workers glint, and they have a steely hue.

The scene changes quickly to another setting—two doors of a factory, or some other great absorbent of labor, and at one side a time-clock. Workmen and workgirls troop in, to mark their time and disappear in murky gloom. A few linger to embrace and "jazz" or "strut" for an instant to Mr. Carpenter's engaging rhythms—and the factory has devoured them.

And now another scene. This is "a Coney Island"—any Coney Island. The workers are at play. The choreography is delightful in its inventiveness, its variety, its sense of rhythmical development and design. The colors of the dancers are as various and garish as their costumes. Their steps are taken from the American musical comedy stage, the cabaret, the dance hall, but they are far from merely literal imitations or reproduction. On the basis of these dance motives a considerable variety of pantomime and of newly invented evolutions and steps that have at last something of the vigor and kick of the American popular music are employed. And there are brilliant solo dances, not introduced as formal diversion so much as inevitable offshoots of the general ensemble spirit and effect.

The three solo dancers are Albert Troy, the "Strutter"; Rita de Leporte, "Herself," and Roger Doge, the "White Wings," or street cleaner.

They disport themselves with a rare gusto and with a technic exhilarating in its unconventional and popular derivation. Right worthily were they applauded. Each excelled in his own metier and characterization. Miss de Leporte performed in the cabaret or chorus girl style. Mr. Troy, with an enormous black silk hat and the gestures of a popular comedian, danced steps wholly his own and disappeared with a marvelous dive over the backs of a half dozen black, or blacked, comedians.

Mr. Doge had a more definitive part in the proceedings, since it was his pantomime of the sleepy colored gentleman which ushered in further developments of the fantasy.

To return to the ensemble. It now disports itself as a parody on scenes that take place at any Summer beach resort. A band plays discordantly. Showmen ballyhoo their wares. A carousel is wheeled into the centre of the stage, and its pillar revolves in one direction while the chorus prances, as the horses of the merry-go-round, in the other. The carousel comes slowly to a halt; the horses slow up, droop their heads or remain as if stopped in mid-air. And so on. One episode follows another quickly. Great distorting mirrors amuse the crowd, which is continually forming and re-forming in fresh shapes and rhythmical groupings.

The small hours of the early dawn arrive. "White Wings" falls asleep and dreams. Coney Island is shrouded in shadow. A chorus of some twenty negro voices sings some wordless but, as it were, half familiar refrain and the workers awake. The jazz in the orchestra quickens, there is a gradual return to the opening scenes—the factory doors, the winking lights, the whistling and clanging, and finally the gangs of labor at the feet of the great buildings and scaffoldings of new structures to arise.

And this motive of labor is pictured with singular impressiveness at the end. Back of the groups that have been until now the centre of attention are seen huge shadows of other workers, bending and swinging, plying their sledges. Their shadows become more tremendous and more monstrous, till they tower threateningly to the skies. Some of them stretch immense limbs, others open their arms as if in entreaty, and the curtain falls.

The pantomime ballet, or by whatever name it may be called, is an art form that is uncommonly flexible and a fertile field for artistic expression. The great revelation of the possibilities of this modernized form came with the Ballet Russe of Diaghileff. Its productions were Russian. Sometimes they were arbitrary adaptions of certain well known scores to an interpretive choreography. Mr. Carpenter's ballet has a distinctively local and even racial quality.

There are some reservations on the purely musical grounds. They lie principally in the direction of a lack of very striking inventiveness in the score. The technic is superb, though the procedure as well as some of the rhythmical ideas themselves savor strongly of Stravinsky. The workmanship is so fine, and imbued with such a spirit, that it conceals itself.

Mr. Carpenter might reply to the criticism of a lack of substantial musical material in his score by saying that he had not tried to be ponderous or to attempt dramatic commentary, but to entertain and amuse. But his intention in spite of his lightness of touch is more thoughtful than that. What he has done is to invent some fairly fetching jazz tunes of his own and to include some scraps of familiar popular songs, such as a suggestion of the "St. Louis Blues," a quotation, for the movement of the carousel, of a phrase from "Massa's in the Cold, Cold Ground," and a trumpet parody of "Yankee Doodle," as, in the last delirious ensemble, Mr. Troy lifts his hat and steps about with a sweep and a fling that make him a pinnacle of the ensemble—and all this with a dexterity and a use of frequently complex rhythms in a manner so dexterous and apparently spontaneous that it is only afterward, with a blink of the eyes, that the listener realizes he has been listening to "five-four" and "seven-four" and "off-beats" and cross accents that the composer, in the most guileless manner, drops from his sleeve. The inclusion of saxophone, banjos and percussion instruments is done well and in a manner that enriches without exaggeration. And what a pleasure, what an exhilaration, to listen to an American composer of Carpenter's discernment, taste, and his virtuoso mastery of his idiom!

The ballet was very well received. The composer and his two coadjutors appeared before the curtain to acknowledge the applause.

February 20, 1926

---

## GALA OPERA CONCERT.

### A Dozen Soloists Take Part at the Metropolitan—Other Events.

Metropolitan stay-at-homes and some late departing members of the opera tour joined in a gala farewell "opera concert" of the season on Broadway last night. Leonora Sparkes, Mme. Sabanieva, the Misses Wells and Arden, and Messrs. Malatesta, Schuetzendorf and Vajda were among the dozen soloists. Mario and Errolle sang a duet from "Carmen," Delaunois and Howard the barcarolle from "Tales of Hoffmann," and Ryan, Errolle and Wolfe a final trio from "Faust."

Boris Levenson, the composer, gave a program of his music last evening at the Little Theatre. He was assisted in arrangements of Jewish folk melodies by Simeon Bellison, clarinet, and the Russian String Quartet. There were manuscript songs for Mary Leavitt, soprano, and violin pieces for Mischa Mischakoff.

Martha Graham of the Eastman School at Rochester, formerly with Ruth St. Denis's dancers, gave a program introducing her own "concert group," assisted by Mabel Zoeckler, soprano, at the Forty-eighth Street Theatre last night. Miss Graham led ensemble dances from Scriabin, Satie, Goessens and Scott.

April 19, 1926

---

# THE DANCE: A REVOLT

## Movement Toward Naturalism Raises an Old Problem Anew—Current Programs

### By JOHN MARTIN.

IT is an interesting anomaly that the progressive modern dancers who have dedicated themselves to the attainment of the abstract should be seeking their goal exclusively through the paths of natural movement. "Exclusively" is indeed an inadequate term to describe the passion with which they reject anything that smacks of artifice or of formula. Only to mention the technique of the ballet is to incur a dark displeasure, and to suggest that there might be some esthetic validity in toe shoes and turned out hips is to place one's self at once in the category of the Philistines. Nevertheless, the nearer the modernists approach to abstract movement the more difficult they find the defense of their antagonism to the ballet, for the ballet has long ago solved the majority of the problems which the progressives of today insist on resolving for themselves.

Between nature and art there exists the same polarity, whether the particular object of consideration is movement or music, color or mass. To be able to walk with perfect balance, with the correct muscular relaxation and tension and the entire body functioning ideally, might be instructive and pleasant to watch; but it has in itself nothing of the character of art. Before it assumes such a character certain aspects must be exaggerated, others eliminated altogether, and the tempo and dynamism varied to conform with a pattern. As these adaptations are made, the movement becomes less and less the movement of nature. In fact, it is a hopeless undertaking to attempt the reconciliation of abstractness and natural movement, for the very terms are mutually exclusive.

#### Technique and Artistry.

The revolt against the ballet, when reduced to its lowest terms, is actually not a revolt against a technique, as it appears; it is rather a revolt against inferior artists who, instead of using a technique for their own purposes, allow themselves to be swallowed up in it. This condition is no whit less forbidding in the so-called free plastique or any other medium, for bad art is indefensible under whatever name. From another point of view, it is scarcely conceivable that Pavlowa or Argentina would be greater if they employed freer technical methods. Indeed, the very restrictions of a traditional form often provide fuel for the flames of art.

It is undoubtedly well to revert to elementary principles ever so often, to return to sources and build again. Otherwise the vitality of the original purpose is likely to become lost in the mazes of unessentials which develop out of it. Nothing, for example, could revivify the ballet so much as the strong reaction against it which prompted a return to nature for reinvestigation and reorientation.

When Delsarte rebelled against the aridity of the gesture of his day, he spent laborious days and nights examining and delving into the natural reactions of the body to emotional stimuli. He tabulated endlessly the action of hands, of fingers, of faces in minute detail, and performed what is perhaps the most exhaustive task of experimentation that has ever been attempted along the lines of natural movement. But it was not long before the fruits of his labors decayed into the same sort of dead formality that existed before he set out upon his labors. It proved just as easy to reduce natural movements to empty gestures as it had been previously to be empty and lifeless with gestures that had long since ceased to have any relation to nature. The real value of Delsarte lay not so much in what he did as in what he loosed on the thought of the day.

Isadora Duncan was a direct result of the Delsarte impulse; and Isa-

dora's impress upon the art of dancing has been without precedent in its magnitude. But here again, no end was accomplished. Isadora's revolt was a philosophical one rather than an artistic one; she believed in physical beauty and a mystical indulgence in it, out of which she created a great and nameless thing that was singularly her own.

To dare to say that Isadora did not accomplish anything lasting is to bring down a torrent of abuse and argument upon one's head, but the evidence, none the less, is all in that direction. To her particular credo natural movement was essential, as unhampered self-expression was its godhead. Though she admired and acknowledged her debt to Nietzsche

for her artistic theory, she was by no means bound by his teaching, as to the duality of art. She accepted the Dionysian phase of it so fully that the Apollonian was allowed to trail in the dust. Obviously, then, natural movement was indicated; for it offered the least possible resistance between the artist and his enjoyment of his own emotional embodiment.

### The German Revolt.

The German revolt against the ballet came also from causes other than artistic. It was the search for health and physical efficiency that led eventually to the discovery that this way lay a new dance. From the standpoint of physical well-being, natural movement again was inevita-

bly right. As the art aspects of it have been perceived, however, it has turned slowly in another direction and where it will finally arrive remains to be seen. It is not difficult to venture that a new classicism is its destination—a classicism not so far removed in its essence from the rejected classicism of the ballet—though no doubt possessing a vitality and a color that are not be found in the old method.

Leonid Massine's theory of the ballet in relation to naturalism and to convention is very interesting. To him the arms and legs constitute the instrument of the stylized forms, while the head and torso must ever remain as a link between the humanity of the artist and his audi-

ence. In other words, if the dancer is completely an artificial instrument he awakens no sympathetic response in the onlooker; yet if he is entirely naturalistic, he has no art.

It takes a visit from an Argentina to upset the calculations of all schools and methods, and to show how unimportant any of them is in itself in comparison with the individual gifts of a fine artist. In the final estimate there are probably as many different schools as there are first-rate dancers, no more and no less; and it makes little difference whether natural movement or abstractions, authenticity or self-expression occupies the position of shibboleth at the moment.

January 13, 1929

## DANCING BY MASSINE RICH IN INVENTION

### He and Martha Graham Outstanding in Choreography at Stokowski's Farewell.

With a second performance at the Metropolitan Opera House last night before a crowded house, the joint production by the League of Composers and the Philadelphia Orchestra Association of Schoenberg's "Die Glückliche Hand" and Stravinsky's "Le Sacre du Printemps" in full theatrical form came to an end. This was also the end of the Philadelphia Orchestra's New York concert season. The event proved to be of major importance in the realms of the theatre and dance, as well as in musical circles, and made a noteworthy contribution to the movement for a synthetic theatre art which shall include all the contributory arts on equal terms.

Under the general directorship of

Leopold Stokowski, the production naturally laid its chief emphasis upon music, but there were other artists whose share in the venture were of more than inconsiderable value. Leonide Massine and Martha Graham were foremost among them. In his choreography of "Le Sacre," Massine achieved brilliant results, and in her performance of the maiden chosen for the sacrifice Miss Graham was seen at the pinnacle of her powers. If she has been inclined of late to withdraw more and more into the psychological aspects of the dance, here in the frenzied choreography designed for her by Massine she revealed once more her technical virtuosity without losing in the smallest degree the dramatic and emotional integrity which have characterized her highly individual art as unique. It was a performance of the first magnitude, compelling, poignant, sure-footed even when scaling the treacherous rhythmic heights of Stravinsky's music.

Unfortunately, Massine did not receive the same sort of cooperation

from the corps de ballet, which was vigorous and enthusiastic, but neither technically nor inspirationally equal to the task he set them. This was more especially true of the girls than of the boys, for the latter, except for occasional inexactness, acquitted themselves with credit. Especially admirable was their support of Miss Graham during the dramatic closing scenes.

In this, his first important appearance as a choreographer in America, Massine covered himself with glory. His mass designs and the individual movements that comprised them were endlessly inventive and filled with the same pagan fire and rapture that surges through the music. Not only in the second act, where the dramatic episode of the sacrifice occupies the action, but more particularly in the first act, which is built on movement alone with no narrative program, was his figuration rich with character and ingenious in the beauty of its devices. Of outstanding brilliance was the "round dance of Spring," the high

moment of the evening except for Miss Graham's sacrificial dance.

The presentation of Schoenberg's "opera" was marred by inappropriate staging. Though the quality of the music and the composer's own libretto is fevered, ugly, spasmodic, with a strain of hysteria running through it, the setting of Robert Edmond Jones and the staging of Rouben Mamoulian are flowing, decorative and mild. Their eye-pleasing qualities are their own undoing. The costumes, particularly of the men, are also unfortunate. Against this handicap, Doris Humphrey labored devotedly and to some purpose. Her plastique was beautiful and eloquent. Charles Weidman had little or nothing to do, and Olin Howland, while he may have followed instructions, was wholly misrepresentative in costume and in action of the composer's printed directions concerning the "chimera." Theatrically speaking, the surface of the Schoenberg work was scarcely scratched.

April 24, 1930

## MONTE CARLO GROUP GIVES 'UNION PACIFIC'

### World Premiere of the American Ballet Draws Enthusiastic Audience in Philadelphia.

Special to THE NEW YORK TIMES.

PHILADELPHIA, April 6—An enthusiastic audience attended the world premiere of the American ballet "Union Pacific," presented by the Monte Carlo Ballet Russe at the Forrest Theatre here tonight. The spectacle is in five scenes and is based upon the building of the first transcontinental railway.

The ballet depicts the intensive rivalry of the crews engaged in constructing the east and west sections of the railroad, which met at Ogden, Utah, in 1869. The "big

tent" scene, featuring Leonide Massine, the barman, and a picturesque group representing the character of the times, was greeted with marked applause and cheers.

Archibald MacLeish, American poet and Pulitzer prize-winner, who wrote the libretto; Nicholas Nabokoff, young Russian composer, now a resident of this country, who composed the score, and others associated in the production responded to curtain calls. Albert R. Johnson designed the scenes and Irene Sharaff collaborated in the stage pictures. The orchestration is by Edward Powell, American musician, and the choreography is by Leonide Massine.

"Union Pacific" was placed in the program between "Les Sylphides" and "Cotillon."

April 7, 1934

# THE DANCE: THE STADIUM

## Some Afterthoughts on the Season of the Fokine Ballet

### By JOHN MARTIN.

THE financial plight of the Stadium concerts this Summer has been a deplorable one, and the failure of the ballet programs to pull them out of the hole is a particularly interesting, though not a surprising, aspect of the situation. Judged purely on surface data, it may appear inexplicable that whereas last year such tremendous crowds stormed the gates for the performances of the Fokine Ballet that traffic was stopped and the police had to be called out, this year the seats have never been much more than half filled and in the majority of cases considerably less than that.

If the situation is examined more closely, however, the mystery begins to dissolve. In the first place, due account must be taken of the weather, always an important element in the Stadium season. Though up to the time these lines are written only two ballet performances have had to be canceled, others have been given under discouraging conditions of uncertainty. This has been true to a certain extent of the musical part of the schedule as well, and no doubt the whole program has also been affected by the campaign for financial support from the public at large, which is likely to act as a dampener of enthusiasm.

Another item which is worth considering is that two performances of ballet a week were announced in advance; last season only two performances in all were announced and another pair added strictly because of popular demand.

\* \* \*

There are other and more fundamental reasons, however, which underlie the whole matter, the chief one being that the ballet has never been a popular art. It has always demanded a certain amount of special preparation from its audience. When it is allowed to seek its own popular level, it becomes on the one hand such routine stuff as graces the average cinema presentation, and on the other hand goes to the extremes of acrobatic display which, if we are to judge by the performances of the Messerers in Europe and of Vecheslova and Chabukiani in this country, characterize the popular ballet of the U. S. S. R.

An inherent lack of responsiveness to the ballet has always characterized the American public. We have never produced a ballet dancer of the first rank, not because of any absence of talent — indeed, European ballet masters have been practically unanimous in their enthusiasm for the adaptability of the American dancer to the ballet — but because of the absence of an audience. What audience there is for the ballet is largely either of European origin or consists of Americans of means whose contacts with the ballet have been established abroad.

American culture did not begin to grow up with any character of its own until the ballet was well on the way toward its period of decline, and the whole shape of American life has been inimical to the aristocratic arts—opera and ballet—which have been adjuncts of court life and have depended upon subsidies, as indeed they apparently still do for adequate presentation.

Financial success by a ballet company in this country is not a common occurrence by any means. The Diaghileff company lost half a million dollars on its two seasons here, and so discouraged the directors of the opera thereby that the development of the ballet in the Opera House, its logical centre, was set back for at least a generation and still shows no signs of recovery there. Box-office success, for the most part, has been confined to the road, and there it has been not merit that has turned the trick, but glamorous names and ballyhoo. Organizations which have lacked one or the other have, irrespective of merit, died the death.

\* \* \*

Actually the anomaly in the case of the Fokine Ballet at the Stadium is not this season's public response, but last season's. Last year, oddly enough, the Fokine Ballet was a novelty. Its latest previous appearances in New York had been in the early Fall of 1927. This was just on the verge of the new revival of interest in the dance. The newspapers were only beginning to consider the establishment of regular dance departments, and a whole generation of youngsters who were about to go into dancing in a big way had never even heard the name Fokine. In the intervening seven years they had occasion to hear it often, but not until the Summer of 1934 did they have an opportunity to see his work.

The extensive publicity campaign of the Monte Carlo Ballet had also stirred interest in the subject of the Imperial Ballet and its great creator, and if mobs had not turned out to see his performances it would have been strange indeed. That they did not do so again this year is deeply regrettable, but the novelty has worn off, there are no "names" in the company, and the works themselves are not in tune with the vitality of the times. The casual public pays as little heed to choreographers' names as to those of the authors of its plays and novels, its song hits and movie scenarios.

There are not enough balletomanes in the world to fill the Stadium eight times in a month. For those who are not deeply interested in the history of the dance and eager to see compositions which, whatever their present evaluation, shaped artistic thought and ushered in a new era for the ballet, it is readily understandable that the recent Fokine season should have made a very limited appeal.

The great revolutionary movement which in the early years of the century placed the young Fokine among the select few in the history of his art has long been accomplished. Its fine insurgency has been imitated and diluted in every conceivable manner. Orgies and bacchanales in the style of ancient Greek and Oriental paintings (sic) have found their way into Hollywood and movie house presentations with such frequency and such blatancy that it is impossible now to face Fokine's epoch-making originals without a difficult mental adjustment.

July 28, 1935

---

# FOLK DANCES SEEN IN BERKSHIRE FETE

## Jacob's Pillow Festival Opens Ten-Week Season in New Theatre at Lee, Mass.

### DE MILLE WORK IS GIVEN

## Ted Shawn, Sammy Spring, Sam Steen, Katherine Sergava Featured on Program

### By JOHN MARTIN
Special to THE NEW YORK TIMES.

LEE, Mass., July 9—The Jacob's Pillow Dance Festival, which plans a ten-week season in its newly built theatre on the old Carter farm near here, got under way this afternoon with a performance on American folk themes by Ted Shawn, Agnes de Mille, Sammy Spring and groups of dancers both professional and folk. It is on this site that Mr. Shawn has housed his Summer dance activities for the last ten years, but the present festival inaugurates a new and enlarged plan of activities with Mr. Shawn as director, but under the auspices of the Jacobs Pillow Dance Festival, Inc., an educational and non-profitmaking organization chartered by the Commonwealth of Massachusetts.

A school embracing various branches of the dance forms the nucleus of the projects, and against this background festival performances dealing with origins and developments of the American dance are planned for Thursdays, Fridays and Saturdays throughout the Summer with a series of guest stars.

### Folk-Dances on Program

The first week's program dealt, logically enough, with American folk-dance and its adaptation to theatrical usage. The pure and unadulterated folk-dance was presented utterly without affectation or pretension by a group of neighbors from Otis and Becket, and certainly it was no handicap that Sammy Spring, the fiddler and caller, happens to be one of the finest of nationally known callers. He brought along with him a square-dance set of eight people and put upon the stage of the new theatre certainly as fine dancing as it is likely to ever support.

If these ageless dances are simple and unsensational, they are formally of great perfection, and when they are done as simply as they were on this occasion they have the power to bring tears perilously close to the eyes of any spectator who is in love with his country and its culture.

The second section of the program consisted of four dances on folk themes composed by Mr. Shawn and frequently presented on his programs in the past. They were effectively danced by Mr. Shawn himself, Sam Steen and a group of boys and girls who entered into the spirit of the occasion. The final section of the afternoon was Agnes De Mille's theatre piece, also in folk themes, called "Hell on Wheels," and dealing with a broken-down theatrical troupe trying to give a performance in a little Western camp in the days when the transcontinental railroads were being built.

The piece is lusty and full of atmosphere in the best De Mille style. It was danced (and played, spoken and sung, as well) by Miss De Mille, Mr. Shawn, Katherine Sergava and the others with fine gusto.

### Theatre Designed by Franz

The new theatre building has been admirably designed by Joseph Franz, the architect of the shed for the Berkshire Symphonic Festival at nearby Tanglewood. Built of native pine with hand-hewn beams, it fits beautifully into the landscape without any taint of quaintness or rusticity.

The stage is of good size and eminently practical. The total effect is of an altogether modern and functional building in charming style. It was formally declared open this afternoon by Reginald Wright, president of the Jacob's Pillow Dance Festival, Inc., in a brief speech, in which he handed over its direction to Mr. Shawn, who responded with a gracious and eloquent dedicatory address.

July 10, 1942

# THE DANCE: DE MILLE'S OKLAHOMA

### By JOHN MARTIN

A COUPLE of lusty yippees are clearly in order for Agnes de Mille and the dancing she has staged for the Theatre Guild's utterly charming "Oklahoma!" It is frequently the case that when artists from the ballet and the concert stage turn to Broadway they unconsciously look down their noses even at their own work. Miss de Mille, on the contrary, has turned in as sensitive and finished a job here as any she has done for more lofty (and less well-paid) divisions of the theatre arts.

Indeed, it is quite possible that her long ballet, called "Laurey Makes Up Her Mind," at the end of the first act of "Oklahoma!" marks an actual advance over what she has done previously. Here for the first time she has created an altogether objective work; in everything that has preceded it she has built a central role so specifically in terms of herself and her highly personal idiom as a dancer that no other dancer undertaking it could hope to be much more than a little imitation de Mille. That is, to be sure, a wonderfully sound way to work, for it bases its entire psychology and the movement that stems from it on the true premises of actual experience; but to have grown through that method into a strength that is independent of it is to have attained the real freedom of the creative artist.

"Laurey Makes Up Her Mind" is a first-rate work of art on several counts. For one thing, it is so integrated with the production as a whole that it actually carries forward the plot and justifies the most tenuous psychological point in the play, namely, why Laurey, who is obviously in love with Curly, finds herself unable to resist going to the dance with the repugnant Jud. Many a somber problem play has been built on just such a question of emotional compulsions and has failed to illuminate it half so clearly after several hours of grim dialogue. Yet this is a "dance number" in a "musical show"!

For another thing, Miss de Mille has turned her back entirely on the established procedure of making "routines." She has selected some delightful young people to dance for her, and she has built her dances directly and most unorthodoxly upon them. As a result they emerge as people and not as automata—warm and believable people made larger than life and more endearing by the formalized movement through which they project themselves. Katharine Sergava with her strangely remote quality of beauty becomes the ideal heroine of a rather terrifying dream in which great personal decisions must be made. Marc Platt,

faced with the difficult assignment of sheer romantic maleness defeated by sinister forces, comes forth with an artistic performance that far surpasses anything he ever did as Marc Platoff of the Ballet Russe. George Church is made to embody those sinister forces quite frighteningly simply by making imaginative use of his bulk, his strength and his ability to move.

Even in the smaller dance numbers throughout the evening, of which there are several topnotchers, Miss de Mille has employed the same method. The radiant Joan McCracken fairly bursts with minxishness whenever she puts foot to stage, and little pale-haired, wide-eyed Bambi Linn darts in and out of the action with a wonderful childish freshness.

As for the choreography itself, Miss de Mille is on sure ground. Not only has she a gift for dramatic invention in this field, but in particular the West is her own and has long been so. Way back in 1928 when she gave her first recital there was a lusty and touching number called " '49" which was in a sense the root of all the more elaborate Western things that have developed since. The first sketch of her "Rodeo" was a little number of the same title in an "American Suite" which she made nostalgically in London in 1938 and showed here a few months later.

Here, incidentally, were born those remarkably convincing riders of invisible horses which were later to play so important a part in Eugene Loring's "Billy the Kid," Miss de Mille's own "Rodeo" for the Ballet Russe and now her "Oklahoma!" They are so pat a symbol of horsemen, in fact, that they have passed more or less into the public domain. Because the material is so much a part of her motor vocabulary, the movement itself and the composition throughout "Oklahoma!" are spontaneous in feeling, simple in form and altogether right. For other reasons far less tangible, the whole thing has texture and sheen and fine imagination.

The land of the cowpuncher, to be sure, is by no means the only country in the de Mille geography, and it is sincerely to be hoped that she can free herself from the success of two straight winners in a row in this métier and go on to other subjects. She has a genius for capturing human people of whatever locale or social level in their simplest and most honest phases, ridiculing them sometimes, fairly devastating them at other times, and at still others making them seem like members of a mighty likable race.

Certainly what she had done for "Oklahoma!" gives rise to a strong temptation to paraphrase one of Oscar Hammerstein's admirable lyrics and chant to Richard Rodgers's haunting tune, "Oh, What a Wonderful Evenin'."

*May 9, 1943*

# THE DANCE: AWARD NO. 2

## In Recognition of the Year's Outstanding Debutante

### By JOHN MARTIN

H AVING duly selected Doris Humphrey's "Inquest" as the best new work of the season, this department now proceeds to the next order of business in its time-honored tradition of prize-giving—namely, the selection of the year's most promising débutante.

This involves a slight departure from the aforementioned t.-h. t., owing to the happy conjunction of two fortuitous circumstances. The first of them is that though the award has always been made in the past to a performer, this past season produced not a single newcomer in that category, search the field as you will. The second of them is that for the first time in memory there has turned up a débutante choreographer of such excellence as to merit some sort of recognition at once. Ergo, condi-

tions are ideal to present herewith an immaterial spray of laurels with a plume and two festoons to Jerome Robbins. On the strength of his maiden composition, "Fancy Free," created for the Ballet Theatre and handsomely presented by it, it is clear that we have a new choreographer of parts in our midst.

### Certain Characteristics

Perhaps from this one work it is too early to make any elaborate analysis of his personal style or any prognostications as to his directions, but a few important points are so self-evident that there is no hazard in mentioning them. Mr. Robbins is manifestly in the non-academic wing of ballet choreographers; his place is beside the moderns of the new dispensation. Human beings, their

states of mind and their surroundings, engage him far beyond any allurements of entrechat six and brisé volé. He has a keen intuition which gives body and substance to his accurate observation of surfaces, and his people emerge with lives and wills of their own.

There is a wealth of true comedy in his portraiture, and as in all true comedy a basic warmth and sympathy are clearly evident under the higher and gayer colors. "Fancy Free," a hilarious interlude about three sailors, three girls and a bartender, is never raucous and besides being humanly genuine at all times it even manages to have its moment of tenderness. No doubt, as he grows older, he will show us more of this side of his talent.

But Mr. Robbins is no mere character-and-situation story teller. He has shown in this single work that he possesses a taut and tidy sense of form; he knows a choreographic theme when he meets it, can develop it neatly, and never allows incident, however attractive in itself, to overshadow general design.

He is completely American and

utterly without pretense or affectation. He goes in for no fancy movements, no insincerities or stock trivia. His pantomime is frank and realistic, and he does not in the least scorn to use techniques which have long proved sound in the music halls. His instincts are definitely of and for the theatre, even to the way he has cast his seven characters and built the dancers right into the choreography. This last virtue may prove less than fortunate when the cast is changed one of these seasons, but better run that risk than sacrifice native creativeness to the safe alternative of bourrées and tours jetés. It is extremely doubtful if Mr. Robbins was, or is, concerned with "Fancy Free" as a timeless masterpiece to be preserved, after the manner of masterpieces, beyond its span of usefulness. He unquestionably has dozens more pieces up his sleeve, and is eager to get at them.

Miss de Mille, Mr. Tudor, Mr. Loring, kindly move over a bit and make room for a new colleague.

*June 11, 1944*

# The Ballet Puts on Dungarees

### A choreographer describes how ballet has emerged from the hothouse and become in America a people's entertainment.

**By JEROME ROBBINS**

TWICE each year, in the fall and again in the spring, the Metropolitan Opera's box-office people face a lobbyful of ballet fans and answer such questions as: "Is Markova dancing 'Giselle' two weeks from Sunday night?" and "When do the murder ballet and the sailor ballet come together?"

Twelve years ago, when Mr. Hurok first brought ballet back to America, not only the Metropolitan's box-office men but a whole generation of ballet fans, who remembered Pavlova and Nijinsky, would have been demolished by that last question. The idea that a murder ballet and a sailor ballet came at all, let alone together, on a ballet program at the Opera House would have sent them into the night moaning softly for their smelling salts.

But in twelve years a good deal has happened to the ballet. I feel that such ballets as "Rodeo," "Billy the Kid," "Undertow" and "Fancy Free" are only a few of many signposts.

A glance at the fall season offers more of them. Out of five new productions three are by young American choreographers, and a fourth, Simon Semenoff's "Gift of the Magi," comes out of America's own literature, an O. Henry story. Two have scores commissioned from young American composers. The hero of one, Michael Kidd's "On Stage!" is a Chaplinesque janitor—a strange apparition in a land once exclusively peopled by princes and princesses, ghost maidens and sylphs.

What has happened is that ballet, that orchidaceous pet of the Czars, has come out of the hothouse and become a people's entertainment in our energetic land. A democratic people's mark on the ballet is directly evidenced in its subject matter, its dancers, and the kind of audiences that attend it.

One discovers, on tour with Ballet Theatre, that all across the country, the people of towns like Waco, Tex., and Joplin, Mo., no less than New York, Boston, Chicago and San Francisco, have been welcoming the ballet's arrival with capacity houses. Broadway, quick to adapt itself to the new enthusiasm, made haste to abandon tap-dancing chorus routines, so that one weary drama critic has already sighed that it would be a relief to see a musical without a ballet. Hollywood is learning to translate dancing to the celluloid techniques through the efforts of first-rate young dancers like Gene Kelly and Jack Cole.

AFTER twelve years, and at the beginning of a season whose new works are so overwhelmingly home-grown, this seems a suitable moment to focus an analytical eye on what promises to be a renaissance of the ballet as remarkable as the one that took place in Russia thirty-odd years ago when such names as Fokine and Diaghilev, Pavlova and Nijinsky first gleamed out of the East.

"Fancy Free," a ballet by Jerome Robbins, is one of the hits of the ballet repertoire. Robbins, also one of the principal dancers in the ballet, is the sailor above pointing at the girl.

The ballet revolution came about gradually, so gradually that one must stop and remember what the first ballet company was like, stepping off the boat from Paris just twelve years ago. The America which received that company had not seen ballet since Pavlova made her final farewell appearance in 1925-26. Faint shreds of memory carried back to Diaghilev's plush-covered ballet seasons in 1917 and 1918, when the customers paid $25 a seat and Otto H. Kahn paid a bill of a quarter of a million dollars at the end of the season. Serge Diaghilev knew his ballet, but his ideas of cost-accounting and double-entry bookkeeping dated from the days when a ballerina was a Grand Duke's mistress as a matter of course, and the gilded youth of St. Petersburg inherited their stalls at the Marinsky Theatre along with their titles and their lands.

IN 1933 Diaghilev had died, Pavlova was a name on an urn of ashes at Golder's Green, and Nijinsky was a patient in a Swiss asylum. Ballet, however, was showing signs of reincarnation in a company gathered by René Blum (brother of Léon who later became French Premier), and an ex-cavalry officer of Old Russia. Its members were the "baby ballerinas," children of émigré Russian nobility trained in the Paris studios of the former Imperial Ballet stars. Most of them were under 20; two of the four primas, Toumanova and Baronova, were actually 14 years old.

The company which stepped off the boat that December day in 1933 looked more like a not very fashionable school than a ballet company. Four mamas and two papas accompanied the children. The girls wore black cotton stockings and cheap flat-heeled shoes. Their thin cloth coats were shabby; their heads were bare or topped by berets; their little noses gleamed in utter innocence of make-up, and they reacted to the ship-news photographers' requests for crossed leg poses

with a cascade of giggles. Only one among them looked like a ballerina: Danilova wore her furs and her jewels in the grand manner.

Hurok welcomed them on the pier with the Russian ceremony of bread and salt. At the opening night party Mr. Kahn drank champagne out of a ballet slipper especially made for the occasion by one of the city's expensive bootmakers.

The very next year saw the beginning of the transformation of the ballet girls. With their American earnings they had all bought fur coats. They wore their lipstick and their chic little Paris hats with an accustomed air, and automatically crossed silk-stockinged knees when the cameras appeared.

ON the stage, too, change was in the air. Ballets began to be paced with an American tempo. American dancers were being auditioned in every city and town, while the Continentals were learning the mysteries of the five-and-ten and "coca-cola-vidout-ice."

American composers and scene designers were being enlisted. There were fewer and fewer "Scheherazades" and "Prince Igors" on the programs. Archibald MacLeish wrote a ballet about the building of the Union Pacific Railroad, for which Albert Johnson designed the settings. Richard Rodgers composed the music for a ballet about a gold-mining town and conducted its première at the Metropolitan. And these ballets enticed a new audience who cared less for champagne out of a ballet slipper than for a good cold beer between ballets.

Today our culture has infiltrated the ballet from topknot to toe-slipper. The Ballet Theatre company numbers but a handful of Europeans. The rest are American boys and girls, who learned their sautés and entrechats in the cities of America. A list of their home towns reads like a railroad timetable of a coast-to-coast journey. The newcomers have

approached the ballet modestly, have learned its traditions with respect, and have contributed the color of their own background. And the ballet impresario's principal worry is the raiding of his company by Broadway and Hollywood.

MORE important, Americans no longer feel they need a trip abroad or at least a dictionary of ballet terms to help them understand the ballet. They may not spot the difference between an entrechat-six and an entrechat-dix (very few can) but they can enjoy a hiking up of dungarees, the flipping of a chewing-gum paper between thumb and forefinger, without any help from experts, while a dash of juke-box jive is a natural accent in the new ballet picture. This is not to say that the ghost maidens and enchanted princesses of classic ballet have been discarded—no program in a big or little city can be without its "white ballet" or the customers feel cheated.

The touch of the exotic and the glamorous will probably always hover about the ballet, just as it will always keep a toe-hold on its classic origins. But the audience's happy reaction to ballets it can understand, about people it can recognize, is an augury of the ballet's future in a democracy.

A choreographer can justifiably look to the ballet as a medium in which he can say pertinent things about ourselves and our world, no less than a playwright or a novelist or a movie scenarist. For its part, the audience will come to expect as much of ballet as it does of a play, a novel or a film. And as the ballet and the theatre draw closer to each other, an exciting prospect opens in which not only musicals, but theatre pieces with vital ideas, will combine drama, dance and music, to the benefit of all three.

*October 14, 1945*

# DE MILLE BALLET PRAISED IN DEBUT

### By JOHN MARTIN

To come to the point at once, the Ballet Theatre has a new hit on its hands in Agnes de Mille's "Fall River Legend" which had its world première at the Metropolitan Opera House last night. It is a psychological melodrama suggested by the famous trial of Lizzie Borden for the murder of her father and step-mother with an axe. Morton Gould has written a stunning score, Oliver Smith has designed a wonderfully ingenious and dramatic setting, and Miss de Mille has outdone herself in both the actual telling of her story and the choreography of its individual scenes.

We start with "The Accused" at the foot of the gallows and hear the charge spoken against her. Then we return with her panoramic memory to the scenes of her life that have brought her to her miserable end, and not only watch

specific events through her eyes but follow her into some of her subjective fantasies. And we finish, of course, where we began. The scheme is by no means a novelty in itself, but Miss de Mille has used it for all it is worth.

She has managed, in addition, to establish a strong case and a deep sympathy for her central figure. Indeed the step-mother who is the villain in the piece is such an incarnation of evil as designed by Miss de Mille and as superbly played by Muriel Bentley that if the girl had not committed the murder herself almost anybody in the audience would gladly have done it for her. It is melodrama, to be sure, but melodrama with perspective, with a point of view, almost with the color of tragedy.

#### Alonso Had Brief Rehearsal

At present the work itself is superior to the performance. Miss de Mille worked on it with a cast of her own while the company was on tour and only within the past few weeks has she had her actual principals to rehearse with. Further than that, the leading role, patently created for Nora Kaye, had to be played by somebody else on short notice when Miss Kaye be-

came ill, and Alicia Alonso gamely stepped into it with a little over a week of rehearsal. That she did a fine job of it under the circumstances is not to say that she will not do a much better one as time goes on. It is essential that she dominate the stage every minute, and last night she did not always manage to do so.

For all these reasons it is difficult to tell whether certain ensemble scenes are more of an interruption to the central line than they should be, or whether a fully integrated performance will hold them in proportion. Certainly one of them, a scene in which the life of the young people of a New England town is seen to circle around the social and religious axis of its church, is a beautiful piece of work. There is much that is gentle and sweet amid the essential grimness of the tale, and the imagined meeting between the girl and her long-dead mother for whose justification she has committed the crime, will be a tremendously poignant scene when it has found its true strength.

#### Kriza in Role of Minister

John Kriza makes an appealing and believable figure of the young

minister, Ruth Ann Koesun is lovely as the girl's memory of herself as a child, Diana Adams brings a charming quality of the ideal to the character of the mother, and there are countless excellent bits by Barbara Fallis, Cynthia Riseley and practically all the others.

Morton Gould himself conducted and shared doubly in the evening's honors.

As if she had nothing else on her mind, Miss Alonso opened the evening with as fine a performance of "Swan Lake" as she has ever given, with Igor Youskevitch as the prince. The program closed with "Gala Performance" with Nana Gollner in her old role of the Italian ballerina, along with Miss Bentley, Shellie Farrell, Antony Tudor and Eric Braun.

Meanwhile, at the Mansfield Theatre Charles Weidman and his dance theatre company gave their first performance of "Flickers," Mr. Weidman's famous spoof of the silent movies, and their only performance of "Dialogue." Also on the bill were the Thurber "Fables for Our Time," "Lynch Town" and Beatrice Seckler's "The Unconquered."

*April 23, 1948*

# LIMON UNIT SCORES HIT AT DANCE FETE

## New London Audience Cheers Company—Martha Graham and Troupe in Program

### By JOHN MARTIN
Special to THE NEW YORK TIMES.

NEW LONDON, Conn., Aug 15 —The American Dance Festival, now in session at the Palmer Auditorium here, presented Jose Limon and his company in their first appearance in the series last night, and this afternoon offered the second program by Martha Graham and her company. The world premiere of Erick Hawkins' "The Strangler," originally scheduled for the latter occasion, was postponed at the last minute until Tuesday.

Mr. Limon's evening was the most brilliant event of the festival thus far, and the final curtain found the audience cheering not only the star and his excellent little company but also its artistic director, Doris Humphrey, who was the choreographer of three of the four works on the bill.

There were no new numbers presented, and the only aspect of novelty lay in the fact that the company had not previously danced anywhere with orchestra and that the scores of two of the works—Lionel Nowak's "The Story of Mankind" and Norman Lloyd's "Lament for the Death of Ignacio Sanchez Mejias"—had been newly and admirably orchestrated by the composers.

It was a widely varied program, however, and one of such superb accomplishments as to both composition and performance that it must be marked down as a red letter event in even so distinguished a festival as this.

Besides the hilarious "Story of Mankind," which has been greatly strengthened in form, especially toward the end where it was originally inclined to peter out, and the eloquent "Lament," the program consisted of Mr. Limon's own charming choreographic setting of the Vivaldi-Bach "Concerto in D Minor" and Miss Humphrey's "Day on Earth," set to Aron Copland's piano sonata and quite the most profound and moving creation of this outstanding choreographer.

Mr. Limon gave further evidence, if any was needed, that he is one of our greatest dancers, and his associates met him on his own ground. Pauline Koner, guest artist in "The Story of Mankind"; Letitia Ide, Miriam Pandor, Betty Jones and little Melisa Nicholaides have all appeared with him before, but this was the first appearance of the young actress, Jovan Fleet, in the role previously filled by Meg Mundy in the "Lament," and a very fine job she did of it.

### Robert Cornman Conductor

Robert Cornman conducted an orchestra that is by no means all that it should be, and Simon Sadoff played the Copland sonata.

Miss Graham's program this afternoon included a repetition of her new group work, "Wilderness Stair," with Pearl Lang dancing especially beautifully in one of the five or six modest solo roles, and the first presentations in this series of the familiar "Herodiade" and "Dark Meadow."

A repetition of "Appalachian Spring" was substituted for Mr. Hawkins' postponed piece. The "Herodiade" was the high spot of the occasion, with fine performances by both Miss Graham and May O'Donnell.

August 16, 1948

# THE DANCE: NEWCOMER

## City Ballet Company Makes a Happy Bow

### By JOHN MARTIN

IT is nice to be able to welcome the young New York City Ballet Company to that group of civic-minded if not actually civic enterprises at the City Center which includes the New York City Opera Company, the New York City Symphony and the New York City Theatre Company. Its first performances on Monday and Tuesday went off excellently, the audiences manifestly enjoyed themselves, business seemed good, the program was both substantial and vivacious, and a big step was taken in the right direction. Welcome, indeed!

The City Ballet is really Lincoln Kirstein's Ballet Society in a new and broader phase of its activity. It brings some admirable assets to the project: a staff consisting of Mr. Kirstein himself as general director, George Balanchine as artistic director, Leon Barzin as musical director; a group of talented and delightful young soloists; a set of artistic principles which, however much they may inspire disagreement from time to time, are incontrovertibly high; a repertoire still small, perhaps not very well balanced yet, but characterized by beautiful taste and a total disregard for war-horses.

### Accent on Youth

The major weakness of the company at the moment is its ensemble, and actually no company is any stronger than its corps de ballet. This is a natural consequence of the fact that all members of the company are either pupils or recent graduates of the affiliated School of American Ballet, and en masse show their inexperience.

It was most to be noted in the performance of the Balanchine-Bach "Concerto Barocco." Though this is a small work employing only eleven people, and though Marie-Jeanne, who had the chief role, is a fine dancer and Francisco Moncion, who supported her, is a fine partner, the composition never achieved shape in performance. That it is inherently of rich formal interest and sharp definition we have long known from its presentations by the Ballet Russe.

The same inexperience was evident in the Balanchine-Bizet "Symphony in C," but here it was of less importance. The work itself is youthful in the extreme, a regular choreographic Fourth-of-July celebration: the fire-works themselves provide the interest, the choreography is all sky-rockets, Roman candles and pin-wheels which follow each other more or less in straight sequence against a definitely light-weight musical background, and require no formal awareness from the performers.

The dazzling Maria Tallchief and Nicholas Magallanes, the amazing, long-legged and gifted young Tanaquil LeClercq and Francisco Moncion, the nimble Marie-Jeanne and Herbert Bliss, the charming newcomer, Jocelyn Vollmar and Todd Bolender, dash through the brilliant measures of the principal roles, while veritable hordes of tireless and exuberant youngsters pour onto the stage like a teenage Niagara Falls that is simply not to be resisted. Of course the audience shouts with delight; but that is begging the question.

These remarks, however, are merely for the record; there is no desire whatever to carp. Indeed, it is perhaps even ungrateful to hint at such things when the same company and the same program brought us also the Balanchine-Stravinsky - Noguchi "Orpheus," which is surely one of the most beautiful, the most completely satisfying, theatre experiences within memory. Its praises were sung in these columns last spring on the occasion of its première, and the same song must be raised again.

Perhaps even louder, for it has proved to be a controversial work. One indignant spectator was heard to remark as she walked down the aisle at its close: "Bad music, bad dancing, bad theatre; only beautiful lighting"; an opinion which gives us at least one point of agreement. It is not, as a matter of fact, an unlikely or a discouraging reaction; the work as a whole is so simple, so unlike what we are used to, so direct and unadorned, that we are likely to approach it with all the wrong set of expectations. The advice here, if you are inclined to be irascible about art, is to buy two sets of tickets and see it twice; the first time to get acclimated, as it were, and the second to enjoy it.

### A Rare Experience

Certainly it is worth the time, effort, money and possible expenditure of wrath, for such esthetic satisfactions do not happen along too frequently in a lifetime of theatre-going. Against Stravinsky's serenely meditative score, Balanchine has conceived a profoundly touching action that is part gesture, part choreography, part theatre movement, and Noguchi has drawn the whole thing together texturally and visually, giving it accent and phrase by a motile décor of supreme eloquence. Here is a re-enactment of an ancient ritual in terms as remote as antiquity itself and as immediate as the mind and heart.

The New York City Ballet Company has certainly begun its career on a high level.

October 17, 1948

## DANCE TROUPE TO TOUR

### Agnes de Mille Will Direct Her Own Company Next Season

S. Hurok will sponsor the tour next season of a new dance company now in process or organization under the direction of Agnes de Mille, to be known as the Agnes de Mille Dance Theatre. The company will consist of dancers, singers and orchestra to the total number of fifty, and the repertory will be made up of works based on Miss de Mille's choreography for various Broadway musical shows plus new numbers in the same general medium.

Trudi Rittman will be musical supervisor, orchestrations will be made by Don Walker, and Motley will supervise the costumes. A coast-to-coast tour is set to open in October, with a New York engagement included.

December 10, 1952

# Now Ballet Is Classic Again

## Guided by Balanchine, the New York City Ballet turns from psychological themes to interest in brilliance of movement.

### By JOHN MARTIN

WHEN the New York City Ballet closes its twelve-week season at the City Center next Sunday it will have set a record for the longest consecutive engagement ever played by a repertoire ballet company in this country. But this achievement is far less important as an endurance test than as testimony to the genuine trail blazing which the company has done in leading the whole art of the ballet successfully into a new phase—the revival of classicism.

Only yesterday the "psychological" ballet, such as "Pillar of Fire," which used movement to express inner states and relationships, was the center of attention; so much so, indeed, that it found its way into the musical comedies by way of "Oklahoma!" This whole trend was really the climactic development of the famous Russian Ballet revolution of nearly fifty years ago, in which Michel Fokine had insisted that "dancing should be interpretative * * * should not degenerate into mere gymnastics * * * should explain the spirit of the actors * * * should express the whole epoch to which the subject * * * belongs. * * *" What with the impact of Freud on the popular imagination in the intervening years, these principles were considerably intensified along psychological lines, and everybody was quite excited about how penetrating and profound the ballet was getting to be.

JOHN MARTIN, dance critic of the Times, wrote the "World Book of Modern Ballet."

Today you can find hardly a trace of that trend in anybody's repertoire. Though the pendulum will inevitably swing back, it has swung at the moment away from interpretation and expressiveness and returned to that abstract classicism against which Fokine rebelled so effectively. This is by no means to say that it has swung back to the pre-Fokine repertoire. The only such "revival" by the New York City Ballet is the one-act version of "Swan Lake," and the manner in which it has been reconstructed departs from the original to such an extent that it was greeted with raised eyebrows in London when presented there last summer.

LONDON'S Sadler's Wells Ballet, indeed, has made a great success of its revivals of nineteenth-century classics, such as "Swan Lake" and "The Sleeping Beauty," in their full length and with the most sensitive regard for authenticity. This is the somewhat more literal form which England's return to classicism has taken. But the New York City Ballet, under the guidance of the brilliant George Balanchine, has restored a much more fundamental classicism than that. It has got at the root of the subject, has cast aside story-telling, dramatic preoccupations, emotional expression and all the "operatic" elements of the old ballet, and has concentrated on pure form, abstract virtuosity, the glorification of the body in movement. This is actually neo-classicism, a term which comes into use whenever any epoch returns to classic principles in its art and adapts them to its own temper and taste.

AS Lincoln Kirstein, the New York City Ballet's general director, has put it in a current program note: "This ballet company believes that ballet is primarily about dancing; secondarily about narrative gesture, pantomime and dramatic impersonation, which can be better achieved in another medium. Just as opera is primarily for the voice, and only incidentally for other theatrical elements, the ballet is for the dance. The New York City Ballet has made its international reputation as a company of dancers who appear in ballets which give the maximum opportunity to reveal the human body in schooled skills of virtuosity, lyricism and the drama of individual mastery of space and time."

The basic vocabulary of movement employed is founded solidly upon the traditional academic ballet technique, without concern for expressive gesture or any other dramatic or psychological by-product. The dancer becomes what the late André Levinson called "a machine for manufacturing beauty." With the endlessly inventive Balanchine to direct "the drama of individual mastery of space and time," the fundamental vocabulary has been extended into dimensions of incredible brilliance which once would have been considered impossible for the human body to achieve.

Such movement is obviously unsuited to story-telling, since it has no contact whatever with realism, yet it must have some underlying principle to govern its continuity if it is to be

utilized for purposes of art. Clearly the abstract formalism of music, to which dancing is closely related in its phrase and its accent, supplies the answer, and on this Balanchine invariably builds his ballets. He has called music "the floor" of dancing.

His company's repertoire contains a number of striking examples of his neo-classicism in which absolutely nothing exists but the music and an invention of dancing built upon its form and flavor—no story, no superimposed theme, no scenery, frequently no costume beyond the simplest of "practice" clothes, no title except that of the music. It would be difficult to reduce the subject to more elementary terms, yet this section of the repertoire is not only the most characteristic of the whole movement but, in many cases, surprisingly enough, the most popular with the public.

In this "pure" category are found "Serenade," colored by the gentle romanticism of Tchaikovsky's music; the dashing "Symphony in C" of Bizet; the pranksome "Divertimento" of Alexei Haieff, and so on.

A SECOND category is made up of ballets with the same purity of style but with a theme imposed upon it. "Ballet Imperial," for instance, is built upon Tchaikovsky's Second Piano Concerto, but set, costumed and choreographed in tribute to the old ballet of St. Petersburg. Another example is Hindemith's rollicking "Metamorphoses" which Balanchine treats as a suite about flying creatures, from acrobats to insects and birds.

A third but brief category comprises story-ballets, such as perhaps Serge Diaghileff might conceivably have sponsored thirty years ago. "Prodigal Son," indeed, he did sponsor, and it is here revived. "Orpheus," to Stravinsky's music, has less pure dancing and more gesture than most Balanchine works, but is still strikingly within the spirit of his neo-classicism, and may well be, paradoxically enough, his masterpiece to date.

And in a class quite by itself is "Tyl Ulenspiegel," on the Strauss tone poem, which is all pantomime and spectacle without a step of dancing, and as uncharacteristic of Balanchine's natural impulses as can well be imagined. It was apparently an "assignment" and not a creation of his own choosing.

TO say that Balanchine is the inventor of the new classicism or that the New York City Ballet is its exclusive exponent would be unwarranted, for the pendulum of taste in the ballet, as in all the arts, has always swung back and forth between classicism and romanticism, and undoubtedly the hour for a general classic swing has struck again.

Why these cyclic changes occur is for the sociologist, the philosopher, the psychologist to explain. Perhaps Hegel's dialectical

theory is pertinent. Perhaps the growth of the arts is organic like that of plants, which never grow in a straight line, but first on one side and then on the other in a rhythmic swing. Perhaps Victor Hugo said all that is to be said on the subject when he declared that nothing is so powerful as an idea whose time has come. In any case, the present manifestation in the ballet could scarcely have come except as it did.

BALANCHINE, always a man of his own ideas, made his mark as a choreographer when he was very young with the famous Diaghileff company back in the Twenties, but he was never by any means merely a tool of Diaghileff. The latter, great impresario though he was, was far more concerned with the literary ideas, the music and the scenery for his ballets than with their dancing, a view altogether alien to Balanchine. When Diaghileff died and his company collapsed, there was a general effort by other companies to carry on the pattern he had established, but Balanchine felt that a new direction was needed. He made several discouraging efforts to establish one, only to conclude ultimately that the shadow of Diaghileff hung too heavily over Europe to make such a project possible.

At this psychological moment, Lincoln Kirstein, who had a dream of his own about creating a ballet in and of America, arrived on the scene. He invited Balanchine to come to New York under the auspices of himself and Edward M. Warburg, to set up the kind of school he wanted to train an entirely fresh set of young dancers untouched by European inertias, and to work toward the establishment in America of a truly classic ballet with traditional roots transplanted in virgin soil.

IN 1934 the School of American Ballet opened its doors, and the following year the American Ballet gave its first brief season. It was the beginning of a long struggle and a hard one. The American Ballet went into the Metropolitan Opera for several stormy seasons, the Ballet Caravan was founded, the two were somehow merged into the American Ballet Caravan and made a "good neighbor" tour of South America. Then the war brought all producing struggles to an end, and only the school remained. But Balanchine knew that he had found the environment where he could build what he wanted to build, and Kirstein had the utmost faith

Michel Fokine, here with Fokina, started the trend toward interpretive ballet.

in him and his ideals.

After the war a different approach was attempted with something called Ballet Society, which was designed to produce exclusively for a subscription audience. If Balanchine had been branded as avant-garde, with a degree of opprobrium attached to the term, Ballet Society would proudly claim the characterization for itself and open its doors only to those who were sympathetic. The battle, however, was not won by this approach, for the militantly sympathetic were few. A more practical approach was called for, and an affiliation was accordingly arranged with the young opera company which was part of the City Center's activities. The ballet company participated in the operas and had two evenings a week (Monday and Tuesday, which were so bad at the box-office that the opera did not want them) for its own programs.

All of a sudden things began to look better. The audience of the City Center—very average and not a bit avant-garde—was in no sense outraged by Balanchine's avant-gardism. It tittered here and there and occasionally laughed out loud quite frankly in the wrong places, but it also applauded vigorously—and it came back for more. For the next season, in 1948, the connection with the opera company was dropped and the ballet was reconstituted as an independent unit within the City Center framework, called the New York City Ballet.

And that was the beginning of a truly substantial success. The contact between an uncompromisingly avant-garde artist and an honest and unpretentious public had been made—to the advantage of both.

Two years later the company was well enough established to be invited by the Sadler's Wells Ballet to Covent Garden for a London season, and when it returned it had suddenly matured, for it had seen itself taken seriously by a serious ballet public. Another two years later—last spring and summer—it made a five-month tour of the Continent, where it was recognized as one of the leading companies of the world, and its forward-looking trend toward a new classicism became the subject of general European discussion and acclaim.

BALANCHINE, once strange and arty to us, is no longer so. On the one hand, we have become accustomed to his approach and his practices and have had our eyes opened to their values; he, on the other hand, has progressively sloughed off his more exuberantly mannered strivings and has come ever closer to the heart of classicism. It has been a matter of give and take between artist and audience, and no healthier pattern for the creation of substantial art has yet been discovered.

The New York City Ballet, to be sure, is not meant to be exclusively a Balanchinian organization; the policy has been to enlarge the range of its activities so as to include as many other choreographers as possible and as many other legitimate styles of ballet. This has been only partially successful, however.

Frederick Ashton of Sadler's Wells has made two solid contributions to the repertoire in the simple, romantic story-ballet, "Picnic at Tintagel" and the more difficult and symbolic "Illuminations." Jerome Robbins, associate artistic director of the company, is represented by several works, of which the most important is "The Cage" in which he has managed to apply an essentially neo-classic approach to a dramatic ballet.

A new production of Antony Tudor's "Lilac Garden," really an early stage of his development of the psychological ballet, is a handsome addition to the list. Todd Bolender's charming "Mother Goose Suite" and William Dollar's dramatic "The Duel" also manage to wear well.

NEVERTHELESS, it is Balanchine whose style dominates both the repertoire and the company. The latter dances his works better than it dances anybody else's, because the dancers are imbued with his principles, and nobody else has yet appeared on the scene who can provide works so admirably designed to exemplify them. Maybe this is a weakness in both company and repertoire which will have to be corrected one day, but at the moment it has not interfered with the achievement of a record run.

January 18, 1953

---

## VIDEO

The National Broadcasting Company learned from rating figures yesterday that it had a much larger audience for its ballet program on Monday evening that it had dared hope for. It estimated that 30,000,000 persons had watched the Sadler's Wells Ballet perform, "The Sleeping Beauty." It was the first time a ninety-minute ballet ever had been televised nationally.

According to a Trendex survey in fifteen cities the ballet had a rating of 22.5 during the first half hour, 21.8 during the second half hour and 21.7 during the final half hour. One significance of the ratings is that they indicate that virtually the entire audience at the beginning remained for the complete ballet instead of tuning to another program.

A rating represents the percentage of TV homes in fifteen major cities, including New York, that were tuned to a given program.

December 14, 1955

---

# DANCE: SEMANTICS

## New Abstract Conceptions Qualify And Vitalize Modern Art Forms

### By ALWIN NIKOLAIS
*Director of the Henry Street Playhouse Dance Company.*

THE circumstances under which motion of the human body becomes the art of dance has had greatly varied definition through the ages. Motion is the tongue of life, and from its multilingual voicings may be translated the oratory of the universe. Yet each period tends to spotlight a particular speech, which ultimately becomes statically verbose within its theme.

Out of revolt from static definitions, concepts and summations modern dance was born. It had childlike wonderment, free and whole. Then, crossing the threshold of adolescence, it passed into the forbidden room and had its biological fill. Its period of introspection and search of the meaning of man's attractions and repulsions to and from his fellow man coincided with the frank, scientific investigations of his psycho-biological compulsions. Here its conceptions atrophied. The eyes of the coterie were schooled to interpret every shape and motion into phallic, foetal, fertile symbols. A conceptual pattern evolved; a definition was made. Relations and styles were dominantly promiscuous and the world was only a gigantic brothel. To interpret it otherwise was to deny both humanism and dance.

### New Wholes

But the world and dance do not stop at the breast and thigh. Man related to man is only like tree related to tree, species somewhat relatively defined. But the roots must acknowledge the soil, and the soil in turn defines the earth. New wholes form, subdivide and regroup. From newer vantage points the seemingly dynamic importances of one time give way to other values, revealing new relationships and meaning, and man stands again in different perspective.

We speak of dance necessitating humanistic relationships and concern, but new semantic meanings of man and his relativity within our present historical strata are constantly being redefined. The tools of the dancer—motion, time, space, light, sound, shape and color—have greatly extended and altered in meaning during the last quarter-century. Concepts of space and time alone seem almost to have reached the universal extrados, and the paradoxical situation is that modernism today not only embraces the aluminum, chrome and steel sleek but, through the fantastic extension of communications, man can live today in multidimensional time and space. He lives within a greatly extended scope of history and distance, and his consequent vantage point and relativity is considerably changed. "Now" and "here" are becoming infinitely more timeless and spaceful. Man becomes more transparent and luminous.

The artist-dancer today can lift his antenna into this multidimensional galaxy to entice the harmonies of new song, new poetry, new fact. Realism and surrealism give way to a truly super-realism. From the 20-20 eye level inspection of his fellow man the dancer can look again to the tele-microscopic power of the inner eye. With his human magic he can put the earth

on a square of stage; he can make the bird fly in stopness and the rock dance. He can assemble nothingnesses into menacing battalions and make the arm red in new metaphors. The arm cannot know its armness unless it has sometimes been a wing, a branch, a star or the eye of the Cyclops.

### Dance Metaphor

Yet the modern dancer of recent years snubbed his greater powers of metaphor, abstract or otherwise. There was very little personal decentralizing beyond characterization, thus tending to deny his remarkably greater capacity and scope of "identity with."

The power of metaphor is one of our most functional endowments. The simple single-purposed gesture of reaching for an object immediately transforms the entire primal body. The hand shapes itself according to the nature of the object as it reaches. It "becomes" the object and the whole body kinetically metamorphoses. (Take for example the body circumstance in reaching for a floating feather as it differs from reaching for a rock.) Without an emotional bias toward the object, a basic direct kinetic statement is made. Yet this example shows a functional act and reproduced in fantasy still stems from the same source.

### Dominant Mechanism

Within it, however, rests a dominant mechanism of the dancer. Remove the mimetic base; eliminate the feather or the rock; maintain only the metaphoric motion and one has, instead of a mimetic act, a kinetic entity with a Gestalt that relates to all wholes of similar content. Now we are moving in the direction of a kind of abstraction that begins to speak of basic natures, and just as we can release ourselves from the mimetic act, so too we can release ourselves from the literal, pedestrian function and look of the body and use it truly as an esthetic instrument.

By utilizing its myriad possibilities of motional metaphor, the universe is in our grasp and we can speak of all natures of things.

The abstract conceptions that are esthetically valid to sculpturing and painting do not become non-art when applied to dancing. Like the painter, we can smash the literal landscape, penetrating the surface substances to disclose its more elementary substance.

So, too, the dancer can smash time. A whole new concept arises. Fleeting seconds of myriad time-stuffs bring a thousand years—past, today and tomorrow—into juxtaposition, creating new revelations through their peculiar alliances. Narrative concepts change. Time rests on the soul in many dimensions, and like a painter's montage, collage or palimpsest, one can create a new logic of time out of fragments of the ages.

### Sound and Silence

With motion, time and space there comes sound; not a decoration or substitute for silence, but the outcry of space as the shape violates its volume; a world to be heard as well as seen in the nature of the thing moving and the stuff through which it goes; not the music of violins and flutes, but the noises and silences of the earth itself.

New concepts do not define art, but they do qualify and vitalize it. With the courage and freedom of his imagination, fantasy and illusion, the dancer can create new esthetic entities out of fresh concepts of motion, shape, time, light, space, color and sound. This will not dehumanize him; it will rather enhumanize. His power of "identity with" is his most vital human facility and to deny it would deny him his greatest scope of love, the essence of art and life itself.

August 18, 1957

The New York Times

**Galina Ulanova in role of Juliet in "Romeo and Juliet"**

# BOLSHOI OPENING HAILED BY CROWD

### Glittering Audience Cheers 'Romeo and Juliet' at 'Met'

The Soviet Union's Bolshoi ballet opened its first American tour last night to the thunderous applause and excited bravos of a glittering audience at the Metropolitan Opera House.

Time and again the Moscow company and its principals were called back by an audience enthralled with their moving production of Prokofieff's "Romeo and Juliet."

At the end of the performance with the Metropolitan Opera House tremulous with excitement, the audience stood applauding and cheering the famous ballet troupe, and the troupe in turn applauded the audience.

Seldom has such an international atmosphere of glamour and excitement been stirred in New York in many years. Even before last night's presentation, few artistic spectacles had generated the public interest that attended the dance ensemble here.

At last night's final curtain, the audience felt that all that was expected of the famous Soviet ballet troupe had been realized.

The insistent audience called the company's prima ballerina, Galina Ulanova as Juliet, and Yuri Zhdanov, as Romeo, back for curtain calls. Miss Ulanova was heaped with flowers as were other members of the company.

Sharing the stage with them through most of the curtain calls was Leonid Lavrovsky, the choreographer and ballet-master of last night's production and Yuri Faier, the chief conductor of the Bolshoi.

The audience was a glittering one. All were required to be seated by curtain time. They had been warned that they would not be seated if they arrived late, and those who did arrive late were shut out.

### Anthems Are Played

At 7:40 P. M., ten minutes after the time set for the rise of the curtain, the orchestra played the "Star-Spangled Banner." There followed the Soviet nation anthem, "Hymn of the Soviet Union." An American and a Soviet flag were hung from a box above the rear of the orchestra seats.

Every one of the 3,616 seats in the Metropolitan had been sold for last night's production. The top price was $50.

In the back and along the sides of the orchestra 200 standees, all that were allowed, were crammed in. Some had waited as long as thirty-nine hours for the privilege of paying $3 to see the performance. Even before "Romeo and Juliet" began, they saw a performance of a different sort.

They lined the stairs near the main entrance to watch the bejeweled and elegantly gowned individuals of New York's society and theatre world enter the opera house.

The only event of comparable magnitude in the city's artistic past appeared to be the world première, Dec. 10, 1910, of Puccini's "The Girl of the Golden

West." It was performed by Enrico Caruso, Emmy Destinn and Pasquale Amato, with Arturo Toscanini conducting and the composer attending. Tickets sold as high as $75 apiece in the hands of scalpers, but the price dropped to $18 before curtain time.

Seats for the Bolshoi première were said to have traded as high as $100 and $150 apiece.

The hours before the opening were spent by members of the Bolshoi company in relaxation. Many of them took leisurely strolls through the streets, window-shopping in the pleasant April sunshine.

The stage of the Metropolitan was a scene of comfortable bustle and last-minute confusion as stage carpenters hammered away at the great Bolshoi theatre sets, some of which had to be scaled down for the smaller Metropolitan stage.

**Stage Flooring Sanded**

Much of the flooring of the stage was sanded and planed to provide better footing for the Soviet dancers. Sherry's laid in ample supplies of vodka, caviar and other less exotic foods and beverages for the heavy crush of pre-ballet parties.

The great auditorium, which has been the focal point of New York's artistic life for three-quarters of a century, presented its customary aspect of gold, gilt, glowing lights, rose carpetry and plum upholstery.

The top Soviet diplomats in the United States—Mikhail A. Menshikov, Ambassador in Washington, and Arkady Sobelov, permanent representative at the United Nations—occupied center boxes. The United States was represented by Frederick T. Merrill, chief of the State Department's East-West contacts section.

The world of theatre and dance was represented by Marlene Dietrich, Greta Garbo, Agnes DeMille, Lillian Gish, Noël Coward, Celeste Holm, Susan Strasberg, Douglas Fair-

banks Jr., Paulette Goddard, Martha Graham, George Balanchine, Mitzi Gaynor and Lucia Chase.

From the musical world came Van Cliburn, Cole Porter, Walter Toscanini, Blanche Thebom, Jan Peerce and his wife, and Alfred Wallenstein.

The diplomatic contingent included Dag Hammarskjold, United Nations secretary general, George Federer, the German consul-general; Diallo Telli, permanent representative of Guinea; Mihail Magheru, Rumanian representative at the United Nations, and Karel Kurka, Czechoslovakia's U. N. delegate.

Others in the audience included Robert W. Dowling, chairman of ANTA, which is the co-sponsor with Mr. Hurok of the Bolshoi visit to the United States; the Baroness Clarice de Rothschild, Serge Obelensky, Senator and Mrs. Jacob K. Javits; Cyrus Eaton, Cleveland industrialist, and Mrs. Eaton;

Gloria Vanderbilt, Mrs. Gwen Cafritz, famous Washington hostess; Spyros S. Skouras, Mr. and Mrs. John Gunther and Arthur Schwartz.

Other principal dancers of the presentation of "Romeo and Juliet" were Yuri Zhdanov, in the role of Romeo; Yaroslav Sekh, as Mercutio; Konstantin Rikhter as Tybalt; Alexander Lapauri as Paris; Vladimir Vasiliev as Benvolio and Alexander Radunsky as Capulet.

The triump was carried into the morning hours. Mr. Hurok invited about 200 persons to a celebration on the roof of the St. Regis Hotel.

There were champagne, caviar and beef Stroganov (beef prepared with a special sauce). An orchestra played Western music, cha chas and rhumbas. Van Cliburn did a foxtrot with a ballerina. Mr. Menshikov also attended.

April 17, 1959

# Martha Graham Still Leaps Forward

**And the dance world and the public watch as fascinatedly as they did 35 years ago.**

By EMILY COLEMAN

THIRTY-FIVE years ago this month the great modern dancer Martha Graham gave her first recital on Broadway. With it, she initiated a change in all of dance — not just in the so-called "modern" area, but in ballet and theatrical dance as well—that has been going forward ceaselessly ever since. The public witnesses its newest thrust each spring when Miss Graham usually gives a round of recitals (the latest will run from next Sunday through April 30 at the 54th Street Theatre).

Inevitably a horde of admirers and disciples crowds the performances; inevitably there are dissenters present who tend to echo the sentiments of Miss Graham's own mother. Her comment on her daughter's calloused bare feet, gaunt unsmiling visage, and austere avant-gardism used to run like this: "You had such darling feet when you were a little girl. Now they're like little animal pads. You know, Martha, you can be so sweet and attractive when you put your mind to it. Sometimes you can be naughty too. Why do you have to do those dreadful dances? People don't love you when you do them."

As audiences from New York to Berlin and on to Tokyo now know, "those dreadful dances" made Miss Graham one of the most significant creative forces of the twentieth century. Her influence on contemporary artistic life has been called both "incalculable" and "immeasurable." A revolutionary in the spirit of Picasso and Stravinsky, she explored the potential of the human body and gave it new dimensions of expression.

"DANCERS for untold generations," states Agnes de Mille in her book, "Dance to the Piper," "will dance differently because of her labors. The individual creations may be lost but the body of her discoveries is impressed into the vocabulary of inherited movement. Boys and girls who have never seen her will use and borrow, decades hence, her scale of movement."

To understand just how drastic and remarkable these discoveries were, one must drop back in time to the mid- and late Twenties. Ballet in the United States was a somnolent art at best, and all over the country countless young women, after what they thought was the fashion of Isadora Duncan, were waving scarves and pale arms as they imitated dying birds and falling leaves. Miss Graham wanted to say

something stronger, more vital, more to the heart of things. To do this, she literally had to invent the movements to express what she wanted to say. True, she borrowed some, but she gave new meaning to them. Her great sweeping side kicks, for example, are—balletically speaking — simply *grands battements à la seconde*. But to her they spoke of ecstasy or despair. She centered her attention on the meaning of the movement rather than the movement itself.

THERE were other techniques of movement she invented herself—contractions, releases, suspensions, falls. And they were all summoned to serve the message of the times. Mystically, she said the spine was "the tree of life." Anatomically, she was arguing that the way the spine sat on the pelvis was more important than the waving of arms or the cold precision of balletically trained legs. And it came as a revelation to many who saw her in the early days. "It just hit me amidships," recalls Martha Hill, director of the dance department of the Juilliard School of Music in New York. "I had been a ballet dancer, but I dropped what I was doing and went over and studied with Martha."

And so did countless others for, both by economic necessity and inclination, Miss Graham has taught almost as long as she has danced. In her school in New York today, some 250 to 300 students take regular or special courses. Of their number, around thirty come from all over the world to observe her style and technique—from countries as far away as New Zealand, India, Japan, Korea, Thailand, Argentina, South Africa and Ghana. Most of these, like her students in the past, will go out and spread the Graham gospel far and wide.

It would be specious to suggest that

EMILY COLEMAN watches Miss Graham as music and dance critic for Newsweek magazine.

Miss Graham fought this great fight alone, this battle to portray the spirit of the age. But her dominance cannot be denied. Just how much she influenced composers, artists and poets through her encouragement and utilization of their works is difficult to assess with certainty. But the mark of Graham is definitely there, just as it shows up in the theatre time and time again.

HOW is one to say how many dancers, choreographers, actors and directors, have reflected in their own work the impact of Miss Graham's incandescent intensity on the stage? The precise degree of coloration may be impossible to gauge, but it is assuredly present. "Martha Graham is not only a great dancer," says Katharine Cornell. "She is also a great actress. She is one of the two or three great American creative artists in all fields."

Miss Graham has achieved much of her distinction through great faith, a strong body, a questing mind, a stubborn spirit, and an all but overwhelming personality. Onstage, she is an unforgettable

figure, dark hair pulled straight back, pale face with its gaunt bone structure, and the whole relieved only by the slash of crimson on her mouth. Offstage she is disarmingly small (5'4"), but in action in the theatre she looks as if she were nine feet tall. Her high kicks are miracles of unfettered movement and, as she darts, rolls, and writhes, she is capable of expressing man's highest hopes and darkest despairs.

For many years, the adoration for her unquestionably led to a Graham cult, and to Miss Graham's being called "the high priestess of the modern dance." "This I hate," she says. "This is something I don't understand. I've never been a priestess and I've never thought of myself as a priestess. I've thought of myself as a skilled woman, as a woman who has been loved. My pupils used to feel that they must never be married. They felt that if they were dancers they must lead a nunlike existence. They *must* be dedicated, but if students think they can be-

come another Martha Graham by not marrying and by not having children, that's what worries me. I don't want a cult."

MISS GRAHAM is also the first to reject the notion —popular in some circles, but without validity—that she "invented" the modern dance. "I hate the term 'modern dance'," she states. "Modern dance isn't anything except one thing in my mind: the freedom of women in America — whether it is Isadora Duncan or Ruth St. Denis or Clara Barton. It comes in as a moment of emancipation.

"I'm astraddle of two bridges, past and present. Modern dance is the moment when an emergence took place from behind the bustle. I couldn't give credit for it to any one person. I give it to the spirit of the times, the demand for an emergence from the Victorian era. It is the body moving in its own time. And it moves from the past just as music and painting do."

NOR does Miss Graham envision modern dance dying with her. "It will never die with me," she says. "It's not a question of its dying with me. If I have contributed one movement, one idea, or one impulse, I have become timeless. I don't care about the form of my technique. That's not the problem. My problem is to work in my time and do what I can in my time. If I can add something to my time, then that is my prize.

"It's not a question of its dying. I came from ancestors. I didn't spring from the head of Zeus. I had companions along the way."

Louis Horst, the composer and dance educator, is inclined to agree with Miss Graham. And he is in a unique position to know. Now 77, he was music director for Ruth St. Denis and Ted Shawn's Denishawn company from 1915-25 and held the same post with Miss Graham from 1926, the date of her first concert on Broadway at the 48th Street Theatre, until 1948, when he began to occupy himself more and more with teaching.

"No, the modern dance can't die," he says. "We always think things are dying when they are not. But a great dancer will come again. Maybe it will be someone out of the Corn Belt," he adds with some amusement. "But she will come, raise her hand, and say 'Behold! I am the Modern Dance!'"

While Miss Graham hardly announced her own arrival on the dance scene in such fashion, Horst does remem-

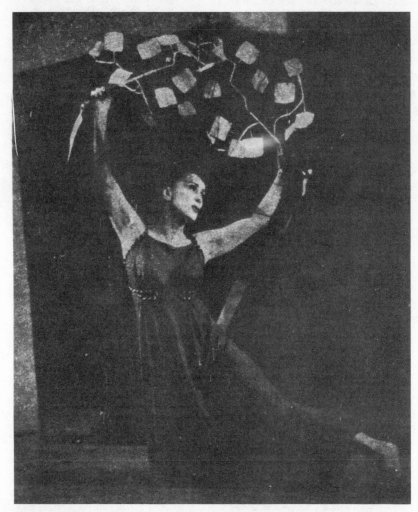

FROM THE GREEKS—Miss Graham in 1961, as Alcestis, the queen who offered to die in her husband's place. Miss Graham also dances such figures as Medea and Clytemnestra.

ber well her first day at the Denishawn school in Los Angeles. "I played for her first lesson," he recalls. "Even then, without knowing her name, I thought 'that girl has something.' She had that feeling of intensity, that feeling of dedication."

Ted Shawn's recollections are neither so rosy nor prophetic. "Martha came in 1916," he often reminisces, "a plain, awkward, abnormally shy girl. She'd hover at the back of the stage, timorous, inhibited. Ruth wasn't interested in her at all. I told her I'd work with her but that she had no dance talent and would never make a dancer. Then one day I noticed her in a dance of barbaric intensity. For the first time she seemed to be really letting go, really dancing."

Miss Graham had come to Denishawn after some argument with her parents, who were less

**"PRIMITIVE CANTICLES"** —
Miss Graham in a work done in
1931, during her "woolen period."

than enthusiastic about dancing as a career. Her father was a doctor who came from a long line of New England stock. Her mother was a ninth-generation direct descendant of Miles Standish. Though she was born in Pittsburgh, the family moved to California when Martha was about 8 years old. With the exception of one moment in church when, as a toddler, she danced spontaneously in the aisle —an incident made much of by her biographers and profilists—there was nothing in Miss Graham's life to suggest dance until she saw a performance of Ruth St. Denis and asked to attend the Denishawn school.

SHAWN eventually cast her as the leading maiden in an Aztec ballet titled "Xochitl," which toured the country with great success. When the Broadway producer John Murray Anderson saw Miss Graham in the part, he engaged her in 1923 for his "Greenwich Village Follies." "I must say I enjoyed it," Miss Graham has recalled. "I had four solos, I had billing, and I had a very nice salary. I was an exotic personality and I could stop the show."

Two seasons of the "Follies" were enough, however. "Something began to stir in me," Miss Graham has since remembered. "Unless I found something to dance which was more than what I was doing, I would have to stop. I did stop. I taught [at the Eastman School in Rochester]. My first original dances were terrible, but they were a beginning."

Horst recalls that it was "a hard battle. Nobody liked what she did, and she had to stubbornly keep on doing it." To be sure that she was creating her own forms, and not just "interpreting" the music, Miss Graham even choreographed her dances first, and Horst and other composers would compose the music

after it was finished. This Graham era, the late Twenties and early Thirties, was also memorable for its total lack of stage décor and its use of singularly unattractive costumes. Miss Graham's own description is "the period of long woolens. Being a Puritan by inheritance, I had to return to that austerity."

WITH "Frontier" in 1935, Miss Graham began what has been called her "American period," although it is difficult to imagine her as ever being anything else but American. "Frontier" celebrated the struggle and victory of the pioneer woman. It also saw Miss Graham venture into stage décor, if Noguchi's suggestion of fence rails and a white-roped horizon could be called a set. For a time, "Frontier" was to Miss Graham what "The Dying Swan" had been to Pavlova, and the work helped to turn Graham from a cult toward a more universal acceptance.

"Every Soul Is a Circus" (1939) and "Letter to the World" (1940) saw Miss Graham extend her dramatic themes and invest her stage with more of the trappings of the theatre. Then, with "Appalachian Spring" in 1944, to a score by Aaron Copland, her hold on the general public became more secure. Copland's music was understandable, as were the emotions of still another woman who had conquered the soil.

Miss Graham has always seemed to keep one jump ahead of her public and, with her pioneer women more or less in focus, she plunged into her Greek period. Dissecting various Greek heroines, all passionate, and mostly homicidal, she tackled Medea ("Cave of the Heart"—1946), Jocasta ("Night Journey"—1947), "Clytemnestra," the first full-length modern dance work in 1958, and "Alcestis" last year.

IN contrast to the violence of the other heroines, Alcestis seemed to sound a new note. Things weren't so grim; she loses her man, but gets him back in the end. This season, Miss Graham's two new works seem to be on an entirely different tack. They are not, she says, "in the Greek cycle." One takes its title, "One More Gaudy Night," from Shakespeare's "Antony and Cleopatra." "This will be just a kind of kidding bacchanale," explains Miss Graham. "Yet you know I never kid. I just bite. You know what I mean. I just take a nip out of somebody."

Miss Graham herself will

not appear in "One More Gaudy Night," leaving that to her company. But she will dance in her second new work of the season, "Visionary Recital." "It's about Samson and Delilah," she notes, "but not Samson as in the Bible. It's about the moment when a man —or anybody—relies on his strength too much and loses the essential fact of his being. I'm not getting off in left field. I'm the beloved of Samson trying to make him true to his essential nature."

"WITH all the strength I have left, with all the skill, knowledge and spiritual power, I want to make my work as vivid, as entertaining as possible," Miss Graham says. "When I say entertainment, I mean it in the serious sense of the word. Whether it is tragedy or comedy, you should catch up the souls of the people in the audience. I don't care how this is done."

Miss Graham's definition of entertainment entails responsibility, not escape. "I never went in for the long things down in the village where people sat around and talked about things," she observes. "If you talk something out, you never do it. If you spend evenings talking with your friends and associates about the dreams you have, those dreams will never go into manifestation—whether it's a poem, a play, or a dance. You have to deny yourself that privilege."

On occasion, it has been suggested that Miss Graham, in all her various guises—long woolen, frontier, Greek — is merely Graham herself in pursuit of her own destiny. This is not entirely so, she answers. "One is searching for a wholeness," she explains, "a completeness. All the things I do are in every woman. Every woman is a Medea. Every woman is a Jocasta. There comes a time when a woman is a mother to her husband. Clytemnestra is every woman when she kills.

"BUT I don't think I am every character in search of myself any more than any person would be. Writers, painters, photographers, choreographers identify themselves with everything they do, otherwise I don't think they'd do what they do. We are all in search of the complete being."

Miss Graham's own personal search for the complete being has been, on many occasions, trying — not only to herself, but to those around her. Her temper, for example, is legendary. "She used to get so mad when I didn't like something," Horst reminisces with a gleam in his eye. "She would pick up

something to throw at me. I said, 'If you throw that I'll slap you.' So she did and I thought I'd use a little therapy, and so I slapped her. I did it on the advice of her sister, who said her father had used the same method."

"She has always been intensive," Horst continued more seriously. "But she has changed a lot, and has become more gentle."

LIKE the poets she admires, Miss Graham frequently expresses herself in metaphors or images. Often, viewed out of context, some of her sayings have been known to generate a certain amount of amusement. To one hapless student, for example, she once said: "My child, remember the divinity of your spine. It is your tree of life." Another was admonished that "this is not just a stretch. I want to see the promise of flight in your body." And her advice to American choreographers is, "You must know the bone of the land."

It is impossible, however, to be anything but impressed when Miss Graham warms to her subject in a long conversation about her art. "There is one quality that matters and that quality is magic," she said very recently in a conversation at her apartment in the East Sixties.

"Magic," she reiterated. "I think this is what the public wants. There is also skill, but there is always skill. There was a ballerina in Russia who was better than Pavlova but she did not have this thing called magic.

"IT'S a curious combination of skill, intuition, and I must say ruthlessness—and a beautiful intangible called faith," Miss Graham continued. "If you don't have this magic, you can do a beautiful thing, you can do thirty-two fouettés, and it doesn't matter. This thing, I guess it's born in you. It's a thing you can draw out in people, but you cannot instill it in people, you cannot teach it."

Miss Graham's beliefs are those of the classic individualist. "I don't believe in modern dance or anything," she said. "I only believe in dance. I'm not interested in any ism. I'm only interested in the best. I'm fighting for perfection. A lone wolf for me means that you will fight tooth and nail for the survival of the fittest wolf. What's worth fighting for is a wonderful, wonderful performance.

"Nothing," she emphasized, "has ever been accomplished by a group. Things have only been accomplished through the glory of certain individuals and, believe me, they have suffered for it."

April 9, 1961

# Ballet: Leningrad Kirov Troupe Here

### By JOHN MARTIN

THE Leningrad Kirov Ballet made its American debut at the Metropolitan Opera House last night and brought us some superb dancing. The ballet chosen for the opening of its season was the full-length "Swan Lake" as restudied by the company's artistic director, Konstantin Sergeyev.

If as a total production it was by no means up to the quality of the dancing it contained, lay it to two causes. One, of course, was the suffocating temperature in the un-air-conditioned opera house; what it must have been like on stage is too appalling to think about. The other and perhaps more basic cause is the company's proverbial shyness of new stages, no doubt because it is not given to much touring about.

It opened in both Paris and London at considerably less than its best, and last night it carried on the same tradition here. Not that it was a bad performance, by any means, but only that it was about half as good as the company's best.

The second act, which is the crucial act of the piece, can become sheer magic in the hands of this company, but last night the magic simply did not operate. Inna Zubkovskaya, the Odette of the occasion, has marvelous qualities as a dancer. She has a power of sustained dynamics that can transform the pas de deux in particular into something of a miracle, even though last night it was only a minor miracle. The variation for some reason failed to function at all.

In the third act, as the wicked Odile, she was more effective. The grand pas de deux is not so brilliant in this

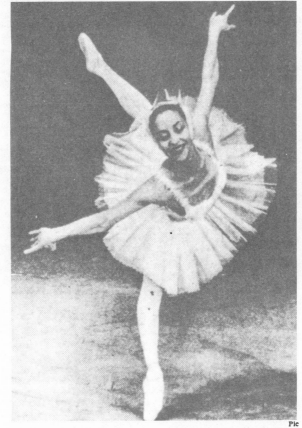

Inna Zubkovskaya, who is featured in ballet "Swan Lake"

version as in some others, but she managed with the expert assistance of Vladilen Semenov as partner to make it exciting and full of life, even though she does not do the famous thirty-two fouettés. For this number, indeed, they were both applauded thunderously.

As for other personal triumphs, there were several. The pas de trois in the first act was magnificently danced by Alla Sizova, Natalia Makarova and Yuri Soloviev.

To Miss Sizova fell the honor of stopping the show completely for the first time in the American season. She is a marvelous dancer, and in all probability will go right on stopping it from night to night.

Alexander Pavlovsky made a vivid and nimble Jester, and in the last act there was a variation of extraordinary skill and beauty by Illa Kon-

leva, a member of the corps de ballet who is not even listed by name on the program. The cygnets little pas de quatre in the second act was exquisitely precise and stylish, and all the character divertissements in the third act had verve and authority.

The corps de ballet as a whole is extremely fine, and in both the second and fourth acts, where it has its real opportunities, it is a delight to watch. Indeed, it seems to be the main purpose of Mr. Sergeyev, the director, to concentrate upon dancing as such throughout, and to let the dramatic and theatrical elements take subordinate places. This is where the performance last night suffered.

He has minimized the plot of the old ballet wherever possible. The first act has no dramatic function whatever, and its only justification is the brilliant pas de trois. Its ensembles are not very excitingly choreographed by way of compensation and do not serve to take our minds off the general emptiness of the scene. Elsewhere, dramatic and character motivations have been removed from many passages, including the second act pas de deux. In a dramatic ballet this is not conductive to continuity or even the token suspense that should inhere in these old works.

•

But it cannot be gainsaid that Mr. Sergeyev has created a dancing ballet company of enormous beauty, and when the magic works, it is incomparable.

Evgeni Dubovskoi was the conductor, and shared in the enthusiastic applause of a packed (and overheated) house.

Tonight we shall have a second Odette-Odile in the person of Kaleria Fedicheva with Sergei Vikulov as her partner.

September 12, 1961

# THE BIG COUNT

## Half a Million People Engaged In Non-Utilitarian Dance-Watching

### By ALLEN HUGHES

FOR the last two Sundays these columns have been devoted to John Martin's comprehensive audit of the 1961-62 dance season in New York. It was a busy season, impressive in quantity and quality. There were disappointments, to be sure, but not enough to mar the season as a whole or to discourage the paying customers.

Indeed, the customers performed well enough to merit an audit of their own. They shall have it—511,209 of them and more.

It is a fact that more than half a million paid admissions were registered by dance box offices in New York from Sept. 1, 1961, to May 31, 1962. Just how many more it is not possible to say, but the figure given here would surely be increased by several thousand if a complete tabulation could be made.

The count of 511,209 covers the paid admissions of the New York City Ballet, the American Ballet Theatre, Ballets U. S. A., the Martha Graham Company, the Leningrad Kirov Ballet, and the Mazowze (Polish) and Ukrainian folk dance companies. It includes also the dance performances given at Kaufmann Auditorium, the Henry Street Playhouse and the Brooklyn Academy of Music.

### The Uncomputed

The given total does not cover the paid-admission figures for dance performances given at Hunter College Playhouse, the Fashion Institute of Technology, the Young Women's Christian Association Clark Center, Carnegie Hall, the Educational Alliance and Brooklyn College. Undoubtedly still other dance performances were given in New York that have not been included.

Because we tend to be impressed more by statistics related to the exchange of money than by those that are not, the people who saw free dance performances have not been added either. There were 15,450 of these at Cooper Union alone.

But to get back quickly to money and big numbers, it can be reported, for example, that the New York public paid more than $1,100,000 to see the major imported dance attractions of the season—the Leningrad Kirov Ballet and the Mazowsze and Ukrainian companies.

We see, then, that the dance business in New York falls easily into the million-dollar-business category, a proof of popular support that everybody understands.

All these figures would probably have been still larger had there not been a pile-up of ballet companies competing with one another at the beginning of the season.

One week after the New York City Ballet opened its fall season, the Kirov Ballet made its American debut at the Metropolitan Opera House. Then, before the Kirov had left town, the American Ballet Theatre came in for two weeks at the 54th Street Theatre. While the Soviet company and Ballet Theatre were still playing, Ballets U. S. A. showed up at the ANTA Theatre.

### Surfeit

It was too much of a good thing at one time, and each company suffered somewhat even while the public was outdoing itself and very likely setting concentrated ballet attendance records for New York.

Why so many people should pay so much money for something as non-utilitarian as dance-watching it is impossible to say. One can conclude only that they like it, and that does not explain anything. One cannot explain either why so many more are liking it now than used to. But they are.

Before World War II, dance was almost a dirty word for most Americans. A small, fiercely loyal band of devotees supported the dance activity of the time, but the rank and file suspected that members of the band were neither quite right nor quite bright. The rank-and-filer who entertained a notion that there might really be something of value in the dance was careful not to broadcast the fact too freely for fear of falling under suspicion himself.

The prejudices of those days seem to have passed for the most part. One can finally admit a liking for ballet without risking social ostracism, and the figures prove that one can go to see it without feeling like a member of a minority group.

Few parents are likely to object, nowadays, if their daughters want to become professional dancers. At least, they do not object for other than practical reasons. Considering the employment opportunities for even the best dancers, they are right to wonder whether their daughters will get enough work to qualify for unemployment benefits in off seasons. (This, it must be understood, is to approach the peak of security in the American dance world.)

With sons, it remains a different story. Too often, boys who want to dance are still regarded apprehensively by their fathers. This is not necessarily because the fathers object so much. After all, they know that dancing is a thoroughly manly activity. No, what a father probably worries about most is what people will think or say if his son takes up dancing.

Still, the national attitude about the dance is far more relaxed than it was as recently as twenty-five years ago, and this relaxation has contributed to the democratization as well as the increase in size of the dance public.

### Familiarity

The freer feeling probably results largely from the public's increased exposure to the dance and the easy familiarity the increase has induced. In the last two decades, for example, serious dance has become a fairly frequent component of Broadway musicals and television programs. It has established itself in schools and colleges and has even been entertained hospitably in the White House.

We have not all suddenly become sophisticated dance patrons, and all of us never will. The truly discriminating public for any art has always been small and will always remain so. But, like any other art in this age, the dance must have the support of a mass public to keep it alive.

No one really believes that all who visit the Museum of Modern Art are connoisseurs of twentieth-century painting and sculpture. But without a big paying public, the real connoisseurs would not have the museum as it now exists to visit, and contemporary painters themselves would be much the poorer in every way without the stimulation and advertising their art gets there.

Serious music-lovers, performers and composers are equally dependent upon the patronage of a public that merely likes rather than lives by music. How much menu-planning, day-dreaming, even sleeping, go on in sight and sound of the New York Philharmonic and the Metropolitan Opera will never be known. But if the cooks, dreamers and sleepers were all to stay home, the orchestra and the opera would be out of business in a hurry.

When any art begins to cater consciously to the lowest common denominator of public taste merely to keep seats filled, the cause of the art is lost, of course. But it is the responsibility of artists and management to see that this does not happen. If it does happen, it is not the public's fault.

The dance is fortunate to be attracting a steadily increasing public, and if it uses the public's support to enrich the art at the highest levels, its future here should be bright.

June 10, 1962

---

### Margot Fonteyn Applauded In London With Nureyev

LONDON, Nov. 3 (Reuters)—Dame Margot Fonteyn and the Russian émigré dancer Rudolf Nureyev were given an enthusiastic reception tonight in the Royal Opera House at Covent Garden. They made their first appearance together this season in a new pas de deux from "Le Corsaire."

Their performance took only eight minutes, but the applause and cheers at the end lasted longer. Enthusiasm could hardly have reached a higher pitch; Dame Margot paid the young Russian the compliment of curtsying to him during a curtain call.

November 4, 1962

# Dance: Missing Message

## Twyla Tharp and Her Company Present Enigmatic Program at Judson Church

### By CLIVE BARNES

HAS it ever struck you that modern art is all about the communication of non-communication? To be frank it had never struck me before last night when, sitting in a sort of pew in Washington Square's Judson Memorial Church, watching Twyla Tharp and her Dancers, it thunderbolted me back on my metaphorical hassock.

For not only was Miss Tharp non-communicating, she was non-communicating about non-communication — a statement that has not got me nearly so far in the end as I had hoped it would in the beginning. Miss Tharp's dances seem to be emotionally about coolness—Miss Tharp herself is so cool that she could use a refrigerator for central heating—and physically about the raw materials of the theater and the dance. She is certainly not yet a good choreographer; yet she is bad in a rather interesting way.

●

Her first, and as it happened almost interminable, dance was called "Re-Moves," and seemed positively obsessed with exits and entrances, some of them executed with considerable theatrical flair. Thus a girl climbs down a rope ladder, and yet another enters inside the rim of an enormous wheel which she gravely propels along. Dance steps repeated to the point of sickness focused attention upon their basic material, as though the choreography had been placed under an unwavering microscope, while Miss Tharp used variations of space with an adroitness almost precocious in one so relatively young and inexperienced.

Consequently, while most of the dance took place in a square arena, certain episodes were transposed to a back inner stage, while for one section a square and naked box of wood, some 20 x 20 feet in size, occupied the arena, with dancers gingerly performing their way around it.

The difficulty of all this came from its absence of any attitude on the one level, or any form on another. The beautiful Miss Tharp and her equally, or almost equally, beautiful companions went through the work's flexing absurdities with an inscrutable look of mild and pious outrage fixed snootily across their faces like visors. And nothing added up, and nothing communicated, and—where I received my thunder-bolt—perhaps nothing was meant to communicate. But picking myself up, dusting myself down and refusing to be shattered by Miss Tharp's cool, I say: "So what!"

"So what!" less emphatically, was what I also said to Miss Tharp's other two pieces, "Twelve Foot Change," which was about three girls in skiing outfits, and "Tank Dive," which was about Miss Tharp in a spectacular backless bathing suit, and very nice too. She is potentially a good dancer, and certainly her dorsal muscles communicated something, so perhaps not all is lost.

Incidentally, writing about the Judson Memorial Church the other day I idly speculated on who this Judson was that he should be so memorialized. I was promptly deluged with angry letters—two of them—telling me in rather shocked terms precisely who he was. Unfortunately I have now forgotten and can no longer find the letters. Is this a moral?

November 1, 1966

## Dance

# Modern Dance— Fifth Generation

### By CLIVE BARNES

THE phrase "modern dance" is a fairly curious one, if only because by now its history goes back for the best part of this century. Ruth St. Denis and Ted Shawn, of ever honored regard, are modern dancers, but modern modern dancers they scarcely are. Indeed modern dance does not have to be modern, and perhaps the time has come when, simply as a typographical convenience, to clear up an increasing illogicality, we should consistently refer to this indigenous American art from as not modern dance but rather modern-dance, the hyphen making a new portmanteau noun and removing the seemingly specific connotation of the false adjective. Punctuation apart—modern-dance is doing fine.

It is now in its third or fourth generations. Indeed if, as I think one should, you are to consider Isadora Duncan, by inspiration although not by precept, as an earlier generation than the Denishawn school of Miss St. Denis and Mr. Shawn, then we now have our fourth or fifth generation of modern-dancers. On this scale our fourth generation dancers are led by two men, curiously dissimilar yet still with much in common—Merce Cunningham and Paul Taylor.

*

Increasingly these two former alumni of Martha Graham are establishing themselves as the new leaders. Their domination will never be as complete as was the domination of Martha Graham and Doris Humphrey—there is too much other talent around, and some of it, choreographically at least, of virtually equal merit. But it is Mr. Cunningham and Mr. Taylor who have so far — with the possible exception of the maverick Alwin Nikolais whose talents are more total-theater oriented—been most successful in establishing themselves as institutions, who have the greatest visibility and attract the best dancers and the most attention. These two have, somehow, more prestige than the others. Mr. Taylor already gives Broadway seasons, and Mr. Cunningham also could as soon as he decides to lose the money for that purpose.

Recently Paul Taylor ended his longest Broadway season —10 performances—and at the beginning of the month Merce Cunningham and his company played a one night engagement at the Brooklyn Academy of Music that will apparently be his sole appearance in New York this season.

The Cunningham program, which brought a full attendance to Brooklyn, was exceptionally well balanced, including two of last season's works, "How to Pass, Kick, Fall and Run" and the deeply impressive "Place," together with a new opening work "Scramble."

The new work has Mr. Cunningham in one of his genial moods—it is plotless and very elegantly decorated by Frank Stella, who uses a pleasing yet ingenious system of colored screens on trolleys which the boldly, simply costumed dancers move around. Within this happily variable decorative pattern Mr. Cunningham's dances occur with a sort of lyric inconsequence that almost seems improvised.

Yet backing up this lightness and brightness is the power-house, ear-splitting noise of Toshi Ichiyanagi's "Activities for Orchestra," wherein an orchestra apparently imitates a stampeding electronic tape. Through all this Mr. Cunningham picks his way smiling gingerly and yet really as confident as a master acrobat on a high-wire.

Mr. Cunningham is very much a persona. He is himself a character who passes through all of his dance works. Many people have been called Chaplinesque, but Mr. Cunningham is Keatonesque, or at least would be if it were not for that impudent, yet nervously faun-like smile that seems to play on his face even when he is not smiling.

He is not smiling in "Place," which is a remarkable and explicit indictment of modern life, with a neurotic pulse and a strange cataclysmic imagery that is as physically terrifying as a theater work is likely to be. Since the first performance, Mr. Cunningham has strengthened and clarified "Place" so it is now even starker, even tougher.

Do I make Mr. Cunningham sound too intense? Perhaps so, because he is essentially a flip artist, an artist who retains a tiny vital core of antic humor even at his most serious—an artist who can take you by the throat, shake you like a terrier might shake a rabbit, then put you down, grin disarmingly and explain that he was only joking.

In "How to Pass, Kick, Fall and Run," Mr. Cunningham is, in fact, only joking. The joke is that while Mr. Cunningham and his company perform dances vaguely based upon sporting images, John Cage, sitting urbanely at the side of the stage, sipping champagne and reading vaguely pointed anecdotes that have the cheerful and strangely cutting pertinence

of a Gertrude Stein non-sequitur.

\*

Paul Taylor also has a permanent persona that seems to emerge through all his work, although it is perhaps more elusive than Mr. Cunningham's. What both of our new leaders possess is the ability to create purposeful choreography that sinks into the mind and consciousness.

This season has been one of Mr. Taylor's most successful. He has offered two new works for New York, "Agathe's Tale" and "Lento," together with a substantially amended version of his earlier "From Sea to Shining Sea."

"Agathe's Tale" is a moral episode about a girl who guarded her virtue perhaps a little too vigilantly and certainly a little too long. Eventually seduced by the Devil, she falls joyously into the arms of the Devil's ward, Pan, and the story has a happy ending.

Mr. Taylor's wit and imagination are constantly in evidence here, but the specially commissioned music by Carlos Suvinach wears badly, its chirpy medievalism sounds feeble, and the ballet, unusually for the Taylor company, is poorly decorated.

"Lento" has at its heart, as a central movement, a lovely pas de deux Mr. Taylor created to Haydn music a few years ago and called "Duet." Now Mr. Taylor had added an opening and closing movement, and created a work of considerable value that may be compared, in part, with his luminously lovely Handel ballet "Aureole," even though "Lento" is not entirely satisfactory in its finale.

Perhaps as interesting as any of the premieres was the recension of "From Sea to Shining Sea," Mr. Taylor's earlier satire on the American way of life, which he has sharpened to the point where it now draws almost as much blood as laughs.

One of the pleasures of this Taylor season was to see how well the company was dancing. It bounced, it flew, it had an elegance and a spirit.

Both Mr. Taylor and Mr. Cunningham have their adherents and by no means do these totally overlap; indeed at times to admire one of these in the presence of supporters of the other is rather like voting for Cain before friends of Abel. Yet the presence of both of these companies, their power and their influence, is a very promising thing for modern-dance. It suggests two separate lines of development, even though both lines arise from the same source.

January 7, 1968

## Dance

# Bejart: Bold Or Banal?

**By CLIVE BARNES**

MONTREAL.

MAURICE BEJART is a choreographer. He was born in Marseilles, he works in Brussels, he is 43 years old, like Russia's Yuri Grigorovich, he has a beard, like America's Jerome Robbins, and he is teetering on the brink of his greatest adventure. It is going to happen in Brooklyn.

In parts of Europe — notably France, Italy, Belgium and parts of Germany—Béjart is regarded as the major choreographer of his day. But so far, despite three successful visits to Montreal, he has yet to appear in the United States, and his company's only visit to London, in 1960, was not a great success.

So he has yet to conquer the Anglo-American dance audiences, undoubtedly the two toughest, most knowledgeable and most sophisticated in the world. Béjart has chosen 1971 as his year of reckoning. In January he comes to the Brooklyn Academy of Music to make his New York debut, and in the summer he takes his company back to London for a three-week season, including one week at the vast London Coliseum, another week at the smaller Sadler's Wells Theater and a third in an enormous tent to be erected in the Pleasure Gardens of Battersea Park. Béjart is jumping in with both feet.

Recently I have been trying to catch up with the latest developments, and I have seen a fair amount of his recent work, comparatively little of which is scheduled for New York, but nevertheless offers the possibility of making a fair assessment of where the choreographer stands right now. Thus I caught a couple of performances of his "Romeo and Juliet" in Dubrovnik, went to Brussels where I saw a repertory program at his home base, Le Théâtre de la Monnaie, and here at the Place des Arts in Montreal I saw another two repertory programs. Despite the unavoidably scattered nature of the experience, it all adds up to a lot of Béjart.

Béjart has always been a puzzle to me. I first encountered his mature work — I had earlier seen a few choreographic essays — in London in 1960. Choreographically I considered it very feeble indeed, yet it did have a very definite theatricality.

Theatricality as a term applied to the dance can at times be a backhanded compliment, and yet it surely does have its virtues. Béjart's work has always commanded my attention from his earliest days. I remember a full-length production of "Orphée" to musique concrète (a form already dated in 1960) that was full of striking ideas, even if empty of much choreographic invention. I remember also his conception of Stravinsky's "Le Sacre du Printemps" as an expressionist fertility rite that looked precisely like the kind of orgy to which one never got invited. The choreography had the monotony of a steam-hammer — and, for that matter, the subtlety.

Keeping loosely in touch with Béjart's work over the years, I saw a Stravinsky program he created for the Paris Opéra consisting of "Le Sacre," "Les Noces" and the very best production of "Renard" I have ever seen. But the attraction here, at least for me, was really the conducting of Pierre Boulez. (It was the first time I have ever traveled to the ballet primarily to hear the conductor — but in those days chances to hear Boulez were hard to find.) Then I saw his "Four Sons of Aymon" in Edinburgh, a very ambitious ballet in Cologne—the ambitions of which I noted more than the achievements —and some years later, it must have been 1966, at the Palais des Sports in Paris, I saw his version of Beethoven's "Choral Symphony."

\*

This I thought was monstrous. Yet I could not but note that it was filling this hall — chiefly with young people—and that he was appealing quite clearly to a greater range of people than ballet normally attracted. Perhaps this was the first pop ballet.

Béjart's popularity is not a matter of chance, but much more of calculation, or perhaps a mixture of calculation and instinct. In the past few weeks I have heard audiences screaming for him — "Béjart! Béjart! Béjart!"—in locations as totally various as Brussels, Dubrovnik and Montreal. Popularity will never be a particularly pertinent test of artistic value, yet the public success of Béjart is so remarkable that it cannot be shrugged off.

Probably "Romeo and Juliet"—not to be seen in New York as it is one of his large arena ballets unsuitable for a proscenium theater—is most typical of Béjart's methods. He uses the Berlioz score, somewhat twisted and modified, seeking not merely to tell the tale of Romeo and Juliet, but from this to move into a peace tract with the actual imprecation to "make love not war." While the sincerity of Béjart's position is not to be questioned, the introduction of slogan politics into the tale of the star-cross'd lovers may, to the sensitive, seem crass to the point of banality.

Yet "Romeo and Juliet" is a wonderfully theatrical work, from its opening at a ballet class to its finale of lovers all over the world being mown down by the guns of oppression. The dancers are another matter, for Béjart's strength lies not in his choreography but in his compelling sense of what works in the theater. At his best, Béjart can play on an audience—especially a young audience—as if it were an electric guitar.

In many respects Béjart bears a more than passing resemblance to France's other leading choreographer of

the day, Roland Petit. But the resemblances are possibly more significant than may at first appear. For example, Petit has always been particularly adept at engaging the newest and most chic of Parisian painters and decorators to embellish his work, whereas Béjart prefers an open, unembellished stage, at times even tending toward Balanchine's spartan spareness of decoration.

Then again, although both Béjart and Petit share an almost infallible sense of the fashionable and immediate, Petit usually aims at the modish *tout Paris* audience, whereas more and more Béjart has directed his sights at the young, disaffected theatrical audience that once worshiped, or at least was stimulated by, Julian Beck and The Living Theater.

Theatrically, the impact of The Living Theater upon his work appears to have been considerable. But Béjart is essentially an eclectic artist. Of the works given here in Montreal—a season deliberately intended to offer a panoramic view of his work— the Wagner-inspired "Les Vainqueurs," a jejeune and pretentious work, shows influences as varied as The Living Theater, Hindu dance, Balanchine, various threads of American modern-dance, including possibly Cunningham, Taylor and Sokolow, and even John Taras.

However, the more I see of Béjart's work the less inclined I am to categorize him merely as somewhere between a master showman and a youth cult—although undoubtedly he is both. Here in Montreal, apart from the

windily deplorable "Les Vainqueurs," I also caught for the first time "Actus Tragicus," set to a couple of Bach cantatas, and "Bhakti," to Indian music.

In both Béjart goes on too long—he has little sense of choreographic proportion — but the Bach piece, obviously influenced by Balanchine and yet with its own special Béjart humanism, is an appealing work, and most of "Bhakti," a subtle realization of Hindu dance and sensibilities into classic dance terms, is simply beautiful.

Béjart seems to be always developing, always trying new things, and even at his worst he has a certain quality of theatrical boldness. Nothing he does is petty—which is probably why he calls forth such strong and often dia-

metrically opposed reactions. He is a major force in 20th-century ballet, and I will be fascinated to see what New York audiences make of him. Because, after all, we do tend to think that 20th-century dance is our particular playground—and Béjart, even at his most derivative and familiar, is, in fact, very different.

On one point there will be no disagreement. His dancers, particularly his male dancers, are not only extraordinarily gifted, they are also unusually good-looking. More than any ballet company in the world, Béjart's exudes a quality that, for want of a better word, I will call "sex." It is not at all a bad quality. It sent Montreal crazy.

October 4, 1970

Martha Swope

A Dance Theater of Harlem soloist

# 'They Told Us Our Bodies Were Wrong for Ballet'

### By JACK SLATER

Why are there so few black dancers in white, classic ballet companies—or, to be precise, why are there only four blacks performing in American ballet's big three: the New York City Ballet, American Ballet Theater and the City Center Joffrey Ballet?

For all of its familiar applicability to other fields, such a question is relatively new in ballet. Yet it is answered with prejudices as old as the slave ships which brought black people to these shores: Black people's feet are too big or too flat for the classic line required in ballet; black people's bone structure is too large, and their buttocks protrude too unattractively; black dancers tend to rely on in-

stinct rather than on the technique of classic ballet; a black skin would destroy the illusion of symmetry of the corps de ballet; blacks generally don't relate to "serious" music, so they can't relate to classic ballet; black dancers would hardly be capable of identifying with an art that began in 16th-century European courts.

The question has been asked and answered in such a manner for more than 40 years—ever since the nation's first black ballet group, the short-lived New Negro Art Theater, gave its first concert at the Roxy Theater in 1932. Now that the Dance Theater of Harlem has opened at the Uris Theater to begin its second New York season —and its seventh year—the question no doubt will be asked again—and then forgotten until another season. Having heard it all of his professional life, Arthur

*Jack Slater is an editor of The Times Sunday Magazine.*

177

Mitchell, the 41-year-old founder and artistic director of the Dance Theater of Harlem, is frankly quite tired of the question. Yet he adds some answers of his own which, clearly, do not arise from predjudice. "There simply are not that many black people who study classic ballet," he says. "There are in fact few white people who study classic ballet, partly because dance in general is the baby of all the art forms in America. As for black people, you have to understand their financial status and their priorities. Black parents are not thinking of dance study for their children —they're thinking of trying to feed their kids, thinking of trying to get enough money to buy a pair of shoes."

Pointing to yet another factor guiding minority youngsters away from ballet, Mitchell adds, "Historically, there has been no one in ballet for black kids to identify with. All kids have idols, but there has been no opportunity — until now, with Dance Theater—for them to say, 'I want to be like her' or 'I want to be like him.'"

In 1955, Mitchell, a Harlem-born youth who had studied at the School of American Ballet, became the first black male to receive a contract with a major, all-white American ballet company, the New York City Ballet. Dancing the roles of Puck in "A Midsummer Night's Dream" and the male principal in "Agon," he subsequently established himself as one of the leading dancers in the world.

On April 4, 1968, however, when the Rev. Martin Luther King was assassinated, Mitchell's career began to assume a new direction. Out of his sense of loss at King's death, the dancer, wishing "to do something," began to rechannel his considerable energies toward working with black youngsters within the discipline he knew. Together with Karel Shook, American ballet master with the Netherlands Ballet, Mitchell created a school devoted primarily to teaching ballet to black youths, a school which was intended to provide classically trained dancers for a black resident company and for other companies. His goal was to transform classic ballet into a "universal experience" or into an art form more easily available to the American black community. The Dance Theater of Harlem, the first

# Is 'classic carriage' a racial conceit?

permanently established black ballet company in America, emerged as a result of that effort.

Yet the history of black people's efforts to enter the world of classic ballet hardly begins with one man's agonized reaction to an assassination. According to Joe Nash, director of the newly created Library of Black Dance near Columbia University, "The story really begins in the early nineteen-thirties, when a man named Hemsley Winfield first imposed ballet technique on a group of black dancers. Winfield started the New Negro Art Theater, and his group's first concert in 1932 signaled a new era for black dancers. Before that time, our dancing was restricted to night-club work or to musical comedies such as 'Shuffle Along.'"

The idea, then, of a black artist working within the discipline of classic ballet is only two, perhaps three generations old. But after Winfield introduced it, the idea took hold, despite the fact that his group, which lacked proper training, collapsed. In the yellowed newspaper clips, faded photographs and old program notes housed at the Library of Black Dance, one can observe that idea reshaping itself, dissolving and re-shaping, over and over again, like a recurring, unfulfilled dream: the American Negro Ballet (1937), the Von Grona Swing Ballet (1939), the Negro Dance Company (1943), the New York Negro Ballet Company (1957), Ballet Americana (1958).

None of those companies ever achieved wide acceptance, and no black dancer in those troupes ever was able to join a white classically oriented company. Antony Tudor, the choreographer and associate director of American Ballet Theater, believes that classic ballet is too tradition-bound to accept blacks comfortably into its ranks. "Classic ballet," he declared in a recent interview, "has become known as conventional white ballet. We are so conservative, and the public is not

yet acclimatized to seeing blacks in ballet. It's rather like chess pieces—the blacks on one side and the whites on the other. It would be strange indeed in chess—and presumably in ballet—to mix the pieces."

Apparently what does apply, however, is the highly sensitive "problem" of the black body itself: the feet, the buttocks, the bone structure. Only two of ballet's Brahmins were unavailable for comment on that subject or on any other aspect of the black dancer in classic companies. Despite persistent attempts to reach them, George Balanchine of the New York City Ballet and Lucia Chase of American Ballet Theater were either "in rehearsal" or "on vacation." Jerome Robbins of the New York City Ballet discussed the subject briefly, but was willing to be quoted only as saying, "I don't do the hiring and firing."

However, Antony Tudor, who, along with Lucia Chase, shares the responsibility for choosing dancers at American Ballet Theater, was reached by telephone in Stockholm and did try to address himself to The Problem. "It's not at all true that the black dancer's body is inappropriate for ballet," he said, "Carmen de Lavallade and Mary Hinkson [formerly a Martha Graham dancer] have magnificent classic lines." Nevertheless: "In my experience, the ballet [foot] arch is more difficult to find in blacks. But it's also true we don't get many beautiful feet among white dancers."

Tudor's colleague Oliver Smith, co-director of American Ballet Theater, went a step further. "It's the position of the spine. The carriage of the black dancer is not classic," he maintained, adding at the same time: "But I've never looked at the black figure that much." Smith explained his viewpoint: "In the 1940's, black ethnic dance companies were organized by Pearl Primus ...and...oh, what is her name?"

"Katherine Dunham?"

"Yes, Katherine Dunham ...and my original orientation toward black dancers came from them, from their work in which the buttocks and the feet were exploited to advantage. There is a certain sinuous movement associated with black dancers, a certain carriage which is not classic."

Christian Holder, one of the two black dancers at the Joffrey, would seem to agree. "Ballet," he said, "is a Caucasian art built around a Caucasian physical stature. It began in the courts of Europe. Black dancers performing now within that art form have really broadened their technique to give ballet their particular gifts. But, physically, the black ballet dancer is not idea; for classic ballet."

But Holder's boss, Robert Joffrey, disagrees. "Physical problems exist in any race," he said. "Scandinavian dancers, for instance, are supposed to have big shoulders. But one can't generalize. The important thing to remember is that if a dancer begins to train too late, physical problems will exist. Classic ballet is not a natural way of moving."

●

In 1951, Janet Collins became the first black premiere danseuse at the Metropolitan Opera Ballet, and four years later Arthur Mitchell provided his "first" at New York City Ballet. But even in the period when Collins and Mitchell were creating a stir, there were other lesser known, less spectacular black artists who had been trained in the classic tradition, who had worked as principals in black companies yet couldn't dance in any capacity with white troupes.

Delores Browne, a principal with the defunct New York Negro Ballet and now a school counselor at the Alvin Ailey American Dance Center, remembers long periods of aimless job hunting during the fifties—and this despite the fact that she was a product of the School of American Ballet, the highly selective academy of the New York City Ballet. After her studies ended, however, her career, which had hardly begun, came to a halt.

"I didn't work for a long time. Nothing was open, I was told. Nothing at all," she says, laughing now as though she were testing an old wound. "Later, I found work with the Negro Ballet.

After rehearsing for nearly a year, we made a debut here, then we toured Europe and were well received. But we came home to nothing. The company disbanded. Then we were out of work again.

"I've seen so many good ballet dancers go down the tube. Why have white companies always thought that their black dancers must be soloists? Why are there hardly any blacks in the corps de ballet?"

Did she envision a time when more backs would enter white companies?

"Years ago, I knew a lot of black dancers who wanted a career in classic ballet, but today I don't see so

many aiming at that. The kids now are more disenchanted and, at the same time, more realistic about the probabilities of their finding work in ballet. They're aiming really for careers in modern-dance, partly because there's more work for them in modern-dance and partly because they have a better sense of history than the dancers I grew up with.

"We believed in the American Dream, believed in integration. We thought that if we were competent, if we studied very hard and worked harder—if we learned the technique—we would be accepted. Well, of course, that didn't happen. We were told something was wrong with

our bodies, that our bone structure was too large, that our feet were too flat. Black dancers today simply are not enchanted by the prospect of a career in classic ballet."

●

Arthur Mitchell agrees with Miss Browne. "There are not hundreds of blacks in major ballet companies," he says, "but how many blacks want to go into such companies? The sense of nationalism has affected all ethnic groups—and dance, too. People are now striving for a sense of *I am*, not *I want to go and be with somebody else*—although Dance Theater is still trying to make ballet a universal thing."

The Dance Theater of Har-

lem began with two dancers and 30 children. Today, the integrated school, attempting to control its growing enrollment, has about 1,200 students, the most talented of which, like the company itself, prove Mitchell's point every day: that, despite their color, their "problematic" bone structure and the all-important classic line—despite all of it—blacks have always belonged in classic ballet. Just how many of Mitchell's students will want classic ballet, however, remains to be seen. Perhaps that's the real question hovering over the Uris Theater these days. ∎

April 27, 1975

# Murray Louis, the Global Choreographer

If Murray Louis should wake up one morning and wonder if he's in Denmark or Dubuque, the confusion will be understandable. "I'm a compulsive choreographer," he says, but he might also be described as a compulsive world traveler. As a result his name is becoming a household word in the dancing world of Europe.

A prolific choreographer who at the age of 49 is still dancing, he is a rarity in American modern dance in that he is not a descendant of the Denishawn-derived traditions of Martha Graham and the Humphrey-Weidman school. He came to dance late, at 21, as a college student in California and shortly after, at the suggestion of his first teacher, Ann Halprin, began to train with Alwin Nikolais.

Mr. Nikolais was a disciple of Mary Wigman, the German expressionist choreographer of the nineteen-twenties and thirties considered by many to be the founder of European modern dance, although Mr. Louis later found the legacy of Miss Wigman to be nearly extinct in her home country.

In 1949 Mr. Louis returned to his native New York to the Henry Street Settlement House and began an artistic collaboration with Mr. Nikolais that has lasted to this day, performing with the Nikolais company and creating a number of his own works. Mr. Louis's style is much nearer pure dance than the mixed-media theater-dance

of his mentor, however, and their companies have become more autonomous in recent years.

### Touring the U.S.

Mr. Louis has been touring the United States with his own company for the last 14 years —"My reputation rests outside of New York," he says with a trace of sadness—and it was after a long European tour last year that the German critic Klaus Geitel suggested he set some of his pieces on European dancers, specifically the dancers of the Berlin Opera Ballet, the Royal Danish Ballet and Rudolf Nureyev.

"And it all fell into place," he recalls. "Berlin was the test for me. It was the first time I had set a work on a foreign company, and the Berlin Opera Ballet is typically European in terms of motley geographical representation. But dance terminology is pretty much international. And my work is classical, not in terms of the steps, but because it's movement for movement's sake. Anyone trained with a decent movement vocabulary can extend himself into this range."

The work, "Calligraph for Martyrs," was a critical and popular success, and Mr. Louis was asked to choreograph a full-evening "Othello," but was unable to do so because of prior commitments.

### New Work for Nureyev

Mr. Louis will next choreograph a new work for Mr. Nureyev, to have its premiere

next month in Madrid. He has structured the piece on his own company and will spend a week in Glasgow next month teaching it to Mr. Nureyev and four male dancers from the Scottish Ballet. The dance, "Moment," is set to Ravel's String Quartet in F.

"It's an abstract dance, an insight into a moment of thought when someone just lets down into themselves and then picks up and comes out again," Mr. Louis said. "It's a poetic rather than dramatic role for a mature male dancer. Nureyev has an extraordinary performance range, and this will exploit that. I'm very excited about choreographing for that instrument, that body."

In early October, the Royal Danish Ballet will perform Mr. Louis's "Hoopla," a zany dance about the circus, and the more elegant, pure dance piece, "Proximities," after five weeks of rehearsal with Mr. Louis and two assistants. "The Danish company has charm and wit in abundance, and I feel these works have the same qualities," he says.

The fact that the venerable Danish company's only imported modern dance works have been by Paul Taylor and Glen Tetley, choreographers who are closer to the tradition of ballet than he is, does not disturb Mr. Louis at all. "Flemming Flindt [the company director] has done some pretty wild choreography for them," Mr. Louis points out.

"In fact, when I saw his 'Triumph of Death,' which is done nude, I thought, 'Good grief, if they can shake like that in a ballet, imagine what they'll do when they're dancing without point shoes.'"

If his work proves a novelty for the Danes, Mr. Louis's European experiences have given him new insights as well. Last February he visited the Royal Ballet school in London and the school of the Royal Danish Ballet in Copenhagen.

"It was incredibly exhilarating—a new honeymoon with dance for me after all these years," Mr. Louis said. "I got over a lot of preconceptions. Foreign dancers are not what they used to be. Ballet is an attitude—both of the figure and the mind—and the thinking has changed. There's a more contemporary attitude. Ballet dancers aren't locked into tradition as they were in the fifties."

Mr. Louis has been offered the directorship of several European opera houses. "They've been offers of such generosity, I've been tempted. I could work with large groups that way, and I'd have a home base. I have no place to be, here. Performance outlets are a serious problem financially, and without a base you begin to question your identity."

Plans are well along, however, for a "monster new Bicentennial work." Starting in late October, Mr. Louis's company will perform it throughout the United States and in Latin America. Can the Orient be far behind?

August 25, 1975

179

## DANCE VIEW

CLIVE BARNES

# Resident Ballet Companies Are Booming, Too

One of the most widely quoted statistics of the so-called dance explosion is that for every person in the United States who bought a ticket for a professional dance performance in 1965 about 16 bought a ticket in 1975. The figure for 1976 is likely to be substantially larger. A lot of this vast increase in activity is accounted for by modern-dance performances. There are now 139 dance companies on the books of the National Endowment for the Arts, and the majority of those are modern-dance troupes. A rather smaller percentage of the increase is due to the larger audiences and greater number of performances being given by America's Big Three classic companies, New York City Ballet, American Ballet Theater and City Center Joffrey Ballet, and by foreign touring companies, as is witnessed by the longer season the Hurok organization takes at the Metropolitan Opera House these days. Yet over and above all this, and vital to the entire picture, are the resident ballet companies across the country.

First let me explain what is meant by a resident ballet company as opposed to a regional ballet company. Briefly, and without total accuracy, a resident ballet company is professional and loosely the equivalent of a resident theater company, such as the Arena Stage in Washington or the Long Wharf Theater in New Haven. In contrast, a regional ballet company is essentially non-professional (although it may employ professional guest artists) and is roughly analogous to the admirable but amateur community-theater groups across the land.

•     •     •

Regional ballet companies are almost always derived from a local dancing school or, more rarely, an association of local dancing schools. The dancers are usually unpaid, they give performances in their home area, and once a year may be selected by traveling judges to take part in an area festival. These help to give the movement focus and to maintain and even improve its standards of dancing and choreography, the latter being where the main deficiency exists. Such performances are community efforts and the results vary enormously; in most instances, they are more rewarding for the participants and their friends and relatives than they are for outsiders. This is perfectly acceptable, and at a grass-roots level the regional ballet movement must be given part of the credit for the stimulation of dance interest across the nation. A little girl who once took ballet lessons and appeared as a mouse in a local production of "The Nutcracker," however good or terrible that production might have been, is likely to feel quite differently about dance for the rest of her life.

The resident ballets also vary in standards and experience. Some are of long standing and well-established, others are new and still struggling. At least one, the Pennsylvania Ballet, is a major company of an international quality. It is perhaps the best resident company in this country; it is unmatched on the East Coast. In fairness, I have not yet seen two of the country's other major resident troupes, the San Francisco Ballet and Ballet West, based in Utah, both of which enjoy large and developing reputations.

Recently, within the space of a week, by chance I saw three of these resident companies: the Pennsylvania Ballet, during one of its brief twice-yearly visits to the Brooklyn Academy of Music, and the Boston Ballet and the Milwaukee Ballet, both on their home turf. Looking at all three companies—and keeping in mind that the Milwaukee troupe is in an earlier stage of its development than the other two—I was struck afresh by the sheer quality of American dancing and particularly by the new-found ability of the male dancers. At one time, only the major companies could offer a semblance of quality in male dancing; luckily, this is no longer the case.

The Pennsylvania Ballet continues to be fascinating. Indeed, it is one of the most cohesive ensemble companies in the world. Its founder, Barbara Weisberger, and its artistic director, Benjamin Harkarvy, have worked together to form a vibrant team of dancers, with no stars but with the entire unit exuding a soft, stellar glow. The company is still perhaps at its best in Balanchine—its Brooklyn performance of "The Four Temperaments" proved admirably temperamental but as smooth as a peach—yet it also has a decent choreographer in Mr. Harkarvy himself, whose tasteful piece of japonaiserie, "Continuum," was having its local premiere, as well as a special relationship with one of Europe's leading choreographers, Hans van Manen.

The Pennsylvania Ballet, in effect, syndicates van Manen. This Dutch choreographer, who is resident with the Netherlands National Ballet, works in Europe primarily with that company as well as Britain's Royal Ballet. But since the end of 1974, he has established an American outlet with the Pennsylvanians and has now remounted five of his ballets for the Philadelphia-based company. The combination of van Manen and Harkarvy has given the troupe a distinctive look, style and approach.

E. Virginia Williams is one of the pioneers of American classic dance—a contribution recognized last Monday when she was one of the recipients of the current Dance magazine awards—and her Boston Ballet, which, like the Pennsylvanians, was much assisted at its birth a decade or so ago by the interest of Balanchine and the award of an ongoing Ford Foundation grant, has become a major force. Yet because it does not have a strong choreographic identity, it lacks the character and personality of the Philadelphia group. Last weekend at Boston's Music Hall it staged a new production of the Petipa/Tchaikovsky classic "The Sleeping Beauty," using the Peter Farmer sets and costumes that it had purchased from the now sadly defunct National Ballet of Washington.

The project was an ambitious one. On a local level, it was clearly worthwhile; Boston audiences, starved of the big touring companies nowadays, have very little chance to see the large-scale ballet spectaculars. And in terms of the Boston dancers, including the apprentices that had to be brought in to fill out the production, the challenge of this kind of experience is extremely valuable, as Ninette de Valois demonstrated when she was building up the infant Royal Ballet in London before World War II. But I wonder whether a production at this level, worthy enough but less than magnificent, of this particular ballet is really justified.

•     •     •

Sara Caldwell with her Boston Opera seems to be more adroit, often carefully choosing her operas from a repertory where there are no comparisons possible with productions by other existing companies. For instance, the company had considered a revival of the full-length Danish classic "Napoli" instead of "The Sleeping Beauty." This would have been more expensive to mount, would certainly have proved far less of a crowd pleaser, and

might have been less pertinent to the needs of the Boston dancers and audience alike. But objectively it could have been the wiser choice.

In general, it seems that the Boston Ballet is aimed first at the conquest and then presumably the education of Boston (it does, incidentally, have a very adventurous new choreographers series, lest I have given the impression that the company is overly conservative) whereas the Pennsylvania Ballet is probably looking more toward national and international recognition. Two approaches, possibly equally valid.

How about Milwaukee? It is a company with a far smaller budget than the other two, and although it is completely professional, it does not yet offer its dancers full union contracts. For the past two years, the director has been the French dancer and choreographer Jean Paul Comelin, and the company has found a permanent home in the very handsome Milwaukee Art Center. The dancers are excellent, nicely trained and beautifully presented; with his assistant, Marjorie Mussman, Comelin is developing a company that does have a certain character of its own. His rhapsodically dramatic version of Glazunov's "The Seasons" was rather too florid for delicate tastes; yet it had an energy that appears typical of this young and apparently emerging company.

April 18, 1976

# The Dance: Baryshnikov in Ailey's Ellington Piece

### By CLIVE BARNES

What makes a gala a gala? Is that rhetorical? Probably not. Of course, one can easily see gala packages—a little bit of this brilliance added to a little bit of that genius, a parade of talent passing across a stage with breathless speed and a wary elegance. But the real gala is one that offers the unrepeatable occasion.

Galas lie a little. When we first had the benefit performance of George Balanchine's "Don Quixote" and Mr. Balanchine himself danced the Don, it was parlayed to the benefit world as a unique occurrence. Of course it wasn't—in the last 10 years Mr. Balanchine must have given at least six or seven performances. But it was, if you will pardon the semantics, unique enough.

●

On Tuesday night the Alvin Ailey City Center Dance Theater came up with what was presumably a unique occurrence—but as with Mr. Balanchine, one trusts that

### The Program

BLACK, BROWN AND BEIGE (world premiere), music, Duke Ellington; choreography, Alvin Ailey; costumes, Randy Barcelo; lighting, Chenault Spence; conductor, Joyce Brown; assistant to Mr. Ailey, Karina Rieger. With Clive Thompson, Elbert Watson, Donna Wood, Enid Britten, Melvin Jones, Carl Paris, Charles Adams, Sarita Allen, Beth Shorter and Anita Littleman.

PAS DE 'DUKE' (world premiere), music, Duke Ellington; choreography, Alvin Ailey; designed by Rouben Ter-Arutunian; lighting, Chenault Spence; assistant to Mr. Ailey, Karina Rieger; conductor, Joyce Brown. With Judith Jamison and Mikhail Baryshnikov. Presented by the Alvin Ailey City Center Dance Theater at the City Center 55th Street Theater.

it is a uniqueness that will have qualifications. It was a piece called "pas de 'DUKE,'" which naturally had music by Duke Ellington, was choreographed by Mr. Ailey himself, but unexpectedly was danced by the singular combination of Judith Jamison and Mikhail Baryshnikov. It had been designed by Rouben Ter-Arutunian with a clever bubble-encrusted backdrop and the dancers in handsome satin jump suits.

It was remarkable how well Mr. Baryshnikov had absorbed the Ailey technique, and how well the two of them went together. It was sheer fun, and Mr. Ailey was at his most persuasively inventive. It is always a delight to see Mr. Baryshnikov doing jazz movements — he performs a little naughtily, like a bright child talking faultlessly in a foreign language with a charming and slightly accentuated accent.

This sprightly jeu d'esprit was not only brilliantly danced, with just the right casual grace, but also very well choreographed. Mr. Ailey seemed genuinely inspired by the dancers, and Mr. Baryshnikov in particular seemed to offer him a challenge to extend his choreographic range.

At first sight at least there seemed a great deal less inspiration in the world premiere of "Black, Brown and Beige," another of Mr. Ailey's Ellington pieces that the choreographer is putting together for his Ellington Festival at the New York State Theater in the summer.

Mr. Ailey has cut the music slightly, with permission, and uses the concept of an Ancestor, nobly played by Clive Thompson, to represent black aspiration through slavery to emancipation, and ending with a passage celebrating black vitality and optimism.

Mr. Thompson and the others dance with a forceful suavity, but the work seems to lack something in form and body. It misses a choreographic outline or a dance statement—it wanders where it should define. Perhaps it can be shaped up, for there are some good moments in it, but they are not altogether formulated.

The evening ended as it had to, with Mr. Ailey's signature work, "Revelations." Even seen for the umpteenth time, this still manages to thrill, and here the company gave it with a festive grandeur—particularly, perhaps, Mari Kajiwara, Mr. Thompson and Dudley Williams. But happy is the gala that can end with "Revelations."

May 13, 1976

# The Literary Arts

Allen Ginsberg at the National Book Awards
ceremony in 1971.

*Jack Manning/NYT Pictures*

# FEARS REALISTS MUST WAIT

## AN INTERESTING TALK WITH WILLIAM DEAN HOWELLS.

**The Eminent Novelist Still Holds a Firm Faith in Realism, but Confesses a Doubt if Its Day Has Yet Come—He Has Observed a Change in the Literary Pulse of the Country Within the Last Few Months—A Reactionary Wave.**

[Copyright, 1894 by S. S. McClure, Limited.]

William Dean Howells leaned his cheek upon the two outstretched fingers of his right hand and gazed thoughtfully at the window—the panes black from the night without, although studded once or twice with little electric stars far up on the west side of the Park. He was looking at something which his memory had just brought to him.

"I have a little scheme," he at last said, slowly. "I saw a young girl once in a little Ohio town once—she was the daughter of the carpetwoman there—that is to say, her mother made ragcarpets and rugs for the villagers. And this girl had the most wonderful instinct in manner and dress. Her people were of the lowest of the low in a way and yet this girl was a lady. It used to completely amaze me—to think how this girl could grow there in that squalor. She was as chic as chic could be, and yet the money spent and the education was nothing—nothing at all. Where she procured her fine taste you could not imagine. It was deeply interesting to me—it overturned so many of my rooted social dogmas. It was the impossible, appearing suddenly. And then there was another in Cambridge—a wonderful type. I have come upon t. m occasionally here and there. I intend to write something of the kind if I can. I have thought of a good title, too, I think—a name of a flower—' The Ragged Lady.'"

"I suppose this is a long way off," said the other man reflectively. "I am anxious to hear what you say in 'The Story of a Play.' Do you raise your voice toward reforming the abuses that are popularly supposed to hide in the manager's office for use upon the struggling artistic playwright and others? Do you recite the manager's divine misapprehension of art?"

"No, I do not," said Mr. Howells.

"Why?" said the other man.

"Well, in the first place, the manager is a man of business. He preserves himself. I suppose he judges not against art, but between art and act. He looks at art through the crowds."

"I don't like reformatory novels anyhow," said the other man.

"And in the second place," continued Mr. Howells, "it does no good to go at things hammer and tongs in this obvious way. I believe that every novel should have an intention. A man should mean something when he writes. Ah, this writing merely to amuse people—why, it seems to me altogether vulgar. A man may as well blacken his face and go out and dance on the street for pennies. The author is a sort of trained bear, if you accept certain standards. If literary men are to be the public fools, let us at any rate have it clearly understood, so that those of us who feel differently can take measures. But, on the other hand, a novel should never preach and berate and storm. It does no good. As a matter of fact, a book of that kind is ineffably tiresome. People don't like to have their lives half cudgeled out in that manner, especially in these days, when a man, likely enough, only reaches for a book when he wishes to be fanned, so to speak, after the heat of the daily struggle. When a writer desires to preach in an obvious way he should announce his intention—let him cry out then that he is in the pulpit. But it is the business of the novel—"

"Ah!" said the other man.

"It is the business of the novel to picture the daily life in the most exact terms possible, with an absolute and clear sense of proportion. That is the important matter —the proportion. As a usual thing, I think, people have absolutely no sense of proportion. Their noses are tight against life, you see. They perceive mountains where there are no mountains, but frequently a great peak appears no larger than a rat trap. An artist sees a dog down the street —well, his eye instantly relates the dog to its surroundings. The dog is proportioned to the buildings and the trees. Whereas, many people can conceive of that dog's tail resting upon a hill top."

"You have often said that the novel is a perspective," observed the other man.

"A perspective, certainly. It is a perspective made for the benefit of people who have no true use of their eyes. The novel, in its real meaning, adjusts the proportions. It preserves the balances. It is in this way that lessons are to be taught and reforms to be won. When people are introduced to each other they will see the resemblances, and won't want to fight so badly."

"I suppose that when a man tries to write 'what the people want'—when he tries to reflect the popular desire, it is a bad quarter of an hour for the laws of proportion."

"Do you recall any of the hosts of stories that began in love and ended a little further on. Those stories used to represent life to the people, and I believe they do now to a large class. Life began when the hero saw a certain girl, and it ended abruptly when he married her. Love and courtship was not an incident, a part of life—it was the whole of it. All else was of no value. Men of that religion must have felt very stupid when they were engaged at anything but courtship. Do you see the false proportion? Do you see the dog with his tail upon the hilltop? Somebody touched the universal heart with the fascinating theme —the relation of man to maid—and, for many years, it was as if no other relation could be recognized in fiction. Here and there an author raised his voice, but not loudly. I like to see the novelists treating some of the other important things of life— the relation of mother and son, of husband and wife, in fact all those things that we live in continually. The other can be but fragmentary."

"I suppose there must be two or three new literary people just back of the horizon somewhere," said the other man. "Books upon these lines that you speak of are what might be called unpopular. Do you think them to be a profitable investment?"

"From my point of view it is the right— it is sure to be a profitable investment. After that it is a question of perseverance, courage. A writer of skill cannot be defeated because he remains true to his conscience. It is a long, serious conflict sometimes, but he must win, if he does not falter. Lowell said to me one time: 'After all, the barriers are very thin. They are paper. If a man has his conscience and one or two friends who can help him, it becomes very simple at last.'"

"Mr. Howells," said the other man, suddenly, "have you observed a change in the literary pulse of the country within the last four months? Last Winter, for instance, it seemed that realism was about to capture things, but then recently I have thought that I saw coming a sort of a counter wave, a flood of the other—a reaction, in fact. Trivial, temporary, perhaps, but a reaction, certainly."

Mr. Howells dropped his hand in a gesture of emphatic assent. "What you say is true. I have seen it coming. * * * I suppose we shall have to wait."

STEPHEN CRANE.

October 28, 1894

---

### STEPHEN CRANE'S SUCCESS

#### English Critics Vying with Each Other in Singing His Praises.

From The Bookman for February.

It is gratifying to record the immense success which Mr. Crane's new novel, "The Red Badge of Courage," is having in England. Since our last issue, in which we stated that Mr. Heinemann had launched Mr. Crane's book with enthusiasm on the English market, we have had successive reports of its warm reception, and the critics seem vying with one another in singing its praises until we understand that Mr. Crane bids fair to be the author of the hour in London. The New Review, of which Mr. W. E. Henley is the editor, has a criticism of Mr. Crane's work written by Mr. George Wyndham in its January number, and the same magazine promises to publish a new story of a warlike character by Mr. Crane in February.

Why is it, we might ask again, that in America critics are less sure and readers slower to discover a good book in spite of the genius in it? Except for a review of his Maggie, a girl of the streets, in "The Arena," printed a few years ago, in which Mr. Hamlin Garland solitarily hailed the author as one to be reckoned with, The Bookman was the first, if we are not mistaken, to call attention to Mr. Stephen Crane and his work. This was done in an article, which was widely copied throughout the States, printed in the May number of The Bookman, on the appearance of "The Black Riders, and Other Lines." Yet he has not received the recognition in his own country which his recent novel at least should evoke—whatever dissentient voices may say about his "Lines"—and which they across the sea have been so quick to award him.

The book has its defects—what book by a youth of twenty-four could be without

Stephen Crane.

them?—but let us be generous to the genius that has been applied to an experience common to every novice in war so as to make it glow and tingle with a tremendous force of reality. The narrative is stamped with truth. The youth's mind as well as the field of active service in which he is a recruit is a battleground. The dark, fearful, and inglorious moments leading up to his acquittal in the end mark the genuine development of the untried civilian into the capable and daring soldier. Exactly what military courage means for the average man you will learn here. Here also are pictures of war that are masterly. The book is marked throughout by the quiet power that war had proved the hero of it to possess.

February 2, 1896

## LONDON LETTER.

Written for The New York Times Saturday Review by
WILLIAM L. ALDEN.

LONDON, Sept. 15.—Mr. Frank Norris's book, "The Octopus," has made a true literary sensation here. I have not yet seen a single review that did not praise it warmly. Fault is found with it in certain respects, but the real greatness of the book is gladly acknowledged.

It has been suggested that Mr. Norris would never have written "The Octopus" if Zola had not previously written his wonderful novels. Probably this is true. The conception of the world as governed by the forces of nature and industry which lies at the basis of "The Octopus" is essential to the conception which runs through Zola's work. The wide scope of Mr. Norris's "epic of wheat" is Zolaesque, and Mr. Norris has undoubtedly copied some of the mannerisms of Zola, and caught something of his style. We may frankly admit all this, for it is nothing to Mr. Norris's discredit. It is the rarest of all events that a newly created book is written. One book begets another. One author dates his ancestry back to some other author. Nine-tenths of all the books that have been written during the last century would act have been written had not other and earlier books appeared.

It is one thing to imitate an author, and quite another to derive inspiration from him. Mr. Norris has not imitated Zola except in certain trivial matters. He follows the methods of Zola, just as nearly all historical novelists follow the methods of Scott. He is moved to write the "epic of the wheat" by the spirit of Zola breathed upon him through the books of the great Frenchman, but "The Octopus" is none the less great because it is begotten by "La Terre" and "Germinal." It would not have been written had Mr. Norris never read Zola, but it would have been a great pity if he had read instead the writing of some smaller man, and gained a milder and less desirable inspiration.

The resemblance between Mr. Norris and Zola interests me, partly because I have a very great admiration for Zola, and partly because the matter of conscious or unconscious plagiarism has for many years been an especial study of mine. It is so easy to accuse an author of borrowing from another, and the accusation is so fatal, that it ought never to be lightly made. Mr. Norris is certain to be accused openly of having imitated Zola, and it is well that the distinction between imitation and legitimate descent should be emphasized. Mr. Norris is of the family of Zola. That is all that need be said about the relationship between the two. If any one, in order to defend Mr. Norris, pleads that he has in no way followed Zola, the defense would be a mistake that in the end would injure rather than benefit Mr. Norris.

October 5, 1901

---

### "SISTER CARRIE."

THEODORE DREISER'S frankly realistic story called "Sister Carrie," originally published seven years ago, is now republished by Messrs. B. W. Dodge & Co., and deserves to be received as a new book, for it did not get a chance for recognition when it first appeared. Except for his provincial avoidance of simple and perfectly understandable phrases, Mr. Dreiser writes very well. He tells what happened to a farmer's daughter from Wisconsin who went to Chicago almost as a child, there to seek her level in the world. She had beauty of a mild sort, a natural sensibility, a rudimentary intellect, a liking for fine clothes and silk and soft places, the good nature which goes with the lack of passion, and no particular burden of education or conscience.

To an extraordinary degree the book is a photograph of conditions in the crude larger cities of America and of the people who make these conditions and are made by them. There is no attempt to complicate the facts as they are with notions of things as they should be morally, or as they might be sentimentally or aesthetically. People's feelings are not considered. The author is quite impersonal. Withal, the story is interesting in spite of the commonplace character of the personages and the low plane of the gallery in which they move. Carrie, without a shining quality, with little to say, with almost no initiative, only her second-rate good looks, her first-rate instinct for soft places, her genius for fitting into such places when she finds them—in brief, her rudimentary femininity—gets a tremendous grip upon the imagination of the reader. She is as perfectly simple and human a creature as one sees trapped very rarely between the dry covers of a printed book. It may be added that the story even upon its first publication seven years ago attracted much attention and won favorable recognition in England. We do not, however, recommend the book to the fastidious reader, or the one who clings to "old-fashioned ideas." It is a book one can very well get along without reading.

May 25, 1907

---

## THE DEPRAVED NOVEL.

Under the influence of what he calls Socialism, a wealthy young man of Chicago has written a novel in which he portrays the American woman as a disagreeable and debased animal, given to luxury and drink, and pictures New York society as another flower of Socialism, Mr. UPTON SINCLAIR has lately pictured it. A writer of larger relative importance, Dr. ROBERT HERRICK, also of Chicago, has lately been lampooning American social life to the same effect and greatly to his discredit. His new novel has literary merit above the ordinary, but some chapters are in questionable taste. To Americans of intelligence these books seem of small importance. They know that the writers have scant knowledge of American society at best; that they exaggerate grossly; that they derive their information from the scandalous gossip of sensational newspapers.

Diseased minds or a determination to make money regardless of honesty and decency, or both, control the writers of such books. They are utterly false to the life they pretend to portray, and they picture nothing graphically but the noisier restaurants and pavements of big towns. Every sane and healthy American man knows that the typical American woman of this hour is clear headed, pure minded, better educated than her grandmother was, better trained physically. She shuns dissipation and notoriety, as she shuns the foibles and fads of the shrieking sisterhood. She is a good hostess, a faithful wife, a loving and careful mother.

These flashy books, however, are doing some harm. They are helping to strengthen foreign prejudice against the United States. In England this Summer Mr. UPTON SINCLAIR'S preposterous caricature of our fashionable society is accepted as a true picture. The inborn tendency of the English is to accept coarseness, extravagance, and vulgarity as truly American. The London Times correspondent in New York thought it worth his while lately to send by cable to his newspaper some of the most objectionable passages in Dr. HERRICK's "Together," as illustrative of American social life and character. Doubtless Mr. JOSEPH MEDILL PATTERSON's "Little Brother of the Rich" will be eagerly taken up in London, as further testimony to American depravity, though, of course, the countless English novels of the same class picturing the aristocracy and gentry as wicked and degenerate, for the edification of parlor maids and footmen, are ignored in polite British society. Their falsity and vulgarity are obvious to the British mind.

Therefore it is worth while to protest against the defamation of American social life by witless or conscienceless novelists, and to protest strongly. While the profits derived from such books may sometimes be large, publishers of repute would be discouraged from giving them a place in their lists if decent and patriotic folks generally made known their opinions of them. The falsehoods of the sensational newspapers are bad enough, but the falsehoods of the sensational novelists survive longer and do more harm.

August 22, 1908

---

## A PLEA FOR THE POET OF TO-DAY

### Vitality and Beauty Have Not, as We Are Told, Passed Out of English Poetry

By LAWRENCE GILMAN

IT is not likely that any one would dispute the assertion that the contemporary poet is a much-abused person. Apparently there is none too lowly to raise supercilious—or at least patronizing—eyebrows when the worth of living writers of English verse is in question. Only the other day I came across a quotation from the diary of John Stuart Mill in which he asked this question: "Is composition in verse, as one is often prompted in these days to think, a worn-out thing, which has died a natural death, never to be revived? Mill raised this dolorous query in 1854 (the year, by the way, as some one has remarked, in which Tennyson was beginning Maud!); but his doubts disturb the breasts of many faint-hearted critics and readers of to-day. The situation is not, of course, extraordinary: what would be extraordinary would be an attitude of lively appreciation and warm sympathy on the part of the critical and the reading public toward contemporary artists; for when has it failed to happen that at precisely the moment when the strabismic and the myopic among readers and commentators were bewailing the decay of poetical or pictorial or musical inspiration, some genius was quietly hatching out masterpieces under their very noses?

I need hardly say that it is far from the purpose of the following desultory remarks to undertake so formidable a task as a deliberate and comprehensive defense of contemporary English poetry. I should merely like to adduce a few examples of verse by living writers in the English tongue which are perhaps not so familiar to the average lover of poetry (if that supposedly legendary being is within ear-shot) as they should be, and which, to my mind, make rubbish of that solemn literary bromide: "Is English poetry a declining art?" My modest purpose is to weave a garland rather than to exhibit a whole garden in bloom.

Of course not even the most completely captivated lover of modern English verse would pretend that it often scales the heights. It is likely that he would own to a final doubt if you insisted upon an answer to the question whether any one now writing

had produced, or was capable of producing, verse that attains often to the quality of:

* * * speak silence with thy glimmering eyes
And wash the dusk with silver;

or:

He will awake no more, oh, never more!—
Within the twilight chamber spreads apace
The shadow of white Death;

or:

O love, my love! if I no more should see
Thyself, nor on the earth the shadow of thee,
Nor image of thine eyes in any spring;

not to mention verse of the kind that floods the spirit with an instant conviction of immortal beauty—such verse of incredible inspiration as:

Death, that hath sucked the honey of thy breath * * *

No, we have not quite returned to that enchanted garden. Yet well, to name at once the most distinguished of imaginative writers in English, though not the most distinguished of English poets, there is Mr. Hardy. Now there is some reason for believing that Mr. Hardy regards himself with more satisfaction as a writer of verse than as a writer of fiction. That, needless to say, has nothing to do with the actual merits of the case; but it is an interesting fact that not long ago, in a letter to an American friend, he expressed an astonished regret at the scant interest aroused by his verse among readers in this country, and his insistence that it be regarded as of at least as much importance as his prose. It is certainly true that Mr. Hardy as a poet is not, in America, at any rate, correctly valued. To those who are accustomed to regard the product of the contemporary verse-maker as meriting the characterization of Swinburne, that master of invective: "a tideless and interminable sea of limitless and inexhaustible drivel" (which nine-tenths of it surely is), one would like to recommend Mr. Hardy.

Assuredly Mr. Hardy is very far from being one of the magicians of poetry; there is no glamour, there is no ecstasy, there is no lyrical rapture at all in his verse. But there is in it a singular intensity, a sombre passion, a quality of emotion—at times saturnine and brooding, at times swift and mordant—peculiar to himself. He can be very haunting, very poignant; and he is ever incurably melancholy—one imagines that he writes always with the Book of Ecclesiastes lying open

before him. Above all, he is remarkably individual. Where else in English poetry will you find anything at all like She: At His Funeral, in his Wessex Poems? Those eight piercing and unforgettable lines might have been written by one who had never heard of Shelley or Keats, Browning or Tennyson. And the same thing is true of that terrible poem, I Look Into My Glass—a poem which should be read only by the indisputably young. And in those four serial poems which, I dare say, are the finest that he has given us: She, To Him, how memorable is the austere and grave beauty of diction and rhythm, how stabbing the emotional cry!

Having, so far as my present casual purpose goes, "done" Mr. Hardy, let me now proceed to wave a commendatory hand in the direction of that group of lyric writers amongst whom, I am free to confess, I find the only poetic achievement among contemporary verse-makers which seems to me incontestably first-rate. I mean the poets of modern Ireland, and particularly Mr. Yeats and his lesser-known brother poet, George Russel ("A. E."). I have no hesitation in admitting that these men seem to me to be writing lyric poetry that, at its best, is not unworthy of being set beside verse by Shelley or Keats or Wordsworth or Blake or Tennyson. And I am equally willing to admit that I know of no one else than these two Irishmen who is writing verse of equal excellence. But the best traditions of English poetry can be sustained as authentically by one or two as by half a dozen, can they not? So, if these men are as excellent as I think them, my plea will have justified itself.

Mr. Yeats and "A. E." are not, of course, the only notable fish in the Irish pond. There is, for instance, Seosamh MacCathmhaoil (more easily remembered as Joseph Campbell), whose The Gilly of Christ contains verse that is deeply touching and truly distinguished; but there is no one who writes with the inspiration and the art of Yeats and Russell. Of the two, "A. E." is the lesser craftsman, the less finely gifted poet; but what exquisite verse he has written! A profound mystic, a rapt and luminous seer, his verse is touched with an unearthly beauty, an exaltation that for purity and rapture has no parallel in modern poetry. Where among his contemporaries will one find verse of just this quality, in which "A. E." is less the seer than the troubled human questioner:

Empty your heart of its mortal dream.

Dark glowed the vales of amethyst
Beneath an opal shroud;
The moon-bud opened through the mist
Its white-fire leaves of cloud.

Though rapt at gaze with eyes of light
Looked forth the seraph seers,
The vast and wandering dream of night
Rolled on above our tears.

And he has written at least one perfect line:

We kiss because God once for beauty
Sought amid a world of dreams.

"A. E." is at times over-didactic, pious rather than poetical—though his piety is of a rare, indeed of the rarest, order. But when he chooses to let the poet in him speak first and the mystic second, when he dons his singing-robes, he achieves verse that would be hard to match for its blend of spiritual exaltation and magical charm.

Of the poetry of Mr. Yeats I would fain write with seemly moderation, with a circumspection which to many may seem requisite; but I find myself unable to conceal the fact that I regard his poetry as among the most excellent in our tongue. I am aware that not every one holds the same view—I remember the Englishman who is reported to have said of it that "it did not seem to come to much." Mr. Yeats, beyond question, has his defects. He is excessively fond of certain formulae, valuable and arresting in themselves, but which he has shown an inclination to overwork; and certain of these cliches, by the way, he got pretty directly from Rossetti and from Maeterlinck—let the curious turn to the opening line of the thirty-first sonnet of The House of Life if they would find in that haunted palace of beauty one of the chambers where Mr. Yeats brooded most lovingly.

But that is unimportant. The significant truth is that Mr. Yeats has given us a body of verse that, as some of us believe, is of superlative beauty and consummate art—that contains the loveliest and the most haunting poetry that has been written in English in a generation.

For those who already know some or all of this poetry, as well as for those who know none of it, I may adduce certain phrases, certain lines, chosen at random from his verse, wherein that transporting glamour, that dream-haunted beauty, that ineffable charm that are the immemorial birthright of the Celtic genius have an intense and abiding life:

Beauty grown sad with its eternity.

The dead are happy, the dust is in their ears.

She was the great white lily of the world.

I kiss you and the world begins to fade.

* * * the shadows of the wood
And the white breast of the dim sea,
And all dishevelled wandering stars.

* * * do not weep
Too great a while, for there is many a candle
On the high altar, though one fall.

Then I would mould a world of fire and dew,
* * * * * * *
And crowd the enraptured quiet of the sky
With candles burning to your lonely face.

The years like great black oxen tread the world,
And God the herdsman goads them on behind,
And I am broken by their passing feet.

God spreads the heavens above us like great wings
And gives a little round of deeds and days,
And then come the wrecked angels and set snares
And bait them with light hopes and heavy dreams,
Until the heart is puffed with pride and goes,
Half shuddering and half joyous, from God's peace.

I believe that, by reason of imagination which is both daring and exquisite, subtlety and originality of rhythm, triumphant felicity of diction, and richness of emotional content, the poetry of this Irishman is worthy to be ranked with that of the masters of English verse. At least it is certain, I think, to be valued in the coming years as an unequalled expression of the Celtic soul—of that race which has ever been "a nurse of the things of the spirit," a home for forgotten waifs of music, a keeper of the mysteries which can never wholly die and never wholly be understood."

But above all, such verse as this, and that of "A. E." and Hardy, is inestimably precious to us of to-day because it teaches us that poetry still feeds upon living pastures and living fountains of waters; that those who love it can still go to it with the hope of finding it, as before, their refuge, their consolation, and their deepest joy.

LAWRENCE GILMAN.

October 22, 1911

---

## MOTHER LOVE

### Mr. Lawrence's Remarkable Story of Family Life

SONS AND LOVERS. By D. H. Lawrence. Mitchell Kennerley.

THERE is probably no phrase much more hackneyed than that of "human document," yet it is the only one which at all describes this very unusual book. It is hardly a story; rather the first part of a man's life, from his birth until his 25th year, the conditions surrounding him, his strength and his numerous weaknesses, put before us in a manner which misses no subtlest effect either of emotion or environment. And the heroine of the book is not sweetheart, but mother; the mother with whose marriage the novel

begins, with whose pathetic death it reaches its climax. The love for each other of the mother and her son, Paul Morel, is the mainspring of both their lives; it is portrayed tenderly, yet with a truthfulness which slurs nothing even of that friction which is unavoidable between the members of two different generations.

The scene is laid among the collieries of Derbyshire. Paul's father was a miner; his mother, Mrs. Morel, belonged a trifle higher up in the social scale, having made one of those "romantic" marriages with which the old-fashioned sentimental novel used to end, and with which the modern realistic one so frequently begins. The first chapter, which tells of their early married life before the coming of their second son, Paul, is an admirable account of a mismated couple. Walter Morel could never have amounted to very much, but had he possessed a less noble wife he might, by one of those strange contradictions of which life is full, have been a far better man than he actually was. His gradual degeneration is as pitiful as it

is inevitable—the change from the joyous, lovable young man to the drunken, ill-tempered father, whose entrance hushed the children's laughter, the mere thought of whom could cast a shadow over all the house. Mrs. Morel was strong enough to remake for herself the life he had so nearly wrecked—he could only drift helplessly upon the rocks. It is wonderfully real, this daily life of the Morel family and the village wherein they lived as reflected in Mr. Lawrence's pages; the more real because he never flaunts his knowledge of the intimate details of the existence led by these households whose men folk toil underground. They slip from his pen so unobtrusively that it is only when we pause and consider that we recognize how full and complete is the background against which he projects his principal characters—Mr. and Mrs. Morel, Paul, Miriam, and Clara.

Paul himself is a person who awakens interest rather than sympathy; it is difficult not to despise him a little for his weakness, his constant need of that strengthening he sought from two other

women, but which only his splendid, indomitable little mother could give him—a fact of which he was constantly aware, though he acknowledged it only at the very end. And it is not easy upon any grounds to excuse his treatment of Miriam, even though it was a spiritual self-defense which urged him to disloyalty. Mr. Lawrence has small regard for what we term conventional morality; nevertheless, though plain spoken to a degree, his book is not in the least offensive.

It is, in fact, fearless; never coarse, although the relations between Paul, Miriam, and Clara are portrayed with absolute frankness. And one must go far to find a better study of an intense woman, so over-spiritualized that she has almost lost touch with ordinary life and ordinary humanity, than he has given us in the person of Miriam. We pity her for her craving, her self-distrust that forbade her to take the thing she most wanted even when it was almost within her grasp; and yet Paul's final recoil is readily comprehensible, his feeling that she was making his very soul her own—would, as his mother said, leave nothing of him. The long, psychic battle between the two, a battle blindly fought, never really understood, is excellent in its revelation of those motives which lie at the very root of character—motives of which the persons they actuate are so often completely ignorant.

Clara is less remarkable than Miriam only because she is necessarily more obvious—a woman in whom the animal predominates, certain after a brief time to weary one like Paul. And better than either, strong of will, rich in love and sympathy, holding her place in her son's heart against even Miriam, who so nearly took him from her, reigning at last supreme over every rival stands the heroic little mother—the best-drawn character in a book which contains many admirable portrayals. From the moment when we first meet her taking her elder children to the " wakes " and trying to nerve herself to endure a life which appears to be an endless waiting for something that can never come, until at the last she wages her valiant, losing fight against the cancer that is killing her by inches, she is always real, a fine, true woman, mother to the very core. Mr. Lawrence has mercifully spared us the terrible details of her illness; it is only her " tortured eyes " we see, and her children's grief and horror. Whether or not it was right for Paul to do the thing he did is an open question; only we are sure that in very truth he " loved her better than his own life." His impotent resentment of her growing weakness is an excellent bit of analysis; the effect upon him of her death, which he seemed to take so calmly—the blankness, the unreality and emptiness of all things—strikes home. Without her his life was meaningless; yet live he must, and for her sake.

The book is full of short, vivid descriptions:

> The steep swoop of highroad lay, in its cool morning dust, splendid with patterns of sunshine and shadow, perfectly still. * * * Behind, the houses stood on the brim of the dip, black against the sky, like wild beasts glaring curiously with yellow eyes down into the darkness.

Each a picture drawn in a sentence. Although this is a novel of over 500 closely printed pages the style is terse—so terse that at times it produces an effect as of short, sharp hammer strokes. Yet it is flexible, too, as shown by its success in depicting varying shades of mood, in expressing those more intimate emotions which are so very nearly inexpressible. Yet, when all is said, it is the complex character of Miriam, she who was only Paul's " conscience, not his mate," and the beautiful bond between the restless son and the mother whom " his soul could not leave " even when she slept and " dreamed her young dream " which makes this book one of rare excellence.　　　　L. M. F.

September 21, 1913

## VACHEL LINDSAY

### "The Congo and Other Poems"

THE CONGO AND OTHER POEMS. By Vachel Lindsay. The Macmillan Company. $1.25.

WHO says that the poet remains obscure, unrecognized, unrewarded, nowadays? It is only five years ago now since Nicholas Vachel Lindsay was offering free copies of his " War Bulletin," containing his current poems, to any one who should write to him " and confess that he reads poetry, who will try to read it through twice, who will send me a brief letter when it is done," while in a letter written about the same time to the Director of the New York Public Library he expressed his hope that " you can persuade some of the poets to read my poetry. It is only fair. I read theirs sometimes." Only five years ago—and today not only poets, but the Poetry Society, read him!

Several of the poems in " The Congo," as in " General William Booth Enters Heaven," are reprinted with little or no change from " The Tramp's Excuse," a very curious and interesting book published in 1909. In that we read that Mr. Lindsay actually sees the scenes of his poems painted upon the air, as the ecstatic religious sees angels visibly descending in the corner of his cell, and the illustrations by the author prove the point. They suggest the naïveté of a devout geographer of Marco Polo's time, or of a precocious child—or else that Mr. Lindsay had caught at the hem of the robe of William Blake. Whether it is conscious on the part of the young American, or instinctive, the parallelism between them is worthy of note. Blake saw visions—so does Mr. Lindsay; Blake illustrated them with marvelous drawings—Mr. Lindsay's are, if not marvelous, at least interesting; Blake sang or chanted his poems—this is Mr. Lindsay's great point of departure from other poets of the day. The fact that it is in Mr. Lindsay's best verses, and not in his poorest, that Blake is most strongly suggested seems to indicate that, though the genius of the American author cannot be compared in any of its dimensions with that of the English seer, as far as it goes it is genuinely akin to it, and not merely the fruit of discipleship.

The great out-of-doors has done much for Mr. Lindsay. Compelled to live in crowds, his gift of hallucination would have become the curse of distortion, and he might have gone the road of Strindberg had his temperament had sufficient iron in it; or, if not, instead of being in his degree a true mystic, he would have become—to coin a needed word—a mere mystician. As it is, the Saint of Assisi himself could have written nothing sweeter or more sincere than the lines:

> My goal is the mystery the beggars win.
> I am caught in the web the night winds spin.
> The edge of the wheat ridge speaks to me;
> I talk with the leaves of the mulberry tree.
> And now I hear, as I sit all alone
> In the dusk by another big Santa Fe stone,
> The souls of the tall corn gathering round
> And the gay little souls of the grass in the ground.

Characteristically enough, this passage is part of a poem devoted to the onomatopoetic rendering of the sounds of a procession of automobile horns. The idea of it is delightful. A philosophic tramp sits by the wayside while " the United States goes by,"

> Scooting past the cattle on the thousand hills—
> Ho for the tear-horn, scare-horn, dare-horn!
> Ho for the gay-horn, bark-horn, bay-horn!

and in and out of the horns the Rachel-Jane keeps on singing, and the tramp bids his soul

> Listen to the whistling flutes without price
> Of myriad prophets out of paradise.

It is a gay, jigging, jumbled poem, full of surface absurdities, but with an underflow of fine poetic feeling. The sad thing about it is that in the execution of his delightful idea Mr. Lindsay forces the note; his onomatopoeia becomes, not a help to the imagination, but a rhetorical " stunt." He forgets that in poetry a hint is as good as a noise and that when the noise continues and preponderates the effort ceases to be poetry and becomes advertising.

As was before intimated, Mr. Lindsay believes with enthusiasm in a return to the chant of antiquity as a means of getting his poetry " over " to his audience, and Miss Monroe claims in her preface to " The Congo and Other Poems " that it is because his poetry is definitely in line with what she calls " the immediate movement in art," " the return to primitive sympathies between artist and audience, which may make possible once more the assertion of primitive creative power," that it is " important." We do not agree. In our estimation, Mr. Lindsay's work is important because it is a free, sincere, frequently poetical expression of life as its author sees it—in short, because it is literature. The fact that it is unconventional literature is a detail. Further, if a poet writes good poetry, the " primitive sympathies between artist and audience " will take care of themselves; and to talk of " primitive creative power " as of something which has ceased to exist and may begin again is absurd. For every creative power is in its very nature primitive, though not every primitive power is creative. Which may explain why not all who have what Mr. Lindsay cleverly calls " the Higher Vaudeville imagination " are poets. Mr. Lindsay not only has it, but is a poet into the bargain. By no means all of his poems are of equal importance; those in this volume on the present war, for instance, are as poor as the general average of current war poems, while " The Congo," in its crude and vivid coloring, its touch of hashish-dream, the melodramatic stage direction for delivery, so closely fitted to the subject, is a splendid flourish of the imagination.

To try to forecast the future of an author is always a waste of time, but in the case of Vachel Lindsay it is a waste that tempts. It is very hard for the modern poet, in this country especially, to amount to anything. As soon as he shows a disposition to originality, instead of being cuffed by fortune to the thorough testing of his spirit, he is acclaimed by self-appointed watchers on the towers as the prophet of a new era in poetry; young men and women seeking an outlet for their own self-consciousness sit at his feet; he is hailed as the voice of the new America and compared with Whitman. Whether Mr. Lindsay has sufficient of the root of the matter in him to continue to put forth new leaves, to bud, blossom, and bear sound fruit under such hothouse treatment, or, maybe, the strength to wrench himself free of it and insist on growing in the open, is yet to be seen. If Mr. Lindsay will forgive us the impertinence, we must say that he seems to us one of those whose virtue goes out of them at the touch of a throng. His daemon walks solitary in the fields, and it is only when he follows it there that his poems have inspiration.　　HELEN BULLIS.

April 11, 1915

# A HUMAN ANTHOLOGY OF SPOON RIVER

THE SPOON RIVER ANTHOLOGY. By Edgar Lee Masters. Macmillan Company. $1.25.

NOT the least charm and piquancy of "The Spoon River Anthology" is the frequency with which it compels one to change his mind. One's first reaction to it is distinct from his second, and between this and his final judgment lie as many impressions as there may have been readings. This is to say that the book is provocative, that it repels and attracts, and mixes these qualities so cleverly as to keep one in a perpetual state of change.

Doubtless one's first reaction to it is unpleasant. One questions at the outset whether a community ever existed so in need of moral prophylaxis as Spoon River. Did a community of so limited an area ever produce so many drunkards, thieves, suicides, murderers, adulterers, not to mention the minor sins of selfishness and hypocrisy? "Here," we said, "is a notebook for Zola; here is the coarseness of Rabelais without his power; here are all the graceless thieves of Villon without his grace to make them lovable; here is a man obsessed by sex, who makes it insistent, paramount, and revels in depicting its subtlest nuances." All this, and more, was embraced in our first reaction to "Spoon River"; yet so different is the work in perspective, so much greater is its total effect than that of its individual sketches, that one would be as unjust to himself as to Mr. Masters to permit this impression to stand as his final one.

It is not, however, that one wholly abandons his first judgment, but that he finds himself constantly modifying it as he progresses in the Anthology, by the fact that Mr. Masters has so arranged the sketches as to bring the finer types of his characters toward the end of the book. When one has despaired of humanity as expressed in Spoon River and has made up his mind that Mr. Masters's conception of the Comédie Humaine is warped, he begins to meet the redeeming minority and to see that Mr. Masters is quite as keen in their behalf as he is relentless in exposing the weakness of the derelicts. Since, however, the weakness of humanity, in its manifold phases, is more dramatic, more picturesque, than its strength, one must confess that from the standpoint of portraiture Mr. Masters's best work is done with the former types.

While the village community presents a microcosm of life and an opportunity to study character impossible to the more hidden and complex life of the city, where degeneracy is found it is likely to be overemphasized by the pitiless exposure which it meets. The weakling or the criminal in a village community has no defenses, no subterfuges; every spring of his action is open to him who can analyze it. In the city the weak and the degenerate tend to segregate; the individual is lost in the class. In the small community the exact opposite obtains; the individual who falls below the community standard or departs from its regularity, stands out with uncompromising distinctness. This is quite as true of the eccentric, the original, or the gifted; their departure from the normal brings them as unsparingly into the light as the defections of the weaker class. The village knows everything, comments upon everything, judges everything; and out of this knowledge Mr. Masters, looking back to his youth in the environs of Spoon River—which is a veritable stream—has reconstructed the life of the neighborhood so as to give us a complete group of portraits of the folk who gave individuality to the community. It is a great creative idea, and if at the outset the weak and criminal aspects of humanity seem to be overemphasized, it is because the village emphasizes them, because they are the first and most obvious facts of the life he has set himself to depict.

In the scheme of Mr. Masters's psychology, however, the novel point is that the subject confesses from the immunity of the grave. The shades of Spoon River rehearse their crimes, sadden us with their little, sordid, futile lives, and now and again hearten us with their dreams and victories. They keep nothing back, not even the aspiration not bold enough to face a philistine world. They reply to each other from the grave, refuting accusations, gibing at hypocrisies, contrasting points of view with delightful humor, satire, and irony.

There is Archibald Higbie, the artist, who could not shake the heavy soil of Spoon River from his feet, and, laboriously working in art schools in Rome, persisted in getting a trace of Abe Lincoln into the face of his Apollo. There is Tennessee Claflin Shope, the laughing-stock of the village, because, in defiance of the Rev. Peet and all authorities of Spoon River, he had presumed to set up his own spiritual standards:

Before Mary Baker G. Eddy even got
    started
With what she called science,
I had mastered the "Bhagavad Gita"
And cured my soul, before Mary
Began to cure bodies with souls—
Peace to all worlds!

There is Hortense Robbins, at whose doings Spoon River was always agape:

My name used to be in the papers daily
As having dined somewhere,
Or traveled somewhere,
Or rented a house in Paris
Where I entertained the nobility.
I was forever eating or traveling
Or taking the cure at Baden-Baden.
Now I am here to do honor
To Spoon River, here beside the family
    whence I sprang.
No one cares now where I dined
Or lived, or whom I entertained,
Or how often I took the cure at Baden-
Baden.

In the matter of ethics Mr. Masters is quite as keen as in the lighter phases of his work. He never blurs his values, one sees in an instant what made or unmade a character. There has, indeed, been some excellent philosophy garnered on the banks of Spoon River for him who cares to profit by it. The sketches of Henry C. Calhoun, Robert Davidson, and others bear out this assertion.

As to poetry, one comes to a question of disputed boundary. No sooner does one set his careful stakes about the preserve of poetry than some invader strides across and upsets them. Poetry is, indeed, a domain of constantly moving outposts, again and again the stakes are set, again and again the ground is yielded, until he is rash who should predict the final territory.

It seems, however, that one convention remains, one differentiation exists between the arts of prose and poetry—that while both have rhythm, but one has a rhythmic beat, a blending of rhythm and tone, which must be distinct from the rhythm of prose. This beat may not be one of conventional feet, amenable to the laws of scansion, but it is none the less recognizable and definite. In many of Mr. Masters's sketches the rhythm, if present, is too subtle for gross ears, while the beat has escaped in some overtone. The majority of the sketches could quite as well be set as prose, since the line division is arbitrary and not inherent, but there remains a minority where the rhythm is not only definite, but of distinct beauty, and, coupled with exaltation, the result is a poem about whose credentials there could be no quibbling. One of the finest of these in poetic heightening and ecstasy is that of Caroline Branson singing a canticle of the flesh, or of Thomas Trevelyan "reading in Ovid the sorrowful story of Itys" and unsealing anew its "little thuribles" of dream and wisdom. Since we have not space for these here is the brief but beautiful summary of the life of Alexander Throckmorton:

In youth my wings were strong and tire-
    less.
But I did not know the mountains.
In age I knew the mountains.
But my weary wings could not follow my
    vision—Genius is wisdom and youth.

Or the words of Anne Rutledge, for Spoon River embraces the Lincoln country:

Out of me unworthy and unknown
The vibrations of deathless music;
"With malice toward none, with charity
    for all."
Out of me the forgiveness of millions
    toward millions
And the beneficent face of a nation
Shining with justice and truth.
I am Anne Rutledge who sleeps beneath
    these weeds,
Beloved in life of Abraham Lincoln,
Wedded to him, not through union,
But through separation.
Bloom forever, O Republic,
From the dust of my bosom!

Poetry is more than form, and while many of Mr. Masters's characters deliver themselves in unequivocal prose, prose that would gain in effectiveness by freeing itself from a purely arbitrary connection with verse, there is a group whose expression must be measured by other standards. This expression may be satirical, it may be ironical, it may be tender, but whatever form it takes, it has an art of its own—by what name we call it is of small moment.

July 18, 1915

## HENRY JAMES DEAD AT HIS LONDON HOME

Special Cable to THE NEW YORK TIMES.
LONDON, Feb. 28.—Henry James died this afternoon at his residence, 21 Carlyle Mansions, Chelsea. He became unconscious on Friday afternoon and remained so until the end.

It was his wish that his body should be cremated. This will be done at Golders Green Crematorium on Friday.

Mr. James had been ill for several months, but late in January his physicians reported that he was improving. The affection from which he suffered, however, was chronic and had been complicated by two strokes of apoplexy.

About two weeks ago Mr. James's condition became grave again, and his recovery was not looked for.

### Renounced American Citizenship.

Internationally famous for his writings, Henry James most recently attracted attention when he renounced his American citizenship and swore allegiance to England. His sympathy with the cause of the Allies and his long residence in England with its intimate associations and friendships, are said to have impelled him to take this step in July, 1915.

The London Times in editorial comment on his action said "his desire to throw his moral weight and personal allegiance, for whatever they may be worth, in the scale of contending nations" was his impelling motive. The London Daily News said: "The decision of one of the two greatest living novelists to seek British citizenship sets a dramatic seal upon the conclusion to which these things—the struggle of ideals between England and Germany—have long pointed."

Mr. James was one of the five children of the Rev. Henry James, and was born in this city on April 15, 1843. Of his three brothers, William became a famous philosopher and Professor of Psychology at Harvard University. Another, Wilkinson James, was a gallant soldier in the civil war, and was wounded at Fort Wagner. Their grandfather was an Irishman, William James, who came to this country to seek his fortune and settled in Albany. He took an active part in the development of the Syracuse salt wells, and when he died left a large fortune to be divided among his eleven children. This grandfather was the root of the genius of the family, and was a man of strong traits, with the keen Irish perception of character. When Henry James was a child his

parents went to Germany and he spent a large part of his boyhood there. Before he reached his twenties the family returned to this country and settled in Newport, R. I., finally removing to Cambridge, Mass.

His education was altogether out of the ordinary, one of its early features including a course in a small institution on Broadway, where colloquial French was supposed to be taught, and at which there was a great number of Cubans and Mexicans. The two brothers, Henry and William James, also attended other private schools, where they specialized in various studies. This was during their early youth, and when the family went to Europe the boys received their training under various tutors and in Swiss and French day schools. They also spent a year between the Universities of Bonn and Geneva, after which Henry James returned to this city, and in 1862 entered the Harvard Law School, although he gave no indication of adopting the law as his life's work.

### Began Writing at Harvard.

It was in this period, when he was at Harvard, that he first began contributing sketches to the magazines and began his literary career, which resulted in the production of nearly 100 novels and tales, together with critical essays and some plays.

Mr. James's father was an able writer, and during the years he spent abroad became a close associate of Thomas Carlyle and other famous literary men. Young James received much training for his future literary labors through boyish acquaintanceship with these friends of his father's. Those who have compared the writings of the father and son have often said that there was a great similarity.

Henry James's first serious literary work was done for the Atlantic Monthly, with which he always maintained a close connection. His first contribution, entitled "The Story of the Year," appeared in March, 1865, and was founded on the civil war. His first serial story, "Poor Richard," ran through three numbers of the magazine and was followed by "Gabrielle de Bergerac" three years later. Then came "Watch and Ward," which was followed by a more ambitious effort, "Roderick Hudson," which ran through twelve numbers. After this novel, which had begun to create interest in the young author, there were three others, "The American," "The Europeans," and "The Portrait of a Lady," all of which appeared in the Atlantic Monthly and attracted wide attention and much admiration.

Mr. James then wrote "Washington Square" for Harper's Magazine and "Confidence" for Scribner's, in addition to essays and articles which were published in the former. These included sketches of European travel as well as criticisms on literature and art and editorial work.

After his first efforts, Mr. James wrote, in the order in which they are named: "The Siege of London," "The Tale of Three Cities," "The Bostonians," "The Reverberator," "A London Life," "The Tragic Muse," "The Lesson of the Master," "The Private Life," "Terminations," "The Spoils of Poynton," "What Maisie Knew," "The Two Magics," "In the Cage," "The Awkward Age," "The Soft Side," "The Sacred Fount," and "The Wings of the Dove." He was also the author of books in French, which were praised by the critics for their elegant diction.

### His Work as an Essayist.

His work as an essayist was also very favorably criticised, "French Poets and Novelists" in particular attracting much attention. In later life, he wrote several plays, one of the most recent of which, "The High Bid," was produced by Forbes-Robertson, in London.

Ranked as he was by the critics as one of the most masterful writers of the past generation, Mr. James's books were never so popular in this country as in England. His writings were of the analytical and metaphysical school of fiction and the full understanding of his works was a matter of endless controversy. To understand Henry James was, in the popular idea, the gift of only a privileged few. Students at Harvard University, who were forced by their course of studies to become conversant with the works of both the gifted James brothers, William the philosopher and Henry the novelist, coined the catch-phrase, "William James writes philosophy-like novels, while Henry writes novels like philosophy."

Being independent of the reading public for his income, since his private fortune was sufficient, Mr. James always adhered religiously to his own principles of romance, regardless of how popular his works might become. Nevertheless he had, particularly in England, a host of readers who virtually formed a cult known as "The Jamesites."

It appeared to be Mr. James's belief that the story that could be told was not worth the telling, and it was his choice, as one of his critics declares, "to rigorously set himself to tell the story that cannot be told." The endless controversy was as to whether he was successful. He contended that it was of more interest to the author to paint the various aimless ways in which human beings are actually thrown together than to construct an artificial complication of circumstances, and he was indifferent as to whether a comedy was spoiled or whether a tragedy broke down before the tragic crisis.

### Charitable and Retiring.

While much has been written in the controversy over Mr. James's books and over his fame as an author, little has been published about the man himself. He was known to be very charitable in the most unostentatious manner. On one occasion, when a novelist died his two little children were left alone in the world. One of his friends put by a small sum for them and wrote to other literary men asking their help to save the babies from an orphanage. He solicited an author whose income reaches $100,000 a year, asking, "Won't you help these little folk?" and was coldly refused. Henry James was appealed to, and his check for £50 was received by return mail.

During the eighties Mr. James lived at 3 Bolton Street, just off Piccadilly, in London, and it was here that much of his best work was done. It was a neighborhood sacred to the memories of many of England's most brilliant men, and was frequented by Pope, Swift, Gray, Parnell, Prior, and many others, and was once the home of John Evelyn, the "sweet-minded philosopher" and friend of Samuel Pepys. Here Mr. James lived in cozy bachelor's lodgings. His manner of life was described by a newspaper writer of the period, who said: "On rising he takes the continental breakfast of coffee and rolls in his rooms, and immediately sits down to his literary work, generally writing by the light of two candles, the London mornings being so dark.

"Mr. James composes slowly and painfully, rewriting and retouching his work continually, his strikingly artistic style being gained only at the expense of real toil. But by his system of working a regular length of time each day he turns out a great amount of manuscript in the course of a year—much more than most authors who compose readily, but only at regular intervals, when 'in the mood,' and then producing a goodly quantity of work at white heat. Mr. James writes until noon and then goes to his club for luncheon. This is the Reform Club, a very exclusive body, composed of the leading British Liberals, and Mr. James is said to be the only American who has been honored with an election."

Mr. James was of a very retiring disposition and greatly disliked publicity.

This was never more strikingly emphasized than at the opening performance of "The High Bid," which was produced at a special matinée by Forbes Robertson at His Majesty's Theatre, Haymarket. At the insistent urging of his friends Mr. James finally agreed to attend the performance and occupied a box on the second tier.

### Fainted at a Premiere.

A most cultured and refined audience sat through the performance in silence, greeting its conclusion with well-modulated applause. As this was dying out the cry "Author! Author!" was raised, and all eyes turned to Mr. James's box, expecting him to rise and bow his acknowledgments. There was a tense moment and then a loud thud. Mr. James had fainted.

Of recent years Mr. James made his home in Rye, an old-fashioned town in Sussex, full of the glorious memories of its days as a Cinque Port and coaching centre, and a favorite spot for artists and authors, among whom were Ruskin, Turner, and J. E. Millais. Here he lived in a great eighteenth century structure known as Lamb House, situated at the end of a little street. From his study could be seen the old Norman church, framed between the ancient houses on either side of the street and lying just across the cross street.

The author worked in the teahouse, attached to the main dwelling, and could turn and look out on the large garden, in which he often sat on pleasant afternoons. Mr. James used to tell his intimates of the "very active" ghost which had frequented Lamb House for many years. He never would admit that he believed in ghosts, nor would he deny their existence. In fact, he was wont to tell the tale of how he waited and watched all one night for the ghost, which was due to appear on that date. In addition to being active the ghost was methodical and regular in its appearances. In preparation for its arrival Mr. James sent his giant housekeeper away. All the night long he watched, while the wind, blowing in from the sea, made eerie noises about the house. When morning came, he used to relate, he found that instead of catching the ghost, he had caught a severe cold.

Before going to Rye he tried to spend a Summer at some retired country village and leased an old house there for the season. He did not remain long in peace. Some guide book used by Americans came out with detailed directions of how to reach the "Home of Henry James, the Noted American Novelist," and a procession of touring Americans began to arrive. They traveled in carriages, on bicycles, and on foot, and when Mr. James found out what had happened, he promptly packed up and returned to London.

Mr. James received the Order of Merit from King George at the distribution of birthday honors in January of this year. He had been a stanch supporter of the British cause in the war, and at the time he took the oath of allegiance to the King was quoted as discussing the relations between this country and England as follows: 'Our whole race tension became for me a sublimely conscious thing from the moment Germany flung to us all her explanations of her pounce upon Belgium for massacre and ravage in the form of the most insolent 'because I choose to, damn you all,' recorded in history.

"How can one help seeing that such aggression, if hideously successful in Europe, would, with as little loss of time as possible, proceed to apply itself to the American side of the world? And how can one, therefore, not feel that the Allies are fighting to the death for the soul and purpose and future that are in us, for the defense of every ideal that has most guided our growth and most assured our unity?"

February 29, 1916

# How Does the New Poetry Differ from the Old?

## Amy Lowell Laments the Lack of Authoritative Criticism in America---Says No One Should Make a Living by Writing

**By Joyce Kilmer**

MISS AMY LOWELL, America's chief advocate and practitioner of the new poetry, would wear, I supposed, a gown by Bakst, with many Oriental jewels.

And incense would be burning in a golden basin. And Miss Lowell would say that the art of poetry was discovered in 1916.

But there is nothing exotic or artificial about Miss Lowell's appearance and surroundings. Nor did the author of "Sword Blades and Poppy Seed" express, when I talked to her the other day, any of the extravagant opinions which conservative critics attribute to the vers librists. Miss Lowell talked with the practicality which is of New England and the serenity which is of Boston; she was positive, but not nar-

rowly dogmatic; she is keenly appreciative of contemporary poetry, but she has the fullest sense of the value of the great heritage of poetical tradition that has come down to us through the ages.

There is so much careless talk of imagisme, vers libre, and the new poetry in general that I thought it advisable to begin our talk by asking for a definition or a description of the new poetry. In reply to my question Miss Lowell said:

"The thing that makes me feel sure that there is a future in the new poetry is the fact that those who write it follow so many different lines of thought. The new poetry is so large a subject that it can scarcely be covered by one definition. It seems to me that there are four definite sorts of new poetry, which I will attempt to describe.

"One branch of the new poetry may be called the realistic school. This branch is descended partly from Whitman and partly from the prose writers of France and England. The leading exponents of it are Robert Frost and Edgar Lee Masters. These two poets are different from each other but they both are realists, they march under the same banner.

"Another branch of the new poetry consists of the poets whose work shows a mixture of the highly imaginative and the realistic. Their thought verges on the purely imaginative, but is corrected by a scientific attitude of mind. I suppose that this particular movement in English poetry may be said to have started with Coleridge, but in England the movement hardly attained its due proportions. Half of literary England followed Wordsworth, half followed Byron. It is in America that we find the greatest disciple of Coleridge in the person of Edgar Allan Poe. The force of the movement then went back to France, where it showed clearly in Mallarmé and the later symbolists. Today we see this tendency somewhat popularized in Vachell Lindsay, although perhaps he does not know it. And if I may be so bold as to mention myself, I should say that I in common with most other imagists belong to this branch, that I am at once a fantasist and a realist.

"Thirdly, we have the lyrico imaginative type of poet. Of this branch the best example that I can call to mind is John Gould Fletcher. The fourth group of the new poets consists of those who are descended straight from Matthew Arnold. They show the Wordsworth influence corrected by experience and education. Browning is in their line of descent. Characteristics of their work are high seriousness, astringency, and a certain pruning down of poetry so that redundancy is absolutely avoided. Of this type the most striking example is Edwin Arlington Robinson."

"Miss Lowell," I said, "the opponents of the new poetry generally attack it chiefly on account of its form—or rather, account of its formlessness. And yet what you have said has to do only with the idea itself. You have said nothing about the way in which the idea is expressed."

"There is no special form which is characteristic of the new poetry," said Miss Lowell, "and of course 'formlessness' is a word which is applied to only it by the ignorant. "The new poetry is in every form. Edgar Lee Masters has written in vers libre and in regular rhythm. Robert Frost writes in blank verse. Vachell Lindsay writes in varied rhyme schemes. I write in both the regular meters and the newer forms, such as vers libre and 'polyphonic prose.'

"It is a mistake to suppose, as many conservative critics do, that modern poetry is a matter of vers libre. Vers libre is not new, but it is valuable to give vividness when vividness is desired. Vers libre is a difficult thing to write well, and a very easy thing to write badly. This particular branch of the new poetry movement has been imitated so extensively that it has brought the whole movement into disrepute in the eyes of casual observers. But we must remember that no movement is to be judged by its obscure imitators. A movement must be judged by the few people at its head who make the trend. There cannot be many of them. In the history of the world there are only a few supreme artists, only a small number of great artists, only a limited number of good artists. And to suppose that we in America at this particular moment can be possessed of many artists worthy of consideration is ridiculous.

"Undoubtedly the fact that a great number of people are engaged today in producing poetry is a great stimulus, and helps to create a proper atmosphere for those men whose work may live. For it is a curious fact that the artistic names that have come down to us are those of men who have lived in the so-called great artistic periods, when many other men were working at the same thing."

I asked Miss Lowell to tell something of this vers libre which is so much discussed and so little understood. She said:

"Vers libre is based upon rhythm. Its definition is 'A verse form based upon cadence rather than upon exact meter.' It is a little difficult to define cadence when dealing with poetry. I might call it the sense of balance.

"The unit of vers libre is the strophe, not the line or the foot as in regular meter. The strophe is a group of words which round themselves satisfactorily to the ear. In short poems this complete rounding may take place only at the end, making the poem a unit of a single movement, the lines serving only to give the slight up-and-down effect necessary to the voice when the poem is read aloud.

"In longer poems the strophe may be a group of lines. Poetry being a spoken and not a written art, those not well versed in the various poetic forms will find it simpler to read vers libre poems aloud, rather than to try to get their rhythm from the printed page. For people who are used only to the exact meters, the printed arrangement of a vers libre poem is a confusing process. To a certain extent cadence is dependent upon quantity—long and short syllables being of peculiar importance. Words hurried over in reading are balanced by words on which the reader pauses. Remember,

also, that vers libre can be either rhymed or unrhymed."

"One objection," I said, "that many critics bring up against unrhymed poetry is that it cannot be remembered."

"I cannot see that that is of the slightest importance," Miss Lowell replied. "The music that we whistle when we come out of the theatre is not the greatest music we have heard.

> Zaccheus he
> Did climb a tree
> His Lord to see

is easily remembered. But I refuse to think that it is great poetry.

"The enemies of vers libre," she continued, "say that vers libre is in no respect different from oratory. Now, there is a difference between the cadence of vers libre and the cadence of oratory. Lincoln's Gettysburg address is not vers libre, it is rhythmical prose. At the prose end of cadence is rhythmical prose; at the verse end is vers libre. The difference is in the kind of cadence.

"Recently a writer in The Nation took some of Meredith's prose and made it into vers libre poems which any poet would have been glad to write. Then he took some of my poems and turned them into prose, with a result which he was kind enough to call beautiful. He then pertinently asked what was the difference.

"I might answer that there is no difference. Typography is not relevant to the discussion. Whether a thing is written as prose or as verse is immaterial. But if we would see the advantage which Meredith's imagination enjoyed in the freer forms of expression, we need only compare these lyrical passages from his prose works with his own metrical poetry."

I asked Miss Lowell about the charge that the new poets are lacking in reverence for the great poets of the past. She believes that the charge is unfounded. Nevertheless, she believes that the new poets do well to take the New England group of writers less seriously than conservative critics would have them take them.

"America has produced only two great poets, Whitman and Poe," said Miss Lowell. "The rest of the early American poets were cultivated gentlemen, but they were more exactly English provincial poets than American poets, and they were decidedly inferior to the parent stock. The men of the New England group, with the single exception of Emerson, were cultivated gentlemen with a taste for literature— they never rose above that level.

"No one can judge his contemporaries. We cannot say with certainty that the poets of this generation are better than their predecessors. But surely we can see that the new poets have more originality, more of the stuff out of which poetry is made, than their predecessors had, aside from the two great exceptions that I have mentioned."

"What is the thing that American poetry chiefly needs?" I asked.

"Well," said Miss Lowell, "I wish that there were a great many changes in our attitude toward literature. I wish that no man could expect to make

a living by writing. I wish that the magazines did not pay for contributions —few of them do in France, you know. And I wish that the newspapers did not try to review books. But the thing that we chiefly need is informed and authoritative criticism.

"We have very few critics, we have practically none who are writing separate books on contemporary verse. When I was writing my 'French Poets' I read twenty or thirty books on contemporary French poetry, serious books, written by critics who made a specialty of the poetry of their own day.

"We have nothing like this in America. The men who write critical books write of the literature of a hundred years ago. No critical mind is bent toward contemporary verse. There are a few newspaper critics who pay serious attention to contemporary verse—William Stanley Braithwaite, O. W. Firkins, and Louis Untermeyer, for example—but there are only a few of them.

"What is to be desired is for some one to be as interested in criticism as the poets are in poetry. It was the regularity of Sainte-Beuve's 'Causeries du Lundi' that gave it its weight. What we want is a critic like that, who is neither an old man despairing of a better job nor a young man using his newspaper work as a stepping-stone to something higher. Of course, brilliant criticisms of poetry appear from time to time, but what we need is criticism as an institution."

"After all," said Miss Lowell, in conclusion, "there are only two kinds of poetry, good poetry and bad poetry. The form of poetry is a matter of individual idiosyncrasy. It is only the very young and the very old, the very inexperienced or the numbed, who say, 'This is the only way in which poetry shall be written!'"

March 26, 1915

# NORTH OF BOSTON

## Robert Frost's Poems of New England Farm Life

### By Jessie B. Rittenhouse

NORTH OF BOSTON. By Robert Frost. New York: Henry Holt & Co. $1.25.

MR. ROBERT FROST has been fortunate in living down the fulsome and ill-considered praise with which he was introduced to the American public. When an American poet comes to us with an English reputation and prints upon his volume the English dictum that "his achievement is much finer, much more near the ground, and much more national than anything that Whitman gave to the world," one is likely to be prejudiced, not to say antagonized, at the outset. Just why a made-in-England reputation is so coveted by the poets of this country is difficult to fathom, particularly as English poets look so anxiously to America for acceptance of their own work. It would seem that we hold the telling verdict when it comes to the practical success of an English poet of today, and without the suffrage of America even men like Alfred Noyes—whose reputation in this country is far greater than in England—would have but a meagre field of operation.

Fortunately for Mr. Frost, his work is able to meet its own test. While it bears no more relation to the work of Whitman than a well-tilled field bears to the earth, this is to the credit of Mr. Frost. He is not a cosmic poet, not a great social seer, he is none of the things that Whitman was, and he refrains from assuming to be something that he is not. Mr. Frost is, indeed, too sincere a poet to look outside of his own experience for inspiration. The field that he has pre-empted is distinctly his own and one hitherto uncultivated in American poetry. It is the life of men and women on stony hill farms "north of Boston," life stripped of externals and lying sheer and bare to this analyst. There have been plenty to interpret rural New England in fiction, and Mr. Frost himself is a story teller plus the poet's spiritual focus upon the one essential motive of the story. He is able, as a writer of the short story (from the demands of the form) cannot do,

to epitomize the many details of a narrative into some poignant episode which will illuminate the entire life he has chosen to reveal. For Mr. Frost is a psychologist, he is concerned entirely with the spiritual motives which actuate these folk on barren hill farms where life is largely reduced to its elemental expression. As faithfully as Sarah Orne Jewett, Mary Wilkins or Alice Brown has been able to interpret, through the much more flexible medium of the short story, the lives of these people, Mr. Frost in a few passages makes us free of their world.

It is a bleak world, infinitely sad. The spectre is always there, looking out of the eyes of men and women whom life has defrauded of joy. New England in literature is always stark and grim, but Mr. Frost is not an implacable realist; the grimness is there, but with it the tenderness of one who sees deeply into this phase of life because he has lived it. Mr. Frost was himself a farmer in New Hampshire and tilled his own acres before he converted them into the intangible estate of poetry.

Farm life, remote from centres, is much the same everywhere. The story of "The Hired Man" could be transferred without loss of color to any other section than New England. The pathetic old figure,

With nothing to look backward to with pride,
And nothing to look forward to with hope,
So now and never any different,

is common to every community. What gives the poem its deep appeal is the insight of the woman who touches so tenderly the vagaries of the poor old derelict who has come back to die. Mr. Frost knows women and his truest studies are invariably of them. "Home Burial," perhaps the strongest of his poems, certainly the most dramatic, probes a woman's nature to the quick. One would have difficulty in finding, in such a compass, so powerful an illustration of the spiritual gulf between a man and a woman. The blunted sensibilities of the man who could dig his own child's grave, and the finer sensibilities of the woman upon whose soul every detail is stamped, could scarcely be rendered more effectively. A single passage from Mr. Frost's poem is hardly sufficient to suggest the play of character, but one may see in the following the truth of his psychology. To the remark,

And so it's come to this,
A man can't speak of his own child that's dead,"

the wife replies.

"You can't because you don't know how.
If you had any feelings, you that dug
With your own hand—how could you?—his little grave;

I saw you from that very window there,
Making the gravel leap and leap in air,
Leap up, like that, like that, and land so lightly
And roll back down the mound beside the hole.

I thought, Who is that man? I didn't know you,
And I crept down the stairs and up the stairs
To look again, and still your spade kept lifting.
Then you came in. I heard your rumbling voice
Out in the kitchen, and I don't know why,
But I went near to see with my own eyes.
You could sit there with the stains on your shoes
Of the fresh earth from your own baby's grave
And talk about your every-day concerns.
You had stood the spade up against the wall
Outside there in the entry, for I saw it."

In the last two lines Mr. Frost has one of his characteristic touches. To the man the spade was a spade, though he had dug his own child's grave with it; to the woman it was a thing of horror, and it was impossible to understand how he could calmly stand it up outside the door as upon any other occasion. It is in these little things that loom so large that one sees the subtlety of Mr. Frost's analysis. Psychology, however, does not make poetry, and one inevitably questions whether the short story would not fit this material quite as well as the form which Mr. Frost has chosen. There is little of poetry in the ordinary acceptance of the term, little of beauty, of magic, but there is the poetry of divination, the vision of souls, the poet's penetration into the one impulse which persists through all the deadening force of circumstance.

While personally a skeptic as to the poetic value of most of the free verse of the moment, it seems to me that Mr. Frost, who is not writing in vers libre, has chosen the exact vehicle for his themes. That rhyme would rob them of their atmosphere is evident from the fact that Mr. Frost has one rhymed narrative, "Blueberries," which is insipid as compared to the homely power of the remaining work in the volume. One's expression is temperamental, innate; the form it takes is not the question, but whether the form befit the substance, whether something true and convincing, result from the union of the two. One can scarcely read these stories, characterizations, or whatever one may term them, without feeling that Mr. Frost and his medium are at one, that he has struck bedrock, penetrated to the reality of life in the field he interprets, and chosen the simplest and most human vehicle of expression.

May 16, 1915

## Fiction and Poetry

### THE NEW CRITICISM

THE suspicion, often passing into ill-concealed contempt, with which many a writer of verse and prose views the literary critic is finely rebuked by Professor J. E. Spingarn in his excellent little book on "Creative Criticism." (Henry Holt & Co.) There have been irresponsible, narrow-minded, dishonest critics, of course, in all ages, and these have deserved whatever censure they may have received at the hands of their victims. But the shortcomings of a certain portion of the critical profession in literature should not obscure the intrinsic value, the high standards that may, and often do, belong to the best exponents of literary criticism. The cruel blundering, for instance, that distorted and condemned the poems of John Keats is certainly not to be taken as a typical example of true literary criticism. In the light of Professor Spingarn's statement of the principles that are now coming into vogue in reaching a just estimate of a literary work, it is interesting to note the advance that has been made in the art of criticism since the days when the inhuman flaying of a John Keats was possible. In that age, when the unspeakable Gifford dominated the critical halls of literature, a poet was judged by a rigorous set of rules and canons, reaching back, for the most part, to Greek precedent and tradition as these were formulated and approved by Aristotle. A thousand questions were asked of the newcomer at the bar of literature, and if his offering failed to fit in theme, in treatment, in style, in morals, the procrustean exactions of the awarding tribunal, he might expect to be treated with a savagery from which a sensitive nature would find it difficult to recover. The poems of Keats were outrageously "different" from the accepted standards in poetry; hence, there was no excuse for their existence—it was the duty of the critic, in the performance of which he took a fiendish pleasure, to cast them ignominiously forth into the oblivion that they deserved. When one realizes the razor-edged narrowness of the critical rules in vogue a century ago the marvel is that any new, original work in poetry succeeded in coming down to us. It was the day of dogmatism in art, the day when the contemporary writer was expected to follow, with exemplary docility, the rules laid down for him by a long succession of masters who flourished in a past of a sufficiently remote antiquity to be the law-givers for a modern world.

WHILE Professor Spingarn points out that modern literary criticism is ever freeing itself from the cumbrous rules and definitions that obscured its faculty for appreciation, he impresses one with the increased efficiency with which it is learning to perform its task. The creative critic no longer asks of a poem whether it is lyric, dramatic, epic, pastoral, didactic, or what not, nor does he weigh the ethical value of the theme, nor the technique involved in its composition. All these matters, formerly of the very first importance in pronouncing judgment on a work of literary art, receive now only slight, or at least secondary, consideration. The single, vital question remains: "What has the poet tried to express and how has he expressed it?" In answering this the critic has to re-create, in a way, the work of the poet. His method is one that is peculiarly favorable to the discovery of new, original genius, for it concerns itself, in every instance, with the individual poet and not with the endeavor to correlate him or his work with some hard-and-fast standard, or definition, that may or may not be applicable to the particular form of expression employed by his muse. "Poets do not really write epics, pastorals, lyrics, however much they may be deceived by these false abstractions; they express themselves and this expression is their only form." The possibility for complete freedom from the trammels of other men's opinions, and thus for more sincere, original work, in this kind of criticism, is apparent. It goes on the assumption that each poet is a law unto himself, and that it is the function of the critic to interpret this law and to determine whether it is adequate to give expression to the poet's theme.

Every poet re-expresses the universe in his own way, and every poem is a new and independent expression. The tragic does not exist for criticism, but only Aeschylus and Calderon, Shakespeare and Racine. There is no objection to the use of the word tragic as a convenient label for somewhat similar poems, but to find laws for the tragic and to test creative artists by such laws as these is simply to give a more abstract form to the outworn classical conception of dramatic rules.

In conformity with his theory of criticism, Professor Spingarn finds that "we have done with the theory of style, with metaphor, simile, and all the paraphernalia of Graeco-Roman rhetoric • • • with all moral judgment of literature • • • with technique as separate from art • • • with the history and criticism of poetic themes • • • with the race, the time, the environment of a poet's work as an element in criticism." In thus simplifying the critic's work, freeing it from its old-time technicalities, he has brought it closer to popular needs and comprehension. At the same time he has awarded to criticism a faculty not formerly attributed to it. For, by re-creating the poet and his work, the critic is transcending the bonds of mere scholarship and entering a field belonging to the poet himself. This "unity of genius and taste" is a central element in Professor Spingarn's theory that will doubtless arouse antagonism. In so far, however, as it elevates a department of literature that heretofore has received more abuse than it merited, it is worthy of study.

*July 1, 1917*

---

### RAINER MARIA RILKE

POEMS OF RAINER MARIA RILKE. Translated by Jessie Lemont. New York: Tobias A. Dwight. $1.50.

TO have a good biographer is said to be the greatest blessing that a genius can possess, and on reading the volume the blessing may be extended to include the translator as well. For in this very thoughtful collection of poems, Rilke makes his first appearance to the world of English readers, and he is singularly fortunate in these translations which, with great art and delicacy, reveal the nuance and palpitations of a very fugitive if, at the same time, a very actual genius.

Rainer Maria Rilke was born at Prague in 1875 and is still among the living authors of his native Bohemia. His poems first were published in 1895 and showed the marked influence of his native country with its mingled intensities of light and shadow. Some years later a sojourn in Russia, and a profound study of its semi-barbaric literature, served to deepen and strengthen his personal qualities which were threatened with a sort of aesthesia. In his later books is seen the growth of a mystical element which finally summed itself up in an intense devotion to the sculptor Rodin, in whose work he discovered "the power of servitude in all nature."

There is among Jessie Lemont's versions a very charming vision given under the title of

KINGS IN LEGENDS.

Kings in old legends seem
Like mountains rising in the evening
  light.
They blind all with their gleam,
Their loins encircled are by girdles
  bright,
Their robes are edged with bands
Of precious stones—the rarest earth
  affords—
With richly jeweled hands

They hold their slender, shining, naked
  swords.

There is also another quite typical poem which gives the quality of Rilke, until now quite unknown to our readers:

TOMB OF A YOUNG GIRL.

We still remember! the same as of yore
All that has happened once again must
  be.
As grows a lemon-tree upon the shore—
It was like that—your light, small
  breasts you bore.
And his blood's current coursed like
  the wild sea.

That god—who was the wanderer, the
  slim
Despoiler of fair women, he—the wise—
But sweet and glowing as your thought
  of him,
Who cast a shadow over your young
  limb
While bending like your arched brows
  o'er your eyes.

*March 9, 1919*

---

### CONRAD AIKEN'S POETRY

THE CHARNEL ROSE AND OTHER POEMS. By Conrad Aiken. The Four Seas Company. $1.25.

MR. AIKEN'S verse is like a stream in Spring. For a stream in Spring is now swift and turbid, now overflowing into ponds upon the meadows; now it cuts its banks and carries down a great wash of mud, now it clears unexpectedly above a pebbly fall. One outstanding characteristic is that it is always in excess, it always seems as though there is much more of it than is necessary for the purposes of Spring. But perhaps Spring knows best; one would not be without the beautiful clear brooks coming down through the woods that swell its tide, nor without the greenness of the meadows after the waters go down.

And Mr. Aiken's poetry, too, runs full-banked and earth-colored, and—like the stream again—it tends to clear as it flows. "The Charnel Rose," which gives its title to the book, and is dated 1915, needs, even the author perceives, the filtration-bed of a preface before the average man will hold it drinkable. "Variations," 1916, is much further on the way toward translucency, while in "Senlin," of the year just ended, we find not only the mystery and willfulness of water, but its fructifying power as well.

Mr. Aiken's themes are by no means new ones. In "The Charnel Rose" we see disillusionment, dust of the sepulchre, at the heart of every dream, until at last, at the end of "our little cave of dusk,"

We are struck down. We hear no
  music.
The moisture of night is in our hands.
Time takes us. We are eternal.

In this, as indeed to some extent in all his poems, the author has intentionally used the methods of music; the use of symbols recurring like themes, the deliberately blurred idea, the return to a given motive, the sensuous appeal strained, as it were, through the intellect to the point almost of perversion. The final effect is, as has been stated before, one of cloudy excess. The listener to music of this type does not become impatient, because it is only very rarely that he knows what the composer is trying to say. The recurrence of a theme is to him simply a kindly device by which he is enabled to carry away from the concert some more or less vague memory of what he has heard, while in poetry, whose medium he does understand, such repetition becomes simply monotonous. The arts are not epicene. The functions and methods of one cannot be taken over wholesale by another. Gradually two human languages have grown up—a language of spoken and written words, and a language of sounds. A symphony is not sufficiently explicit to take

the place of Mr. Aiken's poetry, and equally, Mr. Aiken's poetry, deliberately cloudy as it often is, is still too explicit ever to result in " absolute music."

In " Senlin," as in much of Mr. Aiken's work, the idea turns and turns, like a dressmaker's mannequin, under a variety of verbal robes, but it is at least a living mannequin. The subtitle is "A Biography," and it aims to show the progress of the soul through a pluralistic universe. Senlin is a man, a forest, a city, a peach tree which,

singing with delicate leaves,
Yet cracks the walls with cruel roots and blind,—

a blade of grass, sport of " the gigantic fates of frost and dew," lover and luster, and finally, perhaps only " a dream we dreamed and vividly recall."

We have before pointed out in these columns how completely Mr. Aiken is the poet of questioning, emotional, contemplative youth. His middle-aged reader very likely listens to him much as did the auditors to Senlin's music, " perplexed and pleased and tired." Yet even those who have retreated furthest from the serious fluidities of their twenties, and in whom perplexity and weariness considerably overbalance the pleasures of perusal, will—or should—be attracted by the pictures of the

land where " white unicorns come gravely down to the water." and stirred by the idea—which doubtless they once had themselves but have forgotten—that the thoughts of a young man about a woman

are truer of god, perhaps,
Than thoughts of god are true.

Mr. Aiken is the first and only poet we know of whose work betrays an interest in the subject of psycho-analysis; and, although he may not always be completely successful in presenting his resumed states of consciousness poetically, it must be remembered that his is the difficulty and also the achievement of the pioneer.

April 20, 1919

## INTOLERANCE AT ZURICH.

It is painful to hear of a violation of literary neutrality in Switzerland. Zurich is the capital of the preter-modern, preter-futurist movement called Dadaism, the home of its organ, of the literary and artistic group of Dadaists. If it is difficult to find exactly what Dadaism is, at least we know from authority that "Dada" is "the symbol of abstraction." Its contempt for the past is shown by the motto of Dada, the saying of DESCARTES, "I don't even wish to know if there were men before me." After exhausting Greece, the Middle Ages, the Renaissance, after Decadence and Symbolism and Free Verse, the young revolutionist poets turn their backs on all tradition. They find even Signor MARINETTI and his Futurism conservative. They are " fierce, bounding, riders of hobbies."

A Zurich correspondent of the Journal de Genève describes a "manifestation" of the Dadaists the other day:

The great Hall of the Merchants was packed with representatives of all Zurich. The first part of the program went off well enough on the whole, though protestations, ironical interruptions, and laughs were heard, but when TRISTAN TZARA, editor of Dada, began to direct his simultaneous poem, interpreted by twenty persons, the greater part of the spectators burst into protests and hisses. Obviously an essay in verbal orchestration would not be wanting in interest, but vox populi, vox dei. The audience was divided into two parties, for and against the author, and many people couldn't understand the gesture of the painters AUGUSTO

GIACOMETTI and ALICE BAILLY, whom we know as serious artists, who brought on the stage a big scarf with the inscription. " Long Live Dadaism!" TRISTAN TZARA was not allowed to read his works, and of his Dada proclamation we heard only a few fragments. The other leader of the Dada movement, the poet SERNER, tried to read a manifesto, but the disturbance reached its height and Mr. SERNER expressed his disdain by gestures, addressing the public in no parliamentary manner.

Such is the punishment of novelty in this hide-bound world. Eighty years ago so sound a writer and critic as CHARLES NODIER spoke of the leaders of the Romantic movement in France as using " a "language that has run away from "grammar and logic, and belongs to "things unforeseen if not impossible." What could be more delightful than an orchestrated poem? The chants of one Illinois gospeller of Beauty, Mr. NICHOLAS VACHEL LINDSAY, seem intended for just that rendering. If not accompanied by music, at least they are to be sung, or parts of them to be sung, in chorus. Indeed, if the communal and folk origin of poetry be admitted, the Dadaist manifestation is not a novelty. It has its roots in the immemorial past. It is only an artistic improvement.

The poet SERNER, weary of wasting pearls, gave up trying to read his poems and

brought on the stage a puppet, at whose feet he laid a bouquet of artificial flowers. This gesture of self-irony, interpreted by part of the audience as an insult, let loose a regular whirlwind. Young men brandished

chairs and threatened to beat Mr. SERNER. It was the most tumultuous meeting that Zurich ever saw. Other Dadaists, ARP, EGGELING the Swede, Mme. PERROTTET the pianist, were to some extent prevented from reading and interrupted by ironical exclamations.

" Unfortunately," writes the bemused correspondent, " we haven't been able to " find out what Dadaism means, but the " other recitations, masks, and dances in-" dicated that the religion of the Dadaists " is literary nihilism and a complete want " of interest in the laws of beauty and " social organization." This is mere blind prejudice. Dadaists have their own idea of beauty. They are young, insolent, looking on VICTOR HUGO and all the great names of French literature with that scornful superiority wherewith a thousand weavers of free verse contemplate TENNYSON. Besides, how they do love to "take a fall out of " the bourgeois—épater is their word for it. A school of poetry which has produced a masterpiece like Mr. VINCENTE HUIDOBORO'S " The Cowboy on the Violin String Crosses the Ohio" might look for plaudits instead of hisses at Zurich or anywhere else. Because, as Dada mystically says, the Dadaists are " sharpening wings in order to conquer " and disseminate little a, b, c," must they be accused of throwing bombs at literature and society? In the fine art of advertising their genius should be admitted even by their enemies.

June 8, 1919

# LATEST WORKS OF FICTION

### WINESBURG, OHIO

WINESBURG, OHIO. By Sherwood Anderson. New York: B. W. Huebsch. $1.50.

CONCEIVABLY these stories might have been written before the advent of the new psychology, but if so they would not have been understood. The characters are actuated by motives not exterior; their actions give something of the startling effect of a head and shoulders snapping suddenly out of a hidden trapdoor in an empty room. But Mr. Anderson's expositions make these sudden, infinitesimal, half-mad actions as natural to

the reader as an excrescence to a physician; both are the result of accumulated secretions. Freud and Jung have taught us how hopes and ideas crammed back into subcellars of consciousness emerge in grotesque masquerade when pressure slackens or becomes too taut; the little tragedies and comedies which take place in Mr. Anderson's town of Winesburg, Ohio, have the support of scientific revelation.

Not that Mr. Anderson's preoccupation has been with science, not even, as in several of the stories, when he deals with characters who live in the borderlands of sanity. His is a purely human curiosity. The passionate school teacher, Kate Swift,

in her yearning to have a share in molding the life of a boy she feels to possess genius, says to him:

I would like to make you understand the import of what you think of attempting. You must not become a mere peddler of words. The thing to learn is to know what people are thinking about, not what they say.

This is Mr. Anderson's creed also, and his realization of it in this book gives it an extraordinary quality of vividness, sincerity, tenderness. The inclusion of the last quality may seem surprising in view of what is perhaps the unfortunate introduction to this review; that may have suggested that Mr. Anderson uses the scalpel. Well, he does, but not in the interests of sensation. He loves what he touches; there is the poetry and pathos of the opening story in the book, " Hands," as tragic

as the stories dealing with Elizabeth Willard, "Death" and "Mother." The latter tells of a mother who lives in the hope of a destiny for her son removed from drabness. Yet she cannot make the boy see it; it is the tragedy of the inarticulate. The woman's futile struggle to speak reminds one somehow of John Barrymore's dumb gestures when he played Falder in "Justice." Then there are the closing words in "The Philosopher," a characteristic passage, again addressed to young George Willard:

If something happens, perhaps you will be able to write the book that I may never get written. The idea is very simple, so simple that if you are not careful you will forget it. It is this—that every one in the world is Christ and they are all crucified. That's what I want to say. Don't you forget that. Whatever happens, don't you dare let yourself forget.

If this book came out of Russia we should do it lip-service. But even its American origin ought not to dim Mr. Anderson's achievement. It is an easy way

of rubber-stamping works of art to compare them to others that have won consideration. Only this prevents us ranking "Winesburg, Ohio," with "Spoon River," or such sketches as Tolstoy's "A Blot of Ink." Besides, Mr. Anderson's voice is his own. He has not been afraid to speak. He has plucked at the heart of the mystery.

June 29, 1919

### LITERARY BOLSHEVISM.

In his capacity as Visiting Professor of English at Princeton, ALFRED NOYES surveys, with a satiric smile, the modern apostles of disintegration and anarchy in literature. He sees "ten thousand "lonely literary rebels, each chained to "his most comfortable peak and chant- "ing a perennial song of hate against all "institutions." Little comfort is to be found in the fact that they are thus securely pinnacled and chained. Though each of them complacently believes that he is a solitary and entirely original genius, they are in reality thinking the same thought, and a thought quite familiar in the multitudinous valleys below. "Their sublime defiance of what "they call the early Victorian period "has long been the established conven- "tion of every popular magazine and "every girls' school in the country." If the forces of aesthetic and moral disintegration are a menace, it is not because of any might on the part of the pinnacled singers, but because their songs express so fully the mood of the modern crowd. "Self-worship is the last step "in the evolution of the conception of "duty," says the sitter upon one very conspicuous pinnacle. "God was once "the most sacred of our conceptions, and "He had to be denied. Then Reason be- "came the Infallible Pope, only to be de- "posed in turn. Is Duty more sacred "than God or Reason!" Obviously not; and so all the world is invited to the pin-

nacles of self-worship.

Professor NOYES engages in the battle as he finds it, attacking the self-worshippers in all their words and works. To him it does not make free verse less odious that it was the vehicle of WALT WHITMAN—as of the tombstone carver of Spoon River, who, whether or not a poet, is an "anthologist" of divination and power. He does not pause to consider whether EMERSON himself, whom he regards as the "subtlest" and the "greatest" of American poets, might not have done well to throw off the rhymes which many believe to have shackled him. When he calls upon us to rally to Victorian standards, acclaiming TENNYSON as "the finest artist in verse in the last century," and an eternal reproach to vers librists, he is undisturbed by any remembrance of the fact that, even in that time which is spent, there were those who amused the age by bidding it "Oh, strive to be Early English before it is too late!" TENNYSON himself, a pioneer of so much that is beautiful, harked backward, both as song writer and dramatist, to the great Elizabethans—only to show us that the echoing answer must be always "dying, dying, dying." This is the foible of the poets, of creators in any form: in their aspiring minds, thought and the vehicle of thought are so intimately one that to separate them is a divorce inconceivable. Yet the basic impulse of beauty, of which all art in all times is the surface

expression, can remain true and strong only by speaking through the mood and the tones of each passing century.

It remains none the less true that "faith in the order and harmony of the "universe is the basis of all enduring "art." In whatever voice self-worship is uttered, or any other harping upon the individual ego, it is ugly, cacophonous—and so ephemeral. As EDWARD CAIRD has said, the great forces of life live only in those who are "ruled from the centre, not from the circumference." Order and harmonious law are not made by man; they are the perennial forces in which alone his soul expands and is a power. In this era of the World War the age-old impulse has found fresh and ampler channels, a more spacious ideal of service to the nation and to the wide world. Yet there have also been broken impulses and shattered standards, so that multitudes are whirled away in impotent eddies of self-centred will. "Today we stand at the parting of the ways." When the new impulse speaks to us through our poets, if it ever does, it is as little likely that it will speak in the Victorian as in the Elizabethan accent. The voice which will call, and to which we shall answer, will be a new voice—the voice of the future. But the impulses to which it speaks will be those of the great past whose generations still live in us, eager only as they have always been to press onward toward the ultimate order.

June 13, 1920

### IMPROPER NOVEL COSTS WOMEN $100

**Greenwich Village Publisher and Her Editor Fined for Producing "Ulysses."**

**WOMAN'S DRESS DESCRIBED**

Margaret C. Anderson and Jane Heap, publisher and editor respectively of The Little Review, at 27 West Eighth Street, each paid a fine of $50 imposed by Justices McInerney, Kernochan and Moss in Special Sessions yesterday, for publishing an improper novel in the July and August, 1920, issues of the magazine. John S. Sumner, Secretary of the New York Society for the Pre-

vention of Vice, was the complainant. The defendants were accompanied to court by several Greenwich Village artists and writers.

John Quinn, counsel for the women, told the court that the alleged objectionable story, entitled "Ulysses," was the product of one Joyce, author, playwright and graduate of Dublin University, whose work had been praised by noted critics. "I think that this novel is unintelligible," said Justice McInerney.

Mr. Quinn admitted that it was cast in a curious style, but contended that it was in similar vein to the work of an American author with which no fault was found, and he thought it was principally a matter of punctuation marks. Joyce, he said, didn't use punctuation marks in this story, probably on account of his eyesight. There may be found more impropriety in the displays in some Fifth Avenue show windows or in a theatrical show than is contained in this novel," protested the attorney.

Assistant District Attorney Joseph Forrester said that some of the chief objections had to do with a too frank expression concerning a woman's dress when the woman was in the clothes described. The court held that parts of the story seemed to be harmful to the morals of the community.

February 22, 1921

## THE UNFLATTERING GLASS.

One may heartily applaud the choice of "The Age of Innocence" as the best novel of 1920 and yet harbor reservations as to its grounds. Is there no other measure of the excellence of a work of art than that it shall "present the whole-"some atmosphere of America and the highest standards of American manners and manhood"? Mrs. WHARTON in unquestionably the leading American novelist of her time and, with the exception of the icy tragedy of "Ethan Frome," sculptural in its perfections of form, nothing that she has done excels "The Age of Innocence." There may have been some expectation that the prize would go to "Main Street," but the justice of the award will not be seriously questioned.

The work of SINCLAIR LEWIS is formless and too often prolix; it is frequently open to cavil on the score of taste; few can endure reading more than a few short chapters at a time. Yet it has a prevailing truthfulness of mood, a candor even in iconoclasm and a critical incisiveness in its description of national traits.

The fact seems to be that the world does not take kindly to the unflattering glass of satire. DICKENS was long under the ban of proud Britons who could not abide it that he neglected people of their own station and "took his characters out of the ash boxes." They read ANTHONY TROLLOPE instead—enjoying especially the passages in which that lover of the stately homes of England burlesqued and lampooned the contemporary of whom he was not even a rival. The ladies of Mayfair and the cathedral close were equally hard upon THACKERAY. "Does he think we are all Becky Sharps or Amelia Sedleys?" one of them exclaimed in high dudgeon. Yet the great public which had no taste, together with the small public which had taste that was good, delighted alike in the great novelists, while they had only a languid tolerance for TROLLOPE. ISBEN shared the satirist's fate in heaping measure. In 1867 even GEORG BRANDES voiced the "first impression" that he was gloomy, pessimistic and a traducer of Scandinavian character—a verdict which contrasts ironically with his "third impression" of 1898.

A fairer and more suggestive comparison, perhaps, is afforded by an American novel of the past, "Unleavened Bread." SINCLAIR LEWIS writes better than ROBERT GRANT, especially in the matter of conversation. On many a page there is a neatness, even brilliancy, of phrase, a vivacity in characterization, that compare favorably with Mrs. WHARTON. But as Selma White was a document as to a certain vain pretension, callow heartlessness and spiritual emptiness in American women of 1900, so "Main Street" is a document as to the small-town stupidity and vainglory (by no means confined to small towns) of 1920.

June 5, 1921

## THE POET OF CHICAGO.

Dazed old fogies, bent by the weight of thirty-five years or more, contemplate with real wonder and terror CARL SANDBURG, the Whitman of Cook County. His name summons a mighty concordant discord of cleavers, butcher-knives, big bass drums, steam sirens and shovels and sawmills, stock yards and skyscrapers, a hullabaloo of the "husky," dust, sweat, smoke, steel, drills and dynamos, and slang and cubic sections. Whereas the elect and capable Sandburgians love him, as Mr. PAUL ROSENFELD tells us in The Bookman, "even when his jaw hangs "loose, when he shovels 'em under Aus-"terlitz." Why?

Because even the bleary quarter-formed verses, the many watery, tattered things, that clutter the pages, for example, of "Smoke and Steel," make him to be perceived, in some strange fashion, a lover, a man who is "taking a chance" with life; and remind us, moreover, that out of the mouth that drools them there have pierced, man-shaped and tender, and will pierce again, some of the songs the most needful and gladdening to us here in America.

Evidently Mr. SANDBURG has had a powerful effect upon criticism, at least upon its language, and one needs an apprenticeship at it before quite comprehending it. Even worshippers at the shrine, it seems, don't see the show too clearly or know what it is about, but "through the rifts stabbed, momentarily, "by this man in the dreary fog, we, too, "glimpse faintly, dizzily, something that "is nothing other than holy land."

So it may be supposed that here is one of those glimpses into the holy land:

Finders in the dark, you Steve with a dinner bucket, you Steve clumping in the dusk on the sidewalks with an evening paper for the woman and kids, you Steve with your head wondering where we all end up.

To be sure, this is one of Mr. SANDBURG'S efforts "to sing for folk." Now, whatever his other merits, "folk" don't hanker for that sort of thing. They want songs that touch their sense of beauty, however artless. They want the sentimentalities loathed by the new makers and critics. WALT WHITMAN aimed at the proletariat and hit the "highbrows." Such seems to be the fate of his Chicago inheritor.

July 10, 1921

# Edna St. Vincent Millay, Poet and Dramatist

*A Review by*
*WILLIAM LYON PHELPS*

RENASCENCE AND OTHER POEMS By Edna St. Vincent Millay. New York: Mitchell Kennerley.

SECOND APRIL. By Edna St. Vincent Millay. New York: Mitchell Kennerley.

ARIA DA CAPO. A Play. By Edna St. Vincent Millay. Poetry Bookshop. London.

A FEW FIGS FROM THISTLES. Poems and Sonnets. By Edna St. Vincent Millay. New York: Frank Shay.

THE LAMP AND THE BELL. A Drama in Five Acts. By Edna St. Vincent Millay. New York: Frank Shay.

THOSE who take delight in harmonizing names may find something to write about in the fact that among all the throngs of very young people who are now producing volumes of original poems one man and one woman are pre-eminent—Stephen Vincent Benét and Edna St. Vincent Millay. Mr. Benét was graduated from Yale in 1919 and Miss Millay from Vassar in 1917. Both have already several books of verse to their credit, and it is not too much to say that both have a national reputation.

Both printed poetry before they could vote; but Miss Millay's first volume of poems appeared the same year she received her degree at Vassar. No one can read "Renascence" without believing in the author's lyrical gifts. The only indubitable sign of youth in her work is the writer's pre-occupation with the theme of death. Nothing is more normal than for a young poet to write about death—the contrast is romantic and sharply dramatic; it is the idea of death that appeals to youth.

The eighth sonnet in the volume, "Second April," is thoroughly typical of Youth standing in contemplation before Death:

And you as well must die, beloved dust,
And all your beauty stand you in no stead;
This flawless, vital hand, this perfect head,
This body of flame and steel, before the gust
Of Death, or under his autumnal frost,
Shall be as any leaf, be no less dead
Than the first leaf that fell—this wonder fled,
Altered, estranged, disintegrated, lost.
Nor shall my love avail you in your hour.
In spite of all my love, you will arise
Upon that day and wander down the air
Obscurely as the unattended flower.

195

It mattering not how beautiful you
 were,
Or how beloved above all else that
 dies.

In Tennyson's first volume, the de-
tails of dissolution appear again and
again, and the thought of death
shadows nearly every page. When
a poet is old, he does not write about
death so much or in his early man-
ner. Death is too close; it has be-
come a fact rather than an idea. To
youth death is an astounding, amaz-
ing, romantic tragedy, and yet some-
how remote from the writer; it may
not cost as much worry as a dentist
appointment or an ill-fitting gown;
but when one is old, death seems
more natural. In St. Paul's early
letters, he talks about the second
coming of his Lord; in the last ones,
about his own imminent departure.

The manner of approaching the
grim subject changes with advancing
years. In Tennyson's first volume,
we find:

The jaw is falling,
The red cheek paling,
The strong limbs failing;
Ice with the warm blood mixing;
The eyeballs fixing.

When he was 80, he wrote:

Sunset and evening star,
 And one clear call for me,
And may there be no moaning of the
 bar
When I put out to sea.

Thus to find the constantly recur-
ring idea of death in the first two
volumes by Miss Millay is quite the
opposite of anything abnormal; I
imagine, apart from her poetic gift,
that she must be a natural, healthy-
minded young girl. It is only fair
to add that, in addition to the roman-
tic idea of death as material for
poetry, there are in the second vol-
ume beautiful tributes to the mem-
ory of a college friend, sincere ex-
pression of profound grief.

No matter how long we live, or
how rich and varied our experience,
Beauty always comes to us as a sur-
prise; thus the reader will be happily
struck more than a few times in
these pages. But it is not surprising
that they should be the work of
youth; for all poets of quality
achieve some perfection in early
years. If one has reached the age
of 22 without writing some admirable
poetry, one might as well resign am-
bition to become distinguished as a
poet. Undergraduate verse is prob-
ably on a higher level at this moment
in America than it has ever been
before; but the wonder is that so
little of permanent value is produced.

The mysterious flashes of inspira-
tion which reveal truth apart from
any conscious process of reasoning—
and which are the glory of poetry
and music—appear more than once
in the poems of Miss Millay. In
"Interim," for example:

Not Truth, but Faith, it is
That keeps the world alive. If all
 at once
Faith were to slacken—that uncon-
 scious Faith

Which must, I know, yet be the
 cornerstone
Of all believing—birds now flying
 fearless
Across would drop in terror to the
 earth;
Fishes would drown; and the all-
 governing reins
Would tangle in the frantic hands
 of God
And the worlds gallop headlong to
 destruction!

The rhetorical flourish in the last
line quoted is not common in these
volumes; there is usually a restraint
in expression rather remarkable, by
which, of course, feeling gains in
intensity. Extravagance of language,
the prevailing fault in this nervous
and excitable age, where everybody
either swears or talks in italics, is
not characteristic of the work of
Miss Millay. It is pleasant also to
see that the greedy attitude toward
life, so frequently seen just now in
novels and poems, is here absent;
she loves life as an artist loves
beauty, without wanting to eat it.
There can be no true love of beauty
if it be mingled with desire. One
often falls into the fallacy of think-
ing one loves beauty when all one
really loves is one's self. Consider the
appalling picture presented in May
Sinclair's "Waddington."

Remembering that the following
poem appears in the earliest volume,
we can have no doubt of our author's
originality:

If I should learn, in some quite
 casual way,
 That you were gone, not to return
 again—
Read from the back page of a paper,
 say,
 Held by a neighbor in a subway
 train,
How at the corner of this avenue
 And such a street (so are the
 papers filled)
A hurrying man—who happened to
 be you—
 At noon today had happend to be
 killed,
I should not cry aloud—I could not
 cry
 Aloud, or wring my hands in such
 a place—
I should but watch the station lights
 rush by
 With a more careful interest on my
 face,
Or raise my eyes and read with
 greater care
Where to store furs and how to treat
 the hair.

She has the poet's sight and the
poet's hearing, which are more to be
envied by us outsiders than any re-
nown. She sees visions in nature
beyond our range, and hears sounds
to us inaudible. These extra powers
give to many of her verses a delicate
charm.

## CITY TREES

The trees along the city street,
 Save for the traffic and the rains,
Would make a sound as thin and
 sweet
 As trees in country lanes.

And people standing in their shade
 Out of a shower, undoubtedly
Would hear such music as is made
 Upon a country tree.

Oh, little leaves that are so dumb
 Against the shrieking city air,
I watch you when the wind has
 come—
 I know what sound is there.

Miss Millay would not be a child

of the twentieth century if she did
not occasionally attempt to write in
the vein of light cynicism and disil-
lusion, in a manner recalling the less
valuable work of Rupert Brooke.
The little volume published this
year, "A Few Figs from Thistles,"
is exceedingly well named, and the
result is one more proof of the truth
of what you find in the Bible. These
whimsies are graceful and amusing
enough, but of no importance—not
even to their author. A fig for such
poetry!

Miss Millay is the author of two
plays—one in prose and one in verse.
Though both have the stamp of lit-
erary distinction, they are not pri-
marily literary plays; they were in-
tended for the stage, and both have
been successfully produced. "Aria
Da Capo" first appeared in Reedy's
Mirror, and was subsequently pub-
lished by the Poetry Bookshop in
London, again in the volume of
"Fifty Contemporary One-Act
Plays," edited by Frank Shay and
Pierre Loving, and once more in the
Provincetown Plays, edited by
George Cham Cook and Frank Shay.
I wish I had seen it on the stage;
the prose dialogue is just what it
should be, and the dramatic move-
ment admirable.

Still more earnestly do I wish that
I had seen the five-cent drama in
verse, "The Lamp and the Bell,"
which was produced at Vassar Col-
lege last June, in commemoration of
the fiftieth anniversary of the found-
ing of the Vassar Alumnae Associa-
tion and dedicated to the class of
1917. It is not too much to say
that the spectators were spellbound.
The echoes of this extraordinary
performance were heard far and
wide. The cast contained more than
forty actresses, graduates, under-
graduates and future students of
Vassar; the talent employed in pre-
paring the production was remark-
able; and the result beyond what
even enthusiasts had hoped.

I confess that as a rule nothing
on earth bores me more than read-
ing a play in verse, except when the
author is a genius, like Shakespeare,
Goethe or Rostand. The reason why
most modern dramas in English are
tiresome is because they really are
dull—incredibly dull, provoking
slumber more potently than pan-
dragora or all the drowsy syrups of
the world. But if one will read the
account of this performance in The
Theatre Magazine, and then read the
play with constant visualization, one
will find material for wonder.

Edna St. Vincent Millay is a poet
and a dramatist. I am already
looking forward to her next book.
Her lyrical poetry is interesting,
because it comes from an interesting
mind.

October 16, 1921

# Edwin Arlington Robinson's Poetry

*A Review by*
*HERBERT S. GORMAN*
COLLECTED POEMS. By Edwin Ar-
lington Robinson. The Macmillan
Company. $4.50.

THE work of Edwin Arlington Robinson stands apart from many modern trends of American poetry. He is engulfed neither by an excessive application to technical experimentation nor an obsession to perpetuate certain contemporary transiencies in verse Those poems which he has done are impregnated with a peculiar and deliberate insistence on the manifestations of the heart and soul. He has perfected an individual utterance, a particular originality, for he has relied not at all on new and bizarre verse forms, but worked in those old and conservative meters that it is now the fashion to treat flippantly. Yet he has so tightened and poured into those old forms a substance so unmistakably his own that they take on a new color and melody.

Tennyson wrote his "Idylls of the King" in iambic pentameter and Mr. Robinson fashioned his "Merlin" and his "Lancelot" in the same form, yet what unalterable opposites the poems of the two men are! There are two reasons for this and they are the reasons why Mr. Robinson is so individual and indubitably himself. It is, first of all, a question of the poet's attitude toward life. Mr. Robinson is the deft analyst, the keen searcher for the hidden impulses of the heart. The alloy of sentimentality is no part of his art, as it was in the case of Tennyson. He broods over his characters until his Arthurian figures are as modern in their passions and bewilderments as the natives of Tilbury Town. The other reason is one of technical dexterity, and manifests itself in a meticulous selection of words and handling of phrases. The meter may be the same as Tennyson, or any other poet, but the placing of words and the admirable fashioning of phrases belong to Mr. Robinson alone. He can place the right word in the right place. And, again, he can cram a line full of meaning until it is compact with wise utterance and inspired overtones.

There is a depth to his poetry that must make it the inexorable opponent of Time. Mr. Robinson's growth in public estimation has been slow but sure. He has never deviated from his chosen path to capture praise; the poet of "The Children of the Night" is also the poet of "The Three Taverns." Substance has always been there; the growth has been in the perfection of method and the accumulation of wisdom through experience. His audience has come to him, some of them realizing overnight that here was one of the fine achievements of mod-

ern American poetry, and others treading the long, roundabout road that must always lead to him if the traveler possesses the instinct for authentic values. The collection of a man's work into a single volume is always a definite gesture at Time, and the assembling of Mr. Robinson's eight volumes together with a handful of later pieces must be regarded as a landmark in the progress of contemporary American poetry. Here between two covers may be found those keen and suggestive Tilbury characterizations, the delightful vagabond—Captain Craig, the admirable full-length portraits of Shakespeare. St. Paul and Rembrandt, the wise Merlin and the exotic Vivien, Lancelot and the white queen Guenevere, the exalted "dime novel"—"Avon's Harvest," and those other sharply etched figures and musical lyrics that are so peculiar a part of Mr. Robinson's work.

There are two ways of treating the work of Mr. Robinson. One is to discuss his books in their chronological order, starting with "The Children of the Night" and ending with "Avon's Harvest." The other is to divide his work up into various classifications and treat it from that standpoint. It is a testimonial to the genius of the writer that such a classification, in which early work is deliberately set beside latest accomplishments, does not cause the poet to suffer. As Minerva sprang full-grown from the forehead of Jupiter, so the genius of Edwin Arlington Robinson sprang full-grown from "The Children of the Night." There are certain unforgettable efforts in that book that will always loom large in any estimate of Mr. Robinson's work. His growth has been one of perfection, of refining more subtly and distinctively the gold that was always there.

There is no particular reason, therefore, for treating Mr. Robinson's work in chronological order. One turns, instead, to certain genres of workmanship, and associated most closely with the poet's name are those figures that populate Tilbury Town. Whether it be that woman-crazed old reprobate, John Evereldown, or the glittering Richard Corey, or that philosophical fatalist, Captain Craig, one encounters the spirit of a unique individuality in them. Mr. Robinson is a master of psychological contrast, and by it he drives splendidly home the root of his matter. Richard Corey might be a gentleman, well gifted in all that the world regards as valuable, but he goes home on a calm evening and puts a bullet through his head. The man Flammonde walks through Tilbury Town adjusting the wrongs of others, yet incomprehensible in

his own mystery. Miniver Cheevy desired violently for "the medieval grace of iron clothing," but, realizing that he was born in the wrong age, merely scratched his head and kept on drinking. And Captain Craig is full of delicate contrasts, spiritual and verbal. Neither must we forget old Eben Flood, drinking solemnly to himself in the moonlight and shaping himself to a sad and subtle comment on a modern wrong. Old King Cole and his "two disastrous heirs" are likewise figures that pursue the memory.

Mr. Robinson is most successful in the art of intimation. He possesses the faculty of compelling the reader to build up an untold story. This will be found in the Tilbury Town poems as well as elsewhere. The story is indicated in a few vivid touches, and around this seemingly meagre outline rises the completed monument. It is the spirit of the thing that the poet captures. Who cares what really happened at Stafford's Cabin, for mere detail while the sense of tragedy shakes the reader? And what do we know of the old tavern in Tilbury Town except that the host was murdered and that a stranger riding furiously through the night almost ran over John Evereldown? This is one of the secrets of great poetry—to suggest far more than is explicitly stated. The important things are beyond words, and the poet that is powerful enough to bring his reader amid these invisible phenomena has accomplished all that poetry may encompass.

The desire to quote "Isaac and Archibald" as an example of the Tilbury poems is frustrated by its length, but the reader of Mr Robinson's poems is advised to turn to it among the first that he absorbs. Rather must two verses of "John Evereldown" be quoted, particularly to exhibit the melodic magic of the poet:

Where are you going tonight, tonight—
  Where are you going, John Evereldown?
There's never the sign of a star in sight,
  Nor a lamp that's nearer than Tilbury Town.
Why do you stare as a dead man might?
Where are you pointing away from the light?
And where are you going tonight, tonight—
  Where are you going, John Evereldown?

Right through the forest where none can see,
  There's where I'm going, to Tilbury Town.
The men are asleep—or awake, may be—
  But the women are calling John Evereldown.
Ever and ever they call for me.
And while they call can a man be free?
So right through the forest where none can see,
  There's where I'm going, to Tilbury Town.

# Fiction and Poetry

Comparable in certain qualities with these Tilbury pieces, but of an essentially higher order because of the subjects, are the historical portraits which are to be found in several of Mr. Robinson's books. At the forefront of these stands the impressive "Ben Jonson Entertains a Man From Stratford." Written in a noble blank verse that is sustained yet flexible to the delicate ironies and humors of the subject, it comprehends in itself one of the fine flowers of American poesy. There is a depth of sympathy and understanding here that is remarkable. Surely this figure of

Our man Shakespeare, who alone
    of us
Will put an ass's head in Fairyland
As he would add a shilling to more
    shillings,
All most harmonious,

is the very man who first drew breath in Stratford. We see him torn between immortal things and the desire to own a house in Stratford. Through the eyes of the large-hearted, mellow, robust Ben Jonson he is shown—a man of some loneliness and sadness, vexed by mutabilities and passing vanities, yet inevitably lifted by mysterious visions. At times he can cry:

Your fly will serve as well as any-
    body,
And what's his hour? He flies, and
    flies, and flies,
And in his fly's mind has a brave
    appearance;
And then your spider gets him in
    her net,
And eats him out, and hangs him
    up to dry.
That's Nature, the kind mother of
    us all.
And then your slattern housemaid
    swings her broom,
And where's your spider? And
    that's Nature, also.
It's Nature and it's Nothing. It's
    all Nothing.
It's all a world where bugs and
    Emperors
Go singularly back to the same dust,
Each in his time; and the old, or-
    dered stars
That sang together, Ben, will sing
    the same
Old stave tomorrow.

But this is one of his clouded times and

He'll out of 'em enough to shake the
    tree
Of life itself and bring down fruit
    unheard-of—
And, throwing in the bruised and
    whole together,
Prepare a wine to make us drunk
    with wonder;
And if he live, there'll be a sunset
    spell
Thrown over him as over a glassed
    lake
That yesterday was all a black wild
    water.

One can but marvel with Ben Jonson at " this mad, careful, proud, indifferent Shakespeare." The poem is one that must last as long as poetry lasts, for it is builded for all time.

And together with this masterful portrait of Shakespeare must be arrayed those other portraits, Napoleon at St. Helena, St. Paul before his last venture into Rome, Aaron Burr and Alexander Hamilton at the parting of the ways, John Brown, who can proudly declare, " I shall have more to say when I am dead," and that remarkable portrait of Rembrandt (here printed for the first

time), as full of those subtle, golden shadows of illumination as the paintings of the great Hollander. One must not forget the vivid picture of Lazarus after he has risen from the dead, or the gray figure of Tasker Norcross, imaginative yet pervaded with an overwhelming sense of reality.

Mr. Robinson's narrative poems are headed by " Merlin." This intensely individual reconstruction of Malory possesses such qualities as must place it with the Shakespeare poem in the fore rank of the poet's many achievements. It is compact with glamourie and woodland beauty. Vivien in Broceliande is a creation that must silence for all time those critics who profess to discover a lack of color in Mr. Robinson's work. The story of " Merlin " might be applied to our own world, where so many old orders are crashing down only to give place to the new. There are scenes of unforgettable beauty in this poem, such as this meeting between the wizard and the woman:

        . . . his eyes
Had sight for nothing save a swim-
    ming crimson
Between two glimmering arms.
    " More like a flower
Tonight," he said, as now he
    scanned again
The immemorial meaning of her
    face
And drew it nearer to his eyes. It
    seemed
A flower of wonder with a crimson
    stem
Came leaning slowly and regret-
    fully
To meet his will—a flower of change
    and peril
That had a clinging blossom of
    warm olive
Half-stifled with a tyranny of
    black,
And held the wayward fragrance of
    a rose
Made woman by delirious alchemy.
She raised her face and yoked his
    willing neck
With half her weight; and with hot
    lips that left
The world with only one philos-
    ophy
For Merlin or for Anaxagoras,
Called his to meet them and in one
    long hush
Of capture to surrender and make
    hers
The last of anything that might
    remain
Of what was now their beardless
    wizardry.
Then slowly she began to push her-
    self
Away, and slowly Merlin let her go
As far from him as his outreaching
    hands
Could hold her fingers while his
    eyes had all
The beauty of the woodland and the
    world
Before him in the firelight, like a
    nymph
Of cities, or a queen a little weary
Of inland stillness and immortal
    trees

Together with " Merlin " must be placed " Lancelot," a poem in which the story is a bit more pronounced. " Lancelot " is compact with those same qualities of colorful beauty that are so supreme in " Merlin." One has but to read the two poems to understand how wrong it is to compare them in any particular with Tennyson's treatment of the same subjects. The two poets are as far apart as the poles in their technique and spiritual development. In " Lancelot " the white queen Guenevere is shaped with the poignancy of acute realization.

Among the other narratives " Avon's Harvest " must be noted, for it occupies a peculiar place in the work of Mr. Robinson. It is a ghost story, a tale of an obsessing fear, but it is developed with a verisimilitude of reality that will cause the reader to gallop through it as he would through a modern novel. After that he must go back again in order to discover new beauties of thought and phraseology.

Two poems which exemplify another aspect of Mr. Robinson's art must be noted in " The Man Against the Sky " and " The Valley of the Shadow." From the first named of these may be developed the philosophy of the poet. The man who stood on high was on the same way that all must travel. The poet gravely states:

And we with all our wounds and
    all our powers,
Must each await alone at his own
    height
Another darkness or another light.

And in " The Valley of the Shadow " Mr. Robinson pictures this world of broken adventurers and thwarted ambitions. The high seriousness of life is always apparent in his work. He is not the pessimist that a first glance might lead one to believe, for he is saved from that by an abundant sense of humor that permits him to see the unreasonable aspects of extremes. At times an ironical impulse makes itself evident, but it is not bitter. Thomas Hardy mingles wormwood with his irony, but the equanimity of Mr. Robinson makes his work anything but acidulous. It is a dubious world at best, full of unreasonable disappointments and the blind vagaries of Fate, but it is shot with a golden glow at times. There is much to live for, quite as much as there is to die for, and the test of living is sanity and poise. There is no better poised poet than Mr. Robinson; the assaults of passion leave him undisturbed. In the spirit of the two poems mentioned above are several efforts that exhibit how engrossed Mr. Robinson really is with the movements and spiritual excursions of the times. In pieces like " Cassandra," " Demos " and " The King's New Jester," to mention but three of these outstanding compositions, he shows how near to life he really is. He is not the detached poet, living aloof from the multitudinous currents of modern existence, that those who are ignorant of his work are liable to believe. As much as any poet living he is stirred and dominated by the fluctuations of the times. But he never loses sight of the elemental things, and they always bring back to his mind the kindling thought that artificial transiencies pass and are as nothing. Man and his struggle fades into night and the eternal mountains remain.

# Ezra Pound, Artist of the Ivory Tower

*A Review by*
*RICHARD LE GALLIENNE*

POEMS, 1918-21, INCLUDING THREE PORTRAITS AND FOUR CANTOS. By Ezra Pound. Boni & Liveright. $2.50.

WHATEVER Mr. Ezra Pound's merits or frailities, no one who knows his work at all will deny him a sense of humor, a gift which he does not seem to have communicated either to his admirers, his non-admirers, or even to his publishers—might properly report that on the "jacket" of a volume humor is out of place. There, of all places in the world, your author must be taken with the seriousness funereal. So that, after all, it is quite natural that on his own "jacket" Mr. Pound should figure as "the great international literary figure that he is." I think that Mr. Pound will smile at this description, though I may be doing him a wrong, for a man's sense of humor seldom extends to the recognition of the limitations of his own greatness; a truth particularly true of professional humorists, who, indeed, seldom have a sense of humor. Mr. Pound, however, is not responsible for the lack of humor which seems to attend upon the mere mention of his name, with his admirers taking the form of abject ecstasy beneath his feet—after all, forgivable, as being constructive, tending, that is, toward that high appreciation of his work which is its just due; with his non-admirers taking the form of a foaming anger, blindly destructive, and robbing the non-admirer himself of the benefit he might otherwise enjoy in open-mindedly approaching a writer whose work has so much rare pleasure to give us, vitalized as it is with beauty and romance—particularly with the romance of an enviable learning. I don't think that Mr. Pound bothers a great deal either about his admirers or his non-admirers, though, after the manner of his chief master, Robert Browning, he occasionally makes private fun in flouting the latter—"you British public—you who like me not "—with his:

Non-esteem of self-styled "his betters",
Leading, as he well knew,
To his final
Exclusion from the world of letters.

Like all serious artists, he writes primarily to amuse and please himself, knowing far better than his non-admirers his real "letters," and bringing to them the homage of profound knowledge and creative imitation. Of course, he is not seldom "harsh and crabbed," the rose of the beauty he brings us is protected from the profane by many a thorn and faery wands of emerald, and, as with the wild rose, it is the more startling, phantasmal, on that account. He is also not seldom deliberately insolent, but his insolence is that of the dandy, the aristocrat, never that of the proletarian iconoclast of letters. A "dandiacal" writer, par excellence, an artist of the ivory tower, for all those vagaries of the vulgar parlance of "modern" colloquialism with which he sometimes aristocratically amuses himself. As, for instance, when in his prose "Pavannes and Divisions," he writes that "the humanizing influence of the classics depends more on a wide knowledge, a reading knowledge, than on an ability to write exercises in latin," and continues: "When the classics were a new beauty and ecstasy people cared a damn sight more about the meaning of the authors and a damn sight less about their grammar and philology." This is so true, and one is so glad to have it said, that one surely need not begrudge Mr. Pound his harmless fopperies of "a damn sight" and his printing "Latin" with a small "l," as he prints "Greek" with a small "g." These and other of his affectations break no bones. It is the privilege of the nobility to drop the final "g," or even their "h's"; they may even, with impunity, as Wilde says, eat peas with a knife—because, of course, they don't do these things all the time.

The "Homage to Sextus Propertius" with which this new opusculum opens—the most important thing in it, as some will consider—is offered in pursuance of the attitude toward the classics above noted, and aims, doubtless, to convey to the English reader something of that "new beauty and ecstasy" about which the contemporaries of Propertius "cared a damn sight more" than his grammar and philology, or even his difficult and wayward prosody. In the matter of translations or transmutations of Propertius Mr. Pound is certainly not handicapped by any important rivalry among his predecessors, and whatever the conservative scholar may have to say to the twelve versions of the Propertian elegies here offered, the lover of poetry, not too learned maybe to be too particular, and in any case loving beauty and vitality more than pedantry, will gladly acknowledge a very living and often thrilling and lovely reanimation of Cynthia's famous lover:

If any man would be a lover he may
walk on the Scythian coast,
No barbarism would go to the extent
of doing him harm.
The moon will carry his candle, the
stars will point out the stumbles,
Cupid will carry lighted torches
before him and keep mad dogs
off his ankles.
Thus all roads are perfectly safe
and at any hour;
Who so indecorous as to shed the
pure gore of a suitor?
Cypris is his cicerone.
What if undertakers follow my
track, such a death is worth
dying.
She would bring frankincense and
wreaths to my tomb,
She would sit like an ornament on
my pyre.

If the reader compares this with the original sixteenth elegy of the third book, he will find that it is practically a literal translation, and if the style be not that of Propertius, the meaning and the vigor are certainly his. But, of course, Mr. Pound does not concern himself with literality. It is the life-blood of his poet he is after. That which was living in 22 or 21 B. C. he aims to bring us still living in 1922 A. D.—the only raison d'être for any translation whatsoever. "Dead languages" are only dead in the hands of dead-alive translators. Take again this version of the first elegy of the second book:

Yet you ask on what account I
write, so many love lyrics
And whence this soft book comes
into my mouth.
Neither Calliope nor Apollo sung
these things into my ear.
My genius is no more than a girl.
If she with ivory fingers drive a
tune through the lyre,
We look at the process.
How easy the moving fingers; if
hair is mussed on her forehead,
If she goes in a gleam of Cos, in a
slither of dyed stuff,
There is a volume in the matter; if
her eyelids sink into sleep,
There are new jobs for the author.
And whatever she does or says,
We shall spin long yarns out of
nothing.

So, of course, a sufficiently human scholar might off-handedly construe his Latin poets in vernacular fashion for irresponsible "modern" youth, indifferent to the dainties that are bred in a book, for the purpose of showing that there is something in these old dead ones after all. To set his audience at ease he would refer to the "hero" this or that as "The guy Aeneas" or "the guy Achilles," or modernize "thus spake the hero" into "the guy shot off his mouth to this effect." (Wasn't it Verlaine who used to sketch out poems he was working on in ribald synonyms?) Sometimes Mr. Pound goes rather far in this direction. In the last quotation, for instance, "mussed"—an ugly word anyhow—was hardly necessary to make the line "seu vidi ad frontem sparsos errare capillos" live again.

To get a general idea of Mr. Pound's method, one may compare one of his renderings with a literal translation—this from the twenty-eighth elegy of the second book:

Jupiter, at length have pity on my
mistress, stricken sore; the death of
one so fair will be accounted to thee
for a crime. For the season has

come when the scorching air seethes with heat and earth begins to glow beneath the parching Dog-Star. But 'tis not so much the fault of the heat, nor hath heaven so much the blame for her illness, as that so oft she hath spurned the sanctity of the gods. This is it that undoes hapless girls, aye, and hath undone many; wind and water sweep away their every oath. Was Venus vexed that thou wast compared with her? She is a jealous goddess to all alike that vie with her in loveliness.

This, in Mr. Pound's nonchalant hands, becomes:

Jove, be merciful to that unfortunate woman
Or an ornamental death will be
held to your debit,
The time is come, the air heaves in
torridity,
The dry earth pants against the
canicular heat,
But this heat is not the root of the
matter:
She did not respect all the gods;
Such derelictions have destroyed
other young ladies aforetime,
And what they swore in the cupboard wind and wave scattered
away.
Was Venus exacerbated by the existence of a comparable equal?
Is the ornamental goddess full of
envy?

To say that thus the noble lord who improvised "Don Juan" into immortality might have freely rendered his author is surely all in Mr. Pound's favor. Yet "an ornamental death will be held to your debit" for "tam formosae tuum mortua crimen erit" savors rather of Ezra Pound of Montana, U. S. A., than of Sextus Propertius of Assisi; and particularly the expression "the ornamental goddess." "Some goddess, Aphrodite!" might be suggested as a variorum reading. Compare with this use of "ornamental" Mr. Pound's pedantically literal use of the word "formal"—"the formal girls of Achaia" for "Achaia formas." For an amusing example of Mr. Pound's "modernizing": "Actia Vergilio custodis litora Phoebi" becomes "upon the Actian marshes Virgil is Phoebus's chief of police"; and, to make the meaning of his part clear, he makes no bones about bringing in a modern instance, as in Propertius's reference to "Ascra's poet old," as thus:

Go on, to Ascraeus's prescription,
the ancient, respected Wordsworthian.

Which is all good fun, "amusing," as the painters use the word, and surely does no harm, being merely a scholar's harlequinade only occasionally indulged in. For the most part this "Homage to Sextus Propertius" is very real and beautiful homage, and it is to be hoped that Mr. Pound may bring more of it to him and for us. As a last quotation, how beautiful is this:

When, when, and whenever Death
closes our eyelids,
Moving naked over Acheron
Upon the one raft, victor and conquered together,
Marius and Jugurtha together,
One tangle of shadows.

"Victor cum vistis pariter miscebitur umbria"—"one tangle of shadows." Here certainly Propertius and Ezra Pound are one. I have left no space to speak of the other contents of this volume, the four new "Cantos" to add to the three previously printed in Mr. Pound's "Quia Pauper Amavi" volume, an English publication in which the Propertius poems and much else in these "Poems" were first

Portrait of Ezra Pound.

printed, including "Moeurs Contemporaines" and "Langue d'Oc"—the former characteristic bits of satire, the latter renderings from various troubadours whose complicated art is so important a component of the curious amalgam which is Mr. Pound's style. There is an "envoi" to a section entitled "Hugh Selwyn Manberley (Life and Contacts)," which I must quote as an example of a more melodius lyricism than Mr. Pound usually allows himself:

Go, dumb-born book,
Tell her that sang me once that song
of Lawes;
Hadst thou but song
As thou but subjects known,
Then were there cause in thee that
should condone
Even my faults that heavy upon me
lie
And build her glories their longevity.
Tell her that sheds
Such treasure in the air,
Recking naught else but that her
graces give
Life to the moment,
I would bid them live
As roses might, in magic amber laid,
Red overwrought with orange and
all made
One substance and one colour
Braving time.
Tell her that goes
With song upon her lips
But sings not out the song, nor
knows
The maker of it, some other mouth,
May be as fair as hers.
Might, in new ages, gain her worshippers,
When our two dusts with Waller's
shall be laid,
Siftings on siftings in oblivion,
Till change hath broken down
All Kings save Beauty alone.

It misgives me as I finish copying this that perhaps this is not Mr. Pound's poem after all, but that "Hugh Selwyn Manberley"—as to whom Mr. Pound must excuse my ignorance, as he vouchsafes no information—is its author; it being, as Mr. Pound's readers know, his generous habit to include the poems of his friends in his own volume—"miscebitur umbris." However, as Mr. Pound has said, while it is very important that poetry should be written, it does not matter who writes it. To show Mr. Pound (or Mr. Manberley, for it is in the Manberley section) in his vein of savage satire, here is a sort of "servente" against the late war:

These fought in any case,
And some believing, pro domo, in
any case * * *
Some quick to arm,
Some for adventure,
Some from fear of weakness,
Some from fear of censure,
Some for love of slaughter, in imagination, learning later. * * *

Some in fear, learning love of
slaughter;
Died some pro patria, non dulce, non
et decor * *
Walked eye-deep in hell
Believing in old men's lies, then unbelieving came home, home to a
lie,
Home to many deceits,
Home to old lies and new infamy;
Usury age-old and age-thick
And liars in public places.

Daring as never before, wastage as
never before,
Young blood and high blood,
Fair cheeks and fine bodies;
Fortitude as never before,
Frankness as never before,
Disillusions as never told in the old
days,
Hysterias, trench confessions,
Laughter out of dead bellies.

# James Joyce's Amazing Chronicle

*A Review by*
*Dr. JOSEPH COLLINS*

ULYSSES. By James Joyce. Paris, France: Shakespeare & Co. 1922. Price 200 francs.

A FEW intuitive, sensitive visionaries may understand and comprehend "Ulysses," James Joyce's new and mammoth volume, without going through a course of training or instruction, but the average intelligent reader will glean little or nothing from it—even from careful perusal, one might properly say study, of it—save bewilderment and a sense of disgust. It should be companioned with a key and a glossary like the Berlitz books. Then the attentive and diligent reader would eventually get some comprehension of Mr. Joyce's message.

That he has a message there can be no doubt. He seeks to tell the world of the people that he has encountered in the forty years of sentient existence; to describe their conduct and speech and to analyze their motives, and to relate the effect the "world," sordid, turbulent, disorderly, with mephitic atmosphere engendered by alcohol and the dominant ecclesiasticism of his country, had upon him, an emotional Celt, an egocentric genius, whose chief diversion and keenest pleasure is self-analysis and whose lifelong important occupation has been keeping a notebook in which has been recorded incident encountered and speech heard with photographic accuracy and Boswellian fidelity. Moreover, he is determined to tell it in a new way. Not in straightforward, narrative fashion, with a certain sequentiality of idea, fact, occurrence, in sentence, phrase and paragraph that is comprehensible to a person of education and culture, but in parodies of classic prose and current slang, in perversions of sacred literature, in carefully metered prose with studied incoherence, in symbols so occult and mystic that only the initiated and profoundly versed can understand—in short, by means of every trick and illusion that a master artificer, or even magician, can play with the English language.

Before proceeding with a brief analysis of "Ulysses," and comment on its construction and its content, I wish to characterize it. "Ulysses" is the most important contribution that has been made to fictional literature in the twentieth century. It will immortalize its author with the same certainty that Gargantua and Pantagruel immortalized Rabelais, and "The Brothers Karamazof" Dostoyevsky. It is likely that there is no one writing English today that could parallel Mr. Joyce's feat, and it is also likely that few would care to do it were they capable. That statement requires that it be said at once that Mr. Joyce has seen fit to use words and phrases that the entire world has covenanted and people in general, cultured and uncultured, civilized and savage, believer and heathen, have agreed shall not be used, and which are base, vulgar, vicious and depraved. Mr.

Joyce's reply to this is: "This race and this country and this life produced me—I shall express myself as I am."

An endurance test should always be preceded by training. It requires real endurance to finish "Ulysses." The best training for it is careful perusal or reperusal of "The Portrait of the Artist as a Young Man," the volume published six or seven years ago, which revealed Mr. Joyce's capacity to externalize his consciousness, to set it down in words. It is the story of his own life before he exiled himself from his native land, told with uncommon candor and extraordinary revelation of thought, impulse and action, many an incident of a nature and texture which most persons do not feel free to reveal, or which they do not feel it is decent and proper to confide to the world.

The salient facts of Mr. Joyce's life with which the reader who seeks to comprehend his writings should be familiar are as follows: He was one of many children of South Ireland Catholic parents. In his early childhood his father had not yet dissipated his small fortune and he was sent to Clongowes Woods, a renowned Jesuit college near Dublin, and remained there until it seemed to his teachers and his parents that he should decide whether or not he had a vocation, that is, whether he felt within himself, in his soul, a desire to join the order. After some religious experiences he lost his faith, then his patriotism, and held up those with whom he formerly worshipped to ridicule, and his country and her aspirations to contumely. He continued his studies in the University of Dublin notwithstanding the sordid poverty of his family. After graduation he decided to study medicine, and in fact he did pursue such studies for two or three years, one of them in the medical school of the University of Paris. Eventually he became convinced that medicine was not his vocation, even though funds were available for him to continue his studies, and he decided to take up singing as a profession, having a phenomenally beautiful tenor voice.

These three novitiates furnished him with all the material that he has used in the four volumes that he has published. Matrimony, parentage, ill health and a number of other factors put an end to his musical ambitions and for several years previous to the outbreak of the war he gained his daily bread by teaching the Austrians of Trieste English and Italian, having a mastery of the latter language that would flatter a Padovian professor. The war drove him to the haven of the expatriate, Switzerland, and for four years he taught German, Italian, French, English to any one in Berne who had time, ambition and money to acquire a new language. Since the armistice he has lived in Paris, finishing "Ulysses," his magnum opus, which he says and believes represents everything that he has to say and which ill advisedly he attempted to

submit to the world through the columns of The Little Review. It is now published "privately for subscribers only."

As a boy Mr. Joyce's favorite hero was Odysseus. He approved of his subterfuge for evading military service, he envied him the companionship of Penelope, all his latent vengeance was vicariously satisfied by reading of the way in which he revenged himself on Palamedes, while the craftiness and resourcefulness of the final artificer of the siege of Troy made him permanently big with admiration and affection. But it was the ten years of his hero's life after he had eaten of the lotus plant that wholly seduced Mr. Joyce, child and man, and appeased his emotional soul. As years went by he identified many of his own experiences with those of the slayer of Polyphemus and the favorite of Pallas-Athene; so, after careful preparation and planning he decided to write a new Odyssey, to whose surge and thunder the whole world would listen. In early life Mr. Joyce had definitely identified himself as Dedalus, the Athenian architect, sculptor and magician. This probably took place about the time that he became convinced he was not the child of his parents but a person of distinction and they his foster parents. A very common occurrence in potential psychopaths and budding geniuses. It is as Stephen Dedalus that Mr. Joyce carries on in "Ulysses." Indeed, that book is the record of his thoughts, antics, vagaries, and more particularly his actions, and of Leopold Bloom, a Hungarian Jew, who has lost his name and religion, a sensuous rags and tatters Hamlet, and who took to wife one Marion Tweedy, the daughter of a non-commissioned officer stationed in Gibraltar.

Mr. Joyce is an alert, keen-witted, brilliant man who has made it a lifelong habit to jot down every thought that he has had, whether he is depressed or exalted, despairing or hopeful, hungry or satiated, and likewise to put down what he has seen or heard others do or say. It is not unlikely that every thought that Mr. Joyce has had, every experience he has ever encountered, every person he has ever met, one might almost say everything he has ever read in sacred or profane literature, is to be encountered in the obscurities and in the frankness of "Ulysses." If personality is the sum total of all one's experiences, all one's thoughts and emotions, inhibitions and liberations, acquisitions and inheritances, then it may truthfully be said "Ulysses" comes nearer to being the perfect revelation of a personality than any book in existence. Rousseau's "Confessions," Amiel's "Diary," Bashkirtseff's vaporings and Cassanova's "Memoirs" are first readers compared with it.

He is the only individual that the writer has encountered outside of a madhouse who has let flow from his pen random and purposeful thoughts

just as they are produced. He does not seek to give them orderliness, sequence or interdependence. His literary output would seem to substantiate some of Freud's contentions. The majority of writers, practically all, transfer their conscious, deliberate thought to paper. Mr. Joyce transfers the product of his unconscious mind to paper without submitting it to the conscious mind, or, if he submits it, it is to receive approval and encouragement, perhaps even praise. He holds with Freud that the unconscious mind represents the real man, the man of nature, and the conscious mind the artificed man, the man of convention, of expediency, the slave of Mrs. Grundy, the sycophant of the Church, the plastic puppet of society and State. For him the movements which work revolutions in the world are born out of the dreams and visions in a peasant's heart on the hillside. "Peasant's heart" psychologically is the unconscious mind. When a master technician of words and phrases sets himself the task of revealing the product of the unconscious mind of a moral monster, a pervert and an invert, an apostate to his race and his religion, the simulacrum of a man who has neither cultural background nor personal self-respect, who can neither be taught by experience nor lessoned by example, as Mr. Joyce has done in drawing the picture of Leopold Bloom, and giving a faithful reproduction of his thoughts, purposeful, vagrant and obsessive, he undoubtedly knew full well what he was undertaking, and how unacceptable the vile contents of that unconscious mind would be to ninety-nine men out of a hundred, and how incensed they would be at having the disgusting product thrown in their faces. But that has nothing to do with that with which I am here concerned, viz., has the job been done well and is it a work of art, to which there can be only an affirmative answer.

It is particularly in one of the strangest chapters of all literature, without title, that Mr. Joyce succeeds in displaying the high-water mark of his art. Dedalus and Bloom have passed in review on a mystic stage, all their intimates and enemies, all their detractors and sycophants, the scum of Dublin and the spawn of the devil. Mr. Joyce resurrects Saint Walpurga, galvanizes her into life after twelve centuries of death intimacy with Beelzebub, and substituting a squalid section of Dublin for Brocken, proceeds to depict a festival, with the devil as host. The guests in the flesh and of the spirit have still many of their distinctive corporeal possessions, but the reactions of life no longer exist. The chapter is replete with wit, humor, philosophy, learning, knowledge of human frailties and human indulgences, especially with the brakes of morality off, and alcohol or congenital deficiency takes them off for most of the characters. It reeks of lust and of filth, but Mr. Joyce says that life does, and the morality that he depicts is the one he knows. In this chapter is compressed all of the author's experiences, all his determinations and unyieldingness, most of the incidents that have given a persecutory twist to his mind, made him an exile from his native land and deprived him of the courage to return to it. He does not hesitate to bring in the ghost of his mother whom he had been accused of killing because he would not kneel down and pray for her when she was dying and to question her of the verity of the accusation. But he does not repent even when she returns from the spirit world. In fact, the capacity for repentance is left out of Mr. Joyce's make-up. It is just as impossible to convince Mr. Joyce that he is wrong about anything on which he has made up his mind as it is to convince a paranoiac of the unreality of his false beliefs, or a jealous woman of the groundlessness of her suspicions. It may be said that this chapter does not represent life, but I venture to say that it represents life with photographic accuracy as Mr. Joyce has seen it and lived it, and that every scene has come within his gaze and that every speech has been heard or said, and every sentiment experienced or thrust upon him. It is a mirror held up to life, life which we could sincerely wish and devoutly pray that we were spared.

In another connection Mr. Joyce once said:

My ancestors threw off their language and took another. They allowed a handful of foreigners to subject them. Do you fancy I am going to pay in my own life and person debts they made? No honorable and sincere man has given up his life, his youth and his affections to Ireland from the days of Tone to those of Parnell but the Irish sold him to the enemy or failed him in need or reviled him and left him for another. Ireland is the old sow that eats her farrow.

He has been saying that for many years, and he tries to make his actions conform with his words. However, every day of his life, if the mails do not fail, he gets a Dublin newspaper and reads it with the dutifulness with which a priest reads his breviary.

Mr. Joyce had the good fortune to be born with a quality which the world calls genius. Nature exacts a penalty, a galling income tax from geniuses, and as a rule she co-endows them with unamenability to law and order. Genius and reverence are antipodal, Galileo being the exception to the rule. Mr. Joyce has no reverence for organized religion, for conventional morality, for literary style or form. He has no conception of the word obedience, and he bends the knee neither to God nor man. It is very interesting, and most important to have the revelations of such a personality, to have them first-hand and not dressed up. Heretofore our only avenues of information of such personalities led through the asylums for the insane, for it was there that such revelations as those of Mr. Joyce were made without reserve. Lest any one should construe this statement to be a subterfuge on my part to impugn the sanity of Mr. Joyce, let me say at once that he is one of the sanest geniuses that I have ever known.

He had the profound misfortune to lose his faith and he cannot rid himself of the obsession that the Jesuits did it for him, and he is trying to get square with them by saying disagreeable things about them and holding their teachings up to scorn and obloquy. He was so unfortunate as to be born without a sense of duty, of service, of conformity to the State, to the community, to society, and he is convinced that he ought to tell about it, just as some who have experienced a surgical operation feel that they must relate minutely all the details of it, particularly at dinner parties and to casual acquaintances.

Finally, I venture a prophecy: Not ten men or women out of a hundred can read "Ulysses" through, and of the ten who succeed in doing so, five of them will do it as a tour de force. I am probably the only person, aside from the author, that has ever read it twice from beginning to end. I have learned more psychology and psychiatry from it than I did in ten years at the Neurological Institute. There are other angles at which "Ulysses" can be viewed profitably, but they are not many. Stephen Dedalus in his Parisian tranquility (if the modern Minos has been given the lethal warm bath) will pretend indifference to the publication of a laudatory study of "Ulysses" a hundred years hence, but he is as sure to get it as Dostoyevsky, and surer than Mallarmé.

May 28, 1922

# THE MAN FROM MAIN STREET

### A Review by
### MAY SINCLAIR

BABBITT. A novel by Sinclair Lewis. New York: Harcourt, Brace & Co. $2.

IN "Main Street" Mr. Sinclair Lewis wrote the history of a highly complex organism, the street that stood for the little Middle-Western town, the Middle-Western town that stood for every provincial town in the United States: a town that was Everytown and yet itself, given in all its raw, reeking individuality. The characters in "Main Street" are not merely individual men and women, they are cells in that organism, that thing of habits, of shrewd eternal instincts, which is more powerful than they, which resists and conquers and absorbs the foreign elements that invade it. "Main Street" is the story of the revolt of an individual and her defeat by the community. Its heroine is a crude and pretentious enthusiast for "culture" sick with discontent. Moved by a feverish loathing of her environment, she tries to reform Main Street, to impose on it her own moth-like pas-

sion for artificial light, to lead it onward and upward. And Main Street, adamant in its solidarity, and completely satisfied with itself, refuses to be led and enlightened. By sheer inertia it crushes the fluttering devotee of the ideal. In the earlier novel the protagonist is Main Street, the community. Mr. Sinclair Lewis's presentation of the conflict is inimitable. But in the nature of the case the interest is scattered, and the book lacks a certain concentration and unity. It is like his description of Main Street, where every house stands out, distinct and vivid, where you smell the ash-heaps in every back yard, but the reader is left to gather these details together, to join house to house down the long vista, as best he may. He is given no clear massive image of Main Street as a whole.

In his last novel, "Babbitt," Mr. Sinclair Lewis triumphs precisely where in "Main Street" he failed. By fixing attention firmly on one superb central figure he has achieved an admirable effect of unity and concentration. Not once in all his 401 close-packed pages does your gaze wander, or desire to wander, from the personality of George F. Babbitt (of the Babbitt-Thompson Realty Company). You are rapt, fascinated, from the moment when you find him waking in the sleeping porch of his house at Floral Heights to that final moment of sorrowful insight when he sees himself as he is. You have the complete, brilliant portrait of a man. You know what he does and his gesture in doing it; what he says, with every trick of speech, every tone and accent; what he thinks and feels, openly and secretly. Nothing is hidden from you, nothing is left mysterious and unaccounted for. Mr. Sinclair Lewis has done his work with a remorseless and unfaltering skill. Yet in himself Babbitt is colorless. He only exists effectively as a wheel in the commercial machine. Apart from his business as an estate broker, a "high-class realtor," he is a bundle of pompous negations, futilities, preposterous vanities. The main effort of his life is to give value and distinction to this nonentity which is himself, to fill up the empty framework of his ego with flattering illusions. Like the heroine of "Main Street," the soul of Babbitt is a contradiction; he is full of floppy self-importance and a futile discontent. Not discontent with his surroundings. He has a contempt for all the little provincial towns that are not his town, Zenith, "the Zip City," "the best ole town in the U. S. A." Babbitt's conflict is not with the community, but with his ego and with his wife and children, so far as they are hindrances to the cheerful, important expansion of his ego. He is a member of the Boosters' Club, of the Athletic Club, of the Benevolent and Protective Order of Elks.

There are wonderful scenes: Babbitt in his bath; Babbitt in his office, dictating letters to his typist—"What I can't understand is, why can't Stan Graff or Chet Laycock write a letter like that? With punch! With a kick!" Babbitt drawing up an "ad."—"Course I believe in using poetry and humor and all that junk when it turns the trick, but with a high-class restricted development like the Glen we better stick to the more dignified approach, see how I mean?" Babbitt making his immortal speech before the Zenith Real Estate Board.

The Babbitts give a party and the conversation is wonderful:

"They're the best folks on earth, those small town folks; but, oh, mama, what conversation! Why, say, they can't talk about anything but the weather and the ne-oo Ford, by heckalorum!"

"That's right. They all talk about just the same thing," said Eddy Swanson.

"Don't they, though? They just say the same things over and over," said Vergil Gunch.

"Yes, it's really remarkable. They seem to lack all power of looking at things impersonally. They simply go over and over the same talk about Fords and the weather and so on," said Howard Littlefield.

"Still at that you can't blame 'em. They haven't got any intellectual stimulus such as you get up here in the city," said Chun Frink.

"Gosh, that's right," said Babbitt. "I don't want you highbrows to get stuck on yourselves, but I must say it keeps a fellow right up on his toes to sit in with a poet and with Howard, the guy that put the con in economics. But these small-town boobs with nobody but each other to talk to, no wonder they get so sloppy and uncultured in their speech and so balled up in their thinking."

Vergil Gunch summed it up: "Fact is, we're mighty lucky to be living among a bunch of city folks that recognizes artistic things and business punch equally. We'd feel pretty glum if we got stuck in some Main Street burg and tried to wise up the old codgers to the kind of life we're used to here. But, by golly, there's this you got to say for 'em: Every small American town is trying to get population and modern ideals. And darn if a lot of 'em don't put it across." * * *

"You don't want to just look at what those small towns are; you want to look at what they're aiming to become, and they all got an ambition that in the long run is going to make 'em the finest spots on earth—they all want to be just like Zenith!"

Like the heroine of "Main Street," Babbitt conceives himself to have "Vision" and "Ideals." He has the preposterous dream of "the fairy child, a dream more romantic than scarlet pagodas by a silver sea." But his "Vision" lands him in certain commercial transactions of doubtful integrity; his "Dream" drives him to philandering with the barber's manicure girl and to the society of Mrs. Judique and "the Bunch." Not for one moment will he admit that he has fallen from the standards of high morality. When the fraudulent salesman, Stanley Graff, in the heat of dismissal, threatens "to squeal all I know" to the prosecuting attorney, Babbitt has an uncomfortable hour. He meditates and recovers. "I wonder—no, I've never done anything that wasn't necessary to keep the Wheels of Progress Moving." And so, when he comes to the minister with his confession:

"I just wanted to ask—tell you how it is, dominie: Here awhile ago I guess I got kind of slack. Took a few drinks and so on. What I wanted to ask is: 'How is it if a fellow cuts all out and comes back to his senses? Does it sort of, well, you might say,

does it score against him in the long run"?

The Reverend Dr. Drew was suddenly interested. "And, uh, brother—the other things, too? Women?"

"No, practically, you might say, practically, not at all."

Babbitt sees himself as a strong character, full of "Inspiration and Pep," of "Zip and Bang"; but in reality he has no will power. He is at the mercy of his habits and desires. He perpetually tries to bring his gross, sensual self into conformity with his moral ideals, and perpetually he slips back. Always he is just going to "quit his darn smoking," and never does. He tears himself from Mrs. Judique and "the Bunch," only to sneak back to them again. Finally he breaks down under the illness of his wife, whom he has tired of and neglected and deceived.

Instantly all the indignations which had been dominating him and the spiritual dramas through which he had struggled became pallid and absurd before the ancient and overwhelming realities, the standard and traditional realities, of sickness and menacing death, the long night and the thousand steadfast implications of married life. He crept back to her. As she drowsed away in the topic languor of morphia, he sat on the edge of her bed, holding her hand; for the first time in many weeks her hand abode trustfully in his.

And suddenly self-revelation comes. In the beginning of the book we find him boasting: "When I was a young man I made up my mind what I wanted to do and stuck to it through thick and thin, and that's why I'm where I am today, and—" At the end he confesses to his son Ted (who has had the courage to go his own way and marry imprudently): "Now, for Heaven's sake don't repeat this to your mother, or she'd remove what little hair I've got left, but, practically, I've never done a single thing I've wanted to in my whole life! I don't know I've accomplished anything except just get along. I figure out I've made about a quarter of an inch of a possible hundred rods. * * *"

It is a very remarkable achievement to have made such a thing as Babbitt so lovable and so alive that you watch him with a continuous thrill of pleasurable excitement. Mr. Sinclair Lewis's method of presenting him is masterly, and in the highest sense creative because it is synthetic. He does not dissect and analyze his subject, but exhibits him all of a piece in a whole skin, yet under such powerful X-rays that the organism is transparent: you see all its articulated internal machinery at work. Never for a moment do you detect the clever hand of the surgeon with his scalpel. Not once does so much as the shadow of Mr. Sinclair Lewis come between you and Babbitt. In his hands Babbitt becomes stupendous and significant.

The minor characters have not perhaps the solidity and richness of the persons of "Main Street," because in "Main Street" the pro-

tagonist is the community, and all the cast are principals, significant members of the group. Here the minor characters are important only in their relation to the central figure, but (with the exception of one fantastic caricature, the poet, Chum Frink) each one of them is drawn with the same devout reverence for reality; each is alive and whole in its own skin: Mrs. Babbitt, Vergil

Gunch, Paul Riesling and his wife, Zilla: the Babbitt children, Ted and Verona. If reality is the supreme test, Mr. Sinclair Lewis's novel is a great work of art.

And it is an advance on its predecessor in style, construction and technique. One might say it would have as many readers but that "popularity" is a mysterious and unpredictable quality. For though

nobody will recognize himself in George F. Babbitt, everybody will recognize somebody else. Here, as in "Main Street," Mr. Sinclair Lewis has hidden the profound and deterrent irony of his intention under the straightforward innocence and simplicity of his tale.

September 24, 1922

# French Successor to Henry James

A Review by
JOSEPH COLLINS

SWANN'S WAY. By Marcel Proust. Translated by C. K. Scott Moncrieff. New York: Henry Holt & Co.

IF a vote of the literary men and women of the civilized world were taken to determine the most notable man of letters in France today, there is no question that M. Marcel Proust would receive the majority—Anatole France being eliminated. Many admirers of the latter would object to his elimination, but he has now ceased to do creative work and is ornamenting his declining days by publishing one of the most delightful autobiographies of the age. If a similar vote of novel readers were taken, that is of those who read for diversion, to kill time or to dispel ennui, M. Proust would not feel flattered. I am led to this conclusion from experiment. I asked a man of middle age in Paris whose early days had been given over to art and his maturity to humanism to read "A L'Ombre des Jeunes Filles en Fleurs," which was awarded the Goncourt Prize three years ago. He reluctantly admitted, after many trials, that it was impossible. I asked a lady in New York who had been devoted to French fiction all her life to read "Sodome et Gomorrhe." Although that was a long time ago, even now she has not accomplished the task. I asked a Frenchman who facilitates his taste for literature by acting as proprietor of a bookshop in New York, in which I sought to purchase "Du Cote de Chez Swann," if he had ever read it. He admitted that he had tried many times, but never had succeeded. And so on through a list of ten intelligent "reading" men and women.

This experience would seem to contradict the statement made above, but in reality M. Proust is an author for writers. He will never be read by the large class of novel readers who create the market demand for novels of action and plot; nor will he appeal to that hardly less numerous class—chiefly women—who find the emotional novel palatable food. However, those who, like the writer, cannot punish themselves by struggling through a detective story and to whom the most skilfully contrived plot can be endured only if the harassment which it causes is counterbalanced by the charm of its literary style or its interpretation of the personality of the author reacting to

conditions more or less common to all mankind, may find in M. Proust a novelist whom they can ill afford to ignore. And no writer of fact or fiction today would be just to himself were he to go on with his art without getting acquainted with this master technician. Just as certain painters, Twachtman, for instance, to whom all young artists go for inspiration, find but a limited market for their pictures, so Proust is in all likelihood to stand as an epoch-making figure in the art of novel writing, whose name will be as inseparably connected with the novel of the future as that of De Maupassant or Poe has been with the short story of the last few decades, even while his wares will find scant sale, save to writers, dilettantes, professional students of letters, Greenwich Villagers and Hermiones.

Ezra Pound, who knows French literature as a miser knows his pocket, said of one of the books of M. Proust: "The ideal description of it would be written in one paragraph seven pages long and punctuated only by semicolons." He also said: "There is work for a master stylist in turning Proust into English; a subtile, uncreative temperament might make a career of this translation." The master stylist has been found in Mr. C. K. Scott Moncrieff. He is to be congratulated, and we trust that he will have the courage and strength to go on with the entire novel, "A la Recherche du Temps Perdue," of which "Swann's Way" is the first instalment—a work in five parts, which has given M. Proust the distinction of having written the longest novel in existence and made him the probable successor in the world of letters to the chair of Henry James, whom he resembles in technique, awareness and analysis.

It is difficult to attempt an estimate of this book without considering it in its relation to the others of the series. Moreover, it lends itself to evaluation on many different planes. But, for the present at least, it is from this book that English-speaking readers must judge the author's work. As all the qualities of style, of method, of individuality which go to make up his art are to be found in it in full flower, it is only in regard to the unity of the series and to the cumulative effect with which the mind of the reader is impressed with the work as a vital force in literature that one must, to

any degree, suspend judgment.

"Swann's Way" opens with the dreamy but vivid thoughts floating through the mind of the narrator in the borderland between waking and sleeping and recalling the sequence of impressions of a childhood which practically all critics and reviewers have identified with his own, but which identity he denies. In a letter to André Lang, in reply to a request for an interview, he said: "I had the misfortune to begin a book with the word 'I,' and immediately it was supposed that instead of seeking to discover general laws I analyzed myself as an individual, a detestable meaning of the word." With these memories the narrative continues for more than one-third of the two volumes. At the outset of this recital of childish memories a figure is flashed upon the consciousness of the reader so unobtrusively and yet so significantly that, although he plays a very subordinate rôle in the actual life of the child, the reader is prepared without question or surprise to accept him as the outstanding figure throughout the remaining two-thirds of the narrative. This figure is Swann, whose initial appearance as the dinner guest of the family on the evening which was stamped indelibly in the child's memory by a peculiar emotional experience. The art of the author is epitomized in this introduction of Swann as a prelude to his linking up with the narrative in which he is to take the leading part. It is through the mind of the child that we are to know Swann. The events of Swann's life are not known to the child until long after this evening, still when they are known they are known only through the child's already formed conception of Swann, and this conception is bound up with the temperamental qualities which brought about the child's reaction to the quite commonplace circumstance of Swann's presence at dinner that night.

The delicate, rather lonely, profoundly sensitive little boy in a charming setting of old French country house, almost overshadowed by an august array of parents, grandparents and great-aunt with decided ideas in regard to discipline, is sent off carelessly to bed without the good-night kiss of his mother, which has come to represent the one emotional expression of his over-regulated existence. After working himself up into a state of nervous excitement in which sleep was impossible, he conceives the idea of sending a note to be slipped into his mother's hand at the dinner table. Although he knows that his punishment may be drastic, his desperation has made him reckless of consequences. But even in such a state of mild frenzy he is still haunted by a dread of the ridicule of the guest, should Swann know of the note.

As for the agony through which I had just passed, I imagined that Swann would have laughed heartily at it if he had read my letter and had guessed its purpose; whereas, on the contrary, as I was to learn in due course, a similar anguish had been the bane of his life for many years, and no one perhaps could have understood my feelings at that moment so well as himself • • • to him that anguish came through Love, to which it is in a sense predestined, by which it must be equipped and adapted; but when, as had befallen me, such an anguish possesses one's soul before Love has entered into one's life, then it must drift, awaiting Love's coming, vague and free, with no precise attachment, at the disposal of one sentiment today, of another tomorrow, of filial piety or affection for a comrade.

Although the reader has no suspicion of it at the time—no more than had the child on the night of the occurrence—he is prepared for the sympathetic subtlety with which Swann's love story is unfolded in the latter part of the first and most of the second volume. Such a story as, viewed from the outside and told by any mere novelist, would be either pathetically or ridiculously sordid, is made the vehicle for interpreting the personality of the Charles Swann whom the writer knew, lovable by reason of delicacy of feeling, charm of nature and every grace which culture of mind, a background of wealth and familiarity with the salons of the Faubourg St. Germain could give.

This story, which is the forerunner of what is referred to by the neighbors as Swann's "unfortunate marriage," is not made known to the reader, as it was not to the child, until after he has long known Swann, the country neighbor and frequent guest, to whose house he was not allowed to go because Swann's wife was not "received" by the ladies of the writer's household or their circle. Finally, while walking one day, the child sees the wife and little daughter of Swann and hears the latter's name, Gilberte, and the fascination of the mysterious and the forbidden takes hold of him. The reader knows at once that another link in the form of a love affair with this daughter is welded in the chain which binds the narrator's life up with that of Swann.

Swann's love for Odette de Crecy, the mistress he has married, and its dissolution is the substance of the book. His consummate mastery of psychological analysis is contained in the pages devoted to the interpretation of the dissolution of their love, and particularly to a reincarnation of all the joys and particularities of their love by a casual encounter with a little phrase of a sonata rendered by Vinteuil.

In his little phrase, albeit it presented to the mind's eye a clouded surface, there was contained, one felt, a matter so consistent, so explicit, to which the phrase gave so new, so original a force that those who once heard it preserved the memory of it in the treasure chamber of their minds. Swann would repair to it as to a conception of love and happiness. • Even when he was not thinking of the little phrase it existed latent in his mind, in the same way as certain conceptions without material equivalent, such as our notions of light, of sound, of perspective, of bodily desire, the rich possessions wherewith our inner temple is diversified and adorned.

This evocation of associated memories and the vicarious appeasement of love's clamors, and the masterly way with which he characterizes the individuals that he encounters in society are the salient, praiseworthy features of the book. M. Proust always insists upon the recognition of the mutual interaction of personality, refusing to consider any person as a set of qualities distinct and fixed. He always views such qualities as fluid and subject to varying reactions from the influence of other personalities. Things exist for him largely in their association with experiences. An illustration of this is in the train of feelings suddenly thrust into his consciousness by the taste of a "madeleine" dipped in tea long after the occurrences associated with the first taste in his childhood of the simple combination of the little cake and the tea had been forgotten by his conscious mind.

Another and one of the most exquisite flashes of feeling in recent fiction is when he closes the section devoted to the memories of the little boy with a tribute to the two roads over which the walks of his childhood at his country home were always started. In truth he has the faculty of making the reader believe that he himself must have experienced the sensations that his characters experience. This is particularly evident in his description of childhood memories. No one who had not felt them could have imagined the peculiar agonies of the child on the night when Swann's presence as a dinner guest became the obstacle to his mother's customary good-night visit. To all the world, except such a child, his performance on that occasion would have been merely a "tantrum"; any by the strange alchemy of nature to only a child who was capable of experiencing such agony for such a cause is it given later in life to catch the million subtle vibrations from a groaning, weeping, laughing, loving and dying world which are to most of us meaningless, or at best commonplace noises.

Although M. Proust has been writing for many years, it was not until the Goncourt Prize was awarded him that he was heard of outside of his circle of friends. When he was one-half of his present age, that is twenty-five, his first book appeared. It was called "Pleasures and Days," and Anatole France wrote a preface for it in which he referred to the author as "an ingenuous Petronius" and "a depraved Bernardine de Saint Pierre," but there is nothing to recall the author of the "Satyricon" in the volumes that have brought him fame, and his style is the absolute antithesis of the literary Latin of the Silver Age. It is possible that M. France may have detected in his young fellow-countryman the curiosa felicitas which Petronius found in Horace, but "Remembrance of Things Past" does not corroborate it.

M. Proust is more than an analytic novelist, more than a writer of self-revelations. In the letter to André Lang, already quoted and published in "Voyage en Zigzags dans la République des Lettres," he expresses his dislike of the term analytic novel, and prefers to substitute for it that of "introspective novel," saying that his favorite working instrument is the telescope, not the microscope, with which it has often been alleged he works. Introspective his work unquestionably is, but not in the limited sense in which the term fitly describes many books devoted entirely to the analysis of the author's own personality. Instead of trying to show his own personality through his reaction to circumstance, M. Proust shows us the world about him through his reactions to it. Instead of making the world his mirror through which to give a reflection of himself, he reverses the process and makes himself the mirror through which the world as he faces it is reflected with almost superhuman subtlety and luminosity. Or, to use his own word, he makes his own personality, with its overrefinement of sensibility, its tremendous breadth of vision, its excessive capacity for sympathy, the telescope through which the reader can view soul stuff that is invisible to the naked eye. It is this larger attitude of concern with the world that distinguishes him in one sense so emphatically from the ordinarily introspective writers; and this larger interest is the more remarkable, and probably by this very fact the more essentially a part of his nature, because he is and has been, if not a de facto invalid, certainly a potential invalid. In his reply to a request for an interview in the letter already quoted he says that the caprices of fragile health did not permit him to make engagements for the future and that he could never make any appointments whatever. This invalidism shows all through his writings. M. Proust has encouraged the reputation of being an invalid. Some of his friends accuse asthma, others maintain he suffers from a disease of the heart, while others still attribute it to "nerves." In reality his conduct and his writing are consistent with neuropathy.

The best brief description of him and of his picturesque mannerisms has been given by one of his friends, M. Maurice Verne:

Byzantine in appearance, his hair cut even with his eyebrows, in antique fashion; his face heavy-chinned, sensual, lazy, intelligent, sombre. A bundle of aching nerves, hypersensitive to his external surroundings. The hypertrophy of the invalid's nervous system renders him so sensitive that lying in bed on the fifth floor of his residence he feels the innocent draft created on the ground floor by the opening of the door of the servants' stairway.

His life reminds one of the hero of Huysmans's famous novel. In his early days M. Proust was a great swell, and there is no doubt that many of his descriptions of incidents and persons are elaborations of notes that he made after attending a reception given by the Duchesse de Rohan or of notables of the Faubourg St. Germain, at which he was an habitué.

His social activity may have been deliberate preparation for his work, as his fifteen-year apprenticeship to

John Ruskin was preparation. Or it may have been a pose, much the same as his mannerism, habits, customs, and perhaps illness, are a pose, though the latter may be wholly a defense phenomenon. Surely he has enjoyed the reputation of being "different." M. Verne writes:

If he paid you a visit, it was toward 2 in the morning. If he consented to receive a visit, he charged you not to come before 11 at night, "as I am very ill and keep my bed save in the intervals

of resting from my attacks. Come tomorrow, if you like, toward 5 o'clock. I will receive you in bed. And this holds good for any day you may choose, unless by chance the day should be the morrow of a day I go out, in which case I will send you word, for on such occasions I suffer until 11 at night."

To his natural gift of a vision as remarkable for breadth as for acuteness M. Proust has added the refinements of an extensive culture. The influence of Saint-Simon, Stendhal and Ruskin is evidenced in all

his writings. But he is no mirror of literary immortals, no purveyor of other writers' ideas, be they critic, philosopher or author. He is a creator of great literature, a master of uncommon style, with a profound knowledge of the human heart and head.

We cannot be sufficiently grateful that he has never heard the name Freud.

November 26, 1922

## "SPOOFING" THE PHILISTINES.

Of between thirty-five and forty thousand registered American poets, with their licenses in due form, Mr. T. S. ELIOT is, according to our knowledge and belief, the most illustrious, original and sky-scraping. We mean, of course, the most illustrious, and so on, of the younger or youngest generation of poets, and more than fifteen years old. Acknowledged ancients like Mr. ROBINSON and Mr. FROST are out of the competition. Mr. ELIOT is, it is understood, a graduate of Harvard, which is now expected to furnish our sublimest young poets while Yale and Princeton specialize in novelists and critics. Mr. ELIOT has himself wandered into criticism, into "The Sacred Wood"; but he was beloved by connoisseurs for his volume of poems even before his "Waste Land" got a $2,000 prize and filled all the registered and unregistered poets with wonder or with envy.

Mr. ELIOT's first publication bore a Provençal title. The richness and solemnity of the notes in "The Waste Land" show the variety of his reading. To some

critics they have the taste of pedantry; to others, more skeptical, they seem the marks of a hoax. Miss EDITH SITWELL's "Promenade Sentimentale," published in The Spectator, and rich in "sheepish buds" and "lambs and cuds" and various other little pleasantries and artificialities, filled Mr. STRACHEY's serious adherents with puzzled but respectful thoughts. It seemed to be obscure. Therefore it must be great; and greatly was it commented upon and explicated. DONNE, COWLEY, BLAKE, BROWNING; "obscurity" conscious or unconscious, SHAKESPEARE'S Sonnets and various other "problems" were discussed. It has come to be the general opinion that Miss SITWELL was simply stringing nonsense together for the purpose of "having fun" with Mr. STRACHEY'S serious constituency.

Mrs. A. WILLIAMS-ELLIS, however, The Spectator's poetry expert, certifies that "Miss SITWELL never tries to pull any one's leg in a poem." By "pulling one's leg" she means what the Americans call "to spoof," "to josh," "to have fun with," to mystify. Mr. ELIOT's "Waste Land" is obscure. Some of his

learned friends boast that LYCOPHRON'S "Cassandra" is no more ambiguous or cloudy an oracle. A writer in The Dial, giver of the prize, assures us that "The Waste Land," in only a little more than 400 lines, contains thirty-three quotations, allusions or parodies. In The Chapbook Mr. HAROLD MONRO, in an imaginary dialogue with Mr. ELIOT, says: "I have heard it suggested that you write for one hypothetical intelligent reader."

"Well," answers Mr. ELIOT darkly. "Do you think such a reader at present exists?" asks Mr. MONRO. "I am not sure," is the answer. "Do you think, perhaps, that he is yet to be born?" "That depends," replies the ever Orphic poet. Mr. ELIOT can afford to wait, if necessary, till the one intelligent reader is born. Meanwhile, he can say with DANTE: "Admire the doctrine hidden under the veil of strange verses." The Philistines deserve "spoofing," but Mr. ELIOT may say of them: "Let them drink molten pearls, nor count the "cost."

March 4, 1923

## NEGRO WINS PRIZE IN POETRY CONTEST

### N. Y. U. Student Takes Second Honors Among Undergraduates of 53 Colleges.

### IS SON OF PASTOR HERE

"The Ballad of the Brown Girl" His Second Success—Chicago Youth Is First.

Countee P. Cullen, a negro student at New York University, has won second prize in the Witter Bynner undergraduate poetry contest, according to an announcement from the Poetry Society of

America, under whose auspices the contest was held. Cullen was one of the 700 undergraduates, representing sixty-three colleges and universities, entered in the competition. The judges were Carl Sandburg, Alice Corbin and Mr. Bynner. Cullen received one vote, while the other two chose Maurice Leseman's "In the Range Country" as the winning poem. Leseman represented the University of Chicago.
Cullen's topic was "The Ballad of the Brown Girl." The poem is 200 lines in length. Its theme is:

Oh, lovers, never barter love
For gold or fertile lands,
For love is meat and love is drink,
And love heeds love's commands.

And love is shelter from the rain
And scowling stormy skies;
Who casts off love must break his heart
And rue it till he dies.

Cullen is the son of the Rev. Frederick A. Cullen of 234 West 131st Street, pastor of the Salem Methodist Church. He is 20 years old and a student in the junior class of the College of Arts and Pure Science. Many of his contributions have been printed in various magazines. His writing first attracted attention when he was a student at De Witt Clinton High School, where he won the poetry prize offered by the Federation of Women's Clubs. His effort for that contest took the form of a parody on Alan Seeger's "I Have a

Rendezvous With Death," which Cullen called "I Have a Rendezvous With Life." This poem follows:

I have a rendezvous with Life,
In days I hope will come
Ere youth has sped and strength of mind,
Ere voices sweet grow dumb;
I have a rendezvous with Life
When Spring's first heralds hum.

Sure, some would cry it better far
To crown their days in sleep,
Than face the wind, the road and rain,
To heed the falling deep.
Though wet, nor blow, nor space, I fear,
Yet fear I deeply too,
Lest Death should greet and claim me ere
I keep Life's rendezvous.

Cullen says he is interested in poetry for poetry's sake and not for propaganda purposes. "In spite of myself," he adds, "however, I find that I am actuated by a strong sense of race consciousness. This grows upon me. I find, as I grow older; and although I struggle against it, it colors my writing, I fear, in spite of everything I can do. There have been many things in my life that have hurt me, and I find that the surest relief from these hurts is in writing."
Cullen, who has another year at New York University before receiving his degree, plans a teaching career after graduation.

December 2, 1923

# Paris, the Literary Capital of the United States

## French Atmosphere For American Writing

### By MERLE SCHUSTER

PARIS

CUSTOMS inspectors at the Gare Saint Lazare have been puzzled by the troupe of little black boxes that seems to arrive with every boatload of Americans. The mysterious little case is carried gently, almost ceremoniously, into the douane. Its owner guards it more than half a dozen trunks of full-fashioned silk stockings. Too heavy for an overnight bag, too small for a valise, is it possible that this is a new variety of kodak? Is there perhaps some recent standardization of hand baggage in those United States? For these little black cases are noticeably uniform in size, weight and color.

The fact is, the little black cases are portable typewriters, brought to Paris by the literary insurgents of America. Each one represents, potentially, the great American novel. Chicago must surrender its leadership as the literary capital of America to Paris.

In Paris the American author seems to get the right perspective of his native land. Three thousand miles away, he finds himself better able to interpret or criticize the land of the free. Permeated by the French atmosphere, he suddenly develops a huge interest in America, and this interest, in turn, expresses itself usually in the form of a full-sized novel. More important novels by American authors have been written in Europe during the last twelve months than in any city in the United States.

Take, for example, "Babbitt," than which there is no more characteristic American novel. Sinclair Lewis wrote it abroad. The contrast of the foreign business man inspired him, perhaps, to write a more biting satire on the American business man than if he had chosen to write about Babbitt in the midst of Babbitts.

Frederick O'Brien comes to Paris to write his South Sea stories. He is here now, working on a new book when he is not watching the world go by his table on the terrasse of Vetzel's Café, opposite the Opéra. Not very long ago he was the centre of an American group at the Café de Dome, on the Boulevard de Montparnasse. In the opposite corner of the same café Sinclair Lewis was having a Cressonère with another group of Americans. The spectacle

of two of the most successful American writers in the same small café, neither recognizing the other, was by no means unusual.

Willa Cather's latest novel, "The Lost Lady," was written last year in Paris. She came here to escape the social whirl of New York's literary circle. Tourists come here to enjoy a round of gayety such as they can find only in Paris. But Willa Cather sought quiet here, and she found it. Certainly there is no city in the world like Paris; one finds here whatever one looks for.

Robert Service makes his home in Paris. He takes frequent trips to New York to arrange to have his books published there, but he writes his poetry here. He came to this city ten years ago to collect his verse into a volume; he married a Frenchwoman and found the atmosphere of Paris so conductive to his best work that he has been working here ever since.

Then, of course, there is the case of probably our most distinguished woman novelist. For ten years Edith Wharton has been doing her work in Paris. She came here during the war to do Red Cross work, and she has chosen to remain in Paris. Her novels are well known in France as well as in America, partly because she also writes in French and is a regular contributor to the best French magazines. Her name is not infrequently to be found in the table of contents of La Revue des Deux Mondes.

Like Edith Wharton, Dorothy Canfield Fisher came to Paris during the war to work for the blind. She, too, has been writing her novels here ever since. In fact, the French influence is dominant in at least her best-selling novel, "Rough-Hewn," and can be traced in her latest book, "Raw Material."

To follow the work of these important writers who have been doing their best work in Paris is interesting enough, but it is perhaps more interesting to note that more and more of the younger generation in literature are finding Paris a haven for attacks on American customs and culture. The fever for writing a book in Paris seems to have infected almost every "young intellectual in America." It is amazing to count the number of American books that were born or are being born in Paris in 1923.

Donald Ogden Stewart wrote a letter to Deems Taylor that describes the fever in his unique style. It read: "Deems, dear, I'm going to have a novel. Break it gently to Mary; tell her about the birds and flowers first, you know what to say. And Deems, I am going to Paris to have it. . . ." Then followed all the symptoms—over-eating, circles under the eyes, irritability, &c., &c.,

until a woman friend said when she read it, "I've had three children myself, but Don seems to know more about it than I do!" The sad truth is that Stewart never did succeed in giving birth to his novel; it turned out to be just another parody, christened "Aunt Polly's History of Mankind."

Edna St. Vincent Millay wrote a novel called "Hardigut" in Paris last year. Her publisher bought the book before he saw it. "Hardigut" was advertised in the advance catalogues of Boni & Liveright as the forthcoming first novel of the woman, sometimes called the greatest poetess since Sapho. Every one expected "Hardigut," a medieval allegorical romance, to be the sensation of the 1923 publishing year. When Miss Millay returned to America with the completed manuscript "Hardigut" suddenly died. It wasn't published. No one knew what had happened to the book. Rumor has it that the publishers asked Miss Millay to call at their offices to discuss certain publishing details. When she got there she asked to see her manuscript for a moment, and then with a gesture that befits only a woman genius tore it up and scattered the fragments. Her admirers whisper something about "literary conscience." The cynics add something about her Nancy Boyd prose style endangering her reputation as a poet.

Gilbert Seldes recently returned to New York. He had left his duties as editor of The Dial to go to Paris last Summer to join the little group of serious writers. In a tiny little court apartment on the Ile Saint Louis, where not even the incessant honking of the Paris taxi horns could disturb, he completed his book on "The Seven Modern Arts." He lived at the time with Louis Galantière, Paris literary correspondent of The New York Tribune, who when not in the throes of translating Jean Cocteau's "Le Grand Ecart" for an American publisher, is deciding which of the two titles shall grace the cover of his first novel soon to be finished. Galantière's work is so well thought of here that those in the know will not be surprised if he is awarded the prize last year given to Raymond Radiguet for "Le Diable Au Corps." Radiguet's book is now being translated for American publication. Galantière is an American citizen of French extraction.

Harold Stearns, of course, does all his writing in Paris. "The Young Intellectual in America" was accomplished somewhere between the Boulevarde Montparnasse and the Delmabre Maison de Bains. At present, when he is not writing his Paris Letter for "Town and Country" or drinking an Amer Picon at American headquarters in Paris—The

Dome—he is working on a new tome, probably another attack on civilization in the United States. In that atmosphere he finds himself best able to collect his resentments against America and Americans.

Side by side with the writers of the last generation who have chosen to do all their work in Paris, such as Alvan Sanborn, Ezra Pound and F. Berkeley Smith, all of whom have married into French families and are completely Francophile, we find such strange mushrooms in the literary field as Gertrude Stein. In her atelier here, she evolved "Geography and Plays" that opens with the incomparable lines:

Sweet tea, sweet tea.
Sweet, sweet, sweet, sweet tea.

*  *  *

Accompanied by several trunks of household effects, from dishpans to dusters, Anzia Yeszierska breezed into Paris last Summer to get atmosphere for the last story in her forthcoming book of short stories. Knowing only the one French word "où," which she thrust into the face of a taxi driver with the address of her destination on a slip of paper, "they say" she managed to get quite an unusual atmosphere.

John Willard, author of " The Cat and the Canary" has just taken an apartment in Paris for the express purpose of completing his new play, "The Green Beetle." He says it will undoubtedly out-mystery his other mystery success. Mr. Willard was calling for his mail one morning at the American Express Company office when he met Solita Solano who used to act in the same company with him. It developed that Miss Solano, too, had come to Paris to write. At a banquet in New York she recently met Mr. George Putnam and casually mentioned to him that she was working on her first novel. Mr. Putnam asked to see what she had so far written. Having read the

half of the manuscript that was finished, he immediately offered to publish the book. Miss Solano is now completing the manuscript and G. P. Putnam's Sons will bring it out under their stamp in August.

Miss Solano has just found an apartment which she will share with three other American girls, Janet Flanner, Leda Bauerberg and Margaret Lee, each of whom is writing her first novel. Curiously enough, these embryonic authoresses subleased the apartment from an American writer, Walter Adolphe Roberts, author of 'Pierrot Wounded and Other Poems." Mr. Roberts has just completed his first novel "Austin Bride" and is on his way to New York now to have it published. The spectacle of an author moving out, with a manuscript under one arm and a portable typewriter under the other, and four writers moving in, each carrying her own little black typewriter case, was characteristic. The number of American writers in Paris seems to be increasing in just that proportion * * * four to one.

In addition to all these writers who come to do serious work in Paris and who really spend at least six hours a day (every day) at their work there is always to be found day or night a group of "young ineffectuals" at the well-known Café de Dome. These are the literateurs who spend their time worrying about when they will start their books. While they worry, of course, the saucers under their liqueurs pile up with amazing speed and the hours flit by on wings.

There is, for instance, "one" Dunning. He has spent most of his twenty years in Paris at this café. They say he is a poet, but none of his poetry has ever been published. No one ever sees his poems, but he is always pointed out as Dunning the poet. He has already attained his reputation, why bother about the

poetry? The story goes that he once saved up 1,200 francs to pay for having a volume published. But the souscoups tempted him to spend that small fortune and he has never since been able to save enough to pay a printer.

Joseph Gollomb has just returned to the Café de Dome. Until last year his chief reason for fame was the fact that he was Zoe Beckley's husband. This Fall, however, his first book, a mystery story, "The Girl in the Fog," written in Paris, was published and favorably accepted by the critics. He is back here writing another novel. One may see him often at the Dome, playing chess or drinking beer with Henry Altimus or Art and Helen Moss.

No one can tell how many other American writers there are in Paris who are working away quietly and unostentatiously. There is the instance of Louise Gebhard Cann, frequent contributor to The International Studio. Miss Cann may be seen at the Bibliothèque Nationale every day working on a "Life of Monticelli" that promises to be the most important opus ever written about that artist. Having been accepted for publication upon completion by an English as well as an American house, there is already talk of a French translation.

Carl Van Vechten wrote "Peter Whiffle" in Paris. It is whispered in Dial circles that Scofield Thayer wrote a book on the theatre during the year he spent abroad. Sherwood Anderson completed several new short stories while he was in Paris last year. John Peale Bishop of Vanity Fair and "An Undertaker's Garland" did some writing here, as did also Don Marquis. Even Olga Petrova did some work on a new play last Summer in Paris when she was not at Jean Patou's or Lanvin's ordering new gowns.

December 23, 1923

## TOPICS OF THE TIMES.

**A New Literary Weekly.** The first number of The Saturday Review of Literature bears in its advertising columns promise of prosperity which its friends will hope to see abundantly realized. In form and in context—judging the latter not only from the initial issue but from the program outlined by the editor—the new Review is virtually a continuation of the Literary Review of The New York Evening Post, as conducted until a few months ago by HENRY SEIDEL CANBY.

He has brought over with him the entire staff of the old Review reinforced by another Evening Post alumnus in the person of CHRISTOPHER MORLEY, who will roll his bowls on his well-known Green only one-sixth as often as he used to do in The Evening Post, but with the old dexterity, if one may judge from his first long-distance try all the way from the coast of Normandy.

A weekly publication devoted exclusively to literary criticism is an experiment in the sense of being a novelty in this country. Its success should not be experimental in view of the extraordinary increase of popular interest in the field of literary discussion—and combat.

The present-day ferment has more than spilled over into the world of books. The wars of the "generations" have been fought in great measure with books as ammunition.

In his former editorship Professor CANBY succeeded in combining neutrality between the combatants with a notably high standard of competence in his individual reviewers. It is his promise that the broad sympathies of his former publication will be retained and that in its columns will be found adequate treatment of both the literature that is "timely" and the literature that is "timeless." That is all one can ask, with the single reservation that suffi-

cient caution be displayed in distinguishing between the timely and the timeless. Not all contemporary criticism is hesitant about slating for eternity what tickles it today.

To the handsome physical make-up of The Saturday Review we would register just one objection. The text of WILLIAM ROSE BENÉT's "Phoenix Nest," successor to the earlier "Lobby," is as charming as ever. But the pale intercalary phoenixes are rather distracting. The bird should once more be relegated to the flames.

August 1, 1924

## THE NEW EUPHUES.

Our learned and adventurous contemporary, The Dial, has a passion for discovery in all the arts. With a catholic hand it seeks originality. Its largesse to its prize poets is most laudable. It makes the waste land of literature blossom and bear. Yet, collector of all genius as it is, its own is most admirable. In its commentary on the "Observations" of Miss MARIANNE MOORE, its latest and perhaps most marvelous

laureate, it falls into such a solemn frolic of fancy, it reveals such multilateral gift of expression, that the reader can't help feeling that the commentary is worthy of the poem. For example:

I should here like to expose certain literary fragments, torn jaggedly from the hard context, fragments which, being felt out with the hammer of our intellect, return the consistency of rock-crystal, fragments which, being thrown upon the hearth of our sympathetic understanding, betray the immense, the salt-veined, the profoundly premeditated

chromatization of enkindled driftwood:
"It is a far cry from the 'queen full of jewels'
and the beau with the muff,
from the gilt coach shaped like a perfume bottle,
to the conjunction of the Monongahela and the Allegheny,
and the scholastic philosophy of the wilderness

* *

to combat which one must stand outside and laugh
since to go in is to be lost."

It used to be a long way to Tipperary, but it is a longer and labyrinthine

way to Pittsburgh; and when you get there or somewhere, the scholastic philosophy of the wilderness has still to be found. Let us compare this elaborate Cretan poetry with the simplest geographic notation of "The Belle of New York":

> It's fourteen miles from Schenectady to Troy,
> You want to keep tab on that, my boy,
> And when you get there it's a darn long walk
> To the great Rialto of New York.

That is pedestrian verse; but its main fault is that it is intelligible. Poetry, to be poetry, must mean nothing at first reading, mean everything, suggest things innumerable and possibly wonderful. It is a cross puzzle without key or diagram. You can't stand outside and laugh at it. You must go into it, get lost in the darkness. In the end you will see the "beacon" which The Dial has "decided to endeavor to keep alight." You will not only see the light, but the chromatized enkindled driftwood burning at the junction and conjunction. The Dialist compares the prose and the intellect of BACON with the intellect and the verse of Miss MOORE, to the disadvantage of the former:

> One may sit a long time in the mullioned and leaded and Tudor embrasures of that Lord Keeper of the Great Seal before one makes out a "beau with the muff" or a "gilt coach shaped like a perfume bottle." Nor if you do espy such, will you likely espy them in the predicament of a confrontation with "the "conjunction of the Monongahela and the "Allegheny." In other words, you will not generally uncover in those deeply spaded Essays wild images of the imagination, images that have been culled abroad, and encompassed here for their own sweet-smelling sakes; still less will you find such intricately juxtaposed to one another, with the odd, quizzical, poet's appetition for the showering criss-cross of quite inextricable and quite soul-dissolving overtones. Miss MARIANNE MOORE and Sir FRANCIS BACON alike possess the analytical mind: Miss MARIANNE MOORE possesses an analytical nose also, and is (as a woman should be) inclined to follow it. And her analyses, inordinately ordinate as they so victoriously are, subserve an end beyond analysis; their admirable elbows admirably ad hoc, their high rearings and higher boltings, their altogether porcupinity impeccable—these are just Miss MOORE's private ways of delivering Miss MOORE's esthetic fact. "By their fruits ye shall know them"; and by their poetical end are these wanderingly suspended periods constituted a poetical technique as legitimate as the traditionally ordained verbal complication of a Provençal sestina.

O GONGORA! O EUPHUES! O EZRA POUND! O GERTRUDE STEIN! O admirable elbows admirably crooked at the gold bar of heaven! In the presence of this altogether concinnity impeccable, high rears and higher bolts in the memory that Pegasus which Commissioner of Public Works J. ROLLIN M. SQUIRE rode in the City Hall Park till he was thrown; from 1885 arise the quite soul-dissolving overtones of his threnody on General GRANT:

> No faltering marked the Titan's task,
> No shrinking from the trial;
> He faced the foe e'er Freedom's hand
> Fell shattered from Time's Dial!

February 8, 1925

---

### A NEW WEEKLY COMING.

**The New Yorker, Out Tomorrow, Aims to Reflect Life Here.**

The New Yorker, a new metropolitan weekly, will make its first appearance tomorrow. The new publication comes just two hundred years after the founding of Manhattan's first periodical, The New York Gazette, in 1725. The new weekly aims to be a reflection of New York life. It will be issued under the auspices of an advisory board which includes Ralph Barton, Marc Connelly, Rea Irvin, George S. Kaufman, Alice Duer Miller, Dorothy Parker and Alexander Woollcott. Advance announcement of the publication says:

"It will be human. Its general tone will be of wit, gayety and satire, but it will be more than a jester. It will be what is commonly called sophisticated, in that it will assume a reasonable degree of enlightenment on the part of its readers."

February 16, 1925

---

# Scott Fitzgerald Looks Into Middle Age

THE GREAT GATSBY. By F. Scott Fitzgerald. New York: Charles Scribner's Sons. $2.

OF the many new writers that sprang into notice with the advent of the post-war period, Scott Fitzgerald has remained the steadiest performer and the most entertaining. Short stories, novels and a play have followed with consistent regularity since he became the philosopher of the flapper with "This Side of Paradise." With shrewd observation and humor he reflected the Jazz Age. Now he has said farewell to his flappers—perhaps because they have grown up—and is writing of the older sisters that have married. But marriage has not changed their world, only the locale of their parties. To use a phrase of Burton Rascoe's—his hurt romantics are still seeking that other side of paradise. And it might almost be said that "The Great Gatsby" is the last stage of illusion in this absurd chase. For middle age is certainly creeping up on Mr. Fitzgerald's flappers.

In all great arid spots nature provides an oasis. So when the Atlantic seaboard was hermetically sealed by law, nature provided an outlet, or inlet rather, in Long Island. A place of innate natural charm, it became lush and luxurious under the stress of this excessive attention, a seat of festive activities. It expresses one phase of the great grotesque spectacle of our American scene. It is humor, irony, ribaldry, pathos and loveliness. Out of this grotesque fusion of incongruities has slowly become conscious a new humor—a strictly American product. It is not sensibility, as witness the writings of Don Marquis, Robert Benchley and Ring Lardner. It is the spirit of "Processional" and Donald Douglas's "The Grand Inquisitor"; a conflict of spirituality caught fast in the web of our commercial life. Both boisterous and tragic, it animates this new novel by Mr. Fitzgerald with whimsical magic and simple pathos that is realized with economy and restraint.

The story of Jay Gatsby of West Egg is told by Nick Carraway, who is one of the legion from the Middle West who have moved on to New York to win from its restless indifference—well, the aspiration that arises in the Middle West—and finds in Long Island a fascinating but dangerous playground. In the method of telling, "The Great Gatsby" is reminiscent of Henry James's "Turn of the Screw." You will recall that the evil of that mysterious tale which so endangered the two children was never exactly stated beyond a suggested generalization. Gatsby's fortune, business, even his connection with underworld figures, remain vague generalizations. He is wealthy, powerful, a man who knows how to get things done. He has no friends, only business associates, and the throngs who come to his Saturday night parties. Of his uncompromising love — his love for Daisy Buchanan—his effort to recapture the past romance—we are explicitly informed. This patient romantic hopefulness against existing conditions, symbolizes Gatsby. And like the "Turn of the Screw," "The Great Gatsby" is more a long short story than a novel.

Nick Carraway had known Tom Buchanan at New Haven. Daisy, his wife, was a distant cousin. When he came East Nick was asked to call at their place at East Egg. The post-war reactions were at their height—every one was restless—every one was looking for a substitute for the excitement of the war years. Buchanan had acquired another woman. Daisy was bored, broken in spirit and neglected. Gatsby, his parties and his mysterious wealth were the gossip of the hour. At the Buchanans Nick met Jordan Baker; through them both Daisy again meets Gatsby, to whom she had been engaged before she married Buchanan. The inevitable consequence that follows, in which violence takes its toll, is almost incidental, for in the overtones—and this is a book of potent overtones—the decay of souls is more tragic. With sensitive insight and keen psychological observation, Fitzgerald discloses in these people a meanness of spirit, carelessness and absence of loyalties. He cannot hate them, for they are dumb in their insensate selfishness, and only to be pitied. The philosopher of the flapper has escaped the mordant, but he has turned grave. A curious book, a mystical, glamourous story of today. It takes a deeper cut at life than hitherto has been essayed by Mr. Fitzgerald. He writes well—he always has—for he writes naturally, and his sense of form is becoming perfected.

EDWIN CLARK.

April 19, 1925

# RADICAL MAGAZINE BACKED BY $1,500,000

**The New Masses, Soon to Appear, Supported by American Fund for Public Service.**

## FIVE EDITORS TO CONDUCT IT

Sherwood Anderson, Van Wyck Brooks and Eugene O'Neill to Contribute.

A new radical magazine of arts and letters, without political affiliations or propaganda obligations but with sympathy and allegiance unqualifiedly with the international labor movement, will shortly make its appearance, according to an announcement made yesterday by James Rorty, one of five editors.

The magazine will be called The New Masses and, according to the publishers, the cost of publication for the first three years has been underwritten by the American Fund for Public Service. At the expiration of that period the magazine is expected to be able to pay its own way.

The list of names of the editors, executive board and contributing editors comprises not only a number of the principal radical leaders but also a number of men and women who have attained renown for their contributions to art and literature.

Morris L. Ernst, General Counsel for the American Fund for Public Service, said last night that the Fund was unreservedly behind the new magazine. He said the Fund's total resources at the present time were approximately $1,500,-000 and of this amount about $1,000,-000 profit was made during the past year on stock investments.

He said the first issue of the new publication would probably make its appearance in about six weeks or two months.

The New Masses, according to the preliminary announcement will print "poetry, short stories, book reviews, dramatic and movie criticism, first hand reports of big strikes and other national events, cartoons, serious drawings and sketches."

The editors are Michael Gold, Joseph Freeman, James Rorty, Hugo Gellert and John Sloan. The list of contributing editors includes Sherwood Anderson and Van Wyck Brooks, both winners of the $2,000 Dial prize for the best work in American letters; Carl Sandberg, winner of the Poetry Society prize of $500 for the best volume of verse published by an American author; Eugene O'Neill, playright and author of "The Emperor Jones," "Desire Under the Elms," "Anna Christie" and other plays; Boardman Robinson, artist and illustrator, and Max Eastman, author of a biography of Lenin, and well-known radical writer.

Others on the list include John Howard Lawson and Elmer Rice, authors of many successful plays; Louis Untermeyer, poet; Upton Sinclair, author of "The Jungle," Cornelia Barns, Carleton Beals, Howard Brubaker, Stuart Chase, Glenn Coleman, Miguel Covarrubias, Stuart Davis, Adolph Denn, Waldo Frank, Arturo Giovanitti, Susan Glaspell, M. J. Glintenkamp, John Howard Lawson, Claude McKay, Gorham B. Munson, Lola Ridge, Jean Toomer, Mary Heaton Vorse, Eric Waldron, Walter F. White, Edmund Wilson Jr. and Charles W. Wood.

The Executive Board will consist of Maurice Becker, Helen Black, John Dos Passos, Joseph Freeman, Hugo Gellert, Michael Gold, William Gropper, Freda Kirchwey, Louis Lozowick, Lewis Mumford, James Rorty, John Sloan and Art Young.

The American Fund for Public Service was incorporated in 1920, when Charles Garland, son of a wealthy Boston man, refused to accept an inheritance of $1,000,000 and donated the bulk of it to the fund "for the benefit of all."

Officials of the fund include Norman Thomas and Lewis Gannett, associate editors of The Nation; Professor Robert Morss Lovett of the University of Chicago, Scott Nearing of the Rand School, William Z. Foster and James Weldon Johnson of the National Association for the Advancement of Colored People.

December 8, 1925

# An Elder Poet and a Young One Greet the New Year

*Thomas Hardy's Powers Undiminished—Robinson Jeffers Displays a Remarkable Gift*

*HUMAN SHOW, FAR PHANTASIES, SONGS AND TRIFLES. By Thomas Hardy. 279 pp. New York: The Macmillan Company. $2.25.*

*ROAN STALLION, TAMAR AND OTHER POEMS. By Robinson Jeffers. 253 pp. New York: Boni & Liveright. $3.*

## By PERCY A. HUTCHISON

IT is not usual for poetry to emanate from a writer so far advanced in age as is Mr. Thomas Hardy, so that the appearance of a volume of close to 300 pages from Mr. Hardy's pen is something to pique interest. To be sure, not all of the poems are of recent date; indeed, several of them go back more than half a century. But for the most part the book is devoted to verse written during the past few years. If one should ask how it comes about that there should be any early poetry in the volume, the answer would, perhaps, be found in Mr. Hardy's age. We take it that these were poems laid aside for a revision they never received, and that the poet had finally reached the conclusion they had best be printed. Together with this volume of Mr. Hardy's verse, the title of which is "Human Show, Far Phantasies, Songs and Trifles," consideration will be given to the work of one of America's younger poets, Robinson Jeffers. Mr. Jeffers's book, "Roan Stallion, Tamar and Other Poems," is the inclusion of one previous private publication with a considerable body of new work.

The fact that in Mr. Hardy's collection poems of an ancient date stand side by side with his latest poetic work offers a starting point for a consideration of the whole. With most poets such divergence of date would presuppose marked divergence both of material and manner. Not so with Hardy. There is little difference, either of theme or style, between the new and the old. The new is neither an advance upon the old nor a falling off from it.

Hardy, both as novelist and poet, arrived at an early maturity; and age has not weakened an intellect which can only be reckoned as one of the most powerful of his time. As the world moves further away from that time and age it is probable that Hardy the poet will eventually be forgotten and that Hardy the novelist will alone survive. This is not written in derogation; it would

209

be out of the common were an artist to attain the same degree of preeminence in two forms of art and his fame show equal longevity in both forms.

If one were to be asked to name the dominating characteristic of Thomas Hardy's literary achievement, the answer first to spring to one's lips would probably be his pessimism. But the reputed pessimism of Hardy has been much overworked. The dominating characteristic of Hardy's work, both in prose and in poetry, is the man's fierce individualism. If he has shown himself, in the main, something of a pessimist, that is a result, not a cause, a secondary and not a primary trait.

There can be little doubt but that Hardy would have been one of the great poets of the later Victorian period had he chosen to devote all his energies to poetry. On the whole, however, his choice of the novel as his principal medium of expression is not to be regretted. That rugged individualism which was the source of his great power as a novelist might, in the long run, have turned out to be an element of weakness had be concentrated on poetry. It is an element of weakness in most of the poetry he has written. Mr. Hardy has always been one who could brook no restraint; and in a poet this may easily lead to all sorts of violence, as it did with John Donne and Robert Browning.

Like these two, Hardy ever refuses to bow to any rule of prosody; he will make no concession to rhythmic grace. With Donne this found compensation in the deep religious mysticism which was the content of so much of his poetry. It was compensated for in Browning by that poet's breadth and wealth of interest and by his dramatic power. Had Hardy made poetry his major occupation some compensation would unquestionably have arisen, but with verse a secondary interest this imperiousness, being never absent, eventually ceases to stimulate and even begins to annoy. With the choice before him of a euphonious or a cacophonous line, Mr. Hardy, like Robert Browning, will decide for cacophony. Indeed, the reader, confronted with single lines torn from their text, would be at a loss as to which of the two poets they belonged. There are abundant instances of this in the book under discussion, as, for example,

*This fleeting life-brief blight,*

or,

*Then cork-screwed it like a wriggling worm,*

or, finally,

*Entroughed on a morning of swell and sway.*

The number of designating phrases which Mr. Hardy found necessary for his title is sufficient indication of the inclusiveness of the book.

There is wit now and again, wit that is sharp and metallic even when it is not also dropped with a hint of venom. And of humor, as distinguished from wit, there is now and again a flash, generally the bucolic humor of the poet's own Wessex. There are poems of tenderness—albeit tenderness which has something of clumsiness about it. And not in-

frequently Mr. Hardy briefly sketches in narrative or dramatic verse what might easily have served for the groundwork of more extensive treatment, either in verse or prose. In the main, however, the poems of this book would have to be classed as lyrics, using that word with the widest application of its many meanings. This, with the title "That Moment," is, perhaps, as near the pure lyric as Hardy comes to in the book.

*The tragedy of that moment*
*Was deeper than the sea,*
*When I came in that moment*
*And heard you speak to me!*
*What I could not help seeing*
*Covered life as a blot;*
*Yes, that which I was seeing,*
*And knew that you were not!*

This is sharp, this is compact; it has the simplicity of Wordsworth, but it has not the beauty of Wordsworth in simplicity. The lines hold, as it were in suspension, a meaning deeper than is seen on the face of the stanzas. The poem is lyric, but it is far from having the supreme touch either of Wordsworth, or, very differently, Landor. The stanzas might have been written by Arnold, with whom Hardy, as a poet, seems to have much of kinship. A lyric of greater beauty—and perhaps one that comes nearer to pure poetry than any other in the book—is this, bearing the title, "Two Lips":

*I kissed them in fancy as I came*
*Away in the morning glow;*
*I kissed them through the glass of*
*her picture frame;*
*She did not know.*
*I kissed them in love, in troth, in*
*laughter*
*When she knew all; long so*
*That I should kiss them in a*
*shroud thereafter*
*She did not know.*

Less pretentious, yet handling still in the lyrical manner the theme of life and death, with just that salt of humor which moves to tears instead of laughter, is this "Musing" on the part of the bereaved dog:

*Why she moved house, without a*
*word,*
*I cannot understand;*
*She's mirrors, flowers, she'd book*
*and bird,*
*And callers in a band.*
*And where she is she gets no sun,*
*No flowers, no book, no glass;*
*Of callers I am the only one,*
*And I but pause and pass.*

As a final quotation the following four stanzas will serve:

*A plain in front of me,*
*And there's the road*
*Upon it. Wide the country,*
*And, too, the road!*
*Pass the first ridge another,*
*And still the road*
*Creeps on. Perhaps no other*
*Ridge for the road?*
*Ah. Past that ridge a third,*
*Which still the road*
*Has to climb furtherward—*
*The thin white road!*
*Sky seems to end its track;*
*But no. The road*
*Trails down the hill at the back.*
*Ever the road.*

That not all is gold that glitters is adequately proved when such verse as is this last volume by Hardy is brought into comparison with much which passes today for poetry. With Mr. Hardy there is no glint of vocabulary, no striving for effect, no seeking after recondite themes. He keeps close to the simple emotional moods

of every-day life. Not a little of his work seems hasty in execution; a little more of craftsmanship and there is not a poem of this very generous collection but would benefit. Yet the reader who is sensitive at all to poetic values will feel that he is put more into contact with poetic values by "Human Shows and Far Phantasies" than he is by most of the showier poets. In the nature of things not a great deal more, whether prose or poetry, can be hoped for from Mr. Hardy's pen. There is depth to this volume, despite an apparent flimsiness; a philosophy showing here and there which is the mellowed, though, of a mind which has brooded deeply, or flamed passionately, throughout a generous term of years. Those who hold that only youth is the light of the world will be likely to pass them by; but all who find in the voice of maturity a note worth harkening to will not let the appearance of this book fall unheeded.

In the year 1642 the Puritan glacier, in the course of its ponderous but invincible progress toward the Commonwealth, closed the London theatres. So powerful had the Puritans become that they would have brought about this closing even had it not been for the additional excuse offered in the plays of John Ford. But Ford's plays removed, in the Puritan mind, whatever shred of justification the theatres might have advanced for continued leniency. And not from the time of Ford until Shelley wrote his Beatrice Cenci was the essential theme of the Oedipus trilogy again attempted in English letters. It is sincerely to be hoped, for the cause of poetry in general, and of American poetry in particular, that no heavy hand will descend upon Robinson Jeffers's "Tamar." That "the curse of Pelops' line," as handled by Sophocles in the Oedipus trilogy, may be lifted into the realm of art, can any one deny? The sole question at issue is—has the transformation into art, the fusion of matter and expression, been accomplished in a manner sufficiently lofty so that the attitude toward the result may be one of utter detachment? This is the test, the sole test; and by this test must "Tamar" be judged.

Jeffers's "Tamar" was printed privately last year; it is now, for the first time, given to the public, together with the other poems of the volume including it in the title. Whether by design that it might serve as an introduction to "Tamar," or whether it was as a mere bit of experimentation that Mr. Jeffers wrote a long dramatic poem, making use of a large part of Sophocles's material, he does not state. But the fact remains that "The Tower Beyond Tragedy" must, since Sophocles may everywhere be found in translation, completely disarm the possible censor of "Tamar." In the latter poem, the scene of which is laid in California, the "curse" is in no wise remitted, and madness ultimately engulfs the house of Cauldwell as effectually as it engulfed the line of Pelops.

It will be unnecessary to follow in any detail the story of "Tamar"; suffice it to say that by the sheer power of his poetic inspiration and execution Jeffers has attained and maintained the degree of detachment

requisite to the theme. In short, in this respect the poem is remarkable in that the narrative seems quite as legendary as the Greek story, while, at the same time, it is vividly in end of the present. Mr. Jeffers, although writing in what must be termed blank verse, in that it is without rhyme, has developed a line peculiarly his own. It is as long as the familiar Whitman line, but without the Whitman surge, which would have been totally unfitted to the purpose. It is a line not lending itself to pleasing setting within the narrow lateral confines of a newspaper column. Of different texture and, if anything, of even sharper projection, is the short introduction to the main theme, and this will be quoted:

*A night the half-moon was like a*
*dancing girl,*
*No, like a drunkard's last half dollar*
*Shoved on the polished bar of the*
*eastern hill-range,*
*Young Cauldwell rode his pony along*
*the seacliffs;*
*When she stopped, spurred; when*
*she trembled, drove*
*The teeth of the little jagged wheels*
*so deep*
*They tasted blood; the mare with*
*four slim hooves*
*On a foot of ground pivoted like a*
*top,*

*Jumped from the crumble of sod,*
*went down, caught, slipped;*
*Then, the quick frenzy finished, stiffening herself*
*Slid with her drunken rider down*
*the ledges,*
*Shot from the sheer rock and broke*
*Her life out on the rounded tidal*
*boulders.*

This is not Mr. Jeffers's best verse by any means. But it has sufficed to indicate his great power of portrayal; and if it also indicates that the reader may expect no softening of realistic detail, it will have served still another useful purpose. If one desire to know what Jeffers can do in a more purely romantic way, this stanza, torn bodily from the middle of another long narrative piece, with its final verse that might have been by Swinburne, will give convincing evidence:

*And Nais, with laughter like the*
*drippings of*
*The little waxen chambers of wild*
*bees;*
*"O nicely! You are at ease*
*In your nice fort of honor and know*
*not lore,*
*You men, that is free wind on sweet*
*wild seas."*

Indeed, it may be questioned whether there is another poet writing in America today—or in England for that matter—who can, when he

so desires, write in so indelible a fashion as the author of "Tamar." Where, for instance, will this be matched?

*⁎ ⁎ ⁎ And surely her face*
*Grew lean and withered, like a mask,*
*the lips*
*Thinned their rose to a split thread.*
Or.

*And the sea moved on the obscure*
*bed of her eternity.*

Or, finally:

*Looking down (he saw) ⁎ ⁎ ⁎ the*
*barn roofs and the house roof*
*Like ships' keels in the cypress tops.*

Robinson Jeffers is not a poet for the adolescent; he is not a poet for the Puritan; he is not a poet whose conception of poetry is confined to the honeyed lyric and to conventional themes. Our guess is that when Dr. Collins turns his light on "Roan Stallion, Tamar and Other Poems" he will find the writer a little out of bounds. But it was a theory of the ancient Greeks that genius was akin to madness; and perhaps it makes little difference which of the two words is placed first. To us it seems that there are in this book pages, many, many pages, which are equaled only by the very great.

*January 3, 1926*

## "COMPOSITION AS EXPLANATION."

Professors of English and English Literature have an irritating habit of recommending young aspirants to study the classics, English and American, to follow the best models, and all that. There are many models, many classics; and some classics are not models for living usage. Even schools of correspondence sometimes fail to enable their clients to find the Philosopher's Stone, the Grand Secret of composition. Hitherto the "problem" has not been "attacked" in the right way. It is solved in The Dial by GERTRUDE STEIN, one of the most painstaking, original and creative of contemporary authors. She recounts her own experience. She erects a philosophical theory which, to those capable of the keen perception and reflection necessary to follow it, is irrefutable.

In her first days of authorship she created "a prolonged present." Then, in "The Making of Americans," she created a continuous present:

A continuous present is a continuous present. I made almost a thousand pages of a continuous present. Continu-

ous present is one thing and beginning again and again is another thing. These are both things. And then there is using everything. This brings us again to composition this the using everything. The using everything brings us to composition and to this composition. A continuous present and using everything and beginning again. In these two books there was elaboration of the complexities of using everything and of a continuous present and the beginning again and again.

Miss STEIN might have added that not merely the consummate ordered whole of a great book, but the prosperity of every sentence in it, may be assured by this method. To take a familiar example, COBBETT'S "HANNAH MORE is a Bishop in petticoats" is an illuminating continuous present. It is most unjust to Miss STEIN to pluck out a few meshes of her close-knit and logical exposition. Our only apology is the wish to direct such of our readers as are interested in the necessaries of composition to an article that will answer all their doubts and difficulties in regard to a subject usually the more darkened the more it is explained. One golden remark about the temporal element we must ask leave

to reprint:

The time in the composition is a thing that is very troublesome. If the time in the composition is very troublesome it is because there must even if there is no time at all in the composition there must be time in the composition which is in its quality of distribution and equilibration. In the beginning there was the time in the composition that naturally was in the composition but time in the composition comes now and this is what is now troubling every one the time in the composition is now a part of distribution and equilibration. In the beginning there was confusion there was a continuous present and later there was romanticism which was not a confusion but an extrication and now there is either succeeding or failing there must be distribution and equilibration there must be time that is distributed and equilibrated. This is a thing that is at present the most troubling and if there is the time that is at present the most troublesome the time sense that is at present the most troubling is the thing that makes the present the most troubling.

Write that on your heart, and not a wave of composition-trouble will roll over your peaceful breast.

*October 24, 1926*

## MARITAL TRAGEDY

*THE SUN ALSO RISES. By Ernest*
*Hemingway. 259 pp. New York:*
*Charles Scribner's Sons. $2.*

ERNEST HEMINGWAY'S first novel, "The Sun Also Rises," treats of certain of those younger Americans concerning whom Gertrude Stein has remarked: "You are all a lost generation." This is the novel for which a keen appetite was stimulated by Mr. Hemingway's exciting volume of short stories, "In Our Time." The

clear objectivity and the sustained intensity of the stories, and their concentration upon action in the present moment, seemed to point to a failure to project a novel in terms of the same method, yet a resort to any other method would have let down the reader's expectations. It is a relief to find that "The Sun Also Rises" maintains the same heightened, intimate tangibility as the shorter narratives and does it in the same kind of weighted, quickening prose.

Mr. Hemingway has chosen a segment of life which might easily have become "a spectacle with unexplained horrors," and disciplined it to a design which gives full value to its Dionysian, all but uncapturable, elements. On the face of it, he has simply gathered, almost at random, a group of American and British expatriates from Paris, conducted them on a fishing expedition, and exhibited them against the background of a wild Spanish fiesta and bull-fight. The characters are concisely indi-

cated. Much of their inherent natures are left to be betrayed by their own speech, by their apparently aimless conversation among themselves. Mr. Hemingway writes a most admirable dialogue. It has the terse vigor of Ring Lardner at his best. It suggests the double meanings of Ford Madox Ford's records of talk. Mr. Hemingway makes his characters say one thing, convey still another, and when a whole passage of talk has been given, the reader finds himself the richer by a totally unexpected mood, a mood often enough of outrageous familiarity with obscure heartbreaks.

The story is told in the first person, as if by one Jake Barnes, an American newspaper correspondent in Paris. This approach notoriously invites digression and clumsiness. The way Mr. Hemingway plays this hard-boiled Jake is comparable to Jake's own evocations of the technique of the expert matador handling his bull. In fact, the bull-fight within the story bears two relations to the narrative proper. It not only serves to bring the situation to a crisis, but it also suggests the design which Mr. Hemingway is following. He keeps goading Jake, leading him on, involving him in difficulties, averting serious tragedy for him, just as the matador conducts the bull through the elaborate pattern of danger.

The love affair of Jake and the lovely, impulsive Lady Ashley might easily have descended into bathos. It is an erotic attraction which is destined from the start to be frustrated. Mr. Hemingway has such a sure hold on his values that he makes an absorbing, beautifully and tenderly absurd, heartbreaking narrative of it. Jake was wounded in the war in a manner that won for him a grandiose speech from the Italian General. Certainly Jake is led to consider his life worse than death. When he and Brett (Lady Ashley) fall in love, and know, with that complete absence of reticences of the war generation, that nothing can be done about it, the thing might well have ended there. Mr. Hemingway shows uncanny skill in prolonging it and delivering it of all its implications.

No amount of analysis can convey the quality of "The Sun Also Rises." It is a truly gripping story, told in a lean, hard, athletic narrative prose that puts more literary English to shame. Mr. Hemingway knows how not only to make words be specific but how to arrange a collection of words which shall betray a great deal more than is to be found in the individual parts. It is magnificent writing, filled with that organic action which gives a compelling picture of character. This novel is unquestionably one of the events of an unusually rich year in literature.

October 31, 1926

# Man's Relation to His World In Thomas Mann's Novel

## "The Magic Mountain" Is a Record of Profound Mental and Spiritual Experience

THE MAGIC MOUNTAIN. By Thomas Mann. 2 volumes. Translated from the German by H. T. Lowe-Porter. 900 pp. New York: Alfred A. Knopf. $6.

By JOHN W. CRAWFORD

ARTIFICES without end have appeared in fiction to crystallize out of complexities those stark clear values which have seemed to express man's dramatic relation to his world. It has remained for Thomas Mann to discover and to exploit the strangest device of all: a tuberculosis sanitarium. The character of Hans Castorp, one of the patients in the Berghof, in the Swiss Alps, provides the novelist with an additional degree of detachment, a further invitation to those more abstract concerns which have so little to do with the preoccupations of life in the flatlands. Hans Castorp passes the long, indistinguishable time intervals by taking stock of himself, his derivations, his significance in the world, and the meaning of the world to him. Castorp, further, comes in contact with other patients, representing every aspect of philosophy, whether reasoned and codified in thought or unthinkingly applied in living. Imperceptibly, yet overwhelmingly at the end, it becomes apparent that, through the supine, passive personality of Hans Castorp, situated in his removed, changeless sanitarium, Thomas Mann has wrought a synthesis out of the whole diversity of modern being.

As the novel opens, Hans Castorp is already on his way to the cure. He is "an unassuming young man," whose sole distinguishing characteristic is his faithfulness to a certain cigar. He is of an old burgher family of Hamburg, settled, sober people who have been the backbone of that tight oligarchy of trade for generations. Hans Castorp has just finished his engineering studies and has a position waiting for him with a firm of shipbuilders, conducted by traditional friends of his family's. He is going to spend three weeks in the company of his unhappy cousin, young Joachim Ziemssen. From the moment Joachim conducts his cousin from the narrow gauge railway compartment, it is apparent that a distinct mode of being exists upon that remote, bewitched mountain. "We up here," Joachim observes, "measure time on the grand scale, and consider three weeks nothing to speak of, a mere week-end."

Thomas Mann transforms Hans Castorp from a civilian with a part to play in the active business of Hamburg to a reflective, experimentative onlooker, by such gradual stages that the transitions are entirely organic. At one point, Castorp is nothing more than the visitor, making only those provisional adjustments to a new environment which spring from a natural wish to benefit by a vacation. Visibly he is inveigled and at length entirely absorbed by the conditions of these exotic surroundings. He develops a cold and a high fever. An examination and the revelations of the X-ray betray the little moist spot in his lungs which is destined to keep him at the Berghof for seven years instead of the original three weeks.

The sensible, physical universe of the Berghof is delimited by the Hofrat Behrens, the surgeon and head physician of the establishment; by the psychoanalyst, Dr. Krokowski; by five hearty meals each day; by the people at Castorp's table; by the strict regimen of rest, alcohol rubs, taking of temperature and so on, and by the imminence of death.

Hans Castorp soon has qualified these general conditions with the particular elements which appeal to him, and which serve to betray and accentuate his essential personality. Both his father and mother are dead, and his grandfather died when he was still a child. He himself is frail. He has not been a patient long before he discovers in himself an infinite, almost morbidly sensitive, tenderness toward suffering and dying. He sets himself the duty of visiting those who are about to end the fight for health, and be carried out, silently, and in the absence of the inmates, and put on bobsleds to be transported down the snow-covered mountainside to the railway.

Thomas Mann is infinitely, scrupulously fair. He is at pains to present Castorp in a dry light, free of prejudice. In addition, he gives unlimited license to all the speculators and theorists assembled at the Berghof, who inevitably cross the path of Castorp, and find his deference and his youth and his teachableness irresistible. The result is that Castorp listens to the Italian libertarian, son and grandson of classic humanitarians, and finds Ludovico Settembrini stimulating, provoking, sometimes aggravating. He also draws out the subtle Jesuit, Naphta. Hans is, too, the devoted friend and ally of the extraordinary Dutch Colonial, Pieter Peeperkorn.

It is impossible to read far into Thomas Mann without realizing that he is a tacit but inexorable advocate of the aristocratic principle. The democracy of Settembrini is allowed fullest expression, but there is always Naphta to riddle it, and to make the gallant Italian slightly ridiculous. In addition, there is the fascinating Russian woman, Clavdia Chauchat, bespeaking the life of the senses, and controverting with the spell of her greenish eyes and her red hair the austere humanity of Settembrini and its effect upon the impressionable Castorp. Further, there is Peeperkorn, reminding the Berghof inmates that sheer physical personality, deriving out of uncharted primitive forces, dominant in its own right, is an unanswerable challenge to reason and dialectic.

So soon as these tentative conclusions are reached, however, and the innate significance of the novel has appeared to have been deposited, crystalline-clear, once for all, the neatly arranged categories disappear at a breath, and it is all to do over again. Mynheer Peeperkorn, although he has won Clavdia Chauchat away from Hans Castorp, and commanded the respectful admiration of Castorp himself, and although he rules the oddly assorted little company, is yet diminished by the very power which has given him ascendency. He is aging, and that is the final answer, perhaps, to the form of the aristocratic principle which he represents.

The end of Peeperkorn is only one among many moments that would have tempted a lesser writer to rodomontade. Thomas Mann takes it all in his stride. He has established, early in the narration, an acceptance of this "eternal day that is ever the same" at the Berghof. Peeperkorn's view of things is given in a number of passages. Perhaps this instance might serve as illustration:

Life, young man, Peeperkorn observes to Hans, is a female. * * * She mocks us. She challenges us to expend our manhood to its uttermost span, to stand or fall before her. To stand or fall. To fall, young man—do you know what that means? The defeat of the feelings, their overthrow when confronted by life—that is impotence. For it there is no mercy, it is pitilessly, mockingly condemned.

Even the brief quotation conveys a sense of the tempestuous ardor of this ageing monarch of a man, a magnificent conception.

Subsequently Castorp involves his friend Settembrini in a quarrel with Naphta. The Jesuit has been scoffing at freedom and the French Revolution, with an acid, malicious wit. Indeed, the dialectics between Naphta and Settembrini are among the most brilliant passages in the book, although it must be admitted that they also at times descend to long-winded argument and become slightly tedious. The Italian rebukes Naphta

for misleading Castorp and filling him full of persuasive paradoxes. The upshot of it is a duel, in the early morning, with pistols. Settembrini has so often offered his determined opposition to suffering, to violence, and to death, has so often been the tolerant yet austere proponent of life and freedom and equality that his part in the duel is somewhat paradoxical in itself. As it happens, he fires into the air, and leaves the maddened Naphta no alternative but to blow his brains out.

After seven years of Castorp's false security, war breaks out in 1914. Thomas Mann wisely abandons his character after a brief glimpse of him in the midst of fighting on the flatlands. The enchantment of the magic mountain has at last been lifted, but it is death, after all, which is to take off the victory.

The reader looks in vain through "The Magic Mountain" for the docketed views and pat opinions of Thomas Mann. That in itself, considering the subject and the nature of the book, is a signal and grateful achievement. What he finds, instead,

is the extraordinary spiritual, mental and physical adventures of Hans Castorp.

The recognition of Hans Castorp, on his isolated peak of arrested temporal experience, set free as he never could have been in the flatlands to explore and participate in many different ways of life and thought for himself, come perilously, breath-takingly near to charting a discovery of the modern world. It is a fine, noble, inspiriting "Yes," which Thomas Mann returns to life. Yet "The Magic Mountain" falls just

short of being that work upon which the thoughtful wanderer among contemporary perplexities may build a serene, untroubled, understanding acceptance of life. But it goes far on the way. In this, the translation of H. T. Lowe-Porter is an adequate, but not invariably a satisfying, assistance; it is workmanlike, but a translation.

May 8, 1927

## BOSTON POLICE BAR SCRIBNER'S MAGAZINE

### Superintendent Acts on Objections to Ernest Hemingway's Serial, "Farewell to Arms."

*Special to The New York Times.*
BOSTON, Mass., June 20.—The June issue of Scribner's Magazine was barred from bookstands here yesterday by Michael H. Crowley, Superintendent of Police, because of objections to an instalment of Ernest Hemingway's serial, "A Farewell to Arms." It is said that some persons deemed part of the instalment salacious.

The action of the Police Department, however, was similar to locking the stable door after the horse had been stolen, because the June issue of Scribner's had been on sale since May 25.

Mr. Crowley would not say where the complaints originated which resulted in the banning of the magazine. The story concerns the experiences of an American ambulance driver with the Italian army.

Charles Scribner's Sons issued this statement yesterday:

"The very fact that Scribner's Magazine is publishing 'A Farewell to Arms' by Ernest Hemingway is evidence of our belief in its validity and its integrity. Mr. Hemingway is one of the finest and most highly regarded of the modern writers.

"The ban on the sale of the magazine in Boston is an evidence of the improper use of censorship which bases its objections upon certain passages without taking into account the

effect and purpose of the story as a whole. 'A Farewell to Arms' is in its effect distinctly moral. It is the story of a fine and faithful love, born, it is true, of physical desire.

"If good can come from evil, if the fine can grow from the gross, how is a writer effectually to depict the progress of this evolution if he cannot describe the conditions from which the good evolved? If white is to be contrasted with black, thereby emphasizing its whiteness, the picture cannot be all white.

"A dispatch from Boston emphasized the fact that the story is 'antiwar argument.' Mr. Hemingway set out neither to write a moral tract nor a thesis of any sort. His book is no more anti-war propaganda than are the Kellogg treaties.

"The story will continue to run in Scribner's Magazine. Only one-third of it has as yet been published."

June 21, 1929

## THE NEW RESPONSIBILITY.

Like the sun-spot cycle, the intellectual climate is forever rotating. Knowledge may not change radically, but the points of emphasis in contemporary thinking and the styles of expression veer. After a decade of rather general destruction, a new spirit is beginning to appear in the temper of current thought. A new sense of responsibility begins to strengthen expressions of opinion. From the satire and the muckraking of the past ten years to the anxiety of some of the most conspicuous recent books is a very appreciable distance. We have passed from the bitter plain-speaking of "Civilization in the United States" to the aspiration of LEWIS MUMFORD'S "The Golden Age" and the grim, though turgid, earnestness of WALDO FRANK'S "Rediscovery of America." Everywhere in the Western world thought is more supple and resilient than it used to be. And more than ever the man of independence is eager to know where he stands in relation to himself, to others and to the universe.

If, as is likely, he is sobered by the wild vagaries of recent experience, the responsible prophet will not generalize too complacently about either the future or the present, for they are two of the primary uncertainties. But those who follow the literary columns, and read the journals of opinion, must be aware of an increasing, disinterested concern for the common happiness of the modern man. Recently he has been shorn of

much of his traditional glory. The revolution in the conception of the material universe, the weakening of religious authority, the psychology of love, the disillusioning, brutal fact of the war itself, have left him at loose ends. Looking about him for guidance, too often he has been victimized by limelight pretenders.

Yet there are some who share his concern and play fair with him. Truth without truculence in "All's Quiet on the Western Front" and "Journey's End"; the detached lucidity of Professor EDDINGTON'S "The Nature of the Physical World"; a firm grasp upon realism in two or three chapters in Professor BEARD'S symposium entitled "Whither Mankind?" persuade the reader to believe that in such books he need question neither ability nor motive. The charlatanism that has been enormously profitable, and cynically fostered by publishers, lecturers and writers alike, seems pathetic by comparison. The scandal-mongering that has often passed for biography and liberated thought sounds as catchpenny as it is. There is a hunger for serious books. We are getting them.

In terms of human emotion, the order that has gone out of life is no petty affair. Stripping life of its traditional ornaments has unsettled every one and plunged some into solitary gloom. It is not so much faint-heartedness as honesty and deep concern that results in such a forthright volume as JOSEPH

WOOD KRUTCH'S "The Modern Temper" with its melancholy conclusion that man has only his intellectual pride left. To many readers Mr. KRUTCH'S systematic analysis of the modern spirit seems wanting in healthy skepticism. For, after all, when mortal man feels in good humor, and looks about him at all his works and finds them good, he is not necessarily ignorant or reactionary. His spontaneous cheerfulness is as legitimate as his gloom. But Mr. KRUTCH'S volume is too able and sincere to be patronized as the folly of one of "our sad young men." Accepting at face value all the recent philosophical conclusions, it portrays modern man as he would be if clear thinking about him were final.

Fixed conceptions have been tumbling about our ears. We live in an unsettled era. Although the formalized periods, like the eighteenth century, are congenial and flavorsome, they are also dogmatic and sterile. The unsettled periods when men question anxiously and search their hearts make the cleanest, firmest progress. After the confusion of leveling, which is a process that engrosses men completely, it is time for leisure and reconstruction. Reducing life to the dead level of factual certainty begins to pall, and seems far short of the facts. More and more people will turn to the responsible thinkers who can command the new points of view in terms of matured wisdom.

July 21, 1929

# A Novel of Provincial American Life

*LOOK HOMEWARD, ANGEL. By Thomas Wolfe. 626 pp. New York: Charles Scribner's Sons. $2.50.*

HERE is a novel of the sort one is too seldom privileged to welcome. It is a book of great drive and vigor, of profound originality, of rich and variant color. Its material is the material of every-day life. Its scene is a small provincial Southern city, its characters are the ordinary persons who come and go in our daily lives. Yet the color of the book is not borrowed; it is native and essential. Mr. Wolfe has a very great gift--the ability to find in simple events and in humble, unpromising lives the whole meaning and poetry of human existence. He reveals to us facets of observation and depths of reality hitherto unsuspected, but he does so without outraging our notions of truth and order. His revelations do not startle. We come upon them, instead, with an almost electric sense of recognition.

The plot, if the book can be said to have a plot at all, is at once too simple and too elaborate to relate in synopsis. "Look Homeward, Angel" is a chronicle of a large family, the Gants of Altamont, over a period of twenty years. In particular, it is the chronicle of Eugene Gant, the youngest son, who entered the world in 1900. W. O. Gant was a stonecutter, a strong, turbulent, sentimental fellow, given to explosions of violent and lavish drunkenness, and to alternating fits of whining hypochondria. Eliza Gant, his second wife and the mother of his family, was an executive woman with a passion for pinching pennies and investing shrewdly in real estate. The Gants grew in age and prosperity with the growth of the sprawling mountain town of Altamont.

By 1900 the Gants were firmly and prosperously established in Altamont— although, under the shadow of the father's whining dread of the tax collector, they continued to live as if poverty and destitution lay just around the corner. They kept a cheap, garish boarding house called Dixieland, living their daily lives on the fringe of a world of paying guests whose necessities had to be considered first. Eugene Gant grew from childhood into an awkward and rather withdrawn adolescence, hedged about by the turbulent lives of his family and singularly lonely in the midst of them. Indeed, each of the Gants was lonely in a separate fashion. Mr. Wolfe, in searching among them for the key to their hidden lives, comes upon no unifying fact save that of isolation.

Through the book like the theme of a symphony runs the note of loneliness and of a groping, defeated search for an answer to the riddle of eternal solitude.

Naked and alone we come into exile. In her dark womb we did not know our mother's face; from the prison of her flesh have we come into the unspeakable and incommunicable prison of this earth. Which of us has known his brother? Which of us has looked into his father's heart? Which of us has not remained forever prison-pent? Which of us is not forever a stranger and alone?

Eugene grew into life hating its loneliness and desolation, its lack of meaning, its weariness and stupidity, the ugliness and cruelty of its lusts. For the rawness and evil of life was early apparent to him—hanging about the depressing miscellaneous denizens of Dixieland, delivering his papers in Niggertown, growing up in the streets and alleys of Altamont. He found a poignant beauty in it, too--the simple beauty of things seen in youth, the more elusive beauty to be found in books, and later, after his years at college and the death of his brother Ben, the terrible beauty flowering from pain and ugliness. But always there remained in him that loneliness, and an obscure and passionate hunger which seemed to him a part of the giant rhythm of the earth.

"Look Homeward, Angel" is as interesting and powerful a book as has ever been made out of the drab circumstances of provincial American life. It is at once enormously sensuous, full of the joy and gusto of life, and shrinkingly sensitive, torn with revulsion and disgust. Mr. Wolfe's style is sprawling, fecund, subtly rhythmic and amazingingly vital. He twists language masterfully to his own uses, heeding neither the decency of a word nor its licensed existence, so long as he secures his sought for and instantaneous effect. Assuredly, this is a book to be savored slowly and reread, and the final decision upon it, in all probability, rests with another generation than ours.

MARGARET WALLACE.

Thomas Wolfe

October 27, 1929

# Latest Works of Fiction

### DECAYED GENTILITY

*THE SOUND AND THE FURY. By William Faulkner. 401 pp. New York: Jonathan Cape & Harrison Smith. $2.50.*

WHEN "Soldiers Pay" was written a few years ago, critics found the author a young man who had a rather uncertain style, sometimes original, sometimes imitative of the school of James Joyce, but who was undeniably worth watching. In his subsequent writing the style became no more settled, but no less promising. What manner of man is this who can use incoherence so effectively on one page and on the next write a most beautifully single-minded narrative? Has he a style or hasn't he? In this novel he has given himself opportunity to try each of his methods in a story that is told in the first person by three separate characters, with a final summing up of the family history in the third person.

"The Sound and the Fury" is the story of the decaying gentility of a Southern family. Benjy, one son, is 35 years old, with the mind of a child of 3. Caddy brings disgrace by her free ways with men. Quentin is overly sensitive and commits suicide. Only Jason is a comfort to his mother; but of all the characters he is the least acceptable to the reader, who knows him for a liar and a cheat. The mother is a whining hypochondriac and the father a drunkard.

With this array of characters, which bids fair to out-Russian the Russians, the author weaves the story of Caddy and her unfortunate marriage, the adoption of her daughter, Quentin, into the household over which Jason has become master, and the complete disintegration of the family, which is only held together as long as it is through the efforts of the negro servants, a peculiarly sane chorus to the insane tragedy.

The first part of the book takes

part in the mind of Benjy, the idiot. It is told in the first person, with the utmost objectivity. Benjy cannot talk; he must be fed. He has not the intelligence to interpret either the words or the actions of the people who make up his world. He can see and he can hear, and what he thus senses makes up his part of the story.

which jumps back and forth across the years with no regard to chronology, the turn of a thought indicated in italics.

The second part is told by the son Quentin when he is a freshman at Harvard and his sister Caddy is being married. He is going to drown himself, and the story of what he does on the day of the sui-

cide adds further to the history of the family.

The third part is told by Jason, who justifies his actions in his own mind, but who reveals through his words and thoughts the most contemptible nature, also verging on the insane.

In the last part the family is at its lowest ebb. Only the mother,

Jason and Benjy remain, together with the aging negro servants.

The author has chosen an unusual medium for his story in not one but four styles. Yet the four are welded together in perfect unity. The objective quality of the novel saves it from complete morbidity.

November 10, 1929

# John Dos Passos Satirizes an America "On the Make"

*THE 42ND PARALLEL. By John Dos Passos. 426 pp. New York: Harper & Brothers. $2.50.*

THIS novel is a satire on the tremendous haphazardness of life in the expansionist America we all have known, the America which came into birth with the defeat of Jefferson's dream of an agricultural democracy, which grew by leaps and bounds and railroad scandals after the Civil War, and which flowered in the period between the Spanish-American War and the stock market crash of last Autumn, which Stuart Chase regards as a sort of punctuation mark. It is an America distinctly "on the make" that Mr. Dos Passos satirizes, an America filled with people with vague hopes of success—no matter what success. There are no "old" Americans in the book—"old," that is, in the sense that Justice Holmes is an "old" American; and there are no "new" Americans in it of the breed that, happily, one discerns here and there already—"new" Americans whose ideals are not wholly of the counting house. There have been intimations that the book—called "The 42nd Parallel" after a mythical line on the maps that cuts through the heart of the United States—is merely the first panel in a series of novels that will, ultimately, attempt to satirize the effect of Americanization on the world. If this is so (and the generally unfinished air about the book leads us to believe it is so), the publishers have done their author a disservice in not spreading the news, for, as it now stands, "The 42nd Parallel" has only a tenuous

sort of unity; it does not coalesce.

The technique of the novel owes something to Joyce, and something to the expressionism that John Howard Lawson has made familiar to theatregoers, the expressionism of "Processional." Fortunately, however, Mr. Dos Passos has stopped a long way short of going the whole hog with the authors who contribute to transition; he has realized that effective art must draw a balance between expression and communication. The actual stories of his five characters are all told in straightaway prose with overtones of satire, a satire that is kindly where Mr. Dos Passos deems kindliness to be in order, and decidedly acidulous in the case of J. Ward Moorehouse, who became an "eminent Public Relations Counsel" (John Dewey's symbol of the present-day America) with the aid of his wife's fortune.

Between the stories of Mac, the "wobbly"; of Janey, the congenial private secretary from Washington, D. C.; of the egregious Mr. Moorehouse who "used to be a newspaper man himself once"; of Eleanor, the interior decorator from Chicago, and of Charley, the drifting young man from the Farmer - Laborite stronghold of the Northwest, Mr. Dos Passos has inserted some "trick stuff" designed to draw his readers into the mood of his book. He has divided the trick stuff into three sorts of features, one a "newsreel" feature, which jumbles up newspaper headlines and snatches of popular song; one a "camera eye" feature which, with its memories of the visitation of Halley's Comet and of days in the

Harvard Yard, is evidently intended to inform the reader of Mr. Dos Passos's stations of observation during the period spanned by the novel, and the third—and most effective, from a philosophical standpoint—a series of Whitmanesque biographies of famous Americans, Steinmetz, Edison, Burbank and La Follette, with cross reference to Henry Ford. This last feature is carried out in rough, chanting lines, but instead of singing of brotherly love, as Whitman did, Dos Passos points his rude song to bring out social ironies. Edison and Ford, as leaders, never "worried about mathematics or the social system or generalized philosophical concepts," in Mr. Dos Passos's opinion, and this lack of worry in the leaders has, the novel implicitly states, filtered down until it has affected all the characters in the book, even Mac, who isn't a "wobbly" for any burning love of humanity, but simply because it gives his energy scope for activity when he and his wife have come to a parting of the ways.

The stories of the five characters do not all touch—which is one indication that Mr. Dos Passos has not finished with them. While one realizes that Mr. Dos Passos may have left his book at loose ends for esthetic purposes—to bring home to the reader the haphazardness of life in a social milieu that shifts as the sands shift—one is left dissatisfied. One feels that his novel is still in a state of nature, that his own point of view, his own philosophical approach, has not been clearly indicated.

As for Americanization and the

world, Mr. Dos Passos touches on this in the Mexico City interlude of Mac, in the visit of Moorehouse to Mexico, and points the way, perhaps, to more on this subject by shipping Charley, his last character, off to France on the penultimate page. The various people of the book, all of whom are thrown from pillar to post and none of whom has any clear idea of the end involved in taking any particular step, are made palpable, but only roughly and objectively so. The book being satire, Mr. Dos Passos has "interpreted" his people in terms of irony to emphasize aimlessness, and probably not one of them would recognize his or her portrait in Mr. Dos Passos's pages. The book, therefore, falls short of being sheerly creative, but it remains, in extenuation, very effective social castigation. And in writing of people who are not unduly troubled by ideas, Mr. Dos Passos has not made the mistake of John Herrmann or Morley Callaghan, for, while his prose is far from the shapely sort of prose that distinguishes Glenway Wescott, and Miss Roberts, it does not run into the deadly "tum tum tum" formula. It could hardly be as shapely as the prose cultivated by Wescott and Roberts, because he is dealing not with an older (and saner?) America, but with a newer American world whose matrix is often rough and out at the edge.

JOHN CHAMBERLAIN.

March 2, 1930

# Hart Crane's Cubistic Poetry in "The Bridge"

*THE BRIDGE. By Hart Crane. 82 pp. New York: Horace Liveright. $2.50.*

THERE is certain to be no unanimity of opinion on "The Bridge," a long poem which we imagine the writer would like to have called a symphonic poem. Mr. Crane, it will be recalled, is the author of the collection "White Buildings," poems which called forth praise from Eugene O'Neill. "The Bridge" is certain to evoke praise and in a meas-

ure deservedly. This, from the publisher's note on the jacket—the publisher's "grace" note we were tempted to call it—states one point of view. "Dedicated to Brooklyn Bridge," the paragraph runs, "this poem is a synthesis of values, past and present, which may be termed particularly American."

It will be concluded from this that "The Bridge" is out of the ordinary, both in substance and manner. And this is true. But the point of issue will be whether the

poet, in seeking individuality for his poem, has not sacrificed contacts with both common sense and beauty. For an example, there is but a tour de force in the line.

*Siphoned the black pool from the heart's hot root.*

And although the following seems immensely effective, its effectiveness will be found on analysis, to lie in its lack of intelligibility rather than in its intelligibility. That is to say, it possesses a purely spe-

cious effectiveness, for it has neither true intellectual nor true poetic value.

*The swift red flesh, a Winter king—*
*Who squired the glacier woman down the sky!*
*She ran the neighing canyons all the Spring;*
*She spouted arms; she rose with maize—to die.*

Perhaps this stanza is clear to the author. The present commentator is willing to admit that it is not clear to him. But perhaps clear-

ness, in the usual acceptance of the term, is not desired by Hart Crane. It is possible that there is a new theory of poetry behind "The Bridge," a question which may be taken up after further quotation. The excerpt, as was the stanza above, is from a section bearing the caption "Powhatan's Daughter," and this part has the further caption "Dance."

> And in the Autumn drought, whose burnished hands
>     With mineral wariness found out the stone
> Where prayers, forgotten, streamed the mesa sands!
> He holds the twilight's dim, perpetual throne.
>
> Mythical brows we saw retiring--loth,

> Disturbed and destined into denser green.
> Greeting they sped us, on the arrow's oath:
> Now lie incorrigibly what years between.
>
> There was a bed of leaves, and broken play;
> There was veil upon you, Pocahontas, bride—
> O Princess whose brown lap was virgin May;
>     And bridal flanks and eyes hid tawny pride.

A word should be said as to the divisions of the poem. Following a dedication to Brooklyn Bridge there is "Ave Maria," a poem in which Columbus is represented as soliloquizing on the deck of his flagship; then the "Powhatan's Daughter" in five parts; "Cutty Sark" and "Cape Hatteras," which impinges on the sea; three so-called "Songs," one of which pictures a burlesque show in New York; "Quaker Hill," in which Isadora Duncan and Emily Dickinson are brought together; "The Tunnel," which is the New York subway, and an epilogue, "Atlantis."

We suggested the possibility of a theory of poetry which "The Bridge" may have been written to exemplify. Such a theory might be called cubism in poetry. And it would call for just such work as Hart Crane has given us--the piling up of startling and widely disparate word-structures so that for the mind the cumulative result is very like the cumulative result of sky-scrapers for the eye when looked on through a mist. If this conclusion is in any degree correct, then "The Bridge" is to be regarded as a successful piece of work. The totality of tonal variations and tonal massings, plus the occasional pictorial achievements, give to the entire piece indisputable weight. Since to the mind of the present writer cubism, whatever value it may have for painting, is wholly valueless in poetry. "The Bridge," nevertheless, remains for him, in spite of its glitter and its seeming intellectual importance, a piece that is in the main spurious as poetry.                    P. H.

April 27, 1930

# Symbolism as a Generating Force In Contemporary Literature

### Edmund Wilson Traces the Movement From Its Beginnings in Poe and Mallarmé to Its Effects on Yeats, Joyce and Proust

AXEL'S CASTLE. By Edmund Wilson. 319 pp. New York: Charles Scribner's Sons. $2.50.

### By WILLIAM TROY

WHEN the introductory chapter of this work first appeared in The New Republic it was entitled "A Preface to Modern Literature," and both from its title and content it was apparent that Mr. Wilson's purpose was to lay the groundwork for a more extended critical survey of contemporary letters. The general title he has now chosen for the collection of his essays as a whole is less transparent, but it has the distinct virtue of creating at once the special atmosphere of the French literary movement which he considers the proper starting point for any approach to modern literature. For "Axel's Castle" calls to mind the ancient and mysterious habitation of Count Axel of Auersberg, the hero of Villiers de l'Isle Adam's "Axel" the fantastic prose poem which gave expression not only to the esthetic idealism of the French Symbolist poets of the last century but also to the attitude behind each of the six contemporary writers whom Mr. Wilson discusses in the preesnt study.

The Symbolist movement in France, beginning as early as the '70s, was a partly deliberate, partly unconscious reaction against the scientific temper of the mid-nineteenth century mind as reflected in such literary groups as the Naturalists in fiction and the Parnassians in poetry. It corresponded very closely to the Romantic movement which had swept over European literature at the beginning of the century a movement which had in its way registered protest against the scientific rationalism of the seventeenth and eighteenth centuries. As the Romantics had rebelled against the ideas brought into fashion by the rise of physics and mathematics, so now the Symbolists sought to break through the distorted patterns of experience built up by the mechanistic philosophy that had grown out of biological experimentation in the nineteenth century.

The term Symbolism itself is probably incapable of exact definition, and in the course of Mr. Wilson's study it is used to include so many things that it seems almost to depart from its original meaning. As a technique Symbolism represents the effort to communicate, by means of a unique personal language, ideas, feelings and sensations more faithfully than they are rendered through the conventional and universal language of ordinary literature. The function of this language is "to intimate things rather than state them plainly"; it depends on suggestion rather than statement. The arch-type of the Symbolist poet in Mallarmé, the superb technician of French verse whose imagery was so personal that few people in his lifetime were able to understand his work any better than the later writing of Joyce is understood in our own day. From Mallarmé (who was influenced by Poe) was derived the method behind the early Celtic symbolism of W. B. Yeats; and Paul Valéry may be considered as a disciple of Mallarmé who has, in the perfection of his verse, refined on the master. T. S. Eliot has openly acknowledged his debt to two other earlier Symbolists Tristan Corbière and Jules Laforgue. It is when Mr. Wilson attempts to fit writers like Proust and Joyce into his scheme, prose writers depending less directly on imagery for their communication, that he is forced to extend the application of his term. Here, symbols, with their "multiplied associations," are supposed to include also characters, situations, places, motifs, patterns of behavior. In other words, the term is applied no longer only to a particular way of using words—but to a particular attitude toward experience as a whole.

In his chapter on Gertrude Stein, Mr. Wilson seems to contradict the assumption that Symbolism, as a distinct and self-conscious literary movement, owed its primary character to its use of words for their suggestive power. By quoting extracts from expository prose by W. B. Yeats, G. B. Shaw, the Courts-Martial Guide, and finally Miss Stein, he illustrates quite convincingly that all words, even those in the most rational prose, those directed solely toward "sense," owe their effectiveness to the same power of suggestiveness. The difference between Miss Stein and G. B. Shaw becomes therefore basically a technical one: a difference of syntax and of the order of selected images.

If this is as true as it seems, if all words actually "intimate rather than state," how can one place Symbolism in a separate esthetic category? The real identity of Symbolism would then seem to consist less in its verbal technique than in certain other features of its program—most notably, as Mr. Wilson so clearly shows, in its over-development of the individualistic conception of the writer's rôle, its detachment of literature not only from social values alone, but from human action itself. This would have the advantage of distinguishing it as surely from Romanticism as from the more opposite tendencies of Classicism and Naturalism.

Mr. Wilson's method of treating the separate subjects of his essays is not one of unqualified appreciation: his judgments are attained after a careful exposition of their works and an analysis that is rigorous and often profound. His effort to differentiate sharply between different work by a single man, as in the case of Paul Valéry, even leads him at times to an excessive severity. In general, Mr. Wilson brings to his problems an intelligence that is alert, informed and catholic to a degree rarely found in contemporary criticism. He writes in a style whose ideal of absolute lucidity has undoubtedly entailed many sacrifices in a writer who is also a poet and a novelist. His manner of dealing with reputations and ideas that still invite hostility in certain quarters is gracefully disarming.

It is of course natural that in a work of this scope one should not be in complete accord with all the judgments stated nor even with the approach followed in several instances. Although Mr. Wilson is excellent in his résumé of T. S. Eliot's poetic and critical development up to the "Waste Land," he is less dependable in his interpretation of the later phases of Eliot's poetry and thought. The sections on "Ash Wednesday" and the chapter on Miss Stein are the least successful in the book. Despite the remarks on Miss Stein's humor the author of "Tender Buttons" remains at the end "the great pyramidal Buddha of Jo Davidson's statue." The failure to relate Miss Stein's esthetic to the system of Bergsonian metaphysics on which it rests makes the discussion as superficial as it is indefinite. The structural analysis of Proust's great epic is unquestionably the best yet available in English; but the centring of the critical problem in Proust's individual psychology is too facile to be useful and compares unfavorably with the metaphysical attack of continental critics like Fernandez and Curtius. Quite the most satisfactory and original essay in the volume is the one on William Butler Yeats, in which Mr. Wilson has not only successfully identified this poet with the direct tradition of French Symbolism but also, for the first time, provided an orderly account of his development up to his position as one of the few truly universal poets of our time.

In the last chapter, there is some-

thing like a stock-taking of contemporary literature, with a consideration of its possible directions in the near future. There are, according to Mr. Wilson, two alternative courses to follow—Axel's or Rimbaud's. The hero of Villier's "Axel" stands for all that increasing individualism, that cultivation of one's private fantasies in the face of contemporary realities, that incarceration in one's own dark tower which has characterized all the successors of Symbolism. Both in his writing and in his career Rimbaud suggests the second alternative—the escape from twentieth-century industrialism and democracy, the cult of the primitive and the childlike. It is Mr. Wilson's conviction that neither of these directions is possible or desirable and that we must look for some combination of the Symbolist vision with the Naturalistic sense of fact. But to those writers whom he has discussed he believes we owe a tremendous debt—"they have yet succeeded in effecting in literature a revolution analogous to that which has taken place in science and philosophy * * * and they have revealed to the imagination a new flexibility and freedom." Mr. Wilson does not, however, undertake to prescribe what we should do with this new freedom; he does not offer any cohesive program; his final faith is in "the untried, unsuspected possibilities of human thought and art."

February 22, 1931

## Book Import Ban Is Lifted on Five 'Classics'; Treasury to Admit 'Casanova' and 'Decameron'

### Special to The New York Times.

WASHINGTON, March 13.—Liberalized features of the tariff act of 1930, exempting from exclusion so-called classics or books of recognized and established literary or scientific merit, led the treasury today to announce a modification of the ban against the importation of recognized translations of these works.

Five works which have been barred from the country, but will now be admitted include "The Arabian Nights," "The Memoirs of Casanova," Rabelais's "Gargantua and Pantagruel," "The Decameron of Boccaccio" and Apuleius's "The Golden Ass."

These works are recognized as classics by the treasury, and the recognized translations may come into the country, although certain editions containing what is regarded as obscene language or with objectionable illustrations may be excluded.

The admissability of books dealing with birth control will be tested soon in a New York Federal court. The point of contention is Marie Stopes's conception of the British viewpoint on "married love." In all probability the decision in this case will set a precedent for the admissability of books of that character.

Seditious literature, another class of forbidden reading, apparently has vanished from the import trade, according to officials. Customs Bureau officials have noticed none of this class of material recently, with the exception of some Soviet posters, which were found to be innocuous.

March 14, 1931

# Pure Poetry and Mr. Wallace Stevens

HARMONIUM. By Wallace Stevens. 151 pp. New York: Alfred A. Knopf. $2.50.

MORE than one critic, and not a few poets, have toyed with the idea of what has been termed "pure poetry," which is to say, a poetry which should depend for its effectiveness on its rhythms and the tonal values of the words employed with as complete a dissociation from ideational content as may be humanly possible. Those who have argued for such "pure poetry" have frequently, if not always, been obsessed with some hazy notion of an analogy between music and poetry. As a shining example of this school take Sidney Lanier, who was a skilled musician as well as a notable poet. Lanier advanced the theory that every vowel has its color value. This was not an association of ideas; the letter "e" was not red because it is in the word red, or green because it is in the word green, but the hearer, experiencing the word should, on Lanier's theory, experience, simultaneously with the sound, a distinct sensation of color. In the second decade of this century—the movement began in the first decade—numerous poetic schools drove theory hard. Perhaps none strove especially to carry out Lanier's color hypothesis, but there were the Imagists, and there was Vorticism and Cubism, and many more "isms" besides. For the most part, these schools have died the death which could have been prophesied for them. Poetry is founded in ideas; to be effective and lasting, poetry must be based on life, it must touch and vitalize emotion. For proof, one has but to turn to the poetry that has endured. In poetry, doctrinaire composition has no permanent place.

Hence, unpleasant as it is to record such a conclusion, the very remarkable work of Wallace Stevens cannot endure. The verses which go to make up the volume "Harmonium" are as close to "pure poetry" as one could expect to come. And so far as rhythms and vowels and consonants may be substituted for musical notes, the volume is an achievement. But the achievement is not poetry, it is a tour de force, a "stunt" in the fantastic and the bizarre. From one end of the book to the other there is not an idea that can vitally affect the mind, there is not a word that can arouse emotion. The volume is a glittering edifice of icicles. Brilliant as the moon, the book is equally dead. Only when Stevens goes over to the Chinese does he score, and then not completely, for with all the virtuosity that his verse displays he fails quite to attain the lacqueur finish of his Oriental masters. The following, "Hibiscus on the Sleeping Shores," is the piece that comes nearest to the Chinese, and this is marred by the intrusion in the last line of the critical adjective "stupid."

I say now, Fernando, that on that day
The mind roamed as a moth roams,
Among the blooms beyond the open sand;
And that whatever noise the motion of the waves
Made on the sea-weeds and the covered stones
Disturbed not even the most idle ear.
Then it was that the monstered moth

Which had lain folded against the blue
And the colored purple of the lazy sea,
And which had drowsed along the bony shores,
Shut to the blather that the water made,
Rose up besprent and sought the flaming red
Dabbled with yellow pollen—red as red
As the flag above the old cafe—
And roamed there all the stupid afternoon.

For the full tonal and rhythmic effect of this it must be read aloud, chanted, as Tennyson and Swinburne chanted their verses. Then, within its limits, its very narrow limits, "Hibiscus" will be found to be a musical attainment not before guessed at. But it is not poetry in the larger meaning of the term. And it is not actually music that one has here, but an imitation of music. And if there is a mood conveyed, the mood could have been equally as well conveyed by other lines equally languid of rhythm. No doubt the theorists in poetry have enriched their craft, but at a disservice to themselves. Wallace Stevens is a martyr to a lost cause. PERCY HUTCHISON.

August 9, 1931

## Chicago Streets

YOUNG LONIGAN—A BOYHOOD IN CHICAGO STREETS. By James T. Farrell. With an introduction by Professor Frederic M. Thrasher. 308 pp. New York: Vanguard Press. $3.75.

YOUNG LONIGAN" is an essay in the stream of consciousness of a tough little Irish sinner from the time he graduates from grade school until he enters high school the following Fall. Through the mind of Studs Lonigan the author has attempted to trace faithfully the ebb and flow of adolescent thoughts. Although the scene is set in Chicago's turbulent and heterogeneous South Side, the objects which landmark Studs' horizon—the vacant lots, the school, the alleys, the poolrooms, the soda counters, the beaches, the Irish district, the Jewish district—these are equally descriptive of a similar area in many another American city.

The Lonigans are typical city folk. Paddy, the father, has managed to buy himself a house after a lifetime of hard work, and can afford to send his children to a good Catholic school. Mr. Farrell opens his story impressively with Studs' irreverent thoughts on his approaching graduation, on his first set of long pants, on the platitudinous farewells of his teachers, and how soon he can smoke without locking himself in the bathroom. The reader senses immediately that the fixed moral code acquired by rote in school is of little importance beside hard-fought street rivalries and cellar conferences on forbidden subjects.

"The street gives no diplomas and grants no degrees," writes Professor Thrasher in his introduction, "but it educates with a fatal precision." Studs, graduated from

school, devotes his time to acquiring the leadership of his gang. By midsummer he is "the big cheese" around Indiana Avenue. Of him has been required a number of fights, a certain demonstrable sexual precocity, a hard-boiled manner and at least a dash of lawlessness. His final triumph comes when he is admitted to the poolroom councils of the older fellows. He may, at the parting of his ways, become a thug or a gangster; he may gradually find his way back to the code of his hard-working parents; but in any case he will always retain the red mark of the streets.

There is no question that this book is no novel. The artistic powers of the author, save where he exercises a selective faculty to make his scenes more typical, are in suspension. His to record and report. The publishers choose to call "Young Lonigan" a novel for lack of a better classification. It is more fitting, however, to regard it as a novelist's notebook, a painstaking record from which another Mark Twain might construct an important epic of youth.

May 1, 1932

# FAITH IN MASSES URGED ON WRITERS

## V. F. Calverton Says in Book That Renewed Trust in Public Is Vital.

### WHITMAN HELD AN EXAMPLE

What is needed in America today is renewed faith in the masses, V. F. Calverton, author and editor of The Modern Quarterly, asserts in his book, "The Liberation of American Literature," published today by Charles Scribner's Sons.

It is essential for American literature to find "something of that faith in the potentialities of the proletariat which Emerson and Whitman possessed in the nineteenth century," in Mr. Calverton's opinion.

"It was Emerson, we should remember," he writes, "who was so enthusiastic about the civilization which was being created in the West by men in shirt sleeves, men of unexalted station and plebeian origin, and who looked to that civilization with its democratic spirit to transform the country. It was Whitman who was ecstatic about the fact that it was democratic America which had elevated the poor man into the lord of creation, and had made the world recognize 'the dignity of the common people.'"

American writers of today, Mr. Calverton argues, although liberated from the affliction of the "colonial complex and the petty bourgeois moral code, are liable to plunge into an even deeper chaos and despair, unless they can succeed in allying themselves with the growing proletarian tradition. The only writers of importance in America today who have not surrendered to the pessimism and pathology which are predominant in American literature are those who are exponents of the proletarian outlook: John Dos Passos, Michael Gold and Charles Yale Harrison."

The need of today, as Mr. Calverton sets it, is a return of the faith in the common man in the mass, but a faith founded upon a collective instead of an individualistic premise. Emerson's and Whitman's belief in the common man was a belief in him as a petty bourgeois individualist, the writer continues; "our belief must be in him as proletarian collectivist."

"In that belief lies the ultimate libration of American literature—and American life," Mr. Calverton asserts. "More, the literature and life of the world; for so long as the vast masses of the population are suppressed by the few, the colossal energy of the race can never be released for creative fulfillment. Just as in its struggle against the feudal aristocracy the middle class with its fresh vigor let loose upon the earth a flood of energy which did not spend itself until it remade civilization, so the proletariat in the twentieth century with its new impulse can remake the modern world."

Nineteenth century authors had a working faith from which to draw their inspiration. Mr. Calverton points out, but this faith has proved fallacious to writers of the twentitth century, who have none of their own from which to draw strength. At best, the literary men of this century "can but break down further the barriers of personality, and, verging still deeper into the pathologic, attempt to dig closer into the roots of the subjective—or, to pursue an easier course, launder their art with the literary starch of sophisticated futility."

September 9, 1932

# FINDS NEW BOOKS STIFLE LITERATURE

## Critic Says Modern Authors Have Forgotten Public to Write for Each Other.

### DECRIES STRESS ON FORM

Writers are so busily engaged in writing for one another, so occupied with "form" and literary style, that literature is due for a long sleep.

"the prey of a sterile aestheticism that substitutes the means of art for the end." unless it re-establishes its connection with the "laboring body of humanity," Van Wyck Brooks, biographer and critic, writes in "Sketches in Criticism," published today by Dutton.

The solemn humbug is more rare than it once was for there is a genuine freedom from pretence in the present generation, but this "negative virtue" is accompanied by "certain positive vices," he writes.

"There has been a strange growth," he says, "of cliques and coteries, mutual benefit and protective societies and magazines devoted to the propagation of secret writings. These curious efforts to communicate and at the same time obstruct communication, to court a public that is generally despised, to express and yet refrain from expressing, to substitute a cipher for a language, are perhaps what they profess to be the most symptomatic literary facts of the moment; but, like the phenomena of spiritualism, they lend themselves to very unflattering psychological interpretation."

"The great game of countless writers of today might be described as a sort of learned spoofing. They spill out, in all sorts of ingenious patterns, the contents of the upper levels of their minds; they fetch up the tags and tatters of a badly assimilated erudition, so that one can almost say with the Florentine humanist, that 'dipthongs and consonants are the talk of the town'; they match unfamiliar quotations; they no longer seek to shock the grocers, they are satisfied if they can dazzle one another.

"These are the fruits of a parvenu intellectuality; and indeed the fashionable pedant, the last-born child of a popular education that was inaugurated with prayer and fasting, occupies the centre of the stage.

"What serious aim dignifies these activities? The passion for experimentation. It would be foolish to say that this passion is without dignity; but it is equally impossible to deny that the dignity is superficial.

"Experimentation in form? But however it may be in the plastic arts, in literature the subject, the content, dictates the form. The form is an inevitable consequence of the thing that is to be said and rises out of it as naturally as the flower rises out of the seed. And so to begin with the form, to seek the form, is to confess that one lacks the thing. It is a frank acknowledgment of literary insolvency."

The writer is inclined to agree with Alfred Stiglitz who once remarked that America has a new generation in art and literature every five years.

October 13, 1932

# Our Literature And Its Effect

## Sub-Standard Intellect And Character Are Deplored

*To the Editor of The New York Times:*
It is necessary for me to say this for the good of my soul.

For fifteen years or so I have religiously been reading the Prousts, the Aldous Huxleys, the Menckens, the Joyces, the Lawrences, the Van Vechtens, the Faulkners, the Cabells, the Evelyn Scotts, the debunking biographers, and all of the rest of the sad sophisticated souls. The most intelligent (well, almost the most intelligent) of my friends would roll their eyes and passionately praise the motley crew, and there was nothing else for me to do but get into line.

Finally, I reached the saturation point, and overboard out of my mind—what there was left of it—went the entire company of anemic amateurs at life.

Back I turned to Fielding and Addison and Burns and Dickens and Kipling (let the pop-eyed young Narcissi date him to their heart's delight) and Galsworthy and Macaulay and Dumas and Thoreau and Emerson—full-sized men, all of 'em. I got what I was looking for—robust, ruddy, protean, worthwhile human life, reflected by authentic genius through the medium of genuine craftsmanship. It was like getting out of a nightmare.

**Our Neurotic Literature.**

For nearly a generation the literature of the world has been neurotic, incompetent and overrated. It has bred effeminacy of thought and deed, a false code of individualism, a corroding selfishness and cynicism which probably have had as much to do with our present troubles as any one thing. As a result of it, too many of our women, with an utterly pathetic and abortive egotism, are seeking something they have not found and will never find; too many of our young men have grown effeminate, mannerless, and mentally rudderless. If you do not believe me, the nearest cocktail party, for an isolated example, will shed a little light, or take a trip to Union Square.

I have been something of a radical in my time—that is to say, if you accept the definition, I have got more out of ideas than out of things, which does not by any means preclude action—but I am sick of filth and effeminacy in my reading and in my theatre; of viewing solemnly displayed paintings born of brainless conceit running amuck over a defenseless canvas to conceal sloppy technique; of sub-standard intellect and character in the people I meet.

The plain truth of the matter is, and I suspect that the thoroughbred who sits in the White House knows it, that we are never going to get back to normal in this country until we get back to the straight thinking and rougher habit of an elder day. The times are largely what we have made them by gushing over cheap gods. G. C.
New York, April 19, 1933.

April 23, 1933

# COURT LIFTS BAN ON 'ULYSSES' HERE

## Woolsey Holds Joyce Novel Is Not Obscene—He Finds It a Work of Literary Merit.

### IGNORES SINGLE PASSAGES

### His Judging of Volume as a Whole, Not in Isolated Parts, Establishes a Precedent.

James Joyce's "Ulysses," a novel which has been banned from the United States by customs censors on the ground that it might cause American readers to harbor "impure and lustful thoughts," found a champion yesterday in the United States District Court.

Federal Judge John M. Woolsey, after devoting almost a month of his time to reading the book, ruled in an opinion which he filed in court that "Ulysses" not only was not obscene in a legal sense, but that it was a work of literary merit.

Under the ruling the book will be published here in unexpurgated form on Jan. 20 by Random House. It will contain an introduction especially written for it by Joyce and also the full decision of Judge Woolsey, which was considered here to establish a precedent in an interpretation of "obscenity."

Judge Woolsey held in brief that single passages could not be isolated from a literary work in determining whether or not the work as a whole was pornographic.

He defended Joyce's purpose in writing "Ulysses" and suggested that attacks against the book had been occasioned because "Joyce has been loyal to his technique and has not funked its necessary implications."

The court, expressing its own reaction to a reading of the book found it to be "brilliant" and at the same time "dull." It had not been "easy to read," he noted, nor had it been clear in all places, though in other places it was thoroughly intelligible.

#### No "Dirt for Dirt Sake."

"In many places," Judge Woolsey wrote, "it seems to me to be disgusting," but nothing, he added, had been included in it as "dirt for dirt sake."

Before announcing his decision Judge Woolsey noted that he had read the whole book and had given special attention to passages singled out by the government as objectionable.

"I am quite aware," he concluded, "that owing to some of its scenes 'Ulysses' is a rather strong draught to ask some sensitive though normal person to take. But my considered opinion, after long reflection, is that whilst it many places the effect of Ulysses on the reader undoubtedly is somewhat emetic, nowhere does it tend to be an aphrodisiac.

"'Ulysses' may, therefore, be admitted into the United States."

Judge Woolsey directed that a copy of the book which the custom censors had seized as it entered this port from Europe be surrendered to Random House, Inc., the assignee. Samuel C. Coleman, Assistant United States Attorney, who brought the matter to the court's attention, said that the decision, in his opinion, was a masterpiece and "thoroughly wholesome."

Judge Woolsey began his opinion by saying that he believed "Ulysses" to be "a sincere and serious attempt to devise a new literary method for the observation and description of mankind."

He explained that in arriving at his conclusions he had also weighed the merits of other books of the same school. He described these books as "satellites of 'Ulysses.'"

#### Holds Purpose Not Obscene.

The principal question he had to solve, the court suggested, was whether or not Joyce's purpose in writing the book had been pornographic.

"In spite of its unusual frankness," he wrote, "I do not detect anywhere the leer of the sensualist. I hold, therefore, that it is not pornographic.

"In writing 'Ulysses' Joyce sought to make a serious experiment in a new if not wholly novel literary genre.

"Joyce has attempted—it seems to me with astonishing success — to show how the screen of consciousness with its ever-shifting kaleidoscopic impressions carries as it were on a plastic palimpsest not only what is in the focus of each man's observation of the actual things about him, but also in a penumbral zone residua of past impressions, some recent and some drawn up by association from the domain of the subconscious.

"The words which are criticized as dirty are old Saxon words known to almost all men, and, I venture, to many women, and are such words as would be naturally and habitually used, I believe, by the types of folk whose life, physical and mental, Joyce is seeking to describe.

"If one does not wish to associate with such folks as Joyce describes, that is one's own choice."

December 7, 1933

# The Poetry of William Carlos Williams

COLLECTED POEMS: 1921-1931. By William Carlos Williams. 134 pp. New York: The Objectivist Press. $2.

LIKE all true revolutionaries in the arts, William Carlos Williams is an unconquerable individualist. In an age of success through easy compromises he has indulged himself in the luxury of integrity. He has written some of the most obscure poetry of our time, just as Einstein has written some of the most obscure equations. But the public has never even faintly shown signs of taking him up through sheer curiosity. He has always had the support and the admiration of many of the most distinguished critics of contemporary poetry. And because he has stuck to his guns he has given other poets the strength to stick to their guns, too.

One of the anthologies in which his poetry is always being decently interred (Harriet Monroe's "The New Poetry," this time) quotes what William Marion Reedy wrote of him:

Williams is forthright a hard straight bitter javelin compared to most of the staccatists. But there is a tang of very old sherry in him, to mellow the irony; a blunt geniality behind the harlequin. As you read him you catch in your nostrils the pungent beauty in the wake of his "hard stuff," and you begin to realize how little poetry—or prose—depends on definitions, or precedents, or forms.

That is right; in fact, it is so true that it reflects a little in its closing phrases on Reedy's own preceding floridities in praise of Williams. Wallace Stevens, who is himself one of the best of the uncatalogueable poets of America, claims in his salty commentary on Williams in the foreword to "Collected Poems: 1921-1931" that Williams is a romantic poet. He also says that "the slightly tobaccoy odor of Autumn is perceptible in these pages," because Williams is past fifty. This poem illustrates our agreement with these judgments. It is called "Man in a Room":

Here, no woman, nor man besides,
Nor child, nor dog, nor bird, nor wasp,
Nor ditch-pool, nor green thing. Color of flower,
Blood-bright berry none, nor flame rust
On leaf, nor pink gall-sting on stem, nor
Staring stone. Ay de mi!
Nor hawthorn's white thorn-tree here, nor lawn
Of buttercups, nor any counterpart:
Bed, book-backs, walls, floor,
Flat pictures, desk, clothes-box, litter
Of paper scrawls. So I sit here,
So stand, so walk about. Beside

The flower-white tree not so lonely as I:
Torn petals, dew wet, yellowed my bare ankles.

That poem has a quality of at least superficial intelligibility that Williams does not always vouchsafe his readers when he writes what he wants to write as he wants to write it. In "The Red Wheelbarrow":

so much depends
upon

a red wheel-
barrow

glazed with rain
water

beside the white
chickens

—one may simply enjoy the bright simplicity of it, or be bored with it, or make the customary attempts to read clueless profundities into it that we are always ready to make for poetry and paintings—often to their creator's amazement. It happens that this is the poem Dr. Williams chose for William Rose Benet's "Fifty Poets" last year and in sending it to him he wrote:

I am enclosing a favorite short poem of mine for your anthology with the paragraph to accompany it which you ask for. It's a nice idea.

The wheelbarrow in question stood outside the window of an old Negro's house on a back street of the suburb in which I live. It was pouring rain and there were white chickens walking about in it. The sight impressed me somehow as about the most important, the most integral that it had ever been my pleasure to gaze upon. And the meter though no more than a fragment succeeds in portraying this pleasure flawlessly, even it succeeds in denoting a certain unquenchable exaltation—in fact I find the poem quite perfect.

Now if all Dr. Williams's poems were accompanied by such program notes they would be much easier to read. But even so, "Collected Poems: 1921-1931" should not be allowed to pass only to those who are professional readers of poetry. This scrupulous winnowing of ten years' writing deserves a better fate than that.

When The Dial gave him its $2,000 award for his service to literature a number of years ago the editors said: "This modest quality of realness which he attributes to contact with the good Jersey dirt sometimes reminds one of Chekhov. Like Chekhov he knows animals and babies as well as trees." He knows more things of heaven and earth than are summed up in that philosophy, too. He knows that poetry only continues to flower when from age to age there are poets intransigeant enough to give it new life. This book is one to stand beside the books of Ezra Pound, his friend, in that fine category.

C. G. Poore.

February 18, 1934

# "In Dubious Battle"

IN DUBIOUS BATTLE. By John Steinbeck. 349 pp. New York: Covici-Friede. $2.50.

YOU may remember "Tortilla Flat," Mr. Steinbeck's last novel, which described with genial gusto and gentle irony the picaresque adventures of a small group of Latin-American vagabonds in a California suburban slum. That was a gay, melancholy and charming book. It did for the lotus eaters of a bum's paradise what "Penrod" did for the small boys of the middle-class suburbs of pre-war days—described them accurately, wittily, ironically, engagingly, as they would appear to bustling outsiders nostalgic for the simple amoral life. You would never know that "In Dubious Battle" was by the same John Steinbeck if the publishers did not tell you so.

It seems to me one of the most courageous and desperately honest books that has appeared in a long time. It is also, both dramatically and realistically, the best labor and strike novel to come out of our contemporary economic and social unrest. It will alienate many of Steinbeck's readers, particularly in California, where "Tortilla Flat" headed the best-seller lists for weeks and where the new story is laid. But it is not cut to any orthodox, Communist or other pattern. It is such a novel as Sinclair Lewis at his best might have done had he gone on with his projected labor novel instead of turning to the far easier, although possibly no less valuable job of striking a blow against fascism.

Steinbeck keeps himself out of the book. There is no editorializing or direct propaganda. His purpose is to describe accurately and dramatize powerfully a small strike of migratory workers, guided by a veteran Communist organizer, in a California fruit valley. It is true the book is focused on strike headquarters— on the two Communist field workers, the little doctor who gives his services to the strikers but remains philosophically and ironically but sympathetically detached from the spirit of fervor, and the strikers' natural leaders, some of whom have no use for "Reds" but decide to strike in person and group rebellion against what seems to them a double-cross on the part of the owners. But the arguments on the other side are also given, though not without the caustic commentaries and violent reactions of the workers and the ideological counter-arguments of their Communist mentors.

All the elements of such a strike are here. The concealed discontent and hostility emerged into the open. The party workers succeed in winning over the leaders to a program of united and effective action. A small fruit-grower, at odds with the powerful interests in the valley, is induced to give the men a camping-ground on his place. A doctor is imported to enforce sanitation and prevent the authorities from using the health laws as an excuse to oust the strikers. Bribes and promises are offered. Overtures are made and rejected. Scabs are imported and the strike enters the stage of violence.

First blood is drawn by "vigilantes," irresponsibles of the kind which short-sighted capitalists— knowing they cannot depend 100 per cent on the law, which, after all, is dependent on popular support—foster and encourage, sometimes getting more than they bargain for. Thousands of peaceful citizens in the valley, resentful against the domination of a "big three" owning group, sympathize with the strikers and supply them with food. The law wavers and tries to get rid of them peaceably before it turns against them. Violence results in counter-violence. The strikers are doomed. But to the irreconcilables they have won a moral victory, a minor victory on a broad front.

But this is a story of individuals as well as one of mass action and of mental and spiritual attitudes translated into action. Mac, the hard-boiled organizer; Jim, the new convert, intense and brooding and passionate; London, the born leader whom Mac and Jim succeed in winning over and putting at the head of the little army—these three principals are real men in other fields of endeavor, lead both public and private lives; are plain human beings off guard and off duty, but something else again as leaders in a cause or a fight. Just so the thousand or more men under them integrate and disintegrate, now an amorphous tangle of individuals and small groups, now an army, now a fanatic mob moving as one, fused into a single will, with double the strength of their numbers, only to dissolve again into helpless disorder. It is his extraordinarily effective and moving handling of these elements which makes Steinbeck's book not only a powerful labor novel of our times but a profound psychological novel of men and leadership and masses.

"In Dubious Battle" will not change the opinions of those already seated firmly in the saddle of their various faiths, opinions and prejudices. These strikers and their leaders and their arguments and actions will, however, win the admiration and sympathy of many middle-grounders. They will repel many others—just as do their prototypes in real life. It's an honest book, and it is also a swiftmoving and exciting story.

FRED T. MARSH.

February 2, 1936

# T. S. ELIOT, POET OF OUR TIME

## His "Collected Poems" Covers a Period of Twenty-five Years

COLLECTED POEMS. By T. S. Eliot. 1909-1935. 220 pp. New York: Harcourt, Brace & Co. $2.50.

By PETER MONRO JACK

MR. ELIOT has become a classic in his own time without having been very well understood or much read. The quality of his poetry had been obvious since 1917, when "Prufrock and Other Observations" was issued from Bloomsbury Street. General recognition, or as one might say, a general offensive, started in 1922, when "The Waste Land" (a Dial prize winner) was published. From then on Mr. Eliot's poetry was largely ignored. Instead he became a public issue. Those who could not read him and those who did not try turned him into a sort of stool-pigeon for almost every contemporary controversy: the bad effects of expatriatism, for instance; the cult of unintelligibility; the traditional "ancient and modern" quarrel; the humanism-fascism-communism, Puritan-Anglo-Catholic, Royalist-democratic, escapist and look-at-the-facts schools; Mr. Eliot was supposed to represent all of them, while he was being used merely as an excuse to talk of them. The name started a fight whenever it was mentioned, or when it appeared in a magazine or review. Every one seemed to feel that he was important and to find him unintelligible, and the result was a series of critical errors that no one can be very proud of today. The misapprehensions persist. Only last month a Pulitzer prize winner (in poetry) complained that Eliot belonged to the Art for Art's Sake school.

Looking over the variety and versatility of the "Collected

Poems" one can see that its obvious distinction is to be "useful" poetry. It has expressed, as no one else has done, the critical and creative intelligence of our day, in its utmost seriousness as well as its potential farce. Consider the serious comedy of J. Alfred Prufrock in his "Love Song," written by Mr. Elliot before he graduated from Harvard at the age of 22. Here already is an astonishingly effective technique in poetry, so admirable that it at once became a formula. (Needless to say Mr. Eliot did not himself repeat it. The "Portrait of a Lady" which follows in all the editions was written a year earlier, and is obviously an approach to the perfected form of "Prufrock.") This "Love Song" set the tone of contemporary verse. It restated the dramatic monologue with a new accent, free from the tricks of Browning and Tennyson's sententiousness, and (we may add) was much more integrated than the examples that Ezra Pound was then producing. It used free verse with stylistic assurance, took over a Dostoevski confessional attitude with its later psychoanalytic implications, explained itself through allusive imagery, and set the whole to a discordant music, mostly recitative, with occasionally a half-formed melody—to make a poem so exactly expressive, so intelligently aware of its effect, that one felt a new certainty in poetry. That it dealt with the difficulties and uncertainties of life made the precision of its form even more remarkable.

The shorter poems that follow show that he had been reading the French symbolists and that he had learned from them that a poem is more valuable when it stands alone, not subsisting on the author's personality. In Eliot's hands this was to move from romanticism toward classicism, to think of a poem in terms of a finished effect, a final symbol, rather than (with romantic poets) the beginning of an acquaintance with a personality. There are a few doubtful phrases in these poems. The second couplet here is more smart than witty ("Morning at the Window"):

*They are rattling breakfast plates in*
  *basement kitchens,*
*And along the trampled edges of the*
  *street*
*I am aware of the damp souls of house-*
  *maids*
*Sprouting despondently at area gates.*

But the poems have been so carefully formulated from the first that lapses such as this (if this is one) are rare, and only one poem ("Ode" from "Ara Vus Prec," a mannered and distasteful poem), has been dropped from the collection. The section ends with the lovely "Figlia Che Piange," designed for an anthology.

"Gerontion," a curiously prophetic poem (dated before 1920) seems to have all the elements of both "The Waste Land" (1922) and "Ash Wednesday" (1930) without a clear articulation. Here is the loss of desire in the symbol of old age, the memories and the questioning that have replaced passion and faith, and the despair at the little that is left. But still there is Christ, the tiger, the conscience that still devours us, the eternal symbol from which there is no escape:

*Think at last*
*We have not reached conclusion,*
  *When I*
*Stiffen in a rented house.*

It is a difficult poem (perhaps the only difficult poem Mr. Eliot has written), not only because it is unresolved, but because it is too complex for its form and too pregnant with its possibilities.

The astonishing poems that follow in formal quatrains, the Burbank - Bleistein - Sweeney poems, with "The Cooking Egg" (an egg not quite fresh, like Mr. Eliot's symbolic world) are acknowledged masterpieces of style. Like "Prufrock" and "Gerontion," their theme is the weakness or the absurdity or the futility of worldly desire, in this person or that; mocked by the heroic tradition of the past and made uneasy by the ever-living conscience of the future. Here Mr. Eliot is at his most savage, pitilessly exposing the poorest pretensions of our day. But again there is the counterpoint that was to be heard more clearly in "Ash Wednesday." The sensual Sweeney stirs in his bath, the subtle professors discuss theology, but

*A painter of the Umbrian school*
*Designed upon a gesso ground*
*The nimbus of the Baptized God.*
*The wilderness is cracked and browned,*

*But through the water pale and thin*
*Still shine the unoffending feet,*
*And there above the painter set*
*The Father and the paraclete.*

It repeats the tone of Shakespeare

  *(those holy fields*
*Over whose acres walk'd those blessed feet*
*Which fourteen hundred years ago were nail'd*
*For our advantage on the bitter cross.)*

and repeats it to our disadvantage, for the easy style of Shakespeare can be sustained only dryly and wryly.

After this "The Waste Land" should have been no surprise, though it must be said that one was not prepared for its brilliance. It put an epic into a short poem, a music into our distraught and demoralized ideas, an ultimatum for our faith, a final immersion in our destructive element, and all of it ringing with memories of Shakespeare and Webster and Donne, Marvel and Day and Baudelaire and Verlaine, Dante, Lucretius, and St. Augustine, Spenser, Milton, Wagner, Tiresias (Ovid), Sappho, Froude, Frazer, Bradley, and the Vedic books: as if to say, "Look here, upon this picture, and on this." No such documentary prosecution of a contemporary age had appeared before, no such challenge; but it was clear that Mr. Eliot could not continue his catalogue of broken images. "The Hollow Men" (1925) is the last and perhaps the most masterful descant on the deadness of an unspiritual life, though following it Mr. Eliot should have printed his incomparable farces of "Sweeney Agonistes" (1926), the last twist of the knife for our vulgar civilization, as it administered by Aristophanes. The dates here are deceptive. The "Ariel" poems here precede "Ash Wednesday" but the "Journey of the Magi" (1927) and "A Song for Simeon" really are precursors, though they are printed as aftermaths. Still one has to be cautious. "Ash Wednesday" was published in 1930, but at least one of its sections (No. II) had been published in Mr. Eliot's "Criterion" in January, 1928, and entitled "Salutation." "Doris's Dream Songs" are incorporated here for the first time, looking like late poems, though they had been printed in Harold Monro's Chapbook in 1926, and the third section had become a piece of "The Hollow Men." It is too easy to be dogmatic about Eliot's progress and his so-called conversion: both were implicit from the first, and the only comment is that his later style is as surprisingly novel and proper as his earlier.

"Ash Wednesday," as simple and lovely exercise in devotion coming after the tortuous patterns of his early poems, has by no means exhausted Mr. Eliot's versatility. The choruses from "The Rock" are here, dramatic and exhortatory; the argumentative rhetoric of "Burnt Norton," the pieces (for children?) that are evidently to go into "Pollicle Dogs and Jellicle Cats," the little imagistic landscapes from New Hampshire, Virginia and Scotland, with a peculiar rhyme-echo scheme—a good deal of quiet minor poetry that probably marks the beginning (as has usually been the case) of a new major development. It is most likely to be in the direction of "Coriolan," the same sort of speech that went into the last act of "Murder in the Cathedral," startlingly direct, caustic, and dramatic, a speech for the people. Certainly the effective stress, rhythm, and pitch (the "stone" always low, the rest higher) of "Triumphal March,"

  *(Stone, bronze, stone, steel, stone, oakleaves,*
    *horses' heels*
  *Over the paving)*

are new to him. But whatever he does is readily interesting and bound to be influential. He has been a poet's poet (though not all poets) and now he might very well be a people's poet. His direction seems to be toward that, and we hope it might be so.

June 14, 1936

# A Distinguished Novel by Franz Kafka

*THE TRIAL. Translated From the German of Franz Kafka by Willa and Edwin Muir. 297 pp. New York: Alfred A. Knopf. $2.50.*

### By LOUIS KRONENBERGER

WHEN the late Franz Kafka's "The Castle" was published in this country some years ago, it created no general stir, but it was immediately seized upon by a few people as a very distinguished book. Time has passed, and other people—though still not many—have concurred in that conclusion. I must confess that I have not read "The Castle," but I mean to, for I have read "The Trial," and not in a long time have I come upon a novel which, without being in any vulgar sense spectacular, is more astonishing. Not in a long time have I found a man who knew his trade as a novelist more thoroughly, yet could add very special and exciting qualities of mind and spirit besides.

"The Trial" is not for everybody, and its peculiar air of excitement will seem flat enough to those who habitually feed on "exciting" books. If its plot is dramatic, its plot is only an envelope for its theme, and its theme is by no means easily grasped. It belongs not with the many novels that horrify, but with the many fewer novels which terrify. It does not trick out the world we know in grotesque and fantastic shapes; it is at once wholly of our world and wholly outside it. It keeps one foot so solidly on the ground that you can think of few books which stay there more firmly with both feet. But its other foot swings far out into space, conferring upon the literal action of the story a depth of meaning—or if meaning is often elusive, a power of suggestion—which can best be called visionary.

"Visionary," however, can be a misleading word. It too easily suggests an unabashed mysticism, a private and prophetic universe divorced from, or at least defiant of, reality. But Kafka, to a striking degree and with a sure insight, *depends upon* reality; were he not using it as a norm, he would get no effects by extending and distorting it. It is not the nature of his events that seems strange, but the arrangement of them; for as a means of operation, he has fallen back upon the technique of the dream, and "The Trial" has a consistently dreamlike character. Two or three things happen in a logical and orderly way; then something unexpected or unexplained arises; then causation is ignored, past incidents melt away, we are off on a new tack. But "The Trial" is dreamlike also in this: that whatever happens does not seem particularly startling. It may seem curious, as things do in dreams; but it shocks, as the same things do in life.

Something of the book's quality may be guessed from a brief mention of its plot. Joseph K., a young bank official, gets up one morning to find that he has been arrested. He knows he has committed no crime, and he is never then or later told what his crime is supposed to be. He is permitted his freedom, except that periodically he must go to court. Court is a weird place, full of other accused people and innumerable petty officials; there K. is allowed to assert his eloquence, but the business of his trial never makes any progress.

There is more to the story than an account of K.'s "trial"; we are told much about his life at the bank and his feud with the deputy manager there; about his relations with his landlady; and about his relations with the young woman who has the room next to his. In all these things K. is made to feel just as uncertain and frustrated as in the matter of his trial; and this frustration, a choking and stifling frustration, contributes most of all to the dream character of the book. It is exactly the sensation we have during a lingering nightmare and from which, when it becomes too oppressive, we manage to wake ourselves up.

No summary can convey the atmosphere which Kafka cunningly distils—the atmosphere of some idiotic and hellish labyrinth where Joseph K., his mental powers proving absolutely useless to him, is forced to wander. Not only is he ignorant of his crime; he is just as ignorant of his trial and his judges, of where things are heading, of the arguments that will be used for and against him. He finds everything a mystery and that those who are supposed to help him are just as mystified as he is. The more he tries to control the situation, to seek good advice, to apply sound tactics, to employ common sense, the more stranded he becomes. On psychological grounds alone the story has a peculiar force and distinction.

But the impact of "The Trial" is much more moral than psychological. Kafka is at bottom a religious writer, with a powerful sense of right and wrong and an unquenchable yearning toward the unrevealed source of things. His story then is a great general parable, the details and secondary meanings of which every reader may interpret as he chooses. But the symbolism of the court and of the law is unmistakable; the helplessness of human beings in the face of the unknowable, the contradiction between ethical guilt and legal innocence, or legal guilt and ethical innocence; the striking demonstration that none of us is ever really free—these things, too, are clear as daylight.

It is a proof of Kafka's other talents as a novelist, a humorist, a psychologist and a satirist that he does not leave his parable a bald one, but works into it every kind of human gesture and lifelike detail. The man who can, while writing symbolically, make a hilarious stuffed shirt out of K.'s advocate, and then—in a later scene—express his religious feeling in the richest organ tones, was a writer in whose death literature suffered a real loss. But we Americans are fortunate in still having ahead of us the pleasure of reading almost all that Kafka wrote.

October 24, 1937

# The Private Exercise of Poetry

*In a World of Conflicting Ideologies, E. E. Cummings Stubbornly Persists in Writing as a Poet*

*COLLECTED POEMS. By E. E. Cummings. 315 pp. New York: Harcourt, Brace & Co. $3.*

### By PETER MONRO JACK

THE work that Cummings has set himself to do, and has done with singular constancy, is a poet's work. It will never be remembered as current topics versified or political propaganda. It is in the tradition of romantic individualism, and Cummings is decidedly one of the few who can say "great God" with some conviction that he'd "rather be a pagan suckled in a creed outworn" than subscribe to the latest popular and party uses of poetry. When he writes

i have found what you are like
the rain.
  *   *   *
the air in utterable coolness
deeds of green thrilling light
                    with thinned
newfragile yellows

he is saying in poetry what he argues in prose, that a poem *means* because it *is.*

Strangely enough, those who have been actively against his poetry are those who should defend it. The diversity and perversity of judgment on him has been as extraordinary as it is exasperating. Max Eastman, who wrote on The Enjoyment of Poetry, cannot "make sense" of Cummings. R. P. Blackmur concludes that his poetry is "a kind of baby talk." Horace Gregory believes that it has never developed. None of this is seriously to be believed. The critics are saying in their various ways how difficult (and perhaps even undesirable) it is to continue the private exercise of poetry in a publicly advertised world of conflicting ideologies. To grow up today (they would say) a poet has to take sides; to progress, he must change styles; to appear in a *collected* edition, he must enlarge and enrich himself as he comes to his conclusion. This may be right, in literary theory and can frequently be well demonstrated, and it is most pertinent to our poetry of today; but it is not always true, and it has nothing to do with Cummings.

Cummings has had the felicity of beginning with a style that is the envy of any poet. The first poem printed here (the first poem he ever wrote would do as well) is an original, a first edition, a copyright. It is quite true that Keats is in it, and the pre-Raphaelites. "Making moan," "mingling robes," even the fatal Keatsian verb "to glue"—they are here, as they will be in a

young poet's work; but they are here in a new way, with a modern language and a most gentle and witty sensibility:

> let thy twain eyes deeply wield
> a noise of petals falling silently

Turning the pages, we find this young lushness tempered and changed with new shiftings of vocabulary, meaning and rhythm. The essential romanticism of feeling and eccentric precision of style persist while the matter varies from sentimental waywardness to cruel satirical disgust, from some of the loveliest love poems of any time to the least dubious ambiguities of sex, from actualities of the war in Paris to speakeasies in New York after the war. There is no compromise and no cure. Corruption and disintegration are as necessary to this poetry as the renewal of Spring and love. Sometimes it is too disgusting to read, some-

times too tender; but even in extremes it is an integration of individual feeling that one instinctively wishes to preserve and defend. It is a counterpoint of words as exacting at its best as a fugue, as exciting at its worst as a romantic prelude of love and death. But it easily holds its quality of style on any page:

> but if i like, i'll take between thy hands
> what no man feels, no woman understands.

Or, to take it where readers like to dislike it:

> d is app ea r in gly
> eyes grip live loop croon mime
> nakedly hurl asquirm the
> dip&giveswoop&swoon&ingly

—it has faults of temper and repetition, but they are deliberate dissonances in a sound composition. This poetry has been more notorious than popular. Let it rest here on a single instance, neither the best nor the worst,

but from a collection that three years ago was rejected by every publisher in New York, and the answer is left to the reader's taste, as any poet and certainly every reviewer would wish:

> how dark and single, where he ends, the earth
> (whose texture feels of pride and loneliness
> alive like some dream giving more then all
> life's busy little dyings may possess)
> how sincere large distinct and natural
> he comes to his disappearance; as a mind
> full without fear might faithfully lie down
> to so much sleep they only understand
>
> enormously which fail—look: with what ease
> that bright how plural tide measures her guest
> (as critics will upon a poet feast)

> meanwhile this ghost goes under, his drowned girth
> are mountains; and beyond all hurt of praise
> the unimaginable night not known

There is no doubt in my mind that this belongs to a person who is born to feel and write like this, a natural poet who has cared less than any others of his time for the year-to-year fluctuations of the market, who really denies that "a measurable universe made of electrons and light-years is one electron more serious or one light-year less imprisoning than an immeasurable universe made of cherubim and seraphim." Cummings writes as a poet—whether minor or major is no matter at the moment—and his recognition is imperative for the continuation of poetry.

June 26, 1938

## A Tragic Chorus

*THE DAY OF THE LOCUST. By Nathanael West. 238 pp. New York: Random House. $2.*

"THE DAY OF THE LOCUST" is an effective grotesque based in Nathanael West's seemingly sincere conviction that, as a resident of Hollywood, he is mighty near being surrounded by crazy people. His novel is not, however, just another slam at the movie colony. The demented who scare Mr. West are not supervisors but that great off-stage mob that has come to California to die.

They take, says Mr. West in effect, an unconscionable time a-dying and meanwhile they become advocates of brain-breathing and of the kilowatt dollar. They hang about nutburger stands learning intolerance from one another. The combination of climate,

cheap living and the entertainment industry, Mr. West appears to believe, have concentrated in one city too many shoddy minds, too many lost people who have energy without rational purpose, who are natural mobsters, instinctive lynchers. Freed in their new anonymity from the restraints of the village life from which they have escaped, they form a tragic chorus for the glamour boys and girls under movie contract.

Out of this chorus Mr. West picks a tough, combative dwarf, a wild Mexican, a maniac from the Midwest, a procuress, a woman athlete, an aging clown, a young artist, a child actor, a handsome, mindless cowboy and a beautiful mindless girl. The young artist pursues the mindless girl, a harassed onlooker while she has an affair with a cowboy and when she goes to live

in the home of a lunatic. Meanwhile he is making notes for his masterpainting, "The Burning of Los Angeles."

Walk-on characters include some cultists who cry out in temples devoted to cleansing the world of salt; beauty contest winners; fighting cocks; a family of cheerful Eskimo vaudevillians; a group of critics of strangers' funerals—who sit estimating the price tags that have been removed from flowers and coffin and study the gait and gestures of the mourners.

Early in his story Mr. West pictures an imitation dead horse in a swimming pool, a life-size monstrosity: "Its legs stuck up stiff and straight and it had an enormous, distended belly. Its hammerhead lay twisted to one side and from its mouth, which was set in an agonized grin, hung

a heavy, black tongue."

Most of the situations in this novel are as ugly as that horse. A child is murdered by being kicked to death; a dwarf is lifted by the heels and slung against a wall; a movie illustrating one of the least conceivable perversions is shown in a bawdy house; a lunatic returns to the "original coil"; the strength and weight of a lynching mob lifts the novel to its climax.

But ugly or not, all these situations build directly to the final impression, and, like it or not, that final impression is strong. As the mob strikes in the final pages the locusts have their day, this nightmare of lust and violence, of distortions and cruel comedy, becomes real.

ROBERT VAN GELDER.

May 21, 1939

# A Tragic Novel of Negro Life in America

*NATIVE SON. By Richard Wright. 359 pp. New York: Harper & Brothers. $2.50.*

*By PETER MONRO JACK*

A READY way to show the importance of this novel is to call it the Negro "American Tragedy" and to compare it roughly with Dreiser's

masterpiece. Both deal seriously and powerfully with the problem of social maladjustment, with environment and individual behavior, and subsequently with crime and punishment. Both are tragedies and Dreiser's white boy and Wright's black boy are equally killed in the electric chair not

for being criminals—since the crime in each case was unpremeditated—but for being social misfits. The pattern in both books is similar: the family, the adolescent, the lure of money and sex, fortuitous events, murder, trial and death. The conclusion in both is that society is to blame,

that the environment into which each was born forced upon them their crimes, that they were the particular victims of a general injustice.

The startling difference in Mr. Wright's "Native Son" is that the injustice is a racial, not merely a social, one. Dreiser's Clyde Griffiths represents a social "complex" that could be reasonably taken care of. Mr. Wright's Bigger Thomas is far beyond and outside of helpful social agencies. He represents an *impasse* rather than a complex, and his tragedy is to be born into a black and

immutable minority race, literally, in his own words, "whipped before you born." Mr. Wright allows Bigger a brief moment of illumination into his hopeless condition before he is finally whipped out of the world.

It will be obvious, then, that Mr. Wright has the simpler and more melodramatic story. Where Dreiser broods slowly and patiently over the intricate social scene, Mr. Wright leaps at the glaring injustice of the racial code, takes it by the throat and spills blood in every direction. His story is direct, lurid and alarming; in effect it is the bloodiest and most brutal story of the year; it makes the reader realize and respond to, as he has probably never done before, the actual, dangerous status of the Negro in America.

The narrative of Bigger's life begins with a symbolic incident worth remarking on. He is 20 years old, living in a one-room tenement apartment in Chicago's South Side Black Belt, with his mother, his young sister Vera and younger brother Buddy; they pay $8 rent a week; they are on relief. Bigger's first job when he wakes on the morning of his story is to kill a huge black rat that has got into the room. His intent destruction of the rat is a characteristic act. Later in the day we see him in a poolroom savagely attacking one of his gang as they are planning a hold-up. Fear of the consequences drives him into this assertive brutality. It makes him feel easier to hit something. His obscure fears are replaced for the moment by the exhilaration of mere physical power. But so far this might be the story of any moral coward, black or white, who tries to turn himself into a tough braggart, an ordinary and rather contemptible item in any social worker's casebook.

It is later in the day when Bigger turns up to the job where the relief people have sent him, as chauffeur to one of Chicago's big executive types of the benevolent kind. This Mr. Dalton has given millions for social welfare, earmarked particularly for the Negro cause, for the National Association for the Advancement of Colored People, although most of it has dribbled into ping-pong tables in exemplary social clubs and the like. Bigger knows nothing about this, nor does he know that a good part of Mr. Dalton's money for charity comes from the exorbitant rents Dalton charges the Negroes to live in the overcrowded, rat-infested tenements that he owns in the Black Belt—in part, from the

very room Bigger had left that morning. Bigger gets the job easily, and all the more easily because his record includes an early sentence for thievery to reform school. The Daltons plan to reform him still more. Before her marriage Mrs. Dalton had been a school mistress.

On the night of the first day Bigger is to drive the daughter Mary to a university lecture. Mary has gone a little farther than her parents in practical sociology and directs Bigger to drive to Communist headquarters instead of the university. There she meets a practically perfect Communist, who shakes Bigger's hand and wants to be called by his first name, Jan. They drive together in the front seat to a Negro restaurant, drink a good deal, drive around the park while Jan and Mary make love, and finally Bigger brings a very drunk Mary home in the car about 2 in the morning, with a package of Communist pamphlets from Jan in his pocket.

How Bigger inadvertently murdered Mary that same night can be told only in the words that Mr. Wright uses. The necessary point is that he found he had killed her out of fear, out of his certain knowledge that he would be suspected (unjustly) of having raped the girl. When her mother, who is blind, comes to the bedroom to which Bigger has just carried her, Bigger puts a pillow over the girl's face to prevent her speaking of his presence there. Unconsciously he exerts more strength than he realizes. Mary is dead when Mrs. Dalton, believing that her daughter is merely drunk, leaves the bedroom without having discovered Bigger.

This is the beginning and end of Bigger's fatal history. The body he burns in the furnace, the head cut off with a hatchet because he cannot force it in, the exhaust fan switched on to clear the air of the basement of the smell of burning flesh. Bigger's mind reaches a rapid solution. As a Negro he will be the first suspect, but Jan, the Communist, he considers, is almost an equal object of mob hatred. He has been told by the politicians that the Reds are the dirtiest kind of criminals; he can easily throw the blame on Jan by asserting that Jan also went home with the girl, he can even collect kidnapping money on the pretense that Mary is still alive. This, one might say, is a typically criminal mind, but it is Mr. Wright's purpose to show it as a typical kind of social and racial conditioning. Bigger's crime is discovered. He commits another crime (this time merely the murder of his Negro mistress) to cover his tracks, but it is now only a matter of time between his flight and his

*Photo by Yavno.*

Richard Wright.

fate. A Jewish Communist lawyer makes a brilliant speech in his defense, but there is nothing to be done save an attempt at explanation.

What Mr. Wright has done with this sensational criminal story is extremely interesting. Dorothy Canfield Fisher, who writes a preface for the book, explains Bigger partly in terms of the neuroses and psychopathic upsets in animals that we have read about in the research-psychology journals. Bigger, then, in a sense is scarcely more percipient than the rat he had killed at the beginning of the story. Mrs. Fisher continues with an excerpt from Owen D. Young's National Youth Commission's report, couched in the usual maze of language: "conclusive evidence that large percentages of Negro youth by virtue of their combined handicap of racial barriers and low social position subtly reflect in their own personality-traits minor or major distortions or de-

ficiencies which compound their problem of personality adjustment in American society." What Mr. Wright has done is to turn this dry phraseology into the living language of today, into a person, not a personality adjustment, into a scene, a drama, a memorable experience.

It will be argued, and I think with truth, that his character, Bigger, is made far too articulate, that he explains much too glibly in the latter part of the story how he came to meet his fate: "seems sort of natural-like, me being here facing that death chair. Now I come to think of it, it seems like something like this just had to be." Later he has romanticized and rationalized himself into the declaration that "What I killed for must've been good! . . . It must have been good! When a man kills, it's for something . . . I didn't know I was really alive in this world until I felt things hard enough to kill for 'em." This, I believe, is

so much romantic nonsense. Dreiser was wiser in allowing the reader to think out Clyde Griffiths in his own realistic terms: he did not interfere too much in the interpretation of his character. Mr. Wright does spoil his story at the end by insisting on Bigger's fate as representative of the whole Negro race and making Bigger himself say so. But this is a minor fault in a good cause. The story is a strong and powerful one and it alone will force the Negro issue into our attention. Certainly "Native Son" declares Richard Wright's importance, not merely as the best Negro writer, but as an American author as distinctive as any of those now writing.

March 3, 1940

# POEMS OF WYSTAN HUGH AUDEN

THE COLLECTED POETRY OF W. H. AUDEN. 466 pp. New York: Random House. $3.75.

**By F. CUDWORTH FLINT**

AFTER beginning the Nineteen Twenties by luxuriating in post-war disillusionment, intellectuals began to look about for a less empty topic. Those who were poor and indignant took up Marxism. The wealthy and exhausted took up Freudianism. Only poetry lagged behind. The newest star—T. S. Eliot's—had risen over a Waste Land. It did move on, but to take its stand above a secluded garden dedicated to the pruned Catholicism of the High Anglicans. The times were not going that way. What poet would be their fellow-traveler in their pilgrimage away from Canterbury?

In 1930 appeared in England the "Poems" of W. H. Auden, and the answer had been found. Here was a mind energetic, inquisitive, modern; a technique dexterous and Protean; an interest in, if not exactly an espousal of, the Communist principles, and an imagery and vocabulary so permeated by the materials and terms of psychoanalysis as at times almost to seem "clinical"—thereby realizing an announced aim of the author. Perhaps this young poet, late of Oxford and just returned from the spiritual Babel of Berlin, would, as soon as his first enthusiasm for collecting information and styles had sobered somewhat, achieve the fusion of Marx and Freud, of the outer revolution and the inner purge, which might be the religion of the era to come.

But Mr. Auden was not going that way. As book followed book—the curious medley of verse, prose and diagrams called "The Orators"; in collaboration with Christopher Isherwood, the satiric extravaganzas, "The Dog Beneath the Skin" and "The Ascent of F6"; in collaboration with the poet Louis MacNeice, a medley in verse and prose of travel and comment on civilization in general entitled "Letters From Iceland," and a similar book (with Isherwood) about China called "Journey to a War"; another collection of poems, "On This Island" (the English title is "Look, Stranger"); several anthologies, including the "Oxford Book of Light Verse," and, after his coming to America in 1939 to live, further collections of poems — "Another Time," "The Double Man," and his recent brilliant "For the Time Being"—from all these it became clear that even his style had been wrongly perceived. Sheer variousness was not its chief characteristic.

IT is true that a line here, a phrase there, may record some one or another of Auden's numerous momentary flirtations: with the style of T. S. Eliot, the later Yeats, Emily Dickinson, A. E. Housman, Gerard Manley Hopkins, and perhaps some of Auden's more elaborate stanza-patterns—molds into which the material is neatly fitted rather than consummations of the rhythms of the lines—derive from his early interest in Thomas Hardy. In spite of all such surface influences, however, he has developed a way with words which is recognizably and emphatically his own.

This way is constituted by a vocabulary rather than a single style. Auden dislikes what he called "damp" poetry; that is to say, romantic or emotionally resonant or "pure" poetry. He even has recipes for avoiding it; he mostly excludes colors and scents from his poems, and emphasizes shapes. His vocabulary ranges from terms of abstract analysis to homely epithets of contemporary realism, as in

Abruptly mounting her ramshackle wheel,
Fortune has pedaled furiously away.

And Auden's movements back and forth along this range are managed with easy swiftness. One, for instance, might not expect a poem entitled "Heavy Date" and beginning in the neutral center of the range

Sharp and silent in the
Clear October lighting
Of a Sunday morning
    The great city lies,

to pass easily to

Love has no position,
Love's a way of living,
One kind of relation
    Possible between
Any things or persons
Given one condition,
The one sine qua non
    Being mutual need.

But in some of the poems from his earliest book (which can usually be spotted at a glance by their short lines and lack of a stanza-pattern) a terseness of syntax, even though the diction is simple, involves the reader in puzzles. There are too many alternative meanings which will account for all the words set down on the page. Auden may have been emulating the riddling brevity of the Icelandic sagas, which have impressed him—he is of Icelandic descent; but, at least to the non-Icelander, an Icelandic riddle is a riddle still. In his later books he has relaxed this terseness, and none of his more recent poems say too little to tell their tale. It is mostly these earlier poems that have given him the reputation of being "difficult."

OBVIOUSLY, a vocabulary such as Auden's is well adapted to satire, and Auden at his best can be an excellent satirist—when the demands of neatness imposed by satirical point are not overcome by his tendency to slapdash improvisation. He himself has recognized this tendency, and some of the longer poems in this "Collected Poems" have been pruned of superfluous stanzas and merely personal allusions.

Come to our bracing desert
Where eternity is eventful,
    For the weather-glass
    Is set at Alas,
The thermometer at Resentful.

Come to our well-run desert
Where anguish arrives by cable,
    And the deadly sins
    May be bought in tins
With instructions on the label

is pointedly satiric. But it will serve as a transition to another of Auden's main accomplishments, which might not be expected from what I have said of his vocabulary.

This is his success in creating a sense of the ominous. Building in his earlier work on his researches into the dreads of the neurotic—he is the son of a physician—and in his later work on a realistically religious estimate of the role of Possibility in man's fate, Auden has become almost a specialist in the terror-to-come. Sometimes such warnings are expressed in the language of psychoanalysis or abstract discussion,

but more often they are conveyed through scenes in which, by a method akin to that of Chirico, the portrayed detail becomes ominous because it is portrayed in isolation from its expected accompaniments. In a Chirico painting, what is that building which exists only to block our view around a corner, whence not even a shadow suggests what may lie beyond? Who is that single figure running in the distance down the deserted street? Similarly, in Auden,

. . . behind you without
a sound
The woods have come up and

*are standing round
In deadly crescent.*

*The bolt is sliding in its groove;
Outside the window is the black
remover's van.*

These scenes implying peril are usually compounded of a rugged countryside and ruined mines and factories (reflecting Auden's early acquaintance with Derbyshire and Yorkshire) and with the distresses of industrialism in the English Midland counties. It is noticeable that since he has come to America this scenic element has faded from his poetry.

ABOUT the time Auden came to the United States it became quite evident to any reader that he was not traveling, as I have mentioned, toward any fusion of Marx and Freud. In his "New Year's Letter" appears a passage discriminatingly appreciative of Marx, but none of his earlier "Communist" poems—few at best —have been retained in this latest collection. For Auden, economic distresses have been rather symptoms than causes; or at least, he has not thought of them as total or chief causes. He has latterly passed on from psychology by the frontier away from economics: the frontier bordering religion. Isherwood was too hasty when he wrote in the "Auden Number" of New Verse (November, 1937) that from Auden's High Anglican rearing the only remains were a tendency to ritualism in constructing plays, and a good ear for music. To be sure, it is not as a disciple of Anglican theologians, nor as a proponent of the visible Catholic Church, that Auden has come to reaffirm the Christian position. Judging by

references in his poetry and criticism, I should say that the Danish theologian Kierkegaard had been the strongest influence; and his present position is not unlike the "Neo-orthodoxy" connected in this country specially with the influence of Reinhold Niebuhr.

In brief, in addition to the world as a spectacle known to art, and the world as a terrain for improvement by regulation known to ethics, Auden adds another interpretation of life: the world as the perpetual invitation and intention to choose love. The primacy and validity of this ideal has been made known to mankind by the transit of the Eternal into the temporal in the Incarnation. But this choice will never—for the individual—be completely successful, completely realized. For it is carried out in the presence of necessities which sometimes confuse and sometimes preclude a proper choice. Again, this choice is carried out within time, and we cannot be certain of all the consequences in future time of our particular choices. Finally, every successful choice has been achieved by skirting at least two opposite errors, even when there are no more. The most generalized forms of error Auden finds to be dualism, which suggests that there is a valid realm where Truth has no validity; the kind of monism which insists that all manifestations in human life of reality must follow a single pattern or kind—esthetic or ethical —of pattern, and atomism: the idea that each human being can create his own universe for himself, and there's an end on't.

It is in "For the Time Being: A Christmas Oratorio"—one of the

two poems making up the book so titled—that this religious position receives its fullest statement, in what most critics agree is a brilliant poem. In it Auden does not forget to present in a delightful prose address the feelings of the outraged scientific liberal, Herod, to whom the Incarnation is the lapse of enlightenment back into superstitious barbarism. But Auden takes his stand with Simeon, who in his meditation finds in the Incarnation the interpretation and support of history, art, science and the redemption of man.

IN the just-published "Collected Poems" Auden has preserved most of what has appeared in the earlier books of poems, except that very little of "The Orators" has been retained: some of the "Six Odes" and a few shorter pieces, but of the prose in that book, only the "Letter to a Wound." Poems appearing first in the two books of travel are reprinted here, and there are twenty-four poems previously uncollected. This is a convenient edition of Auden, and those previously unacquainted with him would do well to begin with it. However, persons wishing to make a thorough study of him must still obtain the earlier separate volumes.

Nobody has any business to presume to sum up a poet until the poet is dead. In fact, a complete summing up might be achievable only as the terminus of a complete losing of interest. In one passage of the "New Year's Letter" Auden, speaking of Art, says of its manifestations

*Now large, magnificent, and calm,*

*Your changeless presences disarm
The sullen generations, still
The fright and fidget of the will,
And to the growing and the weak
Your final transformations speak,
Saying to dreaming, "I am deed."
To striving, "Courage. I succeed."
To mourning, "I remain. Forgive."
And to becoming, "I am. Live."*

THIS is not a complete theory of all Art; indeed, Auden has elsewhere, through the person of Caliban, who is using the idiom of Henry James, gone into the matter more fully, more delightfully, and with needed extensions of doctrine. Still, the quoted lines express what is true of much art. But not, I think, quite of Auden's. It is not full of presences that are magnificent and calm. On the contrary, most of it is full of the fright and fidget, the striving and the weak. These, however, are fixed by the poet's scrutiny, immobilized for our inspection by the novel tactic of the really just phrase.

Hence, we grow familiar with our fright and fidget; we see just what these are; we come to the realization that we are not, we cannot continue to be, like *that;* and so, in its own way, Auden's poetry carries out its admirable therapy. Nevertheless, it would be a great mistake to concentrate solemnly on the therapy. For though we now see that Auden is one of the most seriously intelligent minds of his generation, he remains deft, agile, dexterous. And joy in dexterity is a right kind of morality also. So let us be joyful in it.

April 8, 1945

# Dilemma of the Modern Poet in a Modern World

By STEPHEN SPENDER

THE literary developments of the last century were measured by every twenty years—the Forties, the Sixties and Eighties. Every ten years, at the least, of this century marks some new development.

To take the example of England alone: 1920, with T. S. Eliot's "The Waste Land," heralded a new development of poetry which superseded the "Georgians." The early Nineteen Thirties saw a phase of political poetry in the work of Auden, Day Lewis, MacNeice and Spender. The late Nineteen Thirties saw already before the end of the decade the emergence of a new generation of anti-intellectual Gaelic rhetoricians—of whom the one great talent was and is Dylan Thomas, and a serious lesser talent Vernon Watkins. If I tried to draw an American parallel, I would possibly betray my ignorance of

American contemporary poetry, but the discerning reader can doubtless see that the parallel of successive generations of modern poets can be drawn.

But this picture of generations succeeding each other in each decade of our century is not analogous to the "movements" which have superseded each other previously. The poets of the Thirties did not repudiate the work of Eliot, and Dylan Thomas has not repudiated W. H. Auden. Moreover, the "old" poets are in a stronger position than the "new" poets today. The new poets themselves feel this, having a great respect for their predecessors, and yet feeling incapable of being like them. There is even, in England a revival of interest in the work of some of the "Georgians," especially that of de la Mare. In fact, despite the gulfs between generations rapidly succeeding each other, there can rarely have been so many poets with generally ac-

cepted reputations writing in English as there are today.

How can one explain this picture of irreconcilable divergencies with such general acceptance of each other's aims? The answer is, I think, not that the modern poet is an exponent of his generation but that he is forced when he is young to speak with the voice of his decade. It is interesting that Eliot has always resented the description of "The Waste Land" as a poem expressing the attitude of its generation. And yet it is impossible to think of "The Waste Land" except as a poem written immediately after the war of 1918. Its background is the despair of Austria and Germany without political hope, the chaos of Russia in the early days of the Revolution, the prophetic nihilism of German expressionism. In reflecting such contemporary attitudes Eliot was not being of his generation in a fashionable sense but in the sense of

accepting a truth about the whole modern environment revealed by the twisting of events at that time.

The "truth" of which I am speaking here is not something abstract. It is reality felt to be significant, experienced in many people's lives and thus an aspect of the modern environment inescapably reflected in modern literature.

We live today in a period of social struggle which will continue for many generations. Each phase of the struggle reveals new aspects of socially experienced truth: that is to say, truth experienced in terms of hunger, misery, aspirations and all the varying fortunes of the struggle. Almost inevitably the poets of each generation will find themselves separated by the overwhelming circumstances of their own particular phase of the struggle from all that has gone before and has gone after them. They will not

only belong to, they will be victims of, their generations.

FOR the individual poet this modern situation presents a special problem. What is delusively called "his generation" is a wave of external stimuli provided by a war, a slump, a boom, the atomic bomb or the utopian dreams of atomic energy, Europe or America, in some particular phase. After a few years of passive sensibility to an environment which consists almost entirely of events and which has no permanent background, he finds that his generation is not "his" at all but belongs to events themselves which have swept away from him, presenting him with a new situation, equally external. He then finds that unless he has developed an interior strength of his imagination equal to the exterior force of events he is in danger of repeatedly having to adapt himself to a changing external situation, and with each change externalizing more and more his own talents. The crisis has arrived in his development when he must at all costs create his own poetic world or face the disintegration of his own personality by the disruptive forces of the external world.

Many modern poets have passed through a phase of inventing poetry as a machine of the imagination to present the disorder of the modern world, to a phase when they have devoted themselves to trying to create an internal order in their poetry. An outstanding example is T. S. Eliot after "The Waste Land." That poem is, among other things, a machinery for creating an imaginative picture of civilization in decay. The functioning of this machine is quite simple.

Let it be assumed that civilization is at an end, is a mere assertment of ghostly lives without spiritual significance, moving among fragmentary ruins which have lost their significance. Then all fragments, whether derived from the past or the present, are equal in value to all other fragments: the only significance attaching to civilization is the sense of poignant loss. Any fragment of the past may be juxtaposed against any fragment of the present to produce the same impression of fragmentariness and loss. The method of choosing a scene from the sordid present and contrasting it with one from the historic past is essentially an arbitrary one and is capable of infinite extension: in fact, the force of "The Waste Land" lies in the arbitrariness which suggests in a short space that the picture of despair might be infinitely extended.

Having arrived at "The Waste Land," Eliot had arrived at the position of complete bankruptcy of the external forces in his poetry, the forces which caused him with some justice to be called "the poet of his generation." His

development could only be a repetition of the discovery of "The Waste Land" in civilization and even in nature ("April is the cruelest month") or else the creation of an order lacking in external events within an area where he could create it—that is, within his own spiritual life.

A PARALLEL crisis arose in the poetry of the English writers of the Nineteen Thirties. They could not accept Eliot's social despair, because already they were living in a different series of events from those of the Twenties. In the Thirties, although the nihilism of the Twenties was still implicit in the European scene, there were also other potentialities, requiring of every sensitive mind an attitude more external and more hopeful than nihilism. For instance, fascism, the unemployment caused by the slump of 1930, the threat of another war, the struggle of the Spanish Republic, and Hitlerism. All this was different from the atmosphere of static calamity immediately after 1918. If we think of poetry as having a living relationship to its environment, in the same way as a human being has toward other human beings, we can see that the attitude of the poets of the Thirties was humanly inevitable.

The writers of the Thirties endeavored to escape from social bankruptcy by postulating social hope. Although their revolutionary ideal spared them for a time from the obvious dilemma of expressing an attitude of complete social despair and thus arriving at a dead end in their social vision, ultimately their problem was the same as Eliot's. For their social vision was dependent on social events which were external to their poetry.

Poetry may prophesy revolutions but it cannot make them, and a poetic world which is dependent on events in the real world may be broken by the real world stubbornly refusing to fulfill the hopes of poets. One might, indeed, write a history of European poetry since the French Revolution describing the attempts of the poets from the Romantic era onward to create an image of society in their poetry and then having that image broken and being forced inward onto themselves, just as the utopian social vision of Coleridge was broken by the French Revolutionary Terror and replaced by the scenery of the English Lake District.

THE modern poet is in the dilemma that he wishes to create a poetry of the modern world but cannot find in contemporary religion, science, philosophy, politics or psychology attitudes capable of giving external events the kind of order of the imagination which we find, for example, in

Shakespeare, Racine or Dante. In being modern he risks being artistically destroyed by the modern world (in the manner of the "social realists") or, else having to declare unremitting spiritual war on the modern (in the manner of Baudelaire and Rimbaud).

The inability of the modern poet to create (by merely introducing the modern world into his poetry) a spiritual attitude capable of resolving the problems of materialism produces the crisis in his work which I have described as almost inevitable in the life of the modern poet. At this point, the poet isolates himself from the social fate, and his attitude to the contemporary world undergoes a kind of reversal. Instead of using poetry as a machinery for illustrating the reality within poetry of the contemporary environment he uses it as a means of illustrating its unreality.

*The winter evening settles down*
*With smell of steaks in passageways.*
*Six o'clock.*
*The burnt-out ends of smoky days.*
*And now a gusty shower wraps*
*The grimy scraps*
*Of withered leaves about your feet*
*And newspapers from vacant lots.*

Here the poet (T. S. Eliot, in 1917) is using poetry as a means of making poetic that which seems essentially unpoetic in the world. He is showing that the ugliest phenomena in the life of the modern city can become poetry. But in "Burnt Norton" (1935) he is using the same material of the modern world in an entirely opposite way—not to make it enter into the world of his poetry but in order to reject it from his philosophy:

*Men and bits of paper, whirled by the cold wind*
*That blows before and after time,*
*Wind in and out of unwholesome lungs*
*Time before and time after.*
*Eructation of unhealthy souls*
*Into the faded air, the torpid*
*Driven on the wind that sweeps the gloomy hills of London,*
*Hampstead and Clerkenwell,*
*Campden and Putney,*
*Highgate, Primrose and Ludgate.*
*Not here the darkness, in this twittering world.*

In the first passage the London scene exists in its own right, as a real fragment of our real world which claims its position as poetic material. But in the second passage the districts of London are invoked as though they were smoky emanations, dark corners of Dante's Inferno, to be dismissed as unreal or as states of mind in the single soul absorbed in its own metaphysical striving from darkness into light.

In the poetry of Auden there is the same development from treat-

W. H. Auden.

ing modern phenomena as reality to treating them as mere appearances which serve only as a useful way of illustrating their own unreality. In the concluding passage of "The Age of Anxiety" the most thoughtful of Mr. Auden's bar-room characters sums up the results of a loquacious evening:

*For the others, like me, there is only the flash*
*Of negative knowledge, the night-when, drunk, one*
*Staggers to the bathroom, and stares in the glass*
*To meet one's madness, when what mother said seems*
*Such darling rubbish and the decent advice*
*Of the liberal weeklies as lost an art*
*As peasant pottery, for plainly it is not*
*To the Cross or to Clarté or to Common Sense*
*Our passions pray but to primitive totems*
*As absurd as they are savage; science or no science,*
*It is Bacchus or the Great Boyg or Baal-Peor*
*Fortune's Ferris-wheel or the physical sound*
*Of our own names which they actually adore as their*
*Ground and goal.*

Without questioning the sincerity or the truth of this, one can note a great deal that is left out of Auden's picture of life today which was present in his earlier work. The picture has shrunk to the metaphysical struggling of one person; and although it is true that the struggle which is for one person exists for everyone, the problem as stated seems too narrow. For at least a great part of the mental problem of people living in our time (if they have intelligence and feeling) is not just what happens to them, but the material fate of millions of other people: the facts that people are starving and dying in concentration camps *over there* (wherever *there* happens to be) and that my going to church will not influence this.

227

To write of the "decent advice of the liberal weeklies" seems suspiciously like a sleight of hand by which liberal journalism is substituted for that which it is about, namely, the injustice of men to men, the remediable misery of men, war and so on, surely problems which cannot be so easily dismissed. Moreover, part of the evil of our time is that it is so easy to dismiss the misfortunes of other people and concentrate on one's own spiritual or esthetic development.

In fact the fate of civilization, that is to say, the fate of other people less fortunate than the cultivated minority weighs on the soul of each individual and is part of his problem, just as much as his personal salvation. The poet whom T. S. Eliot might still in his later work become, would be the poet who achieved the synthesis of the poetry of a despairing civilization with that of the poetry of the individual whose development belongs to eternity

It seems that the general development of modern poets is to plunge themselves in the modern world and then to reject it, using a modern idiom and imagery which they have acquired as a more forceful way of rejecting their environment. It is certainly a great achievement to have created within modern conditions a school of metaphysical writers who state one half of the modern predicament. Nevertheless it remains only one half. The other half is the territory explored in "The Waste Land," but explored there as the breakdown in the values of civilization, and not in terms of the anguish of a great portion of contemporary humanity, an anguish which under parallel circumstances in the Old Testament found its prophets who gave it its voice.

*Stephen Spender, one of the most distinguished British poets of our time, is the author of many books of both poetry and prose, the most recent of which are "European Witness," a study of modern Germany, and a volume of poetry, "Poems of Dedication."*

January 4, 1948

# The Dusty Answer of Modern War

THE NAKED AND THE DEAD. By Norman Mailer. 721 pp. New York: Rinehart. $4.

By DAVID DEMPSEY

PERHAPS Mr. Mailer should not be damned for attempting to reduce by frontal assault what better writers have failed to win by infiltration. "The Naked and the Dead"—the story of an imaginary battle in the Pacific—trumpets his dusty answer to the brutality of modern war. Undoubtedly the most ambitious novel to be written about the recent conflict, it is also the most ruthlessly honest and in scope and integrity compares favorably with the best that followed World War I. Even in its repetitiousness, wordiness, and overanalysis of motive, it is a commanding performance by a young man of 25 whose gifts are impressive and whose failures are a matter of reach rather than grasp.

"The Naked and the Dead" is an enormously long novel, washed up by the choppy waters of disillusionment, leaving nothing to the imagination. It is a saturation bombardment, with every target hit at least three times. It is virtually a Kinsey Report on the sexual behavior of the GI. Its style is an almost pure Army billingsgate that will offend many readers, although in no sense is it exaggerated: Mr. Mailer's soldiers are real persons, speaking the vernacular of human bitterness and agony. It gives off a skyglow that is quite faithful to the spectrum of battle, and exposes the blood, if not always the guts, of war. Yet for all its virtuosity, its deafening emotional cannonades, it is primarily a series of brilliant skirmishes; the central objective is never taken.

For one thing, we are not quite sure what the objective is. Mr. Mailer obviously doesn't like war, or the people who fight it, but this is hardly an original theme. He tries very hard to show that much of its unpleasantness comes from the nature of the participants, and that their nature, in turn, is warped by the circumstances inevitable in the conditions of war and the climate of a military organization. But not entirely.

THE generation that grew to manhood on the eve of the last war was not ideally suited to saving the world for democracy. It had been blighted by depression. Its minorities—two of the characters are Jewish, one a Mexican-American—had not yet been assimilated fully into the national dream. Even the dominant groups represented competing sectional and economic interests. In peace, the differences are adjustable. In war, Mr. Mailer believes, they become intensified, for the system gives men unprecedented degrees of power. How the GI—in his less virtuous moments—got the way he did, is the subject of this novel.

The battle is seen through the eyes of a single platoon, plus a major and a general. For the author's clinical purposes, they are an exposed nerve, exhibiting the whole shock of battle. A fighting unit, the men are nevertheless a collection of individuals. Each is studied, in crisply written flashbacks, as the product of a certain environment. If there is any doubt that Mr. Mailer is a perceptive, skillful writer, these vignettes will dispel it. By contrast, the main narrative is often sluggish; too much of the boredom of war is translated literally; the nexus between the characters' pasts and their battle existence is sometimes thin. The general, furthermore, on whom so much of the story's motivation depends, is clearly an over-intellectualized version of a Fascist, neither convincing nor typical.

These are faults, but they detract little from the book's overall power. The scene in which Gallagher continues to get letters from his dead wife—written before she died in childbirth but delivered for a month after he had been notified; the death of Wilson, among the most lingering in all war literature; the pointless, sadistic effort on the part of Platoon Sgt. Crofts to get his men to scale a mountain—these are moments which deeply touch the heart of war. They are a triumph of realism, but without the compassion which gives final authority in the realm of human conduct. "The Naked and the Dead" is not a great book, but indisputably it bears witness to a new and significant talent among American novelists.

May 9, 1948

# In a Place Where Love Is a Stranger

LIE DOWN IN DARKNESS. By William Styron. 400 pp. Indianapolis: The Bobbs-Merrill Company. $3.50.

By JOHN W. ALDRIDGE

THE last two or three decades have been remarkable in this country for the rise of a small group of Southern novelists distinguished for their vigor, originality and high creative seriousness. To call their names—Faulkner, Warren, Wolfe, Welty, Glasgow, Porter, Gordon, Roberts—is to call the roll of the most talented and artistically dedicated portion of the

*Mr. Aldridge, who teaches at the University of Vermont, is author of "After the Lost Generation."*

American literary vanguard. If we were asked to define the one quality which has set these writers apart and given them their special excellence, we should undoubtedly say that it is their power not so much to portray character as to evoke the moral circumstances in which character is created and made tragic.

If we were asked to name the source of this power, we should need only to point to the accident of their common Southern birth, their native Southern sense of history. And also their experience of that rich and living landscape which gives the South its dramatic personality and its writers their fund of dramatic images and myths.

The brilliant lyric power of William Styron's "Lie Down in Darkness" derives from the richest resources of the Southern tradition. Although ostensibly a story of psychological and moral breakdown, it is primarily a novel of place and must be judged in terms of its successful evocation of place. Like his best older contemporaries Faulkner and Warren, Styron possesses a poetic sensibility of the very highest order. Through it he is able to respond to and project back into language those intricate relationships between natural setting and human agony which, at least since Hardy's heath and Conrad's sea, have formed the heart of our greatest fiction.

In fact, so completely does Styron dramatize these relationships that one feels justified in saying that the Southern landscape against which the action is portrayed is the most successfully realized character in the novel. The human figures give the effect of receding as one plunges deeper and deeper into their environment, until finally they seem like pygmies lost in a great flowering effusion of jungle.

Yet one soon senses that Styron is up against a problem from which only the dramatic manipulation of landscape can free him. In the story of the pathetic ruin of the Loftis family he is trying to deal directly with the moral dilemma of people who because they cannot

love are doomed to damnation, and who because they are doomed are without the virtues which would give them substance as characters.

Properly speaking, the Loftises are characters in whom the capacity for fictional life simply does not exist. Removed from the vibrant natural world which Styron and the South have created for them and which serves as a sort of running barometric commentary on the changes in their psychic

weather, they would therefore become mere shadow figures indulging in a trivial pantomime entirely beneath our concern.

HOWEVER, it is testimony to Styron's remarkable literary gifts that, taken in context, his story assumes the significance of a penetrating modern allegory. The crumbling, guilt-ridden Loftis marriage clearly symbolizes the disintegration of an age of faith and love. The neurotic searching and ultimate

suicide of the beautiful Loftis daughter Peyton—described in the most powerful passage of female interior monologue since Molly Bloom's soliloquy in "Ulysses"—illustrate the tragedy of that hopeless flight into chaos by which modern man has sought to repudiate the sins and the wisdom of his fathers.

It would be a disservice to Styron, and worse than meaningless in these times, to say that he has produced a work of genius. Only the sustained

greatness of a richly productive lifetime still deserves that kind of praise. Yet one can say that he has produced a first novel containing some of the elements of greatness, one with which the work of no other young writer of 25 can be compared, and that he has done brilliant justice to the Southern tradition from which his talent derives.

September 9, 1951

# Rhythm And Insight

SELECTED POEMS. By Muriel Rukeyser. 111 pp. The New Classics Series. Norfolk, Conn.: New Directions. $1.50.

By RICHARD EBERHART

"MYSELF is for my time" is the last line of this selection by Muriel Rukeyser from her voluminous work, begun in 1935 with "Theory of Flight." Those who recall the excitement and force of her appearance as a revolutionary young poet in the mid-Thirties will understand her necessity for a violent reaction to the contemporary scene. It had to

be coped with directly, with passionate insight. One's time is a variable phrase. Muriel Rukeyser's time may achieve indefinite extension.

This volume is witness that her poetry is not limited to the Thirties or Forties. It is remarkable that the doctrines which one felt as typical ("Not Sappho, Sacco") have sunk under the weight of utterances which have become general or universal. Her insight as an artist, in other words, has overcome partisan spirit. The depth of her understanding is what makes the poetry ring true.

It was part of her revolution to outlaw rhyme. The direct pressure made for a long, fierce, loose, informative line. It precluded predominant interest in

absolute form. With her it is exactitude of feeling rather than of form. Yet when the passion seems instantaneous sometimes perfection of form is achieved as if without effort. This happens in "This Place in the Ways," the first poem in the book. One can search the poem to its last syllable without objecting to a flaw. It is an example of that economy of statement when passion, knowledge and insight are controlled in an inevitable harmony.

IN the first part of the book there are several compelling lyrics, pure accomplishments, speaking "that naked music." A third through the book I had a feeling of an affinity with D. H. Lawrence. I felt that

Lawrence would have liked her poems, and would have liked to write "The Children's Orchard."

Examples of her longer works include "Ajanta," portions of the "Elegies," and "Orpheus." The collection's defect is too many cut poems, too many partially reprinted pieces.

Studied either historically or for immediate pleasure, this swift-moving and rich volume shows Muriel Rukeyser's grasp of the essential, her practice of positive speech.

*Mr. Eberhart is well known as a poet and critic; his "Selected Poems" was published recently.*

September 23, 1951

# The World Below

INVISIBLE MAN. By Ralph Ellison. 439 pp. New York: Random House. $3.50.

By WRIGHT MORRIS

THE geography of hell is still in the process of being mapped. The borders shift, the shore lines erode, coral islands appear complete with new sirens, but all the men who have been there speak with a similar voice. These reports are seldom mistaken as coming from anywhere else. As varied as the life might be on the surface, the life underground has a good deal in common—the stamp of hell, the signature of pain, is on all of the inhabitants. Here, if anywhere, is the real brotherhood of hell. Fleeing toward hell, Dante beheld a man whose voice seemed weak from a long silence, and he cried to him, saying, "Have pity on me, whoever thou art, shade or real man!"

Shade or real man? Visible or invisible? The Invisible Man would have smiled in recognition if hailed like that. He lives, he tells us, in an underground

hole. To fill this dark hole with light, he burns 1,369 bulbs. He burns them free. A fine Dostoevskyan touch. In his "Notes From the Underground" Dostoevsky says: "We are discussing things seriously; but if you won't deign to give me your attention, I will drop your acquaintance. I can retreat into my underground hole."

The Invisible Man is also discussing things seriously. His report in this novel might be subtitled, "Notes From Underground America," or "The Invisible Black Man in the Visible White Man's World." That is part of his story, but the deeper layer, revealed, perhaps, in spite of himself, is the invisible man becoming visible. The word, against all of the odds, becoming the flesh. Neither black nor white flesh, however, for where the color line is drawn with profundity, as it is here, it also vanishes. There is not much to choose, under the skin, between being black and invisible, and being white, currently fashionable and opaque.

"LET us descend into the blind world here below," Virgil says, and the Invisible Man de-

scends through the ivy-covered college doors. His report begins the day that rich men from the North, white philanthropists, appear on the campus of a Negro college in the South. They are there for the ceremony of Founders Day. The Invisible Man, a student at the college, is chosen to act as the chauffeur for one of them. He shows him, inadvertently, the underground black world that should not be seen. Before the day is over, both the millionaire and the student have been disillusioned, and the student, expelled from the college, leaves for New York.

In the city he becomes increasingly invisible. Hearing him rouse the crowd at the scene of a Harlem eviction, a key party bigwig sees a bright future for him in the brotherhood. The mysteries of the Order, revealed and unrevealed, as they fall to the lot of the Invisible Man, have the authentic air of unreality that must have bemused so many honest, tormented men. The climax of the book, and a model of vivid, memorable writing, is the night of the Harlem riots. Mr. Ellison handles this surrealist evening with so much authority and macabre humor, observing the forces with such detachment,

*From the title page drawing by E. McKnight Kauffer for "Invisible Man."*

that the reader is justified in feeling that in the process of mastering his rage, he has also mastered his art.

Perhaps it is the nature of the pilgrim in hell to see the visible world and its inhabitants in allegorical terms. They do not exist, so much as they represent. They appear to be forces, figures of good and evil, in a large symbolical frame, which makes for order. But diminishes our interest in their predicament as people. This may well be the price of living underground. We are deprived of uniqueness, no light illuminates our individuality.

*Mr. Morris' most recent novel is "The Works of Love."*

The reader who is familiar with the traumatic phase of the black man's rage in America, will find something more in Mr. Ellison's report. He will find the long anguished step toward its mastery. The author sells no phony forgiveness. He asks none himself. It is a resolutely honest. tormented, profoundly American book.

"Being invisible and without substance, a disembodied voice. as it were. what else could I do?" the Invisible Man asks us in closing. "What else but try to tell you what was really happening when your eyes were looking through! And it is this which frightens me: Who knows but that, on the lower frequencies, I speak for you?"

But this is not another journey to the end of the night. With this book the author maps a course from the underground world into the light. "The Invisible Man" belongs on the shelf with the classical efforts man has made to chart the river Lethe from its mouth to its source.

April 13, 1952

---

## SPEAKING OF BOOKS

### By DIANA TRILLING

ACCORDING to publishers' reports. there has been a marked falling off in fiction sales in recent years. Even when other books are selling fairly well, novels fail to reach as large audiences as might once have been expected for them a new novel can sell as little as 10,000 copies and make the fiction best-seller lists.

This does not surprise me, especially of our fiction which lays claim to artistic rather than popular appeal. For some years it was my job, as regular reviewer for one of the weekly magazines, to look at all the serious new novels some forty or more a month. If, out of this number, there were a half-dozen which warranted critical examination, it was a good month. If there turned up a single volume which one could read with more than clinical interest, it was a rare month. And now that I am no longer required to read new novels, I doubt if I pick up three a year.

And yet I haven't lost my taste for fiction. On the contrary. I return to the novels of the past with increasing delight. I simply cannot find anything

*Mrs. Trilling is a former fiction critic of The Nation. Next week, on this page, John W. Aldridge will present his views on the contemporary novel.*

to enjoy in most of our contemporary product.

Now obviously there was never an age so golden that many of its new books were worth reading. The novels which outlast their generation are always few in proportion to those which are forgotten—it is not significant if in seven years of reviewing one never meets a new classic But it is important, I think, that one encounters so few volumes which, short as they themselves may fall of the values which make for permanence. yet suggest a literary culture capable of producing first-rank fiction.

What accounts for this situation? The usual explanation is that the modern world has become so complex and awful that the novelist is unable to deal with it. Just as the painter can no longer represent life but can only give us abstractions. just so the novelist cannot create character and scene in the terms established by the traditional fiction form.

I do not agree with this formulation, which seems to give assent to the phenomenon it explains. One can fully recognize the confusion and fear of our age and yet not accept it as a necessity that the artist respond to them as he does. Checking over the ingredients of the nineteenth-century novel love and hate, human folly and grandeur,

social ambition, the impulse to power, family feeling, the life of money we can find them still available to the writer who would dare believe that despite the peculiar horror of our times they are still relevant to the human condition.

Granted that it is difficult to look at the present-day world with optimism, what precisely is the mood which informs the contemporary novel? If it were pessimism, our fiction would not be the soggy thing it is. The modern novel hasn't produced a single pessimist of stature since D. H. Lawrence, whose despair was of course its own kind of tragic affirmation. We have only to compare Lawrence's "The Woman Who Rode Away" with Paul Bowles' "The Sheltering Sky"—the themes are similar—to see the vast difference between an expression of tragic despair and mere *chic*.

Lawrence loved the novel because it was the "book of life." Our present novels which pretend to continue in his spirit are not even books of death. They are fashion-drawings of what the sophisticated modern mind wears in its misery —and it is no accident that their authors are so welcome in the pages of our expensive fashion magazines.

I am not denying that the present-day world robs us of the ease in which art best flourishes. But so long as we retain the ability to strike all the various poses which characterize contemporary fiction—the senti-

mental poses, the self-pitying poses, the poses of doom—we certainly cannot be said to have been robbed of will. The problem becomes, how do we use our will? Do we use it to assert the human possibility; or do we give rein to the perverse and destructive will which is somewhere in all of us, the negative will of infancy.

THE fact that the majority of our most talented writers are choosing the latter path is in itself, of course, a cultural situation. When a whole artistic generation suddenly goes childish. there must be more involved in such a manifestation than merely the individual temperaments of the performers. It is nevertheless my sense of the matter that where there is will at all, even the will to write a book, there is also free will and that whatever the life-destroying conditions of our times, the pressures of external circumstances are not yet of a kind to render the individual artist incapable of coping with them. The very refusal of the general public to buy the novels now offered it indicates to me an essential health in American society on which the writer can draw for sustenance. For I interpret the decline in fiction sales, not as indifference to art, but as an insistence that our artists do better by life than they like to think that life is doing by them.

June 15, 1952

---

# 'WORDS ARE THINGS WHICH RING OUT'

### The Strange, Mighty Impact Of Dylan Thomas' Poetry

THE COLLECTED POEMS OF DYLAN THOMAS. 199 pp. Norfolk, Conn.: New Directions. $3.75.

### By LOUIS MACNEICE

DYLAN THOMAS, who has recently been described by a well-known critic as the greatest living poet in English, is perhaps the most startling phenomenon in an era of startling poetic experiment. Born in Wales in 1914. he burst on the public at about the age of 18 with a fully fledged idiom which was entirely his

own and bore no resemblance to the work of his immediate predecessors.

There is nothing of the analyst or of the journalist in Thomas; true to his origins, he is sheer downright Bard. This in the Nineteen Thirties might have seemed old-fashioned; instead it was hailed or deplored as the very extreme of modernism. At first sight much of his poetry seemed incomprehensible; many poets before him, such as Rimbaud. Hart Crane and Edith Sitwell, had tried strange collocations

*Mr. MacNeice, the British poet and critic. is the author of a forthcoming volume of verse. "Ten Burnt Offerings."*

of images and transpositions of epithets, but none had shuffled the pack so thoroughly at every deal. Many readers in his early days thought him completely mad, but there is method in his madness. In the flesh he is a most picaresque personality and very good company if you surrender to his charm. So with his work: surrender to its strange and powerful physical impact and by degrees the "meaning" will emerge, which is not so much meaning in the rational sense as myth.

IT has often been said of Dylan Thomas. as a verse reader. that he could read anything to make it sound

like Something. The same dangerous facility, the same unremitting Golden Voice (a gold that can shade into peach into rose into ham) is the primary component of his poetry; thought, emotion and eye are secondary compared with it. And while we cannot say that this is the right way round, it is probably better way than that of those poets who begin with any single one of the three last; poetry, after all, is made with words and words are things which ring out — though many people have forgotten it. Thomas never forgets it because he is a born actor; he is always projecting; all of his poems have stage lighting. Then why is his influence disastrous?

There has been more bad poetry produced in England by the imitators of Thomas than by those of Eliot and Auden lumped together. The answer is really quite simple: neither Eliot nor Auden is exclusively "poetical"; both *qua* poets have some truck with prose. Therefore, since an imitator always looks for a formula, the Auden and Eliot imitators, prose being an amateur field, can achieve their formula more easily, whereas in "poetical" poetry the stage is reserved for professionals and no one can cut a figure there unless he projects his voice—as Thomas and Milton can—and also unless he has left his everyday voice behind him. Auden, like Shakespeare, would use any word in or out of the dictionary; Thomas, like Milton, practices poetic diction and would not, as he once told me, indeed could not, use a word like "pub."

To deplore a poet's influence is of course no aspersion on the poet. Thomas, who can admire a writer so unlike himself as his namesake Edward Thomas, has never welcomed the claims to his paternity made by such writers as the New Apocalyptics (era mid-World War II) who demanded that all poetry should be "like ivy growing on an old wall." I should be sorry for any ivy that was dragooned in the way that Thomas dragoons his words; a quick glance at any of his manuscripts disproves what is still a popular fallacy (to which I once subscribed) that his poetry is "poured out anyhow." Why is that improbable word put in line three of stanza one? Because it is a second cousin three times removed of that word in line six of stanza twelve.

Not every reader will catch every

such cross reference or double meaning but Thomas' painstaking craftsmanship bears certainly no resemblance to a lava stream—or to ivy—while it does get results, which means that much of it is memorable; who remembers a line by most of the would-be Thomases who lack both his ear and his industry? Before World War II Thomas made one of his very

*R. Thorne McKenna*
Dylan Thomas.

rare pronouncements about his own poetic process, an often quoted statement to the effect that he allows his images to proliferate centrifugally, but he added a qualifying clause—not so often quoted—which made it clear that this process was subject to deliberate control on his own part. The degree of this control varies and in many poems, especially of his middle period, Thomas seems to have relaxed it so far as to lapse for the moment into the ranks of his jackals.

So individual a poet is difficult to analyze. It is little use murmuring "magic," though there is, of course, as there must be even in Augustan poetry, some imponderable (another question-begging word) which makes this poetry poetry. Nor is much to be gained by the scholarly search for literary influences and comparisons; Thomas has never read Rimbaud and too much has been made of that bardic Welsh literature which he cannot read in the original.

Wales itself, on the other hand, is a most important, perhaps *the* most important, factor. His "Portrait of the Artist as a Young Dog," the easiest introduction to Thomas, gives a most vivid and humorous and moving picture of the Wales of his childhood—which also means the childhood of his Wales. His schoolfellows from Swansea attach a great influence to his father, who, it seems, was accustomed in ordinary conversation to throw out such Thomist tropes as "happy as the grass is green." Thomas may be very "modern" and very "romantic" but most of the romance and many of the daring modernisms stem from a country which retains the youth of its traditions and combines bawdry with the Bible.

In a way Thomas is a simple poet; as with Blake, his prophetic revelations are based upon songs of innocence. The themes are very few but elemental; the versification is versification; the individual images are paralleled in folk-talk — "It's raining cats and dogs," "Aunt Ellen has green fingers." What makes his work "difficult" is its transferences and transitions, yet in his best poems the unity of mood and the delicacy of music bind the whole together and atone for minor nonsenses. In any poet's poem the shape is half the meaning and in poems like "And Death Shall Have No Dominion," "After the Funeral," and "Fern Hill" Thomas emerges a superlative shaper, a "maker." And though death, mutilation, frustration, sadism, masochism, and loneliness all are expressed in his work, he is the best living example of Yeats' conception of the poet as one who knows "That Hamlet and Lear are gay." In a world of deaf mutes and emasculated reporters we should all be grateful for a poet with such bravado and warmth:

> *Dressed to die, the sensual*
> *strut begun,*
> *With my red veins full of*
> *money,*
> *In the final direction of the*
> *elementary town*
> *I advance for as long as*
> *forever is.*

April 5, 1953

# West Coast Rhythms

**By RICHARD EBERHART**

THE West Coast is the liveliest spot in the country in poetry today. It is only here that there is a radical group movement of young poets. San Francisco teems with young poets.

*Mr. Eberhart, lecturer and critic, and author of "Undercliff" and other books of verse, recently toured the West Coast.*

Part of this activity is due to the establishment of the Poetry Center at San Francisco State College three years ago. Its originator and moving spirit is Ruth Witt-Diamant, who began by offering readings by local poets and progressed to importing older poets from the East. She hopes next to stimulate the writing of verse drama.

Part of the activity of the young group has been inspired by Kenneth Rexroth, whose presence in San Francisco over a long period of time, embodying his force and convictions, creates a rallying point of ideas, interest and informal occasions. The influence of Kenneth Patchen is also felt by this group. Robinson Jeffers looms as a timeless figure down the Coast.

Some of the interest may also be attributed to the universities, colleges and schools where an unusual number of poets teach and write. These poets are older

than the youngest group, which is still in its twenties.

The second important center of poetry on the West Coast is Seattle, where the University of Washington is notable for its work in poetry. Theodore Roethke has enlivened this region for a number of years. Stanley Kunitz has been there this past year. Nelson Bentley, William H. Matchett and Kenneth Henson are active young poets there. Carol Hall, Caroline Kaizer and Richard Hugo, not directly connected with the uni-

versity, are also producing. Melvin LaFollette, a graduate, writes in Vancouver.

In the Bay region there are several poetry readings each week. They may be called at the drop of a hat. A card may read "Celebrated Good Time Poetry Night. Either you go home bugged or completely enlightened. Allen Ginsberg blowing hot; Gary Snyder blowing cool; Philip Whalen puffing the laconic tuba; Mike McClure his hip highnotes; Rexroth on the big bass drum. Small collection for wine and postcards . . . abandon, noise, strange pictures on walls, oriental music, lurid poetry. Extremely serious. Town Hall theatre. One and only final appearance of this apocalypse. Admission free."

HUNDREDS from about 16 to 30 may show up and engage in an enthusiastic, free-wheeling celebration of poetry, an analogue of which was jazz thirty years ago. The audience participates, shouting and stamping, interrupting and applauding. Poetry here has become a tangible social force, moving and unifying its auditors, releasing the energies of the audience through spoken, even shouted verse, in a way at present unique to this region.

The Bay region group, by and large, is anti-university. Its members make a living at odd jobs. Ambiguity is despised, irony is considered weakness, the poem as a system of connotations is thrown out in favor of long-line denotative statements. Explicit cognition is enjoined. Rhyme is outlawed. Whitman is the only god worthy of emulation. These generalizations would probably not be allowed by all members of the group. They may serve, however, as indicators.

The most remarkable poem of the young group, written during the past year, is "Howl," by Allen Ginsberg, a 29-year-old poet who is the son of Louis Ginsberg, a poet known to newspaper readers in the East. Ginsberg comes from Brooklyn; he studied at Columbia; after years of apprenticeship to usual forms, he developed his brave new medium. This poem has created a furor of praise or abuse whenever read or heard. It is a powerful work, cutting through to dynamic meaning. Ginsberg thinks he is going forward by going back to the methods of Whitman.

My first reaction was that it is based on destructive violence. It is profoundly Jewish in temper. It is Biblical in its repetitive grammatical build-up. It is a howl against everything in our mechanistic civilization which kills the spirit, assuming that the louder you shout the more likely you are to be heard. It lays bare the nerves of suffering and spiritual struggle. Its positive force and energy come from a redemptive quality of love, although it destructively catalogues evils of our time from physical deprivation to madness.

In other poems, Ginsberg shows a crucial sense of humor. It shows up principally in his poem "America," which has lines "Asia is rising against me./ I haven't got a Chinaman's chance." Humor is also present in "Supermarket in California." His "Sunflower Sutra" is a lyric poem marked by pathos.

Lawrence Ferlinghetti is the publisher of the Pocket Poet Series from his bookshop in San Francisco, the City Lights Pocket Bookshop. Small, inexpensive paper books have already appeared by Rexroth, Patchen, W. C. Williams, with Ginsberg, Denise Levertov and Marie Ponsot scheduled to follow. Rexroth's "Thirty Spanish Poems of Love and Exile" has efficient translations of Guillen, Alberti, Lorca, Machado and others.

In this series Ferlinghetti's "Pictures of the Gone World" offers his own poetry in a flowing variety of open-running lines. He develops a personal, ritual anecdote as a fresh type of recognition, with acute visual perceptions. He seems to have learned something from James Laughlin. His work measures a racy young maturity of experience.

Most of the young poets have not yet published books, but two others who have should be mentioned. They are: James Harmon and Paul Dreykus. Harmon's "In Praise of Eponymous Iahu" (Bern Porter) is struggling between a traditional, mellifluous type of lyric like "Song" and realistic poetry in the manner of "Hawk Inlet." "Stone and Pulse," by Dreykus (Porpoise Book Shop) has esthetic poems like "Light on Two Canvases," about Miro, and a realistic one "For Observation," about "An angerfleshed man."

OF the still bookless poets, Philip Whalen has somewhat Poundian poems and a highly successful refrain "Love You" in a direct and forceful poem entitled "3 Variations: All About Love." Gary Snyder's poetry is most like Rexroth's, not due so much to direct influence as to identity of sources. Both owe much to Far Eastern verse and philosophy, both are deeply bound into the natural world of stars, birds, mountains and flowers. Michael McClure writes with grace and charm on "For the Death of 100 Whales" and "Point Lobos: Animism," striving for "The rising, the exuberance, when the mystery is unveiled."

Surrounding this young Bay region group are older poets like Josephine Miles, Yvor Winters, Robert Horan, James Schevill (whose verse drama about Roger Williams was recently produced in Providence), Anthony Ostroff, Leonard Wolf, Thomas Parkinson, Albert Cook and others.

The young group is marked naturally by volatility. It seems to be a group today, but nobody knows whether it will survive as a group and make a mark on the national poetic consciousness. Poetry being a highly individualistic expression of mind, soul and personality, it would seem that the idea of a group at all is a misnaming. It may be so. These poets all differ one from another. It may be that one or more individualists will survive the current group manifestation.

It is certain that there is a new, vital group consciousness now among young poets in the Bay region. However unpublished they may be, many of these young poets have a numerous and enthusiastic audience. They acquire this audience by their own efforts. Through their many readings they have in some cases a larger audience than more cautiously presented poets in the East.

They are finely alive, they believe something new can be done with the art of poetry, they are hostile to gloomy critics, and the reader is invited to look into and enjoy their work as it appears. They have exuberance and a young will to kick down the doors of older consciousness and established practice in favor of what they think is vital and new.

September 2, 1956

# Tormented Triangle

GIOVANNI'S ROOM. By James Baldwin. 248 pp. New York: The Dial Press. $3.

### By GRANVILLE HICKS

WHOEVER has read James Baldwin's first novel, "Go Tell It on the Mountain," or his collection of essays and sketches, "Notes of a Native Son," knows him to be one of our gifted young writers. His most conspicuous gift is his ability to find words that astonish the reader with their boldness even as they overwhelm him with their rightness.

*Mr. Hicks is author of the novel "There Was a Man in Our Town" and other books.*

The theme of "Giovanni's Room" is delicate enough to make strong demands on all of Mr. Baldwin's resourcefulness and subtlety. We meet the narrator, known to us only as David, in the south of France, but most of the story is laid in Paris. It develops as the story of a young American involved both with a woman and with another man, the man being the Giovanni of the title. When a choice has to be made, David chooses the woman, Hella.

David tells the story on a single night, the night before Giovanni is to be guillotined as a murderer. He tells of his life in Giovanni's room, of deserting Giovanni for Hella and of making plans to marry her, of the effect of this on Giovanni, and of the effect of Giovanni's plight on his own relations with Hella. Mr. Baldwin writes of these matters with an unusual degree of candor and yet with such dignity and intensity that he is saved from sensationalism.

Much of the novel is laid in scenes of squalor, with a background of characters as grotesque and repulsive as any that can be found in Proust's "Cities of the Plain," but even as one is dismayed by Mr. Baldwin's materials, one rejoices in the skill with which he renders them. Nor is there any suspicion that he is working with these materials merely for the sake of shocking the reader. On the contrary, his intent is most serious. One of the lesser characters, in many ways a distasteful one, tells David that "not many people have ever died of love." "But," he goes on, "multitudes have perished, and are perishing every hour—and in the oddest places!—for the lack of it." This is Mr. Baldwin's subject, the rareness and difficulty of love, and, in his rather startling way, he does a great deal with it.

October 14, 1956

# End of the Line

THE WAPSHOT CHRONICLE. By John Cheever. 307 pp. New York: Harper & Bros. $3.50.

### By MAXWELL GEISMAR

THE NEW YORKER school of fiction has come in for so many critical strictures lately that one almost wishes John Cheever, a talented member of this group, would confound the critics and break loose. One reads the present novel, which is not quite a novel either, but which starts out so well, with this hope—but at the end I am not quite sure whether Mr. Cheever has broken loose, or hasn't. The story is entertainment, for the most part, which hovers on the edge of a more serious purpose.

The Wapshots are a rundown New England family founded in Revolutionary times and now reduced to the lowest circumstances. Their town, St.

*Mr. Geismar, a literary historian and critic, is author of "Writers in Crisis."*

Botolphs, has descended the scale with them. The father, Leander, commands a venerable excursion boat, in order to feel useful to himself, but exists through the courtesy (and cash) of his rich relative, Honora. (This society is a matriarchy where the women, by outliving the shipbuilders, ship captains and prosperous merchants, now exercise a sterile and capricious power.) The two young Wapshot boys, Moses and Coverly, are the heirs of a decaying dynasty.

The story opens with an entertaining Independence Day parade in the old-fashioned manner, and Mr. Cheever constantly evokes the illustrious past of the town—and of nineteenth century New England—and contrasts this with its dingy and mediocre prospects. The "modern girl" of the chronicle is Rosalie Young, who has run away from her reli-

gious family, and who has no further interests or values of her own beyond her cheerful and abundant sexuality. But Rosalie is really seeking something else, love and friendship, through the only path she knows. When she yields herself to Moses, and the horrified Honora is trapped in a closet by the frolicsome couple, the true action of the story begins.

This is also a central theme in Mr. Cheever's work: the power of human love and desire, which turns out to be a shield for human loneliness and melancholy—along with a note of broad farce, or of downright burlesque at times, which accompanies the tragicomedy of sex. It is at this point that the chronicle of the Wapshots breaks through the proper confines of "sensibility" in the typical New Yorker story. The depth of the narrative lies in the accent on human "unrequital," and in the lyrical apostrophes to the sea-born Venus, to love and women. The ironic twist lies in the antics of lovers.

THERE is another high point when Moses sets out to make his fortune in Washington and meets the "higher morality" of the reform administration. There is a brilliant bit of satire when his brother, Coverly, an innocent small-town adolescent, is subjected to a battery of psychological tests in the world of business. But this suggests also that the last half of the book is a picaresque of modern times set against the earlier, nostalgic background of the New England past. The two parts don't quite hang together, and the story as a whole becomes rather fragmentary and episodic. One has the final impression of a series of related "sketches," which do not quite achieve either the impact of the short story proper or the inner growth and development of a novel.

March 24, 1957

# It Was Spring in Dublin

THE GINGER MAN. By J. P. Donleavy. With an introduction by Arland Ussher. 327 pp. New York: McDowell, Obolensky. $3.95.

### By CARL BODE

THE formula is Ireland, sex and the human comedy, but seldom has a novelist concentrated so much on sex. The plot is picaresque; its episodes are unified only by the personality of the hero. The most important action is the Ginger Man's leaving plain Marion for Mary of the insatiable kisses, but there are several affairs in between. The style is poetic, sometimes elliptical, and often with a flavor of Joyce and "Ulysses."

It is spring in post-war Dublin as the story opens. The red-bearded Ginger Man is the hero. His name is Dangerfield, and he is described as American, an

ex-G. I. engaged in educating himself in and around Trinity College. However, J. P. Donleavy's ear for American speech is far from subtle (though he was born in Brooklyn), and Dangerfield actually speaks like a Celt. He lives in poverty and dirt with his wife, Marion, and their grubby child. He himself, it should be added, is literally the dirtiest American in recent fiction. His foil in the novel is another American, one O'Keefe, who happens to be as shy about women as the Ginger Man is bold. His frustrations counterpoint Dangerfield's successes.

Life with Marion palls, and the Ginger Man decides that living on sheep's head is not to his taste. The couple separate. After much turmoil the Ginger

Man moves to London, where he discovers friends who welcome him and even give him money. He finds the city immensely interesting after the pinched meanness of Dublin. The novel ends with a Christmas party in London, where Dangerfield bawls that Christmas is a fraud and Judas was English. Wild man that he is, he astounds everyone and delights his friends with his frankness.

There is about the book a kind of Marx Brothers humor. Dangerfield diddling a landlord or escaping by a hair from the ladies' lavatory, a cat and dog fight between Dangerfield and his Marion or his Mary, Miss Frost (the boarder) being seduced to the accompaniment of stilted conversation—all this is shown by Mr. Donleavy as if it were a series of pictures. Yet the comic action can move as well, in the elliptical, hopscotch

style mentioned earlier. Only the peaks of a conversation are given, only the barest movements noted.

THE zany hero—the rogue, the comic roisterer—for all his low adventures still makes a comment on the human condition that is serious if banal. It is that despite its sordidness life has strength. Much of the strength comes from sex, and this is what the novel dwells upon. To justify that fact, if it needs justification, we might keep in mind Judge Woolsey's remark in his opinion admitting "Ulysses" to our country. It should be remembered, said the judge, that the locale was Celtic and the season spring.

May 11, 1958

# The Tragedy of Man Driven by Desire

LOLITA. By Vladimir Nabokov. 319 pp. New York: G. P. Putnam's Sons. $5.

### By ELIZABETH JANEWAY

THE first time I read Lolita I thought it was one of the funniest books I'd ever come on. (This was the abbreviated version published in the Anchor Review last year.) The second time I read it, uncut, I thought it was one of the saddest. I

mention this personal reaction only because Lolita is one of those occasional books which arrive swishing behind them a long tail of opinion and reputation which can knock the unwary reader off his feet. Is it shocking, is it pornographic, is it immoral? Is its reading to be undertaken not as a simple experience but as a conscious action which will place one on

this, or that, side of a critical dividing line? What does the Watch and Ward Society say of it? What does Sartre, Graham Greene or Partisan Review?

This is hard on any book. "Lolita" stands up to it wonderfully well, though even its author has felt it necessary to contribute an epilogue on his intentions. This, by the way,

seems to me quite as misleading as the purposely absurd (and very funny) prologue by "John Ray Jr., Ph. D.," which is a beautifully constructed caricature of American Academic Bumbledom. But in providing a series of trompe-l'oeil frames for the action of his book, Vladimir Nabokov has undoubtedly been acting with intent: they are screens as well as frames. He is not writing for the ardent and simple-minded civil-libertarian any more than he is writing for the private libertine; he

233

is writing for readers, and those who can read him simply will be well rewarded.

He is fond of frames and their effects. A final one is provided within the book itself by the personality of the narrator, Humbert Humbert ("an assumed name"). Humbert is a close-to-40 European, a spoiled poet turned dilettante critic, the possessor of a small but adequate private income and an enormous and agonizing private problem: he is aroused to erotic desire only by girls on the edge of puberty, 9-to-14-year-old "nymphets." Juliet, Dante's Beatrice and Petrarch's Laura all fell within this age range, but to poor panting Humbert Humbert, the twentieth century denies the only female things he really desires.

THEN, as in a fairy tale, his wish comes true. Lolita is its fulfillment. She is the quintessence of the nymphet, discovered by total accident in an Eastern American small town. To get her, Humbert puts himself through a pattern of erotic choreography that would shame a bower-bird. He is grotesque and horrible and unbearably funny, and he knows it. He will settle for anything, and does. The "anything" involves marrying Lolita's widowed mother, Charlotte, with all the lies and swallowing of distaste that this implies. Charlotte promptly arranges to send the child away so that the two "lovers" can be alone together, and Humbert begins to consider the distasteful lies necessitated by murder.

Fate, however, intervenes (McFate, Humbert calls him, envisioning him as an old, lavish and absent-minded friend addicted to making ambiguous gifts, a sort of deified Bernard Goldfine). Charlotte is killed in an accident. Dream come true! With his little stepdaughter (he drops the "step" to strangers), Humbert sets out on an odyssey of lechery that approaches the flights and "fugues" of schizophrenia.

It turns into a nightmare. Through two years and two lengthy circuits of the American scene, Humbert spirals down the levels of his inferno. Possessed, insatiable, he can never stop wanting Lolita because he never really has her, he has only her body. In the end, his punishment matches his crime. Lolita runs off with a monster; Humbert attempts to track them (giving a hilarious impersonation of a Thurber bloodhound as he does), bounces into a sanitarium, bounces out and lives in despair until Dolly, who used to be Lolita, finds him. She is now an entirely different person, a triumph for the vital force that has managed to make a life out of the rubble that Humbert's passion created, and the monster's mindless activity merely confirmed. For a moment Humbert stands revealed to himself as her destroyer. But this confrontation does him no good. He sheers off into action again and rushes away to find and murder the monster in a long tragi-farcical shambles that somehow combines the chase scene from "Charley's

Aunt" with the dénouement of "Titus Andronicus."

In his epilogue, Mr. Nabokov informs us that "Lolita" has no moral. I can only say that Humbert's fate seems to me classically tragic, a most perfectly realized expression of the moral truth that Shakespeare summed up in the sonnet that begins, "The expense of spirit in a waste of shame/ Is lust in action": right down to the detailed working out of Shakespeare's adjectives, "perjur'd, murderous, bloody, full of blame." Humbert is the hero with the tragic flaw. Humbert is every man who is driven by desire, wanting his Lolita so badly that it never occurs to him to consider her as a human being, or as anything but a dream - figment made flesh— which is the eternal and universal nature of passion.

The author, that is, is writing about all lust. He has afflicted poor Humbert with a special and taboo variety for a couple of contradictory reasons. In the first place, its illicit nature will both shock the reader into paying attention and prevent sentimentally false sympathy from distorting his judgment. Contrariwise, I believe, Mr. Nabokov is slyly exploiting the American emphasis on the attraction of youth and the importance devoted to the "teen-ager" in order to promote an unconscious identification with Humbert's agonies. Both techniques are entirely valid. But neither, I hope, will obscure the purpose of the device: namely, to underline the essential, inefficient, painstaking and pain-giving

selfishness of all passion, all greed—of all urges, whatever they may be, that insist on being satisfied without regard to the effect their satisfaction has upon the outside world. Humbert is all of us.

So much for the moral of this book, which is not supposed to have one. Technically it is brilliant, Peter-De-Vries humor in a major key, combined with an eye for the revealing, clinching detail of social behavior. If there is one fault to find, it is that in making his hero his narrator, Mr. Nabokov has given him a task that is almost too big for a fictional character. Humbert tends to run over into a figure of allegory, of Everyman. When this happens it unbalances the book, for every other character belongs in a novel and is real as real can be. Humbert alone runs over at the edges, as if in painting him Mr. Nabokov had just a little too much color on his brush; which color is, I suppose, the moral that poor Humbert is carrying for his creator.

Never mind. This is still one of the funniest and one of the saddest books that will be published this year. As for its pornographic content, I can think of few volumes more likely to quench the flames of lust than this exact and immediate description of its consequences.

*Mrs. Janeway is both a critic of fiction and, in such books as "The Walsh Girls" and "Leaving Home," a writer of it.*

August 17, 1958

# The Discovery of What It Means to Be an American

### By JAMES BALDWIN

"IT is a complex fate to be an American," Henry James observed, and the principal discovery, an American writer makes in Europe is just how complex this fate is. America's history, her aspirations, her peculiar triumphs, her even more peculiar defeats, and her position in the world—yesterday and today—are all so profoundly and stubbornly unique that the very word "America" remains a new, almost completely undefined and extremely controversial proper noun. No one in the world seems to know exactly what it describes, not even we motley millions who call ourselves Americans.

*Born in Harlem, Mr. Baldwin has intermittently lived and worked in France and Switzerland for the past ten years. He is the author of two novels, "Go Tell It on the Mountain" and 'Giovanni's Room.'*

I left America because I doubted my ability to survive the fury of the color problem here. (Sometimes I still do.) I wanted to prevent myself from becoming *merely* a Negro; or, even, merely a Negro writer. I wanted to find out in what way the *specialness* of my experience could be made to connect me with other people instead of dividing me from them. (I was as isolated from Negroes as I was from whites, which is what happens when a Negro begins, at bottom, to believe what white people say about him.)

In my necessity to find the terms on which my experience could be related to that of others, Negroes and whites, writers and non-writers, I proved, to my astonishment, to be as American as any Texas G. I. And I found my experience was shared by every American writer I knew in Paris. Like

me, they had been divorced from their origins, and it turned out to make very little difference that the origins of white Americans were European and mine were African—they were no more at home in Europe than I was.

THE fact that I was the son of a slave and they were the sons of free men meant less, by the time we confronted each other on European soil, than the fact that we were both searching for our separate identities. When we had found these, we seemed to be saying, why, then, we would no longer need to cling to the shame and bitterness which had divided us so long.

It became terribly clear in Europe, as it never had been here, that we knew more about each other than any European ever could. And it also became clear that, no matter where our

fathers had been born, or what they had endured, the fact of Europe had formed us both, was part of our identity and part of our inheritance.

I had been in Paris a couple of years before any of this became clear to me. When it did, I, like many a writer before me upon the discovery that his props have all been knocked out from under him, suffered a species of breakdown and was carried off to the mountains of Switzerland. There, in that absolutely alabaster landscape, armed with two Bessie Smith records and a typewriter, I began to try to re-create the life that I had first known as a child and from which I had spent so many years in flight.

It was Bessie Smith, through her tone and her cadence, who helped me to dig back to the way I myself must have spoken when I was a pickaninny, and to remember the things I had heard and seen and felt. I had buried them very deep. I had

never listened to Bessie Smith in America (in the same way that, for years, I would not touch watermelon), but in Europe she helped to reconcile me to being a "nigger."

I DO not think that I could have made this reconciliation here. Once I was able to accept my role—as distinguished, I must say, from my "place"—in the extraordinary drama which is America, I was released from the illusion that I hated America.

The story of what can happen to an American Negro writer in Europe simply illustrates, in some relief, what can happen to any American writer there. It is not meant, of course, to imply that it happens to them all, for Europe can be very crippling, too; and, anyway, a writer, when he has made his first breakthrough, has simply won a crucial skirmish in a dangerous, unending and unpredictable battle. Still, the breakthrough is important, and the point is that an American writer, in order to achieve it, very often has to leave this country.

The American writer, in Europe, is released, first of all, from the necessity of apologizing for himself. It is not until he is released from the habit of flexing his muscles and proving that he is just a "regular guy" that he realizes how crippling this habit has been. It is not necessary for him, there, to pretend to be something he is not, for the artist does not encounter in Europe the same suspicion he encounters here. Whatever the Europeans may actually think of artists, they have killed enough of them off by now to know that they are as real—and as persistent—as rain, snow, taxes or business men.

Of course, the reason for Europe's comparative clarity concerning the different functions of men in society is that European society has always been divided into classes in a way that American society never has been. A European writer considers himself to be part of an old and honorable tradition—of intellectual activity, of letters—and his choice of a vocation does not cause him any uneasy wonder as to whether or not it will cost him all his friends. But this tradition does not exist in America.

On the contrary, we have a very deep-seated distrust of real intellectual effort (probably because we suspect that it will destroy, as I hope it does, that myth of America to which we cling so desperately). An American writer fights his way to one of the lowest rungs on

the American social ladder by means of pure bull-headedness and an indescribable series of odd jobs. He probably *has* been a "regular fellow" for much of his adult life, and it is not easy for him to step out of that lukewarm bath.

We must, however, consider a rather serious paradox: though American society is more mobile than Europe's, it is easier to cut across social and occupational lines there than it is here. This has something to do, I think, with the problem of status in American life. Where everyone has status, it is also perfectly possible, after all, that no one has. It seems inevitable, in any case, that a man may become uneasy as to just what his status is.

But Europeans have lived with the idea of status for a long time. A man can be as proud of being a good waiter as of being a good actor, and, in neither case, feel threatened. And this means that the actor and the waiter can have a freer and more genuinely friendly relationship in Europe than they are likely to have here. The waiter does not feel, with obscure resentment, that the actor has "made it," and the actor is not tormented by the fear that he may find himself, tomorrow, once again, a waiter.

This lack of what may roughly be called social paranoia causes the American writer in Europe to feel—almost certainly for the first time in his life—that he can reach out to everyone, that he is accessible to everyone and open to everything. This is an extraordinary feeling. He feels, so to speak, his own weight, his own value.

It is as though he suddenly came out of a dark tunnel and found himself beneath the open sky. And, in fact, in Paris, I began to see the sky for what seemed to be the first time. It was borne in on me—and it did not make me feel melancholy—that this sky had been there before I was born and would be there when I was dead. And it was up to me, therefore, to make of my brief opportunity the most that could be made.

I was born in New York, but have only lived in pockets of it. In Paris, I lived in all parts of the city—on the Right Bank and the Left, among the bourgeoisie and among *les misérables*, and knew all kinds of people, from pimps and prostitutes in Pigalle to Egyptian bankers in Neuilly. This may sound extremely unprincipled or even obscurely immoral; I found it healthy. I love to talk to people, all kinds of people, and almost everyone, as I hope we still know, loves a man who loves to listen.

This perpetual dealing with

people very different from myself caused a shattering in me of preconceptions I scarcely knew I held. The writer is meeting in Europe people who are not American, whose sense of reality is entirely different from his own. They may love or hate or admire or fear or envy this country—they see it, in any case, from another point of view, and this forces the writer to reconsider many things he had always taken for granted. This reassessment, which can be very painful, is also very valuable.

This freedom, like all freedom, has its dangers and its responsibilities. One day it begins to be borne in on the writer, and with great force, that he is living in Europe as an American. If he were living there as a European, he would be living on a different and far less attractive continent.

THIS crucial day may be the day on which an Algerian taxi-driver tells him how it feels to be an Algerian in Paris. It may be the day on which he passes a cafe terrace and catches a glimpse of the tense, intelligent and troubled face of Albert Camus. Or it may be the day on which someone asks him to explain Little Rock and he begins to feel that it would be simpler — and, corny as the words may sound, more honorable—to *go* to Little Rock than sit in Europe, on an American passport, trying to explain it.

This is a personal day, a terrible day, the day to which his entire sojourn has been tending. It is the day he realizes that there are no untroubled countries in this fearfully troubled world; that if he has been preparing himself for anything in Europe, he has been preparing himself—for America. In short, the freedom that the American writer finds in Europe brings him, full circle, back to himself, with the responsibility for his development where it always was: in his own hands.

Even the most incorrigible maverick has to be born somewhere. He may leave the group that produced him—he may be forced to—but nothing will efface his origins, the marks of which he carries with him everywhere. I think it is important to know this and even find it a matter for rejoicing, as the strongest people do, regardless of their station. On this acceptance, literally, the life of a writer depends.

The charge has often been made against American writers that they do not describe society, and have no interest in it. They only describe individuals

people very different from my-self caused a shattering in me of preconceptions I scarcely knew I held. The writer is meeting in Europe people who are not American, whose sense of reality is entirely different from his own. They may love or hate or admire or fear or envy this country—they see it, in any case, from another point of view, and this forces the writer to reconsider many things he had always taken for granted. This reassessment, which can be very painful, is also very valuable.

in opposition to it, or isolated from it. Of course, what the American writer is describing is his own situation. But what is "Anna Karenina" describing if not the tragic fate of the isolated individual, at odds with her time and place?

The real difference is that Tolstoy was describing an old and dense society in which everything seemed—to the people in it, though not to Tolstoy—to be fixed forever. And the book is a masterpiece because Tolstoy was able to fathom, and make us see, the hidden laws which really governed this society and made Anna's doom inevitable.

American writers do not have a fixed society to describe. The only society they know is one in which nothing is fixed and in which the individual must fight for his identity. This is a rich confusion, indeed, and it creates for the American writer unprecedented opportunities.

That the tensions of American life, as well as the possibilities, are tremendous is certainly not even a question. But these are dealt with in contemporary literature mainly compulsively; that is, the book is more likely to be a symptom of our tension than an examination of it. The time has come, God knows, for us to examine ourselves, but we can only do this if we are willing to free ourselves of the myth of America and try to find out what is really happening here.

Every society is really governed by hidden laws, by unspoken but profound assumptions on the part of the people, and ours is no exception. It is up to the American writer to find out what these laws and assumptions are. In a society much given to smashing taboos without thereby managing to be liberated from them, it will be no easy matter.

It is no wonder, in the meantime, that the American writer keeps running off to Europe. He needs sustenance for his journey and the best models he can find. Europe has what we do not have yet, a sense of the mysterious and inexorable limits of life, a sense, in a word, of tragedy. And we have what they sorely need: a new sense of life's possibilities.

In this endeavor to wed the vision of the Old World with that of the New, it is the writer, not the statesman, who is our strongest arm. Though we do not wholly believe it yet, the interior life is a real life, and the intangible dreams of people have a tangible effect on the world.

January 25, 1959

# U. S. RELAXES BAN ON MILLER NOVEL

## Admits 'Tropic of Cancer,' Once Barred as Obscene, for Literary Purposes

### By ANTHONY LEWIS
Special to The New York Times.

WASHINGTON, March 19—The Customs Bureau has decided to permit the importation of Henry Miller's long-banned novel, "Tropic of Cancer"—but only for literary and scholarly purposes.

The book has been excluded from the United States as obscene since its publication in Paris in 1931. But it has been praised by such literary figures as T. S. Eliot and has become a major symbol of avant garde writing.

The new ruling was sought by Dr. Clark Foreman of New York, director of the Emergency Civil Liberties Committee.

Dr. Foreman brought a copy of "Tropic of Cancer," published in English by the Obelisk Press of Paris, back from Europe last fall. Customs officials seized it when he landed Oct. 1 at New York International Airport, Idlewild, Queens.

His attorney, Leonard B. Boudin of New York, wrote to customs officials asking for the return of the book. He contended that the work was now recognized as one of literary merit and that Dr. Foreman "has a serious interest in the study of the book and a need for it in his work."

### A General Explanation

The Customs Bureau, with the Treasury's approval, decided to return the book to Dr. Foreman. The precise reason for its decision was not stated, but officials gave a general explanation today.

They indicated first that the literary recognition given "Tropic of Cancer" had carried some weight.

Second, officials said Dr. Foreman was regarded as a person of responsibility, not bringing the book in to satisfy a commercial or prurient interest.

Dr. Foreman, a sociologist, plans no special scholarly work on the book. His lawyer, Mr. Boudin, said today that Dr. Foreman was a "very well read man who likes literature."

As recently as 1953, the United States Court of Appeals for the Ninth Circuit found "Tropic of Cancer" entirely obscene and upheld its seizure by Customs officials.

The book is a first-person account of a low-level vagabond existence in Paris.

The biographical work "Twentieth Century Authors" says of Henry Miller that his exuberance, iconoclasm and aggressive Bohemianism "inspire in most of his readers either a passionate admiration or an acute antipathy."

March 20, 1959

# SPEAKING OF BOOKS

### By MALCOLM COWLEY

I LAMENT the decline in prestige and power of what used to be the bad words in the language, the obscene or blasphemous words that could not be printed. One might read the polite fiction and drama of two centuries, say from 1725 to 1925, without finding the words themselves, though sometimes they appeared in softened forms like "heck" and "darn" or even "d—n." Sometimes there were shocked or sly allusions to their persistence in spoken English. In spite of the horror they aroused, or partly because of it, they had a recognized place and function. Now they have lost them both.

Their place until World War I was in the language of mule skinners, cánawlers, gandy dancers, bindle stiffs, pine butchers, gobs, leathernecks and others whose hardy lives were seldom shared by women. Their primary function was to express a variety of strong emotions, including pain, amazement, outrage, admiration, loathing and exuberance, but seldom romantic yearning. On occasion they might serve as exhortations or even prayers. "Giddap!" the teamster shouted when his wheels were hub-deep in mud. "Giddap, you——" whereupon he uttered what novelists liked

*Mr. Cowley's several books of criticism include "The Literary Situation."*

to call "a picturesque flood" or "a crimson stream" of profanity. By using such phrases the novelists revealed an ambiguous attitude toward the words in question. They seemed to be saying that the words were "low" socially, but that they also expressed the strength of the lumberjack, the freedom of the wanderer, the daring of the soldier, and the hairy maleness of anyone who spoke them.

Anyone who used bad words where ladies might overhear them was "not worth a tinker's curse," as people said of him undamningly. That suggests another function of the words: they were an exclusively male idiom that helped to keep women in a protected but subordinate position. They did not kindle the fires of passion, but instead tried to quench them by making passion ugly and ridiculous. They were passwords to a sort of vast clubhouse in which men could live untamed by female gossip and unsubdued by yearning.

How did they lose their secret quality? The process must have started in France during World War I, when American boys of sheltered families discovered that there was an extensive oral literature, mostly British or Negro, in which bad words were used to produce comic effects. They committed some of the songs to heart and later sang them at parties in the States. Often the listeners included girls, also of sheltered families, who heard the songs without flinching and felt proud to be learning passwords into the forbidden world of men.

JAMES JOYCE used many of the passwords in "Ulysses" (1922), and his example had a lasting effect on American writing. Still more of them were baldly printed in "Lady Chatterley's Lover" (1928), another book that—in those days—had to be smuggled in from Europe. It used the words for a paradoxical purpose, that of evoking passion and tenderness, whereas they had been used in the past to ridicule both emotions.

Since then the secret language has been subjected to a long process of expropriation. Its territory has been invaded by a series of novelists, from Hemingway and Henry Miller to Norman Mailer and James Jones, each of whom has laid hands on one or more of its treasures and made them part of the public domain. Now there are very few treasures left to steal. When the unexpurgated version of "Lady Chatterley" was published here, its new readers found there was not a word in the book that had not been printed in American novels (nor an idea, one might add, that was not being expounded by marriage counsellors).

As a result of these linguistic raids, the public has gained the right to read some valuable works of fiction that used to be outside the law. But I wonder whether the language itself has gained anything except a few exact but ugly synonyms. Today a novelist wouldn't dare to say that one of his characters uttered "a crimson stream of profanity." Instead he would set everything down, phonographically, and the crimson stream would be found to consist of three or four stereotyped phrases in disordered sequence. The bad words have lost their mystery and magic. They are like the venerated idols of a tribe, kept in a secret sanctuary but finally captured by invaders. When brought to light they are revealed to be nothing but coarse-grained and shapeless blocks of wood.

Once they were capable of working miracles. The mere enunciation of a word was enough to pull triggers and set fists or hobnailed boots in motion. "When you say that, smile!" the hero used to mutter through clenched lips. Now the bad words have become barnacled with smiles, encysted in smiles, buried under layers of blandness. What can a lumberjack say now when he wants to start a fight? In what words can a f her curse his erring son, or a husband his unfaithful wife?—or an amateur carpenter express his outrage when the hammer comes down on his thumb? If he has lost faith in the bad words he can only say "Ouch!" with a feeling that the English language has failed him.

June 28, 1959

# Excerpts From Court Ruling on 'Lady Chatterley'

*Following are excerpts from the opinion of Federal Judge Frederick vanPelt Bryan yesterday on "Lady Chatterley's Lover":*

There were no disputed facts before the Postmaster General. The only issue before him was whether "Lady Chatterley's Lover" was obscene.

The complainant relied on the text of the novel and nothing more to establish obscenity.

As the Postmaster General said, he attempted to apply to the book "the tests which, it is my understanding, the courts have established for determining questions of obscenity." Thus, all he did was to apply the statute, as he interpreted it in the light of the decisions, to the book. His interpretation and application of the statute involved questions of law, not questions of fact.

The Postmaster General has no special competence or technical knowledge on this sub-

ject which qualifies him to render an informed judgment entitled to special weight in the courts. There is no parallel here to determinations of such agencies as the Interstate Commerce Commission, the Securities and Exchange Commission, the National Labor Relations Board, the Federal Communications Commission, the Federal Power Commission, or many others on highly technical and complicated subject matter upon which they have specialized knowledge and are particularly qualified to speak.

## No Special Competence

No doubt the Postmaster General has similar qualifications on many questions involving the administration of the Post Office Department, the handling of the mails, postal rates and other matters. But he has no special competence to determine what constitutes obscenity within the meaning of Section 1461, or that "contemporary community standards are not such that this book should be allowed to be transmitted in the mails" or that the literary merit of the book is outweighed by its pornographic features, as he found.

Such questions involve interpretation of a statute, which also imposes criminal penalties, and its application to the allegedly offending material.. The determination of such questions is peculiarly for the courts, particularly in the light of the constitutional questions implicit in each case.

It has been suggested that the court cannot interfere with the order of the Postmaster General unless it finds that he abused his discretion. But it does not appear that the Postmaster General has been vested with "discretion" finally to determine whether a book is obscene within the meaning of the statute.

No such grant of power to the Postmaster General has been called to my attention and I have found none. Whatever administrative functions the Postmaster General has go no further than closing the mails to material which is obscene within the meaning of the statute. This is not an area in which the Postmaster General has any "discretion" which is entitled to be given special weight by the courts.

It is not the effect upon the irresponsible, the immature or the sensually minded which is controlling. The material must be judged in terms of its effect on those it is likely to reach who are conceived of as the average man of normal sensual impulses, or, as Judge Woolsey says, "what the French would call l'homme moyen sensuel."

The material must also exceed the limits of tolerance imposed by current standards of the community with respect to freedom of expression in matters concerning sex and sex relations. Moreover, a book is not to be

judged by excerpts or individual passages but must be judged as a whole.

All of these factors must be present before a book can be held obscene and thus outside constitutional protections.

Judged by these standards, "Lady Chatterley's Lover" is not obscene. The decision of the Postmaster General that it is obscene and therefore nonmailable is contrary to law and clearly erroneous. This is emphasized when the book is considered against its background and in the light of its stature as a significant work of a distinguished English novelist.

D. H. Lawrence is one of the most important novelists writing in the English language in this century. Whether he is, as some authorities say, the greatest English novelist since Joseph Conrad, or one of a number of major figures, makes little difference. He was a writer of great gifts and of undoubted artistic integrity.

The text of this edition of "Lady Chatterley's Lover" was written by Lawrence toward the close of his life and was his third version of the novel, originally called "Tenderness."

The book is almost as much a polemic as a novel.

In it Lawrence was expressing his deep and bitter dissatisfaction with what he believed were the stultifying effects of advancing industrialization and his own somewhat obscure philosophic remedy of a return to "naturalness." He attacks what he considered to be the evil effects of industrialization upon the wholesome and natural life of all classes in England. In his view this was having disastrous consequences on English society and on the English countryside. It had resulted in devitalization of the upper classes of society and debasement of the lower classes. One result, as he saw it, was the corrosion of both the emotional and physical sides of man as expressed in his sexual relationships which had become increasingly artificial and unwholesome.

The novel develops the contrasts and conflicts in characters under these influences.

The plot is relatively simple. Constance Chatterley is married to a baronet, returned from the First World War paralyzed from the waist down. She is physically frustrated and dissatisfied with the artificiality and sterility of her life and of the society in which she moves. Her husband, immersed in himself, seeks compensation for his own frustrations in the writing of superficial and brittle fiction and in the exploitation of his coal-mining properties, a symbol of the creeping industrial blight.

Failing to find satisfaction in an affair with a man in her husband's circle, Constance Chatterley finds herself increasingly restless and

unhappy. Her husband halfheartedly urges her to have a child by another man whom he will treat as his heir. Repelled by the suggestion that she casually beget a child, she is drawn to Mellors, the gamekeeper, sprung from the working class who, having achieved a measure of spiritual and intellectual independence, is a prototype of Lawrence's natural man. They establish a deeply passionate and tender relationship which is described at length and in detail. At the conclusion she is pregnant and plans to obtain a divorce and marry the gamekeeper.

This plot serves as a vehicle through which Lawrence develops his basic theme of contrast between his own philosophy and the sterile and debased society which he attacks. Most of the characters are prototypes. The plot and theme are meticulously worked out with honesty and sincerity.

The book is replete with fine writing and with descriptive passages of rare beauty. There is no doubt of its literary merit.

It contains a number of passages describing sexual intercourse in great detail with complete candor and realism. Four letter Anglo-Saxon words are used with some frequency.

These passages and this language understandably will shock the sensitive minded. Be that as it may, these passages are relevant to the plot and to the development of the characters and of their lives as Lawrence unfolds them. The language which shocks, except in a rare instance or two, is not inconsistent with character, situation or theme.

The tests of obscenity are not whether the book or passages from it are in bad taste or shock or offend the sensibilities of an individual, or even of a substantial segment of the community. Nor are we concerned with whether the community would approve of Constance Chatterley's morals. The statute does not purport to regulate the morals portrayed or the ideas expressed in a novel, whether or not they are contrary to the accepted moral code, nor could it constitutionally do so.

## Personal Views Ruled Out

Plainly "Lady Chatterley's Lover" is offensive to the Postmaster General, and I respect his personal views. As a matter of personal opinion I disagree with him for I do not personally find the book offensive.

But the personal views of neither of us are controlling here. The standards for determining what constitutes obscenity under this statute have been laid down. These standards must be objectively applied regardless of personal predictions.

There has been much discussion of the intent and purpose of Lawrence in writing "Lady Chatterley." It is suggested that the intent and

purpose of the author has no relevance to the question as to whether his work is obscene and must be disregarded.

This would seem to end the matter. However, the Postmaster General's finding that the book is nonmailable because it offends contemporary community standards bears some discussion.

I am unable to ascertain upon what the Postmaster General based this conclusion. The record before him indicates general acceptance of the book throughout the country and nothing was shown to the contrary. The critics were unanimous. Editorial comment by leading journals of opinion welcomed the publication and decried any attempts to ban it.

In one best-selling novel after another frank descriptions of the sex act and "four-letter" words appear with frequency. These trends appear in all media of public expression, in the kind of language used and the subjects discussed in polite society, in pictures, advertisements and dress, and in other ways familiar to all. Much of what is now accepted would have shocked the community to the core a generation ago. Today such things are generally tolerated whether we approve or not.

I hold that, at this stage in the development of our society, this major English novel does not exceed the outer limits of the tolerance which the community as a whole gives to writing about sex and sex relations.

One final word about the constitutional problem implicit here.

It is essential to the maintenance of a free society that the severest restrictions be placed upon restraints which may tend to prevent the dissemination of ideas. It matters not whether such ideas be expressed in political pamphlets or works of political, economic or social theory or criticism, or through artistic media. All such expressions must be freely available.

A work of literature published and distributed through normal channels by a reputable publisher stands on quite a different footing from hard core pornography furtively sold for the purpose of profiting by the titillation of the dirty-minded.

To exclude this book from the mails on the grounds of obscenity would fashion a rule which could be applied to a substantial portion of the classics of our literature. Such a rule would be inimical to a free society. To interpret the obscenity statute so as to bar "Lady Chatterley's Lover" from the mails would render the statute unconstitutional in its application, in violation of the guarantees of freedom of speech and the press contained in the First Amendment.

July 22, 1959

# WHAT'S THE MATTER WITH POETRY?

### By KARL SHAPIRO

ALMOST every art in the twentieth century is a flourishing art—except poetry. Painting, music, sculpture, architecture, even the novel and the drama, have contributed richly to the age we live in. Our poetry, on the other hand, can boast only a tangle of subtleties and grotesques and the obscurantism for which it is famous. It is a diseased art.

It is diseased because the standards of poetry, criticism, and the teaching of both are today dictated by the *coup d'état* of Modernism, a minor intellectual program which took the stage more than a full generation ago, about 1915. These standards are enforced rigorously by literary constables ready to haul away any dissenters. Dissenters from what? Who are these literary guardians of the law? And what law must be obeyed? These are strange questions, but I think they can be answered here to some degree.

Poetry, of course cannot be charted like a history lesson, yet there are moments in literature when the historical demon takes over and guides the progress of letters. A literary junta or gang can seize power as surely as a political gang. Real life, political or literary, goes on outside the "official" life with its maneuvers and diplomatic pronouncements, but history unfortunately takes note mostly of the official view. Yet, in the long run it is usually the artist himself and poetry itself which controvert the dogmas of the culture official and the academician. A poet such as D. H. Lawrence or Dylan Thomas is never recognized by officialdom but by a living audience. This audience, by its very nature, lacks spokesmen and apologists and for all practical purposes is nonexistent. But when true poetry comes along it makes itself felt.

OFFICIAL poetry, on the other hand, is always thrust before us by its spokesmen. In countries where there are official or governmental academies, literary recognition is a cut-and-dried matter, and the poet may sport a ribbon and a title. It is disturbing to think that something like an academy has been transplanted to the literary soil of the United States in the last several decades, and that this *Académie Américaine*, so to speak, has spread its influence far and wide. When writers nowadays use the term "academic" as a term of abuse, they are referring to this officialdom and not to the presence of writers in the university.

Such terms are very silly but they are anything but meaningless. If we could bear in mind that "academic," "intellectual," "Modern," and what T. S. Eliot calls "Classical," all mean one and

*Mr. Shapiro, a Pulitzer Prize winning poet, is a member of the University of Nebraska faculty. He will publish a new book on modern poetry ("In Defense of Ignorance") next spring.*

the same thing and all refer to a specific type of literature, then we might be able to understand the nature of this official literary movement.

Ours is probably the only poetry in history that has had to be *taught* in its own time. A contemporary art that must be taught to adults before it can be enjoyed is sick. To support and justify this ailing poetry the adherents of Modernism have taken refuge in Criticism. Modern literary criticism is the largest and most formidable body of criticism known. Its authors, amazingly, are often poets themselves, or those poets who have subscribed to the culture program of the "Classical" school. Their obscurantism is as great as that of the poetry it tries to defend.

What we have in our time is not a flourishing poetry but a curious brand of poetry compounded of verse and criticism. It is accurate to call this hybrid "criticism-poetry." The person who can understand modern poetry must first be initiated into the vast and arcane criticism of our day. This is why almost every college or university in America must *teach* modern poetry. It is like teaching a foreign language and the key to it is criticism.

Anyone who has taught this "criticism-poetry" knows that the student is left cold or horrified, once he is able to see behind it. The only advantage of this situation is that it has provided employment for thousands of college instructors. Needless to say, criticism does not flourish in a time of great or healthy poetry, if it exists at all. Criticism is a branch of philosophy and in rare moments a literary art. In our time it is neither. Modern criticism is a propaganda for a handful of power-hungry writers, many of whom are the authors of the criticism itself.

A CRITICISM-POETRY is a mind-centered poetry, an ideological poetry, a poetry of theologies and social theories. Such a poetry prides itself on its "impersonal" character, yet it aims at cultural authority in all realms of value. That poetry of this stripe can become a touchstone is hard to believe, unless we remember that it is both vocal and ambitious, and that it parades "tradition" as its main argument. The holier-than-thou character of modern criticism-poetry arises from its adoration of what is past, conservative, hierarchical, though in practice this literature is full of concealed or open violence and the worst kinds of system-mongering. The absolutism of this type of poetry leads it into every conceivable ideological trap, from communism and fascism to Freudianism and theosophy. A contemporary poet without an Ism is considered by the academy to be a kind of rustic. Robert Frost, for instance, is not a Nobel Prize winner, even though he is a far greater poet than most who have been so honored. This is because Frost has no ideology to parade.

The ideological revolution in poetry,

if we call it that, was an actual historical event that took place in the decade roughly spanning the years 1915-25. During that brief period certain key works of literature and criticism were published which provided the canon of Modernism. It is this canon which is still referred to when we speak of Modern Poetry. Here is a fair sampling of those works: T. S. Eliot's "Prufrock," "The Waste Land," and "The Sacred Wood"; Ezra Pound's "Mauberley," "A Draft of XVI Cantos"; I. A. Richards' "The Meaning of Meaning"; T. E. Hulme's "Speculations"; Wallace Stevens' "Harmonium"; Marianne Moore's "Observations"; Paul Valéry's "La Jeune Parque"; W. B. Yeats' "The Tower"; James Joyce's "Ulysses"; Ernest Jones' "Essays in Applied Psychoanalysis"; etc.

This is not an arbitrary list, nor is it meant to imply that all the writers in the list met one night in a dark room to form the Modernist Club. Yet it is a list (much abbreviated here) that indicates close allegiances in ideas, in techniques, and in tendencies. T. E. Hulme's book of criticism called "Speculations" (1924) is something like the "Mein Kampf" of modern criticism. In it is laid down almost every precept of modern poetics; the political reactionism, the religious fundamentalism, and the hatred for "romanticism," spontaneity and freedom. The convergence of Hulme's program and that of the Symbolists, with a few other ingredients thrown in, permitted the Eliots and Pounds to establish a philosophy of literature which has become dominant, although only because of a careful and relentless pursuit of their program.

THERE is, of course, not the slightest divergence of aim between Eliot and Pound at any period of their careers. They are the Dr. Jekyll and Mr. Hyde of modern poetry. If Eliot appears the more savory of the two personalities, that is because of his identification with the British church and state. Pound's statelessness and anti-religious views render him, on the other hand, a rather fearful specter and an embarrassment to Modernism. Yet both writers operate from identical premises and seek a common conclusion to their cause. What is this common cause?

It is first the establishment of a culture orthodoxy. In politics the orthodoxy is anti-democratic, embracing either monarchism or fascism or, among some of our Southern poets, a nostalgia for ante-bellum days. In letters it prescribes anti-romanticism, the annihilation of poets such as Blake, Lawrence

and Whitman, as well as all anti-intellectuals and "optimists." In religion it prescribes ritual and dogma, whether on the conventional or the occult level (as in Yeats). With the anti-religious moderns, the ritualism may extend to form, as in Wallace Stevens. And in the case of a poet like Pound, culture can take the place of religion itself. Pound's cultural evangelism shows all the characteristics of a new religion, one which presumably he would have tried out had the corporate state survived.

In education, which the Modernists consider their special province, the orthodoxy is extended to include certain chosen works of poetry which supposedly contain all that is worth saving of the Western tradition (for example, Homer, Dante, the Metaphysical and Symbolist poets). Sociology, ethnology, economics, ethics, and of course esthetics are all taken care of in the Modernist curriculum.

Every college sophomore is dismally aware that criticism has supplanted poetry in the study of literature. He is acquainted with curious textbooks designed to make him understand the most minute and esoteric techniques of poetic style (which even poets are unaware of), without ever being taught who wrote the poem, or when or what its relevance is. The poem is treated as a biological specimen, thoroughly dead and ready for dissection. This kind of pedagogy is derived straight from the precepts of modern criticism and it is partly an attempt to isolate the public from a living poetry. A far-reaching result of such teaching has been to make poets tend to write for the purpose of criticism—to provide models for the critic to work with. So standardized has this poetry become that dissenting poets such as Dylan Thomas came to associate the American university with bad verse. It is possible that the general public, which refuses to support

this depersonalized verse, takes the same view.

The "poetry of ideas" is always a third-rate poetry, and Modern poetry is such. It is not the business of the poet to translate ideologies, philosophies, and psychologies into verse, as we have done for so many years. Nobody knows Shakespeare's "philosophy." All we know is the beauty and the relevance of his perceptions. Shakespeare is not popular with the Modernists; they think of him much as Voltaire did—as a "savage." Voltaire was an ideologist.

THE revolt against Modernism seems to be gaining ground at long last. New poets are turning away from criticism and the dictatorship of the intellectual journals; they are even turning away from the sanctimonious evangelists of the Tradition. They are once again seeking that audience which has for so long been outlawed by the aris-

tocrats of the Word. They are seeking to regain spontaneity and the use of the human voice, in place of the artificial culture myth and the bleak footnote. They are beginning to use subjective judgment in place of the critical dictum. They are returning to Whitman, the only world-poet America has produced, and Lawrence and such American contemporaries as William Carlos Williams.

If the new anti-modernist poetry is brutal, illiterate and hysterical, that is the price we have to pay for the generation-old suppression of poetry by criticism. It appears at long last that the poetry of the textbook will shortly find its way to the library stacks where, in fact, its death-wish has always pointed.

*December 13, 1959*

# The Film: A Source of New Vitality for the Novel

### By ROBERT GESSNER

IN the spring of 1927 an alert, wren-like man perched on a lectern in Trinity College, Cambridge, and sang lyrically of the novel. Tempted "to conclude by speculations on the future," E. M. Forster asked, "Will it be killed by the cinema?"

The rhetorical question didn't imply the end of fiction. "Indeed," Forster said, "the more the arts develop the more they depend on each other for definition."

Time, however, has answered Forster more conclusively than he suspected. The development of cinema has indeed "killed" the type of novel he admired, in the same way that Flaubert killed the novel of Balzac and Joyce may be said to have buried Flaubert. Killed or buried, all continue to be read and imitated, although with varying devotion. Novels of the sort Forster extolled and he himself wrote continue to be written by a diminishing few. To name two, Lawrence Durrell in his "Justine" tetralogy and James Gould Cozzens in "By Love Possessed" are quite alive in their castles behind their moats of metaphor.

The art of fiction in our time has been significantly affected by three concepts so closely identified with motion pictures

*Mr. Gessner, Professor of Motion Pictures, Television and Radio at New York University, has had wide experience in the field of cinema techniques.*

that they can be called cinematic: the sharper visualization of description and narration at surface levels; the increased manipulation of time and space through flashbacks and cross-cuts; the presentation of a clearer view of thought and emotion on the deeper levels.

Some clarification should be quickly noted. The evocation of an image in the mind of a reader is not *ipso facto* cinematic, since all story telling is, in some degree, picture-making. What a magnificent image Cervantes created when he portrayed Don Quixote astride a shaggy nag tilting a lance at windmills! Nor are shifting of scenes or parallel actions necessarily cinematic. Flaubert, for example, employed both techniques in "Bouvard et Pécuchet" and "Madame Bovary." Nor is the so-called psychological novel automatically cinematic because it allows the reader to see through an inner eye, which is what Henry James did in "The Portrait of a Lady" back in 1881.

No; what determines whether a novel is cinematic is the degree and the persistence with which the author has applied these concepts consciously or unconsciously. The history of an art may be charted by the way its innovations have been utilized. After all, Freud and Edison did more than project light in darkened rooms.

That the first and second of these cinematic techniques have become the trademarks of craftsmen-novelists who write with an eye on a sale to the

movies is obvious. John O'Hara, Robert Ruark, Budd Schulberg, Irwin Shaw—the reader can easily pick his own example. The Hollywood-minded novelist merely gilds the celluloid lily. What is significant is the effect the cinema's innovations have had on the novel as an art form.

How the eye of the camera has changed the point of view of the novelist on the surface level can be seen by comparing the novels written by Forster with those of Ernest Hemingway. The author is an at-the-elbow guide in Forster's "Howards End," published in 1910:

"She broke off and listened to the sounds of a London morning. Their house was in Wickham Place, and fairly quiet, for a lofty promontory of buildings separated it from the main thoroughfare. One had the sense of a backwater, or rather of an estuary, whose waters flowed in from the invisible sea, and ebbed into a profound silence while the waves without were still beating. Though the promontory consisted of flats—expensive, with cavernous entrance halls, full of concierges and palms—it fulfilled its purpose, and gained for the older houses opposite a certain measure of peace."

Now compare this with early Hemingway, "Cat in the Rain." It is fifteen years later, again we are at a window; but the author as The Man from Cooks has disappeared:

"The American wife stood at the window looking out. Outside right under their window a cat

was crouched under one of the dripping green tables. The cat was trying to make herself so compact that she could not be dripped on.

"'I'm going down and get that kitty,' the American wife said.

"'I'll do it,' her husband offered from the bed.

"'No, I'll get it. The poor kitty out trying to keep dry under a table.'

"The husband went on reading, lying propped up with the two pillows at the foot of the bed.

"'Don't get wet,' he said."

This is pure cinema. The first sentence—or, as a cinema-maker would put it, "shot"—establishes the woman at the window. The second sentence gives us the wife's vision in a medium shot, followed by a closeup of the cat. Characterization comes through action, or lack of action in the husband's case. Dialogue becomes a means of characterization, bearing the least amount of exposition or narrative. The eye tells almost all; the ear is descriptive.

Carried to extremes, the cinematic innovation of allowing description of material objects to carry other values may result in one-dimensional writing. After removing the author-as-guide from the scene, some lazy writers have been content to call on Central Casting, Wardrobe, the Prop Department and the Makeup Man. Françoise Sagan, in "Aimez-vous Brahms" for example, says merely that her heroine Paule "puts her coat on; she dressed very well." Alberto

Moravia's latest, "The Wayward Wife," is a cinematic puppet, wooden but animated — which may unwittingly reveal Moravia's attitude toward women as well as his debt to movies.

The second cinematic concept, the increased manipulation of time and space through flashbacks and crosscuts, has been popularized by such writers as John P. Marquand and John Dos Passos. In Marquand's 1937 novel, "The Late George Apley," he drew the portrait of a proper Bostonian by juxtaposing scenes occurring in different places; in his "H. M. Pulham, Esquire" of four years later, he painted his portrait with brush strokes from different periods of time. In subsequent novels the flashback became Marquand's major device in giving a then-and-now pertinence to his hero's problem.

DOS PASSOS seems to have had the most fun juggling time and place. In his 1930 novel, "The 42nd Parallel," he offers fifty-six illuminating short subjects—nineteen "newsreels" and twenty-seven "camera eyes"—in addition to his feature picture. In his 1925 novel, "Manhattan Transfer," he presents three crosscuts on the very first page. "Three gulls wheel above the broken boxes * * *" Dos Passos says in the first paragraph. "The nurse, holding the basket at arm's length as if it were a bedpan, opened the door * * *" he begins the second paragraph. Then the third: "On the ferry there was an old man playing the violin * * *."

This freedom from time and for time, which becomes paradoxically timelessness, enthralled our most talented novelist, William Faulkner, when he wrote "The Sound and the Fury" (1929). Here, through three separate streams of consciousness, he followed the Compsons over a three-day period. Jason Compson could not forget the past; Quentin tried to forget the present, and Benjy had no sense of time. Curiously, in his most recent novel, "The Mansion" (1959), Faulkner repeats the pattern with three versions of the narrative: those of the deaf woman Linda Kohl, Mink Snopes, and his favorite Greek chorus, lawyer Gavin Stevens.

Faulkner's absorption of cinematic technique is particularly impressive since he is the most prominent of our novelists to have written expressly for the screen. In 1958, after he had made numerous trips to Hollywood, Faulkner declared: "The aim of every artist is to arrest motion, which is life, by artificial means and hold it fixed so that a hundred years later, when a stranger looks at it, it moves again since it is life."

OF the French novelists, Albert Camus has been most effective in bringing the actions of the mind and body into a visual focus. In his 1942 novel, "L'Etranger" ("The Stranger"), Camus used subjective and objective approaches simultaneously, fusing motion and introspection, and in so doing charged his prose with a higher emotional voltage than even Hemingway. Here is the climax of the novel when nameless "I" kills an Arab in a senseless violence, psychically symbolical of the Algerian conflict:

"I couldn't stand it any longer, and took another step forward. I knew it was a fool thing to do; I wouldn't get out of the sun by moving on a yard or so. But I took that step, just one step, forward. And then the Arab drew his knife and held it up toward me, athwart the sunlight.

"A shaft of light shot upward from the steel, and I felt as if a long, thin blade transfixed my forehead. At the same moment all the sweat that had accumulated in my eyebrows splashed down on my eyelids, covering them with a warm film of moisture. Beneath a veil of brine and tears my eyes were blinded.

"Then everything began to reel before my eyes, a fiery gust came from the sea, while the sky cracked in two, from end to end, and a great sheet of flame poured down through the rift. Every nerve in my body was a steel spring, and my grip closed on the revolver. The trigger gave, and the smooth underbelly of the butt jogged my palm."

In this extraordinary passage we are seeing not only the reality of the physical world, but also the psychic unreality—the detail of sweatdrops on eyebrows and the cosmic flame pouring down through the rift in the sky.

Today's French avant-garde novelists are the latest to see unique possibilities in the visualization of thought and emotion. "We try to convey a vision —both inner and outer—which resembles no other," explains Claude Mauriac, author of the recent novel, "Le Dîner en Ville" ("The Dinner Party") and the motion-picture critic of Figaro Litteraire in "Le Voyeur" (1955) fragments action and surface description in surrealistic splashes.

Nathalie Sarraute in "The Planetarium," published here this spring, goes further than any contemporary novelist to dissolve the boundary line between the objective and subjective worlds. In almost every paragraph she includes dialogue, internal monologue, glimpses of physical reality and a psychic atmosphere. "To succeed in reproducing these invisible reactions, these movements," Mme. Sarraute explains, "it is necessary for me to post another consciousness on the outer boundaries of the character's consciousness, one that is more clear-seeing than his own, and which records these movements as they develop, more or less in the manner of a movie camera. I then show them back to the reader, in slow motion."

ALL these adventurous novelists, especially Faulkner and Dos Passos, have acknowledged their debt to James Joyce, that fountainhead of original waters. It should not be surprising to learn that Joyce was the legitimate father of the cinematic novel. It is possible to trace how the parturition came about. At 20 years of age Joyce read a novel which Remy de Gourmont reviewed as an "anticipation of the cinema" — Edouard Dujardin's "Les Lauriers Sont Coupés," wherein, for the first time, the reader is constantly inside the mind of the main character. There was no immediate influence, however, nor was there any immediate reaction arising from Joyce's frequent attendance at the Trieste cinemas, the Edison and the Americano.

During those years in Trieste he was working on "Stephen Hero," and its writing was not going well. He thought of Stephen as "growing from an embryo," told in direct narrative, episodes chronological and explicit—a purely naturalistic novel. In 1906, having cast the manuscript of "Stephen Hero" into the fire after repeated rejections, Joyce began afresh, this time as "A Portrait of the Artist as a Young Man."

While at work on this new version Joyce significantly interrupted his writing for several months in order to establish and manage the first movie hall in Dublin, which he appropriately called "The Volta" — but the light failed to disclose a profit, and he returned to Trieste and his novel.

The technique Joyce used in the "Portrait" can only be described as cinematic. The first chapter is in four parts: Stephen as an infant; Stephen, years later, at school (playground, classroom, dormitory, infirmary); Stephen at home for Christmas; and Stephen again at school (playground, refectory, rector's study and playground again). Here is flashback and crosscut, editing of time and space; here is the intensity and compression of the camera, minus the literary padding of "Stephen Hero."

Theodore Spencer best described the difference between "Portrait" and "Stephen" as things seen under a "spotlight" which were previously in "daylight." Here is a passage, selected at random from this jewel box, which foreshadows Faulkner, Dos Passos, Heming-

way, Camus and a host of latter-day saints:

"He stood still in the middle of the roadway, his heart clamouring against his bosom in a tumult. A young woman dressed in a long pink gown laid her hand on his arm to detain him and gazed into his face. She said gaily:

" '—Good night, Willie dear!'

"Her room was warm and lightsome. A huge doll sat with her legs apart in the copious easychair beside the bed."

**W**ITH "Ulysses" (1922) Joyce made a more complete transference from social to psychological action, growing more cinematic in the process, and—cruel irony—more blind. "In its intimacy and in its continuity," Harry Levin observed in his renowned study of Joyce, " 'Ulysses' has more in common with the cinema than with other fiction."

Through his fascination with cinema as an art uniquely ca-pable of capturing the speed and complexity, the subtleties and explosions of our age, Joyce gave the novel a new life. This is the historical answer to the question Forster asked. Instead of killing the novel as an art form, the cinema has provided it with an unprecedented vitality. Indeed, the cinematic novel, for better and for worse, is still in its infancy.

August 7, 1960

# From Under the Counter to Front Shelf

TROPIC OF CANCER. By Henry Miller. Introduction by Karl Shapiro. Preface by Anaïs Nin. 318 pp. New York: Grove Press. $7.50.

**By HARRY T. MOORE**

**S**INCE "Tropic of Cancer" first appeared in Paris as a paperback twenty-seven years ago, it has been smuggled into English-speaking countries which turn their Customs inspectors into censors. The high praise of such writers as T. S. Eliot, George Orwell, Edmund Wilson and Herbert Read made it contraband of uncommon quality. Now the book has at last become available in the author's native country.

It was Henry Miller's first published volume, and it is as good as anything he has turned out since. It glows with the joy of discovery: I can write! Its engaging first-person narrative, the monologue of a man who draws people to him, tells the story of an American expatriate —not a Henry James gentleman in a Place Vendôme hotel, but rather a Left Bank vagabond merrily sponging on his friends. Like him, they are members of the international, semi-literary, Parisian-tenement set; and they enjoy having him around.

All of them, particularly the narrator, have frequent erotic adventures with every type of woman from the local poules to rich American widows. Every bit of this is set down graphically, with precise physical details and Old English locutions employed both descriptively and conversationally. Yet, with cinematic abruptness, the narrative often switches from amatory scenes to lyric evocations of the faubourg soft in the dusk or the river streaked with lights. The style throughout is plain, though always energetic and vivid, with split-angled Braquelike images rising from the hard texture of American speech.

**T**HE Miller man, here and in later books, is in effect the de-

*Mr. Moore, research professor at Southern Illinois University, writes frequently on modern literature.*

scendant of Dostoevsky's Underground Man, without his nastiness, and of Rilke's Malte Laurids Brigge, without his fastidiousness. Miller's hero even has his feminine ideal, the American girl here called Mona, who recurs in his other books under a slightly different name; and although he marries her, she remains elusive. Yet his hectic devotion to her doesn't stop him from having all those other jubilantly recorded love affairs.

Miller's books are not "confessions" in the Rousseau sense. The "Tropic of Cancer" man is capable of acridness, but for the most part he moves from one escapade to another with the easy, conscienceless zest of a child. It might be said of him, as Yeats said of Miller's American forerunners and true masters, Whitman and Emerson, that he lacks the vision of evil in his assertion of self-reliance, in his song of himself.

He has been a generally liberating influence upon other writers, for many of his values, particularly his attacks upon standardization and his reverence for life, have been widely circulated and adopted, if only unconsciously. Overtly, his influence is most apparent upon celebrants of rootlessness such as the beatniks, or upon Lawrence Durrell, whose later works are the outgrowth of his "The Black Book," which in its turn is an outgrowth of Miller. Durrell says of Miller: "American literature today begins and ends with the meaning of what he has done." Of course to many readers "Tropic of Cancer," strong language and all, may seem dated, but perhaps to many others the publication of the book here and now will re-emphasize its enduring freshness.

Henry Miller, who is now in his seventieth year, was a late-comer to literature. Sometime between apprenticeship as a tailor in the 14th Ward of Brooklyn, and his floating existence in the 14th Arrondissement of Paris, Miller held down an executive position in the philistine-bourgeois-square world, for he put in several years as a West-

ern Union employment manager in New York—which gives his escape into the ragged geometry of Montparnasse a special Gauguinesque flavor.

After "Tropic of Cancer" he wrote other volumes calculated to make the Customs men increase their vigilance, notably "Black Spring" (1936) and "Tropic of Capricorn" (1939), which in theme and treatment are on a level with "Tropic of Cancer." At the time of World War II Miller returned to the United States, where he brought out several "harmless" books, including "The Colossus of Maroussi" (1941), an account of his travels through Greece with Lawrence Durrell, and "The Air-Conditioned Nightmare" (1945), a report of his wartime journeys through America. He then settled in California, with little money; but suddenly the G. I.'s discovered his European books, which began to sell faster than they could be reprinted.

**O**VERSEAS publication continued with the trilogy "The Rosy Crucifixion," which, like most of Miller's pre-war books, cannot be imported into the United States. "The Rosy Crucifixion," which deals with the author's earlier New York life, tends to be monotonous in a way that the preceding auto-biographies were not. In the "Tropic" and "Black Spring" volumes, the erotic sections are elaborately explicit, but they are also frequently ceremonial; the more recent books, although they contain magnetic narrative passages and scenes of high Miller comedy, too often become a wearying chronicle of sexual acrobatics.

The question comes up in relation to all these Miller volumes and particularly "Tropic of Cancer," the first one to be put before the general public: Are they—besides being anarchic, anti-military, anti-prison, anti-money and anti-respectability—are they obscene? Miller himself, in his essay, "Obscenity and the Law of Reflection," quotes D. H. Lawrence to the effect that obscenity is almost impossible to define. In recent

legal decisions concerning Lawrence's "Lady Chatterley's Lover," the literary quality of the book has usually motivated a favorable verdict. Of course Lawrence had a special purpose in "Lady Chatterley," which he intended to be therapeutic for an age he regarded as sexually sick, and it must be said that he might well have been horrified by parts of Miller's work; there are indeed tenuous distinctions along the borders of the salacious. Yet, to consider for a moment one of the great classics of vulgarity, was Chaucer ever better, in his treatment of character and situation, than in his Fescennine masterpiece, "The Miller's Tale"?

Chaucer was simply telling a story, as Henry Miller is simply reflecting life. And if, in the Miller essay mentioned above, he quotes Romans XIV: 14, in his own behalf, he is not doing so irreverently, for he is a deeply religious man and a respector of all religions. The section he cites from St. Paul's letter to the Romans includes the famous statement, "There is nothing unclean of itself: but to him that esteemeth any thing to be unclean, to him it is unclean."

Now it must be granted that parts of "Tropic of Cancer" will hammer away at some of the strongest of stomachs, even in this epoch in which so many books are really scabrous. However, in the present volume, among other things, Miller projects with gusto some of the great comic scenes of modern literature. There are, for example, the Dijon sequence in which the narrator goes to teach for a while in a broken-down provincial lycée; the last episode of the book, which involves the Miller man and one of his friends and a French family in a crazy farce; and, above all, the scenes describing a Gandhi disciple looking for fun in Paris. If literary quality is a criterion, these passages run far ahead of any considerations of obscenity, in themselves they guarantee that Henry Miller is an authentic, a significant author whose ripest work has been too long forbidden in his homeland.

June 18, 1961

# Hemingway's Prize-Winning Works Reflected Preoccupation With Life and Death

## '54 NOBEL AWARD HONORED CAREER

### Novelist Was Identified With Bullfighting and Warfare —Noted Game Hunter

Ernest Hemingway achieved world-wide fame and influence as a writer by a combination of great emotional power and a highly individual style that could be parodied but never successfully imitated.

His lean and sinewy prose; his mastery of a kind of laconic, understated dialogue; his insistent use of repetition, often of a single word, or name—built up and transmitted an inner excitement to thousands of his readers. In his best work, the effect was accumulative; it was as if the creative voltage increased as the pages turned.

Not all readers agreed on Mr. Hemingway; and his "best" single work will be the subject of literary debate for generations. But possibly "The Old Man and the Sea," published in 1952, had the essence of the uncluttered force that drove his other stories. In it, character stands hard and clear, indomitable in failure. Man—an ordinary although an unusual man —is a victim of, and yet rises above, the elemental harshness of nature.

### Won the Nobel Prize

The short novel won the Pulitzer Prize in 1953; it unquestionably moved the judges who awarded Mr. Hemingway the Nobel Prize for Literature the following year. And it was an occasion for relief and joy among those devotees of the novelist to whom "Across the River and Into the Trees," in 1950, had marked a low point in his career.

A great deal of Mr. Hemingway's work showed a preoccupation—frequently called obsessive—with violence and death. He loved guns; he was one of the great aficionados of the bullfight. He identified with the deadly adventures of partisan warfare; he swung a burp-gun in guerrilla fighting.

He wrote a great deal of hunting, fishing, prizefighting; with directness and vigor; with the accuracy of a man who has handled the artifacts of a sport, taken them apart, loved them. He was at times a hard liver and a hard drinker. But in a sense this was all part of his being a hard and constant worker—at his profession of observing life and recording it

faithfully as he saw it.

Mr. Hemingway's fascination with the calibers of cartridges, and exactly what each could do to a living target, and physical conflict generally, brought a barb from Max Eastman in 1937. Mr. Eastman, a writer who had flexed his own muscles in Marxist dialectics rather than in battle or in the hunt, wrote:

"Come out from behind that false hair on your chest, Ernest. We all know you."

When Mr. Hemingway and Mr. Eastman met in the New York offices of Charles Scribner's Sons, blows were exchanged as Mr. Hemingway bared his chest to prove that the hair was not false. In the later part of his life, Mr. Hemingway wore a beard, coarse and grizzled. It became one of the most famous beards in the world, and a kind of symbol of the man himself.

After Mr. Hemingway became a successful writer, much effort was made by psychologists, amateur and professional, to discover why he wrote as he did. In spite of much rummaging around in his childhood and in his days as a young man in Paris, many of the conclusions about him were contradictory. Mainly by trial and error, he had taught himself to write limpid English prose.

### Apprentice as a Writer

Of his apprentice days as a writer in Paris, he wrote this:

"I was trying to write then and I found the greatest difficulty, aside from knowing what you really felt, rather than what you were supposed to feel, was to put down what really happened in action: what the actual things were which produced the emotions that you experienced * * * the real thing, the sequence of motion and fact which made the emotion * * * I was trying to learn to write, commencing with the simplest things."

"All I want to do is write well," he once said.

Mr. Hemingway had a deadpan wit to which he gave many a special twist, as when he translated Spanish literally. Santiago, the main character in "The Old Man and the Sea," is a great American baseball fan and engages in the following dialogue:

"The Yankees cannot lose."

"But I fear the Indians of Cleveland."

"Have faith in the Yankees, my son. Think of the great Di Maggio."

"I fear both the Tigers of Detroit and the Indians of Cleveland."

"Be careful or you will fear even the Reds of Cincinnati and the White Sox of Chicago."

The man who could thus put

the nuances of American baseball into the Spanish locutions of a humble fisherman; who rarely lost his sense of the humor that he found was as much a part of war and disaster as was courage itself, was born in Oak Park, Ill., a middle-class suburb of Chicago.

The date was July 21, 1899. Ernest Miller Hemingway was the second child of a family of six children; there were four sisters and a younger brother. His father was Dr. Clarence Edmonds Hemingway, a large bearded physician who was more devoted to hunting and fishing than to his practice.

His mother was Grace Hall Hemingway, a religious-minded woman who sang in the choir of the First Congregational Church. She gave her son a 'cello, and for a year made him practice on it. But the boy's father had greater lures. He gave the boy a fishing rod when he was 3 and a shot-gun when he was 10.

### Ambulance Driver

With his graduation from Oak Park High, he completed his formal education. He read widely, however, and had a natural facility for languages.

It was wartime, and torment for a spirited young man not to be in the fighting. Finally he managed to get to Italy, where he wangled his way into the fighting as a Red Cross ambulance driver with the Italian Army. Although he arrived too late for the great Italian rout at Caporetto, he learned all about it and described it brilliantly in "A Farewell to Arms," published in 1929.

On July 8, 1918, while he was passing out chocolate candy to frontline troops at Fossalta di Piave, Mr. Hemingway was badly wounded in the leg by an Austrian mortar shell and was hospitalized for many weeks. He received the Medaglia d'Argento al Valore Militare, a high Italian military decoration.

He returned to Chicago, suffering from chronic insomnia. For a while, he edited the house organ of the Cooperative Society of America. But, inexorably, he drifted to the expatriate Left Bank world of Paris. He had a letter from Sherwood Anderson to Gertrude Stein, and he was soon one of the group of writers who frequented the bookstore of Sylvia Beach — Shakespeare & C°., at 18 Rue de l'Odéon. Here he met, among many others, André Gide and James Joyce.

Mr. Joyce and Mr. Hemingway did a certain amount of drinking together. The author of "Ulysses" was a thin, wispy and unmuscled man with defective eyesight. When they were making the rounds of the cafes and Mr. Joyce became embroiled with a brawler, as he frequently did, he would slip behind his

hefty companion and cry, "Deal with him, Hemingway! Deal with him."

It was in Paris that Mr. Hemingway began to write seriously. He was greatly aided by the advice of the austere and sometimes curmudgeonish Miss Stein, whose unadorned style of writing influenced him greatly. If she was exacting, she was also sympathetic, although she was inclined to deride Mr. Hemingway's mania for firearms and thereby often hurt his feelings.

After several trips back to the United States, Mr. Hemingway settled in Europe. But instead of sitting his life away at the Café des Deux Magots, as many of his contemporaries did, he worked hard at his writing.

He wrote with discernment about the persons around him. They were his expatriate countrymen, together with the "Lost Generation" British and general European post-war strays, and he limned them with deadly precision.

### Underwent Privations

Before he was established as a writer, Mr. Hemingway underwent the privations that were almost standard for young men of letters in Paris. He lived in a tiny room and often subsisted on a few cents worth of fried potatoes a day. With the publication in 1926 of "The Sun Also Rises" after three years of indifferent response to his work, he achieved sudden fame.

In "The Sun Also Rises," Mr. Hemingway showed the felicity for titles that characterized his work. The title is from the book of Ecclesiastes in the Bible and is in a passage that showed the seemingly meaningless coming and going of the sun, the tides and the winds as the lives of his characters seemed to the author to come and go pointlessly.

A concise biography of Mr. Hemingway that focused on his Paris years was written by his friend, Archibald MacLeish:

Veteran out of the wars before he was twenty;

Famous at twenty-five: thirty a master—

Whittled a style for his time from a walnut stick

In a carpenter's loft in a street of that April city.

In 1928, Mr. Hemingway returned to the United States, where he lived for the next ten years, mostly in Florida. He hated New York City and its literary life and kept away from it as much as he could. He was still only 30 when he published his highly successful "A Farewell to Arms."

When "Death in the Afternoon" was published in 1932, Mr. Hemingway said he had seen 1,500 bulls killed. The great success of the book estab-

lished its author as one of the great popularizers of bullfighting.

For several years Mr. Hemingway hunted big game in Africa and did much shooting and fishing in different parts of the world. "Winner Take Nothing" was published in 1933 and "The Green Hills of Africa" in 1935.

The latter was one of the best contemporary accounts of the complex relationships between the hunter, the hunted and the African natives who are essential to the ritual of their confrontation. At the same time, the book told as much of Hemingway, the writer's writer, as of Hemingway, the big game hunter, For example:

"* * * the feeling comes when you write well and truly of something and know impersonally you have written it that way and those who are paid to read it and report on it do not like the subject so they say it is all a fake, yet you know its value absolutely * * *"

Like many American intellectuals, Mr. Hemingway offered some degree of support to Left-Wing movements during the Nineteen Thirties. In at least one of his books, "To Have and Have Not" (1937)—his only full-length novel with an American setting—one critic found he had spoken favorably of "social consciousness," and to another he had sounded "vaguely Socialist."

### Action and Tragedy

But more readers will remember the work as a tale of action and tragedy in the Florida Keys. They will recall not so much the social aspects of Harry Morgan's career, but probably the remarkable love affair between the doomed boatman and his slatternly wife. Mr. Hemingway might stir the "social conscious-

ness" of individual readers; but if so, he did it by exact characterization, never by didactics.

Nor had Mr. Hemingway ever joined the cafe-sitters who cheered on the progress of the Left. In 1936, with characteristic directness, he went to Spain. He covered the war for the North American Newspaper Alliance. And in 1940 his novel of the Spanish Civil War, "For Whom the Bell Tolls," showed both that his own deepest sympathies were with the Loyalists, and that he was agonizingly aware of the destructive effect upon their cause of the Commnuist commissars.

Indeed, the novel was in the broadest sense a lament for everyone involved in the conflict. Its striking title came from John Donne, who had reminded that no man is an island, and had written (in his seventeenth "Devotion"):

"* * * never send to know for whom the bell tolls;

it tolls for thee."

In the year World War II broke out, Mr. Hemingway took up residence in Cuba. But soon he was back in action in Europe, resuming thes combat correspondence he had begun in Spain.

Mr. Hemingway was with the first of the Allied armed forces to enter Paris, where, as he put it, he "liberated the Ritz" Hotel. Later he was with the Fourth United States Infantry Division in an assault in the Huertgen Forest. The Bronze Star was awarded to him for his semi-military services in this action.

In 1950, "Across the River and Into the Trees—the story of a frustrated and generally "beat up" United States infantry colonel who goes to

Venice to philosophize, make love and die — disappointed critics. It touched off "Across the Street and Into the Grill," by E. B. White in The New Yorker. This was probably the supreme parody of Hemingway.

In 1950, The New Yorker also published a multi-part profile of Mr. Hemingway by Lillian Ross, who had spent several days with him in New York. It was a brilliant but savage series; it stirred much controversy and appears to have made more friends for Mr. Hemingway than for Miss Ross. But the most impressive riposte came from the novelist himself. When the profile was published in hard covers, Mr. Hemingway in The New York Herald Tribune listed it among the three books he had found most interesting that year.

"The Old Man and the Sea," two years later, pleased virtually everyone. It relied on the elemental drama of a fisherman who catches the greatest marlin of his life—only to have it eaten to the skeleton by sharks before he can get it to port.

#### Hurt in Air Crash

The 1954 Nobel Prize citation from the Swedish Academy said in part:

"For his powerful, style-forming mastery of the art of modern narration, as most recently evinced in 'The Old Man and the Sea.' "

On Jan. 23, 1954, the writer and the fourth Mrs. Hemingway, the former Mary Welsh (whom he called Miss Mary) figured in a double crash in Uganda, British East Africa. First reports said both had been killed.

Actually, after one light plane crashed, a second had picked up the couple unhurt. Both Mr.

Hemingway and his wife suffered injuries in the crack-up of the rescue plane; and a friend who visited them in Havana soon after found that the novelist's injuries had been more severe than was generally supposed.

Mr. Hemingway's other published writings include "Three Stories and Ten Poems," 1923; "In Our Time," 1925; "The Torrents of Spring," 1926; "Men Without Women," 1927, and "The Fifth Column and First-Forty-nine Stories," in 1938.

Mr. Hemingway earned millions of dollars from his work; for one thing, a great many of his stories and novels were adapted to the screen and television. These included "The Killers," an early gangster story, celebrated for its dialogue; "The Snows of Kilimanjaro" and "The Short Happy Life of Francis Macomber," both set in East Africa; "The Sun Also Rises," "A Farewell to Arms," "For Whom the Bell Tolls" and "The Old Man and the Sea."

Mr. Hemingway's first wife was a boyhood sweetheart, the former Hadley Richardson, whom he married in 1919. She accompanied him on one of his early trips to Paris. They were divorced in 1926.

The next year Mr. Hemingway married Pauline Pfeiffer. This marriage was terminated by divorce in 1940 and in that year Mr. Hemingway married a novelist, Martha Gellhorn. After their divorce Mr. Hemingway married Miss Welsh.

A son, John, was born to Mr. Hemingway and his first wife. Two other sons, Patrick and Gregory, were born to the author and his second wife.

July 3, 1961

# Bombers Away

CATCH-22. By Joseph Heller. 443 pp. New York: Simon & Schuster. $5.95.

### By RICHARD G. STERN

"CATCH-22" has much passion, comic and fervent, but it gasps for want of craft and sensibility. A portrait gallery, a collection of anecdotes, some of them wonderful, a parade of scenes, some of them finely assembled, a series of descriptions, yes, but the book is no novel. One can say that it is much too long, because its material—the cavortings and miseries of an American bomb-

er squadron stationed in late World War II Italy—is repetitive and monotonous. Or one can say that it is too short because none of its many interesting characters and actions is given enough play to become a controlling interest. Its author, Joseph Heller, is like a brilliant painter who decides to throw all the ideas in his sketchbooks onto one canvas, relying on their charm and shock to compensate for the lack of design.

If "Catch-22" were intended as a commentary novel, such sideswiping of character and action might be taken care of by thematic control. It fails here because half its incidents are farcical and fantastic. The book is an emotional hodge-podge; no mood is sustained long enough to register for more

than a chapter.

As satire "Catch-22" makes too many formal concessions to the standard novels of our day. There is a certain amount of progress: the decent get killed off, the self-seekers prosper, and there is even a last minute turnabout as the war draws to an end. One feels the author should have gone all the way and burlesqued not only the passions and incidents of war, but the traditions of representing them as well. It might have saved him from some of the emotional pretzels which twist the sharpness of his talent.

*Mr. Stern is the author of "Golk" and other books.*

October 22, 1961

# Faulkner's Home, Family and Heritage Were Genesis of Yoknapatawpha County

## AUTHOR RECEIVED LEADING PRIZES

### Novels Praised as Powerful Tragedy and Scorned as Raw Slabs of Depravity

The storm of literary controversy that beat about William Faulkner is not likely to diminish with his death. Many of the most firmly established critics of literature were deeply impressed by the stark and somber power of his writing. Yet many commentators were repelled by his themes and his prose style.

To the sympathetic critics Mr. Faulkner dealt with the dark journey and the final doom of man in terms that recalled the Greek tragedians. They found symbolism in the frequently unrelieved brutality of the yokels of Yoknapatawpha County, the imaginary Deep South region from which Mr. Faulkner drew the persons and scenes of his most characteristic novels and short stories.

Actually Yoknapatawpha was Lafayette County and Jefferson town was the Oxford on the red-hill section of northern Mississippi where William Faulkner was reared and where his family had been deeply rooted for generations. The author once told a class at the University of Virginia that it was pronounced Yok-na-pa-TAW-pha and that it was a Chickasaw Indian term that meant "water passes slowly through flatlands."

While admitting that Mr. Faulkner's prose sometimes lurched and sprawled, his admirers could point out an undeniable golden sharpness of characterization and description.

### 'In the Image of the Land'

Of Mr. Faulkner's power to create living and deeply moving characters, Malcolm Cowley wrote:

"And Faulkner loved these people created in the image of the land. After a second reading of his novels, you continue to be impressed by his villains, Popeye and Jason and Joe Christmas and Flem Snopes; but this time you find more place in your memory for other figures standing a little in the background yet presented by the author with quiet affection: old ladies like Miss Jenny DuPré, with their sharp-tongued benevolence; shrewd but kindly bargainers like Ratliff, the sewing machine agent, and Will Varner, with his cotton gin and general store. . . ."

Mr. Faulkner was an acknowledged master of the vivid descriptive phrase. Popeye had eyes that "looked like rubber knobs." He had a face that "just went away, like the face of a wax doll set too near the fire and forgotten."

The apt phrases that Mr. Faulkner found for the weather and the changing seasons were cited by his admirers. There was the "hot pine-winey silence of the August afternoon." Or "the moonless September dust, the trees not rising soaring as trees should but squatting like huge fowl." Also, "those windless Mississippi December days which are a sort of Indian summer's Indian summer."

### Some Saw Little Merit

Many critics contended that Mr. Faulkner served up raw slabs of pseudorealism that had relatively little merit as serious writing. They said that Mr. Faulkner's writings showed an obsession with murder, rape, incest, suicide, greed and general depravity that did not exist anywhere but in the author's mind in anything like the proportions that these subjects assumed in his novels and short stories.

A favorite device of the detractors of Mr. Faulkner's writings was to produce a condensed and completely deadpan description of his plots. The result was often a horrendous compilation of wickedness and jibbering. As for Mr. Faulkner, he seldom argued about his work.

For most of his literary life he detested talk about literature. He said that when one of his books was about to be published he had to remind himself that strangers were going to read it.

Mr. Faulkner was the fourth American to receive the Nobel Prize for Literature. The previous winners were Sinclair Lewis (1930), Eugene O'Neill (1936) and Pearl S. Buck (1938). Ernest Hemingway became the fifth American in 1954. The 1954 Pulitzer Prize for fiction was awarded to Mr. Faulkner for his novel "A Fable."

William Faulkner was born in New Albany, Miss., on Sept. 25, 1897. In the sharply stratified society that preoccupied Mr. Faulkner in his writings it could be said that he came from an upper middle - class family — one not quite of the old feudal cotton aristocracy.

The first Falkners — the "u" is a recent restoration by William Faulkner — came to Mississippi in the Eighteen Forties. The family is replete with colonels, one of whom was assassinated on the street by a business rival. William Faulkner was the oldest child of Murray Faulkner and Maude Butler Faulkner. Murray Faulkner at one time ran a livery stable in Oxford and later became business manager of the University of Mississippi at Oxford.

In William Faulkner's fiction the Sartoris clan is the Faulkner family. The Sartorises are forced to make humiliating compromises with the members of the grasping and upstart Snopes family.

"General Johnston or General Forrest wouldn't have took a Snopes into his army at all," a character says.

William Faulkner played quarterback on the Oxford High School football team and suffered a broken nose. He failed to graduate. Later he wrote: "Quit school to work in grandfather's bank. Learned medicinal value of his liquor. Grandfather thought it was the janitor. Hard on the janitor...."

Oxford, where Mr. Faulkner grew up, is a typical Deep-South town. It has the traditional courthouse square flanked with statues of Confederate soldiers, and a quiet main street lined by one-story buildings and stores.

It is in Lafayette County in the northern part of Mississippi, about sixty miles southeast of Memphis. It is the seat of the University of Mississippi.

The 1949 motion picture "Intruder in the Dust," based on Mr. Faulkner's novel of that name, was filmed by Metro-Goldwyn-Mayer in Oxford. It was directed by Clarence Brown and its cast included Juano Hernandez, Claude Jarman Jr. and Elizabeth Patterson.

The film depicted racial intolerance and bigotry in a small Southern community but had a "happy ending" in which an elderly, proud Negro accused of murder—played by Mr. Hernandez—is saved from lynching by a white Southern lawyer with the help of a white boy and an elderly white woman. The movie was called "great" by Bosley Crowther, The New York Times critic. It made The Times' list of the year's ten best films, but it did not make money.

In an interview in 1958, Mr. Faulkner was asked for his reaction to the movie version of "Intruder in the Dust." He said:

"I'm not much of a moviegoer, but I did see that one. I thought it was a fine job. That Juano Hernandez is a fine actor —and man, too."

He also said he had written about a dozen movie scripts for Hollywood after his popular novel "Sanctuary" was published. He said that most of the scripts were done for Howard Hawks, his friend, and added:

He sent for me later to help adapt what Ernest Hemingway said was the worst book he ever wrote, 'To Have and Have Not.' Then I did another one, from that book by Raymond Chandler, 'The Big Sleep.' I also did a war picture, one I liked doing, 'The Road to Glory,' with Fredric March and Lionel Barrymore. I made me some money and I had me some fun."

Private flying and World War I service as a Royal Canadian Air Force pilot gave Mr. Faulkner material for such tales as "Pylon," a story of daredevil barnstorming pilots. Back home, he was a special student at the University of Mississippi for a few months and became postmaster at the hamlet of University near Oxford. He was dismissed for reading and playing bridge when he should have been distributing mail.

One who knew Mr. Faulkner as a student at the University of Mississippi is George W. Healy Jr., editor of The New Orleans Times-Picayune. In a telephone interview yesterday, Mr. Healy said that most Mississippians who knew Mr. Faulkner well loved him, but that the author was not an easy man to know.

"I first knew Bill when he was postmaster at the University of Mississippi post office in 1922," Mr. Healy said. "He was fresh back from World War I after having served as a pilot in the Canadian Air Force and after having done a little private flying. His father, whose first name was Murray, was business manager of the university and Bill went there to study law.

"But Bill got fired as postmaster because he used the post office as a kind of men's club. One day a post office inspector came in while a bridge game was in progress and a little while later Bill told us he was leaving."

### Preferred Cartoons

Mr. Healy related that when he was editor of the university's humor magazine, The Scream, Mr. Faulkner approached him with some poetry he had written.

"Bill also had some cartoons that he had drawn and I liked the cartoons better than the poetry," Mr. Healy said.

The editor recalled that Mr. Faulkner later did some house-painting jobs in Oxford and then went to New Orleans where he "holed up while writing his first novel, 'Soldier's Pay.'" This is the story of a disfigured flier's return after World War I. It was published in 1926 by Liveright. A reviewer in The Times said it showed a 'deft hand.'"

Mr. Healy noted that while he was writing the novel, Mr. Faulkner also wrote for The Times-Picayune "Mirrors of Chartres Street," a column of street scenes and vignettes.

Mr. Faulkner's period of literary apprenticeship included a foray into New York literary circles that ended in a brief and unhappy interlude as a clerk in the book department of Lord & Taylor. He was briefly a newspaper reporter in New Orleans where he saw something of Sherwood Anderson, who gave him valuable counsel.

### 'Marble Faun' in 1924

"The Marble Faun," a book of poems by Mr. Faulkner, appeared in 1924. Reviewers found the poems somewhat derivative.

With the publication of "The Sound and the Fury" in 1929, Mr. Faulkner gave strong indications of being a major writer. The critics found in it something of the word-intoxication of James Joyce and the long, lasso-like sentences of Henry James.

"Sanctuary," published in 1931, was Mr. Faulkner's most popular and best-selling novel. His friends did not believe him when he said that he had written it only for money.

It is a novel about the harrowing experiences of a sensitive Southern girl, Temple Drake, who, like many of Faulkner's characters, reappears in another book—in this case "Requiem for a Nun." One of Mr. Faulkner's most memorable characters, Popeye, was created for "Sanctuary."

Among Mr. Faulkner's other notable books were "The Sound and the Fury" and "As I Lay Dying."

The former, described by one critic as "noe of the few original efforts at experimental writing in America," is told partly through the mind of an idiot named Benjy.

Mr. Faulkner lived and did most of his writing in Oxford in a beautiful old colonial house that he bought in 1930. He was a slightly built man who carried himself somewhat tensely and when he was bothered or bored he could exhibit quick anger. He had thick iron-gray hair and a dark mustache and aquiline nose. When he felt like it he could be charming and his manners were impeccable. His accent was the easy drawl of the Deep South. One observer found in his manner "something old-fashioned, even archaic." In his Southern mansion he usually wanted to be left alone and there were explosive incidents when persons sought to intrude upon him.

When the Nobel Prize for literature for 1949 was awarded to Mr. Faulkner it was with considerable difficulty that members of his family persuaded him to go to Stockholm, Sweden, to receive the award.

He wore white tie and tails for the first time. The cash prize amounted to $30,000, which Mr. Faulkner set up as a fund for good works in his home town.

The clash of opinion over the question of desegregation in the public schools drew Mr. Faulkner somewhat out of his general aloofness to public problems. In 1956 he was interviewed and wrote on the problem of the Negro in the South. His writing on the subject showed a somewhat agonized attempt to understand several points of view on the question.

On June 20, 1929, Mr. Faulkner married Mrs. Estelle Oldham Franklin, who had two children by a previous marriage. One daughter, Jill, was born to the marriage of Mr. Faulkner and Mrs. Franklin.

William Faulkner was not the only novelist in his immediate family. A younger brother, John Faulkner, wrote several novels, including "Men Working," (1941), a story of Southern farmers who discovered a modern miracle they called "the WP & A," and "Chooky," (1950), a tale of a Southern boy who leads two Negro playmates through a series of adventures.

William Faulkner was among the Nobel Prize laureates invited by President Kennedy to a White House dinner this year. At the time the novelist was with the University of Virginia and was living at Charlottesville. He declined, saying: "Why that's a hundred miles away. That's a long way to go just to eat."

In 1957, when Mr. Faulkner first arrived at the University of Virginia, he was quoted as saying:

"I like Virginians because Virginians are all snobs and I like snobs. A snob has to spend so much time being a snob that he has little time left to meddle with you."

On another occasion, Bennett Cerf, head of Random House, Mr. Faulkner's publisher, had taken the bourbon-sipping author to task for not answering his mail. Mr. Faulkner was said to have replied:

"Mr. Cerf, when I get a letter from you, I open it and shake it and if a check doesn't fall out I tend to forget it."

Mr. Faulkner accepted an invitation in April to the United States Military Academy to hold informal discussions with the cadets on literary topics. Thirty young women from Vassar College also attended the seminar.

Mr. Faulkner held the cadets rapt as he discussed the destiny of man in a "ramshackle world." The Nobel Prize-winning author said a writer should "cut his throat and quit" whenever he felt satisfied with a book he had written.

He also told the cadets that "The Sound and the Fury" was the book closest to his heart because it had caused him the most anguish. He said that it was to him what a crippled child was to its mother.

Mr. Faulkner also discussed his latest novel, "The Reivers," with the cadets.

"The Reivers" was published by Random House on June 4 and was widely acclaimed by critics. For example, Orville Prescott in his review of the novel in The New York Times wrote:

"The good news about "The Reivers" is that it is one of the best novels Mr. Faulkner has written and much the most direct, simple and readily comprehensible. All his familiar mannerisms are present, but so muted and restrained that they cause no difficulty.

"In the past, Mr. Faulkner's humor has tended to be cruel or even grotesque. In "The Reivers" it is not exactly hilarious, but it is gay, engaging and kindly."

---

July 7, 1962

# Growing Up With Oskar

THE TIN DRUM. By Günter Grass. Translated from the German by Ralph Manheim. 592 pp. New York: Pantheon Books. $6.95.

### By FREDERIC MORTON

*Mr. Morton, author of "The Rothschilds," is also a critic of contemporary German literature.*

AFTER World War II there were two kinds of German writers. On the one hand was Thomas Mann: an enormous creative force, German in origin and experience, venerable and universal in his office as monarch in the world of letters. Mann's death left only the other kind: writers who have had an almost obligatory theme thrust upon them—the Third Reich and its legacies.

Among them are men of genuine talent. The Austrian Heimito von Doderer, for example, produced in "The Demons" a very powerful though very local epic of Vienna poised on the brink of the brown thirties. Heinrich Böll, Germany's foremost literary intellectual, writes novels that are not dramatic inspirations but provide highly sophisticated commentaries on his character's dilemmas. These and some others are widely translated; yet none of them has contributed, like Moravia or Camus, to the international stock of characters or ideas. Now, suddenly, one of their countrymen has broken through.

Günter Grass turns the trick with "The Tin Drum." When it was published in Germany three years ago, it immediately entered the mainstream of European literature. It won foreign praise and prizes, and created what no German since Thomas Mann has been able to create: international literary excitement. Grass works with a range of theatrical inventiveness that shades from Goethe at his most Mephistophelean to Ionesco at his most perverse. "The Tin Drum" is a formidable, if formidably uneven, novel. It is also a prime example of The Novel of the Absurd.

Grass's hero, Oskar, begins as the misbegotten child of the Nazi era and ends—what could be more modern?—as a jazz musician in a mental hospital. In between, he enjoys a career made up of appalling and hilarious pranks. The arch-prank of all occurs when Oskar reaches his third year: he refuses to grow and thus exempts himself from all adult demands.

AT the same time he receives a tin drum for a gift. Henceforth, he drums the way other people chain-smoke. To percussion, muffled or thunderous, he capers through life. He also develops a voice that cuts like a diamond: he can cut glass anywhere within range of his vocal chords, and among many other objects, he ruins his teacher's spectacles. He creeps under the rostrum at a Nazi rally and makes his drumsticks confuse the party faithful with "Jimmy the Tiger." He places his sticks in the hands of a stucco Jesus who then begins to drum. Reaching the age of romance, he seduces one of his loves with the help of fizz-powder he smuggles into her navel—among the unlikeliest aphrodisiac tricks in contemporary fiction.

All this, of course, can be read as one long macabre joke. But so can Thomas Mann's story of the confidence man, Felix Krull, with whom Grass's hero has been inevitably compared. Both Oskar and Felix are anti-bourgeis super-imps; both, relating their lives in the first person singular, parody the *Bildungsroman*, the German novel in which ideas as dramatized through the hero's character development are governed by an artistic and aristocratic sensibility and by an Edwardian esthetic. In fact, Krull's life forms a *Bildungsroman*, a man whose values have been turned upside down.

Oskar, by contrast, is a mid-century creation. Without manners or principles, he has only a capacity to be struck hard by the world's stupidity and viciousness. For him, pain is the engine of mockery. It spews out laughter at a universe made of wounds and voids.

The details of this universe stud "The Tin Drum" with a persuasiveness which constitutes its primary source of

power. Oskar, like his author, spent his childhood in Danzig. With masterful minutiae the petit-bourgeois background of an **East Prussian port town** is reconstructed. Everything is there: gossip, sausage picnics, money troubles. In the foreground is Oskar's family: his pretty mother, who when photographed likes to display an arch queen-of-hearts card to the lens; her husband Alfred, the industrious grocer who loves to cook; his friend Bronski, a well-manicured Polish post-office worker with whom Alfred's wife sleeps —but only at the respectable, circumspect afternoon hour appropriate to such affairs; and the evening card party uniting al three in sly but cozy peacefulness while Alfred cooks mushroom omelet in the kitchen.

UPON such a world Oskar, the demon dwarf, vents his derision. It is the sturdy hypocrisy, the homey corruption of his milieu that make Oskar's surrealist caricatures so inevitable. Through him the reader perceives the phosphorescent underbelly of the middle class. The Breughel landscape suddenly swarms with the consummate monsters of Hieronymus Bosch.

In its first pages "The Tin Drum" has no particular political coloration, but the book's weird double focus prepares the reader for Hitler's advent later on. Grass brings off what no German has managed or even dared to attempt—to show that the Nazis were not a black breed apart, imposing their exotic evil on the good little people. The Nazis were the good little people themselves. Alfred, the cuckolded, food-loving grocer, becomes a storm-trooper. He and his friends (not Bronski, who abrupty becomes an inferior Pole) go on posing for the family album, their pictures somehow enhanced by the brown uniforms. It's not only Oskar who sabotages the sunniness of such pictures; it's also the approach of war. Oskar's mother dies of what is less a death than a lethal, lyric nightmare. Both Alfred and Bronski—whom Oskar suspects of being his father— are killed. And in both cases history and Oskar, curiously intertwined, are the co-killers. Oskar's antics and experiences match in their savageness the general course of events. In fact, during the Reich's collapse and in the years immediately following, the book often lapses into a jungle of symbols, into matted phantasmagorias. Cleverly constructed, they prove Grass's flair for sustained garish virtuosity, but fail to enrich or to advance the story. There is too much mere metaphor-mongering, too much expressionist delirium over-carefully staged. Sometimes Grass can't resist a coy exegetical annotation.

More than once the book insists on gratuitous shockers. For example, a tomb-cutter's boils are squeezed in rhythm to the prayer rite of a burial party. Such scenes scream out a blasphemy in high C as if—a frequent anxiety among avant-gardists—the only way to hold a reader were to offend him.

But the success or failure of this or that dithyramb matters little. What matters very much is Oskar's gradual and heartbreaking acquisition of a human face. He drums himself into prosperity as a jazz musician during the postwar years. But who applauds, who surrounds him? Who if not more food-loving grocers cooking better omelets to feed even bigger phosphorescent underbellies? And is he, Oskar, any better than they? Who betrayed Bronski to the Nazis, and Alfred to the Russians?

Like the hump which abruptly, belatedly, curves out of Oskar's spine, so guilt and compassion afflict our dwarf. They deform him — into a man, a creature not merely fascinating but touching. At the end a human being crawls out from under the brilliant dramatic device. As a literary type Oskar's lineage goes back far beyond Krull, to King Lear's fool. As a human being he is real enough to make one wonder—despite all his excess—whether a little bit of him may not be lodged in many of us. At the end he flings his tiny self into a repentance an unrepentant world terms insane. And yet there must be a number of us worldlings who close the book and still hear the tin drum sounding.

April 7, 1963

# Mata Hari With a Clockwork Eye, Alligators in the Sewer

V. By Thomas Pynchon. 492 pp. Philadelphia and New York: J. B. Lippincott Company. $5.95.

### By GEORGE PLIMPTON

SINCE the war a category of the American novel has been developed by a number of writers: American picaresque one might call the archetype, and its more notable practitioners would include Saul Bellow with "The Adventures of Augie March," Jack Kerouac, "On the Road," Joseph Heller, "Catch-22," Clancy Sigal, "Going Away," and Harry Mathews, who last fall produced a generally overlooked though brilliant novel entitled "Conversions." The genus is distinguished by what the word "picaresque" implies—the doings of a character or characters completely removed from socio-political attachments, thus on the loose, and, above all, uncommitted.

Such novels are invariably lengthy, heavily populated with eccentrics, deviates, grotesques with funny names (so they can be remembered), and are usually composed of a series of bizarre adventures or episodes in which the central character is involved, then removed and flung abruptly into another. Very

often a Quest is incorporated, which keeps the central character on the move.

For the author, the form of the picaresque is convenient: he can string together the short stories he has at hand (publishers are reluctant to publish short-story collections, which would suggest the genre is perhaps a type of compensation.) Moreover—the well-made, the realistic not being his concern—the author can afford to take chances, to be excessive, even prolix, knowing that in a work of great length stretches of doubtful value can be excused. The author can tell his favorite jokes, throw in a song, indulge in a fantasy or so, include his own verse, display an intimate knowledge of such disparate subjects as physics, astronomy, art, jazz, how a nose-job is done, the wildlife in the New York sewage system. These indeed are some of the topics which constitute a recent and remarkable example of the genre: a brilliant and turbulent first novel published this month by a young Cornell graduate, Thomas Pynchon. He calls his book "V."

"V" has two main characters. One of them is Benny Profane —on the loose in New York City following a Navy hitch and a spell as a road-laborer. Born in 1932, Profane is Depression-formed, and his function in the novel is to perfect his state of "schlemihlhood"—that is to say being the victim, buffeted by circumstance and not caring to do much about it—resigned to being behind the 8-ball. Indeed, in one poolroom fracas the 8-ball rolls up to Profane, prostrate on the floor, and stares him in the eye. His friends are called the Whole Sick Crew, a fine collection of disaffected about whom one observer says "there is not one you can point to and say is well." Typical of them is the itinerant artist Slab, who calls himself a catatonic expressionist. Beset by a curious block he can only paint cheese danishes—Cheese Danish No. 56 is his subject at one stage of the book.

Profane tags along with these oddballs through a series of episodes, mostly punctuated by drinking bouts, one of them a notable chapter in which he joins a patrol in the sewers to kill alligators grown big, blind and albino from 50-cent Macy pets finally flushed down the city drains by bored children.

Profane does not take easily to the idea of the alligator chase: it is an active course not consistent with the passivity of schlemihlhood. Even though aimless enough (one of the pleasures of the Whole Sick Crew is to ride the subway endlessly up and down the West Side, a process called "yo-yoing"), Profane's true affinity is with an artfully constructed mannequin he discovers in the research department of a factory where he is a temporary nightwatchman. "Shock," this figure is called, used for tests in auto wrecks, entirely lifelike —a blood reservoir set in its thorax—to be propped up in the death seat of aged cars and subjected to crashes . . . a personification of the inert, the true inanimate schlemihl.

SET in contrast to Profane is a young adventurer named Stencil. He is active as opposed to passive, obsessed by a self-imposed duty which he follows, somewhat joylessly—a Quest to discover the identity of V., a woman's initial which occurs in the journals of his father, a British Foreign Office man, drowned in a waterspout off Malta. The search for V., a puzzle slowly fitted together by a series of brilliant episodic flashbacks, provides the unifying device of the novel — a framework encompassing a considerable panorama of history and character. V., turning up first as a young girl in Cairo at the start of the century, reappears under various names

*Mr. Plimpton is editor of The Paris Review.*

and guises, invariably at times of strife and riot, in Florence, Paris, Malta, South Africa. Finally one finds her disguised as a Manichaean priest, trapped under a beam in a World War II bombing raid on Malta and being literally disassembled by a crowd of children.

V. is obsessed with collecting on herself bits of inert matter: she has a star sapphire sewn into her navel; she has two artificial feet made of gold, an artificial left eye, the works of a watch. She (as one of the children remarks) actually comes apart, and one immediately compares her to Profane's auto-crash mannequin. One can speculate that both Profane (consciously) and Stencil (unconsciously) seek in their respective manner the symbol of inertness, and that Pynchon's novel can be described as a voluble explication of the death-wish. Perhaps.

The identity of V., what her many guises are meant to suggest, will cause much speculation. What will be remembered, whether or not V. remains elusive, is Pynchon's remarkable ability—which includes a vigorous and imaginative style, a robust humor, a tremendous reservoir of information (one suspects that he could churn out a passable almanac in a fortnight's time) and, above all, a sense of how to use and balance these talents. True, in a plan as complicated and varied as a Hieronymous Bosch triptych, sections turn up which are dull—the author backing and filling, shuffling the pieces of his enormous puzzle to no effect—but these stretches are far fewer than one might expect.

Pynchon is in his early twenties; he writes in Mexico City —a recluse. It is hard to find out anything more about him. At least there is at hand a testament—this first novel "V." —which suggests that no matter what his circumstances, or where he's doing it, there is at work a young writer of staggering promise.

April 21, 1963

# NEW SINGERS AND SONGS

## We've an American Poetry Now and the Heirs
## Of Its Creators Are Thriving in Their Season

### By M. L. ROSENTHAL

THE recent deaths of Robert Frost and William Carlos Williams remind us forcibly of the slipping away of a wonderful series of generations of American poets. They flourished in the three decades after 1910. In the 1930's, when Edwin Arlington Robinson died and Hart Crane and Vachel Lindsay committed suicide, the new poetic impulse they represented was in full flood still. Even as late as Edgar Lee Masters' death in 1950 and that of Wallace Stevens in 1955, many of the familiar, famous names continued to be with us. A number, happily, remain present and active. But now, suddenly, in the past two years alone, we have lost not only Frost and Williams but H. D. (Hilda Doolittle), Robinson Jeffers, E. E. Cummings and Kenneth Fearing. A complex of later groups is taking up their "space."

Before looking at the successors, I want to linger a moment over the older group. What was it that these poets, so intransigently individualistic, nevertheless accomplished together for their art and for their country? First, of course, they gave us a body of splendid poems the best of which, for the most part, are to this day unknown even to the educated public. They liberated technique from narrow formalism and imitativeness, while they heightened the sense of relevant tradition and of the need for rigorous artistic self-discipline. They followed Whitman's lead in exploring native motifs and idioms, and on the other hand they opened our poetry to a host of foreign influences. They cultivated psychological and culturally critical frankness, creating a fearless poetry that faced the tragic meanings of the age with candor if sometimes with boisterous mockery. We may quarrel with certain excesses, but that too is a sign of a living, daring body of work. We have an American poetry now, though only the poets and too small a number of readers know it.

*Mr. Rosenthal is professor of English at New York University and author of "The Modern Poets" among other literary studies.*

Who are the Frosts, the Williamses, the H. D.'s of the future? Impossible to tell when we are dealing with such unique personalities. Longevity, as various wits have remarked, makes something of a difference, and so may the early adversity and neglect that a number of outstanding writers have known. I can conceive of Howard Nemerov's becoming a sort of Frost—or perhaps more accurately, a sort of Frost-plus-Auden—of the future. He has the copiousness, ability to tell a story, wit, wide curiosity and poetic cunning to carry it off, although he is quite unlike Frost in his quick urban intelligence and, especially, in his long, subjectively symbolic sequences. Or we can call Denise Levertov a kind of feminine Williams, spontaneous, personal, open, yet rich in the deployments of her art. Or perhaps Galway Kinnell, with his glad eye for the particular and his way of looking at himself looking at the world, will be our latter-day Williams. But such speculation is tiresome, unjust to all the parties concerned.

Literature is full of meaningful echoes, but no real writer is merely the echo of another. The unexpected and the uncategorizable are the usual thing in poetry. The latest turn in the work of Conrad Aiken, the quiet strengthening over the years (largely unnoticed) in the work of the 65-year-old Horace Gregory may well mean much more for poetry's future than the easy audacities of last year's vacuum-packed sensation who swept up all the prizes.

My mind staggers when I think of this aspect of my subject: how little attention is paid to the development of poets after their first impact, for instance, and how much excellence without fanfare is destined to be ignored or to be recognized only by near-accident. We have a better soil than climate for poetry. If I should list a few poets in their fifties, or just becoming 50 this year, who have done a considerable amount of work and have won critical praise and interest, how many would most readers of this piece feel they knew at all well? Here are the names: Richard Eberhart, Karl Shapiro, Theodore Roethke, Winfield Townley

Scott, Elizabeth Bishop, Delmore Schwartz, Josephine Miles, Robert Penn Warren, Brother Antoninus, Charles Olson, Stanley Kunitz. It would be easy to triple the list, and in the process to add some names that should be at least as recognizable as those mentioned.

THE steadfast effort to sustain moral perspective on Eberhart's part, the intense search for identity of Shapiro, and his trying-on-for-size of many guises in the course of it, the wry astringency of Miles's observations—to select but a few dominant characteristics—are phenomena of revealing importance to us. Scott, whose nostalgic poetry is beautiful and yet abrasive; Brother Antoninus, who shows us what it is to be a religious poet while struggling with daily realities of American life; Olson, who has been trying to crack through the assumptions and expectations both of our modern

values and of our modern verse; Kunitz, who has gathered for us in too small a body of writing some of the most wounding motifs of the age—these are all sensibilities at once unique and representative. We ignore them at our own expense, given the fact that each has a language, a style, a way of making poems that is absorbingly suggestive in itself.

The single poet of outstanding power and virtuosity to emerge since the last war is the 46-year-old Robert Lowell. He seems the likeliest heir, in the quality of his genius, to the mantle of Eliot. Our leading "confessional" poet, between his early "Land of Unlikeness" and his 1959 volume, "Life Studies," he turned more and more to the exploitation of his own private experiences, family background and psychological predicaments as the controlling center of his work. It is a direction indicated not only by his own growth as a poet, but by the whole tendency of serious *(Continued)*

*Photographs by Rollie McKenna (left, center) and Paul Bishop.*

Karl Shapiro.　Anne Sexton.　Brother Antoninus.　Denise Levertov.　Robert Lowell.

poetry since the great Romantics and especially since the later Yeats.

Private humiliation and disorientation become in this perspective (as in certain French poets whom Mr. Lowell has studied and translated) the clue to the general human condition. One is tempted to discount the tendency, sometimes, as a type of nasty exhibitionism leading to an esthetic dead end, particularly as it is little more than that in the hands of half-poets. But that is to ignore and to dismiss out of a too-ready squeamishness the profound reorientation of sensibility taking place in our social and personal relationships and reflected in fiction and drama as well as in poetry. In any case, the art of Mr. Lowell is extraordinary in its passion and energy; past the self-degradation, unpoisoned by it and indeed redeeming it, something beautiful comes to birth.

Among the poets we may loosely group with Lowell on the score of either a certain confessional strain or a wildly nervous energy with a self-lacerating backlash to it are Theodore Roethke, Delmore Schwartz, W. D. Snodgrass and Anne Sexton. All have written moving poems based on private anguish. Some of Roethke's relatively early poems based on childhood memories of his father's greenhouse are amazingly

vivid evocations. His attempts in other work to get deep into the primal psyche are often forced and sub-Joycean (rather than sub-conscious, as intended), but they do catch the pathos of a compulsion to regress and at the same time, curiously, often carry a roaring bawdy humor as well.

INDEED, almost all the dark and depressive poetry I am alluding to now has its paradoxically high-spirited side, sometimes "manic" and hysterical, perhaps, but also expressive of a highly intelligent and humane irony behind what appears the authors' self-indulgence. Roethke's work, again, can be quite simple; he has written some of the most elementally sad poems we have. Recently, he has received a good deal of recognition in England, where among others he has influenced the gifted poet Ted Hughes and his American wife, the late Sylvia Plath. Miss Plath's very last poems, as represented in a recent issue of the Sunday Observer, were morbid but brilliant. In the absolute authority of their statement they went beyond Roethke into something like the pure realization of a latter-day Emily Dickinson.

The reader who is unfamiliar with current poetry may feel

that he is better off without having to come to terms with such intractable melancholy as I have been describing. And it is true that, take it by and large, our best poetry is often savagely, bitterly, alienated, or at least driven to some extreme of neurotic exacerbation. (See Frost's "A Servant to Servants," among many forerunners that might be named.) Thus, Snodgrass' most successful poem, "Heart's Needle," concerns the suffering he and his small daughter underwent during the ordeal of his divorce and remarriage. As is characteristic of poets writing in this mode, he associated private with public suffering and built into the poem an imagery of cold weather that suggests the wintry state of the human spirit and even the cold war. Anne Sexton's poems deal often with her own mental illness and Delmore Schwartz's with an oppressed psychic condition that is felt as very much a function of the times. (Here I am speaking more of Schwartz's earlier work than his more relaxed recent poetry.)

If proof were needed, then, that this is an age of vast and painful psychological pressures and dislocations, in which the private self feels engulfed by impersonal forces, especially by the recurrence of war and violence and the equally recurrent

threat of more, and worse, to come, than our poetry would certainly provide it. The war poems of Randall Jarrell, and his concern generally with the vulnerability and pity of innocence, the search for reconstruction of the fragmented self in Muriel Rukeyser's poetry, Eberhart's struggle to subdue the active death-consciousness of his work, the sense of pervasive vileness that permeates Allen Ginsberg's wailing autobiographical indictments—these and many other examples amply illustrate the point. One would think our poets were en masse obsessed with the thought at the beginning of James Wright's "Saint Judas":

*When I went out to kill myself, I caught*
*A pack of hoodlums beating up a man. . . .*

To counteract the clear suggestion of unrelieved depression, anxiety and hostility, we need to recall certain basic principles. A poem that is well-earned through its mastery of its own language, voice and structure, is implicitly an assertion of human value no matter what its explicit theme or viewpoint may be. Their understanding of this principle is one of the things that is so heartening about the poets whose names are usually associated with Charles Olson's

—Miss Levertov, Robert Duncan, Robert Creeley and Paul Blackburn.

The actual writing of each of these poets is quite unlike that of the others, but like Lowell they all understand—as Whitman long ago taught — that looking hard at one's own realities is the primary act of courage as well as of sensuous response. They have (Creeley especially) cultivated a way of presenting emotion-laden scenes and situations flatly; Creeley so much so that often he shaves the poetic part of his poem away entirely. Levertov and Blackburn have too intrinsically lyrical a feeling for their phrasing and for the presentative life of the poetic image to go to this extreme.

The feeling that there is more to a successful poem than "mere poetry" is a dangerous one, but some great poets have had it; in practice it means that such a pitch of realization has been reached, or such a desire to break out of given molds, that the poet has a fierce revulsion against any assumption that what he does is an esthetic *performance* instead of an exploration of the possibilities of imaginative projection and emotional discovery. Robert Duncan's work, particularly, reflects this attitude. Despite great unevenness, he seems potentially the most challenging poet on our scene to take up a truly revolutionary artistic direction.

Because of the tendencies I have been emphasizing, I have neglected a number of fine poets whom we might call. if rather misleadingly, "moderates." Richard Wilbur's poems, sometimes of incomparable richness and deftness, stand by themselves in their own modest perfection. He shares the concerns of the age, of course, as his poem against the McCarran Act and his "Advice to a Prophet"—concerning the right way to shock ourselves awake to the horror of the Bomb— show clearly. A very pure, vivid intimacy with language and the possibilities of traditional form have made him a poet of almost Classical cast.

One may quarrel, as I have, with this self-limiting quality against which poets like Duncan strain; and yet, in another mood, I am sure the quarrel is presumptuous, for one should be grateful to have what Wallace Stevens called the "noble accents" and the "lucid, inescapable rhythms" of the true "bawds of euphony." A neglected poet, James Schevill, has been constructing an interesting body of poetry out of a scholarly sensibility—a unique ability to catch the special qualities of historical moments, biographical data, particular scenes fraught with contemporary and traditional significance.

Poets like William Stafford, Gary Snyder and Robert Bly, very close to the life of their local regions, have been cultivating a descriptive precision and economy that still allows room for the play of a sense of strangeness and for a colloquial bite in their language. The spiraling intensities of W. S. Merwin, closing in on his own location in a spinning or fog-laden world; the gay, knotty, complexly centrifugal flights of Theodore Weiss; the self-discounting, witty, offhand, yet penetrating poetic wisdom of Reed Whittemore—these will suggest how many thriving poets we have, each working in his own way and only tentatively and momentarily, if at all, classifiable.

Do I think them all equally successful and promising for the future? Of course not. But I have tried here less to take sides than to indicate the large number of poets worthy of respect and of far more attention than they presently receive who are now at work. They are the descendants of the great generation that preceded them, who made it possible for serious poetry to thrive on the American scene, and their poetry holds many keys to the subjective meaning of contemporary American life.

June 30, 1963

# AND THE CRITIC IS HEARD IN OUR LAND

## By IRVING HOWE

**B**Y his very calling, the literary critic is an uneasy man. He believes in the worth of what he writes, and in his more exalted moments he will even say that criticism can be a way of testing the values of a culture, a way of defending the possibilities for civilized existence. Yet if asked to define precisely what criticism does or claims to do, he is likely to suffer embarrassment.

Criticism is neither an exact science nor quite a creative art; it has no well-defined limits of discourse; and there are no fixed requirements for setting up in practice as a critic, the way there are for psychoanalysts, lawyers and electricians. Recently a modest amount of honor and attention has come to the literary critic in America, but the more that comes to him, the more does the truly serious critic, as distinct from the parasitic busy-bodies in "the world of books," feel uneasy.

He should feel uneasy. For criticism begins— it does not end—as a plunge into subjectivity, a measurement of personal taste, an effort to articulate one's primary response to a poem or novel. While doing that, the critic can talk about almost anything else: no barriers stand in his way, except those of intelligence and tact. He is finally on his own, systematically exposing his feelings and sensibility, and having to justify the claim that what he thinks about

*Mr. Howe, professor of English at Hunter College, is the author of several volumes of criticism, most recently "A World More Attractive."*

a book merits the notice of other people.

If at the outset he speaks from the urgencies of personal response, he must also try to go further. He must struggle to find some rational basis for his literary affections and rejections, so that they can become available to other minds. The personal response, to have value, must become a social act, and to become a social act it must be grounded in public argument and empiric demonstration.

During the last few decades literary criticism has acquired a new importance and prestige in the United States. It has become fiercely professional, a bulky cultural "institution" as well as a lonely personal discipline. Young people now train themselves elaborately and perhaps a shade too solemnly for careers as critics. And among American intellectuals there is a tendency to look upon a critical book or essay as something with an independent value, quite apart from its function as a gloss on literature.

Now a good critical essay—which like good work in any field, comes rarely — can yield pleasure to cultivated minds, the kind of pleasure we all have when engaged in reflective conversation about books. We like to match our opinions and discover, if possible, why one of us admires, say, Wallace Stevens's poems and another does not. For there is an intense and lovely pleasure in the act of sharing pleasure; and a happy requirement of the life of the mind is to expose oneself to the views of another person whom one respects. But to say all this is to suggest a reason why literary criticism can be stimulating at almost any time; it

is not to explain why it has become so influential in our own. A proper answer would take volumes. Here, instead, are a few paragraphs.

*Modernist literature is difficult, and criticism responds to and thrives on difficulty.* By "Modernist" I mean something quite different from contemporary. Western culture has apparently just emerged from a great period of modernist achievement—even as traditional kinds of writing, painting, musical composition and architecture have been created all the while. When we speak of "modernism," we are pointing to a distinctive and radically new cultural style. We mean, for example, the kind of writing that is besieged by moral and intellectual restlessness, the kind that accepts as its end the replacement of set answers by nagging questions—and which keeps straining, consequently, toward new forms, new language, new shades of feeling.

Above all else, the modernist outlook is committed to uncertainty: where truth had once been seen as absolute, there now reigns the problematic. To many traditional critics and ordinary readers, the modernist writer often seems willfully inaccessible, obscure and even outrageous. Poets like Eliot and Stevens, novelists like Joyce and Kafka have been with us for some decades now; their work has been studied and overstudied; yet they remain the revolutionists of 20th-century literature, the true heroes of the avant-garde. And ordinary readers are quite right when they find such writers difficult, though quite wrong if they conclude that the difficulty is not worth troubling over.

THE modernist writer can no longer accept the formal claims of society; he finds the traditional modes of expression worn out; he suspects the neatness and apparent coherence of the old literary forms, and in his search for freshness, is perfectly ready to risk exaggeration and fragmentariness. The usual morality seems to him stale, perhaps a mere hypocrisy. He wishes to arouse strong feelings in his audience, even if they are feelings of hostility; he wishes to shake men out of lethargy, middle-class comfort, the life of slow dying. And so he deliberately affronts his audience, turning to the grotesque, the shocking, the frightful, the weird and the sick.

It is here that literary criticism finds a special task. Those critics who in the last several decades became the champions of modernist writing were doing more than exercising their analytic talents and dialectical brilliance; they had become partisans in a cultural revolution, spokesmen for a cause. Edmund Wilson and William Troy writing some of the first studies of Joyce's "Finnegans Wake"; Richard Blackmur composing an early appreciation of Wallace Stevens's poetry; F. R. Leavis defending the achievement of T. S. Eliot against the hostility of incomprehending English dons—such critics won the gratitude of their audience. They were helping readers get past the difficulties of avant-garde writing, so as to see the order behind its apparent disorder, the beauty behind its seeming clutter, the urgency of moral speech behind its surface of confusion.

*Criticism, at its best, has been a defender of seriousness and distinction against the vulgarities of "mass culture."* At the very time that literary critics were rising, with wrath and exegesis, to defend "modernist" writing, there was spreading in every industrialized society a new cultural blight. This blight consisted of a synthetic, commercialized pseudo - culture, deliberately manufactured to divert and distract the semi-educated millions who had gained the rudiments of literacy but not the traditional values of high culture. This sleazy "mass culture"—or as the Germans call it, *kitsch*—bears toward the genuine thing a relationship somewhat like that of a clever wax to a real fruit. It feeds on boredom without creating either the disturbance or satisfaction of genuine art, and it arises in response to the need for filling up the quantities of leisure time which industrial society has made available—but has not trained people to employ creatively.

In fiction, the movies, television and journalism—in every channel of mass communication—there has been a flood of shoddiness, some of it brutal and vulgar (see the cheap paperbacks) and some of it fashionable and slick (see the playboy magazines). In response to all this, the work of serious critics has taken on a tone of urgency, even of combative gaiety. Critics like Dwight Macdonald, Clement Greenberg and Harold Rosenberg have analyzed and attacked the falsities of "mass culture," doing battle against the smooth descendants of the Philistines and barbarians who had first roused the ire of Matthew Arnold in the late 19th century. (And doing battle, incidentally, also against certain kinds of newspaper reviewers who write not literary criticism but undiscriminating puffery.)

SOME critics, repelled by the vulgarities of "mass culture," have retreated into a willed aristocratism, toying with fantasies of cultural élites. But the best critics have fought the battle against "mass culture" in the name of a true democratic culture—if not always democracy as it exists in its imperfections, then democracy as a humane standard and ideal.

*Criticism has recently won a strong foothold in the American universities.* Until the last few decades, teachers of literature in American universities placed the major stress upon philological and historical studies. Most professors looked upon literary criticism as a kind of dilettantism, perhaps interesting for magazines and drawing rooms, but hardly worth the notice of scholars. Between the critics and the scholars there was, consequently, a large amount of suspicion. The critics attacked the scholars as sterile pedants, and the scholars dismissed the critics as mere journalists and impressionists. Neither group was entirely wrong.

But in the last 20 or so years critics have slid into the universities, and criticism has become recognized, perhaps even a bit uncritically, as a major part of literary study. By now modern literature is analyzed with awesome industry, graduate students often yearn to be free-wheeling critics rather than narrow-gauged scholars, and the scholars themselves increasingly try their hands at criticism.

There is another reason for the triumph of criticism in the universities. Large numbers of freshmen — and quite a few seniors too — cannot read a novel or poem or piece of expository prose with reasonable skill. Many teachers of literature and composition try to cope with this problem by employing the techniques of criticism in the basic work of the classroom. The close study of language, the analysis of literary structure, the discovery of such intellectual refinements as irony, symbolism and dialectic —these elements of modern criticism have recently been borrowed in hundreds of college classes. With what success is another question; some of us regard the victory of criticism as a mixed blessing, especially when it lacks the foundation of historical understanding. But that criticism has triumphed in the college teaching of the humanities there can be no doubt.

CRITICISM *has become a mode of discourse which extends beyond the study of literary texts and aspires toward reflection upon the whole of human existence in our time.* The temptation has always been there, it is perhaps inescapable, but only in recent decades has the wish to transform literary criticism into a kind of humanist contemplation become a dominant one. For in recent years literary critics have been among the few intellectuals who have ventured to speak about "the human condition" as if it were still an appropriate and manageable subject rather than a siren-call to pompous rhetoric. As academic philosophy and sociology have become increasingly inbred and specialized, literary criticism has assumed the burden of philosophical and social reflection, taking for its province the full range of experience. And this has obviously answered a strong need among cultivated readers for some principle of integration, or at least some integrating style of thought, by which to confront modern life.

Critics like Yvor Winters, Lionel Trilling, F. R. Leavis and Richard Blackmur are not merely specialists in one or another area of literature. They are also earnest and ambitious

commentators on the intellectual problems of our time. They are social moralists and, on occasion, amateur prophets. They undertake tasks which in an earlier time might have been done by priests, philosophers and party ideologues. To engage in such reflections has been the chief privilege, as also the most insidious peril, of modern criticism. It has satisfied an authentic yearning for "wholeness" of speech, but also has pandered to the more dubious appetite for packaged cultural formulas.

To many readers, then, literary criticism has come to seem the last of the disinterested kinds of discursive writing; they see it as untouched by the betrayals of politics, free from the abstruseness of modern philosophy, and uninhibited by the special pleading of theology. The critic thus tends to become a guardian of taste, a minister of values, a protector of the undefiled word.

But what does he actually do, this critic? So many different things and in so many different ways it would be hopeless even to try to list them here.

A while back it was fashionable to bunch critics into "schools," what Melville called "fast-fish." There were sociological or Marxist critics who assimilated literature to a study of its social origins and implications; Freudian critics who looked upon the novel or poem as an opening for depth analysis; "New Critics" who pre-ferred to treat the literary work as an autonomous object, with formal properties of its own, to be studied apart, or almost apart, from the pressures of history and the contamination of ideas.

AT the moment there is less excitement, certainly less controversy, in the world of criticism than there was, say, 20 years ago. The lines of separation between the "schools" have largely melted away; most critics now are "loose-fish." What remains are individual critics, some good and many dull, but most of them frankly eclectic in their methods. The best write from personal taste and conviction. Indeed, it is a strength of criticism — as well as a major reason for the loyalties it evokes — that neither machines nor committees, foundations nor scholarly teams can take over its work.

The critic, says Cleanth Brooks, tries "to put the reader into possession of the work of art." A good formula, which all critics would accept; but beyond it, every man on his own. The fundamental task in achieving the end proposed by Brooks is simply to describe a particular novel or poem. Simply, indeed! It is anything but simple; and anyone who has ever tried, for instance, to say how a new and original writer is both similar to and different from writers of the past knows how agonizingly difficult a job it can be.

Some critics try to get at the work through discussing its social background, some through studying its linguistic organization, some through relating it to an established tradition of earlier writing, some through dissolving it into an archetypal pattern of myth, still others through evoking its distinctive moral flavor.

Edmund Wilson writing about Proust offers a lengthy plot summary that is so skillfully structured, it brings Proust's enormous novel into a sudden and unexpected coherence. Virginia Woolf, more oblique and impressionistic, evokes the quality of a great writer through a quick flash of comparison: Jane Austen, like the Greek tragedians, "in her modest everyday prose, chose the dangerous art where one slip means death." Richard Blackmur writing about the poetry of E. E. Cummings concentrates on a linguistic oddity, the poet's obsession with the word "flower," and thereby builds a case that Cummings's work is marred by sentimentalism.

ALLEN TATE, writing about "Our Cousin, Mr. Poe," begins with a personal recollection from his boyhood, which soon enables him to "place" Poe in the context of Southern culture and thereby define with some delicacy the nature of his work. Philip Rahv writing about Dostoevsky brings to bear an expert knowledge of 19th-century intellectual history, so that he can relate the great Russian novelist to ideas that were swirling through Russia and Western Europe at the time. And F. R. Leavis, writing on George Eliot, focuses on refinements of moral evaluation, trying to specify what it is in her work that gives one so strong a sense of maturity and humaneness.

From historical placement to linguistic analysis, from evocations of a writer's fundamental vision to study of his metrical patterns, from chancy psychoanalytic portraiture to austere graphings of literary structure — these are but a few of the possibilities open to the critic. The more experienced and intelligent he is, the more skeptical he becomes about all of them. If he bears down heavily on technique, he may well miss the essential spirit, the "vision," of the novel or poem. If he talks loftily about the "vision," he may fail to specify the precise way in which the novelist or poet has embodied it in his work. Either way, he resorts to desperate forays, partial strategies, methodologies of ambush — and all leave him uneasy, for in the end the novel or poem remains intractable, beyond his full grasp.

Yet critics try. They look behind the literary work, they look ahead of it, they look into its depths. And at their best — with iron nerves and a passion for clear sight—they look at it.

February 9, 1964

# The Last Minstrel

77 DREAM SONGS. By John Berryman. 84 pp. New York: Farrar, Straus & Co. $3.95.

### By JOHN MALCOLM BRINNIN

JOHN BERRYMAN, a superb and difficult poet who belongs, as only his peers seem to know, in the absolute first rank of American poets, comes into a new phase of his majority.

Readers who have encountered some of Berryman's "dream songs" in various journals will be familiar with the character "Henry" and his alter ego, "Mr. Bones" (perhaps the very last minstrel in the stranded Tom Show of the universe). The world they are caught in is Berryman's, and so is the world they create. And what a world it is!—as the tumble and dross of actuality is sorted out, hammered together, piled up in tottering columns and otherwise reconstituted with the canny, zany, faux naif calculations of a verbal sculptor who pretends like mad that he's mad.

In the process, a lot of debris remains unaccounted for, and it will be a rare reader who, at a glance, is sure that a thousand odds and ends are, after all, relevant. In dreams, anything goes. But what Berryman loses in demanding that the reader share his anarchy of dreams, he gains in all the ways in which dreams, like movies, accommodate ellipses, allowing objects and fields of interest to shift and change instantaneously.

THE programmatic aspects of the sequence are not difficult to identify. We have a hero—Berryman - Henry - Mr. Bones—who is by circumstance picaresque but by nature passive and sly-boots wise. He suffers the deaths of friends, he reviews with astonishment the turns his life has taken, he worries about his career and his "place." Toward the pageant of brutality and stupidity that parades through his life and times he reacts with hopeless merriment. Behind it all there is philosophical ampleur, an acceptance that elevates the character in any of his guises and, in some moments, ennobles him.

Strictly in terms of technique, the book is a knockout. Subsuming all the work of nearly 30 years, including and surpassing the remarkable "Homage to Mistress Bradstreet," Berryman seems to have grown in a progress that calls to mind Andre Gide's "Gradation, gradation—and then a sudden leap." Such bravado and such excellence calls for celebration.

*Professor of English at Boston University, Mr. Brinnin is most recently represented in "The Selected Poems of John Malcolm Brinnin."*

August 23, 1964

# THE WAY UP FROM ROCK BOTTOM

HERZOG. By Saul Bellow. 341 pp. New York: The Viking Press. $5.75.

### By JULIAN MOYNAHAN

THE position of the 43-year-old hero and title character of Saul Bellow's latest and best novel is absurd. Moses E. Herzog believes in reason, but is suffering from a protracted nervous crisis, following the collapse of his second marriage, that leads him to the brink of suicide. He deplores the current vogue for crisis ethics, dionysiac revivals and thrilling apocalypses, yet is professionally an intellectual historian of the Romantic Movement who travels about with a paperback volume of Blake's poems in his valise.

He is an urbanite from Montreal who has spent most of his life in Chicago and New York, yet the only thing he owns is a decaying farmhouse in a depopulated area of the Berkshires. He believes that "brotherhood is what makes a man human," yet he has been cuckolded by his best friend and has come to manhood in a period when six million of his fellow Jews were exterminated by the Nazis and their allies.

He sees his mission as "this great bone-breaking burden of selfhood and self-development," but he has apparently failed as a father, a lover, a husband, a writer, an academic and he faces each day and each night the real possibility that his psyche is being invaded by the self-disintegrative processes of an actual psychosis.

And he sees in a last absurd paradox that his balance, if it is to come, must come "from instability." The novel, in its almost perfect narrative art, makes us see the truth and wisdom of that paradox, not only for Herzog himself but for all of us at this point—at this "post-Christian" point, as the book hesitantly but finally puts it—of modern history.

Over the past 10 or 15 years, Jewish writers—Bernard Malamud, J. D. Salinger, Norman Mailer, Philip Roth, *inter alia*—have emerged as a dominant movement in our literature. "Herzog," in several senses, is the great pay-off book of that movement. It is a masterpiece, the first the movement has produced (unless Henry Roth's magnificent try at a masterpiece, "Call It Sleep," written in the 1930s, can somehow be brought into the picture), and it is Bellow's most Jewish book. There are no gentiles in it. It is full of Jewish wit, humor, pathos, intellectual and

*Mr. Moynahan, whose reviews appear in publications on both sides of the Atlantic, is the author of "The Deed of Life: The Novels and Tales of D. H. Lawrence."*

moral passion, hipness about European social thought and foreign literatures. Like the prophets, Herzog cries out for "a change of heart," and like all Jews in this generation, he feels himself to be a survivor with the responsibility of testifying to the continued existence of values which the Eichmanns had tried to send up in the smoke of burning flesh.

"Herzog" is a great book because it has great characters. First, Herzog himself. He wanders about, distracted, charming and nervy, a kind of intellectual Oblomov on the run, a Pierre Bezhukhov of the thermonuclear century. His mood shifts in great swoops and glides; he revisits in imagination the scenes of his broken marriages, his broken career, his childhood. He disappears from New York, turns up in Vineyard Haven, flies to Chicago, where, gun in hand, he spies through a window his ex-wife's lover bathing Herzog's own small daughter and realizes he can never seize the swift logic of the assassin.

AT last he comes back to the Massachusetts farmhouse where owls roost on the posts of his former marriage bed and the toilet bowl contains the tiny skeletons of birds. Throughout his mental and physical journeying, he has been composing letters—to friends and enemies, professional rivals and colleagues, to General Eisenhower and Friedrich Nietzsche, to his second wife, Madeleine, to a woman named Wanda with whom he had a brief affair during a foundation-sponsored lecture tour in the Iron Curtain countries.

The letters are cranky, brilliant, poignant and, of course, they are never sent. As the electricity at the farm is switched on by a local handy man, Herzog at last quiets down: "At this time he had no messages for anyone. Nothing. Not a single word." He is written out for the time being, like his creator; he is bare but not barren. The book, composed throughout in the tonality of Herzog's voice and consciousness goes silent. But we know that the voice, which, for all its wildness and strangeness and foolishness is the voice of a civilization, *our* civilization, has been recorded for posterity.

Madeleine is a great character. She is beautiful, brilliant, cracked, and is working for a doctorate in Russian church history with the aim of rising like a phoenix from the ashes of her former husband's scholarly reputation. A slut in the home, she is a bitch in bed, a dazzler in conversations with free-floating intellectuals about Soloviev the younger, and she is very touching because she is so fully and roundly

drawn. Herzog is all for justice, while Mady's passion is for justification: the marriage has been a tragedy and a farce. Her lover, Valentine Gersbach, a red-headed knave who poles himself along on a wooden leg like a Venetian gondolier, is a great character. He is full of schmaltz and spouts the latest stencils of psychology while he takes dishonest advantage of a friend. The author draws this modern Tartuffe with love, hatred and a racy vividness.

The narrative movement of "Herzog" has a beautiful fluidity. Plot, in the skeletal, Aristotelian sense dissolves back into an all-encompassing awareness—the container becomes the contained—and the book is structured with great subtlety, by the "whim" of mood and memory.

Two devices in particular are worth mentioning. The narrative line flows to and fro between first and third person report with complete verisimilitude and no typographical fuss whatsoever. Here I think Bellow owes something to J. P. Donleavy, whose peculiar fictional methods and merits still remain a largely unacknowledged influence in American writing, and behind Donleavy stand the Leopold Bloom chapters of "Ulysses." In "Herzog," this blending permits the author to combine a kind of passionate autobiography with a more objective "history." Moses E. Herzog is at once an object lesson called "He" and a suffering self called "I."

The other device is the letters, which crop up constantly by wholes and by fragments, and which are set in italic type. Anyone who has ever written a novel knows

that when the form of a book establishes itself, it immediately becomes impossible to say many things that one wants to say without fouling the esthetic nest. Form channelizes, preventing the dissipation of imaginative energy; but, by the same token, it also constrains or may even eliminate a writer's opportunity to make direct statements.

Now Bellow is a very intelligent man who has read all the books in all the libraries and has thought hard and bravely about the central problems of our society and culture. "Herzog," which, incidentally, is also the pay-off for letting creative writers into our university communities over the last couple of decades, uses the letters as a part of the total form to address the intelligence of the reader direct, and it does this without pedantic asides and without inflicting on us the *longueurs* of Shandean footnotes. After "Herzog" no writer need pretend in his fiction that his education stopped in the eighth grade. Our redskins can wash off the greasepaint and let the pale cast of thought glimmer through without committing esthetic solecisms.

SOME of Herzog's letters are playful, some are pixilated; but all of them are, in the last analysis, responsible. Taken together they compose a credo for the times. Through his nervous and distracted hero Bellow appears to me to be saying this:

The age is full of fearful abysses. If people are to go ahead they must move into and through these abysses. The old definitions of balance and sanity do not help on this journey, but the ideals these terms gesture at remain, even though they require fresh definition. Love still counts, justice still counts, and particularly intellectual and emotional courage still count. The book reserves its sharpest criticism for those people—and no doubt they are to be found among public men as well as among theologians and artists—who try to cope homeopathically with the threat of violence under which we all live by cultivating an analogous, imaginative violence or intemperate despair. As Moses E. Herzog says in his manner of "strange diatribe":

"We love apocalypses too much . . . and florid extremism with its thrilling language. Excuse me, no, I've had all the monstrosity I want."

And of course laughter still counts. Dr. Strangelove's cry, "Look, *mein fuehrer*, I can walk!" has reminded people that a sick joke in a sicker world may act as a healing medicine. So it is with Herzog. He is sick and he makes for health.

What I have given is a crude paraphrase. Bellow's argument is new and perennial. The book is new and classic, and its publication now, after the past terrible year, suggests that things are looking up for America and its civilization.

September 20, 1964

# AMID THE HORROR, A SONG OF PRAISE

FOR THE UNION DEAD. By Robert Lowell. 72 pp. New York: Farrar, Straus & Giroux. $3.95.

### By G. S. FRASER

WHEN Samson, in the Book of Judges, had killed a lion, he passed the same way some time later "and, behold, there was a swarm of bees and honey in the carcass of the lion." Offering the honey to his Philistine friends and in-laws, Samson asked them the riddle, "Out of the strong came forth sweetness," and they could not answer it. The story struck Yeats as a beautiful parable about the "unchristened heart" of the true poet who, like Homer, produces out of violence and rankness and death pure exultation. Of all living American and English poets, the parable applies best to Robert Lowell.

No other English or American poet of his generation has, in his handling of language, the same sheer brute strength; no other poet is so deeply moved not only by moral but by physical horror and disgust (which can include self-disgust), and by a kind of blind Samson-like ferocity. And yet, insensibly, in Lowell's hands the tale of the world's horrors becomes a tale of the world's wonders, the catalogue of obscure absurdities, a song of praise. And the lumbering, cumbrous, thickthewed movement of his verse can ripple suddenly into a touchingly tender vulnerability, like Samson's vulnerability to Delilah.

MR. LOWELL'S last volume of original poems, "Life Studies," had a mixed reception. In England, A. Alvarez hailed it as a breakthrough to a new kind of poetry, one of raw, direct experience. But John Malcolm Brinnin told me that he thought "Life Studies" was a sad

*Mr. Fraser, an English critic, has written several studies of English and American letters, including "Vision and Rhetoric" and "The Modern Writer and His World."*

falling-off from the extreme intricate rhetorical formality, the elaborate religious symbolism, of Lowell's earlier poems. It seemed to him that, having created a beautiful public language, for the public theme of the Christian consciousness appalled by the hard heart of the modern world, Mr. Lowell had wantonly deserted this for excessively private psychoanalytical notebook jottings. "Life Studies" on the whole eschewed myth and legend, and found its main material in personal experience and family history. But it took family history, like personal experience, as a set of brute particulars.

A fact, so to say, became "poetical" in its very irreducible factuality. Lowell's friends, his relations, his experiences in mental hospitals were in no sense generalized or clarified. Rather, they were named, in all their confusingness, as sacred objects in themselves. Similarly, Lowell's rhetoric in "Life Studies" became much looser and suppler than it had been in his earlier poems. The contrast was rather like that between the extreme formality of Ezra Pound's "Sestina: Altaforte" (1909) and the apparently off-the-cuff casualness of "Hugh Selwyn Mauberley" (1920). The earlier poems had been elaborately composed, "throughcomposed" in the musical sense, in difficult forms; the poems of "Life Studies" aimed at an appearance of improvisation and carelessly felicitous abruptness. If there was an esthetic moral to be drawn from "Life Studies," it was that literally anything that happens to a poet, however chaotic, fragmentary, or absurd, can, without any sort of literary doctoring, suddenly become poetry.

This free-wheeling manner of composition obviously has its dangers. It could lead—and in some younger poets influenced by Mr. Lowell it does lead—to exhibitionism and raggedness. More subtly, it may lead to a kind of pumping up of emotions, a forcing of the note, a making more of a situation than is really in it. Yet Lowell's new volume, "For the Union Dead," which seems to me the most powerful and direct volume of poems he has yet published, justifies those who like Alvarez (and like myself) welcomed his second manner. What can be seen now more clearly, however (and this may partly vindicate Brinnin), is that under the apparently casual surface of the second manner there lurks a power of concentrated phrasing and a gift of ordering, of subtle transitions of topic and mood to develop the full impact of a ruling theme, which has been earned by the more impersonal and more obviously formal discipline of the earlier poems.

Nor could "For the Union Dead," like "Life Studies," be accused of an excessive privacy. The imagination behind the poems is like the imagination of a great historian, reliving the past while relating it always to the troubles of the present; an imagination at once passionately literal and fiercely prophetic, like the imagination of Carlyle.

Let me try to illustrate both the historical range and that passionate exactness. In a poem on Buenos Aires, such a phrase as "the leaden, internecine generals," or such a stanza as this,

*Literal commemorative busts
preserved the frogged coats
and fussy, furrowed foreheads
of these soldier bureaucrats,*

condenses miraculously what it would take a historian many pages or chapters to say about the sad, violent, and heavy farce of Argentine political history. Similarly, a poem on Jonathan Edwards seems to sum up all that one has read, or felt, by Edwards or about him. In his literalness, his fierceness, his occasional brutality, and in his deceptive casualness, Mr. Lowell seems extremely anti-academic. Yet in another sense he has a first-rate academic intellect, an

instinctive feeling for the heart of a historical situation and an ability to relate it directly to a contemporary one.

The wonderful title poem, for instance, is partly a noble tribute to the heroism and idealism of the New England abolitionists; but it is partly also an indictment, fierce and vivid, of the decay of New England ideal-

ism, and of the indifference of Northern liberalism to what might be called the constructive meekness of Negroes in the United States today.

The central symbol of this poem is the statue, in Boston, of Colonel Shaw, who commanded a Negro battalion in the Civil War, and who stood for all the simple dignity and integrity of old Boston. Mr. Lowell counterpoints this image with one of modern Bos-

ton, shoddily destroying its own style and history:

*. . . One morning last March*
*I pressed against the new*
*barbed and galvanized*
*fence on the Boston Common.*
*Behind their cage,*
*yellow dinosaur steamshovels*
*were grunting*
*as they cropped up tons of*
*mush and grass*
*to gouge their underworld*
*garage.*

He counterpoints Colonel Shaw's image, also, with the image of our present callousness to violence and wrong:

*The ditch is nearer.*
*There are no statues for the*
*last war here;*
*on Boylston Street, a commer-*
*cial photograph shows Hiro-*
*shima boiling*

*over a Mosler Safe, the "Rock*
*of Ages"*

*that survived the blast. Space*
*is nearer.*
*When I crouch to my television*
*set,*
*the drained faces of Negro*
*school-children rise*
*like balloons.*

It is part of Mr. Lowell's strength in this volume that he is not merely a poetic consciousness, but a poetic conscience.

October 4, 1964

# A MAN DESPERATE FOR A NEW LIFE

AN AMERICAN DREAM. By Norman Mailer. 270 pp. New York: The Dial Press. $4.95.

By CONRAD KNICKERBOCKER

IN "An American Dream," his first novel in 10 years, Norman Mailer burns his remaining bridges. He tells a sometimes bizarre, always violent, absolutely contemporary story of evil, death, and strange hope. Reading it is like flying an airplane with the instruments cross-wired; I'm not sure I liked the experience, but I'll remember it for a long time.

It's such a vulnerable book. What wrenching innocence, what cool nerve, to write melodrama in the Age of Herzog! They'll carve it to pieces, as they have so much of Mailer's work, not for what it is, but for what it is not. If only, they'll say, if only his characters had not already fallen so far toward the bottom of the pit. (If only Eitel, the script writer in "The Deer Park," had been more like Monroe Stahr or Augie March or Huck Finn or whomever they wanted characters to be like at the moment.) If only Norman would *behave.* If only Rojack in "An American Dream" had written a sweet Jewish letter to himself instead of killing his wife, we could forgive Mailer and give him our Mafia kiss, ignoring the possibility that melodrama might be our most natural medium.

Yes, and if only America had a literary conscience, Norman Mailer would be its accusing specter. More than anything else, he needs what no writer in this country can find despite how much we kid ourselves: a cohesive, sensitive audience, instead of splinter groups, to pit himself

*Mr. Knickerbocker frequently reviews fiction in these pages. He is at work on a biography of the late Malcolm Lowry.*

against. His is now the desperation of a man shouting to a hurrying crowd on a street corner. He might have been happier as one of those half-crazy wandering poets who exalted Irish villagers 200 years ago, singing of Cuchulain and the death of heroes; or a medicine man on the banks of the Pedernales, incanting the seasons, armed with the absolute power of curses; someone the crowd believed in and listened to.

Instead he wrote a big novel that said what modern war is really like and wrote a couple of other novels that were a lot better and will last longer than anyone predicted at the time. He tried and discarded the various agendas of the day, but thought hard, and wrote some brilliant commentary, sometimes because the things going on were so much more astonishing than fiction. This is the kind of man the nation endows with slightly less charisma than it affords to Tuesday Weld. No wonder he sometimes pops like a 10-cent fire cracker when he intended to go off like a time bomb.

CONSIDER the stakes, quick success, earned almost too easily, followed by the struggle to come to terms with it and with his abilities. How to live with all of that and with the peculiar nature of the fame we confer. He became full of kinks, obsessive, eccentric, exhibitionistic, but also bold, dazzling, concerned, unfashionable. He summed up the whole tough luck. Enemies of promise were kicking down the doors day and night. No other writer still alive has had it quite that bad. Rather than submitting to the slow gladiator's death that always wins the most cheers (lengthy defeats hypnotize us), he kept going. For these reasons I think he is one of the few really interesting writers anywhere.

Despite its surface extremities, but because of the intensity and relevance of Mailer's own experience, "An American Dream" defines the important themes. It fails as an affirmation of sane alternatives, but perhaps we are beyond these. Mailer is obsessed with the cabala of American power. He searches for the mana, the magics, submerged and hideous, that move the age. He strips skin to show the primitive muscle in the American rituals of authority and prestige. He sees a world in which demonic forces, electronically and typographically amplified, are a storm compared to the manageable spirits that lingered beyond the circle of tribal campfires. The hope of a different kind of life, or the lack of hope—that is why some of us continue to read fiction. Mailer discusses the possibilities on his own terms in his own voice. Never mind the occasional literary nostalgia, the existential veneer, the chiaroscuro. I hear him, achingly so much a part of us in so many ways we are loath to accept.

Stephen Richards Rojack, the hero of "An American Dream," bereft of his magics of manhood and image, is desperate for a new life. He has returned from the war a hero with a Distinguished Service Cross to become, at the age of 26, a public figure and Congressman, just as the author, at about the same age after the success of "The Naked and the Dead," found himself to his great confusion "a node in a new electronic landscape of celebrity, personality and status." Telling himself he is fleeing from the sense of death that came to him through the blue eyes of one of the German soldiers he killed, Ro-

jack commits political suicide by running on the 1948 Progressive party ticket. (Mailer had a fling at radical politics during his exploration of availabilities beyond the status quo.) Rojack had realized that his public personality was being created by just that, the public, with all the frightful cosmetic apparatus it commands. He feels himself to be an actor, the worst doom, just as Sergius O'Shaugn-

essy, the narrator of "The Deer Park," had always thought of himself as a spy and a fake.

Unable to summon the mana that a political career demands, Rojack retreats to another kind of image - making. He teaches existential psychology at a New York university, writes a popular book entitled "The Psychology of the Hangman," and interviews addicts on television. He becomes a face.

Yet so strong remains his fascination with the handmaidens of power that he has also become the husband of an heiress, Deborah Caughlin Mangaravidi Kelly, a Great Bitch whose raw-meat requirement is unconditional surrender. Self - trapped and empty at the end of a descending road, Rojack cries, "Let me be not all dead," and begins to find his way toward another horizon.

HIS route is to murder his wife, one of the few murders to figure crucially in a serious work of American fiction since "An American Tragedy." Mailer intends "An American Dream" to be a sequel 40 years after. But while Dreiser's Clyde Griffiths languishes, a passive victim of the system to the last, Rojack finds the beginnings of liberation in his deed. Mailer believes that to discover new circuits is the necessary recourse of a man whose switchboard has been sabotaged. Acts that place the individual beyond the point of no return may be the only ones that break barriers. Hemmed in by the safety rails of "social welfare and psychoanalysis," Rojack does not want to be adjusted; he wants to be alive.

Murder ups the ante. The police are suspicious, but through pure dumb luck he stays out of jail. Parallel to his encounter with the law runs his brief affair with Cherry, a tarnished

nightclub singer who is as at home with impending death as most ladies are with the P.T.A. Finally, his New York life in ruins, he hits the road in the classic denouement of the American dream, redresses balances in Las Vegas, where all justice is served, and then heads south across the border.

Mailer manhandles the reader straight through the plate glass into the center of the event. Things that happen, he tells us, are real; only dreams and hallucinations are in doubt. We protest; life and art cannot be this excessive. Their design cannot be as vicious, exotic and random as this, nor as dangerous. But late at night, dozing over the front page or on a crowded street, one confronts the full menace of what Mailer describes.

Beneath the glare of events, "An American Dream" beats with the pulse of some huge night carnivore. It defines the American style by presenting the most extreme of our realities—murder, love and spirit strangulated, the corruption of power and the powerful, the sacrifice of self to image, all of it mixmastered in booze and heat-and-serve sex, giving off the smell of burning rubber to the sound of sirens.

At the end, no one stands with Rojack. The tough guys, the Sutton Place hosts, gossip columnists, television finks, swingers and dolls, timid college presidents and self-revulsed cops, all the hangers-on waiting for the action are gone. He must learn to make his own center alone. The structure always takes; it never gives. Yet Rojack survives, just as the men of "The Naked and the Dead" endured because there were certain limits they would not go beyond. As appealing as the idea of flight is to Mailer (O'Shaugnessy fled California to Mexico), the strongholds of power hold him;

Rojack will probably return. Here, as at the end of "The Deer Park," the author's imagination falters. He would like to believe that flight brings another chance, a new life— but he knows it does not, at least for people as entangled as Rojack.

MAILER will never write a novel about an ordinary man who missed the boat. His characters are all direct extensions of the main contemporary style: hard, doing each other in, engaged in illicit psychic traffic. Auto-erotic priests of the power-prestige-profit trinity, his people operate; they all still have mana of a twisted kind.

None is as he first seems. Deborah peels like a rotten onion. Socialite luncheoneer and sponsor of charity balls, she also has the sexual tastes of the fat girl in a Mexican whore house; beyond that, incest, perhaps espionage — the perfect dilettante of the 1960's. Ruta, her sneaky German maid, must have attended charm school with Ilse Koch. Deborah's father, Barney Kelly, has memorized the grimoire of business success. He commands an assassin's heart and the skill to use money like a rapier. With General Cummings of "The Naked and the Dead," Hollingsworth of "Barbary Shore," Herman Teppis and Marion Faye of "The Deer Park," these characters stand as vivid caryatids, pillars of hell, semblances of our times more true than most.

Mailer has evolved a rhetoric that moves far beyond his original naturalistic endowments. His words always hinge on the event, but he gives perspective to events with a kinetic poetry that turns the huge losses of his characters into, strangely, gains of a kind. The counter-forces of experience are what he is after.

He told me recently that writing the first, serial version of "An American Dream" last year against deadlines for Esquire forced him to create a structure tighter than those of his previous novels. Since the Esquire version, he has rewritten perhaps 40 per cent of the book, fleshing out scenes and adding them, sounding every sentence, he said, 10 times for timbre.

WHAT desperate work, preparing an entirely public statement for a public that nominates its seducers mainly for their gaudiness! Mailer accuses in full rabbinical voice, but the guilty congregation is still watching for Tuesday Weld. He may be one of the last of a breed, a writer who tries to address the entire country. Malcolm Lowry once said that the only writers who count are the ones who burn. "You cannot trust the ones who are too careful." Mailer burns; he is not careful; he can be trusted. In past years his Dionysian rites of thought and act—sorcery to summon up all the shades of experience — sometimes ended with broken glasses and stale butts scattered through the mind's house. Now he is whipping his powers into line.

"Not safe. Not wise. Not admired," Gore Vidal once said in Mailer's defense.

"You are not responsible," James Baldwin told him another time, in a Greenwich Village bar.

"An American Dream" strives for a coup d'état instead of a negotiated artistic détente. Unwise, irresponsible, devoid of the charm that now passes for literature, it diagrams the pentacle around which so many of us dance with such fateful urgency.

March 14, 1965

# Recognition

THE COLLECTED POEMS OF THEODORE ROETHKE. 274 pp. New York: Doubleday & Co. $5.95.

THEODORE ROETHKE: Essays on the Poetry. Edited by Arnold Stein. 199 pp. University of Washington Press. $5.

By RALPH J. MILLS Jr.

THEODORE ROETHKE'S poetry replaces the earlier, more selective "Words for the Wind" of 1958, chosen by Roethke himself as an active poet in mid-career. It restores

*Mr. Mills, of the English department of the University of Illinois, is the author of a study of Theodore Roethke.*

the whole of his first book, "Open House" (1941), and adds his later volumes, "I Am! Says the Lamb" (1961) and "The Far Field" (1964). A few hitherto uncollected poems, among them the marvelous "A Rouse for Stevens" and "Supper with Lindsay," have been gathered in a concluding section.

Altogether, we have what is certain to be the definitive text of Roethke's work until such time as scholars and critics, drawing on his many notebooks and manuscripts, augment this existing body with minor or fragmentary pieces or unpublished revisions. But it is in terms of the present book that most readers will make their assessment of Roethke's poetic accomplishment.

Perhaps it will seem to be laboring the obvious to insist on Roethke's

major stature when he was so honored with prizes during his last years and even after his death in 1963. Yet he belonged to a generation of American poets which, until recently and in spite of a scattering of official recognition, suffered eclipse by the figures of Eliot, Yeats, Pound, Stevens and others, toward whom critics have busily turned for the past 30 years.

Arnold Stein's collection of essays on Roethke by a variety of poets and critics (including Stephen Spender, John Wain, William Meredith, Frederick Hoffman, Roy Harvey Pearce, Denis Donoghue, Louis Martz, W. D. Snodgrass and this reviewer) is a strong indication of change in the critical climate and offers a number of helpful approaches to the poems. The "Collected Poems" affords us

an over-all view of Roethke's development into one of the richest and boldest lyric poets of our age. Looking back over the early verse of "Open House," we may be struck by the fact that he began, not with the greenhouse poems which first drew attention to him, but with work, as William Meredith notes, showing the influence– so popular with his contemporaries too–of Auden and, less popularly, debts to Yvor Winters and Léonie Adams. The latter was the truest one, came closest to his actual feelings and perceivings; for much of his best early writing is contained in poems purely descriptive of nature or pieces in which the processes of nature are linked covertly with moods of the human psyche:

> And soon a branch, part of a
> hidden scene,
> The leafy mind, that long
> was tightly furled,
> Will turn its private substance
> into green,
> And young shoots spread
> upon our inner world.

The direction in which this sort of analogy leads in Roethke's poetry is original and radically experimental. In the opening pieces of "The Lost Son" (1948), he abolishes the barriers between the sensitive interior world of his own responses and the equally subtle and shifting universe of flowers, small plants and animals. An exchange is established between them which, under the urgency of Roethke's exploratory drive and his astonishing imaginative and technical powers, brings him to the poetic breakthrough of the sequence poems of that volume and the next, "Praise to the End!" (1951).

The initial group of greenhouse poems (based on his boyhood experiences in and around the greenhouses of his father's floral concern) must have revealed to him the enormous possibilities of the correspondence between the human and natural processes, for he commits himself to his new vision in poems such as "The Minimal":

> I study the lives on a leaf:
> the little
> Sleepers, numb nudgers in
> cold dimensions,
> Beetles in caves, newts,
> stone-deaf fishes,
> Lice tethered to long limp
> subterranean weeds . . .

In the sequence poems which follow, Roethke plunges into a unique verse. He traces the evolution of the self in a nameless protagonist (closely identifiable with the poet) by rendering the psychic life — fluid and borderline states of consciousness, delicate and . evanescent assertions and withdrawals, moments of crisis — from childhood to a certain level of maturity. The poems are strange and dreamlike but win over the reader by their sheer mastery of the poetic means. Nursery rhyme and nightmares, sexual innuendo and mystical illumination, are juxtaposed in poems whose narrative pattern is not linear but proceeds by indirection and symbolic notation, by approximating poetically the very motions of the psyche itself.

Out of the periods of dark struggle emerge visionary moments when the self attains a profound union with creation:

> Arch of air, my heart's
> original knock,
> I'm awake all over:
> I've crawled from the mire,
> alert as a saint or a dog;
> I know the back stream's
> joy, and the stone's eternal pulseless longing.
> Felicity I cannot hoard.
> My friend, the rat in the
> wall, brings me the clearest messages;
> I bask in a bower of change;
> The plants wave me in, and
> the summer apples;
> My palm-sweat flashes gold;
> Many astounds before, I lost
> my identity to a pebble;
> The minnows love me, and
> the humped and spitting
> creatures.

July 17, 1966

# YAKOV'S ORDEAL

THE FIXER. By Bernard Malamud. 335 pp. New York: Farrar, Straus & Giroux. $5.75.

**By GEORGE P. ELLIOTT**

FOR quite a few years it has been clear that Bernard Malamud would be able to tell his story when he found it. The best of the tales he has already told ("The Assistant," short stories like "The Magic Barrel") have elements in common which the failures (led by "The Lady of the Lake") lack; so it has been possible to guess at the contours of the story he would tell when the time came.

Its central character would surely be a money-worried, East European, not particularly religious Jew who respects learning and whose thought is full of Yiddish turns. He is busily trying to get through a risky world which he never made but has partly chosen—not Italy, not Oregon, probably New York City. The story will of course be told gracefully, with the

MR. ELLIOTT is a novelist, critic and teacher whose latest book is the novel "In The World."

economy and assurance of a thorough professional, and in tone it will be humane, at once funny and painful. Less easy to guess was what balance the story would strike between the meticulously realistic and the fabulously fantastic. One would certainly be asking: What does the hero's being a Jew stand for? Above all, it was clear that both Jewishness and what Jewishness stands for are apparently at the heart of the Malamud story.

Occasionally in Malamud's previous books, the hero's Jewishness has been no more symbolic than his Americanness; he grew up in it as he grew up in the 20th century. But often it has been a great concern to him, and more often to his author. The test case has been the hero of "The Assistant." Born a Catholic, he becomes a Jew in the last sentence of the book. From what has gone before, we know that this becoming is more than religious conversion; and from experience of the world, we know that by and large Jews are born, not made, that Jewishness, whatever it may be, is not something one is naturalized into. For Malamud, Jewishness has evidently symbolized some sort of exalted condition of the humanistic spirit which might be summed up in the formula: "to suffer is to be Jewish." Historically, this is nonsense; nearly all men suffer and very few are Jews. Metaphorically, it is no better; though the Jewish people may have done better than most peoples at putting suffering to spiritual use, there is nothing exclusively Jewish about doing so.

Like many literary intellectual American Jews, Malamud has at best employed "Jewishness" as an ill-defined, pseudo-mystical quality latent in all men but manifest in Jews: a vague, irreligious substitute for the concept of "the chosen people." At worst, he has employed it as a contemporary, secular equivalent to the most arrogant Christianity. "To be Jewish is to be human" offends and invites attack by non-Jews in the same way as "to be saved you must be Christian" offends and invites attack by non-Christians.

Nevertheless, if the uncertain meaning of this special "Jewishness" has prevented Malamud from satisfactorily handling the issues he has raised, he has been dealing with some great ones: justice, degradation, suffering. And his fiction has always been open to imaginative life; by not treating these issues as solvable problems, his world remains marvelous and his characters have souls, not psyches. They look for salvation in this world, not the next, and they discover that

256 .

love and good works are not enough. What is enough? Malamud's answer, insofar as he has tried to give one, has been "Jewishness." Few non-Jews, and not all Jews, find this answer acceptable; indeed, from the near-flippancy of tone with which Malamud has tossed it in, he has not been satisfied with it either.

Now, in "The Fixer," Malamud has found most of his story, and the publication of the book is a matter for some public rejoicing. The basic ingredients one had expected are here —with two exceptions: the setting is not contemporary New York but Kiev in the years before World War I, and the story, though it centers on the persecution of a Jew by anti-Semites, is not about "Jewishness." Both surprises prove altogether fortunate.

In that alien, familiar world, Malamud the realist is at one with Malamud the tale-teller, for the real Russian anti-Semitism of that era was a fantasy outrageous enough for the wildest fable. Of course New York is now fantastic (as Irvin Faust's stories show) but it is not suitable to the purpose—few New Yorkers believe in exterminating Jews, our Government opposes such belief, we have no pogroms. And in history, our slaughtering the Indians and enslaving the Negroes had nothing in common, ideologically or religiously, with full-blown anti-Semitism.

Or Nazi Germany might have seemed Malamud's best setting for this story. Many generations hence it may serve for some appalling fable; now, it is unusable. Realistic fiction cannot center on an absolute victim. It especially cannot center on one who, like a Jew in Belsen, is given no opportunity to act outside his victimization; his every character trait is forced to subserve a horror which is so strong as to obliterate our other emotions and the character himself. In story-telling, an absolute victim serves his circumstances. But we already knew about these from history. A story about a pure victim is—must be—propaganda. Such propaganda has its uses; they are not the uses of art. In Czarist Russia, Malamud found a society far enough from him to look fabulous, but close enough for its ordinary side to be clear.

The Russian state approved anti-Semitism, if often surreptitiously (it was almost certainly the Czar's secret police

who forged that bible of modern Jew-killers, "The Protocols of the Elders of Zion"); yet the state also contained powerful elements that opposed such persecution. It was Christianity, of course, which ages ago invented anti-Semitism in the first place, not restraining but giving supernatural sanction to everybody's natural impulse to find scapegoats. At the time of Malamud's story there was a strong faction in the Russian

churches, both Orthodox and Catholic, which still fed the popular superstition; yet again, powerful church elements opposed it. Jews were degraded and oppressed, especially in the Ukraine, most especially in Kiev, that holy city; but they were not threatened with genocide; in the eyes of the law they were persons, as they were not to be in Nazi Germany. Russia, however perverted, no matter how much madness and dissolution it was rotten with, was still recognizably a civilized state, not a monstrous parody of one.

Malamud's Yakov the fixer (or handyman) can, then, be at the bottom of society but still of it. He may be destroyed, but he will not be officially denied as a person. Most important to fiction, he can contribute to his own downfall—perhaps not more than Oedipus at the crossroad did by killing his attacker, ignorant that it was his father, but just enough to make a good story possible. Yakov is framed and worse; the anti-Semitic laws he violates are stupid and crazy; and most of the legal officers he faces are wicked and brutal. All the same, we know and he knows that if he had obeyed the law he would not have suffered as he does.

The bones of the story are these. Yakov is thirty or so, a poor man in a poor shtetl. When his wife runs off with another man, Yakov, who is not a believer and who has a few vague humanistic ideas he has picked up here and there, mostly from reading a little Spinoza, goes to the nearest city, Kiev, with some notion of making money to get to America. Friendless, jobless, nearly penniless, one cold night he rescues a drunken Russian who has collapsed face-down in the snow. For reward, this man, who wears the button of the Black Hundreds (a society of virulent anti-Semites), offers him a good job as general manager in his small brick factory. Yakov does not say he is a Jew, and though the factory is in a quarter of the city in which Jews are forbidden to dwell, he lives in the plant both because it is rent-free and also to discover who has been stealing the owner's bricks.

The thieves turn out to be the foreman of the plant and his assistants, who hate Yakov for doing his job well. One day a boy whom Yakov has chased out of the yard a couple of times is found dead in a cave not far away, the body stabbed in dozens of places. Rumor declares this a Jewish ritual murder, that the Christian boy's blood has been used to make matzos. Before long, Yakov is accused of the crime and ar-

rested. Circumstantial evidence feeds popular anti-Semitism, and the case becomes a cause célèbre. Police, priests, the Czar himself, and masses of Russians demand that this atrocity be punished. There is danger the case will be used to provoke a pogrom.

The bulk of the story details Yakov's more than two years in prison, most of this time in solitary confinement. The machinery of the state is trying to break him down — guards, prison officials, state attorneys, above all the secret police. However, the investigating magistrate is convinced Yakov is being framed, both by the murdered boy's depraved mother and by the state itself, and he gathers evidence for an acquittal. Before long he is himself imprisoned and hangs himself. Through terrible deprivation, degradation, and pain, Yakov refuses to confess. This section of the story is perhaps overextended. Of necessity, it recalls all the other accounts of political imprisonment and torture with which the literature of our century is graced, from Alexander Berkman's autobiographical "Prison Memoirs of an Anarchist" through Koestler's half-journalistic "Darkness at Noon" to Orwell's fantastic "1984" and the recent "Lazarus" by James Hartenfels. Malamud's version stands up to the best of them; but even at its best, the genre is literarily thin, the theme now nearly exhausted; if "The Fixer" were not so well told, this part would invite a good deal of skipping.

Legally, Yakov cannot be helped until he is indicted, and his persecutors delay the indictment intolerably. When it becomes clear that he will die before breaking (they do not use the extremest forms of torture), a public indictment is arranged. Meanwhile, the Jews of Kiev have hired a lawyer—a former anti-Semite—for the defense. The book closes with Yakov riding in a police carriage through crowd-lined streets, on his way to the court where he will be indicted, very likely convicted — though perhaps acquitted. At the least, evidence in support of his innocence will be publicly presented; all who are not blind with anti-Semitism will know the trial is itself a crime.

We have seen Yakov offend the law (pretending to be a Christian and living in a proscribed section of Kiev) in full knowledge that he is doing so; he is punished by men and the state; his prolonged suffering cannot be taken as an atonement for sin. Yet Malamud tells

Yakov's story so well that he obliges us to a play of reflection on some ultimate matters — justice, freedom, power, the law. He does this both by the very structure of the story and also by authorial nudges. "Freedom exists in the cracks of the state," says a Jew who thinks Yakov may win. And on the last page, Yakov thinks: "One thing I've learned, there's no such thing as an unpolitical man, especially a Jew. You can't be one without the other, that's clear enough." In both places, as in many others, the character is almost blatantly speaking for the author.

But this is not an allegory, this equaling that. The story is dense with local history: such things really happened in Russia in those years. Moreover, it casts light upon a number of matters which are neither narrative particularities nor ultimate abstractions: the nature of modern anti-Semitism; how politics swells as religion shrinks; how the ideal of individualism is conditioned by the reality of politics; why secret police are so reactionary; the need for decent men both to take political action and also to oppose governmental efficiency; Nazi Germany; white America . . .

"Jewishness," thank God, is not one of the issues in the story. "Jewishness" in a lot of recent American fiction seems to be neither Judaism nor Jewry, neither a definable religion nor an historical people, but a vague quality pretending to mystical virtue but delivering little more than sentimental smugness —tradition deteriorated into props. As presented by many writers, especially by Malamud in his previous books, "Jewishness" has become what is left when Jews are no longer sure who chose them or for what (though they agree it has something to do with unjust persecution and a lot to do with suffering) but continue nevertheless to act as though they have been chosen for a superior destiny. One quality that survives intact is the famous Jewish humor, verbal, self-deprecating, aggressive, understating, oblique; this irony serves the needs of anxiety and ambivalence now as well as it used to serve the mortal dread that generated it.

In "the Fixer" there are Jews but not this sentimental "Jewishness," and they are Jews in the way of the actual world. Yakov is a Jew because he is born one and everybody agrees he is one, and his attitude toward being a Jew is that it is a nuisance which he'd like to be shed of but which, being stuck with it, he had better make the

best of—like actual Jews who are non-believers. Malamud does not make him seem in some inexplicable fashion persecuted because he is better, or better because he is persecuted. Yakov is a good man, but, from what we learn, no better than the investigating magistrate. The deputy warden is a vile man, but no viler than a Jewish prisoner who to serve himself bears false witness against Yakov.

And, very wisely, Malamud reminds us of how Spinoza's fellow-Jews persecuted him, that gentle, humane man, and cast him out for a scapegoat. Anti-Semitism in the book is a social madness which encourages ordinary sane people to accede to the dreadful acts of brutal sane people; so does anti-Semitism do this in the actual world. In sum, Malamud does not attempt the impossible task of identifying "Jewishness," nor does he use it for ambiguous ends. "The Fixer" is not a Jewish story primarily, but a political story, ultimately about all men.

It is not a psychological novel: it does not set out to illuminate the obscure workings of certain characters' minds, and Yakov, whom we know much the best, is a normal man. It is not an esthetic novel, dazzling the reader with form and surface. But to the extent that it forces one to contemplate some ultimate matters, it transcends the political and becomes philosophical or metaphysical. Metaphysically, it has a weakness.

THE story ends on a note of hope—but where does the hope come from? Yakov's moral strength in resisting his evil enemies could quite plausibly have led him to stoic resignation. For a long stretch, he has no external reason to think that the injustice done him will ever be remedied or even known, and only the vaguest reason to hope that he will be so much as legally indicted. It is true that in Russia historically there was reason for some minimal hope for a victim in his plight. But Malamud keeps this actual cause for hope out of the story for so long after the death of the investigating magistrate that when he reintroduces it toward the end, it functions almost like a *deus ex machina*; it is in this last section of the novel that Malamud begins to "teach" the reader too much. .

For much of the story, Yakov is stripped and pressed for none but a destructive end—despairing madness, honorable suicide, unjust execution. Any hope of a political deliverance pales before a doom as bitter as his. The emotions and expectations aroused in the reader are too ferocious to be assuaged, much less satisfied, by due process of law; for they are outside the law, above any statutes or courts. Malamud has not finished tragically the tragic story he was telling. Maybe he has two fine stories to tell, one political, the other metaphysical. Maybe the political and metaphysical are two aspects of his one supreme story. In any case, at the end of "The Fixer" he lets the two modes get in each other's way. If our only hope for redemption in this world is through political means, we have no hope; metaphysically, at the deepest passional level, this is what the story means, though not what it says on the surface.

September 4, 1966

# Literature as a Necessity of Life

By ALFRED KAZIN

EVERY now and then I meet people — they tend to be physicists, psychiatrists, theologians — who are well read in English and European literature, well read in a thoroughly cultivated, old-fashioned way, who have managed this steadily from childhood while perfecting special knowledge of a wholly different field. These people don't know what it means to major in English, for they have grown up with literature as one of the many traditions that people used to grow up with.

Universities, too, used to be this old-fashioned. Until well into the 19th century, there was no special chair for English literature at Oxford or Cambridge. Literature was classical literature, the great tradition of Greece and Rome which was supposed to have descended from the great tragedians, poets, moralists, rhetoricians and sages, right down to the latest British Prime Minister — Gladstone still translated Homer and could still put down a critic in Parliament with a quotation from Horace. There was a tradition — classical, Christian, humanist, aristocratic — that embodied the *humanitas* of Christian Europe as against those outsiders from Asia whom the Greeks had called barbarians.

This tradition was founded on the metaphysics of Plato, on the truth of Christian revelation, on the Renaissance code of the gentleman, on theology as the queen of the sciences. In the days when science was still called natural philosophy, the proper study of man was man, which meant moral philosophy — questions of value that depended on the right interpretation, in some immediate human context, of the great tradition. Because there was a great tradition, literature in the universities meant the preservation and transmission of classical literature—and this included classical politics, history, philosophy and ethics as well as tragedy, epic and lyric.

There was no need for courses in Shakespeare when Shakespeare, whose religious views were ambiguous anyway, could be read for oneself, seen in the playhouse, enjoyed in private precisely because he was so much more robust and bawdy than Cicero. Like the contemporary physicist or psychiatrist who reads great novels for pleasure, 19th-century statesmen, bishops, scientists, and political revolutionaries found the great books simply necessary. Maxim Gorky says that in 1919, amid the frightful cold and hunger of war Communism, he found Lenin in the Kremlin reading "War and Peace." One remembers the devotion of Marx to Balzac, of Freud to Dostoevsky, as one remembers John Quincy Adams translating German Romantic poems, Lincoln shakenly quoting from "Macbeth" when he had a vision of his end. Even General de Gaulle, whose family sponsors a Victorianism of official taste that is one of the many reversals that the French have had to bear, wittily quoted Villon when one of his ministers spoke of censoring Sartre.

There are still people, there used to be many more such people, to whom literature is familiar and necessary, a personal tradition in the van of a still greater tradition. To these people, literature, among other virtues, embodies the great past; it is the storybook of human experience; through its past move forever, as in the other-world of Dante, the great heroes, thinkers, sages, saints and villains.

Recall how absurd the teaching of one's own literature once seemed to the best literary scholars, to cultivated people generally. Compare that confidence with the extraordinary effort and concern that we now put into the teaching of modern literature, American literature, contemporary literature, freshman composition, public speaking, remedial reading, elementary grammar. Put into the picture, too, the extraordinary number of people, extremely intelligent, highly competent, perfectly civil and humane, to whom great literature means absolutely nothing, who manage to get along without Shakespeare and Tolstoy. When Napoleon asked Pierre Laplace how God figured in his theory of the universe, the great astronomer replied that he had no need of that hypothesis. There are now many intelligent people, active in the professions and sciences, who have no need of imaginative literature.

Not for them the raptures of Lenin before "War and Peace," the emotion Lincoln displayed at a single speech from "Macbeth," the shudder of awe that Goethe thought man's deepest experience and that Robert Oppenheimer felt one morning in 1944, in the New Mexican desert, when he saw the first atom bomb explode. So far as the world's rulers, everywhere, are concerned, Shake-

MR. KAZIN, critic and teacher, is the author most recently of "Starting Out in the Thirties."

speare *was* Bacon and Bacon Shakespeare.

There was a time in the early twenties when young Communists in Russia gave up smoking so that Tolstoy could be printed on cigarette paper, but when Andrey Sinyavsky and Yuri Daniel were sentenced to hard labor for the crime of sending their honest stories and essays where they could be published, most Russians, it is safe to say, were as unconcerned as most Americans are unconcerned when the poet Robert Lowell declines an invitation to read at the White House as his way of protesting our part in Vietnam.

Literature, which used to be the queen of the arts, is, so far as many people now are concerned, simply not where the world's wisdom and experience, and above all its future, are felt to lie.

Yet English departments, that modern invention, seem to get bigger and busier all the time, to take in more and more periods, approaches, writers, and even writers-as-teachers. How misleading all laments over the past can be. The past is so much our business that it cannot help obstructing our view of our own situation. This is in point of fact the most revolutionary era in recorded history, the most thoroughgoing transformation of established habits of living and thinking that has ever been known. It is not possible, it is not meaningful, that the pleasure that certain aristocratic politicians in England took in Homer ninety years ago should be a criticism of the overpoweringly dynamic society and fiercely democratic aspirations by which many of us live.

I N the days when Gladstone translated Homer for his own pleasure, a great portion of the British common people lived in squalor and ignorance, and children could still be hanged for petty thievery. In 19th-century Russia, the sum total of oppression and misery was in such contrast to the imaginative achievements of a few aristocrats who wrote novels that the greatest talent and most powerful conscience among these aristocrats, Tolstoy, could not bear the disparity and tried as desperately as any saint ever did to convert men to charity by the force of his own example. One needn't, perhaps, go as far as that marvelously gifted writer, Jean-Paul Sartre, who says that literature is insignificant now, so long as it does not affect the hunger and humiliation suffered by millions of people in Asia, Africa and Latin America. But the greatest moral fact of our time *is* our awareness that everybody counts, that life could surely be better for millions of people whose existence did not matter to the rest of us just twenty years ago.

By contrast with so much reme-

dial social suffering, the culture offered by literature can be very superficial indeed. If we ask the vital question of what literature does *for* us, how it changes us, how it uplifts and sustains and unites us, what is the *use* of so much reading, how it advances us in knowledge and sympathy and moral consciousness — such claims for literature were made by Shelley and Keats and Matthew Arnold with the highest confidence — then we have to say, thinking of all too many examples, that literature is often no use to those who know it most intimately and who know most about it.

Many a German professor who was moved by the perfection of a Rilke sonnet had no feeling for the many so-called inferior beings whom his countrymen slaughtered in their racial pride. It is my experience of people skilled in literature, either as writers or scholars, that professional concern with literature is by no means a guarantee of unusual intelligence or moral imagination; literature for them is professional, a skill as technical and self-sufficient as any other — especially for those who possess this skill.

Yet no matter how much one insists on the autonomy of literature, one knows that this is only a half-truth, the truth about literature seen from the side of the creator or the specialist, not from the broad response to literature made by human experience through the ages. For when we ask why there have always been scientists to whom literature is of the highest importance, why Darwin found his consolation in good novels, why so many of the world's greatest thinkers have felt, as Freud did about Dostoevsky, that before literary genius analysis lays down its arms, we recognize that, until our day, great literature never *had* to make any claim for itself.

To all educated people, which meant people with a sense of history, literature was the word, the sacred word of all great tradition — religious, philosophic, moral and scientific. Great literature was mimesis and poesis — it was the image of life, the image of human action and, as Coleridge said, of the soul in activity. It was the making of a thing of beauty, evident and sufficient unto itself, that afforded man, in his fullest esthetic capacity, a sense of sublimity, of elevation, of the highest truth captured in the greatest possible enjoyment. Matthew Arnold, on his journeys as a school inspector, would read over to himself in his pocket diary, as from a breviary, the famous quotations he had collected from Homer and Sophocles and Dante — perfectly sure that we needs must know the best that has been thought and said in the world.

Arnold was just as aware as we are today that science was progressing by leaps and bounds, where literature, it may be said, has no need to progress, for it is concerned with the permanent elements in human nature, with what Faulkner at Stockholm was to call "the problems of the human heart in conflict with itself . . . the old universal truths lacking which any story is ephemeral and doomed — love and honor and pity and pride and compassion and sacrifice . . . ." But Arnold still believed that Europe represented a great humanist tradition, that even when supernaturalism succumbed to skepticism, the memory of Europe's tradition, embodied in its greatest works of literature, would serve as a consolation, a mediator of the many single facts being discovered by science. The thoughtful individual would always possess literature as his key to the great tradition. Arnold called his quotations touchstones.

The great tradition no longer exists. It is because the greatest experience of all contemporaries, more than the anguished cries for social justice of the oppressed, is some sense of absurdity involved in the almost complete de-sacralizing of all intellectual activity, that our students now turn so eagerly to humanities and great books courses, to those 19th-century novels that people used to read for themselves. It is because literature is not part of their tradition, had not entered into their lives before they came to college, that our students have to be told what literature is and why great literature is great.

It is because the question of questions — what is our destiny, how we shall think of our own death — has never been more open than it is now that our students encounter with astonishment, with rapture, with unconscious gratitude, and who knows with how much unconscious resentment, the dialectic of Plato, the sublime certainty of Moses and Jesus, the vision of Dante, the Heaven and Hell of Milton, the torrents of language in Shakespeare, the penetration of Pascal, the irony of Jane Austen, the revolutionary passion of Blake. Intellectually and spiritually, our students do not know that the wheel has been invented, and try to do it themselves. That is how deprived they are — and how clever.

Yet everyone of good sense recognizes that culture in the old sense, the culture founded on literature, expressed the limited aspiration of a very small group of people. Hence the teacher of literature in America, talking to the brightest but most disbelieving generation that ever was, has to introduce his students to Satan, Jonah, Elijah, Agamemnon, Aeneas, Ulysses, Falstaff, even Huckleberry Finn; and sometimes,

so eager are we now to try *anything* that will get students to recognize their share of common humanity, to Holden Caulfield, Seymour Glass and the salesman who had a death in Arthur Miller. . . .

In the face of this extraordinary ignorance and this extraordinary eagerness, of so much carrot and so little stick, so many moral bribes and cajolings, one can, of course, speak loftily about inadequate training at home and the dangers of mass education. But speaking as someone whose own culture is entirely literary-historical, I would ask: how *can* our democratic society find self-evident the great tradition founded on the exquisite perceptions of a few? And, above all, how is it possible, at a time when every crucial social, intellectual and political experience diminishes the intellectual authority of religion, to suppose that the great tradition is self-evident to students who know only too well how utilitarian their education must be, and who are being pushed and harried so that they will not be left behind in the terrible race for their own and the national advantage?

This is where modern literature comes into our curriculum — and literary criticism as a way of articulating values. There was a time when teachers limited English literature to dead authors: the limits of investigation for scholars were vaguely fixed at 1914, when all late Victorians conveniently expired. The assumption, then, was that behind the steady and logical development of English literature ran one increasing purpose; contemporary literature, which one read for oneself, would no doubt some day be added to this tradition.

But the particular mark of the greatest modern literature is that it sees man as unaided—"a stranger and afraid," said A. E. Housman "in a world I never made" — face to face with what Conrad in "Heart of Darkness" called "the horror," and in "Lord Jim," the "destructive element." The great thing about modern literature — one sees its beginnings at the end of the 18th century, that seedtime of revolutions — is the attempt to put man

himself, his real self, his creative nature, squarely into his imaginative picture

of the world—to have him confront his destiny, unaided and even defenseless as he is, and so give his culture, which he alone makes, the strength now exerted by his fear of death.

People who are easily dismayed by change, who do not see man in a long enough perspective, often think of modern and contemporary literature as nihilistic. But there are always fewer nihilists around than one thinks, and in literature they are especially rare; it requires an original mind, like Nietzsche's, even to conceive of a fundamental heresy in man's spiritual orientation. The great 20th-century writers, like T. S. Eliot, who naturally began their careers by trying new forms, now seem to us, as thinkers, wholly traditional. But what no one who knows Eliot's poetry and critcism can miss is the extraordinary effort that this man put into re-establishing the literary tradition and the moral insights of the church when the unity of the continent and the integrity of the past had been destroyed in man's minds by the horrors of 1914-18.

So in our day, remembering the thirty million dead of the Second World War, the savage despotism that now rules more than half the world, the powerlessness and the increasing sense of nemesis about the Third World War that sensitive people must feel about the drift of affairs in our own country, one looks to the works of Robert Graves, Evelyn Waugh, E. M. Forster, William Faulkner, Ernest Hemingway, John Osborne, J. D. Salinger, Robert Lowell, James Baldwin, Edmund Wilson—as to the work of Albert Camus, Jean-Paul Sartre, Colette, François Mauriac, Boris Pasternak — to find again the defense of man, man in the full integrity of his personal experience and his complex human nature, man who creates reality as much as he perceives it.

Everything in our society just

now emphasizes the conceptual, abstract, manipulative and even anxious side of man. But only in modern literature, in the courageous novels and stories, plays and essays of all our contemporaries in spirit, is justice done to what is not, after all, always mediatable by reason— to what is unknown perhaps because it is unknowable and even irrational—to that which belongs to man's dream life, to his inner life, to the buried life, as Matthew Arnold called it, he possesses in imagination—

*But often, in the world's most crowded streets,*
*But often, in the din of strife,*
*There rises an unspeakable desire*
*After the knowledge of our buried life;*
*A thirst to spend our fire and restless force*
*In tracking out our true, original course;*
*A longing to inquire*
*Into the mystery of this heart which beats*
*So wild, so deep in us — to know*
*Whence our lives come and where they go.*
*And many a man in his own breast then delves,*
*But deep enough, alas! none ever mines.*
*And we have been on many thousand lines,*
*And we have shown, on each, spirit and power;*
*But hardly have we, for one little hour,*
*Been on our own line, have we been ourselves—*

Only in literature can man express the full paradox of his condition, the urgency of his private symbols—and above all else, the directness, the uniqueness, the concreteness of his being man, *this* man, and not any one else. As against the many empty claims to knowledge that fill the air, the poet can say, with E. E. Cummings—

*when skies are hanged and oceans drowned,*
*the single secret still will be man.*

July 30, 1967

## Master of Modern Plain

RANDALL JARRELL, 1914-1965. Edited by Robert Lowell, Peter Taylor and Robert Penn Warren. 308 pp. New York: Farrar, Straus & Giroux. $6.50.

By JULIAN MOYNAHAN

THE poet and critic Randall Jarrell, who was killed by an automobile while walking along a highway in 1965, belonged to the

generation of American poets—that of Delmore Schwartz, Robert Lowell, Karl Shapiro, Richard Eberhart, John Berryman, Elizabeth Bishop and Howard Nemerov—which met the Second World War head-on. Jarrell had been a flier, and his poems about the men in the Flying Fortresses, killing and dying "six miles from earth" and "under glass" are

among the best in English that that war evoked. Though he ended violently, his most recent published verse, to be found in "The Lost World" (1965), is quite out of keeping with the current fashion for poetry of extreme situations, harsh confession and "acting out."

Through the operation of a sort of Proustian involuntary memory, the speaker recovers his child self and its enchanted milieu—a residential neighborhood near the big studios of

Hollywood during the 1920's. According to Samuel Beckett's analysis of Proustian memory, "it restores not merely the past object, but the Lazarus that it charmed or tortured," intact, liberated from time, real, and suffused with being. Beckett also mentions that we gain access to our lost worlds and selves through suffering; but Jarrell, who was never one to wear his heart on his sleeve in his verse, speaks mainly of the wonder of a total recovery of experiences assumed to have been totally eroded by time.

Jarrell's best poetry is about war, memory, what used to be called "natural magic" and about women. Critics have noticed his fascination with the mythological and folk theme of metamorphosis; and Karl Shapiro, in the volume at hand, remarks that Jarrell was the "one poet of my generation who made an art of American speech as it is, who advanced beyond Frost in using ... the actual rhythms of our speech."

In keeping with this tonality, Jarrell's females are shown in the very midst of quotidian reality: the aging woman at the supermarket who seeks to transform her life by purchasing Joy and All; the dull girl in the college library slumbering over her home-ec textbook. Another lady shopper regrets plaintively the changes that time brings:

> When I was young and miserable and pretty
> And poor, I'd wish
> What all girls wish: to have a husband,
> A house and children. Now that I'm old, my wish
> Is womanish:
> That the boy putting groceries in my car
> See me.

Yet the poet's sense of the magical can erupt in the midst of the quotidian to change the pathetic and banal into the marvelous. He sees the library girl finally as the Corn Queen dreaming of her Spring King, and the dreary Government worker watching the caged animals in his finest poem, "The Woman at the Washington Zoo," comes at last to this:

> Vulture,
> When you come for the white rat that the foxes left,
> Take off the red helmet of your head, the black
> Wings that have shadowed me, and step to me as man:
> The wild brother at whose feet the white wolves fawn,
> To whose hand of power the great lioness
> Stalks, purring . . . .
>           You know what I was,
> You see what I am: change me, change me!

"Randall Jarrell, 1914-1965" is composed of tributes, memoirs and reviews of Jarrell's works; it is arranged alphabetically and designed to draw the portrait of a literary genius who was, in addition to being a poet, a great or near-great critic of modern poetry, the author of a clever anti-academic academic novel ("Pictures from an Institution") and of several superb children's books (including, unforgettably, "The Bat-Poet"), a translator of German fairy tales and of Goethe, and one of the unquestionably great teachers of literature and writing, in and out of the classroom, during the past 25 years.

Allen Tate and John Crowe Ransom, who had taught him at Vanderbilt and Kenyon College, are represented in the volume, along with Hannah Arendt, who tried to persuade Jarrell to learn more German, and Marianne Moore, who contributes a brief, penetrating analysis of his poetic craftsmanship. Denis Donoghue and Sister M. Bernetta Quinn offer comprehensive studies of his poetry, while Karl Shapiro and Alfred Kazin, who both have deep reservations about the contemporary alliance of the arts with educational institutions, Government and the foundations, raise the question of whether Jarrell was sufficiently arrogant and self-protective about his poetic gifts to reach the ultimate heights of achievement. The book ends with a moving reminiscence of their last years together by his wife, and with a tender, playful love poem to her that remained unpublished at his death.

The editors, wisely I think, attempt no final assessment of his work. At his best, Jarrell was a great master of the modern plain style, the style which in poets like Frost, Hardy and Philip Larkin (Jarrell's favorite younger English poet) is used to connect the vicissitudes of ordinary experience with modes of primary feeling which move deep down within, and between, all of us. This kind of writing can be done well at any age: think of Hardy's perfect poems to his dead wife, written in his seventies—and it is very terrible that Jarrell should have been silenced. But he did leave a great deal of accomplished work for us, and the young poets, to go on with.

MR. MOYNAHAN, author of a critical study of D. H. Lawrence, is professor of English at Rutgers.

January 3, 1967

---

# Portnoy's Complaint

*By Philip Roth.*
*274 pp. New York: Random House.*
*$6.95.*

### By JOSH GREENFELD

Guilt-edged insecurity is far more important when it comes to the making—and unmaking—of an American Jew than, say, chicken soup or chopped liver. For guilt is as traditionally American as Thanksgiving Day pumpkin pie and, at the same time, on native grounds as far as Jews are concerned: it was the Jews who originated that mother lode of guilt, the theological concept of original sin; it was a Jew who developed psychoanalysis, that clinical faith based on a belief in the transferability and negotiability of long-term debts and credits in guilt.

So, not surprisingly, a special blend of guilt-power usually fuels the American-Jewish character in fiction, sends him soaring to his manic highs and plummeting to his abject lows. Whether it is Salinger's Seymour or Bellow's Herzog or Malamud's Assistant (who, in fact, becomes a Jew just because of his guilt), almost formula-like the American-Jewish hero goes forth to confront the twisted root-causes of his guilt—only to flood

Mr. Greenfeld, a freelance writer, is the author of "O For a Master of Magic," a novel.

*Philip Roth.*

261

his engine with the paralyzing second thoughts of the self-tormenting neurotic, the fringe-level psychotic. For unable to live with his guilt, he is also unable to conceive of living without it.

But while the American-Jewish novelist has thus had a subject, though he has been searching diligently, questing imaginatively, he has lacked an ideal form. Now, with "Portnoy's Complaint," Philip Roth ("Goodbye Columbus," "Letting Go," "When She Was Good") has finally come up with the existentially quintessential form for any American-Jewish tale bearing—or baring —guilt. He has done so by simply but brilliantly casting his American Jewish hero —so obviously long in need of therapy—upon a psychoanalyst's couch (the current American-Jewish equivalent of the confessional box) and allowed him to rant and rave and rend himself there. The result is not only one of those bullseye hits in the ever-darkening field of humor, a novel that is playfully and painfully moving, but also a work that is certainly catholic in appeal, potentially monumental in effect—and, perhaps more important, a deliciously funny book, absurd and exuberant, wild and uproarious.

Since substantial chunks of "Portnoy's Complaint"— about two-thirds all together— have previously appeared in Esquire, Partisan Review, and New American Review, almost everyone should know by now that Alexander Portnoy, Roth's analysand, is both the worldly 33-year-old Assistant Commissioner of Human Opportunity for the City of New York *(sic)* and still another *heimishe* American-Jewish son and neverman, the victim of an endless childhood eternally wandering toward adulthood (sick). But because from so perfectly follows function Roth manages to evoke new whines out of all the old battles. And though his plot line at first seems as circuitous as a string of wasted 50-minute hours, soon it is evident that every curlicue is a real clue, and the story finally

ties together with the epiphanous neatness of any patient's last gestalt.

"These people are unbelievable!" Portnoy complains of his parents early on to the ever-present, always silent analyst. "These two are the outstanding producers and packagers of guilt in our time!" And he proceeds to recap in shticks and bits his urban eat-in-kitchen upbringing by them (The very first distinction I learned . . . was not night and day or hot and cold, but *goyishe* and Jewish . . . Jew Jew Jew Jew Jew Jew! It is coming out of my ears already, the saga of the suffering Jew! *I happen also to be a human being!*"

Yet for all his railing against his parents—his depiction of that old sentimental favorite, the Jewish Mother, as not only a downright guilt-giver but also a deft castrater; his caricature of her ever-popular silent-as-an-analyst partner, the Jewish, father, as an uptight insurance agent and eunuch—Portnoy is still so compulsively ensnarled in the web of his relationship to them that at one moment he whimpers imploringly: "At this late date! Doctor, what should I rid myself of, tell me, the hatred . . . or the love?" Yet at almost the very next moment he beleats forth impassionedly all of his hang-up anguish: "Doctor Spielvogel, this is my life, my only life, and I'm living it in the middle of a Jewish joke! I am the son in the Jewish joke—only it ain't no joke! Please, who crippled us like this? Who made us so morbid and weak? Why, why are they screaming still, 'Watch out! Don't do it! Alex—no!' and why, alone on my bed in New York, why am I still hopelessly beating my meat?"

On one level, since few writers are as hip as Roth to the nuances of middle-class neuroses or as turned in with such a show-biz sense of mimicry to the diction of the American Jewish milieu, Portnoy's past comes off as a kind of universal pop boyhood of the forties, with a Jewish accent and comic twist. On another level, since few writers are as explicit as Roth and given the justifiable

mechanics implicit in a patient-analyst situation, Portnoy's adolescence s revealed with a rare candor: not only is his gnawing special sense of Jewishness—and guilt—completely detailed, but also his compulsive nonstop masturbatory rites of puberty and his first vain attempts to enter the adult world of heterosexuality are fully annotated.

As Portnoy matures—at least chronologically—he desperately wants to tear off his American-Jewish hair shirt, to let go, to live a life without mother and father, a sex life free and unfettered, without guilt, to be bad in other words ("Because to be bad, Mother," he apostrophizes, "that's the real struggle: to be bad—and enjoy it! That's what makes men of us boys, Mother . . . LET'S PUT THE ID BACK IN YID!"). But instead he finds— or his analyst does—that "neither fantasy nor act issues in genuine sexual gratifications but rather in overriding feelings of shame and the dread of retribution, particularly in the form of castration."

However, if sexually stunted, psychologically doomed, Portnoy still makes a bravura run for it. His adventures—and misadventures—involve a penchant for unscenely masturbation, a fetish for untimely fellatio, and even the staging of a mini-orgy in Rome. He also manages to squeeze by a succession of picturesque girl friends whose nicknames are Jonsonian in their humor: The Pumpkin: a full-bodied but flat-chested Middle Westerner, "The first of Antioch nymphs to go barefoot to class"; The Pilgrim: *"Supergoy . . .* one hundred and fourteen pounds of Republican refinement, and the pertest pair of nipples in all New England"; and the *pièce de résistance,* The Monkey, who turns out to be more like a sexual lioness.

But what finally drives Portnoy to the analyst's couch is a traumatic sojourn in the State of Israel ("Hey, here we're the WASPS!"). For there he meets his *bête noire,* his undoer, a *Jewish Pumpkin,* physically reminiscent of his mother,

whom he tries to ravage only to be rendered impotent in the process ("Doctor, maybe other patients dream—with me, *everything happens.* I have a life without latent content. The dream thing *happens!* Doctor! *I couldn't get it up in the State of Israel!* How's that for symbolism, *bubi?"*)

And the novel ends at a beginning, with the straight-man analyst speaking his only line: "So. Now vee ,may perhaps to begin. Yes?"

I feel very much the same way about the ultimate significance of this much ballyhooed, eagerly awaited novel. If viewed as the apotheosis of a genre, the culmination of a fictional quest—and it is, I think, as I've tried to say, the very novel that every American-Jewish writer has been trying to write in one guise or another since the end of World War II—then it may very well be what is called a masterpiece—but so what? It could still also be nothing more than a cul-de-sac.

However, if by this definitive outpouring into a definitive vessel of a recurring theme, thus guilt (screaming, strident, hysterical, hyperbolic, hyperthyroid) has been successfully expatiated, and future American-Jewish novels will be all the quieter, subtler, more reflective and reasoned because of it, then this novel can truly be judged a milestone. For guilt in esthetic terms is every bit as debilitating and destructive and time-consuming a hang-up as in behavioral terms. And it is only by moving out beyond guilt, to the problems and turf implicit in adult independence and sovereignty, that any literature—or genre—can hope to begin to approach maturity.

But meanwhile, whether a deadend auto-da-fé or open-end bar mitzvah peroration (and not just "Today I am a penis") on the road to cultural manhood—read "Portnoy's Complaint." And don't feel the least bit guilty about enjoying it thoroughly: I know not since "Catcher in the Rye" have I read an American novel with such pleasure. ∎

February 23, 1969

# Poetry in the Sixties–Long Live Blake! Down With Donne!

### By LOUIS SIMPSON

In the 1960's poetry got off the page and onto the platform.

In the previous decade poetry, together with other forms of self-expression and political expression, had been mute. Dylan Thomas made his American tours and boomed out his lyrics, and audiences were stunned; but Thomas disappeared, and again there was silence in the land. Then, in the late fifties, Allen Ginsberg did his readings of "Howl," and the fashion of listening to poetry was upon us.

It made a considerable difference. For years, under the New Criticism, we had been told that a poem was a construction rather than a performance. The perfect poem talked to itself, and the reader's reactions to it were a kind of eavesdropping. The poem was born of tension and irony, and consequently, in a kind of rage, it "disdained to have parents." If you were fond of a poem—watch out! This was probably the Affective Fallacy. If you were curious about the man who wrote it, or the "meaning" of the poem—watch out again! This was the Intentional Fallacy.

Being a poet in those days, or a reader of poetry—but were there any readers?—was like being in Hell. Every step was surrounded with Thou Shalt Not's, and the only guide through the difficult task of reading a poem was the critic, an Empson, Richards or Blackmur, who might keep you from making a sentimental fool of yourself.

As for reading poetry aloud—it was understood that, as the poem was a self-contained object, the sound of the human voice had little to do with it. If you were compelled through some unfortunate circumstance to read a poem aloud, the only way was to read it as flatly as possible. To give the words any sort of expression would be cheating. For example, there is the recording of Elizabeth Bishop reading her poem "The Fish"; in speaking the final words, "rainbow, rainbow, rainbow!" she manages to suggest that seeing colors has been a distasteful experience.

It was Ginsberg almost single-handed who changed things. This is giving a great deal of credit to one man, and I suppose that my crediting Ginsberg with so much will be resented, for instance, in San Francisco, where poets had been reading in coffee-shops before he came along. But it is one thing to read foolish poems aloud, and another to read poems such as "Sunflower Sutra"

**Mr. Simpson** teaches at the State University of New York at Stony Brook. His "At the End of the Open Road" received the 1964 Pulitzer Prize for poetry.

and "America." Or "Kaddish" (1961).

*. . . She reads the Bible, thinks beautiful thoughts all days.*

*'Yesterday I saw God. What did he look like? Well, in the afternoon I climbed up a ladder—he has a cheap cabin in the country, like Monroe, NY the chicken farms in the wood. He was a lonely old man with a white beard.*

*'I cooked supper for him. I made him a nice supper—lentil soup, vegetables, bread & butter — miltz — he sat down at the table and ate, he was sad.*

*'I told him, Look at all those fightings and killings down there. What's the matter? Why don't you put a stop to it?*

*'I try, he said—That's all he could do, he looked tired. He's a bachelor so long, and he likes lentil soup.'*

Ginsberg was humorous; and he'd learned — from William Carlos Williams — to write of common American things in plain language. Ginsberg's original contribution, however, was a note of hysteria that hit the taste of the young exactly. He spoke for the spiritually disenfranchised, numbers of wretched young people from middle-class homes, who had grown up after World War II—weeds of an affluent society. They flocked to his readings; they had found someone who spoke aloud for them; more than this, someone who gave them a way to live—ragged and bearded—without feeling ashamed, and even with pride. Hemingway created the life-style of the Lost Generation; Ginsberg created that of the Beat. It was a spectacular achievement.

Ginsberg's success brought wider recognition for the writings of his teacher. In the 1960's William Carlos Williams would be the prime model for younger poets. For years Williams had lived a poetic credo that was not fashionable. He had done much of his writing according to the principles of Objectivism, which stated that the poem should be taken from nature—and by nature the Objectivists meant broken bottles and garbage cans, as well as flowers.

The Objectivist poem was an Imagist poem carried one step further. The personality of the author was to be excluded; subjectivity was tolerable only in so far as it reflected a mood of the external world. Poetry was a kind of lens, selecting and concentrating reality, which was external to the mind. Williams derived his thinking from painters of the 30's, Demuth and Sheeler, as well as from his own solitary thoughts in the dismal landscape of New Jersey. His poems were like Sheeler's paintings of gray wood and sandy stone. Williams looked with a depersonalized gaze, not far from insanity, at the objects produced by an industrial, commercial society, which he loathed. By gazing long and hard he compelled himself to love them—or at least, to draw forth their essence. Or, if objects do not have an essence, they are manifestations of America, the great unknown. And he loved America.

*Plaster saints, glass jewels*
*and those apt paper flowers, bafflingly*
*complex—have here*
*their forthright beauty, beside:*

*Things, things unmentionable,*
*the sink with the waste farina in it and*
*lumps of rancid meat, milk-bottle-tops: have*
*here a tranquillity and loveliness . . .*

There were others besides Ginsberg who had learned from Williams. Williams searched for American speech-rhythms and he claimed to have found the "variable foot." Now the Black Mountain poets began to be heard from. They were mad about technique; they had discovered a way for the poet to write verse-lines in the rhythm of his breathing. Charles Olson has explained the way in which Black Mountain poets wrote, but as I cannot understand Olson's prose, I shall quote an explanation of it by Robert Creeley, another member of the school:

"He [Olson] outlines . . . the premise of 'composition by field' (the value of which William Carlos Williams was to emphasize by reprinting it in part in his own 'Autobiography'); and defines a basis for structure in the poem in terms of its 'kinetics' ('the poem itself must, at all points, be a high energy-construct and, at all points, an energy discharge . . .'), the *principle* of its writing (form is never more than an extension of content), and the '*process*' ('ONE PERCEPTION MUST IMMEDIATELY AND DIRECTLY LEAD TO A FURTHER PERCEPTION . . .'). He equally distinguishes between breathing and hearing, as these relate to the line: 'And the line comes (I swear it) from the breath, from the breathing of the man who writes, at that moment that he writes. . . .'"

This was Projective Verse. In coffee-shops all over the country young poets read aloud, breathing hard and pausing significantly at the end of each line, and as some of them had short breaths their poems were long and skinny. There was an owlish solemnity about these proceedings; if you were trapped in a corner and couldn't get out, you would be in for a bad night. Perhaps a theory of any kind is better than no theory at all—for people who must have a theory. But what dreariness, and what a dismal lack of humor!

Next to Williams, Ezra Pound was the master most spoken of. Many of the people who knew that Pound's "Cantos" were sacred had never taken the trouble to read them. But every age has its cant, and Pound is not responsible for the sycophancy of his admirers. There was, indeed, an element in the "Cantos" which, when it was added to the elements derived from Williams, would produce the typical "avant-garde" poem of the 1960's. That is, a poem that would let in the author's opinions of history, myth, anthropology — you name it—as well as describe the visible objects in the poet's pad. Williams himself in "Paterson" had moved away from Objectivism toward a poetry that would include everything that came into his mind; but it was Pound who was the master of the method. The "Cantos" were a stream of consciousness; everything seemed to be happening at once—poetic images, facts, prose documents were jumbled together. To what purpose? Just live in the poem, and don't ask silly questions! The poem is like life itself, "open" and interminable. There is no such thing as form, anyway not as it has been understood, with a beginning, a middle, and an end. The "well-made poem" is dead. Ask not whether a poem is good or bad. Ask, rather, if it is interesting. Anything that comes into the mind of a real poet, i.e., a bard, is interesting.

Long live William Blake! Down with Donne!

The better poets who subscribed to this theory were a lot better than the theory. Robert Duncan and Gary Snyder were better. One reason for their excellence was that, like Ginsberg, they had a sense of humor, and this indeed made their poems interesting. I have just read a new poem by Snyder. It's a funny, curiously touching poem, a mixture of mystical Asian words and realistic descriptions, all subsumed in

an epiphany to Smokey the
    Bear.

*And if anyone is threatened
by advertising, air pollution,
or the police, they should
chant SMOKEY THE BEAR'S
WAR SPELL:
DROWN THEIR BUTTS
CRUSH THEIR BUTTS
DROWN THEIR BUTTS
CRUSH THEIR BUTTS
And SMOKEY THE BEAR will
surely appear to put the enemy
out with his vajra-shovel.*

Ecology, the study of relations between different forms of life and between life and environment, is beginning to be a subject for poems. At the present time a manifesto by poets is going the rounds; it urges the necessity for preventing mankind from exterminating the other species.

The poets I have been talking about were those most admired by younger poets. This is not to say that these were the most widely read poets of the time. For every reader of Ginsberg or Snyder there have been twenty of Rod McKuen. He has sold two million copies. His publishers say that he is the leading poet of the age—just as Jacqueline Susann, by the same measure, is the leading novelist. There is a beautiful simplicity about judging literature by the number of books sold. As Dr. Johnson said, a man is seldom so innocently employed as when he is making money, and Rod McKuen is certainly innocent.

Come with me, then, and *"Listen to the Warm"*:

*On this Tuesday away from
    you
I wonder if the time will ever
    pass
till we're together
even for a while again.*

*But yesterday you touched me
and we drove to the toll
    beach
and ran in the sand.
Sorry no one could see
how beautifully happy we
    were.*

Well, what's wrong with it? It's simple, it makes lots of people happy. Only an effete intellectual snob would find fault with it.

Right you are. The world is like a sand-pile with lots of nice gooey wet blobs to play with. It's a soda-pop, a weenie-roast, a sticky, marshmallow kiss. The world is the province of Youth.

If only Youth were as happy to be ignorant as middle-aged losers say it should be! But Youth, alas, has brains, and these days Youth is having a pretty hard time. Even if Youth does not read Dante, Youth will learn about life—in the slums or the rice-paddies—and Youth sooner or later will want to have poetry. Not this slop.

Which brings me to poetry and politics. The 1960's were different from previous years in that poets began talking from the platform about political matters. There were poetry readings against the war in Vietnam, and readings of black poetry. Poems were read at meetings to help the children of Biafra, and poems were read during sit-ins.

Some of the poets who read against the war travelled from place to place and exposed themselves to a great deal of discomfort and to some abuse. The names of Galway Kinnell, Robert Bly, Denise Levertov are respected today not only because they are fine poets, but because they have shown qualities of self-sacrifice and courage. It may be said that these qualities, however admirable, have little to do with the quality of poems. I don't agree. In the hands of a poor writer, a cause is likely to produce bad art; he would have produced bad art anyway. But if the writer has intelligence, his political activity is an extension of his awareness, and, if it does not produce masterpieces at once, in the long run it is bound to add to his writing—as will everything he does. Or does *not* do. Many writers have become empty vessels simply because they stopped living with any interest. Eliot's prayer, "Teach us to sit still," is dangerous stuff; to use it properly you had better have, as did Eliot, spiritual resources.

The bad poem about the war, or about the Negro, was bad for the reasons that poems are usually bad; there was a statement, sure enough, but the ideas could have been had from a newspaper, and the subject was not connected to the writer personally. You did not feel that this man was compelled to write this poem and that the poem was therefore original—for anything that a man does out of the necessity of his own unique being must be original.

Among the black poets LeRoi Jones spoke most vehemently for revolutionary attitudes. But there were other poets who had something to say and who were now beginning to be heard, thanks to the waking consciousness of America in regard to the Negro. Robert Hayden, Mari Evans, Dudley Randall and black poets whose works are in anthologies but not yet published in books, were being read seriously for the first time. It made a great difference to black children in schools to be able to read poems by black writers that had something to say to them personally.

Looking back at the poetical-political sixties, what Senator Eugene McCarthy says in "The Year of the People" rings true, and it is so well said that I won't try to paraphrase it:

"As a general rule, I believe that the artist should remain somewhat detached and independent of politics, but when the issues are as crucial as they were in 1968, no citizen, no matter what his vocation or profession may be, can remain completely aloof. It was a year in which artists had to be, as Albert Camus has said, both artists and men even to the point of being prepared to neglect their special work or call-ing in order to involve their person, their time, and their art in the country's problems. 'If we intervene as men,' wrote Camus, 'that experience will have an effect upon our language. And if we are not artists in our language first of all, what sort of artists are we?'

"In 1968, the artists served their land and language well."

I have left till last a discussion of individual poets whose work has struck me as particularly fine, no matter what group they belong to, or no group at all. It all comes down to talent, after all. This has not always been remembered, and in recent years the art of criticism—following the collapse of the New Criticism—has practically ceased to exist. Instead we have had literary politics and polemics. It is easy to know beforehand what attitude The New York Review of Books or Evergreen Review will take toward a poet. The question is not, "What is he?" but "Is he one of us?" Reputations are made, invested in, and upheld. But who cares for poetry? Who pays attention to the individual?

One recent poet and critic has paid attention, and though he has committed some absurdities (for example, he does not consider Robert Duncan or Donald Hall) — yet in "Alone With America" Richard Howard has undertaken to criticize 41 poets for what they are, ignoring what schools they may belong to. Forty-one! There is something ridiculous about such charity. Yet this is a fault on the side of the angels. Time and again Howard is able to find something to praise, and he treats everyone's poem as though it were important. Which, of course, it is—but we have almost forgotten how to think so. Does this book herald the beginning of a new era, when poems will be read instead of being either ballyhooed or ignored? I hope so.

I too have a list, of poets who have recently published excellent books. These poets have one thing in common—they write in free form. I am of Whitman's opinion: "The poetic quality is not marshalled in rhyme or uniformity." When the free-form poem works, it is as wonderfully irregular as a lilac or rose-bush.

First, George Oppen, whose "Of Being Numerous" was awarded a Pulitzer prize. Oppen shows how Pound's "Cantos" can be used as a basis from which to develop. Oppen's language has been stripped clean of references to things outside the poem itself. Yet, as in Pound,
*The context is history
Moving toward the light of the
    conscious*

Reading Oppen I am aware of all that has been excluded by a very discriminating mind in order to arrive at significant life. The mind, moving toward clarity, sheds those matters that are, as Gatsby said, "just personal." As it begins to know itself, the mind moves, and thought is felt as movement, along the line. We experience the life of the mind in its physical reality, the movement of verse:

*What is or is true as*
*Happiness*

*Windows opening on the sea,*
*The green painted railings of*
    *the balcony*
*Against the rock, the bushes*
    *and the sea running*

Unfortunately, as there is not an automatic forward propulsion by meter, poets who write in free form have difficulty sustaining a mood, or train of thought, or narrative. Jim Harrison, author of "Locations," has tackled the problem by writing "suites," longer poems in sections which are really short poems related not by a logical narrative but by association. He has gone to Rilke and Apollinaire for models—and sometimes, most noticeably in "Suite to Fathers," the model sticks out:

*From Duino, beneath the mist,*
*the green is so dark and green*
*it cannot bear itself. . . .*

Harrison writes about landscapes, birds and beasts, a hunter's wandering. His poetry moves heavily, convulsively, as though burrowing through quantities of psychic material —turning it over, sniffing around it. This poet seems determined to experience much and not make up his mind. It is as though he wishes to lose himself in the life he is describing:

*My mouth stuffed up with*
*snow,*
*nothing in me moves,*
*Earth nudges all things this*
*month.*
*I've outgrown this shell*

*I found in a sea of ice—*
*its drunken convolutions—*
*something should call me to*
*another life.*

"Inside the Blood Factory," by Diane Wakoski, has its limitations—one reader spoke to me of her "absence of music"; by music I think he meant the resonance we get from the images of poets who are not so engrossed in their personal lives. Wakoski's poems are confessional, and we have had so many confessions. But there is a difference between Wakoski's confessions and those of other writers; she takes you, in the poem itself, through the experience she is talking about — whereas others just complain about their feelings. Wakoski's poems are a struggle, sometimes gay, sometimes desperate; always there is the hard work of actually thinking on the page.

And last, "The Naomi Poems," by Bill Knott, who publishes under the name Saint-Geraud. Here we have entered a strange world where anything at all may happen. The images are astonishing. Whatever you may think of Knott's poems, they have not been written before by anyone else. This is a passage from "Prose-poem":

*Ringed by starfish gasping for*
*their element, we joined to*
*create ours. All night they in-*
*haled the sweat from thrusting*
*limbs, and lived. Often she cried*
*out: Your hand!—It was a star-*
*fish, caressing her with my low*
*fire.*

This is called "Hair Poem":

*Hair is heaven's water flowing*
*eerily over us*
*Often a woman drifts off down*
*her long hair and is lost*

Poetry such as this strikes me as extending our awareness. And with poets such as these we have come a long way from the timid, silent fifties. ■

December 28, 1969

# The Double Dream of Spring

*By John Ashbery.*
*95 pp. New York:*
*E. P. Dutton & Co*
*$4.95.*

### By DAVID KALSTONE

John Ashbery takes his title, "The Double Dream of Spring," from a painting by de Chirico; and so puts us on warning that we are stepping through the looking glass into those deep perspectives and receding landscapes of the mind. He leads us, once we are prepared to follow, to yearned-for, difficult states, free of casual distraction. "To reduce all this to a small variant,/ To step free at last, miniscule on the gigantic plateau—/ This was our ambition: to be small and clear and free." Sometimes explorers, sometimes pilgrims, the speakers in these poems are certain in varying degrees of being able to shake off the clutter of a world which, wryly phrased, "could not be better."

For Ashbery's purposes the generalizing pronoun becomes a bristling necessity. Everyone else is they: "They are preparing to begin again:/ Problems, new pennant up the flagpole/ In a predicted romance." Sometimes escape is within his grasp; sometimes he rests with the brilliant

**Mr. Kalstone,** who teaches at Rutgers, is the author of "Sidney's Poetry: Contexts and Interpretations.":

clarity of describing what traps us. "Definition of Blue" plays wittily through the cant words of historians and broadcasters— "capitalism," "romanticism," "impetuses" — words whose tripping rhythms drain away in colorless sentences, just as, he suggests, imaginative escape in the modern world depends only upon an "erosion" producing "a kind of dust or exaggerated pumice/ Which fills space and transforms it, becoming a medium/ In which it is possible to recognize oneself."

This comic decay allows us "A portrait, smooth as glass . . . built up out of multiple corrections/ And it has no relation to the space or time in which it was lived." The joke is on us, including the grammatical joke that it is the portrait which lives, fragments of personality out of touch with anything but the mirroring tricks which keep it together; "the blue surroundings drift slowly up and past you/ To realize themselves some day, while you, in this nether world that could not be better/ Waken each morning to the exact value of what you did and said, which remains."

In "Young Man With Letter," Ashbery reminds us of the "phraseology we become." Once again it is the

hardening of life into habit and patterned phrase which he wants us to recognize; the metaphysician's version of "You are what you eat." But here is the surprising course that insight takes within the poem:

*Another feeble, wonderful creature*
*is making the rounds again*
*In this phraseology we become, as*
*clouds like leaves*
*Fashion the internal structure of a*
*season*
*From water into ice. Such an abstract*
*can be*
*Dazed waking of the words with no*
*memory of that happened before,*
*Waiting for the second click. We*
*know them well enough now,*
*Forever, from living into them,*
*tender, frivolous and puzzled*
*And we know that with them we will*
*come out right.*

This is Ashbery at his best, with all his characteristic difficulty, but also with his humor and his lyric gift. That cliché (making the rounds) is coaxed alive by the strange sad comparison with the seasons. Ashbery performs what he then identifies, "dazed waking of the words." eventually "living into them." So, most of the poems in this book perform discoveries, satisfied with nothing merely accidental, nothing less refined than "fables that time invents/ To explain its passing."

I suspect that Ashbery may think of himself as a kind of restorer, removing the varnish and grit from a canvas, or perhaps taking away the canvas entirely, asking us to think the shapes back into the painter's mind. More than any other poet writ-

265

ing now, he sees familiar objects and dimensions *only* as revealing an interior landscape. At that, most of the bric-a-brac is removed, and only the larger landmarks remain. "Spring Day," "Summer," "Evening in the Country," "Rural Objects" — these are his titles, but the suggested countryside and weather is always a way of discovering something else, rearranging "annihilating all that's made." Robbed of their solid properties, the smallest and surest words become part of a new geography, as the world "close" changes when we read from one of

the following lines to the next: "There were others in the forest as close as he/To caring about the silent outcome. . . ."

One can't ignore the difficulty of these poems, deliberately forcing the reader to learn something like a new musical scale. The only way to train for them is to read them, discovering half-way through one of his volumes that you have learned the language. His is a perilous method, demanding that the poet take us with him to the clear regions he describes, or at least convince us —as Ashbery does, not always, but often, in his best poems— that he has been there himself. "The Double Dream of Spring,"

his fourth book of verse, strikes its own special note; it is less opaque, more aware of the melancholy difficulties of withdrawal and of getting the final pleasure from sealing in experience. There are, more than before, glimpses of inevitable failure:

> *—and winter, the twitter*
> *Of cold stars at the pane, that*
> *describes with broad gestures*
> *This state of being that is not*
> *so big after all.*
> *Summer involves going down*
> *as a steep flight of steps*
> *To a narrow ledge over the*
> *water.*

As these last lines remind us, for all his French qualities— some of these poems have been first written in French and translated back to English— Ashbery's are very American poems; they are haunted by the late and great poems of Wallace Stevens, though further in retreat. His ecstasies are often willed and stern, and though it may seem strange to say so, his difficult manner is meant to lead, in its odd sophistication, to something as direct and liberating as the command of Thoreau: "Simplify! Simplify!" ■

July 5, 1970

# *The Way We Write Now*

### By JOHN GARDNER

Everyone seems to be agreed lately that the serious novel in America is going through a change. The realistic novel is dead, one hears; and something exciting is rising from its ashes. I take a dimmer view, but I do think something is happening, and the decline of realism is a superficial part of it. What is happening is that after a period of cynicism, novelists are struggling—for the most part in ways doomed by indifference to novelistic form—to see their way clear to go heroic. Strange new worlds are in, cynicism and despair are out, replaced not by true affirmation but by psychological survival tactics.

Let me begin with some statements of the obvious. American novelists, even Americans by choice like Vladimir Nabokov or Jerzy Kosinski, can never get rid of the qualifying effect of American literary and cultural tradition—that is, the American character—as long as they write to or about Americans. I would say that this means, not so much historically as symbolically: the Transcendentalists, with their cult of the child, Indian or illiterate (Faulkner's Negroes, children, or idiots); "lifelike" speech (the Jewish idiom is as good as Huck Finn's for cutting down soulless sophisticates); and Whitmanish quop by way of form—the optimistic expectation that the book will somehow pull through, like nature. It means childlike faith such as Emerson's, which organizes reality's clutter and smashes through reason's discouraging howevers, but when

John Gardner is author of the novels "Grendel" and "The Wreckage of Agathon," and teaches English at Southern Illinois University.

forced to see facts gives way in a rush to petulant, childish despair like that of Howells or Twain-grown-old. If James and Fitzgerald, and in his own way Melville, got past the blithe and unsustainable innocence that is the heart of the American character, it remained their literary subject, as it remains the subject of their heirs, John Cheever, John Updike and William H. Gass. For Nabokov it's frequently the butt of the joke, as in "Lolita" and "Ada."

Our experience of extremes (happy Emerson, black-hearted Melville, light and dark as simple as virtue and wickedness in a Congressman's election speech) makes all Americans radicals. Our normal view is that if everything isn't terrific, it stinks. Thus American self-doubts about Vietnam, race relations and ecology lead instantly to a conviction that life is unendurable, God is horror, and our wives and children all hate us. So in the sixties black humor came in—the Vonnegut shrug—and nihilism, as in William Burroughs, and smart-mouth satire of the kind third-rate novelists are still turning out, Brock Brower, for instance, in "The Late Great Creature." Where not crushed entirely, the built-in American hunger for audacious affirmation went desperate and kinky, as in Norman Mailer's "An American Dream," which tried to save the fat from the fire by witchcraft. Most critics assumed it was all some kind of metaphor, not yet having heard Mailer's theories on telepathy and the moon.

In the absence of any remotely tenable audacious suggestion (Faulkner, by now, was as dead as Captain Marvel), we began to get by in the late sixties on the merely audiculous, that is to say, the heroics of a strenuously encouraged mouse. It came to be generally understood—partly

because of William Gass's tour-de-force novella "Willie Masters' Lonesome Wife" and his numerous articles (later collected in "Fiction and the Figures of Life")—that though real existence may be senseless and painful, art makes up for it. And art, when the artist is unable to say anything helpful, means style.

Gass's own writing doesn't illustrate his theory. Some of Robert Coover's does, though not his best book, "The Origin of the Brunists." All of John Barth's does. The "reality" of "The Sot-Weed Factor" or of "Giles Goat-Boy" is the words of the novel, nothing else. Giles finds that a librarian is reading the very book he's inside. Every novel is a funhouse, as Barth has it elsewhere, in which the novelist pulls levers and the hayseed reader rides. The themes in Barth are the traditional American themes—there are even moral problems and thrilling solutions. But Barth is not so brazen as to recommend his solutions to humanity (if humanity exists).

The recent cult of style has the splendid effect of making novels more enjoyable, less sludgy; but the assertion that style is life's only value—that style redeems life—is false both to life and to the novel. Gass, in his own novel "Omensetter's Luck," has nothing in his theory to protect him from a too-long middle section that is mostly the verbal acrobatics of an oversophisticated, exhausted character, and nothing to explain why the end of the novel, which involves moral affirmation and a change of heart—a typically American, totally convincing resurgence of innocence—is so profoundly moving.

Similarly, his own comments on the short works collected in "In the Heart of the Heart of the Country" have nothing to do with the moral and poetic power of the stories. "The Pedersen Kid" Gass describes as "an exercise in short sentences." One

watches in vain for the flicker of a smile. Gass isn't joking. He's Huck Finn grown up and teaching philosophy in St. Louis. In another age, an age not embarrassed by audacity, Gass might take pleasure in the fact that his books are moving affirmations, and he might consistently construct his fables around the search for value, rather than around language peaks. As it is, by the luck of good character, he surpasses and contradicts his age and, to a large extent, his theory.

Jerzy Kosinski, another celebrated stylist ("The Painted Bird," "Steps," "Being There") is truer to both. The blood-curdling sketches and story fragments which make up "Steps" have undeniable effect—like falling from a silo and landing on a plow—except for the honest country reader who, not inexcusably, throws away the book. The obsessively dark vision is dedicated "to my father, a mild man" and has an epigraph on self-control from "The Bhagavadgita." In other words, Kosinski isn't imitating reality but making up a world whose only real-life parallel is the life of the damned. Escape to purgatory and ultimate salvation are not, he seems to feel, his business as an artist. His business is not empathy and the analysis of moral and psychological process but strictly appropriate presentation of a morally static surface. His business is "style."

The purity of the experiment is revealing. Where style really is the whole concern, there can be no real drama—how people come to be damned or saved—and no "lesson." Like twelve-tone music, the technique can express only boredom and horror. Granted, boredom and horror are legitimate subjects. What makes Kosinski's triumph suspicious is that, to the disillusioned optimist (Twain too furious and heart-broken to make jokes, or Updike's Skeeter, the outraged idealist who delivers tirades in "Rabbit Redux") "Steps" seems an accurate description of life, whatever dedication and epigraph may hint. The affirmations lie outside the book, which itself supports a gross oversimplification traditional with Americans. Needless to say, the unrelieved blackness readers find in "Steps," though Kosinski may not mean it, is the whole bag of tricks in William Burroughs, who believes every groaned-out word. In "The Ticket That Exploded," style is explicitly a cruel false hope to us soft machines, a thing we must destroy.

The antithesis to the search for salvation through style is the gospel according to Donald Barthelme. He avoids style at any cost, and also avoids psychological or moral analysis, escaping despair by America's oldest, still commonest trick: the childishness and befuddled innocence

of Yankee Doodle, Huck Finn or Holden Caulfield — the childishness (in this case mad) that sneaks past oppressive reason.

"The intellect," said Thoreau, "is a cleaver." In a world whose findings drove Melville half insane, the Transcendentalists' ideal child indefensibly asserted convictions that felt right to basically sentimental and good-hearted, though often fierce and wrong-headed, Americans. In a world where the mechanics of DNA and RNA prove conclusively what Melville could only fear (it's DNA that makes Burroughs so furious) and where our noblest intentions have resulted in what some call genocide, our traditional optimistic feelings are, for some crazy reason, as intense as ever. To say we're wrong is like telling a lion to settle down and be a horse.

Barthelme's crazies can express and validate those romantic feelings, at the same time checking our cocksure tendency to meddle and preach and reform every passing jay. We laugh at his seven psychological dwarfs in "Snow White," since they're lunatics and fools; but their feelings about people and the puzzlement and ultimate wonder of things are exactly our own. It has nothing to do with black comedy—Beckett's "Happy Days," for instance, which angrily laughs at brainless optimism. (Barthelme's characters are not exactly optimists.) Like Ralph Waldo Emerson ("I contradict myself?"), Barthelme's crazies systematically evade the issue, and they encourage the reader to evade it too, with neurotically healthy vigor. They work like the Christianity of those Updike adults who have shucked religion but carry on from childhood a security ultimately untouched by their knowledge that it's groundless.

At times Barthelme himself becomes the sacrifice—when he says "baff" for "bath" and no one but Barthelme can be speaking (not some narrator or character). He flaunts his psychological weakness as Twain flaunts Huck's ignorance, and for the same purpose: to stay clear of the grownup lies. Frequently the management of plot is the model of our evasion of what might wreck us. Notice, for instance, in the story "Prunella" in "City Life," how neatly Barthelme slips every real-world difficulty. He distorts reality but he survives and (mostly) smiles. He stays with what feels important but can't be defended, reshaping the world to fit the soul and accepting the oddity caused outside, for example a father who's been run over and killed but is also, for some reason, sitting on the bed and weeping.

Barthelme's affirmation was never meant to have poetic power and has

less first-rate humor than his admirers claim, but his work, slight or not, is mainline American — "innocent eye," non-analytical mind, faith over knowledge, celebration without irony of trifles that Americans love, like the phantom of the opera. Barthelme — and this is the important point—affirms not a value or system of values

but a way of being. His choice rules out novelistic form (conflict, profluence, enlightenment) and is typical, or so I hope to show, of what is now going on, the rise of groundless, cautiously optimistic affirmation, the good as psychological survival tactic.

Superficially, no two writers could be more unlike than Stanley Elkin and Joyce Carol Oates. Elkin at his best is a mad barbarian turned stand-up comic (his favorite devices are the pun and the punchline) who answers all whining and pessimism with perverse assertions that whatever the whiner whines about is in fact a great good. In "A Bad Man" he praises, with incredible verbal energy, a bad man. In "The Dick Gibson Show" he turns that friend of midnight drivers, the trivial and dreary all-night talk show, to a fast, loud circus of bickering and outrageous, consciously Chaucerian tales. In his forthcoming novella collection he goes further, hitting lunatic magnificent heights—or maybe depths. Not that he avoids reality. His characters are forever arguing with themselves, with each other, or with the reader ("Perhaps you will say . . ."). But the purpose of each discouraging, sensible objection is to trigger an altiloquent, crazy-man response.

Elkins's message, in fact, is in nothing he proclaims or pretends to proclaim, not even in the fancy symbolism, but in energy pure and simple. In his earlier writing ("Criers and Kibitzers" and "A Bad Man") he sees all human relationships in terms of power. In "The Dick Gibson Show" (which is therefore a better book) relationships which begin as power-struggles soften toward understanding and appeals for love. Nevertheless, it's raw energy that Elkin loves—in prose and in characters. He's Ahab smashing through the mask with jokes, an eternal child whose answer to oppressive reason is to outperform it, outshout it. Grizzly reality is his straight-man.

I happen to know that Joyce Carol Oates, the goriest writer

in America, shuts her eyes during the bloody parts of Polanski's "Macbeth." One knows from her best stories and from watching the gentle and humorous minor characters in her novels, that her values are Jamesian and that she possesses the razor-sharp intellect needed to make Jamesian distinctions. Nevertheless, she writes "Gothic" novels and has described the genre as "a fairly accurate assessment of modern life." Unlike all the other writers I have mentioned, she is capable, I think, of doing what great novelists always do, which is to build tight form out of singleminded psychological and moral analysis.

She has occasionally done this in long stories (for instance, "Free") though not in her best or most typical stories ("In the Region of Ice" and "The Wheel of Love") which have, though the technical means are different, the effect of her novels. In novels she avoids analysis in a way that seems intentional, fragmenting the world (and the novel's rhythm) by a use of close, almost myopic examination followed by startling cuts—to another character, another era—that disorient the reader like the kick of a mule. Crisis situations arise and vanish before either the reader or characters can assess them, making fine intellect a useless tool (she writes repeatedly of the brilliant but mad) and producing an image of history, personal or public, as a track of machine-gun wounds. Value affirmations are as fleeting as destructions, and often as grotesque.

The result is that, as for Barthelme or Elkin, thought-out values—the solid foundations of character that Henry James or Jane Austen fictionally develop and recommend to the reader—are replaced by a philosophically groundless survival tactic: horror and uneasy compassion as a fixed state of mind. If her purpose is to "understand," say, the Detroit riots in "Them" that is not, I think, her artistic achievement. The technique she chooses—like Barthelme's, in this one respect—makes the reader a certain kind of person for the moment, an innocent who, wide-eyed and trembling, survives.

Odd as the suggestion will no doubt seem, John Updike does much the same, though in another way. He is, in one sense, a realist—he has a keen, deadly accurate eye and a sure feeling for his time and place. His work makes nonsense of the theory that the realistic novel is dead. But his realism, like that of James, is rich in mythic and symbolic overtones, archetypal patterns. He writes repeatedly about children and grown-ups, country and city, past and present, often, as in "Couples," the Arcadian past of nymphs and satyrs (in "Couples" they shape-shift to Merrymount revelers) and a present where Arcadia is sought in vain by people of psychologically arrested development. In fact, as the critic Larry Taylor has shown in his book on Updike, all of Updike's work can in a way be approached as a brilliant symbolistic exploration of the pastoral tradition.

Updike's chief way of "understanding" a problem is to discover its symbolic equivalents. Symbolism is his way of thinking and hope of salvation, as perfected style is the hope of Gass or energetic affrontery the hope of Elkin. In "Couples," again, he plays a good deal with (among a thousand such symbolic counters) the fact that in Christian tradition fate is represented by a circle, faith by a straight line, but that in hyperbolic geometry, all lines make circles.

Get the symbolic equations right, Updike says in effect (and include enough sex and precise description to keep the characters human), and the confusion will all snap clear. The most baffling and painful questions take on order once you find all the possible analogies between (in "Rabbit Redux") copulation, religion, space exploration, Parkinson's disease, the war in Vietnam, and race relations. All writers use this method to some extent, but in Updike it becomes more important than plot, character or style, any of which he will alter for a symbol. Symbolism, in other words, is for Updike, as it was for Hawthorne and Melville, a good-luck piece.

The method is medieval, which doesn't mean wrong, and the hope is as groundless, philosophically speaking, as Elkin's clowning or Miss Oates's widened eyes. In "Rabbit Redux," his finest book so far, Updike finds in the method not only solace but a seemingly firm platform from which to launch further affirmations, and in these he goes far beyond most other writers in terms of value commitment. I honor him heartily for that, yet I wonder if even here the assertions stick. Even here he is relatively in-

different to what James believed was the real business of the novel, whether the novel is realistic or not.

Though Updike comes to some of his convictions through the experience of his characters, he never puts his money on psychological and moral analysis, drama, inevitably unfolding novelistic form. That process gives Updike his rough draft, I suspect—the lines of his plot and those many fine moments of insight, penetration. But given the draft, he stops thinking about the real, scientifically inexpressible mechanics of people and events. He begins juggling and ornamenting, working up his complex allegory and moving farther and farther from dramatic necessity. At the point of the main dramatic conflict in "Rabbit Redux," the novel turns to tirade, a retreat from drama. What Rabbit really thinks about it all is left uncertain.

In short, as other writers lately are doing for other reasons, Updike abandons close analysis and dramatic inevitability in favor of, simply, a way of being—Huck Finn as ingenious equation-maker. There's the problem in all our finest contemporary fiction, I think. It's the reason for the thin, unglued quality in even the most dazzling technical performances. Whether you write about dragons or businessmen, it's in the careful scrutiny of cleanly apprehended characters, their conflicts and ultimate escape from immaturity, that the novel makes up its solid truths, finds courage to defend the good and attack the simple-minded. ∎

*July 9, 1972*

---

# Pablo Neruda, Nobel Poet, Dies in a Chilean Hospital

### Lifelong Political Activist
#### By STEVEN R. WEISMAN

To the end of his life, Pablo Neruda was as engaged in political activism as in his poetry. His verse encompassed a huge variety of styles: symbolic and straightforward, lyrical and polemical, graciously detached and bitterly sarcastic, filled with fantasy and rooted in harsh reality, surreal and real.

The last poem he was reported to have written was harsh and blunt. Published in Argentina, it denounced the violent coup against the Socialist regime of President Allende. It was said to have been written four days after the coup.

By Reuters

SANTIAGO, Chile, Sept. 23—Pablo Neruda, a Nobel Prize winner who was regarded as one of Latin America's greatest poets, died tonight in the Santa Maria Clinic. He was 69 years old.

He was taken to the clinic last Wednesday. His third wife, Matilde Urrutia, was with him when he died.

Mr. Neruda had undergone major surgery in another San-

tiago clinic two months ago for cancer of the prostate. He died of heart collapse, his doctors said.

His death came only 12 days after that of his friend, President Salvador Allende Gossens in the military coup that toppled his left-wing Government.

Mr. Neruda, a Communist, had returned ill from his post as Ambassador to Paris at the end of last year.

Last February Mr. Allende accepted Mr. Neruda's resignation as ambassador, prompted because of the poet's "delicate health."

At the time of the coup, there had been conflicting reports on Mr. Neruda's fate. Some Chilean newspapers reported that he had died during the fighting, and other reports said that he was being held prisoner by the ruling junta.

An enormously prolific man, Mr. Neruda produced more than 2,000 pages of poetry, only a small portion of which has become available in the United States, even after he won the Nobel Prize for Literature in 1971.

He never saw any conflict between his political activism,

which began in the flames of the Spanish Civil War in the nineteen-thirties, and the thundering, frequently apolitical scope of his verse.

He became the leading spokesman for Chile's Left until the ascendancy of President Allende. But more than this, he was considered the leading voice of all of Latin America, for he wrote of its geography and the texture of its culture in celebrating tones of Walt Whitman, who he frequently said was one of his earliest models.

As a regionalist, he was found by critics to transcend regionalism, and many critics regarded Mr. Neruda as the greatest living poet of the Spanish language.

His political activity was more than mere window-dressing for poetry that needed to justify its engagement in politics. At the time of the Spanish Civil War, Mr. Neruda did not simply write sympathetically of the Spanish Loyalists. He used his office as consul in Madrid to bring Chile to their aid.

He won election to the national Senate in 1944 as a Communist and began a lifelong career of efforts to reduce the influence of the United States there and in Latin America. He wrote exposés of Chilean politicians and went into exile. In 1970, he was the Communist candidate for Chile's presidency until he withdrew in favor of Mr. Allende.

His most polemical verse was often the verse least appreciated by critics. Many said that his tendency toward Communist orthodoxy delayed his Nobel Prize, for which he had been nominated several times before he won.

But the range of his poetry was always undeniable. He began his career with "Twilight" and "Twenty Poems of Love and a Song of Despair," which were youthful poems to many, in the sense that they relied on adolescent, romantic longings in the context of conventional metrical style.

In 1933, Mr. Neruda published one of his greatest works. "Residencia on la Tierra," ("Residence on Earth"), which was hailed as among the finest surrealist poetry ever written. In it, he spoke of the Chilean landscape on real, imaginary and strangely metaphorical levels.

He repeated many of these techniques in one of his longest poems, the "Canto General," which comprised some 250 separate poems in 15 cycles. Of it, Nathaniel Tarn, one of his principal critics and translators, wrote that the verse "rises on the debris of the Old World celebrating in extended, rolling lines an Edenic nature with its rivers, jungles, beasts and plants" and a history of South America from earliest years to the present.

Mr. Neruda spoke of his writing as "impure poetry" in the sense that it reflected bitter realities in his native land. In one poem, "Gallup," he spoke of riding a horse and finding it to be only a skeleton coming apart under him, returning to dust and being reclaimed by the mountains.

Mr. Neruda's original name was Ricardo Eliecer Neftali Reyes y Basoalto. He was born on July 12, 1904, in Parral, a small agricultural community in southern Chile.

When he was a year old, his father, a railroad man, moved the family to the densely forested area to the south, from where Mr. Neruda was to draw much of the imagery of his poetry. As a youngster, he enjoyed reading a variety of European writers and hunted for subjects for poems.

At 15, he submitted his first poem to a magazine, signing the name Pablo Neruda—taking the surname from a Czech short-story writer, Jan Neruda.

In Santiago at Chile's leading teachers' college, Mr. Neruda entered poetry contests and began his preoccupation, in verse, with the brooding themes of love, death and the passage of time. "Twenty Poems of Love and a Song of Despair," published in 1924, is thought by critics to mark his first transition into a more personal style.

Mr. Neruda continued to publish stories, prose poems and regular verse in the nineteen-twenties. In 1927 he was appointed to the consular service and was assigned successively to Burma, Ceylon, the Dutch East Indies and Buenos Aires.

In 1934 he was sent to Spain, where he published "Residencia en la Tierra" in 1935 and collaborated with Federico Garcia Lorca, among others, on a poetry magazine.

The Spanish Civil War pushed Mr. Neruda into his more engaged poetical stance. "Since then," he later wrote, "I have been convinced that it is the poet's duty to take his stand along with the people in their struggle to transform society, betrayed into chaos by its rulers, into an orderly existence based upon political, social and economic democracy."

Mr. Neruda was recalled to Chile for overstepping his authority in Spain. Later he served as consul in Mexico before returning home again in 1944 to take up an active role in the Communist party.

In the fifties he traveled in Europe, Communist China and the Soviet Union and wrote his "Odas Elementales," which returned to simple celebrations of ordinary objects, sights and smells. By the sixties, critics observed that Mr. Neruda had moved on to more laconic, resigned verse.

In 1966 he toured the United States for the first time and was received ecstatically at poetry readings in New York. Until the end of his life, he continued to address himself bluntly to political affairs in the United States and elsewhere.

September 24, 1973

# Diving Into The Wreck

*Poems 1971-1972.*
*By Adrienne Rich.*
*62 pp. New York: W. W. Norton & Co.*
*Cloth, $5.95. Paper, $1.95.*

### By MARGARET ATWOOD

This is Adrienne Rich's seventh book of poems, and it is an extraordinary one. When I first heard the author read from it, I felt as though the top of my head was being attacked, sometimes with an ice pick, sometimes with a blunter instrument: a hatchet or a hammer. The predominant emotions seemed to be anger and hatred, and these are certainly present; but when I read the poems later, they evoked a far more subtle reaction. "Diving Into the

---

Margaret Atwood's most recent books are "Surfacing," a novel and "Power Politics," poetry.

Wreck" is one of those rare books that forces you to decide not just what you think about it; but what you think about yourself. It is a book that takes risks, and it forces the reader to take them also.

If Adrienne Rich were not a good poet, it would be easy to classify her as just another vocal Women's Libber, substituting polemic for poetry, simplistic messages for complex meanings. But she *is* a good poet, and her book is not a manifesto, though it subsumes manifestoes; nor is it a proclamation, though it makes proclamations. It is instead a book of explorations, of travels. The wreck she is diving into, in the very strong title poem, is the wreck of obsolete myths, particularly myths about men and women. She is journeying to something that is already in the past, in order to discover for herself the reality behind the myth, "the wreck and not the story of the wreck/the thing itself and not the myth." What she finds is part treasure and part corpse, and she also finds that she herself is part of it, a "half-destroyed instrument." As explorer she is detached; she carries a knife to cut her way in, cut structures apart; a camera to record; and the book of myths itself, a book which has hitherto had no place for explorers like herself.

This quest—the quest for something beyond myths, for the truths about men and women, about the I and the You, the He and the She, or more generally (in the references to wars and persecutions of various kinds) about the powerless and the powerful—is presented throughout the book through a sharp, clear style and through metaphors which become their own myths. At their most successful the poems move like dreams, simultaneously revealing and alluding, disguising and concealing. The truth, it seems, is not just what you find when you open a door: it is itself a door, which the poet is always on the verge of going through.

The landscapes are diverse. The first poem, "Trying to Talk With a Man," occurs in a desert, a desert which is not only deprivation and sterility, the place where everything except the essentials has been dis-

269

carded, but the place where bombs are tested. The "I" and the "You" have given up all the frivolities of their previous lives, "suicide notes" as well as "love-letters," in order to undertake the risk of changing the desert; but it becomes clear that the "scenery" is already "condemned," that the bombs are not external threat but internal ones. The poet realizes they are deceiving themselves, "talking of the danger/as if it were not ourselves/as if we were testing anything else."

Like the wreck, the desert is already in the past, beyond salvation though not beyond understanding, as is the landscape of "Waking in the Dark":

*The tragedy of sex*
*lies around us, in a woodlot*
*the axes are sharpened for. . . .*
*Nothing will save this. I am alone,*
*  kicking the rotting logs*
*with their strange smell of life,*
*  not death,*
*wondering what on earth it all*
*  might have become.*

Given her view that the wreck, the desert, the woodlot cannot be redeemed; the task of the woman, the She, the powerless, is to concentrate not on fitting into the landscape but on redeeming herself, creating a new landscape, getting herself born:

*. . . your mother dead and you*
*  unborn*
*your two hands grasping your head*
*drawing it down against the blade*
*  of life*
*your nerves the nerves of a midwife*
*learning her trade*
*  —from "The Mirror in Which*
*    Two Are Seen as One"*

The difficulty of doing this (the poet is, after all, still surrounded by the old condemned landscape and "the evidence of damage" it has caused) is one of the major concerns of the book. Trying to see clearly and to record what has been seen—the rapes, the wars, the murders, the various kinds of violation and mutilation—is half of the poet's effort; for this she requires a third eye, an eye that can see pain with "clarity." The other half is to respond, and the response is anger; but it is a "visionary anger," which hopefully will precede the ability to love.

These poems convince me most often when they are true to themselves as structures of words and images, when they resist the tempta-

tion to sloganize, when they don't preach at me. "The words are purposes/the words are maps," Rich says and I like them better when they are maps (though Rich would probably say the two depend on each other and I would probably agree). I respond less fully to poems like "Rape" and references to the Vietnam war—though their truth is undeniable—than I do to poems such as "From a Survivor," and "August" with its terrifying final image:

*His mind is too simple, I cannot go on*
*  sharing his nightmares*
*My own are becoming clearer, they*
*  open*
*into prehistory*
*which looks like a village lit with*
*  blood*
*where all the fathers are crying:*
*  My son is mine!*

It is not enough to state the truth; it must be imaged, imagined, and when Rich does this she is irresistible. When she does this she is also most characteristically herself. You feel about her best images, her best myths, that nobody else writes quite like this. ■

December 30, 1973

# *Author as Editor and Publisher*

By *RONALD SUKENICK*

The publishing industry can no longer support quality fiction. For novelists this situation may be an opportunity in the guise of a disaster. To grasp this opportunity a sizeable group of established novelists has formed The Fiction Collective to select, edit, produce and distribute the books of its peers on the basis of literary merit, free of the implicit commercial standards of the book business.

There are still, of course, accidents—novelists of quality who also have mass market appeal. However, the publishing industry has been increasingly forced by inflation, profit demands and the logic of its inefficiencies toward the immediate, large audience; while serious fiction, in its slow discourse with the culture, most often finds its initial public among the happy few. At the same time that publishing has been starving out serious fiction, the genre has experienced a resurgence of vitality and inventive-

ness. What we currently have is a mass market industry that cannot afford to produce small, reasonably priced editions of quality fiction, imposing its exorbitant financial necessities between a revitalized novel and its potential audience. Thus, readers are denied the opportunity to choose among, or even know about, the remarkable diversity of literate fiction published obscurely by the small presses, buried among the large ones, or not published at all.

In response to this situation, The Fiction Collective will make serious novels and story collections available in simultaneous hard and quality paper editions of uniform format and will keep them in print permanently. The Collective is not a publishing house, but a "not-for-profit" cooperative conduit for quality fiction, the first of its kind in this country, in which writers make all business decisions and do all editorial and copy work. It is the result of more than a year's discussion among several groups of writers, including those associated with the Brooklyn College writing program, Fiction magazine and Swallow Press who have combined their efforts with other writers such as Jack Gelber, B. H. Friedman and

**Ronald Sukenick** is the author of "Up," a novel, and "The Death of the Novel and Other Stories."

Steve Katz. Manuscripts are considered by recommendation of individual members, read by the group and accepted by a 50 per cent vote. A company in Michigan prints editions of 500 hardbound and 1,500 in paper for approximately $3,000, which is loaned to the Collective by the writer. The Collective needs to sell only 400 hard and 1,200 paperback copies at $7.95 and $3.95 to break even, and it now appears that its first books will go into second printings of 2,000 before publication. Overhead is almost nonexistent, and Brooklyn College has supplied office space and services. (The Collective may be written to c/o Brooklyn College, 96 Schermerhorn Street, Brooklyn, N. Y. 11201.)

In its first year of operation the Collective will publish at least eight books of fiction by Jonathan Baumbach, Peter Spielberg, B. H. Friedman, Mark Mirsky, Jerome Charyn, Russell Banks and others, including myself. Three titles are already off the press for October publication: Baumbach's "Reruns," Friedman's "Museum," and Spielberg's "Twiddledum Twaddledum." The Collective's books will be distributed by Braziller, which is featuring them in its catalogue, and which will get a commission of 25 per cent of gross billings after discount, and 25 per cent of subsidiary rights. As soon as the writer's investment is paid back, he splits profits evenly with the Collective and gets 60 per cent of its share of other rights. Braziller, besides being in on the spirit of the enterprise, has an option to cash in on a given book; they can assume publication when it sells more than 4,000 copies by paying an advance on royalties starting at 12½ per cent. In the spring Braziller will publish an anthology of new work by the Collective's many members and associates, edited by the Collective and titled "Statements."

The Collective has received a great deal of support from writers, people within the industry and others who believe, as we do, that it will have an important and needed impact on the literary scene if it succeeds, allowing fiction to develop a community and an audience of the kind that has always sustained poetry. It is hoped that the Collective's share of receipts, possibly augmented by grants, will allow for a staff to read unsolicited manuscripts and the financing to publish deserving writers who cannot afford the present $3,000 initial investment. At the same time, recognizing that it cannot possibly handle all the quality fiction that deserves to be published, the Collective hopes to serve as a model for other groups of writers.

For American novelists, the publisher has played the role of unacknowledged father, boss and sugar-daddy, whose recognition legitimizes one's identity as a writer. The Fiction Collective offers recognition by one's peers. This clear insistence on the standards of those who, finally, know what the art is all about, opens a path toward the maturity of the American novel, as well as a way for American novelists to assume their full prerogatives and responsibilities. ∎

September 15, 1974

## THE THEATER

### AMUSEMENTS.

#### "HEDDA GABLER."

Henrik Ibsen's latest play, a four-act "social drama" called "Hedda Gabler," written only two years ago, was performed for the first time in this country at the Amberg Theatre last night. This is a conversational drama, involving a minute and depressing study of the small, cramped society of Christiania, from the point of view of the dissatisfied philosopher. Hedda is a young woman of social position who has vague longings that she cannot define and fleeting ambitions that are never to be realized. She despises her husband and has no love for the child that is to be born.

She does not love Judge Brack, the frank libertine, but she permits him to say things to her no well-disciplined woman would ever listen to. She has no strong feeling for the drunken genius, Lövberg, who was once her lover, but she is jealous of the influence of another woman over him. She entices him to his destruction without seeming to realize what she is doing. A desire for a new sensation of some sort rather than any clearly-defined idea of promoting the success in letters and science of her plodding husband by destroying his one dangerous rival seems to control her. When she has done her worst, and the result does not satisfy her, she kills herself. And the world rolls on.

The moral seems to be that a woman of Hedda's possibilities ought not to be fettered by the petty conventionalities of a narrow social life. But it does not matter what the moral is. Neither the moral drift nor the substance of Ibsen's plays bothers folks who hope for any possible good result, on the English speaking stage, of his influence.

A finely written prose drama like this enables good actors to make fine points, to indicate and suggest small traits of character, to present portrayals, in short, of exquisitely fine workmanship. People who understand the art of acting derive great enjoyment from such performances, once in a while. One does not want to look at cartoons all the time.

The performance at the Amberg Theatre last night was all exceedingly careful, and Hugo Ranzenberg's portrayal of Lövberg was strong and picturesque. Mme. Haverland is a rather mature and heavy actress for the title part. Her acting lacks the fascinating quality it should possess in order to give the play its full meaning. The cast is worth preserving:

| | |
|---|---|
| Jörgen Tesman | Herr Strassmann |
| Hedda Tesman | Anna Haverland |
| Juliana Tesman | Frl. Schmitz |
| Thea Elvsted | Frl. Wolf |
| Assessor Brack | Herr Eggeling |
| Eilert Lövberg | Herr Ranzenberg |
| Bertha | Frl. Schatz |

February 18, 1892

# Ibsen and the American Stage

IT is not my purpose to enter upon an essay on Ibsen, or, worse still, a defense. It is rather to suggest to some of the people who ought to know better that before they go further in treating Ibsen either as subject of joke or a cult of the long-haired they should, according to their lights and disposition to be fair, make some investigation of the object of their criticism.

There is a large space between the doctrinaires and extravagant poseurs who read all kinds of impossibilities between the lines of our author and the people who merely sneer at him without knowing anything about the subject. It is on this ground that I invite those who pretend to have any interest at all in dramatic art to take their stand. Of course, I exclude those who are too lazy or incompetent to take anything different from the fare to which they are accustomed.

That there are some of his plays for which an audience drawn at random from the street would be unprepared I do not deny, but that it is only a matter of a few years, when many of them will be as familiar in repertoire as any of the present classics is likely.

## Old Fashioned in a Decade.

That they will live so long I do not assert, for they will undoubtedly be old-fashioned in a decade, when the common ideas of honesty and the stage shall have been readjusted. In other words, by the time we have caught up with him we shall probably begin to speak of him as old-fashioned. Men of open mind will admit a true pioneer of the stage. Indeed we may even find that some of the critics who now condemn his plays as disgusting, in terms nastier than any stage would tolerate, may merit the cynical definition of the "Green Carnation."

"The critic is a man who runs at the end of the procession yelling, 'Come on.'" The influence of Ibsen upon composition for the stage has undoubtedly been enormous. It needs no acuteness to detect the Ibsen manner in the plays of Pinero, Maeterlinck, and D'Annunzio. Among our own countrymen, in a smaller way, a lot of writers for the stage have fallen into the procession without knowing very well why or whither they were going.

A common error is the belief that he did not apply the conventional rules of construction because he was ignorant of them. Nothing could be further from the truth. You will notice that the greatest lawyers of the country are retained on the side of corporations which wish to know how to evade the laws without punishment.

It is a trite saying that you can drive a coach and four through any act of Parliament, but to be able to do so it may require as great an intelligence as that of the man who created the act.

## Advice to Actors.

Similarly, Ibsen did not begin to avoid the conventions of stage treatment until long after he had been well saturated with the methods then in vogue. You may remember that the pioneer of modernity in acting in this country, Mr. James A. Herne, (himself a great admirer of Ibsen,) was a stage manager who had learned by heart the devices of the old school before rejecting them.

So I would suggest to actors, especially who speak of Ibsen with a sneer, if they will follow his works chronologically they will see how he improved in construction with each play; how one by one he rejected the familiar devices of the craft as he found it, and substituted subtler methods which increased the dramatic value while rejecting the purely theatric. There is no doubt that Ibsen has found many times when he could say from his heart, "Deliver me from my disciples."

There are people who search for strange and uncanny meanings beyond the text, but to the sane student of Ibsen there is

There are people who search for strange and uncanny meanings beyond the text, but to the sane student of Ibsen there is sufficient occupation in the marvelous mechanism of his plots and the wonderful way in which he builds most poetic symbolism out of situations and dialogue in itself sufficiently commonplace, or rather, I should say, natural. His types of character, his examples of selfishness, foolishness, and vanity are not villains of the stage, but men we see about us every day, honored—lots of them—and respected.

## American Types in Ibsen.

Had the "Pillars of Society" been written by an American at the present time, with an American setting, it might render the managers and producers subject to prosecution for libel, so nearly do the types and conditions fit the actual types and conditions in America to-day. The blasphemy of Berwick is nothing but the blasphemy of Baer; they alike seize upon common property and break laws in the name of God. Of course I am referring now entirely to his later naturalistic plays.

## Artists and Morality.

Of his more fantastic poetic plays I do not treat. Nor do I wish to discuss his morality. With that the artist, as an artist, has nothing to do. If he proves that adherence to conventions is capable of results as terrible and tragic as violations of them he is immoral or a creator of new ideals, according to the point of view. He is a decadent or freak, according to the mindsight of the man in front.

At any rate, he is not more immoral than is the exaltation of Rip Van Winkle, the drunken vagabond, who neglects his family, or Zaza or Camille, whose vicious lives are made lovable by the sophisticalart of the dramatist.

The role of the philanthropic producer of plays which the public has not learned to like is an ungrateful one. The timidity of managers and the poverty of actors has restricted the performances of Ibsen to schools-of-acting benefits or other places where audiences may be found made to hand. I can recall only two serious professional performances of his work.

And yet he is the most difficult of all modern authors to play. No actor can suggest "repose" on the stage unless you feel that beneath his calm of manner the "torrent and whirlwind of passion" is possible. And as repression is the last thing acquired on the stage, the extra naturalness which this author demands is impossible except to the actor who has endured without embracing melodrama. In other words, it demands an intelligent "past." So I fear some of the attitude of the public is due to the fact that in many instances the performances have not been directed by artists of experience.

## Call Ignorance Reverence.

It requires something more than sympathy to interpret an author. It requires technique, and in Ibsen's case it requires the immense courage to lay aside the whole bag of tricks which are always effective and to construct a new technique which shall be worthy of the advanced art of the dramatist. In most cases the sympathy has been keen, but the performance amateur. It is simply dodging to present a play in the raw without illuminating "business," and justify ignorance by calling it reverence.

My own observation in rehearsing the "Pillars of Society" has been that rehearsals usually are such a grind, a horrible necessity, often as interesting as five-finger exercises, have been a continual delight, not only to the principals, but to the smallest member of the cast. As one subtle meaning after another unfolded itself—as the exquisite art of the dramatist became patent—there came a glow on the faces of the artists which established that they had found a labor of love—a compensation for giving up the bright sunshine of Spring days to toil in a dark theatre.

In New York, which in a few years has seen Wagner grow from a fantastic cult to appreciation from every one who has any part in the progress of culture, there is surely hope that this master will come to his own. And this in spite of habit, vested interest, prejudice, laziness, and ignorance.

The dramatist who laughs now will imitate to-morrow. The auditor who yawns now will go back to his former dramatic love to find that "pie is no longer as mother used to make it." The manager who bemoans the lack of plays will find these at his hand.

And the actor will discard the iron jacket which he thought the only wear and be in action what Ibsen has been in thought—free and natural and true as men are, not as other actors were.

*Wilton Lackaye*

April 17, 1904

---

## WHO'S BERNARD SHAW? ASKS MR. COMSTOCK

### And, Having Read the Irish Author's Letter, He Finds Out.

"George Bernard Shaw? Let's see—Shaw; who is he?" asked Anthony Comstock yesterday when a TIMES reporter found the head of the Society for the Suppression of Vice at his home in Summit, N J.

Mr. Comstock, wearing a blue jumper, was caught at the business end of a wheelbarrow, enriching the soil of his timothy patch. He walked up with the reporter to his front porch and sat down.

"Shaw?" said Mr. Comstock reflectively. "I never heard of him in my life. Never saw one of his books, so he can't be much."

The reporter had in his pocket a copy of THE NEW YORK TIMES in which appeared the letter written by Mr. Shaw, the author and playwright, after he had learned that his books had been removed from the "open shelves" in the New York Free Libraries. This order of removal Mr. Shaw characterized as a piece of "American Comstockery." The reporter submitted the letter, and Mr. Comstock read it carefully.

"Everybody knows," wrote Mr. Shaw, "that I know better than your public library officials what is proper for people to read, whether they are young or old."

When Mr. Comstock read that, he literally grew pale with indignation.

"Did you ever see such egotism?" he commented angrily. "I had nothing to do with removing this Irish smut dealer's books from the public library shelves, but I will take a hand in the matter now.

"I see this man Shaw says down here that he knows that his works 'can, and probably do, do harm to weak and dishonest people.' Well, that lays him, his works, his publishers, the people who present his plays, and all who or which has anything to do with the production or disseminating of them, liable to the law, which was made primarily to protect the weak. He convicts himself."

Mr. Comstock took up the laws to safe-

guard public health and public morals. He began with 1626, when the famous case of the King vs. Kurl came up, he said. The reporter was inclined to ask questions, but Mr. Comstock would brook no interruptions. "Take it down, son," he said, "and later we'll talk about the questions."

Then Mr. Comstock said, and the reporter wrote it down, that it was evident that "this fellow Shaw believes the proper method of curing contagious and vile diseases is to parade them in front of the public. He evidently thinks that's the way to treat obscene literature."

Mr. Comstock also said he believed that Mr. Shaw was ignorant of the laws of his own country relating to the forbidden in literature. He said he would refer Mr. Shaw to the King vs. Kurl case, in 1626, when Mr. Kurl was foiled in his wicked attempt to spread a pamphlet that was held to be unfit. That was the time, too, when the ecclesiastical courts were deprived of jurisdiction over such cases. He would also refer Mr. Shaw to the Queen vs. Hecklin case, in the trial of which Lord Chief Justice Cockburn delivered his famous opinion, holding that the test was "whether or not the books in question tend to corrupt the minds of those into whose hands they can fall." Mr. Comstock put emphasis on the word "tend."

The legal phase of this question was brought up in the United States in 1873, when a Judge, Mr. Comstock said, held that "it is not a question of whether the books may corrupt your or my mind, but whether they might corrupt any one into whose hands they may fall." That includes the "weak" ones mentioned by Mr. Shaw, Mr. Comstock argued. He also

said that the old English common law was the basis of the State and National laws relative to the question in this country.

"This very morning," said Mr. Comstock, "I confiscated for destruction 23,000 pictures and had the man convicted in the Special Sessions. Last week I confiscated 100,000 such pictures from a German in Brooklyn. For a third of a century I have battled in the ranks of the society with which I have the honor to be affiliated—battled for the morality of the young people of this country. I have done work in Canada, in Paris, in London, and in most of the civilized countries of the world. The society has made over 23,000 arrests; it has destroyed 93 tons of unfit matter.

"There are over 35,000,000 boys and girls 21 years old and under in this country. If a person stood 367 days watching 100,000 such boys and girls pass him every day, at the end of that time there would still be over 20,000 in this country whom he hadn't seen.

"It matters little if the literary style is of a high order if the subject matter is bad. I had a man convicted who was painting and selling pictures of paintings hung in the Paris Salon and in the art hall at our Centennial Exposition. The only question is, 'Can this book or picture or play hurt any one morally, even the weak?' All else is of minor consequence.

"Before this, in the fight for the morals of our 35,000,000 young men and women, we have convicted Englishmen and Irishmen. I have destroyed their stuff by the tons. The English and the Irish have furnished their full quota of unfit books and pictures and plays. And if this Irish

writer, Shaw, describes himself fairly in his own words, we will bring his works and the people that disseminate them to the test of the law.

"I understand that the Shaw books have been put back upon the shelves from which they are said to have been taken. Before now we have routed objectionable books from library shelves where they were accessible alike to the young and old. Complaints are frequently made to me by parents concerning such books, and I have quietly had many a one withdrawn from the tables where everybody could see them. This Shaw is not outside of our rules.

"You say he has plays also and some of them have been presented and liked in New York City? Well, they will be investigated, and the plays and the playing people will be dealt with according to the law if it be found that they are such as are indicated by this Shaw himself. We will investigate his books."

Mr. Comstock was asked what he thought of Mr. Shaw's assertion in his letter that "marriage is the most licentious of human institutions."

"I'll be doggoned if I know," answered Mr. Comstock. "There are two or three paragraphs along there that I don't understand, and I doubt if he did when he wrote them."

Then Mr. Comstock went back to work in his timothy patch. He was anxious to do some work before it rained. He looked up at the sky and spoke no further word about Bernard Shaw. But unless all indications fail, there will be trouble about the Shaw books and plays.

September 28, 1905

---

## DRAMA CRITICISED BY WIRE.

### Chicago Tired of Waiting for First-Hand Opinions on New Plays.

The Chicago Tribune is trying an innovation in dramatic criticism among newspapers outside New York City. New plays that prove successful are likely to be held tight and fast in New York for many months, so that when Chicago gets her first look at them they are an old story. The Tribune did not like this.

It has sent its dramatic critic, W. L. Hubbard, straight to Broadway to take in all the first nights and successful pieces and telegraph to his newspaper just what he thinks of them. He has had

his say about "Peter Pan" and "The Lion and the Mouse," and he seems to think his fellow-townsmen lost nothing by seeing the Western company in Mr. Klein's piece instead of the company which has been doing it in New York all season.

Mr. Hubbard has been going about very quietly, and last night his friends in this city said they thought he had returned to Chicago. He could not be found at his hotel.

If The Tribune's idea becomes popular among newspapers in cities outside this great theatrical centre of the country first-nighters along Broadway will before long think it no strange thing to see half the men in an audience scurrying out toward the end of the last act to "get a wire."

May 3, 1906

---

# RIOT IN THEATRE OVER AN IRISH PLAY

## Vegetables and Asafoetida Balls Hurled at Actors in "The Playboy" at the Maxine Elliott.

### WOMEN JOINED IN PROTEST

That Irish play by J. M. Synge, "The Playboy of the Western World," became a fair, a Donnybrook Fair, at its first performance in the Maxine Elliott Theatre last night. It has had more or less of a lively time in the other cities where The Irish Players have presented it, but the disturbances elsewhere were as prayer meetings in comparison with the reception it got here.

The curtain rose, and that was the signal for a stir that swept through the theatre like the rustle of leaves that foretells a storm. The shabby actors in the humble dress of the Irish peasant appeared and began their lines.

Christopher Mahon, (Fred O'Donovan,) the leading character, was on the stage with Margaret Flaherty (Eithne MaGee.) They went on with their lines, he trying to persuade her to his will and she resisting. He insults her and she runs for a flatiron to assault him, and he, hoping to restrain her by fear, cries out:

"I killed my father a week and a half ago for the likes of that."

Instantly voices began to call from all over the theatre:

"Shame! Shame!"

A potato swept through the air from the gallery and smashed against the wings. Then came a shower of vegetables that rattled against the scenery and made the actors duck their heads and fly behind the stage setting for shelter.

A potato struck Miss MaGee, and she, Irish like, drew herself up and glared defiance. Men were rising in the gallery and balcony and crying out to stop the performance. In the orchestra several

men stood up and shook their fists.

"Go on with the play," came an order from the stage manager, and the players took their places and began again to speak their lines.

The tumult broke out more violently than before, and more vegetables came sailing through the air and rolled about the stage. Then began the fall of soft cubes that broke as they hit the stage. At first these filled the men and women in the audience and on the stage with fear, for only the disturbers knew what they were.

Soon all knew. They were capsules filled with asafoetida, and their odor was suffocating and most revolting.

One of the theatre employes had run to the street to ask for police protection at the outset of the disturbance, but the response was so slow that the ushers and the doortenders raced up the stairs and threw themselves into a knot of men who were standing and yelling "Shame!"

### Many Disturbers Thrown Out.

The employes grabbed these men and began hustling them toward the doors. Every one they got there was thrown out

and followed until he became a rolling ball that thumped and thumped down the stairs. On the lower floor a big man caught them and threw them out without bothering to open the swinging doors first. They crashed through with enough momentum to carry them out in the middle of the street.

It was said later that when the police were appealed to for help they were loath to interfere. Those that were thrown out were kept out, but for some minutes no policeman came into the theatre. Then word of the trouble got to the West Thirtieth Street Police Station, and twenty men in uniform and all of the detectives on hand were sent on a run through the street.

Broadway had thrown a big part of its crowd into Thirty-ninth Street in front of the theatre, and the sidewalks and roadway were jammed with men and women. The police went through this crowd without ceremony and began clearing it. Inspector Leahy arrived hotfoot and ordered out part of the reserves from the station and all of the plain clothes men he could reach.

Men still were rolling down the stairs and yelling out that they were being outraged and would have the law on somebody. Up the steps ran half a dozen policemen. If they hesitated at the outset to take a hand in the row, they seemed to be anxious to make up for it now. No questions were asked, but they reached for every man who was on his feet and dragged him to the stairs, where willing hands helped him to the street.

One of these men was Shean O'Callaghan, a big harness maker, who yelled out in fury as he was being thrown out.

### Potato Shower Continued.

Even while the police were at work missiles kept striking the stage, and the actors, with one eye on them, were going on with their parts. A potato struck Miss MaGee and rolled to the wings. Lady Gregory, who has followed the play about on its troublesome course, picked it up and said she would keep it as a token of her visit to this country.

During the rattle and bang in the house there could be still heard cries of protest. "Shame! shame!" and one man shouted out an oath and yelled that it was a disgrace to put such a foul thing upon the stage.

Just then a policeman reached for him and dragged him to the door. He said he wanted the policeman's number, declaring, "I will have you broken." The policeman stood him up in a well-lighted corner and waited until the man found a pencil and took a note of his number. Then he threw the man out with a violence that threatened him with permanent injury. But once outside he scampered away.

Three women in evening dress came rustling out to the doors. With them was a man who wanted to know:

"What authority have you to put me out?"

The policeman just pushed him out and the women followed him.

Then came C. J. O'Lee, Mrs. Shelle O'Lee, Miss Coll O'Lee, Miss Mora O'Connor, and Patrick Cavanagh, all of them members of the Philo Celtic Club. They were very much excited and kept exclaiming that it was an outrage that such a play could be staged in this city and those who protested should be treated so brutally. They were shown out.

### First Act Repeated.

Still the play went on, and when the first act was finished an announcement was made that it would be repeated, so that all present could see it. This is the first time such a thing has happened in the history of the stage in this country. The scenes were shifted again and the stage setting at the beginning rearranged. And then the players came on and began again at the beginning.

And still the missiles flew. By this time the police were so thick that there was no longer danger of more than sporadic cases of violence. But through the first act again and through all of the other acts there were still cries of protest and still vegetables fell upon the stage. One man threw an old Waterbury watch that struck one of the actors and then fell jingling to the stage.

During the trouble Lady Gregory talked to the reporters. She said:

"I wish the men who threw the things on the stage had taken better aim, for I can't believe that they intended to hit anybody. Miss MaGee would have been injured if her thick hair had not protected her. She was struck on the head, but fortunately she escaped without hurt.

"The play was first produced in January, 1907, in Dublin, but we had no trouble like this. The police put a stop to it. The second time it was put on in Dublin the disturbers were put out right at the beginning. We had some trouble in Boston and in Providence, but nothing like this."

George C. Tyler, manager of the show, said: "We will keep the play on and play it through if it takes us all night."

When the actors had ended the performance, for which most of the audience remained, though little could be heard, the police had made ten prisoners. They were Barney Kelly of 2,165 Fifth Avenue, Frank O'Coffey of 5,918 Fourth Avenue, Brooklyn; Shean O'Callaghan of 227 East Thirty-ninth Street, a harnessmaker; N. Mathias Harford, clerk, of 664 Third Avenue; Matthew Gambier, liquor dealer, of 165 East Sixty-sixth Street; John F. Neary, instructor, of 487 Kosciusko Street, Brooklyn; John P. Barren, mason, of 142 West 101st Street; John Joseph Cassidy, bartender, of 63 East 122d Street; Dennis Croly, carpenter, of 133 East Ninetieth Street; Patrick O'Connor, electrician, of 305 East Thirty-fifth Street. Miss Rosina Emmett of 62 Washington Square South went to the police station as a witness against O'Callaghan.

### Last Act in Night Court.

From the police station the scene shifted to the Night Court. It was already crowded when the two patrol wagons rolled up to the door with the ten prisoners in charge of Capt. McElroy of the West Thirtieth Street Station, and the hundred who had followed from the theatre found it almost impossible to get a position where they could hear the proceedings. Apparently the trouble had not been unexpected, for Attorneys Dennis A. Spellisy of 257 Broadway and John T. Martin of 154 Nassau Street were ready to appear for the defendants.

When Magistrate Corrigan called the cases Mr. Spellisy entered the plea that the prisoners in hissing and jeering and hooting had only attempted to voice their disapproval of the play.

"That's all right," replied the Magistrate; "they can express their disapproval if they like, but they must keep within decent bounds, and they have no right to act like rowdies."

Mr. Spellisy, who is an Irishman, broke in to make a comment on the play.

"I was in the theatre myself," he said, "and the sketch was the nastiest, vilest, most scurrilous and obscene thing I have ever seen. I don't blame them for hooting and hissing it."

"But kept within the legal limits," returned the Magistrate.

The case of Shean O'Callaghan of 227 East Thirty-ninth Street, who was charged with throwing eggs at the actors from a vantage point in the balcony, aroused the most interest and he was fined $10. One of the witnesses against him was Miss Emmett, a niece of Robert Emmet. She said she saw O'Callaghan throw four eggs.

Six others who it was alleged by the policemen, hooted and jeered and stood upon the seats in their efforts to show their resentment at the staging of the play were also fined in amounts from $2 to $5. The other three were let go.

The Messrs. Shubert issued this statement:

"We did not receive any advance protest of any kind from the Irish societies, and we had no intimation that it would be distasteful to the Irish people. If we had received any such warning we would have taken up the question, and would doubtless have arranged matters so as not to have booked this special piece. We do not see anything objectionable in the work ourselves, and we have the highest respect for the producing management, but we would not voluntarily or intentionally offend the Irish societies or the Irish public of this city."

"The Playboy of the Western World" is objected to by the Irish people because it shows an Irish girl loving a man who murdered his father and willing to marry him as her ideal hero. Seumas MacManus, the Irish author and lecturer, said to a TIMES reporter on Sunday in reference to this play:

"In the 'Playboy' is shown a simple Irish maiden of the remote coast speaking in language that few girls of the street in New York or Chicago would bring themselves to use in ordinary conversation. Yet this play pictures these modest Irish maidens as tumbling over one another to win a blackguard, whose fascination is that he murdered his father.

"And, apart from the gross immodesty and repulsive vulgarity which the Irish colleen stands for in this play, I know of no other viler libel that could be put upon her than, as in the play, to show her throwing herself at the head of a scoundrel—throwing herself at him because he was now her ideal hero."

November 28, 1911

### Playwrights Take Notice!

*To the Editor of The New York Times:*

Comedy, nothing but comedy, is the essence of the plays that are now being produced. It is undoubtedly a relief to forget one's pains and cares for a while and to laugh and be merry; but it is just as important to devote a little of our time to serious, profound thought. The gay and happy view of life is presented from the stage. Why not regard the deep and serious questions as well? I don't mean those plays that aim to move the audience to tears, but the plays that bring forth various problems of life in a pure, clear, and straightforward manner. The plays that make us see and understand matters with greater reason and with a broader mind.  JULIA SIEGEL.

Brooklyn, N. Y., Nov. 3, 1915.

November 8, 1915

## NEW GROUP TO STAGE PLAYS

### The Provincetown Players to Put On Ten of Their Own Here.

The Provincetown Players, a group of actors and playwrights, who, for the last two Summers, have produced their plays at the Wharf Theatre in Provincetown, Mass., will open their first season in New York at their theatre at 139 Macdougal Street on Nov. 3. The organization plans a twenty-week season, presenting ten new plays, under the personal direction of the authors, a new bill to be staged each two weeks.

The productions will be simple in stage settings and, except for two salaried officers, who will devote their entire time to the work, the members will receive no financial return, either for their plays or services. Two of the plays to be given at the Macdougal Street theatre were among eleven which were produced by the players at the Wharf Theatre during the Summer of 1916.

Among the active members are George Cram Cook, Susan Glaspell, Mary Heaton Vorse, Hutchins Hapgood, Neith Boyce, Edna Kenton, Edwin Davies Schoonmacher, William Zorach, Frederick L. Burt, John Reed, Max Eastman, Ida Rauh, Floyd Dell, Eugene O'Neil, Charles Demuth, Wilbur Daniel Steele, Marguerite Zorach, Edward A. Ballantine, and B. J. Nordfeldt.

October 28, 1916

# LITTLE

# THEATRE

# PLAYS

By JOHN COBBIN.

If one were asked to point out the most interesting development of the past decade in our theatre—does nobody put the question? Surely, that was a voice from Washington Square? Yes, and the answer is, the Little Theatre movement.

We have lost much of late. The old stock companies are a faded memory, and the attempt to replace their loss with a genuine repertory theatre speedily proved abortive. Even the individual exponents of our classical art—Irving and Terry, Mansfield and Forbes Robertson—are receding into the limbo of half-remembered things. There was a time when it seemed that Gillete, Thomas, and Fitch were founders of a school of really national drama; but they, too, have apparently spent their force. Yet we have now a thing of note which nobody consciously planned, or even expected—a thing which has come upon us overnight, like a harvest of mushrooms in a neglected pasture. In her recent book on the subject, Constance D'Arcy Mackay records the upspringing of over fifty Little Theatres in the United States during the past five years.

To Miss Mackay's thinking, the very name of Little Theatre is "salted with significance." But when it comes to analyzing its peculiar salt she is rather distressingly vague. Many chapters are devoted to the annals of Little Theatres from New Orleans to Duluth, from Montclair, N. J., to Colesburg, Ill: but her summary of artistic achievements, even her outline of the promised future, is to be found only in vagrant and scattered phrases.

Has the Little Theatre enriched dramatic art through "scenic experimentation"? There has been much talk of this, in which Miss Mackay joins. But the impulse toward new modes of investiture was felt before the Little Theatres popped up their heads. Gordon Craig was a wellknown name; we had seen Max Reinhardt's production of "Sumurun," and the methods and style of Josef Urban were familiar. Reinhardt's foremost disciple among us, Robert Edmund Jones, has labored indifferently for the commercial and the "little" theatres. If the scenes of Washington Square productions have a distinguishing note it was frankness with which homespun talent imitates the new style—the frankness and often the crudity. Some notable results have been achieved, but the sets of saltiest significance are those that consciously burlesque the new style, as in Lawrence Langner's "Another Way Out."

Acting in the Little Theatres Miss Mackay describes as "professional and semi-professional." It is much better to call it frankly amateur, provided the term be rightly understood. An amateur is one who is mainly moved by the love of what he does In any art this is the most valuable of all qualities, for it means genuineness, inspiration. And it is a quality singularly needful in the American theatre. The productions of our Little Theatres have delighted most by their unaffected sincerity. But, with rare exceptions, the acting has been more notable for its intention than for its achievement. In plays that are slight or bizarre the effects of the sympathetic amateur are enough, but in dealing with dramatic material of the first order an actor requires not only a seeing mind and a willing heart but a flexible and vigorous technique. Many of the most notable

offerings, from the stark realism of "The Clod" to the mellow and legendary beauty of Maeterlinck's "Miracle of St. Antony," have been gravely impaired or ruined by a lack of technical skill. One actor combined with the spirit of the amateur a thoroughly competent equipment in technique, José Ruben; but he came from the professional stage and has returned to it, together with Comrade Philip Moeller, in the service of Mrs. Fiske.

In one respect the contribution of the Little Theatre has been truly momentous. We owe to it a wholly new order of play, and, indeed, a new school of playwrights. "Experimentation," says Miss Mackay, "is the Little Theatre's raison d'être," and here one applauds to the echo. The greatest bar to the development of our commercial theatre is that of necessity it addresses itself to the million. Let us not be unduly scornful. The fact has vast potentialities for good. It cannot be said too often that the appeal of really great art is universal. Nor is there anything which the great public welcomes so eagerly in a so-called theatrical novelty as novelty—provided, of course, that it is able to see and sense the new note. But, though its power of sensation is vast, its vision is strictly limited. In order to be sure of recognition, a new talent has to appear before it full grown—athletically agile, expertly articulate. And these are qualities which few new talents possess.

We owe to the Little Theatre the gay richly colored burlesques of Philip Moeller; the keenly intelligent satires of Lawrence Langner; the sensitive feminine perceptions of Susan Glaspell—as admirable in the satiric comedy of "Suppressed Desires" as in the biting tragedy of "Trifles"; the fervid imaginations of Zoe Akins; the tense and heartfelt realism of Eugene O'Neill. These are rare spirits, all. Of the "makings" of the full-fledged dramatist they have already revealed the most precious portion. That the Little Theatres have enabled them to test their quality before a sympathetic public is a service of very great moment. If it has enabled them to sense their limitations it will be a benefaction equally great.

The quality which they have in common is intelligence—the clear and subtle sense of values in life and in its dramatic representation. In the main this is expressed in satire. And at its most pungent the satire of these denizens of Washington Square and Greenwich Village has the rarest of all knacks of turning inward upon themselves. The outside world has dealt roughly with the moral, or rather immoral, poses of the Villagers; but to find them dissected with a scalpel you will have to go to Susan Glaspell's "Suppressed Desires" and to her "Close the Book," which is a part of the new Provincetown bill; to Mr. Langner's "Another Way Out," and his late lamented "Family Exit." Short of some actual accomplishment of the first order, these satirical skits are the best possible evidence that there is really an artistic community among us; for, popular prejudice to the contrary, the critical faculty is the twin brother of the creative, and as indispensable to important writing as technique is to important acting.

The obvious limitation of the Little Theatre school is that as yet they have produced only one-act plays. Mr. Langner, it is true, gave us three acts of "The Family Exit," but in reality the play was only a one-act idea twice repeated, quite lacking any inner structure on the larger scale. It is

one thing to fly like a bird and another to make a succession of leaps (albeit with the aid of wings) like a grasshopper. There is more than mere prejudice in the popular preference for larger helpings of drama. The difference is that between a sketch, however luminous and inspired, and the finished painting.

This lack of sustained work is perhaps only the outward sign of a deeper shortcoming—a lack of vital interest in the life about us. Miss Glaspell's satires strike at the vagaries of the abnormal psychologist and the equally abnormal new-moralist. Mr. Langner is obviously a disciple of Shaw and Butler; his playthings are ideas: but, where his masters are, beneath the surface, ardent philosophers and moralists, his interests seem never to strike below the surface texture of absurdity. If the Little Theatres produce no more substantial fare than these one-acters they will indeed be a crop of mushrooms—the most delectable of morsels, but still morsels.

### The Little Theatre and Commercialism

In Miss Mackay's very first sentence she declares the Little Theatres "the arch-foe of commercialism," and later quotes Mr. Belasco's denunciation of them as "a menace." Surely these hostile attitudes are shortsighted on both parts—and not a little absurd. If the Little Theatres ever produce a drama of the larger calibre a good part of it at least will be a popular drama, and profitable financially as spiritually. To assume that an artist stands above a just, even a liberal, reward for his labors is sophomoric cant. And are even the commercial managers wholly lost in commercialism? To any one who really knows them, the idea is absurd.

One case is as obvious as it should be instructive, that of Arthur Hopkins. "The Poor Little Rich Girl" was as genuine a work of the imagination as any that has come out of Washington Square, and the plays of Clare Kummer are satire of the freshest and most delightful. Mr. Hopkins employs the new scenic art, and with results that are beautiful in the extreme. And though his actors are thoroughly equipped technically, he somehow imbues them with the best spirit of the amateur. No less than our artistic Villagers, he is given to "experimentation." "We Are Seven" and "The Deluge" were plays of the rarest potentialities, though failures. And now, in "Barbara," he has given us a play full of the tenderest and most imaginative sentiment, enabling Marie Doro to rise to a plane of sheer beauty as unexpected of her as it is unexampled on our stage. In many

ways the play is unreal and its characterization absurdly crude, but those who see it will have an artistic memory of the first water.

The quality which distinguishes these productions from those of the "arch foe" of the Little Theatres is a greater breadth of human appeal. In some ways this is perhaps a limitation. Keen as is Miss Kummer's satire, it seldom rises to the realm of ideas—which so many good folk find so uncomfortable. The object of her shafts is human nature as we see it and know it commonly. She is no

true sister of Bernard Shaw—or of Miss Glaspell and Mr. Langner. But in its way her satire is quite as delightful, and she has a quality strangely absent from the Little Theatre plays—sensibility and romance which are genuine, however playful.

Is it possible that the aloofness of the Little Theatres from the larger stage is conditioned, not by arch enmity to commercialism, but by inability to command those deeper and more abiding emotions which are indispensable to drama of the first order?

As for the imaginative plays which

Mr. Hopkins has produced, their distinguishing quality is tender sentiment and deep human feeling. Too often in Broadway the quality appears in forms that are debased and trivial, so that many of us loathe their very name. But at their deepest and truest they are an essential of great art. The best hope for Little Theatre work that is more penetrating and sustained perhaps lies in the mood that inspired Miss Glaspell's "Trifles" of last year and Mr. O'Neill's "In the Zone," which is the outstanding feature of the current bill

at the Comedy.

Taken as a whole the output of the Little Theatres is slender and fragmentary, but it is a genuine outgrowth of our own soil and climate. It has definitely enriched our drama and holds at least the germ of promise of much greater things to come. It may some day even deserve Miss Mackay's epithet of "the most vital note in the art of the United States today."

November 11, 1917

---

## THE PLAY
### By Alexander Woollcott

#### Eugene O'Neill's Tragedy.

BEYOND THE HORIZON, a tragedy in three acts and six scenes, by Eugene O'Neil. At the Morosco Theatre.

| | |
|---|---|
| Robert Mayo | Richard Bennett |
| Andrew Mayo | Edward Arnold |
| Ruth Atkins | Helen MacKellar |
| Captain Dick Scott | Max Mitzel |
| James Mayo | Mary Jeffery |
| Mrs. Kate Mayo | Erville Alderson |
| Mrs. Atkins | Louise Closser Hale |
| Mary | Elfin Finn |
| Ben | George Hadden |
| Dr. Fawcett | George Riddell |

The fare available for the New York theatregoer is immeasurably richer and more substantial because of a new play which was unfolded yesterday afternoon in the Morosco Theatre—an absorbing, significant, and memorable tragedy, so full of meat that it makes most of the remaining fare seem like the merest meringue. It is called "Beyond the Horizon," and is the work of Eugene O'Neill, son of that same James O'Neill who toured the country for so many years in the heroics of "The Count of Monte Cristo."

The son's advent as a dramatist has

been marked by several preliminaries in the form of one-act plays, done by the Washington Square Players and by the Provincetown folk at their little theatre in Macdougal Street, but "Beyond the Horizon" is the first of his long plays to reach the stage, and even this one comes not for a continuous engagement, but for a series of special matinees. It is presented at the Morosco by John D. Williams with a cast chosen from his own "For the Defense" company, eked out by borrowings from the "Storm" cast at Mr. Broadhurst's theatre. This amalgam, while rather conspicuously imperfect in one rôle, is for the most part admirably suited to the work in hand, player after player rising gratefully and spontaneously to the opportunities afforded by a playwright of real power and imagination.

The only reason for not calling "Beyond the Horizon" a great play is the natural gingerliness with which a reviewer uses that word—particularly in the flush of the first hour after the fall of the final curtain. Certainly, despite a certain clumsiness and confusion involved in its too luxurious multiplicity of scenes, the play has greatness in it and marks O'Neill as one of our foremost playwrights, as one of the most spacious men to be both gifted and tempted to write for the theatre in America. It is a play of larger aspect and greater force than was "John Ferguson," a play as vital and as undiluted a product of our own soil as any that has come this way since the unforgotten première of "The Great Divide." In its strength, its fidelity, its color, its irony, and its pitilessness, it recalls nothing quite so much

as one of the Wessex tales of Thomas Hardy. As to whether it will be, or could be, popular—well, that lies not within the province of this reviewer (nor the wisdom of anybody) to say.

"Beyond the Horizon" rehearses the tragedy of a man whose body and mind need the open road and the far spaces, but who, by force of wanton circumstance and the bondage of a romance that soon burns itself out, is imprisoned within the hill-walled boundaries of a few unyielding acres, chained to a task for which he is not fitted, withheld from a task for which he was born. He fails, and his failure distils a poison for all about him. He sinks, amid wretched and disheartening poverty, into consumption, and the life in him wanes before your eyes, through scene after scene written with splendid art and a cunning knowledge of that plague, with its alternating psychology of hope and depression. At the end, he crawls out of the farmhouse to die in the open road, his last glance straining at the horizon beyond which he had never ventured, his last words pronouncing a message of warning from one who had not lived in harmony with what he was.

The accompanying and minor tragedy is that of the brother, a sturdy, generous, earth-bound fellow, born to till those very acres, and sure to go wrong if he ever left the clean earth and the work amid things of his own creation. So in the Hardyesque irony of the O'Neill mood, it is this brother whom Fate and his own character drive out into the lonely open. The measured tread of Fate can be heard among the overtones of this remarkable tragedy.

O'Neill is not only inexorable in the working out of his play to its saddening conclusion, but a bit intractable in the matter of its structure, a bit unyielding both to the habits of the average audience and the physical limitations of the average playhouse. The breaking of his final act into two scenes, mark of a chronic looseness of construction, is distinctly dissipative in its effect and his scenario calls for two pretentious exteriors which the very palpable draperies (painted in the curiously inappropriate style of a German post card) do not provide very persuasively.

If the play itself has a certain awkwardness and if its mere mounting is sometimes clumsy, the cast, at least, is uncommonly fine. As the home-bound wanderer, Richard Bennett plays with fine eloquence, imagination, and finesse—a performance people will remember as they remember his John Shand in "What Every Woman Knows." Save for an occasional Farnumesque posture, trailed from the "Storm," Edward Arnold plays the brother with tremendous force and conviction. Then Helen McKellar proves herself a first-rate actress as the woman, while Louise Closser Hale darts (like a trout for a fly) at the best part that has come her way since Prossy bridled in "Candida." Then Erville Anderson, as the old father—well, there are riches in this performance as there are in this play which make the reviewer "yearn for the open spaces" of the Sunday newspaper. Q. V.

February 4, 1920

---

## THE PLAY
### By ALEXANDER WOOLLCOTT

#### Eugene O'Neill at Full Tilt.

THE HAIRY APE, a play in eight scenes, by Eugene G. O'Neill. At the Provincetown Theatre.

| | |
|---|---|
| Robert Smith | Louis Wolheim |
| Paddy | Henry O'Neill |
| Long | Harold West |
| Mildred Douglas | Mary Blair |
| Her Aunt | Eleanor Hutchison |
| Second Engineer | Jack |
| A Guard | Harry Gotrieb |
| A Secretary | Harold McGee |

The little theatre of the Provincetownsmen in Macdougal Street was packed to the doors with astonishment last evening as scene after scene unfolded in the new play by Eugene O'Neill. This was "The Hairy Ape," a bitter, brutal, wildly fantastic play of nightmare hue and nightmare distortion. It is a monstrously uneven piece, now flamingly eloquent, now choked and thwarted and inarticulate. Like most of his writing for the theatre, it is the worse here and there for the lack of a fierce, unintimidated blue pencil. But it has a little greatness in it, and it seems rather absurd to fret overmuch about the undisciplined imagination of a young playwright towering so conspicuously above the milling, mumbling crowd of playwrights, who have no imagination

at all.

"The Hairy Ape" has been superbly produced. There is a rumor abroad that Arthur Hopkins, with a proprietary interest in the piece, has been lurking around its rehearsals and the program confesses that Robert Edmond Jones went down to Macdougal Street and took a hand with Cleon Throckmorton in designing the eight pictures which the play calls for. That preposterous little theatre has one of the most cramped stages New York has ever known, and yet on it the artists have created the illusion of vast spaces and endless perspectives. They drive one to the conclusion that when a stage seems pinched and little, it is the mind of the producer that is pinched and little. This time O'Neill, unbridled, set them a merry pace in the eccentric gait of his imaginings. They kept up with him.

O'Neill begins his fable by posing before you the greatest visible contrast in social and physical circumstance. He leads you up the gangplank of a luxurious liner bound for Europe. He plunges you first into the stokers' pit, thrusting you down among the men as they stumble in from the furnaces, hot, sweaty, choked with coal dust, brutish. Squirm as you may, he holds you while you listen to the rumble of their discontent, and while you listen, also, to speech more squalid than even an American audience heard before in an American theatre. It is true talk, all of it, and only those who have been so softly bred that they have never really heard the vulgate spoken in all its richness would venture to suggest that he has

exaggerated it by so much as a syllable in order to agitate the refined. On the contrary.

Then, in a twinkling, he drags you (as the ghosts dragged Scrooge) up out of all this murk and thudding of engines and brawling of speech, to a cool, sweet, sunlit stretch of the hurricane deck, where, at lazy ease, lies the daughter of the President of the line's board of directors, a nonchalant dilettant who has found settlement work frightfully interesting and is simply crazy to go down among the stokers and see how the other half lives aboard ship.

The follows the confrontation—the fool fop of a girl and the huge animal of a stoker who had taken a sort of dizzy romantic pride in himself and his work as something that was real in an unreal world, as something that actually counted, as something that was and had force. Her horrified recoil from him as from some loathsome, hairy ape is the first notice served on him by the world that he doesn't belong. The remaining five scenes are the successive blows by which this is driven in on him, each scene, as written, as acted and as intensified by the artists, taking on more and more of the nightmare quality with which O'Neill seemed possessed to endow his fable.

The scene on Fifth Avenue when the hairy ape comes face to face with a hotte parade of wooden-faced churchgoers who walk like automata and prattle of giving a "Hundred Per Cent. American Bazaar" as a contribution to the solution of discontent among the

lower classes; the scene on Blackwell's Island with the endless rows of cells and the argot of the prisoners floating out of darkness; the care with which each scene ends in a retributive and terrifying closing in upon the bewildered fellow—all these preparations induce you at last to accept as natural and inevitable and right that the hairy ape should, by the final curtain, be found dead inside the cage of the gorilla in the Bronx Zoo.

Except for the role of the girl, which is pretty badly played by Mary Blair, the cast captured for "The Hairy Ape" is an exceptionally good one. Louis Wolheim, though now and then rather painfully off the beat in his co-operation with the others, gives a capital impersonation of the stoker, and lesser parts are well managed by Harry O'Neill as an Irish fireman dreaming of the old days of sailing vessels, and Harold West as a cockney agitator who is fearfully annoyed because of the hairy ape's concentrating his anger against this one little plutocrat instead of maintaining an abstract animosity against plutocrats in general.

In Macdougal Street now and doubtless headed for Broadway, we have a turbulent and tremendous play, so full of blemishes that the merest fledgling among the critics could point out a dozen, yet so vital and interesting and teeming with life that those playgoers who let it escape them will be missing one of the real events of the year.

March 10, 1922

# "Expressionism" in German Theatres and Our Own

## By SHELDON CHENEY

THE man out front probably knows little about Expressionism. By "the man out front" I mean the average intelligent playgoer. By "Expressionism" I meant that progressive or disrupting force that has shaken the theatres of certain European countries out of the old channels of polished realism, symbolism and romanticism, substituting a ruder but (where successful) a more moving sort of play and production, a sort of shorthand-explosive-mile-a-minute drama that has brought the refined elder critics to a sad state of gasping protest, confusion and dismay, the "new art" critics to ecstasies of enthusiasm and applause, and everybody concerned to a free-for-all critical battle.

The man out front has not been particularly interested in these inside quarrels over the latest "ism." Quite properly he goes to see a play not in the light of theories but for what he gets out of it. In America, moreover, he has until very recently heard the word "Expressionism" only as a faint echo across seas. If he saw the Hopkins-Jones production of "Macbeth" at the Plymouth Theatre last season, like the New York critics, he knows all about it. Yet what he saw was not an Expressionist production at all, but a Shakespearean play—rather badly acted—before a remarkably fine collection of mixed Expressionistic and romantic sets.

Perhaps he has heard and accepts as final the phrase "Expressionism is the Bolshevism of art." All-enveloping enough to serve temporarily as a cloak for ignorance, this hardly allows for the landslide toward modern art that is just now developing in our galleries and theatres.

Recently I was myself the man out front at a series of Expressionist productions—having gone to Europe saying to myself that I would see the theatres and galleries, not as critic or student, but entirely for the enjoyment to be got out of them. And, as the average intelligent playgoer would, I had (again speaking in modernist fashion) a roaring good time esthetically. So far as the subject in hand goes, this is what I saw:

Plays rushed through swiftly, almost recklessly, in rapidly succeeding short scenes—short as compared to the "regular" three-to-five-act drama, but gratefully long compared to the tiring snapshot scenes of the movies. Plays that distort life, intensifying emotional crises, driving characterization to the point of caricature, backgrounds lost, detail forgotten, naked humanity exhibited, hideous or beautiful, life in the rude and life at its sublimest moments—only never the middle-class normal life that glorifies the even and colorless way, and hides its human moments. Plays lose in technique, neglectful of, or more likely defying, all the "conventions" of play-writing, all the formulas of plot, complication, climax and conclusion so painfully constructed by nineteenth century playwrights and professors—plays, rather, in which the only rule of technique seems to be to leap into violent action at the first bound, and then to jump from peak to peak of emotion, compressing a lifetime into every moment, packing every speech with a torrent of ideas, laying bare life in the raw. In short, plays not always smooth and intelligible and certainly not pretty, but plays that act on you like emotional sledgehammers, that move you and purge your soul like the old Greek dramas—which is curious enough, considering our refined and reverent attitude toward classic plays. Plays that shock you and stir your finest emotions, that outrage you and yet leave you with a sense of spiritual exaltation.

This is the justification for Expressionism. It breaks most of the established laws of playwriting and production, perhaps of academic art. But it moves the spectator emotionally, dramatically, esthetically, beyond ninety-nine-hundredths of the serious offerings of our current theatres. One who goes to sit through plays often these days is likely to get a sudden revealing perspective on the whole institution of the theatre, seeing it in a flash as a worn-out, devitalized, soft-spoken old shadow of something descended from Greek gods and English kings.

At least the faults of what I am calling the Expressionist play do not lie in the direction of inanition, pussyfooting and dry rot. Such plays may turn out to be merely the violent gestures that go with the birth pains of something finer and serener to come, and the name Expressionism may not outlast a decade of critical wranglings; but the strength, the violence, the brutal directness of this drama may well be the force that will revitalize the whole institution of the theatre. These qualities may bring it back from being on the one hand merely a medium of "amusement" and on the other a playground for intellectuals, scenic artists and sentimental or terribly serious investigators into the sex-crimes of humanity.

Seated one night in the great severe auditorium of the Volksbühne in Berlin, I was reflecting that the German theatre, like the American, had made most of its progress of the last decade in the field of stage decoration rather than in developing fresher modes of playwriting and acting. But when the curtain rose—on Toller's "Masse Mensch"—it disclosed, not anything in the nature of decoration, but an apparently limitless black stage, with three figures down front picked out by three crossing shafts of light: two workmen, and between them, hands clasped in theirs, a working woman in blue.

Whether it was the absolute simplicity of the scene, or the dynamic suggestion in the forward-straining attitudes of the three actors, or the direct way in which they plunged into what they had to say, or all these together, I cannot be sure. But within a minute I had been caught up and engulfed in the swift reality of the action. The ideas of the impending drama were quickly posed: radical against more radical, the men for complete revolution with all it implies in a war-taught world, the woman joining them but tempering her allegiance with belief in the individual man rather than the man-mass—and her position immediately complicated by love-interest in an individual on the opposing side.

Following the briefest of pauses, the curtain rose again on a dark stage, with rising platforms and merely a glimpse, between parted black curtains, of two columns and a chalker-up-of-quotations on an impossibly high stool, to suggest a stock exchange. The action was as theatrical, sketchy and violently direct as before—the capitalists (in exaggeratedly avaricious make-up) offering hundreds of thousands of lives as their contribution in war, with a horrible outraging glee—the whole ending in a grotesque capitalistic dance.

Then a scene of the strikers' meeting, a mass of some sixty workmen, on what may be compared to athletic-ground bleachers, their faces flooded with hot light, and the stage around them dark—a wedge-shaped mass that swayed with emotion as the men's leaders and the woman spoke from their midst. Altogether it was a tremendously moving scene because the spectator got the explosive quickness and the tremendous power of the mass, together with the confusion of individual purpose. And it was particularly moving when the group spoke, or half shouted, as a unit in a sort of speaking chorus, varying from a low undertone to a staccato roar.

Followed other scenes, exaggerated dream scenes, and equally distorted "real" scenes. One was an outlandish sort of campfire meeting where the revolution's leader played an accordion, and there was something like a dance of death, and the girl in blue pleaded for a life and lost. Most stirring of all was a second workers' meeting, this time the strikers rushing in by ones and twos and groups, fleeing before the unseen soldiers, gathering courage as they gained in numbers on the bleachers, wildly debating, finally standing together solidly to sing out the "Internationale." Then suddenly a volley of shots, and the entire mass of men and women falling. After that utter silence as the curtains parted at back to reveal the soldiers with leveled rifles.

No melodrama ever held a more magnificent thrill. It was melodra-

ma, sensational, violent melodrama, but melodrama carved out of today's life. Following another strange dream scene, during which the girl was cramped into a red cage, came the last "reality" scene, black platform again, against black curtains, with comparatively quiet action that seemed for a moment like the conventional final-act let-down. Until, suddenly, after the last main character had disappeared through the curtains, two old women, horribly realistic apparitions, crawled up out of nowhere, grabbed and hid the trinkets left by the girl, found a crust of bread only to fight over it like wild beasts, then, as two shots rang out, disgorged their loot and cringed back into the starving abject creatures they originally were.

This last ironic pendant to the play, almost unrelated to the story, like a perverse afterthought, is typical of the Expressionist left-wing writers, almost like the perversity of the painters who delight in cutting off the head of a main character and sticking it apart in a corner somewhere. Even Germans have said that "Masse Mensch" is incomprehensible in spots, and I, with my very imperfect understanding of the language, found it more so.

But whether I understood it all with the mind or not, I look back to it as one of the most emotional productions I have ever witnessed. A second attendance in no way dulled the pleasure. It remains not only my most vivid impression of the German stage, but lingers in my mind as the best example of the Expressionistic play and play-producing method that I saw. It is a smashing conception put over with little regard for surface realities, boldly produced practically outside of time and place, yet intensely of the times—a direct, daring, utterly theatrical, vividly living dramatic experience. The author is actually in prison in Munich for his part in revolution. And a few days later I saw seemingly these same workmen and thousands more singing the "Internationale" at a mass meeting in the Grosses Schauspielhaus.

With what justification, it may be asked, can this sort of thing be called Expressionism, rather than Cubism, or just a new sort of melodrame, or what not. It is necessary to go back to the world of painting, where the word originated, for an answer. The last great phase of visual art was called Impressionism, and it is possible to define that term with some approach toward exactness, because its technical system of broken color is a scientific matter, and because its implications of subjective approach and atmospheric simplification of nature are based on the common root idea of the word "impression."

But there is no such short road to a definition of Expressionism. The avowed Expressionists (and there are hundreds of them) are impatient of being tied to any one technique, deriving from Impressionist, Cubist, and any others that suit their purpose of directness. They are broader than the frankly technical "schools," because they insist only that the approach to art must be changed, that the seven-

teenth, eighteenth, nineteenth century obsession with representation be scrapped, that emphasis on creative expression take its place.

Obviously "expression" may mean many things. A cat at night expresses itself in one way, a drunken man himself in another, and the Chopin-chemise dilettante dancer in another. But in art there does exist such a thing as individualistic creation or expression (more or less), as against (less or more), that is taken from the surface aspects of nature. In art one may place more emphasis on emotion and less on truth to observed fact. One may be concerned with the "feel" of the cow or the barn or the grass and not its spitting image. Add to this that most Expressionist artists go back to the belief, long lost or disregarded, that there is something in the nature of abstract esthetic form that distinguishes the true work of art, and that this something is more important than any other element. Remember that this "formal quality" is a matter of conception and expression, not of subject matter—and there is made out a pretty good case for calling the whole thing "Expressionism" and letting it go at that.

"Expressionism," in any event, is a blanket term that has come into wide use in Europe as designating all those tendencies of modern art that subordinate objective imitation to emotional expressiveness; that seeks to fix and intensify the artist's feeling, with only secondary regard for its sources in nature or its truth to outward aspects. The practice of such an art, depending as it does on the direct liberation of emotion, has brought about a general, and perhaps a perverse, disregard not only for the inessential details of actuality, but for refinement of technique. So that, after the Expressionist tells you that obsession with representation has all but killed art in the last five centuries, he is likely to mention also his second pet antipathy, for technical display and "finish." Negatively, he is anti-realistic (in the surface sense), and he is against pretty surface refinement and facile decoration. Constructively, he puts against these things something presumably bigger—naked emotional values and revealed esthetic form.

Before attempting to point out parallels in drama, it may be wise to speak of two more so-called Expressionistic plays. The only 100 per cent. example available for reading in English is George Kaiser's "From Morn to Midnight," the dramatic story of a routine-trained bank clerk who is jolted off his own track and for a single day tastes life at its richest, lives up and over the summit of life in a day's doings—a jerky, violently conceived and emotionally compelling play in seven crises. As another illustration, there is Eugene O'Neill's "The Hairy Ape"—an American example of the type—a swiftly moving, elemental, unpretty, unnatural, emotionally conceived play-sequence, presented in eight scenes. It has just now been brought to Broadway by Arthur Hopkins,

from that Provincetown Players' stage which has seen so many beginnings of better things for the American theatre.

Taking the points of the definition above in reverse order, one may recognize these parallels. All three playwrights have scrapped the older formulas of playmaking, their dramas being, in many scenes, without respect to a climatic arrangement, up to a crisis and down again—each rather traveling a circle of life through a series of crises of more or less equal importance—or possibly simply rolling along without any theory of technique at all. Secondly, they leave one—the two German examples particularly—with a sense of dramatic form revealed, of an indefinable quality achieved, that sends one away exhilarated, almost ecstatic, at the end, emotionally stirred and dramatically purged. Thirdly, the obvious disregard for nature, the distortion of its outward aspects in character and place and its sequence in time, suggests that they have shifted the emphasis from representation to expression, from truth of detail and of word to a compressed, dynamic, individual emotion projected white hot in chunks and shreds.

They have not discarded realism in its better sense; they have gone through it to the heart of reality, and, like the painters, reveal that heart shorthand, forgetful of background and careless of detail. They utterly give the laugh to naturalism, plausibility and smooth sequence, they ride language at a speed it has never attained before, they throw in pet bits of writing or pet gobs of sentiment or pet propaganda at the most unexpected moments, they caricature classes or individuals mercilessly; but somehow God saves them dramatically, drunklike, if you will, in the end.

I might take other examples, for I saw Kaiser's latest play, "Kanzlist Krehler," recklessly and theatrically acted at its première in Berlin, and one of Hamsun's abnormal stories set Expressionistically at Munich, and even Shakespeare propped up with modernist abstractions to heighten his dramatic moods, and a combined musical-comedy-and-bedroom farce in typical modernistic disintegrated settings.

Also I might, nearer home, trace out how Eugene O'Neill, starting as Realist, showed us last season in the eight-scened "Emperor Jones," with its explained abnormality, a logical forerunner to the frankly headlong and Expressionistic "Hairy Ape." But within the limits of this article the original three examples will serve better than many to bring out the two remaining points.

The first concerns language—which the Expressionist playwrights sling around somewhat as the radical painters sling paint. The second concerns the probable permanence of Expressionist elements in drama. As to language, and its pointing of ideas, here is a typical fragment from the snow field scene in "From Morn to Midnight," when the clerk flings away his snow-shriveled cuffs: "Soiled. There they lie. Missing in the wash. The mourners will cry through the kitchen; a pair of cuffs is lost. A catastrophe in the boiler. A world

in chaos."

The staccato abruptness, the word used for its immediate suggestion without regard to grammatical constructions, the side-by-side universal-trivial placing of ideas, are all of the method. In Kaiser's newest play, "Kanzlist Krehler" (also a story of a clerk thrown off the routine track), there are pages and pages of dialogue where hardly a speech runs beyond the single word, to be followed by half-page and full-page speeches where words and ideas are built up into emotional mountains. "Compress, pile up," might be the motto on Kaiser's dictionary. Something of the same range from compressed to torrential emotion is to be detected in the first scene of "The Hairy Ape"—and even the skeptical will grant that the noisy atmosphere of that scene is typical!

Is it caprice, is it unthinking reversion to violence, is it merely another form of post-war excess in a world rendered abnormal by confusion and suffering, is it a revulsion from pre-war overrefinement in art

and culture? Every playgoer and critic will doubtless have his guess when he begins to meet the thing in repetition—as even the American will meet it, with "The Hairy Ape" already on Broadway, the Theatre Guild promising to do "From Morn to Midnight," Eugene O'Neill waxing more Expressionistic year by year, and a lot of lesser authors standing on the verge. Oh, yes, there was Susan Glaspell with "The Verge" earlier in the season, with finely Expressionistic reaches of thought and naked emotion and disregard for "the trivial laws of nature"—and half a dozen scenic artists able and trying to stage things Expressionistically whenever there is the slightest excuse for getting out of the old ruts.

If I may record my guess now, it is that caprice and unconsidered violence do too often have a part in it now, and that in current examples there is an overplus of shock for shock's sake, and of profanity, horrors, sex perversion and supernaturalism. That the whole is founded on

a natural revulsion from overrefinement, timidity and tedious formulas; but also that the thing as a whole goes down to the bedrock foundation of esthetic progress, that it is creative and constructive as well as destructive, that it holds the key to future progress on the stages of the Western world.

It is the only force that is live enough, strong enough, in the field of art and playwriting today to revitalize the worn-out, misused, unimaginative current theatre. Call it Expressionism, or merely Post-Impressionism, or Post-Realism, or what you will—labels do not matter. But you must already grant it the validity of a revolutionary movement with soundly philosophic principles and some little actual achievement. Perhaps it is the awakening Hairy Ape of drama—but it's not likely merely to grope its way into confusion and the arms of a gorilla. Perhaps it will mate with serenity—and then what?

April 30, 1922

# MOSCOW PLAYERS WELCOMED HERE

**Famous Art Theatre Company Greeted by Fellow-Countrymen and Americans.**

## DENY BRINGING POLITICS

**Stanislavsky Looks to the Trip to Spread Their Doctrine of Realistic Art.**

The players of the Moscow Art Theatre, under the leadership of their Director, Constantin Stanislavsky, one of the two founders of the famous co-operative organization, arrived yesterday on the White Star liner Majestic. They will open at Jolson's Fifty-ninth Street Theatre on Jan. 8 and will present plays of Tolstoy, Gorky, Tchekhoff and other Russian dramatists in their own language.

They were a large group, more than fifty in all, but only a part of the society of dramatic art which Stanislavsky began to build in Russia in 1898. It was their first visit to this country, and some of their fellow-countrymen who are more widely known in America, actors and musicians, were at the pier with American representatives of the theatre to bid them welcome. The Russians did so after their national custom, men rushing into one another's arms, with salutations upon both cheeks, while those of this country contented themselves with hearty handshakes.

Stanislavsky and his fellow-artists look to this trip as a means of spreading their doctrine of realistic art in the theatre and also to retrieve their financial fortunes. The revolution in Russia and their recent tour on the Continent left the company in anything but prosperous circumstances, and it held together as it did only through the commanding personality of Stanislavsky.

### Resent Suspicion of Propaganda.

When politics was mentioned, and it was reported that the American Defense Society had protested against their entrance on the theory that they were Communist propagandists, they became as angry as men may and still preserve a courteous exterior.

"It is not so," said Stanislavsky through an interpreter, shaking his head. "We have no connection with the Soviet Government. We are interested only in art. It is our art that we have come to bring you, not politics."

Stanislavsky confessed, indeed, that instead of being at all interested in political matters he had once been under arrest for two hours by the Soviet authorities because his name became mixed up by mistake in some list of proscribed persons. He did hope, however, that by the interest in the Russian Theatre which he believed would be aroused here there would also develop a kindlier feeling toward the Russian people, who are portrayed in the Russian drama of Tolstoy and Tchekhoff.

The players were greeted as soon as the Majestic tied up in her slip by Morris Gest, who brought them to this country partly because of the success he had with the Chauve-Souris. With him were Nikita Balieff, who obtained his early training in the Moscow Art Theatre; Leon Bakst, designer of the Dinghileff ballet; Sergei Rachmaninoff, the Russian pianist; Alexander Siloti, conductor and pianist; Professor Nicolas Roerich, painter, and Boris Anisfeld, who has done many of the scenic settings at the Metropolitan Opera House. There were also Augustus Thomas of the Producing Managers' Association and a committee from the Actors' Equity Association, including Francis Wilson, President, and Frank Gillmore, Secretary, who made the Russian players honorary members of the association for the period of their stay in America.

### Welcomed With Bread and Salt.

After the immigration authorities had passed the company and their baggage had been examined they went to the reception room on the pier, where they were formally welcomed to the United States, and the traditional Russian bread and salt welcome was offered to them. An ikon was presented by Balieff to Stanislavsky, and then a loaf of Russian bread and a container of salt were offered to him. This is one of the oldest customs of Russia, and no good Russian would think of going to a new home or a new country without it, lest good fortune fail in the new surroundings.

Stanislavsky, who has been called the "gray godfather of the Russian theatre," went with a police escort to the Hotel Thorndyke, where he rested in preparation for the rehearsals which will begin today. He is a tall, powerfully built man of nearly 60 years. His hair is

almost snow white, and his shaggy eyebrows lend a leonine expression to a face molded and carved in stern lines. Keeping his theatre together during the trying days of the revolution and after had taxed all his powers.

"We worked a little harder; we built up the things of the spirit by hard work, otherwise we would have perished," he said. There were many times during the red days in Russia when members of the theatre company went long times without food and often without money.

### Tchekoff's Widow a Member.

Another interesting figure was Olga Knipper-Tchekova, widow of Tchekoff, the Russian writer, who constructed for his play which the Art Theatre Group will present. She has been with the company since its organization, twenty-five years ago. Others of that original group who are still with the company playing the parts which they first created are Vassily Katchaloff, Ivan Moskvin, who created the rôle of Tzar Feodor; Leonid M. Yeonidoff, Vassily Luzhsky, Alexander Vishnevsky, Vladimir Gribunin and Nikolai Alexandroff.

These names go back over a period of development of the Russian Art Theatre that spells romance. It was born in a moment when Stanislavsky, an amateur actor, dreaming great dreams of his art which he had not been able to carry into effect, Vladimir Nyemirovitch-Dantchenko, who had been more concerned in the business end of the theatre, but who also cherished ideals of what the theatre should be. They met in a Moscow café in 1897 and sat for eighteen hours talking of the stage and what they wished to do. They determined to do it, and that marked the beginning of the Moscow Art Theatre.

It was begun as, and has always remained, a co-operative institution. Its members drew salaries, and whatever profits there might be were divided among them after the needs of the theatre had been provided for. As they have been more interested in their art than in becoming wealthy, the theatre grew magically.

### Seats Obtained by Lottery.

The most prominent actors and actresses in Russia were attracted to its ranks, and it boasts that it has never had an empty seat. Indeed, the way in which seats are obtained in Moscow is unique. A visit to the box office provides one with a number, and a visit later in the day brings the information as to whether a lottery drawing entitles the holder of that number to buy seats. Persons visit the theatre as many as ten times before being so lucky as to obtain the number which offers them the opportunity to enter.

The opportunity to share in the management of the theatre brought to it many of its members. When a new production is determined upon a meeting of

the members is called, and it is decided who is to produce the play, and that person has absolute authority, always under the direction of Stanislavsky.

But the Moscow Theatre itself is only a part of the organization Stanislavsky created. To train the young actors and actresses who show talent for the stage he formed four studios, small theatres in which they are developed until the time when they are ready to take their place in the greater theatre. They form a constant source of supply of artistic material in which is the life of the Art Theatre, and in which the director takes perhaps more interest than in the Art Theatre itself. Recently he has added an operatic studio. In them all nearly 1,000 persons are employed.

### Has Produced 71 Plays.

In the years since its founding the theatre has produced seventy-one plays—Pushkin, Gogol, Ostrovsky, Tolstoy, Turgenieff, Dostoievsky, Tchekoff, Andrieff and Gorky, all the life of the stirring Russia which was to break forth in the revolution. It was so typically Russian that only once before did a company leave the country, in 1905, when, to escape the revolution of that year, they made a tour to Germany and Austria.

When the revolution of 1917 came the company fell upon its most evil days, and there happened a minor theatrical Odyssey which ended only last Spring. In Moscow the group was under a constant threat because of the supposedly bourgeois tendencies in its repertory, and it was only by the courageous enthusiasm of Stanislavsky that it was able to carry on.

The Odyssey began when a small group of the company was caught in Kharkoff at the close of the Spring of 1919 when the armies of Denikin took the town. They had the alternative of trying to get back through the lines or of continuing into Central Europe. It seemed the wise thing to retreat with Denikin, that a portion of the company might continue in more favorable surroundings than those in Moscow. One man, Nikolai Podgorny, felt that he was bound to go back to Moscow and he worked his way through the lines after days of hardship.

The others, including Mme. Knipper-Tchekhova and Mme. Germanova, with Katchaloff, Massalitinoff, Bersenieff, Alexandroff and Pavloff, went on. They took ship to Constantinople, found refuge for a season in Sofia and finally reached Berlin, always playing where they stopped. They played in Prague, Vienna and Scandinavia, making a living and little more. But when the prospect of an American tour appeared they decided to return to Moscow and did so last Spring, after almost three years of exile, to play together again and regain the power of working in a group which has contributed so largely to their success.

January 5, 1923

279

## THE PLAY
### By JOHN CORBIN.

#### Russian High Comedy.

THE CHERRY ORCHARD, a comedy in four acts by Anton Tchekov, translated from the Russian by Jenny Covan. At Jolson's 59th Street Theatre.

Liuboff Andreievna Ranevskaya..
............................Olga Knipper-Tchekhova
Anya .......................Alla Tarasova
Varya ....................Vera Pashennaya
Leonid Andreievitch Gaieff..
....................Constantin Stanislavsky
Yermolai Alexelevitch Lopakhin..
....................Leonid M. Leonidoff
Peter Sergelevitch Trofimoff..
....................Nikolai Podgorny
Boris Borisovitch Semyonoff-Pishtchik..
....................Vladimir Gribunin
Charlotta Ivanavna.......Maria Uspenskaya
Semyon Panteleivitch Yepikhodoff..
....................Ivan Moskvin
Dunyasha ............Varvara Bulgakova
Firce ..................Vassily Luzhsky
Yssha ................Nikolai Alexandroff
A Tramp..................Alexei Bondirieff
A Station Master.........Ivan Lazarieff
Post Office Clerk..........Lyoff Bulgakoff

The Moscow players proceeded last night from the lower depths of Gorky to the high comedy of Tchekhoff, revealing new artistic resources. Stanislavsky, Olga Knipper-Tchekhova, Moskvin, Leonidoff and half a dozen others entered with consummate ease into a rich variety of new characterizations. The stage management was less signal in its effects, but no less perfect. Yet for some reason "The Cherry Orchard" failed to stir the audience, even the Russian portion of it, as did "The Lower Depths" and even "Tsar Fyodor."

This is a play of comedy values both high and light. The milieu is that of the ancient landed aristocracy, beautifully symbolized by an orchard of cherry trees in full bloom which surrounds the crumbling manor house. Quite obviously, these amiable folk have fallen away from the pristine vigor of their race.

The middle-aged brother and sister who live together are unconscious, irreclaimable spendthrifts, both of their shrinking purses and of their waning lives. With a little effort, one is made to feel, even with a modicum of mental concentration, calamity could be averted. But that is utterly beyond their vacuous and futile amiability; so their estate is sold over their heads and the leagues of gay cherry trees are felled to make way for suburban villas.

Beneath the graceful, easy-going surface of the play one feels rather than perceives a criticism on the Russia of two decades ago. Here is a woman of truly Slavic instability, passing with a single gesture from heartbreak to the gayety of a moment, from acutely maternal grief for an only child long dead to weak doting on a Parisian lover who is faithless to her and yet has power to hold her and batten on her bounty. Here is a man whose sentiment for the home of his ancestors breaks forth in fluent declaiming, quasi-poetic and quasi-philosophic, yet who cannot lift a finger to avert financial disaster.

In the entire cast only one person has normal human sense. Lopakhin is the son of a serf who has prospered in freedom. He is loyal enough to the old masters, dogging their footsteps with good advice. But in the end it is he who buys the estate and fells the cherry trees for the villas of an industrial population. It is as if Tchekhoff saw in the new middle class the hope of a disenchanted yet sounder and more progressive Russia. The war has halted that movement, but indications are not lacking that it is already resuming.

With such a theme developed by the subtly masterful art of Tchekhoff there is scope for comedy acting of the highest quality. It is more than likely that the company seized every opportunity and improved upon it. But to any one who does not understand Russian, judgment in such a matter is quite impossible. Where effects are to be achieved only by the subtlest intonation, the most delicate phrasing, it fares ill with those whose entire vocabulary is da, da.

As an example of the art of the most distinguished company that has visited our shores in modern memory, this production of "The Cherry Orchard" is abundantly worth seeing. The play in itself is of interest as the masterpiece of the man who, with Gorky, has touched the pinnacle of modern Russian comedy. But if some Moscovite should rise up and tell us that in any season our own stage produces casts as perfect and ensembles as finely studied in detail, it would be quite possible to believe him.

January 23, 1923

# PLAYWRIGHT OF MUSSOLINI'S NEW ITALY
## Luigi Pirandello Who After Writing Sixty-five Novels Now Stalks Stark Truth Upon the Stage

*By ELEANOR MARKELL*

GALA night in Rome. Notables, literary, artistic and social, gathered to honor Luigi Pirandello, poet, novelist, dramatist, philosopher. "There he is, the man with the pointed beard, gray hair and shining eyes." The word was passed excitedly from group to group of foreigners. "Ecco il Pirandello," said the Italians approvingly, as he was repeatedly called before the curtain—a man in the prime of life, short, wiry, quick in movement, whose unlined face was dominated by intense eyes.

The play, "Ma non è una cosa seria" ("But Not a Serious Matter") was interesting, but the focal point throughout the evening was Pirandello himself, and yet two short years before his plays had been hooted from the stage.

New Yorkers will presently have the opportunity to see this retiring professor, whose dramas have set the capitals of the world talking. For he is to be present at the American première of one of his plays. He will come with the same quiet dignity, the same absorption in his work, which are his striking characteristics at home. He lives in Rome on the heights just beyond the old Porto Piu, and there I found him hard at work on his latest play, "Each in His Own Way," which will be seen in New York this season.

I reached Italy this Spring just as the Pirandello wave of enthusiasm was mounting. The French Government had presented him with the Cross of the Légion d'Honneur in recognition of his attainments. His plays were being presented in Milan and Venice, a performance of "Henry the Fourth" was given before a packed house in critical Florence while I was there. I reached Rome to find the gala evening arranged in his honor and hardly a week passed while I was there without a presentation of one of his plays. After I had talked with him I began to understand this nation-wide enthusiasm for the new playwright, for I found the spirit of youth in a man of 56, an eager search for truth coupled with the judgment of years.

Pirandello will not change his views or their expression in the least to win favor; there is no evasion. He hits straight from the shoulder, and one must be alert to keep up with him. His words pour forth in a torrent and his hands outstrip his tongue in expressive movements, while his little brown eyes, birdlike in their brightness, dart questioningly.

"I have lived," said Pirandello, "through the period of the hopes and the bitter disappointments of united Italy. My early life was spent under the influence of that first burst of hope and enthusiasm of that liberated, free, united Italy, but I had hardly reached manhood before those hopes faded, that enthusiasm turned to disillusion. This experience turned my mind early to deeper subjects. What had appeared reality had been proved illusion. I entered that search for truth which is nation-wide today. Each question I submitted to the test—Is it truth, is it illusion?

"Under the stress of the experiences of the last years many of our old theories have gone down. In the social conventions we are reaching out for new standards and in the field of politics under the leadership of Mussolini we have turned from the Marxian program of class struggle and have gone back to our own inspired leader Mazzini and have adopted his ideal of class co-operation, which is better suited to the spirit of our people."

No writer so expresses the spirit of young Italy today as Pirandello, and yet before he took up dramatic writing six years ago he had done enough work for a well-rounded career in novel writing. He has long been known as a novelist of parts and has three hundred and sixty-five novels and short stories to his credit. In these stories must be sought the Pirandellian theories. There are to be found the life principles which after forming for fifty years in his mind he has now given to the world in dramatic form. The vehicle only is new; the thought the cumulative work of a lifetime. Pirandello has dipped deeply into philosophy, and the problems which he puts before us with such dramatic force are those for which modern philosophy searches for answers—the questions which young Italy is feverishly and most earnestly debating.

Few who have not been in Italy since the war realize the depths to which the country had sunk before Mussolini rescued it. It was out of these sobering experiences that young Italy turned to their modern philosopher who could put his theories before them not in dry essays but in living forms on the stage. He answered a need. That was what gave Pirandello his opportunity, and that he was able to voice the new thought of his nation with force and artistic expression explains to a large extent his present vogue. But he is also meeting with marked

success in Paris, and now London and New York seem about to fall into line, which would indicate that his plays have in them a universal element, are the expression of no one nation and are for no particular period.

Pirandello was very ready to talk of his work and to make clear his meaning on certain moot points in his plays. Take that brilliant but baffling comedy "Six Characters in Search of an Author," which has puzzled, delighted and intrigued Paris, New York and London, Pirandello explained that the Six Characters who break in upon the rehearsal of a play and demand an opportunity to express themselves are merely conceptions in his mind of characters more or less clear. "The play was an effort," he said, "to represent on the stage states of consciousness; to put into tangible form conceptions of characters as they were taking form in the mind of the author. The conceptions were not all equally clear. Some of the Six Characters—as the Children, for example—were never clearly conceived. That of the Father stood out most sharply in my mind and approached most nearly to a completely conceived character. The Stepdaughter also was almost fully conceived, the Mother was never clearly defined and represented the blind forces of life, while the children were but forms and never really alive."

Pirandello's tragedy "Henry the Fourth" is also illuminated by his interpretation of certain points.

The story is of a young man who after having been mad for twelve years suddenly recovers his sanity. His first impulse is to announce his cure and return to his life. Then he suddenly discovers that his hair is gray. When he was last conscious his hair was black. How many years, then, has he been held in this vise immovable? What will have happened in the world during a time long enough for his hair to gain the hue of age? His fiancée, what has happened to her? Has she waited for him or has the current of her life flowed on past him?

Revealing to no one his mental condition, he learns, by skillful questioning, that life has in fact flowed by, unheeding him. That all his former companions have gone their ways, including his sweetheart, who has married, become a widow and now accepts the attentions of his former rival to a degree which links her name with scandal.

His resolve is taken. Life has tricked him, he will trick life. As a madman he had supposed himself to be Henry IV. of Germany and his attendants were costumed as

belonging to his court. He will continue to live as Henry IV. and his revenge will be that every one who appears before him will be obliged to play a part which he will dictate. Not only attendants but all who come will be forced to dance to his tune. Immured in a villa outside of Rome he passes eight years amid the regal splendor of a court dispensing favors and justice with an emperor's hand.

Then suddenly life knocks at the door in the person of his former sweetheart, come with an alienist on his nephew's initiative to see what can be done. It is the first great test to which his deceit has been put; almost he goes down before it. Then recovering himself he pricks the bubble of each of their lives successively and leaves them confused and gasping. But he is not strong enough to continue the pretense. In a weak moment he lets his attendants know the truth. To resume the game he finds impossible. Yet his place in the old life has been filled and it is too late to make another for himself. In a moment of rage, thinking himself insulted by his old rival, and himself scarcely conscious of whether he is in reality the emperor or not, he calls his faithful attendants about him and seizing one of their daggers plunges it through the rival's heart. He who played with life for eight years must now pay the price for his pretense. Nothing is left for him but to remain immured through life in this living death.

I asked Pirandello if when Henry IV. recovered consciousness it was the discovery of the faithlessness of the woman he had loved which determined him not to return to life. "Yes," he answered, "that was the emotional reason, but back of that lies another and far more important reason based upon the inevitable law that man must ever go forward. There is no place for him to return to the past."

Seven Italian companies are now playing this drama.

One of the newly translated plays, "The Life Which I Gave to Thee," was written for Duse and there is a possibility that she may give it while in America this Winter. This is the story of a mother's devotion for a son; of his sudden death, and of her fierce determination that he shall not be accounted dead. To this end she continues the correspondence with her son's sweetheart in his name that he may continue to live in the heart of this other woman who loves him. Finally driven by a presentiment, she knows not of what, but which must be obeyed, the woman to whom the letters are written leaves her husband and children to

reach her beloved. Desperately the poor mother tries to keep the truth from her when suddenly upon the scene appears that other mother, the mother of the woman herself, struggling to avert a catastrophe in her daughter's life. The two mothers meet and in the face of this living tragedy the dead young man's mother admits her deceit just as the young woman of the romance bursts in upon them. She reads the truth in the two mothers' faces and her heartbroken cry sounds for the one mother the real death of her son. He has ceased to live for his beloved. He is in truth gone forever.

This is one of the latest plays to come from Pirandello's pen. Indeed, it was so recently completed as to be still a part of himself. He found it difficult to speak of it as freely as of his other works. "It is quite different from anything I have written previously," he said, "and more nearly I think pure art, and yet the entire work took me less than a month."

His still later work, "Each In His Own Way," is still in manuscript. In a way it is the complement of "Six Characters," which was a representation of the creatures of an author's brain while in the act of conception. "Each In His Own Way," on the other hand, is the presentation of the finished product and of the action and interaction between the stage and the audience of the result.

The contrast between these plays and "But Not A Serious Matter" shows the range of his genius. "But Not A Serious Matter" is the triumph of spontaneous life, of foolishness, of unreasonableness. It shows the success of the spontaneous life against man-made forms and the means used to attain that success. "There is not one reason, one right," Pirandello said, "but as many reasons and rights as there are individuals and for the same individual as many as the feeling creates in infinite variations. Every character from his particular point of view is right and there is no unique and higher point of view from which to judge the other."

Pirandello is of those whom he himself describes as men who have leaned over the abyss of life to look at the movement of the incoherent and contradictory current of life. Such men, he says, have understood the conventions for what they really are—transitional, frail and brittle—and are thereby liberated from their dominion. Conventions, he says, must not hold man and yet man cannot throw them away, for they are his only refuge against the fierce storm of life.

November 4, 1923

## FORBIDS MIXED GROUP.

### Mayor's Ban on White and Negro Children in O'Neill's Play.

The first scene of Eugene O'Neill's "All God's Chillun Got Wings" was not played by a mixed group of white and negro children last night. On Monday night, as the result of verbal permission, it was said, from Mayor Hylan, the mixed group of children appeared, but this arrangement was altered as the result of a letter received yesterday afternoon.

The letter, received late in the afternoon from John P. Sinnott, the Mayor's secretary, briefly carried the information that the appearance of the negro and white children was to cease, "to take effect immediately."

Miss M. Eleanor Fitzgerald and James Light, officials of the Provincetown Players, who said they received the Mayor's tentative permission last week for the appearance of the mixed cast of children, reached City Hall too late yesterday afternoon to effect any change in the new edict. In consequence, last night's performance was given without the scene in which the white and negro children appear.

August 20, 1924

## THE PLAY

By STARK YOUNG.

### Triumph at the Plymouth.

WHAT PRICE GLORY, a play in three acts, by Maxwell Anderson and Laurence Stallings. Settings designed by Woodman Thompson; staged and produced by Arthur Hopkins. At the Plymouth Theatre.

| | |
|---|---|
| Corporal Gowdy | Brian Dunlevy |
| Corporal Kiper | Fuller Mellish Jr. |
| Corporal Lipinsky | George Tobias |
| First Sergeant Quirt | William Boyd |
| Captain Flagg | Louis Wolheim |
| Charmaine de la Cognac | Leyla Georgie |
| Private Lewisohn | Sidney Elliott |
| Lieutenant Aldrich | Faye Roope |
| Lieutenant Moore | Clyde North |
| Lieutenant Schmidt | Charles Costigan |
| Gunnery Sergeant Sockkel | Henry G. Shelvey |
| Private Mulcahy | Jack MacGraw |
| Sergeant Ferguson | James A. Devine |
| A Brigade Runner | John J. Cavanaugh |
| M. Pete de la Cognac | Luis Alberni |
| Another Brigade Runner | Arthur Campbell |
| Brig. Gen. Cokeley | Roy LaRue |
| A Colonel | Keane Waters |
| A Captain | William B. Smith |
| A Lieutenant | Fred Brophy |
| Another Lieutenant | Thomas Buckley |
| A Chaplain | John C. Davis |
| Town Mayor | Alfred Renaud |
| Spike | Keane Waters |
| Pharmacist's Mate | Thomas Sullivan |
| Lieutenant Cunningham | J. Merrill Holmes |
| Lieutenant Lundstrom | Robert Warner |

Just a year ago Maxwell Anderson saw his "White Desert" win praise and pass too quickly off the stage through untoward circumstance. Last night at the Plymouth Theatre he and Laurence Stallings could feel nothing but satisfaction over their new play. "What Price Glory?" is something you can put your teeth into.

On the whole what is usually called the plot is hardly the main interest in this war play. The story, so far as it appears, is of the captain and the sergeant, old enemies with old scores to settle. The captain goes away on leave, the sergeant takes his sweetheart. When the captain returns he finds the girl's father demanding that the man who has deflowered her should wed her and pay him 500 francs. Chance turns the tide on the sergeant, and the captain is prevented from marrying off the pair only by the call to the front. In the dugout of the next act the sergeant gets a start on the captain by acquiring a wound in the leg that might send him back to the town where the girl is. Alsation officers are captured, however, and the captain wins the staff's offer of a month off for his reward. The two arrived in each other in the girl's barroom and carry the struggle through till the call comes to go back to the front, revoking the month's leave.

The fundamental quality of "What Price Glory?" is irony. Irony about life and about the war, but iron so incontrovertible in its aspect of truth and so blazing with vitality as to cram itself down the most spreadeagle of throats. The chaos, the irrelevance, the crass and foolish and disjointed relation of these men's lives and affairs to the war shows everywhere, and the relation of the war to their real interests and affairs. This is a war play without puerilities and retorts at God and society, and not febrile and pitying, but virile, fertile, poetic and Rabelaisian all at once, and seen with the imagination of the flesh and mind together.

The irony of "What Price Glory?" culminates in the creation of Captain Flagg, the best drawn portrait in the realistic method that I have seen in years. In him the irony becomes superb. He is the true labor of war, the rough surface of the deep and bitter in human nature; he is intelligent, tender, brutal and right. He deserves much and wins little either from the world without or from within himself. He is a bum and a contemptuous hero. And he was played last night by Louis Wolheim with a security and a variety that I have never seen him achieve before, as well as with intelligence and a kind of husky wit.

The acting in the performance as a whole was above the average. In some places it needed more projection; it remained too much behind the footlights and too little toward the audience; it was too merely natural and not enough theatre. But in the main it went well. William Boyd as the sergeant rival to the captain played better and better as the acts went on. The scene where the captain and the sergeant stood at the bar and drank and quarreled over the girl was one of the best moments of this season; the stage managing also at this point, with the clearing away of the other persons to the far side of the stage and the pointing up of these two tragic, bitter and fantastic figures set there against each other, was perfect. Woodman Thompson's settings were fair but without a creative and dramatic relation to the play.

"What Price Glory?" is not one of those examples of the art of the theatre that discover a story, a pattern of action, that is in itself the very essence and expression of the play. It has not invented images of action or event that embody unescapably the dramatic idea, as the sleep-walking scene in "Macbeth," to take a lofty instance, does, or the great fables that survive the ages of men. It moves in the reverse direction—toward, that is, the creation and employment of character and dialogue for the dramatic purpose. And yet the proportions of story and war and talk and personality are perhaps part of the total idea behind the play. And the story has the advantage of being made cumulative, so that its heaviest weight and greatest tension fall where they should fall, in the final scene.

"What Price Glory?" lags somewhat in spots, no doubt; in the first and second acts it might well be shortened a little. But though it may have lagged, I for my part felt nothing of it, because of the sting and freshness of the writing, because of the speeches, the words and meanings and rhythms, like the beating of the pulse in your ears.

September 6, 1924

# FOUR LEGS TO A HORSE

## Realism—Free and Equal Born Critics— Judging the Art of the Theatre by Resemblance Only

By STARK YOUNG.

DEMOCRACY, as Plato said long ago, is a charming form of government in which the ass is as good as the rider, the pupil is as good as the master, and everything indeed is ready to burst with liberty. And for us that means, doubtless, that never before were there in the world so many God-given and casual judges of art, people with born rights to an opinion. It happens that the art of the theatre more than any other art of today belongs to men and women and comes directly out of them. And so for the theatre there are multitudes of free and equal judges.

What these judges measure art by most is that one element in art that they are most likely to be able to see, which is resemblance. To what extent does the work of art copy its subject matter? How good is it as imitation? How much is an actual surface depicted? On that point this average judge feels expert, at home; and if left to judge on this score of likeness he will know how good a work of art is. He will press for realism, then, in the art that he regards as serious. Realism and democratic thinking spread together. Any one looking at the painting of a horse can tell whether or not it has four legs.

In the art of music there is no man so ignorant as to demand that music imitate the sound of guns, beasts, waterfalls, or anything else in the world. Nobody demands that a Palladio façade or the tower of the Woolworth Building look like a hill, a tree, a garden or anything else outside the piece of architecture that it is. In painting the case is less free and clear, but there are many persons who would allow Botticelli to paint the sea in one way, Winslow Homer in another, Hokusai in another still. Many people know the limitations of that painted corn that we see in county fairs, set forth so exactly as to deceive the farmer himself; they know that this is hardly art. But most people go on measuring the theatre by its fidelity to what they have seen and heard with their eyes and ears.

This is to be expected; for where music uses sound for its creative purposes, painting colors, poetry word symbols, and architecture, wood and stone, the art of the theatre uses actions and the bodies of men and women. These are the materials of the art. The purpose of the art is to create men, women, actions, plus idea or conception. The material therefore in this art is close to the created idea. It is natural, then, for any one inexpert in the essential nature of all art to confuse the means and the end, when judging the art of the theatre, and to set up imitation, reproduction, resemblance, as the main test. And so, with every one among us judging the theatre and so many people shaky on the essential nature of art, it follows that this test by likeness, by imitation, is the one the theatre has most to meet.

### Actors Acting Natural.

THE actors of recent years, since this is asked of them, have run more and more to the imitation of the externals of life, the reproduction of what we see and hear about us. At their best the majority of our Broadway actors can only imitate. They afford us the pleasures of external recognitions. They lack style, manner, distinguished recitation, except in so far as these qualities appear within the realistic method. To see Louis Wolheim and William Boyd in "What Price Glory" is a pleasure and is good realism in the theatre; they imitate the two officers with precision and intelligence. This is true of such acting at its best. Otherwise it ends in merely giving us the actor himself in action. All our theatres are full of ladies and gentlemen who ask us to be happy in merely watching them. Whether they have developed their spirits with thought and deep living or achieved for themselves the weight of a rosy head on a magazine cover, we are to interest ourselves in them just the same. But they give us little as art, and of life only so much as resembles themselves; and on this basis the audience will have to applaud their merits.

The visit of the Moscow Art Theatre, whose best work is based on realistic methods, did our theatre both harm and good. Sitting there before that company of actors, how many of our players consoled themselves with the fact that Moskvin, Ouspensky or Tarasova, were copying people as they are! After that many an actor must have told himself that one might go back to one's play and be the drummer, the spinster, the farmer, the old judge once more, with a mind at peace and an artistic conscience fired to greater self-complacency, And dramatists likewise, seeing the plays of Chekhov and Gorki, said no doubt to themselves that the plain subjects out of our daily life were good enough for them.

But what these actors may not have understood so clearly is that Moskvin in "The Lower Depths" created a character more subtle and real than reality itself as seen in most men's eyes. Tarasova and Katchaloff were super-real in their content and ideas. Ouspensky, when she stepped out of the line of peasants and sang the verse of that song, brought something to the stage that was magnificent and wild, with enough resemblance to make it credible in a realistic method, but with a power and ferocity added that made it not external life but a great and unforgetable idea. The characters in "The Lower Depths" were not people unflinchingly painted from the life; they were for the most part numbers, one coming after another, and they seemed to be real people because to the exact surface of these was added an inexhaustible reality of idea.

What the dramatists of our familiar life should see is that Chekhov's plays exercise every faculty of selection for their compelling ends. And meanwhile they are realistic in so far as anything is realistic. To say that realism is putting down things as they are is plainly nonsense, since there is no areness to things and what they are depends on who sees them. But realism can be said, however, to be a method in which the effect is wrought by means of only such details out of life, such elements, as we see and hear and know in this external sense to be possible. Chekhov uses this realistic method, but his result is as arranged, as created, as personal, as Shakespeare's is. For the authors of "Thoroughbreds," "Havoc," "Cobra" and otherwise, there is no comfort in Chekhov.

### Unchallenged Nonsense.

REALISM without creative talent runs toward nothingness, just as the poetic or formal manner runs to dry abstractions. Both are good when they are good. Fine realism like that in "What Price Glory" must always be rare. It demands distinction and imagination. Most of the realism in our theatre has neither truth nor creation; it is only a sort of poor journalism slipping along over the surface of the matter. But there is nothing to be said against realism itself. The trouble comes when the realistic test is applied right and left and made the final test.

And yet the season is scarcely a month old and we hear everywhere, in theatres packed to capacity with judges of the art, the test of imitation applied. The play or the acting is good or bad as it is like what every one present has seen around him or heard. Naturalness becomes the keystone of art, not in the sense of being

natural to the character of the work of art, but natural to something outside of it. But on that basis the best actor of a hobo would be found by the roadside. The dog in Veronese's "Marriage at Cana" is not bad painting because it is more formal and elegant than a dog in a kennel. In the art of the theatre, as in any other art, imitation is a test of excellence only where imitation is intended; any work of art is free, always at its own peril, to be as near or as far from the outer aspect of its subject matter as it chooses.

Nobody requires Freudian data in fairy tales. Nobody wants pores bored in the skin of the Venus de Milo to make her better art. Nobody advises a bridegroom to arrive at sincerity by paring his nails as he stands before the altar. And yet in the theatre one may declare that a thing is "good though artificial," as if that made any sense, the only wrong artificiality being that which is false to the nature of the work of art in hand. A performance is denounced as theatrical, as if the theatre should be anything else. Molière, we are told, is crude and

unsophisticated, doubtless because his dramas do not copy our daily life, but are based on forms and traditions; which is like calling Louis XIV. unsophisticated because he bowed very low, or the gardens of Versailles crude because they lie in lawns and avenues instead of native woodlands wild.

Nobody really means all this, as the admiration of Chaliapin, "Cyrano de Bergerac," or Charlie Chaplin proves. But we go on saying it just the same. We respond vitally to what is alive in the theatre; if we try to be critical we fall back on more imita-

tion for our standards of value. Duse in "Cosi Sia" did not imitate the manners of a peasant woman. An equally great artist might copy them to the letter. But that does not make one artist better or worse than the other. To say, in the art of the theatre, that Duse was bad in that rôle because she did not make the gestures of a peasant is like saying, in the art of music, that Beethoven's "Pastoral Symphony" is good because it sounds like a curse.

September 14, 1924

# CHARTING THE AMERICAN DRAMA'S DRIFT

*By WALTER PRICHARD EATON*

Stocktaking of the Culture of the Land Reveals Profound Changes in the Province of the Stage Since 1900

*AMERICA'S contributions to world culture have been to a large extent submerged by the material achievements of her people. Moreover, her cultural progress has been severely criticized both at home and abroad. Nevertheless, in some fields the United States has reached new heights.*

*In an effort to take stock of American culture, The New York Times has asked a recognized authority in each of the several provinces of the arts to discuss the situation as he sees it. In the previous issue of this magazine Simeon Strunsky discussed literature; in this issue Mr. Eaton discusses the state of the American drama. Articles in weeks to come will include music, by Deems Taylor; art, by Forbes Watson; architecture, by Harvey Wiley Corbett.*

TWENTY years ago Clyde Fitch had reached the height of his talent and popularity; his posthumous play, "The City," was produced just after his death, in 1909, and startled the town with its use of an oath which now appears to be the slang of débutantes. Twenty years ago Eugene Walter's play, "The Easiest Way," was produced by Belasco. Twenty years ago, on Labor Day evening, John Drew officiated at the annual dramatic rite of opening the Empire Theatre with a light comedy—probably from the French, and some little way from the French. Twenty years ago Richard Mansfield, las of the actors in the great romantic line, died exhausted by his labors in mounting "Peer Gynt." Twenty years ago Maude Adams was the most popular actress in America. Twenty years ago there were fifteen hundred theatres across the country, and a successful play left New York for a tour of two full seasons. Twenty years ago the motion pictures were mere chaser acts in vaudeville. And twenty years ago "amateur theatricals" were a joke.

A superficial view of the theatre in America today, taking the country as a whole, would perhaps indicate that the last two decades have marked a serious setback. While the number of playhouses in New York City, our theatrical centre, has enormously increased—increased, in fact, beyond the point where there is a human possibility of supplying them all with worthwhile plays—the number of theatres through the country housing the spoken drama has shrunk, is it estimated, about 60 per cent.

There are now entire States that remain practically unvisited by traveling companies of standard merit from one year's end to the next. Even a city like Boston, which twenty years ago was still a good "show town," now turns a cold shoulder to the legitimate drama. Its population largely huddles for entertainment in the numerous suburban

movie palaces, or at most patronizes the musical reviews. By and large, there can be little doubt that a much smaller proportion of our population attends the spoken drama than attended it two decades ago, and the stage and its people mean less in the life of the nation. Any one old enough to recall the universal love for Joe Jefferson and his Rip forty years ago, or Maude Adams and David Warfield and Sothern and Marlowe twenty years ago, or the excitement attending a tour of Mansfield—the saving of one's pennies for weeks beforehand, the nightly attendance in the balcony to see his entire répertoire—can realize a little sadly how different things are today. Practically only George Arliss and Otis Skinner today can profitably tour the country and draw the old crowds. Many of our best players, and our best plays, do not even venture from the confines of Broadway.

That this is a serious loss to the theatre cannot be denied. Whatever New York's own opinion may be, New York is not the nation. And whatever the movie fans' opinion may be, the average movie is not an adequate substitute for the warmth of a fine actor's human personality, the music of his voice, the concentrated excitement and intellectual progression of a good spoken drama. The person who would assume that nothing is lost when you substitute Pola Negri in "Barbed Wire" for Maude Adams in "The Little Minister," or

Rod La Rocque in "The Fighting Eagle" for Richard Mansfield in "Richard III" or "The Devil's Disciple" or "Peer Gynt" (or all three), is a trifle weakminded.

Yet a new generation has grown up since 1907, and thousands upon thousands of the boys and girls who compose it are either unacquainted with the spoken drama or somewhat hostile to it and bored by it when they do have an opportunity to make its acquaintance. Moreover, they are even hostile to such a movie as "The Last Laugh." It demands a concentration of emotional attention they seem unwilling to give. That this means a serious loss to the theatre can hardly be denied. The loss is felt even in New York, where the newer theatres are built without galleries, and where even the balconies are often half empty. It means the theatre has in twenty years quite measurably withdrawn from the consciousness of a great number of Americans. There is no sense in trying to blink or deny this fact.

If you desire verification, go to a city like Buffalo, and note first the comparatively small crowd paying $2 to see some spoken drama in a dingy, outworn theatre, and then the vast throng pouring in three or four times a day to a million dollar plush and gilt movie palace (the whole family going, perhaps, for the price of an orchestra chair at the theatre) and sitting amid moron magnificence while the great organ imitates the meow of a cat or Adolphe Menjou shows how

"a full evening dress suit" should be worn.

You are struck with two inescapable reflections; first, these people are undoubtedly getting more, materially, for their money; and, second, what they are getting as entertainment is probably much nearer their actual tastes and capacities. Many of them the theatre could only recapture by offering an equal material luxury at a similar price scale, and many more of them it could not get back on any terms. The movies have provided them with a form of entertainment much nearer to their heart's desire.

It is a curious accident that this development of the motion picture has taken place at exactly the time when the late nineteenth century renaissance of the drama in Europe and England had swept over to America and profoundly influenced our stage. Ignoring for a moment any question of the relative merits of American plays in the '90s and today, a list of the playwrights then and now shows that we now have at least five competent craftsmen to one in 1895. Moreover, in the '90s most playwrights grew up in the theatre and saw the drama strictly in terms of the theatre, not of life or human society. The theatre was not generally regarded as a possible career for more broadly educated men, and certainly not as a subject for academic study.

It was just twenty years ago that Professor Baker started his pioneer course in playwriting at Harvard, with Edward Sheldon as his first graduate. Today Harvard, instead of being the only major college with a course in the practical theatre arts, is about the only one without such a course. And out of such courses have come in the last decade a steady stream of young men (and young women, too) inspired with a serious dramatic purpose and guided by practical training.

When you consider that last Winter, for example. "Broadway." "In Abraham's Bosom," the Pulitzer prize play; "Saturday's Children," the two Sidney Howard successes. "Chicago." "The Barker" and "White Wings." were all written by graduates of these academic courses; and when you consider, further, that Eugene O'Neill is such a graduate, and nearly all the directors of the Theatre Guild, and Robert Edmond Jones and Kenneth Macgowan and numerous other dramatists, designers, producers and actors in the new American theatre, you cannot help realizing what we might call the increased intellectual respectability of our stage. While it plays a lesser part in the total life of the nation, it plays a far larger part in the life of the potential artists of the nation.

A quarter of a century ago so observant and effective an artist as Clyde Fitch was rare in our playhouse. Today his dual respect for stagecraft and for the truthful reflection of actual life is the possession of many writers, even if no great number have equaled his fertility of invention. When, in three or four seasons, these dramatists can give us plays at once as entertaining or moving and as shrewdly critical or reflective of our age as "What Price Glory?" "The Field God." "Saturday's Children," "The Show Off," "The Silver Cord," "Broadway," "Chicago" and "The Hairy Ape," we are safe in saying that our theatre has progressed measurably toward a more significant type of entertainment.

It has lost audiences, but it has gained artists. It has lost much of its glamour for the crowds, or passed from their lives entirely. But it has gained in serious appeal to those who still have opportunity and inclination to patronize it. It reflects America more truthfully to fewer Americans.

Whether or not the art of acting has declined in the past quarter century is a fruitless speculation. The art has changed, certainly. It is a fact, however, that the great eras of acting have been eras when the drama was in a slump; in periods of lively creation the actor seems to take second place. And, at any rate, the art of production has immeasurably improved; the synthesis of arts, which is the theatre at its best, calls for a guiding intelligence and a ready command of the resources of the painter, the mechanic, the architect, as well as the actor and author. Such intelligence has come into our theatre, bringing with it artists of all sorts. There is, in New York at any rate,

experiment, life, a creative zest in production, known in the past to but few theatrical workers.

IT may be quite true that few productions today equal in ensemble perfection Mrs. Fiske's production of "Leah Kleschna" more than twenty years ago. It is certainly true that when the Theatre Guild revived "Peer Gynt" it could find no actor for Peer who could give to the play one-quarter of the stabbing irony and romantic verve which Mansfield gave it. On the other hand, the entire New York stage of a quarter century ago could not provide in a season so varied a range of drama, staged with so uniform a fitness of setting, atmosphere and acting, as the Theatre Guild alone can now provide. In the welter of productions now shown in New York, in a mad effort to keep the seventy or eighty theatres open, some quite terrible plays, abominably staged, are exhibited. There is a tragic amount of sheer incompetence. But there is also a large amount of highly competent production, more, it seems to me, than ever before in our history.

It may be that no little of this competence has been inspired and to some extent guided by the foreign examples of stagecraft which have in recent years been so numerous here. The twentieth century in Europe has been an age of experiment, following the nineteenth century renaissance. Our theatre, like that of England, moved more slowly. It accepted Ibsen reluctantly at first. Few that can look so far back will forget how Clement Scott in London and William Winter in New York attacked the old Norseman as an enemy of society. Our surrender to naturalism was so belated that James A Herne, as late as 1899, fought a losing battle.

Our theatrical visitors were mostly players in the royal line- Irving, Terry, Bernhardt—whose material was familiar. But in the past twenty years we have seen first a Reinhardt pantomime, the Russian Ballet, Granville Barker's gold fairies, and latterly many other disturbingly effective innovations. The Theatre Guild, often attacked because of its supposed neglect of native playwrights, has certainly done a great deal to acquaint us with foreign plays like "Liliom" and "R. U. R.," broadening our artistic sympathies and expanding our standards.

Moreover, many of our younger artists, like Robert Edmond Jones and Lee Simonson, have gone abroad for study and brought back new ideas and inspiration. Our playwrights, instead of getting their contact with European plays through the diluted and false medium of the old-time adaptations or the somewhat later medium of English plays more or less faintly affected by Ibsen and Hauptmann, have secured this contact either by witnessing straight translations or even by seeing the plays acted in the original.

Before the Moscow Art Theatre

came here, for examplet, Chekov was almost a sealed book to us. But now Eva Le Gallienne is able successfully to produce "The Three Sisters." That alone is important; but it may well be that some native dramatist, seeing such a production, will be helped and fortified in his own search for greater naturalism. It is not easy, especially in our complex modern age, ever to lay definite finger on this or that foreign influence. But certainly there are more such influences at work in our theatre today than ever before, and they are influences toward freer experiment, toward a wider choice of theme and style, and toward more exacting as well as more imaginative standards of production. We should gladly admit and encourage this, nor have the slightest fear that it will check our efforts to foster a native drama.

The dramatic renaissance that came to flower in the British Isles before the war, with Galsworthy, Shaw, Barrie, Singe, Yeats, Lady Gregory, Stanley Houghton and many others as its later leaders, following the pioneering of Jones, Wilde and Pinero, bridged the gap between English drama and English literature, which had yawned since the days of Congreve (with once a slender cable thrown across by Sheridan). It bridged the gap because these writers discarded traditional molds of drama and threw themselves enthusiastically into the currents of their time, writing with their eye on the object. A current of the times, certainly, was the awakening of a social conscience, and Shaw and Galsworthy are especially significant as they gave voice to this feature of their era. And it was on similar lines that the American drama was shaping in the pre-war days.

OUR native drama had long shown itself to be most vital and lively when it was a good-natured picture, at least superficially realistic, of our democracy, but with a flavor of burlesque exaggeration. Witness "A Texas Steer," "Shore Acres," "The College Widow." That type of homely comedy still survives in the plays of Cohan and Craven and their ilk. Clyde Fitch gave it the veneer of the Avenue and the technique of the French "well-made play." But William Vaughn Moody in "The Great Divide" cut deep through to social and spiritual contrasts. Walter in "The Easiest Way" presented a tragic social problem. Fumblingly, inadequately, to be sure, Klein in plays like "The Lion and the Mouse" tried to ally the drama with the social literature of the hour (as Sinclair's "The Jungle"). Broadhurst, Sheldon, Ernest Poole made plays about political problems. We produced no Shaw and no Galsworthy; but we were moving along their lines slowly, and from the base of our native, racy comedy entertainment.

Then came the World War. Great Britain has produced few, if any, significant new dramatists since the

war to reflect the newer age. She apparently is having to begin all over. We, on the other hand, appear more fortunate. In our shrewd, superficially realistic and sometimes irresponsibly burlesque native entertainment, refined more or less by our pre-war dramatists into a weapon for sociological reform, the younger post-war writers found something certainly not ill adapted to express their satirical reflections on a society that had just pulled the universe down around their ears If this is an age of "debunking" (and soon some one will debunk the debunkers!), what form is better adapted for the purpose than a recognizable realism with a burlesque edge? Even Hoyt and George Ade, if they had not been so good-natured and happy in a happy world, could have written satire.

But they could not have written "What Price Glory?" because they lost no legs "for democracy," nor "Chicago." because to Ade police reporting was a romantic vocation. "The Show-Off," too, would be quite beyond them, not alone because its realism is so thoroughgoing in the finer details of speech and character, but also because it is bitterly static. "The Show-Off" is unreformed at the end. Life goes on as before. The banner of blatancy still waves. "The Show-Off" is a "slice of life" drama, a piece of satirical naturalism, written in the style of our native comedy.

SO we might go through a considerable list of recent plays, finding in them, below the immediate entertainment value, a refinement of our native technique to carry the spirit of the new age; its satirical questionings, its not too mournful pessimism, its somewhat bewildered sense of freedom from ancient restraints. All this is a sign of life in our theatre, a sign that the drama is stepping along with literature—not quite, perhaps, on a level with it, but certainly not lagging far behind, as it did forty years ago, and on the whole considerably closer to it than it was twenty years ago.

There are two dramatists of the hour, both products of the new academic training in theatre craft, who deserve consideration by themselves —Eugene O'Neill and Paul Green. O'Neill, like Mark Twain and Upton Sinclair, has been translated into various tongues. He is virtually our first international dramatist. But while Twain and Sinclair have gone around the globe because they each represent a certain phase of America comprehensible to aliens, O'Neill owes his international fame to the sheer theatrical effectiveness of his plays and the way in which they transmute raw life into beauty, and sometimes into psychological subtlety.

THE HAIRY APE" has a brutal, cursing stoker for a hero; "The Emperor Jones" has an ex-Pullman porter. Both plays, free and experimental and ro-

mantic in form, lay a spell in the theatre, inspire thought and, above all perhaps, create a sense of tragic beauty. It is difficult to escape the conviction that perhaps unconsciously O'Neill is searching his way out of the realism of our age into a new type of poetic drama; is feeling about for a new significance and spiritual value in the welter of modern life. Were it necessary to find a pre-war American dramatist from whom to stem him, that dramatist would be William Vaughn Moody.

It is too early yet to make predictions about Paul Green, the young instructor at the University of North Carolina, who learned to write vivid one-act plays in Professor Koch's courses there, and who last Winter showed New York his two long plays, "The Field God" and "In Abraham's Bosom." He unquestionably possesses dramatic talent of a high order, if as yet moving somewhat stiffly in the longer form. He also possesses, like O'Neill, a strong vein of poetry which transmutes the realism of his prose into rhythm and envelopes his tragedies with an ennobling beauty. But his present signifi-

cance for us lies in the fact that his dramas are strictly parochial—as parochial as Synge's "Riders to the Sea." He writes of the life of his native North Carolina; he demonstrates that out of the amateur and academic theatre of his State can come a genuine and powerful expression of the local life. His plays may well become weapons for the liberalizing of the lives of his people.

Which brings us to a final word on the new American theatre. Twenty years ago "amateur theatricals" were still just that. Today the number of seriously conducted amateur groups through the country is counted by the hundreds, while in numerous places so-called Little and Community Theatres, with paid directors but amateur actors and designers, supply steady dramatic entertainment of a much higher order than is normally available in the professional theatre in those sections—if indeed any professional drama of any sort is available.

On the Pacific Coast there are several handsome, well-equipped community playhouses, which are the lively centres of the cultural

life of their cities—notably at Pasadena and Santa Barbara. The Little Theatres of Texas are beginning to produce local plays, on local themes. It is a fact today that more than one play successful in the professional theatre of Broadway has subsequently netted its author higher royalties from amateur productions. "The Goose Hangs High," for example, brought more royalty to its somewhat astonished author the first month after its release to amateurs than it brought him during any month of its Broadway run.

This is entirely a development of the last two decades, almost of the last five or six years, and is in part the answer of those Americans dissatisfied with the artistic and intellectual poverty of the movies, in part the result of our increased leisure and our need for an outlet in some form of creative self-expression. Moreover, the movement is increasing and growing stronger and more confident. Young people, coming from the colleges with an interest in the theatre arts, are more numerous each year.

A new type of theatre is shaping in America. That it reaches as yet

anything like the number of people lost to the professional theatre in the past twenty years nobody of course would be foolish enough to assert. But in some places it does —in Pasadena, for example. And it reaches them far more intimately, inspires them to far more active participation. It can even inspire them to such significant authorship as that of Paul Green in North Carolina. With this movement on the march, with groups of men and women in a thousand towns and cities giving their time and enthusiasm to the problems of staging, acting, even writing plays; with many of them working toward the dream of civic playhouses in their communities, it seems a bit premature to mourn the decline of the legitimate drama in America, or predict its speedy demise.

In fact, there was never a time perhaps when the drama lover could himself take so active a part in our theatre, and feel himself so much a factor in the beautiful process of creating theatrical illusion and bringing the spoken drama to life.

February 19, 1928

# "THE BEGGAR'S OPERA IN GERMAN"

BERLIN, Nov. 12.

ONE wonders what John Gay's emotions would be if he could gaze upon the version of his "The Beggar's Opera" which is being played at the Theater-am-Schiffbauerdamm. Mixed, might describe them. But, having seated himself in his favorite tavern before his favorite brand of ale, he would, after the first moments of annoyance, come around to acquiescence, perhaps even to enthusiasm. For Bert Brecht (the adapter), Kurt Weil (the composer) and Erich Engel (the director) have achieved that miracle of miracles—they have drawn the circle of perfection around an

evening in the theatre.

No longer is it the light fantasy, the gay, flitting burlesque of the English original. Although Brecht is one of the few authors of the younger generation who has humor, it is of a heavier, earthier sort. The spectres of Kant and Marx loom somewhere dimly on the horizon. Here, however, they were sufficiently nebulous to leave the comedy unclouded. The "social background" is suggested, but in a fashion that allows you to take it or leave it if you will. It was three hours of joy undiluted.

I must frankly confess that I have never seen the original on the stage, and my skimming through it in uni-

versity days leaves me with only a vague if pleasant memory. But I am told that the plot, in large lines, remains the same, except for the ending. Gay's highwayman hero went gladly to the gallows in order to escape the numerous females who laid claim to his affections. Here a burlesque on an opera finale was substituted. To melodramatic music the Sheriff announces that the King has signed a last-minute pardon. Macheath removes the noose from his neck and joins the whole cast in a chorus of rejoicing. It was undoubtedly one amusing way of rounding off the evening.

And the contributions of director

and composer were on an equal level with that of the adapter. Engel, with the aid of the designer, Caspar Neher, set his stage in shabby irregularity. A burlap curtain extended only half way to the proscenium and left free the stucco horizon, on which lantern slides were cast. And how he juggled his players! There was, for instance, the engaging roughness of Harald Paulsen as Macheath, the egotistical cynicism of Erich Ponto as Peachum, the fragile sensuality of Roma Bahn as Polly, the lusty vulgarity of Rosa Valetti as Mrs. Peachum. And Kurt Gerron. And Kaethe Kuehl. Please say when, or I shall be juggling off the whole dramatis personae.

C. HOOPER TRASK.

December 2, 1928

# NEW NEGRO DRAMA OF SUBLIME BEAUTY

**Marc Connelly's "The Green Pastures" Excels as Comedy, Fantasy, Folklore, Religion.**

THE GREEN PASTURES, a "fable" in two acts and eighteen scenes, by Marc Connelly, suggested by Roark Bradford's Southern sketches, "Ol' Man Adam an' His Chillun." Staged by the author; settings by Robert Edmond Jones; produced by Laurence Rivers. At the Mansfield Theatre.

| | |
|---|---|
| Mr. Deshee | Charles H. Moore |
| First Mammy Angel | Anna Mae Fritz |
| Archangel | J. A. Shipp |
| Gabriel | Wesley Hill |
| The Lord | Richard B. Harrison |
| Adam | Daniel L. Haynes |
| Eve | Inez Richardson Wilson |
| Cain | Lou Vernon |
| Cain's Girl | Dorothy Randolph |
| Zeba | Edna M. Harris |
| Cain the Sixth | James Fuller |
| Voice in Shanty | Josephine Byrd |
| Noah | Tutt Whitney |

| | |
|---|---|
| Noah's Wife | Susie Sutton |
| Shem | Milton J. Williams |
| Flatfoot | Freddie Archibald |
| Ham | Homer Tutt |
| Japheth | Stanleigh Morrell |
| Abraham | J. A. Shipp |
| Isaac | Charles H. Moore |
| Jacob | Edgar Burks |
| Moses | Alonzo Fenderson |
| Zipporah | Mercedes Gilbert |
| Aaron | McKinley Reeves |
| Pharaoh | George Randol |
| First Wizard | Emory Richardson |
| Head Magician | Arthur Porter |
| Joshua | Stanleigh Morrell |
| Master of Ceremonies | Billy Cumby |
| King of Babylon | Jay Mondaaye |
| Prophet | Ivan Sharp |
| High Priest | Homer Tutt |
| Hezdrel | Daniel L. Haynes |

### By J. BROOKS ATKINSON.

From almost any point of view, "The Green Pastures," which was put on at the Mansfield last evening, is a play of surpassing beauty. As comedy, fantasy, folklore, religion, poetry, theatre—it hardly matters which. For occasionally there comes a time when those names hardly matter in comparison with the sublime beauty of the complete impression. And Marc Connelly has lifted

his fable of the Lord walking on the earth to those exalted heights where utter simplicity in religious conception produces a play of great emotional depth and spiritual exaltation —in fact the divine comedy of the modern theatre.

It has been suggested by Roark Bradford's volume of two years ago, entitled "Ol' Man Adam an' His Chillun," being the tales they tell about the time when the Lord walked the earth like a natural man. It has been best described as Uncle Remus's "Story of the Bible." In eighteen scenes it follows the chronicle of biblical history as ignorant religious negroes of the South might conceive it in childish terms of their personal experience. Beginning with a disarming vignette of a darky preacher teaching a class of negro children the main events of the Lord's creation, it moves swiftly into the fantastic comedy of a vision of heaven in terms of a fried-fish party, progresses to celestial drama of heart-breaking sincerity and concludes on a note of exhilarating faith. For everything that he has taken from Mr. Bradford's volume, Mr. Connelly contributes stuff of the

finest imaginative splendor. You might not expect so much from an unpretentious negro fable. The beauty of the writing, the humility of the performance put the theatre to its highest use.

Mr. Connelly has made the transition from negro comedy to universal drama by the effortless process of increasing emphasis upon the enduring themes. At first you are delighted by the naive incongruities of the spectacle—the negro angels at their fried fish party, the tiny pickaninny in whose throat a fish bone gets lodged, the Lord in his private office cautioning Gabriel not to blow his horn, Noah blowing the steamboat whistle on the Ark, the elephants clambering up the gangplank. All through the play these magnificent strokes of imaginative comedy make "The Green Pastures" a rare piece of work.

But hardly has the fried fish party among the angels gotten under way before you realize that Mr. Connelly's play has nobler projects in mind. In fact, it has the Lord as its principal figure. Dressed in the formal garb of a parson, with his long coat and white tie, he is unpretentious. Even in his speech he is of humble origin.

But straightway you perceive that he is a good man the fusion of all the dumb, artless hopes of an ignorant people whose simple faith sustains them. He is a Lord of infinite mercy. There is a reverential moment when he creates the earth and rears up Adam in the sweetness of a new garden. There are moments of anxiety when, walking on the earth, he shakes his head sadly, and remarks, "Bad business. I don't like the way things are going at all." "What seems to be the main trouble?" he inquires of Noah. "Well, the chief trouble seems to be," Noah replies, "that the district is wide open." There are moments of rudely expressed glory when the Lord rewards Moses for his faithful service, and moments of wrath when the Lord denounces the Babylonians.

And more: there are moments when even the great Lord of creation suffers with the suffering of the world. "Being God is no bed of roses," he remarks wearily to Gabriel. He is a simple man, and a good man. In the end he is not above learning himself.

Probably this is the quality that exalts "The Green Pastures" into drama of great pith and moment. Putting the Lord on the stage in such simple terms that your imagination is stimulated into a transfiguring conception of sheer, universal goodness—that is Mr. Connelly's finest achievement. During the eighteen scenes he introduces harmonious material. The spirituals sung as chorals while the scenes are being changed carry the mood forward to the next episode. And Robert Edmond Jones, who has an imagination of his own, has designed settings that give the theme a vaulting impetus. But the Lord, walking humbly through Heaven and on the earth, telling folks to enjoy themselves, gives the play its divine compassion.

The cast and chorus include about ninety-five negro performers. Under Mr. Connelly's direction they have been molded into a finely tuned performance. Most of them appear on the stage too briefly to leave a personal impression. But the humbleness of Alonzo Fenderson as Moses and of Tutt Whitney as Noah, the rapt wonder of Daniel L. Haynes as Adam and the reverent comedy of Wesley Hill as Gabriel are performances of note. As the Lord, Richard B. Harrison has the part of greatest responsibility. He plays it with the mute grandeur of complete simplicity. This is a paternal and lovable creation. When, amid a thousand worries, he walks to the celestial window, looks about with an air of anxiety, orders the sun to be "a might cooler," and then remarks appreciatively, "That's nice," you believe in him implicitly. In fact, you believe in the entire play; it is belief incarnadined. Such things are truer than the truth.

*February 27, 1930*

# THE PLAY

## 'The Children's Hour,' Being a Tragedy of Life in a Girls' Boarding House.

THE CHILDREN'S HOUR, a drama in three acts, by Lillian Hellman. Settings by Aline Bernstine, executed by Sointu Syrjala. Staged and produced by Herman Shumlin at Maxine Elliott's Theatre.

| | |
|---|---|
| Peggy Rogers | Eugenia Rawls |
| Mrs. Lily Mortar | Aline McDermott |
| Evelyn Munn | Elizabeth Seckel |
| Helen Burton | Lynne Fisher |
| Lois Fisher | Jacqueline Rusling |
| Catherine | Barbara Leeds |
| Rosalie Wells | Barbara Beals |
| Mary Tilford | Florence McGee |
| Karen Wright | Katherine Emery |
| Martha Dobie | Anne Revere |
| Dr. Joseph Cardin | Robert Keith |
| Agatha | Edmonia Nolley |
| Mrs. Amelia Tilford | Katherine Emmet |
| A Grocery Boy | Jack Tyler |

### By BROOKS ATKINSON.

If the author and the producer of "The Children's Hour," which was acted at Maxine Elliott's last evening, can persuade themselves to ring down the curtain when their play is over, they will deserve the admiration and respect of the theatregoer. For Lillian Hellman has written a venomously tragic play of life in a girls' boarding school—cutting in the sharpness of its dramatic style and in the deadly accuracy of the acting. In the last ten or fifteen minutes of the final act she tries desperately to discover a mettlesome dramatic conclusion; having lured "The Children's Hour" away from the theatre into the sphere of human life, she pushes it back among the Ibsenic dolls and baubles by refusing to stop talking. Please, Miss Hellman, conclude the play before the pistol shot and before the long arm of coincidence starts wabbling in its socket. When two people are defeated by the malignance of an aroused public opinion, leave them the dignity of their hatred and despair.

The point is that Karen Wright and Martha Dobie, headmistresses of a girls' boarding-school, are innocent. After many years of industry they have developed a country school with an enviable reputation. Among their students, however, is Mary Tilford, granddaughter of their chief patroness, and Mary is a diabolical adolescent. Miss Hellman has drawn that evil character with brilliant understanding of the vagaries of child nature. Purely as a matter of malicious vanity, Mary spreads the rumor that the headmistresses have an unnatural affection for each other. Horrified and convinced, her grandmother withdraws Mary from the school and warns the parents of other students. The scandal destroys the school and turns the two headmistresses into social exiles. To recover their self-respect, as well as the prestige of the school, they bring a libel action against Mrs. Tilford, but they cannot prove their innocence. That dazed and defeated situation seems to this correspondent to be the logical as well as the most overpowering conclusion to the play.

Having a lamentable respect for the theatre, Miss Hellman then pushes on into suicide and footlights remorse. She gilds the lily until it loses its freshness. For up to that moment "The Children's Hour" is one of the most straightforward, driving dramas of the season, distinguished chiefly for its unflinching characterization of little Mary. She is a vicious maid, but her strength and courage are tremendous. Her capacity for lying, cruelty and sadistic leadership is almost genius. That is the crucial character for two acts of the play. It has not only been ruthlessly drawn in the writing, but it is superlatively well acted by Florence McGee, who forces every drop of poison out of it. She plays it with as much spirit as a wildcat and considerably more craft and intelligence. In fact, you do not know whether to admire Miss McGee for her headlong acting or to fear the tyrannical part she is acting.

Nor is that the only piece of acting to admire in this piercingly directed production. Mr. Shumlin has chosen his actor thoughtfully and directed them with a clear mind. Anne Revere's reticent Martha Dobie and Katherine Emery's broken Karen Wright are portraits of dramatic significance. Robert Keith plays the part of a manly fiancé with splendid decision, and Katherine Emery plays the sanctimonious patroness with womanly pride and genteel rectitude. As a supercilious and vile-tempered aunt, Alice McDermott gives an excellent performance. All the girls are well acted, especially Barbara Beals's overwrought little Rosalie.

In short, Miss Hellman has written and Mr. Shumlin has produced a pitiless tragedy, and both of them have daubed it with grease-paint in the last quarter of an hour. Fortunately, they can remove that blemish. Instruct the guardian of the curtain to ring down when the two young women are facing a bleak future. That will turn "The Children's Hour" into vivid drama.

*November 21, 1934*

# THE PLAY

## 'Waiting for Lefty' and a Program of Sketches and Improvisations by the Group Theatre.

GROUP THEATRE SKETCHES, by Sanford Meisner, Florence Cooper, Bob Lewis, Clifford Odets, J. E. Bromberg, Walter Coy, Elia Kazan, Tony Kraber, Morris Carnovsky.

WAITING FOR LEFTY, play in six scenes, by Clifford Odets. Directed by Sanford Meisner and Clifford Odets. At the Civic Repertory Theatre.

| | |
|---|---|
| Fatt | Morris Carnovsky |
| Joe | Art Smith |
| Edna | Ruth Nelson |
| Miller | Gerrit Kraber |
| Fayette | Morris Carnovsky |
| Irv | Walter Coy |
| Florrie | Phoebe Brand |
| Sid | Jules Garfield |
| Clayton | Russell Collins |
| Clancy | Elia Kazan |
| Gunman | David Korchmar |
| Henchman | Alan Baxter |
| Secretary | Paula Miller |
| Actor | William Challee |
| Grady | Morris Carnovsky |
| Dr. Barnes | Roman Bohnen |
| Dr. Benjamin | Luther Adler |
| Agate Keller | J. E. Bromberg |
| A man | Bob Lewis |
| Voices in the audience | Herbert Ratner, Clifford Odets, Lewis Leverett |

### By BROOKS ATKINSON.

As actors in plays of conscious intellectual significance, the young people of the Group Theatre have been fumbling around without much success ever since they mounted "Men In White." But their afternoon program, consisting of random sketches and Clifford Odets's "Waiting for Lefty," which was repeated yesterday at the Civic Repertory Theatre, is an invigorating revelation of their skill and force as an acting company. For the first time in a good many months it is possible to write about them without fussy reservations. Like many other individuals and organizations, the Group Theatre is most stimulating when it is not competing with the entertainment business on Broadway, which is not interested in the studio craft of acting nor in the drama of social revolution.

Uptown the Group Theatre communicants are suspected of having no sense of humor. Nothing said between these column rules this morning is intended to suggest that they are native wits or mountebanks. But the fact remains that their bill of turns and improvisations is winningly good-humored. Their classroom presentation of the grave-digger scene from "Hamlet" is an amusing proof of the fact that words are less significant in the drama than acting styles and ideas of direction. In a nonsensical improvisation, labeled "Two Bums on a Bench," Mr. Bromberg and Mr. Carnovsky suggest that the written word is virtually superfluous, for they clown their way through an unintelligible comic sketch speaking nothing but gibberish. The most overpowering number in the preliminary program is entirely in pantomime to the off-stage music of the allegretto of Beethoven's Seventh symphony. What psychological effect the music has in the theatre this reporter is unable to explain on the spur of the moment. But without props, scenery or costumes Mr. Bromberg and two assistants translate their pantomimic surgical operation into a vivid silent drama. Among the other items there are parodies, slapstick bits and unblushing cowboy songs.

The dynamics of the program are the property of Mr. Odets's "Waiting for Lefty." His saga, based on the New York taxi strike of last year, is clearly one of the most thorough, trenchant jobs in the school of revolutionary drama. It argues the case for a strike against labor racketeering and the capitalist state by using the theatre auditorium as the hall where the taxi union is meeting. In four or five subordinate scenes, played with a few bare props in corners of the stage, the personal problems of several representative insurgents are drawn sharply. Mr. Odets is the author of "Awake and Sing!" which the Group Theatre expects to produce next week. "Waiting for Lefty" is soundly constructed and fiercely dramatic in the theatre, and it is also a keen preface to his playwriting talents.

His associates in the Group Theatre have never played with more thrust, drive and conviction. "Waiting for Lefty" suits them down to the boards. Incidentally, the progress of the revolutionary drama in New York City during the last two seasons is the most obvious recent development in our theatre. In addition to the Theatre Union, with its productions of "Stevedore" and "Sailors of Cattaro," there is the Artef band, which is playing "Recruits" in Yiddish as beautifully as the Habima troupe played "The Dybbuk." Now the Group Theatre gives its most slashing performance in a drama about the taxi strike. This program will be repeated at intervals this Winter.

*February 11, 1935*

## Justice and Fate the Theme of 'Winterset'

WINTERSET, a play in three acts, by Maxwell Anderson. Settings by Jo Mielziner; staged and produced by Guthrie McClintic. At the Martin Beck Theatre.

| | |
|---|---|
| Trock | Eduardo Ciannelli |
| Shadow | Harold Johnsrud |
| Lucio | Morton L. Stevens |
| Piny | Fernanda Eliscu |
| Miriamne | Margo |
| Garth | Theodore Hecht |
| Esdras | Anatole Winogradoff |
| First Girl | Eva Langbord |
| Second Girl | Ruth Hammond |
| Hobo | John Philliber |
| Judge Gaunt | Richard Bennett |
| Carr | Billy Quinn |
| Mio | Burgess Meredith |
| Sailor | St. John Terrell |
| Radical | Abner Biberman |
| Policeman | Anthony Blair |
| Sergeant | Harold Martin |
| Two young Men | Stanley Gould / Walter Holbrook |

#### By BROOKS ATKINSON.

After having written in verse of heroes of history, Maxwell Anderson has gone one step further. In "Winterset," which was beautifully played at the Martin Beck last evening, he has written a verse tragedy of tatterdemalions along the East River waterfront. To report it with any sort of respectable decision a reviewer needs more time than there will be before the next edition. For "Winterset" is not all of a piece. There are moments in it when the verse seems superfluous or ostentatious, or when it seems actually to impede the drama. Before offering comment like that as final, however, one would like to be certain, for "Winterset" lives on a plane of high thinking, deep emotion and eloquent writing. It is packed with terror. It is a courageous poem to justice and integrity. In short, it is beautiful. Whether or not it is perfectly wrought does not seem to matter much at this moment.

There has been a legal murder. Some one has been convicted and executed for a pay-roll assassination he did not commit, and the gloomy ruin under one of the piers of Brooklyn Bridge is swarming with evil people who are determined to keep the secret buried. Trock, whose soul is blood-stained, is ready to kill every one else in the world lest his guilt be whispered. But the son of the man who was executed is walking the earth, bound that justice shall be done to his father's memory. He stumbles into the one human refuse heap where the evidence he needs is lurking. "Winterset" is the tragedy of his quest—of his love, his faith, his courage and his hatred of the world.

Some years ago Mr. Anderson wrote a stirring play in defense of Sacco and Vanzetti. The bitterness that lies deep in the souls of every one who believed in their innocence has shot "Winterset" through with ferocity against injustice. In some of the speeches that are screamed in a grimy, damp tenement basement on the waterfront it has ripened into poetry as hard as iron and as sharp as steel. Mr. Anderson is still raising his voice against the wickedness of society, and the tone is angry, rebellious and hot with scorn. With the romantic portions of his play he seems, in this reviewer's opinion, to be more self-conscious; and the tragedy concludes with an invocation that sounds formal and prolix. But when Mr. Anderson's personal convictions are engaged by the tragic story he is relating, he writes like a man inspired, and "Winterset" is a frightening drama laden of baleful significance. The emotion transcends the incidents that create it.

The production is a brilliant work of art. In the scene under the bridge Jo Mielziner has caught the remote majesty and immediate clutter of that vivid corner of the city; and his cheerless, barren tenement basement is a proper place for treachery and stealth. Mr. McClintic is up to this sort of thing and has collected actors worthy of high enterprise. As the judge whose mind has cracked under the strain of conscience Richard Bennett gives a memorable performance—gentle in manner, kindly in tone, pathetically broken in mental process. As the little tenement girl who falls in love Margo's innocence of spirit and pleading tone of voice echo the theme of the tragedy. Burgess Meredith gives a sinewy performance as the son who is still on his father's mission. Mr. Meredith is the sort of actor who can put a solid foundation under a scene and a play.

Nor does that complete the bulletin of fine acting. Eduardo Ciannelli's cruel, sneering Trock is a vigorous portrait of malevolence. Harold Johnsrud as the Shadow, Theodore Hecht as the frightened accessory to the fact of the murder, Anatole Winogradoff as the pious patriarch, Anthony Blair as the comic policeman, Abner Biberman as the snarling radical—act like men who know their profession.

If the verse is not always lucid in its meaning, the actors are not blameless. Mr. Winogradoff does not speak clearly, and sometimes the words falter on Mr. Meredith's lips. But the poet in Mr. Anderson has not made full peace with the dramatist. He has not stretched the seams of his drama taut. At its best, however, his poetry is clean and piercing, and his tragedy a work of uncommon stature. Mr. Anderson and Mr. McClintic are well matched. They know how to make drama.

September 26, 1935

## THE PLAY

### Sidney Kingsley's 'Dead End,' a Realistic Drama of the East River Waterfront.

DEAD END, a play in three acts, by Sidney Kingsley. Staged by the author; setting by Norman Bel Geddes; produced by Mr. Geddes. At the Belasco Theatre.

| | |
|---|---|
| Gimpty | Theodore Newton |
| T B | Gabriel Dell |
| Tommy | Billy Halop |
| Dippy | Huntz Hall |
| Angel | Bobby Jordan |
| Spit | Charles R. Duncan |
| Doorman | George Cotton |
| Old Lady | Marie R. Burke |
| Old Gentleman | George N. Price |
| First Chauffeur | Charles Benjamin |
| "Babyface" Martin | Joseph Downing |
| Hunk | Martin Gabel |
| Philip Griswald | Charles Bellin |
| Governess | Sidonie Espero |
| Milty | Bernard Punsly |
| Drina | Elspeth Eric |
| Mr. Griswald | Carroll Ashburn |
| Mr. Jones | Louis Lord |
| Kay | Margaret Mullen |
| Jack Hilton | Cyril Gordon Weld |
| Lady With Dog | Margaret Linden |
| Three Small Boys | Billy Winston / Joseph Taibi / Sidney Lumet |
| Second Chauffeur | Richard Clark |
| Second Avenue Boys | David Gorcey / Leo Gorcey |
| Mrs. Martin | Marjorie Main |
| Patrolman Mulligan | Robert J. Mulligan |
| Francey | Sheila Trent |
| G.-Men | Francis de Sales / Edward P. Goodnow / Dan Duryea |
| Policemen | Frances G. Cleveland / William Toubin |
| Plainclothesman | Harry Selby |
| Interne | Philip Bourneuf |
| Medical Examiner | Lewis L. Russel |
| Sailor | Bernard Zaneville |

Inhabitants of East River Terrace, Ambulance Men, &c.—Elizabeth Wragge, Drina Hill, Blossom MacDonald, Ethel Dell, Marc Daniels, Elizabeth Perlowin, Edith Jordan, Marie Dell, Bea Punsley, Bess Winston, Anne Miller, Elizabeth Zabelin, George Bond, Matthew Purcell, Herman Osmond, Rose Taibi, George Buzante, Betty Rheingold, Lizzie Leonard, Catherine Kemp, Mag Davis, Nellie Ransom, Betsy Ross, Charles Larue, Paul Meacham, Tom McIntyre, George Anspecke, Jack Kellert, Elizabeth Lowe, Gene Lowe, Charlotte Salkow, Morris Chertov, Charlotte Julien, Willis Duncan.

#### By BROOKS ATKINSON.

By adding a little thought and art to considerable accurate observation, Sidney Kingsley has compiled an enormously stirring drama about life in New York City, "Dead End," which was produced at the Belasco last evening. Somewhere along the East River a raffish dead-end street meets the rear entrance to a fashionable apartment house where private yachts have a slip of their own. It is one of those dramatic corners on which Manhattan advertises the distance that divides poverty from riches, and it is a brilliant place to study the case history of the metropolitan gangster. Norman Bel Geddes has filled the stage of the Belasco with one of those super-realistic settings that David Belasco liked to contrive, solid down to the ring of shoes on asphalt pavement. When the curtain goes up on a scene torn out of the daily life of Manhattan you are prepared for a show. When the curtain falls you know that you have also listened to a drama.

What Mr. Kingsley has in the bottom of his mind is the social condition that breeds gangsters. One of his characters is a notorious gangster who came out of just such an environment and has slunk back to see his mother again and to meet the first girl he ever loved. Swarming around his feet is a shrill, dirty, nervous and shrewd mob of boys who are gangsters in the making. Before "Dead End" is over Mr. Kingsley shows how a celebrated gangster can come to his end in a dirty gutter, when the Federal agents find him, and how a street urchin can develop into a gangster. Once Baby-Face Martin was only a tough kid like Tommy. When Tommy serves his apprenticeship at reform school, it is Mr. Kingsley's contention that he will be like Baby-Face Martin—a cheap killer, despised by his family and feared by every one who crosses his path.

Not that Mr. Kingsley has turned "Dead End" into a public social document. In its objective photograph of one section of New York it draws inevitable comparison with "Street Scene." It is full of characters who move casually in and out of a loosely-woven story; it is strident with gutter argot. What you have seen and heard in New York, wondering and apprehensive as you trudge along our begrimed seacoast, has found lodgment in this flaring anecdote of an average day.

The boys' parts are played with such authenticity that there was a foul sidewalk canard last evening that a mob of East Side street arabs had been carted west in their street clothes. Certainly the pitch of their voices has the piercing note of the tenement streets, and their water-skater running across the stage has the rhythm of half-naked pierhead swimmers. According to the office encyclopedia, however, Billy Hallop, as the leader of the mob, is Bobby Benson of the radio, famous these many years, and the others are members of the Professional Children's School or the Madison Square Boys Club, or come from stage families.

Although they are at war with the world, they have made their peace with the professional actors who play the mature parts. Joseph Downing as the head gunman, Elspeth Eric as the sister of one of the boys, Marjorie Main as the contemptuous mother of the gangster, Sheila Trent as a cheap prostitute, Theodore Newton as the brooding artist whose constant presence binds all the bizarre elements of the drama, give excellent realistic performances.

Sometimes Mr. Geddes breaks his dramas on the wheel of stage designing. But this time he has reared up a setting that pushes the thought of the author's drama ruthlessly into the audience's face. Not only in its accuracy of detail but in its perspective and its power his setting is a practical masterpiece. Mr. Kingsley is fortunate in his association, for "Dead End" is worth the best our theatre affords. As thought it is a contribution to public knowledge. As drama it is vivid and bold. When the Pulitzer judges gave Mr. Kingsley a prize for "Men In White," they picked a first-rate man.

October 29, 1935

## 'CHILDREN'S HOUR' BANNED IN BOSTON

Mayor Acts After Report by City Censor Who Saw Hellman Play Here.

### PRIVATE SHOWING BARRED

By The Associated Press.

BOSTON, Dec. 14.—A New York dramatic success, "The Children's Hour," was added tonight to the long list of plays banned in Boston as indecent.

Praised by the full roster of New York critics, and now in the thirteenth month of its Manhattan run, the three-act tragedy of life in a girls' boarding school was to have been presented here for a month under auspices of the American Theatre Society, an affiliate of the Theatre Guild.

Boston's censorship, which has doomed numerous plays and hundreds of books found acceptable elsewhere, was invoked by Mayor Frederick W. Mansfield.

He declared he was "unalterably opposed" to the play's production here after reading it and a report of the city censor, Herbert L. McNary, who saw it in New York.

"The Children's Hour," explained Mr. McNary, "has been identified with a theme that would automatically bring it to the attention of the Board of Censors.

"The theme centers about homosexuality and nothing could be done with the play to relieve it of this."

The Mayor barred the play despite the offer of the producer, Herman Shumlin, to bring the scenery and entire cast of sixteen here next week at his own expense for a private pre-view so that the Board of Censors could give first-hand judgment.

### Mayor Finds "Ghosts" Filthy.

In declining Mr. Shumlin's proposal, Mr. Mansfield remarked, also, that he thought that Ibsen's "Ghosts," which has played here for the past week, was "filthy."

The "Children's Hour," written by Lillian Hellman, was to have opened here Jan. 6, backed by a distinguished subscription list of 5,000 regular patrons of the Theatre Guild and Theatre Society.

The play's tale is that of two headmistresses of a girls' school about whom students circulate false rumors in resentment at discipline. Although the preceptresses are cleared in the last act, one commits suicide.

Tonight A. G. Munro, manager of the Shubert Theatre, where the play was to have been presented was busy canvassing suburban cities and towns on the chance that officials elsewhere might view the play differently.

Such procedure was successful several years ago in presentation of Eugene O'Neill's "Strange Interlude," which thousands went to see nightly in suburban Quincy after it was banned in Boston.

### O'Casey's Play Also Banned.

The last play banned in the city was Sean O'Casey's "Within the Gates," which dealt with a Bishop's illegitimate daughter. This proscription, started by Catholic clergy, led to a furore of controversy.

One of the repercussions was the attempt of Henry Wadsworth Longfellow Dana, grandson of the poet, from whose poem the title of the play banned today was taken, to read the O'Casey play in a public hall.

He was prevented by police, but adjourned his audience to a private residence, and there read portions of the Irish dramatist's work.

More recently, police arrested four members of the cast on the opening night here of "Waiting for Lefty," a play by Clifford Odets, dealing with a strike of New York City taxi-drivers. They were charged with profanity, but, after expurgation of some words, the play received a clean bill of health.

December 15, 1935

## WPA DRAMA

SCENES of international importance arising out of the Italo-Ethiopian conflict and involving the outstanding personalities in world affairs will be brought to life before an American audience as the world première of the Federal Theatre's "Living Newspaper" unfolds on the stage of the Biltmore Theatre on Wednesday night.

"The Living Newspaper," which is the first of twenty-five Federal Theatre producing groups to open with a production in a legitimate theatre, will subsequently present dramatizations of other current outstanding world events.

In addition to presenting the Ethiopian situation in dramatic form, Morris Watson, former Associated Press writer and now managing supervisor of "The Living Newspaper," has arranged to flash on the screen of the Biltmore the latest news bulletins as they are received by wire, cable and teletype from all parts of the world.

After the opening night three complete programs will be offered, with continuous performances from 9 P. M. until 12, each lasting one hour. Twenty-five cents is the price of admission.

The first "Living Newspaper" presentation, which was directed by Bertram Harrison and written by Arthur Arent and the entire staff, will portray a series of fourteen scenes depicting those events which aroused the greatest public interest and which were of the greatest international significance.

The regular staff of "Living Newspaper" actors has been increased for the first production by the addition of twenty Negro actors taken from the Negro Theatre of the Federal Theatre. In addition a company of African Dancers, another individual group, will appear in a number of scenes picturing Ethiopian dancers.

"The Living Newspaper" is sponsored by the Newspaper Guild.

January 19, 1936

## THE PLAY

### Frank Craven in Thornton Wilder's 'Our Town,' Which Is the Anatomy of a Community

OUR TOWN, a play by Thornton Wilder; directed and produced by Jed Harris. At Henry Miller's Theatre.

| | |
|---|---|
| Stage Manager | Frank Craven |
| Dr. Gibbs | Jay Fassett |
| Joe Crowell | Raymond Roe |
| Howie Newsome | Tom Fadden |
| Mrs. Gibbs | Evelyn Varden |
| Mrs. Webb | Helen Carew |
| George Gibbs | John Craven |
| Rebecca Gibbs | Marilyn Erskine |
| Wally Webb | Charles Wiley Jr. |
| Emily Webb | Martha Scott |
| Professor Pepper | Arthur Allen |
| Mr. Webb | Thomas W. Ross |
| Woman in the Balcony | Carrie Weller |
| Man in the Auditorium | Walter O. Hill |
| Lady in the Box | Aline McDermott |
| Simon Stimson | Philip Coolidge |
| Mrs. Soames | Doro Merande |
| Constable Warren | E. Irving Locke |
| Si Crowell | Billy Redfield |
| Baseball Players | Alfred Ryder, William Roehrick, Thomas Coley |
| Sam Craig | Francis G. Cleveland |
| Joe Stoddard | William Wadsworth |

### By BROOKS ATKINSON

Although Thornton Wilder is celebrated chiefly for his fiction, it will be necessary now to reckon with him as a dramatist. His "Our Town," which opened at Henry Miller's last evening, is a beautifully evocative play. Taking as his material three periods in the history of a placid New Hampshire town, Mr. Wilder has transmuted the simple events of human life into universal reverie. He has given familiar facts a deeply moving, philosophical perspective. Staged without scenery and with the curtain always up, "Our Town" has escaped from the formal barrier of the modern theatre into the quintessence of acting, thought and speculation. In the staging, Jed Harris has appreciated the rare quality of Mr. Wilder's handiwork and illuminated it with a shining performance. "Our Town" is, in this column's opinion, one of the finest achievements of the current stage.

* * *

Since the form is strange, this review must attempt to explain the purpose of the play. It is as though Mr. Wilder were saying: "Now for evidence as to the way Americans were living in the early part of the century, take Grover Corners, N. H., as an average town. Mark it 'Exhibit A' in American folkways." His spokesman in New Hampshire cosmology is Frank Craven, the best pipe and pants-pocket actor in the business, who experimentally sets the stage with tables and chairs before the house lights go down and then prefaces the performance with a few general remarks about Grover Corners. Under his benign guidance we see three periods in career of one generation of Grover Corners folks—"Life," "Love" and "Death."

* * *

Literally, they are not important. On one side of an imaginary street Dr. Gibbs and his family are attending to their humdrum affairs with relish and probity. On the opposite side Mr. Webb, the local editor, and his family are fulfilling their quiet destiny. Dr. Gibbs's boy falls in love with Mr. Webb's girl—neighbors since birth. They marry after graduating from high school; she dies several years later in childbirth and she is buried on Cemetery Hill. Nothing happens in the play that is not normal and natural and ordinary.

* * *

But by stripping the play of everything that is not essential, Mr. Wilder has given it a profound, strange, unworldly significance. This is less the portrait of a town than the sublimation of the commonplace; and in contrast with the universe that silently swims around it, it is brimming over with compassion. Most of it is a tender idyll in the kindly economy of Mr. Wilder's literary style; some of it is heartbreaking in the mute simplicity of human tragedy. For in the last act, which is entitled "Death," Mr. Wilder shows the dead of Grover Corners sitting peacefully in their graves and receiving into their quiet company a neighbor's girl whom they love. So Mr. Wilder's pathetically humble evidence of human living passes into the wise beyond. Grover Corners is a green corner of the universe.

* * *

With about the best script of his career in his hands, Mr. Harris has risen nobly to the occasion. He has reduced theatre to its lowest common denominator without resort to perverse showmanship. As chorus, preacher, drug store proprietor and finally as shepherd of the flock, Frank Craven plays with great sincerity and understanding, keeping the sublime well inside his homespun style. As the boy and girl, John Craven, who is Frank Craven's son, and Martha Scott turn youth into tremulous idealization, some of their scenes are lovely past all enduring. Jay Fassett as Dr. Gibbs, Evelyn Varden as his wife, Thomas W. Ross and Helen Carew as the Webbs play with an honesty that is enriching. There are many other good bits of acting.

* * *

Out of respect for the detached tone of Mr. Wilder's script the performance as a whole is subdued and understated. The scale is so large that the voices are never lifted. But under the leisurely monotone of the production there is a fragment of the immortal truth. "Our Town" is a microcosm. It is also a hauntingly beautiful play.

February 5, 1938

## Saroyan's 'The Time of Your Life' Opens Theatre Guild's Twenty-second Season

THE TIME OF YOUR LIFE, a play in three acts by William Saroyan. Staged by Eddie Dowling and the author; settings by Watson Barratt; produced under the supervision of Theresa Helburn and Lawrence Langner; presented by the Theatre Guild in association with Mr. Dowling. At the Booth Theatre.

| | |
|---|---|
| Newsboy | Ross Bagdasarian |
| Drunk | John Farrell |
| Willie | Will Lee |
| Joe | Eddie Dowling |
| Nick | Charles De Sheim |
| Tom | Edward Andrews |
| Kitty Duval | Julie Haydon |
| Dudley | Curt Conway |
| Harry | Gene Kelly |
| Wesley | Reginald Beane |
| Lorene | Nene Vibber |
| Blick | Grover Burgess |
| Arab | Houseley Stevens Sr. |
| Mary L | Celeste Holme |
| Krupp | William Bendix |
| McCarthy | Tom Tully |
| Kit Carson | Len Doyle |
| Nick's Ma | Michelette Burani |
| Sailor | Randolph Wade |
| Elsie | Cathie Bailey |
| A Killer | Evelyn Geller |
| Her Side Kick | Mary Cheffey |
| A Society Lady | Eva Leonard Boyne |
| A Society Gentleman | Ainsworth Arnold |
| First Cop | Randolph Wade |
| Second Cop | John Farrell |

### By BROOKS ATKINSON

There is something very precious about William Saroyan. Out of his enthusiasm for all the living comes a quality of shining beauty. His "The Time Of Your Life," which the Theatre Guild put on at the Booth last evening, is only a reverie in a bar room, without much story and none of the nervous excitement of the theatre. Nothing holds this sprawling drama together except Mr. Saroyan's affection for the tatterdemalions who are in it. But his affection is no casual sentiment. It has the force of a genuine conviction about people. It is innocent at heart and creative in art. Beautifully acted by Eddie Dowling in a bar-fly role, "The Time of Your Life" is something worth cherishing—a prose poem in ragtime with a humorous and lovable point of view.

\* \* \*

Taking a handful of undistinguished characters, Mr. Saroyan lets the talk flow out of them, and before you know it he has written a dance in praise of life. They are loitering in Nick's waterfront saloon somewhere in a frowzy corner of San Francisco. The chief one among them is a well-heeled, steady drinker who fancies that he is a student of life. He is quixotic and mystic with some oddments of philosophy rattling around in his genially be-fuddled head. The other characters strike a general average—a kindly saloon-keeper, a street-walker with dreams, a colored musician, an aspiring tap-dancer, a fabulous teller of tall tales, a worried cop, a boy in love, a crazy Arab lounging in the corner.

\* \* \*

What they do is hardly enough to fill a one-act play. But what they think interests Mr. Saroyan profoundly, and is likely to interest you. For some of the warmest and heartiest comedy in the modern drama comes bubbling up through Mr. Saroyan's pungent dialogue, and although it is not realism it is real. He is no logician. Facts do not make much impression on his exultant mind. He is not much interested in the technique of writing drama. But his imagination is dynamic, and his sense of humor has a vast appetite. The mood of "My Heart's in the Highlands" was country and lyric. The mood of "The Time of Your Life" is city and somber. But his saloon loungers facing the world with longing and wonder are glorious company and as eloquent as a piece of music.

\* \* \*

No wonder the producers had trouble on the road shaking the play down into some sort of stage order. Mr. Saroyan's style of impulse and inspiration fits none of the theatre's smoothest grooves. But it is difficult to see how the performance could be much truer than the one the Theatre Guild has brought to town under the dual direction of Mr. Dowling and Mr. Saroyan. In the central part Mr. Dowling gives a rich and compassionate performance in a savory vernacular that blends with the setting. Although Julie Haydon's shy, unreality of expression suits her to a play of this sort, she does not define the character of the street-walker with much insight. As a whole, the cast is excellent. It includes some memorable scenes by William Bendix, Len Doyle, Gene Kelly, Tom Tully and Reginald Beane. Watson Barratt has given it a flavorsome setting.

\* \* \*

Probably Mr. Saroyan will learn more about the theatre the longer he stays in it. Any one can see that "The Time of Your Life" does not use the stage efficiently. But that is no more than a pedantic reflection on the waywardness of Mr. Saroyan's genius. For he is creative, which is the most precious thing in any art, and he has rubbed his elbows in life without soiling his spirit.

October 26, 1939

---

# THE PLAY IN REVIEW

### By LEWIS NICHOLS

The theatre opened its Easter basket the night before and found it a particularly rich one. Preceded by warm and tender reports from Chicago, "The Glass Menagerie" opened at the Playhouse on Saturday, and immediately it was clear that for once the advance notes were not in error. Tennessee Williams' simple play forms the framework for some of the finest acting to be seen in many a day. "Memorable" is an overworked word, but that is the only one to describe Laurette Taylor's performance. March left the theatre like a lioness.

Miss Taylor's picture of a blowsy, impoverished woman who is living on memories of a flower-scented Southern past is completely perfect. It combines qualities of humor and human understanding. The Mother of the play is an amus-

### The Cast

THE GLASS MENAGERIE, a play in two acts, by Tennessee Williams. Scenery by Jo Mielziner; original music composed by Paul Bowles; staged by Eddie Dowling and Margo Jones; produced by Mr. Dowling and Louis J. Singer. At the Playhouse.

| | |
|---|---|
| The Mother | Laurette Taylor |
| Her Son | Eddie Dowling |
| Her Daughter | Julie Haydon |
| The Gentleman Caller | Anthony Ross |

ing figure and a pathetic one. Aged, with two children, living in an apartment off an alley in St. Louis, she recalls her past glories, her seventeen suitors, the old and better life. She is a bit of a scold, a bit of a snob; her finery has worn threadbare, but she has kept it for occasions of state. Miss Taylor makes her a person known by any other name to everyone in her audience. That is art.

In the story the Mother is trying to do the best she can for her children. The son works in a warehouse, although he wants to go to far places. The daughter, a cripple, never has been able to fin-ish school. She is shy, she spends her time collecting glass animals—the title comes from this—and playing old phonograph records. The Mother thinks it is time she is getting married, but there has never been a Gentleman Caller at the house. Finally the son brings home another man from the warehouse and out comes the finery and the heavy if bent candlestick. Even the Gentleman Caller fails. He is engaged to another girl.

Mr. Williams' play is not all of the same caliber. A strict perfectionist could easily find a good many flaws. There are some unconnected odds and ends which have little to do with the story: Snatches of talk about the war, bits of psychology, occasional moments of rather flowery writing. But Mr. Williams has a real ear for faintly sardonic dialogue, unexpected phrases and an affection for his characters. Miss Taylor takes these many good passages and makes them sing. She plays softly and part of the time seems to be mumbling—a mumble that can be heard at the top of the gallery. Her accents, like the author's phrases, are unexpected; her gestures are vague and fluttery. There is no doubt she was a Southern belle; there is no doubt she is a great actress.

Eddie Dowling, who is co-producer, and, with Margo Jones, co-director, has the double job of narrator and the player of The Son. The narration is like that of "Our Town" and "I Remember Mama" and it probably is not essential to "The Glass Menagerie." In the play itself Mr. Dowling gives his quiet, easy performance. Julie Haydon, very ethereal and slight, is good as the daughter, as is Anthony Ross as the Gentleman Caller. The Caller had been the hero in high school, but he, too, had been unsuccessful. Jo Mielziner's setting fits the play, as does Paul Bowles' music. In fact, everything fits. "The Glass Menagerie," like spring, is a pleasure to have in the neighborhood.

April 2, 1945

---

# THE PLAY IN REVIEW

### iceman Cometh,' Mr. O'Neill's New Work, With Four-Hour Running Time, Has Its World Premiere at the Martin Beck

THE ICEMAN COMETH. Eugene O'Neill's marathon play in four acts. Staged by Eddie Dowling; scenery designed and lighted by Robert Edmond Jones; production under the supervision of Theresa Helburn and Lawrence Langner; associate producer, Armina Marshall; presented by the Theatre Guild. At the Martin Beck Theatre.

| | |
|---|---|
| Harry Hope | Dudley Digges |
| Ed Mosher | Morton L. Stevens |
| Pat McGloin | Al McGranery |
| Willie Oban | E. G. Marshall |
| Joe Mott | John Marriott |
| Piet Wetjoen | Frank Tweddell |
| Cecil Lewis | Nicholas Joy |
| James Cameron | Russell Collins |
| Hugo Kalmar | Leo Chalzel |
| Larry Slade | Carl Benton Reid |
| Rocky Pioggi | Tom Pedi |
| Dan Parritt | Paul Crabtree |
| Pearl | Ruth Gilbert |
| Margie | Jeanne Cagney |
| Cora | Marcella Markham |
| Chuck Morello | Joe Marr |
| Theodore Hickman | James E. Barton |
| Moran | Michael Wyler |
| Lieb | Charles Hart |

### By BROOKS ATKINSON

Mr. O'Neill has written one of his best plays. Dipping back in his memory thirty-four years, reaching down to the tatter-demalions of a mouldy bar-room, he has come up with a dark and somber play that compares with the best work of his earliest period. "The Iceman Cometh," he calls it to no one's satisfaction but his own, and it was acted with rare insight and vitality at the Martin Beck last evening. Writing it for a performance that lasts more than four hours is a sin that rests between Mr. O'Neill and his Maker. Long plays have become nothing more than a bad label with our first dramatist.

But if that is the way Mr. O'Neill wants to afflict harmless play-goers, let us accept our fate with nothing more than a polite demurer. For the only thing that matters is that he has plunged again into the black quagmire of man's illusions and composed a rigadoon of death as strange and elemental as his first works. Taking his characters again out of the lower depths, as he did in the "S. S. Glencairn" series, he is looking them over with bleak and mature introspection. And like all his best work, this one is preeminently actable. The Theatre Guild performance, under Eddie Dowling's direction, is a masterpiece of tones, rhythms and illumination.

289

The whisky-ridden derelicts who drag their broken carcasses through Harry Hope's bar came out of O'Neill's youth when he, too, was drinking too much and dreaming of becoming a writer. They are men whose only lives are illusions—"pie dreams," O'Neill calls their memories which they foolishly translate into hopes for a future that will never exist. When the play opens they are happily living together in a spirit of human rancor, broken, tired and drunken but buoyed up by romantic illusions about themselves.

What shatters their stupor is the arrival of an old comrade who has reformed. He has found peace at last, he says. He does not need whisky any more, he says, because he has purged himself of illusions and knows the full truth of himself. Instead of making them happy, however, his reform movement destroys their decaying contentment. Without illusions, they find themselves standing alone and terrified. They cannot face the hollowness of themselves without the opium of illusions. But they are released in the last act by the awful discovery that their teacher

has freed himself from illusions by committing a crime that will sit him in the electric chair. He is free from illusions because he has resigned from life and is already dead in spirit. Whereupon, the derelicts drink up again and happily relapse into the stupor of the bottle.

* * *

That is the abstract story of "The Iceman Cometh." But the concrete drama on the stage is infinitely more flavorsome. Among its battered wretches it includes a raffish lot of social outcasts in amazing variety—an I. W. W. émigré, a broken gambler, a cop who was thrown off the force, a British infantry officer who stole regimental funds, a Boer commando leader who showed the white feather, the well-educated son of an embezzler, some prostitutes and barkeeps. The Lord knows they talk too much, for Mr. O'Neill insists on grinding their bitterness into very small and precise pieces. But it is good talk—racy, angry, comic drumbeats on the lid of doom, and a strong undercurrent of elemental drama silently washes the gloomy charnel-house where

they sit waiting.

Surely it is no accident that most of Mr. O'Neill's plays act well. Although he seems on the surface to be a literal writer, interminably fussing over minor details, his best plays move across the stage as methodically and resolutely as a heavy battle attack, and over-run strategic points with a kind of lumbering precision. The performance of "The Iceman Cometh" ranks among the theatre's finest works. To house these rags and tags of the human race, Robert Edmond Jones has created a mean and dingy last refuge that nevertheless glows with an articulate meaning, like a Daumier print, as one alert spectator observed.

To anyone who loves acting, Dudley Digges' performance as the tottering and irascible saloon proprietor is worth particular cherishing. Although the old man is half dead, Mr. Digges' command of the actor's art of expressing character and theme is brilliantly alive; it overflows with comic and philosophical expression. As the messenger of peace, James Barton is also superb — common, unctuous, cheerful and fanatical; and Mr.

Barton reads one of the longest speeches on record without letting it drift off into sing-song or monotony.

* * *

As the barroom's master of cosmic thinking, Carl Benton Reid is vigorously incisive, and lends substance to the entire performance. Nicholas Joy is giving the best performance of his career as the unfrocked captain. As the garrulous night bartender, Tom Pedi with his querulous vitality streaks an amusing ribbon of color throughout the drama. There are also notable performances by John Marriott, as the discredited gambler; Paul Crabtree, as an I. W. W. traitor, and E. G. Marshall, as a fallen Harvard man.

If there were any justice in the world, all the actors would get a line of applause here. But this bulletin, like Mr. O'Neill's play, is already much too garrulous. Let us cut it short with one final salute to a notable drama by a man who writes with the heart and wonder of a poet.

October 10, 1946

# FIRST NIGHT AT THE THEATRE

A STREETCAR NAMED DESIRE, a play in three acts, by Tennessee Williams. Staged by Elia Kazan; scenery and lighting by Jo Mielziner; costumes by Lucinda Ballard; produced by Irene M. Selznick. At the Barrymore Theatre.

| | |
|---|---|
| Negro Woman | Gee Gee James |
| Eunice Hubbel | Peg Hillias |
| Stanley Kowalski | Marlon Brando |
| Harold Mitchell (Mitch) | Karl Malden |
| Stella Kowalski | Kim Hunter |
| Steve Hubbel | Rudy Bond |
| Blanche du Bois | Jessica Tandy |
| Pablo Gonzales | Nick Dennis |
| A Young Collector | Vito Christi |
| Mexican Woman | Edna Thomas |
| A Strange Woman | Ann Dere |
| A Strange Man | Richard Garrick |

### By BROOKS ATKINSON

Tennessee Williams has brought us a superb drama, "A Streetcar Named Desire," which was acted at the Ethel Barrymore last evening. And Jessica Tandy gives a superb performance as rueful heroine whose misery Mr. Williams is tenderly recording. This must be one of the most perfect marriages of acting and playwriting. For the acting and playwriting are perfectly blended in a limpid performance, and it is impossible to tell where Miss Tandy begins to give form and warmth to the mood Mr. Williams has created.

Like "The Glass Menagerie," the new play is a quietly woven study of intangibles. But to this observer it shows deeper insight and represents a great step forward toward clarity. And it reveals Mr. Williams as a genuinely poetic playwright whose knowledge of people is honest and thorough and whose sympathy is profoundly human.

* * *

"A Streetcar Named Desire" is history of a gently reared Mississippi young woman who invents an artificial world to mask the hideousness of the world she has to inhabit. She comes to live with her sister, who is married to a rough-and-ready mechanic and inhabits two dreary rooms in a squalid neighborhood. Blanche—for that is her name—has delusions of grandeur, talks like an intellectual snob, buoys herself up with gaudy dreams, spends most of her time primping, covers things that are dingy with things that are bright and flees reality.

To her brother-in-law she is an unforgiveable liar. But it is soon

apparent to the theatregoer that in Mr. Williams' eyes she is one of the dispossessed whose experience has unfitted her for reality; and although his attitude toward her is merciful, he does not spare her or the playgoer. For the events of "Streetcar" lead to a painful conclusion which he does not try to avoid. Although Blanche cannot face the truth, Mr. Williams does in the most imaginative and perceptive play he has written.

* * *

Since he is no literal dramatist and writes in none of the conventional forms, he presents the theatre with many problems. Under Elia Kazan's sensitive but concrete direction, the theatre has solved them admirably. Jo Mielziner has provided a beautifully lighted single setting that lightly sketches the house and the neighborhood. In this shadowy environment the performance is a work of great beauty.

Miss Tandy has a remarkably long part to play. She is hardly ever off the stage, and when she is on stage she is almost constantly

talking — chattering, dreaming aloud, wondering, building enchantments out of words. Miss Tandy is a trim, agile actress with a lovely voice and quick intelligence. Her performance is almost incredibly true. For it does seem almost incredible that she could understand such an elusive part so thoroughly and that she can convey it with so many shades and impulses that are accurate, revealing and true.

* * *

The rest of the acting is also of very high quality indeed. Marlon Brando as the quick-tempered, scornful, violent mechanic; Karl Malden as a stupid but wondering suitor; Kim Hunter as the patient though troubled sister—all act not only with color and style but with insight.

By the usual Broadway standards, "A Streetcar Named Desire" is too long; not all those words are essential. But Mr. Williams is entitled to his own independence. For he has not forgotten that human beings are the basic subject of art. Out of poetic imagination and ordinary compassion he has spun a poignant and luminous story.

December 4, 1947

# AT THE THEATRE

## The Cast

DEATH OF A SALESMAN a play by Arthur Miller. Staged by Elia Kazan; scenery and lighting by Jo Mielziner; incidental music by Alex North; costumes by Julia Sze; produced by Kermit Bloomgarden and Walter Fried. At the Morosco Theatre.

| | |
|---|---|
| Willy Loman | Lee J. Cobb |
| Linda | Mildred Dunn |
| Happy | Cameron Mitchell |
| Biff | Arthur Kennedy |
| Bernard | Don Keefer |
| The Woman | Winnifred Cushing |
| Charley | Howard Smith |
| Uncle Ben | Thomas Chalmers |
| Howard Wagner | Alan Hewitt |
| Jenny | Ann Driscoll |
| Stanley | Tom Pedi |
| Miss Forsythe | Constance Ford |
| Letta | Hope Cameron |

### By BROOKS ATKINSON

Arthur Miller has written a superb drama. From every point of view "Death of a Salesman," which was acted at the Morosco last evening, is rich and memorable drama. It is so simple in style and so inevitable in theme that it scarcely seems like a thing that has been written and acted. For Mr. Miller has looked with compassion into the hearts of some ordinary Americans and quietly transferred their hope and anguish to the theatre. Under Elia

Kazan's masterly direction, Lee J. Cobb gives a heroic performance, and every member of the cast plays like a person inspired.

* * *

Two seasons ago Mr. Miller's "All My Sons" looked like the work of an honest and able playwright. In comparison with the new drama, that seems like a contrived play now. For "Death of a Salesman" has the flow and spontaneity of a suburban epic that may not be intended as poetry but becomes poetry in spite of itself because Mr. Miller has drawn it out of so many intangible sources.

It is the story of an aging sales-

man who has reached the end of his usefulness on the road. There has always been something unsubstantial about his work. But suddenly the unsubstantial aspects of it overwhelm him completely. When he was young, he looked dashing; he enjoyed the comradeship of other people—the humor, the kidding, the business.

In his early sixties he knows his business as well as he ever did. But the unsubstantial things have become decisive; the spring has gone from his step, the smile from his face and the heartiness from his personality. He is through. The phantom of his life has caught up with him. As literally as Mr. Miller

can say it, dust returns to dust. Suddenly there is nothing.

This is only a little of what Mr. Miller is saying. For he conveys this elusive tragedy in terms of simple things—the loyalty and understanding of his wife, the careless selfishness of his two sons, the sympathetic devotion of a neighbor, the coldness of his former boss'—the bills, the car, the tinkering around the house. And most of all: the illusions by which he has lived—opportunities missed, wrong formulas for success, fatal misconceptions about his place in the scheme of things.

Writing like a man who understands people, Mr. Miller has no moral precepts to offer and no solutions of the salesman's problems. He is full of pity, but he brings no piety to it. Chronicler of one frowsy corner of the American scene, he evokes a wraith-like tragedy out of it that spins through the many scenes of his play and gradually envelops the audience.

\* \* \*

As theatre "Death of a Salesman" is no less original than it is as literature. Jo Mielziner, always equal to an occasion, has designed a skeletonized set that captures the mood of the play and serves the actors brilliantly. Although Mr. Miller's text may be diffuse in form, Mr. Kazan has pulled it together into a deeply moving performance.

Mr. Cobb's tragic portrait of the defeated salesman is acting of the first rank. Although it is familiar and folksy in the details, it has something of the grand manner in the big size and the deep tone. Mildred Dunnock gives the performance of her career as the wife and mother—plain of speech but indomitable in spirit. The parts of

the thoughtless sons are extremely well played by Arthur Kennedy and Cameron Mitchell, who are all youth, brag and bewilderment.

Other parts are well played by Howard Smith, Thomas Chalmers, Don Keefer, A᾿ Hewitt and Tom Pedi. If there ᾿ ere time, this report would gratefully include all the actors and fabricators of illusion. For they all realize that for once in their lives they are participating in a rare event in the theatre. Mr. Miller's elegy in a Brooklyn sidestreet is superb.

**February 11, 1949**

---

# Eugene O'Neill Dies of Pneumonia; Playwright, 65, Won Nobel Prize

## He Also Took Pulitzer Award for Drama Three Times— Ill for Several Years

Special to THE NEW YORK TIMES.

BOSTON, Nov. 27 — Eugene O'Neill, noted American playwright whose prolific talents had brought to him both Nobel and Pulitzer Prizes, died today of bronchial pneumonia. His age was 65.

The announcement of the death was made by Dr. Harry L. Kozol of Boston. Mr. O'Neill had been ill for several years with Parkinson's disease, a form of palsy that made writing virtually impossible.

The writer had been in and out of various hospitals in eastern Massachusetts in recent years, but had sought to keep the visits unpublicized.

Mr. O'Neill died in a Boston apartment where he had been living recently. His third wife, Carlotta Monterey, and Dr. Kozol were at the bedside.

He also leave a daughter, Oona O'Neill, who resides with her husband, Charles Chaplin, the actor, in Lucerne, Switzerland, and London. The funeral will be private.

---

Eugene Gladstone O'Neill was generally regarded as the foremost American playwright, his achievements in the theatre overwhelming those of his ablest contemporaries. Whatever judgment posterity may make, the history of the stage will have to find an important niche for him, for he came upon the scene at an opportune moment and remained active long after the American theatre had come of age.

In the words of Brooks Atkinson of The New York Times, Mr. O'Neill broke a number of old molds, shook up the drama as well as audiences and helped to transform the theatre into an art seriously related to life. The genius of Mr. O'Neill lay in raw boldness, in the elemental strength of his attack upon outworn concepts of destiny.

The playwright received the Pu-

The New York Times, 1946
**Eugene O'Neill**

litzer Prize on three occasions and was the second citizen of this country to win the Nobel Prize for Literature.

The author of some thirty-eight plays, most of them grim dramas in which murder, disease, suicide and insanity are recurring themes, Mr. O'Neill was in recent years too wracked by illness to write and lived a secluded life in a little house by the sea with his third wife, a former actress.

But the decline of his fortunes saw no loss of public interest in his works. His plays continued to be produced to acclaim here and abroad and the fall of 1951 saw a real O'Neill "revival" on Broadway. The American National Theatre and Academy scheduled his "Desire Under the Elms" to launch its new season and the Craftsmen, a small dramatic group, produced the same play at the Barbizon-Plaza Theatre. In addition, the New York City Theatre Company picked "Anna Christie" as the second offering of its winter season.

A revival of "Ah, Wilderness!," the playwright's nostalgic comedy of first love, found its way to the television screen when the Celanese Theatre offered it, with Thomas Mitchell in the role originated by the late George M. Cohan.

Actually, no modern playwright except the late George Bernard Shaw had been more widely produced than Mr. O'Neill. He was as well known in Stockholm, Buenos Aires, Vienna, Mexico City, Calcutta and Budapest as in New York.

There was as much color and excitement in his early life as there was in his plays. Indeed, much of his success was attributable to the fact that he had lived in and seen the very world from which he drew his dramatic material.

As a young man he spent his days as a common sailor and his nights in dives that lined the water's edge. Out of these experiences came such plays as "The Hairy Ape," "Anna Christie" and "Beyond the Horizon," all of which **have had a lasting life in the theatre.**

**Mr. O'Neill was born on Oct. 16, 1888, in a third-floor room of the Barrett House, a family hotel** that used to stand at Forty-third Street and Broadway. His father was the James O'Neill who starred for so many years in "The Count of Monte Cristo." His mother was the former Ellen Quinlan, who was born in New Haven but was reared in the Middle West. The first seven years of Eugene's life were spent trouping up and down the country with his actor-father and housewife-mother.

The boy's days as a theatrical camp follower ended at his eighth birthday, when he was enrolled in a Roman Catholic boarding school on the Hudson. In 1902, when he was 13, he entered Betts Academy in Stamford, Conn., considered at the time one of the leading boys' schools in New England.

He was graduated in 1906 and went to Princeton. After ten months at the university, he was expelled for heaving a brick through a window of the local stationmaster's house. It marked the end of his formal education.

The youth got a job as a secretary in a New York supply company business but quit after a few months to go to Honduras with a young mining engineer named Stevens. The two spent several months exploring the country's endless jungles and tried their hand at prospecting for gold. The venture ended after Mr. O'Neill became ill with fever and was shipped home by a kindly consul.

### Worked for His Father

For a time the young man worked as an assistant stage manager for his father, who was touring in a play called "The White Sister." But he soon succumbed to the lure of far-off places and shipped as an ordinary seaman on a Norwegian freighter

bound for Buenos Aires. This began his acquaintance with the forecastle that was to stand him in good dramatic stead later on.

In Buenos Aires he took such jobs as came his way. Tiring of that, he shipped again, this time for Portuguese East Africa. From there he sailed right back to Buenos Aires, then worked his way to New York on an American ship.

In New York he lived at a waterfront dive known as "Jimmy the Priest's," and incidentally acquired the locale for "Anna Christie." For a time he joined his father's troupe as an actor of bit parts. Later he turned up at his father's summer place in New London, Conn. In August, 1912, he went to work as a reporter on The New London Telegraph. His newspaper career lasted for four months, because, as he readily admitted, he was more interested in writing verse, swimming and sunbathing than in gathering news.

Just before Christmas in 1912 he developed a mild case of tuberculosis and was sent to the Gaylord Farm Sanitarium at Wallingford, Conn. He spent five months there and was to say later that it was while at the sanitarium that his mind got a chance to "establish itself, to digest and to evaluate the impressions of many past years in which one experience had crowded on another with never a second's reflection."

At Gaylord, too, he began to read Strindberg. "It was reading his plays," Mr. O'Neill later recalled, "that, above all else, first gave me the vision of what modern drama could be, and first inspired me with the urge to write for the theatre myself."

After his discharge from the sanitarium he boarded with a private family in New London for fifteen months. During this period he wrote eleven one-act plays and two long ones. He tore up all but six of the one-acters. His father paid to have five of the six short plays printed in a volume called "Thirst," published in 1914 and now a collector's item.

### Studied at Harvard

The elder O'Neill also paid a year's tuition for his son at Prof. George Baker's famous playwriting course at Harvard. The year over, Mr. O'Neill returned to New York and settled down in a Greenwich Village rooming house. The young man proceeded to soak up more "local color" at various Village dives, among them a saloon known as "The Working Girls' Home," where John Masefield, the British poet, was for a time a bartender.

Mr. O'Neill lived in the Village until 1916, when he moved to Provincetown, Mass., and fell in

with a group conducting a summer theatrical stock company known as the Wharf Theatre. He hauled out a sizable collection of unproduced and unpublished plays and one of them, a one-acter called "Bound East for Cardiff," was put into rehearsal. It marked Mr. O'Neill's debut as a dramatist.

The Wharf Theatre did not go out of business at summer's end but set up shop in New York and called itself the Provincetown Players, a name that was to become famous. The company produced more of Mr. O'Neill's plays and the budding playwright began to be talked about in theatrical circles farther afield. At about the same time, as well, three of his one-act plays, "The Long Voyage Home," "Ile" and "The Moon of the Carribbees," were published in the magazine Smart Set.

In 1918 Mr. O'Neill went to Cape Cod to live, occupying a former Coast Guard station on a lonely spit of land three miles from Provincetown. He started working on longer plays and, in 1920, had his first big year when he won the first of his three Pulitzer Prizes for "Beyond the Horizon." The play marked Mr. O'Neill's first appearance on Broadway. The other prize winners were "Anna Christie" in 1922 and "Strange Interlude" in 1928.

### Ranked as Money Maker

"Beyond the Horizon" established Mr. O'Neill not only as a ranking playwright but as a money maker. The play ran for 111 performances and grossed $117,071. Mr. O'Neill needed the royalties badly; he had to use the $1,000 Pulitzer Prize money to pay off some debts.

The Theatre Guild began pro-

ducing his plays with "Marco Millions" in 1927 and staged all his plays thereafter. At least three of the plays, "Mourning Becomes Electra," "Strange Interlude" and "The Iceman Cometh," marked a new departure—they ran from four to five hours in length, requiring odd curtain and intermission times.

Mr. O'Neill's dramas ranged from simple realism to the most abstruse symbolism but one play —"Ah, Wilderness!"—was more in the tradition of straight entertainment and was interspersed with sentiment usually lacking in his introspective analyses of human emotions. The play ran for 289 performances.

Mr. O'Neill did not always meet with approval. At times, even, he was the object of bitter denunciation, especially from persons who believed his works smacked of immorality. By his choice of themes he several times stirred up storms that swept his plays into the courts.

"All God's Chillun Got Wings," which figured in the headlines for weeks, was fought by New York authorities on the ground that it might lead to race riots. "Desire Under the Elms" kicked up a big fuss in New York and almost was closed in the face of mounting protests. It never did open in Boston. The play was permitted to go on in Los Angeles, but after a few performances the police arrested everybody in the cast.

"The Hairy Ape," which starred Louis Wolheim in the role of Yank, a powerful, primitive stoker, was one of the dramatist's most popular works. The play ran for ten weeks, went on the road for a long tour and later was popular abroad.

### "Electra" Highly Rated

Many critics felt that "Mourn-

ing Becomes Electra," which opened on Oct. 26, 1931, and had fourteen acts, was Mr. O'Neill's greatest masterpiece. Mr. Atkinson called it "heroically thought out and magnificently wrought in style and structure." John Mason Brown said that it was "an achievement which restores the theatre to its highest state" and Joseph Wood Krutch observed that "it may turn out to be the only permanent contribution yet made by the twentieth century to dramatic literature."

After "Days Without End" was produced in 1934—a play that received scant praise and lasted only fifty-seven performances — Mr. O'Neill was not represented on Broadway again until 1946, when "The Iceman Cometh" was staged.

In the intervening years, he settled in California and began the most ambitious project of his life. —a cycle of nine related plays dealing with the rise and fall of an American family from 1775 to 1932. The venture never came off. In 1936, he won the Nobel Prize but could not go to Stockholm to receive it because of an appendicitis operation.

In a letter to the prize committee, Mr. O'Neill said:

"This highest of distinctions is all the more grateful to me because I feel so deeply that it is not only my work which is being honored but the work of all my colleagues in America — that the Nobel Prize is a symbol of the coming of age of the American theatre.

"For my plays are merely, through luck of time and circumstance, the most widely known examples of the work done by American playwrights in the year since

the World War—work that has finally made modern American drama, in its finest aspects, an achievement of which Americans can be justly proud."

### Play About His Family

After "The Iceman Cometh," Mr. O'Neill wrote a play called "Long Day's Journey Into Night," which will not be produced until twenty-ve years after his death. He refused to talk about it but he had shown the manuscript to a few friends, and it was reported that the play deals with his own family life.

Mr. O'Neill was stricken with Parkinson's Disease, a palsy, about 1947. The disease caused his hands to jerk convulsively, making it impossible for him to write in longhand. He tried to compose a play by dictation but discovered he could not work that way. Despite the infirmity, he remained in good spirts and displayed evidences of his wit when friends dropped in.

The dramatist married the former Kathleen Jenkins in 1909, who bore him a son, Eugene O'Neill Jr. The son, who became a noted Greek scholar, committed suicide at Woodstock, N. Y., on Sept. 25, 1950. The first marriage ended in divorce in 1912, and six years later, Mr. O'Neill married the former Agnes Boulton. They were divorced in 1929. A son Shane, and Oona were born to this marriage. Mr. O'Neill married Miss Monterey on July 22, 1929.

November 28, 1953

---

# Theatre: Tennessee Williams' 'Cat'

## The Cast

CAT ON A HOT TIN ROOF, a drama in three acts, by Tennessee Williams. Staged by Elia Kazan; scenery and lighting by Jo Mielziner; costumes by Lucinda Ballard; production stage manager, Robert Downing; presented by the Playwrights Company. At the Morosco Theatre.

Lacey .................... Maxwell Glanville
Sookey .................... Musa Williams
Margaret ............ Barbara Bel Geddes
Brick .................... Ben Gazzara
Mae ................ Madeleine Sherwood
Gooper .................... Pat Hingle
Big Mama ............... Mildred Dunnock
Dixie .................... Pauline Hahn
Buster .................. Darryl Richard
Sonny .................... Seth Edwards
Trixie .................... Janice Dunn
Big Daddy ................. Burl Ives
Reverend Tooker .......... Fred Stewart
Doctor Baugh ......... R. G. Armstrong
Daisy .............. Eva Vaughan Smith
Brightie .............. Brownie McGhee
Small .................... Sonny Terry

### By BROOKS ATKINSON

FOR Tennessee Williams and for the rest of us, the news could hardly be better this morning. For "Cat On a Hot Tin Roof," which opened at the Morosco last evening, is a stunning drama.

Again Mr. Williams is discussing some people of the Mississippi Delta, which he knows well. And again the people are not saints and heroes. But this time Mr. Williams has broken free from the formula or the suspicion of formula that has hovered around the edges of his plays.

"Cat on a Hot Tin Roof" is the work of a mature observer of men and women and a gifted craftsman. To say that it is the drama of people who refuse to face the truth of life is to suggest a whole school of problem dramatists. But one of its great achievements is the honesty and simplicity of the craftsmanship. It seems not to have been written. It is the quintessence of life. It is the basic truth. Always a seeker after honesty in his writing, Mr. Williams has not only found a solid part of the truth but found the way to say it with complete honesty. It is not only part of the truth of life: it is the absolute truth of the theatre.

In a plantation house, the members of the family are celebrating the sixty-fifth birthday of Big Daddy, as they sentimentally dub him. The tone is gay. But the mood is somber. For a number of old evils poison the gaiety—sins of the past, greedy hopes for the future, a desperate eagerness not to believe in the truths that surround them. Most of them are living lives as uncomfortable and insecure as the proverbial "cat on a hot tin roof."

Nothing eventful happens in the course of the evening, for Mr. Williams has now left the formulas of the theatre far to the rear. He is interested solely in exploring minds. "Cat on a Hot Tin Roof" is a delicately wrought exercise in human communication. His characters try to escape from the loneliness of their private lives into some form of understanding. The truth invariably terrifies them. That is the one thing they cannot face or speak.

They can find comfort in each other only by falling back on lies—social lies, lies about health, lies about the past, lies about the future. Not vicious lies, for the most part. The central characters want to be kind to each other. But lies are the only refuge they have from the ugly truths that possess their minds.

•

As the expression of a brooding point of view about life, "Cat on a Hot Tin Roof" is limpid and effortless. As theatre, it is superb. Mr. Williams and his brilliant director, Elia Kazan, have used the medium of the theatre candidly. Jo Mielziner has graphically

suggested a bed-sitting room on what amounts to an apron stage that thrusts the action straight at the audience. Most of the play is written in long duologues without dramatic artifice. Occasionally the actors speak directly to the audience without reference to the other characters.

The acting is magnificent. There is about it that "little something extra" by which the actors reveal awareness of a notable theatrical occasion. Barbara Bel Geddes, vital, lovely and frank as the young wife who cannot accept her husband's indifference; Ben Gazzara, handsome, melancholly, pensive as the husband; Burl Ives as the solid head of a family who fears no truth except his own and hates insincerity; Mildred Dunnock as the silly, empty-headed mother who has unexpected strength of character—give marvelous performances.

There are excellent performances also by Madeleine Sherwood, Pat Hingle, Fred Stewart, R. G. Armstrong and some other good actors. "Cat on a Hot Tin Roof" is Mr. Williams' finest drama. It faces and speaks the truth.

March 25, 1955

# Theatre: Beckett's 'Waiting for Godot'

## Mystery Wrapped in Enigma at Golden

### By BROOKS ATKINSON

DON'T expect this column to explain Samuel Beckett's "Waiting for Godot," which was acted at the John Golden last evening. It is a mystery wrapped in an enigma.

But you can expect witness to the strange power this drama has to convey the impression of some melancholy truths about the hopeless destiny of the human race. Mr. Beckett is an Irish writer who has lived in Paris for years, and once served as secretary to James Joyce.

Since "Waiting for Godot" has no simple meaning, one seizes on Mr. Beckett's experience of two worlds to account for his style and point of view. The point of view suggests Sartre—bleak, dark, disgusted. The style suggests Joyce—pungent and fabulous. Put the two together and you have some notion of Mr. Beckett's acrid cartoon of the story of mankind.

## The Cast

WAITING FOR GODOT, a tragicomedy in two acts by Samuel Beckett; staged by Herbert Berghof; presented by Michael Myerberg, by arrangement with Independent Plays, Ltd.; scenery by Louis Kennel; costumes by Stanley Simmons; production supervisor, John Paul. At the John Golden Theatre.

Estragon (Gogo) ............ Bert Lahr
Vladimir (Didi) .......... E. G. Marshall
Lucky .................... Alvin Epstein
Pozzo ...................... Kurt Kasznar
A Boy .......... Luchino Solito de Solis

Literally, the play consists of four raffish characters, an innocent boy who twice arrives with a message from Godot, a naked tree, a mound or two of earth and a sky. Two of the characters are waiting for Godot, who never arrives. Two of them consist of a flamboyant lord of the earth and a broken slave whimpering and staggering at the end of a rope.

Since "Waiting for Godot" is an allegory written in a heartless modern tone, a theatregoer naturally rummages through the performance in search of a meaning. It seems fairly certain that Godot stands for God. Those who are loitering by the withered tree are waiting for salvation, which never comes.

The rest of the symbolism is more elusive. But it is not a pose. For Mr. Beckett's drama adumbrates — rather than expresses—an attitude toward man's experience on earth; the pathos, cruelty, comradeship, hope, corruption, filthiness and wonder of human existence. Faith in God has almost vanished. But there is still an illusion of faith flickering around the edges of the drama. It is as though Mr. Beckett sees very little reason for clutching at faith, but is unable to relinquish it entirely.

•

Although the drama is puzzling, the director and the actors play it as though they understand every line of it. The performance Herbert Berghof has staged against Louis Kennel's spare setting is triumphant in every respect. And Bert Lahr has never given a performance as glorious as his tatterdemalión Gogo, who seems to stand for all the stumbling, bewildered people of the earth who go on living without knowing why.

Although "Waiting for Godot" is an uneventful, maundering, loquacious drama, Mr.

Lahr is an actor in the pantomime tradition who has a thousand ways to move and a hundred ways to grimace in order to make the story interesting and theatrical, and touching, too. His long experience as a bawling mountebank has equipped Mr. Lahr to represent eloquently the tragic comedy of one of the lost souls of the earth.

The other actors are excellent, also. E. G. Marshall as a fellow vagrant with a mind that is a bit more coherent; Kurt Kasznar as a masterful egotist reeking of power and success; Alvin Epstein as the battered slave who has one bitterly satirical polemic to deliver by rote; Luchino Solito De Solis as a disarming shepherd boy—complete the cast that gives this diffuse drama a glowing performance.

Although "Waiting for Godot" is a "puzzlement," as the King of Siam would express it, Mr. Beckett is no charlatan. He has strong feelings about the degradation of mankind, and he has given vent to them copiously. "Waiting for Godot" is all feeling. Perhaps that is why it is puzzling and convincing at the same time. Theatregoers can rail at it, but they cannot ignore it. For Mr. Beckett is a valid writer.

April 20, 1956

# The Temple of 'The Method'

**Many of tomorrow's stars—and quite a few of today's—are developing their talents through the remarkable teachings of the Actors' Studio.**

### By SEYMOUR PECK

FOR the Hollywood glamour set visiting New York, the most fashionable place in town, far surpassing the boutiques of Bergdorf, Bendel and Bonwit, or such boîtes as "21," the Stork and El Morocco, has become an ancient, austere former church building in a bleak neighborhood on Forty-fourth Street, west of Ninth Avenue, that houses the earnest classroom activities of the ascetic Actors' Studio.

During the past year such stars as Marilyn Monroe, Grace Kelly, Rock Hudson, Joan Crawford, Leslie Caron, Eva Gabor and Marge and Gower Champion have dropped in on various classes at the studio, conspicuously grateful to be admitted, sitting on hard folding chairs in dedicated attitudes, leaving behind temporarily their press agents, their fan club posturings and all thoughts of the William Morris office.

The Studio lets them observe its classes but does not conceal its basic

SEYMOUR PECK, of The Times Sunday staff, has observed the members of Actors' Studio both in class and in their Broadway shows.

interest in finding new, relatively unknown young people of promise and helping these young people fulfill their promise. Why then do these stars, seemingly secure in their success and talents, feel so strongly drawn to the Studio? The answer lies in the impact the Studio has had on stage, screen and TV acting since its quiet, penniless start on October 5, 1947.

From its classes has come a galaxy of new talent—Julie Harris, Marlon Brando, Montgomery Clift, Kim Stanley, Eva Marie Saint, Karl Malden, David Wayne, Rod Steiger, Jo Van Fleet, Kim Hunter, Eli Wallach, Maureen Stapleton, Ben Gazzara, John Forsythe, Paul Newman, Patricia Neal and many more. Its members and teachings have dominated such movies as "On the Waterfront," which was even rehearsed in part at the Studio, and "East of Eden," which rocketed to fame an obscure, sad-faced youth from Studio ranks, James Dean, and such plays as "Cat on a Hot Tin Roof," "Bus Stop" and "A Hatful of Rain." At the Studio, the Hollywood star, who often becomes frozen in conventional modes of acting, anxiously seeks out ways to make his style fresh and varied.

BY and large, it is Elia Kazan who has been responsible for establishing the prestige of the Studio to the world. It is he who, with Broadway producer Cheryl Crawford, scrambled about feverishly to raise the few bucks to rent the first meeting room for the Studio nearly nine years ago. It is he who, with Miss Crawford, still presses for contributions so that the Studio can function without charging any tuition whatever to the hundred actors in its classes. Above all, it is Kazan who, as director of "On the Waterfront," "East of Eden" and "Cat on a Hot Tin Roof," brought so many Studio actors to prominence.

But Kazan is the first to assert that the Studio exists today around the personality and methods of another man. "Today when you say Actors' Studio," Kazan points out, "you mean Lee Strasberg. He's the heart, he's the soul of the Studio."

It is Strasberg, a grave, rather monk-like and untheatrical-looking man of 54, who is the Studio's artistic director and conducts its classes each Tuesday and Friday morning from 11 A. M. to 1 P. M. Couples bring into class scenes

they have chosen themselves and re-
hearsed by themselves from any play-
wright — Shakespeare, Shaw, O'Neill,
O'Casey. Each couple performs its
scene and then listens to the criticism,
often scathing, of Strasberg.

"For you this scene isn't even the
*beginning* of reality," Strasberg said
bluntly to a young man after he and
an actress did a scene about two in-
articulate people meeting for the first
time. "It was all on an external level.
You read the lines, you moved here,
you moved there. You were not really in
a place, you were always on a stage."
The actress, too, had failed to capture
the sense of real life, Strasberg said.
Her character had come to the house
in the play for the first time, yet she
did not show any curiosity about it.

"The place is wonderful," Strasberg
said, "yet when you looked out the
window, you didn't look all around, at
everything to be seen. You were meet-
ing this man for the first time but you
never asked yourself, 'How do I look?'
You never fixed your dress, or your
lipstick and powder. You showed no
interest in the fact that you are *you*
and the impression you are making
on this man is important."

I⊤ is Strasberg's insight into what
performers have done wrong, his un-
canny ability to suggest ways of im-
proving themselves, that spurs them
always to greater effort. "He makes
you think you can do anything," Eva
Marie Saint recently told a friend in
Hollywood. Miss Saint, who admits to
having been "tense, self-conscious and
painfully shy" when she came to the
Studio, credits Strasberg with "lib-
erating" her.

"Showing any emotion was some-
thing to be ashamed of for me," she
said. "Mr. Strasberg made us do silly
things. Once I was asked to pick a
tree. I picked my favorite, the weep-
ing willow. Then I had to be that
tree onstage, in front of everybody. It
was just silly enough to shake me out
of my dread of appearing ridiculous
in public."

Outsiders sometimes scoff at the
"silly" things done in the Studio, but
not so vehemently as they once did.
In the light of the Studio's accomplish-
ments, it no longer seems ludicrous
that Kazan, in the years when he
taught at the Studio, once asked his
students to turn themselves into a zoo.
At another class Marlon Brando was
asked to be a wax statue melting in
the sun. Kazan suddenly clapped his
hands at one session, then called on
individual actors to make up short
scenes in which three hand claps would
be a logical outgrowth of the action.

At one time Kazan became con-
cerned with how a dramatic actor,
untrained in singing or musical com-
edy tricks, might render a popular
song on a dramatic level. He asked
the class to come to the next session
with a scene that would tell a full
dramatic story, but which would use

only the popular song for its words.
"The idea of getting up there and sing-
ing is a nightmare to me," Michael
Strong confessed to his fellow actor,
Fred Stewart, after class. That was
it! Stewart and Strong came back
with a scene in which an actor, played
by Strong, was having nightmares over
having to get up and sing. He was
onstage in the nightmare, the conductor
was pointing at him and insisting he
start, and just then, to make the night-
mare complete, he discovered he had
no pants on.

For the same exercise Karl Malden
sang "Some Enchanted Evening," not
as a mighty star but as a humble
workman with a broom, cleaning up
an empty theatre and sort of amused
at the sound of his own voice in the
vast auditorium. Oddly enough, June
Havoc, a comedienne, devised the most
somber scene.

"It went like this," Miss Havoc said
recently, deep in recollection "I am a
hag. I've lost my spirit. I'm married
to this beast of a man who won't get
up in the morning and go to work.
I've set three alarm clocks for him
and still he won't get up. I am so
driven by the dreary nothingness of
my life that finally one morning I
make myself utterly pleasant and
brew him a lovely cup of breakfast
coffee with poison in it, while I sing
'Tea for Two.'"

M OST of these exercises aim spe-
cifically at making the actor think for
himself, at making him flexible, at
helping him to face any challenge. In
the Studio, preparing his scene without
any director to tell him what to do, the
actor constantly explores and widens
the boundaries of his own resources.
Before him always is the image of
"the ideal" that Strasberg holds up.

"I stress," Strasberg has told his
class, "the difference between the actor
who thinks acting is an imitation of
life, and the actor who feels acting is
*living*. Unless the actor onstage really
comes alive, really lives a character, he
gives a superficial interpretation. He
deprives the audience of a sense of the
full completion of life."

Voice, speech
and movement—these are not
to be overlooked. But Stras-
berg regards them as merely
external aspects of the acting
art. "We deal with the actor's
inner life," he says. "Our
emphasis is laid on thought,
sensations, imagination, emo-
tion, which are the basic in-
gredients of any human
being."

B EING as natural and spon-
taneous as an actual human
being may also lead the actor
to be as humanly unpredicta-
ble. Playing Cherie, the night
club singer, in "Bus Stop,"
Kim Stanley found herself at
one performance doing some-

Maureen Stapleton.

Rod Steiger.

Paul Newman.

thing she had never done be-
fore. She was so moved by
the tender declaration of love
that Bo, the cowboy, makes
to her that she felt her face
grow warm with emotion
and wanted to cool it. She
went to the window which is
covered with frost—the action
of "Bus Stop" takes place
during a blizzard—and put
her hands on the window. The
frost was, of course, fake and
neither Miss Stanley's hands
nor her face were cooled. "But
after all, it isn't life," Miss
Stanley commented later in
her dressing room. "It is only
the stage."

Whatever the impulse that
seized her in that scene, Miss
Stanley denies that there must
be "a mystical immersion in

the soul and spirit of the character." Strasberg supports Miss Stanley's contention. "If the actor who played a drunk had to live the part literally, he would have to go out and get drunk every night before coming to the theatre," he said to his class one day. "But an actor has equivalent experiences which he can combine in many ways to fulfill the character he is playing."

During several recent classes, none of the members had scenes ready to do before the class. So Strasberg spent a good deal of time elaborating on the techniques by which actors may attain "truth" onstage.

These techniques have come to be known as The Method, and their validity and authenticity are debated in theatre circles these days with increasing heat. The Method was the brainchild of the renowned Russian director, Constantin Stanislavsky. In adapting it to the modern American theatre, Strasberg has imposed his own refinements upon it.

The Method requires that an actor, in preparing a role, delve not only into the character's life in the play but, far more important, into the character's life before the curtain rises. The things that happened to the character offstage, in years past, perhaps in his childhood, and how they affected him, must be figured out and acted out in rehearsal. For the play itself is only the climax of a character's existence. The actor must experience everything that propelled him to that climax.

"If you do this," Strasberg informed his students, sitting around him in the large, bare meeting hall of the Studio, "the action of the scene will result almost without your knowledge."

THE Method has seldom been more ardently pursued than in the current drama. "A Hatful of Rain," written by Studio member Michael V. Gazzo. In rehearsing the play, which describes a wife's fight to keep her marriage going after her husband falls prey to narcotics, Shelley Winters, Ben Gazzara, Anthony Franciosa and the cast—Studio adherents all—probed into the lives of the husband and wife before the play starts, into the incidents that lead them to their crisis in "A Hatful of Rain."

Later, when the cast had memorized all the lines, director Frank Corsaro ordered them to put the lines aside and go through every scene

completely ad lib. "Your own words may not be as good as the playwright's," says Shelley Winters, "but you find values for yourself, moods, pauses, embarrassments that are sometimes more helpful than words."

These and other tenets of The Method are designed to relax the actor, to make it easier for him to get at his emotions, to make tears, laughter, anger, joy flow. They free the actor to reveal himself onstage. "Some actors are frightened of The Method," says Kim Stanley, "because they do not want to reveal their innermost selves on a stage. It's not easy. An actor may prefer to hide onstage with 'characterization,' with gimmicks."

In his concern with the actor's deepest, most private emotions, Strasberg seems to resemble the psychoanalyst in modern medicine. The psychoanalyst helps a person to find his real inner self, to clear away his confusions and inhibitions, and to function at his best as a human being.

To get away from Stanley Kowalski and "Streetcar," Marlon Brando played Archduke Rudolf in the gay "Reunion in Vienna" at the Studio.

Similarly Strasberg helps the actor to find his talent, to clear away the confusions and inhibitions that keep his talent from free, full expression, and to make that talent function at its best.

THE psychoanalyst aids the patient to find the truth about himself through endless exploration of his past life. Strasberg wants the actor to find the truth of the character he is playing by endlessly exploring that character's past. The psychoanalyst requires the

patient to "associate freely" —that is, to speak whatever thoughts come into his mind while he is lying on the analyst's couch. Strasberg similarly believes that an actor cannot determine in advance exactly what he will do in a scene.

The ideal actor will come onstage as though completely unaware of what is to happen and how he will react to it, as though it were all taking place for the first time. He will be carried through the scene by his true, sensitive, almost subconscious, human awareness of how the character he is playing would behave.

In "A Hatful of Rain," says Shelley Winters, she and Ben Gazzara have never said the same thing the same way twice. "When you're trained this way, and you're talented, you can't plan a scene," Miss Winters once explained. "You have to trust to yourself to see where it goes. But what comes out is so much more interesting and uncliché-ish."

One exercise in The Method that strongly suggests psychoanalytic practice is the emotional memory exercise. The patient in analysis recalls an episode from his past to shed light on his present condition. The actor in the emotional memory exercise recalls an episode from his own past to be better able to achieve an emotion he needs for a particular scene. Shelley Winters used this device for a scene in

--- EXPERT OPINION ---

At one Actors' Studio class shortly after he opened in "A Streetcar Named Desire" in 1947, Marlon Brando watched two girls do a rather gloomy scene from another Tennessee Williams play. When they were done, Brando rose and complained, "I couldn't make out a word they said. They mumbled."

"A Place in the Sun" which called on her to weep.

"To weep is not easy," she said. "But you recall something from your own life, when you were unhappy and cried. You recall it through your senses, rather than through the actual words or thoughts at the time. You remember how a room felt, was it hot or cold, how it smelled, the color of your clothes, the feel of your dress. You recall that your throat was dry because you were trying not to cry. You recall all these sensory impressions and the feeling comes back

and the tears come. It works. It works for me every time. I can't tell you why it works but it works."

What moment from her own life did Miss Winters recall to summon up tears for "A Place in the Sun," she was recently asked. "If I told you, and you printed it, I would sue you," she answered.

WHILE Actors' Studio and The Method win an ever-growing body of adherents who feel "liberated" by them, they continue to have their opposition. These opponents argue that, far from freeing actors, The Method is molding them all into one cast, a naturalistic, shuffling, mumbling, itching and scratching imitation of Marlon Brando. Classical style will forever elude the Studio actor, these critics argue, since he is prepared only for the slangy, stuttering, everyday manner of the modern play.

Studio devotees say in reply that The Method will in fact help them to find a new, marvelous, American way of playing the classics, that will be right for our country and our times. And they point to the long list of distinguished Studio members to prove there are many kinds of actors in their ranks.

ONE real problem for the Studio is perhaps indicated in the present feeling of Julie Harris about it. For all her respect and gratitude toward the Studio, she has not worked in it for several years. Among the reasons is that "all this technique and study of acting is hard for me. I don't like to think too much, I like to throw myself in. I guess that's lack of discipline. I remember I did a scene with Joe Sullivan from 'The Glass Menagerie.' He was the Gentleman Caller and I was the daughter. He picks me up and we dance around. As we danced, my shoe hit some of the little glass animals and a couple of them broke. Which was all right; it was supposed to happen. He says, 'I'm sorry,' and I was supposed to say, 'Oh, that's all right.'

"But instead, I burst into tears. I lost control of myself and had hysterics. Talking to Lee afterward, I said I didn't intend to do that, but a feeling came over me. If I ever did that again, the feeling wouldn't leave me all day. I'd be sick. There's got to be some difference between the real and the imaginary. I don't have a perspective in this and I don't want to get involved. It could be the end

of me. I could picture myself some night having to die onstage—and really dying."

The Studio is sensitive to this kind of thought and keeps seeking solutions and answers. Meanwhile, there is no doubt its work is on the ascendant on Broadway. There is hardly a play on Broadway that does not have Studio members in key roles; a few have even been directed by Studio members. To develop playwrights,

the Studio has invited Robert Anderson, author of "Tea and Sympathy," to conduct a new writers' class.

ITS health increases from year to year, and so does its membership. Last year over 1,000 actors were granted auditions. Maintaining high standards, Strasberg, Kazan and Miss Crawford admitted only fifteen to membership in the Studio. And the Studio

rigidly excludes one of the most remarkable young actresses the theatre has seen in many years—Lee Strasberg's own daughter, Susan, whose performance as Anne in "The Diary of Anne Frank" has made her, at 17, a star. The Studio will not accept applicants under 18. "You can't train young people before they're 18," Strasberg insists. "What are you going to train? You've got to give them an

opportunity to develop their own personalities first."

Thus, Susan can only look forward to the day when she will be old enough to audition for the Studio. "Do you think I'll be ready to audition next year?" she recently asked her father, tremulously. "What if I audition and they turn me down?"

May 6, 1956

# Theatre: Tragic Journey

### By BROOKS ATKINSON

WITH the production of "Long Day's Journey Into Night" at the Helen Hayes last evening, the American theatre acquires size and stature.

The size does not refer to the length of Eugene O'Neill's autobiographical drama, although a play three and three-quarter hours long is worth remarking. The size refers to his conception of theatre as a form of epic literature.

"Long Day's Journey Into Night" is like a Dostoevsky novel in which Strindberg had written the dialogue. For this saga of the damned is horrifying and devastating in a classical tradition, and the performance under José Quintero's direction is inspired.

•

Twelve years before he died in 1953, O'Neill epitomized the life of his family in a drama that records the events of one day at their summer home in New London, Conn., in 1912. Factually it is a sordid story about a pathologically parsimonious father, a mother addicted to dope, a dissipated

## The Cast

LONG DAY'S JOURNEY INTO NIGHT, a drama in four acts by Eugene O'Neill. Staged by Jose Quintero; setting by David Hays; lighting by Tharon Musser; costumes by Motley; production stage manager, Elliott Martin; presented by Leigh Connell, Theodore Mann and Mr. Quintero. At the Helen Hayes Theatre.
James Tyrone............Fredric March
Mary Cavan Tyrone...Florence Eldridge
James Tyrone Jr...Jason Robards Jr.
Edmund Tyrone......Bradford Dillman
Cathleen ............Katherine Ross

brother and a younger brother (representing Eugene O'Neill) who has TB and is about to be shipped off to a sanitarium.

Roughly, those are the facts. But the author has told them on the plane of an O'Neill tragedy in which the point of view transcends the material. The characters are laid bare with pitiless candor. The scenes are big. The dialogue is blunt. Scene by scene the tragedy moves along with a remorseless beat that becomes hypnotic as though this were life lived on the brink of oblivion.

"Long Day's Journey Into Night" could be pruned of some of its excesses and repetitions and static looks back to the past. But the faults come,

not from tragic posturing, but from the abundance of a great theatre writer who had a spacious point of view. This summing-up of his emotional and artistic life ranks with "Mourning Becomes Electra" and "Desire Under the Elms," which this department regards as his masterpieces.

*

Like those dramas, it comes alive in the theatre. Although the text is interesting to read between covers, it does not begin to flame until the actors take hold of it. Mr. Quintero, who staged the memorable "The Iceman Cometh" in the Village, has directed "Long Day's Journey Into Night" with insight and skill. He has caught the sense of a stricken family in which the members are at once fascinated and repelled by one another. Always in control of the turbulence of the material, he has also picked out and set forth the meaning that underlies it.

The performance is stunning. As the aging actor who stands at the head of the family, Fredric March gives a masterly performance that will stand as a milestone in the acting of an O'Neill play. Petty, mean, bullying, impulsive and sharp-tongued, he also has magnificence — a man of

strong passions, deep loyalties and basic humility. This is a character portrait of grandeur.

Florence Eldridge analyzes the pathetic character of the mother with tenderness and compassion. As the evil brother, Jason Robards Jr., who played Hickey in "The Iceman Cometh," gives another remarkable performance that has tremendous force and truth in the last act. Bradford Dillman is excellent as the younger brother—winning, honest, and both callow and perceptive in his relationship with the family. Katherine Ross plays the part of the household maid with freshness and taste.

•

All the action takes place inside David Hays' excellent setting of a cheerless living-room with dingy furniture and hideous little touches of unimaginative décor. The shabby, shapeless costumes by Motley and the sepulchral lighting by Tharon Musser perfectly capture the lugubrious mood of the play.

"Long Day's Journey Into Night" has been worth waiting for. It restores the drama to literature and the theatre to art.

November 8, 1956

# The Theatre: Illuminations by Inge

### 'The Dark at the Top of the Stairs' Opens

### By BROOKS ATKINSON

WILLIAM INGE has written another drama that has a modest look but that is full of his particular insights and sympathies.

He calls it "The Dark at the Top of the Stairs," and it was wonderfully well acted at the Music Box last evening. The title refers to the shadowy quality of the future that seems so ominous and terrifying to growing children. But it also could be described as an uncommonly forgiving drama about the things that people do not know about each other.

For this easygoing sketch of ordinary people stops long

## The Cast

THE DARK AT THE TOP OF THE STAIRS, a play in three acts, by William Inge. Staged by Elia Kazan; produced by Saint Subber and Mr. Kazan; scenery by Ben Edwards; costumes by Lucinda Ballard; lighting by Jean Rosenthal. At the Music Box.
Rubin Flood..............Pat Hingle
Cora Flood..............Teresa Wright
Sonny Flood...........Charles Saari
Boy offstage..........Jonathan Shawn
Reenie Flood..........Judith Robinson
Flirt Conroy..............Evans Evans
Morris Lacey...........Frank Overton
Lottie Lacey...........Eileen Heckart
Sammy Goldenbaum......Timmy Everett
Punky Givens............Carl Reindel
Chauffeur................Anthony Ray

enough to make some stunning revelations about the private lives of husbands, wives, sisters and children. Not scandalous revelations: just quick and poignant glances into the privacy of hearts and souls. Under Elia Kazan's spontaneous direction, the performance is glowing and illuminating. The

cast is perfect; the acting is superb.

Imagine yourself in a small town in Oklahoma in the early Nineteen Twenties. In his setting, Ben Edwards has caught the drafty hideousness of one of those middle-class houses that are lumped as "McKinley Style" in our folkways. It is the home of a salesman who is traveling in harness wares, his wife, his adolescent daughter and his younger son. They are average people. The adults are concerned about money. The children are involved in the painful social affairs of the young.

•

Nothing of consequence happens to any of them. But Mr. Inge has written about them with so much tenderness and understanding that

his play is both amusing and touching. The amusing stuff concerns the quaint manners and the homeliness of the problems — feuds between brother and sister, the polite social insincerities of a hearty, garrulous adult relative who knows all the answers, the absurd proportions of family quarrels, the superstitions and ignorance of small-town Middle Westerners about Jews and Catholics.

But out of his memories of the time and place Mr. Inge has drawn other things that are deeply moving. The good manners and bright spirit of a lonely Jewish boy who finds himself among friendly people; the anguished reception of the news of his suicide after he has been publicly humiliated at a dance; the horror with which one married sister confesses that her marriage is a failure and the shocked silence with which the other sister listens; the husband's shamefaced confes-

sion of the fears with which he views his economic future.

Mr. Inge writes these scenes in a colloquial style. But they carry weight. They reveal the lonely agony of people who live together without really knowing one another, suffering in silence, communicating only when the situations are desperate.

A believer in the realities, Mr. Kazan has directed a beautiful, carefully detailed performance that looks simple but expresses at times

some complex, shattering emotions.

In the three chief parts, Teresa Wright as the wife, Pat Hingle as the husband and Eileen Heckart as his sister-in-law are superb. Miss Wright gentle, soft and wondering; Mr. Hingle boisterous with a whining note of worry in his voice; Miss Heckart raucous, overeager and panicky inside — they preserve the homespun quality of the play and also disclose the darkness at the top of the stairs of their lives.

But this is a performance in which the young actors are especially important. Fortunately, they are all gifted actors. Judith Robinson as the oversensitive daughter who is terrified of the social crises of parties; Evans Evans as an exuberant adolescent girl who is bursting with the joy of life; Charles Saari as the poker-faced boy with a devastating knack of being silent when his elders are hoping for a kind word; Timmy Everett as the young Jewish boy whose humble manners reveal

the barren correctness of the years he has spent in military academies—they are all winning, perceptive young actors who recognize the shy, rueful truths of the drama.

Call "The Dark at the Top of the Stairs" Mr. Inge's finest play. Although the style is unassuming, as usual, the sympathies are wider, the compassion deeper and the knowledge of adults and children more profound.

December 6, 1957

# Theatre: Archibald MacLeish's New Play, 'J. B.'

## Poet's Epic of Mankind Staged at Yale

### By BROOKS ATKINSON
Special to The New York Times.

NEW HAVEN, April 23— Being in an expansive mood, Archibald MacLeish has written an epic of mankind. He calls it "J. B." It was acted for the first time at the Yale University Theatre last evening.

Since Mr. MacLeish is a poet very much committed to the life of our times, he is entitled to choose a big theme because he can develop and sustain it. As poetry that illuminates and comments on recent human experience, "J. B." is a notable piece of work. Like Thornton Wilder's "The Skin of Our Teeth," which is in a lighter vein, "J. B." will have a long life in the theatre since it speaks to the common experience.

It has been sensitively staged by F. Curtis Canfield and beautifully set by Donald Oenslager. Within the limited resources of a university theatre, it is acted intelligently. But the two chief parts call for acting on a heroic scale. The full glory of "J. B." will not appear until it is gloriously acted.

The J. B. of the title is the modern counterpart of Job. Mr. MacLeish is studying the condition of a modern Job on whom God and Satan visit the calamities of our century. In the design of the play he has managed to bring a religious theme into a worldly environment equivalent to the earthiness of the Book of Job. For "J. B." is set in a circus tent. On a platform attached to the central pole of the tent, two circus venders play God and Satan in masks. The scenes of Job's tribulations are acted in a circus ring.

In the first scene J. B. is a happy and prosperous family man sitting down to a bountiful Thanksgiving dinner with his wife and children. Without being pious about it, he believes himself to be close to God. To test J. B.'s fidelity, God has horrors in store for him—the death of a son in a senseless accident overseas after the Armistice, violent

### The Cast

J. B., a drama in verse by Archibald MacLeish. Staged by F. Curtis Canfield; scenery by Donald Oenslager; costumes and masks by Richard Casler; lighting by Joan Larkey; incidental music by Samuel Pottle; production manager, Erwin Steward; stage manager, William Francisco Jr. At the Yale School of Drama, New Haven.

| | |
|---|---|
| Mr. Zuss | Ray Sader |
| Mr. Nickles | Bernerd Engel |
| Distant Voice | Russ Moro |
| Sarah | Margaret Andrews |
| J. B. | James Shepherd |
| Rebecca | Ann Satterthwait |
| Ruth | Suzanne Hull |
| Mary | Janie Herndon |
| David | James Inman |
| Jonathan | Brandon Stoddard |
| First Maid | Judith Williams |
| Second Maid | Linda Robinson |
| First Messenger | Ian Cadenhead |
| Second Messenger | William O'Brien |
| Girl | Edith Lebok |
| Bildad | Richard Forsyth |
| Zophar | Joseph Hardy |
| Eliphaz | Fletcher Coleman |
| Mrs. Adams | Bette Engel |
| Jolly Adams | Janie Herndon |
| Mrs. Lesure | Judith Williams |
| Mrs. Murphy | Edith Lebok |
| Mrs. Botticelli | Linda Robinson |

deaths for his other children, the destruction of his factory by a bomb, the loss of his wealth and comforts, the desertion of his wife, the scourge of boils, the collapse for no apparent reason of everything he has loved and enjoyed.

•

J. B. is staggered by this awful parade of catastrophes that seem to have no relevance to his personal life. Satan is certain that sooner or later he will curse God. Although J. B. listens to the professional cant of politicians, preachers and medicinemen, who have glib answers, he is not impressed. He grieves and rails. But he reiterates that the Lord giveth and the Lord taketh away, and in the end he adds that magnificent phrase of mortal submission: "Blessed be the name of the Lord."

"J. B." is written in sharply-phrased verse that vividly conveys the facts of the story and the spiritual torment of the characters. Since Mr. MacLeish is not a solemn poet, much of his writing is pungent, particularly in the characters of the men who play God and Satan. They are earthy men when they are not wearing their masks. Some of the verse is too compact to be immediately intelligible in the theatre, where time is always in a hurry; and Mr. MacLeish has a tendency to begin some of his scenes in the middle.

**Bernerd Engel as Satan and Ray Sader as God in "J. B."**

When a majestic Distant Voice quotes lines directly from the Book of Job through an amplifier, the dignity, gravity, simplicity and music of the King James Version set a literary standard that any modern poet has difficulty in meeting. But "J. B." is a stirring work. In its acceptance of the horrors of our century, in compassion for the characters, in its valiant affirmation at the end, it is impressive and moving. In essence it is highly personal; everyone can see in it his own experience.

•

Mr. Canfield's production takes "J. B." on a high artistic level. As stage designer, Mr. Oenslager has made a contribution that is practical, symbolic and beautiful. His set consists of a vast, airy circus tent, a chaste playing ring with modest circus decorations and a railed-in platform on a post that is tilted off center and gives an impression of spontaneity. Mr. Oenslager has modernized an old fable without losing its wonder.

In the parts of God and Satan Ray Sader and Bernerd

Engel give admirable performances that have flow and resonance, humor and awe. They also make the crucial transitions from human beings to symbols with an ease that does not tax a theatregoer's belief. As J. B. and J. B.'s wife, James Shepherd and Margaret Andrews give balanced performances that express the spiritual relationships of the characters and convey the sense of Mr. MacLeish's fable. But these are the parts that need to be played heroically, with great passion, great suffering, great fortitude. Only experienced actors of considerable force can exhaust the vitality that these characters contain.

Some day "J. B." will be played magnificently by a professional company. In the meantime, we have the Yale School of Drama to thank for a loving and perceptive first performance that discloses the spiritual values of a tumultuous epic. Mr. MacLeish has written a play worthy of his time. Looking on our century with a welkin eye, he has imposed his own sense of order on the chaos of the world.

April 24, 1958

## Even a Stable or a Silo Is Home For Off-Broadway's Theatres

When the curtain rises for the first time next month at the Players Theatre on Macdougal Street in Greenwich Village, the number of legitimate theatres off Broadway will be about the same as the number on Broadway.

The thirty legitimate houses in and around Times Square today represent a steady decline from the seventy-five that flourished in the area a quarter of a century ago. The number of off-Broadway theatres has risen steadily, particularly during the last decade, and the count now is about thirty.

None of the off-Broadway theatres is housed in a new structure. Rather, these playhouses have emerged as testimony to the ingenuity of architects and interior designers. An example of this trend is the conversion of the building recently acquired by Donald Goldman, a producer and founder of the Players Theatre. The name has been adopted for the group's new home at 115 Macdougal Street. The three-story structure, built before the turn of the century, was originally a stable for the equestrian squad of the Police Department. Later, it was changed to a garage.

The conversion problems that beset Giorgio Cavaglieri, the architect, began with the removal of an old elevator on which horses were carried to and from the upper floors. The pillars and walls that supported the elevator and its shaft had to be replaced with walls and stairs.

After that carpenters leveled the floor on the street level. It was originally built at an angle sloping to the center of the floor, a design that facilitated the work of the blacksmith and the men who cared for the horses.

After the floor was leveled, 200 seats were installed, the stage was constructed and dressing rooms were put in behind it. In addition, a restaurant and bar were put in on the street level. The second and third floors, formerly used for horse stalls and later for parking space were redesigned to accommodate a theatrical school, an art gallery or general offices, depending on the requirements of future tenants.

Elsewhere in Greenwich Village, where the majority of the off-Broadway houses have cropped up in recent years, some of the most unlikely structures have been made into theatres.

### Cherry Lane Was Silo

The Cherry Lane, at 38 Commerce Street, occupies a building that originally was a silo. Later in the nineteenth century, the structure was converted to a tobacco warehouse, then into a box factory. It became a theatre in 1924 coincidental with a trend that gave a large section of Greenwich Village its bohemian atmosphere. It was an era of literary renaissance in which such names as Floyd Dell, F. Scott Fitzgerald and Edna St. Vincent Millay spread far beyond the Village bistros made famous by them.

Before the Nineteen Twenties, the predecessor of the Circle in the Square, at 5 Sheridan Square, was a restaurant on the street floor. The apartments above were frequently occupied by Theodore Dreiser, Sinclair Lewis and other literary personalities during World War I. Later, it became the Greenwich Village Inn, where night club entertainers such as Pearl Bailey and Cab Calloway held forth.

In 1950, the structure was taken over by a theatrical group that converted it to the Circle in the Square. Despite the extensive alterations that resulted in a theatre-in-the-round, several structural columns rise out of the center of the floor as reminders that the building was not constructed with an eye to the requirements of the theatre.

Despite their odd domiciles, the off-Broadway theatres flourish. The Sullivan Street Playhouse, at 181 Sullivan Street, formerly was Cafe Society Downtown, and the Renata Theatre, at 144 Bleecker Street, was once a private club. On Second Avenue and Tenth Street, east of Greenwich Village, a former church building was transformed into the Gate Theatre.

Uptown there are other examples of extensive alterations of buildings into theatres. The Davenport Theatre, at 138 East Twenty-seventh Street, opened forty-three years ago, was originally the home of a family whose name it bears and who still owns it. It also was a church and later a meeting hall.

Here, too, the building was virtually rebuilt before its conversion into a theatre was completed in 1915. The ceiling was raised for a balcony, which was decorated with gold leaf in emulation of the Royal Theatre in Vienna.

The Seven Arts Center, at 120 Madison Avenue, is another example of a structure that was completely revamped. Originally, in 1906, it was the Colony Club.

### Had Squash Courts

Its facilities included two squash courts, a running track, a swimming pool and sleeping quarters for members. Years later, when the Colony Club moved to Park Avenue and Sixty-second Street, the Seven Arts Center took over the building.

The track is now a playgoers' gallery overlooking the theatre-in-the-round. The downstairs reception parlor was made into an art gallery and the spacious bedrooms were converted to classrooms. The ballroom is a theatre used for film showings. and the second floor is a larger theatre. The dining rooms have been maintained for theatregoers, and the swimming pool is reserved for the use of members of the Seven Arts Center.

Other uptown, off-Broadway theatres include the Theatre Marquee-Rue, Fifty-nine at 110 East Fifty-ninth Street, a former dance studio. The building that houses the Winter Garden, at 1634 Broadway, was known originally as the American Horse Exchange.

Giving impetus to such conversions, the city eased its building codes in 1953 by allowing construction of theatres in the basements and lofts of office buildings.

November 9, 1958

## Tenacious Producer

### Joseph Papp

JOSEPH PAPP, whose running battle with Park Commissioner Robert Moses over free Shakespearean performances in Central Park has had political repercussions, is a young entrepreneur of awesome energy. His refusal to accede to Mr. Moses' order to charge admission to the park showings or abandon them recently led the Commissioner to characterize him as "an enthusiastic, I might almost say fanatic, very temperamental Shakespeare producer."

Man in the News

But, as a supporter of Mr. Papp noted, "these are terms of respect" in the theatre.

Behind Mr. Papp's tenacity in the present dispute is the story of his dream to create a free Shakespeare theatre for the people of New York. He himself is a New Yorker, born in the slums of Williamsburg, Brooklyn, in 1921. He started his Shakespearean movement in a church basement in the Lower East Side in 1954.

He was convinced that the theatre as it stood was too formal and beyond the means of New York. So, he began the Shakespeare Workshop, which accepted contributions only.

### Actors Worked Free

With actors willing to work for nothing, with $200 and lighting equipment dug out of an old Bronx movie house, the Shakespeare Festival was born. Mr. Papp then, as now, supported himself as a stage manager for the Columbia Broadcasting System.

"After watching those audiences," he said of the basement venture, "I felt I could never give up."

He says he learned then that there is a tremendous audience for live theatre and Shakespeare anywhere.

In the summer of 1956, the City of New York made the East River Amphitheatre available to the workshop. The season proved "a smash."

Ironically enough, Commissioner Moses, impressed by the response, opened the way for Mr. Papp to work in other parks the following season.

With the help of private contributions and grants from foundations and funds, the troupe opened the summer of 1957 in Central Park. Using a stage mounted on a truck, Mr. Papp then took his productions to other boroughs.

Each season poses a financial problem. Undaunted, Mr. Papp generally badgers anyone who will not move fast with the money.

But, according to an associate, one of his favorite comments is, "Don't tell me anything is impossible. Let's try it first."

Five feet, nine and a half inches tall, with dark brown hair and a John Barrymore profile, Mr. Papp could easily act in his troupe. He has toured with "Death of a Salesman" and under the G. I. Bill of Rights, he once studied acting and directing in Los Angeles.

However, he leaves the acting in the family to his wife, Peggy Bennion.

Early this week, Mr. Moses circulated an unsigned letter that referred to Mr. Papp's "socialist background." The reference was probably to Mr. Papp's appearance before the House Committee on Un-American Activities on June 19, 1958, when he invoked the Fifth Amendment on whether he had been a member of the Communist party.

Mr. Papp temporarily lost his job at C. B. S. because of his stand, but was reinstated after an arbitration ruling.

As for his quarrel with Mr. Moses, Mr. Papp said yesterday:

"I have a feeling that Shakespeare will be presented in Central Park this summer in spite of the enormous power of the Commissioner of Parks."

May 2, 1959

# Theatre: 'Rhinoceros'

Zero Mostel, left, Anne Jackson and Eli Wallach in a scene from Ionesco's "Rhinoceros" at Longacre Theatre.

## Ionesco Comedy Stars Wallach and Mostel

### By HOWARD TAUBMAN

DON'T look now, but those creatures throwing up dust and trumpeting primitively may be rhinoceroses debouching from the Longacre Theatre. Or better still, look and listen, for they are comic and they are serious, too.

They come from the vivid imagination of Eugene Ionesco and they inhabit his play, "Rhinoceros," which opened here last night. It is an antic piece with overtones of gravity. And it has been staged and performed with a mad, inventive gusto that never loses sight of the important things behind the parody,

### The Cast

RHINOCEROS, a play by Eugene Ionesco, translated by Derek Prouse. Staged by Joseph Anthony; presented by Leo Kerz, in association with Seven Arts Associates Corporation; costumes by Michael Travis; scenery and lighting by Mr. Kerz; production stage manager, Bill Ross; sound engineered by Saki Oura. At the Longacre Theatre, 220 West Forty-eighth Street.

Waitress ..............Flora Elkins
Logician ............Morris Carnovsky
Grocer ..............Dolph Sweet
Grocer's Wife .........Lucille Patton
Housewife .............Jane Hoffman
Berrenger ............Eli Wallach
John ..................Zero Mostel
Old Gentleman ........Leslie Barrett
Cafe Proprietor .....Joseph Bernard
Daisy ................Anne Jackson
Mr. Nicklebush ......Philip Coolidge
Dribble ..............Mike Kellin
Shiftor ..............Michael Strong
Mrs. Ochs ............Jean Stapleton
Fireman ..............Dolph Sweet

horseplay and calculated illogicality.

In "Rhinoceros," Mr. Ionesco is telling an allegory for our time, which has been beset by various, blighting uniformities. But he is not preaching. Nor is he concerned with the conventions

of routine dramatic construction. He pokes fun unremittingly at conventional ideas, established institutions and all sorts of people, including himself. He cavorts and capers. He exaggerates wildly, and lets some of his actions run on too long. But just when he seems to be losing his touch, he discovers a new vein of fun.

Thanks to the play's success in a number of cities abroad, its subject may be familiar. If you have not heard on its contents, they may be summed up quickly. Mr. Ionesco imagines a city in which first one person, then a few, then all but a feckless clerk turn into rhinoceroses. His theme is a single motive, but he is fertile with delightful variations.

In working out his variations, Mr. Ionesco manages to say a good deal about the inconsistencies and irrationalities of human behavior. He ticks off the logician, the unionist, the straw boss, the ordinary run of men and women. He makes mincemeat of intellectual pretensions and then, of course, laughs at pompous simpletons.

Mr. Ionesco's mind is playful, full of quips and wanton wiles. Some of his jokes are obvious, no doubt deliberately. Others stem from a fresh view of the world. Mr. Ionesco has a fondness for the counterpoint of talk. In the first act he builds a pair of overlapping dialogues with a clever orchestrator's ingenuity. Then he follows with a discourse by the logician that is both humorous and satirical.

He is not above exchanges that are like Pat-and-Mike bits. Says one character of the office chief: "He turned into a rhinoceros." And the other responds: "He had such a good chance to become a vice president."

Is it Mr. Ionesco's final joke that his last man in a world of rhinoceroses is the weak, ineffectual clerk, Berrenger? If this is the play-

wright's intention, one cannot cavil. But if his moral is that the meek shall have to redeem the earth from its totalitarian follies, one would disagree violently. It requires courage, will and knowledge to hold fast to individuality—and to fight against mob psychology.

Joseph Anthony has caught Mr. Ionesco's wild, irreverent mood. To one who saw a rather stuffy, subdued version of "Rhinoceros" in London last June, this production was a joyous revelation. The staging here has the knockabout high spirits of Mack Sennett comedy. Indeed, it carries this mood too far at times, settling for noise when ideas run thin. But like Mr. Ionesco's fancy, the staging repeatedly renews itself with fresh inventions.

As Berrenger, Eli Wallach gives a sustained, varied performance that remains in a low key. As his irascible, self-righteous friend John, Zero Mostel is a superb comedian, full of bouncing movement and roaring, cooing inflections. Anne Jackson turns Daisy, the girl Berrenger admires in his modest way, into a broadly stylized ingenue; her comic signature is the familiar gesture of a leg lifted backward archly. Morris Carnovsky, Mike Kellin and Michael Strong contribute soberly droll impersonations.

There are diverting, rowdy bits by Philip Coolidge, Jean Stapleton, Leslie Barrett, Jane Hoffman, Flora Elkins, Lucille Patton, Dolph Sweet and Joseph Bernard. They help to fill Leo Kerz' oddly rakish sets with motion and turmoil.

Mr. Ionesco may be an avant-gardist, but there is nothing recherché or difficult about "Rhinoceros." Here he uses lighthearted means to remind human beings how easily they can turn beastly.

January 10, 1961

# Theatre: 'The Blacks' by Jean Genet

## The Cast

THE BLACKS, a play by Jean Genet, translated by Bernard Frechtman. Staged by Gene Frankel; presented by Sidney Bernstein, George Edgar and Andre Gregory, by arrangement with Geraldine Lust; scenery by Kim E. Swados; lighting by Lee Watson; costumes and masks by Patricia Zipprodt; movement by Talley Beatty; music supervised by Charles Gross; production associate, Alfred Manacher; production stage manager, Maxwell Glanville. At the St. Marks Playhouse, Second Avenue and Eighth Street.

Archibald Wellington .Roscoe Lee Browne
Deodatus Village.......James Earl Jones
Adelaide Bobo..........Cynthia Belgrave
Edgar Alas Newport News.Louis Gossett
Augustus Snow............Ethel Ayler
Felicity Trollop Pardon..Helen Martin
Stephanie Virtue Diop.....Cicely Tyson

Diouf............Godfrey M. Cambridge
Missionary................Lex Monson
Judge............Raymond St. Jacques
Governor.................Jay J. Riley
Queen...........Maya Angelou Make
Valet..............Charles Gordone
Drummer...........Charles Campbell

### By HOWARD TAUBMAN

IN writing and performance, Jean Genet's "The Blacks" at the St. Marks Playhouse is a brilliantly sardonic and lyrical tone poem for the theatre.

In form, it flows as freely as an improvisation, with

fantasy, allegory and intimations of reality mingled into a weird, stirring unity. If you like your drama plain and naturalistic, "The Blacks" will leave you unsettled and disoriented. But if you are willing to venture into the diabolical chambers in which the French playwright conjures up his demons of the imagination, you will encounter one of the most original and stimulating evenings Broadway or Off Broadway has to offer.

If you wish an inkling of what M. Genet is up to, you must know the three sentences with which he prefaces his script. In the English of Bernard Frechtman, who has made the excellent translation of "The Blacks," these sentences are:

"One evening an actor asked me to write a play for an all-black cast. But what exactly is a black? First of all, what's his color?"

M. Genet's investigation of the color of black begins where most plays on this burning theme of our time leave off. Using the device of performances within a per-

formance, he evokes a group of players involved in a ceremony. On an upper level of the stage there is a court composed of a queen, valet, missionary, judge and governor. Below them is a group of ordinary mortals who weave in and out of a variety of impersonations that shift subtly and often abruptly.

All the players are dark-skinned. Those of the court wear white masks and for the greater part of the evening they represent the whites, the colonial masters, the dominant, superior race. While they roar, preen themselves and ultimately cringe, the illusion of their whiteness is meant to be transparent. By using Negro players in these roles M. Genet adds another level of bitter comment.

The ceremony is a trial for a murder that you eventually discover has not taken place. It occurs before a catafalque that turns out in the end to be merely a white sheet over a pair of chairs that the valet and missionary had complained about missing. But there is no mistaking the fierce motif that courses through M. Genet's furious flights of language encompassing obscenity and purity, violence and tenderness, hatred and love.

That motif is the meaning, in all its burden of the past and in the determination that shapes the future, of being a color that happens to be black. "Invent hatred," cries a character early in the drama. A little later comes an invocation to Africa and darkness and the hatred they have engendered. There is a ferociously satirical scene in which the Negroes below recite a "litany of the livid" as the devout in a church might intone the litanies of the Blessed Virgin.

In its conception "The Blacks" calls for an interpretation that summons most of the magic of the theatre but abjures its literalisms. Music including the minuet from "Don Giovanni" and the Dies Irae, the dance from the tribal movements of Africa to the sinuosities the Western world has grafted on it, architectural forms like platforms and curving ramps, acting and speaking that are formal and rhapsodic by turns—all these elements are required by M. Genet.

Gene Frankel has staged a performance that paces M. Genet's theatrical tone poem with humor and passion. The craftsmen and artists who have contributed to this interpretation deserve their meed of credit. So do the actors, who bring vibrancy and intensity to their performances. Read the names of all in the cast with respect, and remember with special warmth Roscoe Lee Browne, James Earl Jones, Cynthia Belgrave, Ethel Ayler, Helen Martin, Cicely Tyson and Godfrey M. Cambridge.

●

Theatregoers acquainted with M. Genet's "The Balcony" know that this vastly gifted Frenchman uses shocking words and images to cry out at the pretensions and injustices of our world. In "The Blacks" he is not only a moralist of high indignation but also a prophet of rage and compassion.

"Everything is changing," says Felicity, who speaks often like a high priestess. "Whatever is gentle and kind and good and tender will be black." So M. Genet has a Negro declare as if in a vision, but surely he looks for the day when these things will be all colors and no color.

May 5, 1961

---

# Repertory in San Francisco

## Actor's Workshop in 3 Disparate Plays

### By HOWARD TAUBMAN
Special to The New York Times.

SAN FRANCISCO, May 14 —The measure of the Actor's Workshop as a repertory company is the skill with which it has presented such disparate and difficult pieces as "King Lear," "A Touch of the Poet" and "The Birthday Party" on successive evenings.

Shakespeare, O'Neill and Harold Pinter pose markedly different problems in movement, pacing and diction. Their styles are worlds apart. Nevertheless, the Actor's Workshop with its company of young as well as seasoned professionals has communicated the essential spirit of all three.

"The Birthday Party" by the talented British playwright, which was performed last night in the Encore Theatre, the smaller of the two houses used by the workshop, has been one of the company's hits. One can see why. As a play it is provocative, and as a performance it

### The Cast

THE BIRTHDAY PARTY, a play by Harold Pinter. Staged by Glynne Wickham; presented by the Actor's Workshop; scenery by Alan Kimmel; costumes by Rivka Berg; lighting by James MacMillan. At the Encore Theatre, San Francisco.

| | |
|---|---|
| Petey | Willis Stever |
| Meg | Winifred Mann |
| Stanley | Robert Phalen |
| Lulu | Susan Darby |
| McCann | Edward O'Brien |
| Goldberg | Robert Symonds |

captures the elusive quality of Pinter's writing.

The play, first presented in London in 1958, preceded "The Caretaker," now running there and due in New York in October. In the earlier play Mr. Pinter writes with an allusiveness that is striking in its originality. He is an actor's playwright in that his laconic dialogue requires the performer to do a great deal to fill in the spaces between the lines. His characters are odd—comic, pathetic and troubled by undefined conflicts.

You take away from "The Birthday Party" as much or as little as you can find in it. Its theme, never specifically articulated, seems to be the malaise of contemporary society. But the play can be regarded as a comedy with grisly overtones or a bitter invention with comic ornaments. In any event, it is fresh in conception and imaginative in development.

The workshop production has been directed perceptively by Glynne Wickham. Robert Symonds, one of the most gifted actors in the company, who was a moving Gloucester in "Lear," does a brilliant job with the role of the enigmatic, vengeful Goldberg. Edward O'Brien as a smiling dimwitted thug, Winifred Mann as a slattern, Willis Stever as a frantic, hunted man and Susan Darby as a bewildered young slut contribute to a fine performance.

"Lear" and "A Touch of the Poet" have been staged comprehendingly by Herbert Blau, co-director of the workshop. Mr. Blau's approach to Shakespeare has the literate man's penetration and the theatre man's flair for the stage. His approach is to evoke the feeling of prehistoric Britain with its crude violence and surging passions.

Michael O'Sullivan plays Lear with a brittle impatience that begins by reflecting the king's four-score years and his imperious rashness. The performance builds in power and tragic size. At times it is a shade hysterical. All in all, it is a brave effort by a young actor at one of the most challenging of Shakespeare's heroic figures.

Laurence Hugo is a fierce, compassionate Kent. William Major is proud and malevolent as Edmund. Tom Rosqui, another of the workshop's versatile players, is affecting as Edgar. Robert Doyle is touching in appearance and movement as the Fool, but he must learn to speak more effectively if he is to realize his potential. Shirley Jac Wagner, Beatrice Manley and Elisabeth Keller are acceptable as the daughters.

In "A Touch of the Poet," Philip Bourneuf gives a rousing performance as Cornelius Melody. Miss Keller as the rebellious Sara and Frances Reid as the submissive devoted Nora play sympathetically. Mr. Hugo's Jamie Cregan has vitality, and Erica Speyer brings elegance to Deborah Harford. Mr. Blau's staging has the uncompromising force that this play, not quite fully realized O'Neill, needs to make its impact.

San Francisco is fortunate to have a company with a taste for so many varieties of theatrical expression and with the capacity to give them conviction on the stage.

May 15, 1961

---

# The Theater: Albee's 'Who's Afraid'

## The Cast

WHO'S AFRAID OF VIRGINIA WOOLF?, a play by Edward Albee. Staged by Alan Schneider; presented by Richard Barr and Clinton Wilder; production designed by William Ritman; stage manager, Mark Wright. At the Billy Rose Theater, 208 West 41st Street.

| | |
|---|---|
| Martha | Uta Hagen |
| George | Arthur Hill |
| Honey | Melinda Dillon |
| Nick | George Grizzard |

### By HOWARD TAUBMAN

THANKS to Edward Albee's furious skill as a writer, Alan Schneider's charged staging and a brilliant performance by a cast of four, "Who's Afraid of Virginia Woolf?" is a wry and electric evening in the theater.

You may not be able to swallow Mr. Albee's characters whole, as I cannot. You may feel, as I do, that a pillar of the plot is too flimsy to support the climax. Nevertheless, you are urged to hasten to the Billy Rose Theater, where Mr. Albee's first full-length play opened Saturday night.

For "Who's Afraid of Virginia Woolf?" is possessed by raging demons. It is punctuated by comedy, and its laughter is shot through with savage irony. At its core is a bitter, keening lament over man's incapacity to arrange his environment or private life so as to inhibit his self-destructive compulsions.

Moving onto from off Broadway, Mr. Albee carries along the burning intensity and icy wrath that informed "The Zoo Story" and "The American Dream." He has written a full-length play that runs almost three and a half hours and that brims over with howling furies that do not drown out a fierce compassion. After the fumes stirred by his witches' caldron are spent, he lets in some sunlight and fresh air, but only an agonized prayer.

Although Mr. Albee's vision is grim and sardonic, he is never solemn. With the instincts of a born dramatist and the shrewdness of one whose gifts have been tempered in the theater, he knows how to fill the stage with vitality and excitement.

Sympathize with them or not, you will find the characters in this new play vibrant with dramatic urgency. In their anger and terror they are pitiful as well as corrosive, but they are also wildly and humanly hilarious. Mr. Albee's dialogue is dipped in acid, yet ripples with a relish of the ludicrous. His controlled, allusive style grows in mastery.

In "Who's Afraid of Virginia Woolf?" he is concerned with Martha and George, a couple living in mordant, uproarious antagonism. The daughter of the president of the college where he teaches, she cannot forgive his failure to be a success like her father. He cannot abide her brutal bluntness and drive. Married for more than 20 years, they claw each other like jungle beasts.

Uta Hagen and George Grizzard, standing, and Melinda Dillon and Arthur Hill make up the cast of the new play.

In the dark hours after a Saturday midnight they entertain a young married pair new to the campus, introducing them to a funny and cruel brand of fun and games. Before the liquor-sodden night is over, there are lacerating self-revelations for all.

On the surface the action seems to be mostly biting talk. Underneath is a witches' revel, and Mr. Albee is justified in calling his second act "Walpurgisnacht." But the means employed to lead to the denouement of the third act, called "The Exorcism," seem spurious.

Mr. Albee would have us believe that for 21 years his older couple have nurtured a fiction that they have a son, that his imaginary existence is a secret that violently binds and sunders them and that George's pronouncing him dead may be a turning point. This part of the story does not ring true, and its falsity impairs the credibility of his central characters.

●

If the drama falters, the acting of Uta Hagen and Arthur Hill does not. As the vulgar, scornful, desperate Martha, Miss Hagen makes a tormented harridan horrifyingly believable. As the quieter, tortured and diabolical George, Mr. Hill gives a superbly modulated performance built on restraint as a foil to Miss Hagen's explosiveness.

George Grizzard as a young biologist on the make shades from geniality to intensity with shattering rightness. And Melinda Dillon as his mousy, troubled bride is amusing and touching in her vulnerable wistfulness.

Directing like a man accustomed to fusing sardonic humor and seething tension, Mr. Schneider has found a meaningful pace for long—some too long—passages of seemingly idle talk, and has staged vividly the crises of action.

●

"Who's Afraid of Virginia Woolf?" (the phrase is sung at odd moments as a bitter joke to the tune of the children's play song, "Mulberry Bush") is a modern variant on the theme of the war between the sexes. Like Strindberg, Mr. Albee treats his women remorselessly, but he is not much gentler with his men. If he grieves for the human predicament, he does not spare those lost in its psychological and emotional mazes.

His new work, flawed though it is, towers over the common run of contemporary plays. It marks a further gain for a young writer becoming a major figure of our stage.

October 15, 1962

---

# Marines in Jail

## 'The Brig,' Play About Punishment, Opens

### By HOWARD TAUBMAN

IF "The Brig" bears any resemblance to the truth, it must be hell to serve a sentence for wrongdoing in the Marine Corps. What's more, it's almost as gruesome to sit through Kenneth H. Brown's play, which was unleashed last night at the Living Theater.

One calls "The Brig" a play only by loose definition of the word. If it's anything, Mr. Brown's work is an attempt at reporting in the muckraking tradition. Men who have spent time in a Marine brig and their jailers could confirm or deny the accuracy of the report. And if what happens on the stage of the Living Theater is a true representation of conditions in the brig, the President or his Secretary of Defense ought to

## The Cast

THE BRIG, a play by Kenneth H. Brown. Staged by Judith Malina; presented by The Living Theater; production designed by Julian Beck; lighting by Nikola Cernovich; assistant director, Saul Gottlieb; stage manager, Dale Whitney. At the living Theater, 530 Avenue of the Americas.

| | |
|---|---|
| Tepperman | Jim Anderson |
| Grace | Henry Howard |
| Warden | Chic Ciccarelli |
| Lintz | Warren Finnerty |
| No. 1 | James Tiroff |
| No. 2 | Tom Lillard |
| No. 3 | Rufus Collins |
| No. 4 | Steve Thompson |
| No. 5 | Michael Elias |
| No. 6 | William Sharf |
| No. 7 | Jim Gates |
| No. 8 | George Bartenieff |
| No. 9 | Steven Ben Israel |
| No. 10 | Leonard Kuras |
| New Prisoner | Henry Proach |

order an investigation forthwith.

●

The prisoners in the cage, which Julian Beck has designed with so much realism that one hesitates to go near the barbed wire that sets off the prison compound from the audience, are in for undisclosed offenses. Unless they are guilty of murder or treason, their punishment is in outrageous excess of the crime.

"The Brig" is not concerned with the crime, large or small. It is intent on demonstrating the full, inhuman brutality of the punishment. Under Judith Malina's taut direction, the performance of Mr. Brown's obsessive script does not spare a detail of the devastating indictment.

As one watches the harrowing cruelty of guards to prisoners and listens to the incessant roaring demanded of the condemned men, one marvels that flesh and blood can endure such bestial treatment. Then one begins to wonder how long the players can keep up the unending staccato movements and raucous bellows. And finally, as one's own ears ache and one's larynx feels sympathetic lacerations, one can become as stir crazy as the poor devils in the brig.

●

With a kind of compulsive concentration, "The Brig" makes a feverish fetish of realism. It purports to describe a day in a brig as if the stage had been turned into a Marine prison. The

Jim Anderson

program carries a page setting forth brig regulations, and the production is calculated to prove the sinister impact of those rules.

301

If you expose yourself to "The Brig," you will have nightmares over its white lines. At the entrance to the cage in which there are bunks for 10 inmates, there are white lines, and in other places in the compound other white lines have been painted. Before a prisoner can step over one of these lines, he must shout, "Sir, Prisoner Number . . . requests permission to cross the white line, sir." After 10 minutes of "The Brig" that phrase has become unendurable; by evening's end you are quivering for relief as if you, too, have been

in durance vile.

If that phrase doesn't upset you, other things will. The guards constantly punch prisoners in the solar plexus. Prisoners repeatedly dress and undress as their tormentors search them. Prisoner No. 2 is ordered to do push-ups, and for failing to execute the required 25, he is forced to jog until he can hardly breathe. Never mind how monstrous the punishment for a prisoner; think how tough a way this is for an actor to earn a living.

There is no surcease for the performers—prisoners or

guards. When the prisoners clean their quarters, the fidelity to reality is paralyzing. Water is sloshed on the floor of the stage. Men get on their knees and scrub. The roared orders and bellowed requests to cross those eternal white lines build to a shattering tumult. Judith Malina, the director, has drilled her cast of male performers—every one listed in the cast above deserves credit—to sound and move like creatures possessed.

Hardly anything happens except the bestial rituals of confinement. In the scene be-

fore the last a prisoner cracks up, rebels and is carried out in a straitjacket on a stretcher. In the final scene a new prisoner arrives and receives his horrifying baptism of incarceration.

If its facts are straight, "The Brig" is a vividly documented "J'accuse." But despite its turbulence and violence, it is a far cry from drama, and it makes a painful evening in the theater.

May 16, 1963

# A New and Hopeful Role for Repertory

## A director welcomes the return of the 'rep idea' to New York at Lincoln Center.

### By TYRONE GUTHRIE

SHORTLY after the New Year, the Lincoln Center Repertory Theater will open for business. With an initial program of three plays, including Arthur Miller's first in nearly a decade, "After the Fall," Eugene O'Neill's "Marco's Millions," and a new comedy by S. N. Behrman, "But for Whom Charlie," it hopes to woo playgoers to its temporary quarters in Washington Square until its permanent Lincoln Center home, the Vivian Beaumont Theater, is ready in 1965. The job of the group is an ambitious one. Save for Eva Le Gallienne's Civic Repertory company in the nineteen-twenties, attempts at repertory have been disastrous in New York. In fact, while repertory theater has long been a familiar concept to European audiences, it is virtually unknown to modern American ones.

Therefore, it may be useful to consider what a repertory company is, and what, if any, are its advantages over the usual system in New York. Customarily, a company is assembled to produce a single play. This runs for as many successive performances as possible, and is only withdrawn when it is no longer profitable.

A repertory company, on the other hand, produces a number of plays. While most national companies in other countries are repertories with programs based on their national classics, they frequently produce translations from other languages or new plays. If these are good enough or

successful enough they are absorbed into the repertory and are periodically revived.

IN their repertories, some of the great and old-established companies have 50 or more plays that can be quickly revived, though not necessarily at a moment's notice. The actors have played the parts, and the scenery and properties are kept in store. Habimah, in Israel, has about 80 plays, the Moscow Art Theater probably even more, and the Comédie Française more still. Naturally, revival is not assured for every production. There are always the flops that, surviving no more than three or four performances, have futures so unpromising that the management does not keep the scenery and dresses intact.

Repertory offers to the public certain considerable advantages, compared with the production of a single play put on for a run. In the first place, the performance of an actor tends to be fresher if he is appearing in several different parts in a given week, rather than repeating the same part night after night for many weeks. There is an optimum number of times any play can be repeated: on average, about 50 or 60. Then the creative element of the actor's work diminishes and the performance becomes more and more stale. I have seen early performances of a play and then seen the same play a year later. It is scarcely recognizable. The actors are saying the same words at the same pace, in the same rhythm, with the same inflections. They are doing the same business, but the heart has gone out of the work.

SOME may say that if the actors were doing a disciplined job the per-

formance would not degenerate. To think so is to fail in distinguishing between the actor's craft and his art. The craftsmanship, with rare exceptions, does not degenerate. The mechanics of the performance remain extraordinarily precise. But the intuitions and feelings which give meaning to these mechanics simply are not indefinitely repeatable.

Repertory, by giving the actors a change of part and an occasional night off, enormously prolongs the life of a performance. This is proved by experience. I have noticed again and again the zest with which a repertory company returns to a play, even after a brief respite. Further, many of the great parts make such heavy demands on the physical and spiritual resources of the chief performers that eight performances a week are an unbearable strain. Actors are constantly called on to make such efforts. They can do it, and in existing commercial conditions they have to. But I know that even finer performances would be given under less strenuous conditions.

Apart from the likelihood of fresher and more energetic performances, repertory has another main advantage for the public. There is the interest of seeing the same group of actors in a variety of roles in quick succession. Under the system of long-running metropolitan hits this cannot occur.

ONE of the serious pleasures of playgoing ought to be to see tonight's bit players in leads tomorrow; to see the same players alternate "straight" and "character" roles, play young and old, sympathetic and unsympathetic, in plays of widely different theme and style. Only so can acting be judged. How, on Broadway, can one compare the performance of X in one ephemeral comedy with that of Y in another? Who knows if Blondie White can really act, when one only sees her type-cast in what producers consider "Blondie White roles"? Type-casting takes half the fun out of acting, not just for the actor but for the audience, too. One of the most boring things about Broadway is knowing from the moment you read a name in the program, unless the *(Continued)*

SIR TYRONE GUTHRIE, who has staged many plays on both sides of the Atlantic, is the artistic director of the Tyrone Guthrie Theater, a repertory group in Minneapolis.

actor is E. G. Marshall, precisely the performance you may expect.

This is not the actor's fault. It is that of producers and directors. Under the stress of desperate economic pressure they simply dare not risk a mistake. They play safe by casting an actor who has already shown that he can look and sound very like their image of a particular character. The actor is then expected to give a performance as nearly as possible a replica of some previous performance of his own. A company that offers a repertory of three or four different plays in as many nights, enables an audience really to sample its quality. If the audience has any sense, one of the most charming and interesting things is to see good actors and actresses grappling with parts no commercial manager would dream of their playing, and doing fine.

IN view of these advantages, it may seem strange that the repertory system has been abandoned in commercial practice. The reason is economic.

If three or four different plays are presented in a given week, the expenses of scene-changing are higher than if only one play were in the bill, particularly if, as is often the case, that one requires only a single set. Again, in a repertory there will be plays which do not use the services of all the actors, or in which a highly paid actor will be playing a part which, had the play been cast in normal commercial circumstances, could have been adequately played by someone much cheaper.

Repertory is also a little more difficult and more costly to advertise. Four titles in press announcements take up four times more space than one; and the charges for advertisements in a newspaper are based upon space. Also, if four plays are being given in a single week, the customer must make just the least bit more effort and show the least bit more intelligence to book a seat for the play, or the night, of his choice. Commercial managers do not trust their customers to take this amount of trouble or to possess this degree of intelligence.

NATURALLY, it can never be as profitable or as easy to manage a repertory company as to run a successful play till it drops dead of sheer exhaustion. Of course, only one play out of eight or nine is successful, but profits on that one are sufficiently large, coupled with the glamour of a great "hit," to entice the necessary backers.

Isn't it more glamorous as well as more interesting to back the kind of play you really like and admire, rather than to plunge on a single play in hopes of a "smash hit"? I think so. But I know that most backers of plays do not even read the script before they cough up their money. They back a famous star. They back because X is backing, and when he backed "Penthouse Momma" he got 879 per cent on his dough. They back for any and every reason, but rarely because they are truly and passionately fond of the theater, and would like to see it conducted in a rational and mature manner.

A repertory theater needs this last sort of support. The profits will not be spectacular; on the other hand, the losses of a well-managed repertory ought not to be nearly so spectacular as those of the so-called "commercial" theater, because the repertory is not a one-shot operation.

A successful production acts as insurance for the rest. But here's the rub. Repertory requires both a larger aggregate investment than the one-shot speculation, and also requires a far longer-term approach. Now this is exactly what the economics of Broadway do not permit. Managements can no longer make long-term plans. They simply cannot afford to do so, not with a budget based on the rents, wages and trade-union conditions that now govern the hiring of actors, stagehands, box-office and front-of-house attendants, and on the staggering promotion necessary if there is to be the slightest hope of success.

NO Broadway manager can plan a series of productions in the hope of gradually collecting the sort of audience he wants. Such an operation takes time to plan and then takes time to establish itself. The cost of this time is so prohibitive that no commercial management can possibly make serious plans for the season after next. Most have no plan beyond next Saturday week.

There are signs, however, that repertory is not dead. The Shakespeare Festivals at the two Stratfords (Connecticut and Ontario) each season offer a repertory of plays, as do the Shakespearean Festivals at San Diego and Ashland, Calif. The Minnesota Theater Company, during its first season, presented a classical repertory, not exclusively Shakespearean. And finally, the Lincoln Center Company, whose inauguration this season is probably the most seriously ambitious and potentially significant event in the history of the American theater, will offer several plays in repertory.

All these companies have one thing in common; their object is not primarily to make money, but to serve an artistic purpose. The Canadian Stratford and the Minnesota Theater company, the two I know best, were financed by public subscription to meet what the subscribers considered a public need. This, it seems to me, is an important forward step in theatrical policy.

For some centuries now — indeed, since the Reformation — the theater in the English-speaking world has been not merely divorced from the religious life of the community but has become simply one more industry. There need be no objection to this if it could be seriously maintained that the plays which do the best business are the best plays. Alas, it is not so. It would not be true to say that the best plays do the worst business, but they often do worse than artistically inferior material.

It must also be remembered that the theater, unlike literature or painting, lives on popular approbation. The finest performance wilts and dies if it does not find a public; and to this extent, business considerations simply cannot be ignored. The trouble starts when commercial considerations push all others out of the picture, when popular success and consequent money-making become the single object of production.

ANY sustained artistic policy is now quite out of the financial reach of individuals; hence, if there is any strong impulse in favor of such a policy it must come, not from individuals, but from substantial groups of people in the community.

This is an excellent thing. Such groups, if they are determined to have a theater, can then create the sort of theater they desire; and can put in charge of it the sort of men in whose artistic judgment and executive ability they feel some confidence. It is important that artistic and executive decisions be left to individuals of some proved professional competence. Committees can formulate the broad outlines of policy; committees can, and should, have a veto on the decisions of their executive officers; but they should not initiate decisions, since generally they agree to what nobody very much minds rather than what anybody very much wants. That sort of decision may possibly work in politics, insurance or banking, but in creative affairs it is just no good at all.

A theater which exists primarily to serve a community, and only secondarily to make a profit, will be more apt to offer repertory. The standard of performance is apt to be higher and out-of-town visitors will be able on three successive nights, if they have a mind, to see three different plays. This, of course, does not apply to New York City where on any night a visitor can take his choice of very many entertainments. But in Minneapolis, for example, it is a powerful consideration.

THERE is another reason for repertory — an economic one. In repertory it is possible to make one successful and popular production carry several lame ducks. The popular piece plays maybe four times a week throughout an entire season. This happens constantly in the repertory theaters in Europe.

In Scandinavia, for instance, most companies employ some singers as well as actors and offer one or two light musical entertainments each season. "Oklahoma" plays a performance or two each week to a packed house and carries August Strindberg's "The Spook Sonata," experimental new plays and other less "commercial" dramas, which are caviar to the general public. And just as a success can be exploited, so can a flop be tactfully and inconspicuously eliminated from the program.

At Minneapolis, however, we did not find it possible to arrange matters thus. We had a very large sale of season tickets (over 21,000). Before buying them, people needed to know which play would be performed on any given night of the season. To gain the very comfortable insurance of a large number of season-ticket holders, we traded the flexibility of our program.

THE advantages of repertory in the matter of public service may, or may not outweigh the fact that it requires more planning and is more costly than the customary system of running a single play. In my experience, the repertory system has proved extremely well able to draw and hold a particular type of public.

For example, Stratford, Canada, after 10 years, has never in any season played to less than 76 per cent of capacity; in several seasons the average was over 90 per cent. The Minnesota Theater Company, in its initial season, with a program that made no concessions or condescensions

303

to supposedly "popular" taste, with a company of nearly forty actors and with four expensively mounted productions, showed a profit.

Neither of these ventures would last 10 nights on Broadway. But I do not think anyone should, on that account, assume that their standard or performance is lower. The standards simply cannot be compared. The success of these repertory projects is due, in my opinion, to the fact that they have searched for, found and carefully cultivated their own audience.

This audience is different from the Broadway audience — I do not say better or worse, but different. It is not merely a customer in the entertainment market; it is the patron, often part owner, of a theater which it has itself created. This can mean a lively, affectionate, mutually stimulating relation between the performers and the audience, and give to the audience a community of interest and feeling which the Broadway audience, composed as it is of completely heterogeneous elements, does not, and cannot, possess.

IT is the hope of everyone who loves the theater and believes it to be something more than an amusement factory that the Lincoln Center Theater Company will create such an audience in New York. It will not be easy, since New York, like all other metropolitan cities, has a decreasing sense of its own identity and unity. But I can imagine, and I certainly hope, that every night a thousand or fifteen hundred people will attend the performances of this company. However different their backgrounds, circumstances and points of view, they will be united by the very sensible and serious wish to see a great play finely performed.

November 10, 1963

## The Theater: 'Dutchman'

### Drama Opens on Triple Bill at Cherry Lane

**By HOWARD TAUBMAN**

EVERYTHING about LeRoi Jones's "Dutchman" is designed to shock — its basic idea, its language and its murderous rage.

This half-hour-long piece, the last of three one-act plays being performed at the Cherry Lane Theater, is an explosion of hatred rather than a play. It puts into the mouth of its principal Negro character a scathing denunciation of all the white man's good works, pretensions and condescensions.

●

If this is the way the Negroes really feel about the white world around them, there's more rancor buried in the breasts of colored conformists than anyone can imagine. If this is the way

### The Casts

THREE AT THE CHERRY LANE, "Play," by Samuel Beckett, staged by Alan Schneider; "The Two Executioners," by Fernando Arrabal, staged by Edward Parone, and "Dutchman," by LeRoi Jones, staged by Mr. Parone. Presented by Richard Barr, Clinton Wilder and Edward Albee; productions designed by William Ritman; stage manager, Robert D. Currie. At the Cherry Lane Theater, 38 Commerce Street.

PLAY
W1 . . . . . . . . . . . . . . . . . . Alice Drummond
W2 . . . . . . . . . . . . . . . . . Marian Reardon
M . . . . . . . . . . . . . . . . . . . Ray Stewart

THE TWO EXECUTIONERS
Executioner No. 1 . . . . . . . . Ron Mack
Executioner No. 2 . . . . Peter Michaels
Mother (Frances) . . . . . Marian Reardon
Ben . . . . . . . . . . . . . . . David Spielberg
Maurice . . . . . . . . . . George Anderson
Husband (John) . . . . . . Charles Kindl

DUTCHMAN
Clay . . . . . . . . . . . . . . . . Robert Hooks
Lula . . . . . . . . . . . . . . . . Jennifer West

even one Negro feels, there is ample cause for guilt as well as alarm, and for a hastening of change.

As an extended metaphor of bitterness and fury, "Dutchman" is transparently simple in structure. Clay, a Negro who wears a three-button suit and is reserved and well-spoken, is accosted by a white female on a train. Lula is a liar, a slut, essentially an agent provocateur of a Caucasian society.

After she disarms Clay with her wild outbursts and sinuous attentions, she turns on him in challenging contempt. His answer is to drop the mask of conformity and to spew out all the anger that has built up in him and his fellow Negroes. When this outburst of violent resentment has finished and Clay has left the train, Lula notices that another Negro has boarded and she sets her slinky charms for him.

Mr. Jones writes with a kind of sustained frenzy. His little work is a mélange of sardonic images and undisciplined filth. The impact of his ferocity would be stronger if he did not work so hard and persistently to be shocking.

Jennifer West in a straight, tight-fitting dress striped like a prisoner's suit plays Lulu with a rousing mixture of sultriness and insolence. Robert Hooks as Clay is impressive as he shifts from patient tolerance to savage wrath. Edward Parone's staging is mordant and intense.

Mr. Parone also has staged Fernando Arrabal's "The Two Executioners" with biting crispness. The piece is a self-consciously ironic étude on the endlessly recurring theme of the woman who destroys her husband and consumes her sons, and it manages to be wearisome in 20 minutes. Marian Reardon as the mother and David Spielberg and George Anderson as the sons play resourcefully, but they cannot prevent one from feeling that one has heard all this before.

●

The curtain raiser is Samuel Beckett's "Play," which for some weeks had shared a bill with Harold Pinter's "The Lovers." Of the two new companions "Play" acquired last night, "Dutchman" is the one that bespeaks a promising, unsettling talent.

March 25, 1964

# The Absurd Absurdists

**By MORDECAI GORELIK**
*Research Professor in Theater, Southern Illinois University, Carbondale, Ill.*

IF the theater of the absurd leaves me less than wildly enthusiastic, that may not prove, necessarily, that I am a relic of the *ancien regime*. I am the American translator (as well as the director, both at California State College, L. A., and at Southern Illinois University) of Max Frisch's "The Firebugs," a play certified as absurdist by no less an authority on the subject than Martin Esslin himself.

Nor is "The Firebugs" the only absurdist play that I have found entertaining. I recall the clownish innocence of "Waitting for Godot," the evil glitter of "The Blacks," the sick humor of "The Connection." "Rhinoceros" is obviously a sardonic parable of conformism; "The Caretaker" depicts a squalid world of social irresponsibility; "Oh Dad, Poor Dad, etc." is a lampoon of momism and the "International set," one of the funniest vaudeville skits in years. The plays of the absurd are undoubtedly an expression of our times and have a devoted following among the younger American stage people. Some of the absurdist dramas are inventive in a way that adds to the resources of grotesque irony onstage. They even provide a mild psychotherapy for certain audiences. And they are part of a significant rebellion against the mildewed family dramas and stale domestic comedies that are the standard brand of canned goods on Broadway.

### Enough, Enough

But when I am presented with callow, pseudo-philosophic plays like "Tiny Alice" and hear them praised for their "awesome depths," or am told that they are "a shaft driven deep down into the core of being," or when I am informed, oracularly, that Goldberg and McCann, the two mysterious gents in "The Birthday Party," are an embodiment of the Judaeo-Christian tradition, I begin to feel that enough is enough. The importance of these sophomoric charades has been tremendously overrated.

Thereafter is a special, remarkable form of social communication, one that, when it is healthy, celebrates the highest aspiration and deepest wisdom of its communicants. Therefore the apologists of absurdism are correct when they say that the absurdist dramas (or nondramas) describe non-communication. Not only do these plays describe it, but they also form part of it themselves. The more lucid absurdist products, such as those named in my first paragraph, reflect, with typical ambiguity, the conflicts that rage in the outer world of taday. The others depict only the inner life of their authors, with a

symbolism that is always obscure and eccentric, and often flagrantly repulsive. Nor will you get anywhere by calling an absurdist play irrational, for its author disdains rationality and has nothing but scorn for the "squares" who look for a minimum of sense in a dramatic story. He thinks he is being communicative enough if the story can be interpreted by his psychoanalyst.

### A Diagnosis

At least one such analyst, Dr. Donald M. Kaplan, of New York, has taken note of certain aspects of homosexual ideology that bear a striking resemblance to the absurdist phenomenon onstage: "...the homosexual's ideologic style does not champion humanity but merely himself...behavior without responsibility—a program ultimately without action...Intelligence, discrimination and reason ... have little status in the homosexual ideological style ...

"The audience is splintered into a mere collection of individuals, each now troubled by a return to his own obscene secrets."* I have no moralistic purpose in quoting Dr. Kaplan, nor am I ready to follow him in all of his conclusions: I rather think that there are all kinds of homosexuals, with all kinds of ideologies. But the diagnosis is too telling to be dismissed offhand; the irrationality, the inner preoccupations, the need to astonish an audience, the absence of a true dramatic action, the dismal idea of the human condition—all from the background of non-drama and metatheatre.

Absurdism's feeling of nausea when confronted with the realities of life can be traced through its current spokesmen, Eugene Ionesco and Jean Genet, through the stage theorist Antonin Artaud, with his lunatic cult of the "theater of cruelty," back to Sören Kierkegaard, who called reason and science an illness, and Martin Heidegger, who views life as a state of permanent anxiety, depression and guilt. According to Ionesco, the world is "a desert of dying shadows" in which learned men, tyrants and revolutionists alike have arisen and died without accomplishing anything. In an exchange of polemics with the English drama critic, Kenneth Tynan, he advised, sarcastically,

*Homosexuality and the American Theater. Tulane Drama Review, Spring, 1965.

"Don't try to better man's lot if you wish him well." For the metadramatist, existence is at one and the same time utterly depressing and totally unknowable: Beckett, who has somehow "retained a terrible memory of life in his mother's womb," when asked by Alan Schneider to explain Godot, could only reply, "If I knew I would have said so in my play."

Not only are the absurdists baffled by their own compositions, but nothing could be further from their thought than a call to remedial action. It cannot be surprising that Beckett puts his characters inside rubbish cans or vases, or buries them up to the chin in a sandpile. The two tramps in "Waiting for Godot" stand around stupidly waiting, and Krapp, in "Krapp's Last Tape," is a decayed old man who keeps mumbling to himself or munches toothlessly on a banana. Senile or moronic types abound in these anti-dramas-alleged human beings made of mud, with arms and legs as inoperative as their minds. The argument is, of course, that the Estragons and Vladimirs and Krapps are not people but tokens of the human race in general. But it may still be questioned whether these cardboard figures involved in no valid dilemma and with no hope of any resolution except idiotic despair, are a true picture of humanity.

The dramatic, or rather, anti-dramatic, action of the absurdist figurines resembles the spasms of a dead laboratory frog or mouse under an electric charge. That sort of action is far removed from anything like the developing struggle of protagonists who have the breath of life, who fight with all their energy on one side or another of vital issues. (And among these protagonists I include even the troubled Hamlet, Prince of Denmark.)

Action may seem useless to those "intellectuals" who feel impotent in the face of today's problems. The rest of the human race believes in action, as anyone can tell who reads the daily papers. And we might wish that some of the monsters of history had felt as powerless as the philosophers of absurdism: a certain Corporal Adolf Hitler, for instance, who took action to turn the world into a permanent hell, and who might have done it, too, if some other people, unaware of the uselessness of action, had not stopped him in his tracks.

It may suit Ionesco to tell us that life is nothing more substantial than a nightmare, but he himself keeps turning out new works and collecting royalties. And Beckett, in spite of a leaden *weltschmerz,* took time off to be a member of the French Resistance, according to Esslin. We have not had to wait for metatheatre to tell us that life is neither simple nor easy: Hamlet's "To be or not to be" speech describes it better than anything in Ionesco, Beckett, Arrabal, Genet or Pinter. Besides, it is a complete nonsequitur that if life is brutal one must let oneself be trampled on. To quote Friedrich Dürrenmatt, who is no cheerful optimist: "The world (hence the stage which represents this world) is for me something monstrous, a riddle of misfortunes which must be accepted but before which one must not capitulate."

If absurdism is an "expression of our times" that does not automatically ennoble it or give it stature. (Vandalism, juvenile delinquency and race hatred are also an expression of our times.) It is true that many of us do destructive things that make no sense. Indeed, the whole modern world is in an absurd state, unbalanced by gigantic conflicts. Two frightful world wars have solved nothing basic, and now the culminating imbecility of the Cold War threatens the existence of everyone on this planet— at the very time when atomic energy has opened the way to an undreamt-of richness and splendor. One might imagine that, in the face of the great issues before us, dramatic writing would reach heights never known before. Instead we have the jejune diversions and cheap obscurities of the absurdists.

And suddenly the immensely difficult craft of playwriting has turned almost childishly simple. Esslin complains, "Everybody who writes a crazy script now sends it to me." As a scene designer I am reminded of the good old days when any beginning designer could establish a reputation if he slanted walls, windows and doors. This device made it possible to be imaginative without really trying—so much so that expressionist scene design has persisted in the university theaters for almost forty years. We may expect a like popularity for absurdist writing. Especially when the younger dramatists have an

example like "Who's Afraid of Virginia Woolf?" to encourage them. To be sure, "Who's Afraid" was no mere piece of automatic scribbling; but what it did was to create a formula that paid off handsomely at the box office and even reached for the Pulitzer Prize.

I don't believe for a moment that Albee thought up, deliberately, this combination of soap opera and absurdist cynicism souped up with "true-to-life," four-letter-word dialogue. Albee is both talented and sincere, and instead of making further use of his golden invention he earned two box-office failures by reverting to the more uncompromising principles of absurdism in "The Ballad of the Sad Cafe" and "Tiny Alice." But his formula will serve others, if not himself: the weird hipster lingo, the juvenile gutter words, will be sprinkled over the latest helping of schmalz. We may also look for some second-hand Pinters—for Pinter, too, has hit upon a successful formula. Endowed with an excellent stage sense, he has turned out Grand Guignol melodramas such as "The Birthday Party" in which the basic motivations are simply omitted, thus inviting critical acclaim in terms of the cosmos and the infinite.

It may have been natural for absurdism to take root in a conquered and war-exhausted France. But who has conquered the United States? This country is a mighty nation at the height of its power; and even if it does not always know what is good for it, that is no reason to describe it in terms of misery. The vigor of American playwright, who, under stress of the Cold War, has abandoned the responsibility of the mind and has entered on a path known to the Germans, at the time of Hitler, as the "inner migration." But theater itself is not so easily betrayed. If its audiences are not wiped out by the holocaust that is now in preparation, it will arrive, one day, at a maturity worthy of the atomic age.

August 8, 1965

# The Theater of the Absurd Isn't Absurd at All

*Writing here recently, Mordecai Gorelik assailed the theater of the absurd as irrational, non-communicative, non-dramatic and steeped in despair. Here the author of "Theater of the Absurd" answers.*

### By MARTIN ESSLIN

I SYMPATHIZE with Professor Mordecai Gorelik's impassioned outcry against absurdist drama, but I must say that I feel he has misunderstood a good many things, both about the theater of the absurd and the present situation in the world.

First, it is logically indefensible to attack a whole convention of an art form wholesale. There are great plays in the absurdist convention and there are others that are execrable. To single out some that are bad and use them as arguments to condemn the entire convention is as illogical as it is unfair. It is a mistake that is often made: In the 18th century, the whole of Elizabethan drama, including Shakespeare, was condemned by the ruling school of criticism as coarse and irregular. And today there are still those who reject non-figurative art or twelve-tone composition on similar grounds.

Second, Professor Gorelik attacks the absurdists, not so much on artistic as on moralistic or ideological grounds. This presupposes that they represent a moral or ideological position. And this is certainly not the case. In present-day Poland, for example, there are decidedly left-wing absurdists, while in France a writer like Ionesco is under fire from the Communists for holding a right-wing position. Genet's latest play "The Screens" uses absurdist techniques to attack colonial oppression in Algeria. Hence Professor Gorelik's line of argument that the absurdists merely lament the state of the world without indicating lines of social action is factually wrong.

*

After all, most of Ionesco's work is a satire on the fossilized and dehumanized lives of an affluent bourgeoisie. Satire may be negative in form, but it always represents a call for positive action. Similarly, Professor Gorelik has misunderstood what "Waiting for Godot" is about. But, of course, there are two other characters as well in that play, Pozzo and Lucky, who spend their time wildly careening about the countryside. One of the questions that the play poses to the audience concerns the relative merits of the contemplative and the wildly active life.

Far from being an expression of "idiotic despair" this particular play, by increasing the audience's awareness of some basic truths about the human situation, will make them able to face reality more calmly and as more integrated human beings, which is the only good basis for rational social behavior and action. Indeed, if Professor Gorelik says that "the rest of the human race believes in action," he ought to have examined the subject matter of some of the absurdists' despair, before demanding that they should always recommend some remedial action. If Beckett or Ionesco express a sense of the inevitability of death, for example, what action would Professor Gorelik recommend to remedy that state of affairs? And,

*Zero Mostel roars in Ionesco's "Rhinoceros,"* 1961

Gorelik accepts it as "a sardonic parable of conformism" but deplores Ionesco's view of the world as "a desert of dying shadows."

Esslin retorts that "satire may be negative in form, but it always represents a call for positive action."

indeed, what action does Shakespeare recommend in plays that deal with similar subject matter, for example, "King Lear?"

*

Must all drama be political? Even the most socially committed dramatist of our time, Brecht, dealt with these subjects repeatedly without suggesting any remedy. Indeed, the fact of dealing with the subject is itself the remedy. If we want to master the despair arising from such basic elements of the human condition, we can only do so by facing up to them and steeling our minds to accept them. That is the subject matter and aim of all tragedy and of most of Man's religions.

If some human beings in a scientific age find it impossible to accept *(Continued)*

"The Screens" by Genet in West Berlin. Genet "uses absurdist techniques to attack oppression in Algeria." French producers have shunned the play.

*P. J. Kelly lives in ashcan in Beckett's "Endgame," 1958*
Gorelik questions whether Beckett's characters, "with no hope of any resolution except idiotic despair, are a true picture of humanity."

Esslin replies, "The artistic expression of the stark facts" may bring about "the conquest of despair."

supernatural consolations like the promise of eternal life, they can still find comfort in the nobility of facing the void with gay defiance and in such values as beauty and total sincerity. These are the values which the best absurdist plays embody, the values that also inspire much other great tragic drama, from Sophocles to Shakespeare and Ibsen. The artistic expression of the stark facts of the human condition is itself its sublimation and the conquest of despair.

Third, Professor Gorelik complains that absurdist drama is formless, meaningless and easily imitated. This, I am afraid, is another argument on the level of: "Fancy Picasso getting thousands of dollars for this drawing, my little girl of five can do better!" It is simply not true that any child could draw better than Picasso. It is also simply not true that absurdist drama is formless and meaningless. On the contrary, the best absurdist plays are masterpieces of controlled form. In fact, the freer and more associative the subject matter of a work of art, the more rigidly structured must it be. Hence the plays of Beckett, Pinter, or the best of Ionesco are as rigidly constructed as the most formal poetry.

## Total Pattern

Each word, even each pause, is inevitable and forms an irremovable part of the total pattern. As regards the apparent ease with which this kind of drama can be imitated: it is true that I have somewhere said that, having written my book on the theater of the absurd, I have become the recipient of many a crazy play. But, on the other hand, in my work as head of radio drama for the British Broadcasting Corporation I get a far greater number of plays that are childishly untalented imitations of Ibsen, Sardou, Brecht or Noel Coward. Ultimately, bad imitations are made of every successful formula and the fact that many people make bad imitations of absurdist plays is merely due to their phenomenal success in the last 10 years.

Moreover, a bad absurdist play is more easily detected than a bad imitation of many other conventions precisely because the naive idea that to write such a play you need merely to write down whatever comes into your mind is totally wrong. The need for sense is manifestly greatest in a form that uses the element of nonsense as an artistic device, just as design and pictorial sense are most needed in abstract painting where ugly forms cannot be excused as being reproductions of ugly models. The premium on originality and genuine invention is highest in the sphere where the crutches of mere reportage of real life have been removed.

## Not So Easy

Nothing could be further from the truth than Professor Gorelik's statement that, with the coming of the absurdists, "the immensely difficult craft of playwriting has turned almost childishly simple." This will appear so only to very childish people, who may also think that ballet dancing is very easy because Nureyev and Fonteyn seem to do it without effort.

Fourth, Professor Gorelik wonders why absurdism, which could naturally take root in a conquered and war-exhausted France, should also have become so popular among intellectuals in the United States. Here Professor Gorelik has misunderstood both our times and the function of this kind of art. It was not the physical conquest of France that gave rise to absurdist writing 20 years ago, it was the ideological malaise caused by the evident failure of some of the cherished ideals of the 19th century — religious, political and social.

In the United States these ideals may not have crumbled as obviously and as decisively as in continental Europe, but they are certainly also being questioned in a world living under the shadow of the atomic bomb and escalating wars. This is the reason why a searching examination of some of the ultimate and inescapable facts of the human condition, a questioning of fossilized beliefs of the past, certainly is at least justifiable, even

in the United States, which today, prosperous as the nation may be, has to bear the burden of all the world's ills, simply by being the most powerful country on earth. It would be an unhealthy and alarmingly callous nation whose intellectuals at such a moment did not put searching questions and steel themselves to face even the grimmest answer.

### Questions

I may be wrong, but my impression is that Professor Gorelik is particularly angry with Edward Albee and especially so with "Tiny Alice."

I must say I personally found "Tiny Alice" neither particularly obscure, nor particularly pretentious. It is a play, which, as I understood it, examined Man's inability ever to hold or ever to attain to the ideal, which he nevertheless is bound to pursue.

This may not be a particularly novel conclusion, nor does it recommend remedial social action. But then, Ibsen's "Master Builder" deals with a similar subject in very similar symbolical terms. What remedial action does that play recommend? And is it any worse for not recommending any?

The theater, after all, is not a collection of recipes for social improvement, but a place where human beings can purge their emotions and attain spiritual insight through contact with the emotional world of its artists.

"Romeo and Juliet" is no worse a play for not providing a recipe for the avoidance of unhappy love. Why should "Tiny Alice" be faulted for not solving one of Man's basic problems if it has been able to communicate a strong and exhilarating emotional experience?

But even if Professor Gorelik were right in maintaining that "Tiny Alice" is a bad play, and a bad absurdist play at that (which I personally doubt), this would prove nothing about other plays in an absurdist convention, some of which are very bad, while others are enduring masterpieces.

August 29, 1965

# Homosexual Drama And Its Disguises

## By STANLEY KAUFFMANN

A RECENT Broadway production raises again the subject of the homosexual dramatist. It is a subject that nobody is comfortable about. All of us admirably "normal" people are a bit irritated by it and wish it could disappear. However, it promises to be a matter of continuing, perhaps increasing, significance.

The principal complaint against homosexual dramatists is well-known. Because three of the most successful American playwrights of the last twenty years are (reputed) homosexuals and because their plays often treat of women and marriage, therefore, it is said, postwar American drama presents a badly distorted picture of American women, marriage, and society in general. Certainly there is substance in the charge; but is it rightly directed?

The first, obvious point is that there is no law against heterosexual dramatists, and there is no demonstrable cabal against their being produced. If there are heterosexuals who have talent equivalent with those three men, why aren't these "normal" people writing? Why don't they counterbalance or correct the distorted picture?

But, to talk of what is and not of what might be, the fact is that the homosexual dramatist is not to blame in this matter. If he writes of marriage and of other relationships about which he knows or cares little, it is because he has no choice but to masquerade. Both convention and the law demand it. In society the homosexual's life must be discreetly concealed. As material for drama, that life must be even more intensely concealed. If he is to write of his experience, he must invent a two-sex version of the one-sex experience that he really knows. It is we who insist on it, not he.

### Two Alternatives

There would seem to be only two alternative ways to end this masquerading. First, the Dramatists' Guild can pass a law forbidding membership to those who do not pass a medico-psychological test for heterosexuality. Or, second, social and theatrical convention can be widened so that homosexual life may be as freely dramatized as heterosexual life, may be as frankly treated in our drama as it is in contemporary fiction.

If we object to the distortion that homosexual disguises entail and if, as civilized people, we do not want to gag these artists, then there seems only one conclusion. The conditions that force the dissembling must change. The homosexual dramatist must be free to write truthfully of what he knows, rather than try to transform it to a life he does not know, to the detriment of his truth and ours.

The cries go up, perhaps, of decadence, corruption, encouragement of emotional-psychological illness. But is there consistency in these cries? Are there similar objections to "The Country Wife," "Inadmissible Evidence," "The Right Honourable Gentleman" on the ground that they propagandize for the sexually unconventional or "corruptive" matters that are germane to them? Alcoholism, greed, ruthless competitiveness are equally neurotic, equally undesirable socially; would any of us wish to bar them arbitrarily from the stage?

Only this one neurosis, homosexuality, is taboo in the main traffic of our stage. The reasons for this I leave to psychologists and to self-candor, but they do not make the discrimination any more just.

### Fault Is Ours

I do not argue for increased homosexual influence in our theater. It is precisely because I, like many others, am weary of *disguised* homosexual influence that I raise the matter. We have all had very much more than enough of the materials so often presented by the three writers in question: the viciousness toward women, the lurid violence that seems a sublimation of social hatreds, the transvestite sexual exhibitionism that has the same sneering exploitation of its audience that every club stripper has behind her smile. But I suggest that, fundamentally, what we are objecting to in all these plays is largely the result of conditions that we ourselves have imposed. The dissimulations and role-playings are there because we have made them inevitable.

Homosexuals with writing ability are likely to go on being drawn to the theater. It is the quite logical consequence of the defiant and/or protective histrionism they must employ in their daily lives. So there is every reason to expect more plays by talented homosexuals. There is some liberty for them, limited, in café theaters and Off Broadway; if they want the full resources of the professional theater, they must dissemble. So there is every reason to expect their plays to be streaked with vindictiveness toward the society that constricts and, theatrically, discriminates against them.

To me, their distortion of marriage and femininity is not the primary aspect of this matter; for if an adult listens to these plays with a figurative transistor-radio simultaneously translating, he hears that the marital quarrels are usually homosexual quarrels with one of the pair in costume and that the incontrovertibly female figures are usually drawn less in truth than in envy or fear. To me, there is a more important result of this vindictiveness—its effect on the basic concept of drama itself and of art in general.

Homosexual artists, male and female, tend to convert their exclusion into a philosophy of art that glorifies their exclusion. They exalt style, manner, surface. They decry artistic concern with the traditional matters of theme and subject because they are prevented from using fully the themes of their own experience. They emphasize manner and style because these elements of art, at which they are often adept, are legal tender in their transactions with the world. These elements are, or can be, esthetically divorced from such other considerations as character and idea.

Thus we get plays in which manner is the paramount consideration, in which the surface and the *being* of the work are to be taken as its whole. Its allegorical relevance (if any) is not to be anatomized, its visceral emotion (if any) need not be validated, and any judgment other than a stylistic one is considered inappropriate, even censorious. Not all artists and critics who advance this theory of style-as-king are homosexuals, but the camp has a strong homosexual coloration.

What is more, this theory can be seen, I believe, as an instrument of revenge on the main body of society. Theme and subject are important historical principles in our

art. The arguments to prove that they are of diminishing importance—in fact, ought never to have been important—are cover for an attack on the idea of social relevance. By adulation of sheer style, this group tends to deride the whole culture and the society that produced it, tends to reduce art to a clever game which even that society cannot keep them from playing.

But how can one blame these people? Conventions and puritanisms in the Western world have forced them to wear masks for generations, to hate themselves, and thus to hate those who make them hate themselves. Now that they have a certain relative freedom, they vent their feelings in camouflaged form.

Doubtless, if the theater comes to approximate the publishing world's liberality, we shall re-trace in plays—as we are doing in novels—the history of heterosexual romantic love with an altered cast of characters. But that situation would be self-amending in time; the present situation is self-perpetuating and is culturally risky.

A serious public, seriously interested in the theater, must sooner or later consider that, when it complains of homosexual influences and distortions, it is complaining, at one remove, about its own attitudes. I note further that one of the few contemporary dramatists whose works are candidates for greatness — Jean Genet—is a homosexual who has never had to disguise his nature.

January 23, 1966

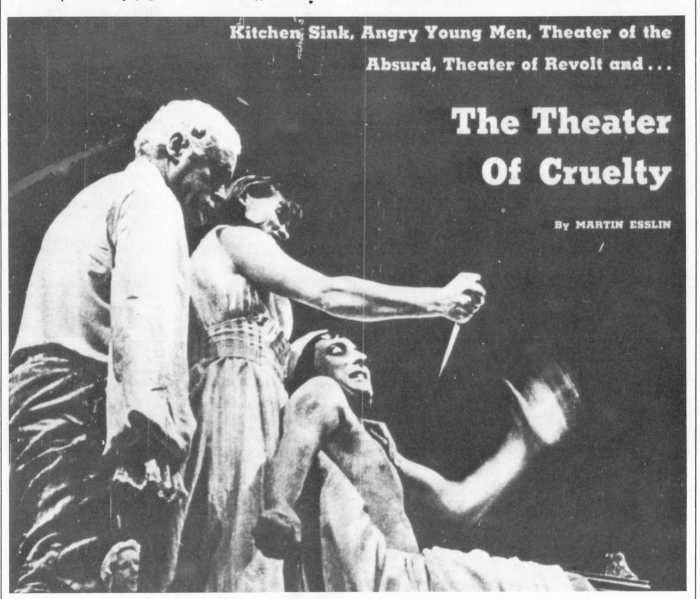

Kitchen Sink, Angry Young Men, Theater of the Absurd, Theater of Revolt and...

# The Theater Of Cruelty

By MARTIN ESSLIN

*Above—*
Scene from a current exemplar of the Theater of Cruelty—Broadway's "Marat/Sade." Patrick Magee as the Marquis de Sade watches as Glenda Jackson playing Charlotte Corday stabs the Jacobin extremist, Jean Marat (Ian Richardson), in his bath during the Terror.

**T**HE great success of director Peter Brook's "Marat/Sade," first in London and now in New York, has made the term Theater of Cruelty a fashionable conversational gimmick and a convenient eye-catcher for a headline. And while it is a

**MARTIN ESSLIN**, a London theatrical producer and director of drama for B.B.C., is currently teaching at the University of California Department of Dramatic Arts and Speech. He is the author of "Brecht: The Man and His Work" and "Theater of the Absurd."

term that is meaningful in the mouth of a director of genius and an expert on the theater like Peter Brook, it is bound to be misunderstood and devalued by people who use it at secondhand and without knowing the background from which it is derived. Since the term was given its present currency about two years ago, every play in which somebody is murdered, beaten up, raped or tortured is instantly labeled an example of the Theater of Cruelty.

Our consumption of such brand names of supposed categories in the

field of Pop drama criticism has become as great as that of the detergent industry—we have had the Kitchen Sink, the Angry Young Men, the Theater of the Absurd, the Theater of Revolt, the Theater of Cruelty. All these concepts have some meaning, but because that meaning can be quickly dissipated by irresponsible use, it is worth looking at the latest of these brand labels to see what it does—or rather, what it does *not*—mean.

In January, 1964, Peter Brook, assisted by Charles Marowitz, presented at London's newly opened experimental LAMDA-Theater (built by the London Academy of Music and Dramatic Art) a program of short sketches and experimental scenes which they called "Theater of Cruelty." Here is how that strange and exciting evening in the theater came about. Peter Brook had set his mind on directing Jean Genet's long, rambling and difficult play, "The Screens," which was written at the height of the Algerian war and which had long remained unperformed. This project was much discussed by the Royal Shakespeare Company, of which Brook is one of three artistic directors, together with Peter Hall and Michel Saint-Denis; there were those who were for such a production, others who opposed it on the grounds that Genet's play was not only obscure but obscene to a degree which made its sanction by the Lord Chamberlain, Britain's censor of stage morals, highly unlikely. But everybody was agreed about one thing: "The Screens" would need unusually long rehearsals—in fact, specially trained actors.

**B**ROOK succeeded in persuading his colleagues that he should be given a chance to try what could be done, and the Royal Shakespeare Company gave him funds to recruit a number of young actors especially for this project and to work with them for a number of months. Brook decided that he would spend quite a time on limbering-up exercises before actually

starting to rehearse Genet's play itself. There would be improvisations, experiments in conveying meaning without speech (by inarticulate sounds or movement alone), attempts to find a new form of *ritual* theater. And all this appeared so interesting that there seemed no reason why the public should not get a look in on these experiments. So the rehearsals were held in public—on a club basis, for members only, to avoid the Lord Chamberlain's interference with the freedom of this experimental workshop.

The nature of the training program, deriving as it did from the objective of preparing a group of actors capable of doing justice to Genet's play, called for an extension of the expressive range of the theater very much on the lines advocated by the great French prophet of a new kind of drama, Antonin Artaud. Artaud had once tried to found a theater which he labeled Théâtre de la Cruauté. So Brook and Marowitz called their evening "Theater of Cruelty."

**W**HO was Artaud and what did he mean by Theater of Cruelty?

Artaud (1896-1948) was an astonishing genius, an eccentric, a poet, an actor and a director, who also spent considerable periods of his life in mental institutions. The son of a Marseilles shipowner, he began to write poetry while still in his teens. At the age of 22 he had to go into a mental institution where he stayed for two years, suffering from bouts of melancholy and mystical exaltation. Released, he went to Paris, where Lugne-Poe, the great director of the Théâtre de L'Oeuvre, was so struck by the expressiveness of his features when he encountered Artaud in the street that he offered him a small part in one of his plays.

So Artaud became an actor. Charles Dullin, another great French actor and director of that period, and a great teacher of acting, took him under his wing, not only as an actor

but also as a designer of scenery. Artaud also acted in films: no real filmlover will ever forget his ascetic face in the part of the monk who comes to confess the maid in Carl Dreyer's famous *"La Passion de Jeanne d'Arc,"* or in Abel Gance's "Napoleon" (in which, strangely enough, he played the part of Marat!).

**I**N 1924, Artaud became a member of the surrealist circle around André Breton, but broke his connection with this group in 1927, when Breton savagely attacked him for the sin of having contemplated something so sordidly commercial as starting a theater. He went ahead with his stage project and ran for a time, together with Roger Vitrac, a venture called *Théâtre Alfred Jarry* (named after that grandfather of all modern avant-garde drama, the creator of the bourgeois caricature, King Ubu). This venture ending in failure, he supported himself as an actor, poet and essayist.

His original output as a dramatist always remained small, for Artaud was a theoretician rather than a playwright. In 1931, at the Paris Colonial Exhibition, he saw a performance of Balinese dancers, with their highly stylized ritual movements and strange music. This was a decisive influence on his thinking. From it there emerged the theory and doctrine of the Theater of Cruelty which he developed in a number of essays and manifestoes published between 1932 and 1935. Having found some financial backing, he finally got his chance to demonstrate his ideas in practice: under the heading of Theater of Cruelty, he staged his own production of "The Cenci," a tragedy based on Shelley's play and Stendhal's story about the Roman patrician girl who was raped by her own father and murdered him in revenge. Artaud himself played the part of the father when this production opened on May 6, 1935, at the Théâtre des Folies-Wagram in Paris.

**O**F the phrase "Theater of Cruelty," Artaud has this to say:

"This Cruelty has nothing to do with Sadism or Blood. . . . I do not cultivate horror for its own sake. The term Cruelty must be understood in its widest sense, not in the material and rapacious sense which it is usually given. In doing so I claim the right of breaking the usual meaning of language . . . to return at last to the etymological ori-

Antonin Artaud as the dead Marat in "Napoleon," a 1926 French film. Artaud, a poet, director and actor who died in 1948 was originator and theoretician of the Theater of Cruelty.

gins of language which through abstract concepts always finally evoke concrete things. One can very well imagine a pure cruelty, without physical disruption. And, speaking in philosophical terms, what *is* cruelty? Spiritually cruelty means rigor, implacable application and decisiveness in an action, irreversible, absolute determination.

"It is wrong to give to the word Cruelty a sense of bloody severity, of the pointless and disinterested pursuit of physical suffering. . . . There is in the exercise of cruelty a sort of determinism of a higher order, to which the executer is himself subject. . . . Cruelty is, above all, lucid, a kind of rigid directedness, a submission to necessity. There is no Cruelty without consciousness, without a kind of applied consciousness. It is this which gives to each act of life its bloodcolor, its cruel nuance, because it is understood that Life is always the Death of someone."

Elsewhere Artaud added: "The erotic Desire is Cruelty, because it burns of necessity; Death is Cruelty, the Resurrection is Cruelty, Transfiguration is Cruelty." In other words, Artaud, who passed through phases of intense religious experience in the course of his stormy life, regarded Christ on the Cross and the re-enactment of the Last Supper in the Eucharist as supreme examples of what he understood by a Theater of Cruelty. This surely is a far cry from the current practice of using Artaud's term to describe any play in which someone has his head bashed in.

Moreover, Artaud had very definite ideas about the *forms*, the artistic means he wanted to employ in his Theater of Cruelty. Deeply influenced by Oriental theater, particularly by Balinese dancers, and the rituals of Mexican Indians, he called for a return to magical devices in décor and sound effects, a hieratic poise in the actors, a delivery of the lines in an incantatory tone reminiscent of priests rather than naturalistic acting, and ultimately an abolition of the separation between actors and audience by placing the spectacle among the spectators themselves. The cruelty Artaud called for was thus tantamount to the demand that theatergoers should go through an experience that really *changed their lives* rather than a mere act of consumption like the absorbing of a good dinner which is immediately excreted without leaving any visible spiritual trace.

ARTAUD'S attempt to demonstrate his ideas in "The Cenci" proved a dismal failure, artistic as well as financial. Deeply disappointed and shaken, he embarked on a journey to Mexico, where he had been invited to lecture at the University of Mexico and where he wanted to study the life and rituals of an Indian tribe, the Tarahumara. When he returned to France in November, 1936, he was at the end of his tether and behaved very strangely, brandishing a walking stick which he claimed had been St. Patrick's own magical cane.

This led to a trip to Ireland, where he planned to study the magic of the Druids. Feeling ill and miserable, he tried to find help in a convent of French nuns in Dublin, but his intentions were misunderstood and he ended up in prison and was finally put aboard a ship to be taken back to France. After trying to jump into the sea, he continued to deteriorate and spent the years till 1946 in a succession of asylums. On his release he became the center of a circle of admirers in Paris, gave some much-debated lectures, exhibited drawings, and recorded a radio program which was eventually banned by the French authorities. On March 4, 1948, he died, aged 52.

Artaud's influence on the French theater has been, and still remains, immense. His book of collected essays, "The Theater and Its Double" (the theater's double being life itself), first published in 1938, remains the Bible of the avant-garde. Roger Blin, the first director of Beckett's plays, acted one or two small parts in that memorable and catastrophic production of "The Cenci." Jean-Louis Barrault helped Artaud as assistant director on that same occasion. Eugène Ionesco and Arthur Adamov were deeply affected by Artaud's ideas.

AND so was Peter Brook. His LAMDA season, which became a considerable success and continued for several months, contained a wealth of brilliant ideas, and also a good many experiments which failed to come off. Charles Marowitz contributed a version of Hamlet, broken up and rearranged rather on the pattern of Alain Robbe-Grillet's and Alain Resnais' film, "Last Year at Marienbad"—very interesting but clearly not a complete success (it was not meant to achieve any such thing, merely to explore what could be done on these lines); but there *were* a number of items which really worked.

The most remarkable perhaps was a ritualistic scene without dialogue, devised and improvised by Brook as an exercise for his actors, in which a girl figure in a raincoat—obviously reminiscent of the then-reigning heroine of scandal in England, Christine Keeler—was arrested, stripped of her clothes as if being prepared for a bath prior to donning prison garb, and then, dressed again in her raincoat and standing amid a group of actors watching while the tin bathtub was being raised like a coffin, miraculously transformed into the other current heroine of that hour (early 1964) not of scandal but of martyrdom: Jacqueline Kennedy.

Thus Brook demonstrated that, through a mere rearrangement of figures on the stage, a magical effect can actually be produced—the same girl in the same raincoat can be transformed from an object of disgust into one of reverence, a tin bathtub into a coffin, merely by a change of context not only in space but also in time. It was not simply the grouping that changed (although not very much); it was that before the ritual cleansing the girl was by implication unclean and, after it, cleansed and pure.

That the ritual also had the attributes of a strip-tease—one of the most daring ever to be performed in public—merely enhanced the effect. Here Artaud's demand that the audience must be physically affected, drawn into the action with an inescapable, inevitable excitement — that being the meaning of the word Cruelty for Artaud—was here triumphantly fulfilled. That excitement, which mingled a purely erotic element with one of genuine ritual and magic, really could be compared to the total involvement of the participants in some primeval magical rite or Aztec human sacrifice. The girl who enacted that rite was Glenda Jackson, the Charlotte Corday of the "Marat/Sade."

SO the Theater of Cruelty as a vogue phrase in the headlines of the British popular press was well and truly launched. The season of public rehearsals at the LAMDA-Theater closed and Peter Brook went on experimenting with Genet's play. In the end these efforts culminated in no more than a production of half of that very long play behind closed doors for invited guests in an improvised theater in some rehearsal rooms in Covent Garden.

The Lord Chamberlain would never have sanctioned a public performance of that wild play. So much became quite clear from the magnificent performance that resulted. It contained some of the greatest moments I personally have ever witnessed in a theater: among them a scene in which an attack by the rebels on a European plantation in Algeria (during which the whole farm is set on fire) was indicated by actors who *painted* the red flames of the conflagration onto great empty white screens of paper which Brook used as the main scenery in his production. This was a marriage of theater and action-painting. It generated an almost unbearable excitement as the stage blazed with tongues of flame that could actually be seen growing out of a paroxysm of rage and passion. But that trial production also showed that Genet's play could never make sense to an audience of unprepared theatergoers, even if — by drastic cutting and cleaning up — it could have passed the censorship barrier.

Now Brook *had* trained his company of actors, but there was no play for them to act. It was at this moment that Peter Weiss's remarkable "Marat/Sade" play appeared on the horizon. It had just had a sensational success in Berlin. And it required just this kind of style of acting and production. Of course, Peter Weiss probably never thought of Artaud in writing his play; it is doubtful whether he ever even realized that Artaud's ideas had any relevance to what he wanted to achieve. But whether he wanted it or not, the label of Theater of Cruelty instantly became attached to his play, which opened in London on Aug. 20, 1964.

The "Marat/Sade" was bound to cause a wave of violent controversy. It so happened that shortly afterward the Royal Shakespeare Company put on a play by Roger Vitrac (Artaud's associate in the Théâtre Alfred Jarry) not by any deeply laid plot for a systematic revival of their work, but simply because Jean Anouilh had rediscovered and readapted the play—a piece of harmless antibourgeois satire which, however, contains the character of a lady who suffers from attacks of flatulence (very discreetly indicated by a trombone player who, on the express insistence of the Lord Chamberlain, had to be visibly present on the stage, no doubt so as to inhibit speculation as

311

to the real provenience of the sounds he produced). In addition, Harold Pinter's play, "The Homecoming," which the Royal Shakespeare also produced, contained some strongly sexy scenes.

The result was a virulent attack on Peter Hall and Peter Brook as the artistic leaders of the company for deliberately producing "dirty plays." Soon the terms Theater of Cruelty and Dirty Plays became interchangeable. And soon every play that contained anything either remotely dirty or remotely cruel inevitably carried the label Theater of Cruelty.

The most recent example of this complete confusion and misuse of the terms is provided by a play currently running at the Royal Court Theater in London, Edward Bond's "Saved." This is another play which the Lord Chamberlain refused to license, and which, therefore, has to be given under club conditions with tickets available only to members of the English Stage Society. Bond is a young man of undoubted talent for dialogue; he is a master of the language of the lowest strata of British society, in this particular case the juvenile delinquents of South London.

"Saved" deals with the effects of loveless sex. A couple who have no feelings for each other outside purely physical attraction produce a child; as the mother is obsessed by sex, the child receives neither love nor care from her. Her cruel neglect of the baby finally leads to its being left unattended in a park, exposed to the tender mercies of a gang of juvenile hooligans who smother it in its own diapers (i.e., its own excrement) and stone it to death. This incident then leads to the further degradation of the mother and father as well as the mother's lover, and the play ends with a long silent scene showing the couple continuing to live together but by routine and habit rather than feeling—duplicating the silent, hate-filled marriage of the

girl's parents. A highly moral tale this, a tract against mindless sex. But the London critics almost totally ignored that aspect of the play and concentrated on the short scene of the baby's murder, labeling it as a prime example of the Theater of Cruelty. Poor Artaud! He had raised the banner of his magical, incantatory, ritual Theater of Cruelty *against* the drab naturalism of the social drama of his day. Edward Bond's fine play is naturalistic to a degree, the very opposite of what the Theater of Cruelty meant to Artaud or, for that matter, to Peter Brook.

INDEED, apart from the brief experimental season at the LAMDA-Theater, there is at this moment *no movement* in the theater which would deserve to be labeled Theater of Cruelty. The fact that Brook dedicated his experiments to the memory and the ideas of Artaud does not mean that he, or anyone else, has inaugurated a systematic revival of these ideas. There is no need for that, anyway. Artaud's ideas, many of which were inspired, many others of which were exaggerated, downright crazy and unworkable, are already exercising an unobtrusive but all the more pervasive influence in the work of innumerable directors, playwrights and stage craftsmen. They have become part of the common currency of all contemporary theater.

There is no need to revive Artaud's strange incantatory noises (which are preserved in recordings he made for the French radio shortly before he died), which sound exceedingly odd and mad and would not work very well in the theater (as Peter Brook's reverent attempts at trying them again clearly showed). Jean-Louis Barrault (who worked with Artaud at the height of the latter's experiments) has absorbed all that he found valuable in the master's ideas in his work at the Marigny and Odéon theaters over the last 20 years; Roger Blin has used

much of what Artaud taught him in his productions of Adamov and Beckett; Ionesco acknowledges Artaud's influence on his writing, and Artaud's essays are the basis of much of the thinking of a multitude of avant-garde theater people all over the world, from Brook to Ingmar Bergman.

We may find elements of ritual theater very much in accord with Artaud's ideas in Edward Albee's "Who's Afraid of Virginia Woolf?" or, in a different manner, in his "Tiny Alice." Whether Albee himself was directly influenced by Artaud or merely indirectly through the general climate of thinking in the avant-garde theater is irrelevant. The influence is there, perhaps via Genet, perhaps via Beckett or Ionesco.

Was Jack Gelber's "The Connection" directly under Artaud's influence? Probably not. But there, too, the marriage of jazz and a theater realistic to the point of painful involvement of the entire audience clearly derives from the long-term influence of Artaud's ideas. Another Living Theater presentation, "The Brig," also very obviously falls into the same category.

In the cinema the new wave in France—Jean-Luc Godard, Alain Resnais, Louis Malle and scores of other young directors—clearly also derives from the general climate of ideas created by Artaud. Yet there is no such thing as a movement that could be labeled Theater (or for that matter Cinema) of Cruelty, for the simple reason that a multitude of different movements has absorbed Artaud's ideas, suggestions and theories in a wide variety of *different* styles and practices.

Brecht, whose theoretical ideas were diametrically opposed to those of Artaud, could also be labeled a practitioner of the Theater of Cruelty because he also opposed the concept of the "culinary theater"—i.e., the drama as an article of thoughtless consumption which leaves the spectator unchanged in his attitude to life and society—

in terms very similar to those used by Artaud. Both he and Artaud wanted a theater that really hits the audience squarely between the eyes, confronts it with life as it really is rather than with a pale, euphemistic, pretty-pretty version of it.

MORE and more in our age the theater is becoming polarized between these two extremes: the rose-colored spectacle of the large-scale musical and the Broadway comedy on the one hand, and the bitter, relentless portrayal of the human condition as it really is on the other. The latter includes no more and no less than any kind of *serious*, as opposed to mere entertainment, theater. In that sense all serious theater conforms to Artaud's program for a Theater of Cruelty. In the sense of a specific style modeled on oriental dancers and primitive ritual, however, there is very little evidence of any but the most generalized adherence to Artaud's concept. And it is in the latter specific sense that Artaud himself would, no doubt, have wanted his term to be understood.

In other words, there are today many directors who have absorbed and been influenced by Antonin Artaud's ideas; there are also many plays which aim at confronting us with the harsh truth about the human condition; there are also many plays which portray cruel acts and brutal situations, some for reasons of cheap sensationalism, others from genuine artistic motives. But none of these are properly described by Antonin Artaud's term. There is much cruelty in the theater today, but there is no movement that could be correctly described as a Theater of Cruelty. And all discussion which starts from the assumption that there is such a movement is nonsense compounded of ignorance and a slavish parroting of half-understood slogans.

March 6, 1966

## Theater in Harlem

# *New Home, New Troupe, New Play*

By **LINDSAY PATTERSON**, *editor of "Anthology of the American Negro in the Theater"*

LATELY, some of the most gifted young black writers have been so busy flaying whitey and wallowing in recriminations that they have forgot-

ten there is still much to be said about black America. Whitey, of course, is being as clever as ever. While they are flaying him, he's off writing epics about black heroes.

It's ironic: the dramatic image of the black man is still largely dictated by the ink of white authors.

That is why it is particularly pleasing to see a play

by a young black author that makes little or no mention of whitey, but presents a slice of black life as it is actually lived; and, in a curious way, Ed Bullins's "In the Wine

312

Time" turns out to be a far more serious indictment of white society than any polemic on the subject.

"In the Wine Time" had its premiere recently at the New Lafayette Theater, founded and directed by Robert Macbeth for Harlem. Last January, the company's previous home was gutted by fire; with the help of foundations and others, it was able to convert a movie house on Seventh Avenue near 138th Street into what may well be the handsomest Off Broadway theater in New York. And if "In the Wine Time" is any indication of the caliber of productions to come, the new Lafayette is on very solid ground artistically, too.

Bullins is a superb craftsman, and he has a wonderful ear for the language of the ghetto, which is almost always cartooned by writers, and hardly ever caught correctly. His most notable achievement, however, is the lack of self-indulgence in his writing, a flaw which many young artists insist upon today with impunity.

Comparisons come naturally to mind, though many young black writers nowadays feel that it is unfair for one to make any comparisons with white writers. That attitude, of course, is nonsense when techniques, form and structure have usually been learned from sources other than Afro-American. Mr. Bullins has learned a great deal from Eugene O'Neill and oth-

ers, and he has taken what he must wisely. But the author has quite a lot going for himself on his own terms. He has a deep sensitivity, love and understanding for his characters that enable him to present a rare thing, a truthful presentation of ghetto dwellers.

There is almost no plot to to "In the Wine Time." It concerns a day in the life of Cliff and Lou Dawson, husband and wife, and Lou's nephew, Ray. Cliff is a former Navy man of the sort who got constantly thrown in the brig for hard drinking and brawling. His wife is pregnant, and though she is not a nag, she is after him to find a job and stop chasing women. He has no qualms about striking her when he is displeased at any assertions she makes, however true they may be. Yet she married him because of his brawling. She thought wrongly that it signified he was a real man. Further conflict arises between the husband and wife over her nephew. Cliff urges the boy to drink the cheap wine they imbibe all day, and he also advises the boy in other matters, chiefly sexual.

However, much more happens in the play than the plot suggests. It is a verbal play, one of revelation, of life in all its horror, dullness and vitality. I was deeply moved by it. Threaded throughout the play are some wonderful touches that give it further authenticity — a nosy next-

door neighbor, two young boisterous couples, and other fine characterizations. A great deal of the dialogue is hilarious.

But then comes the ending (my only major criticism) and Mr. Bullins must have been thinking of a different play or, more likely, he did not trust his own instinct to let the play flow to a natural conclusion. He chooses suddenly to become melodramatic, and the shift does not fit the piece.

Nor is Robert Macbeth's direction always in the best interest of the play. At times the pace is too slow; at other times one feels that action is being created where it was not the playwright's intent. High above the stage and also extending out into the auditorium is a walkway on which some of the incidental action takes place rather distractingly. It seemed too remote and far away to be part of the play.

Mr. Macbeth has a fine talent for staging close, intimate scenes, but his larger, more active scenes sometimes become too expansive and his placement of characters seems awkward. But this is a new stage and, with this initial production, it is obvious that Macbeth was trying to explore all its possibilities.

The setting of a dilapidated two-family frame house by Roberta Raysor is magnificent, right down to the pretentious Venetian blinds in

the windows. All of the actors are first rate, especially Sonny Jim as the boisterous husband and Bette Howard as the level-headed wife.

"In the Wine Time," running through Jan. 19, should be seen by white as well as black audiences. It is not only relevant to the black experience, but to all experience. It has that quality called universality.

It was a source of black pride that the large first-night audience was composed almost entirely of black intellectuals under 40 (H. Rap Brown was there), with less than a dozen whites in attendance. Several years ago the audience would have been at least half white, with some white dignitaries presiding over an opening night ceremony. There was no ceremony.

I hope Ed Bullins remains his own man, true to his own artistic vision, and does not — as some of his contemporaries have — allow himself to be pushed into serving propaganda before he serves his full apprenticeship as a writer and thinker. He has a beautiful talent, the stuff that major writers are made of. Maybe someone should give him $10,000 with the stipulation that he leave the country for a year. Perhaps that way his anger might not be persuaded to turn into hate.

December 22, 1968

# Nudity: Barely The Beginning?

**By MARTIN ESSLIN**

LONDON.

At the highly respectable, not to say staid, Shakespeare Memorial Theater at Stratford-on Avon this year, history was made when, in Marlowe's "Dr. Faustus," the audience was shown not only the face that launched a thousand ships but her breasts and buttocks as well. This vision of Helen of Troy appeared clothed only in a tiara.

More and more, nudity seems to be invading the theater in our time. Is that a good thing or a bad thing

for art? Is it a symptom of declining morals? A sign of social decadence? One might well ask these questions, for one thing is certain: the new permissiveness in the theater is a significant development.

Of course, there has always been nudity in the theater. The art of stripping is one of the liveliest and oldest of folk arts. But it used to be confined to burlesque houses. What we have now is nudity in "artistically serious" drama: be it the nude scene in an avant-garde musical like "Hair" or the nearly 45 minutes that Sally Kirk-

land is nude in Terrence McNally's Off Broadway play, "Sweet Eros." Off Broadway, there is also Rochelle Owens's "Futz" and this week another play by Miss Owens, "Beclch," may shock the bourgeoisie with its infinite expanses of skin. In London, there are the nude *males* in John Herbert's play about homosexuality in a prison, "Fortune and Men's Eyes."

In trying to assess the significance of all this, we must clear our mind of some widespread misconceptions. Above all: the naked human body on a stage is *not* in itself erotically stimulating. On the contrary, anybody who has visited a nudist colony knows that complete nakedness, particularly in the mass, is positively anti-erotic in effect. The nude scene in "Hair," for example, is *touching* rather than titillating; it reveals the vulnerability, the helplessness

of the young people in the play, and arouses compassion rather than lust.

Nudity *can* be made stimulating, but then the whole trend of the play must work toward it, by creating a *situation* in which the nude body will appear as the culmination of erotic fantasy and desire. But once all this effort to build up a situation of this kind has been expended, the effect would be just as erotic, indeed *more* erotic, if the lady or gentleman in question were *not* completely nude.

Indeed, partial nudity, by setting off the audience's imagination, can be more stimulating than complete nakedness. I firmly believe that the strong taboo against complete nudity on the stage, which is now in the process of crumbling, was based more on the audience's embarrassment, its fear of witnessing the confusion and shame of

performers on the stage, than on any real fear that nudity would overexcite the spectators. To see an actress who looks beautiful in a lovely costume revealed as spindly legged or otherwise imperfect in figure is, after all, as embarrassing as seeing her forget her lines, or slipping on a banana skin during a sentimental scene. And the same is even more true of male performers: a pot-bellied hero would be ridiculous. How many good actors are there who could withstand that kind of ordeal?

What is it, then, that seems now to have weakened these resistances and taboos? Undoubtedly, the complete disappearance of legal restraints on the frank discussion and description of sexual matters in literature has been a decisive factor. If one can *read* all the physical and anatomical details on love affairs in books like "My Secret Life" or John Updike's "Couples," it becomes clearly rather silly not to have them enacted or presented on the stage as well. Moreover, in the age of the bikini and the topless waitress, life itself has preceded the theater. Nudity, or near-nudity, has become commonplace. We have become inured to nude scenes in the cinema, in advertisements, in magazines. Why should, how *could*, the theater lag behind? It was only the lingering aftereffect of puritanism, which always regarded the live theater with special fear

and surrounded it with specially severe legislation in the Anglo-Saxon countries, that could possibly have delayed the blossoming of nudity on stage as long as it has.

And now that it seems to be going, what effect will it have on the art of drama? My guess would be: not much. The theater has always contained a strong and healthy element of exhibitionism and voyeurism. We simply would not go to the theater if we did not have a desire to see beautiful human beings in the flesh. Beautiful people alluringly dressed never left much to the imagination. To see them in the nude will not give us much more beyond informing us of the exact shade of the color of their pubic hair. And this, in some cases, might be disillusioning.

And what about the sexual act? Kenneth Tynan was asked some time ago whether he would allow intercourse to be performed on stage. And he quite correctly replied: Yes, if it were artistically necessary. What he forgot to mention is, of course, that the sexual act *has* often been shown on stage. Take the bedroom scene in "Romeo and Juliet" where the lovers discuss whether the bird they heard was the nightingale or the lark. They are in bed, we know that it is their marriage night. What difference does it make that we are not actually getting the physical aspect of the act in close-up?

Seeing it would add nothing to the erotic atmosphere of the scene; on the contrary, it might destroy the illusion. And that is just one example: how many Feydeau farces are there where people are seen in bed! The actual physical detail, here too, is unimportant.

Where the enactment of sex *does* have a value is precisely in plays like Michael McClure's "The Beard," currently playing to full houses in London. Here it is not the sexual act, but the *unorthodox* sexual act — cunnilingus — which matters. The public display of a practice which many members of the audience indulge in themselves, but which they regard as deviant or specially sinful, must have a reassuring effect. If it can be shown publicly, it may not be quite as horrifically sinful as they had, in their tortured minds, believed it to be.

This also is the attraction — and therapeutic value — of the present spate of plays about homosexuality. If art can relieve guilt feelings, can relieve a sense of belonging to an outcast minority, this, in my opinion, is wholly to the good. For that, after all, is what art is about: to make us aware of the common humanity which unites us all, to establish genuine communication between human beings at the deepest level, that of shared emotion.

So, ultimately, the appearance of nudity on the stage

in serious drama is merely one, and a fairly belated, symptom of the sexual revolution of our time — which may well be a revolution as important and decisive as any political or social revolution of past ages.

\*

It is, after all, not the wickedness of the times which has led to a situation like the present confused state of permissiveness mixed up with remnants of puritanism, but rather the breakdown of the iron rules of the past (which, incidentally, were always observed more in their breach than in actual fact). Modern psychology, modern medical knowledge, the rise of science, the loss of faith in rigid ethical rules of all kinds—these are the real causes of the crumbling of ancient taboos.

What is needed is a new, humane, enlightened, rational system of sexual ethics, without fear of hell-fire, without guilt and shame. To evolve such a code we need, above all, free discussion and the maximum of knowledge. The various experiments of the artists, whether writers, painters, actors or directors, must be seen as attempts — however modest, however foolish, however misguided, however adolescent they may appear— toward that surely very necessary and desirable end.

December 15, 1968

---

# *Theater*

## 'River Niger' Is Rife With Solid Insights

RIVER NIGER, a play by Joseph A. Walker. Directed by Douglas Turner Ward; lighting by Shirley Prendergast; setting by Gary James Wheeler; costumes by Edna Watson; incidental music by Dorothy Dinroe; stage manager, Wyatt Davis. Presented by the Negro Ensemble Company, artistic director, Douglas Turner Ward, executive director, Robert Hooks. At the St. Marks Playhouse, 133 Second Avenue.

Wilhelmia Brown .......... Frances Foster
Johnny Williams ....... Douglas Turner Ward
Dr. Dudley Stanton ..... Graham Brown
Ann Vanderguild ...... Grenna Whitaker
Mattie Williams .......... Roxie Roker
Mo .................... Neville Richen
Gail ................ Saundra McClain
Skeeter ............. Charles Weldon
Al ..................... Dean Irby
Jeff Williams ........... Les Roberts
Voice of Lieut. Staples ...Morley Morsena

By MEL GUSSOW

Joseph A. Walker has written a powerful and compassionate new play in "The River Niger," which opened the season auspiciously at the Negro Ensemble Company last night. This is a family play, with a universality

that should make it relevant to white and black audiences, but it is firmly rooted in the contemporary black experience. The playwright knows his people and we grow to know them too, to understand their fears, appetites, frustrations and vulnerabilities. Some of the glimpses are so intimate that we feel like intruders.

•

The impact of the evening is a result not only of the play, but also of the production. Under Douglas Turner Ward's direction, and with Mr. Ward himself playing the pivotal role, the N. E. C. this time thoroughly earns the word ensemble in its title.

Mr. Ward plays Johnny Williams, a house painter and unpublished poet. His poetry is filled with passion and hope, as in the poem that gives the play its name, but his life is one of compromise and failure. He has sacrificed himself to support his family and transfers his deferred

dream to his son Jeff, a first lieutenant in the Strategic Air Command. The play is about Jeff's return to the family, which he later characterizes as "a homecoming to last myself a lifetime"—a series of collisions between generations, sexes, comrades, attitudes and philosophies.

The play is also about battlefields, where and how we choose to fight—or to lay down our arms. For Jeff's childhood friends, the battlefield is the street, the weapons are guns and dynamite. For Jeff, it is within society, with his mind—but not, he insists, as anyone's "supernigger."

Jeff's demand for individuality is counterpointed by his father's frustration. He is an old warrior, scared to death that his wife will catch him sipping whisky, when actually—as we know—his wife is his silent accomplice as he dodges reality. She would rather ignore her husband's dereliction than refuse

him his dignity.

Dignity is in abundance in the Williams household—and also humor. Everything is cut down to size, particularly by the mother-in-law. As played by Frances Foster, she is an impudent 82, an offender of the faith. Even when narrowing her eyes into an alcoholic glassiness of vision she adheres to first principles: "I calls 'em like I see 'em." And so does the playwright.

The play suffers only in that it tries to cover too much ground, to be too many things. Although the action takes place in one household, the events sweep from violence in Harlem streets to political activism in South Africa, and the characters cover three generations and a diversity of life styles and personal tragedies. In the end, the drama lapses into melodrama.

Some of the situations may seem familiar. They may in fact remind you of other plays, such as "Ceremonies in Dark Old

Men," but Mr. Walker has a distinct voice and his own sensitive awareness of what makes people different. The play is rich with character, atmosphere and nuance.

"The River Niger" is doubly rewarded by the performance. As director, Mr. Wards lets us slowly feel the ambiance of this home, and the actors offer us access to the characters' emotions. It is an excellent company—Graham Brown as Johnny's wily old crony, Les Roberts as the intense Jeff, Grenna Whitaker as Jeff's assertive fiancée, Neville Richen as the leader of a street gang.

The most memorable performances come from three N.E.C. veterans. Miss Foster, Roxie Roker and Mr. Ward. Miss Foster's part is the showiest, but she does not mock the lady, instead, keeps her tough and insolent. Miss Roker in the subtle role of the wife is gently affecting, receiving our sympathy by not playing for it. Mr. Ward's character is as full-bodied as his old barber in "Ceremonies in Dark Old Man," and he fills every inch of it, communicating the man's bravado and also his unswervable integrity.

At the preview I attended, the audience gave the play and the cast a standing ovation. They deserved it.

December 6, 1972

# The Unwanted People of 'Hot L Baltimore'

### By MEL GUSSOW

In his new play, "The Hot L Baltimore," Lanford Wilson writes with understanding and sensitivity about unwanted people. His characters are locked in interior worlds, clinging to solitary, futile dreams—and stubborn about not being defeated.

The play is filled with runaways—a brother and sister pair of urchins with a fantasy about organic farming in Utah, a young wanderer seeking a grandfather he has never met, a waif who can individually identify the far-off whistle of trains.

•

These characters and many more — from adolescence to senility — sit in, and pass through, the lobby of the condemned Hotel Baltimore, a hotel so derelict that the "e" has dropped out of its marquee (giving the play its title). Like the hotel itself, the characters belong to an immutable past where trains were on time and where playwrights could afford to be sentimental and unfashionable.

### The Cast

THE HOT L BALTIMORE, a play by Lanford Wilson. Directed by Marshall W. Mason; settings by Ronald Radice; costume coordination by Dina Costa; stage manager, Howard McBride. Presented by the Circle Theater Company. At 2307 Broadway.

| | |
|---|---|
| Bill | Judd Hirsch |
| Girl | Trish Hawkins |
| Millie | Helen Stenborg |
| Mrs. Bellotti | Trinity Thompson |
| Postman | John Heuer |
| April | Conchata Ferrell |
| Mr. Morse | Rob Thirkield |
| Jackie | Mari Gorman |
| Jamie | Zane Lasky |
| Mr. Katz | Antony Tenuta |
| Suzy | Stephanie Gordon |
| Friend | Burke Pearson |
| Paul Granger 3d | Jonathan Hogan |
| Mrs. Oxenham | Louise Clay |
| Rogers | Peter Tripp |
| Hack man | Howard McBride |
| Delivery boy | Marcial Gonzales |

There are moments in this play (and in his others) when Wilson—with his passion for idiosyncratic characters, atmospheric details and invented homilies—reminds me of William Saroyan and Thornton Wilder. The comparison is not at all to his disadvantage. He, too, is a very American playwright, with a nostalgic longing for a lost sensibility.

The Baltimore slowly awakens, not, as in "Grand Hotel," with international intrigue and high romance, but with everyday encounters and human comedy. The play unfolds until we feel the pace of the hotel and the pulse of the characters. As he had done before, the playwright overlaps conversations. Two, even three couples talk simultaneously—as in life. The dialogues start and stop together giving the play a musical flow.

The play seems to meander —it is a full three acts—and eventually a few of the guests become repetitive. There is little plot or action, but there is emotion. A brief altercation over a checkerboard becomes the sum of a generational conflict. At the playwright's invitation we share lives that are both comic and wistful. This is a play to be savored and to be cherished.

Wilson began his career off Off Broadway and since then he has had many plays produced on and off Broadway and in regional theaters. As is fulfilling a dream of one of his characters, he has returned to his off Off Broadway roots—as a resident playwright at the Circle Theater. He has bestowed his new play on the Circle, and Marshall W. Mason, co-founder of the company and, the most frequent interpreter of Wilson, has responded with a harmonious production.

Together with the set designer, Ronald Radice, Mason has turned the stage at the theater (comfortably refurbished since my last visit) into an authentically seedy hotel lobby, complete with buzzing switchboard, potted plants and what appears to be a marble staircase—a reminder of the Baltimore's elegant past.

The actors rise to the occasion. There is excellent work from, among others, Mari Gorman and Zane Lasky as the brother and sister, Judd Hirsch and Antony Tenuta as the harassed hotel manager, and Conchata Ferrell and Stephanie Gordon as contrasting resident whores. The pivotal character in this group portrait, the girl with the train fixation, is played with vivacity by Trish Hawkins. Listen to her recite the American cities she has visited, making each name sound freshly minted and bracing.

February 8, 1973

# The Stage: 'Streamers'

## Rabe Brings Vietnam Trilogy to a Close

### By CLIVE BARNES

With "Streamers," which opened last night at the Mitzi E. Newhouse Theater, David Rabe brings to a conclusion his Vietnam trilogy, which began with "The Basic Training of Pavlo Hummel" and continued with "Sticks and Bones." In some ways, this is the best play of the trio—although, surprisingly perhaps, it is the most conventional, the least adventurous. But it has a dramatic power

### The Cast

STREAMERS by David Rabe. Directed by Mike Nichols; settings by Tony Walton; costumes by Bill Walker; lighting by Ronald Wallace; production stage manager, Nina Seely. Presented by the New York Shakespeare Festival, Joseph Papp, producer, Bernard Gersten, associate producer. At the Mitzi E. Newhouse Theater, Lincoln Center.

| | |
|---|---|
| Martin | Michael Kell |
| Richie | Peter Evans |
| Carlyle | Dorian Harewood |
| Billy | Paul Rudd |
| Roger | Terry Alexander |
| Sergeant Rooney | Kenneth McMillan |
| Sergeant Cokes | Dolph Sweet |
| M.P. Officer | Arlen Dean Snyder |
| Hinson | Les Roberts |
| Clark | Mark Metcalf |
| M.P. | Miklos Horvath |

and, more significant, a dramatic idea that is absolutely a knockout.

What is violence? What is the concatenation of violence —what is the domino effect? No, not in Southeast Asia, but in the ordinary, deadly practices of everyday life? What are the promptings of seemingly illogical murder— the moment when mind and hands become derailed and irrational?

"Streamers" was first given by the Long Wharf Theater in New Haven last month, directed by Mike Nichols. Mr. Nichols, in this transfer for the New York Shakespeare Festival, has tautened the production slightly and made a few changes of cast. The results are notably improved—indeed, what seemed a fine staging in New Haven, looks exemplary in New York.

•

The play is oddly compelling—at first sight it seems like one of those World War II barrack-room dramas, full of bad language and worse machismo, with all the men showing lovable oddity and all too human vulnerability.

But Mr. Rabe's purpose is to show the face of violence. He takes the interlinking themes of two minorities— homosexuals and blacks— and indicates the sudden awful pressures that can detonate a disaster.

He offers as his symbol the army parachutist who careens to the ground when his parachute—for no very apparent reason—fails to open and becomes, in army lingo, a "streamer." We are all, Mr. Rabe is suggesting, subject to streamers, as people and—remember the moral pattern of this Vietnam trilogy—as a nation. Violence is, indeed, as American as apple pie.

Mr. Nichols has directed

the play as briskly and as efficiently as an army drill sergeant at basic training. Yet he has never forgotten the interplay and intercutting of Mr. Rabe's characters, the rich homosexual, the bright boy, the tolerant black, the bad black and two fat old sergeants, dim with alcohol and numbed with emptiness. All these are put together as an ensemble, and the result is engrossing. We seem to be watching real people rather than stage characters and, as a result—which is helped by Tony Walton's bleak designing—the melodramatic burst of blood at the end becomes as credible as a street accident.

●

The acting proved first rate. Paul Rudd's decently bewildered all-American kid, Terry Alexander's persuasively new-look young black, easy, tolerant but no Uncle Tom, Peter Evans's neurotic homosexual were all fine, as were the poetically sodden sergeants, Kenneth McMillan and Dolph Sweet. But what helped give the play a different dimension from the Long Wharf production was Dorian Harewood as the mean black, Carlyle. He was particularly brilliant in a cast that had no flaws.

Mr. Rabe has produced an unusually well-made play, and Mr. Nichols has staged it with understanding and subtlety. In the past—and even in the New Haven production of this play—Mr. Nichols's virtuosity as a director has been showing like a slip. Not here. At last, you have to think about his brilliance—it does not emerge in neon lights.

April 22, 1976

# THE CINEMA

### 'THE BIRTH OF A NATION.'

#### Film Version of Dixon's "The Clansman" Presented at the Liberty.

"The Birth of a Nation," an elaborate new motion picture taken on an ambitious scale, was presented for the first time last evening at the Liberty Theatre. With the addition of much preliminary historical matter, it is a film version of some of the melodramatic and inflammatory material contained in "The Clansman," by Thomas Dixon.

A great deal might be said concerning the spirit revealed in Mr. Dixon's review of the unhappy chapter of Reconstruction and concerning the sorry service rendered by its plucking at old wounds. But of the film as a film, it may be reported simply that it is an impressive new illustration of the scope of the motion picture camera.

An extraordinarily large number of people enter into this historical pageant, and some of the scenes are most effective. The civil war battle pictures, taken in panorama, represent enormous effort and achieve a striking degree of success. One interesting scene stages a reproduction of the auditorium of Ford's Theatre in Washington, and shows on the screen the murder of Lincoln. In terms of purely pictorial value the best work is done in those stretches of the film that follow the night riding of the men of the Ku-Klux Klan, who look like a company of avenging spectral crusaders sweeping along the moonlit roads.

The "Birth of a Nation," which was prepared for the screen under the direction of D. W. Griffith, takes a full evening for its unfolding and marks the advent of the two dollar movie. That is the price set for the more advantageous seats in the rear of the Liberty's auditorium.

It was at this same theatre that the stage version of "The Clansman" had a brief run a little more than nine years ago, as Mr. Dixon himself recalled in his curtain speech last evening in the interval between the two acts. Mr. Dixon also observed that he would have allowed none but the son of a Confederate soldier to direct the film version of "The Clansman."

March 4, 1915

# Our Domestic Movies and the Germans

### By BENJAMIN DE CASSERES

THE evolution of the American motion picture has been a logical and purely native development for twenty years. The logic of its growth has been the strictly mechanical logic that developed the automobile and the building of bridges. It has been as purely native as American magazine fiction or the best selling American novels.

The two outstanding features of the American motion picture have been—with five or six notable exceptions—total absence of epical and poetic imagination and the invariable happy ending.

Camera tricks are not imagination. A perfect technique in film cutting is not story telling. Action is not emotion. Mere sequence is not fatality.

The American creative mind is not imaginative. The American mind is Mark Twain and Bret Harte at their worst. It is a childish, slapstick, sentimental mind. Its notion of drama is physical crisis. It is an exuberant and hilarious liar.

All's well that ends well in the fifth reel, in the best of all possible countries, has been the formula of moving-picture producer, directors and scenario writers. They may not believe this privately, but their customers have demanded it—and their customers are the American people.

The happy ending is essentially American. In the American drama and the American novel this has been a veritable Eleventh Commandment. Thy hero and thy heroine shall iris out in a love clinch.

The motion picture had to follow the formula—or die. No 100 per cent. American believes he is going to die, that Virtue is not rewarded in this world, or that Vice and Villainy do not bite the dust. To suggest anything else is European, heretical, artistic, "decadent."

Formulas: The heroine must look like Little Eva, the hero must look like Little Lord Fauntleroy grown up into a Howard Chandler Christy manikin, the villain must look like Bill Sikes or an Italian bootlegger. There must always be a light in the window for No. 136 when he returns from State prison, and the wayward daughter must always be first soused up on cocktails by a married man in a New York "dive."

The sophisticated laugh at these things in the motion pictures. But they are really laughing at the American mind and its mental and emotional processes. The American motion picture has thus been a true reflector of ourselves. It has held the mirror up to the American nature.

No American newspaper—or any other newspaper in the world, as a matter of fact—would dare print all it knows, either editorially or in its news columns. Why, then, should the motion picture do it? In a country where there is a universal conspiracy of silence concerning things as they really are—with censors, paid and unpaid, standing by with clubs to enforce silence—why should the motion picture rush in where editorial writers and dramatists fear to tread?

What has been the effect of the German pictures on the hard-and-fast formulas of American picture production? That they have caused a tremendous mental and emotional commotion in the greatest of American amusement enterprises one can feel by being present at any place where motion-picture people congregate. Conversation has not progressed for ten minutes when the latest German film becomes the crux of the talk. What do you think of Pola Negri? Of Mia May? Of Ernst Lubitsch? Of Joe May? Of Emil Jannings? Of Paul Wegener? Of Dagny Servaes? Of Henny Porten? Who is the greatest director—Lubitsch or May? Does Lubitsch achieve better mob effects than Griffith? Camera work, lighting, architecture, sets—all these are overhauled and dissected for the thousandth time.

"Doctor Caligari" was a flat failure financially. But it has almost become a classic. Wherever motion-picture people talk the word "Caligari" is always heard. It has led to fisticuffs. If you want to "start something," mention "Caligari." This astounding product of the motion-picture art has jolted the average American motion-picture mind more than all the other foreign pictures combined. No American producer would have dared it. But its influence is already apparent in some of the pictures we are making. To me it is the greatest motion picture ever made, and will probably stand alone for some years to come.

Then there were "Deception," "Passion," "The Golem," "All for a Woman," "The Last Payment," "The Red Peacock," "The Loves of Pharaoh," "The Mistress of the World"—an imaginative thriller that outdoes anything ever done over here—with great spectacles and plays like "The Indian Tomb," "The Triumph of Truth" and "The Hangman," yet to come. These are nearly all Famous Players' productions.

The influence of the German films has mainly been in the direction of rousing the American producer's imagination. "Always audacious!" seems to be the motto of Europeans in all branches of creative art. "Always safe and sane!" seems to be the motto of all American art. This distinction is nowhere more apparent

than in the motion pictures we produce here. Our most daring picture was " The Birth of a Nation." This is really our one native epical contribution to pictures. Lubitsch has confessed that this picture influenced him tremendously—as indeed it influenced all German motion-picture production.

Mr. Robert Kane, general production manager of the Famous Players, is supervising the editing and titling of these German films. These pictures came to this country and were evidently produced in Germany in a shape that the most amateurish of American picture " fans " would laugh at. Some of them must have taken all day to show.

" In these German pictures," said Mr. Kane, " it is the Teutonic mind that we have to struggle with. The German mind cannot condense. It is prolix. It must put every detail of the story as originally written in novel form on the screen. Editing seems to be a totally unknown art in the film studios of Germany. It is as though a newspaper should print every word in all The Associated Press stuff that comes over the wire at night—just slap it in. That's the way they slap everything on the screen over there. Our task is to boil these stories down to from five to nine reels without losing the ' guts ' of the story and keeping the beautiful ' shots ' intact. It is often a herculean task.

" ' The Mistress of the World,' as it came to us originally, was in fifty-four reels, with 94,000 feet of stuff that we could not use. It took four months of work to cut it to twenty reels, put titles on it which match up with the action and strike the Ameri-

can tempo.

" ' I am free to admit that these German films that we are putting on have had, in spite of their enormous defects of technique in story telling, close-ups and fadeouts, a great educational value on all of us who are working in the third—and to me the greatest—mode of teaching and amusing—I mean the eye. There are three modes of producing art—the lips, the mouth and the eye. The lips give us oral literature; the hands, writing and painting and sculpture; the eye gave us the motion picture. Through the motion picture the eye will become the great educator.

" These German films excel in pictorial effect because artistic Europe has eyes. Europe is all color, scenery, variety, a clash of cultures. She is theatrical—she is always looking for ' effects.' It is the continent of the picturesque. All this has flowered in her imagination.

" And it is just here that pictures like ' Doctor Caligari,' ' The Mistress of the World,' ' The Golem,' ' The Loves of Pharaoh,' ' The Triumph of Truth ' and ' The Indian Tomb ' are having their effect on American producers and directors. We need better and greater stories and more imagination in their treatment. We need more of the bizarre, the grotesque, the exotic in our productions —but always retaining those things that we have achieved and that every motion-picture producer in Europe admits that we excel in—story telling, mechanical technique and picture tempo.'

" Do you think that the penchant of the German producers for histori-

cal subjects will affect the character of the stories that we film here? "

" Yes," replied Mr. Kane. " Historical pictures like ' The Golem,' ' Deception ' and ' The Loves of Pharaoh ' have a great educational as well as an entertaining quality. The eternal story of the calf love of Jack and Jill is beginning to wear. If every child under our compulsory system of education is compelled to study history, why shouldn't that child be interested in history when seen as action on the screen?

" The German producers are, however, in an advantageous position when it comes to producing historical pictures. They can produce a great historical picture in Germany for $200,000. The same picture could not be produced here for anything near that figure. We want to do, we can do, all those things that the Germans are doing—but the outlay is so stupendous that the success of the experiment must be assured before we begin. It is as great a risk as starting a great metropolitan newspaper—something that has not been attempted for many years.

" In some pictures the Germans, like the French and Italians, go the limit. I have seen films built on some of the stories of Sudermann and Hauptmann—some of them great, moving, pathetic stories—that could not pass a blind censor in any Anglo-Saxon country. In most of the films that we are producing dozens of ' shots ' must be eliminated. They are the last things in the risqué.

" There is one thing, though, in the German pictures that will never influence us over here—that is what

the Germans call ' comedy.' The German sense of humor is perverse where it is not just cheap slapstick. At least it seems so to our eyes. When we laugh at their ' comic ' actors in our projection rooms it is not at their comedy, but their attempts at it."

As to the talk of " German propaganda," I can personally say, after analyzing the German pictures that I have worked on for more than a year, that it is pure pish-posh. Artistic propaganda—yes, maybe. But intelligent people never had a grievance against the artistic activity of the Germans. Personally, I think we have a great deal to learn from them—in the matter of music, beer and motion pictures.

Edwin Björkman, whose " The Soul of a Child " was recently published, was born in Stockholm, Sweden, in 1896. He came to this country in 1891, spent most of that year in Chicago, thereafter settling for five years in St. Paul and Minneapolis, and moving in 1897 to New York, where he has lived since. He has made translations of plays by Strindberg, Björnson, Bergstrom, Schnitzler, Heiberg and Gustaf af Geijerstam, and is the author of " Is There Anything New Under the Sun? " " Gleams " and " Voices of Tomorrow."

March 26, 1922

---

# THE SCREEN

NANOOK OF THE NORTH, produced by Robert J. Flaherty, F. R. G. S., for Revillon Freres; " My Country," one of Robert C. Bruce's " Wilderness Tales," held for a second week. At the Capitol.

If a man goes among a strange people whose life is reduced to an elemental struggle for existence, if he has the disposition to photograph these people sympathetically, and the discernment to select his particular subjects so that their life in its relation to their opposed environment is illumined, the motion picture which he brings back may be called " non-dramatic " only by the acceptance of the trade's arbitrary use of the term. Such a picture has the true dramatic essentials—and such a picture is Robert J. Flaherty's " Nanook of the North," which is at the Capitol this week.

Beside this film the usual photoplay, the so-called " dramatic " work of the screen, becomes as thin and blank as

the celluloid on which it is printed. And the photoplay cannot avoid the comparison that exposes its lack of substance. It is just as literal as the " travel " picture. Its settings, whether the backgrounds of nature or the constructions of a studio, merely duplicate the settings of ordinary human experience—or try to. And its people try to persuade spectators that they are just ordinary people, ordinary, that is, for the environment in which they happen to be placed. So the whole purpose of the photoplay, as a rule, is to reproduce life literally. And this is the purpose of the travel film. But the average photoplay does not reproduce life. Through the obvious artificialities of its treatment, through the unconcealed mechanics of its operation, through its reflection of a distorted or incomplete conception of life, rather than of life itself, it usually fails to be true to any aspect of human existence. It is not realistic in any sense. It remains fiction, something fabricated. It never achieves the illusion of reality.

But " Nanook of the North," also seeking to give an impression of reality, is real on the screen. Its people, as they appear to the spectator, are not acting, but living. The struggles they have are real struggles. There is no make-believe about the conflict between them and the ice and snow and wind and water that surround them. When Nanook, the master hunter and

a real Eskimo, matches himself against the walrus, there is no pretense about the contest. Nanook's life depends upon his killing the walrus, and it is by no means certain that he will kill him. Some day he may not. And then Nanook will die. So the spectator watches Nanook as a man engaged in a real life-and-death struggle. And how much more thrilling the sight is than that of a " battle " between two well-paid actors firing blank cartridges at each other!

And people want character in their hero, courage and strength, quick and sure resourcefulness and, for them, a friendly disposition. They have all these things in Nanook when he faces a Northern blizzard, when he harpoons a giant seal, when he builds an igloo, when he stands on a peak of ice directing the movements of his followers. He is emphatically a leader, a man, who does things, a man who wins but who, at any moment, may lose. He is a genuine hero then, one who is watched with alert interest and suspense and far-reaching imagination. What " dramatic " photoplay can show such a one!

Nor is he alone. His family, his wife, his children, his dogs, and the paraphernalia of his life are around him. So he is not isolated. The picture of his life is filled out, humanized, touched with the humor and other high points of a recognizably human existence. Thus

there is body, as well as dramatic vitality, to Nanook's story. And it is therefore far more interesting, far more compelling purely as entertainment, than any except the rare exceptions among photoplays. No matter how intelligent a spectator may be, no matter how stubbornly he may refuse to make concessions to the screen because its pictures are " only the movies," he can enjoy " Nanook of the North."

And this is because of the intelligence and skill and patience with which Mr. Flaherty has made his motion picture. It took more than just a man with a camera to make " Nanook of the North." Mr. Flaherty had to wait for his light, he had to select his shots, he had to compose his scenes, he had to direct his people, in order that Nanook's story might develop its full force of realism and drama on the screen. So it is due to Mr. Flaherty that Nanook, who lives his life by Hudson Bay, also lives it at the Capitol.

Also at the Capitol, held over for a second week and well deserving the distinction, is the third of Robert C. Bruce's " Wilderness Tales," entitled " My Country." Mr. Bruce's country is the Far Northwest, and as he revels in it many will envy him his possession of it.

June 12, 1922

---

# THE SCREEN

### By MORDAUNT HALL.

**Frank Norris's "McTeague."**

GREED, with Gibson Gowland, Jean Hersholt, Chester Conklin, Sylvia Ashton, ZaSu Pitts, Austin Jewell, Oscar and Otto Gottel, Jan Standing, Max Tyron, Frank Hayes, Fanny Midgley, Dale Fuller, Cesare Gravina, Hughie Mack, Tiny Jones, J. Aldrich Libbey, Rita Revela, Lon Poff, William Barlow, Edward Gaffney, S. S. Simonx and others; adapted from Frank Norris's "McTeague," directed by Erich von Stroheim. At the Cosmopolitan.

The sour crème de la sour crème de la bourgoisie, and what might be its utterly ultra habits, were set forth last night before an expectant gathering in

the Cosmopolitan Theatre in the fleeting shadows of the picturized version of Frank Norris's "McTeague," which emphasized its film title of "Greed." The spectators laughed, and laughed heartily, at the audacity of the director, Erich von Stroheim, the producer of "Foolish Wives," and the director who was responsible for part of "Merry Go Round." Last January this picture was thought by its director to be perfect in forty-two reels, which took nine hours to view. He capitulated to its being cut down to about 30,000 feet, and is said to have declared that any audience would be content to sit through six hours of this picture. However, it was cut to less than half that length.

It is undeniably a dramatic story, filled with the spirit of its film title, without a hero or a heroine. The three

principals, however, deliver splendid performances in their respective rôles. Gibson Gowland is unusually fine as McTeague; but from beginning to end this affair is sordid, and deals only with the excrescences of life such as would flabbergast even those dwelling in lodging houses on the waterfront.

Mr. von Stroheim has not missed a vulgar point, but on the other hand his direction of the effort is cunningly dramatic. There is McTeague, who graduates from a worker in the Big Dipper Gold Mine to being a dentist without a diploma. He hails his new work with silent satisfaction, and when Trina Sieppe, Marcus Schouler's sweetheart, comes to his "painless parlors," he examines her teeth, informing her in due time that she must have three of them extracted and put in a bridge. The cost immediately enters her mind, but finally there is acquiescence, and she succumbs to the ether. McTeague gazes upon her quiescent countenance, and then, after fighting against his desire, he kisses her.

Sometime afterward he tells Marcus that he is in love with Trina, and the latter surrenders his sweetheart, who on the morning she went to McTeague's parlors had bought a chance in a lottery, the high prize of which was $5,000. Soon after this one hears that Trina has won the $5,000, and Marcus's countenance is black and ominous. Then follows an obnoxious wedding scene with grotesque comedy. Hans Sieppe, the bride's father, insisting on drilling the figurantes, even to chalking marks on spots for them to stand on. Mr. von Stroheim outdoes himself in the wedding breakfast sequence, as the participants at the meal all attack the edibles in a most ravenous manner, the male element being protected from their ignorance of etiquette by napkins tucked around their necks.

In the struggle for existence Mrs. McTeague clings to her $5,000 even after McTeague is forbidden to practice dentistry and is forced to seek his livelihood as best he can. She gradually becomes a miser, counting her gold on her bed and concealing it in her trunk as fast

as she can when she hears her husband's heavy tread. Then she grows eager for every penny she can extort from him, going through his pockets when she knows by his breathing that he is asleep.

It all ends as might be anticipated—in the murder of the woman by McTeague, who escapes to Death Valley with the sack of golden coins, which his wife had polished with such meticulous care night after night.

Marcus, who, in spite of protestations of friendship had never forgiven McTeague for depriving him of the $5,000, is one of the first to read of the reward offered for the murderer. It is not long before he and a posse are plunging forth into the sun-scorched desert in search of their quarry. The Death Valley scenes are stark reflections of what happen in such circumstances and true to Frank Norris's story. Mr. Gowland gives a realistic portrayal of a man struggling along on the hot sands with the blazing sun overhead. He has the gold. He has killed his wife. And Marcus is after him! The climax is not only mindful of Frank Norris's story, but also of Jack London's "Love of Life." Mr. von Stroheim has introduced situations which make the fight for existence still stronger in its appeal than one would have imagined. Fancy two men struggling in the desert suddenly seeing the only possible chance of life—water—being carried away by a frightened mule!

Irving Thalberg and Harry Rapf, two expert producers, clipped this production as much as they dared and still have a dramatic story. They are to be congratulated on their efforts, and the only pity is that they did not use the scissors more generously in the beginning.

Mr. Gowland slides into the character and stays with it, and in spite of McTeague's aggressiveness and obvious hot temper, he and his wife are the only characters with whom one really would care to shake hands. Mr. Gowland is clever in his exhibition of temper and wonderfully effective in the desert scenes with his sweaty arms and bleary eyes.

Marcus Schouler is impersonated by Jean Herscholt, an efficient screen actor, but in this film he is occasionally overdressed for such a part. His rôle also calls for demonstrations which are not always pleasant. ZaSu Pitts portrays the rôle of Trina, into which she throws herself with vehemence. She is natural as the woman counting her golden hoard, and makes the character live when she robs her husband of trifling amounts. The other members of the cast are capable.

December 5, 1924

# Art, as Applied to Films, Discussed by Miss Gish

### By LILLIAN GISH.

PERHAPS the chief handicap under which motion pictures presently labor is the overenthusiasm of their more conspicuous champions. The latter are determined that the motion pictures shall fall into the category of the fine arts, and the motion pictures, grateful as they should be for the compliment, suffer from the burden of importance thus placed upon them and the heroic and understandable effort completely to justify themselves in their champions' eyes. The word art, it seems to me, is the most carelessly handled word in our language. Interest and beauty in themselves no longer suffice to satisfy persons; austere labels must be pasted upon them. We are not content to accept things, however estimable they may be in their several and diversified ways, for what they actually are; we must constantly invest them with a spurious dignity and elect them to a metaphorical Legion of Esthetic Honor.

What if motion pictures are or are not art? It is as easy to prove that they are art as it is to disprove. But such devices, I believe, are futile, save by way of gratifying a more or less human disposition to have others regard one's own particular work in the world as something of perhaps greater importance than it really is, and that we in ourselves know it is. What is art? Art is simply beauty reflected through a beautiful fancy. There are moments in moving pictures—moments only, it may be—when the moving pictures thus fall within the definition. There are hours—many hours, one fears—when, by the same definition, they fall far outside the pale, just as drama and painting and sculpture and music at times similarly do. If the moving pictures are not art because of a thousand cheap moving pictures, then painting is not art because of a thousand Greenwich Village daubs, and music is not art because of a thousand "Yes, We Have No Bananas."

#### Power of Silence.

Drama is art, they tell us, and motion pictures are not. It appears that the latter cannot be regarded as art because they lack the human voice that is drama's instrument. Furthermore, are not some of the finest and greatest moments in drama the silent moments, the moments when not a word is spoken and when the ache or joy, the pain or the ecstasy of human beings is expressed by the features and movements of the characters alone? Again, what if drama were converted into moving pictures with absolute and undeviating faithfulness to the text? This is surely possible, even if it is not a common occurrence. What we get, or may get, is drama read to an audience by silent actors as, in the library, it is read to an individual by the silent actors who walk the stage of his imagination. Again, if motion pictures lack the third dimension, so does painting. If they haven't intellectual content, neither has much of what is agreed to be the world's best drama. If they can be enjoyed by children, so can "Huckleberry Finn" and "The Mikado."

As I have said, although such arguments may be superficially diverting to persons who look on art as a debating platform rather than as a source of beautifully experienced emotion, they are a mere waste of time. Call the moving pictures what you will, they sometimes induce such emotions, and, by their own confessions, in the hearts and minds of cultured men and women. Not too often, I know; but a thing is to be judged fairly not by considering it in its lowest manifestations but in its highest. The Alps are not all Matterhorns.

#### A Few Pointed Comments.

Although the first short commercial moving picture, "The Kiss," was produced in 1896, the first real motion picture, as we know motion pictures today, "The Great Train Robbery," was produced only twenty-three years ago. In these twenty-three relatively short years, the motion picture has advanced a hundred times more greatly than architecture advanced in its first countless aboriginal centuries. If it does not deserve yet to be called an art, may it not conceivably be an art in time? Doesn't such a picture as "The Last Laugh" begin to show the way? Hasn't it sound beauty, sound form, a powerful and intelligent emotional content? Isn't it acted as well as the best drama played during the same year that it was shown? Isn't it as intelligently moving? Aren't its roots as deep in human life?

The aim of the moving picture isn't to uplift the mind any more than the aim of drama is. Like the drama, it isn't designed to teach, but only to make men and women reflect upon what they already know, and in their reflection differentiate between nobility of thought and emotion and meanness of thought and emotion. This aim, the best of motion pictures, as the best of drama, set themselves to realize. The battle ahead of the pictures is not an easy one, but I feel that they have the courage and resource within them to hazard it. There will be many casualties; there will be many defeats; but I believe they will triumph some day. And they will triumph not because some one has called them an art or not an art, but very simply because, at bottom, they have the same materials to work with that drama has. Let us remember that even now experiments in talking pictures are progressing. And let us remember, too, that if the motion picture is silent, and hence, according to some, not to be considered as an art, so also are Michael Angelo's "Moses," Tintoretto's "Miracle of the Slave," the Beauvais Cathedral, "L'Enfant Prodigue," Joseph Conrad's "Heart of Darkness" and a sunset over London Bridge.

September 26, 1926

# EMERGENCE OF MOVIES AS A DISTINCTIVE ART

RALPH BLOCK, editor-in-chief of the Paramount Studio, Astoria, has in the current issue of The Dial an unusually interesting discussion on motion pictures. The article is headed, "Not Theatre, Not Literature, Not Painting," and in the course of his analysis, a very clever one. Mr. Block says that primitive art is usually recognized as art only after it has become classical. He also follows this up with the assertion that in the manner of all primitive expression, the movies violate accepted contemporary canons of taste.

While he praises Chaplin by asserting that the comedian touched the edge of irony, true irony, in "A Woman of Paris," Mr. Block opines that Chaplin's forms were conventional and worn, cast in the clichés of ironies of cheap fiction.

"An art may have a large body of esthetic tradition and be moribund," writes Mr. Block. "It may have none to speak of and be very much alive. The movies are this kind of art. It is not possible to understand them, much less truthfully see them, within the limitations, judgments and discriminations of the esthetic viewpoint. The movies are implicit in modern life; they are in their very exaggerations—as a living art often may be—an essentialization of that which they reflect. To accurately size them up, they should be seen functionally, phenomenalistically, in relation to their audience."

Mr. Block avers that, like music, painting and the drama in their primitive stages, the movies are manifestations in some kind of esthetic form of a social will and even of a mass religion.

"The movie is a primitive art, just as the machine age is a new primitive period in time," says Mr. Block. "But being a machine, the motion camera is not a simple instrument. Like the pianoforte, it is an evolved instrument, predicated on the existence and development of other forms. It is itself still in an evolving state. Indeed, those who make use of it and those who appreciate it without empirical knowledge of its use have failed to grasp, except in a loose intuitive sense, a full understanding of the complicated laws that govern it.

#### Pantomime and Pantomime.

The writer says that it is fashionable to say the camera is impersonal, but that those who use the camera know this is untrue. "Indeed," he asserts, "even abstractly, it is no more impersonal than a steel chisel or a camel's hair brush. The camera is, on the one hand, as intimate as the imagination of those who direct it; on the other hand, it has a peculiar selective power of its own."

"Experience," continues Mr. Block, "rather than theory, has taught many actors on the screen the need of plasticity, composure, modulation of gesture and an understanding of how to space movement—a sense of timing. The screen actor at his best—the Beerys, Menjous and Negris—tries to give fluency to pantomime so that action may melt out of repose into repose, even in those moments when an illusion of arrested action is intended. He recognizes that against his own movement as a living organic action is the cross-movement of the celluloid. It is only by long experience that the motion picture actor discovers a timing which is properly related to the machine; but the experience has already produced screen pantomimists whose rythmic freshness

and vitality the modern stage can rarely match.

### Techniques of Living Attitude.

"Good motion picture direction has little to do with literacy or cultivation in its conventional sense. Several of the most cultivated and literate gentlemen in the movies are among the most prosaic directors. They have brought with them a knowledge of other arts, which has blinded them to the essential quality of the camera. They think of the movies as a form of the theatre, of literature or of painting. It is none of these things. It demands at best a unique kind of imagination which parallels these arts but does not stem from them. It is true that the rigid economic organization of the modern studio demands the same kind of prevision and preparation on the part of the director as on the part of any other creator. Even aside from urgencies of this kind, the St. Clairs, Lubitschs, Duponts, Einsteins are under the same imaginative necessity to organize their material as a Cézanne or Beethoven. But there the similarity ceases. Directors of this kind know that their greatest need is the power to ..ze reality—in its widest sense—and make it significant in forms of motion. This power, this understanding, is a gift by itself."

"The movie is in other words a new way in which to see life," declares this expert. "It is a way born to meet the needs of a new life. It is a way of using the machine to see what the machine has done to human beings. It is for this reason that the best motion picture directors arise from strange backgrounds, with a secure grasp on techniques of living rather than on academic attitudes. They are not always preoccupied with proving that life is so small that it can be caught in the net of art. It is the pragmatic sanction hovering over them which offends academicians.

### Faint Praise.

"Here and there are indications that the movie is arising out of its phenomenalistic background into the level now occupied by the novel, and the theatre, touched by the same spirit of light irony, and predicating the orientation of a special audience."

But there are no signs at this moment that it can rise higher than this point. Pictures such as 'The Cabinet of Dr. Caligari,' are interesting laboratory results in experimental psychology, but they have as little to do with the direct succession of the motion picture as Madame Tussaud has to do with Rodin. 'The Last Laugh' and 'The Battleship Potemkin' are technical explosions, important only in their power to destroy old procedures and light the path ahead.

"American directors have always mistaken cruelty on the one hand and sentimental realism on the other for irony. Satisfaction for the sadistic hunger of the crowd is present in almost all popular entertainment. Griffith early understood this crowd desire, and his technique in exploiting it has filtered through a thousand pictures since. De Mille, Von Stroheim, Brenon. and the many unnamed have all used it in one form or another. Bu none has reached the irony empty of brutality—an unobstructed godlike view of the miscalculations of existence, yet touched by human compassion. There are no Hardys or Chekhovs in the movies. 'The Last Laugh' dribbled out into German sentimentality, although in substance it seemed familiarly like one of Constance Garnett's translations. The comedians, Keaton, Langdon, as well as Chaplin, have touched near the edge of true irony, but only as children might. Chaplin rose to the intention in 'A Woman of Paris,' but his forms were conventional and worn, cast in the clichés of ironies of cheap fiction.

"In the end, what remains wonderful about the movie is its instrument. Its ideas are still sentimental or bizarre, reflecting the easy hungers of life, and of today's shifting surface of life; it fails as yet to draw from the deep clear wells of human existence. Aside from its need of another kind of audience—even another world, a deep ironic point of view in the motion picture would require a great individual spirit equipped with a true knowledge of the medium. And none of this kind has arisen. He is rare in any art at any time.

*February 6, 1927*

## Music and Cinema

The relationship existing between music and the cinema was explained recently by S. M. Eisenstein, the director of "Old and New," the Russian film now at the Cameo, who said:

"In instrumental music there are the so-called overtones and undertones resounding along with the basic tones. In optical phenomena we may observe similar tonal byproducts of the main or basic appearances.

"Conservative composers consider the overtones and the undertones as elements tending to vitiate the pure acoustics; but modern composers like Debussy and Skriabin turn the overtones to good account by way of creating various shadings and expression.

### A Tradition Violated.

"The same may be said about filmcomposers; it is the tradition in cinematography to mount sequences with a view of expressing only the dominating, the significant moments.

"In our new film, 'Old and New,' we deliberately violated that tradition by attempting to mount our 'shots' with a view to producing the effect of visual overtones and undertones. We tried to accomplish this effect not only through the proper sequence of 'shots' but also and mainly through the right cadence in the very movement of the film. Our departure from tradition is thus a departure into the fourth dimension, with the time factor lending a new aspect to the three-dimensional reality. By means of the film camera which is a kind of time-and-space recorder we will soon be able to orientate ourselves easily in the fourth dimension of cinematography."

*May 11, 1930*

## THE SCREEN
### By MORDAUNT HALL.

#### Mr. Jannings and Miss Dietrich.

THE BLUE ANGEL, with Emil Jannings, Marlene Dietrich, Kurt Gerron, Rosa Valetti, Hans Albers, Eduard V. Winterstein, Reinhold Bernt, Hans Roth, Karl Hussarr-Puffy, Wilhelm Diegelmann and others, based on a novel by Heinrich Mann, directed by Josef von Sternberg and supervised by Erich Pommer; Paramount news; "Go Ahead and Eat," an audible film comedy. At the Rialto.

In a film tragedy titled "The Blue Angel," which was directed by Josef von Sternberg in Berlin for Ufa, that talented German screen player Emil Jannings, who left Hollywood because of the vocalizing of pictures, makes his first appearance in a talking production. Marlene Dietrich, the attractive Teutonic actress who is to be seen at the Rivoli in Mr. Sternberg's "Morocco," shares honors with Mr. Jannings in this foreign work.

The plot of "The Blue Angel" recalls that of "The Way of All Flesh," Mr. Jannings's first American silent film, but in this current chronicle, instead of being a bank employe, Mr. Jannings impersonates a professor of English literature in a German boys' high school. The story is cleverly told in most of the sequences, while penultimate scenes would be all the better if they were curtailed or modified, as the actual ending is quite impressive.

The fall from grace of an elderly man is a favorite theme with Mr. Jannings, one that has served him in most of his films since the making of "The Last Laugh." As the characters here are different, however, the interest is rekindled and the broken English of the persons involved is accounted for with a certain crafty logic.

As an actor who speaks his lines, Mr. Jannings is perhaps even better than he was in his mute productions, for the speech to a great extent governs his actions and it stays him from his penchant for unnaturally slow movements. There are times here when no words pass the lips of the characters for uncomfortable seconds, but the final analysis is that it is a decidedly interesting picture with exceptionally fine performances contributed by Mr. Jannings and Miss Dietrich, the latter being much more the actress than she is in "Morocco."

Professor Immanuel Rath's (Mr. Jannings) humdrum existence is ably stressed. The landlady where he lives knocks on his door at the same time every morning and announces that his breakfast is served. As the hour of 8 rings out from the old clock tower the professor always is crossing the street or entering the school building. He, for some reason or other, omits the greeting of "Good morning" to his pupils, who stand when he enters the classroom and only at his bidding take their seats. As a professor of English he insists on English being spoken. He is a man without a sense of humor, careful about his attire and stolidly opposed to the students betraying any mirth or glee. His curiosity concerning the youngsters who frequent the cabaret, "The Blue Angel," is aroused by finding in his classroom picture postcards of the stellar feminine performer at that gay resort. She is known as Lola Frohlich (Miss Dietrich), who is supposed to be an English singer.

Lola is a rather taciturn creature, but occasionally she reveals subdued enthusiasm, coupled with a dry sense of humor. It is not unfunny to her to have the professor looking for his students in her dressing room, particularly when three or four of them flee after being warned that the pedagogue is in the offing. One evening, however, when the youths are hiding in a cellar, Lola, after the professor has resented the conduct of another man toward her, hears that the police are on the scene, and the urbane Rath also takes refuge in the retreat afforded his pupils, who incidentally have lifted the cellar covering and have been watching with keen amusement the professor's admiration of Lola.

Once in the cellar with the young scapegraces, the professor is a target for ridicule and blows. The result is that when he, following a night away from his own abode, arrives late at his classroom, the pupils revolt and the noise they make is heard throughout the building, with the consequence that Professor Immanuel Rath is asked by the school principal for his resignation.

But all is not lost for the disgraced professor, for Lola becomes his wife. There follow time lapses in which one perceives the professor turned into a clown, wearing a false nose and a ridiculously large collar. This goes on until he eventually becomes insane, imitating the crowing of a rooster, which he had once done for a laugh in his rational days. While the professor is on the stage as the foil for a conjurer, Lola is enjoying the attentions of a lover, and she is observed by her elderly spouse. It is then that his senses leave him, and he eventually staggers over to his old classroom and dies at his desk as the bell in the old clock tower is striking the hour.

Not only is Mr. Jannings's and Miss Dietrich's acting excellent, but they are supported by an unusually competent cast.

Having quite a good story, Mr. von Sternberg's direction is infinitely superior to that of "Morocco," and the settings for this film are very effective.

*December 6, 1930*

# THE CINEMA IN THE FRENCH CAPITAL

## Rene Clair's New Talking Picture, "A Nous La Liberte," Mystified The Critics at First Showing

PARIS.

AFTER slumbering for several months, the native motion-picture producers awakened one morning last week to find Paris the centre of all cinematographic attention in Europe. Directors from every city, with their stars, came to the Champs-Elysées for the première of René Clair's third talking film, "A Nous la Liberté."

The vogue for the work of this director, created by his previous "Sous les Toits de Paris" and "Le Million," is at its height, so that expectation for the new film was great. Tout Paris came out for the event which was widely ballyhooed.

Preliminary press reports had stated that the young director was still searching for a new form in "A Nous la Liberté." They also said that, dissatisfied with the distended effects of his first two productions in sound, he was now embarking on a trail which might lead to a definite pattern for his future work.

Small wonder it is, then, that during the hour following the last scene, the lobby was jammed with excited representatives of film companies from various parts of the world who were sending detailed telegrams that evening of what new ideas Clair had brought to the screen.

Just as at the crowded press showing of a week previous, however, no two persons had a similar impression of the film. Having been the only American journalist invited to the trade showing, I had listened with interest to the critical comments evoked. If he had done nothing else, the director had mystified the critics. So he bewildered the first-night audience.

### Writers Are Puzzled.

On all sides one hears the question of what did Clair mean by his film. Is he poking fun at the films? Is he embittered against life? Has he let his sense of fantasy get out of hand? Or is he still groping for a medium by which he can compress his dreams into the demands of the motion picture?

His tale, from his own pen, is simple. The opening of the film finds Emile and Louis as convicts. The entire life of the prison is given a definite tempo, such as Clair gave "Le Million" by monotonous hammering effects. Louis escapes and eight years later is found as the director of a large phonograph factory. The prison is changed into an industrial enterprise. The monotonous effects continue and the former prisoners are now laborers. Emile enters the factory as a workman and soon discovers his former cellmate. They again become cronies. But other of the convicts discover the director and reveal his identity to the police as he is inaugurating a new factory and being proclaimed one of the leading citizens of the country. He abandons his business and together with his friend takes to the open road singing "A Nous la Liberté."

The public cheers portions of the film, such as the capture of Emile by factory foremen, who insist that he must work even though he prefers to tramp the countryside; or when the orators are eulogizing Louis's career as the police are assembling to arrest him. But the glimpses which still bring Clair nearest to the cinema public are those when he allows his sense of humor to run loose. Two such scenes, although prolonged as they were in "Le Million," throw the house into hysterics at every performance.

A long bench in the factory is shown where every laborer has his dull task of placing one rivet into a phonograph panel. Attracted by a girl, Emile misses his chore and then scrambles madly through the line to place his rivet. The whole factory is thrown into confusion as every workman tries to make up for the gap.

There are the chase flashes such as Clair has always employed. And one of his most ironical moments comes when prominent government and civic officials forget their sense of ceremony to pursue a myriad of 1,000 franc notes which are blown off the roof of the factory by a strong wind.

### The Principals.

The director has chosen a cast of unknowns whose work is virtually the visualization of his ideas. Rolla France, Germaine Aussey, Raymond Cordy, Henri Marchand, Paul Olivier and Jacques Shelly have the principal rôles.

January 10, 1932

# THE SCREEN

## Paul Muni in a Film of Robert E. Burns's Book, "A Fugitive From a Georgia Chain Gang."

I AM A FUGITIVE FROM A CHAIN GANG, based on a book by Robert E. Burns; directed by Mervyn LeRoy; produced by Warner Brothers. At the Warners' Strand.
James Allen......................Paul Muni
Marie Allen...................Glenda Farrell
Helen..........................Helen Vinson
Pete..........................Preston Foster
Second Warden.......Edward J. McNamara
Allen's Secretary.............Sheila Terry
Barney........................Allen Jenkins
The Warden....................David Landau
The Judge..................Berton Churchill
The Bomber....................Edward Ellis
Alice..........................Sally Blane
Red..............................James Bell
Chairman Chamber of Commerce..Oscar Apfel
Nordine.........................John Wray
Rev. Robert Allen.............Hale Hamilton
Linda..........................Noel Francis
Sheriff....................Erville Alderson
Texas......................William LeMaire
And others.

### By MORDAUNT HALL.

From Robert E. Burns's story, "I Am a Fugitive From a Georgia Chain Gang," Warner Brothers have made a stirring picture, which was presented last night before a packed house at the Warners' Strand under the title of "I Am a Fugitive From a Chain Gang." It is a vehement attack on convict camps, with most of the details culled from the book on which it is based.

The producers do not mince matters in this melodrama, and even at the close there is none of the usual bowing to popular appeal. Several sequences are worked out with genuine suspense, and, although one might be justified in presuming that some of the cruelty is exaggerated, the sight of scores of men working with shackled ankles is enough to make much of the narrative seem credible.

Paul Muni plays the leading rôle, giving a convincing and earnest performance as James Allen, an ex-sergeant in the A. E. F., who is a victim of circumstances. He is the central figure, being one of the throng of felons in irons who are dealt with in an inhuman fashion by the guards. Here the warden of the camp appears to take a delight in lashing delinquents with a leather thong and woe betide an escaped convict who is caught. It seems scarcely possible that guards, even though they are dealing with hardened characters, would become as vicious as those in the film. Such, however, is the story, and whether the conditions exist is not the question, for it is a motion picture now at the Broadway theatre.

First there is the happy-go-lucky group of men in khaki talking on their journey back to their respective homes about what they intend doing in the future. The war has made Allen ambitious to do construction work, rather than submit to the tedium of his former job in a shoe factory. His reception by his mother and other members of his family is quite irritating to him, for they do not understand what he has been through during the war. He tries his luck at several towns in various sections of the country, but fails to get employment for any length of time.

His downfall is brought about through listening to a tramp named Pete, who suggests that they go to a lunch-wagon and ask for food. When the only cash customer in the wagon leaves, Pete whips out a pistol and points it, first at the lunch-wagon owner and then at Allen, ordering the latter to take what money there is in the cash register. The police arrive and Pete is killed. Allen is searched and found in possession of the money. He is convicted and sentenced to five years' hard labor, and thereafter one sees him undergoing the torture with others in the chain gang.

His escape is presented in a gripping, if melodramatic, manner, with Allen hiding under water, breathing through a reed as the guards and bloodhounds pursue him. Eventually he reaches Chicago, where he succeeds in winning promotion with a bridge-building concern. The spiteful blonde from whom he rents a room hears that he is a fugitive from justice and she threatens to expose him unless he marries her. This part of the story must be taken for what it is worth.

The film then is concerned with his arrest and his finally consenting to return to the prison camp, provided that he receives a pardon in ninety days. When the time comes, the prison commission refuses the pardon and there follows his second escape, in a motor truck, which is pictured most effectively. In this sequence is an ironic touch, when he blows up a bridge to halt the posse that is after him in an automobile.

There is a touch of genuine romance, but in the end it is a broken man who vanishes from the screen.

The scenes of the convicts using picks, shovels and sledge-hammers in the quarries and elsewhere are set forth realistically. Each convict has to have his chains passed on by an expert, who ascertains whether the thirteen links between one leg and the other have not been tampered with. There is also the staggering gait that the felons inherit after they are released and their callousness to certain things once they are freed.

There are thirty-five players in the cast and most of them lend adequate support to Mr. Muni, particularly David Landau, Preston Foster, Allen Jenkins, Hale Hamilton and Glenda Farrell.

November 11, 1932

## The Duesseldorf Murders.

M. based on a story by Thea von Harbou; directed by Fritz Lang; a Nerofilm production; distributed by Foremco Pictures Corporation. At the Mayfair.

The Murderer..............Peter Lorre
The Mother...............Ellen Widmann
The Child................Inge Landgut
The Safebreaker.......Gustaf Grundgens
The Burglar...............Fritz Gnass
The Card.Sharper...........Fritz Odemal
The Pickpocket............Paul Kemp
The Confidence Trickster......Theo Lingen
The President of Police.
                        Ernst Stahl-Nachbaur
The Minister.............Franz Stein
Superintendent Lohman......Otto Wernicke
Superintendent Groeber......Theodor Loos
The Blind Beggar........Georg John
Counsel for the Defense..Rudolf Blumner
The Watchman..............Karl Platen
The Criminal Chief......Gerhard Bienert
The Landlady..............Rosa Valetti

Based on the fiendish killings which spread terror among the inhabitants of Düsseldorf in 1929, there is at the Mayfair a German-language pictorial drama with captions in English bearing the succinct title "M," which, of course, stands for murder. It was produced in 1931 by Fritz Lang and, as a strong cinematic work with, remarkably fine acting, it is extraordinarily effective, but its narrative, which is concerned with a vague conception of the activities of a demented slayer and his final capture, is shocking and morbid. Yet Mr. Lang has left to the spectator's imagination the actual commission of the crimes.

Peter Lorre portrays the Murderer in a most convincing manner. The Murderer is a repellent spectacle, a pudgy-faced, pop-eyed individual, who slouches along the pavements and has a Jekyll-and-Hyde nature. Little girls are his victims. The instant he lays eyes on a child homeward bound from school, he tempts her by buying her a toy balloon or a ball. This thought is quite sufficient to make even the clever direction and performances in the film more horrible than anything else that has so far come to the screen. Why so much fervor and intelligent work was concentrated on such a revolting idea is surprising.

It is unfurled in a way that reveals Mr. Lang and Thea von Harbou, his wife, evidently studied what happened in Düsseldorf during the score of atrocious murders, which incidentally caused young women to go about armed with pepper in case they were picked out by the slayer as possible victims. In the film the Commissioner of Police gives all his attention to trying to track the murderer down. He goes about his work in a systematic fashion, but when another crime is perpetrated he is talked to heatedly over the telephone by his superior.

So far as the film spectator is concerned, there is no mystery concerning the criminal. He is perceived looking into a mirror, making grimaces at himself, and later dawdling along the street, looking into shop windows. He has a habit of whistling a few bars of a tune, and apparently it is something he has little control over, for this whistling is actually responsible for his capture.

Mr. Lang has the adroit idea of having thugs, pickpockets, burglars and highwaymen eventually setting about to apprehend the Murderer. His crimes are making things too hot for them and, bad as they are, they are depicted as being almost sympathetic characters compared to the Murderer. Every criminal in the town is told by the chief crook to be on the lookout for anybody who looks suspicious. Beggars and peddlers, as well as the thieves and swindlers, are all eager to catch the Murderer.

It is not astonishing that anybody doing a kindly turn for a child is suspected of being the criminal. A harmless individual is almost mobbed by hysterical women and enraged men. Meanwhile the Murderer is at large and has boastfully written of his last crime to the newspapers. The letter is analyzed. It was written evidently on a rough wooden table, and the sleuths draw circles about the map of the town as they widen their search.

But his capture does not come about through the minions of the law. It is a blind man, a peddler of toy balloons, who gives the alarm. He had sold a balloon a few days before to the man who had whistled the notes of an operatic tune. Suddenly the blind man several days later hears the melody whistled again, and it dawns upon him in a few seconds that the Murderer is passing. He gives the alarm, and in the course of the chase a youth, who had marked in chalk the letter "M" on his hand, slaps the suspect on the back.

There is a wild chase, the crooks being eager to get their man. They are willing to risk being held for crimes, and when the Police Commissioner understands from a prisoner that he and others were following the Murderer, the official is so stunned that he lets the cigar he is smoking drop from his mouth. One perceives the panting Murderer trying to get the lock off a door, his eyes wilder than ever, and perspiration dripping from his forehead. But the frantic, shrieking man is finally captured by the thieves, and a most interesting series of scenes is devoted to his trial. He bleats that he is a murderer against his will, whereas those before him commit crime because they want to. A thief presides at the trial. The Murderer has counsel, who says that the Murderer needs a doctor more than punishment. Then the Murdered is handed over to the police and a mother of one of the fiend's little victims declares that the death of the man will not give her back her child.

It is regrettable that such a wealth of talent and imaginative direction was not put into some other story, for the actions of this Murderer, even though they are left to the imagination, are too hideous to contemplate. M. H.

April 3, 1933

# LAMENT FOR THE CINEMA DEAD

*To the Screen Editor:*

In The Times for Oct. 21 you print a letter from Mr. Monroe North asking why such a film classic as "The Birth of a Nation" is not shown again and again as works of art in other mediums are made permanently available. Mr. North's letter brings up what is becoming one of the gravest problems of our day, albeit recognized by almost no one. If we fail we shall be heavily condemned by the future.

In the years between about 1912 and 1929-30 the silent screen produced besides a vast amount of ephemeral trash a body of serious and intelligent filmwork that was as remarkable for its quantity as for its quality. In the beginning there were the heavy but magnificent Italian films of antiquity like "Quo Vadis" and "Cabiria." After 1914 America entered upon her Golden Age, the period dominated by Griffith. Of his three acknowledged masterpieces, "The Birth of a Nation," "Intolerance" and "Broken Blossoms," the second is the supreme expression of a poet possessed with the idea of "the progress of human evolution, continually retarded by the brutal forces of actuality." Around him are grouped half a dozen lesser figures, poetic, too, in their love of freedom and movement—Ince, De Mille, Hart, Mack Sennett, Chaplin, Fairbanks.

Post-war films in America, with a few signal exceptions, were inferior to the earlier ones, more patently Hollywoodish, but for a time, as in, for instance, "Robin Hood," "Smilin' Through," "The Covered Wagon," "The Thief of Bagdad," they were still very interesting. They were, however, no match for the new films in Europe. Sweden began during the war a series of admirable films, now forgotten, filled with the Northern feeling for nature. In 1919 "The Cabinet of Dr. Caligari" ushered in the great German era. "The Golem," "Torgus," "Vanina," "Dracula," "The Burning Acre," "Destiny," "Siegfried," "Warning Shadows," "Waxworks," "The Student of Prague," "Nju," "Tartuffe," "Faust," "The Last Laugh"—many will recall the golden light and dark shadows of these superb films.

The latter half of the decade saw the return of realism in Pabst in Germany, Feyder and Clair in France, Stroheim and Lubitsch in America, and, above all, in the directors of the new Soviet cinema, Eisenstein, Pudovkin and Dovjenko, best known as the creators, respectively, of "Potemkin," "The End of St. Petersburg" and "Earth."

In addition to these major developments, there have been Oriental films like "Shiraz" and, latterly, Japanese work; documentary, like "Moana" and "Turksib"; various types of silhouettes and cartoons, and the very ancient fairytales of Georges Melies. Yet, thanks to sound, not only is very little of this ever shown, but nearly all of it is in danger of being lost.

I don't know that any significant films (saving such a sad case as the destruction of nine-tenths of "Greed" before it was ever released) have actually been lost as yet. Of some of the old German pictures, however, the negative is gone, and there are only one or two prints that remain. There is said to be just one copy of the complete "Caligari." There are probably not more than two or three copies of the famous "Dracula" of Murnau, although I believe one is in this country. One of the few prints, or it may be the negative, of "Warning Shadows" is treasured like a Titian by the Comte de Beaumont. Where the negative does remain, it is often so badly worn that it is impossible to strike new prints from it.

And everything that still remains, negatives and prints, are slowly but steadily disintegrating. "The Birth of a Nation" was originally twelve reels long. Since then something has been cut out every time it has been revived, until it is barely half as long. When I last saw "The Pawn Shop" the celebrated alarm-clock scene was no longer in it. One might go on ad infinitum citing examples of how time has already spoiled films. The obvious moral is that unless care is taken, whole films, Siegfrieds and Fausts, will go the way of these sections. Even now the lives of some hang by a thread. A fire, an impatient and indifferent storekeeper, a few years in sun or damp, and they will be gone beyond recall.

Our inexcusable negligence in this matter will be afterward condemned more severely than the malice or ignorance which has caused us the loss of many greater works of art in the past. To have beautiful films, to know they are beautiful, and then let them quietly rot on our hands, as if, in refutation of Keats, the beauty had departed and left dry husks! It is an unprecedented situation.

What is to be done about it? For the films themselves the solution is now negatives from prints. There is a litte loss in quality, but nothing beside the loss of the entire film. Along this line England is making a series of 9.5mm. prints for home consumption of the UFA classics, including Fritz Lang's "Spies." But to do this on any satisfactory scale calls for a vastly greater backing from the public. As long as no one will go to see even "Potemkin" unless it is accompanied by a barrage of sound, so long will these films continue to rot. We cannot expect to reverse conditions overnight. It will be long before we are making new prints of "Tarje Vigen" or "La Femme de Nulle Part." But by taking even a little interest in old films, where none exists at the moment, we can at least take a step in the right direction. There must be, as Mr. North says, a few people who will care to do this much. It would be an unspeakable shame for us if we were to let the silent film become only a memory.

KIRK BOND.

Baltimore, Md.

December 2, 1934

# FROM THE POSTMAN

**Reviving Distinguished Films.**

*To the Screen Editor:*

On reading the cinema section of **The Times** two Sundays ago I came across an article, "Lament for the Dead." Mr. Bond's issue is, of course, quite correct, but it occurred to me that more than likely a very large number of your readers were not aware that there is an organ-ization in New York that is reviving all the fine old distinguished films that it can possibly obtain.

Every other Saturday evening at the New School for Social Research, 66 West Twelfth Street, we revive at least one of the old pictures. In the past two months we have already shown "The Student of Prague," "Shattered," "Beggar on Horseback," and the rarely seen film "Old and New" by Eisenstein, "Storm Over Asia" and "The Last Moment," that extremely fine picture made in Hollywood by Paul Fejos at a cost of less than $1,000.

On Saturday we are reviving "The Cabinet of Dr. Caligari," and on the same program are showing some experimental pictures that have never been seen. On Dec. 29 we are reviving an early Marx Brothers picture, "Animal Crackers," and Disney's "Four Seasons."

Between Jan. 5 and March 11 we are going to show ten more films, among them "Stark Love," "Golden Mountains," "China Express," "Mirage de Paris," "A Nous la Liberte" and "Hell's House." So, you see, the old films are not completely deceased.

Many of the films that Mr. Bond mentioned, though, are unfortunately no longer available. We have attempted to obtain "Variety," "Last Laugh," "Metropolis," "Greed," "The Crowd," "Woman of Paris" and quite a few others. There is a possibility that we will succeed in unearthing a few of the American films.

EDWARD KERN,
Film and Photo League.
New York City.

December 16, 1934

# OLD FILM DRAMAS SEE LIGHT AGAIN

## Museum Sets Out to Collect Movies From Earliest Time to the Present.

### By MILTON BRACKER.

Somewhere in the furthest reaches of the Bronx or along the nearest sandy strip of New Jersey a more or less mysterious gentleman described only as a "veteran enthusiast" may at his minute be engaged in burrowing into a scrapheap and pouncing upon a treasure for the evolving Museum of Modern Art Film Library at 485 Madison Avenue.

Simultaneously, in any of the somber film storage lofts within the city limits, an equally vague associate may be engaged in standing before a window, deftly fingering a strip of film between himself and the light and striving to identify it.

Iris Barry, curator of the library, considered these men as crosses between employes and fans. But upon their work, it was made plain, rested much of the hope of the library, which has just begun a development program expected to last from two to five years.

The library was made possible by a grant from the Rockefeller Foundation.

### The Library's Program.

As the statement on the founding of the library put it, "the film library will undertake to assemble, catalogue and preserve as complete a record as possible, in the actual films, of all types of motion pictures made in this country or abroad from 1559 to the present day and to exhibit the films at museums and colleges."

Thus the man at the window may ponder, as he pores over a weathered strip, not "is this genuine Sévres or plain Jersey clay?" but "is this simply Mac Marsh going over the cliff again to escape the Fate Worse Than Truth? Or is it reel Thirteen of 'The Iron Claw'?"

Barely a month ago the staff moved into its fifteenth-floor suite, with blue, plushy carpets and walls of either pale ultramarine or vigorous one is in. The pink-walled library proper contains a nucleus of all sorts of movie books.

The films themselves to the disappointment of visitors, who, by the way, are not officially welcome until things are a bit settled—are not in the office. Safely bans limit the storing of films to protected lofts. The library vault will be in the Bronx, just where has not been determined.

However, officials have available in a projection room with ten flowered black chairs, noninflammable 16 mm. copies of prizes ready for cataloging.

### Early Films Shown.

Three shown at what might be called a preview during the week were: "The Great Train Robbery," called the first American movie with a plot, made in 1903; the May Irwin-John C. Riee kiss, fifty feet of film which ran 3.125 seconds in the late nineties and caused many in the audience to run a temperature; and "Joie de Vivre," a new animated cartoon made in Paris.

The train robbery film seemed to prove pretty conclusively that in the palmy days when it was made, jerkiness, exaggerated posturing and creeping backdrops to make trains "speed," were all part of the infant industry. No villain would dream of dying without spinning around thrice; and in general, the audience, comprised largely of men and women who daily pick the best of the modern films apart, had to agree that the cinema has progressed.

July 14, 1935

# THE SCREEN

## Heralding the Return, After an Undue Absence, of Charlie Chaplin in 'Modern Times.'

MODERN TIMES, written, directed and produced by Charles Chaplin; musical score by Mr. Chaplin; settings by Charles D. Hall; released through United Artists. At the Rivoli.

| | |
|---|---|
| A Tramp | Charles Chaplin |
| A Gamin | Paulette Goddard |
| A Cafe Proprietor | Henry Bergman |
| A Mechanic | Chester Conklin |
| The Burglars | { Stanley Sandford<br>{ Hank Mann<br>{ Louis Natheux |
| President of a Steel Corporation. | Allen Garcia |

### By FRANK S. NUGENT.

The hands of the cinema clock were set back five years last night when a funny little man with a microscopic mustache, a battered derby hat, turned up shoes and a flexible bamboo cane returned to the Broadway screen to resume his place in the affections of the film-going public. The little man—it scarcely needs be said—is Charlie Chaplin, whose "Modern Times," opening at the Rivoli, restores him to a following that has waited patiently, burning incense in his temple of comedy, during the long years since his last picture was produced.

That was five years ago almost to the day. "City Lights" was its name and in it Mr. Chaplin refused to talk. He still refuses. But in "Modern Times" he has raised the ban against dialogue for other members of the cast, raised it, but not completely. A few sentences here and there, excused because they come by television, phonograph, the radio. And once—just once—Mr. Chaplin permits himself to be heard, singing some jabberwocky of his own to the tune of a Spanish fandango.

Those are the answers to the practical questions. They do not tell of Mr. Chaplin's picture, or of Chaplin himself, or of the comic feast that he has been preparing for almost two years in the guarded cloister in Hollywood known as the Chaplin studio.

But there is no cause for alarm and no reason to delay the verdict further: "Modern Times" has still the same old Charlie, the lovable little fellow whose hands and feet and prankish eyebrows can beat an irresistible tattoo upon an audi-ence's funnybone or hold it still, taut beneath the spell of human tragedy. A flick of his cane, a quirk of a brow, an impish lift of his toe and the mood is off; a droop of his mouth, a sag of his shoulder, a quick blink of his eye and you are his again, a companion in suffering. Or do you have to be reminded that Chaplin is a master of pantomime? Time has not changed his genius.

Speak then, of the picture, and of its story. Rumor said that "Modern Times" was preoccupied with social themes, that Chaplin—being something of a liberal himself—had decided to dramatize the class struggle, that no less an authority than Shumiatsky, head of the Soviet film industry, had counseled him about the ending and that Chaplin, accepting that advice, had made significant changes.

Mr. Chaplin's foreword to his picture was dangerously meaningful. "'Modern Times,'" it reads, "is a story of industry, of individual enterprise—humanity crusading in the pursuit of happiness." Verily, a strange prelude to an antic.

Happily for comedy, Mr. Chaplin's description is only part of the truth and we suspect he meant it to be that way. Hollywood has quoted him as saying, "There are those who always attach social significance to my work. It has none. I leave such subjects to the lecture platform. To entertain is my first consideration."

We should prefer to describe "Modern Times" as the story of the little clown, temporarily caught up in the cogs of an industry geared to mass production, spun through a three-ring circus and out into a world as remote from industrial and class problems as a comedy can make it.

It finds Charlie as a worker on an assembly line in a huge factory. A sneeze or a momentary raise of his head is all that is needed to disrupt the steady processional of tiny gadgets whose nuts he must tighten with one swooping twist. At lunch hour his boss places him in an experimental automatic feeding machine. Like Charlie, the device goes berserk. Bowls of soup are tossed in his face, a corn-on-the-cob self-feeder throws moderation to the winds and kernels to the floor. The machine alternately grinds corn into his face and wipes his mouth with a solicitous, but entirely ineffectual, self-wiper. Charlie recovers in a hospital. When he returns, discharged as cured, he runs into the unemployment problem.

So much for the industrial crisis. Finished with it for the time, the picture involves its hero in a radical demonstration, a prison riot, several police patrol wagons, a gamin (Paulette Goddard, his new leading lady), who is homeless and helpless as he; a job as night watchman

in a department store, more trouble with the law, a new job as a singing waiter in a restaurant and still more trouble with the law. There is, for good measure, a return to the factory, but no longer as a piece of human machinery on the assembly line.

Sociological concept? Maybe. But a rousing, rib-tickling, gag-bestrewn jest for all that and in the best Chaplin manner. If you remember his two-reeler, "The Skating Rink," you will be pleased to hear that Mr. Chaplin has not forgotten it either, and has found a

place somewhere in his story for a more modern companion piece. You have seen him as a waiter years before, and you should be delighted to learn that he has not forgotten his tray-juggling technique. You should know, of old, his facility for dodging the Keystone cops and he clatters away just as nimbly now even though his pursuers wear more modern uniforms.

So it goes, and mighty pleasantly, too, with Charlie keeping faith with his old public by bringing back the tricks he used so well when the cinema was very young, and by

extending his following among the moderns by employing devices new to the clown dynasty. If you need more encouragement than this, be informed then that Miss Goddard is a winsome waif and a fitting recipient of the great Charlot's championship, and that there are in the cast several players who have adorned the Chaplin films since first the little fellow kicked up his heels and scampered into our hearts. This morning there is good news: Chaplin is back again.

Also at the Rivoli, and deserving of mention even on a bill that pre-

sents Mr. Chaplin, is Walt Disney's latest cartoon, "Mickey's Polo Team." Certainly the rowdiest of all the Disneys, it contains a wild and woolly polo match between a team comprised of Mickey, Donald Duck, the Goof and the Big Bad Wolf and another four representing Harpo Marx, Stan Laurel, Oliver Hardy and Mr. Chaplin. Jack Holt is referee.

*February 6, 1936*

# THE SCREEN

## A War Film Without War Is 'Grand Illusion,' the New French Drama Showing at the Filmarte

GRAND ILLUSION, based on a story by Jean Renoir; screen play by Mr. Renoir and Charles Spaak; music by Jerome Kosma; directed by Mr. Renoir; an R. C. A. production; released by World Pictures Corporation. At the Filmarte.

| | |
|---|---|
| Marechal | Jean Gabin |
| De Boeldieu | Pierre Fresnay |
| Von Rauffenstein | Eric von Stroheim |
| Rosenthal | Dalio |
| Peasant Woman | Dita Parlo |
| An Actor | Carette |
| A Surveyor | Gaston Modot |
| A Soldier | Georges Peclet |
| A Teacher | Edouard Daste |

### By FRANK S. NUGENT

Surprisingly enough, in these combustible times, the French have produced a war film under the title "Grand Illusion." It served to reopen the Filmarte last night and it serves to warn the British that they no longer have a monopoly

upon that valuable dramatic device known as understatement. Jean Renoir, the film's author and director, has chosen consistently to underplay his hand. Time after time he permits his drama to inch up to the brink of melodrama: one waits for the explosion and the tumult. Time after time he resists the temptation and lets the picture go its calmer course.

For a war film it is astonishingly lacking in hullabaloo. There may have been four shots fired, but there are no screaming shells, no brave speeches, no gallant toasts to the fallen. War is the grand illusion and Renoir proceeds with his disillusioning task by studying it, not in the front line, but in the prison camps, where captors and

captives alike are condemned to the dry rot of inaction. War is not reality; prison camp is. Only the real may survive it.

Renoir cynically places a decadent aristocrat, a German career officer, in command of the camp; he places his French counterpart among the prisoners. Theirs is an affinity bred of mutual self-contempt, of the realization of being part of an outgrown era. The other prisoners are less heroic, but more human. They are officers, of course, but officers of a republic, not an aristocracy. One is Marechal, ex-machinist; another is Rosenthal, a wealthy Jew. Von Rauffenstein, the German commandant, held them both in contempt. The elegant Captain de Boeldieu respected them as soldiers, admired them as men, faintly regretted he could not endure them as fellow-beings.

So it becomes a story of escape, a metaphysical escape on de Boeldieu's part, a tremendously exciting flesh and bone escape on

the part of Marechal and Rosenthal. Renoir's narrative links the two adventures for a while, but ultimately resolves itself into a saga of flight. As an afterthought, but a brilliantly executed one, he adds a romance as one of his French fugitives finds shelter in the home of a young German widow. The story ends sharply, with no attempt to weave its threads together. It is probably the way such a story would have ended in life.

Renoir has created a strange and interesting film, but he owes much to his cast. Eric von Stroheim's appearance as von Rauffenstein reminds us again of Hollywood's folly in permitting so fine an actor to remain idle and unwanted. Pierre Fresnay's de Boeldieu is a model of gentlemanly decadence. Jean Gabin and Dalio as the fugitives; Dita Parlo as the German girl, and all the others are thoroughly right. The Filmarte is off to a good beginning.

*September 13, 1938*

## Eisenstein's 'Alexander Nevsky' Opens at the Cameo —New Films at Paramount, Criterion and Rialto

ALEXANDER NEVSKY, from a story by Sergei Eisenstein and D. I. Vassiliev; directed by Eisenstein and Peter A. Pavlenko; musical score by Sergei Prokofiev; produced by Mosfilm Studios in the U. S. S. R.; released here by Amkino. At the Cameo.

Prince Alexander Nevsky

| | |
|---|---|
| | Nikolai Cherkassov |
| Vassily Buslai | N. P. Okhlopkov |
| Gavrilo Olexich | A. L. Abrikossov |
| Master Armorer | D. N. Orlov |
| Governor of Pskov | V. K. Novikov |
| Nobleman of Novgorod | N. N. Arski |
| Mother of Buslai | V. O. Massalitinova |
| Olga, a Novgorod girl | V. S. Ivasheva |
| Vassilissa | A. S. Danilova |
| Master of the Teutonic Order | V. L. Ershov |
| Tverdilio, mayor of Pskov | S. K. Blinnikov |
| Anani, a monk | I. I. Lagutin |
| The Bishop | L. A. Fenin |
| The Black-robed Monk | N. A. Rogozhin |

### By FRANK S. NUGENT

After more than six years of unproductivity, not all of it voluntary, Sergei Einsenstein, the D. W. Griffith of the Russian screen, has returned to party favor and to public honors with "Alexander Nevsky," a rough-hewn monument to national heroism which had its New World unveiling at the Cameo last night. This is the picture which saved Eisenstein's face, and possibly his hide, after his "Bezhun Lug" was halted after two years' shooting because of its allegedly unsympathetic treatment of the Communist revolution. It is the picture which prompted Josef Stalin to slap its

maker on the back and exclaim, "Sergei, you are a true Bolshevik." And it is a picture, moreover, which sets up this morning an unusual problem in reviewing.

For Eisenstein's work can no more withstand the ordinary critical scrutiny, a judgment based on the refinement and subtlety of its execution than, say, the hydraulic sculpture and rock-blasting that Gutzon Borglum is dashing off on Mount Rushmore. Eisenstein is sublimely indifferent to detail, whether narrative or pictorial. His minor characters are as outrageously uni-dimensional as those Griffith created for "Intolerance" and "Birth of a Nation." He is patently unconcerned about a change from night to day to night again during the space of a two-minute sequence, and if it pleases him to bring on torchbearers at midday, simply because the smoke smudge is photographically interesting, he is not deterred by any thoughts of their illogic.

His concern, obvious from the start, is only with the broad outline of his film, its most general narrative and scenic contours and with a dramatic conflict arising, not out of the clash of ideas or ideologies (although these have been unsubtly appended), but from the impact of great bodies of men

and horse. His picture, whatever its modern political connotation, is primarily a picture of a battle and it must stand, or fall, solely upon Eisenstein's generalship in marshaling his martial array. And of his magnificent pictorial strategy there does not appear to be any question: it is a stunning battle, this re-enactment of his of the beautiful butchery that occurred one Winter's day in 1242, when the invading Teutonic knights and the serfs, mujhiks and warriors of Novgorod met on the ice of Lake Peipus and fought it out with mace and axe, with pike and spear and broadsword.

The Russians won by might and strategy and the collapse of the ice under the weight of German armor, and Prince Alexander rings out the defiant charge, "Go home and tell all in foreign lands that Russia lives. Let them come to us as guests and they will be welcome. But if any one comes to us with the sword he shall perish by the sword. On this the Russian land stands and will stand." So has Eisenstein discharged his party duty; and so the comrades at the Cameo cheered last night and outthrust their chins at Hitler. Which is all right, too, since it pleases them.

But no propagandistic drum-beating is more than a muffled thump against the surge of Eisenstein's battle. Nor are his people much more than specks upon the bloody ice. Nikolai Cherkassov's Alexander is an exception, since both the role and its player are cast in the heroic mold. But the others, simply through their creator's indifference to their needs, are caricatures (like the Teuton priests), or gargoyles (like the traitors, spies and enemy knights), or simpering nothings (like the little heroine) or mere focal points for watching the display of medieval arms (like the rival Russian soldiers). It is impossible not to admire Eisenstein's colossal unconcern with these refinements of film-making, not to marvel at his stylistic insistence that all people walk along a skyline, and not to wish, in the same breath, that more directors had his talent for doing great things so well and little things so badly.

*March 23, 1939*

# MR. OLIVIER COMES CLEAN

**By BOSLEY CROWTHER**

THERE are certain people in this world who do not consider it sporting to nip at the jolly old hand which extends a fistful of bawbees—but Laurence Olivier, the popular British actor, is not one of that sacrosanct order. He believes, as Ethel Merman used to put it, in calling a spade a low-down, dirty spade, and he doesn't mind telling the world that he has no personal use at all for motion pictures.

Mr. Olivier is currently in town rehearsing to appear with Katharine Cornell in the stage play "No Time for Comedy," after coming on from Hollywood, where he performed a leading role in Samuel Goldwyn's "Wuthering Heights." He is one of those few actors—and the English seem to have a monopoly—who shuttle back and forth from stage to screen with the imperturbable regularity of a Channel boat. And each time he makes port, he gives a highly respectable accounting. So he speaks with superior knowledge when he discusses the actor's place in films.

"One thing I discovered this time in Hollywood," he was saying the other day with the finality of a fade-out, "and it is that the screen is a director's medium. He is the chap who has all the fun. He can tell the actor what he has in mind when he calls for a certain mood or attack in an individual scene, or he need not be communicative—whichever pleases him. There is absolutely no continuity in picture-making, so far as the actors are concerned. They just fit into a puzzle as it is being made up by the director."

\* \* \*

Of course, to the average movie-goer this may all seem like an academic question—like which came first, the chicken or the egg? But to a fellow who has a serious regard for himself as an interpretive artist (not to mention a substantial schooling in stage technique) it is pretty dad-blamed important.

"Acting for the films," said Mr. Olivier, "is about as satisfying as looking at a Michelangelo fresco with a microscope. You may spot a few details that way which might otherwise be missed, but you also lose the whole, the main thing. It is impossible to get a full, free characterization before any eye which has as close a scrutiny as that of the camera. The sum total of the actor's work in a picture depends entirely upon the arbitrary manner in which the director puts together his mosaic.

"Believe me, I say this with all respect for William Wyler, our director in 'Wuthering Heights,' who I hope has made me, in this picture, a good film actor—which I am not. But, frankly, I don't see how any star, no matter who, can ever obtain the personal freedom to shape a character as he chooses on the screen.

\* \* \*

Mr. Olivier, who will be remembered by screen audiences from "Fire Over England" and, more recently, "The Divorce of Lady X" with Merle Oberon, has another observation to make. He finds the screen demands much more literalness than the stage. Stage audiences, he says, have come to accept certain conventions of scene, speech, and so forth, which actually contribute to the ease and freedom of the actor. Lines may be phrased in dialogue, intimacies may be exchanged, delicate moods may be established, which the audiences accept naturally. But the same things put upon the screen would draw howls of derisive laughter. This, Mr. Olivier thinks, is due partly to the fact that living actors are able to establish a personal communion with their audiences which the screen cannot achieve; partly to the embarrassment of movie audiences before anything which is tenuous or intimate.

"In short," said Mr. Olivier—"and this is all winding up in a terrible admission, for which I'll get a ton of coal dropped on my head—I just don't like the motion pictures. I haven't yet the authority to boss the director, and I don't fancy the business enough to wait. I play in films for one thing only—money."

Hey, Diogenes—look this way!

March 26, 1939

---

# THE SCREEN IN REVIEW

## Twentieth Century-Fox Shows a Flawless Film Edition of John Steinbeck's 'The Grapes of Wrath,' With Henry Fonda and Jane Darwell, at the Rivoli

THE GRAPES OF WRATH, screen play by Nunnally Johnson based on the novel by John Steinbeck; musical score by Alfred Newman; directed by John Ford; produced by Darryl F. Zanuck for Twentieth Century-Fox. At the Rivoli.

| | |
|---|---|
| Tom Joad | Henry Fonda |
| Ma Joad | Jane Darwell |
| Casy | John Carradine |
| Grampa | Charley Grapewin |
| Rosasharn | Dorris Bowdon |
| Pa Joad | Russell Simpson |
| Al | O. Z. Whitehead |
| Muley | John Qualen |
| Connie | Eddie Quillan |
| Granma | Zeffie Tilbury |
| Noah | Frank Sully |
| Uncle John | Frank Darien |
| Winfield | Darryl Hickman |
| Ruth Joad | Shirley Mills |
| Thomas | Roger Imhof |
| Caretaker | Grant Mitchell |
| Wilkie | Charles D. Brown |
| Davis | John Arledge |
| Policeman | Ward Bond |
| Bert | Harry Tyler |
| Bill | William Pawley |
| Father | Arthur Aylesworth |
| Joe | Charles Tannen |
| Inspection Officer | Selmar Jackson |
| Leader | Charles Middleton |
| Proprietor | Eddie Waller |
| Floyd | Paul Guilfoyle |
| Frank | David Hughes |
| City Man | Cliff Clark |
| Bookkeeper | Joseph Sawyer |
| Tim | Frank Faylen |
| Agent | Adrian Morris |
| Muley's Son | Hollis Jewell |
| Spencer | Robert Homans |
| Driver | Irving Bacon |
| Mae | Kitty McHugh |

**By FRANK S. NUGENT**

In the vast library where the celluloid literature of the screen is stored there is one small, uncrowded shelf devoted to the cinema's masterworks, to those films which by dignity of theme and excellence of treatment seem to be of enduring artistry, seem destined to be recalled not merely at the end of their particular year but whenever great motion pictures are mentioned. To that shelf of screen classics Twentieth Century-Fox yesterday added its version of John Steinbeck's "The Grapes of Wrath," adapted by Nunnally Johnson, directed by John Ford and performed at the Rivoli by a cast of such uniform excellence and suitability that we should be doing its other members an injustice by saying it was "headed" by Henry Fonda, Jane Darwell, John Carradine and Russell Simpson.

We know the question you are asking, have been asking since the book was acquired for filming: Does the picture follow the novel, how closely and how well? The answer is that it has followed the book; has followed it closely, but not with blind, undiscriminating literalness; has followed it so well that no one who has read and admired it should complain of the manner of its screen telling. Steinbeck's language, which some found too shocking for tender eyes, has been cleaned up, but has not been toned so high as to make its people sound other than as they are. Some phases of his saga have been skimped and some omitted; the book's ending has been dropped; the sequence of events and of speeches has been subtly altered.

The changes sound more serious than they are, seem more radical than they are. For none of them has blurred the clarity of Steinbeck's word-picture of the people of the Dust Bowl. None of them has rephrased, in softer terms, his matchless description of the Joad family's trek from Oklahoma to California to find the promised land where work was plenty, wages were high and folk could live in little white houses beside an orange grove. None of them has blunted the fine indignation or diluted the bitterness of his indictment of the cruel deception by which an empty stew-pot was substituted for the pot of gold at the rainbow's end. And none of them has—as most of us feared it might—sent the film off on a witch hunt, let it pretend there had just been a misunderstanding, made it end on the sunrise of a new and brighter day.

Steinbeck's story might have been exaggeration; at least some will take comfort in thinking so. But if only half of it were true, that half still should constitute a tragedy of modern America, a bitter chapter of national history that has not yet been closed, that has, as yet, no happy ending, that has thus far produced but two good things: a great American novel (if it is truly a novel) and a great American motion picture.

Its greatness as a picture lies in many things, not all of them readily reducible to words. It is difficult, for example, to discuss John Ford's direction, except in pictorial terms. His employment of camera is reportage and editorial and dramatization by turns or all in one. Steinbeck described the Dust Bowl and its farmers, used page on page to do it. Ford's cameras turn off a white-striped highway, follow Tom Joad scuffling through the dust to the empty farmhouse, see through Muley's eyes the pain of surrendering the land and the hopelessness of trying to resist the tractors. A swift sequence or two, and all that Steinbeck said has been said and burned indelibly into memory by a director, a camera and a cast.

Or follow the Joads in their piled-up, rattling, wheezing truck along Highway 66, and let the Russian realists match if they can that Ford shot through the windshield, with three tired faces reflected in it and the desert through it. Or the covered wagon's arrival at the first of a series of Hoovervilles, with a litter of humans and dogs and crates in its path, and the eloquence of their mute testimony to poverty and disillusion and the degradation of the human spirit. We could mention a score of others, but they would mean no more unless you, too, had seen the picture. Direction, when it is as brilliant as Mr. Ford's has been, is easy to recognize, but impossible to describe.

It's simpler to talk about the players and the Nunnally Johnson script. There may be a few words of dialogue that Steinbeck has not written, but Mr. Johnson almost invariably has complimented him by going to the book for his lines. A sentence from one chapter is made to serve a later sequence; sometimes Ma Joad is saying things the Preacher originally said; sometimes Tom is borrowing Ma's lines. But they fit and they ring true, and that applies, as well, to Mr. Johnson's reshuffling of the Steinbeck sequences, his coming to the end of the saga before Steinback was willing to punch out the final period.

And if all this seems strange for Hollywood—all this fidelity to a book's spirit, this resoluteness of approach to a dangerous (and, in California, an especially dangerous) topic—still stranger has been the almost incredible rightness of the film's casting, the utter believability of some of Hollywood's most typical people in untypical roles. Henry Fonda's Tom Joad is precisely the hot-tempered, resolute, saturnine chap Mr. Steinbeck had in mind. Jane Darwell's Ma is exactly the family-head we pictured as we read the book. Charles Grapewin's Grampa cannot be quite the "heller" we met in the novel: the anti-profanity dictum bothered him more than the rest of them; but Mr. Grapewin's Gramp is still quite an old boy.

We could go on with this talk of the players, but it would become repetitious, for there are too many of them, and too many are perfect in their parts. What we've been trying to say is that "The Grapes of Wrath" is just about as good as any picture has a right to be; if it were any better, we just wouldn't believe our eyes.

January 25, 1940

# THE SCREEN IN REVIEW

## Orson Welles's Controversial 'Citizen Kane' Proves a Sensational Film at Palace

CITIZEN KANE; original screen play by
Orson Welles and Herman J. Mankiewicz;
produced and directed by Orson Welles;
photography by Gregg Toland; music
composed and conducted by Bernard Herr-
mann; released through RKO-Radio. At
the Palace.

| | |
|---|---|
| Charles Foster Kane | Orson Welles |
| Kane, aged 8 | Buddy Swan |
| Kane 3d | Sonny Bupp |
| Kane's Father | Harry Shannon |
| Jedediah Leland | Joseph Cotten |
| Susan Alexander | Dorothy Comingore |
| Mr. Bernstein | Everett Sloane |
| James W. Gettys | Ray Collins |
| Walter Parks Thatcher | George Coulouris |
| Kane's Mother | Agnes Moorehead |
| Raymond | Paul Stewart |
| Emily Norton | Ruth Warrick |
| Herbert Carter | Erskine Sanford |
| Thompson | William Alland |
| Miss Anderson | Georgia Backus |
| Mr. Rawlston | Philip Van Zandt |
| Headwaiter | Gus Schilling |
| Signor Matiste | Fortunio Bonanova |

### By BOSLEY CROWTHER

Within the withering spotlight as
no other film has ever been before,
Orson Welles's "Citizen Kane" had
is world première at the Palace last
evening. And now that the wraps
are off, the mystery has been ex-
posed and Mr. Welles and the RKO
directors have taken the much-de-
bated leap, it can be safely stated
that suppression of this film would
have been a crime. For, in spite of
some disconcerting lapses and
strange ambiguities in the creation
of the principal character, "Citizen
Kane" is far and away the most
surprising and cinematically excit-
ing motion picture to be seen here
in many a moon. As a matter of
fact, it comes close to being the
most sensational film ever made in
Hollywood.

Count on Mr. Welles; he doesn't
do things by halves. Being a mer-
curial fellow, with a frightening
theatrical flair, he moved right into
the movies, grabbed the medium by
the ears and began to toss it around
with the dexterity of a seasoned
veteran. Fact is, he handled it
with more verve and inspired in-
genuity than any of the elder crafts-

Orson Welles, in "Citizen Kane"

men have exhibited in years. With
the able assistance of Gregg Toland,
whose services should not be over-
looked, he found in the camera the
perfect instrument to encompass his
dramatic energies and absorb his
prolific ideas. Upon the screen he
discovered an area large enough for
his expansive whims to have free
play. And the consequence is that

he has made a picture of tremen-
dous and overpowering scope, not
in physical extent so much as in its
rapid and graphic rotation of
thoughts. Mr. Welles has put upon
the screen a motion picture that
really moves.

As for the story which he tells—
and which has provoked such an
uncommon fuss—this corner frankly
holds considerable reservation. Na-
turally we wouldn't know how close-
ly—if at all—it parallels the life of
an eminent publisher, as has been
somewhat cryptically alleged. But
that is beside the point in a rigidly
critical appraisal. The blamable
circumstance is that it fails to pro-
vide a clear picture of the character
and motives behind the man about
whom the whole thing revolves.

As the picture opens, Charles
Kane lies dying in the fabulous
castle he has built—the castle called
Xanadu, in which he has surround-
ed himself with vast treasures. And
as death closes his eyes his heavy
lips murmur one word, "Rosebud."
Suddenly the death scene is broken;
the screen becomes alive with a
staccato March-of-Time-like news
feature recounting the career of the
dead man—how, as a poor boy, he
came into great wealth, how he be-
came a newspaper publisher as a
young man, how he aspired to po-
litical office, was defeated because
of a personal scandal, devoted him-
self to material acquisition and
finally died.

But the editor of the news feature
is not satisfied; he wants to know
the secret of Kane's strange nature
and especially what he meant by
"Rosebud." So a reporter is dis-
patched to find out, and the re-
mainder of the picture is devoted
to an absorbing visualization of
Kane's phenomenal career as told
by his boyhood guardian, two of
his closest newspaper associates and

his mistress. Each is agreed on one
thing—that Kane was a titanic ego-
maniac. It is also clearly revealed
that the man was in some way con-
sumed by his own terrifying selfish-
ness. But just exactly what it is
that eats upon him, why it is there
and, for that matter, whether Kane
is really a villain, a social parasite,
is never clearly revealed. And the
final, poignant identification of
"Rosebud" sheds little more than
a vague, sentimental light upon his
character. At the end Kubla Kane
is still an enigma—a very confus-
ing one.

But check that off to the absorp-
tion of Mr. Welles in more visible
details. Like the novelist, Thomas
Wolfe, his abundance of imagery is
so great that it sometimes gets in
the way of his logic. And the less
critical will probably be content
with an undefined Kane, anyhow.
After all, nobody understood him.
Why should Mr. Welles? Isn't it
enough that he presents a theatri-
cal character with consummate
theatricality?

We would, indeed, like to say as
many nice things as possible about
everything else in this film—about
the excellent direction of Mr.
Welles, about the sure and pene-
trating performances of literally
every member of the cast and about
the stunning manner in which the
music of Bernard Herrmann has
been used. Space, unfortunately, is
short. All we can say, in conclu-
sion, is that you shouldn't miss
this film. It is cynical, ironic,
sometimes oppressive and as realis-
tic as a slap. But it has more vital-
ity than fifteen other films we
could name. And, although it may
not give a thoroughly clear answer,
at least it brings to mind one deep-
ly moral thought: For what shall
it profit a man if he shall gain the
whole world and lose his own soul?
See "Citizen Kane" for further de-
tails.

May 2, 1941

# THE SCREEN

## How Italy Resisted

OPEN CITY (CITTA APERTA), screen play by
Sergio Amidei and F. Fellini; directed by
Roberto Rossellini; English titles by Pietro di
Donato and Herman G. Weinberg; produced
in Italy by Excelsa and released in United
States by Mayer-Burstyn, Inc. At the World.

| | |
|---|---|
| Manfredi | Marcello Pagliero |
| Don Pietro | Aldo Fabrizi |
| Pina | Anna Magnani |
| Marcello | Vito Annicchiarico |
| Marina Mari | Maria Michi |
| Capt. Bergmann | Harry Feist |
| Francesco | Francesco Grandjacquet |
| Ingrid | Giovanna Galletti |
| Lauretta | Carla Rovere |
| The Sexton | Nando Bruno |
| Police Warden | Passarelli |
| Chief of Police | C. Sindici |
| Hartman | Van Hulzen |
| Austrian Deserter | A. Tolnay |

### By BOSLEY CROWTHER

It may seem peculiarly ironic
that the first film yet seen here-
abouts to dramatize the nature
and the spirit of underground re-
sistance in German-held Europe in
a superior way—with candid, over-
powering realism and with a pas-
sionate sense of human fortitude—
should be a film made in Italy.
Yet such is the extraordinary case.
"Open City" ("Citta Aperta"),
which arrived at the World last
night, is unquestionably one of the
strongest dramatic films yet made
about the recent war. And the fact

that it was hurriedly put together
by a group of artists soon after
the liberation of Rome is signifi-
cant of its fervor and doubtless
integrity.

For such a picture as "Open
City" would not likely be made
under normal and established con-
ditions. In the first place, it has
the wind-blown look of a film shot
from actualities, with the camera
providentially on the scene. All of
its exterior action is in the streets
and open places of Rome; the in-
terior scenes are played quite
obviously in actual buildings or
modest sets. The stringent neces-
sity for economy compelled the
producers to make a film that has
all the appearance and flavor of a
straight documentary.

And the feeling that pulses
through it gives evidence that it
was inspired by artists whose own
emotions had been deeply and re-
cently stirred. Anger, grim and
determined, against the Germans
and collaborationists throbs in
every sequence and every shot in
which the evil ones are shown.
Yet the anger is not shrill or
hysterical; it is the clarified anger
of those who have known and
dreaded the cruelty and depravity
of men who are their foes. It is

anger long since drained of aston-
ishment or outrage.

*  *  *

More than anger, however, the
feeling that flows most strongly
through the film is one of supreme
admiration for the people who
fight for freedom's cause. It is a
quiet exaltation, conveyed mainly
through attitudes and simple
words, illuminating the spirit of
devotion and sacrifice. The heroes
in "Open City" are not conscious
of being such. Nor are the artists
who conceived them. They are
simple people doing what they
think is right.

The story of the film is literal.
It might have been taken from the
notes of any true observer in occu-
pied Europe—and, indeed, is said to
have been based on actual facts. It
is the story of an underground
agent who is cornered by the Ger-
mans in a certain quarter of Rome
and who barely escapes them until
he is informed upon by his own
girl friend. In the course of his
flight he necessarily involves his
resistance friends: a printer of an
underground newspaper, his wife-
to-be and her small son, and a
neighborhood priest who uses his
religious office to aid freedom's
cause. The woman is killed during

a raid on an apartment, the cap-
tured resistance leader is tortured
to death and the priest is shot
when he refuses to assist the Ger-
mans with any information.

*  *  *

All these details are presented in
a most frank and uncompromising
way which is likely to prove some-
what shocking to sheltered Amer-
ican audiences.

Yet the total effect of the pic-
ture is a sense of real experience,
achieved as much by the perform-
ance as by the writing and direc-
tion. The outstanding performance
is that of Aldo Fabrizi as the
priest, who embraces with dignity
and humanity a most demanding
part.

Marcello Pagliero is excellent,
too, as the resistance leader, and
Anna Magnani brings humility and
sincerity to the role of the woman
who is killed. The remaining cast
is unqualifiedly fine, with the ex-
ception of Harry Feist in the role
of the German commander. His
elegant arrogance is a bit too vi-
cious—but that may be easily un-
derstood.

February 26, 1946

# THE SCREEN IN REVIEW

## 'Les Enfants du Paradis,' Film From France, With Arletty in Cast, Opens at Ambassador— Marcel Carne Directed Movie

LES ENFANTS DU PARADIS (Children of Paradise); scenario and dialogue by Jacques Prevert; music by Joseph Kosma, Maurice Thierte and Georges Mouque; directed by Marcel Carne; produced by Pathe Studios in France and released here by Tricolore Films. At the Ambassador.

| | |
|---|---|
| Baptiste Deburau | Jean-Louis Barrault |
| Frederick Lemaitre | Pierre Brasseur |
| Garance | Arletty |
| Lacenaire | Marcel Herrand |
| Jericho | Pierre Renoir |
| Avril | Fabien Loris |
| Anselme Deburau | Etienne Decroux |
| Nathalie | Maria Cassares |
| Madame Hermine | Jeanne Marken |
| The Blind | Gaston Modot |
| Count de Montray | Louis Salou |
| Director | Pierre Palau |
| Scarpia Barigni | Albert Remy |
| Inspector of Police | Paul Frankeur |

### By BOSLEY CROWTHER

The strong philosophical disposition of the French film director, Marcel Carne, to scan through the medium of cinema the irony and pathos of life—a disposition most memorably demonstrated in his great pre-war film, "Quai des Brumes"—has apparently not been altered by the tragic experience of the last few years, as witness his most ambitious picture, "Les Enfants du Paradis." For, in this long and fervid French picture, which was more or less clandestinely made during the Nazi occupation under circumstances of the most exacting sort—and which had its American première at the Ambassador Theatre yesterday—M. Carne is Platonically observing the melancholy masquerade of life, the riddle of truth and illusion, the chimeras of la comédie humaine.

And if that sounds like a mouthful, you may rest emphatically assured that M. Carne has bitten off a portion no less difficult to chew. For his story concerns the criss-crossed passions of a group of Parisian theatre folks—clowns, charlatans and tragedians—in the mid-nineteenth century. It is a story of the fatal attraction of four different men to one girl, a creature of profound and dark impulses, in the glittering milieu of the demi-monde. And to render it even more Platonic, he has framed this human drama within the gilded proscenium of the theatre, as though it were but a pageant on the stage—a pageant to hypnotize and tickle the shrilling galleries, the "children of 'the Gods'."

Obviously such an Olympian—or classical—structure for a film presumes a proportionate disposition to philosophize from the audience. And it assumes a responsibility of dramatic clarity. Unfortunately, the pattern of the action does not support the demand. There is a great deal of vague and turgid wandering in "Les Enfants du Paradis," and its network of love and hate and jealousy is exceptionally tough to cut through. Its concepts are elegant and subtle, its connections are generally remote and its sad fatalistic conclusion is a capstone of futility.

It is said that the film was considerably cut down into its present two-hour and twenty-four-minute length, which may account for the lesions in the pattern and for the disjunction of the colorful musical score. That would not account, however, for the long-windedness of Jacques Prevert's script, sketchily transcribed in English titles, and for the generally archaic treatment of Passion and Destiny.

Withal, M. Carne has created a frequently captivating film which has moments of great beauty in it and some performances of exquisite note. Jean-Louis Barrault's impersonation of the famous French mime, Baptiste Deburau, is magically moody and expressive, especially in his scenes of pantomime, although it is hard to perceive the fascination which he is alleged to have for the lady in the case. And as the latter, the beauteous Arletty intriguingly suggests deep mysteries in the nature of a richly feminine creature—but it is difficult to gather what they are. Pierre Brasseur is delightfully extravagant as a selfish, conceited "ham," Marcel Herrand is trenchant as a cutthroat and Louis Salou is brittle as a swell.

On the basis alone of performance and of its bold, picturesque mise en scene, "Les Enfants du Paradis" is worth your custom. What you get otherwise is to boot.

*February 20, 1947*

# THE SCREEN

## 'Treasure of Sierra Madre,' Film of Gold Mining in Mexico, New Feature at Strand

TREASURE OF SIERRA MADRE: Screen play by John Huston; based on the novel by B. Traven; directed by John Huston; produced by Henry Blanke for Warner Brothers Pictures, Inc. At the Strand.

| | |
|---|---|
| Dobbs | Humphrey Bogart |
| Howard | Walter Huston |
| Curtin | Tim Holt |
| Cody | Bruce Bennett |
| McCormick | Barton MacLane |
| Gold Hat | Alfonso Bedoya |
| Presidente | A. Soto Rangel |
| El Jefe | Manuel Donde |
| Pablo | Jose Torvay |
| Pancho | Margarito Luna |
| Flashy Girl | Jacqueline Dalya |
| Mexican Boy | Bobby Blake |

### By BOSLEY CROWTHER

Greed, a despicable passion out of which other base ferments may spawn, is seldom treated in the movies with the frank and ironic contempt that is vividly manifested toward it in "Treasure of Sierra Madre." And certainly the big stars of the movies are rarely exposed in such cruel light as that which is thrown on Humphrey Bogart in this new picture at the Strand. But the fact that this steel-springed outdoor drama transgresses convention in both respects is a token of the originality and maturity that you can expect of it.

Also, the fact that John Huston, who wrote and directed it from a novel by B. Traven, has resolutely applied the same sort of ruthless realism that was evident in his documentaries of war is further assurance of the trenchant and fascinating nature of the job.

Taking a story of three vagrants on "the beach" in Mexico who pool their scratchy resources and go hunting for gold in the desolate hills, Mr. Huston has shaped a searching drama of the collision of civilization's vicious greeds with the instinct for self-preservation in an environment where all the barriers are down. And, by charting the moods of his prospectors after they have hit a vein of gold, he has done a superb illumination of basic characteristics in men. One might almost reckon that he has filmed an intentional comment here upon the irony of avarice in individuals and in nations today.

But don't let this note of intelligence distract your attention from the fact that Mr. Huston is putting it over in a most vivid and exciting action display. Even the least perceptive patron should find this a swell adventure film. For the details are fast and electric from the moment the three prospectors start into the Mexican mountains, infested with bandits and beasts, until two of them come down empty-handed and the third one, the mean one, comes down dead. There are vicious disputes among them, a suspenseful interlude when a fourth man tries to horn in and some running fights with the banditi that will make your hair stand on end. And since the outdoor action was filmed in Mexico with all the style of a documentary camera, it has integrity in appearance, too.

Most shocking to one-tracked moviegoers, however, will likely be the job that Mr. Bogart does as the prospector who succumbs to the knawing of greed. Physically, morally and mentally, this character goes to pot before our eyes, dissolving from a fairly decent hobo under the corroding chemistry of gold into a hideous wreck of humanity possessed with only one passion—to save his "stuff." And the final appearance of him, before a couple of roving bandits knock him off in a manner of supreme cynicism, is one to which few actors would lend themselves. Mr. Bogart's compensation should be the knowledge that his performance in this film is perhaps the best and most substantial that he has ever done.

Equally, if not more, important to the cohesion of the whole is the job done by Walter Huston, father of John, as a wise old sourdough. For he is the symbol of substance, of philosophy and fatalism, in the film, as well as an unrelenting image of personality and strength. And Mr. Huston plays this ancient with such humor and cosmic gusto that he richly suffuses the picture with human vitality and warmth. In the limited, somewhat negative role of the third prospector, Tim Holt is quietly appealing, while Bruce Bennett is intense as a prospecting lone wolf and Alfonso Bedoya is both colorful and revealing as an animalistic bandit chief.

To the honor of Mr. Huston's integrity, it should be finally remarked that women have small place in this picture, which is just one more reason why it is good.

*January 24, 1948*

# Focus on Miracles

**Cocteau's formula for better films is youth behind a 16-millimeter camera.**

### By JEAN COCTEAU

PARIS.

DISCUSSION, dialogue, is the life of France. It contrasts with the practice of monologue by its disrespect for the rules, by its traditional anarchy and by its individualism which has almost become a disease. In France we are always discussing, disputing and quarreling. This spectacle amazes foreigners and makes France seem a puzzle.

But if ever France ceased this constant dialogue and should drop, as one might say, her habits of contradiction and of living in mental effervescence, and if ever she should bow before the kind of monologue that killed the Germany of Hitler (and would kill any people accepting it) she would fall into a dull platitude that would certainly crush her whole internal structure.

She draws her sparks of genius from her apparent disorder. And I may add that it is a mercy that the authorities have not perceived it but do all they can without knowing it to assist this disorder which is so fruitful in results. If they understood what they were doing, they would doubtless try to do consciously what they are already doing unconsciously, and from that moment the whole apparatus would become overpretentious and fail to operate.

IN my opinion the art of discussion which is based in dialogue is of first importance for a people. The chief danger threatening the moving-picture creators, not only in France but throughout the world, is the high cost of production and the fear of risk to

the important investment of producers. It robs the creator of full usage of all those contrasts, of the experiments and of those daring and wonderful mistakes that permit the triumph of art over matter by the breaking down of rigid habits that are stultifying.

A producer in France, where sales possibilities are reduced to a minimum, must invest 100 million francs before he can net 14 million francs (on which he pays crushing taxes). The film probably costs him 60 million. If he doesn't give it up as a bad job it is because he is caught in the machinery of the business and keeps on in defiance of all wisdom. At that rate he is little by little turned into a Maecenas, and a very soured one.

It seems to me, and I don't mind repeating it, that the danger to the American producer is the same as it is for us. It must be even greater in the United States because the enormous sales don't encourage the film companies to stray from the narrow path they believe will lead to success. This dries up the sap, or in other words, it stifles Youth. Who is going to gamble his money on a daring venture along a road that has not been tried? Yet everyone knows that art is born in those little volumes that sell badly, in their time—in those shabby pamphlets passed about by hand and in small reviews that publish only a tiny number of copies. In these we afterwards find the names the world respects and adores. From them springs the seed that may fall anywhere and bloom. It is from such isolated chamber music played in the dark corners that the greatest rhapsodies come.

WHO, I ask you, has built up the great prestige of

France? Certainly not her politicians. It was Villon, it was Rimbaud, and Lautréamont, Verlaine and Nerval and Beaudelaire. France despised them, exiled them, allowed them to starve or commit suicide or die in hospitals.

We should protect this mysterious patrimony. And it would ill become us to overlook the importance of the cinema industry, which is an art on the way to becoming a *complete* art, if we were to treat it like a factory turning out luxury products and if we failed to try by every means to place it within range of everyone who is capable of giving it new life.

AN art which youth is barred from practicing freely is sentenced to death in advance. The camera should be like a fountain pen which anyone may use to translate his soul onto paper. Anyone ought to be able to learn to cut, to take and to direct and add a sound track to a film and not have to specialize in a single branch of this difficult work; in short, not to be a cell in one organ of the factory, but a free agent who plunges in on his own and then devises his own method of how to swim.

I can't conceive at the present time of a young man of 18 being offered the opportunity that was given me at that age to produce "Le Sang d'un Poète" without any technical assistance and without ever having set foot on a movie set.

Yet that was the luxury allowed himself by a man who was interested in breaking away from conventions, the Viscount de Noailles.

DESPITE what we are told, the scale of money values has not changed proportionally

and it would be harder today to get twelve millions than it was to have that million then. And who in 1948 would offer such a sum to a young picture enthusiast to do with whatever he wanted without any material, spiritual or moral obligation?

I therefore had a great opportunity and it is this opportunity which I claim for those who have the age and the courage that I had then.

The 16-millimeter film in my opinion presents the only solution, and in this I think America should take the initiative. She has the power to afford such an experiment, an intensity which would not be affected by the small sales. Besides, these sales might become unexpectedly large in time.

American 16 - millimeter cameras are little marvels. It is probable that it won't be long before they become equipped for sound. It is to be hoped, however, that this development is deferred as long as possible, for sound has a tendency to be carelessly slapped onto the image, and the use of sound, in the form of gags, or of other sound inventions, superimposed on the image, would merely excite the imagination of the young innovators beyond their wisdom.

FOR my own part I have just been using a 16-millimeter camera to make a film with the utmost freedom in my garden. I was released from any material worries because, using a reversible Kodak film, that which might cost me five millions was reduced to five thousand francs. With this I have made a film that is far from being like the usual one a professional might produce. I invented and improvised as I went along, and for actors I

had the people who spent their Sunday at my country place. The result is a series of scenes which are perhaps a little ridiculous and wholly unsalable, but which, by reason of the total freedom to express whatever comes into one's head, contains a force impossible to obtain when one is faced with the possibility of ruining a film company.

Picasso is probably the only man in the world who can make a remarkable object out of nothing. At his touch rubbish sparkles in a world that is Picasso's own.

The 16-millimeter films offer us an opportunity of trying for similar miracles. A close-up, an unexpected angle, a false movement, a slow-up or reversal may cause objects and forms to follow and obey us as the animals did Orpheus.

SINCE we were listening to the overture to "Coriolanus" as I began the filming, I have entitled my film "Coriolanus" and I intend to turn it into a sound film later with an explanatory text which will be just as far removed from the action as is the title. Mayhap this joke of mine will never see the light. It is possible, too, that it may slip out of my hands and that numbers of persons may be pleased to find in it later a whole mass of meanings it does not contain or which it perhaps does without my knowing it.

I hope from the bottom of my heart that Hollywood will add to its great commercial film industry a younger branch which will not be asked for any guarantee but will be encouraged to produce accidents. For it is from the accident with its attendant shock that a work of art is born.

October 24, 1948

# FILM SOCIETY MOVEMENT CATCHES ON

**By THOMAS M. PRYOR**

A CINEMATIC counterpart to the little theatre movement is rapidly developing into sizable proportions in this country. Since the war, somewhere in the neighborhood of 200 film societies have been organized by persons whose interest in the film medium goes beyond the purely entertainment functions of the commercial theatre. Dealing exclusively in 16-millimeter films, ranging in length from a single reel

to feature size, the film societies reportedly have an audience of not less than 100,000 persons.

In the absence of a central clearing house of information regarding the varied activities in this comparatively new field, it is practically impossible to assert that thus and so is a fact in the ordinary sense of the word. The film societies, patterned after the Cine Clubs which were introduced in France in the early Twenties and which are again flourishing there

after practically ceasing to exist during the war years, are only one of many outlets through which non-theatrical films are reaching an audience that now numbers several million in this country.

**Peak**

Interest in non-theatrical movies reached a peak in the United States during the war, and, in 1945, it was estimated that this type of film could reach an audience as large as 40,000,000. Just where the

attendance stands today cannot be stated with any degree of certainty, but it remains impressively high, and indications are that it will increase rather than diminish during the next several years. Labor unions, churches, women's clubs, civic organizations, social groups and a vast army of home consumers have a keen interest in 16mm. pictures.

Everything from Hollywood entertainment features of the recent past to studies of animal life, scientific subjects and discussions of labor-management relations are available on 16mm. film. Sources for obtaining such pictures are

constantly expanding and in many cities public libraries have established movie circulating departments from which the pictures may be borrowed free of charge just like books.

Such film libraries exist today in Milwaukee, Cleveland, Dallas, Akron, Charlotte, Louisville, Detroit, Cincinnati, Minneapolis, St. Louis and other cities. None of the public libraries in New York City have film lending departments, but films are available at the public library in Rochester, N. Y.

## Sprouting

Unlike the far more numerous users of 16mm. films for educational and informational purposes—these are known as "functional pictures"—the film societies are primarily interested in furthering the study of cinematic art. Practically every college town in the country has a going film society, composed of groups numbering from as few as twenty to 500 or more. The size of audiences as well as the existence of film societies is subject to wide variations. Many a group which got off to an enthusiastic start dwindled abruptly or disbanded completely after a few ill-chosen programs.

One of the most unique film societies is the New York group called Cinema 16, which was organized three years ago by Amos Vogel and today has a membership of more than 2,500. Cinema 16 now is attempting to become established as a sort of general supplier of programs for other societies around the country and this season will have programs going in Washington and Chicago and also in Los Angeles, where Kenneth Macgowan, film producer and chairman of the Department of Theatre Arts at the University of California at Los Angeles, is in the process of organizing a Cinema 16 branch.

When Cinema 16 offered its first program here at the Provincetown Playhouse in October, 1947, the audience numbered 200. Sponsored by Jean Renoir, John Dos Passos, John Huston, Robert Flaherty, John Grierson, Yehudi Menuhin and Oscar Hammerstein among others, Cinema 16, starting its new season on Oct. 9, now will hold two showings monthly, on Wednesday evenings at the Central Needle Trades Auditorium, and on Sunday mornings, beginning at 11:45 o'clock, in the Paris Theatre.

By showing such brilliant examples of documentary and experimental film techniques as "The City," "Monkey Into Man," Grierson's "Night Mail," Rene Clair's "Le Chapeau de Paille d'Italie" and Liam O'Flaherty's "The Puritan," Cinema 16 found a ready public, many of whom were unaware of the existence of a vast source of mentally stimulating and pictorially exciting motion pictures.

Film society audiences run the gamut from pseudo-intellectuals and sophisticates, professing a marked disdain for Hollywood's fictional creations, to more reasonable and intellectually sound admirers of motion pictures. Among the last are many "occasional" patrons of the commercial movie theatre who have a healthy respect for Hollywood's best creative efforts, but also recognize the film as a potent force in modern society and a medium of expression which has yet to be fully developed.

September 18, 1949

# THE SCREEN

## Vittorio De Sica's 'The Bicycle Thief,' a Drama of Post-War Rome, Arrives at World

THE BICYCLE THIEF, story and screenplay by Cesare Zavattini, based on the novel of the same name by Luigi Bartolini; directed by Vittorio De Sica; produced in Rome by De Sica Production Company, and released here by Mayer-Burstyn. At the World.
Antonio ................. Lamberto Maggiorani
Maria ....................... Lianella Carell
Bruno ......................... Enzo Staiola
The Medium ................... Elena Altieri
The Thief ............... Vittorio Antonucci
Baiocco .............. Gino Saltamerenda

### By BOSLEY CROWTHER

Again the Italians have sent us a brilliant and devastating film in Vittorio De Sica's rueful drama of modern city life, "The Bicycle Thief." Widely and fervently heralded by those who had seen it abroad (where it already has won several prizes at various film festivals), this heart-tearing picture of frustration, which came to the World yesterday, bids fair to fulfill all the forecasts of its absolute triumph over here.

For once more the talented De Sica, who gave us the shattering "Shoe Shine," that desperately tragic demonstration of juvenile corruption in post-war Rome, has laid hold upon and sharply imaged in simple and realistic terms a major—indeed, a fundamental and universal—dramatic theme. It is the isolation and loneliness of the little man in this complex social world that is ironically blessed with institutions to comfort and protect mankind.

Although he has again set his drama in the streets of Rome and has populated it densely with significant contemporary types, De Sica is concerned here with something which is not confined to Rome nor solely originated by post-war disorder and distress. He is pondering the piteous paradoxes of poverty, no matter where, and the wretched compulsions of sheer self-interest in man's desperate struggle to survive. And while he has limited his vista to a vivid cross-section of Roman life, he actually is holding a mirror up to millions of civilized men.

His story is lean and literal, completely unburdened with "plot," and written by Cesare Zavattini with the camera exclusively in mind. Based on a novel by Luigi Bartolini, it is simply the story of a poor working man whose essential bicycle is stolen from him and who hunts feverishly to find it throughout one day. The man is a modest bill-poster; he must have a bicycle to hold his newly found job; he has a wife and small son dependent on him; the loss is an overwhelming blow. And so, for one long, dismal Sunday he and his youngster scour the teeming streets of Rome, seeking that vital bicycle which, we must tell you, they never find.

That is the picture's story—it is as stark and direct as that, and it comes to a close with a fade-out as inconclusive as a passing nod. But during the course of its telling in the brilliant director's trenchant style, it is as full and electric and compelling as any plot-laden drama you ever saw. Every incident, every detail of the frantic and futile hunt is a taut and exciting adventure, in which hope is balanced against despair. Every movement of every person in it, every expression on every face is a striking illumination of some implicit passion or mood.

Just to cite a few episodes and crises, there is the eloquent inrush of hope when the workman acquires his bicycle after his wife pawns the sheets from their beds; there is the horrible, sickening moment when he realizes that the bicycle is gone, seized and ridden away before his own eyes by a thief who escapes in the traffic's swirl; there is the vain and pathetic expedition to hunt the parts of the bicycle in a second-hand mart and there is the bleak and ironic pursuit of a suspect into a church during a mass for the poor. There are also lighter touches, such as a flock of babbling German seminarians rudely crowding the father and boy out of a shelter into the rain and a dash after the thief into a bordello, with the little boy compelled to remain outside.

Indeed, the whole structure of this picture, with its conglomeration of experiences, all interlocked with personal anguish, follows a classic plan. It is a plan in which the comedy and tragedy of daily life are recognized. As a matter of fact, both the story and the structure of this film might have been used by Charlie Chaplin in the old days to make one of his great wistful films, for "The Bicycle Thief" is, in essence, a poignant and bitter irony—the irony of a little fellow buffeted by an indifferent world.

As directed by De Sica, however, the natural and the real are emphasized, with the film largely shot in actual settings and played by a non-professional cast. In the role of the anguished workman, Lamberto Maggiorani is superb, expressing the subtle mood transitions of the man with extraordinary power. And Enzo Staiola plays his small son with a firmness that fully reveals the rugged determination and yet the latent sensitivity of the lad. One of the most overpowering incidents in the film occurs when the father, in desperation, thoughtlessly slaps the anxious boy. Lianella Carell is also moving as the mother—a smaller role—and Vittorio Antonucci is hard and shabby as the thief. He is the only professional in the large cast.

One further word for the music which has been aptly written and used to raise the emotional potential—the plaintive theme that accompanies the father and son, the music of rolling bicycles and the "morning music," full of freshness and bells. De Sica has artfully wrapped it into a film that will tear your heart, but which should fill you with warmth and compassion. People should see it—and they should care.

Excellent English subtitles translate the Italian dialogue.

December 13, 1949

# THE SCREEN IN REVIEW

## Intriguing Japanese Picture, 'Rasho-Mon,' First Feature at Rebuilt Little Carnegie

RASHO-MON, screen play by Akira Kurosawa and Shinobu Hashimoto; based on the novel "In the Forest" by Ryunosuke Akutagawa; directed by Akira Kurosawa; produced by Jingo Minoura. A Daiei Production released here by RKO Radio Pictures. At the Little Carnegie.
The Bandit ................. Toshiro Mifune
The Woman ................. Machiko Kyo
The Man ................. Masayuki Mori
The Firewood Dealer ........ Takashi Shimura
The Priest ................. Minoru Chiaki
The Commoner ............. Kichijiro Ueda
The Medium ............... Fumiko Homma
The Police ............... Daisuke Kato

### By BOSLEY CROWTHER

A doubly rewarding experience for those who seek out unusual films in attractive and comfortable surroundings was made available yesterday upon the reopening of the rebuilt Little Carnegie with the Japanese film, "Rasho-Mon." For here the attraction and the theatre are appropriately and interestingly matched in a striking association of cinematic and architectural artistry, stimulating to the intelligence and the taste of the patron in both realms.

"Rasho-Mon," which created much excitement when it suddenly appeared upon the scene of the Venice Film Festival last autumn and carried off the grand prize, is, indeed, an artistic achievement of such distinct and exotic character that it is difficult to estimate it alongside conventional story films. On the surface, it isn't a picture of the sort that we're accustomed to at all, being simply a careful observation of a dramatic incident from four points of view, with an eye to discovering some meaning—some rationalization—in the seeming heartlessness of man.

At the start, three Japanese wanderers are sheltering themselves from the rain in the ruined gatehouse of a city. The time is many centuries ago. The country is desolate, the people disillusioned, and the three men are contemplating a brutal act that has occurred outside the city and is preying upon their minds.

It seems that a notorious bandit has waylaid a merchant and his wife. (The story is visualized in flashback, as later told by the bandit to a judge.) After tying up the merchant, the bandit rapes the wife and then—according to his story—kills the merchant in a fair duel with swords.

However, as the wife tells the story, she is so crushed by her husband's contempt after the shameful violence and after the bandit has fled that she begs her husband to kill her. When he refuses, she faints. Upon recovery, she discovers a dagger which she was holding in her hands is in his chest.

According to the dead husband's story, as told through a medium, his life is taken by his own hand when the bandit and his faithless wife flee. And, finally, an humble wood-gatherer—one of the three men reflecting on the crime—reports that he witnessed the murder and that the bandit killed the husband at the wife's behest.

At the end, the three men are no nearer an understanding than they are at the start, but some hope for man's soul is discovered in the willingness of the wood-gatherer to adopt a foundling child, despite some previous evidence that he acted selfishly in reporting the case.

As we say, the dramatic incident is singular, devoid of conventional plot, and the action may appear repetitious because of the concentration of the yarn. And yet there emerges from this picture—from this scrap of a fable from the past—a curiously agitating tension and a haunting sense of the wild impulses that move men.

Much of the power of the picture—and it unquestionably has hypnotic power—derives from the brilliance with which the camera of Director Akira Kurosawa has been used. The photography is excellent and the flow of images is expressive beyond words. Likewise the use of music and of incidental sounds is superb, and the acting of all the performers is aptly provocative.

Machiko Kyo is lovely and vital as the questionable wife, conveying in her distractions a depth of mystery, and Toshiro Mifune plays the bandit with terrifying wildness and hot brutality. Masayuki Mori is icy as the husband and the remaining members of the cast handle their roles with the competence of people who know their jobs.

Whether this picture has pertinence to the present day—whether its dismal cynicism and its ultimate grasp at hope reflect a current disposition of people in Japan—is something we cannot tell you. But, without reservation, we can say that it is an artful and fascinating presentation of a slice of life on the screen. The Japanese dialogue is translated with English subtitles.

December 27, 1951

## 'On the Waterfront'

### Brando Stars in Film Directed by Kazan

ON THE WATERFRONT; screen play by Budd Schulberg; based on an original story by Mr. Schulberg and suggested by the series of Pulitzer Prize-winning articles by Malcolm Johnson; directed by Elia Kazan; produced by Sam Spiegel, a Horizon picture presented by Columbia; at the Astor.

| | |
|---|---|
| Terry Malloy | Marlon Brando |
| Edie Doyle | Eva Marie Saint |
| Father Barry | Karl Malden |
| Johnny Friendly | Lee J. Cobb |
| Charley Malloy | Rod Steiger |
| "Pop" Doyle | John Hamilton |
| "Kayo" Dugan | Pat Henning |
| Glover | Leif Erickson |
| Big Mac | James Westerfield |
| Truck | Tony Galento |
| Tillio | Tami Mauriello |
| Barney | Abe Simon |
| Mott | John Heldabrand |
| Moose | Rudy Bond |
| Luke | Don Blackman |
| Jimmy | Arthur Keegan |
| J P | Barry Macollum |
| Spec | Mike O'Dowd |
| Gillette | Marty Balsam |
| Slim | Fred Gwynne |
| Tommy | Thomas Handley |
| Mrs. Collins | Anne Hegira |

A SMALL but obviously dedicated group of realists has forged artistry, anger and some horrible truths into "On the Waterfront," as violent and indelible a film record of man's inhumanity to man as has come to light this year. And, while this explosive indictment of the vultures and the meek prey of the docksides, which was unveiled at the Astor yesterday, occasionally is only surface dramatization and an oversimplification of the personalities and evils of our waterfront, it is, nevertheless, an uncommonly powerful, exciting and imaginative use of the screen by gifted professionals.

Although journalism and television already have made the brutal feudalism of the wharves a part of current history, "On the Waterfront" adds a graphic dimension to these sordid pages. Credit for this achievement cannot be relegated to a specific few. Scenarist Budd Schulberg, who, since 1949, has lived with the story stemming from Malcolm Johnson's crusading newspaper articles; director Elia Kazan; the principals headed by Marlon Brando; producer Sam Spiegel; Columbia, which is presenting this independently made production; Leonard Bernstein, who herein is making his debut as a movie composer, and Boris Kaufman, the cinematographer, convincingly have illustrated the murder and mayhem of the waterfront's sleazy jungles.

They also have limned a bestial and venal boss longshoreman; the "shape-up" by which only his obedient, mulct, vassals can earn a day's pay; the hard and strange code that demands that these sullen men die rather than talk about these injustices and a crime commission that helps bring some light into their dark lives.

Perhaps these annals of crime are too labyrinthine to be fully and incisively captured by cameras. Suffice it to say, however, that while Mr. Kazan and Mr. Schulberg have not dug as deeply as they might, they have chosen a proper and highly effective cast and setting for their grim adventure. Moving cameras and crews to the crowded rookeries of Hoboken's quayside, where the film was shot in its entirety, they have told with amazing speed and force the story of Terry Malloy, ex-prize fighter and inarticulate tool of tough, ruthless and crooked labor leader, Johnny Friendly. The labor leader is an absolute unregenerated monarch of the docks who will blithely shake down his own men as well as ship owners; he will take cuts of pay envelopes and lend his impecunious union members money at usurious rates and he will have his pistol-toting goons dispatch anyone foolish enough to squeal to the crime commission attempting to investigate these practices.

•

It is the story also of one of these courageous few about to "sing" to the commission — a luckless longshoreman unwittingly set up for the kill by Terry Malloy, who is in his soft spot only because his older brother is the boss' slick, right-hand man. It is the tale of Terry's meeting with the dead man's agonized sister and a fearless, neighborhood priest, who, by love and reason, bring the vicious picture into focus for him. And, it is the account of the murder of Terry's brother; the rampaging younger man's defiant testimony before the commission and the climactic bloody battle that wrests the union from the boss' tenacious grasp.

Journalism may have made these ingredients familiar and certainly more inclusive and multi-dimension, but Mr. Kazan's direction, his outstanding

Karl Malden, Marlon Brando and Eva Marie Saint, as they appear in a scene from the new film "On the Waterfront."

cast and Mr. Schulberg's pithy and punchy dialogue give them distinction and terrific impact. Under the director's expert guidance, Marlon Brando's Terry Malloy is a shatteringly poignant portrait of an amoral, confused, illiterate citizen of the lower depths who is goaded into decency by love, hate and murder. His groping for words, use of the vernacular, care of his beloved pigeons, pugilist's walk and gestures and his discoveries of love and the immensity of the crimes surrounding him are highlights of a beautiful and moving portrayal.

In casting Eva Marie Saint —a newcomer to movies from TV and Broadway—Mr. Kazan has come up with a pretty and blond artisan who does not have to depend on these attributes. Her parochial school training is no bar to love with the proper stranger. Amid scenes of carnage, she gives tenderness and sensitivity to genuine romance. Karl Malden, whose importance in the scheme of this drama seems overemphasized, is, however, a tower of strength as the militant man of the cloth. Rod Steiger, another newcomer to films, is excellent as Brando's fearful brother. The pair have a final scene that is a harsh and touching revelation of their frailties.

Lee J. Cobb is muscularly effective as the labor boss. John Hamilton and Pat Henning are typical "longshoremen," gents who look at home in a hold, and Tony Galento, Tami Mauriello and Abe Simon —erstwhile heavyweight boxing contenders, who portray Cobb's chief goons—are citizens no one would want to meet in a dark alley. Despite its happy ending; its preachments and a somewhat slick approach to some of the facets of dockside strife and tribulations, "On the Waterfront" is moviemaking of a rare and high order. A. W.

July 29, 1954

# Screen: A Truthful Italian Journey

## 'La Strada' Is Tender, Realistic Parable

### By A. H. WEILER

ALTHOUGH Federico Fellini's talents as a director have not been displayed to advantage heretofore in these parts, his "La Strada" ("The Road"), which arrived at the Fifty-second Street Trans-Lux yesterday, is a tribute both to him and the Italian neo-realistic school of film-making.

His story of an itinerant strong man and the simple-minded girl who is his foil and helpmeet is a modern picaresque parable. Like life itself, it is seemingly aimless, disjointed on occasion and full of truth and poetry. Like the principals, it wanders along a sad and sometimes comic path while accentuating man's loneliness and need for love.

We have no idea, why "La Strada," which won a prize at the 1954 Venice Film Festival, has not been exposed to American audiences until now. Perhaps it is because Signor Fellini's theme offers neither a happy ending so dear to the hearts of escapists nor a clear-cut and shiningly hope-

### The Cast

LA STRADA, story and screen play by Federico Fellini and Tullio Pinelli; dialogue by Signor Pinelli; directed by Signor Fellini; produced by Dino De Laurentiis and Carlo Ponti and released by Trans-Lux Films. At the Fifty-second Street Trans-Lux.
Zampano ............... Anthony Quinn
Gelsomina ............ Giulietta Masina
Matto (The Fool) ...... Richard Basehart
Colombaini ............... Aldo Silvani
and
Marcella Rovere and Livia Venturini

ful plot. Suffice it to say that his study of his principals is honest and unadorned, strikingly realistic and yet genuinely tender and compassionate. "La Strada" is a road well worth traveling.

The story, let it be said at the outset, is, like its protagonists, simplicity itself. A boorish and brutish strong man literally buys a happy but mentally incompetent lass from her impoverished mother to serve as his clown, cook and concubine. She is replacing her sister, who has died. He teaches her some simple routines as they bowl along in his motorcycle-trailer—clowning and simple tunes on a cornet—to serve as a come-on to his pitifully corny act of breaking chains across his chest.

Although her timorousness fades into happiness as they

play villages, fairs and country weddings, her idyllic existence is broken when they join a small circus on the outskirts of Rome. Here a clown and high-wire artist goad her man, who is finally jailed for threatening the buffoon with a knife.

The clown, who has invited her to join him on the road, realizes that she is peculiarly dedicated to her hard master and advises her to wait for the bestial strong man.

"Everyone serves some purpose," he tells her, "and perhaps you must serve him."

Later, the pair meet the clown and the strong man beats and unwittingly kills him. Since the girl's constant whimpering serves as the strong man's conscience, he deserts his ill-fated companion. At the drama's climax, when he accidentally learns of her death, he breaks down in sudden and helpless realization of his solitude.

Despite this doleful outline, Signor Fellini has not handled his story in merely tragic or heavily dramatic fashion. In Giulietta Masina (Mrs. Fellini in private life) he has an extremely versatile performer who mirrors the simple passions and anxieties of the

child-like girl with rare and acute perception. She is expert at pantomime, funny as the tow-headed, doe-eyed and trusting foil and sentient enough to portray in wordless tension her fear of the man she basically loves.

Anthony Quinn is excellent as the growling, monosyllabic and apparently ruthless strong man, whose tastes are primitive and immediate. But his characterization is sensitively developed so that his innate loneliness shows through the chinks of his rough exterior. As the cheerful and prescient clown, Richard Basehart, like the haunting background score by Nino Rota, provides a humorous but pointed counterpoint to the towering and basically serious delineations of the two principals.

Signor Fellini has used his small cast, and, equally important, his camera, with the unmistakable touch of an artist. His vignettes fill his movie with beauty, sadness, humor and understanding.

Although there are English subtitles and the voices of the Messrs. Quinn and Basehart have been dubbed into Italian, "La Strada" needs no fuller explanations. It speaks forcefully, poetically and often movingly in a universal language.

July 17, 1956

# Screen: Shameful Incident of War

## 'Paths of Glory' Has Premiere at Victoria

PATHS OF GLORY: screenplay by Stanley Kubrick, Calder Willingham and Jim Thompson: based on the novel by Humphrey Cobb; directed by Mr. Kubrick; produced by James B. Harris; presented by Bryna Productions and released through United Artists. At the Victoria. Running time: eighty-six minutes.
Colonel Dax .......... Kirk Douglas
Corporal Paris .......... Ralph Meeker
General Broulard .... Adolphe Menjou
General Mireau ...... George Macready
Lieutenant Roget ...... Wayne Morris
Major Saint-Auban .... Richard Anderson
Private Arnaud ....... Joseph Turkel
Private Ferol ......... Timothy Carey
Colonel Judge ......... Peter Capell
German Girl ........ Susanne Christian
Sergeant Boulanger ..... Bert Freed
Priest .............. Emile Meyer
Private Lejeune ....... Kem Dibbs
Private Meyer ........ Jerry Hausner
Shell-Shocked Soldier .. Frederic Bell
Captain Nichols ..... Harold Benedict
Captain Rousseau ...... John Stein

### By BOSLEY CROWTHER

CREDIT Kirk Douglas with having the courage to produce and appear in the screen dramatization of a novel that has been a hot potato in Hollywood for twenty-two years. That is Humphrey Cobb's "Paths of Glory," a shocking story of a shameful incident in World War I—the

**Kirk Douglas**

court-martial and execution of three innocent French soldiers on charges of cowardice, only to salve a general's vanity.

Obviously, this is a story—

based on an actual occurrence, by the way—that reflects not alone on France's honor but also on the whole concept of military authority. Yet Mr. Douglas has made a movie of it an unembroidered, documentary-like account—with himself playing the role of an outraged colonel who tries vainly to intercede. It opened at the Victoria yesterday.

To a certain extent, this forthright picture has the impact of hard reality, mainly because its frank avowal of agonizing, uncompensated injustice is pursued to the bitter, tragic end. The inevitability of a fatal foul-up is presented right at the start, when an ambitious general agrees to throw one of his regiments into an attack that he knows has little chance to succeed. And it looms with ever mounting horror as he orders an example to be made of three men picked at random from the thwarted attackers and dogs them unmercifully to their doom.

All this is shown with shattering candor in this film,

which was shot in Germany and was directed by Stanley Kubrick, who also helped to write the screenplay with Jim Thompson and Calder Willingham. The close, hard eye of Mr. Kubrick's sullen camera bores directly into the minds of scheming men and into the hearts of patient, frightened soldiers who have to accept orders to die.

Mr. Kubrick has made it look terrific. The execution scene is one of the most craftily directed and emotionally lacerating that we have ever seen.

But there are two troubling flaws in this picture, one in the realm of technique and the other in the realm of significance, which determine its larger, lasting worth.

We feel that Mr. Kubrick —and Mr. Douglas — have made a damaging mistake in playing it in colloquial English, with American accents and attitudes, while studiously making it look as much as possible like a document of the French Army in World War I. The illusion of reality is blown completely whenever anybody talks.

December 26, 1957

# 'Seventh Seal'

## Swedish Allegory Has Premiere at Paris

### By BOSLEY CROWTHER

SWEDISH director Ingmar Bergman, whose "Smiles of a Summer Night" proved him an unsuspected master of satiric comedy, surprises again in yet another even more neglected vein with his new self-written and self-directed allegorical film, "The Seventh Seal."

This initially mystifying drama, known in Swedish as "Det Sjunde Inseglet," opened yesterday at the Paris, and slowly turns out to be a piercing and powerful contemplation of the passage of man upon this earth. Essentially intellectual, yet emotionally stimulating, too, it is as tough - and rewarding—a screen challenge as the moviegoer has had to face this year.

The specified time of its action is the fourteenth century and the locale is apparently Sweden—or it could be any other medieval European country- in the fearful throes of the plague. A knight, just

## The Cast

THE SEVENTH SEAL, written and directed by Ingmar Bergman; produced by AB Svensk Filmindustri; distributed by Janus Films. At the Paris, 4 West Fifty-eighth Street. Running time: 105 minutes.
Knight ............... Max von Sydow
Squire ............ Gunnar Bjornstrand
Death ................... Bengt Ekerot
Jof ..................... Nils Poppe
Mia ................... Bibi Andersson
Lisa ...................... Inga Gill
Witch ................. Maud Hansson
The Knight's spouse ... Inga Landgre
Girl ............... Gunnel Lindblom
Raval ............... Bertil Anderberg
Monk .................... Anders Ek
Smith ................... Ake Fridell
Church painter ........ Gunnar Olsson
Skat ............... Erik Strandmark

returned from the Crusades, meets black-robed Death on the beach and makes a bargain for time to do a good deed while the two of them play a sort of running game of chess.

●

While the game is in progress, the knight and his squire go forth to find the land full of trembling people who darkly await the Judgment Day. Some are led to self-pity and torturing themselves by their priests, who also have provided a symbol of wickedness in an innocent girl condemned as a "witch." Others are given to snatching

a little fun while they may; and, recalling Mr. Bergman's last picture, you should guess what sort of fun that is.

But en route, the knight, who, significantly, was disillusioned by the Crusaders and is still seeking God, comes across a little family of traveling actors who are as fresh and wholesome as the morning dew. Except that the young father of the little family has a way of seeing visions from time to time (to his pretty wife's tolerant amusement), the happy couple are as normal as their chubby child. And it is this little family that the sad knight, still uncertain, arranges to save when he and a gathering of weary wanderers, including his defiant squire, must submit to Death at the end of the game.

If this sounds a somewhat deep-dish drama, laden with obscurities and costumes, it is because the graphic style of Mr. Bergman does not glow in a summary. It is a provocative picture, filled with intimations that is true—some what you want to make of them and some as clear as the back of your hand.

For instance, it could be that Mr. Bergman means the plague to represent all mortal fears of threats beyond likely

containment that hang over modern man. Certainly, there can be little question what he means when he shows the piteous herds of anguished and self-tormenting people driven by soldiers and priests.

●

But the profundities of the ideas are lightened and made flexible by glowing pictorial presentation of action that is interesting and strong. Mr. Bergman uses his camera and actors for sharp, realistic effects. Black-robed Death is as frank and insistent as a terrified girl being hustled to the stake. A beach and a cloudy sky are as literal and dramatic as a lusty woman's coquetries. Mr. Bergman hits you with it, right between the eyes.

And his actors are excellent, from Max von Sydow as the gaunt and towering knight, through Gunnar Bjornstrand as his squire and Bengt Ekerot as Death to Maud Hansson as the piteous "witch." Nils Poppe as the strolling player and Bibi Andersson as his wife are warming and cheerful companions in an uncommon and fascinating film.

*October 14, 1958*

---

# 'The 400 Blows'

## A Small Masterpiece From France Opens

### By BOSLEY CROWTHER

LET it be noted without contention that the crest of the flow of recent films from the "new wave" of young French directors hit these shores yesterday with the arrival at the Fine Arts Theatre of "The 400 Blows" ("Les Quatre Cents Coups") of François Truffaut.

Not since the 1952 arrival of René Clement's "Forbidden Games," with which this extraordinary little picture of M. Truffaut most interestingly compares, have we had from France a cinema that so brilliantly and strikingly reveals the explosion of a fresh creative talent in the directorial field.

Amazingly, this vigorous effort is the first feature film of M. Truffaut, who had previously been (of all things!) the movie critic for a French magazine. (A short film of his, "The Mischief Makers," was shown here at the Little Carnegie some months back.) But, for all his professional inexperience and his youthfulness (27 years), M. Truffaut has here turned out a picture that might be termed a small masterpiece.

The striking distinctions of it are the clarity and honesty

## The Cast

THE 400 BLOWS (Les Quatre Cents Coups), screen play by François Truffaut and Marcel Moussy; directed and produced by M. Truffaut; produced by Les Films du Carosse and Sedif and presented by Zenith International Film Corporation. At the Fine Arts, Fifty-eighth Street west of Lexington Avenue. Running time: ninety-eight minutes.
Antoine Doinel ...... Jean-Pierre Leaud
Rene ................... Patrick Auffay
Mme. Doinel ............ Claire Maurier
M. Doinel ............... Albert Remy
The Teacher ........... Guy Decomble

with which it presents a moving story of the troubles of a 12-year-old boy. Where previous films on similar subjects have been fatted and fictionalized with all sorts of adult misconceptions and sentimentalities, this is a smashingly convincing demonstration on the level of the boy—cool, firm and realistic, without a false note or a trace of goo.

And yet, in its frank examination of the life of this tough Parisian kid as he moves through the lonely stages of disintegration at home and at school, it offers an overwhelming insight into the emotional confusion of the lad and a truly heartbreaking awareness of his unspoken agonies.

It is said that this film, which M. Truffaut has written, directed and produced, is autobiographical. That may well explain the feeling of intimate occurrence that is packed into all its candid scenes. From the introductory sequence, which takes the

viewer in an automobile through middle-class quarters of Paris in the shadow of the Eiffel Tower, while a curiously rollicking yet plaintive musical score is played, one gets a profound impression of being personally involved—a hard-by observer, if not participant, in the small joys and sorrows of the boy.

Because of the stunningly literal and factual camera style of M. Truffaut, as well as his clear and sympathetic understanding of the matter he explores, one feels close enough to the parents to cry out to them their cruel mistakes or to shake an obtuse and dull schoolteacher into an awareness of the wrong he does bright boys.

●

Eagerness makes us want to tell you of countless charming things in this film, little bits of unpushed communication that spin a fine web of sympathy—little things that tell you volumes about the tough, courageous nature of the boy, his rugged, sometimes ruthless, self-possession and his poignant naïveté. They are subtle, often droll. Also we would like to note a lot about the pathos of the parents and the social incompetence of the kind of school that is here represented and is obviously hated and condemned by M. Truffaut.

But space prohibits expansion, other than to say that the compound is not only moving but also tremendously meaningful. When the lad fin-

ally says of his parents, "They didn't always tell the truth," there is spoken the most profound summation of the problem of the wayward child today.

Words cannot state simply how fine is Jean-Pierre Leaud in the role of the boy—how implacably deadpanned yet expressive, how apparently relaxed yet tense, how beautifully positive in his movement, like a pint-sized Jean Gabin. Out of this brand new youngster, M. Truffaut has elicited a performance that will live as a delightful, provoking and heartbreaking monument to a boy.

Playing beside him, Patrick Auffay is equally solid as a pal, companion in juvenile deceptions and truant escapades.

●

Not to be sneezed at, either, is the excellent performance that Claire Maurier gives as the shallow, deceitful mother, or the fine acting of Albert Remy, as the soft, confused and futile father, or the performance of Guy Decomble, as a stupid and uninspired schoolteacher.

The musical score of Jean Constantin is superb, and very good English subtitles translate the tough French dialogue.

Here is a picture that encourages an exciting refreshment of faith in films.

*November 17, 1959*

# Screen: Sudden Shocks

## Hitchcock's 'Psycho' Bows at 2 Houses

### By BOSLEY CROWTHER

YOU had better have a pretty strong stomach and be prepared for a couple of grisly shocks when you go to see Alfred Hitchcock's "Psycho," which a great many people are sure to do. For Mr. Hitchcock, an old hand at frightening people, comes at you with a club in this frankly intended blood-curdler, which opened at the DeMille and Baronet yesterday.

There is not an abundance of subtlety or the lately familiar Hitchcock bent toward significant and colorful scenery in this obviously low-budget job. With a minimum of complication, it gets off to a black-and-white start with the arrival of a fugitive girl with a stolen bankroll right at an eerie motel.

## The Cast

PSYCHO, screen play by Joseph Stefano, from a novel by Robert Bloch; directed and produced by Alfred Hitchcock for Paramount Pictures. At the Baronet Theatre, Third Avenue and Fifty-ninth Street, and DeMille Theatre, Broadway and Forty-seventh Street. Running time: 109 minutes.
Norman Bates ........Anthony Perkins
Lila Crane ...................Vera Miles
Sam Loomis ..............John Gavin
Marion Crane ............Janet Leigh
Milton Arbogast ........Martin Balsam
Sheriff Chambers ......John McIntire
Dr. Richmond ...........Simon Oakland
Mr. Cassidy ..........Frank Albertson
Caroline .................Pat Hitchcock
Mr. Lowery ............Vaughn Taylor
Mrs. Chambers ..........Lurene Tuttle

Well, perhaps it doesn't get her there too swiftly. That's another little thing about this film. It does seem slowly paced for Mr. Hitchcock and given over to a lot of small detail. But when it does get her to the motel and apparently settled for the night, it turns out this isolated haven is, indeed, a haunted house.

The young man who diffidently tends it — he is Anthony Perkins and the girl is Janet Leigh—is a queer duck, given to smirks and giggles and swift dashes up to a stark Victorian mansion on

**Anthony Perkins in "Psycho"**

a hill. There, it appears, he has a mother—a cantankerous old woman—concealed. And that mother, as it soon develops, is deft at creeping up with a knife and sticking holes into people, drawing considerable blood.

That's the way it is with Mr. Hitchcock's picture—slow buildups to sudden shocks that are old-fashioned melodramatics, however effective and sure, until a couple of people have been gruesomely punctured and the mystery of the haunted house has been revealed. Then it may be a matter of question whether Mr. Hitchcock's points of psychology, the sort highly favored by Krafft-Ebing, are as reliable as his melodramatic stunts.

Frankly, we feel his explanations are a bit of leg-pulling by a man who has been known to resort to such tactics in his former films.

The consequence is his denouement falls quite flat for us. But the acting is fair. Mr. Perkins and Miss Leigh perform with verve, and Vera Miles, John Gavin and Martin Balsam do well enough in other roles.

The one thing we would note with disappointment is that, among the stuffed birds that adorn the motel office of Mr. Perkins, there are no significant bats.

June 17, 1960

---

# NOW YOU SEE IT—

## The Place of Illusion In Cinema Art

### By BOSLEY CROWTHER

WHAT do you see when you see a movie? This question, abruptly put to the average for-fun moviegoer who seldom bothers with the how-comes of films, might get him so snarled in calculations that he'd never get free of the mental knots.

Is a movie a concrete representation of something that has actually occurred, either in fact or in imitation of presumed reality? Is it a form of communication in which pictures instead of words are used to excite in the mind of the viewer a succession of thoughts and images? Is it an optical experience—or illusion—with no reality outside of its singular occurrence on the screen of a theatre? Or is it one of a dozen other things?

These are questions about which the experts have been pondering and arguing for many years—indeed, ever since the first theatre audience was made

to scream and scatter by the moving picture of an onrushing railroad train. And they haven't yet come to full agreement on precisely what a movie is, so you'd hardly expect the average fellow to be quick with incisive ideas. But thinking about it is important for the continuing maturing of the screen, and, for those who like intellectual twisters, it is downright jolly good fun.

### Theory of Film

Latest invitation to the pastime—or to pursuit of knowledge of cinema art—is a new book by Sigfried Kracauer entitled "Theory of Film." Like other works on the subject, notably those of Sergei Eisenstein and Vsevolod Pudovkin, the great Soviet Russian theorists, it is pretty heavy going along the esthetics front. And the price of it is $10 (Oxford University Press), so it isn't something you'd pick up to kill a couple of hours.

However, it is well worth studying for the wealth of analysis it contains and for the opportunity it affords the serious student or the dedicated film-maker to sharpen and oppose his own ideas.

For instance, this observer was more and more disturbed by Mr. Kracauer's insistence that a basic and essential property of the true motion picture

is something he terms "camera-reality." By this he means (we gather) that a film, to have full validity, must be a recording and revelation through the camera of physical reality.

Thus the ideal motion picture —one that perfectly contains and blends what he designates as the "realistic" and "formative" tendencies—would be (and again, we say, we gather) such a film as Vittorio de Sica's "The Bicycle Thief," Federico Fellini's "La Strada" or Robert Flaherty's "Nanook of the North."

Now, there is certainly nothing wrong with realism—or an illusion of physical reality—in a certain type of motion picture. Indeed, it is essential to the film designed to convey the impression that its occurrences are recorded actuality—that is to say, occurrences snatched directly from life by the watchful camera, impromptu and unrehearsed. And we certainly agree with Mr. Kracauer that the motion picture is uniquely qualified to communicate the illusion of physical reality and make artful expression out of it.

### Magic

But we cannot subscribe to his obsession with the magic of the literal photograph as the basis of the ideal motion picture and the sine qua non of cinema art. For there are other good

ways of conveying illusion, which is what the movies are, than by means of exclusively realistic and "episodic" photographs.

Thoroughly potential and acceptable material for cinema is the stuff of fantasy and romance. This cannot rationally be conveyed to achieve the essential illusion by realistic photography. A degree of fantastification or romanticizing in the graphic display is usually necessary to accomplish validity.

There is a strong inclination on the part of average filmgoers and even theorists to lose themselves in the notion that the art of movies and the best things they see on the screen are the consequence of thorough literalism. In their healthy enthusiasm and emotional susceptibility, they forget that picture making is a complex craft of synthesis—that all sorts of tricks, including tricks of dialogue and photography — are used to absorb the viewer with the illusion the artists wish to convey. If the artists do a good job, an illusion is achieved and a conviction is established and the picture is hailed as art. If they do a bad job, it is apparent they have been up to artifice and tricks. Everybody goes home muttering, "Hollywood!"

December 11, 1960

# Screen: Sordid View of French Life

## 'Breathless' in Debut at the Fine Arts

### By BOSLEY CROWTHER

AS sordid as is the French film, "Breathless" ("A Bout de Souffle"), which came to the Fine Arts yesterday—and sordid is really a mild word for its pile-up of gross indecencies—it is withal a fascinating communication of the savage ways and moods of some of the rootless young people of Europe (and America) today.

Made by Jean-Luc Godard, one of the newest and youngest of the "new wave" of experimental directors who seem to have taken over the cinema in France, it goes at its unattractive subject in an eccentric photographic style that sharply conveys the nervous tempo and the emotional erraticalness of the story it tells. And through the American actress, Jean Seberg, and a hypnotically ugly new young man by the name of Jean-Paul Belmondo, it projects two downright fearsome characters.

●

This should be enough, right now, to warn you that this is not a movie for the

## The Cast

BREATHLESS, screenplay by Jean-Luc Godard based on a story by Francois Truffaut; directed by M. Godard; produced by Georges De Beauregarde; presented by Films Around the World, Inc. At the Fine Arts Theatre. Fifty-eighth Street west of Lexington Avenue. Running time: eighty-nine minutes.
Patricia Franchini........Jean Seberg
Michel Poiccard....Jean-Paul Belmondo
Liliane.................Liliane David
Inspector.............Daniel Boulanger
Parvulesco.........Jean-Paul Melville
Berrouti...........Henri-Jacques Huet
Used Car Dealer.......Claude Mansart
Editor.....................Van Doude
Informer.............Jean-Luc Godard

kids or for that easily shockable individual who used to be known as the old lady from Dubuque. It is emphatically, unrestrainedly vicious, completely devoid of moral tone, concerned mainly with eroticism and the restless drives of a cruel young punk to get along. Although it does not appear intended deliberately to shock, the very vigor of its reportorial candor compels that it must do so.

On the surface, it is a story of a couple of murky days in the lives of two erratic young lovers in Paris, their temporary home. He is a car thief and hoodlum, on the lam after having casually killed a policeman while trying to get away with a stolen car. She is an expatriate American newspaper street vender and does occasional

stories for an American newspaper man friend.

But in the frenetic fashion in which M. Godard pictures these few days—the nerve-tattering contacts of the lovers, their ragged relations with the rest of the world—there is subtly conveyed a vastly complex comprehension of an element of youth that is vagrant, disjointed, animalistic and doesn't give a damn for anybody or anything, not even itself.

●

The key is in the character that M. Belmondo plays, an impudent, arrogant, sharp-witted and alarmingly amoral hood. He thinks nothing more of killing a policeman or dismissing the pregnant condition of his girl than he does of pilfering the purse of an occasional sweetheart or rabbit-punching and robbing a guy in a gentlemen's room.

For a brief spell—or, rather a long spell, for the amount of time it takes up in the film—as he casually and coyly induces his pensive girl friend to resume their love affair, it does look as if there may be a trace of poignant gentleness in him, some sincerity beneath the imitation of a swaggering American movie star. But there isn't. When his distracted girl finally

turns him in and he is shot in the street, he can only muster a bit of bravado and label his girl with a filthy name.

The girl, too, is pretty much impervious to morality or sentiment, although she does indicate a sensitive nature that has been torn by disappointments and loneliness. As little Miss Seberg plays her, with her child's face and closely cropped hair, she is occasionally touching. But she is more often cold and shrewd, an efficiently self-defensive animal in a glittering, glib, irrational, heartless world.

●

All of this, and its sickening implications, M. Godard has got into this film, which progresses in a style of disconnected cutting that might be described as "pictorial cacaphony." A musical score of erratic tonal qualities emphasizes the eccentric moods. And in M. Belmondo we see an actor who is the most effective cigarette-mouther and thumb-to-lip rubber since time began.

Say this, in sum, for "Breathless": it is certainly no cliché, in any area or sense of the word. It is more a chunk of raw drama, graphically and artfully torn with appropriately ragged edges out of the tough underbelly of modern metropolitan life.

February 8, 1961

# Screen: 'Viridiana' Here From Spain

## Luis Bunuel Film Is at Paris Theatre

### By BOSLEY CROWTHER

LUIS BUNUEL is presenting a variation on an ancient theme in his new Spanish film, "Viridiana," which came to the Paris yesterday. The theme is that well-intended charity can often be badly misplaced by innocent, pious people. Therefore, beware of charity.

That is the obvious moral that forms in this grim and tumorous tale of a beautiful young religious novice who gets into an unholy mess when she gives up her holy calling to try to atone for a wrong she has done. But we strongly suspect that Señor Bunuel had more than this in mind when he made this intense and bitter picture, the first he's made in Spain in thirty years.

We sense all the way through this drama of the shocking education of this girl in the realities of passion and the grossness of most of mankind a stinging, unmerciful sarcasm directed at the piously insulated mind and a strong strain of guarded criticism of social conditions in Spain.

VIRIDIANA, written and directed by Luis Bunuel; produced by Gustavo Alatriste and released by Kingsley International. At the Paris Theatre, 4 West Fifty-eighth Street. Running time: ninety minutes.
Jorge................Francisco Rabal
Viridiana..............Silvia Pinal
Don Jaime............Fernando Rey
Ramona............Margarita Lozano
Lucia................Victoria Zinny
Rita.................Teresa Rabal

When his heroine, Viridiana, is violently and unhealthily repelled by the tendered affection of her uncle, who sees in her a perfect image of his long-dead wife, there is clearly implied recognition of the tangled libido of the girl and the pitiful confusion of the uncle in a bind of propriety, sentimentality and lust. That he hangs himself in remorse and anguish after the girl has fled reveals Señor Bunuel's recognition of the grotesqueness of the gentlemen's code.

And when the girl gives up her holy calling and returns to her dead uncle's farm with a rabble of derelicts and beggars to make amends for what she has done, there is stark evidence of his disgust at the pallid charitable gesture in the greed and meanness with which he has imbued these bums.

Señor Bunuel makes no bones about it. The most powerful stuff in his film are

the macabre scenes of these people showing how vicious and contemptible they are. They snivel, cheat, steal, abuse one another, ostracize and brutalize one who has a foul disease and finally cut loose in a wild carouse that fairly wrecks the place. Played as a thundering obbligato to the milky generosity of the girl, these scenes carry the moralizing muscle and ironic punch of the film.

Following them, there is little more than drabness in the evidence that the girl ends up playing cards and listening to rock 'n' roll music with her uncle's robust illegitimate son.

●

Whether Señor Bunuel means his picture as a reflection of all people or just the people of Spain is not clear nor, indeed, is it essential. It is an ugly, depressing view of life. And, to be frank about it, it is a little old-fashioned, too. His format is strangely literary; his symbols are obvious and blunt, such as the revulsion of the girl toward milking or the display of a penknife built into a crucifix. And there is something just a bit corny about having his bums doing their bacchanalian

dance to the thunder of the "Hallelujah Chorus."

However, it is stringently directed and expertly played. Silvia Pinal is lovely and precisely as stiff and forbidding as she should be as the misguided novice. Fernando Ray makes the uncle a poignant dolt and Francisco Rabal is aggressive and realistic as the illegitimate son. Margarita Lozano does a good job as a cowed and inhibited maid and Teresa Rabal is lively as the latter's nosey child.

As usual in Señor Bunuel's pictures, the black-and-white photography is artful and true, and the English subtitles do politely by the sometimes coarse Spanish dialogue.

●

Also on the bill is a sarcastic little bit, called "Very Nice, Very Nice," which indicates that humanity is in quite a frenzy in this age of atomic bombs. Using the montage technique at a dazzling and breath-taking speed, it jumbles faces and snatches of dialogue so wildly that it leaves you dizzy and slightly disturbed. Can we all be quite as frantic as this optical mélange makes us look? (That question might not be bothersome if one had not just seen, Señor Bunuel's film!)

March 20, 1962

# So Deeply Obscure, So Widely Discussed

### By HOLLIS ALPERT

IT used to be an article of intellectual faith that movies were designed primarily for 12-year-old mentalities. Adults—that is, mature, thinking adults—went to the movies, if at all, with a patronizing, snickering attitude, or with a deep-felt guilt. During this period of disdain, which can be dated roughly between 1940 and 1950, Wolcott Gibbs, the late drama critic for The New Yorker, was put on the movie beat for a time, and then quit cold, out of fear for his sanity and sensibilities.

Mr. Gibbs today would receive little sympathy from mature, thinking, adult circles. He would, in fact, be regarded as a thoroughgoing square, for, as anyone knows who reads movie critics or listens to the latest chitchat at coffeehouses in Manhattan and Hollywood, movies—the *real* movies, that is—require more work, understanding, and appreciation in depth than 12-year-old mentalities, unless at the genius level, can possibly provide.

Some of the most fervent critical huzzahs, and some of the most worshipful audience appreciation, are now reserved for films so tantalizingly elusive in their meanings, so deeply obscure, that six people can discuss a particular movie and not seem to be talking about the same movie at all. New terminology has come into being, such as "cubist thriller," "the machinery of visual image-making, conjoined with musical sounds and the contrapuntal assistance of vocalized images and ideas," "a jaggedly abstract piece of visual music," "a rarefied film, seeming to exist in a state of psychic shock, bemused by its own vision of a despairing world."

THIS is not how movies used to be described, except in the most narrowly restricted, esthetic, avant-garde milieus. Yet the above samples were taken from Time, The Herald Tribune, and The New York Times, which did not happen to be covering some small, effete experiments shown at a Cinema 16 screening, but such successful foreign feature imports as "Breathless," "L'Avventura," and "Last Year at Marienbad." To be sure, the critics were not speaking of Hollywood films, nor do they generally describe our native fare in such terms, unless the film under discussion happens to be a badly photographed, "improvised" movie like "Shadows," which Dwight MacDonald of Esquire regarded as one of the motion-picture landmarks of modern times.

There is currently, without doubt, a vogue for the recherché film, an extraordinary fascination for the intriguing possibilities of cinema, and any effort which seems to explore a new avenue, or to break away from conventional studio craftsmanship, finds a vocal corps of enthusiasts. A case in point was a recent import, "Paris Belongs to Us," which showed a group of young Parisians, beating their breasts in some unexplained anguish and uttering some of the most pointless dialogue heard on the screen since "Breathless."

Several important saints of the French *nouvelle vague* rose up jointly to praise and explain this first feature film of Jacques Rivette, who graduated to film making from film reviewing for the French journal, Cahiers du Cinema. "The Universe which Jacques Rivette shows us," wrote directors Claude Chabrol, Alain Resnais, Agnes Varda, and Francois Truffaut, among others who fashioned the joint statement, "one of anguished confusion and conspiracy, is not just a reflection of sensibility and interrogation. One would indeed have to be shortsighted to miss seeing a vision of the world today."

All clear? If not, perhaps M. Rivette's own words will be more helpful. "I have not made an abstract film," he stated, "but one which would be symbolic in the cubist's sense, demanding a certain effort in order to reveal reality."

A goodly crowd of New Yorkers went to one of Manhattan's numerous little art houses, the 55th Street Playhouse, egged on by respectful reviews and advertising that implied "Paris Belongs to Us" was in the "Marienbad" vein, and seemingly willing to make the effort required to see a vision of the world today. "Ninety-nine per cent of them left the theater bored," said a disenchanted spokesman for the theater. "Some left before it was over. Maybe it was the subtitles; they didn't seem to make much sense."

He also admitted that an advertising gimmick had gone awry. The theater had offered, to persons who came to see the movie once, a free ticket to see it a second time, this to ease their bafflement the first time around. "We counted six people who used the free ticket," he said. There is now a theory that the six tickets were given to unpopular relatives of the original beholders, proving perhaps that intellectual touting of a film can go only so far, and that eventually a film will attract or repel an audience on its own.

M. Rivette, I have been given to understand, did better in Paris, where the *nouvelle vague* still holds a spell over a substantial segment of the French audience. Indeed, it is the New Wave that must be given a good deal of the credit (or blame) for stimulating so fervent an interest in artier examples of the contemporary cinema.

THE French revolution, as it has been termed, is some five years old, and it has produced at least a dozen films of high quality, and a host of incredibly bad ones. It can hardly be condemned, since experiment, freshness, and originality are bound in the long run to improve film-making standards, but there is no denying that it has also engendered *(Continued)*

**EXPERIMENTAL**—A new Mexican film, "The Exterminating Angel," by Luis Buñuel, shows guests at a party who are strangely unable to leave. It can have many interpretations.

**HOLLIS ALPERT** writes regularly on the movies for The Saturday Review. His most recent book is a collection of essays on the cinema, "The Dreams and the Dreamers."

some new fashions in film obscurity.

Ours seems to be a period in which the obscure in art gets a goodly share of attention. Film has actually been a little delayed in catching up with contemporary trends in painting, writing, and music—the painting that has broken up or dispensed with the image; the novel writing that has eliminated plot, characterization and, in fact, everything but words; the music that has become not only atonal but noninstrumental. There is always a certain heady excitement about the new, or that which seems new and the term "genius" is frequently evoked to describe someone who is merely attempting to keep abreast of the latest artistic fad.

NOW that movies too are being made that cannot be easily understood and are being welcomed accordingly, it is an admission of sorts that cinema has gained entry into the conclave of the serious arts. Forty years ago, Gilbert Seldes put movies into his list of "The Seven Lively Arts." By rights, today, he should narrow the list to six. For the products of Hollywood are not admitted any longer to be lively. Those huge screens, the huge close-ups of the all too familiar "big" stars, the cumbersome pace, the deadly obviousness of the dialogue—these, according to current theory, are symbolic not of liveliness, but of deadness.

Film lives on, according to those who adhere to the latest cinema gospels, in the work of certain directors: Antonioni, Resnais, Truffaut, and Godard. Luis Bunuel came back to high regard with "Viridiana," for which several interpretations were possible. Already Ingmar Bergman is being regarded as a traditionist, imposing though his body of work may be, and Fellini, brilliant and flamboyant as he is, well, he had been making himself too clear. However, in "Fellini 8½," his most recent effort, he appears to be mending his ways. According to advance word, the film has confused many of its viewers abroad.

In "The Trial" Orson Welles seems to be frantically attempting to catch up with the avant-garde which, for a time, he led. But even though the obscurity of the film was appreciated, the consensus was that the old master had failed not to say what had already not been said by Kafka in the novel.

On the other hand, Alfred Hitchcock has come into some belated recognition from fanciers of the new cinema. For

one thing, it became known that Truffaut, Resnais and Bergman, among others, regarded him as a master director. It was even found that his films, obvious in their suspense, menace, and horror, had a tantalizing underside of obscurity that could be read into them. Mr. Hitchcock presumably paid his respects to this intellectual homage by leaving the ending of his latest films, "The Birds," open to endless speculation. Time called the ending "vaguely Nouvelle Vague," and I'm sure Mr. Hitchcock was pleased.

MUCH of the recent excitement among those eager to discover and assess the new film revolved around "Last Year at Marienbad," in which two men and one woman, none named or clearly identified, play out a puzzling triangular drama in a palace-like hotel. It is a haunting, fascinating film, made by a gifted and original French director, Alain Resnais, who gained note with a series of striking short films, and international fame with "Hiroshima, Mon Amour."

I, among other critics, found "Marienbad" a brilliant tour de force, and my only quarrel is with those who would give to it and find in it meaning that it does not have. Nor can I go quite so far as Jacques Brunius in a recent issue of Sight and Sound, the British film journal, who wrote, "I am now quite prepared to claim that 'Marienbad' is the greatest film ever made, and to pity those who cannot see this."

BRUNIUS may make his claim, but his several thousand words of explanation that follow are a great deal more confusing, and also more pretentious than the film itself, about which, by the way, its director Resnais thought there were at least a dozen possible interpretations.

A great help to the publicity for the film was the fact that the author of "Marienbad," Alain Robbe-Grillet, and director Resnais disagreed publicly about the film's meaning, or lack of it. One might have thought that this alone would have been enough to stop speculation about what "Marienbad" really meant, for obviously there was no specific meaning; and, as Resnais put it, the film may be approached, like a piece of sculpture, from many angles, and may mean all things to all men.

I made a point of seeing "Marienbad" three times, each time to check a theory about it I had come across. Poetic the film remained, on each viewing, visually beautiful it remained, but it also re-

ET TU, HITCHCOCK?—Rod Taylor and Tippi Hedren in "The Birds." In it director Hitchcock pays his respects to the avant-garde by leaving the picture's end open to speculation.

mained obdurately obscure. Regretfully I discarded each of the parlor theories, the most popular being, according to my own informal poll, that the wooer (designated only as X in the script) is urging the reluctant lady into the shadows of death.

Another theory that does not hold up, when tested through three viewings, is that X is Orpheus and the beautiful young woman is Eurydice, the grand hotel in which she dwells with "the man who is perhaps her husband" being an elegant, baroque hell.

For the mathematically minded, there is another prevalent theory, that "Marienbad" has arithmetical and geometric elements. Note first that the situation is a "triangle," practically classic or basic in nature. Note also the "Marienbad" game, in which seven cards or matches are laid down, then five, then three, then one. Now observe the shape that has been arranged for the playing of the game. Lo, a triangle! Note, too, the use of the numbers three and seven throughout the film, those magical numbers of myth and alchemy. And observe, said one parlor film enthusiast, that the woman has three visions of her possible fate in her elegant bedroom, and that her wooer challenges the man (who is perhaps her husband) to the game three times.

UNFORTUNATELY, none of these theories provides a a meaningful solution to a film which has achieved its greatest success by resisting final analysis. It was Stanley Kaufmann who, in Show Magazine,

raised what is to my mind the important question. "Does 'Marienbad,'" he asked, "open up artistic immediacies to truth, or is it simply a case of art anarchy?"

Mr. Kaufmann qualified his answer by stating he was glad the film existed and that he would enjoy seeing more in the same style. "But," he went on, "I believe that this kind of film is self-limiting and eventually futile."

With this judgment I would agree. Such an example of futility came on view in "The Lovers of Teruel," a film which attempts to blend, in the words of its director and author, Raymond Rouleau, "the drama, the dance, and the camera." The phantasmagoria, in sickly color, that results is neither good drama, dance, nor cinema, showing off more of the pretensions than the gifts of ballerina Ludmila Tcherina, cameraman Claude Renoir, and M. Rouleau himself.

IT is in such examples of film-making that the danger of exploring new film paths is most clearly exemplified, along with the excitement and the adventure of such undertakings. The spurious is likely to become accepted along with the genuine, and placed in similar categories. It was apparent at the Cannes film festival last May that the nonobvious had come very much into style. A new Mexican film by the relentlessly experimental Luis Bunuel, "The Exterminating Angel," caused many extraordinary interpretations, not to say flights of fancy, in explanation of its meaning.

This movie showed some wealthy guests at a dinner party, who, mysteriously,

found themselves unable to leave, and so became involuntary prisoners in the home of their host. Their civilized veneers disintegrated as time wore on.

Film writers from several countries gave it an award as the "best film" of the festival. And one critic exclaimed: "It embodies all the best elements of 'Marienbad' and 'L'Avventura.'" In this reaction can be discerned the obscurantist syndrome of contemporary film evaluation.

**B**EFORE "Marienbad," it was the "L'Avventura" of that gifted, probing film-maker, Michelangelo Antonioni, that entranced those who fancy the "difficult" film. Here is a case of a film that is susceptible to probing; its artistry and meaningfulness are unquestioned, and while it is perhaps too early to say that it is the second greatest film ever made (as an international film jury so listed it recently in London), Antonioni is without doubt one of the great film artists of our time. And where it has obscurities, these are purposeful and play a part in the ultimate meaning of the story.

"L'Avventura's" major obscurity had to do with the disappearance of a girl, Anna, during a yachting cruise in the Mediterranean. The boat had stopped at a barren, volcanic island, and suddenly, almost under the very eyes of her fiancé, Sandro, and her best friend, Claudia, she is gone. Did she hide, drown, or go

aboard a passing fishing boat? No one knows, and no one ever finds out, including the audience.

Antonioni's intent here was to show the relationship that resulted, following the disappearance of Anna, between Claudia and Sandro. During their search for Anna, they become enamored, unwillingly, of each other, and have a purposeless affair, in which guilt plays as much a part as passion. Antonioni was making a comment on the easy eroticism that he saw as part of modern life, and he saw his characters trapped in their own inability to give meaning to their lives. A valid, even profound theme for a story.

**B**UT the game of analysis revolved around that one question: *what happened to the missing girl?* One of the most imaginative answers was that of literary critic Edmund Wilson, who proposed a somewhat supernatural solution to Dwight Macdonald, who in turn duly reported it in Esquire.

A little background, first: Sandro, while in a hotel with Claudia, makes love to a *poule* he has come across late at night, and is subsequently discovered by Claudia. This *poule*, said Wilson, resembled the missing girl, and his theory has it that "Anna returns in another body, a corrupted one that she uses to revenge herself on Sandro and Claudia for having forgotten her."

This explanation particularly amazed Antonioni who had already explained the scene while at Cannes for the premiere showing of the film. Sandro's distasteful behavior, he pointed out, was symptomatic of present-day, impulsive erotic behavior. "The tragedy in 'L'Avventura'," he said, "stems directly from an erotic impulse of this type—unhappy, miserable, futile."

**A**S for the missing girl, Antonioni declined to discuss her fate, implying that he had deliberately not carried the story that far, thus leaving a fascinating loophole in his film for those who would analyze and analyze.

This is deliberate obscurity, of course, but some is not so deliberate. "Breathless," we are now aware, was largely an improvised film, first thought of as a parody of the cheap "B" melodramas made during the heyday of the Monogram and Republic studios. Its title was borrowed from Hitchcock's original title for the movie that became "North by Northwest."

"Godard, the director," said its star, Jean Seberg, "would come in each morning and hand us a few greasy pages of a so-called script he pulled out from his back pocket." She added carefully, "I don't think the picture is the masterpiece some of the American critics have termed it."

Miss Seberg's candor is refreshing. She has, after all,

much to gain by going along with the critical encomiums handed to "Breathless." Meanwhile, eager film-makers, noting the success of "Breathless," rushed, under the banner of "the personal," "the expressive," "the abstract," "the cubist," "the neo-romantic" film, to put their visions on the screen.

**B**UT the cockroach climbing the wall in Shirley Clarke's "The Connection" does not qualify as artistic film-making, and the wobbly use of the hand-held camera in "The Small Hours," a recent and disastrous venture by a New York independent, Norman C. Chaitin, does not make for cinematic advancement, even though Richard Griffith, curator of the film library at The Museum of Modern Art, said it did.

"There is no story," said Jonas Mekas about his independent film, "Guns of the Trees." "I create through my ignorance and chaos. Order doesn't interest me."

His film substantiates his claim, but it has been shown at a film festival, and discussed in scholarly film journals. I saw it and thought it both distasteful and inept. But according to the latest theories of film, you never know what's hiding behind all the murk. It may be genius. It may be a masterpiece. I hope I'll be pardoned for remaining skeptical.

April 21, 1963

# *Cahiers—An In Word That Means Far Out*

**By EUGENE ARCHER**

**I**S Alfred Hitchcock the screen's most profound religious moralist? Do those five flop movies Ingrid Bergman made with Roberto Rossellini actually constitute a formidable contribution to film esthetics? Were the Westerns and gangster melodramas turned out under the restrictions of the old-time Hollywood studio system better art than most of the prestigious independent productions from abroad?

*Cahiers du Cinema* thinks so. Plenty of the magazine's supporters think so too. They are expounding these surprising theories, and a great deal more besides, in some of the

most unexpected quarters of the globe. In less than a decade, this flair for controversy has helped to turn a tiny little Parisian monthly into the most talked about film publication in the world.

It is talked about a lot more than it is read. Professionals in the field, misled by the *Cahiers* penchant for glorifying the unsuccessful, scoff at the vagaries of "those crazy Frenchmen." Andy Warhol's rebellious underground movie crowd endorse it for the same dubious reason. *Cahiers* has become an "in" term, like "pop" and "camp" and "the auteur theory." It is an in word that means far out.

*Cahiers* is far out, all right. Under the canny leadership of

its most articulate critic, François Truffaut, the magazine shook up the French film world back in 1956 by coming out strongly against social consciousness, literary scenarios, classical acting and all the traditional accoutrements of "significant" cinema. *Cahiers* preferred Hitchcock, Hawks and Hollywood, and all they represent.

Truffaut was an aggressive young man who wanted to attract attention and make his own movies, not necessarily in that order. He succeeded at both goals. At *Cahiers*, he pushed his vanguard of wild young Hitchcocko-Hawksiens to the forefront by giving the magazine its credo. He coined the notorious *politique des auteurs*.

The *auteur* theory promotes the interesting idea that movies are an art. If they really are, then there must be an artist—and that's the point. *Auteur* theorists hold that there is an artist, and one alone—and this is the director. Not the producer, whose day is definitely past; not the actor, because anything he does for himself is subordinate to the way his performance is cut together; not the writer, because any director worth his salt is going to be responsible for the words that get spoken, even if he doesn't actually write them himself. *Auteur* means author, anyway.

Truffaut went further. He said it didn't matter if the director chose his subjects or not—he would still manage to transform his material into a personal expression, just as a painter would a bowl of fruit. Even if the film were taken away from him in the cutting room, what appeared on the screen would still be *his*. In

the *Cahiers* line, personality is All.

## Touché

The theory raised more problems than it resolved. It never did explain why a number of highly talented, eminently "personal" directors, nonetheless turned out some very silly pictures. Still, *Cahiers* made a valuable point, by stressing the importance of visual style in a visual medium, and by minimizing the significance of "worthwhile" subject matter. *Cahiers* blasted away at big bad movies, dismissing "Ben-Hur" in a sentence (it made them appreciate the real merit of Cecil B. DeMille), and drawing attention to striking work in neglected genres, such as the John Ford Westerns and the Hitchcock melodramas. In the *Cahiers* credo, if an apple could inspire a great painting, a murder mystery—a "Laura" or "Psycho" or "The Lady From Shanghai"—could be a great film.

It also came up with some far-fetched notions, particularly when youthful Cinémathèqueophiles discovered unsuspected glories in the works of Jerry Lewis ("The Nutty Professor"), Vittorio Cottafavi ("Goliath and the Dragon") and Edgar G. Ulmer, who used to grind out Ann Corio epics for Monogram. As Truffaut later explained, "There weren't many real auteurs, so we had to invent some."

That was all right in Paris, where individualism is rampant anyway. It might have gone no further if Truffaut had not wangled the financing for "The 400 Blows." He helped Jean-Luc Godard make "Breathless"; "Hiroshima, Mon Amour" and "The Lovers" started winning awards; and the New Wave made its splash. Soon all the *Cahiers* critics were putting their theories into action.

The movement didn't last, but it proved its point. These wild young *Cahiers* theorists turned out some of the freshest, liveliest and most personal movies of recent years. In no time at all, *Cahiers*-type magazines were springing up in England, in India, in South America, even behind the Iron Curtain. The Village Voice critic Andrew Sarris introduced the *auteur* line to America, amid howls of outrage from the Establishment.

Everywhere *Cahiers* ideas appeared, they drew fire but their influence went right on growing.

### Avid Readers

No one has been more influenced than the filmmakers themselves. If there is anyone who loves to hear the art of the director extolled, it is a film director. Hitchcock and Howard Hawks were honored by full retrospectives at museums all over the world. Their admirers suffered through "I Was a Male War Bride" and "The Farmer's Wife," and the directors submitted equally uncomfortably to hours of exhaustive interviews by erudite French historians—and then they proceeded to turn out "Marnie" and "Man's Favorite Sport," two of their most resounding duds. Too much intellectual analysis, it seems, can be a dangerous thing.

*Cahiers*, of course, can always rationalize a failure by one of its idols, since a creative personality is likely to emerge even more sharply in a bad picture than in a good one. Other directors, envying the high premium on individuality, have pursued the *Cahiers* line to the extent of negotiating new contracts, giving them the kind of operating freedom undreamed of in the old days. Today's directors bar their backers from the set—though so far, no one in Hollywood has quite dared to emulate the feat of Italy's Federico Fellini, who literally made up "8½" as he went along. That one emerged as a Freudian autobiography of a director's creative process—about as *Cahiers* as a film can get.

If the director has finally taken over the movie field, it is not entirely the fault of *Cahiers*—but the cult certainly helped. Revivals of films by the magazine's preferred old *auteurs* are doing business, and the current favorites are in demand for the best jobs. The once controversial *Cahiers* line is becoming a way of life.

Everywhere, that is, except in Paris. There the magazine is already arrière-garde, under vigorous attack by offshoots of new Young Turks. But then, *Cahiers* has earned the right to flounder. Its best critics are off making films.

*May 23, 1965*

# Voice of the 'Underground Cinema'

### By ALAN LEVY

**ALAN LEVY** is a freelance writer who specializes in theatrical and entertainment subjects.

**W**HEN Jonas Mekas's first film, "Guns of the Trees," was shown at the Festival of Two Worlds in Spoleto, Italy, the festival's founder, Gian Carlo Menotti, walked out and a countess fainted. When Mekas's subsequent film, "The Brig," won the Grand Prix de St. Mark at Venice as the best documentary, Mekas informed the judges that it was not a documentary at all, but a filming of a realistic play. Mekas himself was a judge at the Third International Film Exposition at Knokke-le-Zoute, Belgium, but when an American "underground" film was denied a screening there, Mekas resigned and seized the projection booth. Belgium's Minister of Justice remonstrated and Mekas projected the film onto the Minister's face. The Belgians retaliated by shutting off the electricity.

Last summer, to the festivals' relief, Mekas boycotted them all and stayed home to organize an Expanded Vision Film Festival, which he hopes to unveil this fall on West 23d Street. He also packaged an exposition of 17 "underground" films that toured Latin America.

To his friends and admirers, Jonas Mekas (pronounced Meck-us) is a 41-year-old New York film buff who, in the European tradition exemplified by François Truffaut ("400 Blows") and Jean-Luc Godard ("Breathless"), became a film commentator and film maker. To critic Dwight MacDonald, Mekas is the "patron saint of the New American Cinema, from which I'm still hoping for something Cinematic, whether New or American." (MacDonald does concede that Mekas is "dedicated, selfless, and courageous.") To the New York police, Mekas is the mastermind behind an unlicensed screening of poet Jack Smith's "Flaming Creatures," the same film that disrupted Knokke-le-Zoute. A "lampoon" of commercialized sex which The Nation called "a feast for open eyes," the film was judged "indecent, lewd, and obscene." Mekas is now appealing a two-month suspended sentence.

**M**EKAS'S column in The Village Voice has been that weekly's most controversial feature for almost seven years. "It is one of the few movie columns in America which can still jar the system awake," says a Voice editor, "and make you want to run out of the house in rage or doubt to post a steaming letter to the editor."

Mekas writes things like: "There are too many bad films; no use talking about them. But 'A Raisin in the Sun' was blown up so high by the critics that it's time to warn everybody: the movie stinks." He dismisses the "official cinema" (as opposed to the "underground" variety) by simply listing titles under the heading: "Walked Out on the Following." He insists on writing about "movies which you can't see anywhere. . . . It is my duty to bring this cinema to your attention. I will bark about it until our theaters start showing this cinema."

Readers write in that they are "embarrassed, not to mention pained" by the column; that Mekas is "a pompous prattler," or that it seems to them he is "going mad." Very rarely, someone calls him "a catalyst" or "a firebrand" who "stands as a remarkably honest and refreshing writer."

For Mekas himself—a gaunt thin-lipped bachelor with the face of a Slavic martyr — these fireworks miss the mark. "I am a poet," he explained softly, " a poet whose involvement comes from inner need, whose language is film, and to whom going to jail is not just a human experience, but a moral obligation. I see more than others."

**W**HATEVER he may be, the making of Jonas Mekas began on a farm in Semeniskiai, Lithuania. The war started when he was 16. First the Russians and then the Germans occupied Lithuania. Mekas worked against both as editor of an illegal newspaper.

He and his younger brother, Adolfas, were sent to a labor camp. After the war, Jonas commuted from a displaced persons camp in Wiesbaden to the University of Mainz, where he studied philosophy. But one day he bought a book

# MATHEQUE

For Jonas Mekas, movies are a time-consuming love.

called "Dramaturgy of Films," by a German director. "The book opened our eyes," Jonas recalled. "We had continued to write in Lithuanian — I, poetry, Adolfas, prose — but we felt lost outside Lithuania. We needed an audience. Language begins to die unless one cultivates it. When I read the book, I realized that, no matter where we went, cinema was the tongue in which we could reach anybody."

The Mekases wanted to go to Israel, but were rejected because they weren't Jewish. They then applied for Egypt (hoping to escape to Israel from there), but Egypt rejected them. Ultimately, the International Refugee Organization ticketed them for America.

They arrived in New York harbor on a November night in 1949 and settled in Brooklyn. For more than two years, they worked as truck-loaders, plumbers' helpers, maintenance men and dishwashers. With their first savings, they bought a Bolex movie camera and shot "thousands of feet of documentary footage of Brooklyn." At least once a day they attended a movie — in theaters, at film societies, at museums. When these proved not satisfying enough, Jonas Mekas formed his own film societies. In 1952, he moved to Manhattan and found work as a messenger for a photo studio. In the next six years he worked his way up to photographer and darkroom technician. He also learned his trade as a filmmaker.

While still employed, Mekas started Film Culture, a quarterly publication that "serves as an outlet for people who have something to say about cinema." Film Culture became a forum for dozens of ambitious, unknown, hitherto unorganized young people making movies above, below and on the sidewalks of New York. Some were painting abstract art directly onto film. Others were filming nudity in unheated cellars. Still others were shooting on the run with police in hot pursuit.

Few of their efforts ever achieved national distribution, but their avant-garde techniques—including hand - held cameras, natural lighting, staccato editing, plus minimal budgets—later graduated into television and commercial films. And John Cassavetes's improvisational "Shadows," Shirley Clarke's "The Connection," as well as two shorts, the Robert Frank-Jack Kerouac "Pull My Daisy" and Dan Drasin's documentary "Sunday," might never have seen the lights of marquees without Mekas's crusading.

**I**T is virtually impossible to classify Mekas by his attitudes toward known quantities. His likes ("Wild Strawberries," "Mad Dog Coll," "Stromboli" and "L'Avventura") and his dislikes ("Last Year at Marienbad" and "L'Avventura" — he recanted on the latter) defy any labeled dogma. "Children and wise men never argue about movies," he says. "Everything

is clear to them. Only we — those in between — are all shook up, confused, lost in the pastures of art."

His two most ardent (and time-consuming) loves at present are the Film-Makers' Cooperative, which rents and releases works of the New American Cinema to "galleries, museums, universities and people," and the Film-Makers' Cinémathèque, where, twice a week, subscribers can attend "the newest works and also study the old masters without the dust of history and the stuffed shirt." Proceeds from both the Co-op and the Cinémathèque go to the filmmakers, one of whom reported that his income from rentals had risen from about $200 in any previous year to $1,700 last year.

Mekas estimates that the "underground cinema" has a loyal audience of about 1,000,-000, in big and little pockets around the country. The latest catalogue of his Co-op lists some 350 films by 80 filmmakers, including a dozen on the West Coast. The entries include an animated cartoon by a 10-year-old named David Wise—whom Mekas calls "the Mozart of the underground cinema"; Andy Warhol's "Pop" movies of a naked man sleeping (six hours long) and of the Empire State Building standing (eight hours); "Queen of Sheba Meets the Atom Man," a remarkable idyll of a huge naked Negro woman and a small unmanly hipster; "Scorpio Rising," a lingering look at the black-leather world of motorcyclists that won its maker, Kenneth Anger, a Ford Foundation grant in the arts, and Stan Brakhage's "Dog-Star Man," a 4½-hour epic concerning the creation of the universe.

Mekas and his brother, Adolfas, have always worked together making movies and complement each other nicely. On location, both are calm and organized. Adolfas encourages actors to "prepare" for a scene; Jonas encourages improvisation. Both write scenarios and either can handle any aspect of filming, although they use skilled cameramen. It is agreed beforehand that one of the brothers will be in charge, while the other is there to help out.

Jonas assisted his brother on "Double-Barreled Detective Story," a forthcoming adaptation of a Mark Twain yarn, and "Hallelujah the Hills." The latter, made in 1963, was an "in" spoof of Chaplin, Sennett, Griffith, Kurosawa, Antonioni, Eisenstein and Ma and Pa Kettle — all contained, often hilariously, within two young men's reminiscences of a girl they both loved. It was invited to more

foreign film festivals than any other American movie that year and was hailed at several as "the most completely American film ever made."

"Guns of the Trees" (1961), made for $27,000, is described by Jonas as "anti-police, anti-government and anti-film." An alienated youth attempts to urinate upon the open bank vault at 43rd Street and Fifth Avenue. On the sound track, the poet Allen Ginsberg proclaims: "I dreamed J. Edgar Hoover groped me in a silent hallway of the Capitol." At intervals there are moments of "white space" when the screen goes blank to punctuate episodes.

"The Brig" (1964) was a film version of Kenneth Brown's grueling play about sadism in a Marine jail. The play had opened at the Living Theater on 14th Street, and then closed when Federal authorities padlocked the theater in a tax dispute with the producers, Julian Beck and Judith Malina. It then moved to the Maidman Playhouse on West 42d Street, sputtered briefly, and closed again.

As a gift to the Becks, the Mekases decided to make a film record of "The Brig" while the scenery was still standing. The Maidman was also locked, but the underground moviemakers and a dozen actors entered via a coal chute, made their way through a cellar and arrived onstage with three cameras. Filming cost $900; editing, $6,000.

When the static, unrelenting result was exhibited at Lincoln Center's film festival, one reviewer groaned: "What price art? In the case of 'The Brig,' a nervous breakdown." The barbed-wire curtain that had separated the theater audience from the actors lost much of its effectiveness on film. Nevertheless, in France, "The Brig" numbers Jean-Paul Sartre and Simone de Beauvoir among its admirers.

Mekas is currently working on a plan to reduce films to 8 millimeters and place them for sale in bookshops and record stores. When he discusses the future, he becomes a true visionary:

"Salvador Dali is working on contact lenses which will throw color images on our retina while we sleep. It is from here just one step to the absolute cinema—Cinema of Our Mind. For what is cinema really if not images, dreams and visions? We take one more step, and we give up all movies and we *become* movies. We sit on a Persian or Chinese rug smoking one dream matter or another and we watch the smoke and we watch the images and dreams and fantasies that are taking place right there in our eye's mind . . . This is the ulti-

mate cinema of the people, as it has been for thousands and thousands of years."

All of Mekas's activities cost money, but he estimates his total personal income for the past five years at $2,000. Much of this came from lecturing at colleges, where interest in the New American Cinema runs high. He draws no salaries from his various writing and administrative posts. What

funds he raises go toward the $500 to $800 required to publish an issue of Film Culture, the needs of a particular crusade or the expenses of moviemaking. Nothing is spent on personal comfort. He was, in fact, evicted recently from his East 13th Street flat for lodging too many other film makers there.

At the moment he is living out of a suitcase somewhere

in the West Nineties, an area he finds "impossibly square." He hopes to settle in Hoboken: "The food is cheaper and New Jersey is my favorite state. It could still be molded into something."

Hardly anybody in filmmaking is better informed on the matter of money than Jonas Mekas, who has none. He says that a 35-cent cheeseburger in Hoboken tastes bet-

ter than a 60-cent cheeseburger in Manhattan . . . that it costs $15,000 to fight a censorship case to the Supreme Court . . . that "men are the root of all evil and money is only the earth metal." Films, he says, are made with "belief, passion, enthusiasm, persistence—anything but money."

September 19, 1965

# Screen: 'Blow-Up' Arrives at Coronet

## Antonioni Views Stress of Jazzed-Up World

### By BOSLEY CROWTHER

IT will be a crying shame if the audience that will undoubtedly be attracted to Michelangelo Antonioni's "Blow-Up" because it has been denied a Production Code seal goes looking more for sensual titillation than for the good, solid substance it contains — and therefore will be distracted from recognizing the magnitude of its forest by paying attention to the comparatively few defoliated trees.

This is a fascinating picture, which has something real to say about the matter of personal involvement and emotional commitment in a jazzed-up, media-hooked-in world so cluttered with synthetic stimulations that natural feelings are overwhelmed. It is vintage Antonioni fortified with a Hitchcock twist, and it is beautifully photographed in color. It opened at the Coronet last night.

It marks a long step for Mr. Antonioni, the Italian director whose style of introspective visualization has featured all his Italian-language films from "L'Avventura" through "Red Desert," and in all of which Monica Vitti has played what has amounted to a homogeneous gallery of alienated female roles. It is his first film in eight years without Miss Vitti. It is his first major film about a man. And it is his first film made in England and in English (except for one vagrant episode in his three-part "I Vinti," made in 1952).

●

The fellow whose restlessness and groping interests Mr. Antonioni in this new film is a dizzyingly swinging and stylish free-lance magazine photographer, whose racing

**David Hemmings**

## The Cast

BLOW-UP; screenplay by Michelangelo Antonioni and Tonino Guerra; directed by Mr. Antonioni; produced by Carlo Ponti and released by Premier Productions Co., Inc. At the Coronet Theater, 59th Street and Third Avenue. Running time: 110 minutes.

| | |
|---|---|
| Thomas | David Hemmings |
| Jane | Vanessa Redgrave |
| Patricia | Sarah Miles |
| Models | Verushka |
| | Jill Kennington |
| | Peggy Moffit |
| | Rosaleen Murray |
| | Ann Norman |
| | Melanie Hampshire |

and tearing around London gives a terrifying hint of mania. He can spend a night dressed up like a hobo shooting a layout of stark photographs of derelicts in a flophouse, then jump into his Rolls-Royce open-top and race

back to his studio to shoot a layout of fashion models in shiny mod costumes — and do it without changing expression or his filthy, tattered clothes.

He can break off from this preoccupation and go tearing across the city in his car to buy an antique airplane propeller in a junk shop, with virtually the same degree of casualness and whim as he shows when he breaks off from concentrating on a crucial job in his dark-room to have a brief, orgiastic romp with a couple of silly teenage girls.

Everything about this feral fellow is footloose, arrogant, fierce, signifying a tiger—or an incongruously baby-faced lone wolf—stalking his prey in a society for which he seems to have no more concern, no more feeling or understanding than he has for the equipment and props he impulsively breaks. His only identification is with the camera, that trenchant mechanism with which he makes images and graphic fabrications of—what? Truth or fantasy?

This is what gets him into trouble. One day, while strolling in a park, he makes some candid snaps of a young woman romancing with a man. The young woman, startled, tries to get him to give the unexposed roll of film to her. So nervous and anxious is she that she follows him to his studio. There, because she is fascinated by him and also in order to get the film, she submits to his arrogant seduction and goes away with a roll of film.

But it is not the right roll. He has tricked her, out of idle curiosity, it appears, as to why the girl should be so anxious. How is she involved?

When he develops the right roll and is casually studying the contact prints, he suddenly notices something. (Here comes the Hitchcock twist!) What is that there in the bushes, a few feet away from where the embracing couple are? He starts making blow-

ups of the pictures, switching them around, studying the blow-ups with a magnifying glass. Is it a hand pointing a gun?

There, that is all I'm going to tell you about this uncommon shot of plot into an Antonioni picture—this flash of melodramatic mystery that suddenly presents our fellow with an involvement that should tightly challenge him. I will only say that it allows Mr. Antonioni to find a proper, rueful climax for this theme.

One may have reservations towards this picture. It is redundant and long. There are the usual Antonioni passages of seemingly endless wanderings. The interest may be too much concentrated in the one character, and the symbolistic conclusion may be too romantic for the mood.

●

It is still a stunning picture—beautifully built up with glowing images and color compositions that get us into the feelings of our man and into the characteristic of the mod world in which he dwells. There is even exciting vitality in the routine business of his using photographs—prints and blow-ups and superimpositions—to bring a thought, a preconception, alive.

And the performing is excellent. David Hemmings as the chap is completely fascinating—languid, self-indulgent, cool, yet expressive of so much frustration. He looks remarkably like Terence Stamp. Vanessa Redgrave is pliant and elusive, seductive yet remote as the girl who has been snapped in the park and is willing to reveal so much—and yet so little—of herself. And Sarah Miles is an interesting suggestion of an empty emotion in a small role.

How a picture as meaningful as this one could be blackballed is hard to understand. Perhaps it is because it is too candid, too uncomfortably disturbing, about the dehumanizing potential of photography.

December 19, 1966

# AGENCY TO PRESS MOVIES' ARTISTRY

## American Film Institute Formed in Washington

### By VINCENT CANBY
Special to The New York Times

WASHINGTON, June 5—The American Film Institute, a non-profit, nongovernmental corporation, has been formally established to preserve and develop the nation's "artistic and cultural resources in film."

George Stevens Jr., 35-year-old director of the United States Information Agency's film division, is resigning that post to become director and chief executive officer of the new corporation, which will be guided by a 22-member board of trustees.

Formation of the institute, which will have headquarters in Washington, was announced at the Madison Hotel here today at a press conference held by George Stevens, Roger L. Stevens, chairman of the National Council of the Arts, and Gregory Peck, the actor, who is acting chairman of the institute's board of trustees.

With an estimated budget of $5.2-million for the first three years, the American Film Institute comes into being as the third-largest such organization in the world in terms of money. Its Soviet counterpart has an annual budget of between $4-million and $5-million, and the Swedish Film Institute an annual budget of $2.25-million.

The United States, where motion pictures had their birth, is one of the last of the major producing nations to establish such an organization. Britain, France, Italy and India have them.

As outlined by Roger Stevens, the institute will concentrate on the following areas:

¶Filmmaker training. It will establish one or more Centers for Advanced Film Study, to act as a bridge between college or university study and a filmmaking career.

¶Film education. The institute will explore ways to help develop and improve the study of film as an art form "with its own esthetics, history and techniques."

¶Film production. The institute will make grants to young filmmakers for the production of documentary and experimental films, both short and feature-length, and will finance the production of such films at its Centers for Advanced Film Study.

¶Film archives. The institute will work to catalogue and preserve old films.

The institute will commission publications of film news, criticism and textbooks.

Of the institute's initial three-year budget three-quarters is already in hand or firmly committed.

### Council Grant Is Largest

The National Council on the Arts, in the largest single grant it has ever made, has given the institute $1.3-million. The Ford Foundation and the Motion Picture Association of America have each pledged themselves to grant $1.3-million, leaving $1.3-million still to be raised.

George Stevens Jr., son of the Hollywood filmmaker and no relation to Roger Stevens, pointed to the dominating influence of film today and said: "We cannot be casual about the training of the people who create these images."

### Peck Replies to Critics

As head of the U.S.I.A.'s film division for the last five years, Mr. Stevens has been responsible for the production and distribution around the world of 600 documentaries and newsreels annually. Under his leadership, the U.S.I.A. began an "internship" program to train young filmmakers. A number of their films, notably the documentary feature on President Kennedy, "Years of Lightning: Day of Drums," have been well received.

Taking notice of criticism that the present board seems to be weighted in favor of the Hollywood motion-picture establishment, Mr. Peck noted: "I have been in the theater and films for 25 years, and this is the first production in which I appeared that was reviewed before it opened."

June 6, 1967

---

# *Study of Film Soaring on College Campuses*

## 60,000 Students Are Enrolled, Twice 1967 Figure

### By ROBERT WINDELER

Mike Nichols and Jean-Luc Godard have become the heroes of many college campuses. The American director and the French moviemaker are the pied pipers of a movement that has 60,000 graduate and undergraduate students enrolled in 1,500 film courses at 120 colleges.

All three figures are double those of last year and are expected to double again in the fall semester, according to Jack Ellis, chairman of Northwestern University's film department.

The burgeoning college film scene was surveyed by The New York Times in interviews with student filmmakers, faculty members on 12 campuses and professional film producers. It also included the viewing of more than 200 student-made films.

Movies have become one of the "hot" college subjects. More than 1,300 of Dartmouth's 3,000 students belong to a film society that shows 100 films a year. The University of California at Los Angeles has 360 full-time film students, and Harvard University instituted a full undergraduate major in film last month.

Francis Ford Coppola, a 29-year-old director who got his master's degree from U.C.L.A. less than a year ago, has just completed directing "Finian's Rainbow," a big-budget musical at Warner Brothers-Seven Arts starring Fred Astaire and Petula Clark.

He continues to collect royalties on his master's thesis, "You're a Big Boy, Now," for which he persuaded such actors as Rip Torn, Geraldine Page, Elizabeth Hartman and Julie Harris to work for next to nothing.

The film, an offbeat story of an adolescent's growing pains, was shot in New York and starred Peter Kastner. It was released in 1967.

### 20 Others Hired

Mr. Coppola was the first film student to make the grade in Hollywood, with its tangle of unions and old-timers' suspicion of youth, in a major way. But in his brief tenure as

United Press International
**Francis Ford Coppola, one of the leading young directors, studied at U.C.L.A.**

a leading director he has, by example, made possible the hiring of 20 other student filmmakers from two Los Angeles universities.

George Lucas, who is 23 and won't collect his master's degree from the University of Southern California until the summer, has gone to work full time for Mr. Coppola's independent company at Warner Brothers, as an assistant director. Two prize-winning films he made will be shown in the third National Student Film Festival, which opened yesterday at Lincoln Center.

Student filmmakers speak with a special fervor about the techniques of Mr. Nichols in "The Graduate" — he used Hollywood's resources to record the concerns of youth — and Mr. Godard's contrasting techniques of cinema verité: the hand-held camera, the inexpensive production.

Peter Werner, a senior at Dartmouth, explained: "At this age we are exposed to films as art. We want to do films as art, not as business. In feature films it is a business but sometimes it can be an art the way it is with Nichols in 'The Graduate' or with Godard."

And Dr. Ray Fielding, head of the film program at the University of Iowa, said, "Godard is the only one they talk about, the only one they follow."

"This has to do with what's

340

happening to communications—film is the future way of transmitting ideas," says Stanley Donner, chairman of the film department at the University of Texas in Austin.

"It's the right combination of security and freedom," Dr. Fielding adds. "They can make a good salary but are at liberty to be creative. They are not slaves to any industry."

About 60 per cent of the graduate students in film at U. S. C. and U. C. L. A. — there are about 360 at each school — don't even wait to pick up their degrees. "When it's a choice between a degree and a good chance to make a film, says Judith MacDougall of U. C. L. A. "you go make the film every time."

Mrs. MacDougall is staying to get a Master of Fine Arts degree only because she is a woman (the industry has lingering prejudice against women directors) and because she has a $3,000 grant for here thesis film, from the Louis B. Mayer Foundation, named for the late movie mogul.

Mrs. MacDougall met her husband, also a student, in the cutting room. Mr. MacDougall became his wife's cameraman for course films and she was his.

They plan to make ethnographic films ogether, probably starting in Africa. Both selected U.C.L.A. because of its proximity to Hollywood, with chances for part-time work and professional help and facilities.

The sound-mixing equipment at U.C.L.A. rivals that of any major studio in Hollywood (New York University and Boston University have the most advanced equipment in the East). But as for trying to break into Hollywood, Mrs. MacDougall says, "I don't think I'd care to fight it."

Daisy Gerber, a 1967 graduate in cinema at U.C.L.A., fought it and won, becoming the first woman assistant director in Hollywood. She is currently working in San Francisco on a Steve McQueen movie, "Bullit."

Most graduates of schools like Northwestern and Columbia University find jobs in corporations with their own film departments or with companies making educational films, but occasionally they will find feature work in New York, Chicago or Europe.

One Columbia graduate, Mary Ellen Butte, directed the film version of "Finnegans Wake" and will adapt and direct Thornton Wilder's "The Skin of Our Teeth."

The graduate film program at New York University, new this year, will nevertheless attempt to send all 32 of its masters candidates — culled from 350 applications — to Hollywood in the fall for a year's apprenticeship. The third year of N. Y. U.'s experimental program will take place abroad, according to present plans, and each student will make a full-length film in Europe or India.

Although the N.Y.U. film faculty, which includes Robert Saudek, former producer of "Omnibus" and "Playhouse 90," as chairman, and James Beveridge, formerly of the Canadian Film Board, has a distict documentary bent, students are free to pursue anything in any manner.

Film programs outside New York and Los Angeles rely on more formally structured courses. At Northwestern and the University of Texas, charitable organizations are counted on to subsidize student films. (At all schools, students pay their own costs beyond a set amount of raw black and white film. They must raise it if they don't

have it themselves; a thesis film at U.C.L.A. costs up to $10,000.)

At the University of North Carolina in Chapel Hill, there is a preponderance of film writing courses, a lack of equipment and a training film of the armed-forces genre that attempts to show filmmaking by the numbers and equates close-ups with kissing themes. At the University of Iowa, the emphasis is on turning out Ph.D.'s who will teach film elsewhere; the theses are always written, never filmed, and a current one being written is a frame-by-frame analysis of Antonioni's "Eclipse."

Most students come to film from other majors, or graduate schools, such as art or political science (two Dartmouth seniors are working on a term "paper" on film for a Government course.)

"This category of young person has a proprietary interest in film," says Mr. Beveridge of New York. "He's impatient with writing, written communication bores him—and it is reflected in his spelling."

Some film students feel they are compulsive. "We're not intellectuals; we're misfits," says David Turecamo of Brooklyn, a 20-year-old sophomore at Northwestern. "I make films because that's all I know how to do. I look at the world in terms of film—'Will it make a movie? and dismiss reality altogether."

"At first I worried that I was just following the latest fad," recalls Gerret Warner of Old Brookville, L.I., a senior at Duke. "But then I realized that I had to make films. I couldn't do anything else."

Duke has no film courses and young Warner commutes once a week to the University of North Carolina, 10 miles away. He persuaded the Duke

Student Union to finance, for $400, his 10-minute black-and-white documentary on railroads, centering on the abandoned Durham station.

Arthur Mayer, a former film distributor in New York, now 83 and a teacher of film history at Dartmouth U.S.C. and U.C.L.A. says:

"A substantial portion of our young people lead two lives—what you might call their real lives and their reel lives. There is only one other subject, the opposite sex, concerning which they are so deeply, constantly and agreeably involved."

Robert Lovenheim of Rochester, a graduate student at U.S.C., adds:

"Filmmakers, particularly students, are 18th-century people, not 20th-century people—we don't care about anything else around us but film; it's one of the last things you can do by yourself, it's total individual expression."

There are regional differences in the themes of student movies. East Coast films tend toward social commentary, even in a straightforward film like "Going to Work in the Morning From Brooklyn" by N.Y.U.'s Daniel Kleinman. Films made at the big schools in the Middle West tend toward introspection. Mr. Turecamo describes his next film as "two hours of pure self-indulgence in black and white and sound."

What little antiwar commentary usually comes from the West Coast, in the form of old war footage interspersed with newsreels of draft demonstrations at Berkeley and Oakland, Calif. The West also produces films utilizing wide open spaces and the majority of color films (black and white costs half as much).

April 18, 1968

# Screen: Life in a Shabby Texas Town on the Plains

## By VINCENT CANBY

Peter Bogdanovich's fine second film, "The Last Picture Show," adapted from Larry McMurtry's novel by McMurtry and Bogdanovich, has the effect of a lovely, leisurely, horizontal pan-shot across the life of Anarene, Tex., a small, shabby town on a plain so flat that to raise the eye even 10 degrees would be to see only an endless sky.

In an unbroken arc of narrative, beautifully photographed (by Robert Surtees) in the blunt, black-and-white tones I associate with pictures in a high school yearbook, the film tells a series of interlocking stories of love

### The Cast

THE LAST PICTURE SHOW, directed by Peter Bogdanovich; screenplay by Larry McMurtry and Mr. Bogdanovich, based on the novel by Mr. McMurtry; director of photography, Robert Surtees; produced by Stephen J. Friedman; for release by Columbia Pictures. At the New York Film Festival, Vivian Beaumont Theater. Running time: 118 minutes. (The Motion Picture Association of America's Production Code and Rating Administration classifies this film: "R—restricted, under 17 requires accompanying parent or adult guardian.")

Sonny Crawford .......... Timothy Bottoms
Duane Jackson ............... Jeff Bridges
Jacy Farros ............... Cybill Shepherd
Sam the Lion ................. Ben Johnson
Ruth Popper ............. Cloris Leachman
Lois Farrow................. Ellen Burstyn
Genevieve ................ Eileen Brennan
Abllene .................... Clu Culager
Billy ...................... Sam Bottoms
Charlene Duggs ........... Sharon Taggart
Lester Marlow ............. Randy Quaid
Coach Popper ............. Bill Thurman

and loss that are on the sentimental edge of "Winesburg, Ohio," but that illuminate a good deal more of one segment of the American experi-

ence than any other American film in recent memory.

•

It is 1951, the time of Truman, of Korea, of Jo Stafford, of "I, the Jury" as a best-selling paperback, when tank-town movie houses like the Royal Theater had to close because the citizens of Anarene, like most other Americans, were discovering, in television, a more convenient dream machine that brought with it further isolation from community—a phenomenon analyzed by Philip Slater, the sociologist, as America's pursuit of loneliness.

"The Last Picture Show" is not sociology, even though it is sociologically true, nor is

it another exercise in romantic nostalgia on the order of Robert Mulligan's "Summer of '42." It is filled with carefully researched details of time and place, but although these details are the essential décor of the film, they are not the essence. It is a movie that doesn't look back; rather, it starts off and ends in its own time, as much as does such a completely dissimilar, contemporary story as that of "Sunday, Bloody Sunday."

•

"The Last Picture Show" is about both Anarene and Sonny Crawford, the high school senior and football co-captain (with his best friend, Duane Jackson, of the always defeated Anarene

341

team), through whose sensibilities the film is felt. As Bogdanovich seldom takes his story very far from Anarene, he sees "The Last Picture Show" entirely in terms of the maturation of Sonny, in the course of the emotional crises and confrontations that have become the staples of all sorts of American coming-of-age literature, from "Penrod" to "Peyton Place" and "Portnoy's Complaint."

They are familiar staples, but they are treated with such humor, such sympathy and with the expectation of a few overwrought scenes, reticence that "The Last Picture Show" becomes an adventure in rediscovery—of a very decent, straight forward kind of movie, as well

as of—and I rather hesitate to use such a square phrase —human values.

Timothy Bottoms, who gave most of his performance in "Johnny Got His Gun" as a voice on the soundtrack for the mummy-wrapped, quadruple-amputee hero, is fine as Sonny Crawford, but then I liked just about everyone in the huge cast.

This includes Jeff Bridges (son to Lloyd, younger brother to Beau), as Duane; Cybill Shepherd, as the prettiest, richest girl in town, who is almost too bad to be true; Cloris Leachman, as the Coach's wife, who gives Sonny some idea of what love might be; Ellen Burstyn (who was so good in "Alex in Wonderland"), as a tough,

Dorothy Malone type of middle-aged beauty (middle-aged? she's all of 40!) who is one of the few people in Anarene to have recognized what life is and come to terms with it; and Ben Johnson, as the old man who most influences Sonny's life.

I do have some small quibbles about the film. Bogdanovich and McMurtry have done everything possible to get the entire novel on screen, yet they have mysteriously omitted certain elements, such as Sonny's family life—if any—and the reasons why the coach's wife is such a pushover for a teen-age lover. The movie is, perhaps, too horizontal, too objective.

I didn't see Bogdanovich's

first film, "Targets," but "The Last Picture Show" indicates that Bogdanovich, the movie critic, had already taken Jack Valenti's advice when, last winter, the film industry spokesman described critics as physicians who should heal themselves—by making movies—if they wanted to be taken seriously as critics. Bogdanovich has.

"The Last Picture Show" was screened at the New York Film Festival Saturday and opened yesterday at the new Columbia I Theater. My only fear is that some unfortunates are going to confuse it with Dennis Hopper's "The Last Movie," to which "The Last Picture Show" is kin only by title.

October 4, 1971

# 'Mean Streets' at Film Festival

**By VINCENT CANBY**

No matter how bleak the milieu, no matter how heartbreaking the narrative, some films are so thoroughly, beautifully realized they have a kind of tonic effect that has no relation to the subject matter. Such a film is "Mean Streets," the third feature film by Martin Scorsese, the once-promising young director ("Who's That Knocking at My Door?" and "Boxcar Bertha") who has now made an unequivocally first-class film.

•

"Mean Streets" has a lot
"Mean Streets, which was shown last night at the New York Film Festival in Alice Tully Hall, has a lot in common with "Who's That Knocking at My Door?", Scorsese's first feature released here four years ago. It is set almost entirely in New York's Little Italy, where Scorsese grew up. Its hero is a second-generation Italian-American, a young man whose nature is a warring mixture of religious guilt, ambition, family loyal-

## The Cast

MEAN STREETS, directed by Martin Scorsese; screenplay by Mr. Scorsese and Mardik Martin; produced by Jonathan T. Taplin; executive producer, E. Lee Perry; director of photography, Kent Wakeford; editor, Sid Levin; distributed by Warner Brothers. Running time: 110 minutes. At the New York Film Festival at Lincoln Center. This film has been classified R.

| | |
|---|---|
| Johnny Boy | Robert De Niro |
| Charlie | Harvey Keitel |
| Tony | David Proval |
| Teresa | Amy Robinson |
| Michael | Richard Romanus |
| Giovanni | Cesare Danova |
| Mario | Victor Argo |
| Joey | George Memmoli |

ty and fatalism.

Charlie (Harvey Keitel) is a nice, clean-cut petty hood, a sort of trainee-executive in the syndicate controlled by his Uncle Giovanni (Cesare Danova), an Old World gangster full of cold resolve and ponderous advice ("Honorable men go with honorable men"). Charlie makes collections for his uncle and aspires to take over a restaurant whose owner is deeply in debt to Giovanni.

Early on, however, it's apparent that Charlie is not quite ruthless enough to succeed in the Lower East Side

territory that defines his world. He has made the mistake of falling in love with Teresa (Amy Robinson), an Italian-American girl who has epilepsy and is therefore out of bounds. He also feels almost maniacally responsible for Johnny Boy (Robert De Niro), Teresa's simple-minded brother who traffics with loan sharks, suicidally.

•

When Charlie tries to flee the territory, with Teresa and Johnny Boy, crossing over the bridge to Brooklyn in a borrowed car, the results are predictable. It's as if an astronaut had decided to take a space-walk in a gray flannel suit.

"Mean Streets," which has a screenplay by Mr. Scorsese and Mardik Martin, faces its characters and their world head-on. It never looks over their shoulders or takes a position above their heads in order to impose a self-conscious relevance on them. There is no need to. It is Scorsese's talent, reflected in his performers, to be able to suggest the

mystery of people and place solely in terms of the action of the film.

This may seem simple but it's one of the fundamentals of filmmaking that many directors never grasp. Bad films need mouthpieces to tell us what's going on.

"Mean Streets," which was shot entirely on its New York locations, unfolds as a series of seemingly casual incidents — bar-room encounters, pick-ups, fights, lovers' quarrels and small moments of introspection—that only at the end are seen to have been a narrative of furious drive.

De Niro ("Bang the Drum Slowly") has an exceedingly flashy role and makes the most of it, but Keitel, modest, honorable and doomed, is equally effective as the hood who goes right, and hates himself for his failure.

"Mean Streets" will be screened at Alice Tully Hall again this evening. It opens its commercial engagement at the Cinema One Theater on Oct. 14, and deserves attention as one of the finer American films of the season.

October 3, 1973

# Hyphenates Seek Unified Film Approach

**By PAUL GARDNER**

The hyphenates are beginning to dominate Hollywood. They are not a mysterious breed of robots from a Roger Corman horror film, but an increasing band of film makers who write-direct-and-produce their own movies.

Their aim is to take the "groupie" effort out of Hollywood films by giving them

one strong creative voice. To do this, a dozen directors have set up their own companies. They're also writing or co-writing their own scripts.

The most illustrious hyphenates are Robert Altman co-writer - director - producer of "Thieves Like Us"; Peter Bogdanovich, writer-director-producer of a new musical,

"At Long Last Love"; John Boorman, writer-director-producer of "Zardoz," and Francis Ford Coppola, who writes-directs-and-produces films for himself—and other people.

For years, creative authority in Hollywood was often an uneasy tug-of-war among directors, producers and writers. The problem did

not exist in Europe because foreign film makers, such as Federico Fellini and Ingmar Bergman, exercised total artistic control.

### European Influence Visible

The European influence is visible in Hollywood as more movies reflect the personality of one film maker—and not an argumentative team that can't shoot straight.

Mr. Altman, who has his own company in Westwood, the artistic and academic center of southern California,

does not use studio office space or editing rooms. "I don't go near the studios," he explained the other day. "Everything I decide to make originates in my own Westwood office."

He added that he became a producer-writer-director to avoid the "group think and group opinion" that exists at studios.

"When you're around a studio, you're easily persuaded into making a 'type' of picture that seems to be the current fad," he said. "I didn't want those attitudes to rub off on me." He often shares credit with a writer because "in the movies, a script is just a blueprint," and he makes many dialogue changes during production.

Mr. Bogdanovich, who occasionally irritates film buffs with his habit of producing one hit after another, agreed that the script was only a blueprint. "A personal director firmly guides the script, which means he has to do some writing," he said. "The musical I've just written, using Cole Porter songs, was all in my head. I had to do it myself."

### Definition of 'Producer'

As for the word "producer," Mr. Bogdanovich who also has his own company, isn't sure what it means today: "Years ago, producers selected the property, the director, the writer and the cast. But today that's all done by a 'creative' director who wants to control his film. I have an associate producer. He handles contracts and budgets."

Mr. Boorman observed that making a film was always a struggle to keep the "artistic and technical elements" together. "Once I became my own producer, everything moved more smoothly," he said. "Making a movie was no longer a corporate venture."

A dozen years ago Woody Allen was asked to rewrite his script, "What's New Pussycat?," more times than he cared to remember. He was determined not to let that happen again. So, he became a writer-director. In fact, he took a new step for Hollywood hyphenates. He began *acting* in his own movies too.

Mel Brooks, the director-writer of "Blazing Saddles," began his career in television. Turning to films, he quickly discovered that he was in a director's medium.

### Self-Defense Cited

"I became a director in self-defense," he said. "I wanted to control my scripts. I didn't want some other guy — the director — saying, 'Naw, the camera won't be on the girl, it'll be on the chair!' As for the producer, so, who knows his name any more, or cares? What you need today is a business manager."

Some old-timers, like Hal B. Wallis, who produced almost 300 films during his 50-year career, look skeptically upon the new breed of writer-director-producers. "If one man does everything, he can fall in love with his work," Mr. Wallis said, "and that isn't healthy. A director needs someone to talk to— his producer. So now what's he going to do? Sit and talk to himself?"

February 25, 1974

---

## In 'Love and Anarchy,' Lust Excels

Despite her Germanic name, Lina Wertmuller is one of Italy's rare distaff director-writers, a biological distinction that has no bearing on the fact that "Love and Anarchy" is a solidly professional work. Her anti-Fascist drama about an abortive attempt on Mussolini's life in the nineteen-thirties, which opened at the Little Carnegie yesterday, is a mite closer to love and lust than to anarchy. However, it is passionate and stirring in its hatred of oppression and its love of the indomitable battlers against tyranny.

Miss Wertmuller obviously is stressing that some of the anonymous masses did a good deal of the fighting and dying against dictatorship by concentrating on such disparate principal plotters as a confused, timorous country bumpkin and a pair of prostitutes in one of Rome's poshest bagnios.

### The Cast

LOVE AND ANARCHY; written and directed by Lina Wertmuller; Italian with English subtitles; photographed by Giuseppe Rotunno; edited by Franco Fraticelli; music by Nino Rota; a Herbert R. Steinmann-Billy Baxter presentation distributed by Peppercorn-Wormser Film Enterprises, Inc. Running time: 108 minutes. At the Little Carnegie Theater, 146 West 57th Street. This film has been classified R.
Tunin ............... Giancarlo Giannini
Salome ............. Mariangela Melato
Tripolina ................... Lina Polito
Spatoletti ................... Eros Pagni
Mme. Aida .................... Pina Cei
Donna Carmela .......... Elena Fiore

But her vignettes grow in tension and meaning as she develops an awareness of the time, the place and her driven people in a succession of vigorous, coarse and violent scenes. Tunin, her callow hero, is simply a freckled, bearded young farmer, who has come to this bordello on vague instructions from an anarchist friend who has been murdered by Fascists. Salome, the blonde, outspoken queen of the establishment and his mentor, is—it turns out—a dedicated revolutionary who joined the oldest profession after her anarchist lover was slain.

Of course, there are complications. Our hero and Tripolina, another of Madame Aida's girls, fall in love. And, Spatoletti, one of Mussolini's rough enforcers who bears a surprising resemblance to Il Duce and is a regular patron of the "maison," also is on hand to mess up the plan. However, Miss Wertmuller and Giuseppe Rotunno, her cinematographer, manage to give these bare outlines substance and color that underline the irony and tragedy of unrequited sacrifice.

Perhaps there is more here for the voyeur than the historian. But the scenes inside the bordello that are reminiscent of Toulouse-Lautrec, as well as having explicit, four-letter dialogue, are vividly multidimensional. The physical aspects of Rome, its streets, squares, monuments and the green countryside also evoke the period and the effects of the dictatorship.

As Salome, Mariangela Melato wears her blond, Jean Harlow coiffure to the manner born. But above all, she is an inflexible patriot who projects idealism as grossly and fervently as she purveys her charms. Giancarlo Giannini's portrayal of Tunin is a shaded stint ranging from the shy peasant— a tender, love-smitten swain —to the man driven to a fatally violent act in a cause he has failed. Lina Polito is pitiably real as the pretty, anguished, brunette Tripolina, whose unwittingly selfish love helps push him toward self-destruction. And, Eros Pagni is properly vicious as the bullying Spatoletti.

"Love and Anarchy" may be slightly biased in its view of Fascist Italy, but Miss Wertmuller has illustrated it with enough power and style to make it memorable and often moving.

A. H. WEILER

April 15, 1974

# The Arts and Society

Norman Mailer at a Vietnam protest rally.

*Don Hogan Charles/NYT Pictures*

## TWO ORCHESTRAS OPEN THEIR SEASON

Symphony Society and Philharmonic Greeted by Big Audiences in Carnegie Hall.

### DAMROSCH SPEAKS OF WAR

The two chief orchestras of New York, the Philharmonic Society and the Symphony Society, (they are mentioned here in alphabetical order,) began their season yesterday, both in Carnegie Hall. The audiences at both concerts were large, both conductors were received with enthusiasm when they appeared, and both began the program with "The Star-Spangled Banner." The concert of the Symphony Society, which took place in the afternoon, was the first of its additional series of concerts which are to be given there, the regular series being continued in Aeolian Hall.

Mr. Damrosch made a speech before beginning his program concerning the playing of German music in this country. While we are at war with Germany, and we must strike as hard and as quickly as possible till victory is assured, the civilization of our country, he said, must not halt, and the needs of religion and of art must be met to the full. Bach, Beethoven, and Brahms are not to be looked on as Prussians, but as great creative artists contributing to the development of the world; they no longer belong to the country in which they were born, but are part of the artistic life of the civilized world. He hoped that his listeners agreed with him and that the coming concerts would be a refuge from war and a solace for its wounds.

Mr. Stransky said nothing; more but his program, containing one American, two French, and two German compositions, implied similar views.

October 26, 1917

## PHILHARMONIC BARS GERMAN COMPOSERS

### No More Music of 'Living,' but 'Old Masters' Retained— American Replaces Strauss.

The Philharmonic Society announced last night that no more music by living German composers will be performed at the society's concerts in New York or elsewhere for the duration of the war. Conductor Stransky, whose programs had been carefully planned to represent all nations impartially, even before America was actively engaged on the side of the Allies, agreed to this decision.

Under the Directors' rule the first work to be barred will be Richard Strauss's "Till Eulenspiegel's Merry Pranks," on the programs for Thursday and Friday of this week. In its place, Secretary Leiffels said last night, the orchestra will play an American symphonic work, "Hamlet and Ophelia," by the late Edward MacDowell.

As the Philharmonic has just concluded a Beethoven-Brahms festival, and is to give next Saturday a program of Bach and Wagner, it was explained that the Directors had decided to adopt the procedure followed in England and France since the war, whereby these "old masters" of music are not made to suffer for the acts of their countrymen today.

The action of the Philharmonic Board followed the recent resignation of President Oswald Garrison Villard of The Evening Post and the renewed offer of resignation by Treasurer Rudolph E. F. Flinsch. Neither has yet been accepted by the board. Mr. Leiffels said last night that Conductor Stransky, who came here from Austria, is a Czecho-Slav, whose compatriots are with the Allies, and that he has taken out first papers to become a citizen of the United States.

January 22, 1918

# ARREST KARL MUCK AS AN ENEMY ALIEN

### Federal Authorities in Boston May Prefer Charges Under the Criminal Code.

*Special to The New York Times.*

BOSTON, March 25.—Dr. Karl Muck, conductor of the Boston Symphony Orchestra, was arrested just before midnight tonight by agents of the Department of Justice and Boston policemen, under the President's alien enemy proclamation, and taken to Station 16, where he spent the night.

Federal officers were early in the evening sent to Dr. Muck's residence at 50 Fenway, but he was not at home. He returned a little after 11 o'clock and was greatly surprised when told that he was under arrest, but he submitted quietly and accompanied the officers to the station house and was locked in a cell.

The arrest of Dr. Muck was ordered by United States District Attorney Thomas J. Boynton, after a series of consultations with Judge Dewey, Assistant District Attorney of alien matters for Massachusetts; and, although he was taken into custody as an alien enemy, under the President's proclamation, it is believed that charges will be brought against him for violation of the Federal criminal code.

Dr. Muck had been preparing all Winter and was to conduct tomorrow evening Bach's "Passion According to St. Matthew," with orchestra, a chorus of 400, a boy choir of eighty, and a soloist—a most ambitious production, for which he has restored the original score at the cost of much labor.

Dr. Muck, while claiming to be a citizen of the Swiss Republic, was born in Bavaria in 1859, before the foundation of the German Empire. And under the interpretation of the President's proclamation, as given here, any man born in Germany before the empire was established is amenable to the regulations under that document. Hence it is under this proclamation that Dr. Muck was apprehended and jailed by the United States authorities.

Dr. Muck's father, Federal agents have ascertained, removed to Switzerland in 1867 and there became naturalized. No warrant was issued for his arrest, for none was needed. He is simply held by the Boston police for the Federal Government.

Assistant United States District Attorney Dewey remained in his office at the Federal Building for hours waiting to get word that the orchestra leader had been taken. That he had no suspicion that he was wanted was evident. It became known this evening that only today his representative called at the Federal Building to obtain passports for him and his wife and was to go to Europe.

Mrs. Muck was informed of her husband's arrest by Charles A. Ellis, manager of the Boston Symphony Orchestra, who told her that Dr. Muck had been detained on a trivial charge, and that he would probably be released within an hour. She had gone to Symphony Hall to attend the rehearsal.

"My husband's arrest is preposterous," Mrs. Muck said to a NEW YORK TIMES reporter at her home. "I have no knowledge of what the charge could be, and I am sure it will prove to be a farce. I know he will be released right away, for Mr. Ellis told me so."

Mrs. Muck spoke with a marked German accent and appeared very much disturbed over the action by the authorities. She refused to believe that they could bring any charges against her husband.

**Refusal to Play National Anthem.**

The agitation against Dr. Karl Muck, conductor of the Boston Symphony Orchestra, started in Providence, R. I., on Oct. 30, when he was accused of refusing a request to play "The Star-Spangled Banner" at a concert given by the orchestra. The Rhode Island Council of Defense the following day adopted resolutions condemning him "for his deliberately insulting attitude" in refusing to play "The Star-Spangled Banner."

Dr. Muck has maintained silence regarding this incident from the beginning, but Major Henry Lee Higginson, the founder of the orchestra, has repeatedly asserted that Dr. Muck did not refuse to play the anthem, but that he (Major Higginson) on that occasion refused to change the program to include the anthem.

A demand for the internment of Dr. Muck was made a few days later by the American Defense Society and other organizations on the ground that he was a dangerous alien enemy. Dr. Muck's answer was that he was a Swiss citizen.

When Dr. Muck conducted in this city under police guard on March 14, the management of the orchestra made public a document purporting to be a certificate of citizenship, given him by the town of Nueheim, in the Canton of Zug, in Switzerland, on March 4, 1881, soon after his twenty-first birthday. His father, a Bavarian, according to this document, settled there and became naturalized when Karl Muck was 6 years old.

The certificate was as follows:

We, the President and Council of the community (or town) of Neuheim, in the Canton of Zug, do hereby certify that the bearer of this document, Karl Muck, single, born Nov. 22, 1858, he (is) our citizen and we recognize him as such at all times.

By virtue of which we give the definite assurance that the above-mentioned citizen shall at any time and under all circumstances be received by our community.

Given at Neuheim on the 4th day of March, 1881.

The President,
KLEMENS ZUERCHER.
In the name of the Town Council.
C. JOS. STAUB.

With the best recommendation to all authorities and their respective protection, the genuineness of the foregoing signature is acknowledged.

Chancellory of the Canton of Am. Zug.
By the Chancellor, A. WEBER.
Zug, March 15, 1881.

In his statement made in this city defending Dr. Muck, Major Higginson said:

"I put the whole case before the United States legal authorities, and received their statement that there was nothing against any member of the orchestra, including Dr. Muck. Later, I went to the Department of Justice in Washington, where the whole case had been stated clearly, and on Dec. 7 received leave to play anywhere in the United States except in the District of Columbia, being barred from that place by a recent law with regard to aliens, there being some aliens in the orchestra."

Dr. Muck was formerly the conductor of the Kaiser's Royal Orchestra in Berlin, and in 1913 accepted an offer of $28,000 a year to come to this country and lead the Boston Symphony Orchestra.

March 26, 1918

# SEEKING "PROLETARIAN" WORKS

THAT many of the leaders of the Soviet Government find time to promote the development of what they label "proletarian culture" has been brought out by occasional reports in the American press during the last few years. The extreme to which this movement is being carried by some of the Communist enthusiasts is apparent from an article entitled "The Class Struggle Reflected in Music," printed in a recent issue of the Moscow News.

Having been attracted by groups of young people practicing mass singing in the Park of Culture and Rest in the Russian capital, under the guidance of the "Russian Association of Proletarian Musicians," whose task is to organize working class choruses and orchestras, the writer of the article interviewed one of the brightest of the girl singers as to the main reason for the organization's existence. This was given as follows by the girl enthusiast:

"We have carried over with us, even in our so-called revolutionary songs, much of the bourgeois influence in music. This must be eradicated. We must clean the last remnant of bourgeois sentimentality from our songs, the last note of music of the bourgeois system from our compositions.

"The worker who understands proletarian culture cannot see beauty in—say, for instance, church hymns. He can see only superstition. The music is an incense which dopes the senses, dulls the brain. We don't want that kind of music. Our hardest task is to undermine the harmful influence of jazz. It has crept into many of our own youth songs. We must learn to distinguish between inspiring, brilliant music that is truly proletarian in character, and meaningless jazz, which isn't really music but only a false stimulant to the emotions.

"Our tunes must be inspiring, but they must also teach the workers, especially the youth, why we need engines, why we need tractors and what a tractor means to Socialist construction. Music can be, and is, of as much propaganda value as the written or spoken word. We cannot separate music from our everyday life and work.

"What do we want with burning hearts? What is a burning heart? Only one trained in the bourgeois school of writing can waste time singing of burning hearts. Motors! They are the hearts of industry!"

Thus far, however despite the enthusiasm of the youthful protagonists for a special proletarian culture, the efforts of the Soviet authorities to stimulate the composition of worth-while music don't seem to have met with marked success. In this connection it has been noted that Nikolai Lenin himself has been quoted as rather scornful of attempts to draw a hard and fast line between "bourgeois" and "proletarian" culture. Anatol Lunacharsky, for many years Commissar of Education and Art and now a high official of the Soviet Publishing Company, also is on record as deprecating such attempts.

October 25, 1931

# RIVERA RCA MURAL IS CUT FROM WALL

## Rockefeller Center Destroys Lenin Painting at Night and Replasters Space.

### 'VANDALISM,' SAYS ARTIST

### Sloan, Urging Boycott, Says He Will Never Exhibit There—Protest Meetings Called.

Rockefeller Center canceled its $21,000 investment in a fresco by Diego Rivera by destroying the offending mural over the week-end.

Yesterday, when the news became known, protest meetings were called and John Sloan, president of the Society of Independent Artists, urged an artists' boycott of Rockefeller Center and announced that he would never exhibit there.

"I cannot believe that either Mr. or Mrs. John D. Rockefeller Jr. was consulted about this deplorable act," Mr. Sloan said last night. "I think the matter must have got out of their hands. I don't mean to attack either of them personally when I call this destruction an outrage. It is a terrible loss for the art of today and the future.

"If this vandalism had been committed last May immediately after Rivera was dismissed from Rockefeller Center, it might have been condemned as 'art slaughter.' My verdict now is that it is premeditated 'art murder.'"

The Society of Independent Artists is now negotiating for space in the RCA Building in Rockefeller Center in which to hold its annual exhibition. As head of this organization, Mr. Sloan said that he would protest against its showing in Rockefeller Center. If the exhibition is held there, he added, he would decline to submit his work. Another large show, to be called the Municipal Art Exhibition and to include some 1,200 examples of painting, sculpture and prints by artists associated with New York, is scheduled to be held in the RCA Building within a few weeks.

Maurice Becker, an artist, of 434 Lafayette Street, said last night that he had been invited to exhibit at the Municipal Art Exhibition but that he would withdraw. He said that H. J. Glintenkamp, another prospective exhibitor, had told him that he would do likewise. Mr. Becker prophesied that many more artists would follow suit when the news of the destruction became generally known.

### Destroyed at Night.

When tenants of the RCA Building left their offices on Saturday, the Rivera mural was concealed under the cream-colored canvas that was put in place shortly after the noted and radical Mexican artist was dismissed last May after having refused to omit a portrait of Lenin and make other changes demanded by the Rockefeller family.

Yesterday when the tenants of the new skyscraper returned to their offices, they saw a blank wall where the Rivera painting had been. The concealing canvas had been removed about midnight on Saturday, a corps of men had hacked out the plaster containing what Rivera considered one of his most important paintings, and the resulting blank wall had been replastered.

This brief statement was given out by Rockefeller Center:

"In answer to inquiries, the following statement was authorized by Rockefeller Center, Inc.: The Rivera mural has been removed from the walls of the RCA Building and the space replastered. The removal involved the destruction of the mural."

This statement was amplified somewhat by a spokesman for Rockefeller Center who explained that some structural changes about to be made in the great hall of the building necessitated the removal of the painting. The extent of the changes he did not know, other than that a new information booth is to be built. He also denied that another artist had been selected to paint a mural to replace the Rivera work and that the wall was being prepared for this purpose. He called absolutely false a report that the destruction of the mural had taken place under the protection of police, and explained that midnight had been chosen for the work so as to cause no inconvenience to tenants.

The destruction of the painting surprised the art world because assurance had been given by spokesmen for Rockefeller Center last Spring that the mural would not be damaged.

Admirers of Rivera's work called a protest meeting to be held at the New Workers School, 51 West Fourteenth Street, next Saturday night and planned another to be held within a week. The committee in charge of the latter meeting consists of Suzanne La Follette, Mr. Sloan, Walter Pach, Ben Shahn and Bertrand D. Wolfe.

### Rivera Cables Protest.

Last night Mr. Wolfe, who is director of the New Workers School and Rivera's New York representative, gave out a statement cabled by Rivera from Mexico City. In it the artist said:

"The Rockefellers have destroyed my mural, but they cannot prevent me from speaking through my paintings to the workers of New York and the United States. My work was photographed despite the prohibition of the management of Radio City and will be published in permanent form.

"In destroying my paintings the Rockefellers have committed an act of cultural vandalism. There ought to be, there will yet be, a justice that prevents the assassination of human creation as of human character.

"The Rockefellers demonstrate that the system they represent is the enemy of human culture, as it is of the further advance of science and the productive powers of mankind.

"My case, which is more than personal, I leave in the hands of the American masses. They will yet take over industry and public buildings and guarantee the further development of man's productive and creative powers."

The dismissal of Rivera from Rockefeller Center last May created a furor both among his artist sympathizers and radical organizations. Rivera, who is widely regarded as one of the great living mural painters, was an active member of the Communist party and never concealed his radical views.

February 13, 1934

---

# GOERING LAUNCHES THE NAZI ART PURGE

## Orders Broad Clean-Up of All Public Exhibits to Get Rid of 'Un-German' Works

### MODERNISTS ARE TARGET

### Decree Orders Disregard of Legal Forms and Property Rights in Movement

Wireless to THE NEW YORK TIMES.

BERLIN, Aug. 3.—The National Socialist purge of static art in Germany that Chancellor Adolf Hitler announced at the dedication last month of the House of German Art was definitely set in motion today. Colonel General Hermann Goering, the Chancellor's chief aide, issued a decree ordering a sweeping clean-up of all German art museums and other public art exhibitions in line with the principles laid down by Hitler and "without regard to legal forms or the property rights involved."

Under this decree as interpreted by authoritative spokesmen, German museums now will be cleansed of all the manifold forms of art that Hitler denounced as "un-German." These include virtually all the modern schools in painting and sculpture since the turn of the century, from impressionism to cubism and surrealism, samples of which are now displayed in an "exhibit of degenerate art" in Munich.

Furthermore, the emphasis laid on the disregard of legal forms and property rights is taken to mean that the order affects not merely State museums, but also the hitherto independent provincial and municipal museums as well as private art foundations heretofore open to the public. Even private ownership of forbidden art becomes dangerous because it carries the suspicion of Bolshevist, or at least oppositional sentiment.

### Dr. Rust in Charge

Technically General Goering's order applies only to Prussia, since technically he is Minister President of Prussia only, but it puts in charge of the purge Dr. Bernhard Rust, who is Minister of Education for both Prussia and the Reich. Dr. Rust immediately called a meeting of all Prussian museum and art school directors together with art directors of other German States to give them their instructions.

One of the first orders Dr. Rust issued was that all museum directors must undergo a "schooling course" and they will have to attend a schooling camp, where military discipline prevails. They will be instructed by approved Nazi art experts in the new artistic principles so that in the future they will be able to distinguish "German art" from merely "modern" or "international" or "degenerate" art.

But it is also expected that most museum and art exhibition directors guilty of having purchased such banned art in the past are to be removed from their posts and some even fear their possessions might be seized to reimburse the public for such purchases. Lawsuits to that end have been filed by the National Socialist authorities before, but have heretofore been defeated in the courts. Whether the courts will continue to stand firm in the face of the new order remains to be seen. One German museum director guilty of having purchased paintings by Russian artists already has fled the country.

### Shifts in Schools Likely

The same shake-up in personnel is expected in all art schools and art academies in the country. In some it is already under way and names of new directors are already being whispered about.

The clean-up is expected to remove from all German art exhibitions all the examples of all artists whose works are now pilloried in the exhibit of degenerate art, which includes such internationally known artists as Lovis Corinth, Franz Marc, Emil Nolde, Carl Hofer, Paula Becker-Modersohn, Otto Mueller, George Gross and others.

Though nothing is said about it officially, it is understood all similar works by foreign artists will likewise be removed. This would include some of the best works of Pablo Picasso, André Derain, Juan Gris, Oluf Hoest, Jens Sondergaard and Edward Munch, the "Nordic" father of much of modernistic art, as well as Oskar Kokoschka and Marc Chagall, who hang in "degenerate art" exhibits already. It follows, of course, that none of these artists, either German or foreign, will be able to exhibit or sell their works in Germany in the future unless they change their style in conformity with Hitler's artistic dictum. What is going to be done with modernistic Italian artists still is a matter of speculation.

The future of the condemned art works still is obscure. In his decree General Goering reserved decision on that question to himself in so far as State property was concerned. But a considerable section of National Socialist artists favors celebrating the final victory of German art with a great bonfire of condemned works—except for a few samples to be preserved as a record of the "degenerate epoch" that Hitler ended.

August 4, 1937

347

# ARTIST'S CREDO

## Man of Letters in the Political World—Essential Values in Art

### By BROOKS ATKINSON

AT least three plays to be produced this year by the new group of playwright-managers will speak a good word for democracy. This does not represent any deliberate plan on their part; they are not pooling their ideas. What it shows is that three leading American dramatists are at the present time concerned about the same thing. The most crucial topic in the world today will be part of the theatrical life of this season, which is proper. Thomas Mann has recently confessed: "In my younger days I shared that dangerous German habit of thought which regards life and intellect, art and politics as totally separate worlds. In those days we were all of us inclined to view political and social matters as non-essentials that might as well be entrusted to politicians." We know now that there are no separate worlds; although they are by no means identical they are closely related. In a world that is furiously aroused over fundamental political views every art must be more or less politically minded.

* * *

BY temperament and experience the man of letters is poorly suited to an active political life. He is, or should be, personally disinterested, which is fatal to success in a skilled trade founded on manoeuvering for the gain. He is, or should be, sincere, and politics is dedicated to insincerity. By temperament he is also easily bored, which is a malady in any public life. He is likely to have a sense of humor, which is a frightful handicap. In general, he is an innocent among the wary-wise.

Being principally interested in the life of man, however, he cannot be indifferent to politics, which intimately affects the life of man. In consequence, the man of letters is being frequently drawn in. Milton was a political pamphleteer as well as the second greatest poet in English literature. Swift wrote about politics so savagely that he is still a force in Irish thought. Sheridan gayly dabbled in politics, having one good Parliamentary speech to his credit. The deeper Tolstoy probed into the life of man the more he became involved in politics. Ibsen began as an epic poet and concluded by writing plays of social and political significance. Shaw has been pamphleteering for years. Although Yeats is the most mystic of modern poets, which should disqualify him from any life of action, he was at one time a working statesman in the one country where a poet is an imposing figure. Not long ago A. P. Herbert annoyed the English ruling class by getting himself elected to Parliament; presently he annoyed them further by putting through a bill to modernize the marriage laws. In spite of their temperamental handicaps, men of letters have always taken political stands, sometimes getting themselves elected to office and honorably acquitting themselves.

* * *

IN the democracies that survive in this malevolent era, writers are now drawn willy-nilly into politics because the future of their profession is at stake. Without the individual freedom and liberty they now enjoy they cannot work at their craft and maintain their self-respect. They have ample evidence of what can happen. Russia, Germany and Italy have destroyed creative art by depriving artists of their freedom of opinion, giving them the choice of being either silent or spokesmen for the party.

When the artist becomes the servant of the State he must retire as high priest of the life of man, most of which lies outside the province of the State and politics. Even in this country it is necessary to keep this broader truth in mind. There is pressure here from special pleaders; the writer is urged to believe that politics and economics are the basic laws of life, and he is invited to drop whatever he is doing and pitch in.

But that, too, is making him a spokesman and limits him to only part of the truth. For the basic subject of art is man and the hopes of his soul. They have a grandeur of scope that must not be arbitrarily circumscribed. Some weeks ago Franz Boaz said in The Nation: "It is one of the curious phenomena of our time that intellectual and spiritual freedom is confused with social and economic freedom." Thus, a scientist confirms an artistic and philosophical belief; that is always a clarifying meeting of minds. Spiritual and economic freedom are intimately related, the "freedom to starve" being the most ironic and tragic. It is further true that perfect intellectual and spiritual freedom is stimulated by a full stomach and a warm house. But even these materialistic fundamentals of creature living can be reduced a little without extinguishing the vital spark of freedom, as in the heroic instances of Socrates, Jesus and Lincoln, or the human instances of Poe, Melville and Whitman, or in the instances of most of the eminent labor leaders of history and today whose idealism has not been destroyed by hard living. Every one knows that the full stomach and the warm house do not automatically produce intellectual and spiritual freedom. We may as well remember that the opposite is also true: there are many free men whose stomachs are not distended and whose houses are draughty, for the spiritual life and the material life are not interchangeable or identical.

* * *

IN a confused world it is incumbent upon the writer to keep his mind clear and also his sense of proportion. It is his job to minister unto the whole man, not merely to a political being; and the subject of man in conflict with or in pursuit of his destiny involves a great many things that cannot be bought, sold or legislated. Man falls in love without the advice and consent of his district leader. His friends are people of his own choosing; and, like the woman he marries, they are the deepest influence in his life. His life in nature is the product of his own perceptions: economics and politics cannot influence his love of sea, land and sky, or deprive him of the glory of sunlight. When he dies he passes completely outside the jurisdiction of government, which, incidentally, is one of the pleasures of mortality. For the life of man has enormous latitude, and the most vital parts of it burn in the hearts and minds of private individuals. The essential impulses in it are a private contract between man and God.

That brings us round again to the fundamental conflict between democracy and the totalitarian State. In Germany national socialism is not secure unless it can control organized religions, and in Russia communism is impossible if the comrades believe in God. For the totalitarian State is jealous of any authority not vested in its leader. As Dr. Mann has been insisting on the lecture platform, democracies must be reborn to combat that fanatical negation. And that is why three leading dramatists, individually facing the task of a new play, find a good word for democracy creeping in.

September 18, 1938

# SOVIET OUSTS CHIEF OF WRITERS' UNION

Special to THE NEW YORK TIMES.

MOSCOW, Sept. 8—Nikolai Tikhonov, president of the Union of Soviet Writers, has been dismissed from his post and Mikhail Zoschenko and Anna Akhmatova, Leningrad writers, who recently incurred the wrath of the central committee of the Communist party for writings smacking of "alien ideologies," have been expelled from the union. This information was disclosed in a resolution of the presidium of the union board printed in all Soviet newspapers today.

The actions were taken as a result of a recent decision of the Communist party central committee, which urged writers to purge the Soviet literary world of writers who spread "bourgeois ideas hostile to the Soviet system and ideology."

Mr. Tikhonov was replaced by a governing board consisting of A. Fadeyev, novelist and general secretary; Konstantine Simonov, author of the Stalingrad novel, "Days and Nights," and V. Vishnevsky, Mr. Tikhonov, and Alexander Korneichuk, assistant general secretaries.

### New Secretariat Named

A new secretariat has been formed, consisting of eight members, Boris Gorbatov, novelist; Leonid Leonov, playwright; E. G. Semper, an Estonian; A. Upit, a Latvian; A. T. Ventzlov, a Lithuanian; C. I. Chikovani, a Georgian; Aibek Mouss for Uzbekistan, and Jacob Kotlas, a White Russian.

The reason for the expulsion of Mr. Zoschenko and Miss Akhmatova was that "their work does not correspond to the demands" of the Soviet state. The only writers who can belong to the union in the future are those who "stand on a platform of Soviet power and participate in Socialist construction," as stated in the second paragraph of the union's charter.

Mr. Tikhonov was dismissed from the presidency because he "failed to undertake any measures to improve the work of Zvezda and Leningrad," literary magazines recently censured by the party's central committee. The magazines contained writings "dangerous" to the cause of Soviet education.

Dissemination of the work of Boris Pasternack, Russian poet, who is highly regarded in the United States, was criticized in the writers' resolution, which termed his poetry "apolitical and idealless, isolated from the masses of the people."

### Literature as Weapon Stressed

"Those responsible for guidance in literature forget that it is a mighty weapon for the education of the Soviet people, especially youth, and that they should therefore be guided in their work by the politics of the Soviet Union," the resolution said. "This led to serious political mistakes."

The resolution added that the central committee had "justly pointed out" similar mistakes by Soviet playwrights.

It was charged that a "spirit of worshiping bourgeois culture alien to the Soviet people," had a marked effect on the Soviet theatre, the decision added.

The Isskusstvo Art Publishing House was censured by the writers for having published a collection of "low-class and vulgar" American and English plays that "poison the minds of our people with an outlook alien to Soviet society."

Critics also were rapped for the "low ideological level" of their work and for not paying the proper attention to the "ideological trend" of recent works.

September 9, 1946

## Musicians' Ban on Furtwaengler Ends His Chicago Contract for '49

### By HOWARD TAUBMAN

A group of world-famous soloists and conductors, including Vladimir Horowitz, Artur Rubinstein and Alexander Brailowsky, pianists; Lily Pons, Metropolitan Opera soprano, and André Kostelanetz, conductor, have warned the Chicago Symphony Orchestra that they would not appear as soloists or guest leaders with that ensemble if Wilhelm Furtwaengler became principal conductor, it was learned yesterday.

The board of the Chicago Orchestral Association, as a result, has decided not to have Mr. Furtwaengler conduct there next season, it was learned. Edward Ryerson, president of the association, admitted last month that his organization had invited the German conductor to Chicago. Since then Chicagoans have made no official statement, but Mr. Furtwaengler announced in Vienna that he had accepted the Chicago offer.

The action taken by leading musicians here on Mr. Furtwaengler was based on the conductor's war record. They maintained that he had remained in Germany throughout the war and had conducted leading German musical organizations, occasionally in the presence of Adolf Hitler and his top aides.

The protest of American musicians was aimed also at Walter Gieseking, German pianist, who is due to return to this country this month after an absence of about ten years. The objections to Mr. Gieseking were generally the same as those to Mr. Furtwaengler.

Mr. Horowitz has warned local concert managers that he would not appear on any series of recitals that also engages Mr. Gieseking. Mr. Rubinstein has taken similar action. This season he declined to appear with the National Symphony Orchestra of Washington which had also engaged Mr. Gieseking.

Mr. Horowitz said that he made his decision about Mr. Furtwaengler and Mr. Gieseking out of respect for the hundreds of thousands of Americans who died in the war against nazism. He said that Mr. Furtwaengler's international prestige was such that he could have had a career anywhere outside of Germany and that he had ample opportunity to desert nazism.

Mr. Horowitz added that he was prepared to forgive the small fry who had no alternative but to remain and work in Germany. Mr. Furtwaengler, however, he said, was out of the country on several occasions and could have elected to keep out.

Mr. Rubinstein sent the following telegram yesterday from his home in Beverly Hills, Calif.:

"I will not collaborate, musically or otherwise, with any one who collaborated with Hitler, Goering and Goebbels.

"Had Furtwaengler been firm in his democratic convictions he would have left Germany. Many persons like Thomas Mann departed from that country in protest against the barbarism of the Nazis. Mr. Furtwaengler chose to stay and chose to perform, believing he would be on the side of the victors.

"Walter Gieseking acted similarly.

"There are reports that Furtwaengler saved some persons from the Nazi regime. This is unconfirmed. Now he wants to earn American dollars and American prestige. He does not merit either."

It was learned that a number of leading conductors who had been approached to be guest directors in Chicago next season had declined, if Mr. Furtwaengler came. These men refused to have their names used, since they did not wish as conductors to seem to be threatening another conductor, but they did not deny that they had taken such action.

Among other soloists who have taken similar action, it was learned, were Gregor Piatigorsky, 'cellist, and Nathan Milstein and Isaac Stern, violinists. It appeared that these soloists and conductors made their decisions independently and conveyed them to their respective managers for communication to Chicago.

From sources in Chicago it was learned that Mr. Furtwaengler had been requested to withdraw. He, in turn, maintained, it was said, that he had a binding contract and expected the Chicago Orchestra to pay him off.

There were other indications that Chicago had decided to forego Mr. Furtwaengler's services. When the German conductor announced his engagement some weeks ago he said it would be for the opening of the season. It was learned yesterday that Victor de Sabata, Italian conductor, has been engaged for the first four weeks of the season.

Among other conductors who have agreed to conduct in Chicago next season are Rafael Kubelik, Czech; Fritz Reiner and Fritz Busch. Some of these, it is understood, would not have accepted any engagement if Mr. Furtwaengler had been named musical director of the Chicago Orchestra.

Mr. Furtwaengler's record has not been without defenders. Yehudi Menuhin, violinist, appeared as soloist with him in Germany about a year ago. Mr. Menuhin said that the conductor had saved the lives of Jewish musicians during the Nazi regime.

Mr. Furtwaengler, who has been conducting in Europe since the end of the war, was cleared by a German denazification court. It was held at that time that though he had shown bad judgment and was morally culpable he was not legally guilty.

Mr. Gieseking remained in Germany throughout the war. At first he was barred by the Allied military officials from resuming his career on ground of implication with the Nazis, but later that decision was reversed. He, too, has been playing in public in many European countries.

January 6, 1949

---

### Picasso Voices Devotion To Communist Art Line

Special to THE NEW YORK TIMES
PARIS, April 24—Pablo Picasso, pride of French Communist art who has been known to paint ladies looking both ways at once and other fancies admired by "decadent bourgeois esthetes" expressed today his devotion to "Socialist realism."

M. Picasso, Communist poets Louis Aragon and Paul Eluard and several score of other Left-Wing artists were listed as signers of a letter to Maurice Thorez, Secretary General of the French Communist party, now convalescing from a long illness in the Soviet Union.

The letter was made public at the end of a two-day meeting of Communist plastic artists and critics, which was said to have been called to bring some of the freer spirits—notably M. Picasso—to task for artistic deviations from the poster art favored by the party here.

April 25, 1952

---

## BAN ON COPLAND WORK AT INAUGURAL SCORED

The League of Composers of 115 West Fifty-seventh Street protested yesterday to the Inaugural Concert Committee in Washington against the dropping of "A Lincoln Portrait," set to music by Aaron Copland, from the Inaugural Concert in Constitution Hall Sunday night.

The committee had taken the action after Representative Fred E. Busbey, Republican of Illinois, had objected to the work on the ground that the composer had allegedly associated with Communist front groups.

Mr. Busbey said later that "there are many patriotic composers available without the long record of questionable affiliations of Copland. The Republican party would have been ridiculed from one end of the United States to the other if Copland's music had been played at the inaugural of a President elected to fight communism, among other things."

In its statement to the committee the league said, in part:

"No American composer, living or dead, has done more for American music and the growth of the reputation of American culture throughout the civilized world than Aaron Copland. To bar from the Inaugural Concert his music, and especially music about Abraham Lincoln, will be the worst kind of blunder and will hold us up as a nation to universal ridicule."

Commenting that Mr. Copland's works, including "Rodeo," "Billy the Kid" and "Appalachian Spring," are "pure Americana," the league urged the committee to reconsider its action.

The "Lincoln Portrait" is written for narrator and orchestra with the text drawn from various speeches and writings of the President. The "Portrait" has been heard frequently in Washington and has been recorded by the New York Philharmonic-Symphony Orchestra. The composer received the Pulitzer Prize in 1945 for "Appalachian Spring."

January 17, 1953

# RED ISSUE BLOCKS EUROPE ART TOUR

## U. S. Information Unit Fears 10 Painters in Show May Be Called Pro-Communist

### ACTION CALLED A 'FIASCO'

### Assisting Museums Refuse to Use a Political Criterion —See U. S. Culture Hurt

**By ANTHONY LEWIS**
Special to The New York Times.

WASHINGTON, June 20— The United States Information Agency is withdrawing from sponsorship of what had been planned as one of the most important exhibits of American paintings ever sent abroad.

It has done so because of a fear that some of the artists included in the show may be accused of pro-Communist leanings.

This is the third flurry within the U. S. I. A. in recent months over "subversive art," and it is regarded as the most significant. A number of leading American art institutions had cooperated in getting up this show, and had considered it an ambitious step in international cultural exchange.

The reaction now among these art groups is one of bitterness and disappointment. They call the affair a "fiasco" and say it will end by damaging the cultural standing of the United States abroad.

### 100 Artists Chosen

The projected show was to have included major works of 100 American artists of the twentieth century. To get the pictures together, the information agency had called on the American Federation of Arts, a nonprofit organization with headquarters in New York.

Then, some weeks ago, a U. S. I. A. representative informed the federation that about ten of the artists on the list were "unacceptable" for political reasons. The phrase "social hazards" was used.

Rejecting any political tests for its artists, the federation's forty-two trustees voted unanimously on May 23 not to participate in the show if any paintings were barred by the Government.

The federation told the information agency it did not want to know the names of the ten suspected artists, because it did not want to participate in circulating any possibly libelous charges against them.

The federation cited a resolution by its trustees in October, 1954, that art "should be judged on its merits as a work of art and not by the political or social views of the artist."

### Wide Range of Artists

Painters selected for the show ranged from such sometime realists as John Sloan, George Bellows, Thomas Hart Benton, Grant Wood, Ivan Albright and Reginald Marsh to such expressionists as Max Weber, John Marin, Yasuo Kuniyoshi and Ben Shahn and numerous examples of the surrealist and abstract.

The information agency has not finally rejected the show or canceled its sponsorship. But it has made clear that it feels it cannot go ahead unless some kind of political test for the artists is accepted. Efforts are under way to arrange a private sponsor.

The federation has planned many shows for the U. S. I. A. in the last few years and has never run into difficulty on anything but contemporary American works. The two major previous episodes involving Communist charges were these:

The U. S. I. A. canceled plans to send to Australia an exhibit called "Sport in Art," which had been sent around this country by the magazine Sports Illustrated. The agency dropped out because some group called the Dallas County Patriotic Council had made political charges against some of the artists when the show went to Dallas, Tex.

The agency raised objections to an art collection from American university and college galleries that was going overseas because it included a picture by Pablo Picasso. The artist is a member of the French Communist party. This tangle was eventually ironed out.

The agency declined to comment today on the reasons for its stand on the art matters. But it is known that fear of Congressional criticism has played an important part.

Last week Representative George A. Dondero, Republican of Michigan, made a speech on the House floor denouncing "brain-washed artists in uniform of the Red art brigade."

The problem has been extremely troubling to officials of the U. S. I. A., including Theodore Streibert, its director.

June 21, 1956

# WRITERS IN SOVIET EXPEL PASTERNAK

## Nobel Prize Winner Scored as Pawn in Cold War

**By Reuters**

LONDON, Tuesday, Oct. 28 —Boris Pasternak, Soviet winner of the Nobel Prize for Literature, has been expelled from the Soviet Writers Union and deprived of the title of Soviet Writer, the Soviet press agency Tass reported early today.

The agency was quoting a unanimous decision by the presidium of the Soviet Writers Union Board, the organizational bureau of the Writers Union of the Russian Federated Republic, and the presidium of the Moscow branch of the Soviet Writers.

The decision said Mr. Pasternak's activities were "incompatible with the name of Soviet Writer." It went on to say that the decision to expel him had been taken in view of his "political and moral fall, his treason with regard to the Soviet people, the cause of socialism, peace, and progress paid for by a Nobel Prize in order to intensify the cold war."

Mr. Pasternak, the 67-year-old author of the novel "Dr. Zhivago," and also distinguished as a poet, was awarded the $41,420 Nobel Prize last week by the Swedish Academy.

The novel, a candid study of Russia during the period of the Bolshevik Revolution and thereafter, was first published in Italy. It has not been published in the Soviet Union.

The decision to expel Mr. Pasternak from the Soviet Writers Union was published in today's Literary Gazette in Moscow, Tass reported.

Earlier, the Gazette had described the award as a "hostile political act," and declared that the Swedes, as the tools of international reaction, were "fanning the cold war."

October 28, 1958

# *Robert Lowell Rebuffs Johnson As Protest Over Foreign Policy*

### *Poet Refuses to Attend Arts Festival — Voices Distrust of U.S. Actions Abroad*

**By RICHARD F. SHEPARD**

Robert Lowell, the Pulitzer Prize-winning poet, yesterday rejected an invitation to appear at a White House arts festival because of his "dismay and distrust" of American foreign policy.

In a letter to President Johnson, the 48-year-old writer said that he was reversing an earlier decision to participate in the festival June 14 because "every serious artist knows that he cannot enjoy public celebration without making subtle public commitments."

Mr. Lowell's rejection was the latest manifestation of sharp discontent with American policies in Vietnam and the Dominican Republic in some intellectual circles, which seem to be torn between support for Mr. Johnson's civil rights policies at home and opposition to his actions abroad.

Mr. Lowell is one of several writers who were invited to the festival, where they will read their poetry and prose. A White House source, asked about the poet's withdrawal, said there have been "no similar cases."

John Hersey and Saul Bellow, two other writers, said they would attend but expressed strong disagreement with the Administration's foreign policy.

Condemnation of foreign policy has been more frequent recently among writers as well as college teachers and students.

On May 19, Lewis Mumford, president of the American Academy of Arts and Letters, denounced United States political and military policy in Vietnam as a "moral outrage" and an "abject failure."

His remarks prompted the resignation of Thomas Hart Benton, the painter, who tried to interrupt Mr. Mumford's talk and then walked offstage.

Last Monday, Archibald MacLeish, writer and poet, said in an address that United States policies in Vietnam and the Dominican Republic had raised the question whether the nation had become indifferent to the opinions of mankind and had outgrown its old idealism.

Mr. Lowell, who lives in New York, declined to discuss the matter beyond making public his letter. He has long been concerned with moral aspects of war and peace, however.

His letter to Mr. Johnson, quoted in full, follows:

Dear President Johnson:

When I was telephoned last week and asked to read at the White House Festival of the Arts on June 14, I am afraid I accepted somewhat rapidly and greedily. I thought of such an occasion as a purely artistic flourish, even though every serious artist knows that he cannot enjoy public celebration without making subtle public commitments.

After a week's wondering, I have decided that I am conscience-bound to refuse your courteous invitation. I do so now in a public letter because my acceptance has been announced in the newspapers and because of the strangeness of the Administration's recent actions.

Although I am very enthusiastic about most of your domestic legislation and intentions, I nevertheless can only follow our present foreighn policy with the greatest dismay and distrust. What we will do and what we ought to do as a sovereign nation facing other sovereign nations seems to hang in the balance between the better and the worse possibilities.

We are in danger of imperceptibly becoming an explosive and suddenly chauvinistic nation, and we may even be drifting on our way to the last nuclear ruin.

I know it is hard for the responsible man to act; it is also painful for the private and irresolute man to dare criticism. At this anguished, delicate and perhaps determining moment, I feel I am serving you and our country best by not taking part in the White House Festival of the Arts."

Respectfully yours,
ROBERT LOWELL.

Mr. Lowell won a Pulitzer prize in 1946 for his collection of poems entitled "Lord Weary's Castle." At one time he was consultant in poetry to the Library of Congress. He is a great-grandnephew of James Russell Lowell and a cousin of Amy Lowell.

A friend of Mr. Lowell said that the writer had apparently reached his decision during a trip to the West from which he has just returned.

Mr. Bellow, author of the widely praised novel "Herzog," said he had discussed the matter with Mr. Lowell but had come to a different conclusion. Mr. Bellow said in a statement:

"The President intends, in his own way, to encourage American artists. I consider this event to be an official function, not a political occasion which demands agreements with Mr. Johnson on all the policies of his Administration.

"Therefore, I do not think it necessary to acquaint him with my position on Vietnam or to

Charles R. Schulze
**Robert Lowell**

send him a statement declaring that I am wholly opposed to the presence of marines in Santo Domingo. I consider the American intervention there to be indeed wicked and harmful but the Administration is more than these policies of which I disapprove.

"It distinguishes itself for instance in the civil rights struggle. Moreover, Mr. Johnson is not simply this country's principal policy maker. He is an institution. When he invites me to Washington, I accept in order to show my respect for his intentions and to honor his high office.

"I am sure that he does not expect me to accept every policy and action of his Administration together with the invitation."

Mr. Hersey, when he learned of Mr. Lowell's action, also prepared a statement.

"Like many others, I have been deeply troubled by the drift toward reliance on military solutions in our foreign policy," he said. "Up to the present, it has been my intention to attend the festival because I have felt that, instead of declining or withdrawing, I could make a stronger point by standing in the White House, I would hope in the presence of the President, and reading from a work of mine entitled 'Hiroshima.'"

Mark Van Doren, who will be chairman of the poetry- and prose-reading portion of the White House program, declined to comment. Other participants could not be reached.

The all-day festival, the most extensive ever held at the White House, is intended to "honor and encourage the arts in the United States."

June 3, 1965

# Dissident Russian Writer in Exile
## Aleksandr Isayevich Solzhenitsyn

**By ISRAEL SHENKER**

For those who believed in his cause, Aleksandr I. Solzhenitsyn was the embodiment of man's highest longings, the author who gave them eloquence. For Soviet officials he was a counter-revolutionary, a reactionary scribbler who served foreign imperialists and betrayed his country in book after book. If evidence of their appraisal were needed, it came suddenly when Mr. Solzhenitsyn was forcibly arrested and, yesterday, bundled aboard a plane and sent into exile. It was a desperate measure to deal with the 55-year-old writer's world-renowned case.

In 1970 Mr. Solzhenitsyn, who had become a leading critic of aspects of the Soviet system and who allowed works suppressed at home to be published abroad, was awarded the Nozel Prize for Literature. He was unable to go to Stockholm to accept the $78,000 award because he feared that he would not be allowed to return.

As for the Soviet authorities, they took the award as

*Man in the News*

an insult to them and to Communism.

Despite official threats and calumny, Mr. Solzhenitsyn went on fighting for what he regarded as fundamental rights, to live where one chooses, to write as one pleases, to see justice done.

**Father Fell in War**

It was a struggle that had its roots in czarist days and in the early years of Communist rule. Aleksandr Isayevich Solzhenitsyn—the name is pronounced saul-zheh-NEE-tsin—was born in Kislovodsk on Dec. 11, 1918. His father had died on the German front the previous summer, and the lad was brought up by his mother in Rostov.

When he tried to write, his manuscripts were rejected, so he studied mathematics at Rostov University. Beginning World War II as driver of horse-drawn vehicles, he was transferred to artillery school and then given command of an artillery spotting company.

In February, 1945, while serving in East Prussia, he was arrested because of what he subsequently termed "disrespectful remarks about Stalin" made in correspondence with a friend—though the correspondence used a pseudonym for the dictator. Without being present for trial, he was sentenced to eight years in a detention camp.

He spent the first part of his sentence in work camps, which he later described in a play, "The Love Girl and the Innocent." Then he was allowed to do mathematical work in a special prison, described in "The First Circle." In 1950 he was sent to a camp for political prisoners, the setting for "One Day in the Life of Ivan Denisovich."

He worked as miner, bricklayer and foundryman, contracted spinal cancer and was operated on unsuccessfully.

**Into Exile 'for Life'**

A month after completing his sentence he was exiled—"for life"—to southern Kazakhstan. On March 5, 1953, when Stalin's death was announced, he was allowed to go out without an escort for the first time. By the end of the year he was close to death, unable to eat or sleep, until he was sent to a cancer clinic—described in "The Cancer Ward"—and apparently cured. In 1956 he was restored to citizenship.

During exile he had taught mathematics and physics in an elementary school, writing prose secretly and composing poetry in his mind, preserving the prose and later recalling the poetry.

The desolation of secret authorship—he was convinced that the authorities would never let him publish—weighed so heavily that he could bear it no longer. He offered the manuscript of "Ivan Denisovich" to Aleksandr Tvardovsky, editor of the literary journal Novy Mir. Mr. Tvardovsky tried to get the Communist Party Central Committee's permission to publish, and finally Nikita S. Khrushchev gave it.

With publication in 1962 came immediate recognition and admission to the Union of Soviet Writers. Abroad, "Ivan Denisovich" sparked not only acclaim but rivalry among publishers contesting the cloudy rights surrounding Soviet works.

Novy Mir published two additional anti-Stalinist short novels by Mr. Solzhenitsyn. In 1964 he was nominated for a Lenin Prize, but he was rejected, for failing to distinguish, as Pravda put it, between "honorable and good people" and "criminals and traitors."

In a 1967 letter to the

351

Fourth National Congress of Soviet Writers, Mr. Solzhenitsyn reported harassment by officials and bitterly denounced "the oppression, no longer tolerable, that our literature has been enduring from censorship for decades." He said that his writings had been confiscated two years earlier and that he was being refused publication and performance rights.

Denunciations by officials increased in number and vigor—one accused him of aiding enemies of the Soviet Union; another called him "psychologically unbalanced" and "schizophrenic"—but he refused to withdraw his demands and charges.

His works, smuggled abroad and published there, displayed a vast, moving canvas of Soviet society in which betrayal was endemic and oppression routine. "August 1914," published in 1972, was an attempt to explain the Bolshevik Revolution, and he planned sequels.

As the circle closed about him—his home under surveillance, his friends shadowed, his wife, Natalya, by whom he has three sons, dismissed from her job—he met foreign journalists, denounced the authorities and warned that if he was imprisoned or killed he had taken measures to insure that his unpublished writings were made available to Western publishers.

Meanwhile his royalties from "Ivan Denisovich" had run out, and he was barred from residence in Moscow.

Last December "The Gulag Archipelago, 1918-1956," a study of the vast Soviet prison camp system, was published in Paris, and there was renewed clamor against him.

"A kind of forbidden, contaminated zone has been created around my family," he told reporters when "August 1914" appeared. Exile seemed to be a desperate official attempt to eliminate the contamination.

February 14, 1974

# RUSSIANS DISRUPT MODERN ART SHOW WITH BULLDOZERS

## Unofficial Outside Exhibition Dispersed—Bystanders Hit and Paintings Confiscated

### By CHRISTOPHER S. WREN
Special to The New York Times

MOSCOW, Sept. 15—In a dramatic confrontation over nonconformist art, Soviet authorities used bulldozers, dump trucks and water-spraying trucks today to break up an outdoor exhibition of unofficial art as it was being set up in a vacant lot.

A crowd of several hundred people, among them artists, Western diplomats, correspondents and curious neighborhood residents, scattered when dump trucks and a pair of bulldozers overran what the artists had billed as the first autumn outdoor art show in the Soviet Union.

Two water trucks, normally used for street-cleaning, pursued the fleeing crowds across the street. A handful of people pelted the trucks with clods of dirt.

### Three Americans Struck

Three American correspondents—two men and a woman—were beaten by young vigilantes who roamed the scene intimidating people to move on. Several uniformed police looked on impassively and made no effort to stop the violence.

The young men who appeared to be organized into teams, ripped up, trampled and threw more than a dozen paintings into a dump truck to be covered with mud and driven away. Artists who protested were roughed up and at least five were arrested. An unknown number of angry spectators were taken to a nearby police station.

Later, one spectator who was released, Aleksei Tyapushkin, reportedly a member of the official Union of Artists and a decorated World War II veteran, said the police had told him that all the confiscated paintings had been burned.

Thirteen organizers of the exhibition sent a written protest to the Communist party Politburo protesting lawlessness, arbitrary misuse of force and violation of constitutional rights. They demanded an investigation, the return of their works and the punishment of those responsible.

A man in a trenchcoat who supervised the operation identified himself as an official of the Executive Committee of the city's southwest district. He asserted that the art exhibit was being broken up because workers had volunteered their Sundays to convert the empty lot into a "park of culture." He gave his name as Ivan Ivanovich Ivanov, a Russian equivalent of John Doe.

Witnesses reported, however, that no work was undertaken at the lot after the exhibition had been disrupted. The young men who had intimidated the exhibitors and spectators assembled afterwards and, upon instruction, left in a group, according to a person who remained at the site.

The American correspondents were assaulted after they had left the lot and were standing on a street near their automobile, watching the water trucks spraying the spectators.

### Camera Chips a Tooth

An attempt to photograph a water truck as it drove over the curb to pursue one group caused a group of vigilantes to come up and smash the camera into this correspondent's face, chipping a front tooth. After this, the vigilantes' leader administered a blow in the stomach while the others seized and held his arms and torso.

Lynne Olson of The Associated Press rushed over and shouted at the vigilantes to stop and the leader turned around and hit her in the stomach with the same force, sending her sprawling.

Michael Parks of the Baltimore Sun was hit in the stomach by another young man while a policeman five feet away looked on.

When Russell Jones of the American Broadcasting Company protested, he was briefly manhandled but was not struck.

About two dozen artists, some from as far as Leningrad, Pskov and Vladimir, had come to exhibit their works at the show, which the organizers said was unofficial but not prohibited.

Some of the artists, the organizers said, have had works displayed in New York, San Francisco, London, Paris and Rome. But they have not been allowed to exhibit formally here and have not been accepted for membership in the Union of Artists because their styles do not conform with Moscow's art doctrine, socialist realism.

### Officials Advised of Plans

Two weeks ago, the organizing group of artists informed the Moscow City Council that they intended to hold an outdoor art show and asked to be informed within a week if there were objections.

At the council's request, the artists took their works for inspection by Communist party officials on Wednesday. On Friday, they said, a City Council official told them the vacant lot was available and that the exhibition would be neither encouraged nor forbidden.

But when the artists began setting up their works today on the lot, off Profsoyuznaya Street, they were immediately confronted by the trucks, bulldozers and water trucks and were ordered to leave.

The violence erupted too quickly to determine who had given the orders, although a few bystanders attributed them to a Mr. Knigin, who heads the local Communist party's ideological section.

Underground art has always encountered difficulties in the Soviet Union. In 1962, Nikita S. Khrushchev, then Premier, in a famous showdown with nonconformist artists, condemned as "filth" an officially organized exhibition that contained some works in abstract and other modern styles. Attempted unofficial exhibitions here in 1967, 1969 and 1971 were closed quickly by authorities, although without violence.

### 'Heroic Optimism' Demanded

Today, the paintings were seized too swiftly for spectators to get any idea of their content. But many of the artists are known for their modernism, abstractions and fantasies, pop art and nudes, as well as somber street scenes and landscapes that do not fit into the mold of heroic optimism demanded of art by Soviet authorities.

However, Oskar Rabin, an artist known abroad and an organizer of the exhibition, said earlier that the artists would not bring any works that would be considered anti-Soviet or pornographic.

The exhibition attracted diplomats from the United States, Western Europe, As a and Latin America. They ended up running for safety.

Those arrested today were identified as Oskar Rabin, his son Aleksandr, Nadezhda Elskaya, Yevgeny Rukhin and Valentin Vorobyov.

Other artists who were expected to exhibit included Vladimir Nemukhin, Lidiya Masterovka, Boris Shteinberg, Aleksandr Malamid, Vasily Sitnikov and Igor Kholin.

September 16, 1974

352

# Paul Robeson Dead at 77; Singer, Actor and Activist

## By ALDEN WHITMAN

Paul Robeson, the singer, actor and black activist, died yesterday at the age of 77 in Philadelphia.

He had suffered a stroke on Dec. 28 and had been taken to Presbyterian Medical Center. Doctors said he was suffering from a severe cerebral vascular disorder.

Mr. Robeson, who had been an all-America football star at Rutgers, where he also won letters in baseball, basketball and track and a Phi Beta Kappa key, had refused interviews and had seen only members of his family and close friends in recent years.

For decades, he was known internationally as a concert artist, singing such songs as "Ol' Man River," and as a stage actor, perhaps best remembered in the role of Othello.

One of the most influential performers and political figures to emerge from black America, Mr. Robeson was under a cloud in his native land during the cold war as a political dissenter and an outspoken admirer of the Soviet Union.

These circumstances, as well as the award in 1952 of a Stalin Peace Prize, combined to close many minds to his artistic merits as a singer and actor.

However, in his 75th year, Mr. Robeson was the subject of high praise by Clayton Riley, the American cultural historian:

"One of the nation's greatest men, an individual whose time on earth has been spent in the pursuit of justice for all human beings and toward the enlightenment of men and women the world over."

This encomium could be printed in a national newspaper in 1972 without raising a perceptible furor, but unstinting praise of Mr. Robeson as a man and as an interpretive artist would have been unusual in the United tSates between 1945 and 1963, the year his arteriosclerosis, and moodiness, forced him into retirement.

Although Mr. Robeson denied under oath that he was a Communist Party member, affiliation with it was generally imputed to him because he proudly performed for so many trade unions and organizations deemed "subversive" and for so many causes promoted in leftwing periodicals. This activity caused such agitation that one of his concerts in Peekskill, N. Y., was disrupted by vigilantes; professional concert halls were refused him and commercial bookings grew scarce. His income dropped from $100,000 in 1947 to $6,000 in 1952.

### Passport Dispute

Another result of Mr. Robeson's overt alliance between his art and his politics was the State Department's cancellation, in 1950, of his passport on the ground that he had refused to sign the then-required non-Communist oath. He declined, he explained, because he believed that the Government had no right to base his freedom to travel on his political beliefs, or a lack of them. He took the department to court, and in 1958, the Supreme Court ruled, 5 to 4, in a related case, that Congress had not authorized the department to withhold passports because of applicants' "beliefs and association."

Although Mr. Robeson's suit had not yet reached the Court, he benefited from its decision and was given a passport. He departed immediately for Britain, asserting, "I don't want any overtones of suggestion that I am deserting the country of my birth. If I have a concert in New York, I will go there and return to London."

He toured Europe and Australia as a singer; and in 1959 he appeared as the Moor, one of his most celebrated stage roles, in "Othello" at Stratford-on-Avon.

Although Mr. Robeson was unwelcome in many quarters, except in the black community, during the cold war, he was widely recognized abroad. On his 60th birthday, in 1958, celebrations were held in a number of countries, including India. There Prime Minister Jawaharlal Nehru described the singer-actor as "one of the greatest artists of our generation [who] reminds us that art and human dignity are above differences of race, nationality and color."

### Ovation at Recital

The same birthday was also an occasion for his first New York recital in 11 years, a sold-out house at Carnegie Hall. "When Mr. Robeson made his appearance," Harold C. Schonberg wrote in The Times, "he was greeted with a long standing ovation." The critic noted that the performer was "a burly, imposing figure with tremendous dignity" whose bass-baritone was not "the voice of the artist in his prime." In a concert in London later that year, he sang in a limited tone range, according to one critic, but brought the house down with "Ol' Man River," the Oscar Hammerstein 2d-Jerome Kern song with which Mr. Robeson had been identified since the late 1920's.

Two of the song's lines — "Let me go 'way from de Mississippi/Let me go 'way from de white men boss" — were Mr. Robeson's call for black identity, and the passion with which he sang them almost always roused an audience.

Two other songs closely identified with Mr. Robeson were "Ballad for Americans" (lyrics by John Latouche, score by Earl Robinson) and "Joe Hill" (lyrics by Alfred Hayes, score by Mr. Robinson). He sang "Ballad" on a national radio show in 1939, and it was an enormous success, leading to a repeat broadcast and a recording. "Joe Hill," a song about a union organizer executed for an alleged murder, was especially popular at labor gatherings. Its final line, "Don't mourn for me — organize," usually brought an audience to its feet.

Mr. Robeson befitted physically the stature his friends accorded him. Standing 6 feet 3 inches tall and weighing 240 pounds in his prime, he was a man of commanding presence. He spoke slowly and deliberately and with force. His bass-baritone, in his best years, was vibrant and evocative, and his control over it was considered admirable.

Whether Mr. Robeson was the black leader that his friends supposed was a matter of conjecture. It was often pointed out that, spending so much of his life abroad, he had relatively few profound associations with the black community in this country. He stood more as a symbol of black attainment, it was said, and of black consciousness and of pride. Once asked why he did not live in the Soviet Union, which he visited frequently, he retorted:

"Because my father was a slave, and my people died to build this country, and I am going to stay right here and have a part of it, just like you. And no Fascist-minded people will drive me from it. Is that clear?"

Born in Princeton, N. J., on April 9, 1898, Paul Robeson was the youngest child of the Rev. W. D. Robeson, a North Carolina plantation slave until he ran away in 1860. His mother, who died when Paul was 9, was a Philadelphia teacher.

A bright student, he won a scholarship to Rutgers in 1915, where he was the third black to attend the then-private college. At the New Brunswick school he starred in football, baseball, basketball and track, winning a dozen varsity letters. Walter Camp, the college football arbiter who twice selected Mr. Robeson as an all-America, called him "the greatest defensive end that ever trod the gridiron."

Robeson of Rutgers, as the sports writers dubbed him, also won a Phi Beta Kappa key in his junior year and was elected to Cap and Skull, the honor society, as a senior. After graduation in 1919 he moved to Harlem, then an emerging black community, and enrolled at the Columbia Law School, where he received his degree. He never practiced, however, because in 1921 he married Eslanda Cardozo Goode, a brilliant Columbia chemistry student, who directed his career toward the theater and who was his stalwart manager until her death in 1965.

She helped to persuade him to take a role in "Simon the Cyrenian" at the Young Men's Christian Association in 1920. "Even then," he recalled, "I never meant to [become an actor]. I just said yes to get her to quit pestering me."

### New Portals Opened

The appearance opened new portals for Mr. Robeson, who perceived that the stage could be his means of fulfillment. He repeated his Harlem performance at the Lafayette Theater in 1921, and the following year he appeared as Jim in "Taboo" at the Sam H. Harris Theater on Broadway. Although his acting still had its rough edges, he was invited to Britain in mid-1922 to play opposite Mrs. Patrick Campbell in "Taboo," which had been renamed "The Voodoo."

Back in New York, he joined the Provincetown Players, a Greenwich Village group that included Eugene O'Neill, in whose "All God's Chillun Got Wings" he starred as Jim Harris.

This led to his appearance as Brutus Jones in "The Emperor Jones," which was specially revived for him. One of the respected critics to laud Mr. Robeson's acting then was George Jean Nathan, who described him as "one of the most thoroughly eloquent, impressive and convincing actors" he had ever come upon.

The unforced beauty of Mr. Robeson's rich baritone prompted his Provincetown Players associates to sponsor his first concert in 1925, a collection of spirituals, in which he was accompanied by Lawrence Brown, who remained his pianist for 35 years.

Mr. Robeson repeated his triumph in "The Emperor Jones" in London, returned to New York to play Crown in "Porgy" and went back to London in 1928 to play Joe in "Show Boat," in which his singing of "Ol' Man River" was one of its most important characteristics.

He lived mostly abroad until 1939, much of the time in Lon-

don. Although the stage and the concert hall in the United States were then one of the few areas where a black could rise to eminence, the white climate was such that Mr. Robeson was often referred to as "a credit to his race," an epithet he found offensive. Moreover, black performers in those days were not accepted as social equals in the white community, whereas there were fewer color barriers in Britain.

### A London Success

One of his spectacular successes in London came in 1930, when he played the lead in "Othello," appearing with Peggy Ashcroft, Sybil Thorndike and Maurice Brown. His performance was to many an unforgettable experience.

Afterward he toured the chief European cities as a recitalist, and played in "Plant in the Sun," "The Hairy Ape," "Toussaint L'Ouverture," "Stevedore," "Black Boy" and "John Henry." Meantime, he also ventured seriously into the movies. His first film, "Body and Soul," had been made in 1924, but it had circulated only in the American black ghettos. Now he starred in "Sanders of the River," "King Solomon's Mines," "Big Fella," "Proud Valley," "The Emperor Jones" and "Show Boat." In all, there were 11 of his pictures.

Mr. Robeson's political ideas took shape slowly, after a jolt from George Bernard Shaw in 1928. Shaw asked him over a luncheon what he thought of Socialism. "I hadn't anything

to say," the actor-singer recalled. "I'd never really thought about Socialism."

In 1934, passing through Germany on his first of many visits to the Soviet Union, he was the object of racial epithets from Hitler's storm troopers, and he was angered. Arriving in Moscow, where he was feted, he was impressed, he said, by the absence of racial prejudice among Soviet citizens.

Later, he often publicly expressed "my belief in the principles of scientific Socialism, my deep conviction that for all mankind a Socialist society represents an advance to a higher stage of life."

In the late 1930's Mr. Robeson went to Spain to sing for the Republican troops and for members of the International Brigades who were battling the Franco revolt, which was backed by Hitler and Mussolini. He said he had been moved to return to the United States by what he experienced in Spain.

"I saw the connection between the problems of all oppressed people and the necessity of the artist to participate fully," he said.

Part of this was evoked in his vigorous rendition of "Ballad for Americans," which voices a certainty that "our marching song" to a land of freedom and equality "will come again." "For I have always believed it!" Mr. Robeson sang, "And I believe it now."

The climate of opinion here was fairly congenial to Mr. Robeson in those years, owing

in part to the American-Soviet war alliance of 1941. His concerts were well attended and his press notices were good.

### Othello on Broadway

These became ecstatic when, on Oct. 19, 1943, he became the first black to play the role of Othello with a white supporting cast (Jose Ferrer and Uta Hagen) on Broadway in the Theater Guild production.

A number of awards and honorary degrees were bestowed upon him, including in 1944 the Spingarn Medal, generally considered the top award in black life. Its donor was the National Association for the Advancement of Colored People.

Meanwhile, Mr. Robeson stepped up his political activity by leading a delegation that urged Baseball Commissioner Kenesaw Mountain Landis to drop the racial bars in baseball; and by calling on President Harry S. Truman to widen blacks' civil rights in the South. He became a founder and chairman of the Progressive Party, which nominated former Vice President Henry A. Wallace in the 1948 Presidential race.

Some of Mr. Robeson's troubles during the cold war were traceable to a remark he made at a World Peace Congress in Paris in 1949. "It is unthinkable," he declared, "that American Negroes will go to war on behalf of those who have oppressed us for generations against a country [the Soviet Union] which in one generation has raised our people to the full dignity of mankind."

He asserted later that his statement had been taken "slightly out of context," noting that he had spoken for 2,000 students from the colonial world who had requested him to express their desire for peace. Nonetheless, his words were widely turned against him in the United States, and one consequence was an attack by veterans' groups and right-wing extremists on crowds arriving for an outdoor concert near Peekskill, N. Y., in August, 1949. The concert was canceled, and Mr. Robeson was irate.

Starting in 1948, Mr. Robeson was questioned several times by Congressional committees. He was usually asked if he were a member of the Communist Party, a query he uniformly declined to answer under his Fifth Amendment rights. He maintained privately, however, that he was not a member.

After falling ill in Europe in 1961, he spent some time in an East German hospital, returning to New York in 1963. He lived quietly in a Harlem apartment until a few years ago, when he moved to the home of his sister, Marian Forsythe, in Philadelphia, where he lived as a virtual recluse. He did not attend a Carnegie Hall program of tribute in 1973 in honor of his 75th birthday, although he sent a recorded message to the gathering, which included many theatrical figures.

Besides his sister, Mr. Robeson is survived by a son, Paul Jr.

January 24, 1976

---

## THE ARTIST AND SOCIETY

### LIVE MUSICAL TOPICS.

The *Musical Courier* does not approve of the suggestion made in this column that musicians should cut their hair and endeavor to look like persons unafflicted with the insanity of genius. There is no accounting for the fixed belief among gentlemen addicted to the piano or violin habit that long hair adds to a performer's artistic appearance. It is reasonable to suppose that these persons do entertain such an idea, for it would be difficult to conceive any reason for their preserving their locks unshorn. But old-fashioned Bohemianism is dying out in other arts, and its dead march among musicians will have to be played ere long. What has become of the slouch-hatted, soiled-shirted, red-nosed reporter of twenty years ago? One or two of them may still be seen hanging around the neighborhood of City Hall Square lamenting the departure of the "good old days" and the ascendency of the college "dude" in journalism. The ruling power in the newspaper world to-day is the educated gentleman, not the unshackled Bohemian.

What has become of the Bohemian literary man, who also wore the queer hat and the una

bridged hair, who drank absinthe and wrote sonnets on the polished table of a barroom with the oaths of a noisy crew of imbibers in his ears? He has followed the Bohemian journalist into the misty realms of the defunct. Society nowadays does not tolerate the François Villon brand of poet. The novelist and poet of to-day is a steady married man, with a little suburban home, a baby, and several dogs. He wears his hair and his hats like other men, and he goes to the theatre in evening dress. The Bohemian artist is gone, too. On a varnishing night now you cannot tell the artists from the critics or the spectators. Society is learning out in power, and its decree that no man has a right to make himself conspicuous or ridiculous in appearance, is beginning to receive general obedience.

The musician, who apparently labors with more ardor than any other brain proprietor to hold himself outside of the pale of social tolerance, has only himself to thank for the attitude of superiority which society assumes toward him. Of course the orchestral player is to a certain extent a nonentity, because his personality is sunk under that of his conductor. He is simply a member of Thomas's or Seidl's or Nikisch's orchestra. The moment, however, that his name appears on a programme as soloist or composer he asserts a fair claim to the recognition of his fellow-men, and when a man asserts such a claim he asserts at the same time his right to the fellowship of his kind.

Now, brethren of the tone world, social recog-

nition means admission to the homes of your fellow-men. The presiding genius of the home is woman. She makes the laws by which that little absolute monarchy is governed and social rule is in her hands. If you want social recognition, you must obtain it from the woman. And you cannot obtain it if you are not neat. With woman order is indeed Heaven's first law. Now you cannot be neat if you wear your hair dragging down over your shoulders and greasing your collar. You cannot be neat if you wear a Jaeger flannel shirt on the concert platform. You cannot be neat if your evening dress does not fit you. You cannot be neat if you do not appear shod, clad, and trimmed according to the formula accepted tacitly by the united sisterhood of womankind.

There is no use of closing our eyes to the obstinate fact that by the world at large musicians are looked upon as human curiosities. There is a general, though vague, feeling that in private life the celebrated pianist or violinist must be a very eccentric personage, given to doing uncomfortable things without fair warning. Beyond doubt this feeling is due to the musician's appearance, and his appearance is largely due to his unkempt hair. This may seem like making a mountain out of a molehill, but it is solid truth, as any musician can discover for himself by a little investigation. Off with the long hair!

July 27, 1890

# About Books, *More or Less:*
# The American Idiom

*By* SIMEON STRUNSKY

WHAT, figuratively speaking, is the life expectancy of an artist in America? Theodore Dreiser in a recent number of The Nation examines the problem. His answer is what one would expect from the conscientious and thoughtful Mr. Dreiser. The artist has a pretty hard time in America, but, after all, it is the only country the American artist has. If it is any additional comfort to the American genius contending against an unfavorable environment, he is invited to remember that genius has nowhere and at no time had a particularly easy time of it. Very much to the point is Mr. Dreiser's appeal to the artist's professional pride. This unkindly environment is in itself a challenge to the artist. It is one of the difficulties which it is his business to overcome. The artist must always shift for himself as best he may. "He is not here or anywhere long before he realizes that this is true, and in consequence seeks to make the most of an untoward scene while he does what he can."

The alternative to doing what you can in your own country is, of course, to migrate to some more favorable clime and do nothing at all. There have been exceptions—Henry James, Sargent, Whistler. But in the first place exceptions are exceptions, and in the second place it is still to be proved that a Whistler or a James would have been frustrated in his own country. Van Wyck Brooks in "The Pilgrimage of Henry James" (Dutton) is the latest to recall the doubts that beset the most famous of American exiles. "A man," said James, "always pays in one way or another for expatriation, for detachment from his plain primary heritage." "Saturation is almost more important than talent." Of Mrs. Wharton he wrote: "She must be tethered in native pastures, even if it reduces her to a back yard in New York." But the problem of the expatriate artist hardly needs discussion at this late day. There can be no case for the uprooted in an age which affirms the truth that art must well up from the soil and the artist must draw life through his roots. This will be admitted by the Americans on the Boulevard St. Michel. They will insist, nevertheless: "Does or does not Mr. Dreiser admit that an artist's chances are smaller if he is born in America than almost anywhere else? It is a matter of comparison and degree."

•.•

ON this point, I am afraid, Mr. Dreiser does not make out a very good case. He does confess to a depressing list of bunkers and hazards on the great fairway of American art. There is our huge and regrettable national wealth, which demands of the artist a greater resolution to starve than is required of him in poorer countries. And there are, of course, the familiar deterrents: The "100 per cent. American home," mother, father, wife, husband; the K. K. K., watchful of Catholics; the Catholics, watchful of clean books; the Rotarians, Kiwanisians, Baptists, Methodists; in other words, the entire demonology of the American "creed," which consists in regulating the life of the other fellow.

It is not a convincing argument. Most of the obstacles here enumerated did not exist twenty years ago, when Mr. Dreiser himself had such a hard time making his way. They flourish today, but "only think of the army of young realists now marching on New York, the scores of playwrights and critics who vie with one another to keep the stage and the book untrammeled." The contemporary untrammeling and vieing are not to be denied. Why, then, pick on the poor K. K. K. and Kiwanis? Why not rather cite the mobilized realists in support of Mr. Dreiser's main contention, that the artist will in the end triumph over the most obstinate of environments? Why not rather stress the point that the more K. K. K.ing we have the more untrammeling and vieing we shall have? Why not assert for art the proud claim that, like faith, it thrives on persecution, and the blood of the martyrs is the seed of the Church?

Ku Klux, Knights of Columbus, Rotary, Kiwanis, the Methodists and the Eighteenth Amendment do enter intimately into the question of America and the artist. They affect the problem of what I have called, loosely, the American idiom. They are an essential part of the problem. It is rather absurd to take fifty million members of the K. K. K., K. of C., employers' organizations and religious denominations and damn them wholesale and out of hand as so many hosts of darkness arrayed against the free artistic spirit. You cannot take half a nation and dismiss it as constituting so many "difficulties and obstacles." By the time you get through enumerating them all you may find that the difficulties and the obstacles make up 95 per cent. of the nation. If the Rotarians, the Ku Klux and the Methodists are a real factor in American life, then they can be no more disregarded by the artist than he can disregard the Mississippi River, the Rocky Mountains, the United States Constitution, the public school, the Ford car and other essentials of the national life. The Methodist and the Anti-Saloon League are, in this sense, as much a part of the "soil" from which the artist must draw his sap as are the mountains and prairies and the New England temperament. I should go further. If the American artist is truly an artist I should expect his sensitive soul to mirror Kiwanis and the Southern Baptists along with the prairie, the New England village and the sun going down behind the Sierras. If genius in these United States is out to sound an authentic note, how can it conceivably make a noise except in the American idiom?

The national idiom must inevitably be shaped by the national realities. The American idiom in literature cannot be the Dostoievsky idiom or the neo-Zola idiom or even the Anatole France idiom, for America is not Russia or Gaul. Mr. Dreiser admits it. It is not a Kiwanensian or a Rotarian speaking, but Mr. Dreiser who declares that a "thoroughly prosperous country such as America is and is presumed to be" cannot be as stimulating to the highest form of art, namely tragedy, as a country "in which misery reigns."

•.•

IT is Mr. Dreiser, and not the National Chamber of Commerce, who asserts that "the contrasts between poverty and wealth have never been as sharp or as desolating as they have been in the Orient, Russia and elsewhere; the opportunities for advancement not so vigorously throttled, and hence unrest and morbidity not so widespread, and hence not so interesting." To be sure, there is enough raw material for tragedy to be found in the most prosperous of countries. Enough unhappy men and women may be found in the Packard and Pierce-Arrow classes to keep an American genius happy. But the American artist—and this is my thought and not Mr. Dreiser's—must be content to look for his tragedy in America, where it can be legitimately found, and not import his tragedy from Russia or Sweden. If he insists in doing so he must not wail because America refuses to recognize herself in the imported package.

It is a point rather well illustrated, I think, in Eugene O'Neill's "Desire Under the Elms." To the extent that O'Neill's concern lies with human greed, with human lust and passion, New England of half a century ago is just as fair game for him as Paris of today would be or Ur of the Chaldees of 4,200 years ago. But when O'Neill injects into his play the land-hunger motive he is obviously importing from Europe. In that old, overworked and overparceled Continent the peasant's savage passion for a foothold on the soil, which is so recurrent a motive in the literature of Europe, is an understandable thing. It is not an understandable thing in the New England farmer of fifty years ago, with a million square miles of the agricultural West to be had for the asking. So fierce is the European peasant's attachment to the land and so bitter is his need of it that if you give him a rock he will turn it into a field by carrying the

soil to it in basketfuls on his back. But New England's abandoned farms are here to testify that earth exercises no such clutch on the Yankee heart, and the Puritan Transmississippi is here to testify that the Yankee found property and contentment elsewhere. When, therefore, O'Neill makes the desire for acreage the mainspring of incest and murder in New England he is, frankly, imitative. He is not speaking in the American idiom.

In the same manner Mr. Dreiser himself wanders from his idiom when he indulges in the mild sneer against the "100 per cent." American home 100 per cent. American husband and wife. Here we have a strong intimation that in the matter of sex morality the only difference between America and the older lands is the well-known Anglo-Saxon hypocrisy. And yet other differences in appreciable degree there must be. They are suggested by the very nature of the embittered artist's indictment against America. If it is true that America's chief idol is Mammon, then it is a reasonable deduction that less attention is paid here than elsewhere to the worship of Astarte and Cytherea. To the extent that the manhood of a nation expends part of its energies on the golf links, the tennis courts, the baseball lots and the propulsion of fifteen million automobiles, it must be true that American manhood has a good deal less time for the practice of amour than the much more sedentary populations of the Continent. Take the severest count in the indictment. Take the popular explanation of Ku

Kluxism, Rotarianism, Anti-Saloon and censorities as only the outburst of repressed sex instincts. Yet the fact of repression is admitted, and the American realist cannot have it both ways. He cannot insist that American men and women stifle their emotions and at the same time insist on representing the facts of American life as though repression did not prevail.

•.•

IT may seem a reckless thing to say, but, after all, the Fourth of July orators are, in substance, right. America is different. The discontented American artist will have to recognize and accommodate himself to that fact just as his fellow-dissenters in politics and sociology are now doing. For instance, under the impress of the late La Follette experiment there has been an inclination in Progressive quarters to re-examine the question of the British Labor Party as a model for this country. Astonishing discoveries have been made. It has been discovered that the field of opportunity is much more open in this country than in England; that American workmen earn more than English workmen and drive more automobiles; that America is far less caste-ridden than England and, therefore, less subject to social revolution; that America has a great many more farmers than England has; and so on. Not such very astonishing discoveries? Well, perhaps not. These are truths accessible in all the textbooks and almanacs. Yet they are now announced with something of the air of stout Cortez wild-

eyed on a peak in Darien. Serious thinkers are discovering the Fourth of July orators.

Some such rediscovery of America awaits the American artist. Does it mean that he will thereby find himself excluded from outlooks and interpretations that are vouchsafed to his European colleague? Very likely. As long as America remains prosperous and democratic he may be prevented from writing a great American tragedy, as Mr. Dreiser suggests. As long as Americans prefer golf to cafés and Buicks to boudoirs the American artist may be lamed in his efforts to probe sex with D'Annunzio and Strindberg. But perhaps he may find compensations. Perhaps he may be qualified to explore channels of life that are closed to D'Annunzio and Strindberg. That is certainly a state of things not to be regretted from the humanistic point of view. The best kind of a world, every one admits, is one in which every nation is free to bring the contribution of its own genius, its own idiom, to the common world stock. After all, Americans do not sit about and mourn because they can grow only corn, wheat and cotton and must leave silk growing to the Chinese and coffee to the Brazilians. The economists think that this is the best method for supplying everybody with more hogs, wheat, silk and coffee than if we went in for silks and coffee, the Chinese for hogs and the Brazilians for wheat. The American artist can do his best for world art by not going in for raising Strindberg in Kansas and D'Annunzio in Indianapolis—under glass.

April 26, 1925

# GOLDEN JUBILEE

### By STUART PRESTON

PETERBOROUGH, N. H.

FIFTY years old this summer, the MacDowell Colony for painters, writers and composers combines the advantages of an ivory tower and a creative workshop. Its twenty-six studios, equipped with north lights, pianos and writing tables for whichever muse the individual colonist may follow, ramble over 600 acres of southern New Hampshire's low wooded hills near the cabin where Edward MacDowell composed his music.

The Golden Jubilee this year, which attracted numerous alumni and friends, was celebrated with the dedication of a bronze tablet marking the founders' grave; a buffet luncheon and an afternoon conference on the problems of the creative artist today. Participants in this discussion were Ben Shahn, Virgil Thomson and Robert Penn Warren,

with Russell Lynes acting as a picador-moderator.

The most practical way of opening any such discussion is to ask a question. With the question Whom do you work for?" James Johnson Sweeney, the colony's President, set the ball rolling. Granted that the idea of working in a vacuum is abhorrent, artists differ in the direction of their desire to create or simply to please. And back the whole discussion there arose the big question of art and society and the obligation of one to the other.

### Painter's Opinion

Shahn stated categorically that he worked for himself, Mammon and God, in that order, but admitted that reconciling those three interests was not easy to do. Shahn has always been more of a public artist than a private one, in the sense

that he considers art must be socially relevant in order to remain healthy and play the vital part it should. Furthermore, he has steadily felt, and often stated, that an artist's wilful obscurity is in no small way responsible for the poor relationship existing between artist and public. His whole career illustrates this point of view and one of his incidental rewards is to have contributed to the improvement of the standards of commercial art.

### Writer's Dissent

Warren dissented from this opinon, holding that the artist's fidelity should be directed to the object he is creating rather than to the spectator. If he consciously attempts to please and respond to every public whim, the artist will find that not only will he lose the freedom for the exercise of his imagination but will lose the public as well. For the true value of the artist lies in his being an elixir of life, a person who is able to reveal

the spectator to himself, a revelation that becomes impossible if the artist follows rather than leads.

Thomson agreed with Warren by declaring it his conviction that the young composer should not be pampered nor consider a little hardship early in life endangering to his future. One fatal disadvantage today is the amount of distraction available, forever tempting the young composer away from his score. He also inveighed against paying excessive attention to public opinion and too much theorizing about the nature of his talent intsead of getting down to work.

Such were some of the highlights of the Peterborough discussion, carried on almost conversationally, but with a sober realization that the artist's predicament is a serious one and that there is a chance of its being illuminated and helped by just such a discussion.

August 18, 1957

# ARTISTS DEFENDED ON MENTAL HEALTH

### Panel Psychiatrist Decries View That Creative Acts Are Linked to Insanity

#### By PAUL HOFMANN

A psychiatrist who treats artists warned yesterday against a trend in psychoanalysis that can make the creative person "feel that he is the sickest of us, rather than the healthiest."

The psychiatrist, Dr. Lawrence J. Hatterer, assistant clinical professor of psychiatry at the Cornell Medical College, agreed with leading psychoanalysts in a panel on "Creativity and Pathology" that genius is an enigma. However, Dr. Hatterer differed with other panelists on the role of neurosis in an artist's personality and work.

In accents ranging from Central European to Middle Western, the panelists used such names as Dante, Shakespeare, Goethe, Hemingway and Picasso to prove their theories. About 400 persons attended the session, the fourth annual Scientific Conference on Psychoanalysis, which was organized by the Council of Psychoanalytical Psychotherapists, Inc. It was held at the Barbizon-Plaza Hotel.

Dr. Hatterer declared that he found that the creative act was not always rooted in sickness, but often was caused by constitution and heredity, or normal needs for status, recognition, love and money.

### Some See Only Disease

A school of psychoanalysts sees only disease in "what some of the most valuable humans in our society struggle to do every day," Dr. Hatterer contended. An artist's search for creative solitude thus becomes unhealthy "withdrawal," he noted, his discipline in his work "compulsiveness," his tension and reflection "anxiety depression," his detachment "narcissism."

Dr. Kurt Eissler, author of psychoanalytical interpretations of Goethe and Leonardo da Vinci, said the creative power of genius—not of mere talent—was necessarily painful because he must create a synthesis between the lowest and the highest in man.

"Man is a synthesis between God and the animal, and this leads to unending conflict" in the artist, he said.

Art is not disease, Dr. Eissler remarked, but a "genius requires his own psychology—he cannot be understood with normal psychology." At times the "demon" in an artist was so strong, the psychoanalyst said, that he permanently hovered near what normal people called insanity. However, he added, such apparent mental disorder really enriched the artist when it was coupled with a genius's unexplained recuperative power whereby he was able to survive crises that would crush a normal human being.

Discussing the subjects of his books and other geniuses, Dr. Eissler asserted that "those giants didn't get much pleasure" out of their creative activity; "it is unbelieveable what a burden genius is."

*February 21, 1966*

# THE CORRUPTION OF INDIVIDUALITY

### More Problems for the Artist—Big Business and Synthetic Freedom

#### By BRIAN O'DOHERTY

IT is difficult to criticize the effects of big business without appearing slightly paranoid, but it is on record that in recent years the visual arts have drawn the type of speculator more usually found in movies, the stock market and advertising. This has created a false climate around the artist, adding one more element of self-consciousness to the paralyzing number he already has to cope with.

It has also created something entirely new in modern art—the "hot property." The "hot property", a money-maker, is the total prisoner of his success, and can be managed, coerced, pressured and discarded as if art were a type of show business. This new twist to the exploitation of the fashionable seems to be a result of pressures created by mass interest and big-business interest in the arts.

### Artists As Actors

In fact, it is the prospect of such success that seems to draw many young artists to their profession. It is not unusual nowadays to hear a young artist talk—like a young actor —of "making it." Judging from some of the letters and photographs that arrive in this office, one would think some young artists were trying to launch stage careers. Their work is apparently the vehicle for their ambition, not an end in itself. Their criterion of success is a write-up in Time magazine or pictures in Life. Adding to the melancholy of these meditations is the memory of a number of shows last season in which a good artist (from his previous performances) sold out for cash. Again, selling out is nothing new, but doing so with an air of preserving integrity is.

This displacement of ambition from the work to the career is, in New York, virtually accepted as normal. The pull is on the artist to become, even against his will, a sort of activist who has to sell himself as well as his work. And the pull is on the middleman (the gallery owner or dealer) to compete in selling the product by means of the usual devices of businessmen.

Caught up in the artificial forces of big business, the artist is having a hard time being his own man. He is under pressure from the public, the dealer, the collector and the critic. He must create under false, but accepted, notions that confuse originality with innovation. He is expected to conform to ideas of individuality that are not his own. From all this has come what might be called "the corruption of individuality"—giving the illusion of being different while being very much the same.

### "Original" Sin

Thus during the past season one frequently saw the spuriously "original" show devoted to the single idea or motif pursued to exhaustion, or, less politely, the gimmick. I remember a show of mailboxes (elegantly painted), another of frankfurters, and others manipulating primary motifs (egg shapes, circles, triangles, etc.) with a bright and anxious emptiness.

Such specialization encourages total recall of an artist by an easily identifiable tag—the "mailboxes man" or the "blue dots man." Individuality is ready-made in ways acceptable to a new semi-educated public.

The attention-getting device is nothing new in art. But its current frequency, in the hothouse, big-money atmosphere is. Thus it is time to clear the lines and define the real artist's position when that position is open to deceptions that many have unconsciously accepted.

The honest pursuit of art is most stringent and demanding, and its rewards are usually not monetary. Since the standards of the genuine artist are self-made, he must go through private tortures to close the gap between performance and an ideal only he can see. There is no room for compromise with the world around him or with himself. Since there is a great deal of the anarchist in every genuine creator, society is more or less his natural enemy. He is engaged in breaking its rules to contribute to a new definition of individual freedom within society. Now especially, when the world has shrunk to the proportions of an overcrowded golf ball, and standards are becoming malleable, we need the dissenter and the stimulation of meeting the challenge he provides. The role of the modern artist has been that of the great individual, the rebellious member of society, keeping that body irritable and alive through his dissent.

In New York, so often described with naive parochialism as "the art center of the world," big business, with its attendant publicity, is producing a set of forces that replaces individuality with a synthetic substitute. The artist is at last having a role provided for him in society—that of the engaging but controllable oddball, playing happily with his bricks in the corner, on display to visitors— a sort of "artist-in-residence" to society.

Since big money in the arts is here to stay, let us hope that its current attempts to rape the artist will result in a future breed less liable to seduction. If not, art may well become a packaged product, with the artist on the assembly line gulled into thinking he's an individual in possession of his freedom.

*June 23, 1963*

# If an Artist Wants to Be Serious and Respected *and* Rich, Famous and Popular, He Is Suffering From Cultural Schizophrenia

By **ROBERT BRUSTEIN**

IT seems likely that if the cultural history of this era ever comes to be written, then the postwar period, and particularly the last decade, will be seen as the time of America's greatest moral collapse and intellectual confusion. So profoundly unsettling are these conditions, in fact, that even the publication of such a record becomes somewhat problematical. Now that the traditional function of history, as an effort to evaluate human events objectively, is under assault, and now that the culture itself has become a grab bag of careerist advancement and media opportunism, "cultural history" may soon become another disposable item — like philosophy, classic languages, pre-20th-century literature and drama, pure science and all those other artifacts of the curious period preceding our present Great Age of Relevance. On the other hand, since it is customary for disintegrating societies to chronicle their own degeneration, it is not unlikely that some modern Tacitus may even now be observing our inexorable march toward ethical, spiritual and artistic bankruptcy.

As the 17th-century commentator Robert Burton determined that the Elizabethans suffered from a malady called melancholy, so our modern historian may conclude that we are weak from an illness called *cultural schizophrenia*, and offer a diagnosis without too much hope of a cure. For cultural schizophrenia is identified by the divided character of its victims—these victims being a number of artists and intellectuals, and many academics as well — which makes them desire simultaneously to

**ROBERT BRUSTEIN**, dean of the Yale Drama School and artistic director of the Yale Repertory Theater, is author of "Revolution as Theater."

be serious and respected, and to be rich, famous and popular. To be sure, these symptoms have always been present in America, but, largely because of our country's long indifference to serious literature, they have rarely been allowed to blossom into full-scale sickness. For most writers in the past, therefore, the choices were more simple: Either to remain single-mindedly devoted to one's calling, like T. S. Eliot and Edmund Wilson, or to separate one's creative from one's moneymaking and moviemaking activities, like William Faulkner and F. Scott Fitzgerald, or to sell out completely, like Clifford Odets, for a Hollywood pool. But something happened in the fifties—something symbolized by the marriage of Arthur Miller and Marilyn Monroe—which broke down the hitherto firm boundaries between culture and show business, and sent writers scurrying after celebrity with the clamorous encouragement of Hollywood, Broadway, television, publishing, the newspapers and the mass magazines.

All this coincided with the coming of age, after World War II, of a large college-educated middle class, demanding products from the newly developed "arts market" — accompanied by the postwar frenzy for change stimulated by the new speed of communications. The "cultural explosion" was beginning to ignite; university education had achieved a new status after the humiliation caused by Sputnik; and first intellectuals, and later academics, were gaining the kind of prominence formerly enjoyed only by popular novelists like Hemingway and Thomas Wolfe. Enforced isolation of America's writers had come to an end.

Soon, Hollywood discovered there were big grosses to be had from movies based on serious literature, and not just "Anthony Adverse" or "Gone With the Wind"; publishers were paying huge advances to authors for unwritten books, which were quickly recouped through movie sales

and paperback rights; the literary and academic celebrities thus created were being toasted on a host of television talk shows; Playboy and Esquire started folding short stories and literary interviews between the pages of their cartoons and nude photographs, while Vogue and Harper's Bazaar slipped in poetry, stories and reviews among their clothing, cosmetic and jewelry ads; and prominent personalities began enjoying incomes of more than $100,000 from lecture tours alone. We were into an age where the appetite for fame joined the hunger for money as the decisive factors in the direction of many careers, and everybody who could hold a pen was in a position to be as famous as a movie star.

PARTLY as a result of this development, the efforts of a previous generation to preserve the divisions between high, middle and low culture were seriously compromised, if not entirely swamped. In the fifties, a vigorous debate had taken place between the social scientists and the little-magazine intellectuals over the relationship of the serious writer to a mass audience. At that time, the sociologists took an essentially egalitarian position, declaring culture to be of value mainly as a statistical phenomenon, and therefore analyzing forms (comic books, movies, popular lyrics, television shows) which had the widest possible appeal, while the literary intellectuals adhered to a basically high-brow position which defended the integrity of the vanguard artist in the face of pressures on him to simplify his work or conform to popular taste. It was something of a paradox, at that time, to find left intellectuals arguing in favor of what looked like cultural aristocracy, but the paradox was only apparent. Despite their insistence on excellence, the intellectuals maintained a consistent radicalism in their opposition to the manipulation of culture for profit, their insistence on freedom of artistic expression,

*Poling a gondola in Venice during the 1970 filming of his screenplay for the movie "Heir."*

**ERICH SEGAL,** the author of "Love Story," is "conspicuously affected by cultural schizophrenia — unable to choose between scholarship and show business."

and their desire to raise the level of taste rather than lower the quality of art—while the social scientists, despite their liberal democratic posture, were apologizing, however unwittingly, for Madison Avenue's engineering and debasement of popular taste.

Political radicals and highbrow intellectuals alike found a home in magazines like Partisan Review — magazines which enjoyed an influence well beyond their small circulations. This influence was achieved through the contributions of men and women who made up America's last great intellectual community —Philip Rahv, Dwight MacDonald, Lionel and Diana Trilling, Irving Howe, Elizabeth Hardwick, William Phillips, Mary McCarthy, Paul Goodman, Hannah Arendt, Eric Bentley are representative names — whose writing usually included attacks on the falseness of this particular novel, or the sleaziness of that particular play, which

had somehow attracted public attention and been inflated beyond its worth. If there was something severe and censorious in these cultural strictures, there was something passionate and engaged also, as if the totalitarian years had underlined the fragility of free thought and unofficial art, and demonstrated the need for continual vigilance to keep them alive. MacDonald, in particular, was always ready in those days to man the barricades against middle-brow culture (or "midcult" as he called it, using a term which itself owed something to the mass media), bombarding Philistines with the same lively style he used to direct against Stalinists, with the declared purpose of preserving standards in a market economy.

**T**HE emergence of a new form of political radicalism in the sixties, however, completely altered the terms of

this debate, and threw the intellectual world into total confusion. For where the high-brow leftist of the fifties found himself in conflict with the middle-brow money ethic of the liberals, the new political radicals demonstrated how it was possible to be avantgarde, popular and rich, all at the same time. In short, the same arguments advanced previously by liberal sociologists on behalf of mass culture were now being adopted by self-declared revolutionaries in support of the "counterculture," while the standards of the intelligentsia, along with the creations of difficult artists, were denounced as élitist, snobbish and antisocial. (It was not long, indeed, before art and intellect themselves were to fall under suspicion as bourgeois forms of Western decadence.)

Whereas the left intelligentsia were caught in a seeming contradiction between their radical politics and high cul-

tural values, the counterculture had the advantage of ideological consistency. Representing itself simultaneously as a mass movement—using new popular forms created by and for youth—and an adversary movement—making war on all established forms and traditions—the counterculture thereby appeared to provide a bridge between political and cultural radicalism, reconciling the conflicting demands of popular taste and revolutionary resistance.

In this, it received support from the new McLuhanism which, while declaring the obsolescence of such high forms as the novel, the poem and the play, paid craven homage to the mass media, using a mode of analysis wholly empty of moral or aesthetic criteria. Scrutinizing culture from the viewpoint of the consumer rather than the artist, always concerned with impact rather than excellence, McLuhanism thus provided the intellectual cornerstone for the exploitation of the media by the counterculture, and the exploitation of the counterculture by the media, raising entrepreneurship to a new eminence, and elevating the importance of the spectator in all performance events.

At the same time, a genuine concern over racial inequality, poverty and the continuing Vietnam war was being used as a scourge against all art which did not try to change the world or alter consciousness or provide ideological instruction; and the whole construct of artistic standards was being dismissed by way of analogy with oppressors imposing their privileged laws on the oppressed. Thus it was that the Beatles, the Rolling Stones, Woodstock, "Easy Rider" and "The Graduate," The Living Theater, "Hair," "Lenny" and "Jesus Christ Superstar," psychedelic adventures and the antics of Abbie Hoffman could be validated as authentic cultural achievements precisely because they *were* popular, and anything private, singular or idiosyncratic could be condemned as square, establishment-oriented or counterrevolutionary. In short, totalitarian concepts of culture began to creep back under the guise of a revolutionary politics.

In the face of this onslaught —in the face of the capacity

of the counterculture to manipulate the media, intimidate its critics, declare its revolutionary aims and enrich itself all at the same time — the energies of the minority intellectuals seemed to dry up and wither away. Some grew silent, others tried to continue the debate but were shouted down, still others changed sides and joined the counterculture, consoled by the thought that they were remaining in the young radical swim. Partisan Review, once the champion of Kafka, Joyce and Eliot — indeed the very locus of American intellectual values — was publishing articles on the glories of Camp and underground films, along with encomiums by its own editors on the artistic power of the Beatles. Indeed, rock music and the drug scene were coming more and more to engage the attention of those who were once literary intellectuals, while others were abandoning a life-long devotion to literature in order to write popular journalism and make movies.

In a parallel development, university teachers, intimidated by cries of relevance, were beginning to surrender their commitments to literature, philosophy, history and psychiatry, and, under the rubric of curricular reform, were offering courses in magic, astrology, rock music, Yoga, Zen and meditation. Charles Reich, a law professor, advised us to seek salvation in bellbottom trousers and love beads. Leslie Fiedler, a literary critic, was devoting his attention to Frank Zappa and the Mothers of Invention. Hair grew longer; alcohol gave way to pot and acid and amphetamines; costumes grew more garish and outlandish. Instructors began vying with each other for the largest enrollments, and even wider exposure through television. And cultural schizophrenia, infecting young and old alike, began to spread like a plague throughout the land.

Three examples, beginning with the most conspicuous and possibly most symbolic figure: Erich Segal.

An associate professor of classics at Yale, whose scholarly work has included translations of Roman plays and commentaries on Latin authors, Segal developed his schizophrenia some years ago,

over which time he has been writing pop songs, collaborating on screenplays, composing books for musical comedies and, most recently, manufacturing the combination best-selling novel and hit movie, "Love Story." Segal's career, however, is evidence that a cultural schizophrenic is not always an enviable person, since for all the admiration that his previous popular efforts have won him from students and friends, his success with "Love Story" has caused him considerable, well-publicized anguish.

Segal, to be sure, contributed generously to his own unhappiness. To appear, as he did with fateful frequency, on television talk shows, looking as if he were made entirely of suede; to answer the disdain for his book by noting that great art has always been rejected by critics (on one occasion, he reminded us that Euripides wasn't appreciated in his time, either); to respond to an invitation to play the piano by pounding out the theme from "Love Story" — this was not just to invite ridicule, it was to court it. In Segal, the media interviewers had found the perfect patsy — a performer willing to play the fool on demand in return for continued exposure in front of the public.

Segal's obvious hunger for celebrity, combined with his natural garrulity, made him extremely vulnerable to the derision which began to follow his every appearance. And his academic credentials confirmed many in the belief that a university professor could be as venal and narcissistic as any other actor. If Segal had simply quit his teaching post and gone to Hollywood, his troubles would have ended; but his cultural schizophrenia would not permit him to make a clean choice between scholarship and show business. With a mixture of desperation and compulsiveness, he began granting interview after interview — calling each one his "last interview" — always hoping to justify himself at last to those in whose mind he had become the academic nitwit *par excellence*. To an interviewer who asked him why he did not give up his professorial function and turn to screenwriting, Segal would reply that his really serious

work was in classic languages ("I was just finishing some erudite footnote when you walked in," he informed one young man); to another interviewer, who chided him with betraying his real gifts by writing "Love Story," Segal would defend the book as a serious piece of literature, an antidote to the obscenities of "Portnoy's Complaint."

And the crying! The deluge of water cascading not only from the eyes of his readership, but from the author himself! Only in the 18th century, in the time of the sentimental novel and play, can one find writers and readers more eager to exercise their tear ducts. But the eyes of Segal's interviewers remained dry; and with more than a little trace of malice, they led him on to greater and greater heights of foolish self-revelation. The following is from a Vogue interview called "Erich Segal's Last Last Interview — Maybe":

Q. "Did you cry when you saw the film?"

A. "No. I had cried too many times in writing the script and the book. How many times can you cry?"

Q. "Were you crying because of what the story was about or because of the work that went into it?"

A. "I was crying because of the story. I believed what I wrote. And a lot of that comes across to the reader. A lot of pseudointellectuals in New York, who put me down at cocktail parties, are spending psychiatric hours trying to work out with their doctors why they did cry at that book. I cried. I admit it."

What could be more perfect? In the economy and precision with which it reveals character, this exchange would be worthy of an accomplished satirist. Still, while Segal's public personality is particularly exposed, and not a little repellent, one senses a genuine anguish beneath the defensive assertiveness which suggests that cultural schizophrenia can sometimes prove a rather painful ailment.

What seems to have taken Segal most by surprise is the contempt that followed his success with "Love Story." Too young to remember the intellectual wars of the fifties, he had matured in a time when cultural schizophrenia

was reaching its peak, and therefore could pursue his show-business career without any conspicuous self-doubts. His contribution to "Yellow Submarine," in fact, had made him something of a campus hero (as a result, he frequently misrepresented himself as the sole author of that movie), and students flocked to his classes less to admire his substantial gifts as a lecturer than to look at the man who once worked with the Beatles. Now the very same students who had been his most ardent admirers were among his most severe detractors, calling him a fink, a sell-out, and a counterrevolutionary for a work which Segal, quite rightly, considered merely an extension of his previous work in the popular culture. Still anguished, retiring into seclusion only to emerge for film festivals, persistently trying to explain himself in the hope that somebody at last will understand, he remains a victim of the culture he had fed on, schizoid to the last, stranded between two worlds, able to sacrifice neither.

**I**F Erich Segal is the court jester in the kingdom of cultural schizophrenia, Susan Sontag is its fairy princess. An intelligent writer, an omnivorous reader, an adventurous critic, Miss Sontag also happens to be an extremely handsome woman — therefore, ripe for plucking by the mass media. And so, after she had published her notorious article on Camp in Partisan Review, the media proceeded to cast her in the role Mary McCarthy had recently relinquished as the dark lady of the intellectual world. Miss Sontag's schizophrenia, however, is considerably more complicated than Erich Segal's, as might be expected from someone of her sensibility. As a result, she has developed a more ambivalent attitude towards her own exploitation, alternating between a kind of Greta Garbo seclusiveness — deploring her fame, and asking only for the respect of her former colleagues on Partisan Review — and a voluntary participation in the making of her media personality.

While Susan Sontag has never written lachrymose novels or Beatles movies, she has been gradually moving away

*Second from left, with members of the cast of her movie "Brother Carl" in Sweden last year.*

**SUSAN SONTAG,** "fairy princess of the kingdom of cultural schizophrenia," is not only the dark lady of the intellectual world but also a cynosure of the mass media.

from the intellectual disciplines in which she first came to public attention, and edging ever closer to forms which promise the potential of mass appeal. Her recent rejection of literary and cultural interpretation (including her own) follows hard upon her embrace of McLuhanism, and so does her new career—making movies in Sweden. Philosophically, Miss Sontag has perfectly good reasons for her career decisions; but too often, these reasons look like rationalizations. The plain fact is that she has permitted herself only half against her will, to become a denizen of the media world where she now enjoys the same kind of glamorous prestige usually reserved for politicians, athletes and movie stars.

And she is pursued for similar kinds of interviews. In the same issue of Vogue in which Erich Segal appears—indeed, on the facing page—

Miss Sontag is questioned about her career, her personal life and the subject of her current intellectual interest, Women's Liberation. The fusion of Susan Sontag, Women's Lib, and Vogue magazine is one of those inevitable astrological conjunctions that outline the pattern of our culture in one bright electrical display—illuminating the coalition that now exists between intellectual personalities, chic radical issues and the fashion marketplace. (Indeed, Women's Lib, for all its noteworthy goals, is rapidly becoming a veritable playground for cultural schizophrenia, dominated as it is by personalities like Gloria Steinem, recently promoted by Newsweek to the status of "saint" and "goddess" from her former functions as a writer of beach books and stalking horse for the C.I.A., and Germaine Greer who, at the same time that she is denouncing

the ego of the male artist as "the pinnacle of the masculine élite" and calling for the "anonymity" associated with the architects of Chartres, can be found substituting for hosts on television talk shows and getting her picture on the covers of mass magazines—most recently in Esquire, as a Fay Wray character in the arms of a Norman Mailer tricked up to look like King Kong).

Miss Sontag's new interest in Women's Lib may be perfectly sincere; but at the risk of discourtesy, I must observe that the issue has always been there for an intelligent woman to write about, even before it became the fashion. Similarly, Miss Sontag may genuinely believe that the movies are a more supple exercise for her sensibility than literature, but it must be observed that they also provide (though her films have yet to achieve this) a faster

and wider audience. And Miss Sontag is nothing if not conscious of her audience. Questioned about the relationship of popular taste to art, she replies:

"I'm tormented by the question of the audience. An artist who thinks about success is damned, but an artist who fails to consider his audience is irresponsible. I am less and less able to justify the position of the private artist who doesn't take responsibility for his work and who places himself completely outside all questions of community."

Here Miss Sontag, still speaking out of her ambivalence, is suggesting a break with the tradition of literary modernism — a tradition of which she was only recently an enthusiastic partisan. By invoking such currently resonant words as "community" and "responsibility," Miss Sontag is able to reject the position that initially stimulated the writings of Flaubert, Joyce and Proust, the music of Stravinsky and Bartok, the painting of Van Gogh and Gauguin, the poetry of Rimbaud and Rilke, the drama of Ibsen, Strindberg and Beckett —in short, the "position of the private artist . . . who places himself completely outside all questions of community." That this private artist suffered deeply in his loneliness, obscurity and penury in order to make the advances that would (much later) benefit the community in a lasting way—and that the "community-minded" and "responsible" individuals she now prefers reap their instant rewards at the cost of a tawdry and ephemeral art—may create some "torment" in Miss Sontag, but not apparently enough to resolve her schizophrenia.

Miss Sontag is similarly agonized over the attitude of the young toward the university and the accumulated wisdom of the past:

Sontag: "I have to assume that they're having an experience which is totally different from mine of 20 years ago. Given that, I'm very much on their side. But I'm split between my experience—I loved academic life — and what I understand from, say, reading Ivan Illich on the failures of the educational system."

Interviewer: "Then do you think the students are wrong?"

Sontag: "No, I think they're right. In every generation young people are more likely to be right because they're in touch with the times. All I'm saying is that I can't entirely identify my experiences with theirs. . . ."

From a trapeze like this one, Miss Sontag can only sway dizzily, drop, and land in the net of the counterculture. Her experience tells her one thing—but the young say another, and they are always "in touch with the times." How effectively that confident audience of the young can sow confusion in the minds of sophisticated thinkers, confusion which can only dissipate thought and diminish art. For if you do not think, conclude and create out of your own experience and learning, whose experience and learning will determine your life? That of the young? From such "splits" and "torments" — from such compulsions to gain the approval of the community and particularly of its young — comes the disease of which we speak.

IN the kingdom of cultural schizophrenia, Norman Mailer is unquestionably the emperor — the most celebrated figure in the pantheon, he completes the court and sets the style. A man who has made his writing virtually inseparable from his personal ambitions — wholly identified as the self-made hero of his self-created drama—Mailer is now almost completely consumed by his theatrical personality, which he displays at will on public platforms, in electoral campaigns, in novels and journalism, on television and finally (and inevitably) on celluloid, where he appears as the star of his own films. Mailer may single-handedly constitute one of the greatest public-relations firms in America, since he is able to generate his own publicity, write about it and sell it simultaneously. Mailer is nothing if not interesting; he has the instinct of a brilliant improvisational entertainer. Yet, it is difficult to remember a single idea of his which really illuminates or a single novel on the level with the best of American literature,

or a single piece of journalism —superbly written though it may be — which will outlast the event it chronicles. What Mailer possesses in super-abundance is style, both as a writer and as a personality, and he has managed to use this style like a spinning disc to hypnotize virtually the entire world—including many perceptive intellectuals — into thinking not only that he is an Emperor, but that he is splendidly garbed.

One of Mailer's more ingratiating qualities is his self-honesty; openly declaring his Napoleonic ambitions, he disarms his critics and defuses their judgments. And Mailer has not been reticent about his extreme competitiveness, his desire for influence and his lust for fame. In his first book of proclamations, appropriately called "Advertisements for Myself," he announced that he had been running for President most of his life; as if to show that he was not speaking metaphorically, he has since campaigned for Mayor of New York City. Moreover, Mailer has covered, as a journalist, almost every major event of the past 10 years, from the 1962 elections to the Clay-Liston heavyweight championship to the demonstrations in front of the Pentagon to the 1968 political conventions to the Apollo moon shot to the Women's Liberation debates —always making himself the central character, yet always avoiding the obligatory "I," as if he could escape the stigma of egotism by adopting third-person *personae* (in various works, he has identified himself as "one," "Aquarius," "the prisoner," "Mailer" and "the reporter"). Precariously balanced between clown and prophet, continually trying to join celebrity with seriousness, Mailer has proceeded remorselessly along his extraordinary career, cheered on from the sidelines by a growing army of intellectuals, camp followers, magazine editors and urban sophisticates who hope to find in Mailer's success the justification for their own cultural schizophrenia.

Given these conditions, Mailer's determination to make movies with himself as director, producer, writer and

star was an inevitable development. In a recent issue of New American Review, Mailer has even offered to function as his own critic and theoretician as well in a brilliant coup of personal press-agentry. His article, entitled "A Course in Film-Making," is a quasi-academic discourse on the making of films, conceived by a man who has thus far made only two home movies, both of them pretty wretched. As for his theory, which Mailer calls "a Leviathan of a thesis," it is a compound of rather pompous abstractions — most of them either banal or wrong or both —about the distinctions to be made between theater and film, film and the novel, movie acting and stage acting, etc.

But the thesis is always subordinate to, and in the service of, Mailer's self-promotion. Identifying himself in this essay as "the director," in his familiar impersonation of third-person humility, Mailer proceeds to describe his film as a perfect example of his new theory, comparing its photographic effects to those of "Citizen Kane," praising the actors (including himself) for being "more real . . . more vivid than in other films" and eulogizing his theory, his movie and himself in what amounts to a perfect orgy of autointoxication:

"He had a conception of film which was more or less his own, and he did not feel the desire to argue about it, or install himself modestly in a scholar's catalogue of predecessors and contemporaries, it seemed to him naturally and without great heat that 'Maidstone' was a film made more by the method by which it had been made than any film he knew. . . . But his film was his own, and he knew it, and he supposed he could write about it well enough to point out from time to time what was special and mysterious in the work. . . ."

But ultimately the quality of the movie is less important to him than its capacity to function as an event in the drama of his career. (He had already planned, if he decided the movie was a disaster, admittedly a pretty unlikely decision, to turn it into a documentary about the making of a bad movie.) Even the plot of the film signifies its purpose in Mailer's fantasy of himself, since it takes place after the assassination of an American President at which time "this film director (played by Mailer) would be one of 50 men whom America in her bewilderment and profound demoralization might be contemplating as a possible President. . . ." Thus, we can see the escalating spiral of ambition inspired by Mailer's cultural schizophrenia where he becomes a director of pornographic films, like the director in "Maidstone," in order to become famous enough to be considered eventually for President of the United States.

At this point, cultural schizophrenia seems to fade into political paranoia — though as this wild country has repeatedly demonstrated, delusions of grandeur may soon lose their delusory quality, if held persistently enough by determined people. We have seen how Mailer has journeyed over the years from a competent novelist to a highly praised journalist, to a charismatic culture hero, and now to a movie star/director, always reaching for that mass acclaim first generated by Hollywood. Now it seems that the pinnacle of media fame may be only a stepping stone to political ambition. And cultural schizophrenia—in a nation which makes Governors and Senators out of its movie stars—can be an impulse not only towards riches, fame and popularity, but towards the will to power as well.

What is being lost from the cultural schizophrenics, however, is the hope of a serious body of thought or important body of art. America is a land notorious for waste, but the waste of sheer creative energy exhausted in the making of careers will not be the least of the sins for which we will answer to history. American writers are finally beginning to gain the "community" they have been seeking with a larger audience; but this community merely distorts the failures of the country through a coarse prism.

Certainly, a sufficient number of our best novelists, poets, satirists, scholars and critics have successfully resisted the lures of the media and continued to perform important tasks; others have achieved considerable success without significantly modifying their vision. But a large majority have been setting more conspicuous kinds of examples. It may well be that our system makes this inevitable and that its rewards are impossible to refuse, short of exile in the wilderness.

Still, whatever the reasons, a vulnerable citadel of the culture now has fallen from which resistance once was possible. We have been witnessing a modern *trahison des clercs*, signified by the surrender of men and women with great potential to America's hunger for personalities. And this is ultimately the tragic side of cultural schizophrenia: that it dampens the spirit and stains the soul, that it barters away not only the self, but the very hopes of future generations for a better life, a better art. ∎

December 27, 1970

---

## FINANCING THE ARTS

---

# *Tragedy Revives Problem of Starving Writer*

### Dr. Robert Underwood Johnson's Proposal for a Great Endowment Fund for Genius Might Bring Back Something Like Medieval Patronage System

WHEN Dora Knowlton Ranous, haunted by the fear of blindness and a third paralytic stroke, which would prevent her from making a living as a writer and translator, took her own life, she brought once more to the world's attention the great problem which has to do with the difference between the value of a writer's services to humanity and the payment which humanity renders for these services. It has been shown that Mrs. Ranous was not in immediate danger of want, but the fact that her extensive services to literature, which included translations of such important writers as d'Annunzio, de Maupassant, and Flaubert, had not brought her a financial reward sufficiently large to make her, in her later years, free of the necessity of writing, is in itself a significant fact.

Dr. Robert Underwood Johnson, Permanent Secretary of the American Academy of Arts and Letters, who, when he was editor of the Century Magazine, had Mrs. Ranous as an editorial assistant, said soon after her death that it was astonishing that no wealthy man or woman had as yet endeavored to establish a fund for the use of impoverished writers.

"It is within my knowledge," he said, "that no fewer than four distinguished American writers or artists are today in mature age in such straitened circumstances as not to be able to do their best work; and that is the point I wish to make, that it is a waste of some of the finest intellects that we have, that after having demonstrated their capacity for high achievements they should be subject to conditions of life which handicap them at the very time of their highest potentialities."

Dr. Johnson believes that the situation calls for a great patron of American art and literature who will by means of a generous gift enable the American Academy of Arts and Letters and its parent organization, the National Institute of Arts and Letters, to protect the writers and artists of the country from pecuniary distress. He is surprised that we have not yet had in America one man of large means with the vision thus to make for himself an undying position as a patron of literature and art.

So far as is generally known, the only philanthropic enterprise in the United States at all resembling that which Dr. Johnson suggests is the one which is administered, with great secrecy, by the Authors' Club. The public is aware that the Authors' Club has in trust a fund from which grants of money are from time to time made to literary workers whose necessities have been brought to the attention of a specially chosen committee. So discreetly is this done that, except for the members of the committee, the club members do not know the names of the people who have been benefited. The benefaction is not limited in its application to writers who are members of the club, and it is believed that the committee prefers to advance money to writers still capable of work who are temporarily hampered by poverty and illness rather than to writers whose literary careers are over. In other words, the money is not used as a pension fund.

Dr. Johnson's proposal that some millionaire should become the patron of all American writers and artists seems at first startlingly novel and startlingly American. But as Dr. Johnson is of course aware, there is plenty of historical precedent for such philanthropy. The American millionaire who acts upon Dr. Johnson's suggestion will only be doing —more systematically and extensively, perhaps—what Maecenas, the friend of Horace and Virgil, did in ancient Rome, and what Lorenzo de Medici and Cardinal Richelieu did in their centuries.

What may be called the theory of patronage has never entirely disappeared from the world of art and letters. But during the last century or so, there has been a general belief that every artist in words or colors should be able to receive from the public payment for his work sufficient for the needs of his daily life. Patronage has therefore been a surreptitious thing which the artist received shamefacedly and the rich man rendered diffidently. And there are those who believe that this alteration in affairs has not been to the best interests of literature and art, or of those who create literature and art. So much of the world's greatest literature has been produced by writers who had not the slightest idea of concealing the fact that they were being supported by wealthy men of literary inclinations, that it is possible to make out a good case for the superiority of the patronage system over the modern commercial treatment of literature and art.

In the early history of English literature one seldom reads of a poet without reading also of his patron. The poet's relation to his patron was not unlike that of the Roman client to the patrician who befriended him. He received food and lodging, and was sometimes expected to act as tutor to the patron's children, or perform some more menial task. He was occasionally given sums of money, especially when he wrote a poem in celebration of some exploit or good fortune of his patron. As time went on the relations between poet and patron became less intimate, but in the early days the poet was generally as much a member of his patron's household as was any servant.

Of Caedmon, the great seventh century English poet, it is related that he was in his youth employed as cowherd at the Abbey of Whitby. One evening as his fellow-servants were passing round the harp and improvising songs after the custom of the age, his turn to entertain the company arrived. He was unable to improvise any song, and the sense of shame was so great that he burst into tears.

"I can only sing the Gospels of the Mass," he said.

"Then sing that," said his friends.

So Caedmon improvised rhyming Anglo-Saxon versions of the Gospel, and sang them to the delight of his companions. The Abbess Hilda learned of the cowherd's new found talent, and released him from his drudgery. She caused him to be educated, supplied him with food and lodging, and thus became, in fact, his patroness.

Before the fall of the monasteries the lot of the poet was much happier than it has since been. The troubadors and meistersingers of the Middle Ages were welcomed at all the monasteries of Europe; it was the established custom of the monks to do whatever they could to assist the development of their genius. And one way of doing this, they knew, was to relieve them from any worry over the material necessities of life.

At the great Abbey of St. Gall in Switzerland there was a school of poets. The poets were given instruction in the theory and practise of their art, and were supported in comfort by the authorities of the abbey. The Emperor Charlemagne founded a school for poets and singers at Aix, which was attended by an enormous company, and greatly enriched the literature of the period.

It is true that some of the troubadors and other wandering poets were not in good favor with the ecclesiastical authorities. Indeed, it may be supposed that the lives and writings of many of them were not what might be called churchly. But any poet was sure of a welcome at one of the Church's great universities. There he would receive food and lodging for as long a time as he desired to stay, and he would be given the privilege of attending lectures by the world's greatest scholars. In return he would be asked to render no service more onerous than serving the altar or singing in the choir.

But after the fall of the abbeys, this sort of enlightened generosity was no longer extended to literature. The poet could no longer find a comfortable home and congenial companions.

Like everything else about him, the story of Shakespeare's patron is a matter of mystery and debate. But his early relations with the Burbages, in whose theatre he acted, seem to have been more like those of a creative artist with his patrons than those of a player with his employers. And one name which is generally given as that of a patron of Shakespeare—connected with a circumstantial story of a gift of £1,000—is that of Henry Wriothesly, Earl of Southampton.

Samuel Butler, the author of "Hudibras," had many a patron in the course of his life. He entered the household of the Earl of Kent, in which John Selden, the writer, was already employed as steward and solicitor. Selden is supposed to have given him encouragement in his literary activities. Later Butler enjoyed the patronage of Sir Samuel Luke of

363

Woodend, Bedfordshire. In the course of time he became secretary to the Earl of Carbery. He also enjoyed the favor of the Earl of Dorset, who helped to make "Hudibras" popular at Court.

Dryden's patron, Sir Gilbert Pickering, and Sir William Trumbull, who befriended Alexander Pope, are well known to the student of literary biography. James Thomson, who wrote "The Seasons," had a varied experience with patrons. Lady Grisel Bailie took him under her protection for a while, and apparently Sir Spencer Compton was at one time his patron, since it is reported that he once presented him with £21. He also basked for a brief period in the favor of Frederick, Prince of Wales. But his chief patron was Lord Lyttelton.

The history of the disheartening ad-

ventures of men of genius with patrons, who sometimes possessed no virtue save that of wealth, is interesting but tragic reading. The humiliation which the men who made English literature experienced when they stood, hat in hand, waiting on the whim of some nobleman who perhaps could scarcely read and write his own name, is a thing which must necessarily have left its imprint on their writings.

The only relief in this chronicle of the economics of literature is furnished by the occasional instances of a writer sufficiently independent to resent forcibly the insults of his patron or to refuse the proffered patronage. Of this sort of incident Dr. Samuel Johnson supplies us with the most illustrious example. Fowke writes that on calling upon the great lexicographer one day he found

him somewhat agitated.

"What is the matter?" he asked.

"I have just dismissed Lord Chesterfield," said Dr. Johnson.

Lord Chesterfield had just sent Dr. Johnson £100 to induce him to dedicate the dictionary to him. And Dr. Johnson's reply had been a "dismissal."

Unfortunately the letter of dismissal has not been preserved. But there is in existence one letter—an admirable example of Dr. Johnson's prose style—in which Lord Chesterfield is most effectively rebuked for an effort at patronage resented the more keenly because of the coldness with which he had treated Dr. Johnson in the early stages of his literary career.

Of course, the matter of governmental subsidization of literature, if the phrase

be allowable, must not be left out of consideration. The English Crown theoretically aids poetry by means of the Laureateship. Dr. Bridges receives, in the traditions of his office have been kept up, a butt of sack and £200 a year. But this can scarcely be said to go far toward solving the problem of England's starving men of genius.

Then there is the English Civil List. Certain men of letters do, it is true, receive money from this. But the amounts paid are generally small—$500 or $1,000 is the usual amount given annually to any one writer—and the money is given only to those who have established reputations, not to young writers who, especially, need relief from the necessity of unliterary tasks.

January 30, 1916

## MRS. H. F. M'CORMICK TO AID OUR COMPOSERS

### Wants Chicago Company to Give an American Opera and Sing German Works in English.

*Special to The New York Times.*

CHICAGO, Nov. 2.—In addition to using her vast wealth to support the Chicago Opera Association Mrs. Harold F. McCormick, daughter of John D. Rockefeller, announced today that she would be the fairy godmother of American composers.

This announcement, read at the luncheon of the Opera in Our Language Foundation, was received with enthusiasm. The works of the American composers, it was explained, must be up to

grand opera standard, but hereafter any composer whose work is of sufficient merit may be sure of hearing from Mrs. McCormick.

Mrs. McCormick pledged herself, moreover, to intercede with Miss Mary Garden, general director of the Chicago company, to the end that at least one opera by an American composer be produced during the coming season, and that the German operas given last year in English be presented again in the English language instead of the original, as planned.

This latter request, it was predicted by those in a position to know, would doubtless be something like a hand grenade in Mary's camp, as the director is known to have a partiality for operas in their original language, and several times has announced her intention of producing German operas in German.

It is the hope of Mrs. McCormick, as expressed further in her letter to the foundation, to have two all-American operas with American casts presented next year, and, if possible, two such works every year thereafter.

November 3, 1921

## PEABODY HOME FOR ARTISTS

SARATOGA SPRINGS, Jan. 14.—Formal announcement was made tonight that in keeping with the terms of her will, Yaddo, the estate of the late Mrs. George Foster Peabody, (formerly Mrs. Spencer Trask), is to be used "as a temporary home or abiding place, from time to time, of those who have shown unquestioned artistic merit and promise of accomplishment, or actual accomplishment."

The property is under the legal ownership of the directors of Pine Garde, organized in 1900 by Mr. and Mrs. Trask, to have charge of the estate after their deaths. These directors include Mr. Peabody; Miss Allena G. Pardee (who was Mrs. Peabody's companion for years); Mrs. Mia Potter Sturgis of Providence, R. I.; Henry van Dyke, Thomas Mott Osborne, Edgar T. Brackett, Daniel Chester French, Dr. John H. Finley, Acosta Nichols and the Rev. Edwin Knox Mitchell.

The use of the house known as Manell Alsaada, an Arabic name, meaning House of Happiness, is reserved to Mr. Peabody during his lifetime.

January 15, 1922

## The Plaint of a Player

In the Sunday edition of THE NEW YORK TIMES I noticed an article written by Mary E. Harriman, in which she stated how much she and her associates were doing for music students in giving them practice in orchestral routine. She seems to feel that she is doing a great work. But is she? I, a musician—and there are many like me—have been "through the game," and when we read such articles we just have to laugh.

At the age of 17 I got into one of the best orchestras in the country, and ever since then I have played in several of the other fine orchestras of America. And now, at the age of 23, I have had to quit the symphony work, with its $60 a week salary for twenty weeks (these are New York prices and season), and I am now playing in a movie—an all-year-around position—and satisfied to know that at the end of the year I still have something left in the bank. And I intend

to stay here, regardless of the work, which is sometimes degrading for a musician who has been fed on Bach and Brahms, &c.

What earthly use is there in giving young men the necessary preparation for work which in the end does not give them enough money to exist on? After these young men stay in orchestras a few years, and they get on to the ways of the world, they leave their jobs and seek other positions—movies, hotels and even dance jobs—for these very same people, like Mrs. Harriman, and they get as much for one night as the symphony man gets a whole week—which will give them a fair chance to live.

Now, my idea is this: Why don't people

like Mrs. Harriman get together and see that the orchestral musician gets a wage with which he will be able to get along without taking work of a lower character? They pay managers, who tell them that the musicians in the orchestra are getting enough, and conductors enormous salaries, and they let the orchestral musicians go to the dogs.

When the present condition of the orchestral player will be righted, Mrs. Harriman and her associates will really be doing a great work. But not until then. C.S.M., An ex-Symphony Musician. Philadelphia, Jan. 21, 1924.

January 27, 1924

## AID SOUGHT FOR AN AUTHOR.

### Mr. Mencken Tells of an Opportunity to Forward a Worthy Cause.

Is there a man of means among your readers who would care to finance a literary enterprise? I think I can certify that it is a thoroughly useful one, and that it promises to return the capital invested. The young man who has it in hand is a scholar of indubitable dignity and ability, and for three or four years past he has been amassing material for a book that will constitute, I believe, a genuine contribution to knowledge. He has sacrificed a great deal to this work. He has lived very modestly on little money, and that little he has got by respectable but somewhat depressing hack work

—translating, reviewing, and so on. Now, ready to start the writing of his book, he finds himself unable to go on. If he continues his hack work, the book will suffer; if he abandons his hack work, his wife and child will suffer.

There are several foundations which finance works of scholarship, but in the main they confine their aid, and quite properly, to scholars with academic affiliations. This young man is not connected with any university. There are also publishers who make advances against serious works, but in this case the amount needed is rather more than any such publisher would care to invest, and, moreover, an advance would probably embarrass and impede the author, if only by forcing him to heed the publisher's wishes regarding the contents and

character of his book. He'll be able to do a much better job if he is completely free. I believe that the material he has accumulated is of great interest and value, that he has the ability to make effective use of it, and that there can be no doubt whatever about his industry and good faith.

A few thousand dollars a year, for two or three years, will suffice him. He will agree to make any reasonable arrangement for the return of the money out of the royalties on his book. I know that he will live very carefully and apply himself with great diligence to the work. I do not promise that it will be a masterpiece, but I think it safe to engage that it will be at least sober, thorough, intelligent and dignified. It deserves to be got upon paper, but

unless some one comes to the aid of the author he will have to postpone writing it indefinitely, and his heavy labors of the last few years will go for nothing. The total investment necessary will certainly not run beyond $10,000. Part of it is bound to be refunded out of the earnings of the book, and maybe all of it.

I shall be glad to enter into communication with any one who may be interested in this project. I assume that he will want to investigate the matter for himself, and take the advice of friends with special knowledge of the subject the book will discuss. My own function is simply that of giving notice of the chance to further a useful enterprise. I may be reached at the American Mercury office, 730 Fifth Avenue.

H. L. MENCKEN. New York, March 14, 1928.

March 17, 1928

# ARTISTS TO ADORN NATION'S BUILDINGS

### Mrs. Roosevelt Is a Sponsor of Federal Plan to Hire 2,500 Over the Country.

### 'WHITE - COLLAR' AID SET

### $5,415,120 Allotted to Employ 28,577 Men and Women in a Commerce Census.

Special to THE NEW YORK TIMES.

WASHINGTON, Dec. 11.—Fully 2,500 artists, including mural painters, sculptors and other craftsmen, will be employed in decorating Federal and other public buildings as a result of plans approved today by Harry L. Hopkins, Civil Works Administrator.

At the same time the Civil Works Administration approved an allotment of $5,415,120 to hire 28,577 unemployed men and women in five special census projects for the Bureau of Foreign and Domestic Commerce. This is under the program for the "white-collar class."

Other approved "white-collar" projects include four studies by the Bureau of Agricultural Economics involving costs of products bought by farmers, rural tax delinquency and land utilization; an employment-payroll survey by the Bureau of Labor Statistics, and a general tax delinquency check-up by the Census Bureau in forty-two States and the District of Columbia.

#### Set-Up for Art Works.

The plan for the artists resulted from a meeting held last week here in the home of Edward Bruce, the painter, and attended by Mrs. Franklin D. Roosevelt, leaders of American art and government officials. It calls for beautifying public buildings, including postoffices now under construction throughout the country.

The project will be directed by a section to be known as the Public Works of Art, under the general supervision of L. W. Roberts Jr.,

Assistant Secretary of the Treasury.

He will have as an advisory committee Charles Moore, chairman of the Fine Arts Commission; Dr. Rexford G. Tugwell, Assistant Secretary of Agriculture; Harry L. Hopkins, Federal Civil Works Administrator; H. T. Hunt, general counsel for the Public Works Administration; Frederic A. Delano, director of the National Planning Commission, and Edward Bruce, secretary.

The work will be carried on over the country by fourteen regional committees, which will select the artists in their respective territories.

The project is part of a general plan started by Assistant Secretary Robert for the Federal support of the fine arts. Mr. Robert said that the artists would be instructed to make pictorial records of national activities under the recovery program and to tell graphically the recent history of the country in mural decorations.

Besides structures in Washington, the buildings to be decorated will include those in Indian reservations, public schools, hospitals, land-grant colleges, custom houses, court houses and municipal libraries.

#### Praised by Mrs. Roosevelt.

Commenting on the plan, Mrs. Roosevelt said:

"I think this plan has tremendous possibilities for awakening the interest of the people as a whole in art and for developing artistic qualities which have not come to light in the past and for recognizing artists who already have made their names among their fellow-artists, but who have had little recognition from the public at large. The art of a country is a sign of its virility and strength."

The census for the Commerce Bureau is designed to provide material for "a series of statistical studies considered highly essential in contributing to the more effective factual guidance of business and government and the preservation and completion of necessary records."

Except for a few technically trained experts who will act as supervisors, the personnel will be selected by the United States Employment Service. About 27,000 of the total force will be employed outside of Washington. All work in the field is to be completed by Feb. 15, 1934.

December 12, 1933

---

## THEATRE BILL IS SIGNED.

### Measure Incorporates a National Organization.

Special to THE NEW YORK TIMES.

WASHINGTON, July 5. — The Wagner-McLaughlin bill, incorporating the American National Theatre and Academy, was signed by President Roosevelt today. This has been designed as a proposal which would give Federal sponsorship to theatrical projects advanced for art alone.

No appropriation was carried in the measure, which provides for establishment of a corporation, with prominent patrons of the arts as original incorporators, whose purpose would be to present theatrical production of the highest type.

The aim would be to stimulate interest in the drama by production of good plays with the best actors throughout the country at minimum cost to the public, encourage the study of drama, and develop the art and technique of the theatre through a school within the proposed national academy.

Miss Mary Stewart French, chairman of the organization committee of the American National Theatre and Academy, announced today that a meeting of the incorporators would soon be held.

July 6, 1935

---

# RELIEF JOBS URGED FOR 10,000 WRITERS

### $6,288,000 to Set Up Wide Program Is Recommended to President by Committee.

### GUIDE BOOK ONE PROJECT

Special to THE NEW YORK TIMES.

WASHINGTON, Aug. 6.—Before the gaudy stage curtain of dilapidated Washington Auditorium, to which they have just moved, upstairs in the stars' dressing rooms and in tiny metal chambers which workmen are noisily completing, administrators of the Work Relief drama, art, music and writers' projects are pushing forward their plans, confident that President Roosevelt will approve an allotment of $27,215,217 for the program. This amount was recommended today by the advisory committee on allotments.

Virtually the only part of the auditorium which was not occupied today was the stage itself and this may be pressed into service as work on the specialized part of the "white collar" program progresses.

Expenditure of $6,288,000, to be used in putting to work about 10,000 jobless writers on relief rolls was recommended by the allotment committee today as part of the arts program, it is understood. The sum allotted will be used for a "wide variety" of useful projects upon which newspaper men, fiction writers and even architects and geologists may be employed, it is said.

#### Reporting Staff Planned.

Establishment of a special reporting staff of 200 to supply President Roosevelt and Harry L. Hopkins, Works Progress Administrator, with weekly "narrative reviews" of the progress of the work program is planned under this writers' program. The writers would write a "readable" rather than technical report of developments.

Those planning the program propose to put 7,000 to 8,000 persons to work compiling a National Guide Book. The country has been divided into five sections, for convenience, and a separate volume will be published for each section, covering its history, sociological and other developments. Included will be an up-to-date report on historical landmarks, restaurants and other pertinent points.

Map makers, sociologists, architects, geologists and other technical persons will be employed in compiling information for this guide, which is described as an improved "Baedeker" of America.

Another plan is to put a number of persons to work in the State Department translating historical documents found in various parts of the country, including New Orleans and the Southwest.

Still another calls for "thorough preparation of an encyclopedia of government functions." This would describe the functions of government agencies in exhaustive style, covering both established and the alphabetical emergency agencies.

With regard to the guide book, which will be the largest single project, officials report that it will be possible to use only about a fifth of the historical material collected. Interesting historical documents and material found will be turned over to State historical societies and libraries for their use.

While the material will be collected in this country at large, the final touch will be put on the guide in Washington, where about thirty writers will correct and rewrite the matter collected.

Except for the task of collecting material, officials plan to get the services of "trained professional writers" rather than novices and to pay them WPA wages established by Mr. Hopkins.

August 7, 1935

# FEDERAL ART PROJECT

## Government's Relief Program to Aid Music Throughout the Country

**By OLIN DOWNES.**

CONDITIONS resulting from the depression have caused the American Government to take a course which might never have been followed if unemployment had not spread on such a scale throughout the land. As one of the measures to meet this situation, the government, in direct and indirect ways, has begun to subsidize music.

It is well known that it is the tradition in Europe for the State to do this, though with different objectives than ours. Overseas the annual national budgets include expenditures of large sums for cultural purposes, of which music is one. In America, heretofore, government expenditures which benefited musicians were made purely for purposes of "relief"—that is to say, a species of charitable dole for the jobless. Now, thanks to the newly organized Federal Music Project, operating under the auspices of WPA, the government is endeavoring to aid not only musicians, but music.

* * *

That is a different story from public moneys spent solely with the purpose of keeping unfortunate and helpless people alive. To keep them alive, in circumstances not of their making, is obviously a first necessity, and one to be met without delay or academic argument. The Federal Music Project, directed by Dr. Nicolai Sokoloff, has a further-looking and more creative aim. It will act, first, to sort out the competent from the incompetent musicians among the unemployed; and secondly, to set the competent to work, not only for themselves, but for the artistic benefit of the community. These activities can have a powerful and highly beneficial influence upon the development of music and of cultural life in America.

A sum of approximately $25,000,-000 has been set aside by the administration, to be employed for the benefit of musicians, dramatists, writers and workers in the other expressive arts. The proportion of this sum that will go to music will only be settled when the numbers of the various groups of artists to be aided are known. There will then be a division according to the proportions of the principal groups. The donation to music is certain to be substantial. The sums administered by Dr. Sokoloff and his agents will be for competent work in music. Applicants, who will be examined carefully and in considerable detail by experts, must prove their ability as musicians. What their particular field of activity may be is of secondary importance. They may conduct orchestras, or copy music, or perform in jazz bands. But they must be able, before the examiners, to substantiate whatever claims they make to knowledge and competency in their specialty.

* * *

Having given satisfactory proof of capacity, they will be given work, and placed in localities and positions where their contribution is most needed. They must be able to do work of a reasonably high standard. For this work they will be paid wages that will not compete with those offered by private employers or non-governmental organizations, but work that will maintain them, at the same time that they produce art valuable to the public.

Dr. Sokoloff's outline of the work of the Federal Music Project is far-reaching. It extends in its ministrations from the unemployed piano tuner to the prospective musical librarian. It tries to relate the work of all these different individuals to a central purpose and give the whole constructive direction.

Very firmly this plan stands against giving a musician, merely because he is unemployed, work which he is not able properly to do, or encouraging him in a profession for which he is proved to be without talent. When such a person, claiming the title of musician, appears before the examiners, and his limitations are unmistakably revealed, he is told to go back on home relief. His subsidy from home relief will not be equal to his pay for musician's work, while pay for musician's work will be considerably lower than the terms offered by private employers or insisted upon by the Musical Union. But in the one case he will not be paid for something he cannot do, and in the second place, while earning a living, he will enrich the life of his fellow-citizens.

In other words, a musician without employment will receive government aid in one form or another, but will not be permitted to encumber the operations of an organization which is determined to make use of the present emergency to foster music.

It is a pity that a similar policy has not been followed by States, cities and private organizations seeking to help the unemployed throughout the land. And the Musical Union, in its acceptance of members and the terms it exacts for their services, good, bad or indifferent, could afford to take this idea into consideration.

Just why some one whose knowledge is superficial and whose methods are impractical should be engaged to give adult education in music is a question difficult to answer. Why a fiddler who cannot play in tune or produce a beautiful tone should be invited, for a consideration, to play for the sick is also a riddle propounded by our civilization. When individuals such as these appear before Dr. Sokoloff's examining committee they will be informed of their limitations and, if able-bodied, they will be recommended for some work other than musical which they are better fitted to do, however ordinary or utilitarian the task may prove.

* * *

In past months relief funds have been dispensed indiscriminately to all those in need. The unskilled and the proficient, the man of routine and the virtuoso. Musicians went with butchers, bakers and candlestick makers into the same capacious hopper and were assisted with the same rather aimless generosity. The Federal Government aims now to take the more competent among the musicians off the hands of the local organizations and, as quickly as possible, to lead them to employment.

In this the active cooperation of individual sponsors and of musical organizations of all kinds is sought. Much is expected of these agencies. One result of this policy of the Federal music project is the symphony orchestra of Syracuse, which had succumbed to financial difficulties. This organization is back on its feet, with a full quota of players and under conditions which arouse hope that public patronage will enable the orchestra to pay a large part of its way with a minimum of pull upon the WPA treasury. Likewise Buffalo, thanks to the music project, has now its symphony orchestra.

Some States in America have done nothing whatever for their musicians. New York State and City have been leaders in this endeavor, but the government now proposes to relieve New York City of the maintenance of some 2,100 players and teachers. Besides New York, nine centres of examination and distribution of jobs and funds have been created in the United States. The plans to be carried out by these agencies include not only work for men unemployed, but reports of the quality of the work they do, and of particular individual ability.

* * *

Among the methods pursued by these agencies are those designed to create a larger listening public by developing musical knowledge and feeding musical interests. Attention will be given to the establishment of more music festivals; to cooperation with entertainment units interested in drama, operetta, vaudeville; to projects for the performance and criticism of native compositions; to the direction of music education and the placing of teachers. This involves the activities of visiting rural music teachers; the providing of leaders as coaches and directors of musical bodies of amateurs; the supplying of musical instruction and concerts for the CCC camps and the National Youth Administration.

* * *

In the camps extraordinary interest has been manifested in forms

of music study, as also in writing, in painting, in dramatics and ensemble performance. It is hoped by Mr. Sokoloff that the rising generation of America, by virtue of these combined activities, can be given opportunities such as have never been offered before of music study and of listening appreciatively to good music.

The Federal Music Project also affords much needed opportunities for young native conductors and composers. Conductors with a background and knowledge sufficient to entitle them to the opportunity will be given tests of their skill in rehearsals with complete orchestras. If they succeed they will earn public appearances. Composers whose works are believed to show talent may hear them played and gain from actual hearing the lessons which only practical test and demonstration may afford.

The examinations of the applicants are designed to be as thorough as careful planning and conscientious scrutiny can make them. Preliminary application papers are very detailed and specific. The board of examiners is only allowed to listen to a limited number of applicants in a day, in order that they may bring fresh judgment to their task and the applicant be extended the best possible chance before being accepted or rejected.

In any State where music has been part of the curriculum of the school system and the budget has included salaries of teachers and supervisors of music, a Works Progress Administration Music Project cannot supply teachers to the schools during school hours. In States where music has never been undertaken, individual cases will be considered on their merits. In order that there shall under no circum-

stances be competition with the private music teacher, only class instruction can be given under the Federal Music Project.

These rules relate to what are termed specifically musical projects. They do not concern so-called "recreational projects." Playing for folk-dancing, athletics, impromptu play orchestras, the activities of recreational workers who play the piano, sing or in other ways stimulate exercises or play are under the jurisdiction of the recreational department. But it is planned that the recreation and musical supervisors shall cooperate so that the performances of musical concert groups shall be made as widely available as possible.

November 3, 1935

# GUGGENHEIM FUND FOR ART IS SET UP

### Promotion of Abstract Type of Modern Painting to Be Its Chief Purpose

## MUSEUM HERE PROPOSED

### Copper Man's Collection to Be Nucleus — Trustees Will Meet on Plans Today

The formation of the Solomon R. Guggenheim Foundation "for the promotion and encouragement of art and education in art and the enlightenment of the public especially in the field of art," was announced here yesterday at the offices of Stanchfield & Levy, attorneys, 1 South William Street.

Formed and endowed by Solomon R. Guggenheim, copper man, the foundation will seek to blaze a new trail in popular art appreciation. Although in recent decades a number of fortunes have been given by wealthy American art lovers to further art appreciation in this country, the newly established foundation differs from all others in having as its chief purpose the furtherance of abstract or non-objective art.

Mr. Guggenheim, an enthusiastic collector of this type of modern art, owns one of the world's largest collections in this field.

#### Millions in Fund

Although no announcement was made about the amount of the endowment, it is believed to be several million dollars, with probabilities of increase.

Plans of the foundation are still in an embryonic state, William H. Higgins, secretary, explained yesterday after the announcement had been made at the offices of Mr. Guggenheim's attorneys. The trustees will hold their first meeting today to consider plans.

Among the possibilities under consideration, according to Mr. Higgins, are the establishment of a museum with Mr. Guggenheim's collection as a nucleus; scholarships, loan exhibitions of abstract art which would travel to all parts of the country, and even a school of art.

If a museum is established, it probably will be in New York so that it would become available to the largest number of visitors. Such a museum would not be opened, at the earliest, until September, when Mr. Guggenheim returns from Europe. The collection now hangs in his suite at Hotel Plaza.

Two exhibitions of the collection already have been held. Last February it was shown in Philadelphia under the auspices of the Philadelphia Art Alliance, and in March and April, 1936, it hung in Charleston, S. C., as a loan to the Carolina Art Association.

It was only about ten years ago that Mr. Guggenheim became especially interested in non-objective art, which makes its appeal to the average laymen by pattern and color rather than any attempt to reproduce objects of nature.

Mr. Guggenheim's first interest in art when he began buying pictures some forty years ago was the Barbizon school. Then he turned to American landscape painters and subsequently to Italian, Dutch and German primitives. Non-objective art is said to have interested him more than any other type.

The reason he explained several years ago at a dinner that he gave to the modern artist Fernand Leger. When asked by this artist the origin of his interest in non-objective art, he explained that he liked it because he felt it "creative," and that all his own business efforts had been in the direction of creation, citing the development of Chile Copper.

Underwood & Underwood Photo.
**Solomon R. Guggenheim**

Mr. Guggenheim is one of the original Guggenheim Brothers, still a member of that firm and associated with many important industrial organizations. He will serve as a trustee of the foundation. The other trustees are:

Henry O. Havemeyer, industrialist of the firm of Havemeyer & Elder, a director of the Chase National Bank, Kennecott Copper Company and other corporations engaged in the sugar, coal and railroad businesses; a trustee of the Metropolitan Museum and son of the late Mrs. H. O. Havemeyer, who bequeathed a great collection of paintings to the Metropolitan Museum.

Willis H. Booth, vice president of the Guaranty Trust Company and a director of International Business Machines, Royal Typewriter, Commercial Solvents and other industrial corporations, and a member of the National Foreign Trade Council.

Silas W. Howland, member of the firm of Guggenheim Brothers, director of Braden Copper, Anglo-

Chilean Nitrate Company and Yukon Gold Company.

Louis F. Rothschild, head of the banking firm of L. F. Rothschild & Co. and a director of Worthington Pump and New River Collieries Company.

Albert E. Thiele, long associated with Guggenheim Brothers and a director of many of the corporations in which this firm is interested.

Louis S. Levy of the law firm of Stanchfield & Levy, a close friend of Mr. Guggenheim and attorney for the foundation.

#### Purposes Told in Charter

In the charter granted by the Board of Regents of the State of New York the express purposes and objects of the foundation are expressed as follows:

"To provide for the promotion of art and for the mental or moral improvement of men and women by furthering their education, enlightenment and esthetic taste, and by developing the understanding and appreciation of art by the public; to establish, maintain and operate, or contribute for the establishment, maintenance and operation of, a museum or museums, or other proper place or places for the public exhibition of art; to make proper provision for lectures, publications or other public information or instruction in connection therewith, and for scholarships, grants-in-aid or similar contributions in connection with such purposes; to acquire by purchase, gift, grant, bequest, or otherwise, works of art, including paintings, pictures, engravings, prints, and other objects of art, books and furniture, and any and all fixtures pertaining thereto or convenient therefor."

In forming his collection of non-objective art Mr. Guggenheim has had the guidance of Baroness Hilla Rebay, herself an abstract artist, who lives at Oberbayern, Bavaria. The collection consists almost exclusively of works by European artists.

Among the artists represented are Rudolph Bauer, Heinrich Campendonk, Marc Chagall, Robert Delaunay, Lyonal Feininger, Albert Gleizes, Vasily Kandinsky, Paul Klee, Fernand Leger, Franz Marc, Amadeo Modigliani, Ladislaus Moholy-Nagy, Otto Nebel, Ben Nicolson, Pablo Picasso, Georges-Pierre Seurat, Shwab and Edward Wadsworth. In addition to the abstract paintings the collection also contains paintings and drawings "with

an object'' or that portray some object in nature.

In a recent letter to the trustees of the foundation Mr. Guggenheim wrote:

"I regret that because of absence from the country I shall not be able to attend the first meeting of your board, which I understand is to be held in the near future.

"In view of my inevitable absence from your first meeting it seems appropriate for me to outline briefly some of the considerations which have led me to establish the foundation.

"I am convinced that an interest in and understanding of art and the development of esthetic standards are important factors in the education of the people and in their enjoyment of life. I desire to encourage the development of the esthetic sense of our people.

"I hope that the foundation will be able to contribute throughout the years to the development in our people of a more active interest in and appreciation of beauty as represented by works of art."

Members of the Guggenheim family have been generous donors to public welfare movements. The John Simon Guggenheim Foundation annually gives fellowships to promising artists, writers, musicians and others to help them to develop their work. The Murry and Leonia Guggenheim Foundation maintains a dental clinic. The Daniel Guggenheim Foundation, established by Harry Guggenheim several years ago, furthers the development of aviation.

The announcement given out by Stanchfield & Levy summed up the purpose of the foundation thus:

"While Mr. Solomon R. Guggenheim has been for a lifetime an outstanding pioneer in the development

of the great mineral resources of the world, he has also been keenly interested in the development and appreciation of art. His foundation is designed not only to supplement the existing movements but also to promote the study and understanding of art as a living and progressive influence in the consciousness of the public.

"He wishes to bring to the people of this country a true realization of the work and achievements in the domain of art, and to furnish an incentive toward the expression of its finer artistic impulses. He has vested in the trustees ample power to cultivate artistic appreciation by the encouragement of study through scholarships and professorships, and to present to the public concrete demonstration of what has been and is being accomplished.

"All this he hopes will stimulate the public interest and improve the public taste and appreciation. He

believes that the people of this country through their social and economic improvements will have more opportunity to develop their art interest, and that this should prove an important factor in adding to the fullness of their living and the enjoyment of their opportunities, to the end that this country may become one of the great art centers of the world and may be accelerated in the process of developing its own great works as the older nations have done. This foundation will be equipped to further such movements in the world of art as the trustees may believe merit support.

"The principal office of the foundation will be at 120 Broadway, New York City, and the trustees will enter upon their duties at once."

June 29, 1937

# MAJOR MUSIC UNITS CANNOT PAY WAY

Deficit for 37 Companies for 1947-48 Season $3,225,348 Despite Public, Private Aid

### By HOWARD TAUBMAN

Virtually no major opera house or symphony orchestra in the world expects to pay its own way next season or in the foreseeable future.

A survey made by THE NEW YORK TIMES of the financial status of leading musical organizations showed yesterday that in nearly every case an operating deficit was as certain as death and taxes.

The deficit of thirty-seven representative opera companies and orchestras in this country for the 1947-48 season was $3,225,348, and the future, it was agreed by managements everywhere, holds out little hope for improvement.

If the deficits for lesser musical outfits in the United States as well as for all the operas and orchestras in foreign countries were to be added, it was estimated that the figures would run up to $15,-000,000.

The actual operating deficits of many organizations, it was pointed out, are even larger than the audited figures. Some orchestras like the New York Philharmonic-Symphony, the Boston and the Philadelphia have endowment funds, and the annual income from these funds helps to cut down deficits measurably.

Save for one or two musical organizations, like the Hollywood Bowl series, that operate in the black because of special conditions, no orchestra or opera house paid its way last year on the basis of money taken in from the sale of tickets. Ticket sales accounted for as little as 30 per cent of the income of some groups and went up as high as 84.2 per cent in the case of the Metropolitan Opera.

Deficits in this country were met in a variety of ways. The most common was the public campaign for funds. Iost of the orchestras in the United States, with the ex-

ception of a handful of the most renowned in the East, were obliged to raise from $50,000 to $200,000 a year in advance of the season.

### Like Community Chest Drives

The campaigns for funds for musical organizations in these towns were conducted in the same way that a Community Chest or hospital fund campaign might be conducted. Committees canvassed the town, sent out appeals by mail and made personal visits to leading citizens. In Dallas the letter carriers delivered a notice to each resident on their routes.

The days of the one Maecenas who personally met deficits each season are finished. No musical organization in this country could any longer point to figures like Otto H. Kahn, a pillar of the Metropolitan for many years; Henry Lee Higginson, who founded and supported the Boston Symphony for many years; Clarence H. Mackay, who helped the New York Philharmonic; Harry H. Flagler, who aided the New York Symphony, and William A. Clark, main support of the Los Angeles Philharmonic.

Funds were raised last season from a large number of people throughout the country in contributions from $5 to $1,000. Donations of more than $1,000 were few. The Central City Opera Association in Colorado, for example, raised a sustaining fund of $25,000 for its 1948 season by getting gifts of $250 from each of 100 citizens.

The experience of musical organizations abroad revealed that deficits in every case were met, not by campaigns and individual contributions, but by state and city subsidies.

The Colon Opera in Buenos Aires which, according to our Argentine correspondent, is regarded "as an adornment of the national culture", is described "as wholly a state enterprise and not a business." Its deficit of 6,000,000 pesos (the peso was quoted at 4.80 to the dollar) was met entirely by government subsidy, in this case from the municipality of Buenos Aires.

The Italian Government set aside funds totaling about $2,200,-000 to cover the opera season in its cities for 1947-48. Because of the drastic rise in the costs of putting on opera a great many of the country's provincial opera houses

could not open at all. However, the four principal theatres—La Scala in Milan, the Rome Opera, the San Carlo in Naples and the Fenice in Venice—were able to remain in business, thanks to state assistance.

### Helped by Governments

In France, Germany, Russia, Hungary, Sweden and all the other European countries opera companies and orchestras depended on large contributions from the public treasuries. This was true even in Great Britain, where the Covent Garden Opera became a national institution last spring. Before that, however, English orchestras and operas had begun in recent years to receive public subsidies in a break with the British tradition that musical organizations were to be privately maintained.

Even in the United States there has been a growing tendency in the last few seasons for public treasuries to contribute to musical organizations. Some cities appeared to be reluctant to call it a subsidy officially, but grants of up to $70,000 were provided for such things as concerts in the schools and special concerts at nominal rates of admission. Denver gave its orchestra the use of the city auditorium free of rent, and Portland, Ore., let its symphony have the auditorium at half the usual rental rates.

The American cities that last season helped their orchestras with grants of assistance were San Francisco, Baltimore, Los Angeles, Denver, New Orleans, Salt Lake City (the state and county contributed), Portland, Ore., Houston, Buffalo and Indianapolis (which made a grant of $50,000).

Of the big eastern organizations the Metropolitan Opera Association had some public assistance in the form of an exemption from the real estate taxes for that part of its building used in the production of opera.

One manager, Harl McDonald of the Philadelphia Orchestra, said, "Please stress the fact that the City of Philadelphia contributes nothing to the orchestra, which is one of its most important advertising implements, and imposes a tax, which we consider unjust." This tax is a 10 per cent admissions tax in addition to the 20 per cent Federal admissions tax.

Characteristic of the response

from managers and heads of musical organizations in this country was this note struck by Helen Black, business manager of the Denver Symphony:

"Everything possible is done to increase our income but no matter what method or methods are used it does not seem possible in the near future, if ever, to earn enough to maintain a professional or even a semi-professional orchestra of the quality demanded by the symphony-loving public today, or of the quality to which the young children should be exposed.

"If we are to improve the tastes of our future audiences it is our contention that schools, art museums and symphony orchestras are a vital part of the educational and cultural facilities of a community. Schools and art museums not expected to pay their way, and symphony orchestras should be in the same category.

"For example, the concerts for school children have an admission price of 25 cents for each concert to assure every child an opportunity to attend. That would not be possible were the prices established on a purely commercial basis. It is our hope that at some time all orchestras will speak of their maintenance fund as just that and stop using the word deficit which has a psychologically bad effect on the minds of the general public. Art museums do not talk about deficits. Why should symphony orchestras?"

It developed in the course of THE TIMES survey that the major conservatories of the country, like the universities and unlike the orchestras and operas, were not expected to try to pay their own way.

A report from the Curtis Institute in Philadelphia indicated that all students were there on scholarships and that the school was maintained entirely by endowment. William Schuman, president of the Juilliard School, said that tuition fees covered only about half the cost of educating the student—less in the case of students with scholarships—and that endowment made up the difference. The Peabody Conservatory in Baltimore said 75 per cent of its gross income came from tuition fees and the difference had to be made up by public campaigns and subsidies.

The difficulties of musical organizations here and abroad were not caused by failure of public

patronage. The survey showed that most of the orchestras and operas queried had booming attendance records. The New York Philharmonic-Symphony played to 93.4 per cent of capacity; the Philadelphia to 92 per cent; the Boston, 90 per cent; the Dallas, 91 per cent; the San Francisco, 93 per cent; the Metropolitan Opera, almost 100 per cent. The average throughout the country was better than 80 per cent.

In the case of the major symphony orchestras and operas, contracts for recording and broadcasting helped to cut down the size of the deficit. The most famous, long-established institutions were the more fortunate in this respect, while the newer groups had little income from these sources. Where a musical organization obtained a commercial sponsor for its broadcasts, it had a chance to come close to getting out of the red.

Bruno Zirato, co-manager of the New York Philharmonic-Symphony, said: "There is no possibility of paying our own way next season from operations, but only by contributions and possibly by commercial sponsorship of our Sunday broadcast concerts." With yesterday's report that the New York Philharmonic-Symphony had made arrangements with a commercial sponsor, it seemed likely that this organization would be able to cut its deficit appreciably.

George A. Sloan, chairman of the board of the Metropolitan Opera, observed that the company's prospects depended a great deal "on our box-office revenues and whether they will hold up to the high level of the past two seasons." He added that "we are making every effort to affect further economies and to increase our revenues; for example, we are now examining closely into the possibilities of television and motion pictures."

**Various Means Used in Drives**

Some managements reported that the raising of sustaining funds was accomplished with little trouble each year. A few said that it took quite a bit of doing.

The Utah Symphony undertook a campaign to raise funds for three years but found that many contributors gave only as much as they would for one year, with the result that there must be an annual campaign. In New Orleans it was found that a joint campaign for several musical organizations produced less satisfactory results than separate campaigns for each.

One management said it could get little support from business organizations in its towns, but most cities reported that business enterprises contributed regularly. In Portland, Ore., the revived symphony got a $10,000 contribution from the musicians' union.

The biggest item in the costs of all musical organizations was

labor. The Metropolitan Opera's figure of 75.5 per cent of its budget for all its employes, artistic, backstage and administrative, was the highest because it requires so large a staff.

The average for other musical organizations was about 60 per cent for orchestra players, conductors and soloists. The highest weekly minimums of instrumentalists were $139.50 at the Metropolitan Opera; $125 for next season at the New York Philharmonic-Symphony; $105 for the Boston Symphony; $100 for the Philadelphia Orchestra. In most other ensembles the weekly minimum was below $100, with the scale going down to $60 and $55 in some of the smaller cities.

The sizes of the halls of the country's musical organizations vary, and that appeared to be an economic factor of importance.

September 1, 1948

# Art: Aiding the Artists

## Ford Foundation's New Program of Grants Meets With Enthusiasm

### By DORE ASHTON

IN East Hampton, Provincetown, Woodstock and New York City—in fact, wherever more than one painter or sculptor is billeted for the summer—a recurring topic of conversation is the Ford Foundation's recently announced grant-in-aid program administered by its Humanities and Arts division.

Though artists generally take a dim view of the grant and fellowship circuit, this time they are watching with decided interest and even enthusiasm. For this is one program designed to overcome two major complaints of the art community: that artists are rarely consulted about fellowships and honors, and that an alarming official interest lately in "new" talent

has overshadowed the value of the mature artist.

But the Ford Foundation grants of $10,000 to ten visual artists will be awarded by juries in which more than three-quarters of the participants will be practicing artists. Moreover, the artists themselves are being asked, along with others, to nominate their own candidates for grants. And, they are being asked, much to their relief, to select candidates who are 35 years or older in "critical" stages in their careers.

This thoughtfully conceived, elaborate program was outlined only after an exhaustive study of problems and possibilities had been completed. Director W. McNeil Lowry, describing this "exploratory"

program, points out that he and his colleagues visited more than seventy communities throughout the country seeking suggestions and stimulating discussions designed to bring to light the actual needs of the artist.

In order to develop as broad a program as possible Mr. Lowry proceeded on the assumption that though the role of the arts is as yet ill-defined in the United States, there has been an obvious surge of interest recently.

"An outside agency such as the Ford Foundation," he remarks, "should not be an exclusive, monolithic force by weight of its money, but should involve the active participation of as many people as possible."

In this way, the grants will constitute just one method among many being considered by the foundation for enhancing the artist's social and economic situation within his society.

The specific intention in the present program is to enable mature artists of high merit to work for more than a year free of his ordinary economic problems. In consulting an astonishing number of artists, Mr. Lowry found, in addition, that often, in critical moments, the mature artist is beset with extra-esthetic problems.

For example, a man with an established "style" might feel inhibited in experiment because his gallery or public has come to expect that particular style. Or, a man who is enthusiastically acclaimed for three or four years may find himself suddenly forgotten and his place taken by what has come to be known as "new talent."

These are problems that the Ford Foundation hopes to dramatize and help to alleviate through the forthcoming grants in aid. There are, as well, many delicate situations within the program itself that must be faced. It might appear, for instance, after all recommendations have been analyzed and pictures and sculptures sent for jury review, that artists selected for highest merit come from one region only. Although the foundation has gone to great pains to insure a broad regional spread, Mr. Lowry explains, if it should so happen that one region predominates in final selections, "that fact will simply have to be faced."

The intricate structure of the program is extremely flexible. Mr. Lowry is a thoroughgoing humanist who understands the necessity of engaging the deep interest of a great many people. A one-time university English and creative-writing professor, Mr. Lowry was the founder of a well-known experimental literary magazine, Accent, and is an author. He was a writer for the Office of War Information and spent five years as a political correspondent for the Cox newspaper chain before taking his job with the Ford Foundation in 1953.

"It is probably that stint as reporter which has most influenced my attitude in this job" he says. "I have listened to thousands of artists in every field and taken notes like a reporter."

By accumulating a vast amount of data through interviews with artists (and, in fact, with practically everyone Mr. Lowry and his staff encounter) the foundation has been able to construct this program in a way that many artists feel comes closer than anything existing to contributing a positive impetus to creative life in the United States.

August 20, 1958

# *Federal Role in the Arts Has Increased in Decade*

### By MILTON BRACKER

In Washington a bill authorizing a National Cultural Center has been approved by Congress and signed by the President. The 9.4-acre site is there and some day—if about $25,000,000 in private funds can be raised within five years—the building may be.

In another part of the capital a white-haired New Englander (who happened to be born in California) is paid by the Government to serve as consultant in poetry to the Library of Congress. His name is Robert Frost. He remarked with hearty irony in an interview that "I'm there chiefly to thank the Government' for recognizing our existence."

In New York preparations are being completed for the departures on Jan. 13 of the San Francisco Ballet for the Near East; on Jan. 17 of the Westminster Choir for Africa, and on Feb. 23 of the Little Orchestra Society for the Far East.

### Aided by State Department

All will be backed by State Department funds, administered by the International Cultural Exchange Service of the American National Theatre and Academy. ANTA—like the American Red Cross—is a private body holding a charter from Congress.

In St. Louis—at the City Art Museum—a show of American painting of the last twenty-five years is being assembled for a tour to open in Italy next September. About twenty-five artists will be represented, in what one non-Government expert describes as potentially the "most important exhibition of American art to go abroad under Government auspices." This is a venture of the United States Information Agency.

In New Delhi on Jan. 5, a new United States chancellery will be dedicated. It is a spectacular example of the work of a modern American architect, Edward Durell Stone, who was commissioned by the State Department through the Office of Foreign Buildings.

### Ancient Relationship

These disparate activities and hundreds of others, have as a common denominator the ancient relationship between the Federal Government and the arts. As it exists in the United States the relationship is virtually impossible to delineate sharply. Yet every time an American passes a coin or puts a stamp on a letter he is touched by it.

Over-all truths of the relationship are hard to extract. But a month's look into many phases of it suggests the following:

¶There is no nationally backed opera like La Scala; no subsidized ballet like the Bolshoi; no state orchestra like the Vienna Philharmonic. Nor is there a central department or agency through which art matters are channeled. Within a given field —music, for example—even well-informed leaders are likely to confront each other with, 'Ch, you mean the other committee," when discussing the myriad Government subdivisions that back one or more musical projects.

¶In recent years, impelled, according to some opinion, by the example of the dictatorships, this country has placed a strong emphasis on the promotion of art for export. This is often noted wryly by artists who would like to see their own particular art subsidized, or at least assisted, for domestic consumption. There is no doubt that the whole question of Government and the arts has tended to narrow into the question of the use of art as an instrument of the foreign policy of the United States in the "cold war."

¶No matter what the Government does or does not do in relation to the arts, it is subject to a barrage of pros and cons. These concern the fear of censorship or control; the possible sponsorship of "subversive" art; the timeless dispute between conservatives and modernists in any art medium; and the individual or group equities of artists competing for commissions.

### Paradox and Controversy

And the whole subject is fraught with paradox, misunderstanding and controversy.

In Chicago, a Government subsidy amounting to about $16,000 was announced by the hard-pressed Lyric Opera Company. But the Government that made the subsidy had its seat not on the Potomac but on the Tiber. The grant, in lire, was to be used largely for travel expenses incurred by Italian singers hired by the Chicago company.

The triumph of Van Cliburn at the Tchaikovsky piano competition in Moscow last May is still commonly held to have been made possible by Government backing. Actually, the funds came from private sources. The Government contribution was a passport.

As for controversy, it has ranged from the political inclination of an individual artist to the design of a 3-cent stamp honoring the American poultry industry; and from the shape of a memorial on a distant beachhead to the recurrent question of whether there should be a Department of Fine Arts.

Abram Chasins, in "Speaking of Pianists," remarks:

"American artists and intellectuals are the natural enemies of American politicians."

### Increased Legislation

Whether this is the case, the fact is that legislation by "politicians" presumably for the benefit of "artists and intellectuals" has tended to increase during the past decade. The pages of The Congressional Record are ripe with tributes to one or more of the Nine Muses, although the rhetoric has not been enough to forestall the death of most of the bills introduced.

In his State of the Union message in 1955, President Eisenhower asserted that the "Federal Government should do more to give official recognition to the importance of the arts and other cultural activities."

He also proposed a permanent Federal Advisory Commission on the Arts, to come under the Department of Health, Education and Welfare. In one form or another, this idea had been—and is—backed by large numbers of individual artists and their organizations. It was —and is—opposed by a few.

The proposal was passed by the Senate but died in the House. More recently there have been renewed proposals for a Department of Fine Arts, headed by a leader of Cabinet rank; for an Assistant Secretary of State for Cultural Affairs; for a United States Art Foundation and a National Theatre.

### Cultural Aide Named

Some of these recalled the Pepper-Coffee bill of 1938, for a Bureau of Fine Arts, or even older proposals. Some are sure to be introduced in the Eighty-sixth Congress. It was announced yesterday that Robert H. Thayer, former Minister to Rumania, had been appointed Special Assistant to the Secretary of State for the coordination of international educa-

tional and cultural relations.

Representative Frank Thompson Jr. of New Jersey is one of the most active legislators in the field. Cynics dub him a "culture vulture." The fact remains that Mr. Thompson and Senatorial co-sponsors have pushed some significant projects over all the usual obstacles into law.

These include the International Cultural Exchange and Trade Fair Participation Act of 1956, which covered the Brussels Fair; the bill to establish a new national art repository in the old Patent Office Building, and the bill for the National Cultural Center.

The co-sponsor of the first of these was Senator Hubert H. Humphrey of Minnesota. It authorized on a permanent basis funds for the cultural presentations program that had been established in 1954 following a special request by President Eisenhower to Congress.

### Attractions to 89 Lands

This has meant that in four years, 111 attractions—ranging from Dizzy Gillespie to the New York Philharmonic; and from Marian Anderson to "The Skin of Our Teeth"—have been sent to eighty-nine countries. This is the program directed by Robert C. Schnitzer of ANTA, who observes that every so often some Congressman phones him to urge the booking of the "Flathead County Glee Club." Such pressure on behalf of home-town talent (and voters) has also been brought to bear on the office of E. Allan Lightner Jr., Deputy Assistant Secretary of State for Public Affairs.

But the criterion remains "quality, quality, quality," according to those close to Mr. Lightner. And Mr. Schnitzer says that after he explains the rigid standards of the selection panels, the Congressman invariably recedes without even threatening to have the whole program canceled. Its 1959 allocation is $2,415,000. A single intercontinental ballistic missile cost $2,000,000.

Last March 28, the bill to save the Patent House Building for an art museum became law. It was backed by Representative Thompson and Senators Humphrey and Clinton P. Anderson of New Mexico. The works to be housed in the Parthenon-like structure at Seventh and F Streets include the National Collection of Fine Arts, now in the Smithsonian Institution; a national portrait gallery, and a contemporary art program.

### In an Artistic Landmark

The Patent Office Building was designed by Robert Mills, who did the Washington Monument. For nearly 125 years it has been one of the capital's artistic edifices. But this is not to say that the measure sparing it from being torn down for a parking lot has automatically satisfied all those who would like to see the National Collection of Fine Arts in a home of its own.

The measure came as the culmination of a long and involved controversy over another site—on the Mall, near the Smithsonian. This was ardently desired, and ultimately obtained

by proponents of the National Air Museum. The latter is temporarily housed in the Smithsonian, too. The director of one of the country's greatest museums says that the best that can be said of the Patent Office Building is that "There are walls standing." If it is to serve as a showplace of fine art, he added, "they've got to renovate the whole thing."

On the other hand, Representative Thompson says he has been assured by experts that the conversion is "entirely feasible." It would be paid for by the General Services Administration. But for the moment, the plan is in abeyance.

The Civil Service Commission has occupied the Patent Office Building since 1932, when the Patent Office moved to the Department of Commerce. The Civil Service Commission is scheduled to move into a new building of its own, but the building is not yet built.

### Site for Entertaining

Thus the transfer of the National Collection of Fine Arts remains indefinitely in the future. But a large floor plan of the Patent Office Building is already on the desk of Thomas M. Beggs, director of the National Collection. He is thinking ahead, even though he knows he will have to be patient.

The National Cultural Center, authorized by law Sept. 2, would symbolize the nation's official interest in the arts and give the President a place to entertain foreign visitors in a setting identified with both the visual and the performing arts.

As co-sponsored by Senator Humphrey and Representative Thompson, the act sets up a board including the Secretary of Health, Education and Welfare and fifteen general trustees. These have not yet been appointed. Eventually, there would also be an Advisory Committee on the Arts—similar to the one so often proposed—made up of specialists in the fields of art covered by the center.

The site is bounded by the Inner Loop Freeway, the Theodore Roosevelt Bridge approaches, Rock Creek Parkway, New Hampshire Avenue and F Street in the sector called Foggy Bottom. But apart from obtaining the site, the Government has so far done nothing to implement the project.

And by the act's own terms, it will come to nothing if "the Smithsonian Institution does not find that sufficient funds to construct the National Cultural Center have been received within five years."

### Dowling to Press Project

Once the trustees are appointed, Robert W. Dowling, chairman of the board of ANTA, is likely to take a leading role in seeing to it that the act does not come to nothing. "I have been rooting for this [the cultural center] for a long time," he said. He has felt that if the Government would give the land, private citizens should give the money.

New legislation apart, the Government's continuing activities in the arts can best be outlined under four headings.

These are international exchange, the design and decoration of public building, Government collections, and coins and stamps. The four are obviously not all-inclusive. For example, the chamber music programs at the Library of Congress fit none of them. But most activities can be conveniently covered by the four.

The patronage of artists for the design and decoration of public buildings, the minting of coins and the issuance of stamps, goes back to the earliest days of the Republic. The Government role as a collector began somewhat later. The Depression and the New Deal brought into being a new and still controversial concept, the use of Government funds not so much to commission specific art works as to support unemployed artists. This led to inevitable disputes over the supposed leftist propaganda painted on Government walls by artists on the Federal payroll.

As pointed out by Clarence Derwent, chairman of the National Council on the Arts and Government, the New Deal arts projects, "while productive of much fine work, fell short of the full recognition of the value of the arts to society because of the public relief aspects of the program."

Since World War II the emphasis has shifted to the utilization of the arts as an arm of diplomacy. The aim is candidly asserted: to promote competitively the free creative tendencies of a nation long accused of letting its capitalist ideology cramp artistic expression.

### Americans' New Side

As William Benton, former Assistant Secretary of State for Public Affairs, put it in the early stages of the program, it was to show that Americans, "accused throughout the world of being a materialistic, money-mad race, without interest in art and without appreciation of artists or music have a side in our personality as a race other than materialism."

Or, as Mr. Schnitzer put it more recently, with regard to the performing arts, "It is propaganda—in the best sense. We are saying, 'Here are some artists whose work we enjoy'" and we hope you'll enjoy it, too."

Actually, the State Department's Division of Cultural Relations dates to July 28, 1938. Three years later the first cultural officers were assigned to American diplomatic missions. In 1946 a major step was taken with the passage of legislation presented by Senator J. William Fulbright, Democrat of Arkansas. Becoming operative in 1948, the Fulbright plan draws on foreign currencies owed to or owned by the United States, chiefly for war surpluses, for a cooperative program of educational exchange.

Two exhibitions, jointly called "Fulbright Painters," currently crossing the country, indicate how this program may operate to the benefit of individual artists. The shows are made up of samples of the work of candidates who qualified under the Fulbright Act to pursue their studies abroad.

### Tours Began in October

One of the exhibitions opened at the Whitney Museum of Modern Art here on Sept. 17. Both sections began tours in October. These were organized by the traveling exhibits service of the Smithsonian Institute in cooperation with the Institute of International Education. By contract with the State Department, the I. I. E. administers the Fulbright student exchange.

Here is a case, then, where a Government program has artistic implications both abroad, where the artists studied, and at home, where their work is being shown. The Fulbright scholarships cover all fields of study and that the painters represent only a small fraction of those who win them.

On the most sensitive level of exchange, in view of current East-West relations, there is the new status for American artists visiting the Soviet Union afforded by the agreement announced in Washington last January. This was signed by the State Department's William S. B. Lacy and the Soviet Ambassador at that time, Georgi N. Zaroubin, who died on Nov. 24.

The accord did not initiate exchanges between the United States and the U. S. S. R. but facilitated them and gave them new importance. Long negotiations by Sol Hurok to bring the Moiseyev dancers here had preceded their arrival, after the conclusion of the Lacy-Zaroubin agreement. Similarly the "Porgy and Bess" company had reached Moscow on its own; Emil Gilels and David Oistrakh had played here; and the Boston Symphony went to Moscow in 1956 under the President's program as run by ANTA for the State Department.

But whereas the ANTA artists had only a "foot in the door" before the accord, according to one spokesman, the pact "opened the door wider" and gave official recognition to the visit of the Philadelphia Orchestra last May and June. This tour also had already been arranged when the accord was reached. But its auspices were enhanced by the new diplomatic understanding.

On the other hand, some cultural exchange experts see in the Lacy-Zaroubin accord an implicit quid pro quo that they regard as restrictive. These sources—within the State Department—feel that a generally freer and broader exchange is more to the point than a 50-50 balance of trade in terms of traveling artists.

Distinct from the State Department's direct role in the exchange program, there are the manifold activities of the United States Information Agency. Since 1953, U. S. I. A. has had a major responsibility in the presentation of varied aspects of American life abroad.

This takes in the dissemination of both live and recorded music. For example, the Symphony of the Air not only played in Tokyo; a film of its

tour has been popular on Japanese television. The entire Voice of America program comes under U. S. I. A. and "Music U. S. A." is broadcast seven nights a week, fifty-two weeks a year.

### Art Show in Turkey

Meanwhile, the fine arts section of the exhibits division of the agency has a show called "Nine Generations of American Art" in Turkey. Another show, "Twentieth Century Highlights of American Painting," involved the distribution of forty color-reproductions virtually all over the world.

U. S. I. A. has also arranged small overseas shows of American serigraphy (silk screen art) and stained glass. In prospect are an exhibition of prints being assembled by the Brooklyn Museum, due to go abroad in March or April, and the collection of modern painting being assembled by the City Art Museum of St. Louis.

The pertinent background fact in connection with the latter project is that early in 1956, U. S. I. A. withdrew sponsorship of three collections of paintings that were to have been sent abroad. The trouble started with denunciation of a show called "Sport in Art" by the Dallas Patriotic Council.

This raised a flurry over "subversive" art and underlined the vulnerability of Government to political criticism whenever it was the sponsor of art activities.

Although there remain nine months before the St. Louis collection starts on its way, such criticism is not expected this time. A museum man associated with the choice of some of the paintings said, "I've been assured that there will be no censorship." An interested official of U. S. I. A. crosses his fingers when the question is raised.

The general implication is that the tensions of the period associated with the late Senator Joseph R. McCarthy, Republican of Wisconsin, have been eased. But Government endeavor in any field of the arts remains subject to attack at almost any moment.

The design and decoration of public buildings is a timeless function of Government. On Nov. 23, the General Services Administration announced selection of a site west of Foley Square for what will be the largest Federal office building outside the District of Columbia. Recently, there has been increasing awareness that American buildings abroad could symbolize the best of the contemporary American tradition.

Assignments to architects are made through the Office of Foreign Buildings of the State Department. The department is completing the fifth year of a ten-year, $200,000,000 program involving new embassies and consulates on four continents.

There is an advisory committee of three leading architects appointed on a rotational basis. The department also has on hand about 800 brochures from architects. It makes its selection on the basis of the advice of the committee, on what it knows of the other architects, and on the special conditions applying in the country where the building is to be erected.

Thus Mr. Stone was commissioned to do the New Delhi chancellery. He was also architect of the United States pavilion at the Brussels Fair. In the case of the new embassy in London, a different technique of choice was used. The department arranged a competition among eight American architects and a seven-man jury chose Eero Saarinen of Michigan as the winner.

An important agency, particularly with regard to public monuments and sculpture, is the Commission of Fine Arts, dating to 1910. When Congress created the American Battle Monuments Commission in 1923, it was provided that any design or material for a memorial had to be approved by the Commission of Fine Arts.

### Ministry Was Opposed

Moreover, pursuant to a Presidential request of January, 1951, the commission was the agency chosen to make the first and only survey of all the Government's activities in the field of art. The report was submitted in 1953. In an introduction, preceding excerpts from testimony of all Government agencies involved, the commission said:

"It is a source of the deepest satisfaction to members of the commission that here in this fortunate country we have freedom to choose what seems most worth while in the cultural life of our time, and that the artist, in creating works of art, is free to express his own inner convictions without compulsion on the part of the state or other outside forces.

"Here we have no centralized control of art activities on the part of the Government, such as exists in many other countries."

And the commission went on to oppose efforts to create a Ministry of Fine Arts or to combine "in a single bureau art activities now carried on effectively in a number of Government agencies."

Nevertheless, the commission—headed since 1950 by David E. Finley, who was until 1956 also director of the National Gallery of Art—is occasionally charged with exercising arbitrary influence. It has been asserted that the seven-man unit has a stranglehold on the design and decoration of all Federal buildings and monuments in Washington, and on the design of battle monuments anywhere.

Critics of the commission have insisted that it hews to an academic line and has facilitated commissions for the generally conservative members of the National Sculpture Society as against non-member sculptors.

A commission source, aware of such charges, points out that since not only authorization, but also appropriation, for any monument stems from Congress, it is to be expected that the commission's advice should follow "conservative" lines. One thing rarely said of Congressmen, the source suggests, is that they are personally inclined toward advanced tendencies in art.

Nevertheless, the supposed grip of the National Sculpture Society on Government commissions invariably comes up whenever the larger question of the Government and the arts is raised.

### Against Centralization

From 1951-54, the society was headed by Wheeler Williams, who since 1957 has been president of the American Artists Professional League. Both groups strongly oppose any centralization of Government art activities.

In a leaflet called "War Cry," the league declares, "We must continue our battle to see that art is not socialized under political bureaucracy."

The society and the league remain firmly aloof from groups like the Committee on Government and Art, and the National Council on the Arts and Government. These have backed legislation pointing toward a permanent advisory council for the arts.

According to Adlai S. Hardin, president of the National Sculpture Society, "The minute there comes a [Federal] bureau with a capacity to advise, some freedom is going to be dissipated."

The Committee on Government and Art, founded in 1948 and made up of representatives of twelve national organizations, including the younger and less influential Sculptors Guild, declared in a statement of principles on May 25, 1956:

"We believe that governmental art policies should represent broad artistic viewpoints, and not the predominance of any particular school or schools.

"In order to aid in making available to the Government the best experience and knowledge of the art world, we believe that there should be advisory bodies composed chiefly of professionals in the respective fields; and that art organizations in these fields should have a voice in nominating the members of these bodies."

### 7 Fields Represented

The National Council on the Arts and Government consists of individual representatives of seven major art fields. In general, it has been aligned with the position of the Committee on Government and Art, whose chairman is Lloyd Goodrich of the Whitney Museum.

Government art collections, which symbolize the nation's official interest in the preservation and formal display of accrued treasures, include the National Gallery of Art, the National Collection of Fine Arts and the Freer Gallery.

In his invaluable "Government and Art," Prof. Ralph Purcell writes that it was not until 1906 that the Government began its role as a collector. He notes that when the British burned the Capitol in 1814, the only two paintings owned by the United States—gifts of Louis XVI—were destroyed.

In 1906, a group of paintings known as the Johnston collection was given to the Government by Harriet Lane Johnston, niece of President James Buchanan and mistress of the White House during his Administration.

The condition was that the small but valuable collection should be placed in a National Gallery of Art, when one was established. Professor Purcell recounts how a "friendly court action was instituted to determine if the art collection already in the Smithsonian Institution would legally constitute a National Gallery of Art."

The court ruled that it would. Thus the early Smithsonian collection, enhanced by the Johnston gift, was newly constituted as the National Gallery of Art.

Oddly enough, the art in the Smithsonian was to lose that title after all. In 1937, when the Mellon collection became the nation's foremost, the title was transferred to it. The National Gallery of Art now comprises the original Mellon bequest, and subsequent additions.

The Smithsonian art was renamed the National Collection of Fine Arts. It is the art that is to be housed in the old Patent Office Building under the recent legislation. Pending settlement in its new home, the National Collection has about 500 portraits and pieces of sculpture on loan to public buildings, including the White House and the chambers of the Chief Justice.

The Freer Gallery of Art, devoted principally to oriental fine arts and the works of Whistler, was the gift of Charles L. Freer in 1906. The gallery was not built until 1920; and the collection was opened to the public as a unit of the National Collection of Fine Arts. The Freer Gallery is administered by the National Collection, of which it is considered a unit, and does not have a separate board of trustees, like the National Gallery of Art.

### Medals Under Mint

Coins and special medals come under the Bureau of the Mint. By law, no regular coin may have its design changed more than once in twenty-five years. The mint traditionally opposes commemorative coins, although not always successfully.

When a piece of medallic art is authorized, the mint may commission an artist directly, have a small competition (as with the Washington quarter in 1932) or a nation-wide one (as with the Jefferson nickel in 1938). It may also utilize its own artists.

This it prefers, particularly in the case of coins, where distribution of the design and maintenance of rims higher than the design's highest point, are technical essentials.

The Commission of Fine Arts acts in an advisory capacity to the mint. But the director of the bureau is ultimately responsible for the project, subject only to approval by the Secretary of the Treasury.

The situation with stamps is somewhat different because of the vast and steadily increasing interest in United States commemorative issues. For many years, these were subject to strong criticism from philatelists, particularly as compared artistically with certain foreign stamps, such as the French.

On March 26, 1957, a seven-member Citizens' Stamp Advisory Committee was established. It has three artist members. Final decision on a new stamp rests with the Postmaster General. Philatelic and art circles generally agree that the pictorial quality of the commemoratives has tended to improve; although controversies over individual stamps continue.

And, indeed, the controversies continue over virtually every phase of the complex Government-Arts relationship in a democracy whose Puritan intellectual heritage started it off with what has been called (by John A. Kouwenhoven, among others) an "anti-aesthetic bias."

December 8, 1958

## SURVEY FINDS RISE IN AID TO THE ARTS

### Chambers of Commerce Are Increasing Patronage

Chambers of Commerce across the country are becoming increasingly active as patrons of cultural causes, according to a nationwide survey by Arts Management, a monthly newsletter now in its fourth issue.

The survey drew replies from 147 cities. They ranged in size from Philadelphia (pop. 2,002,512) to Bettendorf, Iowa (pop. 5,132). The responses covered forty-five states and the District of Columbia; and they came from groups representing more than 100,000 business and individual chamber members.

Asked how important local arts and cultural activities were in attracting tourists to the community, 8.8 per cent of those queried said the arts were a "prime factor." Other ratings were: very important, 33.4 per cent; moderately important, 38; insignificant, 17.1; and no answer, 2.7.

On the question of the importance of such activities in attracting new industry, the breakdown ran: Prime factor, 7.5 per cent; very important, 42.2; moderately important, 34; insignificant, 13.6; no answers, 2.7.

Nearly 20 per cent of the chambers reported making financial contributions to the arts. For example, the Urbana, Ill., Chamber of Commerce underwrites an annual art fair.

#### Art Committees Formed

And a full 80 per cent of the chambers said they supplied non-financial services, such as public relations assistance, to local arts groups or institutions. Many Chambers wrote of having created special committees to maintain liaison with cultural groups—and a total of 27.9 per cent reported having special arts committees.

Written comments supplementing direct answers indicated to the newsletter that Chambers of Commerce were increasingly coming to regard cultural life as contributing to economic vigor.

Alvin Toffler, 34-year-old editor of Arts Management, summed up the project this way:

"The results of the survey reflect the growing rapprochement of business and the arts. There was a time when they were hostile to one another, and the artist lived in a garret and nursed his alienation from our society.

"The idea of a Chamber of Commerce showing an interest in the arts would have provoked bitter laughs. Today this is changing. Not only chambers but corporations themselves are getting involved in the arts.

"What the long-range results of this trend will be nobody can predict. But it will necessarily affect the traditional alienation of the artist and in this way it is likely to have a deep impact on the content of the arts in America."

In its next issue, the newsletter will report on building progress in the arts, according to A. H. Reiss, associate editor. Arts Management's office is at 38 East Fifty-seventh Street.

May 14, 1962

## ARTS COALITIONS AID FUND DRIVES

### Community Councils Gather Here and Praise Method

#### By HEDRICK SMITH

Art patrons in an increasing number of American cities are turning to a community-chest approach to support their cultural activities.

In such cities as St. Paul, Cincinnati, Fort Wayne, Ind., and New Orlean, the symphony orchestras, little theaters and art museums have benefited from the united fund method.

In St. Paul, for instance, art groups were able to raise only $47,000 a year in separate fund drives. Since the formation of the St. Paul Council of Arts and Sciences these groups have raised as much as $180,000 annually.

The trend was reported yesterday by George M. Irwin, a Quincy, Ill., businessman who is president of the Community Arts Councils, Inc. The group, whose directors met here, comprises arts councils in about 100 American and Canadian cities. Local art patrons make up the member groups.

#### Call on Fund Experts

"We've brought in united fund people to teach us fund-raising techniques," Mr. Irwin said. This information will be used in a workshop on fund-raising to be sponsored by the national organization this May in St. Louis.

A similar workshop was held in New York last March. It was attended by about 10 theater directors, orchestra managers and the organizers of civic art festivals.

Another project of the national organization this year is to learn how local groups feel about accepting direct subsidies from the Federal Government.

Many art groups accept support from local and state governments but so far "have felt a little trepidation about the Federal Government's stepping in with direct subsidies," Mr. Irwin explained. "Before we go to Washington, we want to see what the people at home want."

The growth of the united approach to arts support is new to many communities. The first councils were formed in the nineteen-forties.

Generally they have drawn together artistic groups to put on community festivals or build art centers.

"We feel there's a big growth potential for such groups because we get so many inquiries about our work," Mr. Irwin said.

Since its incorporation in 1960, the national organization has helped foster the formation of about a dozen local arts councils. In each community the approach has been different because of individual needs.

Perhaps the most important function of the councils, Mr. Irwin said, is being able "to speak to the community as a united voice for the arts and to promote a general awareness of of the arts not only in the given community but as part of a national trend."

October 21, 1962

## Kennedy Sets Up Arts Council, By-Passing Bills in Congress

Special to The New York Times

WASHINGTON, June 12 — President Kennedy established today the President's Advisory Council on the Arts as the first governmental body to be specifically concerned with arts, artists and art institutions.

The council will be composed of the heads of Federal departments and agencies concerned with the arts, and 30 private citizens who have played a prominent role in the arts. their names will be announced shortly.

Mr. Kennedy said that he hoped the council would keep arts in the United States under survey and "make recommendations in regard to programs, both public and private, which can encourage their development."

He recognized that Congress has before it bills to establish a council and invited the legislators to give the council a statutory basis. However, creating the council now "is both appropriate and urgent." the President said.

There have been reports that the House Rules Committee would continue to block any legislation to set up a council on the arts this year. Because of this situation, the President issued his executive order.

The President suggested that the council should look into five specific problems and areas: examining the opportunities for young people to develop their gifts and to participate in an active cultural life; evaluating "the many new forms and institutions which are developing;" assessing Governmental policies and programs; considering public recognition of excellence, and considering the implications of the national cultural scene for foreign exchange programs in the arts.

June 13, 1963

# PRESIDENT SIGNS ARTS COUNCIL BILL

## Congressional Leaders Hail First Cultural-Aid Law

### By C. P. TRUSSELL
Special to The New York Times

WASHINGTON, Sept. 3— President Johnson today signed a bill to create a National Council of the Arts. It is the first time in the nation's history that legislation to encourage the arts has been enacted into law.

The council, a 25-member panel, will function in the fields of music, drama, dance, folk art literature, architecture, painting, sculpture and industrial and fashion design.

A formal White House announcement of the signing was made in the relase of a list of bills on which the President had acted today.

There was no statement and no information as to how soon the President would make his selections of the panel.

The council will be headed by a full-time chairman whose salary is set at $21,000 a year. The other members will receive $75 a day and travel expenses.

### Duties Are Listed

The council will be charged with duties and responsibilities as follows:

¶To recommend ways to maintain and increase the cultural resources of the United States.

¶To propose methods to encourage private initiative in the arts.

¶To advise and consult with other state, local and Federal agencies on methods of coordinating existing resources and facilities, and for fostering artistic and cultural endeavors and use of the arts, both nationally and internationally, in the best interests of this country.

¶To make studies and recommendations as to how creative activity and high standards and increased opportunities in the arts may be encouraged and promoted.

### Congressmen Pleased

Congressional leaders who sponsored the bill in the Senate and House hailed the signing.

Senator Claiborne Pell, Democrat of Rhode Island, was one of the first to be notified.

"This "is precedent-setting legislation," he said. "Its concepts have been pending before the Congress since 1877, and its passage marks an important step forward in the development of the nation's cultural resources."

Senator Hubert H. Humphrey, the Democratic Vice Presidential nominee, expressed great satisfaction.

"This is a day we have long looked forward to," he said.

Senator Jacob K. Javits and Representative John V. Lindsay of Manhattan, two Republican sponsors, expressed deep satisfaction.

Senator Javits termed it an "historic breakthrough for the American people." Commenting on the inclusion of industrial and fashion design in the arts, Senator Javits said this was a "recognition that art has a place in the garment industry of New York, and that their beauty can be brought to many people."

Representative Lindsay expressed "delight," saying "six years of work has come to fruition."

In a House speech late today, Representative William B. Windnall, Republican of New Jersey, attacked White House policy on the arts. He declared that he had supported the arts council bill but cultural policy was being now motivated by political considerations.

"The President has not yet made any appointments to the National Arts Council," he observed, "but he did make some appointments to the John F. Kennedy Center for the Performing Arts. The appointments give a clear warning that the long-sought National Cultural Center has already become a political football."

He went on:

"The chief qualification for service as a trustee appears to be support of the Democratic party, even to the extent of including Edwin I. Weisl, the newly appointed political boss in New York. Of the 15 appointments, only three can be said to be direct participants in the arts, although, I do recognize that Ed Pauley has been known to dabble in oils in California.

"Despite the great contribution which American Negroes have made to all of the arts, including the performing arts, only one has been appointed to the board of trustees of the J.F.K. Center for the Performing Arts."

The measure that went to the White House fell short of the original plans of sponsors. They had hoped also for a National Arts Foundation, which could start Federal assistance through matching grants to states and nonprofit organizations.

President Kennedy urged approval of a Federal advisory council on the arts in an educational program message to Congress on Feb. 6, 1962. A special Senate subcommittee held hearings and a bill was reported to the Senate, but late in the session. The bill became lost in the adjournment rush.

On May 29, 1963, August Heckscher, special consultant on the arts to President Kennedy, published a report in which he recommended the establishment of an advisory council in the Executive Office of the President. He also recommended a National Arts Foundation to administer grants-in-aid as a logical step in a national cultural policy.

On June 12, 1963, President Kennedy, by Executive Order, established the President's Advisory Council on the Arts, and continued the position of the Special Assistant on the Arts.

September 4, 1964

# The New Art Patron: His Last Name Is 'Inc.'

## Corporate Contributions Help Performers and Audiences More Than Ever Before

### By RICHARD F. SHEPARD

American corporations are giving more to the arts these days than ever before.

In the opinion of persons in several fields of culture, there is every indication that the trend will snowball in the next several years. Even the companies that once based their status as patrons of the arts on the annual issue of illustrated calendars are moving into a new era.

For want of complete information on corporate giving, as distinguished from special foundation grants, it is difficult to estimate total company contributions. Yet, there is a sizable activity. Some is in direct cash but more is in impressively dispersed sponsorship of everything from scenery to the Metropolitan Opera to high-priced art collections.

The National Industrial Conference Board has segregated some statistics in a survey of contributions by 420 companies. These concerns donated $8,239,000 in 1962 for civic and cultural institutions such as symphonies, little theaters, libraries and museums. This represented only 5.3 per cent of all contributions reported by the companies, which gave the bulk of their gifts to educational, health and welfare projects.

### Represented 'High Point'

John H. Watson 3d, manager of the board's company donations department, said that the survey was by no means comprehensive. Even so, the board reported the allotment of 5.3 cents of each contribution dollar represented a "high point," because in earlier surveys such contributions averaged only 3 cents.

Despite the increase, such monetary contributions are tiny compared to the sums that companies give to education and to health institutions.

On the community level, countless companies eagerly contribute to local symphonies, art exhibitions and, lately, to cultural centers. They sponsor television programs that they know will not appeal to the mass audiences. But there seems to be a double-edged hesitancy about contributing to other-than-local cultural activities.

August Heckscher, president of the 20th Century Fund, feels that corporate participation in the arts is growing. But, he observes, many companies are reluctant to contribute, or even to divulge the extent of their contributions to cultural activities except locally for fear of aggravating "taxpayers," who might see just another corporate device for tax deductions.

A second reason for corporate hesitancy is the desire of companies to be associated as directly as possible with projects. Thus, a company may be more than happy to sponsor concerts, dances, recitals and art but it will be reluctant to contribute to the larger projects where it is one donor out of many.

Gardner Cowles, a vice president of the Museum of Modern Art, issued a call for large-scale support from corporations many months ago.

"I had very little luck with companies," said Mr. Cowles, who is president and editor of Cowles Publications. "Most corporation heads took the attitude that this was out of their bailiwick. I fell on my face on that."

Mr. Cowles, saying that he believed sizable company support for museums is five to 10 years off, conceded that corporate reluctance was not uniform.

For instance, Henry Bessire, director of development at the Lincoln Center for the Performing Arts, is encouraged by company responses.

### Seek Broader Base

"In the last five or six years corporations have become increasingly aware of the need for supporting cultural institutions," Mr. Bessire said. "Lincoln Center was one of the first to seek substantial corporate gifts and we hope that our success has contributed to a forward trend in this area. Corporations are now joining with individuals, foundations and governmental units to build a broader base among supporters of the arts."

Lincoln Center has received $9 million from 361 corporations, or 8 per cent of the total contributions received from private sources. Forty-seven companies gave $50,000 or more. Mr. Bessire says that the current appeal for funds is bringing further donations from corporations that had given previously.

Arts Management, a newsletter specializing in information or cultural activity, surveyed 50 large corporations and found that 16 include the arts in their budgets. It reported donations in 1962 ranging from $2,400 by a California company, which gave $119,000 in all, to $237,000 by the Ford Motor Company Fund, which contributed about $5 million to other causes.

The record of achievement is long and constantly growing. Here are some examples:

The Standard Oil Company (New Jersey) has worked in the visual arts for more than 20 years, starting by commissioning American painters to depict the oil industry's war effort. In 1949, it released a brilliant full-length motion picture documentary, "Louisiana Story," produced by the late Robert Flaherty with music by Virgil Thomson.

The International Business Machines Corporation has been a patron of the arts since 1939, when it collected paintings from the 79 countries in which it was then doing business. It has expanded its art activities and maintains permanent galleries, with changing exhibitions, at 16 East 57th Street.

Basic-Witz Furniture Industries, Inc., has commissioned a young composer, Robert Evett, to write a concerto for symphony entitled "Anniversary Concerto: 75" in honor of the company's birthday, and more recently, it sponsored a Van Cliburn concert.

S. C. Johnson and Son, Inc., makers of wax products, have invested $750,000 in a collection of 102 paintings by contemporary American artists for showing both here and abroad.

January 11, 1965

# Vast New Program of Aid For Arts Urged on Nation

## A Report by Rockefeller Brothers Fund Cites Need for Support

### By RICHARD F. SHEPARD

A vast, comprehensive program of augmented nationwide support for the performing arts is called for in an exhaustive report issued today by the Rockefeller Brothers Fund.

The 55,000-word report, two years in the making, finds that the arts are in trouble despite a cultural boom, and urges increased support by Government at all levels, foundations, business and the public.

The most extensive inventory of its kind ever undertaken here, the report examines the problems, goals and methods of progress for nonprofit, professional performing arts such as resident theater, symphonies, operas and dance troupes.

Its objective is to explore ways to expand the performing arts in the United States without sacrificing indispensable high standards. The report is the seventh done by the fund's Special Studies Project. Since 1958 the project has studied foreign policy, defense, education, economics, democracy and economic and social aspects of American life.

The performing arts were chosen as a topic because, the report says, "the arts are not for a privileged few but for the many; their place is not on the periphery of society but at its center."

Most of today's cultural expansion represents amateur activity, the report finds. Comparatively few Americans see live professional performances, which are largely seasonal.

### Specific Goals Fixed

The report concludes that ultimately performing arts should be considered as a year-round contribution. It makes specific proposals, as an interim goal, for permanent companies for each of the arts, to supplement those already in existence.

The study, published today by the McGraw-Hill Book Company in a $4.95 clothbound edition and a $1.95 paperback under the title "The Performing Arts: Problems and Prospects," says, "In spite of tremendous growth and exciting promise, the performing arts as we see them today are in trouble."

A 30-person panel, headed by John D. Rockefeller 3d, board chairman of the Lincoln Center for the Performing Arts, met in five two-day sessions to agree on 27 recommendations. The panel was made up of representatives of the arts, humanities, business and labor.

It made its decisions on the basis of what was learned from 40 witnesses from the arts and other fields, from 30 specially commissioned papers, and from more than 400 interviews conducted by staff members. The staff surveyed 100 corporations, 8 states and 47 municipalities.

"Our work is not intended to provide all of the answers," Mr. Rockefeller said. "Rather it is a challenge. The presentation of facts on a focus basis can be meaningful and helpful. We are attempting to point the way to action. The arts are foging ahead. They are moving fast and facing real problems."

### Problems Are Listed

Some of the problems outlined in the report are:

¶A lack of service and information organizations to provide badly needed statistics that could guide growth.

¶A dearth of performing arts organization that could provide facilities for presentations or that could sponsor dance or opera companies in large population centers.

¶Poor pay for most performing artists, and short seasons that make for unemployment.

¶A need for technological research. "The performing arts have been laggard in sharing the research revolution."

¶A need for marked improvement in the quality of training for artists. For instance, there is an acute shortage of well-trained stringed instrument players for orchestras.

¶Perennial crisis financing. Fiscal problems increase even at a time when there is more public interest in the arts.

¶Woefully inadequate physical facilities, despite the growth of centers.

While more than 100 so-called cultural centers are being built or planned, the report states only about 30 are true art centers that can handle more than one performing art. Others are basically sports arenas or convention halls.

The major recommendations fall into the following categories:

### GOVERNMENT

While government should in no circumstances "vitiate private initiative, reduce private responsibility for direction or hamper complete artistic freedom, the relationship, traditionally standoffish, between government and the performing arts must be examined anew.

"Increasingly the question has been not whether government should act but how it should act and at what level and by what principles it should shape its policy," the report observed.

The Federal Government should develop the newly formed National Council on the Arts, strengthen existing Federal arts programs and administer programs that indirectly affect the arts with a greater awareness of their cultural implications. It should also provide matching grants for the construction of facilities.

The report called for changes in the copyright law, which now permits juke boxes to avoid royalty payments, and suggested that the duration of copyrights be extended to protect artists. It urged abolition of the 10 per cent tax on tickets for the commercial theater, which it described as "the experimental laboratory for drama in the United States."

State government should foster arts councils, remove tax burdens and restrictive legislation, support touring programs, encourage regional cooperation and assess arts resources.

Local governments can strengthen local arts groups by insuring adequate facilities, providing funds for operating costs, supplying supporting services, purchasing arts organization services for schools and community activities and exempting such groups from taxes and license fees. Perhaps most important, the study of the arts, for appreciation and performance, should be part of school curriculums.

### BUSINESS

Of all corporate contributions to all causes, only 3 or 4 per cent go to the arts. Only a few more than half of all corporations give anything at all to the arts. Corporate contributions can make a life-and-death difference to performing arts organizations. Companies should realize that a healthy cultural environment is in the self-interest of the business community.

### FOUNDATIONS

The performing arts are often inept in seeking foundation grants. Foundation support is "minuscule," although there is some evidence of a general increase. The role of local foundations may be as important as any single factor in the development of the arts. They should provide continuing support.

National foundations can contribute most effectively in areas of planning and innovation. Foundations are particularly well suited to encourage bold and venturesome projects.

### PUBLIC

Of the nation's total philanthropic giving, cultural projects receive only about $200 million a year, or less than 2 per cent of the whole. Performing arts get much less than half of this small sum. Despite tax burdens on larger incomes, high and middle income brackets can still provide more support.

### EDUCATION

Training schools and conservatories of recognized standards, which have been disappearing in the last decade, must be strengthened because they produce the majority of solo artists and ensemble musicians of our finest musical institutions as well as our best-trained actors and virtually all our professional dancers.

Universities and colleges will play an increasingly important role in training artists. They should adjust admission policies and curricular requirements for such students and should attract the most highly qualified artists to their faculties. There is an urgent need to redress the existing imbalance in the financial support of the physical sciences and that of the arts and humanities in universities.

Effective exposure of the young to the arts is as much a civic responsibility as health and welfare programs.

### AUDIENCE

The performing arts should not be required to live entirely on box office receipts, and "indeed, they cannot do so and still fulfill their true cultural mission."

There is a need for touring companies as well as for many more resident professional performing arts organizations

throughout the country. The mobility of the arts must be increased by new means on a new scale.

Broadcasting and records play an important role in making quality works available to large audiences. Commercial television should improve its methods of presentation and programming, and communities should provide support for educational TV.

"Thriving amateurism" can play a major role in creating audiences for high-quality professional performances and should be encouraged.

### ORGANIZATION

"Board members should be as carefully screened as performers."

Officials should be receptive to change and innovation. Full-time paid chief executives and presidents should be considered.

"Too often the dilettante mentality—belief that all that is needed for success is talented artists—prevails. But a good orchestra, a good theater, a good opera or dance group cannot be established or run by well-wishing volunteers."

Often unions cooperate with management to help the performing arts. On the other hand, featherbedding and needless extra charges afflict the theater. No artist should be called upon to subsidize the performing arts by working for low wages.

### GOALS

The nation's artistic goal will be realized when "the performing arts are considered a permanent year-round contribution to communities around the country and our artists are considered as necessary as our educators."

Until this long-term goal is achieved, an interim objective would be to develop and maintain a number of companies that would operate on a 12-month basis, in contrast to the seasonal operation of most organizations at present.

These would consist of the following:

¶Fifty permanent theater companies, approximating the metropolitan areas with populations of more than 500,000, sufficiently large to support year-round resident theater.

¶Fifty symphony orchestras, which would provide, along with full-orchestra concerts, musicians for smaller musical groups.

¶Six regional opera companies, offering short seasons in several metropolitan areas not yet ready to support year-round performances. These would be in addition to the present four major resident companies and two permanent national touring companies.

¶Six regional choral groups.

¶Six regional dance companies in addition to the two major resident dance groups already established.

The report estimates that, at present, $60 million is being spent each year to operate high-quality nonprofit arts organizations, excluding commercial theater and semi-professional and amateur activity.

"Well-informed estimates of the annual operating cost of the establishment outlined for the future fall between $150 million and $200 million," the report said. "Therefore, somewhere between $90 million and $140 million of additional operating funds would be needed."

Tickets could account for between $50 million and $80 mil-

lion a year, the report continued. The proposed arts establishment would then need between $40 and $60 million annually from other sources for normal operating expenses. This estimate is based on current costs, and does not take into account capital expenditures for more and better halls and theaters.

"The larger amount is not much over one-hundredth of 1 per cent of the nation's present annual income," the panel observed.

In addition to Mr. Rockefeller, the following persons were panel members:

Patricia M. Baillargeon, board member of the Seattle Repertory Theater and Seattle Youth Symphony.

Walker L. Cisler, a director of the Detroit Symphony Orchestra.

Kenneth N. Dayton, a director and past president of the Minnesota Orchestral Association.

T. Keith Glennan, president of Case Institute of Technology.

Samuel B. Gould, president of the State University of New York.

William B. Hartsfield, trustee of the Atlanta Symphony Orchestra and the Atlanta Music Festival Association.

August Heckscher, director of the Twentieth Century Fund and trustee of the National Repertory Theater Foundation.

Margaret Hickey, senior editor for public affairs of the Ladies' Home Journal.

Norris Houghton, co-founder of the Phoenix Theater.

Devereux C. Josephs, vice chairman of the board of Lincoln Center, trustee of the Metropolitan Museum of Art and the New York Public Library.

Abbott Kaplan, chairman of the board of the Theater Group and chairman of the California Arts Commission.

Dexter M. Keezer, economic adviser of McGraw-Hill, Inc.

Louis Kronenberger, professor of theater arts, Brandeis University.

Warner Lawson, dean of the Col-

lege of Fine Arts of Howard University, member of the advisory committees on arts for the State Department and of the John F. Kennedy Center for the Performing Arts.

John H. MacFadyen, architect and former executive director of the New York State Council on the Arts.

Stanley Marcus, director of the Community Arts Fund of Dallas, the Dallas Symphony Orchestra and the Dallas Theater Center.

Henry Allen Moe, president and board chairman of the New York State Historical Association and president of the American Philosophical Society.

James F. Oates Jr., trustee of the American Museum of Natural History.

Perry T. Rathbone, director of the Boston Museum of Fine Arts.

Oliver Rea, managing director of the Minnesota Theater Company Foundation, Tyrone Guthrie Theater.

Joseph Verner Reed Sr., chairman of the board and executive producer of the American Shakespeare Festival Theater.

Samuel R. Rosenbaum, trustee of the Recording Industries Music Performance Trust Fund.

Emile H. Serposs, director of the music division of the Chicago public schools.

Charles M. Spofford, director and chairman of the Metropolitan Opera Association's executive committee and vice chairman of the board and executive committee chairman of Lincoln Center.

Dr. Frank Stanton, president of the Columbia Broadcasting System.

James A. Suffridge, international president of the Retail Clerks International Association.

Helen M. Thompson, executive vice president of the American Symphony Orchestra League.

Frazar B. Wilde, board chairman of the Connecticut General Life Insurance Company.

Harold Lionel Zellerbach, president of the San Francisco Ballet Guild.

*March 8, 1965*

---

### Johnson Signs Culture Bill at White House Ceremony

WASHINGTON, Sept. 29 (UPI)—President Johnson signed today a multi-million-dollar cultural development program "to make fresher the winds of art in our land." As a first step, he announced plans to create a national repertory theater.

At a White House Rose Garden

ceremony attended by the who's who of the arts, from painters to television performers, Mr. Johnson said the Government-financed repertory theater would take theater classics to audiences throughout the country.

In addition, Mr. Johnson said, the Federal Government working

with states, cities and private organizations all over the country, will:

¶Support a national opera company and a national ballet company.

¶Create a film agency to make it easier for talented young Americans with movie aspirations to break into the field.

¶Commission new works of music by American composers and support symphony orchestras.

¶Create residence grants at colleges and universities to attract great artists to the campuses.

*September 30, 1965*

---

# Tax Laws Make U.S. a Patron of Arts

**By JOHN CANADAY**

In the midst of discussions as to the responsibility of the Federal Government in sponsoring the arts, it is clear that, inadvertently, in terms of money, the Federal Government has for some time been the most lavish patron of the arts since the Renaissance.

Taxes are the answer, as outlined in an article by Jerome S. Rubin in the current issue of Horizon magazine. "The phenomenal growth of public

art collections in this country has corresponded very closely with the imposition of certain taxes over the past generation or so," says Marshall B. Davidson, Horizon's editor, in an introduction.

And, in the meantime, the Government has been reluctant to assume the role of patron in any overt form except in the extreme depth of the Depression.

The 16th Amendment of 1913, permitting the imposition of a Federal tax on income, snow-

balled in an unexpected direction. The "baronial collections" amassed over generations in Europe became impossible in America, less because the market in old masters was reduced than because the collection of baronial wealth became impossible.

Nevertheless, the loophole of tax exemptions on gifts has created collections of staggering dimensions. What was formerly amassed over generations has been amassed in decades, surpassing in quantity and often

equaling in quality the collections of the past. But the collections are necessarily public, since estate taxes and the gift tax on the transfer of property to family and friends is prohibitive in the financial stratosphere where great collecting must take place.

Mr. Rubin, himself a lawyer with a strong side interest in art, notes that another lawyer-collector, John G. Johnson of Philadelphia, estimated that one of his clients, Henry Clay Frick, was spending between $2-million and $4-million a year on art. J. Pierpont Morgan, P. A. B. Widener and H. O.

376

Havemeyer, other baronial names in American collecting, were also among Mr. Johnson's clients, although he missed a couple of top rankers—Benjamin Altman and Andrew B. Mellon.

In a younger group, Henry Walters in Baltimore, Henry E. Huntington in California ($750,-000 for Gainsborough's "Blue Boy") and Albert Barnes rivaled the collectors of the golden age and, like them, had to meet the problem of saving their collections by giving them up in one way or another.

What Mr. Rubin calls "the felicitous union of public benefaction and private tax saving" was responsible for the origin of the splendid National Gallery of Art in Washington.

In 1934, Mr. Rubin explains, Andrew Mellon had "a brush" with the Commissioner of Internal Revenue, who found a deficiency in the financier's 1931 income tax to the amount of $1,319,080.90, plus a 50 per cent

fraud penalty. Matters grew yet more fantastic when Mellon—who had been Secretary of the Treasury during the year in question—denied fraud to claim, instead, a slight overpayment of $139,045.17.

The Commissioner's riposte was a refiguring that raised the deficiency and penalty to a total of $3,089,261.24, to which Mellon's riposte-riposte was that he had neglected to claim a charitable deduction for the gift of five paintings to a charitable trust conceived with the idea of establishing a national art gallery in Washington.

The paintings were no mean quintet—Raphael's "Alba Madonna," Perugino's "Crucifixion," Titian's "Venus With a Mirror," Jan van Eyck's "Annunciation" and Botticelli's "Adoration of the Magi." They had been purchased from the Hermitage in Leningrad for $3,-247,695 at a time when the Soviet Government was, in effect,

trading culture for industrialization.

#### A Bird in Hand

Mellon had not made public his plans for the gallery, but the Board of Tax Appeals, apparently deciding that the bird, now being publicly out of the bush and firmly in hand, was worth the deduction, allowed it. Thus, the National Gallery (with another $36 million from Mellon in subsequent gifts) was born as the greatest single tax deduction of its kind in history, and perhaps the most rewarding, all told, to the public.

Since then, the National Gallery's collections have grown beyond anyone's fondest dreams as other collectors have saved money and won immortality by giving millions of dollars back to the millions of the national population, who in the end, of course, must bear the tax loss.

The public does not always get its money back in such worthwhile form. In recent years, the complexities of tax

laws have been manipulated by collector-investors who have as keen an eye for the fluctuations of the art market as for any esthetic values — and often a keener eye.

Leaping from one fad to another, the agile art lover can buy a contemporary painting cheap and then give it to a museum at an appraisal value so large that he makes money by buying in order to donate. The fact that what he gives may be appraised as next to worthless 10 or 20 years from now makes no difference.

Mr. Rubin's article is a witty and dizzying survey of what has happened already and a somewhat disturbing hint — only a hint—at what is going on. It leaves no question as to the appropriateness of awarding the title of American Medici to the Internal Revenue Service.

December 28, 1965

# The Arts Feeling Economic Squeeze

**By HOWARD TAUBMAN**

The arts, which in recent years have been grappling with inflation, are now threatened by the slowed economy and the precipitous fall in the stock market.

For orchestras, operas, dance companies, theaters, museums, cultural centers and other institutions, the impact has been frightening. At some institutions fear for survival has intensified. Others, including the most prestigious and secure, worry that services will have to be curtailed.

Heads of arts institutions and expert observers believe that the full impact of inflation, the slowed economy and the drop in stock prices will not be felt until later in the year when new fundraising campaigns begin. But there are enough signs to make clear that grave troubles lie ahead:

¶Some arts institutions that had planned extensive fund-raising campaigns have postponed them indefinitely.

¶People who have made generous pledges to arts institutions have asked to delay payments because the worth of securities, which they plan to use for such payments, has depreciated drastically.

¶Major corporations have announced reductions in profits, and contributions to the arts in a few instances

are beginning to be cut.

¶In their efforts to meet increased operating costs caused by unavoidably higher outlays for salaries and materials, arts institutions are being forced to forgo important commitments. Thus, museums are holding up on new acquisitions, and performing arts companies are cutting down on tours.

¶Single-seat sales for concerts, plays and other events have fallen off, though the effect on subscriptions will not be manifest until later in the year.

The Museum of Modern Art may be taken as an example of how the economic situation has affected a well-established institution. According to John M. Hightower, who became director a few weeks ago after serving as director of the New York State Arts Council, the museum's endowment has fallen in recent months from a worth of $25-million to $17-million.

"For the moment," Mr. Hightower said, "income from this endowment has not been seriously affected, thanks to the nature of our investments. But if dividends are reduced, as may very well happen, we would be badly hurt.

"To sum up our situation: in the last few years we have been forced to increase our deficit, and if it continues to increase at the projected rate the museum could be out of business by 1975. The only solution is to find more

money from new sources. The state of the economy is a big problem, and so is the fact that the Federal Government seems to be trying to turn off the tap of foundation money."

Mr. Hightower said that more financial help than ever before would have to come from government bodies. He described the $20-million appropriation requested by President Nixon this year for the National Arts Endowment as "woefully inadequate."

He added that the $18-million voted this year by the state Legislature for emergency assistance to cultural institutions would be helpful but that it would turn out to be merely "a stopgap" if its remained only a one-year appropriation.

Amyas Ames, chairman of Lincoln Center for the Performing Arts and the New York Philharmonic, asserted that the overriding problem for arts institutions was inflation, but added that the stock market drop was bound to have a serious effect.

"I am deeply concerned that we are moving into a most difficult period," he said. "In a time like this the good things are likely to be hurt. The basic things go on, but in a recession there is an extra deep crisis for the arts, for education, for scientific research.

"The New York Philharmonic, for example, is doing better han last year on subscription renewals, but I fear a slowing down in the arts as the result of the troubles of the economy. I would hope for this reason that in a time

like this people would pay more attention than ever to the arts, for they are so central to the quality of living."

Kyran McGrah, director of the American Association of Museums, observed that for most museums there was not much area for maneuver and no place to cut back.

"The best a good many museums can manage is to maintain the status quo," he said, "and that is painful. Just look at the increase in attendance.

"In 1967, American mutain seums had a total attendance of about 300 million, and in 1968 the figure leaped to 560 million. By next year it is expected to reach a billion. If the museums do not get significant help, they will have to eliminate services, especially educational activities for children and adults."

Ralph W. Burgard, director of state, county and city relations for the Associated Councils of the Arts, pointed out that the nation's economic difficulties had begun to have their effect in 1969.

"A good many united arts campaigns failed to make their goals last year," he said. "The pressure is therefore increasing on government bodies. Everyone knows that cities are impoverished and faced by difficult problems, but it may be that the county governments can do more for the arts."

G. S. McClellan, president of the Business Committee for he Arts, said that it was a little too early to know whether the business situation would have a widespread depressing effect on corporate contributions to the arts.

"There has been a lot of worried talk," he conceded. "Corporate executives would

find it more difficult to cut down on such things as hospitals and schools than on the arts. On the other hand, some corporations might see the cultural area as one where they might get a more satisfactory return for their money than from some other areas, such as campuses with their student turmoil. However, most corporate budgets are made in the fall and we'll know better then."

Many American orchestras have already reached a critical situation because of inflation, expanded seasons and increased salaries. Their troubles in some cities have been intensified, according to a leading concert manager, by urban unrest.

"In one Midwestern city," this manager said, "where there has been a lot of civil disturbances, orchestra patrons have become wary of attending concerts because the symphony's hall is not in the best part of town and people are afraid to go out at night."

The future of concerts and other cultural touring events is being conditioned by the national mood, which is affected by the war in Indochina, the draft and civil rights as well as the economic decline.

"What happens on campuses is important to the arts," another manager said. "Ten years ago there were about 50 campuses that catered to fine cultural tastes by bringing in good music, theater and dance performances, and now there are more than 300. But tastes on campuses are changing, and the recent unrest is adding to the speed of change.

"In music, what is wanted now more often than not is pre-classical and contemporary programs. Pop groups are increasingly 'in.' And as a result established musical organizations are losing part of their market and are sustaining further economic losses."

May 23, 1970

# ARTS MANAGERS LEARN BUSINESS

## Harvard Program Teaches Modern Techniques

### By JON NORDHEIMER
Special to The New York Times

CAMBRIDGE, Mass. — Some 85 managers of museums, galleries, orchestras, theater and dance companies, community arts centers and other artistic ventures have recently completed a four-week course in modern management tools.

At the Third Institute in Arts Administration, an annual program sponsored by the Harvard Summer School, they learned how to apply market research, computer simulation and systems analysis to the arts.

The program's basic premise is that cultural institutions must stop keeping their accounts on the backs of envelopes and begin using their resources better. "No longer can arts organizations afford to have as their administrators either 'artistic fellow travelers' untutored and inexperienced in management practices or 'interested' businessmen with limited artistic orientation" said the foreword to the program's casebook. "Rather they must turn increasingly to those individuals with both training in administration and sensitivity to artistic standards."

### Case Method Used

To help, Harvard has adapted its case method, the time-honored technique used to educate generations of lawyers and business executives by which students solve the problems of real and sometimes disguised cases.

Supervising the program were Douglas Schwalbe, director of the institute and managing director of Harvard's Loeb Drama Center, and Profs. Thomas C. Raymond and Stephen A. Greyser of the Harvard Business School. Tuition was $595.

Professor Raymond, who has made a specialty of studying the impact of outside forces on organizations, said the main object of the course was to teach "how to administer effectively without affecting the quality of the artistic product." The task was complicated somewhat, he said, by the fact that the students knew "amazingly little about basic fiscal things."

In a sense, management in the arts is harder than in ordinary business. A toothpaste manufacturer measures his success simply by looking at his balance sheet, but in the arts achievement is obviously much less tangible. Still, he said, artistic organizations have much in common with business.

They must raise money, budget it, hire and fire, advertise, deal with unions and allocate resources, he said.

### Four Main Categories

Several other universities, including Wisconsin and the University of California at Los Angels, have degree programs in arts management, but the organizers of the Harvard program believe theirs is the only one designed to train officials in mid-career.

The 24 cases used in this program fell into four main categories, basic management, administering arts organizations, impact on management of artistic criteria and public policy and the arts administrator.

For example, the "Symphony of the Sierras" case explored the problem of an orchestra manager trying to decide whether and how to raise ticket prices, taking advantage of audience research data. Another dealt with "Lights Out at the Met," a review of the 1969 labor dispute at the Metropolitan Opera and its implications.

Still other cases were concerned with the problem of assessing the cultural needs of a community and balancing them against available resources.

August 6, 1972

# First Private Foundation To Aid the Arts Is Set Up

### By GRACE GLUECK

The first private foundation on a national scale devoted solely to the arts and the humanities is now being incorporated by a group of arts patrons and professionals. To head it, W. McNeil Lowry will leave next June his post as vice president of the Ford Foundation's humanities and arts division, where since 1957 he has dispensed more than $306-million.

Aimed at fostering "creative talents and humanistic values," the multimillion dollar Foundation for the Humanities and the Arts will have, according to Mr. Lowry, "as major a presence as any foundation now existing in the private sector." Although

Mr. Lowry refuses to give financial details, other sources in the field predict that the foundation's endowment, drawn solely from private patrons, will stand at several hundred million dollars in five to seven years.

The giant private foundations now existing, such as the Ford Foundation, the Rockefeller Foundation and the Andrew W. Mellon Foundation, give relatively modest budgetary shares to the arts in their broad spectrum of programs.

Ford, the largest private contributor in the arts, appropriates between 7 and 10 per cent of its annual regular budget for them.

The only existing agencies that give money exclusively to the arts and the humanities are the Federally funded National Endowment for the Arts and the National Endowment for the Humanities. In fiscal 1973 the former gave $38-million to the arts, and next year will give over $60-million. The humanities agency gave nearly $40-million in fiscal 1973; next year it will give a possible $57.5-million.

Mr. Lowry emphasizes, however, that it is private patrons—including foundations — that provide the major support for the arts, and says that the balance will not shift "during our lifetime" to Government funding. Because of its private commitments, he noted, the new foundation would be able to "concentrate on creative and humanistic values without the urgent and often vital pressures of short-term empirical goals."

Noting that he spoke for incorporating members of the new foundation, Mr. Lowry suggested that the formation of an exclusively arts-oriented agency was "a great symbolic move at this time, in view of an almost universal questioning of the American tradition and its moral and spiritual health."

The new foundation, according to Mr. Lowry, will not substitute for any resources now being invested in the humanities and the arts by national and local foundations, public tax programs or private arts patrons.

In fact, he noted, while not duplicating any other funds, it would cooperate with the Ford, Rockefeller, Mellon and other private foundations in the field, and with the National Endowments for the Arts and Humanities, as well as with state and municipal agencies. He said he felt that the new agency would actually stimulate other foundations to increase their arts

appropriations.

That sentiment was echoed yesterday by McGeorge Bundy, president of the Ford Foundation, which made a commitment last year to continue its level of support of the arts for another decade. Mr. Bundy said he welcomed the prospect of the new foundation as "enlarging the resources going into the arts. We've always felt that one of the best things that can happen is pluralism—for others to take increasingly strong roles."

The foundation's incorporating members, who will soon elect a board of trustees, include artistic, intellectual and public leaders. Among them are Robert Lowell, the poet; Mrs. Vincent Astor, the philanthropist; Lincoln Kirstein, ballet director, writer and critic; Rudolf Serkin, the pianist; the singer Betty Allen and Representative Frank Thompson Jr. of New Jersey, who helped write the original legislation that established the National Endowments.

The new foundation is unique in its broad-based support. Whereas existing foundations are financed by single-family endowments, this one will draw on a wide variety of funding sources.

The idea for the foundation came to him, Mr. Lowry said, after he had been prodded during the last few years by a number of people "who wanted to know how to go about starting one. I finally realized I was being asked indirectly to do it myself."

At first doubtful over the financing of such a project, he came to feel that peo-

ple of wealth in various communities wanted a chance to participate in a national fund, "to influence a national value system."

Existing foundations did not allow for individual participation, he explained, and the new foundation would provide a "mechanism" through which donors could contribute what they wanted to local projects but also have "a national input." The majority of the board of trustees, he suggested, would be "strongly involved professionals," who would serve with a small core of knowledgeable patrons of the arts.

Among the roles of the new foundation, Mr. Lowry said, would be that of giving "the widest currency to testaments of the importance of creative and humanistic values and resources throughout the American society, from a platform not encumbered by other critical, social, economic, educational and political issues."

Its activities might include:

¶Providing technical assistance for artistic persons and culturally oriented groups and institutions, embracing management, legal and fiscal goals, returns from investment and the building of audiences.

¶Affording "directly or indirectly opportunities for young humanists and talented creative or performing artists at key stages in their careers."

¶Supporting "experiments, demonstrations and studies that form pilots; opening new avenues in the creative and performing arts so as to

strengthen the humanistic tradition and set standards of quality and leadership."

¶Directly supporting "key artistic and humanistic groups or institutions on criteria of quality."

¶"Studying, collecting and disseminating throughout the United States the procedures and results of successful projects through which the arts have helped to give personal and social identity and goals to persons of all economic, ethnic and other particular cultural or social significance."

Mr. Lowry is 60 years old, an age when the Ford Foundation requires its executive officers to retire. He explained that although the foundation had nevertheless asked him to continue as a general executive officer until 1978, he had decided that "the new foundation has overriding importance."

The Kansas-born, ex-teacher of literature has spent 20 years on the staff of the Ford Foundation, serving as director of its education program, vice president for policy and planning and acting chief executive officer. In 1957 he set up the humanities and arts division, the first such program in the United States, and has since served as its head.

During his tenure, the division has made such major grants as $80.2-million to assist 61 symphony orchestras, $7.7-million to eight ballet organizations, and extensive funding to theater and opera companies and other performing and creative arts groups. A strong believer in private

philanthropy, Mr. Lowry said that in his new job he would continue to work with Congress and the public in advancing the cause of organized private philanthropy "as one means of ensuring pluralism and diversity in choices made within the American system."

Yesterday Mr. Bundy said of Mr. Lowry: "We take an affirmative attitude toward Mac and any new projects of his. We warmly wish him success."

### The Patrons

Following is a list of the foundation's incorporating members:

Betty Allen, singer.
Mrs. Vincent Astor, philanthropist and museum trustee.
Aaron Copland, composer.
Phylis Curtin, singer.
Larry Deutsch, secretary-treasurer, Adolph's, Ltd.
John Houseman, director, producer, writer.
C. Bernard Jackson, executive director, Inner City Cultural Center, Los Angeles.
Phillip C. Johnson, architect.
Lincoln Kirstein, writer, scholar; general director, New York City Ballet
Roy E. Larsen, vice-chairman, Time, Inc.
Sherman Lee, director, Cleveland Museum of Fine Arts.
Goddard Lieberson, musician, president, CBS-Columbia Group.
Robert Lowell, poet.
W. McNeil Lowry, foundation executive.
Lloyd Rigler, President, Adolph's Ltd.
Andrew C. Ritchie, curator, scholar, museum director.
Merrill Rueppel, Director, Boston Museum of Fine Arts.
Mrs. Madeleine Haas Russell, museum trustee, San Francisco.
Mrs. Stella Saitonstall, arts patron.
Alan Schneider, director, writer.
Rudolf Serkin, pianist; director, Curtis Institute.
Laurence Sickman, Director, William Rockhill Nelson Gallery, Kansas City, Mo.
Peter Smith, director, Hopkins Center, Dartmouth College.
Representative Frank Thompson Jr. of New Jersey.
Virgil Thomson, composer, critic, writer.
June Wayne, artist.
Harold L. Zellerbach, director, Zellerbach Paper Corporation.

December 5, 1973

# Museums Cut Back in Funds Crisis

**By GEORGE GENT**

Since 1966, financial pressures have resulted in cutbacks in facilities, services or staff for 36 per cent of all the country's museums, a just-released nationwide survey disclosed. And, despite large increases in state and Federal funding of the arts, 63 per cent of the more than $513-million received by the art, history and science museums covered in the study came from the private sector.

The report, the most comprehensive ever on American museums, is previewed in a booklet titled "Museums U.S.A. Highlights," issued by the National Endowment for the Arts. The full study, representing the first large-scale research effort of the Endowment and the National Council on the Arts, is

scheduled to be published in a book next spring.

### Other Findings of Study

Among the other findings were:

There are approximately 1,821 art, history and science museums in the 50 states and the District of Columbia that met the six criteria established for inclusion in the study: permanence of facilities; availability to visitors; operating budget of $1,000 or more a month; at least part ownership of collections; at least one specially trained employe for each major subject; nonprofit tax-exempt status of the organization.

¶A total of 308,205,000 visits were made to these institutions in fiscal 1971.

¶Budgets reflected in the study ranged from $3,700 to

more than 20-million. Forty-four per cent of all museums had annual operating budgets of less than $50,000 and 10 per cent had budgets of $500,000 and over.

¶The total museum work force, including volunteers, is more than 110,000. Of these, 30,400 are full-time paid personnel, 18,700 are paid part-timers and 64,200 are volunteer

### Old Facilities Cited

The study also showed that the primary facilities of 41 per cent of the nation's museums are at least 30 years old and that 20 per cent are using facilities more than 50 years old. The majority of the nation's museums also provide special programs for school children, the study shows, with 73 per cent of the institutions

offering regularly scheduled programs and 20 per cent more providing them on occasion.

Commenting on the study, Nancy Hanks, chairman of both the National Council and the National Endowment, said it was hoped that the survey's findings "will be of great assistance" to museums in assessing themselves; to the local state and Federal Government funding sources in helping to determine their needs, and to the public "in understanding the role of the museum in the life of the community and the nation."

The survey was conducted by the National Research Center of the Arts, Inc., an affiliate of Louis Harris & Associates. An advisory panel of 26 museum experts participated in all phases of the study along with members of the National Council's and National Endowment's Museum Advisory Panel.

December 9, 1973

# The Coming Crisis for the Arts: Who's Going To Foot the Bill?

## By ROBERT BRUSTEIN

FUNDING for the performing arts —a relatively arcane subject that usually doesn't interest anyone except us poor beggars who have to rattle the tin cup—is now threatening to become a topic of national debate as a result of a report recently issued by the Ford Foundation. The report, which was four years in the making and cost $500,000 to produce, is titled "The Finances of the Arts." What this weighty, massive, 446-page document manages to say—by means of summaries of answers to questionnaires, graphs, statistics, computer analysis, sociological data and other such entertaining devices—is that if you think the performing arts are in financial trouble now, just wait until 1981. Assuming even the most optimistic upturn in the economy, the "earnings gap" (the Foundation's current euphemism for "deficit") is expected to increase threefold in the next seven years, and the increase is more likely to be almost sixfold when all the inflationary effects are taken into account.

The Ford report concludes its narrative section with the warning that "if the arts are to remain healthy and to make the contribution to the conditions of human existence they are capable of, they will require increasing support from public funds, from corporations and, above all, from the private sector, particularly private patrons." Conspicuously missing from this list of sponsors are the private foundations, traditionally one of the most important sources of funding for the performing arts. And the Ford report hints that its own Foundation will not only be unable to increase its support in the future but will probably be cutting back soon because of the impact of inflation on its portfolio (the Rockefeller Foundation, second to Ford in this area, has already cut its arts budget almost in half in response to a reordering of priorities by its new president, John Knowles). Thus, the Ford Foundation has spent half a million dollars—a sum equal to the total annual budget of a modest resident theater—to announce that the only hope for the future lies with the National Endowment for the Arts, the city and state cultural councils, the business community, and the "private sector," namely, you, me, and our various wealthy relatives and friends.

Well, I don't know about you, but I am not in very good shape these days to make charitable contributions to the performing arts in addition to the

*Robert Brustein is director of the Yale Repertory Theater and dean of the Yale School of Drama.*

**"At the present time, the U.S. contributes less to the arts per capita than any other major country."**

price I pay for theater, opera, symphony, ballet and dance tickets, and I have an ominous feeling that the problem is widely shared—that if the arts had to depend on the voluntary largesse of private patrons, they would soon be extinct. This feeling was recently confirmed by a somewhat less expensive survey that we at Yale conducted through an appeal inserted in one of our Repertory Theater programs asking for tax-free contributions to

help keep our theater afloat: we received from a (very enthusiastic) audience of more than 10,000 exactly $33.50. What this may suggest—and what the Ford report fails to consider—is that inflation is presently hitting the individual pocketbook so hard that the private sector is no longer able to afford many donations to the per-

forming arts, if indeed it can still afford the price of a subscription ticket.

So, if the private sector is not likely to prove a very dependable fount of money for the performing arts, what about the other sources mentioned in the Ford report? Let us consider the prospects for funding from some of these sources—and also consider the record of Ford itself, along with the other private foundations—with an eye to the possibility of their underwriting the cultural well-being of the country in the future.

Certainly, the business community represents a great reservoir of support in this area, but so far, that reservoir remains relatively untapped. A number of committed businessmen have been trying to open the sluices through councils, committees, conferences and exhortations, and smaller corporations often make contributions to the local dance company or symphony. Still, grants of this kind are usually minimal, designed more as token civic gestures than as genuine support. A larger contribution is made by the national corporations (corporate giving almost trebled between 1965 and 1970), and institutions like Xerox, Exxon and IBM have been underwriting many expensive television programs that feature theater, music, and dance. Unfortunately, much of this seems to be an alternative form of commercial sponsorship in which the corporation moves its product through an appearance of public spiritedness rather than hard sell—and it doesn't do much, if anything, for the performing arts organization outside of providing it with exposure and a small royalty from the television appearance. There are a number of exceptions to this generalization (one that I know of personally is the CBS Foundation's altruistic grant to Yale for support of playwrights and production of their new plays), but on the whole the business community has yet to regard the performing arts as valuable in themselves and not just a dignified vehicle for institutional advertising. I would be surprised, though delighted, to find this policy changing in future.

What about the Government? Admittedly, Federal funds for the arts have been expanding over the past ten years, and, contrary to the fears of those who thought the National Endowment

for the Arts would be philistine in its posture and political in its control, this agency now constitutes the most enlightened, as well as the most generous, source of support in the country. Under the leadership of Nancy Hanks, appropriations for the arts have grown from $2.5-million in fiscal 1965 to $72-million in fiscal 1975, and there is every reason to hope that if the increase continues at its present rate, the contribution of the United States to the performing arts may soon be equal to that of the city of Vienna. Obviously, the National Endowment, despite its great strides and its promise of hope for the future, is still far from matching the record of the arts councils in England and Europe (for example, West Germany's support for the theater alone amounts to $35-million annually); at the present time, the U.S. contributes less to the arts per capita than any major country, including Canada.

The plain fact is that the National Endowment's rapid acceleration is not overcoming its late start, while Congressional resistance grows stronger as the annual appropriation approaches the $100-million mark (this year, the Endowment's request was sliced by $8-million). President Ford's determination to combat inflation by cutting down on Government spending is not a happy omen for performing artists either, who are still considered by many lawmakers to be effete and extravagant threats to a balanced budget (Iowa's Republican Congressman H. R. Gross, in trying to cut the arts budget even further last July, referred to these artists as "little Twinkle Toes and those promoting lessons in belly dancing," which is an improvement, I suppose, on Richard Nixon's characterization of them as "Jews and leftwingers").

Moreover, the arts appropriation is presently spread over so many areas that it manages to feed virtually everybody without filling anyone's belly; those institutions operating outside of New York (which has the most generous state council in the country) are still fighting for existence, dissipating vital creative energies in the endless search for cash. Speaking only of the theater panel of the National Endowment for the Arts, where I served for two years under the leadership of Ruth Mayleas, we were always struggling to reward theaters of

quality in the face of pressure to distribute grants on a geographical basis. The fact that professional theaters were hardly a dominant feature of life in, say, Montana or Idaho, made this kind of representative democracy an absurdity, and accounted for the competing claims on the Endowment's funds of the American Resident Theater Association—a nationwide consortium of university drama departments, with amateur theater groups composed entirely of graduate students—which is now trying to grab a slice of the limited pie.

Still, the National Endowment for the Arts, whatever its limitations, has by far the most progressive and objective standards for determining assistance to the performing arts; it provides, with the help of expert panels, relief to all qualified institutions, including the most experimental, regardless of their size or popularity.

The private foundations, on the other hand, have not, as a whole, proved as scrupulous or faithful in their support of performing arts organizations, partly because of limitations in their staffs and partly because of an oversensitivity to fashion. Certainly, these foundations have been helpful to the arts, but they lack the Endowment's evenhandedness; their reluctance to provide basic support for more than brief circumscribed periods has made their granting of awards, and their withdrawal of awards, sometimes look whimsical and capricious.

One problem is the vagueness of criteria. Either these private foundations lack confidence in their own judgments or have special interests that color their decisions. To illustrate the first instance, I am reminded of an attempt, during the First Annual Congress of Theater (FACT) at Princeton last June, by a representative of a small Midwestern foundation to "quantify subjective criteria," as she called her effort to define the standards and procedures of her board of directors. Among the criteria weighed by this board, she said, were quality of leadership, quality of planning, quality of community impact, quality of fiscal management, quality of audience development—in short, everything but artistic quality. The standards, in other words, were not aesthetic but rather sociological, educational and administrative, since these

were more easily measured; nobody on this particular foundation, apparently, was willing to make a simple judgment on an applicant theater's values and record.

The larger foundations, on the other hand, are even less specific about their criteria, especially since they are usually reluctant to play the role of passive benefactor willing to provide straight operating funds and prefer rather an interventionist role that encourages institutions to innovate with what is colloquially called "funny money" (grants for special projects) and that even helps to initiate new arts institutions (as the Ford Foundation did with the short-lived Mummer's Theater in Oklahoma). This suggests that the directors of these private foundations are sometimes under a compulsion to be "creative" themselves. And since such foundations are often more social-minded than artistically oriented, the applicant institution frequently finds itself twisted into pretzel-like contortions in order to find some new project that might attract financial attention: video-taped performances, school tours, children's shows, seminars with the audience, senior citizen specials, minority group appeals —anything, in fact, but the basic programs that make up its artistic identity.

Furthermore, these larger foundations tend to favor certain kinds of enterprises over others—guided not by quality but rather by the special prejudices of their directors. For example, the Ford Foundation—far and away the largest benefactor of the arts (it gave $109-million between 1965 and 1971 compared with $15-million from the Rockefeller Foundation, its closest competitor)—was unquestionably largely responsible for the growth of the resident theater movement in America, which owes its present strength to the unflagging support of MacNeill Lowry, the Foundation's former director of arts and humanities. But because of Mr. Lowry's strong personal conviction that the professional arts could never flourish in a university setting, no professional university-based arts institution, to my knowledge, has ever received support from the Ford Foundation; it was only because of the backing of the Rockefeller Foundation, which, under its arts and humanities director, Norman Lloyd, took the opposite view, that Mr. Lowry's opin-

ion did not become a self-fulfilling prophecy.

Other lacunae are even more curious. While the Ford Foundation made grants amounting to $29.7-million to Lincoln Center in New York City, $5-million to the Kennedy Center in Washington, D. C., $5-million to the American Conservatory Theater in San Francisco, $3.5-million to the Alley Theater in Houston and almost $2-million to the Mummer's Theater, among many others, it never recognized the existence of one of the most enterprising institutions in the country, the New York Shakespeare Festival. As Stuart W. Little describes it, in his recent biography of Joseph Papp: "Throughout the history of the Festival, in the face of repeated requests and even pleas for help, during a period when rather large grants were being made to almost every other theater organization in the country, Ford gave not one penny to Papp, and the fat file folders of correspondence stored just outside Papp's office, covering 15 years of request and rejection, revealed exchanges that were acrimonious and bitter." (Some of these exchanges are preserved in the book, and they make fascinating reading.)

In the early days, the Foundation used to argue that free Shakespeare in Central Park was unfair competition for Broadway; later, it was more vague as to its reasons for ignoring Papp. Lowry merely expressed "difficulty" in seeing how the Public Theater season would fit into Ford's program for the theater, which included "production opportunities for the new playwrights" (Papp's season included the Pulitzer Prize-winning "No Place To Be Somebody"). In the face of such a reply, it was understandable that Papp would complain in a letter to Lowry's superior, McGeorge Bundy, that "it was certainly humiliating to go around hat in hand after achieving national and international prominence as a theater institution and being subjected to quaint and ill-informed opinions about standards in the arts." (Bundy's reply was equally curt.) Interestingly enough, it was not until Papp joined the Establishment network by taking over Lincoln Center that the Ford Foundation swallowed whatever bitterness it felt toward him and made the Beaumont a grant of $1.5-million spread out over three years.

This controversy suggests some of the problems regarding private foundations and the arts: Lacking a sufficiently large permanent staff or sufficient consultants, these foundations are inclined to become too dependent on the whims and prejudices of their directors, if indeed the directors are not being overruled by board members even more ignorant of the special needs of artists. It is remarkable, considering the large amounts of tax-free funds dispensed annually by these foundations, that they make so little effort at public accountability; now that some of them are preparing to cut their arts budgets even further, the likelihood is that their choices will grow even more conservative, if not subject entirely to arbitrary internal decisions.

So what of the future of the performing arts in America? It looks dismal. At a time when more and more people are discovering the pleasures of culture, the financial base for these arts is gradually crumbling. The National Endowment is growing too slowly; the private foundations are retrenching; the business community is still largely self-interested; and the "private sector" is being staggered by the growing inflation. One can foresee the day, if some radical solution isn't discovered quickly, when many of these performing arts organizations will be closing their doors.

There is one way, however, in which the "private sector" can still have some impact on the performing arts—not by financial contribution, which will always be minimal (and negligible for experimental groups) but rather by social and political pressure in demanding that the formal agencies take on more responsibility. The Government must be made to realize that the arts have a value to the nation at least one-hundredth that of defense—to acknowledge this would solve the problem immediately — or alternatively, the Government must be induced to assume its proper obligations in regard to health, poverty, science, education and urban problems, so that the private foundations, which now contribute 86 per cent of their annual budgets to these programs, could increase rather than shrink their already meager 9 per cent share to the arts and humanities. But this solution requires not only a compassionate administration but an enlightened citizenry, one that recognizes the importance of the arts to the spiritual well-being of the nation. For the soul, as a Bernard Shaw character has observed, is a very expensive thing to keep: "It eats music and pictures and books and mountains and lakes and beautiful things to wear and nice people to be with. In this country you can't have them without lots of money; that is why our souls are so horribly starved." Only when this kind of food is recognized, in our own starved country, as essential nourishment for intellectual, emotional and spiritual growth— and not just a luxury in affluent times—will the crisis threatening the performing arts come to an end.

September 15, 1974

# Strike Threat at Met Part of U.S. Trend

**By C. GERALD FRASER**

The strike threatened by the Metropolitan Opera Company's orchestra for Jan. 1 is only the latest in a series of labor disputes that have silenced orchestras across the nation.

In the 1974-75 and 1975-76 seasons, increasingly militant classical musicians have stopped work in Dallas, Denver, Detroit, New Jersey, Omaha, Pittsburgh and Kansas City. All the stoppages have been settled except the one in Kansas City.

Since 1970, there have been strikes by musicians of 16 major American symphony orchestras, many of them the first in the long histories of the organizations. Musicians are demanding more money and a greater say in music-related policy matters.

At the Metropolitan Opera the main issue is money. The musicians, whose contract expired Aug. 24, want a one-year contract guaranteeing 52 paid weeks and a 12 percent cost-of-living increase.

The Metropolitan Opera Association, which runs the opera company, has asked the musicians to sign a two-year contract that reduces guaranteed paid weeks from 51 to 44 with no pay increase the first year, and in the second year provides 46 paid weeks and a 5 percent increase.

Currently, the opera orchestra's 100 musicians earn a minimum of $19,635 a year, or $385 a week for a 51-week year.

One of these musicians is Herbert Wekselblatt, a tuba player and a chairman of the orchestra committee. The musicians, he said, have studied music all their lives—some from the ages of 3, 4, 5 and 6—and have worked at their profession practically all their adult lives. Those working for the Metropolitan Opera, he said, are "lucky," and they enjoy their work.

"But we are in a difficult situation," he explained. "Management says that they will have to close the Metropolitan if the musicians insist on more money. Management says that the house is in trouble.

"But we have 100 musicians whose own houses are also in trouble. It's management's job to go out and get the money.

"We can't keep the Metropolitan open by ourselves."

Anthony A. Bliss is the Metropolitan Opera's executive director. He represents the opera's management and he says management cannot keep the opera open by itself.

"We have a very warm sympathy for all our employees," Mr. Bliss said. "I completely agree that people in the arts are entitled to look for their full-year support from their own profession."

But Mr. Bliss said there are "hard realities." All of the contract settlements — between symphony orchestras and their management—over the country, he said, "may be maneuvering the [classical music] industry into a situation we may not be able to cope with."

What "deeply concerns" him, Mr. Bliss said, is the effect of the settlements on an "organization's ability to survive and the effects of settlements on we who are facing negotiations."

**Disputes About Money**

I. Philip Sipser, a lawyer who has represented musicians of 43 symphony orchestras, indicated that the musicians are glancing at one another's settlements. Mr. Sipser, who is also special counsel to the

American Federation of Musicians, the musicians' union, said:

"The Metropolitan Opera orchestra has always been at the same level or slightly higher than the the five top orchestras — Chicago, New York, Cleveland, Philadelphia and Boston — and those immediately below it.

"But as a result of the last two years of collective bargaining, all these orchestras will now be getting more money in 1976 and 1977 than will the Met Opera orchestra."

And generally, most of the orchestras' labor disputes have been about money; the musicians want more, the orchestra management usually says that inflationary costs leave them with less.

Donald Sloan, president of the Kansas City Philharmonic Asociation, said it had operating deficits of $108,000 in 1973, $221,000 in 1974 and $334,000 in 1975.

To meet the musicians' demands, he said, would mean an increase in the current budget of $600,000 and a deficit for this season of $1 million. Musicians originally asked for a 52-week contract with a minimum scale of $270 a week. The association offered a 28-week guarantee at $215 a week.

In Pittsburgh, after a 46-day strike that ended Nov. 13, the Pittsburgh Symphony Orchestra's 104 musicians won a three-year pact that includes $400 a week, or $20,800 yearly pay. The Pittsburgh Symphony Orchestra is one of the nation's richest, with an endowment of about $19.4 million.

But Seymour Rosen, the symphony society's managing director, said that the recession has reduced the endowment's earnings and despite a rise in ticket prices, the orchestra lost $28,-000 in 1974. John E. Angle, president of the society and a retired United States Steel Corporation executive, has vowed that "we are going to pursue sound financial operations."

Sound financial operations are exactly what the musicians want, according to Hal C. Davis, president of the powerful, 79-year-old American Federation of Musicians, to which all professional musicians belong.

Over the years, said Mr. Davis, "these players in the main were underemployed and underpaid.

"Indeed, because of the structure of the symphony societies over the years prior to the past decade, symphonies were the toys, the playthings of the wealthy. Families made substantial contributions and maintained the orchestras.

"But as the tax situation changed and the economic situation altered," Mr. Davis continued, "families were no longer in that position—to be the sole support of the symphony orchestra. So, they—the or-

## Wage Scales and Selected Working Conditions For Major Orchestras

| | Total Weeks Worked Yearly | Final Year of Current Contract | Basic Weekly Scale Final Year of Contract | Guaranteed Annual Wage, Final Year | Number of Days Paid Vacation |
|---|---|---|---|---|---|
| **Atlanta** | 44 | '77 | $280 | $13,440 | 21, Plus 5 Hol. |
| **Boston** | 52 | '77 | 400 | 20,800 | 42 |
| **Chicago** | 52 | '76 | 380 | 17,760 | 49 |
| **Cincinnati** | 52 | '76-'77 | 325 | 16,900 | 42 |
| **Cleveland** | 52 | '77 | 350 | 18,200 | 42 |
| **Detroit** | 51 | '75 | 305 | 15,555 | 35 |
| **Houston** | 52 | 6-1-'76 | 280 | 14,560 | 42 |
| **Los Angeles** | 52 | '74-'75 | 330 | 17,200 | 35 |
| **Milwaukee** | 47[1] | '76-'77 | 302.50 | 14,822.50 | 35 |
| **Minnesota** | 48 | '75-'76 | 320 | 16,000 | 35 |
| **National** | 52 | '75 | 305 | 15,860 | 42 |
| **New Jersey** | 24[2] | '74-'75 | 230 | 5,520 | None |
| **New Orleans** | 38 | '76-'77 | 302.25[3] | 11,485 | 21 |
| **New York Phil.** | 52 | '75-'76 | 380 | 20,760[4] | 49 |
| **N.Y. Met. Opera** | 51 | '74-'75 | 385 | 19,635 | 35 |
| **N.Y.C. Ballet** | 31+6 Optional | '75-'76 | 330 | 12,210 | 14 |
| **N.Y.C. Opera** | 40[5] | '76 | 340 | 12,830[6] | 5%[7] |
| **Philadelphia** | 52 | '74-'75 | 350 | 18,200[8] | 49 |
| **Pittsburgh** | 51 | '74-'75 | 305 | 15,550 | 42 |
| **Rochester** | 38 | '74-'75 | 270 | 10,260 | 14 |
| **San Francisco** | 52 | '74-'75 | 330 | 17,200 | 42 |

(1) '74/'75. 47 wks.; 9/'75. 48 wks.; 9/'76 49 wks.  (2) Not in original contract settled in arbitration  (3) Plus or minus cost of living clause  (4) Includes $1,000 recording guarantee  (5) Not including tours  (6) Not including tours or rehearsals  (7) Cash equal to 5% of pay for each day worked  (8) Plus $2,000 recording guarantee

*Source: American Federation of Musicians*

The New York Times/Dec. 21, 1975

chestras—turned to corporate gifts. But that, of course, wasn't sufficient, either.

"And now, the players have become very sick and tired of subsidizing those orchestras, by working their fingers off and not receiving proper compensation and not having any guaranteed annual income."

Mr. Davis has also said that "participation in decision making" has become equal in importance to money and job security.

In Omaha, having a say was the big issue. The Omaha Symphony Orchestra is a part-time job for its musicians, on strike since May 22. Members average $1,000 a year, and the orchestra's status is between a community and a metropolitan orchestra.

Last January, Thomas Briccetti was hired as conductor and musical director. To upgrade the symphony, Mr. Briccetti said he wanted to hire a core of 15 full-time musicians at $140 a week for a 30-week season. Mr. Briccetti also planned to demote three principal musicians including Myron Cohen, the concertmaster since 1946.

The musicians insisted that the conductor should not have the final say in hiring and dismissing. The musicians wanted to be consulted and were successful in their strike. The orchestra will retain its

members through the 1976 season, and new audition and grievance procedures involving the members have been established.

Similarly, in Detroit a symphony orchestra work stoppage that began Sept. 30, ended Dec. 2 with a three-year contract that included provisions for a six-musician artistic advisory committee and a 15-musician nonrenewal committee. The nonrenewal committee will vote on dismissals sought by the symphony's musical director. Although musicians won a $400-a week wage in the third year—1978—of their contract, the major issue, according to Paul Ganson, a member of the negotiating committee was nonrenewals, "just what role musicians will have in renewing someone," he said.

### No Box-Office Support

"We, the entire orchestra, are trying to enlarge the role of the musicians in the Detroit environment, now controlled by an overzealous management," Mr. Ganson said. He said that decisions were often made with "fiscal responsibility rather than musical responsibility."

The Detroit Symphony was one of only two in the country, Mr. Ganson said, that last year had a surplus—$490,000. And Marshlal Turkin, executive director of the orchestra, is predicting a deficit in three years.

Deficits plague symphony orchestras because Americans are apparently not willing to support—at the box office or in donations—that kind of music. To most Americans, classical or serious or good music is European-originated 18th-century and 19th-century music.

Americans say this music should be available to all. "No city has cultural credibility without [a symphony] orchestra," said Judith L. Kreeger, a lawyer and president of the Miami Ballet Society.

But, in the recording industry, for example, it is jazz, rhythm and blues, rock and country music that in effect subsidize the production of classical music records. Major recording companies such as Columbia and RCA report that classical music is from 5 to 10 percent of their total output.

The American Symphony Orchestra League of Vienna, Va., reports that accumulated deficits of major symphony orchestras have increased 150 percent in the last five years. This, despite an increase in private contributions to major orchestras—up $8 million since 1970 to $32 million.

Attendance is up, league statisticians reported. Twenty-three million tickets were sold last year, and professional orchestras gave 7,535 concerts.

The league says there are about 1,400 symphony orchestras in the United States. Of those, 121 have budgets of more than $100,000. Twenty-nine have annual budgets of more than $1 million, and these are called major orchestras. Eighty-nine symphonies have budgets of from $100,000 to $1 million; these are metropolitan orchestras.

Urban symphony orchestras have budgets of from $50,000 to $100,000, and there are at least 42. And there are 1,100 college and community orchestras budgeted below $50,000 a year. According to the league, orchestras cost $135 million to operate.

And the major orchestras spend a little more than 60 percent of their funds paying musicians and conductors.

In the labor-management sense the musicians are employees, and the association (or society) is the employer, administrator and business manager. The conductor, who is usually the musical director, is also an employee of the association.

Each major symphony has an orchestra committee made up of a number of musicians. The committee usually acts as representative for the group. The number of musicians in an orchestra varies from a required 106 in the New York Philharmonic to a required 55 in the Rochester Philharmonic.

The nation's 10 highest-paying orchestras, as this season opened, were the New York Philharmonic, New York Metropolitan Opera, Boston, Chicago, Philadelphia, San Francisco,

Cleveland, National (Washington), Pittsburgh and Detroit.

There is one aspect of the symphony orchestra business that all agree on—union, musicians, associations and conductors. That is, that Federal support is the only real salvation for fiscal stability.

James DePreist, principal guest conductor of the National Symphony and, starting next September, musical director of the Quebec Symphony Orchestra, cited European nations'

subsidies as the reason that classical music is in Europe everywhere available.

The vast majority of Americans, he said, are not devotees of classical music. "It is a minority interest, but no one is quite certain in this country how large that minority could be."

Mr. DePreist said musicians have to be well paid "not for just the work they do, but for the years of study that go into making a musician.

You are expected to perform perfectly," he said. "Mistakes are not tolerated."

Another aspect that all agree upon is that musicians will continue to demand more and more control in their orchestras. Some aspects, like hiring and dismissing, are significant. Some, like a nonsmokers' bus on out-of-town trips and stools for bass players at rehearsals, are less so.

But the issue will remain. Sixten Ehrling, formerly—for

10 years—conductor and musical director of the Detroit Symphony, said "the power of the conductor seems to be diminishing.

"All the great orchestras were built under dictators," he said. "Whether they can be maintained with a more democratic system is difficult to say."

December 21, 1975

---

### Ailey, Citing Costs, Drop Lincoln Center Season

The Alvin Ailey American Dance Theater has canceled its two-week season at the New York State Theater in Lincoln Center (Aug. 16-28) because of escalating performing costs. Mr. Ailey said: "It is sad and frustrating that our company must now join the Joffrey Ballet, Dance Theater of Harlem and American Ballet Theater in having to reduce public appearances for economic reasons." Now on a world tour, the company finished a noteworthy three-week engagement at the City Center on West 55th Street on May 22.

June 29, 1977

---

## REGIONALISM

---

### CHICAGO OPERA IN DEMAND.

**Calls for Dippel's Company from Many Cities—May Tour Europe.**

*Special to The New York Times.*

CHICAGO, Sept. 17.—St. Louis, St. Paul, and Milwaukee are more anxious than they were last year for performances by the Chicago Opera Company. Indications are that the sale of seats in these cities will considerably surpass the sale of last season. In the East there also is a call for the Chicago company. Brooklyn bids for one performance for Nov. 14 and New York will have six during the latter part of the season. Ten Thursday night performances will be given in Baltimore if $50,000 worth of tickets is subscribed in advance. Already about $30,000 has been

covered by the subscriptions, and indications are that the total amount will be taken by the middle of October.

The management of the Chicago Opera Company announces that Miss Marta Wittkowska, the youthful Polish contralto, has been engaged for the season. Miss Wittkowska came from Poland with her parents when only 10 years old and has lived at Syracuse, N. Y., excepting the years she has spent studying and singing in Europe.

Clarence Whitehill, the baritone of the Metropolitan Opera Company, who will be heard here in the German productions principally, has also been engaged as a member of the company. Mr. Dippel has engaged for a limited number of Wagnerian performances Mme. Johanna Gadski and Mme. Olive Fremstad, both from

the Metropolitan.

A cablegram to The Daily News from Berlin says that great interest has been aroused in that city by a report from Vienna that Manager Dippel is negotiating with the managers of the opera houses in Vienna and Berlin, with a view to bringing the Chicago company over for a brief season of performances next year at the noted opera houses of the European centres. The authorities at the Berlin Opera House say the report that arrangements for such a tour have been completed are premature, so far as Berlin is concerned, but they admit that probably the project is being favorably considered.

September 18, 1911

## KAHN URGES CITIES TO DEVELOP DRAMA

### They Should Throw Off Yoke of Broadway and Not Be a 'Hinterland,' He Says.

Otto H. Kahn, who recently urged that the large American cities should all build opera houses and form opera circuits, gave similar advice regarding the drama in a letter yesterday to the New York Drama League in response to a request for his views.

After urging that community theatres of a repertory character should be established in cities throughout the country, Mr. Kahn said:

"Let the country at large emancipate itself from Broadway and not be satisfied to be the 'hinterland' of New York from a theatrical standpoint."

The present system, under which the country looks mainly to the theatrical managers of New York for theatrical entertainment, is undesirable and is proving less and less successful, according to Mr. Kahn, who continued:

"Far too much of young America's artistic talent goes to waste for lack of guidance and opportunity.

"The stock companies, unfortunately, have been vanishing more and more, though I am glad to learn that of late there has been somewhat of a reversal of that tendency.

"The remedy so far as the field of dramatic art is concerned, is to be found, I believe, as I have already indicated, mainly in the development of the stage outside of New York.

"I am, of course, aware of the large number of community theatres, little theatres, college theatres, &c., which have sprung up in recent years, which have much useful work to their credit, and whose advent and activities are to be cordially welcomed. But most of these theatres, thus far, are very limited in their means and scope of action, in their influence and in their effectiveness.

"Ways ought to be studied, found and put energetically into operation, both through local proceedings and through a nationally active organization, in conjunction, perhaps, with the principal independent theatres of New York, to make these theatres things of greater and more real concern to their respective towns and cities, to render them of broader significance, of larger range, and, when deserved, of wider reputation.

"They should successfully challenge the 'movies' for public patronage. They should become centres for quickening and broadening the public interest and for shaping and advancing the public taste."

January 18, 1926

## BEAUTIES OF ART TAKEN TO PUBLIC

### Branch Museum, the First Ever Established, Proves a Great Success in Philadelphia.

### IS OPENED AS EXPERIMENT

Special Correspondence, THE NEW YORK TIMES.

PHILADELPHIA, July 15.—Forty-five thousand persons during a period of two months have testified to the preliminary success of an experiment being conducted jointly by the Carnegie Corporation and the Pennsylvania Museum of Art just beyond the western boundary of Philadelphia.

The two organizations set out in May to ascertain whether branch museums might gain a popularity comparable to that enjoyed in the larger American cities by branch libraries. The Sixty-ninth Street section, which boasts of being the fastest growing American community, was selected for the test, which is to be carried on over a five-year period.

Quarters were found in the Community Centre, the first floor of which was donated rent free for the experiment by John H. McClatchy. The Carnegie Corporation advanced $45,000 and Mr. McClatchy subscribed $30,000 additional.

Under the direction of Philip N. Youtz, the curator, who formerly was with the People's Institute; the American Association for Adult Education, and Columbia University, the branch museum opened its doors on May 8. The first day's visitors read this explanatory inscription on the wall:

"This first branch has been opened that the museum may be of wider service to the public, in the hope that branch museums may become as essential a part of American life as branch libraries."

Museum officials are enthusiastic over the early results. Miss Eleanor Sheldon, the assistant in charge during Mr. Youtz's absence in Europe, where he is making a study of museum methods, has found that the visitors average from 500 to 600 a day and that they have numbered as high as 2,300.

#### Many Men Visitors.

An encouraging sign has been the large proportion of men who drop in to spend a half hour or so examining a collection of paintings, sculpture, metal work or whatever the current exhibition is featuring. To accommodate the largest possible part of the population, the rooms are open daily from 10 o'clock in the morning until 10 at night and Sundays from 2 to 10 P. M.

In the brief period since its beginning the museum has housed four successive exhibitions in its three alcoves and main gallery, the intention of the experimenters being to change the collections monthly or oftener and to borrow not only the possessions of the parent museum but to show private loan collections as well.

July 19, 1931

# THE SUMMARY OF A NATIONAL TOUR

*Miss Le Gallienne has just returned from a season's tour that took her across the country. She gives below her thoughts on the present—and future—state of the American theatre.*

### By EVA LE GALLIENNE.

THE American public is waking up to two important facts concerning the theatre. First, that the talkies do not replace the living theatre, and secondly, that novelty is not entirely imperative in the field of drama. A really great play remains a great play forever—it is dateless and eternally interesting. The public is also becoming aware of the value of interpretation as a factor; it is beginning to realize the fascination of seeing a great play variously interpreted, both from the angle of playing and of direction. These are indeed hopeful signs, and returning from the first long tour I have taken since starting the Civic Repertory Theatre, I feel indeed full of hope and confidence in the great renaissance that is so obviously about to occur in our American theatre.

Is the theatre dead? No! and again No!—and it never will be. There is much work to be done—difficult work, but who can be interested in easy accomplishment? J. R. Williams, my friend and manager, has written a statement covering certain facts about our tour which I feel it imperative to include in this article.

He says:

"We have been on tour twenty-seven weeks. Our season has lasted from October to the end of April, with the customary lay-off before Christmas and during Holy Week. During this tour we have played in places as far removed as New Haven, Conn., and Seattle, Wash., and Boston and El Paso, Texas. Altogether we played in twenty-four States and in forty-six different cities and towns which contain at the minimum a population of 12,000 and a maximum (Chicago) of 3,000,000.

"We have disbursed in operation close to a quarter of a million dollars. The major part of this sum has been spent for such items as railroading, newspaper advertising, hauling of scenery, stage bills and other expenses incidental to a frequent change of scene of operation. The early months of touring with 'Alice in Wonderland' and 'Romeo and Juliet' meant carrying actors, musicians, stage hands, an aggregation of musical-comedy size. The expenditures were in proportion, of course. Not only were our own costs large, but playing in these many places was the cause for employment of local help, such as stage hands, musicians, box-office men, cleaners and the various groups that constitute the usual theatre staff. Combined with our company these ran into the hundreds.

"The touring player patronizes local hotels, he spends in local restaurants, he patronizes the local clothier, the local haberdasher. He spends as he goes along. He carries along with him every physical and other need that he must satisfy at home. Hence the coming of a road company means to each community more business, a larger cash disbursement.

"A most pleasurable feature of the tour has been the cooperation of the railroads. After we had sent home 'Alice in Wonderland' and 'Romeo and Juliet' our number, of course, was smaller than the tremendous group we had been carrying for sixteen weeks; but everywhere we were greeted and helped by the railroad people. It soon became evident that our coming and the gratifying audiences that came to see us were construed by the railroad folk as proof positive of a revival of the road for the spoken theatre. And the signs of this revival pleased them. The fact that an increasing number of attractions will mean a substantial financial return to them was not the reason for their helpfulness. There was a rather predominant desire to do everything possible to them to insure that the road shall regain its old importance, romance and luster."

The most thrilling experience that this tour has brought to me has been the amazing reactions of youth to the living theatre. In some cases we have had young people motor 400 miles to see a play, having to return these 400 miles after the performance. I have been most interested in talking to them, trying to find out why they made this effort. Their unanimous reaction has been that the talkies, no matter how splendid, do not take the place, and never can, of the living drama.

We have all of us enjoyed magnificent picture productions. In my mind particularly stand out "Henry the Eighth," with Charles Laughton; "Rasputin," in which Ethel Barrymore gave one of the greatest performances I have ever seen, and of course all of Garbo's pictures—for she, in my opinion, is the greatest artist on the screen.

But these talkies, no matter how splendid, cannot be compared with the medium of the living theatre. What people never seem to realize is that these two mediums are in their essence and in their expression totally different. Both equally important, both equally beautiful—but simply different. That is why I have always maintained that there never can and never should be any competition between them.

The pictures have immense advantages over the theatre. They have a wider range of interpretation, far more money to spend; they have at their command the greatest talent now existing in the world. On the other hand, the theatre, too, has its advantages, and it is this advantage that the young

people of America, as I have seen them on this tour, have come to appreciate and understand.

\* \* \*

There exists a kind of communion between a great audience and a great artist in the living theatre. The audience becomes an integral part of the performance, and in its giving finds greater joy in what it receives. No matter how much you may want to cheer a great actress on the screen (or no matter how much you may want to throw rotten eggs at her) this cannot make the slightest difference. That particular work has been accomplished finally, some time before, and the creature playing before your eyes is not actually there.

To watch an actor in the living theatre worthy to be watched at all is interesting for the surprises his performance may hold; it is not static: it may rise to immense, suddenly inspired heights, and to these heights the enthusiasm, sympathy and understanding of the audience can greatly contribute. It seems to me that this living communion between the workers within the theatre and the workers without forms the most exciting difference between the two media we have been discussing.

It happened in several towns that there came many young people who had never seen a legitimate play; they had been completely brought up on the talkie. In nine cases out of ten they all commented on the fact that the actual presence of human magic was infinitely more important than the screen replica—and invariably they used the words "It's so different." I believe that the present generation growing up all over the country has become satiated with the mechanical medium of motion pictures as its only form of entertainment, that it is definitely starved for the warmer, more human touch that the living presence gives.

Twenty years ago the "movie" was a great novelty, and even now

we must admit that its increasingly high standards, very great financial advantages and the fact that it is enabled to present great artists in shadow form in often great material at phenomenally low prices, give it a superlative power in the entertainment world. But still I maintain that there is a difference.

Would that we had "talkies" of Bernhardt, Henry Irving, Duse, Modjeska, Ada Rehan, Booth, &c., &c. But even had we these, we could never appreciate the full vibrance of their direct presence. The young people all over the country are beginning to feel this. They sincerely want the return of the living sta.

I personally believe that the legitimate theatre has deserved its evil days. It became too prosperous, too comfortable, too arrogant. I think the "talkies" have been of great benefit to the theatre. They have, of course, lowered the output of productions, but they have immeasurably raised the standard of such plays that are still produced.

I feel passionately that we must not fail these young people of America. Their interest must not be discouraged by presenting them with low standards of production or acting. We must serve them well —never fail them—and reward their eager enthusiasm.

The importance of bringing back the "road" is, it seems to me, an immense factor in the future of the American theatre. At one time it used to be the backbone of the entire system. Actors should never get too soft, too rich, too self-satisfied. They must remain rogues and vagabonds and servants of the public. They need to learn again the joys and pains of "trouping"— the discomfort and the lack of security, the old fun and the old aspiration. And "trouping," of course, does not consist of a nice, safe visit to Boston, Philadelphia or Chicago. "Trouping" means the split weeks, the one-nighters: San

Jose, Oklahoma City, Emporia, Wichita, Des Moines; places where you play in schools, auditoriums, halls, catching trains at 6 in the morning and again onward by sleeper jump after the show; it is in these places, for many years so neglected, that the greatest response is shown—a sincere and wonderful gratitude, which should be to any one who loves the theatre sufficient reward for any discomfort or effort.

There have been pioneers of late years—Ethel Barrymore, Mr. Hampden and now this year Katharine Cornell with her splendid repertory of great plays so beautifully produced—and my own efforts. The reception we have received in this difficult year in which we were all warned not to set foot on the dangerous roads of touring has been indicative of the new trend toward the re-creation of the American theatre.

It is with immense satisfaction that one sees other peo gathering courage to follow on our trails. The Theatre Guild, for instance, whose magnificent productions have contributed so much to the drama of America, has announced its plan next year for an extended tour with some of its most important presentations.

\* \* \*

For the last eight years I have been primarily interested in creating in this country the type of theatre so universally acknowledged important in most of the great European countries: a repertory theatre presenting the great plays of the world at popular prices.

The director of a repertory theatre, it seems to me, is more or less in the position of a curator of a museum. The repertory must be catholic in the sense that even though you adore Velasquez you still include Matisse or Modigliani. The people's repertory theatres should be to the community what a great library is. In fact, it should be a great library of plays brought

alive for the people—plays both classic and modern, American and international. In connection with such a theatre there should always be a free school giving thorough training to young people of little means, who could in no other way learn the art to which they wish to devote their lives.

I feel that this great country with its immense potentialities, having solved so many of the material problems in life for its people, should now seriously dream—for facts must begin in dreams—of creating a great national repertory theatre of America, nationally subsidized, and first concentrating upon one great centre, which would logically at this moment be in New York City. Afterward, it would create other centres all over the country of equally high standard (and the highest standard is imperative), which could then form a rotating system from one centre to another and feeding the smaller towns around each of these great centres, a sort of planetary system, bringing the great and ever acknowledged power and recreation (in the true sense of the word) of fine drama to the people.

Connected with each of these centres as a matter of course should be free schools, libraries, art galleries exhibiting free the works of young artists without the means to promote themselves, so they might have the chance of recognition. In short, it would be a great system of national American repertory theatres and drama centres throughout the country that would undoubtedly be of vast importance in our cultural life.

Why should we not create a great American people's theatre presenting a universal choice of plays, fine enough in its standard, solid enough in its vision, that we might not be afraid to send it all over the world to stand as representative of this phase of our culture?

May 6, 1934

---

# WEST FACES EAST, SAYS ORMANDY

AFTER three consecutive seasons as conductor of the Minneapolis Symphony Orchestra, followed by annual tours with the orchestra to thirty-eight cities in Minnesota and neighboring States, Eugene Ormandy has decided that the East definitely underestimates the taste of the Middle West.

According to Mr. Ormandy, Middle Western musical standards are just as high as those found among symphony audiences in the East. Programs featuring Bach, Handel, Corelli and Vivaldi, combined with works by Sibelius, Ravel, Prokofieff, Kodály and Bartok, are enthusiastically received by concertgoers in Youngstown and Columbus, Ohio; Indianapolis and Pittsburgh. In fact, the classicists cannot be too lofty nor contemporary composers too modern to please Middle West audiences—always pro-

vided that these works have already been introduced and accepted by the East!

"For whatever the derivation and direction of political and economic trends in Minnesota and near-by States, the Middle West chooses to face East in musical matters. And just as Philadelphia and New York look to Europe as the source of musical stimulation, so does the Middle•West look to New York and Philadelphia," said Mr. Ormandy.

He pointed out by way of explanation that "the sponsors of the great orchestras are for the most part men and women who were born in the East or whose ancestral roots are still in New England or along the east coast. These people come to New York several times a year, and in addition there are large numbers of university students from the East who go to Minnesota and other Middle West-

tern universities, thus influencing musical trends."

It takes about a year for a musical phase which has begun in New York to reach the Middle West, estimated Mr. Ormandy. "When Tchaikovsky ceased to be New York's most popular symphonic composer and Beethoven cycles began to be the rage, I soon felt the reaction in Minnesota. The response to request programs which the Minneapolis Symphony gave at the end of the season over the radio told the tale. For a long time the 'Pathétique' shared with Dvorak's 'New World' symphony first place on the list of symphonic works that the average member of our unseen audience would have chosen to take with them to a desert island. Gradually the requests changed. Now requests for Beethoven and Brahms are in the majority."

Audiences show a very warm and human interest in the lives and personalities of composers. Mr. Or-

mandy cited as an example the tremendous sucess of Bruckner's Seventh symphony, which he introduced in Minneapolis. There were seven recalls at the end of the performance. A short preliminary speech telling something about Bruckner the man, as well as the composer, first aroused the audience's interest in a personality who has become a great favorite in the Middle West.

The outstanding musical events in the Middle West continue to be the broadcasts of Toscanini, said Mr. Ormandy. "These broadcasts are helping to make America a musical unit. Far from dulling interest in local concerts, the Toscanini broadcasts stimulate interest in concertgoing among people who have never before attended, while veteran subscribers to the symphony orchestras continue to go so that they may compare local performances with those they have heard over the air."

July 29, 1934

# WPA ART MUSEUMS PROVIDED IN SOUTH

## 19 'Experimental' Galleries Set Up Already in Effort to Spread Visual Education.

Special to THE NEW YORK TIMES.

WASHINGTON, July 7. — With more than 200,000 new works of art completed by WPA artists through-out the country and 120,000 of these already allocated to tax-supported institutions, the WPA has turned its attention to establishing galleries throughout the South, where such museums are not numerous.

To help bring "visual education" to the South, nineteen "experimental" galleries, which it is hoped will become permanent local institutions, have already been opened in Virginia, the Carolinas, Florida and Tennessee.

Displays of pictures and other art are changed every two weeks. The galleries all have local sponsors, and in North Carolina, for instance, the government expended only $12,-000 during the first five months of operation, whereas local contributions totaled $14,000.

The museums, situated in accessible places in the downtown areas of fairly large cities and towns, have already been visited by 250,-000 persons. Lectures and exhibitions in Miami were attended by 10,000 during the first week of operation.

The first two weeks of exhibitions in these museums draw on local paintings and art, the second two weeks WPA art work, and after that local money is employed in bringing exhibitions from the Phillips Memorial Gallery in Washington and the galleries in New York and other art centers.

WPA galleries have been estab-lished in Big Stone Gap, Va.; Asheville, Winston-Salem and Raleigh, N. C.; St. Petersburg, Jacksonville and Miami, Fla.; Nashville, Chattanooga and Knoxville, Tenn.; Florence, Columbia and Greenville, S. C.; Mobile and Birmingham, Ala., and Oklahoma City and Tulsa, Okla.

A gallery will be established Aug. 10 in Lynchburg, Va., and one July 20 in Greensboro, N. C. Plans call for galleries in Mississippi, Georgia and Arkansas.

Holger Cahill, WPA art chief, said that "enthusiastic support" had been received in this effort to establish community art centers.

July 8, 1936

# HOUSTON'S 'ALLEY'

## Arena Stage, in Its Tenth Year, Has Become a Theatre of Distinction

### By BROOKS ATKINSON

HOUSTON, Tex.

TEN years ago the Alley Theatre in Houston consisted of an energetic, good-humored lady with an idea and the enthusiasm of many other local amateurs. The word "Alley" in the title referred to the brick corridor that led from the street to the studio where the first production, "A Sound of Hunting," was performed. Incidentally, a sycamore tree grew in the studio through the roof admitting dollops of water on rainy nights.

Today the Alley Theatre consists of the same bustling lady, Mrs. Nina Vance, a professional cast and a business staff, many amiable assistants, and an inviting, informal building that contains an arena stage and seats 215 theatregoers. The standards of producing rank with the best. Direction, scenery, lighting, costumes are of first quality. The standards of acting are uneven; not all the minor parts are as well acted as the major.

The current bill, entitled "Three Love Affairs," is composed of short plays. Thanks largely to the perception and skill of Jeanette Cliff and Ernest Graves and the light touch of Bettye Fitzpatrick, "A Phoenix Too Frequent," by Christopher Fry, is expertly acted in the first of the three plays. Sean O'Casey's "Bedtime Story" and Noël Coward's "Still Life" are the other two.

Although the O'Casey rumpus is funny and the Coward lament is touching, the labored Irish accents in the first dampen the O'Casey exuberance, and the literalness of the acting in the subordinate parts of "Still Life" tempers the rueful romanticism of the Coward play. Since "Still Life" is a literary improvisation, it needs skimming acting in the small parts to set off the melancholy of the central theme.

In its tenth year the Alley has become a theatre of distinction. It will be one of the residential theatres included in the Wide Wide World telecast today. The Houston City Council has promised to repair the street and sidewalks before the merciless television cameras start searching for anything imperfect in the approaches to the theatre.

The Alley Theatre has also been invited by the United States State Department to represent the American Regional Theatre at the Brussels World's Fair. To a visitor to Houston, however, the State Department invitation looks uncomfortably like a threat.

### Three Reasons

In the first place, it puts Mrs. Vance under the necessity of raising $30,000 or more to pay most of her expenses. In the second place, a company that has perfected the arena style of playing will have to act on a proscenium stage at Brussels. It will have to jettison its greatest artistic asset and pretend to be something that it is not. Since fine arena staging is the most distinctive thing that residential theatres around the country have achieved in the past decade, proscenium staging at Brussels will misrepresent an important part of our national theatre art.

In the third place, the State Department has suggested to Mrs. Vance that she is free to take to Brussels a play by any American author except Arthur Miller. Its reservation manages to insult, not only one of America's foremost dramatists, but the American theatre in general — the commercial, community and university theatre — and also hundreds of thousands of theatregoers in North and South America, England and Europe.

Mrs. Vance has many plays from which to choose. But her production of the revised version of "A View From the Bridge" was one of her finest last year and had one of the longest runs in the history of the Alley. If there were any way in which a private American theatre could establish an honorable working basis with the State Department, "A View From the Bridge" would be the equal of "Anniversary Waltz" and "The Fifth Season," both of which Mrs. Vance has produced. To this somewhat irascible department, any contact between the American theatre and the American Government is invariably at the expense of the theatre's self respect.

### Art and Entertainment

Left to its own devices, the Alley Theatre has made a number of contributions to the culture of Houston—"The Chalk Garden" (which had a long run), "The Lark," "Hedda Gabler," "The Glass Menagerie," "Death of a Salesman," "The Skin of Our Teeth," "The Enchanted." Since the Alley has to pay its own way, like any other working theatre, it seasons art with popular entertainment.

It has also produced several original scripts. But Houston audiences are like audiences in most of the country in one respect: they respond slowly to plays they have not heard something about in advance. If the theatre's laws the theatre's audiences give, the management of residential theatre cannot be blamed for the neglect of unproduced playwrights.

There are two other residential theatres in Houston—Theatre, Inc., now in its fifth year, and Herbert Kramer's Playhouse, now in the third year of his management.

At the moment Theatre, Inc., is dark between "The King and I" and "Inherit the Wind," which will open next month. Theatre, Inc., is a nonprofessional group under the dynamic leadership of Johnny George, another dedicated theatre lady. It plays on a proscenium stage in what used to be Houston's Little Theatre. To judge by local comments and colored photographs of previous productions (all of them musicals) the standards of workmanship are high.

### Potential Audience

At the Playhouse, which has an arena stage now improvised into an open stage with three sides, Mr. Kramer is producing Robert Anderson's "Tea and Sympathy" in a performance that is sincere, able and moving. The Alley Theatre believes that its potential audience numbers 15,000; Theatre Inc., 20,000. Mr. Kramer is an expansive showman who thinks his potential audience is nearer 60,000. Greater Houston now has a population of a little more than 1,000,000. Although the symphony orchestra and the art museum have solider backing, the theatres are alive, alert and intelligent. In time they may have as much prestige as most communities instinctively confer on music, painting, sculpture and public libraries.

March 16, 1958

# ROAD'S GROWING AUDIENCES

## The Existence of 5,000 Thriving Regional Theatres Noted

**By ALICE GRIFFIN**

*Hunter College professor, radio station WNYC drama critic and regional drama editor for The Theatre Magazine.*

"AMERICA'S lost audience" is a favorite lament among theatre folk who, from a vantage place at Sardi's, try to diagnose the ills of the fabulous invalid they believe our theatre to be. "Back in 1885," they wail, "there were 5,000 theatres the length and breadth of the land."

The news for those experts whose view is bounded on the north by the 54th Street and south by the Billy Rose playhouses, is that there *are* 5,000 theatres in the country today, from modern million-dollar structures to modest arenas.

Except to the play-leasing houses to whose prosperity they contribute, these theatres are little known in New York. Their financial woes are nothing so spectacular as those of Broadway, which were aired during the recent Equity strife. Most of them operate in the black. Without national fanfare these 3,000 community theatres and 2,000 university theatres are bringing live theatre to cities and towns coast to coast. Their audiences, who not only support local productions but attend touring shows as well, are numbered in the millions.

### "Big Comeback"

Recently Variety hailed "Legit's Big Comeback in Sticks," reporting that the Broadway Theatre Alliance, a booking subsidiary of Columbia Artists Management, will be touring plays to 150,000 subscribers in almost eighty towns this fall.

The fact that there are audiences for theatre . small and medium-sized towns was front-page banner-head news in the theatrical trade paper.

It was news to most New York theatre offices, except that of The Theatre Guild's American Theatre Society, whose business it is to build audience subscriptions for touring shows. This organization reports 116,332 subcribers for last season, as compared to some 84,000 a decade ago. It is no coincidence that in the twenty cities on the ATS circuit, locally-produced theatre has been flourishing, too.

The regional theatre has grown tremendously in quantity and quality in the past fifteen years. As contrasted to the professional touring shows, regional theatre, which consists today of college and community producing organizations is generally nonprofessional. But the line between professional and nonprofessional is no longer distinct.

Gone are the days of the militantly amateur, primarily social, little theatre group, which performed to entertain its members rather than its audiences. Gone is the annual college play, at times in Greek, overseen by a member of the English or classics department. A stage director and a technical director are the minimum professional staff for university production. And almost every community theatre puts a professional director on salary as soon as the budget allows. Where the director is a professional, the productions—a series of plays balanced between drama, comedy and classics — are generally good. And there is a nationwide audience for good theatre at fair prices.

Regional theatre died in the early years of the century, was revived briefly with the little theatre movement just before

and after World War I but expired again (with some notable exceptions still with us, like Le Petit Théâtre du Vieux Carré in New Orleans), sprang up once more, only to be defeated by the depression. Why should it suddenly take hold during the last decade and a half? Here are three reasons: good management, trained personnel, and the fact that the theatre, slowly, is coming to be accepted not as the esoteric pursuit of a few but as an institution that contributes to the cultural good of the community.

### Business and Art

The first little theatre groups abhorred commercialism. As a result, many of them went bankrupt. Today's community theatres realize that their pursuit is a business as well as an art. For example, the flourishing Sacramento Civic Repertory Theatre's board of directors is made up of one committee responsible for artistic policy and another — bankers, lawyers, and business men—that guides the finances.

Presenting plays for college and community audiences is only part of the job of the university theatre. It is their training that turns out regional theatre directors who can guide a community drama group, staging its plays, building sets, and, if called on to do so, teaching creative dramatics to children or designing the auditorium of the new playhouse.

University theatres have come into their own in about the past twenty years, although the first four-year course leading to a degree in theatre was established at the Carnegie Institute of Technology in 1914. Such state university theatres as Wisconsin and Minnesota, work actively to build up theatre throughout the state, whether by touring or encouraging communities to organize drama groups. A major contribution of

the university theatre is that it keeps the classics — European and American — alive on the American stage.

The American Educational Theatre Association, national organization of the directors and teachers of university theatre, met Aug. 27 to 29 at the University of Denver. Because many of its leaders, men like Campton Bell of the host university and Frank Whiting of the University of Minnesota, are men of vision as well as talent, A. E. T. A. meetings are among the most stimulating and rewarding of such conferences.

But the picture is not entirely rosy. Five thousand sounds impressive until we remember that there are more than 3,000,000 square miles in our country, the majority of whose adult inhabitants have never seen live theatre.

As mentioned above, the productions are good. Good, but not great. A technical display to gild over lack of inspiration is a tendency of our times manifest in the theatre as well as elsewhere.

In 1885, the big weeks in those 5,000 playhouses were those in which a touring star made a guest appearance with the resident company. Why not a similar tour by some of our stars, like Judith Anderson or Lunt and Fontanne, who would appear in classics with university companies? The talented young actor could learn more from playing Cassio to Ferrer's Iago than from playing Iago himself. To rehearse with Morris Carnovsky as he prepares the role of Shylock would be more instructive than a shelf of books. And the inspiration of the star would lift the entire production. A. E. T. A. and the American National Theatre and Academy with the blessings of Equity, have been working on the idea of guest stars for regional theatres, but stars of the caliber of those mentioned above have yet to accept the invitation.

September 18, 1960

# ANOTHER TEST FOR DECENTRALIZATION

**By AUSTIN C. WEHRWEIN**
**MINNEAPOLIS.**

THE professional American theater, caged by commercialism on Manhattan Island, neurotic with self-doubt and guilt complexes, loathed and loved by those who live in it, is about to experience an experiment that could help liberate it.

This experiment begins here on Tuesday when Tyrone Guthrie

opens a 20-week repertory season with a "modified modern" dress production of "Hamlet" in which he dismisses the concept that Hamlet "is a constipated young man in long black tights."

Here, 1,000 miles from Broadway as the jets fly, in a gleaming $2,500,000 glass-walled, 1,437-seat open-stage theater bearing Mr. Guthrie's name, the people of the Twin Cities (population 1,400,000)

will launch a full-scale, truly professional regional repertory organization. Indeed, the theater will be supported on a scale and in the style that symphony orchestras have come to expect and enjoy.

### Repertory Tradition

This is not little theater; not stock; not straw hat; not road show; and it is definitely not show biz.

It is a happy marriage of community chest-type of impulse that

raised contributions of $1,800,000 and the highest degree of professionalism innocent of profit motive. It is a long-awaited step toward the repertory tradition of Europe, Britain and Russia but without government support or direction.

If it works here, interest already smoldering in places like Milwaukee, Detroit and Cleveland is very likely to burst into flame, the cultural course of this country may

well be changed.

"I don't think a theatre should be any more self-supporting than the public library," Peter Zeisler, production director, who with Oliver Rea, the administrator, makes up the troika that created the enterprise out of shared disgust for Broadway show biz.

For the Upper Midwest the four-play season is the most important cultural event since the first concert by the Minneapolis Symphony 60 years ago. For the world of drama it is one more test of the long dream that decentralization spells salvation.

"A dream itself is but a shadow." Hamlet tells Guildenstern. No shadow at the box office, the season is already a smash. Long before opening, advance subscription ticket sales ($18 top, down to $5.40) exceeded $221,000.

And total advance sales (single top $5, down to $1.50) exceeded $325,000. Optimism abounds that it will be a cinch to reach the 75 per cent capacity needed to meet the $660,000 operating budget, which for comparable New York productions would be at least double.

Mail orders have come from as far off as New York, San Diego and Biloxi. But much credit is given to 1,000 tireless women volunteers who have worked over an area in a 100-mile radius from the Twin Cities pushing the project at teas, cocktail parties and dinners. Rita Gam and jovial Douglas Campbell, Mr. Guthrie's assistant, talked to a labor meeting and A.F.L.-C.I.O. bought out an entire performance.

Dayton's department store sold about 40 per cent of the season subscription tickets on its credit card and permitted the use of its 400,000-name mailing list for direct-mail advertising. A $377,000 Ford Foundation grant that came as a bit of a windfall will go a long way towards insuring financial help

during the three years picked as the tryout run. The troika is cautious, however. The project's real success will be measurable, they warn, three years hence when the novelty has worn off.

By artistic standards this is also a season of high promise. Besides "Hamlet," Mr. Guthrie,—Tony to his close friends, Dr. Guthrie to a revering cast and Middlewesterners too shy to use his title, Sir,—will direct Chekhov's "The Three Sisters."

Mr. Campbell, like Mr. Guthrie a veteran of the Old Vic, will stage Molière's "The Miser" and Arthur Miller's "Death of a Salesman." The acting company includes Hume Cronyn, his wife Jessica Tandy, George Grizzard, late of "Who's Afraid of Virginia Woolf" and now the lead in "Hamlet," Rita Gam and Zoe Caldwell. Some supporting roles will be taken by University of Minnesota graduate students on leave under grants from the Mc-Knight Foundation.

**Theater Design**

The theater, the acoustics of which are still doubtful and yet to get the acid test, was designed by Ralph Rapson, head of the university architectural department. The auditorium is horseshoe shaped. The seats, which are upholstered in subdued colors, sweep around the deep brown wooden open-platform asymetrical stage in a 200-degree arc. Ramps to the area below the stage allow startling entrances and exits through the audience areas.

In off-season the theater will be used for chamber music and jazz concerts, lectures, and other plays but probably never for standard road shows.

All this began four years ago when Oliver Rea and Peter Zeisler were working on the musical "Juno," which had a short run on Broadway. They agreed they were disenchanted and shared a hunch that the country might be right for decentralization. They joined forces with Mr. Guthrie, a kindred spirit whose successes at the Stratford (Ont.) Shakespeare Festival and the Old Vic made him a natural for this project. Along the line a luncheon with Brooks Atkinson, to whom they went for advice as a veteran champion of the far-off Broadway drama, resulted in a story about their dream in The New York Times. Response from around the country resulted in a Rea-Guthrie coast-to-coast "shopping trip."

The turning point was reached after Mr. Rea happened to meet John Cowles Jr., editor of The Minneapolis Star and Tribune, at a football game in Iowa City. Mr. Cowles, hearing that the shopping team was coming to Minneapolis to see Dr. Frank Whiting, director of the University Theater, promised to swing into action. He set up a meeting for Mr. Rea and Mr. Guthrie and it made no great difference that the individualistic Mr. Guthrie showed up in sneakers without socks. He is nothing if not eloquent.

Mr. Cowles lined up the keen, energetic young men that make the next-in-line group in the Twin City power structure and, as Mr. Guthrie put it, "Minn will come through."

Mr. Cowles quietly laid the groundwork for getting a $400,000 grant and a tract of land adjacent to the Walker Art Center from the Walker Foundation. Contributions began to flow in; They came from all the usual sources touched in community service drives and from 3,500 families, the Junior League, the Women's Club and even 37 cents from a Sunday school class

in a small town called Mankato.

Mr. Rea and Mr. Zeisler are now émigres from Broadway by choice and Mr. Guthrie, who will commute off season to his home in Ireland, has the rank of professor at the 28,000-student university which, in the words of Dr. Whiting, has a love affair with the theater without messy entanglements.

**Pay Scale**

A chance to take part in a new theater enterprise and the promise of steady work in classic plays has made it possible to pay a scale well below that of the commercial theatre and thereby draw on talent that normally would not be available outside of big show-biz centers. Mr. Rea, for his part, was willing to take a $14,000-a-year salary, and the top actor's remuneration is $400 a week, easily one-fifth of what a Broadway play might be worth to a good actor.

Here a theater can have roots, Mr. Guthrie says. No actors chasing too few jobs, or managers chasing too few theaters, or plays produced by people from somewhere else for buyers from Indianapolis. Not just show business and shop-keeping. Not one actor in 10,000 gets a chance to appear if four plays in one season, he added, not to mention the startlingly few jobs available at all.

To Mr. Cronyn this engagement is like a doctor's taking a year off from his routine daily practice to do basic research.

"It is so much healthier and worth while. It's clean."

May 5, 1963

# *Arts on West Coast: Challenge to East*

**By HOWARD TAUBMAN**

One of the profound changes taking place in the United States cultural landscape is the marked tilt toward the Pacific. It is as noticeable in the energy and diversity of artistic and intellectual activity as in the westward flow of population and industry.

*Critic at Large*

The West Coast has the desire, imagination and means to challenge the long-standing dominance of the East. This much was unmistakable to one who spent some weeks recently on the West Coast.

Symptomatic of the fresh vigor and boldness is the kind of planning going on at the new San Diego campus of the University of California. Although the second of 10 planned colleges will not open until the fall, there is a blueprint for an institute for advanced study in the arts that has no parallel in the country.

The institute will include a drama center under the direction of Michael Langham, who helped build the theater at Stratford, Ont., into one of the continent's finest; a Bach center headed by Rosalyn Tureck, distinguished Bach

scholar and interpreter, and centers for writing, films, 20th-century music and the visual arts.

The plans for this institute have yet to be approved by the university's regents. But there is hope that the authorities, even under Gov. Ronald Reagan's new administration, will affirm the wisdom of a bold approach to integrating the arts for the benefit of undergraduates, graduate students and the community at large.

The West, it is true, still looks uneasily to the East for models, guidance and critical applause. The Los Angeles

Music Center, which will open the last two of its three buildings in the spring, is an adaptation of the principle of New York's Lincoln Center for the Performing Arts, but the chances are strong that it will end by hewing its own path.

The ideas promulgated in the city-sponsored plan for the development of the arts resources of San Francisco are less dependent on the experience of the East. They envision new buildings, new institutions and, what is most significant, new cooperation among all elements of the public—rich, middle class and lower class—in a sweeping attempt to make the arts accessible to nearly all in the Bay region.

Harold L. Zellerbach, industrialist, chairman of the San Francisco Art Commission and

head of the committee that brought in the report, gathered a group of leading businessmen, public officials and others interested in the arts for a luncheon to discuss the city's future. There was agreement that a big job needed to be done.

"But who would be willing to lead, as John D. Rockefeller 3d led in New York in building Lincoln Center?" Mr. Zellerbach was asked later.

"I am prepared to give it most of my time in the next few years," he replied. "I did not assume the chairmanship of the development committee frivolously. I know we'll need a lot of public and private money. There is plenty of it here, old and new, and our problem is to get substantial sums directed to the cultural upbuilding of the city and the Bay area."

The shape of cultural things to come on the West Coast cannot be defined in every detail, but certain trends are clear:

¶There is a marked growth in professional theater. Most of it is nonprofit and subsidized. Little of it resembles the free-enterprise structure of Broadway.

¶Major orchestras continue to prosper and to improve, thanks to local support and pride and thanks also to the large incentive grants made last year by the Ford Foundation.

¶Grand opera remains a fixture on the San Francisco scene. Tours by the San Francisco company have become prohibitively costly, and the prospects are that Los Angeles, San Diego and Seattle will raise the caliber of their own companies.

¶The dance is winning greater acceptance, and local companies like the San Francisco Ballet are gaining stronger footholds in the principal cities.

¶Museums are becoming more selective in choosing special areas of interest. As a result there is likely to be a series of distinctive ones up and down the Coast.

¶Colleges and universities play an increasingly prominent role in the creation, performance and diffusion of the arts.

¶Most important, creative artists have fresh opportunities to have works performed, published, shown and appreciated in their own part of the world, instead of having to seek recognition, as many have had to do, in the East or abroad.

Although not many Westerners say so out loud, they are thinking—and beginning to act —as if they were ready to take on the East in cultural competition. They know that in many ways they are late starters—that the commercial theater has been centered in New York for almost two centuries, that the great Eastern museums accumulated their Old Masters when the accumulating was a lot less expensive, that opinion-making in the arts radiates from the East. But they are confident that the course of the nation's evolution is bound to favor them.

They do not talk merely of the future. They insist that Los Angeles has made enormous strides in the last decade. They point to the impressive, many-faceted expansion of activity in Seattle. They note that San Francisco has shaken itself out of what seemed a complacency and is moving forward again. They speak of the vitality with which Oakland, troubled in recent years by economic and racial imbalance, is supporting its cultural institutions.

Nor are the largest cities the only ones with fresh programs and driving energy. The smaller communities are full of plans and hopes. Anthony Reid, executive director of the California Arts Commission, said that the state body had had innumerable requests from small towns for advice and assistance in bringing in performing and visual arts as well as cultivating their own. He said that the commission would ask the legislature for an appropriation of $650,000 in 1967, an increase of $500,000.

Some idea of the ambitious scope of the West Coast's cultural future may be gained from a closer look at developments in the arts.

## Theater

First, the theater. Although the Institute for the Advanced Study of the Arts is still in the early planning, the drama project is well along. Mr. Langham has agreed to leave Stratford and will go in 1968 to San Diego the campus actually is on a glorious site in suburban La Jolla. A new theater with an auditorium seating about 1,700, plus a smaller one with 250 seats for experimental work, is being designed by a Chicago architect. It will be on the San Diego campus but will be a joint venture of town and gown.

The estimated cost, $3-million, will be met equally by both. The university's $1.5-million will come from its construction budget; the community's is being raised by the Theater Arts Foundation of La Jolla.

Mr. Langham is expected to recruit a professional company of the highest competence and to put on a 26-week season of classic and modern plays. He will also head the university's drama center, where the emphasis will be on graduate instruction.

John Stewart, who helped plan the program for the Hopkins Center when he was teaching at Dartmouth, moved to San Diego to help think through the new campus's approach to the arts. He has become provost of Muir College, which will open in the fall, but remains immersed in plans for the arts. He proudly showed a visitor the mesa chosen for the new theater.

Nor will this be the only theater around San Diego. The Old Globe, which goes professional for its annual summer Shakespeare festival, wants to become an all-year professional theater. And Cal-Western University, which has its main campus on Point Loma with dramatic Pacific Ocean vistas, has acquired a building in the heart of the city, and has set up a theater program aimed eventually at professionalism.

In Los Angeles, the Center Theater Group has been formed to provide the 2,100-seat Ahmanson Theater and the 800-seat Mark Taper Forum—the new Music Center houses—with what is hoped will be first-rate productions. Lew Wasserman, head of MCA, Inc., the entertainment industry's giant, has assumed the presidency, and has promised that the repertory company in the Taper and the productions in the Ahmanson will have sufficient backing. Like the other constituents of the Los Angeles Music Center, the Theater Group is not expected to make a profit.

"I had no intention of getting into this," Mr. Wasserman said during a chat one day. "But Mrs. Norman Chandler, who has led in building the Music Center, kept after me for several months, and I finally could not say no. I think we can build an important theater life in Los Angeles. We have the talent. We can find the ideas. And we can raise the funds needed to meet the deficits we expect."

Sidney F. Brody, president of the Los Angeles County Art Museum, was equally confident of Los Angeles's capacity to back up its ambitions.

"We plan to start a drive early in 1967," he said. "We'll ask for $5-million as a starter but hope to end with more than $10-million."

Mr. Brody referred to the numerous fine collections in the Los Angeles area, making only modest mention of his own, which is one of the best.

"We have reason to hope that some of these, if not all, will eventually come to the museum permanently," he said.

There will be space for the works in the new quarters, Mr. Brody said.

"I'll tell you a secret," he continued. "Among the holdings we inherited there is a lot of mediocre stuff. We're getting rid of it, thinning our collection to make way for quality. And quality is what we want and will have."

No one in Los Angeles would identify publicly the choice collections the museum has its eyes on. But people are thinking of the masterpieces being assembled by Norton Simon, the industrialist. Mr. Simon, however, is keeping his own counsel.

At the University of California at Los Angeles, where the Theater Group was founded in 1959, there is a determination to establish another professional unit.

In Los Angeles and environs, a number of theater companies have been functioning professionally and semiprofessionally. But they rarely make money. Their artistic and administrative staffs subsidize them.

Some touring shows are accommodated at the Chandler Pavilion, the Music Center's largest hall. The Huntington Hartford Theater downtown is available for plays, and the Greek Theater produces its own. But the large Cole Porter Theater, which was announced for the new development area in Century City, is now in abeyance, and knowing observers wonder whether it will ever be built. It was expected to be a home for touring musicals and new shows destined for Broadway.

In the San Francisco area, the American Conservatory Theater, headed by William Ball, begins a long season this month. Under the plan for the city's arts resources development, it or a successor will get a home of its own, complete with large and small auditoriums. There are also plans for a large theater, which could accommodate big productions, including musicals. The future of the Curran and Geary Theaters, the two standbys for touring shows, is regarded as uncertain.

At Stanford University, 30 miles down the peninsula, a professional repertory company has been installed. Now in its second season, it provides the academic community as well as the surroundings area with a subscription series of four plays. It also serves as a training ground for undergraduates and graduate students concentrating on drama.

Stanford also has a summer festival of the arts, which brings together for six weeks not only theater but also concerts, opera, dance and art exhibitions. Leading regional companies, it is hoped, will provide drama for next summer's event.

On the Berkeley campus of the University of California, Travis Bogard and Robert Goalsby of the drama department, which now confines itself to student work, look forward to forming a professional company of university graduates. They have a larger vision of a permanent professional company that will serve not only Berkeley but other campuses of the country's largest university as well.

Oakland has just established its own professional repertory theater, with Rachmael ben Avram as director. It began in the fall with a revival of "The Glass Menagerie," with Mildred Dunnock as Amanda. "Romeo and Juliet," "The Importance of Being Earnest" and "The Skin of Our Teeth" complete the first season's subscription list. Oakland believes that the company has a fine chance of making a solid place for itself.

In Seattle, the repertory theater, in its fourth year, appears to be solving some of its financial and artistic problems. Allen Fletcher, the new artistic director, is optimistic. He thinks that the community is determined to give the theater its patronage and sufficient contributions to keep standards high.

The University of Washington, which has its campus there, has been stressing its drama department. It recently brought in Duncan Ross, a well-known Canadian teacher of acting, to join the faculty. There are expectations that the Repertory Theater and the university will cooperate increasingly.

## Music

In music, established institutions are flourishing up and down the West Coast, and there are all sorts of interesting initiatives being taken by community and university organizations.

Zubin Mehta has won friends

for himself and the Los Angeles Philharmonic, which he conducts. Josef Krips has restored solidity to the San Francisco Symphony. Milton Katims continues to raise the stature of the Seattle Symphony. Gerhart Samuel, a gifted young conductor largely unheralded in the East, is doing fine .work with the Oakland Symphony, to judge by one concert.

The San Francisco Opera under Kurt Herbert Adler continues to deserve respect as a company of impressive international quality. In Los Angeles, John A. McCone, once the head of the Central Intelligence Agency, has accepted the chairmanship of a board designed to develop an opera company of quality.

At the colleges and universities, well-known performers and creators are visiting or are in residence. Karlheinz Stockhausen, German avant-garde composer, is lecturing this year on the Davis campus of the University of California. Roger Sessions, the American composer, is visiting at Berkeley.

Under the leadership of William Bergsma, American composer, the University of Washington has developed a wide-ranging musical program and has built a commensurate faculty. Bela Siki, accomplished

Hungarian pianist, arrived recently, and so did the Philadelphia String Quartet, made up of former members of the Philadelphia Orchestra, which performs extensively on and off the campus.

## Art

Museums everywhere on the coast are forging ahead with enlarged programs and plans for expanding old, restricted quarters. The Los Angeles County Museum has its grandiose new buildings on Wilshire Boulevard, and is setting out, with well-organized support from leading collectors and other friends of the visual arts, to build a catholic collection of high quality.

From talks with some of its board members, it became clear that Los Angeles would not be satisfied with a museum limited to excellence in one or two periods. They left the impression that the city had the size, means, vision and ambition to build its fine-arts collection into one that in a decade or so could compare favorably with those of other leading United States cities.

San Francisco has proclaimed its purpose to enlarge and coordinate its museum facilities. There is a drive to get more

space for the collection in the Palace of the Legion of Honor, and there is an awareness that further provisions must be made at the De Young Museum if it is to house adequately the recently offered Brundage collection of Oriental art.

At Berkeley, a new museum is to be completed in 1968, in time to celebrate the centennial of the university's founding. This museum, under the guidance of Peter Selz, is expected to be strongly avant-garde.

In Seattle, an additional building for the museum has been provided on the former World's Fair grounds. The emphasis is on Oriental and 20th-century Northwest art, but there is a desire and a hope for expansion in other directions.

The most remarkable new museum building on the West Coast is going up in Oakland. On a striking four-acre site in the heart of the city, a museum center designed by Kevin Roche, associate of the late Eero Saarinen, is 90 per cent complete. Even in its unfinished state, its three levels looked to a traveler several weeks ago like a modern version of a vast Mayan temple. Its three main sections will be devoted to the fine arts, history and science, but there will also be exhibition halls for changing

shows, a 300-seat theater, a lecture hall and other amenities.

According to James M. Brown 3d, the director, the museum's fine-arts division will seek to establish its own identity. It will put one of its stresses on California art, especially of the 19th century.

The $7-million museum was financed by the city through a bond issue. In a sense, this institution is a symbol of Oakland's determination to share in the exhilarating West Coast push for civic and cultural progress.

Sitting over a late afternoon drink, Mr. Brown and Mr. ben Avram sought to analyze the new community spirit.

"I think it's most impressive in the way everyone is cooperating—the leaders of the community and the public," Mr. Brown said. "It has affected us who direct the artistic institutions. Mr. Samuel, Mr. ben Avram and I and some others meet regularly at lunch.

"What began as a one-shot social occasion has become a regular and useful thing. We exchange ideas and help each other. Is this what people mean by cultural cross-fertilization? If it is, we have it."

January 3, 1967

---

# Los Angeles, Now the 'In' Art Scene

**By HILTON KRAMER**
Special to The New York Times

LOS ANGELES—So far as the American art scene is concerned, Los Angeles is now more or less established as the country's most important "second city." San Francisco may be a pleasanter place to live, Chicago may have a better museum, and Cambridge, Mass., may boast more stringent critical minds, but Los Angeles is where the artists are—especially young artists.

Though still a long way from seriously rivaling New York as the intellectual and financial nerve-center of the American (and much of the international) art world, Los Angeles is nonetheless a place where new art is produced in great abundance—a city with an artistic culture of its own.

The esthetics of the new art movements combined with the ethos of the youth movement have created an open, easy-going, highly receptive atmosphere that is sympathetic to whatever is far-out and untried, and young artists from the country over, as well as from abroad, have flocked here in increasing numbers. And in their wake have come—mostly as visitors, however—more and more art dealers, collectors, museum curators, and art journalists whose special province is the latest thing. These visitors often find,

however, that it is more useful to go to artists' studios than to count on seeing their work in public exhibitions. With the exception of a very few galleries and some of the small university museums in the area, there seems to be little effort to mount serious exhibitions of the new art.

Thus, in a statement introducing the current show of "24 Young Los Angeles Artists" at the Los Angeles County Museum of Art, there is a passing reference to the "much discussed lack of frequent exposure" of the new art, an oblique acknowledgement, perhaps, that this particular museum, being the largest of its kind on the West Coast, has been a special target of criticism in this respect.

In organizing the current show, the museum's senior curator of modern art, Maurice Tuchman, and his associate curator, Jane Livingston, have selected the work of artists in their twenties and early thirties who, with very few exceptions, are still unknown outside local art circles. Though the exhibition actually includes a few paintings, drawings and free-standing sculptures, the main emphasis lies elsewhere—either on mixed-media styles that require a kind of theatrical tableau for their realization or on abstract imagery of the most stringent starkness and purity.

These have indeed been the

esthetic polarities that have characterized the new art of the area during the last decade, and most of the artists in the current show seem more concerned to develop the ideas of their immediate predecessors than to break new ground for themselves. Still, the effect is not of anything second-hand—not, anyway, in the majority of cases—but of a generation of artists entirely at home in the new styles, working with a certain ease and familiarity in exploring the implications of ideas they find especially congenial.

On the one hand, these ideas point to a rampant informality. Thus, in the largest work in the show, called "Wall Piece," John White has created on the walls of the museum a huge gallery-size collage-construction of paper, straw, masking tape and other materials that is different from a hundred other collages of its type only insofar as it does not exist as a discrete object. It is a temporary tableau that will be destroyed when the show is taken down.

On the other hand, these ideas are also concerned with a critical purity of image. Thus, Mary Corse's large white-on-white glass paintings, with their subliminal rainbow effects, transfer to the painted surface some of the esthetic notions already familiar to us in the glass sculpture of Larry Bell and

in the mixed-media works of Robert Irwin, two of the most influential artists on the Los Angeles scene. Mr. Irwin's influence can also be seen in Barbara Munger's wall-size thread construction, another essay on white-on-white effects.

Between these extremes, there are works employing electric light, paintings on felt, paintings on the wall of the gallery, and one construction of rope sacks containing grass sod and Crisco—yes, Crisco—that should (and is no doubt intended to) leave an indelible mark on the carpet of the gallery, if not on our sensibilities.

Oddly enough, the most surprising discovery in the show is the most modest. Two small, very poetic and painstaking drawings of sea surfaces by Vija Celmins in a highly realistic style have an effect, in this context, out of all proportion to their size.

Miss Celmins's work is certainly going to be of great interest to connoisseurs of drawing who are otherwise not going to find much to their taste here. Indeed, her presence in the "24 Young Los Angeles Artists" show leaves one wondering what other surprises of this kind the busy art scene may be harboring.

June 1, 1971

## Dance
# Truly, America Dances

By DORIS HERING

BACK in the thirties, when the old Theater Arts Magazine was a cozy reading habit, I always found myself particularly attracted to a feature called "Tributary Theater." It had to do with a new world outside New York. It seemed so varied; the actors were intriguingly unfamiliar. There was excitement in the stage sets, too. They had a look of vaulting imagination unfettered by Broadway economics.

Sometimes, since dance was my first love, I wondered why there wasn't also something called "Tributary Dance." Weren't there flourishing dance companies all over the country, just as there were theater groups and symphony orchestras? Indeed there weren't.

True, a handful of choreographer-directors like Ruth Page in Chicago and Catherine Littlefield in Philadelphia were forging a way. And we were beginning to develop our first generation of serious and influential American dance teachers like Mary Ann Wells in Seattle, Lillian Cushing in Denver, Edna McRae in Chicago, Edith James in Dallas. For the rest, American dance in the nineteen-thirties was the most schizoid world you could possibly imagine.

On one hand, you had those marvelous itinerant Russians — the Ballet Russe in its various manifestations. What an effect they had. What an effect they are still having.

There are still plenty of communities in this country where only Russian names are accepted as symbols of balletic knowledge. Only two years ago when Sergei Denham, director of the defunct Ballet Russe de Monte Carlo, died in New York, I happened to be in Houston, Texas. At a party, perfect strangers came up to me and solemnly offered their condolences. I was from New York and so I automatically became an official mourner. Actually I had never met Denham, but their affection for the Ballet Russe was so abiding that it made no difference.

In New York back in the thirties, the split in American dance acquired particular momentum. The modern dancers, with their sturdy legs, their solid torsos, their cupped hands, were casting out that monarchistic demon called ballet. Strangely, they were rebelling against a way of moving which had not yet really taken hold in this country. As long as an art is itinerant, and ballet then was, its effect is sporadic and peripheral.

The moderns didn't realize this. They mistakenly attacked ballet's code of movement and its subject matter, rather than the conditions under which it was being propagated.

*

But rebel they did. The ballet baby swam vigorously out with the bath water.

Only Martha Graham realized (it may be one reason why she is currently so reluctant to keep her works in repertory) that a prime function of modern dance was to enrich the mainstream of western theatrical dance, to give it a deeper, more organic point of view and to give it a repertory relevant to its own time and environment. From the very beginning of his career in the 1940's, Jerome Robbins realized this, too. Both artists have breached the gap between a migratory art and an inbred one—between ballet as it was then and modern dance as it was then. They have done so with infallible genius. If America had produced no other choreographers but these two, all the world could be forever grateful.

How about America at large? How about each and every American community with its growing generations of healthy, activity-minded young people and its gradually increasing leisure time? Where did dance fit into the picture? Were touring exotics the answer? Was Greenwich Village concert dance the answer? To a few, yes. But a vital art doesn't merely pass by, nor should it sink into false comfort on the college campus. It changes people's lives and keeps on changing them day after day.

In a way, Lincoln Kirstein, managing director of the New York City Ballet, realized this in the 1940's when he refused to allow the company to tour. He had the vision and the colossal patience to build a company with which its own community could identify.

But "out there" things were also happening. Some 40 years ago a raven-haired Atlanta girl named Dorothy Alexander was not only teaching and pioneering a five-year dance curriculum in every Atlanta public school, she was also forming a ballet company. A few years later two Dayton, Ohio, girls, Josephine and Hermene Schwarz, began to teach in their front living room for a few cents a class. They, too, formed a company.

Eventually Ballet Russe couples, Ballet Theater couples, other itinerant dancers who wanted to marry and raise families, began to open schools in cities like Tulsa, Fort Worth, Tucson, Miami, Dallas. They also began to realize that teaching was only the beginning. Their talented dancers needed a performing outlet—at home.

Oh, they were different, those new pioneers. Some could scarcely speak English. They tackled the Texas plains with toe shoes in hand. Later, in the fifties and sixties, others, fleeing the strong hand of Britain's Ninette de Valois, learned for themselves in the Midwest what it meant to build from the ground up. Others braved the Bible Belt, where itinerant dancers might have been briefly accepted because there was no danger of their staying more than a day or so. But resident dancers! Well, they'd better not poke their heads too far outside of their studios.

I well remember just a few years ago visiting a community in South Carolina where a resident dance company was performing in a wretched elementary school auditorium, the kind which specializes in peeling paint and graffiti. Only a few blocks away was the modern auditorium of a university supported by a strict Protestant sect. I asked the ballet director why she didn't use the auditorium. She replied that dance was not permitted there.

Since I had been invited to give an intermission speech, I mentally turned my collar around, borrowed from the Martha Graham litany, and intoned solemnly about dancers being the "Acrobats of God." It worked. The following year the dancers were permitted to use the more suitable auditorium.

As the regional companies were slowly coming into being, they were learning everything the hard way. Most of them were isolated both physically and creatively. That's still true today —but to a far lesser degree. Even now stalwarts like The New York City Ballet, American Ballet Theater and The City Center Joffrey Ballet have scarcely hit a number of key cities.

How desperately needed, then, are America's resident or regional ballet companies. They provide a continuity when no national touring companies are available, and they spearhead an enthusiastic and increasingly discriminating audience when the itinerants do turn up.

Physically, dancers must begin their performing lives at an earlier age than other artists. You can paint when you're 90, play the piano when you're 80. But fundamentally you're finished dancing when you're 50. Regional companies give the teen-ager a chance while he's still in the home nest. They also give the fledgling a chance to see if the rigors of the performing life are really what he wants.

*

The male dancer, too long the forgotten man of American dance, is gaining prestige because businessmen have given dance a new respectability by becoming active on many ballet boards. Only a few weeks ago at Lincoln Center, as I watched 12 stalwarts line up across the stage for curtain calls after American Ballet Theater's Etudes, my heart thumped with pride as I realized how many of those fellows had come up through regional ballet companies.

Why do many dancers still come to New York, rather than staying at home? Economics. Most resident companies cannot yet support their dancers. But the tributary tide is turning. Instead of continuing to feed artists into the competitive hopper which New York has come to be, the regional movement is gradually drawing dancers and choreographers from New York to places where they can lead more satisfying

lives. Four years ago at a regional ballet festival in northern California, I asked 250 young dancers whether they would still leave for New York if their companies could support them at home. Unanimously they said "no." They had developed a pride of place. They had directors who cared for them as individuals. Money was not their first concern.

We like to think of New York as the creative center of our artistic universe, as the only place "where it's at." Yet, for the most part, New York does not really foster talent. It consumes it. I'll bet there isn't a "loft dancer" in New York who really enjoys scurrying down a dirty lower East Side street and hiking up four flights to an expensive but impossibly drab expanse of floor, ceiling and whitewashed walls. If you can walk along the Pacific to get to your studio, as the dancers do in Laguna Beach, or have a studio looking out over the trees, as the Cornish Ballet of Seattle does,

isn't it easier to find yourself—be yourself?

But what about the problem of isolation? Like starvation, it's erroneous to believe that it fosters artistic growth. And so during the past 16 years the regional companies have been moving one by one into a bold world of their own. They have become a movement, performing in annual festivals, sweating it out in summer choreography conferences.

How do they fund their participation in these projects? They try everything from flea markets and car washes to careful assaults on local foundations and the increasingly helpful state and community arts councils. This year, for example, the Missouri State Council on the Arts gave each company in the state sufficient funds to attend a festival in Kansas City, with the stipulation that they go even if they were not selected to perform.

There is a National Association for Regional Ballet, funded by the National Endowment for the Arts, work-

ing to give the strong companies the national stature they need and the less experienced companies a realistic image along the way. The ultimate goal: more resident professional companies all over the country as time and conditions are ripe. Then and only then will New York cease to be the small, whiplash tail wagging the large, unwieldy artistic dog.

This Friday* and Saturday the three top-seeded regional companies — Atlanta Ballet (directed by Robert Barnett, formerly a principal dancer with the New York City Ballet); Dayton Civic Ballet (still directed by Josephine Schwarz); and Sacramento Civic Ballet (directed by Barbara Crockett, who began her career with the San Francisco Ballet), are joining for two performances in the Delacorte series in Central Park.

Thus three tributary ballet companies will be briefly reversing the current. But only briefly. For their cities need them, as more than two hundred other American cities

need the companies they too have spawned. Whether the companies are small or large, modest or ambitious, adventuresome or conservative, they are giving American dance a shining new identity. They are also giving a new generation of American choreographers the chance to develop their own pace because they have the opportunity for experimentation without even exposure.

As for the initial split between modern dance and ballet, there is every reason to believe that it is becoming smaller and smaller as the tributaries continue their two-directional flow. Thus regional ballet may be our century's healthiest contribution to the evolution of American dance.

Perhaps Isadora Duncan's dream of "America dancing" may also be at our fingertips.

*Doris Hering is executive director of the National Association for Regional Ballet and critic at large for Dance Magazine.*

September 3, 1972

# Cultural Activities in the South Grow With Its Economy

## An Increasing Amount of the Art Work Is Gaining National Recognition

### By B. DRUMMOND AYRES
Special to The New York Times

VALLE CRUCIS, N.C., Oct. 31—Half a century ago, H.L. Mencken surveyed the arts scene in the South and concluded bitingly that Dixie was the "Sahara of the Bozart."

"One would find it difficult," the Baltimore polemicist wrote, "to unearth a single second-rate city between Ohio and the Pacific that isn't struggling to establish an orchestra, or setting up a little theater, or going in for an art gallery, or making some effort to get in touch with civilization. You will find no such effort in the South."

Mencken would have to rewrite that oft-quoted essay were he to return to the South of the 1970's. Dixie is still no cultural oasis, but as they say in Southern arts circles these days, some flowers are beginning to bloom in the desert.

Arts activity in the South has increased markedly in recent years as the region has become more and more an economic and political power. Increased wealth and urbanization have left a broad scattering of symphony orchestras, civic ballets, little theaters, art galleries and museums, art schools, cultural centers and cultural councils.

### Worthy of National Note

Much of the activity is, at best, semi-professional. But more and more of it is professional and worthy of national note.

Here in the remote mountains of western North Carolina, for instance, curators from two major American art museums—the Corcoran in Washington and the Whitney in New York—showed up this weekend for a seminar with some of the South's leading contemporary artists and sculptors.

The seminar was officially titled the "Southern Rim Conference," a title meant to say something about the level of arts activity in the South today. The Southern Rim, or Sun Belt, is the arc of Southern and Southwestern states that is accruing economic and political power faster than any other region in the country.

"Cultural power, too," said William Dunlap, a professor of art at nearby Appalachian State University, one of the seminar's sponsors.

### Whitney Representative

Jane Livingston, the Corcoran representative at the seminar, said of the region, particularly the South: "There is a tremendous amount of art energy down here now, just tremendous. There is quality. There is style. The rest of the country needs to hear what is being said at this seminar, needs to know about Southern art today."

Marcia Tucker, the representative from the Whitney, agreed, but doubted

that the rest of the country was listening, particularly New York. She said she would leave the Whitney at the end of the year because "the management is too parochial, too much into the New York thing."

James Surls, a Texan who sculptures massive wooden works with axes and chain saws, contended that New York was no longer "the be all and end all."

"The South supports me now, buys my stuff, encourages me," he said. "It's as interesting to stay at home as it is to go to New York. Things are beginning to happen down here."

No "rim" city is doing more to support the arts than Houston, according to Paul Schimmel, the curator of the Contemporary Arts Museum there.

### Oil Money Played a Part

"A lot of Southern towns have money now," he said, "but Houston has the most because of the oil crisis. More and more patrons are emerging, and that's drawing in more and more artists.

"The farther Southern artists get from the old paint-the-dilapidated-shack school, the more people buy and invest, even businessmen like banks. Houston's the hot one."

But other Southern cities, big and little, also are showing signs of notable cultural activity.

Atlanta, for example, already has what is probably the best of the dozen or so Southern symphony orchestras. But its increasingly sophisticated cultural community recenty began to demand an orchestra befitting a metropolis that advertises itself as "the next great American city."

On a somewhat smaller metropolitan scale, Anniston, Ala., now has an annual Shakespeare festival that runs a month and is professional enough to

draw theatergoers from Atlanta, a three-hour drive to the east.

In a South that is becoming increasingly urbanized and sophisticated, how Southern are today's Southern artists?

So far as painting and sculpture go, the conference here this weekend provided no real answers.

A lot of Dixie beer was downed, and there was a lot of talk about good old boys, kudzu, the Klan, chickens, war, blacks and guilt. But no artist would admit to deliberate injection of the South into a painting or sculptured piece.

### Strong Narrative Tendency

Marcia Tucker, the Whitney curator, detected a strong narrative tendency in the works of the artists represented.

"You can find narrative in a lot of American painting today," she said. "But it's particularly strong in Southerners. They just love to tell tales."

But what about a distinctive Southern theme?

"I'm from the South and sometimes what I draw is about the South," John Alexander, an Alabamian now living in Houston, said. "But I don't just paint about the South. Is it Southern to put hair on a North Carolina church the way I once did?

"I don't know. It was a hairy church."

November 1, 1976

---

## CULTURE FOR THE MASSES

---

# TIMES'S PICTURES WIN BRITISH PRAISE

---

### Rotogravure Supplement Is Hailed as a Notable Piece of Enterprise and Art.

---

### BRANGWYN IS ASTOUNDED

---

### And Joseph Pennell Regards the Reproductions of Paintings as Superb Work.

---

Special Cable to THE NEW YORK TIMES.

LONDON, April 18.—It is not too much to say that THE NEW YORK TIMES Easter colored supplement, illustrating the gems of the Altman collection, and, even more, the first rotogravure supplement, caused a genuine sensation in art circles here and elicited many commendations on the enterprise displayed, as well as what is termed the immense service rendered to the cause of art.

Of the artists who praised the supplements none showed a livelier interest and a keener or more critical appreciation than Frank Brangwyn, the mural painter, who has the unique distinction of being the only foreign artist commissioner to do decorations for the Panama Exposition.

Mr. Brangwyn was busy on one of the eight large panels, representing the four elements—earth, air, fire, and water—which he is doing for one of the two great courts of honor, when THE TIMES correspondent visited him in his charming studio in Temple Lodge, Hammersmith.

The artist climbed down from his perch on the scaffolding and then spoke of the rotogravure reproductions.

"Astounding!" he said. "Splendid! I have never seen anything as good, even in high-class magazines. The 'Yonker Ramp and His Sweetheart,' by Frans Hals, on the front page, is a splendid reproduction, like a highest-class photograph. Why, you can even see the grain of the canvas, the brushmarks and all. It is perfectly astounding.

"That other large Frans Hals, 'The Merry Company After a Meal,' is also especially fine. All are excellent, but its is curious and interesting that the Frans Halses came out the best. Those are two of the finest reproductions I have ever seen. I never expected to see anything like this in a newspaper. I hope THE TIMES can keep up this high standard.

"One great pull of these reproductions over the magazines is their size. You can get a much better and truer idea of the original from these rotogravures than from small magazine pictures. If that Frans Hals was framed, you would think you were looking at a fine guinea photograph.

"One cannot complain of the public not getting art education since THE TIMES brings these masterpieces to the very doors of the people. The color reproductions are excellent, too, but the rotogravures, I think, surpass them.

April 19, 1914

---

## IS ART ARISTOCRATIC?

Brooklyn, N. Y., April 16, 1922.
To the Editor of The New York Times:

It seems to me that in your editorial of today "About Novels" you have taken Joseph Hergesheimer to task unjustly for his pronouncement that "any art is, in essence, aristocratic, proud, free from cheapness of the mob." And your conclusion, "so Shakespeare and Molière can't have been artists," because, as one may reasonably infer, they have been popular, is, in my opinion, unwarranted.

In the first place, there is really no conclusive proof that Shakespeare enjoyed the popularity generally attributed to him by his biographers. Is it not remarkable that we know less about him than of any of his less illustrious contemporaries? It is indisputable that his contemporaries shared equally the plaudits of his generation. We know it to be a fact that Shakespeare's erstwhile partner, Alleyn, and the latter's father-in-law, Henslowe, who set up a circus within proximity of the Globe Theatre, inveigled audiences away from many of Shakespeare's performances. And Karl Mantzius tells us that in "books of travel by strangers who visited London at this time, we look in vain for the name of Shakespeare. Not a line is found even about any of his plays." And from another source we learn that Queen Elizabeth, presumably the patron of art, preferred a comedy by Shirley to a tragedy by Shakespeare. How will you reconcile these facts in face of the extraordinary popularity that is claimed for Shakespeare?

It is true that Molière attained greater popularity during life than his illustrious English contemporary. But Molière would scarcely have achieved world fame if his merits were judged solely by the entertainments he wrote specially for the amusements of the King and the people of Paris—the entertainments that brought him popularity. His made-to-order pieces are meretricious, undeserving of serious consideration. It is true that some of his finer plays, such as "L'Ecole des Femmes," achieved success, but that was because as Karl Mantzius tells us in his "History of Theatrical Art," "the general public was hardly able to understand the new element introduced by Molière, but it was amused and involuntarily attracted." Molière's better plays, however, fared worse with the public. "Tartuffe" was prohibited, because it exposed the bigotry and religious hypocrisy of the Society of the Holy Sacrament, a clique which had become a scourge to its fellow-creatures by its insolent, interferences in other people's affairs. "Le Misanthrope" probably the profoundest of Molière's plays, did not arouse the tempestuous, uproarious applause which rewarded his lesser works. "Le Bourgeois Gentilhomme," and "M. de Pourceaugnac" divertissements, written to amuse, Boileau calls unworthy of Molière's genius. In his endeavor to please the public, Molière fell.

Genius and popularity are, I believe, incompatible. A review of the world's literature will adequately prove that the really great men were unpopular during their lives. And the reason thereof is obvious. The genius is in the vanguard of new thought in every field of human endeavor. The bulk of the army is miles and miles behind him and it can only see what he sees after it has traversed the distance he had covered a generation before.

Shakespeare's and Molière's art was in the essence "aristocratic, proud." Shakespeare and Molière had the energetic, original, gay manner of artists. They knew no discipline, they were free, untrammelled from all codes, religious or moral. There was no model imposed upon them as nowadays. And the literature of that epoch is wonderful because the poet gives a faithful, honest and trustworthy portrayal of his time: of the violent disposition of his people, of their unchecked roughness, their unbridled passions, their uncouthness.

Art is aristocratic. The masses cannot judge unless they are educated up to it. It goes without saying that whatever is popular is inartistic. Let us look about us and see what the public admires: Coney Island, vaudeville, Billy Sunday, Jack Dempsey, Babe Ruth, Laura Jean Libbey, The New York Journal, the movies (good, bad or indifferent), Mayor Hylan (400,000 majority). And yet you want the artist to cater to the tastes of the very same public? Sheer madness!

"The highest art," says Romain Rolland in "Jean Christophe," "the only art which is worthy of the name, is above contemporary law. It is a comet sweeping through the infinite. It may be that its force is useful; it may be that it is apparently useless and dangerous in the existing order of the workaday world, but it is a force—it is movement and force, it is the lightning from heaven, and for that very reason it is beneficient. The good it does may be of the practical order, but its divine benefits are like faith of the supernatural order. It is like the sun from whence it has sprung. The sun is neither moral nor unmoral. It is that which is: it lights the darkness of space. And so does art."

This is what art means. The genius is one who can reach out and attain this loftiness, and no man will ever put asunder what he has created. Art is infinite. The genius who conceives it, also. It seems to me that no man who understands art will quarrel with Mr. Joseph Hergesheimer's definition of it.

WILLIAM J. PERLMAN
April 23, 1922

## PUBLIC'S INTEREST IN FINE ARTS GAINS

**Attendance at the Museums Increases Except in Boston and Philadelphia.**

**NOW 167 SUCH GALLERIES**

**Hoover Social Trends Committee Finds Art "Movement" Meeting With Wide Degree of Success.**

The appreciation of the fine arts in America, as indicated by attendance at nineteen principal art museums, has grown rapidly in re-

cent years except in Boston and Philadelphia, the oldest cultural centres of the country, where the fine arts have lost ground, according to the latest published monograph in the series of studies undertaken by the Hoover Research Committee on Social Trends.

In contrast to the failing public interest registered at the gate of the Boston Museum of Fine Arts and the Pennsylvania Academy between 1924 and 1930, a "conspicuous gain" was shown by the museums of arts in Baltimore, Toledo and Newark. In New York City, as in other large centres, the increase was not so large as in these, yet the attendance at the Metropolitan Museum of Art, which in 1924 was 1,062,901, rose in 1930 to 1,288,828.

The other art centres showing gains in museum attendance were Pasadena, Cal.; Washington, D. C.; Chicago, Ill.; Indianapolis, Ind.; New Orleans, La.; Worcester,

Mass.; Detroit, Mich.; Minneapolis, Minn.; St. Louis, Mo., and Cleveland, Ohio.

In addition to stressing the increase during the past decade in the number of public art galleries and museums, the great outlays of money for such institutions and a relatively large growth in the number of visitors, the monograph emphasizes the increase of more than 50 per cent in the number of art students, not only in the art schools and in the art courses in colleges and high schools, but in the elementary schools.

"Organized education inside the schools," according to the monograph, "does not by any means give the complete picture of the conscious attempt to open the eyes of the American people to the significance of the arts. The fact that adults can be educated at all is almost a discovery of yesterday, but it is one that has been seized upon by enthusiasts for the arts."

It is estimated that between 1910 and 1930 the capital invested in art museums rose from $15,000,000 to $58,000,000. During the decade 1920-30, of the 236 new public museums that were founded, 60 were art mu-

seums, bringing the total of that class of museum to 167.

In most libraries, the monograph notes, it has been found necessary in recent years to double the range and extensiveness of the fine arts departments.

Commenting finally on what is being done "to interest the American people in the fine arts," the monograph records:

"The machinery for doing this is increasing in cost and bulk, and probably in effectiveness. The rising importance of art in all fields may reasonably be described as a movement. How much of this movement is the result of a popular demand and how much of it is being guided from above is a problem that need not be solved here. The vast abstraction called the Public may not consciously desire that other abstraction called Art. It does accept it, to an appreciable degree, when it is offered."

The authors of the monograph are Dr. Frederick P. Keppel and R. L. Duffus. It is published under the title "The Arts in American Life" by the McGraw-Hill Book Company.

*March 27, 1932*

# COLOR REPRODUCTIONS AND THE PUBLIC

**Demand Indicates Taste Remains Conservative, Stresses Decoration**

**By SAM HUNTER**

AN inquiry into best-selling reproductions at selected galleries, museums and department stores gives evidence of no startling recent departures in popular taste. If anything, public taste today seems characterized by its lack of insistence on any particular types of painting, its genial accommodation to whatever publishers have made available. And, with one or two exceptions, publishers of reproductions have not been distinguished by their enterprise in encouraging a living, popular taste.

The lag between the acceptance of vital contemporary art by painters themselves and by the critical intelligence of the time, and the recognition and consent of the public is as apparent as ever. It is a lag generally of thirty or forty years. The campaign for modernism that Roger Fry opened when he introduced post-impressionism to a startled British public in the 1910 Burlington House show and that was continued here in the Armory show of 1913, is only now being fought and won in the field of low-price reproduction. Today Cézanne, Van Gogh, the early Picasso are regularly reprinted and seem to meet general public approbation; yet there is some question

whether this represents an advance in seriousness.

For example, the most popular modern today in the more fashionable print shops is, by all odds, Dufy. Picasso's "blue" period and neo-classic "Woman in White"; Braque's early, most representational still-life; early Matisse interiors; Monet's floral pieces, Degas' ballerinas; and Renoir's children (the portrait of Margot Berard is the favorite at the Museum of Modern Art) are generally sought out. The appeal here is primarily decorative. Any discrimination shown is always toward the more conservative aspects of the artist's work.

**Decorative Accent**

We can only be grateful for the revulsion in taste away from the golden age of color reproductions, not too long past, when Maxfield Parrish's coy nudes and Pierre Cot's and George Watt's sentimental allegories were reigning favorites. Although there is an apparent defection from sentimental subject-matter toward decorative effect, it isn't at all clear that this represents a progress in discrimination.

The fact that Vlaminck, Huldah, Eisendieck, Edzard and Marie Laurencin seem to have as much vogue as the masters of the modern movement they feebly echo, indicates it is a social emotion rather than a sensibility that is at work determining what will be bought. Public taste is so difficult of definition because it functions in a region of dream and

myth. The legend of fashionable Parisian life with its nullification of real problems, social or esthetic, is apparently just as effectively symbolized in a boulevard by Edzard or a ballerina by Huldah as it is in work of great artistic merit by Pissarro and Degas.

It is interesting that Van Gogh has lost a good deal of the modishness he formerly enjoyed. "Sunflowers," a perennial favorite, today doesn't sell at all. A dealer explained this as snobbism. His paintings have become too familiar and acceptable. This desire for novelty has in the case of Cézanne shifted taste from the oils to his water-colors.

The emphasis on decorative appeal has brought with it greater emphasis on size and shape of the painting reproductions and the picture frame. According to one dealer, horizontal reproductions invariably are more marketable than those with a perpendicular accent because they accommodate themselves better to spaces above mantels and settees. The picture frame is also a strong determining factor in sales. Picasso's "Three Musicians" has been salable in one print shop only since it was placed in a spectacular, off-the-wall frame. In some of the larger department stores some modern reproductions are cased in massive and expensive white flowered frames

**At Lower Prices**

Department store best-sellers are consequently lower priced sentimental Bahama subjects by Thieme, exotic parakeets by

Botke, and illustrative sporting episodes for the American male by Sessions. Decorative birds and floral pieces in air-brush technique are also popular.

The real bane of serious dealers is the interior decorator who approaches possible purchase with a swatch of drape to be matched. If the sale of Dufy's "Nice" is any criterion, fashionable apartment interiors are running to moonlight blue. As one dealer put it in summation, "Some people are never sure whether they wish to buy a painting reproduction or a mirror."

Among Americans Eilshemius, Homer and Marin are current best-sellers in the print shops. The Associated American Artists Gallery lists Nicolai Cikovsky's "Springtime in Virginia," Francis Chapin's "Boy With Book," and Luigi Luicioni's "Route Seven," from its gellatone reproduction series, as favorites today. Gladys Rockmore Davis' portraits of children and Dale Nichols' saccharine pastoral landscapes are popular in other galleries. Benton, Wood and Curry have maintained their popularity among contemporaries.

The current apotheosis of sentimental, prettified Americana has momentarily unseated painting with an emphasis on social struggle, Gropper's social satire and the work of contemporary Mexicans. A Museum of Modern Art official explained the continuing popularity (second only to Renoir's "Margot Berard"), of Orozco's "Zapatistas," with its possibly inflammatory subject of revolution, as a reflection of the decorative appeal of the painting's strong surface rhythms.

*January 4, 1948*

# THE MUSEUM AND COMMUNITY ACTIVITIES

By ALINE B. SAARINEN

TOLEDO, OHIO.

ONE of the phenomena which most amazed the directors of foreign museums, when they visited the United States last winter, was the American museums' sense of responsibility to their communities and, in particular, their emphasis on educational activities. European museum directors bother very little about such things. partly because art is not as isolated into marble buildings as here; partly because European cities, with their aggregate of architecture are "museums" in themselves; and partly because the tradition of art appreciation is deeper in Europe than in America.

Moreover, most European museums grew from great royal or religious collections, whereas most American museums—emerging only after 1875—evolved from art schools, academies and art societies which all were aware of educational needs. The foreign visitors were not only amazed, but, with the exception of those who spoke patronizingly of three-ring circuses and box-office attractions, were interested and approving.

### Revelation to Europe

This testimony of interest makes the United States Information Agency seem especially alert and sensible in having sponsored an exhibition for European consumption showing how American museums serve the public and the astonishing response of the public in using their museums.

The exhibition made its brief American preview appearance at the Toledo Art Museum, which organized the show. It consists of twenty-four demountable panels of extremely lively candid-camera shots—about 188 of them —taken in thirty-one institutions, including both the big museums and such off-beat places as the Walters Art Gallery and the Corning Glass Art Center.

It covers such areas as art classes for children and adults; children and adults in the galleries; the use community organizations make of museums (mostly, it would seem, for eating); the range of United States museum exhibitions, both permanent and temporary; the accelerated activity in circulation of exhibitions and teaching equipment; the activity in remote communication through the mediums of TV, radio, films and publications; the alliances with music; and such miscellaneous services as those provided in libraries of art books, slides, reproductions and phonograph records.

It adds up to an impressive picture. Granted that neither attendance figures nor the statistics on five-year-old finger-painters are proof of a museum's qualitative greatness, these records of community participation and service are significant indications of a growing awareness—long neglected and overdue in America —of the values and enjoyments of visual expression, both active and passive.

### Community Record

It is appropriate that the Toledo Museum should have been chosen to organize this particular show, for it is a museum with a justifiably proud record of good community relations. Toledoans are proud of their museum and it is, incidentally, one of the few cities where the first person you ask can give you accurate directions to the museum. A city of 300,000, its annual attendance is more than twice that figure.

Perhaps the reason lies in the fact that as long ago as 1903— nine years before the museum moved into its Greek facade building and thirty years before the wings with extra galleries and a peristyled auditorium for concerts were added—the Toledo Art Museum inaugurated free art classes for children. This pioneering program — since introduced into almost all American museums—grew steadily so that today in addition to art classes (which use over 1,800 quarts of tempera water paint, 6 tons of paper and 7 tons of modeling clay annually), there is a closely integrated program of gallery use with most of the city's public and parochial—and some of the private—schools. Many of the 130,000 youngsters who came in 1953 are third-generation museum-goers—and for many Toledoans, the museum is a sort of alma mater.

What they can see in this permanent collection is certainly worth a visit. The great benefactor was Edward Drummond Libbey, who brought the glass industry to Toledo and was a perceptive collector in the first decade of this century.

Somehow eschewing the Bougereaus and Barbizon pictures which were tempting his wealthy contemporaries, he acquired such masterpieces as Holbein's Catherine Howard, with its marvelous elliptical design of gold braid enhancing the austere portrait; Velasquez' rougish "Man With a Wine Glass"; an explosive Turner "View of Venice" and a Rembrandt "Self-Portrait" of 1636.

The museum, under its two directors — George Stevens and Blake-More Godwin—has tried to live up to such qualitative standards in its subsequent acquisitions. They have done remarkably well. There is, for instance, Piero di Cosimo's tondo of the "Virgin and Child," a haunting picture where the sleeping, but dead - appearing Christ Child seems to prefigure a Pietá scene; two Grecos—an "Annunciation," where color and light flicker over a solid structure of figures, and the "Christ in Gethsemane" from the Arthur Sachs collection; a triumphant and lush Rubens, "The Child Jesus Crowning St. Catherine"; David's small version of "The Oath of Horatio," with color and tightly calculated composition more intense than in the big Louvre painting.

Among recent purchases are two fascinating altar-wings by the Flemish master, Mabuse. Signed and dated 1521, they are splendid examples of the curiously mannered Italianate style of this period.

It was interesting to see the U. S. I. A. exhibition against this background. It supplied the one element that seemed missing in the show—any indication of the fact that despite their late starts American museums, in provincial cities as well as in great metropolitan seaboard centers, have amassed dozens of great paintings to rival those abroad.

It is important that we have community centers to awaken and educate appreciation of art. But unless there are some great works present, there will be no yardstick against which to direct and develop standards. The Toledo Museum works in both directions.

July 11, 1954

# Museum Gets Rembrandt for 2.3 Million

### Record Price Is Paid by the Metropolitan at Auction Sale

By SANKA KNOX

A painting by Rembrandt was auctioned last night for the highest amount ever paid for any picture at public or private sale—$2,300,000. The painting, "Aristotle Contemplating the Bust of Homer," was purchased in four minutes of bidding by the Metropolitan Museum of Art.

From the platform of the Parke-Bernet Galleries at 980 Madison Avenue, Louis J. Marion, the auctioneer, simply announced that "an Eastern museum" had won the prize.

Later, the museum's identity was ascertained and James J. Rorimer, director of the Metropolitan, who did the bidding, disclosed that the purchase had been made possible by contributions from "several trustees and private individuals."

#### Friends Helped Museum

Mr. Rorimer said that the museum would not have been able to buy the Rembrandt out of its limited purchase funds. But, he said, as it was "considered important to add the piece to our already great collection of some thirty Rembrandts," friends of the museum offered help.

" 'Aristotle' is one of the great paintings in the world," Mr. Rorimer said, "and it would have been heartbreaking, with Wall Street so close, to have lost out on it."

The world's costliest painting will go on display soon.

The Metropolitan Museum last night also bought for the Cloisters "Scenes From the Life of St. Augustine" by a fifteenth-century South Netherlands painter known as the Master of St. Augustine. It cost $110,000.

"Aristotle" achieved several titles in the annals of art last night. It became the first picture in history to command an opening bid of $1,000,000. It tripled the amount paid at auction for the "Adoration of the Magi," the Rubens masterpiece that set a record of $770,000 in 1959. And, it made a crucial contribution to the highest total yield on record for an art auction—$4,679,250.

The Rembrandt masterwork and twenty-three other paintings collected between 1922 and 1936 by the late Mr. and Mrs. Alfred W. Erickson formed last night's auction. Mr. Erickson, founder of the Erickson Advertising Agency, which became McCann-Erickson, Inc., died in 1936.

The collection remained in the Erickson residence at 110 East Thirty-fifth Street until

Mrs. Erickson's death last February.

The proceeds of the sale, ordered by the trustees of her estate, will be divided into ninety equal legacies.

The renown of the "million-dollar" Rembrandt had brought 20,000 visitors to the galleries in a three-day exhibition before the sale.

### 2,000 Attend Sale

Nearly 2,000 attended the sale, most of them waiting in line on the street for an hour or two. The sale was held in four galleries. One was the main room, reserved for collectors, dealer-agents for collectors and representatives of museums.

In the other galleries, spectators witnessed the dramatic sale on closed-circuit television.

As "Aristotle" was brought on stage, the spotlights transforming the flowing sleeves of the robe into gold, the audience seemed to catch its breath, then broke into applause.

When the picture was knocked down to the Metropolitan, the applause became an ovation.

A different kind of applause, spiced with a chorus of feminine "oohs," greeted the second-highest-priced picture in the sale—Fragonard's "La Liseuse," a tender study of a young girl reading. Chester Dale, a collector, bought it, and announced that it would go to the National Gallery, where many of his paintings now hang.

### Many Names Withheld

Many of the pictures were bought by agents, and the names of their clients were withheld.

The identities of some buyers were made known, however. The Carnegie Institute of Fine Arts in Pittsburgh bought Perugino's "S. Augustine with Members of the Confraternity of Perugia" for $125,000 and Franz Hals' "Man With a Herring" for $145,000.

Knoedler's, perhaps bidding for a client, bought the third Rembrandt in the collection. "Prince Frederick Henry of Orange, Governor of the Netherlands," for $110,000.

A few of the paintings were bought by foreign dealers. One was the $180,000 Rembrandt; another was Raeburn's "Quintin McAdam as a Boy," which brought $60,000. and a third was a portrait of "Princess Sibylle of Cleves, Electress of Saxony," which sold for $105,000.

A magnificent "Madonna and Child" by the fifteenth-century Venetian, Carlo Crivelli, brought $220,000, and a regal portrait of "La Marquise de Baglion, as Flora" by Nattier fetched $175,000.

An undisclosed buyer bought a major work by Rembrandt, "Portrait of an Old Man," for $180,000. This painting and two companion portraits of a man and woman by Jan Mostaert had been purchased by the Ericksons for $95,000. The portraits last night brought $44,000.

But the star of the show was assuredly "Aristotle."

A large and late work that has been placed by experts among the top works of the master's career, "Aristotle" has been compared with such a masterpiece as "The Bridal Couple" or "The Jewish Bride" in Amsterdam's Rijksmuseum.

In the large, dark-and-golden composition, Aristotle's face glows with calm and thought, shadows falling lightly under hollowed cheekbones. His eyes gaze far away, his hand rests on the head of the poet.

Rembrandt was out of fashion and on the edge of bankruptcy when he received a commission in 1652 to do a portrait of a philosopher for Antonio Ruffo, a Sicilian nobleman.

The picture was completed the following year, and the artist received 500 florins, or $7,800 today—a high price for his time. Don Antonio complained of the size—about 56 by 54 inches—and of the painting's "unfinished" look, but later ordered companion pieces.

The painting changed hands several times, coming into the possession of a succession of collectors abroad, the last of whom, Rodolphe Kann of Paris, sold it to Joseph Duveen in 1907.

### Sold to Mrs. Huntington

Duveen, who played an expansive role in forming the great American collections after the turn of the century, sold "Aristotle" for "six figures" to Mrs. Collis P. Huntington, widow of the railroad millionaire.

Four years after Mrs. Huntington's death in 1924, Duveen, who again owned the picture, sold it to Mr. and Mrs. Erickson.

The Ericksons paid $750,000 for the work, but kept it for only a short time. After the stock market crash in 1929, "Aristotle" left the Erickson

residence at 110 East Thirty-fifth Street and went back to Duveen's for $500,000. When the business picture brightened in 1936, the Ericksons again bought the Rembrandt, this time for $590,000.

### Replaces a Raphael

Until "Aristotle," with flowing sleeves turned to gold under the gallery lights, was sold last night, the title of most costly painting had generally been accorded to Raphael's "Alba Madonna." This treasure from the Hermitage in old St. Petersburg was bought by Andrew W. Mellon from the Soviet Government for about $1,100,000 in 1931. This is in the National Gallery in Washington.

It can be argued that the price on the "Alba Madonna" is not a fair measure, on the basis that the dollar in 1931 had about twice the purchasing power of today.

Another contender for the title under the devalued-dollar argument was the "Count Duke of "Olivarez" by Velásquez, which Mrs. Huntington purchased in 1909 for $600,000. This is in the Huntington-founded Hispanic Museum here.

"Titus in an Armchair," sold for $270,000 in 1927, held the record for a Rembrandt at auction until last night.

Many Rembrandts have, however, brought far higher prices in private sales. A self-portrait in the National Gallery cost $575,000 and "The Mill," also in the National Gallery, cost $500,000 in 1911.

*November 16, 1961*

# A BANNER YEAR, OF SORTS

## Records Have Been Broken All Over the Place During 1961, But Not Necessarily for the Better

**By JOHN CANADAY**

WITH the end in sight, 1961 is winding up as a year filled with broken records in the art world, climaxed during the past two weeks with the excitement over the Rembrandt. (Surely "the Rembrandt" is sufficient identification by now.) People lined up 82,679 strong to see it in its new home at the Metropolitan a week ago on the first Sunday of exhibition after breaking the price barrier. It was the biggest single day's attendance in the museum's history.

People were not, of course, reacting to art, but to a price tag. This is the least funny of many odd attitudes toward art today. But people are odd in other ways when they come to grips with art, or try to come to grips by floating around the periphery, nibbling at the edges, or plunging into the middle, no holds barred, of the art fracas.

### Paradox

The most curious thing about people is that they have decided they have to know all about art and do something about art at just exactly the time when they could have been least expected to be interested at all. Art in recent years has become an exercise in inner privacy for the artist, and a specialized activity, strictly extramural to the rest of life, for the relatively few people with the time, money and temperament to collect it or think about it. But in their contrary way, people in general, who take art in their stride as long as it is part of life, are showing that as soon as it plays hard to get, they will chase it.

This year they will have chased it at the Metropolitan alone to a record number about double the number who entered the museum five years ago. The Nov. 1, or pre-Rembrandt, total for 1961 was 2,719,884. At 85 cents a head they could have paid for the Rembrandt in advance, and would have had $11,901.40 left over for popcorn at last Sunday's triumph. But there are so many art lovers that during the same hours when the Rembrandt was setting a record at the Metropolitan, the Museum of Modern Art was setting its own, with 6,375 people coming to see the Chagall windows.

### Further Records

Total attendance at museums in New York City that day must have pushed up toward 100,000, which is the population of Utica, a few miles to the north. But proportionately this attendance was slight compared

to the crowds that came to Utica's Munson-Williams-Proctor Institute during the first eight months after it went into its new building and refurbished an old one in period style. Richard B. K. McLanathan, then the director, was boggled to discover that last June, with the first year only two-thirds over, his art exhibitions had racked up a total of 162, 481 visitors. Another 48,722 had visited the period piece. In other words, the visitors were double the population of the city. Try that in New York.

But you don't need a $2,300,-000 painting. a set of well publicized stained glass windows, or a new building complete with children's play rooms to get people in. You don't even have to be a museum. More than 700 people a day crowded into the small two-room Perls Gallery last March to see a combined show of two magic names, Miro and Calder. A record of a similar kind was set, all unexpectedly, by another dealer week before last. His gallery is closed Mondays, but he came down to pick up the morning mail and was still there at 5 o'clock that

afternoon, divided between terror and delight because he couldn't get the door closed against a stream of visitors following favorable notices in the Sunday papers.

It would take a minor bit of research to determine exactly how many art books were published this year, from paperbacks to encyclopedias, and a major one to find out how many were sold, with old favorites still going strong. Last month a series of books on art appreciation, distributed by mail, passed the 2,000,000 mark, which must be a record in several directions. And the number of man hours spent by audiences at art lectures all over the country, ranging from the elementary and misinformed to the esoteric and scholarly, is beyond calculation.

Now, much of this geysering interest must be discounted and some of it must be viewed with

alarm. We must discount the percentage of people who are stimulated by persuasions that sell them on art just as they are sold on the proposition that to be well dressed is worth the money. As a compound evil, these people are sold just as many art fads as they are sold fashion fads. Thus taste may be distorted, and as part of the exhibition cycle the artist also may be corrupted without realizing it. When we try to brush aside the fashion-followers as superficial and hence inconsequential, we may discover that nasty roots have gone deep into the structure of contemporary art and even into our way of seeing the art of the past.

When you begin thinking along these lines, the year's broken records take on a sinister air; you begin to wish that the avalanche could be stopped. But no avalanche has ever

paused in its course in order to give us time to examine it, so we seem to be stuck with this one. It is shaping the character of art today, and it is shaping all of us who deal with art today whether we are artists, critics or public.

This may be lamentable, but it is also natural—if we assume that art is always shaped by its time, must reflect its time. Our time is such that art must be shaped—maimed, if you wish, for maiming is a kind of shaping—by the same things that shape, or maim, our lives.

What we can hope, even against much contrary evidence, is that when all the ruckus has died down and our decades have been subjected to the famous weeding-out of time, the residue may be creditable to us. We can believe that the sightseers at the Metropolitan last Sunday included some neophytes who

had never known what Rembrandt means, who began their discovery on that visit, and who are the only ones who count. We can believe that among all the people who buy art books and sit through art lectures there is a fraction that thinks instead of soaking in a cultural bubble bath.

All the mess of mumbo-jumbo, hoopla, and follow-the-leaderism has one great encouraging characteristic: it boils. It boils harder and harder year by year, which means that there is true fire somewhere. It might purify itself by boiling, who knows?

This is argument by metaphor, which is always a dodge, and prophecy by hope, which is never to be trusted. But it is a cheerful way to approach the end of the year.

November 26, 1961

## Businesses Turn to Art Works To Brighten Offices and Plants

### By GEORGE AUERBACH

Art collections, once the domain of museums and wealthy patrons, are now being displayed in offices and even in industrial plants. Several concerns are using reproductions of classic works, etchings and original paintings to create an informal atmosphere or to individualize an area.

Coupled with the increased demand for art work is a greater availability of reproductions and original paintings. Many museums rent pictures, and numerous companies produce quality reproductions of masterpieces.

Pictures for Business Corporation

has been formed to assist architects and organizations in selecting and farming works of art. Among the concern's clients are the Bethlehem Steel Company, the American Telephone and Telegraph Company, the Colgate-Palmolive Company, the McGraw-Hill Publishing Company, the Hanover Bank and the First National City Bank.

Pictures for Business has organized more than 100 collections of paintings and prints. The subject of the art work, the colors used in the paintings and the frames are selected to blend with the interior decor of the office and the taste of the person working in the area.

### Work Areas Decorated

While most of the art is destined for offices, several concerns have recently requested paintings for general work areas in their plants, according to Fred Rosenau, president of Pictures for Business.

One of the reasons for the spurt in demand for art in executives' offices, he says, is that many companies have moved into new buildings, where little emphasis is placed on individual taste. In order to relieve the monotony, many companies hang pictures, creating an informal or personalized atmosphere.

Pictures also can be used to alter the apparent dimensions of a room. A vertical shape can make a short wall appear longer. A low ceiling may be heightened by a horizontal picture. A good deal of red coloring in a painting will make a large space

appear smaller. Landscapes or sea scenes that give an illusion of depth induce a feeling of increased space.

The company offers four types of art work in as many price categories:

¶ Reproductions of watercolors and oils in frames, $25 to $50 each.

¶ Original graphic works such as woodcuts, lithographs and etchings done by contemporary artists, $50 to $100.

¶ Watercolors or small oil paintings by known artists, $150 to $500.

¶ Oil paintings by recognized artists, $500 and up.

The company has an inventory of thousands of prints and has set up a model executive business area at its headquarters, 745 Fifth Avenue, for displaying the art work.

February 4, 1962

# Cultural Centers Are Springing Up in Cities Big and Small

### Sixty-nine Localities Planning Projects for the Arts

Rising public interest in the arts has resulted in a cultural building boom across the country.

A national survey finds some form of building activity con-

nected with the arts planned or under way in sixty-nine cities and involving about $375,000,-000.

The survey, conducted by Arts Management, a trade publication, indicates that the projects consist mainly of museums, theatres and concert halls.

The cultural developments range from Manhattan's $142,-000,000 Lincoln Center for the Performing Arts—the largest

and most costly of all the projects—to a $10,000 art center in Key West, Fla.

Trenton, N. J., is the latest city to join the culture boom. Plans were announced last week for a $6,000,000 development sponsored by the New Jersey State Department of Education.

### Project on 11 Acres

The project, which will be known as the New Jersey State Cultural Center, will contain a library, a museum, an audi-

torium and a planetarium. Frank Grad & Sons are the architects. The building site consists of nearly eleven acres fronting on West State Street in Trenton, near the route of the proposed John Fitch Expressway along the east bank of the Delaware River. The project is scheduled to be completed early in 1964, in time for the New Jersey Tercentenary.

A $30,000,000 National Cultural Center for the performing

Arts is planned in Washington. The Federal Government will provide the building site, but Congress has stipulated that the construction money must be provided by public donations.

A national fund-raising campaign, headed by Mrs. John F. Kennedy and Mrs. Dwight D. Eisenhower, is scheduled to begin Nov. 15. Half the proceeds may be kept by participating cities for their own cultural programs.

### Center in Syracuse

The completion of the first phase of a $24,000,000 music center in Los Angeles is scheduled late in 1963. The first section of the project will be a 3,310-seat symphony hall, called the Memorial Pavilion. In addition there will be two theatre structures.

Half the $24,000,000 construction cost is being met by public donations, the other half by the County of Los Angeles. The building site is a seven-acre tract bounded by First, Hope, Temple and Grand Streets.

A cultural center will be part of an urban renewal program being planned in Syracuse, N. Y. A $700,000 center for the arts and sciences is planned in Peoria, Ill.

Winter Park, Fla., is planning a theatre, museum and concert hall in a single structure that will cost nearly $2,000,000.

Laramie, Wyo., Hartford, Conn., and San Leandro, Calif., are planning art centers, and cultural projects are also planned in Odessa, Tex., Gadsden, Ala., and Tenafly, N. J.

Thirty-four of the sixty-nine cities participating in the cultural building boom are planning museums or have them under way. Oklahoma City is planning a combined arts and science museum. Tampa, Fla., will have a new children's museum and a museum devoted to the American Indian is planned in Quincy, Ill.

#### Concert Halls Planned

Concert halls are planned or under construction in thirty of the sixty-nine cities. A number, such as those in Baltimore and St. Petersburg, Fla., are part of civic centers. Others, such as those in Hartford, Conn., and Lakeland, Fla., are connected with colleges.

Twenty-eight cities have theatres in the planning stage or under construction. Framingham, Mass., for example, is planning a permanent theatre-in-the-round. Salt Lake City, Utah, is spending $1,250,000 on a new theatre; Asheville, N. C., $500,000, and Ypsilante, Mich., $400,000.

A great deal of money also is being spent to remodel and enlarge existing theatres, concert halls and museums. Theatres are being remodeled in Savannah, Ga., and Beckley, W. Va. The arts center in Tacoma, Wash., is being altered and refurnished. Museums in Greensboro, N. C., Grand Rapids, Mich., and Colorado Springs, Colo., are being expanded.

July 29, 1962

---

# Cultural Councils in 13 States Reflect an Upsurge of Interest

## Coordinators of Local Projects Divide on the Relation of Subsidies to Private Support.—U.S. Aid Favored

### By MILTON ESTEROW

A growing number of state councils on the arts, to provide cultural opportunities in thousands of communities, are developing throughout the nation.

Thirteen states, reflecting the national upsurge of interest in the arts, have such groups or plan to establish them, according to a survey by correspondents of The New York Times. Most of the councils have been formed in the last three years.

The councils are established by state legislatures to raise artistic standards and increase public exposure to all the arts. Some use state funds; others believe their main duty is to spur private patronage.

Stimulants to the councils have included President Kennedy's support of the arts, the rise in leisure time and an increasing respect for the role of the arts in a democratic society.

The states that have councils or plan them are New York, California, New Jersey, Connecticut, North Carolina, Michigan, Minnesota, Missouri, Ohio, Nebraska, Nevada, Washington and Virginia.

The councils vary from 11 members to 100 and include leaders in the arts and in business.

### Work in Localities

The councils are stimulating arts activities locally, spurring the establishment of community groups and bringing live performances to people who have never had an opportunity to see them.

The Federal Advisory Council on the Arts, which President Kennedy established last week, is expected to stimulate the council movement further.

In addition, Senator Jacob K. Javits of New York and nine other senators have introduced a bill to grant up to $100,000 annually to states that have set up arts councils.

The bill, first introduced in 1957, is in committee. Senator Javits said yesterday that the bill's chances of coming to the Senate floor were excellent. "Action on the floor," he explained, "depends on recommendations made by the President's Advisory Council." But there is pessimism about the bill's chances of passing the House.

Some governors believe arts councils are not the responsibility of state governments. A number of states are still considered "cultural dust bowls."

A correspondent of The Times in Wisconsin reported: "No state program for support of the arts is contemplated here. People are struggling to convince the Legislature that support of schools is a legitimate concern of the state."

One of the most significant contributions is being made by the New York State Council on the Arts, which was established three years ago at Governor Rockefeller's request.

The state council has supported extended tours by organizations such as the Phoenix Theater, the New York City Opera Company and the Buffalo Philharmonic. Its budget this year is $653,000.

### State Guides Others

John H. MacFadyen, the council's executive director, said the council received frequent requests from other states for information on setting up a program. He has prepared a guide outlining it.

"Each state has its particular artistic identity, and to this extent the programs that emerge will naturally differ," Mr. MacFadyen said.

In California, a bill to establish a fine arts commission is expected to pass the Legislature. The measure, modeled on the New York State Council, is supported by Gov. Edmund G. Brown.

Economy has influenced legislators to favor state assistance to the arts. Unions affected by the movie slump have argued that state and community help for theaters would ease the Hollywood recession.

A Connecticut bill creating a state commission on the arts was signed into law on June 6 by Gov. John Dempsey. The 15 members will survey public and private cultural facilities in the state.

In New Jersey, Gov. Richard J. Hughes recently named an 11-man commission to study the arts. Members include the artist Ben Shahn and the playwright Selden Rodman. The state's first cultural center, which will cost $6,000,000, is being built in Trenton. It is scheduled for completion next year.

For many years, North Carolina has considered support of the arts a vital concern. It owns and supports an art gallery in Raleigh and has contributed to the North Carolina Symphony Orchestra and subsidized outdoor dramas.

The General Assembly of North Carolina is considering a proposal to appropriate $325,000 for a school for the performing arts.

The proposal, strongly supported by Gov. Terry Sanford, is said to have a better-than-even chance of acceptance. The state school for music, dance and drama would operate at the high-school and college levels.

In Missouri, Gov. John M. Dalton named a 25-member arts committee last December. A bill has been introduced in the Legislature to create a Missouri Council on the Arts.

In Minnesota, the Legislature has rejuvenated a lagging arts

program that is 60 years old and has passed a State Arts Council bill.

Kentucky has a varied program—all instituted since 1960. Through the State Council on Public Higher Education, the state contracts with the Louisville Symphony Orchestra—at $50,000 annually—for performances at state colleges. The Lexington Little Symphony, backed by state funds, plays in small cities in cooperation with local civic groups.

The Kentucky Council of Performing Arts was recently set up.

Michigan established a cultural commission in 1960, and it now has 100 members. William E. Stirton, a vice president of the University of Michigan who was serving as chairman, resigned in January, but he has continued his interest in the commission's activities.

Mr. Stirton said the commission had helped in establishing

an artist in residence—a pianist —in Flint, and had encouraged communities to hold concerts and to develop arts centers.

In Virginia, the Barter Theater at Abingdon has received an annual appropriation of $12,-500 to $15,000 for many years.

The Virginia Museum of Fine Art in Richmond sends "artmobiles" with exhibitions to cities and towns. The museum helps plan programs through a statewide Confederation of the Arts established two years ago.

Nebraska created the Council for Nebraska's Cultural Resources in 1961. Its financing has come through private subscriptions and donations from individuals and corporations.

Dr. Walter Militzer, chairman of the council and dean of the University of Nebraska's College of Arts and Science, said that "at this point the council is a state coordinating agency for various local groups in cultural pursuits."

In Nevada, Gov. Grant Sawyer is appointing a 10-member committee to determine possible steps toward a program. Dr. Craig Shepherd, head of the University of Nevada's Art Department, will be chairman of the council.

Washington created a state arts council in 1961, but only $2,000 has been appropriated for the next two years.

In Ohio, a bill to create an Ohio Arts Evaluation Commission to help in determining the role of state agencies in the growth of the arts is being considered in the Legislature.

"It has not yet been conclusively determined that new government support for the arts will be truly effective," Mr. MacFadyen said. "However, I believe that if this support develops with sound artistic objectives, a significant contribution to the arts in America will follow."

June 17, 1963

# EVERYBODY IS IN THE QUEUE

THE CULTURE CONSUMERS: A Study of Art and Affluence in America. By Alvin Toffler. 263 pp. New York: St. Martin's Press. $5.

### By ROBERT LEKACHMAN

IN Houston last October a dozen affluent Texans pooled $100,000 in a venture called Art Investments, Ltd. Their intent, as Business Week reported it, is to "combine their own cultural betterment with a chance at financial gain." Their initial acquisitions include eight paintings and a metal sculpture which in due course they hope to sell profitably, using the proceeds to purchase new items rich in cultural interest and growth potential.

In New York City the $160 million complex of arts buildings grouped in Lincoln Center moves toward completion to the accompaniment of the usual din from construction workers and the increasingly familiar shrieks of anguish from musicians and arts executives discontented with acoustics, ticket prices, lease arrangements, space, or all four. In Winston-Salem, N. C., and St. Paul, Minn., and at least 123 other communities, active Arts Councils run coordinated drives, often on Community Chest principles, for the support of local theater and music groups.

Culture as an industry has arrived. On the principle that what interests us nationally must be measured, the researchers have gone to work. This year at its Christmas meetings, the American Economic Association will take official note of the performing

arts as an economic phenomenon with the presentation by two well-known Princeton economists of a paper entitled "The Economics of the Performing Arts." The same economists are working on a full-scale study supported by the Twentieth Century Fund. Over the last two years the Rockefeller Brothers Fund has kept 30 panelists at work— among them businessmen like Devereux Josephs and Stanley Marcus, theater people like Norris Houghton and Louis Kronenberger, and cultural entrepreneurs like Samuel Gould— discussing the place, function, and financial support of performing arts institutions. Their book-length report is expected in February.

What is the market? Buying the tickets are hordes of college students who often have available to them lavish theaters and auditoriums constructed under university auspices. Also buying are very large numbers indeed of ordinary Americans. It is likely that attendance at concerts, recitals, ballet and dance performances, plays, operas and art exhibitions rises each year faster than either population or income. Up-to-date corporations, eager to attract young executives to their outlying plants, frequently stress, and sometimes create, appropriate esthetic amenities. In the more affluent suburbs the public schools traffic more and more briskly in music and art.

And we know that not all of this huge market is simply listeners and watchers. Little-theater groups, amateur orchestras and chamber ensembles, choral singers and Sunday painters are legion in the land. The purveyors of art books, painters'

supplies, ballet costumes and musical instruments accordingly rejoice.

What does it all mean? Taken at face value, this ever-expanding market for "culture" is a deeply cheering sign that education and affluence have stimulated in middle-class and upper-class Americans a yearning for artistic experience. Instead of simply piling up still more material possessions, they seek instead to improve the quality of their lives. In this quest they are willing to open their minds and their senses to such novel experiences as contemporary painting and electronic music. Thus in criticism of the dejected English aphorism "more means worse," "more" means larger audiences willing to expose themselves to artistic experiment, eager to learn from the exposure and capable of developing sophisticated tastes for art, music, and drama.

OR this is the line taken by Alvin Toffler in his unpleasantly titled but extremely useful journalistic survey of the market for culture, "The Culture Consumers." The evidence, he alleges, all goes to prove that the quality of artistic artifacts has steadily risen as the quantity of cultural experience has grown.

Mr. Toffler cites the high quality of American long-playing records, the very wide repertory of recorded music (the revival of Baroque music is the famous instance) and the fine monaural and stereophonic equipment installed in many homes. He points to the tremendous circulation of respected books in paperback, the increasing boldness of concert programs out-  *(Continued)*

---

*Mr. Lekachman, professor of economics at Barnard College, wrote "A History of Economic Ideas."*

side of New York as well as inside, the wide popularity of American performers in other countries (even France), the innovating activities of some of the amateur theater groups and the world-wide triumph of American abstract expressionism, which has made of New York City the painting capital of the world. Sketchy, allusive and impressionistic as much of Toffler's evidence has to be, the case has its impressive points.

The opposite of the Toffler view is the traditional aristocratic suspicion that when the middle class becomes interested in the arts it is not the middle class that is uplifted but the arts that are degraded. Of what avail is the magnificently equipped university theater if it is used to put on "Mary, Mary," a current favorite of college groups? Why bother to construct a Repertory Theater at Lincoln Center in order to produce Arthur Miller's "After the Fall," which any Broadway entrepreneur would willingly have merchandised? If the New York Philharmonic sells out, is it because the new esthetes bring their scores, listen critically to the performance and apply what they have learned to their own musical groups, or because all the world loves a celebrity and "Lenny" is unmistakably a king among celebrities?

Why rejoice in the figures of museum attendance when the Metropolitan vulgarly advertises the enormous price that it paid to acquire Rembrandt's "Aristotle Contemplating the Bust of Homer"? Did the crowds which dutifully filed by it attend because they were impressed by the large financial outlay for a piece of colored canvas? Or did they come because they judged Rembrandt, Aristotle or Homer, or all three, to be "personalities"? After their several seconds of contemplation, how many of the viewers sought out other Rembrandts? How many returned to the museum another day? Were some impelled to pick up Aristotle's "Poetics" or Homer's "Iliad"?

When art becomes one more of the ploys of a bored society, the temptations placed before art's creators and servants are deeply subversive of art's purposes. The fashionable painter and the fashionable performer pander to their audiences. Even the writer, poet or musician in dignified residence on the college campus is diverted from his proper work by lectures, conversations and demonstrations, and still more by the easy praise and adulation of the young.

The pampered, prosperous artist is unlikely for long to be a good artist, for most good

modern art implies alienation. It follows that the artist who becomes a good, responsible citizen, a resident of the fashionable suburbs, a canny manager of an investment portfolio, soon ceases to create art.

And finally the pace of corruption has been accelerated by the operations of the mass media. The Time-New Yorker tone of blasé sophistication conveys the middle-brow's weekly reassurance that he really knows all that he needs to know about painting, sculpture, drama and music. In the meanwhile, a serious periodical like Odyssey stops publication for want of subscribers. The new patron of the arts consumes "experience" as he munches breakfast foods: the irritants have been removed from both. Ill-educated palates crave pap. The mass media obligingly "process" an endless quantity of "material." So runs the tale told by the critics of.

---

### The New "Literates"

THE rise of a mass public for the arts can, in its way, be compared with the rise of mass literacy in the 18th century in England. It must have amused the nobility to find their social inferiors struggling with their ABC's. Yet mass literacy has been one of the really fundamental advances achieved by mankind in its long and gory history. The rise of interest in the arts by a mass public in the United States could, despite all the humor it provides to the caricaturist and the critical "establishment, despite all the tinsel and tomfoolery it entails, herald something quite important in the social development of modern man.— "The Culture Consumers."

---

mass culture, and the outraged prophets of "mid-cult."

For my part, I am unhappy with both of these polar positions. Simple conclusions are probably wrong conclusions when the range of issues is so bafflingly wide, the country so huge. There is, to begin with, the central distinction between creation and performance. As a nation we are notoriously proficient in the engineering techniques which insure higher-fidelity phonograph reproduction and dramatic stage lighting— although we seem not yet to have mastered the science of acoustics. It remains to be demonstrated, except perhaps in painting, that we are equally capable of providing the environment in which artistic and

musical creation flower. Much of the evidence in Toffler's brisk trot through the arts concerns the technical quality of performance, the enlargement of physical facilities and the spread of such new organizational devices as the arts council and the cultural center, not the creation of new music and drama.

At the heart of creation is mystery. Thus it is likely that we shall never have very good luck in defining the environment most favorable to the production of masterpieces. Great art has in the past been produced under the auspices of religious and aristocratic patrons. It has been written or painted as well by the destitute; Rembrandt appears to have painted as well in prosperity as in bankruptcy; as a titled aristocrat, Leo Tolstoy had to create around him a highly artificial poverty. We really don't know whether prosperity or poverty best favors art. It all seems to support the Yiddish proverb, "'for example' is not an argument."

Even the more accessible issues are tricky to analyze. What should we know in order to reach sensible conclusions about the meaning of the boom in culture? Most simply we need to know more about the people who go to the plays, exhibitions, concerts and recitals.

HOW often do they go? Does interest in one art generally lead to interest in others as well? Is there a tendency for the same people to increase the amount of their participation or to decrease it after a time, possible in favor of another hobby? How many of the spectators are also amateur performers? How much trouble do the concert audiences take to hear new music and to understand what they hear? Are the theater groups content to produce, year after year, Broadway hits of various vintages or do they experiment with Brecht, Beckett and Ionesco? Do the amateur music groups steadily improve in technique and expertise or do they loyally repeat the same chestnuts season after season?

We are dealing with one sort of audience for the arts if the largest part of it consists of restless, changeable and replaceable occasional visitors to the temples of music and drama; but an entirely different audience if its members consist substantially of men and women whose interests and perceptions sharpen with experience, training and comparison.

It would be foolish to deny that much in American life favors the less cheerful of the two possibilities. As a people

we are impatient and have a weakness for novelty. The gratifications of art may come too slowly and too hard for those among us who have been encouraged to believe that learning is easy. The very accessibility of art has had the paradoxical effect of reducing its importance. One sign of the ailment is the exhibition of Michelangelo's "Pieta" in the Vatican Pavilion at the New York World's Fair. Inevitably the great work of art was cheapened by the blatant commercialism which was its background.

WHEN paintings line the walls of banks, they become office furniture. When classical music soothes riders in automatic elevators, art becomes

therapy. Art, like religion, like intellect, stands in danger of conversion into the instrument of lesser goals than its own: social status, mental health, even commercial advantage.

Still, this cannot be the end of the matter. For some, the boom of interest in the arts may indeed be as empty of real meaning as were some aspects of the recent "religious revival." But it is also possible that for others, the new attachment to the arts may be an expression of discontent with the flow of ordinary experience, a search for the intensity and the form which are missing in the American social landscape. The civil rights movements and the Peace Corps have expressed the aspirations of the idealistic young.

If it is conceded that even their affluent parents possess souls and immortal longings, then art, music and theater represent more than a fashion in consumption or an opportunity to join "cultural betterment and financial gain."

The argument is open rather than closed. Just possibly we are advancing in the direction of the Great Audience which is appropriate to the Great Society —an audience whose knowledge expands from year to year, whose sensitivity deepens with experience, discussion, training and reflection, and whose openness to new modes of expression continually increases. Such an audience would certainly contain many amateurs of nearly professional skill. At best

the dialogue between the professionals and such amateurs might stimulate alike the creativity of the professional and the critical enjoyment of the amateur.

Alternatively the boom in culture may turn out to be just that — a sheerly quantitative phenomenon, a fad in consumer expenditure fairly comparable to the vogue for professional sports and vintage wines, a status indicator for the comfortable middle class akin to the sports car and European travel, a product to be merchandised like Grand Rapids Scandinavian or Stockbrokers' Tudor. The outcome is uncertain. That, possibly, is a very cheerful thing to say.

December 13, 1964

# 70,000, Yes 70,000, Hear Philharmonic in Park

**By HAROLD C. SCHONBERG**

Last week, officials of the New York Philharmonic were a little worried. They were afraid that only a small audience would turn out in Central Park to hear the orchestra play the Beethoven Ninth, under the stars in the Sheep Meadow.

Hah!

Around 8 last night, from Columbus Circle to West 72d Street, from the Plaza to East 72d Street, in they poured. They came toting blankets, babies, pushing baby carriages and escorting dogs.

They came singly, in big parties and arm in arm. They plopped down, some with picnic baskets, and made themselves comfortable.

Young women nestled in the arms of their young men. Battery radios were put into play to while away the time. But from these radios did not come rock 'n' roll, but Vivaldi, Haydn, Schubert. The earliest arrival turned up around 4 P. M. but nobody could point him out. By 8 P. M., he had long been swallowed up by the crowd.

Refreshment stands were

doing a rush business. Hawkers were selling plastic pillows for 50 cents and getting rid of quite a few. People kept coming and coming, picking their way carefully over other people. It was like Coney Island. The policemen on duty—and half the force seemed around—were goggle-eyed.

"I never seen anything like this," one said.

By the time the concert began, the Sheep Meadow was well packed. Charles H. Starke, Director of Recreation of the Parks Department, estimated a turnout of 70,000.

Some policemen thought he was being conservative. Others thought he was padding a bit But no matter how you looked at it, there were an awful lot of people.

The program pulled no punches. It consisted of the first performance of William Schumann's "Philharmonic Fanfare," Wagner's "Meistersinger" Overtime and the Beethoven Ninth. William Steinberg conducted the orchestra and the Manhattan Chorus, and the vocal soloists were Ella Lee, Joanna Simon, Richard Casilly and John West.

August 11, 1965

# New, Newer, Newest

**By JOHN SIMON**

"SPEED KILLS!" is the drug-traffic signal displayed on many walls with which Kilroy tries to head us away from methadrine. But an even more dangerous killer is our living speed itself, the speed with which we embrace and drop fashions, tastes, beliefs; the tempo of our race through esthetic and spiritual environments for the sake of being contemporary, mod, now—with it, ahead of the game, out of sight. But there is just as

little sense in outrunning the Joneses as in keeping up with them; in either case, we are living our lives to impress others, instead of to express ourselves.

Most of us would resent being called cultists, yet we are sectarians and victims of the Cult of the New. We want the latest models of cars and clothes, this year's hit songs and school of painting. In automobiles and other technological commodities the new model may indeed introduce significant improvements, though more often than not it is just a new line here, an additional gadget there. The master-car, the Rolls-Royce, changes minimally, if at all, from year to year. Clothes, particularly women's, change radically but pointlessly every year. Just when we get used to the miniskirt, we must learn to love the maxi, both of which may coexist while anathemas are hurled at the midi. That, of course, will be next year's fashion. At least these changes are insignificant and seldom irreversible; indeed, reversibility is what they depend on.

But when we come to art—and I don't mean pseudo-art, like pop music—this greed for the new becomes disastrous. And it cannot all be blamed on the producers and middlemen; a large part of the guilt is the consumers'. For in the arts, as elsewhere, the obsolescence is built not so much into the product as into the consumer's mind. It is there that, thanks to various overt and covert forms of advertising, the "new" has been implanted as an end in itself. And a very convenient criterion it is for minds that neither know nor care much about the arts; for whereas it is extremely hard to determine what is good and what is bad, anyone can distinguish the new from the old. The Theater of Cruelty succeeds the Theater of the Absurd, and is itself closely followed by the theater of improvisation whose heels are trampled by theater of mixed media, which is jostled by the theater of total participation and theater in the streets, which is tailed by theater in the nude.

In art, merely to enumerate all the movements that have cropped up since the still-surviving abstract expressionism would easily use up the rest of this column.

There are three main causes of this unappeasable itch for novelty. First, there is the snob value of the new, the one-upmanship in having already bought, read, seen, heard, smelled (there was a short-lived cinematic gimmick — smellies!) the latest thing. There is even something vaguely endearing about this: next to being creative and innovative, being a pioneer in recognizing and promoting significant innovations is held to be best. But there, alas, is the catch: the innovation has to be significant.

Secondly, there is the misunderstanding of the nature of art. Some confuse art with technology (this category, by the way, includes a good many so-called artists). Thus the new painting, which uses a shaped canvas, is seen as an improvement; the new sculpture is better because it moves — as if sculptures were supposed to race one another (some day, no doubt, this too will come); the new stage production is better because it uses mixed media—you get several genres for the price of one. This derives from equating an art form with a contraption, say, a television set, which may indeed be more useful for incorporating ultra high frequency; it is also the ultimate offshoot of that debased and debasing doctrine, "the medium is the message."

Art is also mistaken for news. In our news-oriented culture (which at all levels, tends to confuse information with gossip), it seems only natural that Clive Barnes should be a more important critic than Walter Kerr because you read Barnes the next morning, Kerr only next Sunday. By the same token, your television reviewers are becoming more important yet: you can have them the same night as the dramatic event. Least noteworthy is the serious, speculative critic, whom you might have to wait for as long as a month or more. What good is he, when the movie or play under discussion everywhere is the one that just opened?

The third, most crucial and disturbing, reason for the Cult of the New is boredom. The same boredom that lies behind far more distressing social ills: divorce, suicide, certain types of crime. One is tired of looking at the same kind of paintings, listening to the same kind of music, going to the same sort of shows. This, regrettably, is tantamount to being tired of the same partner in love, tired of the same *modus vivendi* within the law, tired of life itself. It is, ultimately, a failure of understanding and love; in our case, understanding and love of the arts.

In a recent interview in Book World, the novelist Doris Lessing remarked, "I tend to like slow-moving books, books that take their time and contemplate all the way through." Of course, such books also take the reader's time, but

the choice is painfully simple: either we create time, or our lack of time destroys us, turning us into automata or addicts, time-servers or good-time chasers. The test of a true work of art is that it does not tarnish: an opera like "Wozzeck" is good for any number of hearings; a painting by Rauschenberg or a sculpture by Oldenburg *should* bore us from the moment after we've looked at it, for it is a facade over a void. If within a short time we get bored with a work of art, either it is not a work of art or we are not art lovers. It is understandable that one of the creators of the most boring pseudo-art, Andy Warhol, should have praised the dullness of Albee's "Tiny Alice" in order to elevate boredom to a positive artistic value.

*

One of the big problems here is overabundance of money in hands short on culture and taste. This is particularly noticeable in the fine arts, where collectors like Robert and Ethel Scull have been leaping (to adapt a phrase of Harold Rosenberg's) from vanguard to vanguard, without showing the slightest resistance to any new movement. Such people turn art into a vulgar market place. There, as Hans Magnus Enzensberger has written, "the future of the work of art is sold before it has even occurred. What is steadily being offered for sale is, as in other industries, next year's model. But this future has not only always begun; it is also, when tossed out into the market, always already past. Tomorrow's esthetic product offered for sale today proves, the day after tomorrow, a white elephant, and, no longer sellable, wanders into the archives in the hope of the possibility that, 10 years later, it might still be palmed off as the object of a sentimental revival." And that is how camp is born —but that is another story and does not concern us here. (Enzensberger's important essay, from which I quote, is entitled "The Aporias of the Avant-Garde," and is reprinted in "Modern Occasions," edited by Philip Rahv.)

Observing that "the forcing of creation by promoters of novelty is perhaps the most serious issue in art today," Harold Rosenberg goes on to note, "Novelties in painting and sculpture receive notice in the press as new *facts* long before they have qualified as new *art*. . . . To deny the significance of the new product begins to seem futile, since whatever is much seen and talked about is already on its way to becoming a *fait accompli* of taste. By the mere quantity of interest aroused by its novelty, the painting is nudged into art history."

That is the art-as-news fallacy I spoke of before, at work with a vengeance. It is the dishonesty and suspect friendships of art dealers, the vainglorious inanity or sheeplike conformity of museum directors and curators, and the ignorance, gullibility, moneyed mindlessness of the collectors that bring about ultimate chaos. The buyers are not even able to recognize that most of

their novelties are really old hat. As Erich Kahler says in his important but little-known book, "The Disintegration of Form in the Arts," "Dada, this exuberantly inventive movement, uncommitted, flexible, humorous as it was, using all imaginable means of provocation, anticipated everything that today is carried out by pedantic bores." The same absurd, anachronistic state of affairs is noted in poetry by the British critic A. Alvarez, who comments on "the odd phenomenon of the latest avant garde being largely a rewrite of that of 50 years ago." No one, he says, exaggerating only slightly, is "bothered that Pound looms behind Charles Olson's shoulder and William Carlos Williams towers over Robert Creeley's. The stuff is felt to be modern simply because it *looks* modern. The avant garde is acceptable because it is essentially reactionary, harmless."

*

The line of defense against these abuses should be drawn, at the very least, in the reviews and critiques. The public is often just as willing *not* to be duped, but, untrustful of itself, it looks for critical spokesmen to bolster its conservative impulses. The critics, however, tend to fail it. The most insidious reason for this is what has aptly been named the Hanslick Syndrome. Eduard Hanslick (1825-1904) was a powerful Viennese music critic, now remembered mostly for his attacks on Wagner, which posterity has proved wrong. The majority of our critics — excepting the obvious lowbrows, and not even all of them —are afflicted with the Hanslick Syndrome. Turn to The New York Times, and you will see the wildest fatuities of a Ronald Tavel or Julie Bovasso hailed as delightful contributions to our drama.

Perhaps you will pardon me, therefore, if I reproduce here from memory (there is no written text) some of the words I improvised last March, upon receiving the George Polk Award for my film criticism. The audience included many reviewers for various mass media.

"In 1934, after a visit with the philosopher Henri Bergson, the great poet and critic Paul Valéry jotted down in his notebook: 'He too thinks of sensibility as a kind of resistance. I was surprised.' This aperçu is even more needed in 1969. We live in a time when critics are only too eager to jump on any avant-garde bandwagon that pulls up before their front doors. They are so afraid of becoming the laughing stocks of the future that they are perfectly willing to reduce the present to a bad joke. Although most reviews are written on wood pulp, they should be as carefully thought out as if they were committed to paper with 100 per cent rag content. This will not ensure the critic's rise from rags to riches, but at least the mind he'll save may be his own."

To be sure, this critical "resistance" must not be overdone. It would be just as deleterious to reject all new art out of hand as it would be to throw the old

overboard as if it were so much ballast. Back in 1918, one of the idols of today's American youth, Hermann Hesse, pointed out the absurdity of the categorical rejection of either the old or the new. The critic who nowadays wants to be fair to both, Hesse observed, has "a bitterly hard time of it. But why shouldn't critics have a hard time? That's what they are there for." What precepts can one give critics, even assuming that they wanted them? The basic critical method—perhaps the only one—is still, as T. S. Eliot put it, "to be very intelligent." But what about the public? Are there any practical hints for the audience?

Here, again, the solution is to think more about art, or not to think about it at all. If one's interests do not truly lie in the arts, there is no point in force-feeding oneself or allowing others to do it to one. In that case, though, one should abstain from pontificating, vociferating, and trying to dictate tastes.

One should content oneself with the old, much-maligned formula of "knowing what one likes," in whose name much less damage has been done than in that of liking what one thinks one ought to like. But if one is going to get seriously involved with the arts, even as an appreciator, one simply has to drink more deeply from the Pierian spring. And this, inevitably, means reading up on the arts, not just consuming them. Nothing is more meaningless than the ever increasing figures of concert, theater and museum attendance that the foundations are so fond of recording and crowing about. Exposure alone guarantees nothing; it is apt to be just another form of rubbing against, gaping at, and reaching out for the new, without absorbing anything.

The most probably useful thing the layman can do is to find two or three very different critics or writers on the art he is interested in, and, like any jury, decide on the basis of hearing out at least two sides of the argument. The only difficulty here is in finding a decent conservative critic of the art in question. Things have changed in a most remarkable way. The wholesale obsession with the new in the arts—as well as a generally much greater, though often merely neurotic, concern with the arts — has as its consequence that far-out avant-garde movements are no longer consigned (as until now, often unjustly, they were) to the lunatic fringes of art; rather, they have become the dead center, the very Establishment. When Thomas Hoving exhibits a huge monstrosity by Rosenquist in the Metropolitan Museum — where even genuine artists, if they were still living, have not been accorded such testimonials; when paintings by true masters such as Poussin and David are dragged down from their usual place to come and lend prestige to Rosenquist's mural, a piece of ill-painted poster art, as the most casual inspection of the sloppy application of pigment revealed; when Robert Scull, the owner of the picture, is, again unprecedentedly, invited to fill up the pages of the Met's Bulletin with uncritical praise of the modern masterpiece he owns — a radical change is upon us.

As recently as half a century ago, as large and important a group as the Surrealists still passed for artistic buccaneers and outlaws; now, however, any miniature movement, say, the light-show makers or the minimalists, is exhibited, sold, written about and extolled wherever you turn. The periphery and dark corners—where one is barely noticed, exhibited, subsidized, published, heard from—are reserved today for the conservatives: artists, critics, and scholars. I am not arguing that the conservatives in art are better than the radicals. But I am saying that until they too are heard from, the serious danger exists that our arts will become ever more frantic, psychotic, solipsistic and, above all, divorced from any relevance to humanity.

September 21, 1969

# It May Not Be 'High' Culture, But It Can Be Brilliant

**By JOHN LEONARD**

OF course, any new "season" is arbitrary. It is a declaration by entrepreneurs that they have concluded their packaging, and are open for business. The business is official culture.

Official culture may be—thank God, it often is—exciting, even brilliant. It isn't High Culture, because we don't have one, or anything that would be recognized as appropriately coherent and dignified by a Thomas Mann or a French Academician or a mandarin of ancient China—anything, that is, that constitutes itself as a legitimizing agency for art, ethics, and etiquette. What we have is the marvelous surprise performance, the jack-in-the-box of genius that pops (or Papps) up while we were otherwise attending to what we thought was our solemn duty.

Official culture is something that happens after 6 o'clock at night. It is a stately affair, for which the consumer is expected to dress up like a duchess or a penguin. "Art," wrote Edward Sapir in 1922, "may be made to mean divers things, but whatever it means the term itself demands respectful attention and calls forth, normally, a pleasantly polished state of mind, an expectation of lofty satisfactions." Exactly. "One old lady who wants her head lifted up wouldn't be so bad," said the late Flannery O'Connor, "but you multiply her two hundred and fifty thousand times and what you get is a book club." The consumers of official culture are a book club. A season is the box in which the book of the month arrives.

Official culture is good for us. We must believe this, or we wouldn't subsidize it. Most of the $80 million a year spent by the National Endowment for the Arts goes to official culture—to museums and theaters and opera houses and art galleries and symphony orchestras and dance companies. Then there are matching grants from state arts councils and civic organizations, from foundations and corporations. The apparatus of official culture is expensive. Although its custodians argue with some justice that more people go to plays, concerts, dance programs, museums and libraries than go to ball games, it still doesn't pay for itself. And so we help pay for it, not on the scale of, say, a Germany—or even, per capita, a Canada—but there wasn't even a National Endowment 11 years ago, so obviously we are serious. Official culture, like certain aircraft companies, is not going to be allowed to close out of town. It is perceived to be a kind of institutionalized schoolmarm, there to civilize the cowboys. But not to surprise or scandalize or threaten, which is what American art does at its exceptional best.

Why isn't official culture "high culture"? In preparation for the new season, I've been rereading Dwight Macdonald's "Against the American Grain"—a book scandalously out-of-print—with particular attention to his famous essay on "Masscult and Midcult." Published in Partisan Review in 1960, it stands up remarkably well. Listen:

"Masscult offers its customers neither an emotional catharsis nor an esthetic experience, for these demand effort. The production line grinds out a uniform product whose humble aim is not even entertainment, for this too implies life and hence effort, but merely distraction. It may be stimulating or narcotic, but it must be easy to assimilate. It asks nothing of its audience, for it is 'totally subjected to the spectator.' And it gives nothing."

And there is this footnote—with Macdonald, there is always a footnote—a quotation from T. W. Adorno:

"People want to have fun. A fully concentrated and conscious experience of art is possible only to those whose

lives do not put such a strain on them that in their spare time they want relief from both boredom and effort simultaneously. The whole sphere of cheap commercial entertainment reflects this dual desire."

By Masscult, Macdonald meant Norman Rockwell and Norman Vincent Peale, Leon Uris and rock 'n' rock, most of radio, television and the movies, "a vulgarized reflection" and "a parody" that competes with High Culture instead of paralleling it, as Folk Culture did before Masscult standardized it out of existence. Whereas "Midcult" — the Book-of-the-Month Club, the Saturday Review, "South Pacific," Herman Wouk, "Our Town," Pearl Buck, "Omnibus," etc.—is Masscult with "a cultural figleaf," "a tepid ooze," "a soft impeachment," the product of "lapsed avant-gardists who know how to use the modern idiom in the service of the banal."

It was Macdonald's fear that Midcult would swallow us up with its pieties, as Masscult sought to brutalize with formulae. His only hope was that a "new public for High Culture becomes conscious of itself and begins to show some esprit de corps, insisting on higher standards and setting itself off—joyously, implacably—from most of its fellow citizens, not only from the Masscult depths but also from the agreeable ooze of the Midcult swamp."

This, you will have noticed, is elitism, on the rocks. I rather like it. The terms work. In a 16-year hiatus, "the agreeable ooze" has taken over television and the movies. And a case can be made that official culture is itself Midcult. But what in fact is High Culture? At pains to define everything else, Macdonald was smoggy on his sine qua non: a muttered "emotional catharsis" here, an ad-lib "aesthetic experi-

ence" there, Periclean Greece, Elizabethan England, Stendhal, Baudelaire, the Impressionists, Stravinsky, Picasso, Joyce, Eliot and Frank Lloyd Wright.

But, hot-damn, the Sixties happened to Macdonald and the rest of us. Cultural coherence flipped out. Whatever perceptions we had of ourselves (sons of the Enlightenment, progressive, perfectible), whatever presumptions we indulged of our destiny as a nation (missionary of democracy, cop of the cosmos) took a brutal beating. Our leaders couldn't appear in public without getting shouted down or shot down. We couldn't win a war against a bunch of little people in pajamas. Our children despised us and lost themselves in rock music, in the raptures and terrors of drugs, in dreams of blood; high-class, middle-class, working-class, they were all longhairs—we couldn't see their ears, and if they hadn't any ears, how could they hear the eternal verities? High Culture was routed in the academy: Freud is a fink. Popular culture turned to cannibalism: Andy Warhol. The blacks stopped wanting any part of us. Women got uppity. Gays came loudly out of the closet. Athletes behaved like ingrates. Homegrown monks appeared on street corners peddling the nostrums of the East. Movies were dirty and the theater was abusive.

Critics like Irving Howe would say of the decade that "It *ordains* life's simplicity. It chooses surfaces as against relationships, the skim of texture rather than the weaving of pattern." Sociologists like Herbert J. Gans would decide that there are many publics and many "taste cultures," no one better than another: a high culture, an upper-middle, a lower-middle, a low, a quasi-folk, a youth, a black and an ethnic, even a "tourist" culture.

Howe sees a new sensibility impatient with ideas, with structures of complexity and coherence, with the habit of reflection, the making of distinctions, the weight of nuance. Gans thinks everything weighs the same, all choices are okay, only fuddyduddies have a hierarchy of values, "taste" is merely appetite. Macdonald, while condescending to review movies for Esquire, would probably deplore "punk rock." Meanwhile, other reviewers had to take television as well as movies seriously, and soup cans and graffiti as well. What other culture was there? Motion, disturbance, affinity, chance may not have been values, but they were facts.

High Culture was not, and never has been, a fact in this country. The closest we ever got to it might have been in the 1950's, when the little magazines of which Macdonald approves had pretty much a monopoly on elevated taste: Kenyon, Hudson, Sewanee, Partisan, Art News, Art, American Scholar, Dissent and Commentary. It was a High Culture of critics; the creators of that culture were almost entirely European.

Let's face it: a God in every one of Emerson's trees doesn't constitute High Culture. Neither does a "Moby Dick," a "Leaves of Grass," a "Huckleberry Finn," a "Great Gatsby," a "Sound and the Fury" or a "Sun Also Rises." Nor a Jackson Pollock or a David Smith or a Georgia O'Keeffe. Nor an Edward MacDowell or an Aaron Copland or a Leonard Bernstein. Nor an Edward Albee or an Arthur Miller or a Tennessee Williams or a Eugene O'Neill. Where's the cohesiveness, the glue of community, that would cause these idiosyncratic talents to adhere? They are schools from which nobody graduates, aberrations without antecedents. We have genius, not culture. We

have performers, most notably in dance, not theoreticians, structuralists. (Henry James, as ever, is the exception; had he not existed, High Culture would have had to invent him.) We surprise, instead of confirming. We export movies and jazz and bluejeans. We perfected musical comedy.

I don't find this depressing. A high, coherent culture didn't do much for Germany or France. The splendid Latin-American novel is so much dandruff on the epaulettes of a caudillo. The East specializes in cultural elitism and human misery. No one in Copenhagen knows where Kierkegaard used to live. Russians are silent, or exiled, or dead. Ours is the untidiness and the fertility of the compost heap. We would prefer not to be annoyed by our artists—we want from them a remedial seriousness, a program on public television—and as a result we are traumatized when they do something beautiful or dangerous. They owe us a trauma.

To be sure, the TV talk shows and the slick magazines and the college circuit and all the residuum strippers of Midcult threaten to gobble them up, not to mention theater parties and quality paperbacks and long-playing records and celebrityhood. Such swamps should be visited only by helicopter. Macdonald says of pay-TV: "The networks oppose this on philanthropic grounds—they don't see why the customer should pay for what he now gets free. But perhaps one would rather pay for bread than get stones for nothing."

Without meaning to be in any way counter-cultural, I think we should pay and get stoned. The season only matters insofar as it surprises with art, beauty, intelligence and a sneak attack on book clubs. ∎

August 29, 1976

# Suggested Reading

Arnheim, Rudolph. *Film as Art.* Berkeley, Calif.: University of California Press, 1957.

Bazin, Andre. *What is Cinema?.* 2 vols. Berkeley, Calif.: University of California Press, 1971.

Bentley, Eric. *The Life of the Drama.* New York: Atheneum, 1964.

Bloom, Harold, advisory ed. *The Romantic Tradition in American Literature.* A reprint series of 33 books. New York: Arno, 1972.

Bluestone, George. *Novels Into Film.* Baltimore, Md.: Johns Hopkins Press, 1957.

Brown, Milton W. *American Painting From the Armory Show to the Depression.* Princeton, N.J.: Princeton University Press, 1970.

Brown, Milton W. *The Story of the Armory Show.* Boston, Mass.: New York Graphic Society, 1963.

Bunnell, Peter C. and Robert A. Sobieszek, advisory eds. *The Literature of Photography.* A reprint series of 62 books. New York: Arno, 1973.

Burchard, John and Albert Bushbrown. *The Architecture of America, A Social and Cultural History.* Boston, Mass.: Little, Brown, 1961.

Capa, Cornell, ed. *The Concerned Photographer.* New York: Viking, 1968.

Chasins, Abram. *Music at the Crossroads.* New York: Macmillan, 1972.

Copland, Aaron. *The New Music, 1900-1960.* Rev. and enlarged ed. New York: W.W. Norton, 1968.

Craven, Wayne. *Sculpture in America.* New York: T.Y. Crowell, 1968.

De Mille, Agnes. *Dance to the Piper.* Boston, Mass.: Little, Brown, 1952.

Doty, Robert M., ed. *Photography in America.* New York: Random House, 1974.

Driver, Tom. *Romantic Quest and Modern Query: A History of the Modern Theater.* New York: Delacorte, 1970.

Dworkin, Martin S., advisory ed. *The Literature of Cinema.* Reprint series. Series I: 48 books, 1970. Series II: 15 books, 1972. New York: Arno.

Ellman, Richard and Charles Feidelson, eds. *The Modern Tradition: Backgrounds of Modern Literature.* New York: Oxford University Press, 1965.

Esslin, Martin. *The Theatre of the Absurd.* New York: Doubleday, 1969.

Gagey, Edmund M. *Revolution in American Drama.* New York: Columbia University Press, 1947.

Giedion, Sigfried. *Space, Time and Architecture: The Growth of a New Tradition.* Cambridge, Mass.: Harvard University Press, 1949.

Gottfried, Martin. *A Theater Divided: The Postwar American Stage.* Boston, Mass.: Little, Brown, 1968.

Hitchcock, Henry Russell and Philip Johnson. *The International Style: Architecture Since 1922.* New York: W.W. Norton, 1966.

Hoffman, Frederick. *The Twenties: American Writing in the Postwar Decade.* New York: Free Press, 1965.

Jacobs, Lewis. *The Emergence of Film Art: The Evolution and Development of the Motion Picture as an Art, From 1900 to the Present.* New York: Hopkinson and Blake, 1969.

Kazin, Alfred. *On Native Grounds: An Interpretation of Modern Prose Literature.* New York: Harcourt, Brace, Jovanovich, 1972.

Knight, Arthur. *The Liveliest Art: A Panoramic*

*History of the Movies.* New York: New American Library, 1959.

Kracauer, Sigfried. *From Caligari to Hitler. A Psychological History of the German Film.* Princeton, N.J.: Princeton University Press, 1947.

Kracauer, Sigfried. *Theory of Film: The Redemption of Physical Reality.* New York: Oxford University Press, 1960.

Larkin, Oliver W. *Art and Life in America.* New York: Holt, Rinehart and Winston, 1960.

McDonagh, Don. *The Rise and Fall and Rise of Modern Dance.* New York: Outerbridge and Dienstfrey, 1970.

McLanathan, Richard. *The American Tradition in the Arts.* New York: Harcourt, Brace, Jovanovich. 1968.

Maynard, Olga. *The American Ballet.* Philadelphia, Pa.: Macrae Smith Co., 1959.

Machlis, Joseph. *Introduction to Contemporary Music.* New York: W.W. Norton, 1961.

Mazo, Joseph H. *Prime Movers: The Makers of Modern Dance in America.* New York: William Morrow, 1977.

Moore, Lillian. *Artists of the Dance.* New York: T.Y. Crowell, 1938.

Morrison, Hugh. *Louis Sullivan, Prophet of Modern Architecture.* Reprint of 1935 ed. Westport, Conn.: Greenwood, 1971.

Mumford, Lewis. *The Brown Decades, A Study of the Arts in America. 1865-1895.* New York: Dover, 1955.

Pevsner, Nikolaus. *Pioneers of Modern Design from William Morris to Walter Gropius.* New York: Penguin, 1961.

Rosenberg, Harold. *The Tradition of the New.* New York: Arno, 1959.

Rosenberg, Harold. *The Anxious Object: Art Today and Its Audience.* New York: Macmillan, 1973.

Scully, Vincent. *American Architecture and Urbanism, A Historical Essay.* New York: Praeger, 1969.

Shattuck, Roger. *The Banquet Years: The Arts in France, 1885-1918.* New York: Random House, 1968.

Sontag, Susan. *On Photography.* New York: Farrar, Straus and Giroux, 1977.

Steichen, Edward. *The Family of Man.* New York: Simon and Schuster, 1955.

Terry, Walter. *The Dance in America.* New York: Harper and Row, 1971.

Terry, Walter. *Ted Shawn, Father of American Dance.* New York: Dial Press, 1976.

Thomson, Virgil. *American Music Since 1910.* New York: Holt, Rinehart and Winston. 1971.

Wilson, Edmund. *Axel's Castle: A Study in the Imaginative Literature of 1870-1930.* New York: Scribner's, 1931.

Yates, Peter. *Twentieth Century Music: Its Evolution from the End of the Harmonic Era into the Present Era of Sound.* New York: Pantheon Books, 1967.

# Index

218; responsibility of, 213; and role of literary critic, 249-251; stress on form in, 218; symbolism in, 216-217; and theories of writing, 211; use of obscene or blasphemous words in, 236

American music: changes in "Vocabulary" of, 143; and Ives, 141-142

American National Exhibition in Moscow (1959), 31-32

American National Theatre and Academy, establishment of, 365

*American Painting From the Armory Show to the Depression* (Brown), 9

American poetry: development of, 247-249; future masters of, 247-249; Lowell, Amy on, 190-191

American Russian Institute, 99

"American scene" cult, 20

American Society of Composers, Authors and Publishers, 137

American theatre. *See also* Theater. and Actors' Studio, 293-296; development of until 1920, 283-285; O'Neill's contribution to, 291-292

Anderson, Jim, 301

Anderson, John Murray, 172

Anderson, Margaret C., 194

Anderson, Maxwell, 282, 287

Anderson, Sherwood, 193-194, 207

Anderson Galleries, 12

André, Albert, 4

*André Kertész: Sixty Years of Photography,* 105

*Anna Christie* (O'Neill), 291

ANTA, 371

Anti-Communism, and U. S. I. A. withdrawal of sponsorship from art exhibit, 350

Antoninus, Brother, 248

Antonioni, Michelangelo, 335, 336, 339

Apollinaire, Guillaume, 45, 46-47, 59

"Appalachian Spring" (Copland), 134

Apuleius, 217

*Arabian Nights, The,* 217

Aragon, Louis, 45, 47, 48, 57, 58

Arbus, Diane, 104

Architectural League, Nervi exhibit of (1959), 81-82

Architecture, 66-98; attacks against modern, 95-98; Beaux Arts influence in, 66-68; eclectic revivalism in, 97; Fuller's influence of, 83; influence of Le Corbusier on, 68; "International" 71-73; Johnson's influence on, 86-88; McKim, Mead & White's influence on, 75-78; and Paris Prize, 67-68; Renaissance in, *see* Renaissance in architecture; Saarinen's influence on, 73-75; and Society of Beaux Arts free schools, 66-68; Sullivan's influence on, 78-81; use of reinforced concrete in, 81, 82

Architecture critics: of Bauhaus, 90-91; and Saarinen, 73-74

Architecture education, and Bauhaus, 91

Architecture exhibits: Berlin Building Exposition (1931), 70-71; "50 Years Bauhaus" (1969), 88; Fuller, R. Buckminster (1959), 83; Gropius, Walter (1931), 71; McKim, Mead, & White archives (1951), 75-78; at Museum of Modern Art (1932), 71-73; Nervi, Pier Luigi (1959), 81-82; Van der Rohe, Mies (1931), 70-71; Wright, Frank Lloyd (1930), 68-70

Arcimboldo, Giuseppe, 21

Argentina, 159, 160

"Aristotle Contemplating the Bust of Homer" (Rembrandt), 396-397

*Arja Da Capo* (St. Vincent Millay), review (1921), 195-196

Arnold, Edward, 276

Arnold, Matthew, 190

Arp, 22, 48

Arrabal, Fernando, 304

Art. *See also* Abstract art; American art. as aristocratic, 394; bought by corporations, 398; changes in, 32, 42; classification of, 22; depiction vs. decoration, 7; federal sponsorship of, 365; Futurists manifesto (1911), 2-3; growth of cultural centers, 398-399; and Guggenheim Foundation, 367-368; increased public interest in, 395; Los Angeles as new center of, 391; museum purchasing policies, 13; "official culture," 404-405; Post-Impressionists in 1912, 3-6; prices, at Armory show, 10; purged in Nazi Germany, 347; realism in, 101, 151; reproductions in Times supplement, (1914), 394; role of women in, 52-53; Socialist realism in, 349; in South, 393-394; three-dimensional, 38; WPA art museums in South, 387

Art centers, 64

Art critics: on adoption of abstraction by American painters, 26; and Black artists, 66; conspiracy in favor of art styles, 35, 36; and debate over modern art, 24-25; on New Art, 11; on O'Keeffe, 12; and photography, 108-109; protest letter against, 35; role of, 35, 36; on Shahn, Ben, 50; and status of abstractionism in art, 22

Art dealers: and American artists, 13; and Post-Impressionists, 4

*Art Digest, The,* 22

Art education, and ateliers, 66-68

Art exhibits: Albers, Joseph, (1949), 25; "American Abstract Expressionists and Imagists, 1961," (1961), 37; American National Exhibition in Moscow (1959), 31-32; at Autumn Salon in Grand Palais des Champs-Elysees (1912), 3-6; Baskin, Leonard (1962), 39-40; Ben-Zion (1948), 23; Blume, Peter (1961), 34; Brancusi (1916), 11; Braque (1924), 12; Burchfield, Charles (1961), 34; Calder mobiles (1939), 21; Carter, Clarence H. (1941), 21; Chagall, Marc (1941), 21; Chapin, James (1935), 20; "conceptualist" (1974), 61-63; Dali (1936), 21; de Kooning, Willem (1948), 23; Eakins, Homer, and Ryder (1935), 20; of eight American artists (1908), 2; "Fantastic Art, Dada, Surrealism" (1936), 20-21; Glarner, Fritz (1949), 25; Gleizes, Albert (1949), 26; Gorky, Arshile (1948), 24; Gottlieb, Adolph (1949), 25; Hofmann, Hans (1948), 23; Hoffman, Malvina (1919), 11; "Homage to Picasso" (1967), 60; Hopper, Edward (1930), 18; increased attendance at, 395; International Exhibition at Art Institute, (1913), 7; Kandinsky (1924), 12; Kees (1949), 26; Klee (1924), 12; Lichtenstein (1963), 41-42; Maillol and Rousseau (1924), 12; Marin (1920), 12; Menken (1949), 26; by Metropolitan Museum of Art, boycott of (1950), 27; Miller, Leon G. (1949), 25; Millman (1948), 24; Miro (1936), 21; Modigliani (1951), 28; Moholy-Nagy (1969), 51-52; Moore (1946), 23; Motherwell (1948), 23; murals of American painters (1935), 18-19; at Museum of Modern Art (1929), 14-15; of National Academy of Design (1927), 13; Newman (1951), 28; O'Keeffe, Georgia (1924), 12; Picasso (1915), 11; Pollock, Jackson (1949), 25; Post-Impressionists (1912), 4-6; "Problem for Critics, A" (1945), 22; Rauschenberg, Robert (1963), 40-41; record